MAKERS

MAKERS

A HISTORY OF AMERICAN STUDIO CRAFT

JANET KOPLOS AND BRUCE METCALF

THE UNIVERSITY OF NORTH CAROLINA PRESS CHAPEL HILL

A PROJECT OF
THE CENTER FOR CRAFT, CREATIVITY AND DESIGN,
HENDERSONVILLE, N.C.

© 2010 The Center for Craft, Creativity and Design, Inc.

Manufactured in China

Designed by Richard Hendel
Set in Scala and TheSans types
by Tseng Information Systems, Inc.

The Center for Craft, Creativity and Design has made every
effort to contact all copyright holders for objects reproduced
in this book. If proper acknowledgment has not been made,
copyright holders should contact the center. We regret any
omissions.

Following the *Chicago Manual of Style*, the names of most
art movements have been lowercased throughout.

The paper in this book meets the guidelines for
permanence and durability of the Committee on
Production Guidelines for Book Longevity of the
Council on Library Resources.

The University of North Carolina Press has been a
member of the Green Press Initiative since 2003.

Library of Congress Cataloging-in-Publication Data
Koplos, Janet.
Makers : a history of American studio craft / Janet Koplos and
Bruce Metcalf.
 p. cm.
"A project of the University of North Carolina Center for Craft,
Creativity and Design."
Includes bibliographical references and index.
ISBN 978-0-8078-3413-8 (cloth : alk. paper)
1. Decorative arts—United States—History—19th century.
2. Decorative arts—United States—History—20th century.
3. Art, American—19th century. 4. Art, American—20th century.
I. Metcalf, Bruce, 1949– II. University of North Carolina at
Chapel Hill. Center for Craft, Creativity and Design. III. Title.
IV. Title: History of American studio craft.
NK807.K67 2010
745.0973—dc22 2009042758
14 13 12 11 10 5 4 3 2 1

CONTENTS

PREFACE

Over the last 130 years, the crafts were rethought and revitalized not once but twice. The first instance, the Arts and Crafts movement at the end of the nineteenth century, involved a philosophical, aesthetic, social, and political response to the negative effects of the Industrial Revolution—from the horrors of child labor and environmental pollution to the disheartening production of shoddy and ugly goods. Exploration of the crafts by architects and artists led to a new valuing of these age-old genres for their utility and cultural symbolism as well as for the satisfying labor inherent in their production.

The Arts and Crafts era as a whole and the folk and ethnic crafts that subsequently attracted artistic appreciation have been studied by scholars and documented in exhibitions, catalogs, and books. The public has responded as well. Arts and Crafts artifacts—Tiffany glass and Stickley furniture, for instance—are enjoying wide popularity.

The second great period of change in the crafts, which began just after World War II, has not yet come to an end. This resurgence moved craft in the direction of design and, even more, in the direction of art's expressive and sociopolitical concerns. Many who were in the first wave of this change are still living, and two generations have come after those pioneers. This second craft resurgence has begun to receive its own analysis and measurement. The literature is growing exponentially, and material is available now that was unknown only ten years ago. Moreover, new funding for research and the recent establishment of a scholarly periodical (the *Journal of Modern Craft*) are encouraging additional study. While many gaps remain, the accumulation of scholarship calls for consolidation and review.

Makers: A History of American Studio Craft does that. This book is a five-year effort by an art critic and a studio jeweler. We make use of our deep experience and differing perspectives to look for the commonalities among craft mediums and their patterns of development. We draw on existing literature to consider why it makes sense to group these practices under the heading of craft, and we tell the story of many individuals who represent the larger phenomena.

The American Craft Museum's History of Twentieth-Century American Craft: A Centenary Project, regrettably unfinished, was an important precedent for this effort. Its books and exhibitions demonstrated a commitment to the "multivoiced and multileveled" nature of craft history, and its curators declared, "We are writing history with objects." Our approach is broader—the whole sweep from 1876 to 1999 in one book—and although we offer no exhibition, we, too, are devoted to objects. But not objects alone: we also recall the words of M. C. Richards, writing an exhibition review in *Craft Horizons* magazine in 1965: "We think about craft as if it were objects, forgetting [that] it's people, and pretending that we are not people reacting to them." She also said, "It is inexact and therefore uninteresting to ignore the fact that history evolves, that individuals evolve and so does their perception." The ceramic artist Jun Kaneko states the complaint in a different way: "The problem with art history and criticism is that it lacks the smell of human beings." Histories remind us of what came before and what remains the same. We need a history told in human terms.

Truly, *people making things* is what the craft field is all about. Our choice, therefore, was to take an approach uncommon in art history. We raise issues and describe events as they occurred in people's lives, not in the scholarly abstract. Every story in this book is bound up in a time, a place, a set of political and social conditions, and an aesthetic philosophy.

The first difficulty is defining terms. Craft is a broad category of handwork. Studio craft means handwork with aesthetic intent, largely or wholly created by individuals (usually art school or university trained) to their own designs. Craft is no more difficult to pin down than art is—which is to say, nearly impossible. We have operated using a blend of definitions, some historical and some current. One is based on materials: today the word generally applies to work in clay, fiber, glass, metal, and wood. Sometimes handmade paper and bookbinding are associated with the term (although neither is included in this text). Craft can also be defined by the use of certain techniques, such as throwing, turning, forging, or felting. It is also possible to follow self-definition: if jewelers think of themselves as craftspeople, then they are. One understanding of craft today is: a self-defined community oriented to specific materials and techniques, usually with an attitude of respect for both, and reliant upon handwork.

Unfortunately, none of these definitions is adequate. Craft materials are used in industry and art as well as in

studio craft, and techniques have the same multiplicity of applications. Neither does self-definition always coincide with objective observation, pro or con. Nor is function or utility a useful determinant, in the first place because there have always been craft objects for display and for symbolic purposes. Moreover, everyday needs have been met by industry since the middle of the nineteenth century, so even utilitarian craft today is made for philosophical and aesthetic reasons.

Craft is not a neat package with defined edges. It overlaps with design, fashion, art, and industrial and folk practices. That breadth may be taken, however, as a sign of its vitality and relevance, as can the fact that a great number of people who do not think of themselves as craftspeople are currently using craft materials, processes, or attitudes to create both art and design. Today artists build furniture, create laborious installations, or talk of bringing their work closer to life. Craft is already there.

We have taken a subjective but commonsense approach to using the word and to the range of work incorporated into the book. Louis Comfort Tiffany and Gustav Stickley appear in these pages although they were manufacturers; Mary Frank is included although she is a painter who created a single body of work in clay. Jeff Koons, however, is not treated—even though he has directed the fabrication of ceramic sculptures that have sold for high prices—because he lacks the direct contact with and respect for the material that characterize craft. We exclude kits or hobby practices that involve copying set forms because studio craft strives for originality. Traditional crafts may similarly involve repetition of precedents, yet there are makers who take the tradition somewhere new, and a few of those individuals are included.

While we have made an effort to acknowledge the broad scope of studio craft and the places where it overlaps other practices, the heart of the book is studio craftspeople. Studio craft emerged in the late nineteenth century and expanded rapidly after World War II. Study of the entire period discloses some surprises, such as the fact that immigrants have had a major influence from the beginning to the present (not just in the 1930s, as is sometimes assumed). Changing definitions and questions of the American character of the work have been frequent, even as craft has maintained a constant openness to interchange with other cultures. Women have played important roles—makers, teachers, dealers, collectors, administrators—at every stage, and they have created important work in craft even when their participation in other arts was curtailed by social convention. Other contraventions of accepted wisdom: individual creative work can emerge within a manufacturing context, and even a maker working alone constitutes a business.

The most important theme in this consideration of craft is probably its relationship, as a modern invention, to consumer society. In a world overfull of mass-produced goods, why would anyone want to make or buy handmade objects? As a field, craft proposes a range of answers to this crucial question. Over the century, there have been innumerable assertions of the value of handwork, some taking opposing viewpoints. As noted, studio craft can be regarded as a humane alternative to factory work. It can also be seen as a critique of the factory system and even of capitalism. At the same time, training in craft may prepare the individual to design for industry with sensitivity to material. It can be argued that studio craft encourages the making of objects that better respond to personal needs and desires than do mass-produced goods and that, as an instance of individual rather than standardized character, it advances the reform of public taste. Craft is also a form of personal expression and thus can invest meaning in an object. And of course craft can be valued as a satisfying process, or as an opportunity for manual virtuosity.

Studio craft has repeatedly offered an alternative way of life, starting during the Arts and Crafts movement, recurring in the Depression years and when servicemen returned from World War II, and taking new forms in the counterculture of the 1960s. A renewed interest in handwork—under the rubric DIY (for "do it yourself")—is expanding as we write. Attentive readers will notice other themes and issues emerging repeatedly. Over the decades, debates continue about the relation of studio craft to movements in modern art and design, and the shifting status of functional works in studio craft.

The various mediums have their particular issues—the emergence of distinct concepts within each and the growth and decline of particular mediums over time—yet clay, fiber, glass, metal, and wood share common concerns, such as the tension between urban and rural craft attitudes and practices. The participation of minority populations in every medium of modern craft shows how these groups changed old folkways (or invented new ones) to adapt to changing social conditions. All craft mediums have experienced revisions in craft education that have expanded craft's application and encouraged individual creativity.

As we examine the crafts over the course of the twentieth century, we look in particular at what distinguishes it from art, design, and popular culture. Its endorsement of traditional materials, techniques, and decoration suggests that these sources have not been exhausted and

retain potency. Craft recoups, revalues, and reclaims through its basic identity with materials and techniques. From that basis, the options widen.

Makers is intended to fill two needs. It is a reference book that can serve critics, collectors, or anyone interested in knowing more about the motivating ideas and stylistic currents that have led to today's crafts. It is also a survey that can add new dimensions to college-level programs on twentieth-century American art or material culture—as an accompaniment to existing courses or for new courses that focus on craft itself. The publication of this book breaks an impasse that has been noted for more than thirty years. Because craft was not included in art history curricula, there was not a tenured scholar of the field to write a history. Yet because there was no comprehensive textbook, it was dauntingly difficult to set up courses, even at schools that offered extensive studio coursework in craft.

The book follows a conventional chronological structure. It is organized by decades, and for the most part, artists are discussed and illustrated in the decade in which their most characteristic work was produced. That may be early or late in a career. Only a handful of individuals appear in more than one chapter. Of course, people do not live, work, and die in neat decade increments, so some fuzzy edges are inevitable in our mapping of the larger pattern. Furthermore, craft has not developed as a succession of masterpieces, and we have tried not to reduce this account to that false simplicity.

The book is the product of a very modest amount of primary research and a great deal of secondary study. Information on craft appears in widely scattered and ephemeral forms. This book pulls together more than a century of research and documentation, drawing on innumerable published sources. We acknowledge our indebtedness to this previous work, and we urge readers to make use of the endnotes along with the bibliography and other material on the book's website to tap deeper and more detailed veins of information.

There are, inevitably, large numbers of worthy works and gifted makers who do not appear here. Many more stories can be told. Some will be found on the website. Others await the efforts of new researchers who will add to this body of knowledge.

MAKERS

CHAPTER 1

THE ROOTS OF STUDIO CRAFT

The Industrial Revolution

Studio craft is a recent invention. It was shaped by a few English gentlemen as a protest against their own times. It is not a direct continuation of the old forms of craft, in which artisans supplied necessities for everyone, but began as a concerted effort to put pleasure back into work and to wrest *making* from the grip of the machine and reinvest it with humanity.

Such ideas were a consequence of industrialization and urbanization in Victorian England during a century of tremendous upheaval. The modernization of manufacturing, with steam-powered factories set up wherever coal could be provided, began in the late eighteenth century. Machines were designed to reproduce—and replace—the motions of hands. What was left to workers was the task of attending the machines, which was far less demanding of skilled techniques than individual craft work had been. Work, once a source of pride and personal identity, was reduced to dull and meaningless repetition.

These changes had enormous social consequences, and nineteenth-century England experienced them first. Families migrated to cities in search of paid work, so cities grew exponentially. In the factories, men, women and children as young as six labored up to sixty hours a week, often for pennies a day. Moreover, the benevolent institutions of rural life (neighbors, guilds, the church) broke down in the cities. There was no public education, no public health care, no pensions. The lack of public water supplies or sewer systems resulted in periodic outbreaks of cholera and other diseases. Rivers were little more than open sewers. Coal smoke was filthy, like smog but worse. There was no zoning: factories and housing occupied the same neighborhoods.

The responses to these appalling conditions took many forms. Novelists such as Sir Walter Scott found refuge in romantic fantasies about medieval Merrie England. Friedrich Engels and Karl Marx saw private ownership of the factories as the problem and called for the reordering of society under the principles of socialism. On the positive side, the Industrial Revolution made England the workshop of the world for much of the nineteenth century. The standard of living rose, even for the very poor, and the middle classes prospered.

Craft and Work

The old ways of manual production were pushed aside, one by one, as new machines were designed and new technologies introduced. Hand weaving was nearly eliminated by factory-made cloth. Natural dyes were replaced by aniline dyes made from coal tar. Hollow bowls and vases of silver and brass could be "spun" on a lathe instead of being hammered by hand. (Both processes require experience and skill, but spinning is much faster.) Wood moldings could be shaped by machine instead of being planed by hand. Glass was pressed into steel molds. These and hundreds of other processes transformed the production of most artifacts.

The nature of industry changed too. At the beginning of the nineteenth century, even mass-produced items were virtually one of a kind. But armies, for example, needed weapons with interchangeable parts to make battlefield repairs easier. Jigs and fixtures (tools that hold work in position for machine operations) were made, and patterns followed precisely. To ensure exactitude, one man operated a machine, performing the same task over and over. Standardization became a watchword of modernity.

Factory workers needed few skills and could easily be replaced by others, as if they were little more than flesh-and-blood versions of machines. Naturally workers grew alienated from their labor. Many critics assumed that division of labor was the culprit. But in most crafts labor had already been divided into various specialties. A sophisticated jewelry shop, for instance, would have jewelers, stone setters, and enamelists working side by side. None were qualified to do the others' jobs. The owner of a shop was often designer and salesman and sometimes handled the most difficult operations. Journeymen—employees who had passed an examination evaluating their skills—did most of the demanding handwork. The wife and children of the owner sometime worked too: some silversmiths' wives did all the polishing. Apprentices handled the lowliest tasks.

De-skilling, then, was a more likely cause of alienation than division of labor. In the most mechanized, least humane situations, factory owners exploited workers ruthlessly. That led to the poverty of the urban workforce and stimulated the Marxist rejection of private ownership.

Traditional crafts may have been most changed by the gradual shift to mass markets. In the old system, even if crafts were distributed widely, they were still supplied by small producers. The factory system, however, demanded a larger marketplace and a more efficient distribution system. Regional differences that had survived for centuries were erased.

The Origin of Arts and Crafts

The Arts and Crafts movement was inspired by the writings of three eminent Victorians: A. W. N. Pugin, John Ruskin, and William Morris. Each was a prolific writer widely read in his own lifetime. Their writings, which are both progressive and curiously backward-looking, give the crafts a philosophical basis, particularly since each insisted that design is not just an aesthetic enterprise but is inextricably connected to social conditions. All three hated the rapid industrialization and urbanization of nineteenth-century England and saw dire social and moral consequences. Each believed it impossible to have truly good design without simultaneously creating a better society. All three saw medieval England as a model, and yet each contributed ideas that became part of the foundation of modernism. Their ideas continue to resonate to this day.

Augustus Welby Northmore Pugin (1812–52) was the only child of a French-born designer who had immigrated to London. The elder Pugin designed Gothic revival furniture but was best known for illustrated books about French Gothic architecture. At the age of thirteen the boy was helping his father illustrate books, and at fifteen he designed furniture for the king's new apartments in Windsor Castle. Shortly after, he started his own business designing and making furniture, and expanded his interests to stage design.

In 1835, at twenty-three, Pugin converted to Roman Catholicism. As he imagined an ideal connection between the true religion (the Catholic church) and the true architecture (Gothic), he constructed an elaborate fantasy about life in medieval England, in which servant, master, and king were united in peace and harmony under a munificent church. He claimed that Catholic England was Merry England.[1] It was as if all the ills of the Middle Ages had never happened.

Pugin's most important book, *Contrasts; or, A Parallel between the Noble Edifices of the Fourteenth and Fifteenth Centuries, and Similar Buildings of the Present Day; Shewing the Present Decay of Taste*, was published in 1836. In it, he linked morality, good design and the Gothic style with a strong note of social criticism and disgust with the effects of industrialization. These were extraordinarily powerful connections. Even a century later, long after the Gothic style had been abandoned, good design was

THE SAME TOWN IN 1840

Catholic town in 1440.

FIGURE 1.1. *Comparison of a fictional "Catholic town in 1440" to the same town in 1840 in A. W. N. Pugin,* Contrasts *(1836).*

progressive ideas as well. He noted that medieval buildings revealed their construction materials; by contrast, neoclassical architecture in nineteenth-century Britain was often made of brick but faced with marble. He claimed that hiding the structural materials of a building (and, by extension, any object) was deceitful.

Pugin claimed the same superiority for truth to material that he claimed for the Gothic style, writing of one church that its inspirational qualities did not derive from "richness of detail, for they are remarkably plain for the most part, but it is owing to the *absence of all artificial resources, and the severity and simplicity in which they have been raised*; there is no attempt at concealment, no trick, no deception, no mock materials; they appear as true and solid as the faith itself."[2] Pugin observed that Gothic timber structures and pieces of furniture were often held together with "through tenons" and pegs, requiring no nails. (Iron was scarce in medieval England.) He was fond of the "tusked tenon," in which a wooden horizontal member passing through a vertical post was secured with a square peg or "tusk." (Figure 1.2)

Pugin's theories must be set against the theological and architectural disputes of his time. A moral value in "truth to materials" is not universally valid. Moreover, Pugin compromised his own doctrines when it was expedient. He designed a great deal of ecclesiastical metalwork, most made of alloys like brass or German silver (copper and nickel) but electroplated with gold or silver to *look* as if it were made of precious metal. In theory,

held by its proponents to have both a moral impact and an ability to improve life.

One illustration from *Contrasts* summarizes Pugin's arguments. (Figure 1.1) In this drawing he depicts a fictional "Catholic town in 1440" and above it "The same town in 1840." The "Catholic town" is a pleasant walled city, surrounded by fields and woods, with at least fourteen churches in view. The city's inhabitants are devout and prosperous, and the architecture is Gothic. The 1840 town, by contrast, is a place of discord and social disharmony. Factory smoke fills the air. There is an enormous prison and a lunatic asylum. The country church in the foreground has a new neoclassical wing and parsonage. An iron toll bridge crosses the river, which is lined with warehouses. Houses of worship for at least six different denominations are scattered around the city, and there is a "Socialist Hall of Science."

In naming socialism as a modern evil, Pugin displayed his political conservatism, but he endorsed some

FIGURE 1.2. *A. W. N. Pugin, designer, made by John Webb, London, Oak Table, ca. 1852. Carved and chamfered decoration; 30 × 45 × 29.5 in. (© V&A Images, Victoria and Albert Museum, London.)*

plating is a form of deception, but in the real world it can be a service to clients.

Pugin also declared that certain forms and processes should follow from the materials being used: "even the construction itself *should vary with the material employed, and the design adapted to the material in which it is executed.*"[3] This is how an engineer thinks; it has nothing to do with meaning or morality. In Pugin's time, however, design and architecture were not associated with engineering. At that time, to design meant to decorate, so to suggest that a designer should consider the structural properties of his materials was fairly radical. It was a modern idea.

A corollary applied to patterns. In the early nineteenth century sophisticated wallpaper design consisted of trompe l'oeil florals and repeated images of Gothic architecture in perspective. Pugin, however, believed that because a wall is solid and flat, wall decoration should never create an illusion of depth. He insisted that wallpapers be composed only of two-dimensional shapes and that those shapes be abstracted (or "conventionalized") so that they could never be mistaken for the real thing.

Pugin's legacy was complicated. From the time of his death in 1852, design reform in England was bifurcated. One side looked back to the Gothic; the other looked forward to revealed structure and materials, and increasing simplicity of decoration. Younger reformers agreed with his linking of social conditions and design, but this association creates a paradox: which comes first? If social improvement comes first, should a designer or craftsman turn to social agitation? Or should he believe in the reformative power of good design to initiate improvement in the lives of ordinary people? These questions would occupy theorists for the next century and would have a significant effect on the development of modern craft.

Pugin's legacy was taken up by **John Ruskin** (1819–1900), the only child of a prosperous and conservative Scottish wine merchant who lived near London. The family traveled often to the Continent and was also deeply religious. Ruskin learned Latin by the age of ten, and his first scientific paper, "On the Causes of the Colour of the Rhine," was published when he was fifteen. He could also draw and paint watercolors. His father hoped he would become a poet; his mother hoped he would become a clergyman. These factors—the comfort and insulation, religiosity, travels, and political conservatism of his upbringing—affected Ruskin's later thinking.

Ruskin's prolific writing career began with the two-volume work *Modern Painters.* By 1850 he was England's premier art critic, and in the 1860s he was one of the most widely read social critics of his time, in part because his writing was vivid, engaging, and persuasive. His contribution to the history of craft came from his writing about architecture. Ruskin was particularly fond of decoration—the carvings and capitals found on every Gothic church—and he placed great importance on Gothic stone carving.

Whenever Ruskin wrote about architecture, he was also thinking about art. Art, to him, was never an isolated thing; it was always connected to the world. To consider a landscape painting was to reflect upon the countryside itself, the larger society in which the landscape was situated, the meaning of the sublime, and the presence of God on earth. Between 1851 and 1853 Ruskin published *The Stones of Venice* in three volumes. While ostensibly an overview of Venetian Gothic architecture, it encompassed many subjects, including a moral system for design and manufacture. In a chapter in the second volume called "The Nature of Gothic," the text that inspired and illuminated the whole Arts and Crafts movement, he justified hand labor for an industrializing world.

Ruskin drew a sharp distinction between neoclassical and Gothic architecture, but not for the same reasons that Pugin did. The most influential passages in "The Nature of Gothic" appear in a discussion of the characteristic elements of the style. Ruskin praised the "savageness" of old Gothic churches, by which he meant a certain rude, unfinished quality. (In the early twentieth century such work would be called "primitive.") He saw the Gothic as noble because (as Christian architecture) it accepted the value of every individual while simultaneously admitting to imperfections. Thus Gothic ornament's creativity was inseparable from its sometimes awkward, rough carving.

Ruskin contrasted "savageness" with the smooth perfection of ancient Greek architecture and, by extension, all revival styles in vogue in England, in which decoration was formulaic and creativity was reserved for the architect. The stone carver, who spent years executing the decorative details, had no hand in the design. Ruskin sympathized with the carver. Observing the variations and odd details in some Gothic churches, he concluded that much Gothic decoration was invented by the carvers themselves. They had been given some control over their work—empowered, we might say today—and thus derived a vital liberty.

Ruskin saw that most workers could not be artists but could produce something of lasting value nonetheless. He wrote, "This is what we have to do with all our labourers; to look for the *thoughtful* part of them, and get that out of them, whatever we lose for it, whatever faults and

errors we are obliged to take with it." He observed: "You must either make a tool of the creature, or a man of him. You cannot make both. Men were not intended to work with the accuracy of tools, to be precise and perfect in all their actions. If you will have precision out of them, and make their fingers measure degrees like cog-wheels, and their arms strike curves like compasses, you must unhumanize them."[4] When he criticized machinelike labor, Ruskin was clearly thinking of the kind of work demanded by mass production.

Ruskin's brilliance was that he intuited how the life of workers was manifested in their production. He felt that they could derive satisfaction from their labor *only* if they were given some creative control. This vision, above all others, inspired the craft revival. There are gaps in his thinking: he said nothing, for example, of living wages. Still he demanded that the public be willing to sacrifice "such convenience, or beauty, or cheapness as is to be got only by the degradation of the workman."[5] He urged readers to follow three rules:

1. Never encourage the manufacture of any article not absolutely necessary, in the production of which *Invention* has no share.
2. Never demand an exact finish for its own sake, but only for some practical or noble end.
3. Never encourage imitation or copying of any kind, except for the sake of preserving records of great works.[6]

Ruskin clearly had handwork in mind when he wrote these rules, for he added an appreciation of old Venetian glassblowing in the next few paragraphs. In craft, variation is not only possible; it is almost unavoidable. It is more difficult to make two identical objects by hand than to make two different ones. If the public were to embrace handmade products because of their social benefit, they would have to be persuaded to refuse perfection for its own sake. He urged his readers to "rather choose rough work than smooth work. . . . Never imagine there is a reason to be proud of anything that may be accomplished by patience and sand-paper."[7]

Ruskin was not calling for an end to all factory production. Instead he proposed that only necessities be mass-produced. To demand that needles and nails be made by hand would require just the kind of slavish labor he wished to eliminate. Yet he showed no concern for the increased cost of handmade goods or any appreciation of the comfort and convenience that mass-produced goods made more available.

In all his theories of labor, Ruskin held the Middle Ages superior to his own times. He emulated medieval

Guilds

The term "guild" has medieval connotations. For hundreds of years, guilds controlled the crafts in Europe. There were guilds for almost every trade, and few could practice a craft without membership in a local guild. Guilds also maintained standards of quality. The onslaught of foreign trade and mass production led to their collapse, however, and by the 1850s most guilds had passed into the realm of nostalgia.

society in one of his most quixotic projects, the Guild of St. George. Constituted in 1878, the guild was intended to gather a group of "companions" somewhere in rural England to till the earth and "learn, and teach all fair arts."[8] Not much happened. The guild gathered some land; Ruskin founded a Museum of St. George in Sheffield. Otherwise, it was a utopian vision that had little impact during his lifetime. Nevertheless, the pattern he established was later influential. It connected craft to a rural setting, and it inspired people to equate craft with a vision of a better society. And for the next hundred years, craft organizations were called guilds.

Frustrated that the aesthetic system he outlined in *The Stones of Venice* was so at odds with prevailing conditions, Ruskin started writing about economics. In 1862 he published *Unto This Last*, an attack on the theories that justified the profit motive and laissez-faire capitalism. The *Saturday Review* complained that he wrote "windy hysterics" and "intolerable twaddle."[9] Yet his notion that government should be the agent of a just economy was influential: he proposed both universal public education and public support of retired workers, ideas that have been widely accepted. His later life was turbulent and ultimately sad, including an unconsummated marriage, the American painter James Abbott McNeill Whistler suing him for libel, falling in love with a thirteen-year-old girl, and finally succumbing to madness. Yet his credo—"In all buying, consider, first, what condition of existence you cause in the producers of what you buy"—would influence discussions about craft and design for another century and remains relevant today.[10]

William Morris (1834–96), the precocious son of prosperous parents, was educated by tutors and in a private boys' school; he headed off to college intending to become a clergyman. At Oxford, Morris met a talented fellow student, Edward Burne-Jones. Together they read *The Stones of Venice* and toured northern France to see the

The Pre-Raphaelites

The Pre-Raphaelite Brotherhood (1848–54) was founded by three students at the Royal Academy: Dante Gabriel Rossetti, William Holman Hunt, and John Everett Millais. All had read Ruskin and earnestly wished to create a revolutionary style of painting that would be deeply romantic, moral, and based on the strict study of nature. They hoped to sweep away the pretense and gaudy effects of the current academic style, which held Raphael to be the greatest painter, and so they looked to Italian painters before Raphael for inspiration. Their paintings were famously labor-intensive, minutely observed down to individual flowers and leaves.

cathedrals that Ruskin admired. In 1854 they discovered Pre-Raphaelite painting.

By 1855 both Morris and Burne-Jones had decided to devote themselves to art. Morris intended to become an architect and obtained a position with a prominent Gothic revival architect, G. E. Street. Burne-Jones set out to be a painter. He met Dante Gabriel Rossetti and introduced him to Morris. Rossetti recruited the two to help him paint a series of murals in Oxford in the summer of 1857. Morris was wholly unskilled as a painter. The murals were never finished and soon faded badly. Nonetheless, the idea of a group of artists working toward a noble purpose became the model for all his artistic enterprises.

Another venture was furnishing the new apartment Morris shared with Burne-Jones on Red Lion Square in London, late in 1856. They found a local carpenter to fashion a table, some chairs, and a wardrobe in a chunky medieval style. With Rossetti they painted the furniture with scenes of Arthurian chivalry. Compared with most Gothic revival furniture of the day, the results were clumsy and amateurish but full of enthusiasm.

It seems paradoxical that a club of young rebels would express their modernity by imitating the Middle Ages. But Morris and his friends chose Gothic style because it signified rebellion against everything they despised in contemporary England: the profit motive, the factory system, social injustice. What appears quaint now was

politically charged then. These pieces of furniture can be regarded as the first examples of Arts and Crafts work. They were protest made tangible and were resolutely handcrafted.

While Morris didn't make furniture himself, he was an avid student of craft. By 1855 he had taken up embroidery—a rather unusual pastime for a Victorian gentleman, since embroidering was considered the province of women, but in the medieval guilds the embroiderers had been men. Morris had wooden frames made, had wool yarn dyed by an old French couple, and started stitching a hanging called "If I can."[11] Manual labor was unsuitable for a gentleman, but Morris literally got his hands dirty: he spent several years in the 1870s with his hands stained blue from working with indigo dye.

Over the next forty years, Morris taught himself how to glaze ceramics, letter and illustrate manuscripts, engrave wooden printing blocks, dye wool and silk, print textiles, and weave tapestries and rugs. Typically he spent an intense period exploring a craft, after which he taught his assistants and employees and then moved on to another pursuit. He was always driven by dissatisfaction with mass-produced goods. For instance, when he started to investigate dyeing, he discovered that colors produced by natural dyes were being driven off the market by the new aniline dyes, which he thought garish and too prone to fading. He researched old techniques of dyeing with indigo, madder, and other natural colors.

Morris's vehicle for craftwork was Morris, Marshall, Faulkner & Co. (later Morris & Co.), founded in 1861. (Figure 1.3) "The Firm," as it was called, began as a

FIGURE 1.3. *Morris, Marshall, Faulkner & Co., England (London), Cabinet on Stand Depicting Legend of St. George, ca. 1861–62. Mahogany, oak, and pine, painted and gilded; 43.75 × 70 × 17 in.* (© V&A Images, Victoria and Albert Museum, London.)

partnership of Morris, Rossetti, Burne-Jones, and four others and created multipurpose interior decoration, including murals, carvings, glass, metalwork, jewelry, furniture, and embroidery. Each partner contributed designs; some were fabricated in-house, while others were jobbed out to London shops. Their first success came with commissions from churches, mostly for stained-glass windows.

By 1875, to end some personal difficulties and put the Firm on secure financial footing, Morris bought out his partners' shares and became sole proprietor. From then on, he paid close attention to the bottom line, like any businessman. Conflicts between business necessities and his moral ideals troubled Morris for the rest of his life.

The economics of craft are difficult. Hand fabrication is almost always slower than mechanized production and thus almost always costs more. The craftsperson has three options: go out of business, earn less, or convince buyers that handwork adds a value that justifies a higher price. The last option falls somewhere between aesthetic theory and salesmanship: what additional value does handwork confer on a product? For a stained-glass window, the argument was easy: it couldn't (and still can't) be made by machine.

The uniqueness of handmade goods can be attractive to customers who seek to distinguish themselves by decorating their homes (or themselves) with objects that are unobtainable by the masses. Taste and price draw a line of social difference. Much of Morris & Co.'s business went to upper-class men for whom cost was no object, and Morris came to detest working for them. He famously once told a client why he was upset: "It is only that I spend my life ministering to the swinish luxury of the rich."[12] He thought art should be distributed across all levels of society, not reserved for the wealthy: "I do not want art for a few, any more than education for a few, or freedom for a few."[13]

Later designers would embrace machine production as a way to solve this dilemma, and although Morris was suspicious of machines, some Morris & Co. products were mechanically made, such as an early marigold-design floor covering printed on linoleum.[14] Four of the five kinds of carpets Morris & Co. produced were machine-woven, and some wallpapers were machine-printed, too.

The Firm produced some articles that middle-class households could afford. Among these was the Sussex chair, adapted from rush-seated French and English country furniture. It was produced in Morris & Co. shops in lots of four or five dozen at a time. Kits, mostly for em-

FIGURE 1.4. *William Morris*, Chrysanthemum Wallpaper, *1876.* (© V&A Images, Victoria and Albert Museum, London.)

broidery, were also affordable and supplied an existing hobby market.

Perhaps Morris's greatest contribution was in wallpapers and textiles. He had a marvelous facility for designing patterns that conformed to the theories of both Pugin (who demanded flatness) and Ruskin (who demanded truth to nature). "Chrysanthemum" is a typical mid-1870s Morris & Co. wallpaper. (Figure 1.4) The pattern required at least nine hand-cut woodblocks and nine color printings. A primary pattern consists of two different flowers with acanthus-like leaves, twisting upward. The flowers are rendered without modeling, but leaves and petals overlap in a somewhat realistic way. A secondary rhythm of flat vines provides a visual counterpoint.

Morris & Co. was an international inspiration. Suddenly, to practice a craft was to be avant-garde. Hundreds of painters and architects turned to textiles, wallpapers, furniture, and metalwork. Many of them moved to the countryside. Most saw the home as the proper site for design reform, and their motto became "Art into Life."

For all his achievements as a maker and designer, Morris was also a thinker with a consistent ethic. Like Ruskin, he felt that the life of the worker was basic to all considerations of art and economy, and that handwork was the only humane form of labor. Morris regarded work as an essential condition of life and thought something was wrong with a system that reduced it to painful toil. "If a man has work to do which he despises, which

does not satisfy his natural and rightful desire for pleasure, the greater part of his life must pass unhappily and without self-respect."[15]

Art to Morris was not just painting and sculpture but also articles of everyday use, primarily situated in the home, where the fruits of labor could have a beneficial effect on everyone. He thus argued that the fine arts and the decorative arts should be equal and unified. To divide art into high and low caused sickness in both: "I hold that, when they are so parted, it is ill for the Arts altogether: the lesser ones become trivial, mechanical, unintelligent, incapable of resisting the changes pressed upon them by fashion or dishonesty; while the greater, however they may be practiced for a while by men of great minds and wonder-working hands, unhelped by the lesser, unhelped by each other, are sure to lose their dignity of popular arts, and become nothing but dull adjuncts to unmeaning pomp, or ingenious toys for a few rich and idle men."[16]

Morris elaborated on his vision in a novel he called *News from Nowhere*, in which a Victorian gentleman wakes up in a surprising future. The revolution has come and gone, and the state has withered away just as Marx predicted it would. There are no factories, no modern technology, and no money. All commodities are given away for free. Everybody works for free too, enjoying road repair just as much as wood carving. People perform the most repellant tasks because they receive the most extravagant praise. Men treat women fully as equals. There's no jealousy, no aggression, no lying, no war. It is a touching fantasy, sweet and sad, and rather remote from human nature.

Morris's last venture was his Kelmscott Press, which he founded to publish beautiful editions of his favorite books. By the time of his death in 1896, worn out at the age of sixty-two, he had also started the movement for preservation of historic buildings and become a popular poet and one of England's most important socialists. His influence on the crafts was (and is) immense. By his own example, he elevated craft from a trade to a vocation, linked handwork with idealism, and became a hero for generations to come. Morris & Co. was a successful business but not a cutthroat capitalist one. It gave dignity back to labor (even if its workers weren't designers, as Ruskin might have wished). Morris insisted that craft could be art and that art must be incorporated into the daily lives of ordinary people. This just might be his most important legacy of all.

THE SIX-MARK TEA-POT.

Æsthetic Bridegroom. "IT IS QUITE CONSUMMATE, IS IT NOT?"
Intense Bride. "IT IS, INDEED! OH, ALGERNON, LET US LIVE UP TO IT!"

FIGURE 1.5. *George Du Maurier, "The Six-Mark Teapot,"* Punch *(1880).*

The Aesthetic Movement

The years between 1870 and 1885 in England and America have been called the Aesthetic period. Morris and his associates revised popular taste in fabrics and furniture, and in addition there were changes in architecture, interiors, and women's dress. (Figure 1.5) While many creative men besides Morris deserve credit, Oscar Wilde—who was not a visual artist—is particularly associated with the Aesthetic period in America because of his 1882 speaking tour, which publicized the movement.

By the 1880s "aesthetic" was used to describe almost anything that was currently fashionable. The movement's underlying doctrine was "art for art's sake," and it embraced the entire scope of painting and sculpture, decorative arts, and popular culture. Among the sources of ideas were Owen Jones's *Grammar of Ornament* (1856), with its examples of Persian, Moorish, Egyptian, and

Whistler the Aesthete

James Abbott McNeill Whistler, an American painter living in London, was associated with the Pre-Raphaelites and the Morris group in the 1860s. In his paintings he adopted a central principle of aestheticism—the expression of beauty through formal qualities. Famous as a dandy, Whistler is sometimes regarded as the original Aesthete. His contribution to the movement was not just his painting but also his Peacock Room, an interior designed for his patron Frederick Leyland (1876–77; now installed in the Freer Gallery in Washington, D.C.).

other exotic styles; Japanese taste ("Indian style" became popular later); Ruskin (in writing); and Morris (in practice). *The Two Paths, Being Lectures on Art and Its Application to Decoration and Manufacture*, Ruskin's only book on decorative art, was published in 1859 and went through nineteen American printings between that date and 1891, more than any other book on the subject.

Like the Arts and Crafts movement, which overlapped and followed it, the Aesthetic movement was supported by the middle class. Its legacy is the idea that the interior of a home should reflect the inhabitant's personal style. Under the influence of a small circle of architects and artists who believed in good design for everyone, antique collecting was introduced as a way of furnishing a home, and interest in plain and simple furniture led to a revival

Eastlake's *Hints*

Charles Eastlake trained as an architect in the 1850s, fell in love with medieval buildings, and then devoted himself mostly to writing. His *Hints on Household Taste in Furniture, Upholstery, and Other Details* (1868) was a compilation of magazine articles illustrated with his furniture designs. Much of it consists of complaints about prevailing taste, such as the overornamentation that he called "the lust of profusion which is the bane of modern design."[1]

Eastlake's taste was shaped by Pugin and Ruskin, and he advocated the same reforms: flattened patterns on rugs and fabrics; elimination of shading and chiaroscuro; revealing both material and construction. He hated varnish on carved furniture, saying, "The moment a carved or sculptured surface begins to *shine*, it loses interest."[2]

Eastlake illustrated his book with designs for what he called "art furniture," which are plain for the times. Ornamentation consists of incised lines, turned posts, isolated bits of carving and metal strap hinges, handles, and key plates. For ceramics, jewelry, picture frames, and fabrics, he used historical examples as well as the work of a few British designers.

Hints on Household Taste immediately caught the public imagination. By 1881 it had been revised and enlarged four times in Britain and had appeared in six editions in the United States. Eastlake's preferences helped prepare the way for greater change to come.

Charles Eastlake, Hints on Household Taste in Furniture, Upholstery, and Other Details *(1868), figure 1, Library Book Case.*

NOTES

1. Charles Eastlake, *Hints on Household Taste in Furniture, Upholstery, and Other Details* (1868; reprint, New York: Dover, 1969), 22.

2. Ibid., 85.

of traditional vernacular crafts. New magazines devoted to the arts ran articles on home decor (later collected and published as books), with the increasing use of photographs aiding visual influence. Charles L. Eastlake's was the most popular of these compendiums, but there were many others, such as Clarence Cook's *The House Beautiful* and H. J. Cooper's *The Art of Furnishing on Rational and Aesthetic Principles*. Writers of the house beautiful manuals regarded taste as an absolute that could be learned.

Amid all this self-betterment writing, the *Furniture Gazette* asserted in 1876 that "there has assuredly never been since the world began an age in which people thought, talked, wrote and spent such inordinate sums of money and hours of time in cultivating and indulging their tastes."[17] The idea that people should live for art was met with a good deal of suspicion and even ridicule in both Britain and the United States. Aesthetes were seen as poseurs and hedonists. Yet despite the inevitable jokes about the new styles, the public took to it with enthusiasm. Furniture manufacturers soon picked up Aesthetic ideas, although the word they used was "artistic." Art furniture and furnishings were soon sold in all the major stores alongside revival styles. Morris's wallpapers (and those of Bruce J. Talbert, 1838–81) were among the earliest Aesthetic productions. Morris's preferences became the hallmarks of the Aesthetic house. Probably the most important legacy of the movement was the concept of fitness for purpose, which led eventually to the functional design of the twentieth century.

Japan was the strongest external design influence on the Aesthetic movement. By the 1870s "every mantelpiece in every enlightened household bore at least one Japanese fan, parasols were used as summer firescreens, popular magazines and ball programmes were printed in asymmetrical and semi-Japanese style and asymmetry of form and ornament spread to pottery, porcelain, silver and furniture."[18] By the time Gilbert and Sullivan's *Mikado* opened in London in 1885, "things Japanese" had been a mania for at least five years.

An article on Japanese houses appeared in the first issue of *American Architect* in January 1876. Japanese buildings and gardens at the Centennial Exposition in Philadelphia that year attracted much attention. The first book on Japan's architecture appears to have been *Japanese Homes and Their Surroundings* by the Bostonian Edward S. Morse, published in 1886. The understatement, simple line, and sense of proportion that could be seen in Morse's book became part of the architecture of the Aesthetic movement, the Arts and Crafts movement, and eventually modernism. Another lesson from

From Aesthetic to Art Nouveau

The Aesthetic movement and the concurrent Arts and Crafts movement had things in common, including their attention to craftsmanship and the geometry of their patterns. But one way to distinguish between them is the latter's greater concern with structure and the former's obsession with surface.

In England, art nouveau had few fans, partly because of suspicion of its French origins. The popularity of its organic tendril motif was ridiculed by Gilbert and Sullivan in the operetta *Patience* as "a sentimental passion / for a vegetable fashion." Art nouveau was a style rather than an ideology and was short-lived, yet its sinuous and sensuous curves have retained their appeal.

the Japanese was that everything didn't have to come in pairs. Also, the whiplash motif in Japanese art may have inspired the art nouveau style.

OSCAR WILDE

Oscar Wilde's role in the Aesthetic movement was to publicize the views of his more artistic associates and his teachers. (Figure 1.6) Wilde (1854–1900) was an Irishman who studied at Oxford. He was a precocious Aesthete, quoted in the newspapers for saying, "I find it harder and harder every day to live up to my blue china."[19] While still at Oxford he was described by a new acquaintance as "aesthetic to the last degree, passionately fond of secondary colours, low tones, Morris papers, and capable of talking a good deal of nonsense thereupon, but for all that a very sensible, well-informed and charming man."[20] His intention, apparently, was to make his life into art. Wilde's distinctive figure (he was tall and heavy) made it easier for *Punch*'s cartoonist George du Maurier to satirize the Aesthetic movement, thus making it known to a wider audience.

In 1882 Wilde came to America to lecture. His tour was planned to coincide with a New York production of Gilbert and Sullivan's *Patience*, which mocked the Aesthetic movement with a character, Bunthorne, who combined features of Whistler and Wilde. A single man, just twenty-six years old and in need of money—he had already run through his small inheritance—Wilde told the press when he departed from England that he was carrying culture to a continent, armed only with his genius.

His lecture, "The Renaissance in English Art," was so exhaustively reported in the papers that he had to create

BOSTON ÆSTHETICISM VERSUS OSCAR WILDE.

FIGURE 1.6. *"Boston Aestheticism versus Oscar Wilde,"* New York Daily Graphic, *January 19, 1882.*

new talks. One was on the decorative arts and the other, on house decoration, was titled "The Practical Application of the Principles of Aesthetic Theory to Exterior and Interior House Decoration, with Observations upon Dress and Personal Ornaments." It was more commonly referred to as "The House Beautiful." He was parroting the ideas of Whistler and the architect E. W. Godwin, with considerable debt to Ruskin and Morris, but of course in his own style. While at the time his only personal experience with decorating was his college room, it was a concern that stayed with him: not so many years later, when he was dying in a cheap hotel, he joked, "My wallpaper and I are fighting a duel to the death. One or other of us has to go."[21]

Wilde's comments on handicrafts in his American lectures were sympathetic. He observed that "all ugly things are made by those who strive to make something beautiful, and . . . all beautiful things are made by those who strive to make something useful."[22] His American tour, extended to eighteen months, with appearances in at least seventy-five U.S. and Canadian cities from coast

to coast, was a triumph. People bought photographs of him, and popular songs were written about him. As the Aesthetic movement ran its course, Wilde, too, moved on to new concerns: he married, became the editor of a women's magazine, and eventually a celebrated playwright.

AESTHETIC IN AMERICA

The American Aesthetic movement offered no manifestos or official publications and had no unified style. It can be discerned in painting, where the attraction to the decorative and an emphasis on formal qualities of line, color, and shape seems to have helped liberate American artists from academic constraints. It can also be seen in the art pottery, art tiles, and art glass that developed when the Aesthetic movement was at its peak in the United States, about 1875 to 1885.

Major decorators of the time were Herter Brothers, Louis Comfort Tiffany's Associated Artists, and John La Farge's Decorative Art Company. Associated Artists' treatment of the White House state rooms in 1882 was the height of Aesthetic decorating in the United States. Only a few such lavish interiors remain intact today, and while many were photographed for books such as *Artistic Houses* (1883–84), it is hard to appreciate these orchestrations of color and pattern in black-and-white photographs. Flat coloring and outlines of black or gold suppressed the illusion of depth; gold, silver, and silks reflected light so that the walls were visually transformed into "fragile films of nothing more substantial than that precious, shimmering thing, ornament."[23] In pursuit of these effects, English wallpapers became so popular that some critics called the Aesthetic movement "this wallpaper movement."[24]

In Boston—probably the American city with the most Aesthetic tastes—H. H. Richardson's Trinity Church, consecrated in 1877, is the religious masterpiece of the style. Another masterwork is Stanford White's 1880–81 design for the "living room" (a new term in that era) at Kingscote, the Newport, Rhode Island, house of David King III. In this addition to a Gothic revival "cottage," White gave architectural elements—ceiling beams, fireplace surround, window mullions, and tilework—a relatively austere, Japanese-influenced, and proto-modernist character.

English Arts and Crafts

In England the taste for the Gothic revival passed out of fashion by 1880, and a new style was invented by several

young architects. The first among them was **Arthur Heygate Mackmurdo** (1851–1942), who had attended some of Ruskin's Oxford lectures and traveled with him to Italy in 1874. After returning to England, he taught himself stone carving, embroidery, cabinetmaking, and repoussé in brass.

In 1882 Mackmurdo formed the Century Guild. The participants in this collaborative group intended to "restore building, decoration, glass-painting, pottery, wood carving, and metalwork to their rightful place beside painting and sculpture."[25] The guild set up workshops for furniture and metalwork and started taking commissions for interior decoration. In Mackmurdo's designs for the Century Guild, all traces of the Gothic are gone. There is no carving, no painting, just exposed dark wood. Mackmurdo stripped down the forms of Chippendale furniture, straightened them, and added exaggerated cornices on top, which, with their distinctive thin, hatlike capitals, were to become icons of the new Arts and Crafts style.

The Century Guild did little work after 1888, but Mackmurdo's mantle was taken up by another architect, **Charles Francis Anneslee Voysey** (1857–1941), who was committed to the unified and very simple interior. Voysey's furniture was made of plain wood, often oak, and he frequently used broad slats on the backs of his chairs and bedsteads. His designs were influential in Europe and America. Frank Lloyd Wright's early architecture owes much to him, as does American Arts and Crafts furniture. After 1912 he earned his living designing textiles and wallpapers.

The **Art Workers' Guild** in London was not a business like the Century Guild but a discussion group. It was formed in 1884 in opposition to two fusty British institutions: the Royal Academy, which exhibited mostly oil paintings; and the Institute of British Architects, which discouraged any engagement with either art or craft. The Art Workers' Guild sponsored lectures and demonstrations and mounted private exhibitions of members' work. It was a great success, and branches were set up in other British cities. (It still exists.) In 1888 several members decided that the message of the "Combined Arts" needed to be carried to the public and that academic painting and sculpture should be excluded. A splinter group explored the idea of exhibitions. In planning sessions, bookbinder T. J. Cobden-Sanderson invented the term Arts and Crafts to describe the new project.

The **Arts and Crafts Exhibition Society** mounted its first show in late 1888, to broad acclaim. The society recruited many of Morris's followers (and Morris himself) and members of the Century Guild. It gradually became the focus of the whole British crafts community. Within a decade, Arts and Crafts societies sprang up in cities across the United States, and they have proven surprisingly durable.

A magazine called the **Studio** published its first issue in April 1893. The magazine exploited mechanized printing technologies such as halftone photographic reproductions (which replaced laborious steel engravings) and full-color chromolithography. The *Studio* represented the artistic cutting edge in England. Sold in the United States as *International Studio*, it was required reading for every fan of Arts and Crafts. It inspired many new publications in Europe and America.

One of the last English Arts and Crafts designers to have a great influence in the United States was **Charles Robert Ashbee** (1863–1942). He refused to join his father's business, going off to King's College, Cambridge, where he read Ruskin and the Americans Ralph Waldo Emerson and Walt Whitman, rejected capitalism, and devoted himself to making the world a better place. Ashbee found his calling in the slums of East London, where he was inspired by Toynbee Hall, founded in 1884 by Oxford teachers and students with the goal of improving the desperate conditions of life among the working poor. University graduates would "settle" for a while at Toynbee Hall, teach classes to working men and women, and perform other good works; the term "settlement house" was therefore applied to the institution and its successors. Ashbee joined Toynbee Hall in the fall of 1886, about the same time he started working for a London architect. After he taught a few classes on Ruskin, he and his students turned their hands to practical work, decorating Toynbee Hall's dining room. The experience fired Ashbee's imagination, and in 1888 he founded the School and Guild of Handicraft.

The school and guild combination was unique. Unlike art schools, it did not just teach how to draw and design on paper. Courses in carpentry, wood carving, metalwork, embroidery, and other subjects were offered. The guild was a social experiment disguised as a business, meant to provide meaningful work in an industrialized society. It produced cabinetry, metalwork and decorative painting, jewelry, enameling, lighting fixtures, blacksmithing, and even entire interior design commissions.

A silver-mounted decanter of 1904 is typical of the Guild of Handicraft's work. (Figure 1.7) The glass jug was probably provided by a London manufacturer and the metalwork added in the guild shop. Most of the metalwork is simple; Ashbee hired workers he felt could benefit the most, rather than the best-qualified craftsmen. True to the collaborative nature of the guild, the

FIGURE 1.7. *Charles Robert Ashbee, designer, maker's mark of The Guild of Handicraft Limited, bottle probably by Powell of Whitefriars, England, Decanter, 1904–5. Green glass with silver mounts and a chrysophase set in the final; height, 10 in. (© V&A Images, Victoria and Albert Museum, London.)*

decanter's designer is not known. Other decanters from the same period show subtle differences, which suggests that individual silversmiths were free to invent variations on basic themes.

The guild put on plays, held songfests, gave weekly dinners, and sponsored trips to the countryside. At first it was a fully cooperative workshop, with all workers having a voice in its business affairs. That experiment was abandoned, however, and by 1898 it was a limited company, like any business. Ashbee's school closed in 1895, mired in debt, but the Guild of Handicraft became quite successful, employing more than seventy workers by 1902. In that year it moved to Chipping Campden, a tiny village about eighty miles west of London. The relocation was part of a "back to the land" movement that contrasted the beauty of nature with the noise, dirt, and poverty of the city and found dignity in rural folkways.

In Chipping Campden the school was reopened. Business was good at first, and prominent people came to visit. But guild designs were copied by manufacturers and department stores, which sold them more cheaply. Worse, city clients were less accessible, leading to a decline in sales. To top off the guild's misery, England was swept by a taste for eighteenth-century revival furniture,

rendering the Arts and Crafts look outdated. By 1906 the guild was losing money, and it was liquidated in 1908, twenty years after it began. A dozen craftsmen remained in Chipping Campden to run their own studios. Ashbee had nevertheless shown that Ruskin's ideal of accepting the faults of untutored laborers could succeed and that Arts and Crafts enterprises could indeed benefit society. The idea of craft fellowships would blossom in the United States, inspired by the notion that a business could operate for the betterment of its members.

World's Fairs

Almost without exception, the published accounts of world's fairs that began to be held in the middle of the nineteenth century omit discussion of craft. Yet the fairs were of pivotal importance in the history of craft. They offered an opportunity for both national and international exposure, and the convention of awarding ribbons, medals, and certificates served as personal validation to artists who exhibited and as commercial affirmation to art manufacturers. The fairs also played important educational and cultural roles, providing craftspeople with new technical and artistic ideas.

World's fairs began with the Great Exhibition in London in 1851, also known as the Crystal Palace exhibition in honor of the marvelous glass and iron building that housed it, designed by Joseph Paxton. The roots, however, go back to more modest national institutions established in France and Britain to promote trade, as well as to gain political standing by showing manufactured objects as "meaningful beyond themselves."[26]

After the Great Exhibition, an event involving twenty or more nations was held somewhere in the world on an average of every two years, bringing together wide varieties of goods and enormous numbers of visitors. In addition to cultural, political, and social purposes, fairs have inspired the creation of amusement parks and theme parks such as Disneyland and have introduced the public to innovations such as telephones, X-rays, asphalt, and picture postcards. Fairs influenced taste and artistic development both through publicity and directly to those who attended.

The first major fair held in America was the **Centennial Exhibition** in Philadelphia in 1876. Almost 10 million people (out of a U.S. population of about 46 million) attended the six-month Centennial Exposition on 236 acres in Fairmount Park. One of the five major halls was devoted to fine arts, introducing much that was new or unfamiliar: "reform" English design, exotic Japanese art,

and the complex patterning of Moorish decoration. The success of a British art needlework display encouraged the immigration of needlework teachers from Britain to the United States. Among the nearly 400 foreign displays of ceramics, Danish reproductions of Greek vessels in museums gave ideas to American manufacturers, and French techniques and Japanese motifs also provided inspiration. In fact, a renaissance in American decorative arts can be traced to ideas generated by the Centennial Exposition displays.

Some women were pleased that the fair's directors had gathered women's arts and inventions in a separate Women's Building, seeing this as a step toward equality. Leaders of the suffrage movement were less sanguine; the Centennial Board had reneged on a promise to provide space in the main building. A women's committee took matters into its own hands and within months raised $30,000 for the first-ever Women's Building. Exhibition of Native American work was also a first at this fair, in displays of mannequins and artifacts that cast them as savages. Although the fair did not make a profit for its investors, it restored national pride and encouraged the recovery of American business hurt by the Civil War and a more recent financial panic. Its cultural success and good press launched world's fairs in America.

The six-month-long **World's Columbian Exposition**, nicknamed "The White City," was held in Chicago in 1893. The fair was meant to commemorate the four-hundredth anniversary of the discovery of America, but it opened a year late due to the worst depression since 1837. The design consisted of Beaux-Arts-style buildings, but the Palace of Transportation, designed by Louis Sullivan, which did not conform, was one of the high points. A Great Wheel by G. W. G. Ferris that revolved every twenty minutes, electric lighting, and a "moving pavement" to carry visitors around the 666-acre lakeshore site were other impressive features.

Colonial revival displays by a few states emphasized American heritage. The Fine Arts building, which for fire safety reasons was the only permanent structure on the site and is now Chicago's Museum of Science and Industry, had almost 9,000 works on view. Actual Native Americans were part of an array of exotic shows, including Algerian belly dancers, and there were replicas of native villages, many from faraway places, all of which supported ideas of white racial superiority. Louis C. Tiffany's crowd-pleasing display of glass gave an enormous boost to his career as a glass designer. The Libbey Glass Company of Toledo erected a fully equipped factory on the Midway Plaisance in which crystal blanks were made, cut, and polished before admiring spectators.

At the 1904 **Louisiana Purchase Universal Exposition** in Saint Louis, Cass Gilbert designed the Palace of Arts, which is now the Saint Louis Art Museum. Nearly 40,000 medals and 50,000 diplomas were awarded to displays in twelve major classifications. This was the first world's fair in which the decorative arts, or "Original Objects of Art Workmanship," were exhibited alongside painting and sculpture rather than with manufactures.[27] The Palace of Arts exhibited and rewarded the achievements of the American art potteries; the exposition established a nationwide standard for Arts and Crafts wares through a selection process coordinated by regional juries.[28]

The **1915 Panama-Pacific International Exposition** in San Francisco was more concerned with fine arts than most previous events. There was a large assortment of outdoor sculptures, and the Palace of Fine Arts (again the only surviving structure) displayed more than 11,400 artworks from all over the world that had been created within the previous decade. The dominance of art potteries ended as ceramics shifted to smaller exhibition venues.

The fine arts came to be seen as an essential feature of world's fairs, but no one presumed that it was art that drew the crowds. The art chosen for display was usually great works of the past, yet most fairs emphasized the future. While the fairs affected institutional aspects of the art world (constructing buildings, familiarizing the idea of temporary exhibitions, establishing sponsoring organizations), they rarely produced new styles, with the exception of ethnographic displays that introduced artists to unfamiliar forms and peoples.

The Cincinnati Wood-Carving Movement

Throughout the nineteenth century, some individuals and businesses still made objects by hand in traditional craft mediums. But until the Arts and Crafts movement offered a justification, no one distinguished handwork from machine fabrication. All production was industry, from the smallest workshop to the largest factory. "Studio craft" was therefore first set apart from industry by the assertion that handwork was socially valuable.

The first work of this new kind in the United States was done in Cincinnati in the early 1870s. Because of its location on the Ohio River, Cincinnati was a major transportation link and manufacturing center before the Civil War. When the rapid development of railroads eroded the city's preeminence, leading citizens looked to culture as a means of restoration. They assembled a conservatory, university, symphony orchestra, art academy, and

art museum, all requiring private patronage. The most prominent family supporting the arts in Cincinnati was Nicholas Longworth (1782–1863), his son Joseph (1813–83), and his granddaughter Maria (pronounced ma-rye-uh, 1849–1932). The Longworths' fortune came from land and agriculture. Both Nicholas and Joseph supported painters and sculptors, and Joseph seeded the Academy of Fine Art with a $60,000 donation in 1887.

In the 1850s and 1860s, Joseph built mansions for himself and his daughter and had the interiors enriched with wood carving by English immigrant Henry Lindley Fry (1807–95) and his son William Henry Fry (1830–1929). Joseph Longworth was so proud of the work they did in his daughter's house—detailed renderings of birds and local plant life on moldings, mantels, cupboards, and elsewhere—that he brought in many visitors to see it.

In 1873 the School of Design of the University of Cincinnati opened a wood-carving department under the direction of Benn Pitman (1822–1910). Pitman had come to Cincinnati from England to teach phonography, a shorthand system invented by his brother some years before. By 1872, perhaps inspired by the success of the Frys, he had taken up wood carving and exhibited his work in an annual industrial exposition. He agitated for the creation of the new department and, with his daughter Agnes as his assistant, began teaching.

A statement in the 1872 catalog for the School of Design explained the new program in the language of the industrial arts education movement that was emerging about the same time (see chapter 2): "The special aim of this School is not merely the study of Painting and Sculpture, but also the improvement of the industrial arts, by affording to the citizens of Cincinnati and particularly to the operative classes, a thorough, technical, and scientific education in Art and Design as applied to manufactures; thereby imparting to them such taste and skill in form and finish of their works, whether large or small, as will always command remunerative employment, and a ready sale for the products of their industry."[29] Since Cincinnati was home to a sizable furniture-making industry, the "operative classes" in question were supposed to be workers from the local factories.

The program was quite successful, with 121 students in the first class. But 94 of them were women, mostly upper-middle-class women who had the time and money to pursue their own desires. Pitman adapted to his new audience, letting them make items for their families and friends. Presuming that women would not be capable of cabinetmaking (with its rather dangerous machine tools), Pitman had local carpenters make up wood forms that his students could decorate with carving. And pre-

suming that they did not have the strength or endurance to carve in deep relief, he taught them to carve shallowly. Within these limitations, the women carvers of Cincinnati excelled.

In an 1874 exhibition of School of Design student work, woodcarvers showed 822 pieces, most of them small (frames, brackets, boxes, and the like). Then even more people signed up for classes, from both Pitman and Henry Fry. Meanwhile, Cincinnati women raised $5,000 to support exhibits in the Women's Building of the 1876 Centennial Exposition in Philadelphia. Some seventy-three Cincinnati women showed objects ranging from a piano to a chessboard. Written up in the national press, "Cincinnati carving" became a model for emulation.[30] The School of the Museum of Fine Arts in Boston offered wood-carving classes in 1879, only two years after it opened. And many of the women who formed one of the first arts and crafts societies in the nation, in Minneapolis in 1895, were wood-carvers.

Pitman carefully controlled the School of Design style. He insisted that his students draw directly from nature, which meant that their subject matter tended to be local plant life. (Ruskin would have approved.) He had the students rework their drawings into simplified, asymmetrical designs. The most elaborate floral carvings were generally confined to forward-facing panels and door fronts. Vertical and horizontal members and side panels were decorated with patterns. On occasion, paintings were added to side panels. Dense decoration festooned every edge and surface. The various arches, columns, brackets, and finials often bore no relationship at all to the carving on panels. The effect was completely Victorian.

A desk by an unknown carver is typical. (Figure 1.8) Like most School of Design furniture, it is constructed entirely of American wood: black cherry, pine, and yellow poplar. The upper part is asymmetrical, reflecting Japanese influence. The drop front is decorated with a spray of dogwood blossoms carved in medium relief. The lower left door has another carving, depicting butterflies and a narcissus bouquet. On the upper left there's a third floral carving, but here the image is carved into the wood surface, instead of standing out from it. Each drawer front is carved with leafy scrolls. Geometric carving decorates the structural parts and both sides. Finally, two twisted columns push the whole composition toward chaos. Nonetheless, the carving is skillful. Taken separately, the designs of the carved panels are quite advanced for their day.

From the vantage point of the present, it is easy to criticize the Cincinnati wood-carving movement. It failed to achieve its goal of educating factory workers,

FIGURE 1.8. Anonymous, Desk, 1875–1900. Black cherry, pine, yellow poplar, brass; 54.5 × 43.75 × 18.75 in. (Cincinnati Art Museum, Gift of Mr. and Mrs. S. Paul Matthews in memory of Cora Brandenburg, 1979.189.)

and the market that Pitman promised never developed. Such labor-intensive furniture could be marketed only as luxury goods, and there was little demand outside Cincinnati. Most of the thousands of objects carved in Cincinnati went to local families, primarily those of the women who made them. The style remained unchanged even after William Fry replaced Pitman in 1893, right up to Fry's retirement in 1926, by which time it was hopelessly antiquated.

And yet Cincinnati wood carving marked a moment. As members of America's leisure class, the women faced the question of what to do with their time. Only the very rich had asked this question before, but now thousands of women were free to choose what to do, within the limits prescribed by their social class. The Cincinnati women wood-carvers could evaluate their work on its own terms. Uniting thought and labor by inventing a design and then carving it, using the whole body in physical work, becoming totally absorbed in an activity, and producing an object that was well designed and well made—all were among the satisfactions of the work. The women discovered that the practice of craft contributed significantly to their quality of life, which distinguished studio craft from trade.

Morris had looked outward, from labor to the whole society. In Cincinnati the focus turned inward, to the

benefits that accrued to the craftswoman herself. The emphasis was on self-improvement rather than social reform. While less altruistic than Morris's ideal, it proved to be equally potent. Even today, people are drawn to the crafts for the same reasons.

Many of the Cincinnati wood-carvers went on to play important roles in art pottery. In general, women took the lead in weaving, dyeing, and other textile fields, and they were in the majority among early Arts and Crafts jewelers. Only in the book arts and in glass were men more important than women in the early years of studio craft.

Art in Textiles

Needlework was a craft elevated to art status by the Aesthetic movement and the Arts and Crafts movement. The change was anticipated in England during the burst of church building that followed the Catholic emancipation of 1829, which generated a need for vestments, altar cloths, and the like. Pugin's support of Gothic style included a revival of historic embroidery styles. The royal family and the South Kensington Museum began to collect textiles after midcentury, and these items served as models. A commercial firm, Liberty's, first used the term "art fabrics," starting about 1876, and others quickly took it up.

Popular in the early Victorian era was German-originated "Berlin woolwork," a counted-stitch technique in which a prestamped design on a black wool ground (pets, flowers, biblical scenes, or adaptations of famous paintings) was worked in vibrant aniline-dyed yarn. Art needlework, by contrast, employed softer colors and more stylized motifs. By the mid-1870s, it was the most popular embroidery form.

William Morris's own embroidery experiments began in the 1850s; he is said to have derived his greatest satisfaction as an artist-craftsman from the embroidery, weaving, and hand-knotted carpets that Morris & Co. produced. His description of needle arts as inherently feminine has been regarded by some contemporary critics as sexist, but he knew of medieval male embroiderers and practiced needlework himself, and his assertive daughter May chose it as her lifework. Walter Crane, who designed textiles, valued embroidery for its direct contact with materials—it is not distanced by the tools or machines of weaving or of fabric printing. May Morris, in an 1893 book on embroidery, distinguished between "pictorial art," in which the ground material is entirely covered, like the canvas in painting, and "decorative art,"

in which textile character plays a stronger role and there is a balance of figure and ground. The pictorial approach involves greater distance or abstraction from the fabric and then (as now) was seen as more intellectual.

Mostly, late nineteenth-century textile techniques and attitudes migrated from England to America, but crazy quilts, another textile innovation of the Aesthetic period, appear to have been made in America first. Crazy quilts were an adaptation of a Japanese textile technique called *kirihame*. Perhaps through trade goods sold in American shops, this appliqué was seen by American women familiar with more orderly forms of patchwork quilting. Possibly the most widely adopted Japanese influence, crazy quilts were described as a "mania" by 1882.

CANDACE WHEELER:
SOCIAL SERVICE TO BUSINESS

In the nineteenth century, American textiles were either imported from or copied from Europe. Candace Wheeler (1827–1923) was a leader in changing that. She was a social activist who created opportunities for women, an inventor of textile techniques, and a businesswoman. Her achievements began after she was fifty years old. She grew up on a farm where her family persisted in a pioneer lifestyle that was old-fashioned even then. She attributed her color sense and textile skills to the spinning and weaving she learned at home. In 1844, at seventeen, she married Thomas M. Wheeler—a surveyor, civil engineer, and architect—and relocated to New York City. The Wheelers moved in artistic circles, and when they began to travel abroad, she met such leading English figures as Burne-Jones. She lived an unremarkable middle-class life until 1876, when she visited the Centennial Exhibition. Like many women, she was impressed by the embroidery work—and the social purpose—of the Royal School of Art Needlework.

Also in 1876, Wheeler's elder daughter died. In her grief, the benevolent model of the Royal School particularly struck her. It had been established to aid gentlewomen in straitened circumstances, and she knew that the deaths of fathers and husbands in the Civil War had left countless American women with no means of support and no profession of their own. She described herself as jumping at the opportunity to create work "for the army of helpless women of N.Y. who were ashamed to beg & untrained to work."[31]

In 1877 Wheeler, with the aid of four other women, formed the New York Society of Decorative Arts (SDA), drawing on skills developed in wartime charity work as well as fund-raising fairs that had been held in the United States since the 1820s for various worthy causes. The SDA

became the parent of about thirty similar organizations in cities across the country. Many grew out of sewing circles, a form of female social gathering that metamorphosed into something new. Through the SDA, women in financial need could sell homemade products to the public. The first president was a woman skilled at public relations, and other founders came from prominent families like the Astors and could easily afford the society's $100 "subscription" fee, which provided start-up funds.

Wheeler emphasized the SDA's differences from the Royal School of Art Needlework to escape the sense of one class helping another: anyone could sell work, not just the destitute. Works by men were accepted because, as she cagily noted, people would pay more for unlabeled works by men and women together than for works by women only. The SDA functioned as a school, library, study center, laboratory, workroom, shop, and gallery; it also sold tools, materials, and literature. The society supported multiple crafts, including needlework, china painting, panel painting, tilework, and carving. Wheeler spoke of it as serving social and psychological rather than just physical needs. That sounds surprisingly like the women's liberation movement of almost a hundred years later: craft as a means of psychological independence.

Wheeler's own early textile designs are simple, structured patterns influenced by the Royal School and Walter Smith's popular system of conventional drawing (see chapter 2). Later she came to regard that system as "false in principle."[32] She asserted that many flowers were naturally simple and regular in form and needed no alteration. Her *Consider the Lilies of the Field* portiere, embroidered and painted with wild meadow lilies, is one of the surviving pieces from her SDA years. (Figure 1.9)

In 1879 Wheeler went into business with Louis Comfort Tiffany, whom she knew from the SDA. Their company, Tiffany & Wheeler, was soon altered with the addition of two other principals (see below), and the name was changed to Louis C. Tiffany & Company, Associated Artists ("Associated Artists" is said to be Wheeler's suggestion). In the style of Morris & Co., it specialized in interior design. According to Wheeler's autobiography (unfortunately not a completely reliable source), she was approached by Tiffany, who said: "It is the real thing, you know; a business, not a philanthropy or an amateur educational scheme. We are going after the money there is in art, but the art is there, all the same. If your husband will let you, you had better join us and take up embroidery and decorative needlework. There are great possibilities in it."[33]

Probably Tiffany saw Wheeler primarily as the director of a workshop that would embroider portieres and

FIGURE 1.9. *Candace Wheeler,* Consider the Lilies of the Field Portiere, *1879. Cotton panels embroidered with wool thread and painted wool borders; 74.25 × 44.5 in. and 73 × 45.5 in. (The Mark Twain House & Museum, Hartford, Conn.)*

other items to his design, since her expertise was in technique. Their first commission was a ninety-square-yard drop curtain for the Madison Square Theatre that took nearly six months to complete and cost the then-considerable sum of $3,000. When the theater opened on February 4, 1880, the *Art Interchange* called it "the most important piece of art needlework which has been done in the country . . . being the first fruits of a distinctly American school of art needlework."[34] It depicted a pond and shore with flowers, rushes, and a blooming tulip tree with clinging vines leading the eye into a misty background. According to the press, it was designed by Tiffany; Wheeler said that it was adapted from an embroidered silk picture by Mrs. Oliver Wendell Holmes Jr., a noted needleworker. Extensive appliqué was used to fill a large area economically—an innovation. On February 26, just weeks after the opening, the curtain burned in a fire accidentally started by a lamplighter. It was replaced on May 1 by a new work from Tiffany & Wheeler—who refused to repeat—depicting a Florida inlet at low tide with river, water plants, flowers, birds, butterflies, and trees.

When the firm dissolved in 1883, Wheeler took the name Associated Artists and, with her younger daughter, Dora, expanded her textile business. Dora was both a designer and a painter trained in William Merritt Chase's studio, as well as in Germany and Paris. Dora and Rosina

Emmet specialized in tapestries depicting female figures from literature and mythology. Today these are cringe-inducing Victoriana, but then they related to history paintings and were widely admired.

Wheeler invented and patented the "American Tapestry" technique of "needle weaving," so called because the needle was used like a shuttle to carry silk embroidery threads into a silk weft. It was time-consuming (and therefore expensive) to produce but appealed to wealthy clients. Her works were characterized by unexpected combinations of materials, such as supple silk and stiff metallics, and by special effects achieved through blended colors. She featured American flower species plus Japanese motifs and historically inspired patterns. She developed a stronger color palette than Europeans used, an idea she adopted from painter friends. She believed that any subject or effect that could be painted could also be used in textiles.

Wheeler observed that "one of the superior charms of embroidery" is that it can show a color and then a second color in reflection. "The same tint in silk will make of itself, according to the light which falls upon it, the deepest, as well as the lightest shades of its own color, and will even reflect its own upon adjacent tints, so that the whole mass will have a color effect that would be beyond the power of the most skilful painter."[35] She wrote that, in appliqué, design was less important than color

and surface relations and noted that this technique could be bold enough for the newly popular large rooms.

Among her best works is a pair of embroidered tulip panels in which the flowers are depicted as past their prime and about to drop their petals. The panels are striking and unusual in their naturalism. Few of the hangings she created have survived, although these ambitious works were the ones she regarded as her most important. They were worn out, apparently, in the homes of the wealthy, including Cornelius Vanderbilt II of New York, Mrs. Potter Palmer of Chicago, and the English actress Lillie Langtry.

Wheeler also embraced mass production. In this she was part of a new wave, going where Morris would not have gone. She partnered with the silk manufacturers Cheney Brothers and other firms to produce woven cottons and silks with repeating patterns. A fabric blanketed with narcissus may have been inspired by the garden at Nestledown, her house in Jamaica, Queens. The staggered placement of leaves and stems creates the effect of a field of flowers and hides the repetition. The fabric is printed in five colors (three tones of green, plus yellow and red) on natural, undyed linen made of unevenly spun yarns that create an irregular texture, a "homespun" look.

Wheeler searched for an inexpensive cloth that could be available to a wider public, usable in a yacht or country cottage, as she put it. She found indigo dyes and plantation weaving of a cotton fabric known as "Kentucky jean" or "blue jean," later called "blue denim," which she popularized, noting that it did not show soil and washed well.

In 1893, at the Chicago world's fair, Wheeler designed a library sponsored by New York State and was the color director for the Woman's Building. She also was on the advisory council of the Woman's Art School of New York at the Cooper Union (one of the few programs open to women) from 1877 until at least 1909. She directed Associated Artists until the turn of the century, when she turned it over to one of her sons. She wrote several books, including *The Development of Embroidery in America*, published in 1921, when she was ninety-four. From a limited background, Wheeler found her way into society, into creative work, and into business, and for decades she was *the* national expert on decorative textiles and interiors.

China Painting and Art Pottery

"Art pottery" was a factory product from about 1870 to 1920. The definition is a sliding one: when the process is entirely mechanized, there's no art to it, but when the process is entirely by hand or entirely by a single person, it is studio pottery; in between is art pottery. This "commercially supported individuality"[36] arose in the United States in tandem with the hobby activity of china painting, which it outlived by a few years. Art pottery was made possible by the Industrial Revolution, which provided the technology for mass production, made the market for decorative work by creating a middle class, and led to the role of the artist in correcting the ugliness and poor quality of industrial products. To emphasize the art angle, the work was often marked not just with the emblem of the manufacturer but also with the initials or signatures of the designer, decorator, and thrower.

The history of art pottery shows a constant tension between creativity and cost. While it was intended to replace boring, standardized forms, intense competition fostered copying as well as the need to contain expenses, which led to more casting than throwing and, ultimately, production of the same kind of dead forms art pottery was meant to replace. The industry headed downhill after about 1915 as interest shifted toward unique works.

In general, art pottery activities were defined by gender. Men made the pots and might decorate them as well, while women were restricted to decorating. But another constant in its history is the efforts of women to do more, usually (by necessity) outside the factory.

Before the art pottery era, fine-quality tableware was imported from Europe, both because it was cheaper than American ware and because Americans thought that European work was better. U.S. manufacturers usually copied European styles; late in the century they copied Japanese and Chinese styles as well. It was, in fact, European and Japanese displays at the Philadelphia Centennial Exposition that sparked an American boom in art pottery and china painting.

China painting—mineral pigments painted onto porcelain blanks—offered creative and commercial opportunities for women. While it was "unseemly" for a young woman to be a professional oil painter, she might practice decorative arts without criticism because of their domestic associations. China painting could be done at home, it didn't require heavy labor, it wasn't messy, tools were small, materials were inexpensive, teachers were female, and buyers were mostly female, too. The product met Morris's injunction, "Have nothing in your houses that you do not know to be useful or believe to be beautiful."[37]

It is estimated that by 1893 more than 25,000 women were seriously involved in china painting. Beginning in 1887, *China Decorator* magazine published designs and

advice. *Keramic Studio* was an important successor. The National League of Mineral Painters, organized in 1891–92 by Susan Frackleton, set up chapters in major cities. But the story begins with two Cincinnati women.

LOUISE McLAUGHLIN AND THE CINCINNATI POTTERY CLUB

China painting arrived in Cincinnati by several routes. In 1873 a youth named Karl Langenbeck received a set of china paints as a gift from Germany. His wealthy and artistic neighbor Maria Longworth Nichols was curious; she borrowed his materials so that she could experiment with them until she was able to obtain her own. Early in 1874, Benn Pitman, wood-carving instructor at the School of Design, visited New York and returned with some mineral colors, though not much information. During the summer he invited students from his wood-carving class (all women) to try china painting. A German visitor to the class explained a few things, but they had to learn on their own how to finely grind the powders and apply them. It may have been this very lack of information, requiring the practitioners to work things out for themselves, that led to exceptional achievements.

Within a year the women were selling their painted pots. Some decided to show their wood carving and china painting at the Centennial Exposition. In Philadelphia, one woman from the class, M. Louise McLaughlin, showed a hanging cabinet of her own design with hand-painted tiles in the doors (which she also made) depicting ladies in the garments of 1776 and 1876. She had modeled the hinges in wax, cast them in bronze, and further worked the surfaces. Displayed in the cabinet was her china painting.

McLaughlin visited the exposition and saw new "Limoges" pottery produced by the Haviland factory in France using a secret technique. She later wrote, "This was a new development in the decoration under the glaze which interested me greatly, and I determined to see whether it could not be done in this country."[38] Back home, she researched the underglaze colors and ordered them from France. It was nearly a year before they arrived. In the interim, she wrote a manual on china painting, dashing it off in a mere two weeks. *China Painting: A Practical Manual for the Use of Amateurs in the Decoration of Hard Porcelain* was published in 1877. It eventually reached ten editions, sold more than 20,000 copies, and "launched a movement."[39] McLaughlin wrote that "articles for use should be decorated with simple natural, or what is still better, with conventional forms."[40] That advice could be traced back to Pugin.

"Limoges" (the name of the city where the Haviland

FIGURE 1.10. *Mary Louise McLaughlin*, Pilgrim Jar, 1877. Ceramic, underglaze slips; 10.25 × 9.5 in. (Cincinnati Art Museum, Gift of Women's Art Museum Association, 1881.44.)

factory was located), called barbotine by the manufacturer, can be compared with oil painting for its deep and rich coloration. It was messier than china painting since colors were applied to unfired clay, and for that reason it required collaboration with a potter. The resemblance of the result to then-current impressionist painting made it acceptable to men as well as women. McLaughlin was not the only one interested. Charles Volkmar, an artist who had studied in France for fourteen years and returned to the United States in 1875, also saw the Centennial Exposition and was impressed by Limoges ware. He returned to France to study, and when he came back to the United States in 1879, he set up a studio on Long Island. The Robertson family of potters in Boston also introduced a line about 1877. But neither they nor Volkmar persisted in this work long enough to have an impact. McLaughlin, by contrast, developed her own technique, mixing mineral colors with raw slip and applying them to a damp object (the French, it was later revealed, used a slip made of pulverized *fired* clay and applied it to a dry pot). In late 1877 McLaughlin fired her first successful piece of "Cincinnati faience," as she called it. (Figure 1.10)

McLaughlin's underglaze decoration subsequently won an honorable mention at the 1878 Paris Exposition, which made her an instant celebrity in Cincinnati. Her faience used motifs from nature, as had her overglaze china painting. But mixing the oxide colors with slip produced a thick impasto, so application was in broad,

heavy strokes, not in tight, small ones, as with china painting. By February 1879 she decided to start a pottery club, America's first for women. She prepared and mailed invitations to join. McLaughlin was president, Clara Chipman Newton secretary, and Alice Holabird treasurer through the eleven-year life of the club. Its founding marked the beginning of a major feud.

Maria Longworth Nichols claimed she had not received an invitation and viewed it as a personal slight, refusing a second invitation. (One "vacancy" was carried on the membership list throughout the club's existence.) Nichols, who had found china painting first, had repeatedly been upstaged by McLaughlin. The rivalry advanced when the Pottery Club rented studio space at the Dallas Pottery, where Nichols and a friend had been working for a few months. Nichols and McLaughlin had special kilns built there because the high-temperature firing used for commercial ware wasn't suitable for underglaze work.

At the Cincinnati Industrial Exposition that fall, Nichols got the upper hand, according to a newspaper account, when she exhibited underglaze work and also high-relief work. But McLaughlin conceived of making the largest underglaze-slip-decorated vase in America, since "size had become a metaphor for progress."[41] This was her *Ali Baba* vase, made in at least three versions. It was the center of attention at the Pottery Club's first reception, turning the tables on Nichols.

The next year, 1880, was a peak for Cincinnati ceramics. McLaughlin published another book, *Pottery Decoration under the Glaze.* In addition, an illustrator for *Harper's Weekly* magazine came to the Pottery Club's exhibition and sale in May and published an illustration that was the first national acknowledgment of the burgeoning ceramics movement. Cincinnati then suffered an "epidemic of pottery"; Dallas Pottery alone was soon firing the work of more than 200 amateurs, all but two of them female. Women began coming from other states to study and work in Cincinnati. McLaughlin said, "For a time it was a wild ceramic orgy during which much perfectly good clay was spoiled and numerous freaks created."[42] It was also that year that Nichols trumped her by founding Rookwood Pottery.

That year T. J. Wheatley received a patent on McLaughlin's underglaze slip technique, which he had learned while working at the pottery where she had begun her experimentation. Soon he began teaching the technique; among his students were several men who went on to work at Rookwood, which also used the technique. Nichols, asked if she was worried that Wheatley would sue Rookwood for patent infringement, said no and added, "Miss McLaughlin used to do Limoges work before Mr. Wheatley ever thought of such a thing."[43] (It was a comment she later conveniently forgot.) McLaughlin had considered patenting her method, but her brother, a leading lawyer in the city, advised against it since mixing oxides with slip was not a new idea. When Wheatley patented it, no one stopped using the process, and he never tried to defend his patent. He succeeded in inserting his name in ceramic history on this dubious basis.

Shortly after McLaughlin's *Ali Baba* triumph in the spring of 1880, Nichols set to work on her own monumental piece. Completed late in the year, her *Aladdin Vase* was thirty inches high and eighteen inches in diameter (the *Ali Baba* was thirty-seven by seventeen inches). The *Aladdin Vase* is recorded as shape #2 in *The Rookwood Shape Book* (1883–1900) and is noted as being sold that year to Tiffany & Co.

When the first kiln was drawn at Rookwood on Thanksgiving Day 1880, Nichols gained the upper hand. The Pottery Club rented a room at Rookwood because it was the only ceramic works in town dedicated to art pottery, and, more important, Nichols had hired Joseph Bailey Sr., the club's technical mentor. Oscar Wilde praised McLaughlin's work when he lectured in Cincinnati in 1882, but by 1885 she had abandoned Cincinnati faience because of a lack of facilities: her potter, Mr. Dallas, had died, and Nichols had hired all the others. Her Cincinnati faience period lasted only about seven years.

In the Pottery's Club's 1884 exhibition, McLaughlin included etchings on brass and copper plaques, panels, bowls, jugs, vases, trays, and one mirror frame. She particularly liked working in metals and ultimately won a silver medal for her etchings on silver and copper at the 1889 Paris Exposition. Invitations for all ten club exhibitions were from her copperplate etchings. She painted oil portraits and began photographic portraiture. Also an illuminator, embroiderer, and lace maker, she has been called "the fulfillment of William Morris's ideal."[44]

At the Pottery Club's tenth reception, in 1890, business was poor because of a national economic slump, and the members voted to disband. They briefly came back together in 1893 to prepare a display for the World's Columbian Exposition in Chicago, where Cincinnati was the only city in the world honored with a room of its own in the Woman's Building.

ROOKWOOD POTTERY

In 1880 Maria Longworth Nichols founded her pottery with money from her father. She had earlier asked him to import a Japanese pottery, including the workmen, so perhaps this new request seemed modest. The osten-

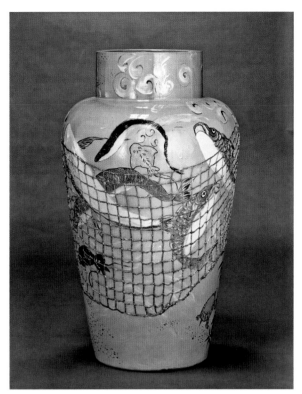

FIGURE 1.11. *Rookwood Pottery Company, decorated by Maria Longworth Nichols, Vase, ca. 1881–83. Painted and glazed earthenware; height, 30 in.; diameter, 18.25 in. (The Metropolitan Museum of Art, Gift of Marcia and William Goodman, 1981, 1981.443. Image © The Metropolitan Museum of Art.)*

sible reason was that all the local potteries fired stoneware at too high a temperature for her decorative work. A local newspaper reported that Nichols was starting her own pottery "to eliminate the inconvenience of the 'great distance' she had to travel from her home to the Dallas Pottery and to exercise her own taste in the choice of forms."[45] A less publicly floated explanation was that her marriage was not happy but that her father would not sanction a divorce, so this was her distraction.

Nichols established her business in an old schoolhouse near the Ohio River and named it after her parents' country estate, pleased that the name recalled the prestigious English pottery Wedgwood. She later wrote, "It was at first an expensive luxury for which I, luckily, could afford to pay."[46] The pottery became internationally famous and survived for more than seventy years.

Nevertheless, the public image of Rookwood in the twentieth century was based on two misapprehensions: that Rookwood was "a woman's pottery" and that it was a producer of "individual works." Its founding was certainly due to Nichols, and she or her father covered its debts for several years. Moreover, she hired her friend Clara Chipman Newton as Rookwood's secretary, rented

quarters to the Pottery Club (all women), and employed women as decorators.

Yet Nichols hired William Watts Taylor, always described as "an old friend" and by some accounts her unsuccessful suitor, as business manager in 1883. He ran Rookwood until his sudden death in 1913—its most successful years. She relinquished her involvement in the pottery in early 1886, following her marriage to Bellamy Storer, six months after the death of her first husband. One of Taylor's earliest acts was to replace Newton, and he evicted the Pottery Club and ceased production of the blanks china painters used. He paid the highest wages to male decorators. The technical staff was all male, and they were the ones who won individual recognition in fairs. In the beginning, Nichols's role as entrepreneur was played up because of its novelty, and Taylor may have perpetuated this emphasis out of personal loyalty or because it made good press. But as historian Ulysses Dietz writes, Nichols "never really knew what it was to be a woman worker in the art pottery world."[47]

Each piece of Rookwood pottery was indeed individually decorated and marked with the decorator's cipher plus other identifying information (a monogram adopted in 1886, the year of manufacture, a shape number), and decorators were identified in some of the literature. Yet Taylor seems to have been romanticizing when he wrote in an article: "Rookwood cannot be understood without an appreciation of its radical difference from commercial industries. Its whole history and development centres upon the one idea of individualism, the entire absence of duplication, and the constant progress towards new forms of artistic expression. Rookwood, therefore, does not say to its artists you must do this thing or that thing in this way or that way."[48] Yet one of the best-known decorators, Albert Valentien, remembered strict guidelines and lack of liberty. Essentially, decorators were free to interpret prescribed designs. Moreover, tour guides at Rookwood in later years impressed visitors by telling them that a vase might pass through the hands of as many as twenty-one staff members, which is hardly a description of individuality.

But even if the encomiums to Rookwood must be regarded skeptically, it was in fact the industry leader, an innovative manufacturer that produced many beautiful objects, from collectible vases to New York City subway tiling. Nichols's unusual taste in china painting did not emphasize florals. She adapted motifs from Hokusai's *Manga*, a Japanese book that she obtained via England in 1875, and she was fond of reptiles, insects, and sea creatures. (Figure 1.11) She modeled dragons on the shoulders of some vases and embellished others with

gilding. She and the Rookwood staff worked their way toward a professional style. "Limoges" underglaze painting dominated and grew more accomplished as styles became simpler and more naturalistic. The *Shape Book* documented each variation by illustration and number. (By 1914, 2,200 shapes had been recorded.)

In 1883 one of the decorators, Laura Fry, conceived of using an atomizer to obtain a subtle gradation of color; this became the basis of Rookwood Standard, the most famous line, which dominated from 1886 to 1910. Rookwood Standard backgrounds consisted of sprayed gradations from yellows and oranges to dark greens or "Rembrandtesque" browns; in the 1890s paler, cooler colors were introduced. Among the popular motifs were portraits of Indians, both bust-length and standing, and studies of dogs, children, and flowers. After the imagery was applied, it was finished with a honey-colored high-gloss glaze that gave an illusion of depth.

Decorator Artus van Briggle was responsible for Rookwood's first use of mat glazes. He was never credited, probably because he soon left the company. Works using this opaque glaze concentrated on shape, color, texture, carving, incising, or modeling. A transparent mat was later developed by Stanley Burt. Called Vellum, it was introduced in 1904 at the Saint Louis world's fair, where it earned two grand prizes. Under Vellum, a painted motif could be seen with a slight haziness. It was immediately realized that this moody, atmospheric effect suited landscapes, and they soon competed in popularity with floral imagery. The effect resembled tonalist painting, which flourished in the United States from about 1880 to 1910.[49] Vellum continued to be used until 1948.

Rookwood's decoration was always conservative and naturalistic. Its consistency contrasts with the emphasis at other art potteries on such techniques as modeling or stylized design. Such continuity might seem to be poor business management, but Taylor was constantly alert for ways to improve his product. When a golden crystal effect occurred by accident, he realized that more technical knowledge was necessary. At the end of 1884 he hired the first ceramic chemist in America: Karl Langenbeck, from whom Mrs. Nichols had first borrowed china-painting colors in 1873. Langenbeck had studied pharmacy and chemistry in Zurich and Berlin and knew how to make analyses.

Taylor patented all Rookwood's techniques to keep competitors at a disadvantage. He was quick to improve the glaze atomizers, converting them from breath propulsion to steam and then to true airbrush operation. In 1891, when Rookwood moved to Mount Adams, overlooking downtown Cincinnati, the kilns were changed

Laura Fry

Laura Ann Fry (1857–1943) trained in sculpture, drawing, wood carving, and ceramics. Her father, William Henry Fry, taught wood carving for almost a half-century at the art school in Cincinnati, and she learned all aspects of pottery manufacture, from throwing to decorating, at Trenton, New Jersey. She was a charter member of the Cincinnati Pottery Club in 1879 and two years later, when the decorating department was organized at Rookwood, she became one of the few decorators who also designed the shapes of early pieces.[1]

Fry left Rookwood in 1887, taught industrial art at Purdue University in 1891, and joined the Lonhuda Pottery in Steubenville, Ohio, in 1892 as it began production of art pottery. Lonhuda adopted her atomizer technique for its Lonhuda faience, which was in direct competition with Rookwood's. Fry sued Rookwood to stop its use of her method. The court eventually ruled against her, saying that although this was a new use for the particular tool, the process was not new. Her technique became the almost universal method in the United States for applying underglaze grounds and the glaze itself.[2] In 1894 she left Lonhuda to organize the Porcelain League in Cincinnati, but she returned to Purdue in 1896 and taught there until her retirement in 1922.

NOTES

1. Paul Evans, *Art Pottery of the United States: An Encyclopedia of Producers and Their Marks* (New York: Scribner's, 1974), 141. Nichols, Taylor, and the throwers devised most of the shapes. According to Herbert Peck, *The Book of Rookwood Pottery* (New York: Crown Publishers, 1968), 37, Pitts Harrison Burt, a prominent Cincinnati stockbroker and friend of Taylor's, stopped by the pottery regularly and was second only to Taylor in the total number of shapes contributed. He was the father of Stanley Burt, who became Rookwood's chemist.

2. Evans, *Art Pottery*, 142.

from coal to oil to make the firing more predictable. Temperatures were judged by eye until Stanley Burt returned from his studies in Berlin in 1896 with the first Seger pyrometric cones, a more precise indication of kiln temperatures.

Study in Europe was one of the exceptional benefits Taylor offered to a select few employees. In general,

The Decorators

Two of the best-known Rookwood decorators were Albert R. Valentien (1862–1925) and Kataro Shirayamadani (1865–1948). Valentien was born in Cincinnati and studied at Cincinnati Academy of Art. At nineteen he went to work for Rookwood and soon was made head of design and decoration. He and Annie Bookprinter, also a decorator, were married in 1887, the first of many Rookwood romances that resulted in marriage. Valentien stayed with Rookwood for twenty-four years, then moved to California.

Shirayamadani, who arrived in 1887, has been called one of Rookwood's most valuable assets.[1] He came to America with the "Japanese Village," a troupe that visited major cities between 1885 and 1887 to demonstrate Japanese trades and arts; he was directed to Rookwood by a dealer of Asian art in Boston. Except from about 1915 to 1925, when he worked in Japan, "Sherry" (as he was familiarly known) contributed his skills and knowledge of Japanese design to Rookwood. "Under his influence," Barbara Perry writes, "decoration enveloped the form, moving around the vessel. The old European fear of the void was overcome, and subtly shaded areas of background were deliberately left devoid of ornamentation, and could be enjoyed for their own qualities."[2] Shirayamadani worked at Rookwood until his death.

NOTES

1. Barbara A. Perry, *American Art Pottery from the Collection of Everson Museum of Art* (New York: Abrams, 1997), 36.

2. Ibid., 32.

Rookwood Pottery Company, decorated by Kataro Shirayamadani, Vase, 1898. Molded white earthenware, underglaze; height, 13 in.; diameter, 4.6 in. (Cooper-Hewitt, National Design Museum, Smithsonian Institution, Gift of Marcia and William Goodman, 1983.88.2.)

morale was excellent at Mount Adams—a handsome building in a beautiful location near the Cincinnati Art Museum, with views, gardens, and a library of art and technical books and ceramic journals for inspiration. The pottery seemed to operate in the spirit of Morris's ideal workplace. It was a popular site for local residents as well as tourists to visit.

Taylor was also skilled at promotion. He cultivated influential friends both locally and nationally. He exploited industrial fairs and art exhibitions to display new lines. To be certain that Rookwood pottery was well represented in Edwin AtLee Barber's 1893 *Pottery and Porcelain of the United States,* Taylor sent him more than twenty pieces over the years. When he learned that Barber was going to issue a catalog of the pottery in the Pennsylvania Mu-

seum collection, he sent additional pieces so that Rookwood would dominate the list of American work.

In 1889 Rookwood received a gold medal at the Paris Exposition (McLaughlin won a silver for overglaze decoration with metallic effects). At the Chicago world's fair in 1893, Rookwood works were shown in multiple displays. It was a moment of triumph, yet the old rivalry continued. The catalog for the Woman's Building identified McLaughlin as having discovered the underglaze method that was Rookwood's foundation. Taylor objected, asked that the catalog be corrected and reprinted, and insisted, in response to a letter from McLaughlin, that Rookwood was indebted only to Maria Nichols Storer for its methods. McLaughlin wrote to Storer, asking her to set the matter straight, but her nemesis replied supporting Tay-

lor and ending her letter by saying: "I have really never *known* how or where your work was done, and I must plead guilty to not having read your book on underglaze decoration. Your reputation can rest so well upon what you yourself have done that it is not necessary that you or anyone else, for you, should seek it in outside things with which you have had absolutely no connection."[50] At the Paris Exposition of 1900, Rookwood won a gold medal and also the grand prix, and Taylor was named Chevalier of the Legion of Honor. More museums took an interest in Rookwood then, and every pamphlet issued after 1900 named as "patrons" all foreign museums with Rookwood works in their collections.[51]

After Taylor's death in 1913, new techniques relied less on individual decorators, in an effort to compete with mass-production potteries. By the 1930s Rookwood was deeply in debt, relying on bank loans to get by. It was sold at a bankruptcy sale in 1941, given away to a Roman Catholic foundation, sold to a clock company, and relocated to Mississippi before its ignominious end in 1967. The story of Rookwood suggests that Taylor's business and promotional skills were essential to the success of the company.

In retrospect, the rivalry that prompted establishment of this storied firm seems to have been a positive stimulus. Maybe both women realized their essential wishes. Maria Nichols Storer accompanied her new husband to Washington when he was elected to Congress, and then to Brussels, Spain, and Vienna in diplomatic posts. She died in 1932, at the age of eighty-three, at the Paris home of her daughter, Countess Margaret de Chambrun. Louise McLaughlin, who never married, was in 1938 acknowledged by the American Ceramic Society as the inventor of the method of underglaze painting used by Rookwood and other potteries.

THE ART POTTERY INDUSTRY

After the Centennial Exposition, American potteries turned to making nonfunctional objects for decorative or expressive purposes. These vessels, though they were produced in factories, were meant to be displayed, exhibited, and collected.

One of the most important potteries was run by the Robertson family in Massachusetts, under the name **Chelsea Keramic Art Works** and later **Dedham Pottery**. James Robertson and his sons were British artisans who settled in East Boston in 1859. James brought with him the technique of pressing leaves and grasses into clay, which was new to America. By 1873 Chelsea had established a line of antique reproductions that were praised as the best copies ever made in America.

FIGURE 1.12. *Hugh Cornwall Robertson, Chelsea Keramic Art Works, The Twin Stars of Chelsea, 1884–89. Stoneware, red-blue reduction glaze with lustrous blue highlights; left: 7 × 3.25 × 3.25 in.; right: 6.25 × 3.25 × 3.25 in. (Museum of Fine Arts, Boston, Gift of Miss Eleanor M. Hearn, 65.1709-1710. Photograph © 2008 Museum of Fine Arts, Boston.)*

Displays at the Centennial Exposition spurred Hugh Cornwall Robertson to improve the character of the pottery. In 1877 Chelsea developed a white clay body that made an excellent base for bright glazes. Hugh made plaques and vases in the Aesthetic style, decorated with flowers and birds. He also saw underglaze painting in Philadelphia, and with his technical background he easily reproduced it. After the death of his father in 1880 and the departure of his brother Alexander for California in 1884, Hugh began to focus on creating Chinese glazes. For five years he struggled to perfect such colors as deep sea green and apple green, mustard yellow, turquoise, and the red called *sang-de-boeuf,* or oxblood. He came to call it "Robertson's blood," as a reflection of his efforts.

The red was perfected in 1888. Hugh felt that his finest examples were the vases known as the *Twin Stars of Chelsea.* (Figure 1.12) They are not precisely the Chinese red, but are medium to dark in hue, with golden highlights or iridescent effects. This work followed the Asian idea that an exquisite glaze over a simple form was fine art. Hugh became obsessed with experimentation and bankrupted the family business in 1889, closing it when he could not afford fuel for the kilns. However, a group of patrons financed another pottery for him, first in Chelsea and then in 1891 in Dedham, southwest of Boston. They insisted that he develop a salable line of dinnerware, and he complied by developing the now-famous Dedham crackle, based on a Korean prototype. Stoneware with a gray crackle and cobalt-blue border designs supported the pottery.

Robertson also produced layered glazes that ran together during firing to produce a dramatically rough surface, which he called "volcanic." His achievement was acknowledged when he received one of the three highest awards at the Saint Louis world's fair in 1904. He died in 1908. Robertson is said to be "historically important for his glaze science, not as an artist."[52] Yet his unreasonable dedication to aesthetic effect rather than the profit motive aligns him with later individual artists. Dedham stayed in business until 1943.

Among other art potteries, **Edgerton Art Studio**, in Wisconsin and Chicago (1893–98; later **Pickard China Studio**, 1898–1937), was notable for its enlightened business in the Morris mold: the studio was surrounded by lawns, trees, and flowers and provided a library and reading room, an apartment building for employees, and a profit-sharing plan. **Avon Pottery** of Cincinnati was founded by Rookwood chemist Karl Langenbeck. In 1895 he published *The Chemistry of Pottery*, which became the standard text in the field.

In contrast to these isolated small businesses, the city of Zanesville, Ohio, became home to so many major producers that it was called the "clay city." The movement of designers and decorators among these potteries makes it almost impossible to attribute unmarked pots to a specific firm. W. A. Long, a druggist, duplicated Rookwood's underglaze process and began his own pottery, called **Lonhuda**, in 1892. Samuel A. Weller began **Weller Pottery** in 1872; in 1894 he set up a collaborative arrangement with Lonhuda Pottery, and after he learned Laura Fry's atomizer process, he dissolved the relationship to produce on his own. **J. B. Owens Pottery Co.** started in 1885 at Roseville, Ohio, and moved to Zanesville six years later. **Roseville Pottery** was established in 1890 in the plant formerly owned by Owens. Within a decade it had acquired three other potteries. In 1900 the company began to make art pottery, and by 1905 it employed 350 people. Its products were offered at a wide range of prices and as inexpensive premiums for the A&P grocery company. This pottery emphasized shape, which distinguished it in a market filled with Rookwood look-alikes.

THE FASHION FOR TILES

During the Aesthetic period, when refined painting and handcrafted objects seemed necessary to any well-furnished home, tiles were a popular product. They were found on floors, on foyer walls, on the facings of fireplaces, inset into sideboards or cabinets or stoves, used as trivets or as clock faces. At least fifty companies were founded between 1875 and 1920 primarily to produce tiles.

The Tile Club

An unusual tile enterprise, the Tile Club was established in the fall of 1877 by a group of young artists and writers living in New York City who met informally in their studios to talk about art. As one of them later put it, a "decorative mania . . . had fallen like a destructive angel upon the most flourishing cities in America, turning orderly homes into bristling and impenetrable curiosity-shops,"[1] and they decided that the club should keep up with the times. They painted on Wedgwood or Minton eight-by-eight-inch blanks; the tiles were monochromatic or nearly so, perhaps because they worked at night by lamplight, which made it difficult to use color.

The height of the club's activity and fashionability was 1878–79. Among the participants were Winslow Homer, Elihu Vedder, and later the architect Stanford White and the sculptor Augustus Saint-Gaudens. Oscar Wilde visited during his U.S. tour. *A Book of the Tile Club*, published in 1887, humorously chronicled activities and outings and publicized the members through illustrations.

In truth, the Tile Club was not as serious as the Cincinnati Pottery Club. Members made little effort to market their wares, nor did they ever really address the particular nature of clay or tile design. The tile was just another painting surface. At most they recognized that special effects could be achieved in the medium, and at the least, the square format was a novelty to them.

NOTE

1. F. Hopkinson Smith and Edward Strahan (Earl Shinn), *A Book of the Tile Club* (New York: Houghton Mifflin, 1887), 5, quoted in Ronald G. Pisano, *The Tile Club and the Aesthetic Movement in America* (New York: Abrams in association with the Museums at Stony Brook, 1999), 14.

John Gardner Low, who had been a decorator at Chelsea Keramic, founded **J. and J. G. Low Art Tiles** in Chelsea, Massachusetts, in 1878, with the aid of his father, John. After studying landscape painting in Paris, J. G. Low returned to the United States in 1861 and began painting decorative wall murals. That led him to decorating ceramics and then to tiles. In 1880 Low Tiles won the gold medal for best art tiles in a display in the English pottery district, an impressive achievement for a firm only a year and a half old. Low and a partner developed

a method for taking a clay imprint of any natural object in very fine detail. He used soft, monochromatic tones of blue and green or earth tones of golden ocher, amber, and brown. The style reflected European tiles of the 1860s and 1870s but sometimes featured Japanese-style birds and flowers. Most output was architectural tiles for fireplace surrounds, but some pieces had metal frames so that they could be hung on the wall like pictures. The eldest Low retired from the firm in 1883, when his grandson, the chemist John F. Low, joined the enterprise. Tile production stopped in 1902.

There were also individual endeavors in tiles. **Charles Volkmar** (1841–1914) at first used the underglaze painting technique he learned in France on neoclassical vessels. In 1882 he became the potter of the Salmagundi Club, assisting members in producing a fireplace surround. He also produced plaques and vases decorated with landscapes and creatures. His landscape tiles had soft mat glazes that suited their poetic moods. Volkmar worked in New Jersey, Brooklyn, and Queens with various partners before being joined by his son Leon in 1902. In 1903 they established Volkmar Kilns in Metuchen, New Jersey, making both high-gloss (Asian-influenced) and semimat glazes.

ODDBALLS, INNOVATORS, AND HOBBYISTS

The brothers Cornwall Kirkpatrick (1814–1890) and Wallace Kirkpatrick (1828–1896) operated the **Anna Pottery** in the Mississippi River town of Anna, Illinois, from 1859 to 1896. The pottery was not included in Barber's 1893 encyclopedia or in its 1901 and 1909 revisions and was largely forgotten. The editor of the magazine *Antiques* reintroduced the Anna Pottery in a five-article series during the 1930s, speculating that the brothers had used the same life-casting techniques as the sixteenth-century French potter Bernard Palissy. But again it dropped from sight until, near the end of the century, an Illinois academic published a book in hopes of resurrecting its reputation.[53]

The Kirkpatricks' early work followed the pattern of local folk pottery, providing functional items and humorous goods for local buyers. Somewhat less usual was their production of political-themed items or artware employing cold-painting techniques, and especially interesting is the fact that George Ohr seems to have visited them during his tour of potteries (see chapter 2) and been influenced by their forms and their irreverent approach.

Some of the Anna Pottery works were Victorian in style, including molded Staffordshire dogs, Toby mugs, and some frilly hand-built vases and cemetery monuments. What distinguished the pottery, though, was its

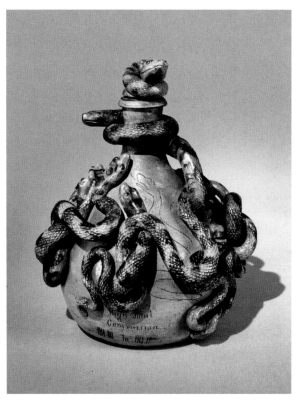

FIGURE 1.13. *Kirkpatrick Bros., Anna Pottery, 8 to 7 Snake Jug, 1877. Stoneware, salt glaze, Albany slip; height, 11 in. (Collection of the Illinois State Museum, 1991.11.)*

snake jugs decorated in polychrome or cobalt blue under a salt glaze. (Figure 1.13) The snakes pass around or through the vessels.

The Anna Pottery also produced trick vessels, some with an intentionally repellent aspect, including pig-shaped flasks made from the late 1860s to the early 1890s. Favored motifs included frogs and toadstools. The Kirkpatricks' production of grotesquery found sufficient market to allow them to stay in business for nearly half a century. If it was not much discussed or shown, it was at least saved, and works are now in many private collections and in Illinois museums.

Susan Stuart Goodrich Frackelton (1848–1932) was born into the clay business and married into it as well, but it was her own initiative that led her to many notable achievements in china painting, art pottery, and salt glazing. (Figure 1.14) She was the daughter of a wealthy Milwaukee brickmaker and grew up familiar with brickyards; her husband imported china and glass. In the early 1870s she studied painting and, like many women of her time, indulged in china painting. By 1877 she had established her own china-decorating business, and by 1883 she had a staff sufficient to decorate and fire 1,500 to 2,000 pieces a week. She published a book, *Trial by*

FIGURE 1.14. *Susan Frackelton, Jar with Lid and Stand, 1893.*
Salt-glazed stoneware; height, 25 in.; diameter, 12 in.
(Philadelphia Museum of Art, Gift of John T. Morris, 1893.)

Fire, in 1885; it went to three editions and was called the bible of china painters. She patented a portable gas kiln in 1886 and 1888 and by 1892 had organized the National League of Mineral Painters to link china painters throughout the country for purposes of education and for competitions. By 1900 the league had around 500 members and held an annual exhibition. She developed Frackelton Dry Water Colors, odorless golds and bronzes for painting on china. The colors were awarded medals by King Leopold II of Belgium in a competition at Antwerp in 1894.

Frackleton is of special interest because she managed "to shake the genteel shackles of china painting"[54] and become an artist potter. She took up the potter's wheel in order to make her own stoneware forms for modeling and carving. She chose local Wisconsin clay, painted decorations in traditional cobalt blue, and used the age-old method of glazing by throwing common salt into the kiln during firing. At the 1893 Chicago world's fair, her work took a gold medal. "To her belongs the credit of elevating the common salt-glazed stoneware to a place beside the finer ceramic wares in this country," wrote Barber in 1901.[55]

Frackelton's recurrent problem was facilities. Her first ware was fired in a brickmaking kiln; later pieces were bisque-fired in Milwaukee and sent to Red Wing, Minnesota, for glaze firing; another arrangement was to throw in Milwaukee and ship to Akron, Ohio, for firing. She abandoned potting before 1904 and relocated to Chicago, where she taught pottery classes in her studio in the Fine Arts Building and wrote and lectured on ceramics and other handicrafts.

Other determined women worked in Nashville and Chicago. **Nashville Art Pottery**, associated with the Nashville School of Art, was directed by Bettie J. Scovel, who went to Cincinnati in 1882 to visit Rookwood. In 1885 she established the pottery, made molded and modeled forms, and experimented with local clays. By 1888 she used original high-fired glazes: "goldstone" (a dark brown that showed golden on a red body) and "pomegranate" (a red-veined effect on a mottled pink and blue-gray ground).[56] Pauline Jacobus, a china painter, also visited Cincinnati. With help from Rookwood's kiln builder and advice from Laura Fry, she set up **Pauline Pottery**, where she "made, fired, and exhibited, in 1882, the first decorated pottery created wholly in Chicago."[57] She began with one small kiln and two decorators, but by 1888, when she moved to Wisconsin, the pottery had six kilns, and she was selling her ware at Tiffany & Co. In 1893 her husband died, his business failed, and she lost the pottery in the subsequent bankruptcy proceedings. She later operated solo. She experimented with low-fire crazing glazes on a whitish body and worked at blending glazes, notably "peacock," a deep blue and dark green.[58]

The **Atlan Ceramic Art Club** of Chicago, the most influential of the many small china-painting clubs, was organized in 1893 by fifteen painters. Atlan members won eighteen medals at the Woman's Building of the Chicago world's fair that year, more than any other club in the country. The group sponsored a course on historic ornament, one on nature as a design source, and another on conventionalizing, which became its specialty.

Atlan was active and influential in Chicago ceramics for more than twenty-five years—in part a reflection of the excellence of the work but also due to the energy of the group's founder, Florence Pratt Steward. Like most Atlan members, she was a graduate of the Art Institute. Another important member was Mabel C. Dibble, who had taught china painting in Milwaukee before moving to Chicago in 1893. She mixed and sold her own enamels, one of which was the popular Dibble Green. *Keramic Studio* devoted its entire October 1906 issue to her.

She became the first midwestern woman to be named a master craftsman by the Society of Arts and Crafts, Boston, and in 1909 she was invited to join London's Royal Society of Arts. In 1911 she published a primer, *How to Use Enamels on China*. Despite Atlan's success with conventionalizing, most china painters employed naturalistic motifs because they sold better; naturalistic versus conventional was an endless debate.

Louise McLaughlin, Studio Potter

McLaughlin persisted in her experimentation in Cincinnati. In 1894 she patented a new method of decoration that involved applying colored slips to the inside of a plaster mold and then casting a slip of a different color. The resulting piece would seem to have an inlaid surface. She abandoned this work because firing was a problem. Later that year she challenged herself to develop hard-paste porcelain, working in a studio at her home and firing a small kiln in her backyard. Porcelain was a medium few had attempted; she was the first American woman to work in this material. At first she employed a potter, but eventually she dismissed him.

In the beginning, there were no colleagues with whom McLaughlin could compare notes, there were no published technical instructions to follow, the formulas she could find had to be adapted to American materials, and besides that, her neighbors complained about the burning of coal in the backyard kiln. Her experiments included combinations of eighteen clay bodies and forty-five glazes. The work was produced in a single firing and was creamy white and translucent. She called it Losanti ware (after Cincinnati's original name, Losantiville) and produced it from 1898 until 1906. (Figure 1.15) The fact that it fired well was more important to her than its lack of the bluish white tint of other porcelains. She admitted, "Altogether my methods would set a practical potter frantic but . . . I feel emboldened to set tradition at defiance and follow any method which proves practicable."[59]

McLaughlin's independence and her complete control of the process placed her among the first studio potters in America, and the first working in porcelain. In August 1899 the work received national exposure in the new magazine *Keramic Studio*. Adelaide Alsop Robineau, editor of the magazine, published parts of a letter from McLaughlin describing the ware. McLaughlin worked small. The largest recorded shape in her Losanti book is twelve inches high, and most were just five to seven inches. Her forms became increasingly simple and classical; she painted with only one tint, or with just a few

FIGURE 1.15. *M. Louise McLaughlin,* Losanti Vase, *1901. 5.75 × 3.87 in. (Cincinnati Art Museum, Gift of Theodore A. Langstroth.)*

harmonious colors. Recognition of her success came in 1901, when she was awarded a bronze medal at the world's fair in Buffalo. Around 1901 she changed from painted to carved decoration, perhaps inspired by European work she saw in magazines; she adapted her skills at wood carving to the new medium. Among her methods was to carve a design in the clay and fill the openings with glaze. She carved twisted vines, leaves, and flowers with the swirling compositional lines of art nouveau, popular at that time. Lusters were among her final experiments in 1906. She stopped because she couldn't afford to rebuild her kiln.

Historians have compared McLaughlin with Robineau—famous for her later work in porcelain—since both were female and both pioneers, but the comparison is not quite just. Robineau's work was later, and she had support (see chapter 2). Here, as before, McLaughlin became interested in an obscure subject, experimented, achieved some major goals, and then gave it up for logistical reasons.

Stained Glass and Art Glass

The Aesthetic movement brought great change to stained glass. Technique, style, and setting shifted markedly. In

addition to its traditional religious use, stained glass began to appear in public buildings and opulent private residences, and in the 1890s it moved into middle-class homes, department stores, and even Pullman railroad cars.

The explanation for this growth can be traced back to Pugin's endorsement of the Gothic and Ruskin's and Morris's praise of the translucence and pure color of medieval stained glass. Research in ancient techniques and traditions by Charles Winston—an English lawyer, archaeologist, and connoisseur of ancient glass—and Eugène Emmanuel Viollet-le-Duc—a French architect who was responsible for restoring many ancient French cathedrals—showed that medieval windows were made up of pieces of solid-color glass (known as pot metal) separated by leading. Influenced by painting, however, nineteenth-century windows added painted color, baked for permanence. Pot metal had long been out of favor when Morris took it up.

Prosperity led to the building of new churches in America, which meant more demand for glass. Most was imported from England, Germany, Belgium, and France, and it was not always of the best quality. The first innovations in American churches came from British designers: in 1874 **Morris & Co.** created a memorial window for an upstate New York church that replaced the usual Gothic-style lancets in a trefoil arch with a large vertical rectangle surrounded by smaller rectangles.[60] Also new was the elegance of the figures and colors more subdued than traditional blues, reds, and greens.

Scotsman **Daniel Cottier** (1828–91), who had trained in Glasgow and had taken classes with Ruskin, opened a New York City workshop in 1873. He introduced new subjects that were not particularly religious, from floral and figural vignettes to river-and-mountain landscapes. He favored a subtle olive, ocher, blue, and gold palette, as seen in his windows for Trinity Church, Boston. **Charles Booth**, a stained-glass artist from Liverpool who was in the United States by 1875, is believed to have created windows for Calvary Church, New York City, in 1878. These eschew both the usual church-window palette and the earth tones of Morris and Cottier in favor of such shades as aquamarine, amethyst, pink, and light yellow. Booth spent a decade in New York City and created windows for Grace Church and the Jefferson Market Courthouse. At that time, in addition to the contentious issue of pot metal or paint, there was also debate about whether abstract patterning or pictorial imagery was more appropriate, and if the design was pictorial, whether it should be flat or illusionistic.

Chicago decorator Louis J. Millet, an advocate of conventionalized designs, with his partner George L. Healy, used tiny fragments of colored and textured opalescent glass to create contrast and detail as well as the main design in windows. When two works in **Healy & Millet**'s new "mosaic" style were exhibited at the Paris Exposition in 1889, the French government purchased the entire show for installation in the Musée des Arts Décoratifs.

Another development was the use of stiff cames of grooved copper or zinc replacing soft lead cames to hold together the glass segments. The new materials expanded possibilities because they were stronger and so required less bracing. They also suited the developing style of geometric designs, particularly strong in the Midwest.

Smith Brothers of New Bedford, Massachusetts, was the largest glass firm in the United States between 1875 and 1895. It was also the only American glassmaker to display its enamel-decorated wares at the Centennial Exposition. But the most important names in the new American glass were John La Farge and Louis Comfort Tiffany. Both became famed for the semitranslucent glass called "opalescent." It had been produced in America for at least fifty years but had not, as a rule, been used for windows. This glass, which was poured and rolled into sheets, could be porcelain-like in appearance, but against the light it could appear as iridescent as an opal.

Art-glass objects followed the expanded market for windows and became popular as collectibles, like art pottery. Work in glass drew on classical, Asian, and Islamic sources but was also reliant on a revival of Venetian techniques that started on the glassmakers' isle of Murano about 1850. Venetian glass objects were too expensive for the general public, but pressed glass vessels in a dazzling variety of colors were substituted. Textured ice glass ("craquelle"), very popular in the last quarter of the nineteenth century, was produced by factories from Massachusetts to West Virginia.

Chicago had glass-cutting and glass-engraving industries at the end of the nineteenth century. Glass cutters, like china painters, applied their skills to manufactured blanks. They also tended to follow familiar patterns, and creative design was less important than the quality (depth and precision) of the cut.[61] These pieces were often given as presents on special occasions. Production was curtailed during World War I, when lead—an essential ingredient of prismatic glass—was need as a war material. After the war, efforts to reduce cost and expand the audience backfired. ("Cheapness," Frederick Carder warned in 1923, "will ruin the industry.")[62]

JOHN LA FARGE: LUMINOUS TAPESTRY

John La Farge (1835–1910) was a cultivated man, born in New York City to French émigrés, educated in literature and law. He turned to painting as an intellectual activity and then followed his fascination with color into mural painting and stained glass, in which he became a celebrated innovator. He also wrote art criticism and history, illustrated books and magazine articles, and designed embroideries, portieres, and mosaics. He accomplished all this despite persistent ill health that was eventually attributed to lead poisoning, probably from painting and glass materials.[63]

Some of La Farge's nonglass work was influenced by Japanese art, which he collected as early as 1856. He regularly visited Europe, beginning in the mid-1850s, when, having read Ruskin, he studied the qualities of medieval windows. He had also read Michel Eugène Chevreul's theories of the optical laws of color, which influenced his painting and then his glass.

La Farge was commissioned in 1874 to do a memorial window for Harvard. He began to experiment with plating (layering glass within a single leaded segment) and fusing fragments of color together with heat. He inserted opalescent glass cut from bottles plus thin slices of onyx and other semiprecious stones. The window became a kind of relief mosaic. In 1879 he filed a patent for this new system of constructing windows. He limited painting to heads, hands, and faces. Along with plating, he embedded cast and cut nuggets of glass. His friend and biographer, the critic Royal Cortissoz, wrote, "There are many of La Farge's windows which therefore seem to be but curtains of jewels hung between us and the light, pieces of some new kind of luminous tapestry."[64]

La Farge opened a glass shop in New York City in 1879; four years later it became the La Farge Decorative Art Company. Although his firm was short-lived, he continued to make windows. His major rival was Tiffany. The two men had much in common and initially had a cordial relationship. Both started as painters, both were influenced by an early acquaintance with American landscape artist George Inness, and both said that encounters with medieval stained glass led them to take up the craft. They both started working with glass in the 1870s and described their frustration with the limited colors available, as well as with the difficulty of finding craftsmen to carry out their ideas. Neither was a hands-on craftsman, but both were attentive to the entire process.

The work of both can be seen as part of the Aesthetic movement's obsession with textures and surfaces, given a new expression in glass. Both were of their time in throwing off tradition and looking for a decisively American vocabulary. Perhaps they also exemplified an age of invention and patent competition, because in the 1880s La Farge sued Tiffany for "stealing" his ideas. There is some evidence that Tiffany or his father solicited La Farge to enter into a partnership. He shared his procedural information, and then, if the allegations are true, they backed out, and Tiffany used the information in his work.[65]

Probably La Farge's earliest windows were those in Stanford White's remodeling of the William Watts Sher-

Decorating Trinity

Accounts of the day speculated that Trinity Church was the first instance of the entire decoration of a church being put under the direction of an artist "with the object of bringing the whole work—general color, decorative detail, and figures—into a consistent and harmonious whole."[1] This unusual idea was the concept of architect H. H. Richardson and the Reverend Phillips Brooks. They persuaded the church trustees to take on the additional expense and then commissioned La Farge to do the job, giving him only four months (September 1876–January 1877) and a total of $8,000, which covered materials and his assistants (some of Boston's best young artists, including Augustus Saint-Gaudens).

La Farge was already known as an oil painter, but the warm colors and enormous and graceful figurative mural paintings at Trinity cemented his reputation. The building is regarded as an exemplar of American architecture, yet La Farge made Richardson's "solid, massive and unmodulated spaces" (Henry Adams's terms) seem "airy, unsubstantial, and multifaceted. To a public used to the bare white interiors of Colonial churches or the cold stone surfaces of the nineteenth-century Gothic style, La Farge opened up a whole new realm of experience."[2]

NOTES

1. *American Architect and Building News* 1 (1876): 345, quoted in Diane Chalmers Johnson, *American Art Nouveau* (New York: Abrams, 1979), 44.

2. Theodore E. Stebbins Jr., "Trinity Church at 125," in *The Makers of Trinity Church in the City of Boston*, ed. James F. O'Gorman (Amherst and Boston: University of Massachusetts Press, 2004), 17.

man House in Newport, Rhode Island, believed to date to 1877.[66] He seems to have keyed his design to the architectural setting, adopting rectilinear organization by depicting a Japanese-style bamboo lattice interwoven with flowers. He used unusual colors in the Watts Sherman windows, such as acidic hues of yellow, orange, and red against a background of complementary blues.

Much more celebrated, and far more public, were the windows he did for Trinity Church, Boston. When the church was consecrated, only seven leaded windows by an English firm were installed, and these were rather ordinary. As the remaining plain windows were gradually replaced by commissioned memorials, Trinity came to represent all the best stained glass of the era, except for Tiffany's.[67]

Four of La Farge's Trinity Church windows are regarded as masterworks. His *Christ in Majesty* is a three-part window installed in 1883. (Figure 1.16) The figure of Christ, his right hand raised in benediction, was inspired by a thirteenth-century sculpture at Amiens Cathedral, an icon to readers of Ruskin: "Christ appears almost silhouetted against a vibrating background of roughly cut blue-green nuggets which, suggesting abstract space beyond, visually lengthen the nave."[68] The saturation of color provoked comparisons to the windows of Chartres Cathedral. Almost equally impressive in their colors are La Farge's *Resurrection* window and his *New Jerusalem* window beside it in the north transept. These, being near balcony seating, can be examined close up to appreciate the depths and textures.

La Farge's style grew out of his process. By participating in the production of his windows, he avoided the stiffness that resulted from stained-glass painters following an artist's cartoon. By piecing and plating, he controlled hue and transparency to achieve painterly effects, and he used cames like lines in a drawing. The layers of plating, when seen close up, "encourage the eye to 'swim' inside a window."[69]

The *Peacock Window*, in the collection of the Worcester Art Museum, started as a residential commission; he ran into problems, so he made another window for that job and continued working on this one, finally completing it after fifteen years. (Figure 1.17) The peacock's assembled-glass feathers in this roughly forty-by-twenty-inch panel seem to pour downward in iridescent three-dimensionality with an almost startling lavishness. This work is made of thousands of pieces, most so small they were picked up with tweezers, set in copper wires so fine that their lines are invisible, and joined in repeated fusings, each involving a certain risk. In the *Peacock Window*, "the background . . . wants to burst beyond its bor-

FIGURE 1.16. *John La Farge,* Christ in Majesty, *1883. Stained glass. (Photograph courtesy of Trinity Church in the City of Boston.)*

FIGURE 1.17. *John La Farge, Peacock Window, 1892. Stained glass; 39.9 × 19.9 in. (Worcester Art Museum, Worcester, Mass., Museum Purchase.)*

TIFFANY: MARKETING ARTISTRY

Louis Comfort Tiffany (1848–1933) was a painter of oils and watercolors, a pioneer interior decorator, an architect, a landscapist, a designer of ceramics, jewelry, tableware, wallpaper, textiles, opalescent glass vessels, tiles, and mosaics as well as of memorials, and a planner of pageantry and celebratory events. Little of this activity is remembered today, when he is known almost exclusively for his glass. This work brought him enormous fame but fell out of fashion after the first decade of the twentieth century. In the 1950s it was rediscovered, and today he is a household name, seemingly far more illustrious than his peers. This is probably due as much to his remarkable marketing skills as to his artistic talent.

Scion of Tiffany & Co., the New York City jewelry firm founded by his goldsmith father, he went to school at Eagleswood Military Academy in New Jersey, where his interest in art was encouraged by the tonalist landscape painter George Inness. He studied in Paris with the orientalist salon painter Léon Bailly and traveled across Spain, North Africa, and Egypt with the American painter Samuel Colman, painting watercolors and oils that he showed at the Centennial Exposition in Philadelphia in 1876 and at the Paris Exposition in 1878. He was attracted to ancient Roman and Syrian glass, Byzantine mosaics, and Gothic stained glass. In 1872, at the age of twenty-four, exploring one of many interests, he studied glass chemistry and techniques under a Venetian foreman in Brooklyn.[71]

Tiffany's first glass works were produced as part of his first business, the Associated Artists decorating cooperative, formed in 1879 with Candace Wheeler, Samuel Colman, and Lockwood de Forest. Within months, only such established firms as Marquand and Co. and Herter Brothers were more fashionable, and Associated Artists surpassed them as most artistic.[72] Wheeler was a friend of many prominent artists and skilled in needlework; Colman had a collection of rare textiles; De Forest, also a painter, contributed his knowledge of East Indian carvings and fabrics. (De Forest later designed Olana, the Aesthetic marvel that is now a New York State park.)

Associated Artists worked with many powerful people who had conservative tastes in the "High Victorian" style. Although Tiffany missed some commissions because he rapidly developed a reputation for independence and unorthodox methods, he and his partners created a new style by blending exotic elements such as glass tiles, Islamic carvings, embroidered hangings, and painted friezes. The style was probably influenced as well by Whistler's Peacock Room (1877), widely publicized as an Aesthetic masterpiece of color, metallic leaf, painting, and integral

der, yet the bird's contours provide just enough central balance to prevent the work from falling into chaos. This is stained glass at its most opulent, and perhaps most decadent."[70]

Some of the work of both La Farge and Tiffany can seem clichéd and sentimental today. But La Farge's best works have a visual intensity coupled with obsessive craftsmanship that is still compelling. He stopped his glass experiments before 1900, as the quality of available material improved and as he did more memorial windows, which were seen from a distance that required him to forfeit details and delicacy for larger patterns.

THE VETERANS' ROOM.

furniture. Replacing lace curtains with Indian muslin, controlling light by using stained glass rather than shutters or heavy valances, and lightening the palette of wall colors were, however, all innovations.

Associated Artists' redecoration of the Veterans' Room at the Seventh Regiment Armory on Park Avenue sheds light on the firm's collaborative nature. (Figure 1.18) Tiffany was credited with the "general character and scope of the decoration," and his associates with the details and execution.[73] It could have been more cohesive, but the clients were happy: a booklet printed by the veterans organization in 1881 praised the military effect, with its ironwork and axe-cut beams.

Stenciled design, glass, and textiles by Associated Artists embellished Mark Twain's Victorian home in Hartford, Connecticut, in 1881 (like the Veterans' Room, still extant). The firm also worked for the Vanderbilts and other wealthy New Yorkers. *Artistic Houses*, the book of photographs of the homes of the glamorous and powerful published in 1883–84, included Tiffany's own apartment and seven other homes decorated by Associated Artists. Another triumph was a commission from President Chester Arthur for the White House. The most striking element was a floor-to-ceiling opalescent glass screen in the first-floor hall, which provided more privacy for the president's family. It was effusively described by a contemporary journalist as "a thoroughly artistic piece of

work, exceptional in taste and in perfect harmony with its surroundings. . . . Four circular sconces, each having seven gas-jets, are each provided with a background, or rosette, 3 feet in diameter, composed of fantastic shapes of colored glass interspersed with little mirrors, to produce a scintillating effect of great variety and brilliancy, which is enhanced by the pendant drops of iridescent glass affixed to the arms that hold the jets."[74] Only twenty years later, Theodore Roosevelt ordered it broken up and removed when Charles F. McKim remodeled the interior.

Tiffany started out by using decorative glass tiles for fireplace surrounds (the Veteran's Room features surprisingly intense peacock blue glass) and also for lighting fixtures in some of the interiors decorated by Associated Artists. The tiles were variously opaque, opalescent, transparent, or iridized with a metallic surface, and were usually square shapes up to four inches across. He could create swirls, rosettes, and geometric and irregular patterns by means of molds or by special pouring techniques. Based on this experimentation, he was granted several patents in February 1881. One dealt with the combination of types of glass in the manufacture of tiles and mosaics, another with a kind of plating used in windows, and the third with the use of a metallic luster glass, which was to be characteristic of his objects.

After Associated Artists dissolved, Tiffany continued

FIGURE 1.19. *Louis Comfort Tiffany, Tiffany Glass and Decorating Company, Summer Panel of the Four Seasons Window, 1892–1900. Stained glass; 40.5 × 36.6 in. (The Charles Hosmer Morse Museum of American Art, Winter Park, Fla. © The Charles Hosmer Morse Foundation, Inc.)*

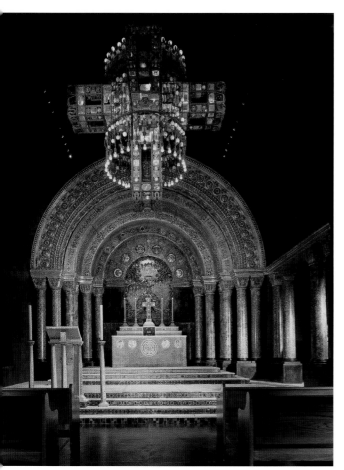

doing interiors as Louis C. Tiffany & Co., although his work on the Lyceum Theater in New York soon bankrupted that business. He did a huge house at the corner of Seventy-second and Madison in New York for his father; he also lived there with his wife and children. He did theater and church interiors and occasional private residences, a notable one being the Havemeyer house in Manhattan, built in 1890–91. In the hall Tiffany used colored glass in every possible place, including windows, lighting fixtures, and glass mosaic wall panels. Here and in other mosaics, he used iridescent glass, mother-of-pearl, and transparent tesserae backed with gold or metal leaf.

In 1885 he established the Tiffany Glass Company, reflecting his changing focus. His best-known works are either grand landscape perspectives or close-ups of trees, shrubs, or flowers.[75] (Figure 1.19) Like La Farge, he avoided staining or painting the glass because it dulled the surface and affected the transmission of light. Rather, he relied on the variations of coloring and the thickness of the glass to give shading or modeling effects. He revived old methods and invented new ones to achieve unusual results: for example, he created "drapery glass" by pushing and twisting hot glass until it moved into rippled folds. Like La Farge, he made use of small, thick pieces of colored glass, which he called "jewels," inserted into windows to punctuate expanses of color.

In 1889 Tiffany, on a European holiday, was astonished to find a window by La Farge *displayed* (not installed in a building) at the Paris Exposition and drawing great praise. Tiffany's own moment of public-relations mastery was 1893, when he created a chapel at the Chicago world's fair. (Figure 1.20) He exhibited in a portion of his father's commercial space, and the result was a huge success, with more than a million people visiting. The chapel was a neo-Byzantine interior that included a marble altar with mosaic front, a reredos behind the altar decorated with peacocks and vine scroll mosaic set into black marble, a jeweled tabernacle, gold-leafed Romanesque arches, and glass-mosaic-surfaced columns with carved capitals. There were also twelve stained-glass windows and a suspended jeweled sanctuary lamp. The unity of design, theatricality of presentation, and the awesome, dazzling materials made it unforgettable.

By 1898 Tiffany was producing thousands of items a

FIGURE 1.20. *Louis Comfort Tiffany, Tiffany Glass and Decorating Company, Tiffany Chapel, 1893, reassembled at Morse Museum of American Art, 1999. Stained glass; 37 × 24 ft., 1,082 sq. ft. (The Charles Hosmer Morse Museum of American Art, Winter Park, Fla. © The Charles Hosmer Morse Foundation, Inc.)*

year (both windows and objects, see chapter 2), and storing vast quantities and varieties of glass. According to contemporary accounts, he stockpiled many tons of glass in about five thousand colors and types. He supervised selection of each color of a window as well as the process of adding colors to blown glass.

While the work was successful and popular, not everyone admired Tiffany's work. Generally, the criticism was that his technique was fine but his design was wanting. One writer said the work was "harsh in design and vapid in sentiment, [though] always rich in color and varied in texture," and a writer for *The Studio* said, "the results still leave much to be desired. The texture is too luscious, the treatment too pictorial, the designs not important enough. The work is a . . . translation from a sketch; the medium still awaits the artist that shall make it his own."[76]

Since much of Tiffany's work was ecclesiastical, his creativity was repeatedly constrained by conservative church officials and church architects as well. He extended his preferred naturalism to church windows by introducing flowers to biblical figures, at first in the form of symbolic lilies and vines. He added lettered passages from scripture to support his choices and quoted the contemporary notion that "God is Nature." But there were still significant objections to this practice, especially when he began to create landscapes without figures. His 1910 Russell Sage Memorial window in the First Presbyterian Church in Far Rockaway, Long Island, was the largest landscape window ever executed. Its startling realism and natural color tones were set within neo-Gothic window frames. The architect was Ralph Adams Cram, a traditionalist who furiously opposed the effect.

It is a measure of Tiffany's and La Farge's success in glass that their time was called the opalescent era as well as the Gilded Age. While La Farge was generally considered the greater artist, Tiffany was the better entrepreneur and is far better known today. Of course, Tiffany's glass objects circulate in antique markets, while La Farge's windows do not. In any case, the sheer size of Tiffany's studio and its vast and inventive production make him important to the history of American glass.

In Short

Studio craft is a response to the fact that industry had led to shoddy products and unpleasant work. The Arts and Crafts movement—which originated in England and was based on the ideas of Pugin, Ruskin, and Morris— provided a philosophical basis for change. Good design, linked to criticism of industrialization, gave Arts and Crafts a moral impact that was still resonant a century later.

Pugin's notions of revealed construction, truth to materials, fitness of form and process to material, and rejection of illusion in walls and floor covering also had a long-lasting influence. Ruskin argued that workers could derive satisfaction from their labor if they had some creative control. Morris taught himself various crafts—a radical, class-defying act—and organized a collaborative decorating business, justifying prices higher than mass-produced goods by quality and uniqueness. He resisted the division of art into high and low, insisting that it should be incorporated in the daily lives of ordinary people.

The spread of these ideas led to the Aesthetic movement, in which design, style, and beauty were popular concerns. Oscar Wilde's enormously successful lecture tour in 1882 emphasized these ideas in the United States and Canada, where the Aesthetic influence can be seen in painting, art pottery, and interior decorating of the time. Simultaneously in England, young architects turned away from Gothic revival style to simpler, less ornamented lines. A group of them formed the Arts and Crafts Exhibition Society, providing a model for societies that sprang up across the United States, some of which still exist.

In America, the Centennial Exposition in Philadelphia in 1876 introduced new styles, forms, and techniques that blossomed first in art pottery, in interior decorating by firms such as Louis Tiffany Associated Artists, and in Candace Wheeler's textile design. These efforts, beginning in amateurism, evolved into distinctively American expressions and produced the first studio craft. The role of women is notable and exceptional in the society of the time. What separated craft from trade, from this beginning, was that it was inherently ideological: it embodied a viewpoint critical of the larger society or insisted on the importance of individual creativity.

CHAPTER 2 1900–1909

HANDWORK AND
INDUSTRIALIZATION

Setting the Scene

The United States in 1900 was only thirty-five years past a tragic war, reunited by force after being divided over the issue of slavery. Some 76 million people lived in America, with most large cities in the Northeast and Midwest. However, 60 percent of the population was rural. The western frontier was substantially settled. Four railroads had spanned the continent by 1883, opening vast markets for trade. Government was minuscule by contemporary standards, and there was no income tax. Economic growth was rampant, although frequently interrupted by depressions, which in those days were called panics.

If there was a national economic policy, it was laissez-faire. The prevailing attitude was that capitalism was innately just, even if some people suffered. One percent of American families held half the country's wealth. Monopolies controlled steel, oil, sugar, flour milling, railroads, coal, beef, even school slates. Meanwhile, immigration was changing the face of America. Chicago, the second-largest city, was also the second-largest Polish city in the world and the fifth-largest German city. More than 10 million Americans were foreign-born. Many Anglo-Saxons found this trend deeply disturbing, and prejudices once aimed at the Irish turned against Italians, Jews, and Eastern Europeans.

In 1900 "separate but equal" was the law of the land for African Americans. In practical terms this meant that whites were free to implement a wide range of Jim Crow laws: blacks were refused the right to vote, to sit at the same park benches as whites, and to drink at the same water fountains. Lynchings were commonplace.

After President William McKinley was assassinated in 1901, the new president, Theodore Roosevelt, embarked on a campaign of "trust-busting" and progressive legislation. In the next ten years, minimum-wage laws, the Pure Food and Drug Act, and federal income tax were enacted. While Roosevelt was a friend of business, he fostered a new attitude toward government, in which the interests of the common people were as valid as those of the rich and powerful.

Progressivism in politics was paralleled by advances in technology and services. Skyscrapers in Chicago

1900
 Price of a first class postage stamp: 2¢
 Average hourly wage: 15.2¢
 Kodak Brownie camera introduced
1901
 Pan-American Exposition, Buffalo, New York
1902
 Alfred Stieglitz forms the Photo-Secession,
 becoming America's foremost promoter of art
 photography
1903
 The Wright brothers conduct the first manned,
 powered flight at Kitty Hawk, North Carolina
 An automobile is driven across the continent for
 the first time; it takes 52 days
1905
 Industrial Workers of the World (IWW) founded
1906
 San Francisco Earthquake kills 700 and destroys
 most of the city's downtown
 Upton Sinclair publishes *The Jungle*, a novel
 exposing the corruption of the meatpacking
 industry
1908
 Henry Ford introduces the Model T
1909
 National Association for the Advancement of
 Colored people (NAACP) founded

and New York became the symbol of urban modernity. American inventors improved methods of production in every industry, lowering prices for all manufactured goods. The vast rail network made travel easy and relatively inexpensive, creating a new industry: tourism. All in all, Americans were more prosperous and comfortable than they ever had been.

Yet many jobs that are now highly mechanized were done by hand, from picking cotton to mining coal. Paid vacations were unusual. In 1900 only 8,000 automobiles were registered in the United States. Only 1 million households had a telephone. Movies had been shown to audiences for only five years, and most people had never seen one. Not even one house in twenty had electricity, and it was supplied only in the evening because there was no use for it other than lighting.

The department store, a Parisian invention, dominated urban retail sales. It sold both everyday goods and luxury items—including art pottery—and even mounted quasi-exhibitions of imported merchandise. Rural consumers relied on encyclopedic mail-order catalogs from Sears, Roebuck and Montgomery Ward. These "wish books" offered goods ranging from underwear to entire houses in kit form.

Department stores, mail-order catalogs, and changing technology finished off the old local craftsmen. Hand production could survive only as long as it didn't compete with mass production and mass distribution. That meant pottery, weaving, blacksmithing, and other crafts could endure in economic backwaters, but commercial china replaced handmade pots, factory-made textiles replaced homespun cloth, and rubber tires replaced wooden wheels. Most people were happy to abandon the old ways: new mass-produced goods had the glow of modernity and the gloss of fashion. Old crafts such as shoemaking, coopering, tinsmithing, and coach making passed away unmourned. Handcraft, excluded from the production of life's essentials, had to find a new identity.

Reform and the Crafts

Reform movements swept across America from the 1890s to 1917. The reformers, many of whom called themselves progressives, were a varied lot, not cohesive enough to endure as a political party. What they had in common was a desire to deal with the ills of modern urban-industrial society, including recapturing power from corporate and party bosses who had plundered the United States during the Gilded Age. They were not trying to turn back the clock; essentially they accepted an industrial society but tried to resolve some of its difficulties. One motivation for reform has been called the social gospel: the belief that it was a Christian duty to right the wrongs created by industrialization. Another was the new "social sciences," which suggested that natural laws would make it possible to find means to improve the human condition. Among the earliest reform steps was the creation of settlement houses beginning in 1886.

Not all progressive efforts would be considered enlightened today, since curbing immigration, suppressing racial minorities, and banning alcohol were part of the plan. Some policies amounted to coercive attempts to make other racial and ethnic groups conform to "American" ways of living. But most progressive projects can be considered part of modernization, aiming for efficiency and rationality. Likewise, the Arts and Crafts movement in America was less an attempt to return to medieval conditions than an effort to retain some of the values of earlier times within the modern system.

Settlements

The first American settlement house was established in 1886, when an Amherst graduate who had studied in Europe started the Neighborhood Guild on the Lower East Side of New York City. Smith graduates founded the College Settlement nearby in 1889, and at the same time, Jane Addams and Ellen Gates Starr began Hull-House in Chicago. By 1910 there were about 400 settlement houses in the United States.

Addams and Starr, college classmates who had traveled to Europe in 1888 and in London visited Toynbee Hall (see chapter 1), founded Hull-House in a crowded immigrant neighborhood that middle-class people would be unlikely to see. Residents worked to improve the urban environment through tenement-house reform, the public playground movement, and efforts at what is now called city planning. The kindergarten movement was first endorsed by settlement workers, and settlement-based reformers agitated for limiting work hours, inspection of factories, and regulation of public utilities. Hull-House became the nation's largest social settlement, and Addams was widely admired.

Settlement workers typically encouraged the distinctive cultures brought to the United States by the newcomers. At the same time, they tried to help immigrants adapt to their new homeland in a process that came to be called Americanization. Art classes were usually a part of settlement activities, and sometimes potteries were as well.

Starr established the Hull-House Labor Museum in 1900 to demonstrate old craft processes in textiles, metals, wood, and books. Its living-history exhibits displayed the craft knowledge of skilled immigrants not only to visitors but also to their own children.[1] Addams saw the museum in terms of John Dewey's philosophy of "a continuing reconstruction of experience," teaching workers the historical and industrial significance of their jobs and thereby undoing some of the fragmenting effects of industrialization.[2] The effect, however, was probably restricted to personal improvement.

NOTES

1. Peggy Glowacki, "Bringing Art to Life," in *Pots of Promise: Mexicans and Pottery at Hull-House, 1920–40*, ed. Cheryl R. Ganz and Margaret Strobel (Urbana: University of Illinois Press, 2004), 15.

2. T. J. Jackson Lears, *No Place of Grace: Antimodernism and the Transformation of American Culture, 1880–1920* (New York: Pantheon, 1981), 80.

Modernizing came with pernicious side effects. The rise of corporations (between 1897 and 1904, 4,200 companies turned into 257 corporations) changed the work environment. Bureaucratic work could seem empty because it was not physical or independent, while banks and municipal services took care of tasks that people previously did for themselves, thus decreasing a person's autonomy. Work—often monotonous—became separated from the rest of life. The rise of the middle class and the development of consumer consciousness may have been positive changes, but the public was newly subjected to the suasion of advertising. For some people, the response to this new world that T. J. Jackson Lears calls "overcivilized"[1] involved a neurotic helplessness then called neurasthenia. The new idea of being "on time," the speed of transportation, and the multiplication of published information increased stress. Some of the educated bourgeoisie sought more "real" or intense physical or spiritual experiences. The military, religion, and nature were among the means. The healthiness of the outdoors was promoted by John Muir, John Burroughs, and others. Numbers of people were looking for meaning in a time of change, and the consequence was an emphasis on introspection and self-fulfillment.

In this context, the craftsman ideal offered an alternative, perhaps even oppositional, culture. William Morris had written in 1894, "Apart from the desire to produce beautiful things, the leading passion of my life has been and is hatred of modern civilization,"[2] and some educated Americans felt the same way. A constituency for the artistic crafts grew in America during the 1890s predominantly among elite women and art professionals, and spread into the middle class during the following decade. Reform in the decorative arts sought to end the estrangement of people from the physical world—an aspiration that still motivates part of the craft world today. But from the start there were difficulties of audience and business practices. Individual craftsmen tried to make a living without exploiting the labor of others, while factories tried to make art. Crafts were produced by serious hobbyists, whose aesthetic achievements did nothing to solve Ruskin's and Morris's lament over the separation

between work for pay and work for pleasure. Seldom, then or now, was the artisan a happy worker embedded in a stable community.

Elbert Hubbard and the Roycrofters

The Arts and Crafts movement grew dramatically in America around the turn of the century, but it was isolated from the mainstream until two men from upstate New York fired the public imagination. One was a furniture maker, Gustav Stickley. The other was a salesman, Elbert Hubbard, one of the epic characters in the story of American craft.

Hubbard (1856–1915) was a natural-born promoter: cheerful, talkative, and creative. When he was only fifteen, a traveling salesman named John D. Larkin hired him to sell soap door-to-door. Hubbard was such a success that Larkin offered him a junior partnership in his new venture, the Larkin Soap Company in Buffalo, New York. The company specialized in mail-order sales, and Hubbard became one of the pioneers of junk mail.

Hubbard wanted to be a writer. He persuaded Larkin to buy out his share of the company in 1893 and moved to Boston to take classes at Harvard—and suffered frequent rejections. Angry and disappointed, he traveled to England in 1894. He claimed to have met Morris (although the meeting was not recorded by anybody in England).[3] Inspired by Morris's Kelmscott Press, Hubbard decided to publish his own books, bypassing the establishment that spurned him.

After settling in East Aurora, New York, Hubbard began publishing not just books but also a magazine to which he gave the curious name the *Philistine*. He opened his own printing shop in 1897. To promote his ventures, he began presenting lectures that combined high-wattage salesmanship and Arts and Crafts theory. His books and magazines became very successful. In 1896 he started a bindery, so books could be made from start to finish. He hired printers and bookbinders as well as unskilled laborers. That year he put up a "chapel"—actually a souvenir shop, library, and lecture hall—followed by a blacksmith shop and a workers' dorm in 1902. In 1903 he opened an inn for the tourists who had begun coming. Some wanted to buy the furniture that had been custom-made for the inn, so a year later a three-story furniture shop opened. The smithy became a copper shop, and the bindery made leather goods. Hubbard opened a bank and operated a 300-acre farm to feed his workers and guests. Unintentionally he had built an Arts and Crafts commu-

nity. He called it Roycroft, after a pair of seventeenth-century English bookbinders, Samuel and Thomas Roycroft.

The Roycroft community was almost everything that C. R. Ashbee had wanted the Guild of Handicraft to be. Hubbard ran a free lecture program that brought in notable speakers such as Henry Ford, Clarence Darrow, and sculptor Gutzon Borglum. Employees could participate in classes, baseball games, group dinners, annual picnics, and a marching band. Guests at the inn could partake of vigorous outdoor activities, including pulling weeds and chopping wood.

Roycroft was a capitalist venture but an enlightened one. Workers were paid somewhat less than average, but satisfaction was high. Hubbard offered an eight-hour day with breaks, at a time when most people worked ten. His frequent gifts of coal, flour, clothing, and hams were also appreciated. Employees who apprenticed in one of the craft shops could work in another if they showed talent or desire. The community flourished. At its peak in 1915, nearly 500 people worked there.

From Roycroft's beginning in the print shop and bindery, books were published not just in the medieval style of Kelmscott Press but also in Renaissance, art nouveau, and Arts and Crafts styles. By 1900, with experienced pressmen and binders, the quality was good. Prices were as low as $2 for unadorned books, while a limited edition with hand coloring, watercolors painted on some pages, or hand-tooled leather covers cost as much as $100.

One of the best designers was Dard Hunter (1883–1966), the son of an Arts and Crafts potter. He arrived at the campus in 1904 and was soon designing furniture and metalwork, adopting a rectilinear and semiabstract style that reflected the latest Viennese taste.[4] Hubbard was so impressed that he paid for Hunter's honeymoon trip to Austria, where he visited the Wiener Werkstätte. By the time he left East Aurora in 1910, Hunter was probably the most sophisticated designer who ever worked as a Roycrofter.

Most Roycroft furniture had sturdy, squared-off legs and posts; broad, flat arms; and simple repeated slats. The most common wood was quarter-sawn oak, although ash, mahogany, maple, and other woods were used. Roycroft furniture was never veneered, in strict observance of the dictum of honest construction, nor was it varnished. Decoration was rare, except for the word "Roycroft" or the Roycroft emblem carved in a conspicuous spot.

Advertisements in the *Philistine* said that Roycroft furniture was "made honestly by hand," even though the shop was equipped with the range of power tools found

FIGURE 2.1. *Roycroft*, Morris Settee, *1910. Oak, leather. (Collection of The Newark Museum, Newark, N.J., Gift of Mr. and Mrs. Christopher Forbes, 1982.127. Photograph © The Newark Museum/Art Resource, New York.)*

in any furniture factory at the time. When the Roycrofters first produced a Morris chair (a generic term for an upholstered armchair with an adjustable back), Hubbard's advertisement trumpeted: "morris chair This is a close replica of the original chair made by the hands of William Morris. Cushioned complete, $50.00."[5] (Figure 2.1) No matter that the Roycroft chair bears no resemblance to the original Morris & Co. version, or that Morris never made any furniture himself.

Copper was the medium of choice for many Arts and Crafts enthusiasts because it is both easier to work than most other metals and much less expensive than silver or gold. A copper and brass bowl from about 1911 is a typically simple piece of Roycroft metalwork: a cylinder with four posts mounted around the circumference and a pierced brass strip around the upper edge. (Figure 2.2) The designer was Karl Kipp, who left banking to take up the Roycroft life in 1908. Within a year or two he was head of the shop. Kipp's story was not unusual: his background was in an unrelated field, and he adopted a craft without serving a long apprenticeship or seeking technical training. He compensated for his shortcomings by designing simple forms.

Kipp absorbed Hunter's Viennese style. Rows of square openings in the brass strip and little balls perched atop the posts are straight out of the Wiener Werkstätte. The surface of the copper cylinder is covered with tiny facets. In silversmithing, these facets are a stage of the

planishing process, which smoothes out a hollow form that has been hammered into shape. A professional silversmith would give the metal a mirrorlike surface. Ashbee's Guild of Handicraft had broken with tradition and left the planishing marks. These surfaces were lively, especially when polished, breaking into thousands of points of light and shadow. When Hunter was in Vienna, he may have seen something similar at the Wiener Werkstätte and brought the idea back with him. But a cylinder doesn't need to be planished. It can be made by simply bending a flat sheet of metal into a circle and joining the two edges together, without denting the metal at all. Thus the marks on Kipp's bowl are not there for any technical reason and might simply be embellishment, contrasting with the smoother brass. But they also function symbolically, showing that the bowl is handmade.

Hubbard, like every craftsperson then and since, had to claim that the work had value beyond its mere utility to justify the greater cost of the hand process. His first step was to stress that the objects were handmade, personal in an increasingly impersonal age. For Hubbard's literate upper-middle-class audience, the marks alluded to Ruskin and Morris. The second step was to wrap Roy-

FIGURE 2.2. *Karl Kipp, designer, Roycroft*, Fern Dish, *ca. 1911. Copper, brass; height, 4.5 in.; diameter, 6.5 in. (The Metropolitan Museum of Art, Purchase, Theodore R. Gamble Jr., Gift in honor of his mother, Mrs. Theodore Robert Gamble, 1982, 1982.118. Image © The Metropolitan Museum of Art.)*

croft in a mantle of idealism: people who thought Roy-croft stood for dignity of labor and a better life would be willing to pay more. He encouraged a cult of personality as another form of marketing, affecting a floppy tie, artistically long hair, and a broad-brimmed hat—much like Oscar Wilde. His casual attitude toward the truth probably alienated some Roycrofters; there are records of a few men and women quitting in disgust.

Roycroft's distinct blend of idealism, capitalism, paternalism, and nationalism was captured in Hubbard's credo:

> I believe in myself.
> I believe in the goods I sell.
> I believe in the firm for whom I work.
> I believe in my colleagues and helpers.
> I believe in American Business methods.
> I believe in producers, creators, manufacturers, distributors, and in all industrial workers of the world who have a job, and hold it down.[6]

Hubbard and his wife died on board the *Lusitania*, torpedoed by a German submarine just off the coast of Ireland on May 7, 1915. Elbert Hubbard II took over the enterprise, but he had none of his father's charisma. The *Philistine* ceased publication almost immediately. The community thrived for a while and then succumbed to the Depression in 1938. Today the inn and a few of the shops survive as a monument to the soap salesman who championed the arts and crafts.

Gustav Stickley

Gustav Stickley (1858–1942) was the second ambitious man who brought the Arts and Crafts movement into the American mainstream. Born Gustavus Stoekel to an impoverished farming family in Wisconsin, he left school at twelve to help support his mother, four sisters, and four brothers. He worked as a mason, building stone walls and learning about physical labor in a way that Hubbard never did. By the time he was eighteen, Stickley was working in his uncle's chair factory. He took to woodworking and became the plant foreman after only four years.

Over the next twenty years, he and his brothers owned or partnered in a series of enterprises, most revolving around the manufacture and sale of chairs. By late 1898 he owned a modest factory near Syracuse, New York, that produced chairs in a jumble of derivative styles. Then, in June 1900, at the furniture industry's annual sales fair in Grand Rapids, Michigan, he introduced a radi-

FIGURE 2.3. *Alexander J. Forbes, Side Chair, after chair designs for the Swedenborgian Church, designed 1894, made ca. 1896. Oak, tule grass (replaced); 36.25 × 21 × 19.75 in. (Los Angeles County Museum of Art, purchased with funds provided by the Decorative Arts Council Fund in honor of Patricia M. Fletcher in recognition of her dedicated service. Photograph © 2007 Museum Associates/LACMA.)*

cal new line of furniture. Some of the designs were very plain, stripped of all ornamental carving. They didn't refer to any particular historical precedent. They were prototypes of the "Mission" style, which would shortly become the dominant form of American Arts and Crafts furniture.

It is not clear who invented the Mission style. The leading candidate is the office of a California architect, A. Page Brown, which designed a rustic Swedenborgian Church in San Francisco about 1894, along with some furniture.[7] (Figure 2.3) The church itself drew inspiration from the old Spanish missions sprinkled along the California coast: simple form, tile roof, exposed wooden trusses inside. The chairs for the church (designed by Brown or one of his assistants) were equally simple: stubby square legs, thick stretchers, handwoven rush seat, and clear finish. Three elements save the chair from being hopelessly clunky: the legs taper slightly from seat to floor and then flare at the foot, the back rails curve to accommodate the sitter's back, and they also tilt away from the seat.

A colleague of Brown's thought enough of this chair

FIGURE 2.4. *Gustav Stickley, table and chair for the Onondaga Country Club, from* The Craftsman *1, no. 1 (October 1901): 51.*

to send one to a manufacturer in New York, Joseph P. McHugh, who liked it and ordered a dozen or so. By 1898 McHugh had put out a line under his own name, which was marketed as Mission furniture. The Mission style blended simplicity with a reference to American history. It was a fortuitous combination. Americans longing for a feeling of rootedness sought a native tradition for design reform. But the United States had no Gothic past, and colonial furniture, already revived after the 1876 Centennial, was by 1900 commercialized and too familiar to be useful to a reform movement. The Spanish mission idea was fresh—never mind that the actual mission furniture that survived was a hodgepodge.

While the English Arts and Crafts movement produced only a few designs that most people could afford, the American Arts and Crafts movement penetrated well into the middle class, although it didn't quite reach Morris's target of producing "art for all." Modest prices could be achieved only by simplification of design, use of cheaper materials, or semi-industrialization of process. Mission style was suitable for rapid machine production. Still, Stickley's products were not cheap. A sideboard could cost $190 in 1903, roughly equivalent to $3,500 today. Even if simple chairs and tables were much less expensive, his customers were making a statement by choosing quality.

A table and chair Stickley made in 1901 for the Onondaga Country Club show all the elements of his signature style. (Figure 2.4) The armchair has no carving anywhere. All the parts are straight pieces of wood, requiring no shaping. The cushions are probably sheepskin, laced together with a leather thong. The front and rear legs are

massive, more than two inches thick. The front, back, and side rails penetrate the legs as through tenons and protrude slightly. Each tenon is pegged from the side. The chair legs are tenoned through the arms, again protruding slightly. Each broad, flat arm is supported by two brackets. Pugin's demand for revealed construction is met, yet the details are subtly decorative, softening and humanizing the design. The visual vocabulary in these chairs can be applied to all kinds of furniture.

For the Onondaga chairs, as for most of his furniture, Stickley chose white oak, usually quarter-sawn. Oak was a native American hardwood, cheap and plentiful compared with the more upscale walnut. He found that it could be darkened by placing the wood in an enclosed space and exposing it to ammonia fumes. Unlike staining with chemical colors, fuming darkened the wood but left the grain fully visible. For variety, Stickley sometimes stained the wood with synthetic aniline dyes, adding green, gray, or brown overtones. The pieces were finished with mat lacquer, shellac, or varnish. These finishing techniques became the standard for all Mission furniture.

Stickley stressed that his furniture was thoroughly functional, comfortable, and well made. A 1907 advertisement said: "The piece . . . is, first, last, all the time a chair, and not an imitation of a throne, nor an exhibit of snakes and dragons in a wild riot of misapplied woodcarving. The fundamental purpose in building this chair was to make a piece which should be essentially comfortable, durable, well-proportioned and as soundly puttogether as the best workmanship, tools and materials make possible."[8] The ad did not exaggerate. Thousands

of pieces of Stickley's furniture have survived, most of them as sturdy as the day they were built.

It is probably incorrect to speak of Stickley himself as making his company's products. The furniture was produced in a factory, using as much machine technology as possible. It belongs in a history of studio craft because it became so strongly identified with the Arts and Crafts movement, not because it was made by hand. Even the designs may not have been Stickley's. The evidence suggests that most of his products—furniture, textiles, and metalwork—were designed by people he employed but rarely credited. It appears that he supervised the design process closely, however, and the company's output bears the indelible stamp of his vision.

Indeed, Stickley had a vision. He leased an ornate mansion in downtown Syracuse to serve as a showroom (1900), renamed his company United Crafts and claimed that it was a guild (1901), established a metal shop (1902), and started a textile department (1903). By 1905 he moved the office of his company (by then called Craftsman Workshops) to New York City and opened a retail outlet in the heart of Manhattan. Everything the company produced was called a Craftsman product.

The Craftsman magazine (begun in 1901) was his main instrument for the dissemination of his philosophy. Many articles appeared to be written by Stickley himself, although they were probably renderings of his ideas and opinions by more talented writers. (His few surviving letters indicate that he could barely spell and that his writing was no more than adequate.) The Craftsman was a house organ for Stickley's company, and the line between advertising and content was intentionally blurred. From the beginning, the magazine offered ringing endorsements of Arts and Crafts ideals. The first issue was devoted to Morris, the second to Ruskin. They were written entirely by one woman, a Syracuse University professor of art history and Romance languages named Irene Sargent. Here she introduces United Crafts in the first issue: "The new association is a guild of cabinet makers, metal and leather workers, which has recently formed for the production of household furnishings. . . . The United Crafts endeavor to promote and extend the principles established by Morris, in both the artistic and socialistic sense. In the interests of art, they seek to substitute the luxury of taste for the luxury of costliness; to teach that beauty does not imply elaboration or ornament; to employ only those forms and materials which make for simplicity, individuality and dignity of effect."[9] Sargent was less than truthful here. United Crafts was by no means a guild, and Stickley had no interest in furthering the cause of socialism—after all, he was a businessman.[10]

Nonetheless, the Craftsman became an inspiration to thousands. It was the first American periodical dedicated entirely to Arts and Crafts and for many was the first encounter with progressive design ideas. The Craftsman was neither radical nor elitist, and it was highly informative. There were articles on housing reform and town planning, Japanese and Native American art, garden design and diverse crafts, including instructions on the rudiments of cabinetry and metalworking. Although it was a promotional tool for Stickley, works by other artists and manufacturers were featured.

In January 1904 the magazine published plans for its first Craftsman house; many others followed. The house designs encouraged readers to imagine an Arts and Crafts Gesamtkunstwerk, a total work of art. The buildings were often amalgams of California bungalows and English Arts and Crafts cottages. Most were modest in size. Dining rooms, living rooms, and front halls flowed together, without narrow doorways. Naturally, pictures of the interiors showed lots of Craftsman Workshops furniture.

Among the Craftsman designers was an architect named Harvey Ellis (1852–1904). Ellis was familiar with current English and European design, and he was an exceptionally talented draftsman. Stickley hired him in May 1903. Ellis immediately illustrated interiors for the Craftsman. The renderings were delicate and imaginative. A dining room pictured in the July 1903 issue is painted in slate blue and purple, with repeated square motifs in the Viennese manner on both the tablecloth and the walls.

The room was never built—Ellis died in January 1904, after only seven months of work for Stickley—but some of the furniture designs shown in his illustrations were. These featured wood and metal inlays, which gave them a new delicacy. A chair from 1903 or 1904 is solidly constructed, but the arched line on the bottom edges provides a subtle sense of lift. (Figure 2.5) The legs and seat back are flattened, giving the chair a lighter appearance when seen from the side. Finally, a broad central splat is flanked by two narrow ones and inlaid with pewter and wood. The chair is graceful and substantial at the same time, without the heaviness of earlier Craftsman designs. Sadly, the inlaid furniture was not a commercial success and was discontinued.

The Craftsman Workshops had better luck with metalwork and textiles. Stickley opened a metal shop that produced furniture fittings, lamps, "electroliers" (chandeliers with electric light bulbs), fireplace sets, copper plaques, trays, and jardinières. He set up a fabric and needlework department, managed by Blanche Ross

FIGURE 2.5. *Harvey Ellis, Craftsman Workshop of Gustav Stickley, Armchair, ca. 1903. White oak, copper, pewter, wood, rush; 46.8 × 22.8 × 20 in. (Carnegie Museum of Art, Pittsburgh, Decorative Arts Purchase Fund, Gift of Mr. and Mrs. Aleon Deitch, by exchange. Photograph © 2008 Carnegie Museum of Art, Pittsburgh.)*

Wood: Reform and Commerce Together

OTHER MISSION FURNITURE

By 1908, 148 American manufacturers were making Mission furniture, some of them copying Craftsman Workshops designs outright. Many made inferior products, using hidden screws, fake tenons, or veneers, hoping that the public could not tell the difference between appearance and substance, or that they would accept the difference if the price was right.

Among Stickley's competitors were his own brothers. Albert (1863–1928) and John George (1871–1921) owned the **Stickley Brothers Company** in Grand Rapids, Michigan. Stickley Brothers was the innovator when it came to inlay. The basic shape of its Balmoral settee (made about 1902) is taken from a plain Craftsman settee, probably designed the year before. (Figure 2.6) The company's designer, David Robertson Smith, tapered the legs, added some gentle curves, and set in a tree design in dark and light wood inlays. The whole is a pleasant variation on Mission form. Stickley Brothers also marketed copper objects, pillows, and wood finishes. Albert and John George were never as dedicated to Arts and Crafts principles as Gustav was, and when the public began to lose interest, they quickly introduced Tudor and Elizabethan lines. The company survived until 1947.

Another family concern was the **L. and J. G. Stickley Furniture Company**, which still produces Mission-style furniture. John George resigned from Stickley Brothers in 1901 and set up a new company the next year with brother Leopold (1869–1957). Some of their designs were blatant knock-offs of Craftsman pieces, but a tall case clock, first made around 1906, is more original. The straight sides set up a rigid geometry, and the body is quarter-sawn oak, which makes a diagonal pattern on the front. Pairs of through tenons in the side frame members get shorter toward the top, creating a subtle rhythm. Both the skirt and the doorframe are arched. All the details intensify around the clock face, which is mildly Viennese in style. The piece terminates with a broad projecting cornice. It is a fine composition, with details and patterns perfectly orchestrated.

Among the many Grand Rapids firms that capitalized on Mission style, the **Charles P. Limbert Company** deserves mention for its solid construction in good materials and for its consideration for its workers. Most of Limbert's furniture was derivative. An attractive piece is a round oak table of around 1905 that offers modest variations on the style of Charles Rennie Mackintosh. Limbert called the furniture "Holland Dutch" despite its Scottish and English antecedents, perhaps in honor

Baxter (1870–1967). Both men and women designed textiles, and much of the needlework was done by local women in their homes. Designs were typically simple motifs printed or sewn on a backing fabric and outlined with stitches in a related color. The department produced table runners, curtains, portieres, pillows, lampshades, and other items in an array of fabrics. Textiles added touches of color to dark Craftsman interiors. Unfortunately, many were made of short-lived fabrics like jute, so few have survived intact. They must have been quite popular: in 1909 twenty-three employees worked full-time in the Craftsman textiles department.

By 1910 Stickley had assembled a well-oiled machine for publicity and production. His magazine had a circulation of about 22,500. Products from the Craftsman Workshops were sold in dozens of department stores nationwide. Craftsman houses were being built. In effect, he had defined the American Arts and Crafts style; for years, many Americans referred to Arts and Crafts as the Craftsman movement, as if it were all Stickley's idea.

FIGURE 2.6. *Stickley Brothers*, Balmoral Settee with Inlaid Decorations, *ca. 1902. Oak, dark and light wood; 42 × 74 × 28 in. (Photograph courtesy of Jerry Cohen.)*

of the many Dutch immigrants around Grand Rapids. In 1906 the factory was moved to rural New Holland, Michigan, where workers enjoyed pleasant working conditions.

CHARLES ROHLFS

One American furniture maker was a true original. Charles Rohlfs (1853–1936) was the son of a cabinetmaker, and he trained as a designer at Cooper Union in New York. By 1872 he was designing cast-iron stoves, but later he became a professional actor. In 1884 he married Anna Katherine Green, the author of best-selling detective novels. Her family disapproved of actors, so Rohlfs gave up the stage to manage a foundry. Around 1887 he started making chairs and benches for his apartment, assisted by his wife.[11]

By 1898 he was running a small shop in the attic of his home in Buffalo. Rohlfs never employed more than eight assistants, so his output was a tiny fraction of Stickley's or the Roycrofters'. He produced a wide range of articles, from massive desks to candlesticks and sconces, along with some metalwork. His furniture was quirky— with influences from Norway, China, and even Moorish Spain—but the best-known Rohlfs furniture recalls art nouveau. These pieces have flat parts cut into odd, curving profiles, and the most elaborate ones have sinuous relief carvings.

A writing desk from about 1900 is a fine example. (Figure 2.7) It is tall—more than four and a half feet high—but only about two feet square. The form is related to the ingenious portable "Davenport desk," with drawers in the sides and a closed front that opens to reveal more drawers. On the right side of Rohlfs's desk are four drawers; on the left side is a door opening onto bookshelves. The whole unit rotates on its base for easy access. Throughout, parts are shaped into idiosyncratic protuberances, or cut out, like the fretwork visible on the front. Rohlfs added shallow curvilinear carvings (said to have been inspired by smoke curling up from his pipe). The desk terminates in two carved finials. On the upper parts of the triangular sides, the wood has been hammered to create a faceted texture—a most unusual woodworking technique![12]

Unlike the three-dimensional whiplash curves of art nouveau furniture, all Rohlfs's curves are strictly two-dimensional. He used butt joints fastened with screws that are concealed by pegs. These are the little bumps visible all over the desk. Butt joints are much faster to make than mortise-and-tenon joints, but they are weaker. Rohlfs probably made up for that by using plenty of screws, and all the pegs contribute to the peculiar charm of his work.

Rohlfs's individuality earned him notable accolades. He was commissioned to make a set of chairs for

FIGURE 2.7. *Charles Rohlfs, Charles Rohlfs Workshop, Desk,*
ca. 1900. Oak, iron; 56.12 × 24.75 × 24.75 in. (Los Angeles County
Museum of Art, Gift of Max Palevsky and Jodie Evans in honor of the
museum's twenty-fifth anniversary. Photograph © 2007 Museum
Associates/LACMA.)

FIGURE 2.8. *Paul Horti, Shop of the Crafters, Desk and Chair,*
designed ca. 1905, made ca. 1910. Mahogany, boxwood, pearwood,
mansonia, sycamore, lacewood, brass, leather (replaced); desk: 48.12 ×
39.25 × 18.25 in.; chair: 33 × 15.37 × 18.12 in. (Los Angeles County
Museum of Art, Gift of Max Palevsky and Jodie Evans in honor of the
museum's twenty-fifth anniversary. Photograph © 2007 Museum
Associates/LACMA.)

Buckingham Palace, and individual pieces sold for as much as $1,000. He was the only American furniture maker invited to show his work at the 1902 International Exhibition of Modern Decorative Arts in Turin, Italy. His work was extravagant and eccentric—and he had no imitators.

SHOP OF THE CRAFTERS

Oscar Onken (1858–1948), a man from Cincinnati who owned a frame-making business, saw an exhibit of Austro-Hungarian furniture at the Louisiana Purchase Exposition in Saint Louis in 1904 that inspired him to open the Shop of the Crafters. Onken managed to hire the Hungarian designer of one of the exhibits, Professor Paul Horti (1865–1907), who had won prizes in international expositions and brought a sophistication to his designs rarely matched by his American counterparts.

Two of the finest pieces produced by the Shop of the Crafters are a desk and chair from about 1910, probably designed by Horti. (Figure 2.8) Both are constructed from mahogany, a beautiful tropical wood that most American Arts and Crafts designers avoided. The general form of the desk is similar to "writing cabinets" produced by British Arts and Crafts woodworkers, which were based on seventeenth-century Spanish cabinets. Horti's variation breaks the cabinet into three parts, with a drop front in the center and the frame integrated into the desk. Four legs on each side emerge from arched trestle feet. A projecting cornice caps the whole.

The chair vaguely resembles late art nouveau designs from Belgium and Germany. Its curves contrast with the strict geometry of the desk. The rear legs start upward in an S-curve and then bend inward to a narrow crest rail. The rail itself dips slightly and is gently rounded over. The four stretchers arch upward, carrying the curved lines through the rest of the chair. Both chair and desk bear a peacock-feather inlay. The ensemble is lighter in design and construction than most American Arts and

Crafts furniture, more elegant, and far more luxurious. The Shop of the Crafters also made heavier and more structural furniture in the Mission mainstream. Some designs were painted, carved, or decorated with tiles. The business closed in 1920.

FRANK LLOYD WRIGHT

The architect Frank Lloyd Wright (1867–1959) is important in the history of studio craft not just because he worked in the prevailing Arts and Crafts style but also because he participated in many of the early debates about the role of crafts in an industrialized nation. He knew Ashbee well and had regular contacts with designers in England and Germany. He was a founding member of the Chicago Arts and Crafts Society in 1897. He is also notable for being a major twentieth-century architect who never rejected ornament.

In his early twenties, Wright worked for the Chicago architect Louis Sullivan, who is noted for ornament in conventionalized natural forms. Wright's earliest houses were decorated with friezes and carvings, and he said ornament was "imagination giving natural pattern to structure itself."[13] Like many of his colleagues, Wright believed that architecture must reflect its time and place: designers should accept industrialism, current social conditions, and local environment to invent a new American design style. His unqualified (if untested) embrace of the machine set him apart from others in the Arts and Crafts movement, and his belief that both machine production and ornament were legitimate set him apart from the European modernists.

Wright thought that a building's motifs and forms might be repeated and varied inside, in details as small as napkins, and the whole would become a *Gesamtkunstwerk*. He called this integrated architecture "organic." He was committed to geometry to such a degree that his early furniture was often rigid and occasionally very uncomfortable. His mature work came straight from the T-square, triangle, and compass. His chairs and tables are architectonic, and his windows are like drawings, without the small irregularities that characterize most handcrafted objects.

Wright designed 100 buildings from 1900 to 1909, the decade of his celebrated horizontal-line "Prairie school" designs.[14] Some projects involved designing not just a house but its grounds, all or most of its furnishings, lighting, rugs, drapery, tablecloths, and leaded-glass windows. For one of his most enthusiastic clients, Mrs. Avery Coonley, he even designed several dresses!

The Frederick C. Robie House in Chicago (completed 1910) is a masterpiece from this period. The second and

FIGURE 2.9. *Frank Lloyd Wright,* Art Glass Doors for Frederick C. Robie House, *ca. 1910. Art glass. (Image © Frank Lloyd Wright Preservation Trust. Photograph by Chris Barrett, Hedrich Blessing.)*

third stories feature low, cantilevered roofs, which accent the horizontality of the building. Each end of the second floor terminates with a prowlike bay window, introducing strong diagonal lines into the plan. These diagonals, as well as the horizontals of the structure, are repeated in details throughout the house. (Figure 2.9)

The centerpiece of the dining room was a suite of six chairs and an elaborate table, seen in a photograph from about the time the house was finished. (Figure 2.10) The ends of the table cantilever out from four piers, echoing the roofline of the house. The piers resemble columns, complete with simple bases and capitals, and each is topped with an electric light fixture shielded with leaded glass. Their interlaced diagonal motif is repeated on a table runner and the windows. The high-backed chairs, made of red oak, are distinguished by spindles that extend from the crest rail almost to the floor, making a semitransparent screen. Together, the chairs describe an

FIGURE 2.10. *Frank Lloyd Wright,* Dining Room of Frederick C. Robie House, *ca. 1910. (Original photograph by Chicago Architectural Photographing Company, © 2009 Frank Lloyd Wright Foundation, Scottsdale, Ariz./Artists Rights Society [ARS], New York.)*

intimate subsidiary space within the room. It was a great design, but hard to live with. The rigidity of the chairs dictated a ramrod posture, and the lights on the piers interfered with dinner service as well as conversation. After the Robies moved out in 1911, the piers and the lights were removed.

Wright was a restless innovator and an enthusiastic promoter of machine technology, so one might expect that his furnishing designs would be mass-produced. Not so. Everything, from chairs to carpets, was contracted out to shops and factories that produced for one house at a time. His later forays into designing for machine production were not notably successful.

GREENE AND GREENE

Some of the most elegant American Arts and Crafts furniture ever made came from California. It was designed by architect brothers Charles Sumner Greene (1868–1957) and Henry Mather Greene (1870–1954). Growing up in Saint Louis, the two attended Calvin Woodward's Manual Training High School (see Craft Education, p. 79) and then went east to study architecture at the Massachusetts Institute of Technology. They received a typical Beaux-Arts training there, which presented architecture as a collection of historical details and styles. By 1894 they had moved to Pasadena, California, and started a practice together, known as Greene and Greene.

With the advent of nationwide rail travel, Pasadena became a winter resort for wealthy families from the East and Midwest. Large resort hotels were built; department stores followed, along with architects and craftsmen, all hoping to cater to the carriage trade. Visitors arrived in time for the Tournament of Roses on New Year's Day; stayed in grand resort hotels for a busy schedule of polo matches, parties, and excursions; and left by early April. These visitors began to build elaborate houses, and Greene and Greene became a favored architectural firm.

At first the brothers designed buildings in revival styles, but in 1901 Charles visited England on his honeymoon, probably seeing Morris & Co. goods along with Arts and Crafts buildings there. In 1902 they discovered the *Craftsman* magazine, and they had been familiar with Japanese decorative arts and architecture since 1893, when they saw a display at the World's Columbian Exposition in Chicago. Japanese construction embodied

Wright and the Machine

Frank Lloyd Wright's ideas about craft are summarized in "The Art and Craft of the Machine," a lecture he gave to the Chicago Arts and Crafts Society in early 1901. As if speaking directly to Ruskin and Morris, he said that there was no point in trying to "restore man's joy in the mere work of his hands—for this once lovely attribute is far behind."[1] In one harsh sentence he dismissed them and indicated that the modern designer must adjust to the inevitable domination of machines.

Wright thought that art and industry could be harnessed together with the goal of producing high-quality goods at low cost. The machine would be humankind's "salvation in disguise" because everything would be affordable and well designed thanks to the active participation of artists. He put his finger on the flaw in Morris's argument: handwork was too expensive to fulfill the needs of the masses. If you wanted art for everybody, you either had to embrace mass production or reorder all of society. Morris hoped for the latter; Wright placed his faith in the machine. He thought factory workers would accept it because they would have more leisure time. Craft, meanwhile, would become "an experimental station" en route to machine function.

NOTE

1. All quotations from "The Art and Craft of the Machine," delivered to the Chicago Arts and Crafts Society, March 20, 1901, reprinted in *Frank Lloyd Wright: Writings and Buildings*, selected by Edgar Kaufmann and Ben Raeburn (New York: Meridian Books, 1967), 55–73.

the Arts and Crafts principles of the honest use of materials, revealed construction, and inspiration from nature.

From 1902 to 1906, Greene and Greene built bungalows in a regional adaptation of Arts and Crafts style. These houses featured unscreened sleeping porches (to enjoy the benefits of Southern California's mild nights) and overhanging roofs to shield interiors from the bright midday sun. Several were furnished with Craftsman furniture. The brothers helped to solidify the bungalow style. "Bungalow" was originally a name for thatched huts in India. The simple, informal character made it popular in California. Eventually, bungalows were built all over the United States and became the emblem of American Arts and Crafts architecture.

Between 1907 and 1910, Greene and Greene built four houses outfitted with custom furnishings: the Blacker House and the Gamble House, both 1907–9 in Pasadena; the Pratt House, 1908–11, Ojai; and the Thorsen House, 1908–10, Berkeley. Each was an Arts and Crafts masterpiece.

Luckily, the Gamble House remains intact with all its Greene and Greene furniture. On the outside, the building blends bungalow style and traditional Japanese architecture. Each side is asymmetrical, with deep eaves shading terraces and sleeping porches. The roofline and the transition between first and second floor are punctuated with the rounded ends of rafters and beams. The connections between beams and columns are marked with slightly protruding pegs, a detail repeated on the furniture inside. The horizontal mullions of the windows, the railings, and some of the beams are shaped in a "cloud-lift" Chinese design motif, which is also repeated inside. Even the chevron pattern of the brick driveway is echoed within by diagonal floorboards.

At the front entrance are three doors, each with a transom. (Figure 2.11) Across them stretches the leaded-glass image of a California live oak tree in yellows, browns, and greens. Some mornings, the rising sun bathes the entry hall in golden light. The ground floor is meticulously constructed in teak and Honduran mahogany walls that rise to a picture rail above eye level. Every surface is sanded, every edge gently rounded. Freestanding and built-in furniture uses the same materials and soft finish, light fixtures and picture frames included. Iron strapwork, leaded glass, ceramic tiles, and painted canvas above the picture rails add variety and texture.

Most of the furniture was designed by Greene and Greene. On the ground floor, it is primarily Honduran mahogany, but in a guest room, a desk and chairs are made of bird's-eye maple, with inlays of silver and Indo-

FIGURE 2.11. *Greene and Greene*, Entry Hall with View of Front Door of David Berry Gamble House, *1908. Leaded glass. (Avery Architectural & Fine Arts Library, Columbia University in the City of New York.)*

nesian vermillion wood. In the master bedroom, walnut chairs, beds, writing desk, dresser, and chiffonier (a tall, narrow chest of drawers) are decorated with inlays in semiprecious stone, abalone, fruitwood, and lignum vitae.

The fine craftsmanship, warm colors, and repeated motifs tie together everything in the house. The dining room is a case in point: one wall is nearly filled by built-in drawers and cabinets, flanked by two light fixtures. The cabinetwork frames a set of leaded-glass windows depicting a trailing vine, which spreads across eleven panels. Small square and rectangular dots on the furniture cover wood screws and repeat similar pegs outside. The splats of the dining room chairs are edged in a vertical profile of the cloud-lift motif. The ensemble is capped with an ingenious adjustable hanging lamp, framed in mahogany.

Charles did most of the designs and dealt with the clients, while Henry produced the working drawings. They were fortunate to find another pair of brothers, Peter and John Hall, to do the contracting and woodworking. The Halls were sons of a Swedish-trained cabinetmaker, so Greene and Greene furniture was made with what has been called Scandinavian wood techniques. In practice, the Halls used a table saw for as much construction as they could and frequently used screws instead of handmade joints. The quality of their work shows that machines, used intelligently, need not produce inferior results.

Response to Greene and Greene's "ultimate bungalows" was not universally positive. It was observed that "there is not a deep, soft chair or sofa in the house. . . . It is studio furniture."[15] After 1910 the brothers received few commissions for houses with complete interiors, partly because they had earned a reputation for being too costly. Not one of their furniture designs was produced commercially. The remarkable partnership dissolved in 1922.

ARTHUR AND LUCIA MATHEWS

San Francisco was the site of another uniquely American style of woodworking. It was the creation of two painters: Arthur Mathews (1860–1945) and his wife, Lucia Kleinhans Mathews (1870–1955).

Arthur Mathews grew up in San Francisco, where he showed early talent in architecture and drawing. He went to Paris in 1885 to study at the Académie Julian. There he absorbed the French neoclassical style, with its stagy allegories, fascination with all things Greek and Roman, and assumption that a painting is an elaborate machine for producing beauty. Back home by 1889, Mathews established himself as a painter, muralist, and educator. The next year he became director of the California School of Design (later the Mark Hopkins Institute), which must have been quite a triumph for an artist only thirty years old. He married his star student, Lucia Kleinhans, in 1894, and over the next few years executed murals for the houses of San Francisco's rich and famous.

The massive earthquake and fire of April 1906 destroyed much of his work. Like most residents, though, the couple saw the disaster as an opportunity to build anew. With the backing of a wealthy businessman, Arthur founded the Furniture Shop and began publishing a new magazine, *Philopolis*. The shop was intended to produce artistic interiors for businesses, institutions, and private clients, much like the Morris's firm. The mission of the magazine was "to consider the ethical and artistic aspects of the rebuilding of San Francisco. We want good art, good architecture, and as a necessity to gain the end, a good civic administration."[16] The Furniture Shop won large commissions from banks, libraries, and fraternal organizations. The furniture for these was designed in historical styles from Chinese to Viennese. Between twenty and fifty men might work on large commissions. The shop also produced painted furniture, picture frames, and decorative objects intended as gifts or for the private use of the buyers. These pieces often feature meticulous carvings and inlays mixed with neoclassical details and painted Californian landscapes.

Arthur and his assistant Thomas McGlynn did most

FIGURE 2.12. *Lucia Mathews*, Four-Panel Screen, *ca. 1910–15. Painted wood with gilding; 72 × 80 × 1 in. (Collection of the Oakland Museum of California, Gift of Concours d'Antiques, The Art Guild, 1966.196.35.)*

of the design, while skilled laborers built the furniture and carved the relief decoration. Lucia painted the decoration and supervised both carving and color coordination. Many critics think that she was a better painter than Arthur. Her skill is displayed in a four-panel screen with a painted image of a magnolia branch. (Figure 2.12) The left panel is dominated by empty space, which balances the concentrated detail elsewhere. Both the screen format and the asymmetry are inspired by Japan. A few of the magnolia leaves are highlighted in applied gold leaf. Lucia rendered the leaves in colors from ocher yellow and moss green to muted red and brown. The screen has none of the classicism that Arthur favored, but the modest beauty of Lucia's painting seems to have endured much better than his grand allegorical productions.

Pottery for All Purposes

Just as Edwin AtLee Barber had surveyed the nation's art pottery in the 1890s, Dr. Marcus Benjamin was commissioned by Congress to survey American potteries in 1905. He toured the country, obtained samples at each factory, and published his findings in *Glass and Pottery World*, in the *Congressional Record*, and in a privately printed book. He noted an emphasis on handcraft and simplicity, a move away from the painted surface toward a variety of exotic glazes, and an emphasis on regionalism that took the form of seeking local clays and local character in decoration. Some mass-production techniques, such

as the use of molds, crept into even the most artistic pottery.

Many of the large commercial facilities of the nineteenth century continued their production in the twentieth. There were also potteries for new purposes, such as therapy, social services associated with settlement houses, and practical applications for graduates of art schools. There were also a few studio potters, working alone and executing all aspects of making. Styles were equally varied, being inspired by antiquarian, technical, decorative, or expressive interests.

GRUEBY POTTERY

William Henry Grueby (1867–1925) began his career as a boy apprentice at J. & J. G. Low Co. in Massachusetts about 1880. (Figure 2.13) After ten years there, he went into business for himself, producing glazed brick, tile, and architectural terra-cotta in Italian Renaissance and Moorish styles. In 1893, at the World's Columbian Exposition in Chicago, his course changed when he saw the work of the French potters Auguste Delaherche and Ernest Chaplet, especially Delaherche's "dead mat" glazes on simple plant-form pottery. Over the next fif-

FIGURE 2.13. *Grueby Faience Company, decoration attributed to Ruth Erickson, Vase, ca. 1901–7. Buff earthenware, applied leaves and stems, dark green body and yellow flowers; height, 16.38 in.; diameter, 7.5 in. (Cooper-Hewitt, National Design Museum, Smithsonian Institution, Gift of Marcia and William Goodman, 1983.88.7.)*

teen years, under a bewildering succession of business names, Grueby created art pottery.

A glaze specialist rather than a designer, Grueby was not the first to produce mat glaze in America but was the first to concentrate on it. His green glaze has been described as dense, light absorbing, and velvety. The color and the soft, nonreflective surface suited "natural" interiors of Arts and Crafts homes. Grueby's mat glaze was introduced in 1898, shown in Boston in 1899, and took two gold medals and a silver at the Paris Exposition of 1900, another gold in Saint Petersburg in 1901, and a grand prize in Saint Louis in 1904. Siegfried Bing of the L'Art Nouveau shop in Paris became his European agent, and the combination of his pottery with Stickley furniture in promotional displays and exhibitions enhanced the reputation of both makers.

Grueby's forms were designed by George Prentiss Kendrick, a metalworker, book designer, and draftsman who joined the company in 1894 and left in 1901, and then by Boston architect Addison B. Le Boutillier. Grueby insisted on hand-modeled decoration rather than less expensive casting. The clay, from New Jersey and Martha's Vineyard, was essentially the same as that used for tile, so the forms tended to be heavy and not very detailed.

Critical and popular acclaim did not mean financial success for Grueby. Part of the reason may have been his commitment to handwork, even when the company employed more than 100 people and was engaged in large-volume production. He went bankrupt in 1908 and never resumed making pottery. The exquisite glaze is his legacy.

VAN BRIGGLE

Artus Van Briggle (1869–1904) had a short but creative life, first at Rookwood and then at his own pottery, which survived him. He trained at the Cincinnati Art Academy before joining Rookwood. In 1893 the company sent him to Paris for further study, and he was exposed to early art nouveau. On his return, his official work was underglaze painting, and he introduced figures in the new style, while his private experiments yielded a mat glaze.

Van Briggle suffered from tuberculosis, and it was suggested to him that the air and climate of Colorado would be beneficial. He moved there in 1899, and by 1901 he had established his own small studio. He had about 300 vases ready for the commercial market by Christmas of that year. They showed the influence of art nouveau in decoration that was not applied but integral.

Van Briggle's pottery emphasized local inspiration. He decorated his pots with indigenous plants such as aspen and columbine. He also created moody and evoca-

FIGURE 2.14. *Van Briggle Pottery, Lorelei Vase, designed 1901. Earthenware; height, 10.37 in.; diameter, 4.5 in. (Collection of Everson Museum of Art, Syracuse, N.Y., Gift of Ronald and Andrew Kuchta in memory of Clara May Kuchta, 80.2.)*

tive works. In the *Despondency Vase* of 1902, a slumped figure, head in hands, wraps around the opening of the vessel—perhaps Van Briggle was reflecting his own emotional state regarding his precarious health. In a piece of similar structure from the previous year, the *Lorelei Vase*, a figure emerges from the body of the pot, her hair swirling like water in a "drama of the intense aesthetic or sexual moment, a diffused congress with nature."[17] (Figure 2.14) These sculptural and sensual qualities make Van Briggle's works some of the best examples of French-style art nouveau in American art pottery.

Van Briggle died in 1904, but his wife ran the company until 1912, when she sold it. Some of his designs continued to be used by the new owners, but after 1920 the company was less involved in art pottery.

TECO

The Gates Pottery Co. of Terra Cotta, Illinois, was unusual in achieving both aesthetic and financial success. It was an offshoot of American Terra Cotta & Ceramic

Co., founded by William Day Gates in 1881 to produce drain tile, brick, and architectural terra-cotta. Gates decided to make and market a line of art pottery without painted decoration, beautiful for its form alone. He spent a decade experimenting, eventually with the help of two of his sons, Paul and Ellis, and his chief chemist, Elmer Groton—all three of whom studied ceramic engineering at Ohio State. The art line, named Teco (pronounced tea-ko) as early as 1895, was exhibited in Chicago in 1900 and first sold commercially the next year.

Gates's first experiments produced marbled or mottled glazes. Then he achieved a soft, waxy mat glaze in a cool, silvery green that became his standard. It was softer and paler than Grueby's and did not break and slide. In 1904, at the Saint Louis world's fair, Teco was the first U.S. art pottery to exhibit crystalline glazes, and the company joined Grueby, Rookwood, and Van Briggle in receiving highest honors there. The next year Gates became president of the American Ceramic Society and presented the formula for crystalline glaze to its membership in a striking reversal of ceramic industry secretiveness.[18]

Gates decided to make only forms that served useful purposes in the house or garden. Some suggest classic inspiration; others sculpturally echo flower forms. With their rectilinear handles or thick vertical piers that reached from base to rim, the pots were intended to harmonize with Prairie school architecture. Sometimes incised linear designs accented the shape. The pottery suited the new effort to discard Victorian clutter and adopt a less formal style of living. Ads in homemaker magazines described Teco as beautiful, restful, artistic, and refined.

All wares were cast, although the original models may have been thrown or hand-built. Elaborate molded designs that required careful finishing and trained personnel were abandoned, and production costs, always at a minimum, were further reduced by the use of the single green glaze until 1910. By this means, Gates came close to the Arts and Crafts ideal of affordability.

In 1910, when other colors were becoming popular for architectural terra-cotta, new autumnal hues were added, including golds, browns and buffs, stone grays, and rose tones. Metallic blues and purples and even a bright canary yellow were used in a few cases. New tiles and tea wares were exhibited in Chicago at the first Clay Products Show, sponsored by the ceramics industry in 1912. After that, there were no further innovations. Gates was busy with architectural terra-cotta. Teco ceased production about 1922.

Gates is notable as a "welfare capitalist" who built his pottery in accordance with Arts and Crafts concepts of

ideal working conditions. The country site was beautiful enough to impress every visitor; pond and gardens furnished design sources as well. The factory newsletter, *Common Clay*, noted, "We build not a factory but a place in which to create beautiful ware—the product of the skilled hands of craftsmen—and the setting has a tremendous influence on work," and Gates said in a lecture, "Without individuality and without enthusiasm you never get good work."[19]

MARBLEHEAD POTTERY

Marblehead Pottery was founded in 1904 in Massachusetts by Dr. Herbert Hall. He wanted a therapeutic exercise for his patients who suffered from the then-fashionable condition of neurasthenia. After completing his ceramics studies at Alfred, New York, Arthur E. Baggs took what he thought would be a summer vacation job at Marblehead, setting up equipment and making initial experiments. He stayed to become supervisor and a designer, and eventually the artist-owner.

Neurasthenia was treated with various cures involving rest or discipline of the mind; Dr. Hall, who did pioneering work in occupational therapy, developed a "work cure" for his patients. He advocated the psychological benefits of craft. The pottery was part of the Handicraft Shops, where weaving, wood carving, and metalwork were taught to convalescents. But its technical requirements proved too demanding for the patients, and by 1906, Marblehead Pottery had become a separate business.

It made its public debut in 1908. By then there was a staff of six. Marblehead decoration was sober, even austere, including simple and often straight-sided vases in close-value colors and mat glazes. Underglaze decoration consisted of geometric motifs in the neck area, incised lines or blocks of flat colors. Some pots have loose renderings of the marshes near Marblehead, conventionalized to near abstraction, resembling Arthur Wesley Dow's prints. (No direct connection with Dow is documented, but his summer school at Ipswich was just a few miles away.)

Marblehead's mat glazes were evenly applied on flawless exterior surfaces; glossy insides could have harmonizing or contrasting colors. The sturdy designs, thrown by an English potter named John Swallow, suited the heavy clay body. The pottery began making majolica around 1912, and the finer quality of the material led to experiments with more complicated and rhythmic free-painted designs. Lusters and Chinese blues and reds were added to the repertoire of glazes. Products included vases, lamp bases, tiles, and tea or cider sets. Designs were listed by number in a catalog; customers chose the background color, while the decorators worked out the rest.

Baggs bought the pottery in 1915. At that time there was a small year-round staff of longtime employees. He was responsible for the technical and artistic direction but spent only part of each year at Marblehead. Between 1913 and 1920, he was also teaching pottery in New York; between 1925 and 1928, he worked with the Cowan Pottery and taught at the Cleveland School of Art. Baggs became professor of ceramic arts at Ohio State University in 1928 and continued there until his death in 1945; he closed Marblehead in 1936.

TILES

Both Arts and Crafts tiles and a Spanish colonial type found a major market in California. Bungalow tiles, unlike the Victorian ones, were usually handcrafted from wet clay and were often earthy in appearance, with mat finishes and pictorial designs. The first tile production in Southern California was orchestrated by Joseph Kirkham, a Wedgwood-trained Englishman, starting in 1900, joined by Fred H. Wilde, another Englishman, in 1903 (**Western Art Tile**). Years later Wilde recounted the difficulties of obtaining materials in the early days: "I found that one sample [of clay] was very good and asked for more. I then found out that it was an outcropping away up in the mountains. They loaded it in sacks and brought it down to the railroad on donkey backs."[20] Around mid-decade, the **Los Angeles Pressed Brick Company** began to produce faience tiles—a thickly glazed earthenware with a handcrafted appearance.

Far more significant was the **Moravian Pottery and Tile Works**, established by Henry Chapman Mercer in Doylestown, Pennsylvania, an Arts and Crafts pottery that was founded in 1898 and survived until 1964. Mercer (1856–1930) came from a wealthy and politically connected family and graduated from Harvard supposing that he would become a lawyer. Instead he became an archaeologist, a museum curator, an antiquarian, a folklorist, and a collector of an astonishing variety of artifacts from historical everyday life, which now make up the collection of the Mercer Museum.

At Harvard, Mercer absorbed the idea that craft was the foundation of the arts; he came to believe that folk art and fine art are inseparable. He grew interested in the local tradition of redware vessels, which was vanishing as German settlers Americanized. He failed at encouraging the recovery of techniques among the families who still had kilns, as well as at his own attempt to learn to throw. Then he made tile "pictures" by pressing designs into wet clay. He designed a hand-operated tile press, ordered

FIGURE 2.15. *Henry Chapman Mercer, Moravian Tileworks, Reaping with a Sickle, Tile Work for Pennsylvania State Capitol, Harrisburg, ca. 1903–6. Clay shards set in concrete; 29.5 × 29.5 in. (Bucks County Historical Society's Spruance Library, Mercer Museum.)*

three tons of clay, and set to work. By the end of 1900, he had developed the clay bodies and glazes that he used for the rest of his life.

First his tiles copied historical materials, such as ornament on cast-iron stove plates of the eighteenth-century German Moravian settlers (he named his pottery in honor of them). These conventionalized patterns appealed to Arts and Crafts taste. Mercer's tiles were not identical: he wanted them to look handmade. Finger marks, color variation, slight differences in size, and imperfect flatness were not troublesome to him (although they annoyed some tile setters). He sold tiles through the Society of Arts and Crafts, Boston (SACB)—he became a craftsman member in 1901 and was designated a master in 1902—and in nearby Philadelphia, where he was encouraged as early as 1898 by the architect Wilson Eyre. In 1901, when Eyre became cofounder and editor of *House and Garden* magazine, he gave Mercer a national audience.

The Moravian Pottery was a financial as well as artistic success. Mercer's profit margin may have been enhanced by his primitive methods and the fact that labor was cheap: he hired and trained farm workers, employing specialists only occasionally. The pottery stayed small, never employing more than ten men—and no women at all.[21] One of his earliest large orders was floor tiles for the home of Isabella Stewart Gardner in Boston (now a museum), which showed he was capable of large-scale production.

An early Mercer innovation was mosaic tiles, arrange-

ments of small shards (not traditional square tesserae) to create pictures, not unlike stained glass. He used concrete as the mortar between the pieces. Mercer squared the arrangements into painting-like panels and larger murals. His most notable project was at the Pennsylvania State Capitol in Harrisburg (1903–6), where 16,000 square feet of red tile flooring contrasts sharply with the marble walls of the Beaux-Arts architecture. (Figure 2.15) The pavement includes nearly 400 mosaics representing the building of the commonwealth, including inhabitants of all races, flora and fauna, and "tools" ranging from beehives to a camera.

Another innovation, "brocade" tiles, consisted of imagery cut out of clay and surface-modeled. These elements were set into a background of concrete. Concrete was uncommon then, and Mercer was among the pioneers in the American use of what would become an essential modernist material. Fonthill, his home and a living museum of tilework, was built in reinforced concrete and includes brocade-tile patterns inspired by fabrics and by Spanish tiles.

Until 1912, Mercer ran Moravian Pottery out of a studio on his family's estate. He then designed and built a larger pottery adjacent to Fonthill to support increased production. Plain tiles in a variety of glazes provided a large part of the income. He also made moldings, brackets, cornices, and engaged columns as well as roofing tiles and a variety of simple press-molded objects such as bowls, cups, mugs, boxes, inkwells, sconces, vases, and candlesticks.

Mercer explored inlay, colored clay bodies, and smoked colors. He experimented with pit firing. He made "picture-book" relief tiles; he re-created the Castle Acre tile, in which glaze has worn off the high points and remains only in the impressed design; he created the look of wear by wiping the surface before firing. By this easy means, he quipped, "you get your contrast at the start and don't have to wait for it until everybody is dead."[22] These were popular for fireplace inglenooks in Arts and Crafts houses.

In 1913, the first year that the SACB awarded medals for excellence of work, they went to three people out of a membership of 900, and one of them was Mercer (the others were silversmith Arthur Stone and carver John Kirchmayer). The Moravian Pottery continued after Mercer's death under his business manager, Frank Swain, and others, before finally closing in 1964. A decade later, ceramist Wayne Bates revived Mercer's methods, and he and Beth Starbuck reformulated the glazes, matching the originals while eliminating toxic raw lead. The pottery is today a "working" museum.

Another top tile maker was **Pewabic Pottery**, which opened in 1903 in Detroit and became nationally known for iridescent glazes and architectural decoration. (Figure 2.16) The founder, Mary Chase Perry (later Stratton; 1867–1961), was born and raised in Michigan and studied at the Art Academy of Cincinnati from 1887 to 1889. In her twenties, with three friends, she opened a china-decorating studio. They used a low-heat gasoline kiln until she met Horace Caulkins and Dr. Charles H. Land, who were developing a high-heat oven for the manufacture of dental porcelain. Their Revelation Kiln was a small, portable kerosene kiln that had a hinged door and was lined with firebricks. Caulkins asked Perry to demonstrate the kiln to china decorators, schools, and commercial potteries.

At the turn of century, Perry and Caulkins opened a pottery in Detroit. She studied at Alfred in the summers of 1901 and 1902, and toured major potteries. In the small company, Perry was designer and glaze chemist, while Caulkins mixed the clay, fired the kiln, and was the business manager. He (and later his wife and son) supplemented sales income to keep the pottery solvent.[23] Another partner, Joseph Herrick, and an assistant threw the pots.

In 1903 Perry got her first commercial order—bowls and lamps for a Chicago company—and it was then that she chose her pottery's name. Pewabic, a Chippewa word for clay of a copper color, drew on the popularity of Indian crafts (and referred to her birthplace). Perry was inspired by Grueby and is thought to have borrowed ideas from the

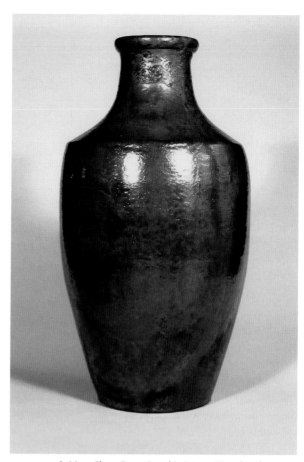

FIGURE 2.16. *Mary Chase Perry, Pewabic Pottery,* Vessel, *n.d. Ceramic, copper red iridescent glaze. (Courtesy of Pewabic Pottery.)*

Moravian catalog, but then she began to focus on glazes, and her forms became simpler. The pottery's reputation was based on six iridescent glazes—rose, green, gold, purple, gold-yellow, and copper—which were inspired by a fragment of Egyptian pottery lent to Perry by a friend, the Detroit collector Charles Freer (his Asian art collection formed the basis of the Washington, D.C., museum that bears his name). By 1909 those were mastered, and by 1911 her popular Persian or Egyptian blue was perfected. Freer became an important supporter, once stating that Detroit would be remembered for Pewabic after all the factories were forgotten.

Caulkins and Perry endorsed the Arts and Crafts ideal of combining beauty and usefulness. She wanted a handmade character, so they kept their operation small. The technical needs were met with the simplest equipment possible. In 1907 a new studio was designed by architect William Stratton—whom she later married—and Perry was among the founders of Detroit's Society of Arts and Crafts.

Pewabic completed commissions for such architects as Ralph Adams Cram, Cass Gilbert, Greene and Greene,

Albert Kahn, and McKim, Mead and White. Pewabic tiles were installed in churches, steamships, hotels, libraries, the gallery at Oberlin College, the Nebraska State Capitol building, and the Detroit Zoo. In 1929 an exhibition at the Metropolitan Museum of Art in New York featured a fireplace Stratton designed in collaboration with Eliel Saarinen. She died 1961, at ninety-four, but Pewabic continued until 1967, when Michigan State University took it on as an adult education facility in ceramic art. In 1981 a group of potters in Detroit formed the nonprofit Pewabic Society, which continues to use the building.

SCHOOL AND SETTLEMENT POTTERIES

Newcomb Pottery, located in a women's school in New Orleans, was the only Arts and Crafts pottery that was part of a college program. (Figure 2.17) It was administered by faculty members, and the college provided space and equipment. It was also exceptional in being located in the Deep South. The first public exhibition and sale of Newcomb pottery was held in June 1896. Between 1900 and 1915, Newcomb Pottery won prizes at eight international expositions and was regularly cited along with Rookwood, Grueby, and other leading potteries. Over its nearly forty-five years of existence, the enterprise hired young women who had attended Newcomb's art school (students were not employed) and produced an estimated 70,000 works.

When Newcomb College opened in 1887, Ellsworth Woodward, head of the art department, believing that New Orleans did not support art because it was not practical and useful, thought a model industry would be the solution. In 1894 he hired Mary Given Sheerer (1865–1954) of Cincinnati to teach china painting and to direct design for a pottery, which was established the next year. Sheerer—a skilled china painter who had studied drawing, painting, and sculpture at art schools in Cincinnati and New York—was familiar with Rookwood and had visited European potteries. Newcomb pots were handmade by a succession of male throwers, notably Joseph Meyer.[24]

Sheerer was concerned with the technical as well as the artistic side of the ware and tried to develop glazes and clay bodies despite her lack of technical training. Woodward denied her request to take a summer course at Alfred and instead brought in Paul Cox to be technical director in 1910. As late as 1921, he balked at the thought of a hiring a woman as the ceramic technician—quite an irony at a women's college.[25] Moreover, Woodward was not interested in making ceramic artists, just workers, and resisted adding instruction in the total ceramics process to the curriculum.

FIGURE 2.17. *Newcomb Pottery, thrown by Joseph Meyer, decorated by Harriet Joor*, Vase, Chinaberry Design, 1902. Earthenware; 7.87 × 8.5 in. (Collection of the New Orleans Museum of Art, 1938.29.)

The first decade was the pottery's golden years, when much of the finest work was produced. About ten decorators worked at any given time. Among the best known was Henrietta Bailey, who, according to Cox, "never gave all of her time to pottery decoration but more of her ware went into prize-winning shows than her general average of work would predict."[26] Marie de Hoa LeBlanc, known for conventionalized designs and favoring strong verticals, won a bronze medal at Saint Louis. Leona Nicholson had a set of seven pieces in the SACB tenth-anniversary show in 1907. She set up her own pottery in her home but fired her wares at Newcomb. Sabina Elliot Wells favored bold designs and color combinations and is known for fish and water lily designs. Sadie Irvine arrived at age sixteen for Newcomb Art School's 1903–4 session and remained at the college until her retirement in 1952. While not one of the major medal winners, she is believed to have originated several of the famous motifs.

Louisiana's climate made it difficult to paint with slip on unfired clay—the McLaughlin/Rookwood technique—so Newcomb devised its own system. That involved incising designs in low relief on unfired vases, giving them a bisque firing, and then painting simplified designs. Each was original, even when a particular motif was repeated. In an article for *Art Education* in May 1898, Woodward wrote: "In the shape of vases it is not possible to avoid

imitation, the best forms having been for centuries established. Imitation in other respects is, however carefully guarded against. All designs [feature] the greatest possible liberty of treatment in their application."[27]

Sheerer tested underglazes and slips on the pottery's white, cream, and terra-cotta bodies. By 1910 she had settled on green, blue, yellow, and black, with a clear gloss glaze. She decided that underglaze painting required "simple, big designs and firm drawing."[28] There were few museums or galleries in Louisiana, so flora and fauna were the available visual stimuli. The motifs included palm, orange, magnolia, jasmine, dogwood, cypress, and pine, and flowers such as spiderwort, iris, caladium, and trillium. Sheerer said, "The whole thing was to be a southern product, made of southern clays, by southern artists, decorated with southern subjects."[29] Sometime between 1908 and 1915, the oak-trees-with-hanging-moss-and-moon motif was introduced and became the most popular Newcomb design.

Sheerer was a follower of Arthur Wesley Dow's principles (see p. 81), and his book *Composition* was used at the school. Bold outline drawing and close-valued colors probably reflect Dow's influence in work made before 1910. In the early years, at least nine Newcomb decorators attended his summer school, some more than once.

Newcomb works were occasionally criticized as technically modest. When Cox came, developing mat glazes was the first order of business. Softer textures and colors expressing a gentle naturalism with light modeling became the new Newcomb style. There were also more curvilinear designs under Cox. Products were somewhat more repetitive.[30] Decorators began adopting abstraction and syncopated rhythms, and the discovery of King Tutankhamen's tomb in 1922 led to Egyptian motifs, but naturalistic pieces were still the most popular with the public. With its attractive setting, flexible hours, and a certain freedom in design, Newcomb Pottery seemed an ideal Arts and Crafts industry. Woodward resisted commercial success. He insisted that the pottery was a school, not a business, and he never proposed making it independent. It finally closed when Sadie Irvine retired in 1952.

The **Paul Revere Pottery** grew out of classes of the Saturday Evening Girls' Club at a Boston settlement house and was named for the noted Revolutionary War–era craftsman. Various accounts give the starting date as 1906, 1907, or 1908, when patron Helen Osborne Storrow purchased a kiln for use in a vocational workshop for young Italian and Jewish immigrant women. The pottery was founded by librarian Edith Guerrier; the director and designer for many years was Edith Brown.

Most products were functional. Rather than formal dinnerware, the output included dishes for children—called porridge sets and bread-and-milk sets—which were cheerfully decorated with simple conventionalized animal motifs, trees, homey mottos, and the child's name. Flaws in workmanship or naïveté in design contributed to the charm. However, several decorators became highly skilled at idealized landscapes. Most designs were arranged within borders to convey a sense of order and were consistent with colonial revival ideas of balance and moderation.

In 1912 Mrs. Storrow purchased a house, where wares were sold from "The Bowl Shop." In 1915 the pottery moved to a suburb, Brighton, to a building designed to look like an English country house, surrounded by trees, flowers, and lawn. In this idyllic setting, someone would read aloud to the girls as they worked. About twenty worked at any given time. The small staff of potter, designer, kilnman, and assistant enjoyed such liberal benefits as paid vacations, in accordance with Arts and Crafts ideals. But this was possible only because of financial assistance from Storrow. The pottery closed in 1942, two years before her death.

Studio Potters

CHARLES FERGUS BINNS

Charles Fergus Binns (1857–1934) was an Englishman who became the first director of New York College of Clayworking and Ceramics at Alfred University in 1900 and, during his long tenure, shaped generations of ceramists in industry and art. (Figure 2.18)

At fourteen, Binns had been apprenticed at the Royal Worcester Porcelain Works, where his father was director. He worked at the factory for twenty-five years, holding a variety of office jobs that taught him nearly every aspect of the ceramic business. In 1884 he was made responsible for educational programs. He studied the collections of the London museums and became a skilled and popular lecturer on ceramics history and other topics. He came to the United States for the first time in 1893, at the age of thirty-six, to superintend a display of Royal Worcester Porcelain at the World's Columbian Exposition in Chicago. He was invited to talk on pottery to china decorators and subsequently to write a series of articles for the *Ceramics Monthly*, a short-lived Chicago publication. In October 1897 he left England permanently. His first year in America was difficult. He spent, in his words, "a long, lonely winter as far south as Virginia and west again to Chicago, lecturing and writing, trying to make a

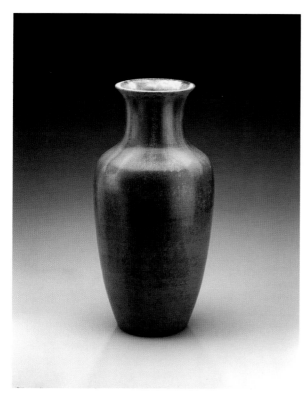

FIGURE 2.18. *Charles Fergus Binns*, Large Vase, *1908. Stoneware, glaze; height, 22.5 in.; diameter, 11.5 in. (Schein-Joseph International Museum of Ceramic Art at Alfred University, 1908.2. Photograph by Brian Oglesbee.)*

dollar do the work of a pound, and hunting for an opening."[31] In 1898 he found work in Trenton with Walter Scott Lenox at the Ceramic Art Company, which was to become Lenox China. Finally his family joined him. In addition to this day job, he was the first superintendent of a new ceramics training program, the Trenton School of Technical Science and Art.

In 1898 Binns was written up in the *Clay-Worker*, an industry periodical, and the next year he was one of about twenty charter members and elected a trustee of the new American Ceramic Society. The ACS was a step toward professionalizing the field at a time when technical knowledge was limited. He was on the leading edge of change when a new spirit of inquiry was applying science to all areas of learning, including the arts.[32]

In the spring of 1900, the president of Alfred University asked Binns to start another school, at the college level. New York was one of several states that hoped to boost industrial revenues by improving technological education. Ohio State University set up the first ceramic program in 1894–95 (Professor Edward Orton Jr., its director, became the longtime secretary of the ACS). Next was the New York School of Clayworking and Ceramics (commonly known simply as "Alfred"), followed by Rut-

gers (1902–3), Illinois (1905), and Iowa State (1906). Alfred was, however, distinctive in incorporating artistic uses of clay. Also unusual was Binns's encouragement of women students.

Alfred's importance must be credited to Binns. He lectured on technology in the labs and on ceramics history in the modeling studios, always dressed in a lab coat that could double as an artist's smock. He expanded the school, consulted for industry, supported his professional organization, and somehow found time for a private life with his wife and children, gardening, and the Episcopal Church.[33] Alfred trained ceramic engineers for industrial work through a long academic course and teachers and artists through a shorter course. He insisted on knowledge of the full process, from wedging to firing, and he promoted standardization of language and formulas.[34]

Binns contributed to magazines such as *Keramic Studio* and the *Craftsman*, and his *Manual of Practical Potting* (published in London in 1895) went to five editions. When his *Potter's Craft: A Practical Guide for the Studio and Workshop* was published in 1910, he wrote in the preface: "This Book is the outcome of an experience extending over a period of thirty-six years. Twenty years ago it would have been impossible, for the science of ceramics was not then born. Ten years ago it would have been wasted[,] for the Artist-potter in America had not arrived, but now the individual workers are many and the science is well established."[35]

An indefatigable correspondent, Binns generously answered technical questions, asserting that the purpose of education was to share information with anyone interested enough to ask. Manufacturers kept secrets, but he answered questions, even for industry. In addition, he received requests for employees, recommended his students, and gave advice when they needed it on the job, earning the nickname "Daddy Binns." Newcomb College was just one educational program that repeatedly hired ceramic technicians he nominated.

Considering all this activity, it is surprising that Binns found time to develop a body of work. It could not have been easy, especially because when he came to Alfred he was not an artist-potter but an expert in technology and history. He felt that he should learn to throw on the potter's wheel, though he was in his mid-forties and the skill did not come easily to him. Richard Zakin has described how Binns made his work "in sections, which vary in height from one and a half to six inches. He defended this working method on the grounds that it 'involves great skill' and that 'as a rule the result attained is better.'"[36] The decisive contours and balances of his forms suited this technique. Binns preferred stoneware

for its substantial body, and partly because of his influence, stoneware was considered the appropriate medium for "serious" ceramics for many years.

By the time Binns retired in December 1931, the tight perfection of his forms defined "the Alfred style." While today some critics ridicule his method—his use of calipers and supposedly even a lathe to shape his pots—this precision was true to his character.

ADELAIDE ALSOP ROBINEAU

Adelaide Alsop Robineau (1865–1929) typifies the widespread shift from china painting to pottery. Her change of focus was recorded in the pages of *Keramic Studio*, which she and her husband published. Influential as an editor, she became perhaps the most famous female ceramist of her time.

Adelaide Alsop was teaching china decorating at Saint Mary's Hall, her alma mater in Faribault, Minnesota, when she met Samuel Robineau, a French-born collector of Chinese ceramics. They married and moved to New York, where she studied painting with William Merritt Chase, exhibited watercolors at the National Academy, and continued to teach. They bought the *China Decorator* magazine of Syracuse and in May 1899 brought out the first issue under the new name *Keramic Studio*. Samuel was president and Adelaide editor.

Adelaide had received china-painting equipment as a gift, learned how to do it by reading various manuals, and found that it generated only a precarious living, so she turned to teaching for a stable income. Her later life as a ceramist was likewise supported by her income as a teacher and editor. These facts have generated contrasting estimations of Robineau's life and work. She was famous in her day; then her work came to seem dated and fell into obscurity; then she was rediscovered in the 1970s by feminists celebrating women of achievement. Some have praised her as "the first American woman to enter what had been considered the domain of men" when she mastered the potter's wheel,[37] while other call her work historicist and unimaginative. The confusion may be due, the art historian Martin Eidelberg suggests, to the fact that her later fame makes it seem that her china painting was more important than it was. In fact, she did not win awards for it, nor was it singled out in journals other than the one she published herself.[38]

Robineau's move to making her own vessels was less her individual innovation than a general shift in the field. Marshal Fry, the leading male figure in the china-painting movement, attended the Paris Exposition of 1900 and reported: "In the estimation of an artist-potter, one is not a keramist who has no knowledge of clay bodies and

Keramic Studio

China painting was served by several instructional manuals, but *Keramic Studio* was the first "quality periodical" in the market. It included exhibition summaries, reports from Arts and Crafts societies and clubs, technical information, and designs. Articles were lavishly illustrated with black-and-white and color plates. Samuel Robineau claimed that *Keramic Studio* became an "instantaneous" success and that he recouped his investment ($1,000) within a year.

Adelaide Alsop Robineau introduced new ideas to the magazine, including art nouveau and conventionalized designs. These were balanced with historicist examples and the naturalistic flower studies popular with her readers. She argued in editorials that naturalism was merely *painting* on china, whereas conventionalization of the motif enabled one to reach the proper goal of *decoration*.[1] Illustrations of historic styles were often accompanied by examples of her work as an "application to modern design."

Robineau wrote for the magazine, as did many important ceramists, including Charles Volkmar, Charles Binns, Taxile Doat, Frederick Hürten Rhead, Kathryn Cherry, and Mary Chase Perry. There were answers for readers' technical questions, critiques of work, and sponsored design competitions. Much content continued to address china painters. Circulation never exceeded 6,000, but readers were loyal. As the magazine slowly changed, it recorded the artistic activity flooding the United States.

NOTE

1. Martin Eidelberg, "Robineau's Early Designs," in *Adelaide Alsop Robineau: Glory in Porcelain*, ed. Peg Weiss (Syracuse, N.Y.: Syracuse University Press and Everson Museum of Art, 1981), 62.

glazes, and who cannot design, mould, and fire his ware as well as decorate it. As the jury at Paris considered the exhibits from this standpoint, overglaze work on ware not made by the decorator did not rank high."[39] That was stating it mildly: decoration on blanks had been sharply criticized and was excluded from the top prizes. It was a death knell for china painting as serious art.

Robineau began making her own pots in 1901 and in the summer of 1902 took a two-week course at Alfred. As early as December 1901, *Keramic Studio* was selling

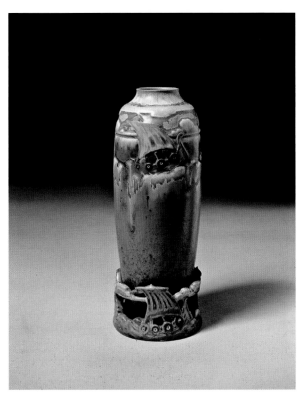

FIGURE 2.19. *Adelaide Alsop Robineau, Viking Ship Vase, 1905. Porcelain; 7.25 × 2.75 in. (Collection of Everson Museum of Art, Syracuse, N.Y., Museum Purchase, 16.4.1A-B. Photograph courtesy of Courtney Frisse.)*

potter's wheels to its readers, as well as Revelation Kilns, which allowed individuals to fire their own pots—both indicators of a changing practice. She made another important change, to porcelain, a shift aided by her husband's translating *Grand Feu Ceramics* by Taxile Doat, a master potter of the Sèvres porcelain factory in France. The Robineaus published the translation as a book in 1905, including illustrations of Adelaide's work and adding an appendix by Binns that identified American substitutes for various materials.

Like most potters of the time, Robineau looked to historical precedents for inspiration. (Figure 2.19) To suit this preference, *Keramic Studio* included articles on historic ornament and designs traceable to Owen Jones's *Grammar of Ornament*. In addition, Robineau, like most Americans, copied current European styles and practices. She published an article extolling the Danish manufacturer Bing & Grondahl's modeled and pierced decoration and sculpted forms, and she adapted the ideas in her own work.

It was her painstaking surface treatment, rather than form, that brought her renown. Again typical of her time, she threw with the aid of a template, a metal cutout used to assure a strong, smooth shape.[40] Like Binns, Robineau

learned to throw relatively late in life. Most of her early objects, including those she showed at the Saint Louis exposition, were exacting and hard-won.

Still, through her own determination and exemplary patience, Robineau achieved an uncommon proficiency and carried out demanding experiments. By late 1904 she began to develop her mature style by working with difficult-to-control crystalline glazes and thrown and carved high-fired porcelains with a distinctive mat glaze. Her most celebrated pieces were produced in the next decade (see chapter 3).

GEORGE OHR

George Ohr (1857–1918) was a small-town Southern potter convinced of his own genius almost a century before the public came around to that view. (Figures 2.20–2.22) Paul Cox of Newcomb Pottery, who knew him, wrote, "It is quite probable that George Ohr, rated simply as a mechanic, was the most expert thrower that the craft has ever known."[41] But he also reported that people at Newcomb found Ohr "so much a clown in all he did that he was a nuisance."[42] A cache of Ohr's pottery, coming to light more than half a century after his death, turned him into a collectible name, even a cult figure.

Ohr grew up in Biloxi, Mississippi, where he had little formal schooling but learned blacksmithing from his father and then tried a succession of other trades. He was introduced to clay by New Orleans potter Joseph Meyer

FIGURE 2.20. *George Ohr, Two-Handled Vase, ca. 1900. Glazed ceramic; 8.25 × 3.75 in. (Collection of the Ohr-O'Keefe Museum of Art, Biloxi, Miss. Photograph by Billy Dugger, Coast Photographic.)*

FIGURE 2.21. *George Ohr*, Scroddled Bisque Bowl, *ca. 1905.*
Glazed ceramic; 4 × 6 in. (Courtesy of the Ohr-O'Keefe Museum
of Art, Biloxi, Miss., on loan from the Soldo Family, Biloxi, Miss.
Photograph by Bob Brooks.)

(later of Newcomb). As Ohr described the experience,
"When I found the potter's wheel I felt it all over like
a wild duck in water." He had discovered his lifework.
He added: "After knowing how to boss a little piece of
clay into a gallon jug I pulled out of New Orleans and
took a zigzag trip for 2 years, and got as far as Dubuque,
Milwaukee, Albany, down the Hudson, and zigzag back
home. I sized up every potter and pottery in 16 States,
and never missed a show window, illustration or literary
dab on ceramics since that time, 1881."[43]

After setting up his own pottery in Biloxi, Ohr
honed his proficiency by making a variety of commer-
cial forms—including flowerpots, water jars, and flue
pipes—using earthenware clay that he dug from the
banks of a nearby river. In the early days, the Blacksmith
Potter, as he was sometimes known, peddled his goods
door to door in a pushcart. He later built a larger pottery
facility with wares displayed inside, outside, and even
on the roof, and he put up a pagoda-like tower visible
from all over town. Ohr's beginnings were like those of
any folk potter: he produced functional wares, fancy dis-
play objects, novelties, and souvenir trinkets—includ-
ing pig-shaped flasks, chamber pots with ceramic feces,
and "brothel tokens." He probably picked up many of
these ideas on his travels. He copied historical examples:
Greek, Chinese, eighteenth-century English, sixteenth-
century French.

Ohr cultivated an eccentric personality of grandiose
claims ("Greatest Art Potter on Earth") and attention-
getting personal mannerisms (long hair and a moustache
that he could hook over his ears). He played the role of
"the mad potter of Biloxi," which got plenty of response,
not all favorable. He developed a distinctive philosophy.

FIGURE 2.22. *George E. Ohr*, Biloxi Art Pottery, *ca. 1893–1909.*
Glazed earthenware; 10.12 × 5.25 × 3.75 in. (Cooper-Hewitt, National
Design Museum, Smithsonian Institution, Gift of Marcia and William
Goodman, 1984.84.33.)

Even in his very first display of essentially conventional
ware—600 pieces at the Cotton Centennial of 1884—he
billed them as "no two alike," and that became his basic
concept. He equated pots with human individuality, even
calling them his "mud babies." This approach differed
sharply from the standardization of industry, the stock
forms of production pottery, or even the series orienta-
tion of most art potters.

In about 1895, Ohr began to throw very thin-walled
pots that he purposely distorted.[44] His new works, always
decorative and sometimes evocatively sculptural, re-
tained the fluid, plastic qualities of their forming stage.
He insisted that form, not glaze, was the essence of his
pottery. His thinking was influenced by the sight of some
of his earliest manipulated pieces blackened and bubbled
after an 1894 fire destroyed a large part of downtown
Biloxi, including his pottery. He saved many of these

ostensibly ruined pieces. Ohr visually framed his pots with elaborate handles, whose curves, while reminiscent of art nouveau, are more likely a reflection of his black-smithing background or simply a playful response to the malleability of clay. A sense of effortlessness in his work offended his peers in the Arts and Crafts movement, where exacting labor was admired.

Although Ohr denied the importance of glazes, his were striking and unconventional. He glazed halves of pots in contrasting colors; expanded his low-fired palette to feature green, yellow, mauve and dark blood red; and spattered colors with black speckles. He also made works without glaze, in some cases using two colors of clay.

By 1900 Ohr had received some recognition, and his name and work appeared in respected company. But when he won a silver medal at the Saint Louis world's fair in 1904, the award was not publicized, and he did not make a single sale. When the U.S. Potters' Association asked in 1905 for samples to include in a display at a convention, he impudently wrote, "I send you four pieces, but it is as easy to pass judgment on my productions from four pieces as it would be to take four lines from Shakespeare and guess the rest."[45]

Ohr's attitudes and effects seem advanced, and it was decades before ceramists again took them up. Yet the work is a product of its time in its small size and Victorian frills. This busy quality was something the Arts and Crafts movement sought to escape. In its charter, the Society of Arts and Crafts, Boston, lamented "the desire for over-ornamentation and specious originality" and insisted on "sobriety and restraint."[46] As others have noted, "restraint" was not a word that anyone would apply to Ohr.[47] Yet a comment by ceramist Frederick Hürten Rhead, that Ohr was "entirely without art training and altogether lacking in taste," can now be seen as displaying the stuffy self-righteousness of which the Arts and Crafts movement was capable, as much as a reflection on Ohr himself.[48]

As china painters turned to the potter's wheel, Ohr had been using it masterfully for twenty years. But he was caught by another mindset of the time, which considered those who used the wheel skilled workmen rather than artists. Ohr, in return, disparaged many art potteries because of the number of people involved in making a work. One of the abrasive placards at his displays read, "It Don't Take A Doz to Accomplish Art Pottery."

Sometime between 1906 and 1910, Ohr gave up ceramics. At his death, 7,000 pieces of pottery were stored, unwrapped, in open crates in the garage his sons ran in the building that had been his pottery. In 1968 they were discovered by a New Jersey antiques dealer

Brouwer's Fire Painting

Theophilus A. Brouwer Jr. (1864–1932) was a painter who turned to pottery. In 1894 he set up a studio in East Hampton, Long Island, called the Middle Lane Pottery, and started experimenting with luster glazes and gold leaf under the glaze. These were first used as special effects on floral pottery, mostly of simple shapes, but soon Brouwer concluded that the glaze was interesting enough by itself. Without training, experimenting freely, he developed iridescent glazes with various textures and even with elusive suggestions of imagery. He called his work "fire painting" because effects where achieved through the manipulation of the kiln, including the unorthodox transferring of pieces from one hot kiln to another. He employed an assistant or two but essentially did all the work himself: making molds, pressing and casting, glazing and firing. He applied the glaze with a brush and then fired and refired the vessel until he had an interesting surface—or he might fire a pot at a higher heat to "erase" unhappy effects. Around 1910 Brouwer gave up pottery to make sculpture in concrete.

looking for old cars. Although the resurrection of his work and reputation emphasized his quirky and erratic personality, making as much of his story as his pots, Ohr now receives the serious attention he clamored for a century ago.

Jewelry: Beginnings

Arts and Crafts societies, the new schools of industrial design, and manual-training movement programs all featured jewelry and metalwork courses. Because these classes were so widely taught, many amateurs made Arts and Crafts metalwork. Only a modest investment in tools was required, which was not the case for ceramics, furniture making, or weaving. Jewelry was often made in the kitchen. Many students went on to practice the craft full- or part-time, and a number of amateurs made important contributions. Especially in the Northeast, jewelers dominated Arts and Crafts societies. When the Society of Arts and Crafts, Boston, gave out medals to its members, fourteen of the first twenty-four went to jewelers. And for decades, more than half the sales in the SACB's showroom came from jewelry. Much unsigned Arts and

Crafts jewelry survives today, most made by students and hobbyists.

Arts and Crafts jewelry, starting in England in the 1890s, was often made of silver instead of gold or platinum. Stones were semiprecious cabochons such as amethyst or moonstone instead of faceted diamonds and rubies. Arts and Crafts jewelers often set enameled plaques in their pieces. Designs frequently consisted of wire frames that contained constructed leaves and flowers. Much was open and airy. Pendants, brooches, and rings were common, along with the "festoon necklace" (discrete parts linked by multiple chains), but few women wore earrings at the time. Other than rings, men's jewelry in the Arts and Crafts style is rare.

Many of the new jewelers rejected both costume jewelry and social jewelry, the two professional types of their day. Costume jewelry, which often replaces precious metals and gems with cheap substitutes such as tin alloys and fake stones, is usually produced in the least labor-intensive, most mechanized way possible, making it anathema to advocates of hand fabrication. Genuine Arts and Crafts jewelry was never made with industrial processes (no die-stamping, no casting from molds) but with hand processes such as chasing and repoussé, soldering, and enameling. Social jewelry, which is typically made of precious metals and gems and is a sign of wealth and status (engagement rings, for example), was avoided because it symbolized class distinctions. Arts and Crafts jewelers proposed a hierarchy of taste instead of a hierarchy of wealth. Because the movement was frequently associated with progressive culture and politics, jewelry was often designed to go with clothing advocated by reformist organizations such as the Free Dress League. These groups called for simple, loose dresses worn without corsets, along with shirtwaists (blouses), jackets, and informal hats. Typical adornment for reform clothing included brooches (often used to secure a shawl), belt buckles, hatpins, and cloak clasps.

MADELINE YALE WYNNE

One of the first Arts and Crafts jewelers to gain critical acclaim was Madeline Yale Wynne (1847–1918). Her father invented the Yale lock, and her experience growing up around his machine shop and factory was good preparation for metalwork. She studied painting at the Boston Museum School starting in 1877, in the school's first graduating class, and later at the Art Students League in New York. At different times she painted, wrote fiction, and made furniture, baskets, leather, embroidery, jewelry, and pyrography (images burned into wood). An early advocate of the crafts, she summered in Deerfield,

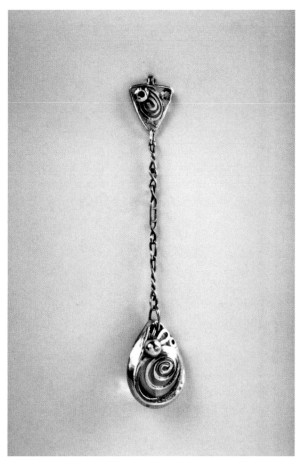

FIGURE 2.23. *Madeline Yale Wynne*, Watch Fob with Crystal Drop, *ca. 1900. Silver and crystal; length, 5.1 in. (Courtesy of the Pocumtuck Valley Memorial Association, Memorial Hall Museum, Deerfield, Mass.)*

Massachusetts, and participated in a textile renaissance there as well as making jewelry in a barn behind her house.

Wynne moved to Chicago around 1893, set up a studio, and became one of the founding members of the Chicago Arts and Crafts Society in 1897 (serving as president from 1901 until her death). The jewelry she showed at the society's first exhibitions provoked quite a bit of comment. A watch fob with crystal drop (ca. 1900) is typical of her metalwork. (Figure 2.23) A watch fob is a relic of the days when every gentleman carried a pocket watch in his vest. The smaller end of the fob would clip onto the watch, and the larger end would drape out of the pocket for easy retrieval. Wynne's fob is made in silver, and the pendant encloses a piece of crystal.

Wynne was self-taught in metalworking, and her approach is direct, even crude. Her wirework is full of dents and dings, links in the chains are unevenly twisted, and some of the solder joints are not fully closed. A trade jeweler would have been horrified. Wynne said that she dealt with jewelry as form and composition rather than

as a set of laws imposed by tradition: "I consider each effort by itself as regards color and form much as I would paint a picture." Thus unrestricted, she could invent and improvise. In one of her belt buckles, she simply took little round pebbles and set them three at a time. The unpolished pebbles gave the buckle a distinctive accent of texture and color.[49]

Some observers called her work "barbaric."[50] That may be an overstatement, but it raises a question that persists today, regarding how technique affects appearance and utility. Some observers hold that lapses in craftsmanship can be a distraction: if the dents weren't there, the overall effect might be improved. Others note that the poorly soldered joints in Wynne's watch fob could make the object more likely to fall apart in daily use. But durability is necessary only if the object is actually subjected to the physical stress of use. What if Wynne didn't care if a watch ever hung from it? She was clear about her position: craft is primarily an aesthetic enterprise, not a demonstration of skill.

BRAINERD BLISS THRESHER

Another of the inspired amateur Arts and Crafts jewelers was Brainerd Bliss Thresher (1870–1950). Thresher was a financier, but in his spare time he practiced a variety of crafts. When he was a teenager in Dayton, Ohio, his family purchased furnishings from Edward Colonna, who was designing train interiors in Dayton at the time. Colonna left for France in 1888 and became one of the foremost art nouveau designers. Thresher must have absorbed some of Colonna's sophisticated understanding of design, for his jewelry is unlike any other American work.

The primary material in a necklace Thresher made in 1905 is horn, accented by eight large amethysts. (Figure 2.24) Cow horn and tortoise shell had been used for centuries to make combs, spectacle frames, buttons, and other sundries; the French jeweler René Lalique pioneered their use in jewelry. Lalique emphasized color and transparency in his work and used quotidian materials like glass and horn alongside ivory, gold, and diamonds. Thresher must have known about Lalique's jewelry, either from contact with Colonna or from the international art magazines.[51]

In this necklace he combines carved horn and amethysts with gold. Like many Arts and Crafts jewelers, he stresses the visual properties of his materials rather than their cost. The necklace depends on color for its impact: the warm brown of the horn, the pale purple of the amethysts, and the yellow of the gold. The color would be seen to best advantage over pale fabric or skin, so

FIGURE 2.24. *Brainerd Bliss Thresher, Necklace, ca. 1905. Carved cow horn, amethysts, and gold; length, 13.5 in. (Private Collection.)*

light could illuminate the horn and amethyst from behind. Each stone is set in a gold bezel, and the whole is held together with rings and links of gold. The horn carvings are a composite of leaf shapes and arabesques, not exactly art nouveau, but close. Using horn allowed Thresher to work fairly large: the necklace is thirteen and a half inches from top to bottom, and the largest carving is more than four inches high. When worn, this would have been a dramatic piece.

Ruskin's intention was to reunite art and labor, but he inspired many upper-class Americans to unite art and leisure. Thresher saw craft as a recreation and pastime. The practice of craft as a recreation could be a relief from the pressure of a difficult job, a demonstration of one's good taste and *savoir vivre*, a polite manifestation of progressive politics, or an expression of the sheer pleasure of satisfying labor. As an amateur, Thresher was not under pressure to work quickly and efficiently. He was productive nonetheless: he exhibited thirty-nine pieces of jewelry in the 1902 Arts and Crafts exhibition at the Art Institute of Chicago. In the 1920s he also made furniture, screens, and wooden panels with carved ivory insets.

Metalsmithing

MARTELÉ

Silversmithing's trajectory differed from jewelry's. Both trades produced luxury goods from the colonial years through the nineteenth century. Both developed into major industries dependent on machine production. The silver industry sometimes embraced the Arts and Crafts movement and its sense of reform, however, while the jewelry industry didn't. One indication of the reform impulse in silversmithing was spare design; another was the conspicuous display of fine handwork.

Perhaps the last major efflorescence of highly skilled handwork in the silverware industry was seen at the Gorham Manufacturing Company in Providence, Rhode Island, one of the largest such businesses in the world. The company had grown by embracing modern technology and business methods, by combining mass production with sales teams and advertising campaigns. Its president, Edward Holbrook, conceived of surpassing Tiffany & Co., the acknowledged leader, with products that would win prizes in international expositions: a line of artistic, luxurious handmade silverware. It was called Martelé, the French word for "hammered."

Holbrook visited France regularly and collected books on new design for Gorham's library. In the late 1890s, he had his designers incorporate art nouveau's whiplash lines and botanical subjects. Martelé silver was toned down compared with the most adventurous French or German work, however: wealthy Americans wouldn't embrace an artistic revolution any more than a social one.

Martelé was formal silverware that would be used on the dinner tables of the rich. Most of the work was hollowware. The forms were hammered up from flat sheet or soldered into tubular forms, shaped, and then decorated with chasing and repoussé. Chasing is a slow, labor-intensive craft, so the cost of labor can be much greater than the cost of silver. For the most elaborate Martelé, a single chaser might work for months on a piece weighing several pounds, and the final cost could be the equivalent of $40,000 or more today.

A 1901 ewer with platter is a superb example. (Figure 2.25) The ewer alone stands about eighteen inches tall. Both pieces are covered with rhythmic whorls of seaweed and waves and a few fish. Images of six women with swirling tresses emerge from the platter. The ewer's handle is a fully modeled figure: decoration and structure are one. Tool marks cover almost the entire form, imparting a pleasing texture and softening the reflections from the polished surface. It is a fully realized example of art

FIGURE 2.25. *Gorham Manufacturing Company (1831–present), retailed by Spaulding and Company,* Martelé Ewer with Platter, *1901. Silver; overall: 19.16 × 8.75 × 6.37 in.; platter: 2.31 × 17.25 in. (The Metropolitan Museum of Art, Gift of Mr. and Mrs. Hugh J. Grant, 1974.214.26A-B. Image © The Metropolitan Museum of Art.)*

nouveau, comparable, in its design and craftsmanship, to anything made in Europe. This was undoubtedly a display piece, since the elongated form would be unstable on its small foot and easily spilled. It functioned as a monument to its owner's wealth and taste, an act of "conspicuous consumption," in Thorstein Veblen's words.

The Martelé line stands as a high point in American hand craftsmanship, unlikely to recur. Gorham assembled a team of more than forty chasers, but the market for such complex and expensive silver soon faded. A financial panic in 1907 forced the company to release many of its younger employees, and art nouveau soon went out of style. The line ceased production in 1912.

LOUIS COMFORT TIFFANY: METALS AND JEWELRY

After Louis Comfort Tiffany began working in blown glass, he added other mediums to his repertoire. In 1898 he conducted experiments in enamel on metal. It was a logical step: enamel is a powdered glass that melts at low temperatures. He could experiment with enamels as he had with glass and apply the same sensibility to a new class of objects.

FIGURE 2.26. *Louis Comfort Tiffany, Tiffany Glass and Decorating Company, Bowl, ca. 1899. Enamel on copper; 6.12 × 9.5 × 9.5 in. (Metropolitan Museum of Art, Gift of the Louis Comfort Tiffany Foundation, 1951.)*

FIGURE 2.27. *Louis Comfort Tiffany, Enameled Peacock Necklace, ca. 1905. Peacock and flamingo enamel, opals, amethysts, sapphires, green garnets, rubies, emeralds, and gold. (The Charles Hosmer Morse Museum of American Art, Winter Park, Fla. © The Charles Hosmer Morse Foundation, Inc. Photograph by Raymond Martinot.)*

The first of his enamels were on hand-hammered metal forms. He hired Patricia Gay to head his new department and Julia Munson and Alice Gouvy to design.[52] Generally his enameled works were vases and boxes featuring imagery already familiar from his windows: fruits, flowers, leaves, and the occasional insect. The metal forms were usually raised or seamed and then chased in low relief. The method resembled Martelé, but the effect was altogether different.

A bowl from 1899 is typical. (Figure 2.26) Its form lacks any historical reference. It has the plump roundness of a plum. To accentuate the feeling of volume, its inside edge is turned down to conceal the thinness of the metal. The bowl is chased with several branches, each loaded with ripe plums that are enameled in lush iridescent purples, the leaves in greens and yellows. The background is mainly orange, but with mottled purples and greens to unify the color scheme. All the enamels are transparent. The colors were built up in multiple firings, one tint over another, to create a marvelous illusion of depth. Where Martelé appeared rigid and formal, this bowl is relaxed and impressionistic. Tiffany's enameled vases, boxes, and bowls were probably all one of a kind, and only about 750 were made.

After the death of his father, Charles, in 1902, Louis Tiffany turned to jewelry, apparently liberated from concerns about competing with his father's firm, Tiffany & Co. His early jewelry used enamels along with semiprecious gems and pearls. One of his masterpieces is a peacock necklace made about 1905. (Figure 2.27) The central medallion depicts the bird in a mosaic of opals of different shades. In a gesture that must have seemed almost perverse at the time, the peacock's wings are rendered in the iron-colored matrix (the surrounding rock) of the opal. Usually the matrix is cut away and discarded, but here it is used for its dark, contrasting color. The peacock is ringed with irregular unmatched amethyst cabochons, again a violation of convention. Elsewhere, the jewel is set with sapphires, green garnets, rubies, and emeralds. The colors of the stones are repeated in enamels on the two flanking panels, again depicting peacocks. After the necklace was completed, Tiffany thought the back was too plain. So three more enamels were made and set on the reverse, depicting flamingoes in pink and pale green.

In 1907 Tiffany closed the enamel department and transferred his designers to Tiffany & Co. In later years, the firm made some extraordinary enameled hollowware in gold and silver, but its jewelry gradually became more conservative.

H. STUART MICHIE

Silversmithing developed outside of industry, too. Many of the early studio craftsmen and craftswomen received their first training in college design programs. H. Stuart

FIGURE 2.28. *H. Stuart Michie, Charger, 1905. Copper and enamel; diameter, 15.5 in. (Collection of Henry T. Michie. Photograph courtesy of the Herbert F. Johnson Museum of Art, Cornell University.)*

Michie (1871–1943) studied at Pratt Institute when Arthur Wesley Dow taught there. Michie went on to London in 1905 to study at two of the prominent Arts and Crafts schools, Central and Camberwell. Returning to the United States, he became an educator himself, principal of the School of the Worcester [Massachusetts] Art Museum from 1909 to 1938. He brought a broad base of knowledge to his teaching: he worked in textiles, printing, lettering, woodworking, metalsmithing, and enameling. His charger is an interesting example of early Arts and Crafts work. (Figure 2.28) It is said to have been made at the Byrdcliffe colony, near Woodstock, New York, in the summer of 1905.

The plate is made of copper, much favored in those early years. Because copper is so malleable, a shallow plate like this, though effective visually, would not have been challenging technically. Michie added six radiating bands around the lip and set a cloisonné enamel of a Japanese-style carp in the center. (Like many of Dow's students, he shared his teacher's enthusiasm for Japanese art.) The image borrows the many-fingered waves seen in Japanese prints, and the carp is a symbol of good fortune. Michie was typical of early Arts and Crafts artists in that he worked in numerous mediums. People trained in a trade would not learn so many different crafts, and their work probably would be more traditional. This was true of silversmithing, particularly around Boston.

ARTHUR STONE

Like most prosperous East Coast cities with concentrations of old money, Boston had a ready market for silverware. Every upper-class bride received a set of silver for her wedding, and where the blue bloods could trace their ancestry back to the *Mayflower*, the colonial revival style was preferred. The area was also home to the American silverware industry, which attracted many foreign-trained smiths to bring their mastery to America. There was Arthur Stone from Sheffield, George Gebelein from Bavaria, George Hunt from Liverpool, Karl Leionen from Finland, Frans Gyllenberg from Sweden, and many others. Stone (1847–1938) was one of the most prominent. He immigrated to the United States in 1884 and worked in several shops before establishing his own in Gardner, Massachusetts, in 1901. Over the years he incorporated Renaissance, Celtic, even Moorish influences into his silver before settling down to a comfortable colonial revival style.

In his tea service from 1907, the basic shapes are rococo, swelling like balloons from narrow bases but shorn of the usual ornate leaves, shells, and froufrou. (Figure 2.29) Everything has been simplified: small handles are not cast but constructed of strips of silver, spouts have almost no decoration, moldings at the bottom edges are reduced to a single groove. Around the body of each piece, Stone chased a repeated art nouveau blossom in very shallow relief. His technique was sophisticated, and he knew the vocabulary of historical silverware, but his sense of design was conservative. He never completely broke with the past.

FIGURE 2.29. *Arthur Stone, Five-Piece Tea Set, 1906–7. Silver; height of kettle and stand, 12.25 in. (Museum of Fine Arts, Boston, Gift of a Friend of the Department of American Decorative Arts and Sculpture, John H. and Ernestine A. Payne Fund, and Curator's Fund, 1987.551-555. Photograph © 2008 Museum of Fine Arts, Boston.)*

FIGURE 2.30. *George Joseph Hunt,* Teapot, *1904. Silver, ivory insulators; 6.12 × 8.37 × 5.37 in. (Museum of Fine Arts, Boston, Gift of Joseph B. and Edith Alpers, 1991.92. Photograph © 2008 Museum of Fine Arts, Boston.)*

GEORGE HUNT

A more stripped-down Arts and Crafts look was used by George Hunt (1866–1947), who, like Stone, had trained in England and immigrated to the United States in the 1880s. By the time he opened his own shop in Boston in 1905, he was involved in the Arts and Crafts movement. He taught metals classes at the Boston Museum School (1905–42) and elsewhere. He was an active member of the Society of Arts and Crafts, becoming a master in 1908.

A teapot from 1904 was made during a sojourn in England, but it has an American flavor of reduction to essentials. (Figure 2.30) The only truly nonfunctional element is the tiny bead running around the narrowest part of the finial on the lid. Every other detail, from the insulators on the handle to the slightly bent lip on the spout, has a functional logic. The insulators keep the handle from getting hot; the lip prevents the spout from dripping. Hunt's undecorated teapot could be seen as an early example of modernist functionalism.

Like Stone, Hunt went on to embrace the colonial revival. Boston's attraction to Gothic revival also generated a lot of business for silversmiths. Boston jewelry came to fruition in the 1910s and 1920s, but its silversmithing, while remaining technically very accomplished, slowly retreated from the avant-garde.

KALO SHOP

In 1900 Chicago was a young and rapidly growing city, home to self-made businessmen, many eager to align themselves with progressive politics and culture. They and their wives supported Hull-House, commissioned new Prairie school houses, and decorated them with ob-

jects to match. Chicago became one of the largest producers of handwrought silver in the country, much of it in the new Arts and Crafts style.

The leader of the Chicago Arts and Crafts silversmiths was Clara Barck Welles (1868–1965). In 1900, at the age of thirty-two, Clara Barck left her native Oregon to take design classes at the Art Institute of Chicago. She may have seen C. R. Ashbee when he came to speak in Chicago that year. In any case, she was inspired to start her own semicooperative crafts venture in suburban Park Ridge. She called it the Kalo Shop, after the Greek word for beauty, *kalon.* (Figure 2.31) It began as an all-female workshop for leather with burned designs, weaving, basketry, and simple jewelry.

Barck married coal merchant and self-taught metalsmith George Welles in 1905, and the Kalo Shop started producing copper and brass hollowware. The couple moved the shop and school into their home, calling it the Kalo Art-Craft Community. Production was centered there, and goods were sold in their downtown retail outlet. Jewelry, flatware, and silverware became the primary focus. Kalo became the city's main producer of handmade silver, with its own distinctive style. While Clara Welles taught jewelry making to a number of women over the years, she hired mostly experienced silversmiths, usually men from Scandinavia. In turn, many of them opened their own shops, continuing the Kalo style. Forms and handles were made from flat sheet, giving the body a geometric quality that was often broken up by planishing. Applied monograms, sawed out of sheet and soldered to the body, are another Kalo feature.

Over the years, the Kalo Shop became a durable Chicago institution. At its peak, twenty-five smiths worked there. Welles's Arts and Crafts style stayed close to its roots in reform and simplicity, although she stopped providing new designs by the early 1940s. In 1959 she

FIGURE 2.31. *Clara Barck Welles, designer, The Kalo Shop,* Sugar Bowl and Creamer, *ca. 1908. Sterling silver, jade; height, 2.31 in. (Collection of the Chicago Historical Society, 1972.218B.)*

gave the business to its employees. It finally shut down in 1970, due not to lack of customers but to a lack of trained silversmiths.

ROBERT JARVIE

One of the many hobbyist Arts and Crafts metalworkers who became professionals was Robert Jarvie (1865–1941). He worked as a clerk for the Chicago Department of Transportation for years, while teaching himself metalsmithing in his spare time. In 1904 he quit his day job to open a shop. One of his specialties was cast-metal candlesticks with elongated stems and broad, flat bases. (Figure 2.32) Parts of the candlesticks resemble Greek urns or Persian ceramic vases, but the shapes are stretched, flattened, and stacked in highly inventive ways. They were typically cast in bronze or brass and sometimes plated with copper. Some were patinated an antique green, others given a lustrous brushed finish.

The candlesticks quickly attracted critical attention, appearing in the *Craftsman* in 1903 and *International Studio* in 1904. The *Craftsman* effused: "The charm of these candlesticks is in their simplicity and purity of form. The graceful outlines and soft luster of the unembellished metal combine to produce dignity as well as

FIGURE 2.32. *Robert Riddle Jarvie*, Pair of Beta Candlesticks, 1905. Copper; height, 12.25 in.; diameter, 5.87 in. (Los Angeles County Museum of Art, Gift of Max Palevsky and Jodie Evans in honor of the museum's twenty-fifth anniversary. Photograph © 2007 Museum Associates/LACMA.)

beauty, and the possessor of one of the Jarvie candlesticks must feel nothing tawdry or frivolous can be placed by its side."[53]

The Jarvie Shop also made lanterns, bowls, trays, bookends, sconces, and smoking items, a typical Arts and Crafts assortment. Jarvie branched out into gold and silver items and by 1912 was producing trophies and presentation pieces. One example is the wonderful *Aero and Hydro Trophy for Hydroaeroplane Efficiency* (1912). Its rectilinear lines and etched decorative panels are reminiscent of Prairie school furniture. This shouldn't be a surprise, as Chicago architect George Grant Elmslie is said to have helped Jarvie design it. The trophy is surmounted by a silver scale model of a Curtis flying boat. The trophy was probably fabricated by John Petterson (1884–1949), who opened a metalsmithing studio in Chicago in 1914. Jarvie closed his shop in 1920.

Textiles: Revivals, Inventions, and Borrowings

Between the Philadelphia Centennial Exposition in 1876 and the end of the century, interest in historic textiles had grown. They were especially desired by patriotic societies, museum period rooms, and historic houses. The preservation and revival of techniques were often fostered by settlement houses. By 1904 more than fifty spinning, weaving, and rug-making programs had been established by missionaries, settlement workers, educators, philanthropists, and artists, located mostly in rural New England, the Southern Highlands, and urban areas with large numbers of immigrants.[54] Yet textiles may be the most problematic Arts and Crafts medium to discuss, because so few examples survive. In addition, whether produced in a home or industrial setting, textiles were typically not treated as art, so the names of designers and makers were unrecorded. Although the Museum of Fine Arts, Boston, for one, established a textile study room in 1898 for the benefit of both students and designers for industry, subsequent work was little better documented.

One new textile enterprise at the turn of the century was a part of the colonial revival and drew interest for social and philosophical reasons. **The Deerfield Society of Blue and White Needlework**, founded in 1896 in the western Massachusetts town of Deerfield by Margaret Whiting (1869–1946) and Ellen Miller (1854–1929) to revive the art of blue-and-white crewel embroidery, is the best-known revival effort. (Figure 2.33) In the early 1890s the two women, from longtime Connecticut River Valley

FIGURE 2.33. *Deerfield Society of Blue and White Needlework, Chairback, Vine and Fig Tree (detail), 1907. Cross-stitch on linen; 14.25 × 29 in. (Photograph courtesy of the Pocumtuck Valley Memorial Association, Memorial Hall Museum, Deerfield, Mass.)*

families, had begun to copy disintegrating eighteenth-century crewel embroidery in local institutional and private collections.

Whiting first copied, then adapted from the fragile remains, concentrating on simple examples. Flax, which was not vulnerable to moths, was used in place of wool, although it was more difficult to use and more readily showed mistakes. Early works used blue and white linen on cotton or linen cloth for bed curtains, tea cloths, doilies, bureau scarves, and table covers. But soon they added colors (greens, browns, and pinks), current textile forms for home decor (portieres, screens, and cushions), and original motifs (birds, sheep, landscape scenes). They employed indigo, madder, butternut, and other natural dyes. While works following the eighteenth-century originals continued to be popular with readers of the *Craftsman* and in the colonial revival market, they produced designs influenced by art nouveau as well.

Only work approved by Whiting and Miller received the society's trademark *D* with spinning wheel. The group, thirty-four members at its largest, exhibited its works nationally and won prizes at both the Pan-American Exposition of 1901 and the Panama-Pacific Exposition of 1915. Their success led to the founding of the Deerfield Society of Arts and Crafts, whose members made baskets, rugs, furniture, and jewelry.

Keeping the project viable was not easy. Among the problems, as one of the Deerfield leaders told *House Beautiful*, was that "an art industry depended on standards, but it could not succumb to standardization; only uniqueness, or what passed for it, promoted sales, since machines could duplicate ancestral designs and fine stitchery."[55] In addition, the work competed with less ex-

pensive folk crafts from Mexico and Japan, which were popular in the Arts and Crafts era.

Whiting and Miller preserved a feminine craft by adapting it to a contemporary market, thus providing a moneymaking opportunity for local women. The society lasted until 1926, when their health no longer allowed them to examine and approve Deerfield stitchery.

Textile production was also part of the program at **Newcomb College**. (Figures 2.34, 2.35) Best known for its pottery, Newcomb engaged in a variety of other creative work, including jewelry making, silversmithing, and bookbinding. After the pottery won a medal at the Paris Exposition in 1900, the founder, Josephine Louise Le-Monnier Newcomb, decided to broaden the curriculum to include crafts and built a separate building to house this new endeavor. Although she died in 1901, the plan went through. In the fall of 1902, the textile class began, taught by Gertrude Roberts Smith, an assistant professor of drawing and painting.

Embroidered items included church vestments, panels, and screens; table coverings and napkins; and clothing accessories. The simplest of materials were combined with good design, executed in four basic stitches—darning, buttonhole, satin, and outline. The program was a great success. In 1904 courses in weaving and spinning were added, the woven fabrics often subsequently embroidered. All pieces that passed a jury carried the Newcomb seal. Typically the colors are the same soft palette as Newcomb pottery and employ similar vegetal and landscape motifs. A runner, for example, might feature at each end a horizontal band of gray-green moss-draped trees.

FIGURE 2.34. *Beatrice de Grange, Three-Section Fire Screen with Southern Pine Tree Motif, ca. 1904. Embroidered textile; 23.5 × 22 in. (Collection of the Foundation for the Crafts of the Newcomb Style. © Suzanne L. Ormond, Mary E. Irvine.)*

FIGURE 2.35. *Gladys Molten,* Wall Panel in Poinsettia Design *(detail), 1910–11. Embroidered textile; 3 ft. 6 in. × 19 in. (Collection of the Foundation for the Crafts of the Newcomb Style. © Suzanne L. Ormond, Mary E. Irvine.)*

Most Arts and Crafts textile activity was carried out by amateurs at home, sometimes following published patterns. The goal was a harmonious effect and freedom from the pressures of fashion. Natural silks, cottons, and linens were preferred, in colors with such poetic names as "wild thyme," "lichen," and "withered leaf."[56] A favorite Arts and Crafts textile was hopsacking, a term that originally referred to rough utility fabrics of jute or hemp—that is, burlap–but came to be applied to various coarse-textured linen, cotton, and wool fabrics for apparel and furnishings.

Batik, an Asian wax-resist technique for textile decoration, came into use in America after the turn of the century. The Museum of Fine Arts, Boston, through Denman Ross, had acquired five batiks from the Javanese Village at the 1893 World's Columbian Exposition. (He added sixty-six more in 1911.) Batiks were also shown at the 1900 Paris Exposition. Charles E. Pellew, who taught at Columbia, wrote an article on batik for the *Craftsman* in 1909. Avant-garde artists, first in Europe and then in America, began to experiment with the technique. Young Americans such as Marguerite Zorach, Martha Ryther, and Lydia Bush-Brown began to make batik textiles in the 1910s (see chapter 3). At the Theosophical colony on Point Loma, near San Diego, Grace Betts, sister of the prominent New York portrait painter Louis Betts, learned batik methods and shared her knowledge with Marian Plummer. The two women produced some outstanding examples on silk. Batik clothing was at first considered rather bohemian, since it was often worn by artists, but gradually it became more fashionable.

Another Arts and Crafts favorite was stenciling; sten-cils could be purchased in art supply stores or ordered from paint-company catalogs or magazines and applied to textiles or to bungalow walls. Rag rugs were also popular. Traditionally, the rugs were woven of worn-out fabrics cut into strips, a practical pioneer effort to avoid waste. But Arts and Crafts weavers sometimes cut up new material to get a specific effect. The rugs, with their casual appearance, were used in bedrooms or bathrooms.

Objectifying Glass

Glass, with its furnace and fuel requirements, was an industrial product at the turn of the century. But two designers stand out for their creativity, even at this scale.

Louis Comfort Tiffany, as noted, was famous for stained glass before the turn of the century. His blown-glass objects, beginning in the 1890s in his **Tiffany Studios** in the New York City borough of Queens, were equally successful. (Figure 2.36) One aspect of his life contributed to another: his landscape painting reflected his interest in nature, which led to the spectacular grounds he created for his Long Island home, Laurelton Hall, which influenced the vegetal forms and colors of his glass and ceramic vessels.

Travel abroad had taught Tiffany not to dismiss decorative arts as somehow inferior to fine arts—at least, that is the argument made by Charles de Kay in *The Art Work of Louis C. Tiffany,* a 1914 book that is generally thought to have been all but dictated by Tiffany, presenting him as he wished to be seen. The text is useful for what it may reveal of his thoughts, since he seldom wrote or spoke about his work.

Tiffany's style has been variously described as eclectic, historicist, nature-based, and proto–abstract expressionist. Only the last is a stretch. He was fifty-two in 1900 and so was inevitably inculcated with nineteenth-century tastes. In the new century, however, he was one of the American artists most identified with art nouveau. Several of his objects and windows were featured in the inaugural exhibition of Bing's L'Art Nouveau shop in Paris, and Bing displayed Tiffany's work at fairs such as the Paris Exposition of 1900. Yet his motifs are more naturalistic than art nouveau's dynamism and abstracted motifs.[57] Except for the peacock, he preferred "native and unassuming flora and fauna" such as wisteria, jack-in-the-pulpit, Queen Anne's lace, apple blossom, spider's web, and mushroom.[58] He drew upon a library of scientific books about plants and animals, and referred to photographs. Laurelton Hall was a sort of living library.

Iridescence was a natural feature of antique glass that

FIGURE 2.36. *Louis Comfort Tiffany, Tiffany Studios, Vase, ca. 1900. Favrile glass; 13.25 × 4 × 4 in. (Brooklyn Museum, Gift of Charles W. Gould, 14.739.8.)*

Tiffany was driven to re-create. Other historical sources were Asian prototypes for his gourd- and pear-shaped vessels and Roman models for his pinched vases. Tiffany gave his glass vessels the invented name Favrile, derived from *faber* (maker) and thus associated with craftsmanship. "Favrile is distinguished by certain remarkable shapes and brilliant or deeply toned colors, usually iridescent like the wings of certain American butterflies, the necks of pigeons and peacocks, the wing-covers of various beetles. Its commonest use is for flower vases and table decorations," wrote de Kay, adding that it appealed to "the people's love of color."[59]

Tiffany's first lamps (1896–98) were almost medieval-looking heavy objects usually having wire frames and blown-glass spheres. As he developed organic shapes for his works in other mediums, the lamps took the forms of mushrooms, maple trees, clusters of water lilies, or wisteria vines. It is not known who had the idea of making the leaded glass curve over hemispherical forms to function as lampshades, although many of his most popular shade motifs are now known to have been designed by his employee Clara Driscoll.[60] But there's no question that Tiffany supervised all his products and was the master of their realization.

The line between business and art has been a di-

lemma again and again in modern craft. Tiffany wished to be seen as an artist, so the de Kay book featured his unique works in all genres but not the mass-produced items—lamps, shades or bases, or ceramic vessels. Though he was producing lamps in editions of more than 100, Tiffany tried to evade charges of commercialism by claiming that they were merely an effort to use up the inventory of glass fragments remaining from his windows. Thus it is ironic that today his name is most widely linked to lampshades.

In the new century, Tiffany expanded his business into more affordable and more public genres. His numerous glass objects were accessible to a wide range of buyers. At the same time, his light fixtures, windows, glass domes, and mosaic tiles appeared in libraries, office-building lobbies, banks, hospitals, university gymnasiums, art museums, restaurants, department stores, hotels, lecture rooms, and waiting rooms all over America.[61] Today we would say that Tiffany was a master of branding, and appropriately so, because he lived in an era when businesses first established corporate identities.

Around 1916 Tiffany seems to have disengaged from design and production and devoted himself instead to his mansion and gardens, as well as to setting up a foundation supporting the decorative arts. Tiffany Studios declared bankruptcy in 1932, a year before the death of its founder.

Frederick Carder (1863–1963), like several other figures at the turn of the century, was something of a renaissance man—designer, technician, educator, businessman, marketer, artist. His early innovation was color in blown glass; he lived to see it fall out of fashion but was still living when it was rediscovered.

Carder was born in Staffordshire, in the glassmaking West Midlands of England. His grandfather owned a pottery, which initially interested him, and he studied art as well as chemistry, electricity, and metallurgy in preparation to enter the ceramic industry. But in 1878, just as a family dispute made it impossible for him to work at the pottery, he discovered glass. Still a teenager, he went to work as designer for Stevens & Williams, one of England's foremost glass manufacturers. The owner was interested in artistic work and encouraged Carder, who with a collaborator produced colored glassware. It was immediately popular, first in the context of Victorian taste and then in art nouveau style. Carder traveled to Germany and Austria to study glass manufacturing and made a similar trip to the United States in 1903. In Corning, New York, he visited the Corning Glass Works and also met with T. G. Hawkes Co., which wanted to make its own glass instead of buying blanks. The incorporation

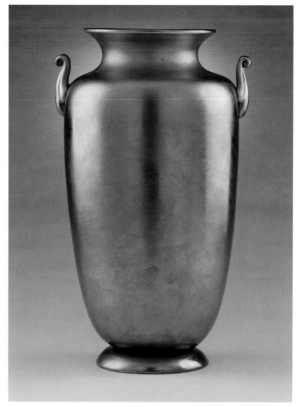

FIGURE 2.37. *Steuben Glass Works*, Gold Aurene Vase, *ca. 1920s. Glass; 11.62 × 7.12 × 6.37 in. (Los Angeles County Museum of Art, Gift of Mrs. Scott Allen. Photograph © 2007 Museum Associates/LACMA.)*

of Steuben Glass Works (named for its home county) was announced in the newspapers within days.

In October 1903, only three months after Carder settled in Corning with his wife and children, the factory was set up and the first glass pieces produced—crystal glass blanks for the Hawkes factory to decorate. Carder later claimed to have retired 40 percent of the $50,000 indebtedness in the first year of operation. But he was not satisfied with making blanks and began producing his own artistic glassware. Carder thought of Steuben as "his" factory and was immersed in all aspects—technical, creative, and practical—for the next thirty years.

Aurene, his first well-known series at Steuben, was inspired by the iridescence of Roman glass. (Figure 2.37) Patented in 1904, it inspired raptures of poetic association from its admirers. Verre de Soie, a clear crystal with iridescence, was developed the next year. By 1913 Carder's iridescence was competing with Tiffany so effectively that he was subpoenaed on a charge that he'd stolen the formula of Favrile through a former Tiffany employee. Carder proved that he was producing the glass before the employee came, and Tiffany's lawyers eventually dropped the suit. The men later became friends.

The difference between them, Lloyd Herman notes, was "that Tiffany was primarily an artist directing skilled technicians to realize his creations, while Carder was an inveterate inventor-researcher who applied his discoveries (and rediscoveries) to a wide range of beautiful, functional glass objects—also made in multiples in a factory."[62]

Steuben's original ten-pot furnace, installed in 1903, was supplemented in 1908 with a sixteen-pot furnace in an enlarged blowing room. There were about 270 employees when, late in 1917, the U.S. government declared Steuben a nonessential industry in wartime, which meant the factory could not purchase certain raw materials. The choice was to close or to sell to Corning. Steuben was sold in January 1918. A few years later, Carder was hired to manage the Steuben Division of Corning Glass Works. He continued his independence under the new regime, and his story continues in chapter 5.

Arts and Crafts Societies

Until the early 1890s, craft societies were devoted to specific mediums. In the mid-1890s, though, generalist Arts and Crafts groups started sprouting up everywhere. The first was founded in San Francisco in 1894,[63] followed by the second in Minneapolis in 1895.[64] By 1898, Arts and Crafts societies had sprung up in Boston, Chicago (organized at Hull-House), Rochester, New York City, and elsewhere.

By and large, the men and women who founded them were educated, upper or middle class, politically progressive, and readers of Ruskin and Morris. Most American societies were modeled after the English Art Workers' Guild and its extension, the Arts and Crafts Exhibition Society. American groups sponsored lectures, educational programs, exhibitions, classes, publications, production workshops, salesrooms, and social events. Many lasted only a few years, but those that endured served the needs of their membership and stimulated public interest at the same time.

The most successful was the Society of Arts and Crafts, Boston (SACB), which still exists. Boston was fertile ground since the area was already the national leader in art education, decorative arts courses having been taught there for almost a quarter-century. In addition, Morris & Co. goods had been sold there since 1870, it was a center of high-end printing, Hugh Robertson had operated art potteries for more than two decades, and art glass had been produced nearby since the 1870s.

On April 5, 1897, an exhibition of almost 1,000 hand-

crafted objects from 108 exhibitors opened at Copley Hall. Only 72 of the exhibitors were makers; manufacturers, retailers, collectors, and four art schools also lent pieces. As a result of the exhibition's success, the SACB was founded later that spring, with art historian Charles Eliot Norton as its first president.

From the beginning, the SACB saw itself as an instrument of reform. Its mission statement declared: "This Society was incorporated for the purpose of promoting artistic work in all branches of handicraft. It hopes to bring Designers and Workmen into mutually helpful relations, and to encourage workmen to execute designs on their own. It endeavors to stimulate in workmen an appreciation of the dignity and value of good design and to counteract the popular impatience of Law and Form, and the desire for over-ornamentation and specious originality." The SACB set about "improving the quality and raising the standards of handicraft."[65] It published a national magazine called *Handicraft*, attempted to open a school in collaboration with the School of the Museum of Fine Arts, and in 1901 opened a salesroom. This was an innovation that attracted members from all over the country and seven foreign nations, and SACB quickly became one of America's leading retailers of craft.

The most powerful group inside the organization was its jury: after 1900, every object the SACB exhibited or sold had to be approved. The jurors were not shy about expressing opinions. They dismissed art nouveau outright, calling it "untrained and undeveloped, of unstocked brain and faltering hand."[66] In effect, the SACB set up its own class of elites, with professionals in charge. It unsurprisingly reflected the gender discrimination of the times. In the first twenty years of its existence, almost 50 percent of the members were women, of whom only seven served on the jury.

As the SACB matured, internal disputes developed. The salesroom began to drive the whole organization, with practicing craftspeople making up three-quarters of the membership. They, of course, were interested in their bottom line and agitated for the store to take lower commissions. Another faction held that social issues should be more important and warned that the membership should not be too concerned "to be rich in money." One member, Mary Ware Dennett, resigned in protest. She complained, "The primary interest of the Society—is things—their beauty, their sale, their increase—etc.—while the primary interest—should be, I think,—the man—his freedom—his industrial and economic independence."[67]

Other craft societies copied the SACB. Although few of them survived very long, the model did. The standards

Charles Eliot Norton and Boston's Cultural Ideas

One of the reasons for Boston's prominence in the Arts and Crafts movement was a widespread demand for craft education stimulated by the Massachusetts Drawing Act of 1870 (see Education, below). Another was the presence of intellectuals deeply influenced by Ruskin. Foremost among these was Charles Eliot Norton (1827–1908), a friend of the older man. Norton graduated from Harvard in 1846, at the age of nineteen. He became Harvard's first lecturer on fine arts in 1873 and spread the Ruskin doctrine far and wide. He likewise stressed the moral value of arts and believed that all forms of visual art shared an underlying unity. Like Ruskin, he felt that the craftsman could flower only in the proper environment. Norton's students included Ernest Fenollosa, Denman Ross, Wallace Nutting, Henry Chapman Mercer, Bernard Berenson, and even Theodore Roosevelt.

Like Ruskin, Norton believed that an elite should steer the cultural affairs of a state, since good breeding and fine culture are diluted in a democracy. Norton's conservatism appealed to ruling-class Bostonians who feared loss of political power, the fragmentation of American society, and the hint of revolution from labor agitation in a time of massive immigration. In these circles craft was seen as a vehicle for social control and assimilation into proper American values. Colonial and English Gothic revival styles were reassuring symbols of stability. Not surprisingly, Boston became a center for both.

formulated by the jury were widely adopted. When a new crop of craft institutions sprang up in the late 1930s and early 1940s, they followed the SACB pattern.

Arts and Crafts Communities

The Arts and Crafts movement in the United States stimulated men and women to set up communities involved with the production of craft. Some wanted to emulate Ruskin's Guild of St. George; others followed religious conviction. All the communities offered a vision of a better society, a response to the feeling that something was wrong with industrialized America. Craft colonies were rural (a critique of the congestion and pollution of cities). They attempted to produce objects in small shops

by hand (a critique of the factory system). They proposed a social system of cooperation and shared activities (a critique of the alienation of modern life). Few of the colonies lasted very long in their pure form, however, as they just weren't economically viable. The ones that survived became businesses and real-estate developments.

The habit of establishing utopian communities goes back to America's beginnings in religious sects such as the Pilgrims, the Quakers, and Mother Anne Lee's Shakers. In the nineteenth century, communities were established by Robert Owen in New Harmony, Indiana, and by Albert Brisbane, who converted a Transcendentalist community at Brook Farm, Massachusetts, to an experiment in early socialism.

As described above, the first and most successful American Arts and Crafts community was the Roycrofters. Although it seemed to be dependent on Hubbard's magnetic personality, it survived his death by twenty-three years and was the last colony to shut down, in 1938.

Rose Valley was the creation of a prosperous Philadelphia architect, William L. Price (1861–1916). Wanting to see Gothic architecture firsthand, Price visited England and France in 1896, with unexpected consequences. He met C. R. Ashbee, whose Guild of Handicraft was prospering in London's East End. By the time he returned to the United States, he was converted. For years thereafter, Price would read William Morris to his family after dinner.

Price was among the idealists who felt that the ills of industrial society called for drastic measures. He embraced Henry George's single-tax theory, which proposed that all land should be taxed at 100 percent of its value. Unable to afford the taxes, property owners would turn their land over to the state. The economy could then be based on the productivity of the worker rather than the holdings of the landowner, and poverty would be eliminated. In 1901 Price enlisted some wealthy supporters and took his first step, establishing Arden, Delaware, as a single-tax community. Basically a land commune, it still functions according to plan.

Price's second project was Rose Valley, a community designed to incorporate "the manufacture of structures, articles, materials and products involving artistic handicrafts."[68] He saw that the factory system was corrosive to appreciation of work done well, declaring in 1905, "It is written that man shall not live by bread alone, and the art instinct, which is a glorified work instinct, is coexistent with the soul, and can no more be abrogated by systems of political economy than it can be destroyed by the greedy maw and itching palm of a dehumanized industrial system."[69]

By May 1901, he purchased about eighty acres of land along a creek southwest of Philadelphia and some empty mill buildings and houses on the property. A guildhall was made from one of the old buildings. By October one of the mills was outfitted as a furniture shop. Price, as head designer, recruited his favorite cabinetmaker, John Maene, to run the shop, and four craftsmen were hired.

Most Rose Valley furniture was aggressively medieval. All work was one of a kind, constructed from oak, much of it heavily carved with Gothic tracery, columns, and medallions. Some incorporated allegorical figures, occasionally in ways quite foreign to real medieval furniture. In a typical large table, the lower tenons are enlarged far beyond the dictates of function, and each sprouts a carved figure. (Figure 2.38) Each figure (whose symbolism is, sadly, not recorded) holds a cartouche, and each is nicely framed by tracery carved in relief on the table's side. Round wooden pegs are visible in the horizontal parts above and below the carved section. Like the tusked tenon, pegs serve both a function and a symbolic purpose: they stand for honest construction and the integrity of crafts in general.

While the Rose Valley shop used power saws and mortising machines, all the carving was done by hand, and the level of craftsmanship was very high. The experiment in dignified labor had its problems, though. Most of the furniture was expensive, and while some of the well-to-do clients may have understood the philosophical basis of the handwork, most probably thought carving signified luxury. The workers were given no hand in design. It is said that the shop was damp and unpleasant, and the workers may have agitated for better working conditions. Price himself was troubled by the amount of time required to operate the business, since it cut into his architectural practice. He closed the Rose Valley furniture shop in 1906. About five hundred pieces were produced.

A print shop, a bookbindery, and a pottery operated briefly. Price also published a magazine, the *Artsman*, from 1903 to 1907. Once the craft studios were shut down, Rose Valley continued for a while as a self-governing community. But in 1911, loans came due, and the project was transformed into a real-estate development with Price-designed houses. The houses still stand; the old guildhall is now a community theater. A network of public paths between them is the only vestige of the original utopian scheme. Price died in 1916, mourned by many.

Another designed community was the **Byrdcliffe** colony near Woodstock, New York. It was founded by a wealthy Englishman, Ralph Radcliffe Whitehead (1854–

FIGURE 2.38.
*William L. Price,
Rose Valley Table, ca.
1902–6. Oak. (Courtesy
of the Athenaeum of
Philadelphia, George E.
Thomas Collection.)*

1929), and his socially prominent American wife, Jane Byrd McCall Whitehead (1861–1955). Whitehead inherited some textile factories in Yorkshire, where he grew up in great luxury. In 1873 his family sent him off to Oxford, where he fell under the spell of Ruskin. Supposedly, he was one of the undergraduates who participated in Ruskin's scheme to dig a road in Hinksley, and he must have known about Ruskin's plans for the Guild of St. George. For fifteen years after graduation, he led a life of self-indulgent luxury, traveling, buying large houses, and spending money.

About 1885 he met Jane, the daughter of a mayor of Philadelphia, who had spent much of her time traveling in Europe. She had studied painting at the Académie Julian and was a versatile artist and designer. Whitehead divorced his first wife in 1892 and married Jane later the same year. The two shared a dream of a rural "convent" of artists and aesthetes, devoted to a simple life of farming and making art. In a letter to her husband written in 1900, Jane speaks of dedicating themselves to "the principle of living like a peasant. . . . We could not carry it out very far but at any rate we strive in that direction. Keeping early hours, eating simple food, and working the ground, as if it were someone else we were doing it for, which if done—without fretting—results in health."[70] The irony of a very wealthy couple trying to live like peasants seems to have been lost on her, but the quotation reveals her longing for a meaningful life.

After a sojourn in Southern California, Ralph found an ideal location for his rural art convent in the Catskill Mountains of New York state. In 1902 he bought a large chunk of property along a mountainside and began building his community. Soon there were more than thirty buildings, including a house for the Whiteheads, a weaving studio, a metals shop, a pottery, a barn, a dormitory for students, and houses for colony residents.

Although the Hudson Valley was already a favorite destination for artists, the Whiteheads put Woodstock on the map. Artists could rent cottages at Byrdcliffe for the summer or buy lots on the colony grounds and build their own houses. Typically, residents spent summers at Byrdcliffe and winters elsewhere. The colony became a magnet for artists and celebrities, with such luminaries as C. R. Ashbee, Clarence Darrow, and Jane Addams visiting. Even when colleagues had arguments with Whitehead and left, they settled in the area, and Woodstock grew as an artists' village.

Whitehead's plan was to have the craft shops produce articles for sale. That would both provide satisfying work for residents and generate cash flow that would support the colony. At first, he concentrated on furniture. (He had trained with a furniture maker for a few months in Berlin, while he awaited his divorce.) The Byrdcliffe shop was spacious and well equipped, including a variety of power tools. This practicality may have been due to the fact that Whitehead hired a local carpenter to run the shop. Yet he did not give his employees the freedom to design; he maintained a clear demarcation between artist and laborer.

Various artists tried their hands at design, so Byrdcliffe furniture had no single style. A few pieces, designed by painter Dawson Dawson-Watson, were fairly

complex, with flowing art nouveau decoration. But Byrd-cliffe craftsmen generally worked in a straightforward Mission style, using native woods such as cherry and quarter-sawn oak. A fair amount of the furniture was made of poplar, which is usually regarded as an uninter-esting wood because it shows no conspicuous grain. At Byrdcliffe, most was stained, sometimes a vivid green.

Since few artists were qualified to build furniture, they participated by painting directly on wooden panels that were then fitted into a piece or by drawing a design to be carved into a panel by the hired help. The result-ing collaborations often departed from established gen-der roles. One of the best designers at Byrdcliffe was a former student of Arthur Wesley Dow's, Zulma Steele (1881–1979). (Figure 2.39) Steele arrived at Byrdcliffe the first summer of its operation, 1903, and stayed there until the mid-1920s. She later painted and made pottery, but her first important contribution to Byrdcliffe was in fur-niture design. A chiffonier with chestnut relief (c. 1905) is typical, a pleasing union of art and craft. It features a large panel of conventionalized chestnut leaves, carved in shallow relief and stained in oranges and browns. The chest functions like a big picture frame for the carving, while the carving is an ornament for the chest. It is not known who actually executed the carving, but it is re-corded that Jane Whitehead stained the case green on January 2, 1905.

Unfortunately, the furniture-making business failed after only two years. Carving and painting were expen-sive: Byrdcliffe pieces cost two or three times as much as comparable Mission-style furniture, Whitehead refused to advertise, and shipping from the remote site was a problem. Most of the shop's products were never sold. They remained in Whitehead's house for many years. Fewer than fifty are known to have survived.

Quite a bit of weaving was done at Byrdcliffe, some by Ralph and Jane Whitehead themselves. Marie Little, like Steele a Pratt graduate, was the resident weaver. She dyed her yarns with local bark and berries, and her palette of natural colors was much admired. Her rag rugs were popular as well. Metalwork was produced at Byrdcliffe, too, but considering the size of the shop, the output was not extraordinary.

Whitehead's dictatorial tendencies alienated most of his collaborators, and he soon tired of supporting his little utopia. The summer school and artist residencies were scaled back. Jane and Ralph experimented with various craft mediums, producing some fine pottery in the 1920s. But the community lost its spark. When Ashbee visited in 1915, he commented: "The landscape is lovely, the conception superb, the craftsmen's houses

FIGURE 2.39. *Zulma DeLacey Steele-Parker, panel designer, Byrdcliffe Colony, Cabinet, ca. 1904. Poplar, copper hardware (original); 27.25 × 38.75 × 14.62 in. (Milwaukee Art Museum, Layton Art Collection, L1993.5.1. Photograph by Efraim Lev-er.)*

with delightful workshops—finely placed. . . . The shell of a great life is here and all empty except for two or three lonely spinsters."[71]

There were other crafts communities, mostly on the East Coast. The Reverend Edward Pressey founded **New Clairvaux** in Montague, Massachusetts, after a visit to the Roycrofters in 1901. Residents raised livestock, grew food, and did woodworking, basketry, and weaving. Pres-sey also published *Time and Tide: A Magazine for a More Profitable Country Life* and operated a small craft school. The colony disbanded after six years. Closer to Boston, maverick Unitarian minister George Emery Littlefield set up a cooperative landowning scheme in Westwood in 1907. He called it **Fellowship Farms**. Like Pressey, Little-field published a magazine (*Ariel*) and operated a craft studio. He never attracted enough homeowners, though, and the co-op was dissolved in 1918. And in 1913, two Danish-born Americans founded the **Elverhöj Colony** in Milton-on-Hudson, New York. They operated a shop and a school but had only eight permanent members. Courses were offered in jewelry, metalwork, weaving, printing, and painting. The Elverhöj Colony is remem-bered mostly for its gold and silver jewelry, set with semi-precious stones.

The communities were dependent on leaders whose romantic idealism was rarely matched by business sense. However, each can be regarded as an attempt to make Morris's *News from Nowhere* come true. The furniture,

pottery, and jewelry left behind testify to a moment when a few Americans passionately believed that well-made objects could produce a well-made life.

Craft Education

The Arts and Crafts movement in the United States was intimately tied to educational reform. Among the impulses for change were Ruskin's ideas that good education consists of training both mind and body, and that craft is an excellent form of discipline. Another impulse was more pragmatic, to provide the skills future workers would need to get good jobs in manufacturing. Both of these reform ideas became vehicles for the popularization and dissemination of the craft movement itself.

In the nineteenth century, the apprenticeship system was breaking down, and factory owners set employees directly to work instead of offering them extensive training. The unfortunate result was that skilled laborers were not being trained in sufficient numbers to meet demand, nor were designers. Immigrants often had the requisite skills, but industrialists began to feel that America should be training its own within the public education system.

Public education in the late nineteenth century was primitive at best. Free education was available to most children, but the majority stayed in school only until they were eleven or twelve. Then they went to work. Primary education consisted of little more than learning how to read, write, and do sums. Learning took the form of rote memorization. Corporal punishment was commonplace. Only the children of the wealthy went on to college, where they generally followed the English model of higher education: study of classical literature in Greek and Latin, the Bible, and possibly a little mathematics and science. As Ralph Waldo Emerson wrote in 1844: "We are students of words; we are shut up in schools and colleges and recitation rooms for ten or fifteen years, and come out at last with a bag of wind, a memory of words, and do not know a thing. We can not use our hands or our legs or our eyes or our arms."[72]

Liberal arts colleges competed with two new types of education. In response to a demand for engineers, polytechnic schools concentrated on mathematics, sciences, and engineering. In addition, normal schools were founded to train teachers for the public education system. In the 1870s, two reform movements emerged. One led to the manual-training movement, the other to establishment of America's first art schools. Education in the crafts was woven from these two strands.

THE MANUAL-TRAINING MOVEMENT

The manual-training movement focused on primary and secondary education. Now called vocational education, it was tied to teaching children a trade. The first American trade school was set up at Robert Owen's model factory town of New Harmony, Indiana, around 1825. But manual training offered a new variation: lectures and recitation were augmented by physical, hands-on work. In its day, this was a revolutionary idea.

Its leading exponent was Calvin M. Woodward (1837–1914), a math professor at Washington University in Saint Louis who was a critic of the old methods. In 1872 he began conducting experiments, and in 1880 he opened the Saint Louis Manual Training School. It was a new school in a new building, open to boys fourteen or older for a three-year course. In addition to mathematics, English (or Latin), history, basic science, and mechanical drawing, students went through a carefully planned sequence of hands-on exercises. The teacher demonstrated the process, and students followed step by step. Each exercise was more complex than the last, and over the school year every student would learn the basics of a craft. Carpentry was taught in the first year, blacksmithing and metal casting in the second, and machining in the third. Always, the goal was to make an exact reproduction of the teacher's example.

Woodward insisted that manual training had larger goals than just preparation for a trade. He claimed that it would also inculcate sound morals and advance the cause of American democracy. He insisted that no other system of education could

> teach us how to educate, construct, and adorn an American citizen. The world's work must be done. Let it be done intelligently and well. No narrow, selfish aim, no prejudice of caste, no false claim of high culture, must mislead our pupils. Give them a generous, symmetrical training; open wide the avenues to success, to usefulness, to happiness, to power; and this age of scientific progress and material wealth shall be also an age of high intellectual and social progress.[73]

He equated good work with self-discipline and bad work with dishonesty and slovenliness. Boys learned to avoid bad habits, and frivolity was discouraged. No "whistling nor playing nor idling" was permitted.

The manual-training movement enjoyed wide support. Taxpayers liked the idea of generalized programs producing adaptable students. Such flexibility was seen as appropriate to a democracy, because a citizen's occupation should not be preordained by his social class or

his father's trade. Businessmen liked the idea of preparing youths for factory jobs so that workers would require less on-the-job training. And those worried about maintaining social order hoped that students would become compliant and self-disciplined citizens. Manual training became the single most successful educational reform in America around the turn of the century. By the 1930s, it was instituted in every state and was a fixture of high-school education.

In an effort to invent a parallel program for girls, educators set up home-economics courses. While some early instances (such as the Toledo Manual Training School) offered girls carpentry and woodworking courses, most home-ec study concentrated on subjects like cooking, sewing, and caring for the sick.

One consequence of the manual-training movement was an increasing demand for public-school teachers trained in the crafts. Since teachers worked from September to June, summer schools started offering craft instruction. Another result was tens of thousands of former wood-shop students turning to woodworking as a hobby, decades later. Craft moved from the trades to a wider and more diffuse role in American culture.

CRAFT IN HIGHER EDUCATION

At the turn of the century, American art academies were few in number. Ambitious artists went to Europe to work in the studio of an established painter or in one of the famous schools, like the Académie Julian. An academic art education involved drawing from plaster casts of Greek and Roman sculpture, then drawing from still life, then from nude models. (Women were usually excluded from such life-drawing sessions to protect their sensitivities.) Finally, students learned painting. As for advanced training in design, it didn't exist in the United States until the late 1870s.

Events in Massachusetts provide a case study in the birth of craft education at the college level. By the mid-nineteenth century, eastern Massachusetts was a major center of textile manufacturing. The best designers were foreign born and foreign educated, mostly from the British Isles, where a state system of design education had been set up in the 1850s. Not wanting to fall behind the British, leading companies and politicians agreed in 1869 that high-school students should be taught mechanical drawing. The Massachusetts Drawing Act of 1870 mandated free instruction in mechanical drawing to public school students over the age of fifteen in all towns with a population over 10,000. It was the first state-mandated art education program in the country.

PLATE 19.
NATURE SYMBOLS.

FIGURE 2.40. Ernest A. Batchelder, "Nature Symbols," in Ernest A. Batchelder, Design in Theory and Practice (New York: Macmillan Company, 1925), plate 19, facing p. 117.

Walter Smith (1836–1886), an Englishman, was brought to Boston to run the new program. He had been schooled in the South Kensington system of design education, which concentrated on abstractions taken from nature. Smith set up a program of formulaic exercises (mostly consisting of copying) and drawing from memory. Advanced work included the study of historical ornament and conventionalization of natural motifs. (Figure 2.40) There was no drawing from nature and no working directly with materials like clay or wood. The system was rigid, but it was easy for an inexperienced instructor to teach. Like most Victorians, Smith assumed that a designer was someone who drew and that a design could apply to any type of object, from wallpaper to inkstands. The particularities of material and technique were left to skilled laborers.

The Drawing Act immediately created a demand for art teachers. The state opened the Massachusetts Normal School in 1873 to train those teachers, with Smith

in charge. (The term came from the medieval *normal*, a tool used to strike a right angle.) Again Smith instituted a curriculum based on the South Kensington system. The new teachers fanned out across the country, disseminating the system.

Smith emphasized job training, but others saw instruction in drawing as a vehicle for the improvement of public taste. In an 1886 U.S. Commissioner of Art report, Isaac Edwards Clarke noted that the 1876 Centennial "taught the people of this country how beauty enriches all the appliances of life; the study of drawing in the common schools will teach . . . children how things are to be made beautiful and . . . thousands upon thousands of home missionaries of the beautiful, will create everywhere such a demand for the element of art in all manufactures."[74] Clarke's view is almost Ruskinian, placing tremendous faith in beauty as a beneficial force. This theory has been called "moral environmentalism," and it had broad support in Victorian America. Often, moral environmentalism was pitted against the vocational orientation of Walter Smith, as if art education were a contest between beauty and commerce. In Massachusetts, beauty won: Smith was dismissed from both his positions in 1881.

The reforms instituted there took on greater urgency in 1876. The Centennial Exposition in Philadelphia showed that American goods were poorly designed when compared with the international competition, and Americans responded by establishing museums and art schools. Many of the museums founded in the 1870s were intended specifically to be repositories of well-designed objects for study. At the same time, college-level design schools were opened to give advanced training for industry. Among the new industrially oriented institutions were the Philadelphia Museum and School of Industrial Art; the School of the Museum of Fine Arts, Boston (known as the Museum School); and the Rhode Island School of Design. All three opened in 1877.

The development of the Boston Museum School is typical. At first it offered classes in drawing and painting. In 1879 a stained-glass designer was hired to teach principles of decorative design. Instruction in wood carving began the same year. Students received technical information on pottery, stained glass, textiles, and printing. The school began offering hands-on studio instruction in metalwork and silversmithing in 1906 and enameling in 1910.

Following the same pattern, art schools all across the country started teaching crafts—a momentous development, with many long-term consequences. Placing craft courses in an academic setting had unforeseen side effects. The men and women who taught these courses were able to earn a comfortable living outside the boundaries of commerce. As teachers, they weren't subject to the demands of factory production or the marketplace.

Industrialists probably didn't anticipate the large numbers of women who gravitated to the art schools, either. For many years about 80 percent of the students at the Boston Museum School were women. At the Massachusetts Normal School, about 65 percent were. For working-class women, teaching was one of the few professions available. Both art school and the teaching profession were good places for a woman to spend time before she married and had children. After marriage, too, art was a suitable pastime, and because relatively little money changed hands, a woman could remain unstained by commerce. There were exceptions, of course, but art schools, along with the crafts that were taught there, became less directed toward the utilitarian ends imagined by their founders.

ARTHUR WESLEY DOW AND DENMAN ROSS

Craft education continued to evolve, oscillating between two poles. One was the South Kensington system's orientation toward drawing and job training; the other aimed to create beauty through direct making. Arthur Wesley Dow (1857–1922) was the exponent of direct experience. (Figure 2.41) Dow is best remembered for his book *Composition: A Series of Exercises in Art Structure for the Use of Students and Teachers*, published in 1899. *Composition* taught its readers how to arrive at beautiful designs through the application of a few general principles. Like such textbooks ever since, Dow's treated composition as a type of drawing, strictly two-dimensional (three-dimensional work was reduced to "modeling" from drawings), to be learned through a series of pen-and-ink exercises.

Before he started teaching and writing, Dow took up woodblock printing. Traditionally, Japanese artists made only the initial drawings, leaving the carving and printing to others. But Dow cut the blocks and did the printing himself, feeling that both tasks were crucial parts of the creative process. When he opened his Ipswich Summer School of Art in 1891, he approached painting, printmaking, and the crafts in the same spirit. In true Arts and Crafts fashion, students harvested local reeds and rushes to make baskets and dug local clay to make pots. Instead of being told what they could do with their mediums, they found out for themselves. For sixteen years the Ipswich School was a tremendous success and in-

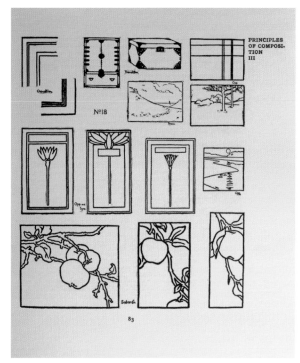

FIGURE 2.41. *Arthur W. Dow*, Composition: A Series of Exercises in Art Structure for the Use of Students and Teachers, *13th ed., with a new introduction by Joseph Mascheck (Berkeley: University of California Press, 1997), 83.*

fluenced craft education nationwide.[75] Dow encouraged his readers to experiment, "make many variations," and "originate new line-schemes." This was a radical departure from Smith's South Kensington system and Woodward's manual-training program.

Denman Ross (1853–1935), a lecturer on design at the Harvard Architecture School, objected to the fusty Beaux-Arts tradition of learning design by laboriously rendering historical ornament. While architects schooled at Harvard had an encyclopedic knowledge of ornament, Ross felt they had little understanding of design principles. His book *A Theory of Pure Design: Harmony, Balance, Rhythm* (1907) placed little emphasis on hands-on experience, and his followers sometimes scrapped studio craft courses.

Who won the dispute between the practice-based Dow and the theory-based Ross? In the end, it was Dow. He taught for years at Teachers College, Columbia University, and his students implanted his ideas in public schools and colleges nationwide. His emphasis on hands-on education was enlarged upon by the philosopher-educator John Dewey (1859–1952). Dewey sought an integrated form of education in which all learning was accomplished through experience: learning by doing. He emphasized the connection between these experiences and the ordinary life of both the individual and the community, which would ultimately render students more adaptable. Dewey later developed an aesthetic theory similarly based on the individual's experience (*Art as Experience*, 1934).[76]

For those who could not afford the time or expense of a formal education, a variety of sources of information were available. It could be said that the Arts and Crafts movement invented "do-it-yourself." While rural Americans had been doing it themselves for generations, many men and women among the growing middle class no longer knew how to work with their hands. China painting, wood carving, jewelry making, and pottery were new leisure-time activities. This audience found technical instruction in magazines like the *Craftsman* or *Keramic Studio*. For inspiration, they could turn to magazines like *House Beautiful* and Edward Bok's *Ladies' Home Journal*, both of which featured interior decoration in the Arts and Crafts style.

NEW SCHOOLS

The establishment of Arts and Crafts schools first happened by accident. A furniture maker named Frederick Meyer mentioned the idea of a practical craft school at a meeting of the San Francisco Arts and Crafts Society in 1906, shortly after an earthquake had destroyed the city. When a reporter for the *San Francisco Call* wrote about the idea, potential students responded enthusiastically. The next summer, Meyer started the California Guild of Arts and Crafts with $45, three rooms, and three teachers. (One of them was Isabelle Percy West, a former student of Dow's at Columbia.) Some forty-three students attended the first classes, and it grew from there. In 1936 it changed its name to the California College of Arts and Crafts.

The Oregon College of Art and Craft started with more of a plan. Julia Hoffman did weaving, metalwork, painting, and photography and acted as a patron of the arts. In Boston she was involved in the SACB, and upon moving back to Portland, she founded an Arts and Crafts Society in 1907. It conducted classes, some of them in members' homes. Unlike most of the Arts and Crafts societies, Hoffman's prospered. By 1934 the school moved to a building in downtown Portland. It now occupies a campus in a former filbert grove west of downtown.

The schools that emphasized hands-on instruction in the crafts, the manual training programs in public schools, and the Arts and Crafts societies formed a solid institutional foundation for the existence of studio crafts in America. If the Arts and Crafts movement had been nothing more than a design style, like art nouveau, it

probably would have withered and died. Styles become unfashionable; people lose interest. That was precisely the fate of the Arts and Crafts look. But style and movement had diverged. The movement was dedicated to ideals: to beautifying the home, to encouraging people to make their own art, to educating children in ways that engaged both body and mind. This grounding in idealism justified the institutions that sprang up in the early 1900s, and it was institutions that helped studio crafts survive the thin years ahead.

In Short

In the first decade of the twentieth century, ideas and ideals were established that supported craft for the next forty years. While work in each medium developed along its own lines—conventionalized decorations and mat glazes in ceramics; nonprecious metal and stones in jewelry—in general the Arts and Crafts propounded simplicity, revealed materials, and avoidance of ostentation. Mercantile ventures such as Craftsman Workshops, Roycroft, and Teco made craft objects affordable and allowed them to penetrate deep into the American middle class. At the same time, Arts and Crafts societies set up exhibitions of handwork by members, including many European-trained immigrants, a few gifted amateurs, and a variety of individuals who saw the opportunity for directness and new ideas under personal control in a small shop or solo operation.

The Arts and Crafts movement also attracted its share of idealists, for whom Morris's vision of joyful handwork in a rural community was immensely attractive. Most American versions, such as Rose Valley and Byrdcliffe, proved to be short-lived for financial reasons, but the alignment of craft practice, grassroots socialism, and rural retreat was to prove long lasting. The philosophy of the Arts and Crafts movement centered on reform, beginning (as in England) with education and commerce. Art schools, museums, and the manual-training movement all had the same goal, to improve American business prospects by improving design. The manual-training movement—craft teaching in high schools—inculcated thousands of students with craft skills that they would later turn to as hobbies.

CHAPTER 3 1910-1919

UPHEAVALS

Setbacks

The second decade of the century was dominated by the Great War. Even though the United States did not enter the war until 1917, the international conflict affected trade and the availability of materials and led to immigration quotas. At the same time, thousands of Americans who shipped overseas for war service returned with a worldly sophistication previously known only by the rich.

The first years of the decade saw the ascendancy of progressive politics. The labor movement finally won some important victories in mill and mining strikes, and public opinion turned to the unions' side. New laws created a fifty-four-hour workweek for women and children, set new safety codes, and established workers' compensation. The decade ended with repression and social conflict in 1919, the year of the great Red Scare.

Revivals

In craft and in design, the reformist zeal that characterized the first decade of the century dissipated. Mission furniture became just a style, marketed by huge retailers like Sears, Roebuck & Co. Writers satirized the whole Arts and Crafts enterprise as being too narrowly focused on "fumed oak, colored burlap, and beaten copper."[1] As Arts and Crafts went out of style, colonial revival replaced it.

This seems a step backward, since for more than fifty years, intellectuals had disparaged historicism. As the Arts and Crafts movement matured, designers had moved to a new stripped-down style independent of the Gothic that Ruskin and Morris favored. Modernist thinkers went one step further, calling for a design language that would dispense with references to the past: the style of the new century should be generated by modern technologies, modern materials, and a modern sensibility. They regarded historicism as evidence of bad taste and intellectual weakness. And yet stylistic revivals continued in the twentieth century. Some reflected an elitist will to impose values on minorities, others were acts of resistance, and some involved new emphasis on uninterrupted folk traditions. Several play an important part in the history of craft.

The colonial revival was the most prominent. It started

in the nineteenth century and continues today. Every colonial-style house with clapboard siding and shutters and every faux-Chippendale chair reminds us of the astonishing durability of the colonial revival. For millions of Americans, the style presents an unshakable image of domesticity, continuity, and security.

The beginnings of the colonial revival are diffuse but can be dated roughly to the 1850s. It started with the preservation of George Washington's headquarters in Newburgh, New York, and later Mount Vernon. In 1876 it entered the middle-class mainstream when an exhibit at the Philadelphia Centennial Exposition including a log cabin with a colonial kitchen, John Alden's desk, and a spinning wheel proved unexpectedly popular.

The burgeoning fascination with the colonial era resulted in the preservation of more old houses, installation of period rooms in museums, and a flurry of genre paintings with colonial themes. A fashion for colonial antiques suggested that Americans could and should look to the period for artistic guidance.[2] Furniture especially was considered to exhibit the familiar virtues of exposed construction, local materials, and honest craftsmanship. Moralists could connect examples from the Northeast colonies to the unyielding probity of the Puritans. And, of course, a truly American style could be enlisted in the flag-waving nationalism of the period, heightened by the Spanish-American War of 1898.

There was a hidden agenda to the colonial revival. Many spoke of the colonial era as representing "our" past, with the full knowledge that the implied "we" was almost exclusively white, Anglo-Saxon, and Protestant. Excluded were all the populations that made the power elite nervous: Irish and Italian Catholics, Eastern European immigrants, Hispanic Americans, African Americans, and Native Americans. The colonial revival, intentionally or not, supported Anglo-Americans' sense of superior status and class.

For some, the colonial aesthetic was a teaching tool for new immigrant populations, inculcating them with democratic American values. The approach was institutionalized in the next decade. R. T. H. Halsey wrote of the American Wing of the Metropolitan Museum (1924), of which he was the first curator, that the study of antiques housed in the museum would be "invaluable in the Americanization of many of our people,"[3] and Henry Ford founded Greenfield Village, near Detroit (1929), on the belief that both rural life and modern technology could teach visitors the value of hard work and personal responsibility.

The nativist impulse also supported Americans reaching out to groups deep in the Appalachian Mountains

1910
 Cost of first-class stamp: 2¢
 Average hourly wage: 18.8¢
1911
 Roald Amundsen reaches South Pole
 Triangle factory fire in New York kills 146 workers, many of whom are trapped by locked exit doors and inadequate fire escapes
1912
 Edgar Rice Burroughs publishes *Tarzan of the Apes*
 RMS *Titanic* strikes iceberg and sinks
1913
 The Armory Show opens in New York; Marcel Duchamp's *Nude Descending a Staircase* creates an uproar
1914–18
 World War I
1914
 United States sends troops into Mexico
1915
 D. W. Griffith releases *Birth of a Nation*
 Albert Einstein publishes his General Theory of Relativity
1916
 Margaret Sanger opens her first birth control clinic
 Dada begins in Zurich with opening of Cabaret Voltaire
 Norman Rockwell does his first cover illustration for the *Saturday Evening Post*
1917
 United States enters World War I
 Bolshevik revolution in Russia
 First commercial jazz recording
 Duchamp enters an inverted urinal, titled *Fountain*, in the Society of Independent Artists show, and it becomes one of the most notorious 20th-century artworks
1918
 Worldwide influenza epidemic
1919
 The Bauhaus founded in Weimar, Germany

beginning at the turn of the century, based on the fact that they were from the same English and Scottish stock. This subtle racism underlies many of the rural settlement projects. However, other privileged whites worked with Hispanics in New Mexico, aiding craft traditions that were still active. Still others helped shepherd a revival—or reinvention—of Native American crafts in the Southwest. Little attention was given to African American folk practices, which included a long tradition of quilt making and reviving African precedents in both pottery and basketmaking.

The Armory Show

In the fine arts, modernism arrived in America with a bang. Big Bill Haywood, the labor leader of the Paterson Strike of 1913, wrote in his autobiography, "Much of the expression of those explosive days was the same, whether in art, literature, labor expansion, or sexual experience, a moving and shaking time."[4] The explosive moment for American art occurred in the same year, the monthlong display of New York's Armory Show, officially the "International Exhibition of Modern Art." It was not the first exhibition of the modern style in the United States—the Newark Museum had shown such work the year before—but with huge crowds and extensive press coverage, the Armory Show caught everyone's attention.

Within the Sixty-ninth Regiment Armory, organizers set up eighteen octagonal rooms with high walls covered with fireproofed burlap and festooned with greenery, all under a dome of yellow streamers. Some 1,300 works of European and American art by about 300 artists provided a lineage from Goya to the cubists and presented the most up-to-date American painting and sculpture as well. The international, or non-American, aspect of the show was overwhelmingly French.

The exhibition was met with both horror and amusement by the public and press (even Theodore Roosevelt wrote an article about it), but the effect on the art world was immediate and permanent. This show had been organized not by a museum or another institution, but by artists. The twenty-five members of the new Association of American Painters and Sculptors (AAPS) were seeking to undercut the power of the conservative American Academy of Design by showing their art and that of their colleagues, which had been rejected by officialdom as too radical. They were quite successful: the Armory Show created a market for contemporary art almost overnight, and after this watershed, the younger generation no longer pursued academy recognition. By 1915 a show

of modern design could be—and was—presented without ridicule.

Some 4,000 guests attended the opening evening on February 17, and perhaps 75,000 had attended by the closing on March 15. The show traveled in reduced form to Chicago, where, due to all the advance notoriety, it drew an even larger crowd, numbering 200,000. It petered out in Boston with a still smaller presentation that Bostonians met with reserve.

At the time, the American artists who were considered advanced portrayed ordinary subjects in a vigorous style and were criticized for that impropriety. The introduction of more radical work by Europeans was planned from the beginning but was expanded when two AAPS members, painters Walt Kuhn and Arthur B. Davies, saw cutting-edge art in Cologne and London. When they returned to the United States, they announced to the press that their exhibition would include the most revolutionary art of Europe, then little known here.

The artist-organizers handled all the administrative details themselves and gave up a year of their art-making time to make the show happen. Marcel Duchamp's *Nude Descending a Staircase* was the favorite butt of the joke makers, famously described as "an explosion in a shingle factory," and Constantin Brancusi's *Mlle Pogany* was also ridiculed. Yet Paul Cézanne, Vincent van Gogh, and Paul Gauguin were recognized as important artists, and Odilon Redon seemed to be everyone's favorite discovery. About $45,000 was realized from the sale of approximately 250 works (including about 100 prints), of which about 200 were foreign and about 50 American. Milton W. Brown, a scholar of the Armory Show, observed: "Especially surprising was the fact that almost all the most advanced works, including those of the Cubists, were sold out. Redon was the best seller with 13 paintings and pastels and more than 20 prints. Both Marcel Duchamp and his brother, Jacques Villon, sold everything they had at the exhibition."[5]

According to Brown, the domestic invitation encouraged submission of nontraditional art such as "original designs in needlework of art value," and some decorative art was included.[6] If so, the identification of that work has been lost in the glare of the modernist paintings. However, one painter later to work extensively in textiles is known to have participated: Marguerite Zorach. Her husband, William, noted in his memoir that her work was among the few American pieces written up by critics. He recalled the scene: "The crowds piled in and out day after day—some hilarious—some furious—none indifferent. There was never anything like it—so completely a surprise—so completely devastating to the complaisant American."[7]

Ceramics Interrupted

This decade in ceramics was one of shifting currents and interruptions. High points were the recognition of Adelaide Robineau's work in Europe and America—reflecting the growth of studio pottery—and the brief efflorescence of University City. The Spanish-style architecture of the Panama-California Exposition in San Diego, 1915–16, sparked a major trend toward bright Hispano-Moresque tiles in California.

The war in Europe administered another blow to the declining china-painting profession by slowing the importation of French blanks and entirely stopping the importation of German ones. After the war, the china-painting industry was more concentrated than before, and art pottery in general also paled. There were a few benefits. The wartime interruption of trade with Europe promoted American dinnerware manufacturing when President Wilson ordered a 1,700-piece set of White House china from the young Trenton firm of Lenox China. Small potteries, although often short-lived, increasingly focused on individual work.

OVERBECK POTTERY

The Overbeck Pottery—"altogether a woman's enterprise both in its origin and operation"[8]—achieved a national reputation despite its obscure location in a Cambridge City, Indiana, residence and despite the pots being sold only from that house and a single Indianapolis department store. (Figure 3.1) The Overbecks were a family of achievers: six sisters and their younger brother. Four of the sisters were involved in ceramics; another, a photographer, was the only one who married, and the sixth was a linguist and musician who ultimately aided the family work by serving as housekeeper for her potter sisters. The workshop was in the basement of the family home, a studio was on the first floor, and a Revelation kiln was in a small separate building in the backyard.

The eldest, Margaret Overbeck (1863–1911), taught drawing at DePauw University, was a decorator at Zanesville Art Pottery, and was a china painter of sufficient skill that *Keramic Studio* devoted almost an entire issue to her in March 1907. She had studied at the Cincinnati Art Academy and with Arthur Wesley Dow at Columbia, as did her sister Mary Frances (1878–1955). Hannah (1870–1931) and Elizabeth (1875–1936) also studied art, and crucially, Elizabeth spent a year at Alfred University, learning ceramic techniques from Charles Binns. It was Margaret's idea to establish the pottery. She was forty-eight, and Mary, the youngest, was thirty-three at the time. The standards for their pottery—handcrafting,

FIGURE 3.1. *Overbeck Pottery, Vase, 1915. Earthenware; 18 × 8 in. (Overbeck Museum, Cambridge City Public Library, Cambridge City, Ind.)*

experimentation, and originality (no duplication)—were set at the beginning.

Margaret died from injuries suffered in an automobile accident in 1911, the year the pottery was founded, but the others went ahead with it. They produced decorative vases and sets of undecorated slip-cast dinnerware so simplified that they must be called proto-modernist, and some casual figurines—both portraits and fanciful characters. Only in the figurines, and in some designs for children's dishes, was there humor in the Overbeck work, but there was no shortage of graceful composition, sturdy forms, and surprising color tones.

Hannah, an invalid for much of her life, was the chief designer; many of her drawings were published in *Keramic Studio*. Her decorations for all the pots were worked out in drawings that were closely followed. Mary eventually was the decorator. Only Elizabeth could throw (the others sometimes made work by coiling, and cups and saucers were cast); Elizabeth also experimented with clay bodies and glazes, working in both earthenware and stoneware.

The decoration, most often glaze inlay and carving, was fitted to the pot. It started with conventionalized flowers in the Arts and Crafts style, but the sisters also produced scenes that included figures, and these were given a similar degree of stylization that evolved seamlessly into deco-style angularity later on. Early works favored mat glazes with flowing incised designs of plants in subdued shades achieved with colored slips. It might be the sgraffito that helped them escape the naturalistic conventions of china-painting style, yet their colors were not natural either.

In several works, overall patterns consist of flat, squarish or linear figures and shapes. Overbeck pots shown at the Panama-Pacific Exposition in 1915 included an eighteen-inch-high earthenware vase of intertwined collaboration: it was a simple shape designed by Mary, thrown by Elizabeth, and decorated by Mary with a complex nasturtium motif composed by Hannah. The colors are all slightly unexpected and difficult to characterize, including a taffy background and grayed teal foliage around squared-off tan-lavender flowers that stand as erect as soldiers. Other works offer scenes of birds, animals, and sometimes highly stylized trees in which a circle indicates foliage. In a rendering of girls in a park with balloons from around 1916, movement is continuous around the form. The pattern is incised, the relief figures and trees in gentle shades of mauve and pale gray-green.

Although Overbeck work continued to emphasize abstract patterning over the years, there is an almost staccato rhythm to the geometric designs on some later pieces; the colors are bright and the glazes glossy. Dating from the late 1920s or early 1930s (Overbeck pots were neither numbered nor dated) is a cast tea service designed by Mary. Black angular handles stand out against a warm gray body decorated with soft-colored deco diamonds, concentric circles, and squared-off spirals. It is a daring flash of abstraction, stable from a distance and disorienting up close. Hannah died in 1931, and after Elizabeth's death in 1936, the range of production was largely limited to Mary's hand-built figurines. She kept the pottery going until her death in 1955.

UNIVERSITY CITY

People's University was a Saint Louis businessman's novel promotional scheme, educational project, and high-end ceramic residency program. While short-lived, it was dazzling for a moment and had long-lasting effects on its leading participants.

When Edward Gardner Lewis, owner of the *Saint Louis Star*, discovered that magazine publishers would pay a 50 percent commission for subscriptions, he set up the American Women's League as a sales force of thousands of women, mostly in rural areas. The reward that enticed these isolated women was a free education in the arts. The program operated primarily by correspondence, but the best students were invited to a campus Lewis built at "University City" in Saint Louis.

In January 1909, Lewis announced a plan for an art academy and pottery on a square mile of land adjacent to Forest Park. Among the structures were an octagonal domed administration tower, an Egyptian-style subscription building, and an Italian-style art academy. There were plans for academies of music and science. The pottery concentrated on porcelain because of the material's prestige; coincidentally, workmen digging construction trenches discovered a vein of kaolin, an essential ingredient in porcelain.

Lewis wanted a showy ceramic school and the most celebrated potters. Taxile Doat, a famous potter at the Sèvres Manufactory in France and author of *Grand Feu Ceramics*, was paid $10,000 a year plus expenses for himself and two assistants. Adelaide and Samuel Robineau were also paid $10,000. She was undoubtedly the most influential woman ceramist in America and, as editor of *Keramic Studio*, was in a position to promote Lewis's programs. Moreover, "In Robineau he found the key elements to sell his League—a woman who had control of a material traditionally associated with men (porcelain) and whose accomplishments came by correspondence."[9] Doat and the Robineaus had no teaching responsibilities but were expected to open their studios to visitors.

Frederick Hürten Rhead, an English ceramic designer then working in an Ohio art pottery, was hired as instructor and technician. Rhead wrote a textbook, planned correspondence courses, and prepared the facilities. China painting became part of the program because it was still popular and had long been taught by correspondence. Lewis hired Kathryn Cherry, a Saint Louis–based artist who had won the gold medal for china painting at the Saint Louis world's fair of 1904 and had also published designs in *Keramic Studio*, developed a line of china paints, and taught regularly at the Alfred University summer school. There were more than 300 correspondence pupils for china painting, and 20 or 30 in residence at University City. The ceramics department was much smaller, with about 30 correspondence students and 10 on campus.

The ceramics facilities were in a Beaux-Arts–style structure of fireproof concrete and brick with studios for each of the artists, two high-fire kilns for Doat and Robineau, and another for low-temperature pottery, along

with classrooms, a lecture hall, and a "museum room." The reported cost of the building was $157,000.

By the end of People's University's first year, some officials were concerned by the enormous expenses. Lewis, who claimed that his subscription scheme was earning around $40,000 a day, was not. Yet the school soon succumbed to financial problems after Lewis was charged with mail fraud (as a result of establishing the first postal bank) and declared bankruptcy. Doat's two French assistants left before the first year was finished. The Robineaus and Rhead left in the spring of 1911, and Cherry followed soon after. From early 1912 until late 1914, pottery was produced under the name University City Porcelain Works. During this nearly three-year period, Doat oversaw production with a small crew of assistants. A plan to move the operation to California was not realized. Doat returned to France as World War I began.

Rhead later wrote of University City's early days: "The working atmosphere during this period was pretty much what one would find at Sèvres or any one of the European national factories. Time was no object. The various craftsmen proceeded leisurely to work out their respective decorative programs . . . where large and imposing exhibition vases must be made in order to properly establish reputation and prestige."[10] The disadvantage was that they were always on view: "Even conventions were invited bodily to come and stare at the 'famous ceramists.' On one occasion, the entire organization including Doat and the Robineaus were made to stand in line for nearly two hours to shake hands with a visiting aggregation of over seven thousand people," Rhead remembered.[11]

Doat was willing to share information, but his glaze assistant was not and after much argument provided only prepared glazes (not formulas) for the others to try out. That disappointed the experiment-oriented Robineau, who had already worked her way through *Grand Feu Ceramics* and had developed her own palette and process. Rhead wrote, "I am convinced that Doat—at this period—learned more from Mrs. Robineau than she did from him."[12]

All the artists produced significant works in residence. Doat's most impressive was the *University City Vase*, an outsize jar decorated with low-relief ornament and four white *pâte-sur-pâte* plaques on green grounds depicting the buildings of University City. The vase itself is lost, but a twenty-two-inch-high porcelain base has survived. The whole was less notable for its traditional idiom, Rhead observed, than for the conditions under which it was produced and the thousands of dollars expended in its production.[13]

Among Cherry's outstanding china paintings is a vase

FIGURE 3.2. *Adelaide Alsop Robineau*, Scarab Vase (The Apotheosis of the Toiler), *1910–11. Glazed porcelain; 16.62 × 6 in. (Collection of Everson Museum of Art, Syracuse, N.Y., Museum Purchase, 30.4.78A-C.)*

with a naturalistic design of sparrows and irises, which suggests an Asian influence in its asymmetrical composition. Even more striking to the contemporary eye is an atypical vase with only a line drawing of flowers and foliage. Perhaps the plan was to enamel it, but she instead left it austere and elegant.

Robineau was the most productive participant, completing about ninety vases during her stay, with the assistance of her husband, who prepared glazes and fired kilns throughout her career.[14] She followed her usual method of setting challenges for herself. Her *Poppy Vase* supports a design of inlaid colored slips—a technique perfected earlier by Rhead and probably learned from him.[15] It is colored pale yellow and blue with washes of stain and then given a transparent glaze that shows small crystals. She also developed the technique of excising at University City. That, along with her translucent semiopaque glaze, is demonstrated in her *Scarab Vase* (1910–11), also called *The Apotheosis of the Toiler*, which is said to have required more than one thousand hours of carving. (Figure 3.2) She considered it the most important work of her career. Excising requires a controlled hand and a great deal of patience, since the clay must be dry to be stable but is then brittle and easy to chip or break. The Scarab Vase employed the Egyptian scarab as a symbol of cre-

ative powers and also the patience and skill demanded of the craftsman. According to Samuel's memoir, the first firing resulted in bad cracks at the base. Doat said that it would be impossible to repair and that Adelaide should conceal the crack with paste. She said that she would fix it or throw it away. She spent hours filling the crack with ground porcelain and then glazed it with the body glaze. It emerged from the second firing with no cracks perceptible.[16]

In 1911, just after her departure from University City, Robineau's display of fifty-five pieces at the International Exposition of Decorative Art in Turin received a grand prize, the highest award possible. She worked in her Rochester studio and taught at Syracuse University until her death in 1929.

FREDERICK HÜRTEN RHEAD

Frederick Hürten Rhead (1880–1942), the youngest of the ceramic experts at University City, had a long and varied career. Like Binns, he was a product of the English potteries (his father was a Staffordshire art director). He came to America in 1902 to work for the small Vance/Avon Faience pottery in Ohio. In 1903 he entered a peacock design in a *Keramic Studio* contest and received an honorable mention. Between 1909 and 1912, he and, on occasion, his father, wrote a series of "Pottery Classes" for the magazine, covering such techniques as sgraffito and slip-trail ornamentation (which he called "raised line process"), inlaid decoration, and casting. It was this connection with *Keramic Studio* and the Robineaus that resulted in his invitation to University City.

A signed poppy plaque outlined with slip trail and reminiscent of art nouveau was produced while Rhead briefly worked for S. A. Weller Pottery in 1904. The flower blooms in an explosive, almost hallucinatory expansion across nearly half of the round plaque, while an assortment of straight and sinuous bare-stemmed buds populate the remainder. He moved on to Roseville Pottery, where he was art director from 1904 to 1908. He was less an innovator than a skilled adapter of designs from other sources, usually as filtered through British commercial potteries. The signature work of the Della Robbia Pottery at Birkenhead, for example, was sgraffito (cutting a design into a layer of slip so that the color beneath shows through), which Rhead "popularized, if not introduced, into the vocabulary of American art pottery."[17] His Della Robbia–style designs were mold-made works distinguished by extensive hand decoration. He said in 1909 that although he liked all types of clay work, incising and carving were his favorites.

When he received the invitation to University City,

FIGURE 3.3. *Frederick Hürten Rhead*, Vase, ca. 1911. Glazed and incised earthenware; 12.37 × 4.14 in., with 3.87 in. lip. (© Saint Louis Art Museum, Gift of the Norman Family in loving memory of Isaac and Elva Norman, 64:2001.)

Rhead had left Roseville and was helping a former colleague set up a studio pottery and also doing some writing. He wrote a technical paper on mat glazes based on ten years of experimentation. He went on to write a handbook, *Studio Pottery* (1910), used for the University City correspondence courses.

Rhead's designs for his own work are usually centralized, vertical, and orderly. He was inspired by nature and often added a line of verse in slip trail (a Staffordshire tradition). At University City, he almost exclusively used mat glazes with simplified forms and methods, primarily in low-fired earthenware. He was assisted in his work by his first wife, Agnes, and a thrower. Only a few of his University City works are known today, two of them tall, slender earthenware vases incised to represent landscape elements of disparate scale. One shows mushroom caps at the base of sinuous trees that rise against a blue sky in which small, puffy clouds look almost like blossoms on the branches. In the other, blue tree trunks rise from the base to the decorative banding at the rim—it is a single tree repeated, with a nearly horizontal curving branch linking one to the next. (Figure 3.3) Behind this screen are a night blue sky and a repeated spiky-mountain motif

on a low horizon. Nature here is reduced to gracefully repetitive motion.

After the failure of University City, Rhead was hired to direct the new Arequipa Pottery in California (see below), where he remained from 1911 to 1913. He established his own pottery in Santa Barbara in 1914 with the help of Ralph Radcliffe Whitehead of Byrdcliffe and Christoph Tornoe, a carpenter, cabinetmaker, and metalworker on whose land he built. Although formally named Rhead Pottery, the concern was also known as the Pottery of the Camarata ("friends" in Italian), which suggests a link to the Gift Shop of the Craft-Camarata, located in Santa Barbara from 1912 to 1917. There he continued his sgraffito decoration. His designs were freer and looser—maybe it was the California ambience— and he also conducted pottery classes (Jane Whitehead was among his students) and experimented with glazes (achieving a Chinese mirror-black glaze after Herculean effort). Rhead Pottery employed two throwers: an Italian who did a dozen or so large garden pieces per day, and an Englishman who could turn 50 to 100 small works each day.[18] Rhead did almost all the decorating; a few pieces were done by Agnes or by Loiz Whitcomb, who became his second wife.

In December 1916, Rhead began publishing the *Potter*, a monthly magazine encompassing historical, artistic, technical, and practical aspects of pottery. Dr. Edwin AtLee Barber was to be editor of the historical department, but unfortunately his first article was also his last, for he died that fall. Both the *Potter* and Rhead's pottery failed in 1917. Rhead went back to the big commercial firms, joining American Encaustic Tiling Company of Zanesville, Ohio, as a designer and quickly expanding into research. He later became art director for what was then the largest American pottery, the Homer Laughlin China Company, where he remained until his death.

AREQUIPA POTTERY

Arequipa Sanatorium, founded by Dr. Philip King Brown, was located just north of San Francisco in Marin County. Many poor women in San Francisco suffered from tuberculosis, and he conceived of a pottery "as a way for women to earn enough money to pay for their care and avoid the humiliation of charity."[19] In 1911 he hired Frederick Rhead as ceramist and instructor. Rhead was interested in using local resources. He found red clay on the pottery grounds, and he encouraged pottery participants to draw inspiration from the surrounding landscape of wildflowers, madrone, live oak, and manzanita.[20] (Figure 3.4)

Slip-trailing was the usual decorating technique at

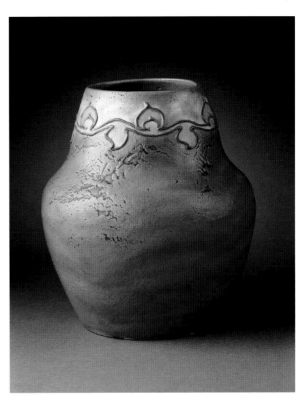

FIGURE 3.4. *Frederick Hürten Rhead, Arequipa Pottery, Vase, ca. 1911–13. Earthenware raised line decoration, meandering leaves; height, 6.12 in.; diameter, 5.75 in. (Los Angeles County Museum of Art, Art Museum Council Fund. Photograph © 2007 Museum Associates/LACMA.)*

Arequipa, probably because its execution doesn't require much technical or artistic sophistication. The most common design under Rhead's tenure featured a simple band of stylized ivy leaves trailed on the neck or shoulder of the vessel. It resembles English textile designs by Voysey or appliqué work seen on Arts and Crafts textiles in the *Craftsman*.[21] Arequipa pots recall the products of Grueby, Newcomb, Marblehead, and others, and they sold well enough that the pottery was self-supporting within a year.

Unfortunately, Rhead's expectations and those of the Arequipa administrators diverged. He hoped to build an industry, but that conflicted with Arequipa's central purpose. When he tried to expand production with professional assistants, he was asked to resign in 1913. Arequipa's strongest work was produced during his tenure.

Rhead was followed by Albert Solon, yet another son of the potteries of England, who expanded Arequipa's output. He wrote in the third annual report of the sanatorium: "We have been able to employ more than twice the number of girls employed before, and market our wares in the best known art stores in the East."[22] Arequipa took a booth at the Panama-Pacific Exposition in 1915 in the

Palace of Education and Social Economy. There was a model of the sanatorium and pottery, and women who had worked there demonstrated processes. Orders and inquiries came from all over the United States following this exposure. But Solon didn't stay long at Arequipa either. After teaching for a short time in the California state university system, he became a manufacturer of decorative wall and floor tile.

The third director of the pottery was Fred H. Wilde, yet another Englishman, who came to the United States in 1885 and worked for art tile companies in New York, New Jersey, Pennsylvania, and finally California. Wilde was sixty when he took over in September 1916. Not surprisingly, tiles became the major focus. A large order came from Mrs. William H. Bliss, a Saint Louis heiress living near Santa Barbara, who wanted floor tiles for her sixty-five-room mansion and gave Wilde some Spanish tiles to copy. In marketing, the fact that Arequipa tiles were products of California had appeal, since it reduced cost and lead time for shipping. Wilde introduced a line of dazzling glazes into tile production, and his Spanish-style tiles were successful.

Although Arequipa, unlike Marblehead, found patients able to do the work, rapid turnover was a problem. Patients worked in the pottery only four to five months, on average,[23] so the best decorators were always leaving, and there was a constant need to train new workers. However, it was wartime economic upheaval that led to the closing of the pottery in 1918.

ERNEST BATCHELDER

Ernest Batchelder (1875–1957) was a teacher, writer, and Arts and Crafts tile maker. Born in New Hampshire, he was educated at the Massachusetts Normal Art School, where in 1899 he earned a diploma in drawing, painting, and design, plus teaching. He then studied at the School of Arts and Crafts in Birmingham, England, a bastion of William Morris ideas. Back in the United States in 1901, he came under the influence of Denman Ross at the Harvard Summer School of Design.

Batchelder moved to California and in 1901 began to teach ceramics, drawing, and design at Throop Polytechnic Institute in Pasadena. Throop (pronounced troop) combined sloyd (a Swedish system of manual training) with the liberal arts and sciences. Between 1904 and 1909 Batchelder was in charge of the department of arts and crafts. The Handicraft Guild of Minneapolis, founded in 1904, invited him to organize its summer school. For the next several years he spent his winters teaching at Throop and his summers in Minneapolis, where he modeled the curriculum on Ross's summer program.

FIGURE 3.5. *Batchelder Tile Company*, Sample Fireplace, *ca. 1902–30. Earthenware; 21 × 28 × 11 in. (Los Angeles County Museum of Art, Gift of Max Palevsky and Jodie Evans. Photograph © 2007 Museum Associates/LACMA.)*

During this period he was also writing. In the preface to his first book, *The Principles of Design* (1904), Batchelder explicitly refers to reworking Ross's ideas. After another trip to England (1905–6), he wrote articles for the *Craftsman* and republished them as *Design in Theory and Practice* (1910).

In 1909 Batchelder left Throop, perhaps because it was changing its focus (it became California Institute of Technology in 1910) or because his own interests were narrowing. That year he bought property in Pasadena. He had ordered Henry Chapman Mercer's Moravian tiles for classroom use at Throop, and now he used them to decorate the chimney and fireplace of his new home. When the house was complete, he built a studio in his backyard and began making tiles in local clays with incised and modeled relief. (Figure 3.5) He designed the tiles, hand-pressed them in plaster molds, and sun-dried them in his yard among the chickens, cats, and flowers that he featured in his designs.[24] Forty of the six-inch tiles could be fired at once in his kiln. He signed every piece. At first he worked almost entirely in brown, with blue glaze rubbed into the indentations in vines, flowers, Viking ships, live oaks, and peacocks and other creatures.

Success, and neighbors' complaints of too much smoke (a typical pottery problem), prompted him to move to larger quarters in a commercial area and, still later, in 1916, to a factory in Los Angeles. Even then, when conveyor belts carried tiles into vast kilns, his motto was "no two tiles the same."[25] Batchelder's rustic-

looking squares harmonized with the dark woodwork and fireplaces of Arts and Crafts bungalows. His designs ranged from art nouveau through American Indian revival to, eventually, art deco. Batchelder had various partners in his commercial tile business. One of his workmen later recalled, "Ernest never had any money; it was always his partners who had the business sense."[26] By the end of the 1920s, Batchelder-Wilson had showrooms in Los Angeles, New York, Chicago, and San Francisco as well as representation in virtually every major city in the United States. Unfortunately, it all came to an end with the Depression. In later years, Batchelder rented a small shop in Pasadena and turned out extremely fragile slip-cast wares, quite different from his earlier work.

FULPER POTTERY

Fulper was an old utilitarian pottery in New Jersey that had produced salt-glazed crocks and other practical goods since its founding early in the nineteenth century. As glass and metal took over the market for storage containers, Fulper experimented with glazes and, around 1910, began producing a line of art pottery called Vase-Kraft (also written Vasekraft), using its regular stoneware clay with new forms and decoration. (Figure 3.6) The

FIGURE 3.6. *Fulper Pottery Company*, Vase-Kraft Table Lamp, *ca. 1915–18. Stoneware, cucumber crystalline glaze, slag glass shade; 17 × 16.75 × 13.25 in. (Los Angeles County Museum of Art, Gift of Max Palevsky and Jodie Evans in honor of the museum's twenty-fifth anniversary. Photograph © 2007 Museum Associates/LACMA.)*

simple shapes are often angular. Lamps were introduced in late 1910, and writers for art and decorating journals joined in praise for "the unity of base and shade in the same material, the utility of the lamp for reading, and the harmony of the glazes and forms."[27]

Vase-Kraft's molded forms could be glossy or mat and included mirrored, luster, flambé, and crystalline glazes. They were fired with Fulper's other products at a very high temperature. One glaze, called Mission Matte, was described by the company as a "brown black glaze resembling the finish of fumed oak or Mission furniture" and thus aimed at the fashion of the time. One of the most-admired glazes was the "famille rose," which was considered to be the rediscovery of an ancient Asian secret. It was applied to classical Chinese shapes and cost vastly more than the moderately priced Vase-Kraft items. Of all the potteries producing Asian-inspired works that relied on form and glaze alone for their appeal, Fulper was the most successful.

O. L. BACHELDER

Omar Khayyam Pottery in Candler, North Carolina, was established in 1914 by Oscar Louis Bachelder (1852–1935), then sixty-two. Bachelder, who came from a long line of New England potters, spent forty years working as a journeyman potter in twenty-eight states. When a boss reduced his wages by 50 percent because of his age, he "bought four acres of clay on credit" and with an equally destitute partner built a wheel and kiln and started making utility goods—twelve-gallon crocks, pitchers, and bowls—as well as vases, candlesticks, and tea sets. He also built his own house, raised vegetables, ground grain, and made bread. When his partner left, he went on alone and gradually began to make money.[28] He married at age sixty-five.

The utility goods were rich browns and tans with variations of green and blue-black. The pottery began to make art goods—"no duplicates." Bachelder may have been the first potter in North Carolina to make this shift. The work sold well, and after ten years he was almost debt-free. He improved his buildings and bought more land and better equipment. He exhibited nationally from about 1918 and won a prize in a 1919 exhibition at the Art Institute of Chicago. Omar Khayyam pottery was sold in New York, Boston (where Bachelder was elected to the Society of Arts and Crafts in 1923), Philadelphia, and Paris.

Bachelder's best work offered utterly succinct, elegant forms and surfaces devoid of decoration. He experimented with glazes, producing attractive pale green and peach colors. He double- and triple-dipped his pieces,

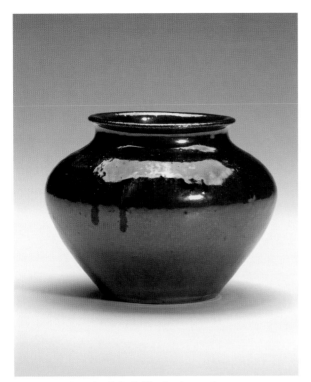

FIGURE 3.7. *Oscar Lewis Bachelder, Bowl, 1914. Stoneware, Albany slip; 5 × 6.5 in. (Mint Museum of Art, Charlotte, N.C., Museum Purchase, Daisy Wade Bridges Fund, from the collection of Pat H. Johnson, H1981.24.2.)*

most often in dark colors. Some of his most outstanding results combined the simple forms with a deep black, high-gloss Albany slip glaze. (Figure 3.7)

A visit to the Centennial Exposition in 1876 inspired Bachelder's interest in pottery. He told a magazine writer who visited him in 1923 (when he was seventy or so) that his vigor "is the result of care and simple diet and freedom from habits that prey upon the body. . . . Live each day as fully as possible. Shut worry away, plan ahead, dream ahead, each year be one year younger, dress as simply as possible, as nearly naked as you can. Let no habit become your master."[29] Bachelder made the shift from folk potter to studio potter. His way of living anticipated the antiurbanism of Ralph Borsodi's popular tract *Flight from the City* (1933) and presaged the alternative lifestyles of potters of the 1960s and 1970s.

Wood: The End of the Craftsman Style

At the beginning of the decade, Gustav Stickley's Craftsman Workshops was an Arts and Crafts empire. His products were sold in department stores nationwide, as well as by mail. There were retail stores dedicated to Craftsman products in Boston, New York, and Wash-

ington, D.C. The circulation of the *Craftsman* magazine reached 22,500—modest when compared with mass-market publications like *Good Housekeeping*, but it was practically required reading for any progressive architect, designer, or craftsperson.

Stickley dreamed of greater things still. One of his most idealistic projects was Craftsman Farms. He purchased about 650 acres of land in Morris Plains, New Jersey, some forty-five miles west of Manhattan, where he envisioned a pastoral housing development for fellow Arts and Crafts enthusiasts. It was to start with cottages and garden plots for sale, later augmented by two Craftsman Workshops factories. Stickley proposed a farm school in which young boys would be taught the virtues of hard work and given a sound education. He hoped to establish a tight-knit rural community. In 1910 he built a community clubhouse and began improving the land, building roads, and planting orchards. Despite articles in the *Craftsman* on both the properties and the school, he found no takers. So he moved into the clubhouse and focused on expanding his business in New York City.

In 1913 Stickley rented a twelve-story office building on East Thirty-ninth Street, near major department stores like Macy's, Gimbel Brothers, and Saks. He installed a restaurant, a men's club, a children's playroom, a library, a design department, a building materials department, and five floors of showrooms. Manufacturers of goods that complemented Craftsman products were invited to rent retail space. The Craftsman Building was like a vertical shopping mall for all things Arts and Crafts. It was a monumental undertaking, and it proved to be Stickley's undoing.

The cost of the building was extravagant: nearly $60,000 a year in rent alone. Meanwhile, various Craftsman enterprises had lost money the year before. Stickley had not changed his designs to accommodate the market, and Mission was falling out of fashion. Then in 1914 the war in Europe caused a spike in both inflation and interest rates. Suddenly, Stickley's middle-class customers had less disposable income, at the very moment his debts increased.

In late 1914, in desperation, Stickley introduced a line of quasi-colonial furniture that he called Chromewald. It featured turned legs and spindle moldings, with curved aprons reminiscent of seventeenth-century American furniture. What set it apart was surfaces painted deep transparent blues, grays, or browns. The effect is still rather shocking today. The line was not a success: only about forty pieces were made, and most of them were given to his family.

In March 1915 Stickley declared bankruptcy. By 1917

his empire collapsed. Craftsman Farms was sold, the magazine shut down, and the Craftsman chair factory was acquired by his brothers. Stickley spent the rest of his life living with one of his daughters, developing wood finishes and planning a comeback. The man who brought the Arts and Crafts movement into America's consciousness died penniless in 1942.

Most of the other companies that produced Arts and Crafts furniture had already adjusted to colonial revival styles by the time World War I started. As usual, larger businesses weathered the downturn better than the smaller ones. A few small outfits continued making Arts and Crafts furniture as late as the 1950s, but the real innovations were in the past.

GEORGE WASHINGTON MAHER

Inventive handmade furniture survived in other guises. George Washington Maher (1864–1926) was a Chicago architect who, like Frank Lloyd Wright and others, designed furnishings and various items, including textiles, to enhance his houses. He started in architecture as an apprentice at age thirteen, eventually working for Adler

& Sullivan (Louis Sullivan's firm). Like Wright, he believed that the architect should develop a unified design scheme that could work on both large and small scales. Unlike Wright, he didn't reject historical motifs. Some of his buildings and furnishings used details from classical architecture, which gives his work a historical continuity.

Maher applied what he called the "rhythm motif theory": after considering the clients' desires and the environment, including local plants and animals, he selected a motif or a theme and orchestrated it throughout the building. Such consistency made the whole harmonious. Maher's work raises the issue of "graphically oriented" furniture, as art historian Edward Cooke calls it.[30] Maher conceived his furniture in drawings that were probably measured diagrams, with views of the front, side, and plan (from above). Sometimes a perspective view would be drawn up. But all these views were flat, so the design was necessarily geometric, a product of drafting tools. Quirky decorations such as Charles Rohlfs's smokelike carvings were impossible, as was consideration of the grain of a specific piece of wood. Decisions about joinery were left to the contractor. In effect, the attentiveness to detail and material that characterizes the work of a hands-on craftsman was sacrificed for a design scheme.

In one house, Maher used the thistle as his motif. In another, a house called Rockledge near Winona, Minnesota (ca. 1914), he used a form vocabulary taken from classical architecture. The house had a low, hipped roof typical of the Prairie school, but the small front porch had a flattened arch with short extensions on either side. For furniture, Maher used the same lines as the front porch. In an oak chair the crest rail repeats the arch, complete with delicate moldings in the manner of the Doric order of Greek architecture. (Figure 3.8) The arches repeat under the arms of the chair. A further reference to the Doric order is in odd little trapezoidal forms and their three pendant cones (regula and guttae) at the top of each narrow spindle. The canted legs are decidedly unclassical and resemble earlier Arts and Crafts furniture.

Does Maher's use of classical details represent a step forward or a step back? If design (and by extension, craft) is presumed to be strictly a modern invention for modern days, then the inclusion of details from any earlier

FIGURE 3.8. *George Washington Maher, Armchair, 1914. Oak, leather; 59.25 × 33 × 26.37 in. (The Metropolitan Museum of Art, Purchase, Theodore R. Gamble Jr., Gift in honor of his mother, Mrs. Theodore Robert Gamble, 1982, 1982.352. Image © The Metropolitan Museum of Art.)*

historical period is inappropriate. In 1914 few people subscribed to such a radical view, but it would emerge in Europe shortly after World War I. If design is presumed to operate in a continuum of history, however, it would be acceptable to use Doric details as Maher did. The furniture for Rockledge anticipates an important debate.

MARGERY WHEELOCK

After the Cincinnati wood-carving movement peaked, relatively few women were making furniture. Most of the craft teaching programs in the country were aimed at training designers for industry rather than imparting a craft to future practitioners. As a result, even if women took woodworking courses, they tended to function as designers, not woodworkers, like Zulma Steele at the Byrdcliffe Colony.

One woman thought to have made furniture—or at least to have executed some carvings—was Margery Wheelock (ca. 1890–ca. 1967). She was a student at the California School of Arts and Crafts, graduating in 1914. She must have been talented, for the school hired her as a staff designer. The following year, the school had the opportunity to produce a model room for the Panama-Pacific International Exposition in San Francisco. She was put in charge of designing the ensemble, under the supervision of director Frederick Meyer. The work was made by Wheelock and the "California College of Arts and Crafts Alumna Group." She may have carved the panels on several pieces.

The room won a gold medal at the exposition. A contemporary drawing shows a wall cabinet and print chest, an elevated model's stand with a chair, a carved chest, a table, an artist's easel, and two additional chairs. There is also a fireplace and hood, a rug, curtains, and a variety of artworks and accessories. Wheelock's furniture does not have the stark simplicity of Mission style; it is both more imaginative and more intricate.

The wall-hung cabinet and print chest are inventive hybrids of medieval and American Arts and Crafts influences. (Figure 3.9) They are made of quarter-sawn oak, like Mission furniture, and some construction details are exposed. The joinery is straightforward, but the brackets and moldings are unusually prominent. Both the cabinet and chest feature carved panels with medieval motifs: a pair of heraldic shields above, a convoluted spray of acanthus below. The board backing the wall cabinet has the same curves and tabs as Shreve and Company silverware (see below), as does the wrought-copper hardware.[31]

Apparently the ensemble was both the beginning and the end of Margery Wheelock's career as a furniture maker. In 1916 she married metalworker Harry St. John Dixon, becoming his designer and bookkeeper. They divorced in the early 1930s; after that, little is known of her, not even the year she died. Luckily, most of the furniture survived and is now in the collection of the Oakland Museum of California.

FIGURE 3.9. *Hazel Verrue and Frederick H. Meyer, A Model Studio, 1915. Pen and ink drawing. (Collection of the Oakland Museum of California, Gift of Lawtitia Meyer, A1974.64.)*

Jewelry and Metals: Regional Differences

Studio jewelry and metalwork matured in the second decade of the century. On the East Coast, silversmiths were influenced by colonial silverware, while jewelers tended to follow the rules laid down by the Society of Arts and Crafts, Boston (SACB), because its salesroom was such an important outlet. SACB was a major force in pushing the new breed of jewelers to improve their craft. In 1907 its jury lamented the volume of inferior pieces, blaming "the dabblers . . . [whose] work, if unchecked, would discredit the movement." The jury stated exactly what good jewelry should be. In 1906 it demanded "simple line borders, repeats of units, the placing of foci [and] the rhythmic combination of lines."[32] The next year, the jury was even more explicit, recommending filigree wirework, open space, leaf forms in repoussé and painted enamels. Jewelers had to conform to this recipe if they wanted to gain entry to the salesroom. In effect, the jury controlled Boston studio jewelry for a generation. The chunky, expressive jewelry pioneered by Madeline Yale Wynne was not acceptable. Work in the new style was highly professional.

In the Midwest and on the West Coast, jewelry could be quite eclectic. Because Arts and Crafts metalwork was not limited to a single style, it didn't suddenly become unfashionable like Mission furniture did. World War I caused problems, though. Before the war, silversmiths came from Europe and found jobs in their trade. Some Scandinavian guilds were said to have provided funds for their young apprentices to emigrate. But once the war started, quotas limited new arrivals. In addition, younger American jewelers and smiths left their shops to enter the military or to take jobs in war-related industries. During the war, the U.S. government limited nonmilitary use of silver, making it difficult for silversmiths to ply their trade. Furthermore, out of a sense of patriotism, wealthy patrons didn't buy luxury goods. Some shops had to reverse their growth: for instance, the Kalo Shop opened a New York City outlet in 1914 but closed it as soon as the lease expired in 1918.

JOSEPHINE HARTWELL SHAW

Josephine Hartwell Shaw (1865–1941) was one of the most prominent Boston studio jewelers in the SACB style. She studied design in Boston in the late 1890s, came to jewelry after stints in other fields, and became an important member of the SACB. Shaw matriculated at the Massachusetts Normal School in the late 1890s, with Arthur Wesley Dow at Pratt Institute and with Denman Ross at Harvard's summer school in 1901 and 1902. She taught art in Philadelphia and Providence before she took up

> ### Jewelry Instruction Manuals
>
> American jewelry instruction manuals began to appear during the teens. Earlier examples were British, most notably Henry Wilson's *Silverwork and Jewellery* (1903). The American manuals, written by teachers and aimed at manual-arts instructors and students, had a strong Arts and Crafts flavor. One of the first was *Copper Work*, written by Augustus F. Rose in 1908. In 1917 Rose partnered with fellow Rhode Island School of Design faculty member Antonio Cirino to write *Jewelry Creation and Design*. (Now titled *Jewelry Making and Design*, the book has never been out of print.) Clearly a teaching tool, the manual describes how to set up a teaching studio complete with a "pan of tools" to be lent to every student.
>
> *Jewelry Creation and Design* reveals its antecedents. Following Dow, the authors insist, "The student of course will not copy any of the illustrations given, as the greatest benefit comes only when the idea is thought out from beginning to end."[1] Nevertheless, the many chapters on design—almost 200 pages—reiterate the South Kensington system of conventionalizing from nature.
>
> **NOTE**
>
> 1. Augustus Rose and Antonio Cirino, *Jewelry Creation and Design* (1917; reprint, Davenport, Iowa: Gustav's Library, 2005), 49.

jewelry making. In 1905 she joined the SACB, and by the next year her work was receiving attention from national magazines such as *House Beautiful* and *Good Housekeeping*. The Museum of Fine Arts, Boston, bought some of her jewelry in 1913—quite an honor, because the museum rarely purchased work from living artists—and she was awarded a medal of excellence by the SACB in 1914.[33]

One of Shaw's contributions to studio jewelry was her use of imported carved jade, often set in bezels like a semiprecious stone. The Boston area was once the center of the China trade, so jade, ivory, lacquer, and other decorative items were available, and she used them like found objects. Her necklace of gold, glass, and jade from about 1915 makes two matched jade carvings the center of the composition. (Figure 3.10) A third piece of jade is set at the apex of the chain. When worn, this smaller carving would be seen on the back of the wearer's neck,

FIGURE 3.10. *Josephine Hartwell Shaw*, Necklace, *ca. 1910–18. Gold, jade, colored glass; 3.62 × 20 in. (Museum of Fine Arts, Boston, Gift of Mrs. Atherton Loring, 1984.947. Photograph © 2008 Museum of Fine Arts, Boston.)*

FIGURE 3.11. *Frank Gardner Hale*, Pendant Necklace, *ca. 1920. Gold, pink topazes, peridots, purple sapphires, and freshwater pearls; 3 in., with 30 in. chain. (Courtesy of Skinner, Inc., Boston and Marlborough, Mass.)*

hinting at the more elaborate pendant on the front. Small rectangles of glass are set throughout the chain and the pendant, adding color.

The finely detailed chain distinguishes Shaw's necklace from machine-made costume jewelry. By breaking her chain into small sections and interspersing short lengths of gold channels, Shaw underlines the fact that her necklace is carefully designed and laboriously made. Even the bits of chain are considered: every third or fourth link is soldered to a gold bead, alternating the tiny voids of the chain links with tiny glints of light.

Shaw created gold and platinum jewelry for wealthy Bostonians for many years. Her business declined during the Depression, and she resigned from the SACB in 1939, two years before her death.

FRANK GARDNER HALE

Frank Gardner Hale (1876–1945) not only followed the SACB style but also helped enforce it: he was a member of the jury from 1910 to 1919. An 1898 graduate of Boston's Museum School, he started off as a graphic designer specializing in sheet-music covers. In 1906 he decided to devote himself to craft and traveled to England to study jewelry. He spent time in Chipping Campden with Ashbee's Handicraft Guild and then in London studying enameling. He returned to Boston in 1907, set up a jewelry studio on Park Square, and joined the SACB.

Hale's jewelry used the elements of the SACB recipe; sometimes the small leafy forms bore fruit, as in a piece from about 1920. (Figure 3.11) It is a gold pendant in the form of a crucifix, with semiprecious gems (peridots, topazes, sapphires) and pearls. The linear structure imitates the growth of vines, so Hale added tiny gold beads to suggest that his vines were bearing fruit, while adding texture and variety. Although not a particularly daring design, it is an effective one. In other jewelry, he combined the Handicraft Guild's use of imagery with metalwork in an innovative way. Not subject to English hallmarking regulations, Hale could combine gold with silver in a single jewel. Just as Hale's stones have a range of colors, so do the white and yellow tones of the metal, which adds a subtle rhythm to his designs.

Later in his career, Hale's designs became more abstract. The leaves and grapes became scrolls and globes

without reference to nature. He continued to use colored gems, and his compositions remained tightly packed and symmetrical. He was also noted for his metal boxes, undecorated save for a flat enameled plaque mounted on the lid. Over the years, Hale exhibited and lectured widely, was a member of several Arts and Crafts societies, and was abundantly honored for his work.

ELIZABETH COPELAND

Around 1900 Elizabeth Ethel Copeland (1866–1957) learned metalsmithing from Laurin Martin, a noted enamelist, at the Cowles School of Art in Boston, and she also took design classes from Denman Ross at Harvard. For nearly forty years, Copeland appears to have made her living exclusively as a metalsmith, no small accomplishment. She created jewelry, although her silver boxes with enameled plaques are more highly regarded now.

A rectangular box from 1912 is made of silver, with amethysts and enamels set on the sides and top. (Figure 3.12) Copeland made a set of oval cloisonné enamels in a conventionalized floral motif. She colored the petal forms with shades of opaque ivory and orange, setting them off against a deep transparent green. The enamel itself is unusually lumpy. Apparently, she fired chunks of solid enamel into round cloisons, creating the effect of stones set in the midst of the panel. The enameled ovals were then bezel-set on the box. The bezel creates a bright line around the enamel, and Copeland echoed the bezel (and her cloisons as well) with floral decorations made

FIGURE 3.12. *Elizabeth Ethel Copeland*, Rectangular Box with Hinged Lid, 1912. *Silver, amethysts, enamel; 3.12 × 5.06 × 4.5 in. (Museum of Fine Arts, Boston, Gift of Mrs. Horatio Appleton Lamb in memory of Mr. and Mrs. Winthrop Sargent, 19.5. Photograph © 2008 Museum of Fine Arts, Boston.)*

of silver strips. The craftsmanship of this decoration is relaxed. The box has a vigorous, primitive quality. Many people felt her boxes were true to the spirit of the Gothic, authentic in their roughness.

Copeland exhibited widely, including at the 1904 Saint Louis world's fair and the 1915 Panama-Pacific Exposition. She retired in 1937, at the age of seventy-one.

ARTHUR STONE

For Arthur Stone (who was introduced in chapter 2), economic reality eventually led to the colonial revival. Antique silver pieces were passed down from one generation to the next; when old silver was damaged or when heirs wanted to complete a set that had been divided among family members, they called on silversmiths. As a result, both old skills and old forms survived. Having worked in the United States since 1884, Stone was well versed in old American silver.

But in the late nineteenth century, heavy ornamentation was in style, with castings, chasing, or engraving. Since less-ornamented things are easier to make, the silver industry welcomed the colonial revival. Acting as tastemaker, the SACB encouraged the colonial revival, too, displaying new and antique silverware together to suggest that there was a strong continuity between the colonial era and the Arts and Crafts movement.

In comparison with manufacturers, Stone could emphasize the heavier weight of the metal he used, or he could talk about rarity (at most, his shop could produce about 200 objects a year), as well as individuality and the value of his work as an heirloom. Curiously, Stone refused to stamp his silver "hand wrought," as many smiths did. Since, as he put it, even "ignorant, careless workmanship" could be called hand wrought, the term meant nothing to him.[34]

A coffee set that Stone designed in 1914 is typical of his colonial revival work. (Figure 3.13) He probably didn't copy a particular historical example, but the set is based on Federal forms. The precedents (1790s to early 1800s) include urn-shaped coffeepots on pedestal feet, sugar baskets with upturned ends and hinged handles, and helmet-shaped creamers. Stone reduced the molding to a minimum and substituted a simple ivory carving for what was usually an elaborate silver finial. His design relies entirely on elegance of form.

Stone operated his shop in Gardner, Massachusetts, for thirty-six years, until he died in 1937. Until 1926, when he suffered a minor stroke, he did all his own design and chasing. He usually had four or five people working for him, including apprentices he hired right out of the local high school. In spite of his conservatism,

FIGURE 3.13. *Arthur J. Stone, Coffee Set, 1914. Sterling silver, ivory; 8.75 × 6.5 × 4 in. (Dallas Museum of Art, 20th Century Design Fund.)*

he provides a key link to postwar American silversmithing. In the mid-1930s, when Stone was in his eighties, a young woman came to him asking for training in the craft. He was happy to oblige. The young woman was Margaret Craver, who would become one of America's first modernist silversmiths.

FRANK KORALEWSKY

One of the icons of the Arts and Crafts movement is the *Schneewittchen* or *Snow White* lock (1905–11), made by blacksmith Frank Koralewsky (1872–1941). (Figure 3.14) It is a tour de force of the craft. Koralewsky apprenticed in his native Germany and came to America with a thorough knowledge of methods and traditions of European blacksmithing. One practice was to make locks and tools as elaborate displays of skill. These objects served as advertisements for the maker's technique and probably as a game of one-upmanship with neighboring smiths. When some American architects complained that the beauty and intricacy of such works could no longer be achieved since the old skills had been lost, Koralewsky decided to prove them wrong.

Schneewittchen is based on the Grimm brothers' fairy tale "Snow White and the Seven Dwarfs." Every part is decorated, including interior surfaces that can't be seen unless the lock is taken apart. The main plate portrays in deep relief Snow White cooking dinner for the dwarfs.

This plate is chiseled out of solid iron, an astonishing piece of work. Several of the dwarfs, also chiseled in deep relief, wander about the scene. To expose the keyhole, a lever surmounted by a sleeping dwarf and a toadstool must be activated. Surrounding the lock is forged openwork and three engraved panels, one each in gold, silver, and bronze, depicting turning points in the tale. Koralewsky proved his point.

FIGURE 3.14. *Frank Koralewsky,* Snow White and the Seven Dwarfs *Door Lock, 1911. Iron with inlays of gold, silver, bronze, and copper, on wood base and backup panel; 20 × 20 × 8 in. (The Art Institute of Chicago, Gift of Richard T. Crane.)*

It took almost seven years to complete the lock, as Koralewsky worked in his spare time. Once *Schneewitt-chen* was finished, it was exhibited at SACB, then the Boston Museum of Fine Arts and the Panama-Pacific Exposition in 1915, where it won a gold medal. Eventually, the lock was given to the Art Institute of Chicago, where it remains.[35]

JANET PAYNE BOWLES

If highly skilled craftspeople like Arthur Stone and Josephine Hartwell Shaw represent the mainstream of studio metalworking in the teens, Janet Payne Bowles (1872/73–1948) stands for the maverick. She married an Arts and Crafts activist, Joseph Bowles, when she was twenty-two, and they moved to Boston. Joseph edited *Modern Art* magazine and published the first edition of Arthur Wesley Dow's *Composition* in 1899. Later the couple briefly lived in an experimental community run by Upton Sinclair (until the building burned down) and came in contact with such leading American progressives as John Dewey. Sometime in the first decade of the century, Payne Bowles took up metalworking.

The marriage collapsed after Joseph became a drug addict, reducing his family to poverty. Payne Bowles moved back to her birthplace, Indianapolis, with their two children. Having achieved some fame as an artist, she was hired to teach art at the progressive Shortridge High School. Metalworking (probably of the manual-arts sort) had been taught there since the 1890s, and the school offered the first jewelry-making course in the state in 1908.[36] Payne Bowles taught there until she retired in 1942.

Her first known metalwork was cast, but over the years she evolved a new technique of melting gobs of metal together into fantastic shapes. This suited her perfectly: she never had a great deal of technical skill, and apparently she liked to improvise as inspiration struck her. Avant-garde thinkers were saying that the purpose of new art was the expression of the inner self, and she agreed. Under extreme heat, metal pools and drips unpredictably, producing unique shapes. She was a pioneer in fusing metal as an art technique. (In the early 1950s, when sculptors such as Herbert Ferber, Ibram Lassaw, and Seymour Lipton sought a three-dimensional equivalent to action painting, they used a similar process.)

A silver spoon from 1912–15 has a bowl roughly hammered from an odd-shaped piece of sheet metal. (Figure 3.15) The handle has been built up from globs of molten metal frozen into peculiar forms that later generations would call surrealistic. The occasional crusty texture contrasts with adjacent areas that Payne Bowles polished to

FIGURE 3.15. *Janet Payne Bowles*, Spoon (Model), *ca. 1912–15. Silver; 3.5 × 1.24 × 1.24 in. (Indianapolis Museum of Art, Gift of Jan and Mira Bowles in memory of their mother, Janet Payne Bowles.)*

a near-mirror finish. A tangled clump of wire added to the bowl of the spoon and a hole underneath it announce that the spoon is not for use at all, but for contemplation. To emphasize aesthetic qualities, she subverted function. (This tactic became common in the 1970s.)

In her own time, Payne Bowles received favorable reviews and was widely exhibited. This success did not prevent her from fabricating tales about awards and fabulous commissions. (In one story, she maintained that an Italian patron had hired her to make twelve chalices for churches in Italy; in another, she had J. Pierpont Morgan asking her to make gold jewelry. They were lies or exaggerations.)[37] Like Madeline Yale Wynne, though, she set her own standards. Her work is unique in American metalsmithing. Luckily for posterity, her son and daughter gave all her known work to the Indianapolis Museum of Art, where it can be seen today.

SHREVE AND COMPANY

One of the many businesses that rose from the ashes of the 1906 San Francisco earthquake and fire was Shreve and Company, the city's leading "made-to-order" silver-

smithing outfit. The company had started during the gold rush in 1852 as a retail jewelry store. Over the years Shreve hired jewelers and smiths until it had a shop capable of making anything from custom jewelry to mass-produced flatware. An early triumph was a ten-inch-tall bear, cast in gold, presented to President Theodore Roosevelt.

Before the turn of the century, West Coast shops like Shreve produced silverware from solid silver. This put them at odds with East Coast manufacturers who churned out silver-plated wares. At first, the West Coast companies were protected by the steep cost of the transcontinental train trip, but these costs fell dramatically during the 1880s. The San Francisco shops didn't have the capital to invest in the machines and steel dies required for mass production, so they had to seek a niche market to survive. One tactic was to produce wares that could easily be customized with bold monograms. Shreve's route was to invent a unique style and hope it would become fashionable.

Around 1900 Shreve was experimenting with medieval motifs applied to simple silver forms. One surviving example is a shallow dish with a broad triangular rim, which is pierced with a trefoil at each corner. Shreve designers (names unrecorded) invented flatware patterns with names like XIV Century and Norman I. While Shreve had to curtail production after the earthquake, it was soon supplying silver goods for members of San Francisco's upper crust as they rebuilt and reappointed their houses. The company's most memorable hollowware of the period, which evolved from that medieval style, is known as the Shreve Strap.

The idea was to take simple, lathe-spun forms and apply vaguely medieval strapwork to the surfaces. The inspiration came from iron hinges on wooden boxes and doors, which had similar spade terminals. To look handmade, the straps were planished, and generous numbers of rivet heads were sprinkled throughout. Although the finished vessels appeared painstakingly riveted together, the rivets were fake, merely symbols of durability and dignified labor. And yet Shreve and Company silverware was made entirely from silver, and it was substantial.[38]

Shreve also specialized in making silver mounts for glass, pottery, and lacquer. A customer could bring in a favorite bowl or vase, and Shreve craftsmen would make rims for the top and bottom and link them with straps. The whole would then be riveted together. The silverwork had the effect of tastefully framing the object while protecting fragile edges.

Shreve trained many designers and silversmiths who went on to establish their own studios, among them Porter Blanchard and Arthur Thumler. But after the teens, the firm fell back on uninspired colonial revival styles. The workshop survived until 1968 and was the last major regional silver producer in the country. Shreve and Company still exists but is pretty much what it started as: a retail store.

DIRK VAN ERP

The quintessential Arts and Crafts metalsmith was Dirk van Erp (1860–1933). His copper lamps are icons of the movement. (Figure 3.16) Even today, when somebody wants a handsome photograph of Arts and Crafts furniture, they'll put a van Erp lamp on the Mission table and plug it in.

Van Erp was born in the Netherlands to a family of coppersmiths, and he learned the trade there. He immigrated to America in 1886, trying his hand as an ironworker and as a prospector in the Yukon before settling down to work at a navy yard near Vallejo, California. In his spare time, he started hammering brass shell casings into vases. These proved popular, so he opened a shop in Oakland in 1908. He timed it perfectly: the building boom after the earthquake coincided with the fashion for Arts and Crafts metalwork. In 1910 he moved his shop to Sutter Street in San Francisco, where it became an institution. The Copper Shop operated for sixty-seven years, closing in 1977.

Van Erp's signature products were electric lamps. A vaselike base, often similar to Chinese pottery, was typically formed by hand from a flat sheet of copper. The surface had planishing marks or was "warty," which accentuated its color. It was patinated in variegated reds and browns and then waxed to prevent color change. A metal lampshade was constructed with panels of translucent reddish orange mica, so that when the lamp is turned on there is a warm and pleasantly atmospheric glow instead of the harsh light of the clear bulb. The effect now seems quaint, but in 1910 Van Erp's lamps were ultramodern. In comparison with standard gas lighting, tied to the gas supply by copper pipe, the new electric lights were relatively mobile.

About one-quarter of the Copper Shop's production was lamps. The shop also produced vases, candlesticks, bookends, and table accessories, mostly in copper but also brass and iron. Van Erp never mechanized. He was a skilled hammerman; his planishing marks were true to process, not applied decoration. The Copper Shop developed some interesting variations on the basic lamp and shade. Van Erp sometimes pieced a vase together from two parts, joining top and bottom with a row of rivets. His daughter, Agatha (1895–1978), sandwiched cut-paper patterns between layers of mica in the shades, creating ornamental shadows.[39]

Textiles

The period was transitional for textiles, with home needlecrafts still routine, a few specialized artisans continuing to produce traditional work, and increasing (though still modest) encouragement of new forms. Juried textile design competitions were held annually from 1916 to 1920, sponsored by *Women's Wear* magazine and by the Art Alliance of America. Many entrants became well known, including Marion Dorn, Ilonka Karasz, Ruth Reeves, Martha Ryther, and Marguerite Zorach. The last of the competitions attracted 1,000 submissions from thirty-four states and Canada. After World War I, Ralph M. Pearson of New York encouraged modern design by opening a sales center for hand-hooked rugs designed (and signed) by painters, sculptors, and designers, among them Thomas Hart Benton, George Biddle, and Ruth Reeves. The rugs were made by rural residents of Maine as a home industry.

Weaving and textile design courses were offered in a few art schools. The University of Wisconsin, Madison, began to offer textile crafts (in the home economics department) in 1911; in 1917 the Saint Louis School of Art (later Washington University) hired a weaving teacher. Among the traditional workers were William H. H. Rose (1841–1913) and his sister, Elsie Maria Babcock Rose (1837–1926) of Kingston, Rhode Island, fourth-generation weavers. For more than fifty years they offered made-to-order fabrics, successfully competing with machine-made goods. Billy Rose was also known as Weaver Rose. He was an eccentric with long white hair, usually attired in togalike tunics worn over trousers, his feet bare. He and Elsie lived somewhat reclusively on a farm. She kept house, gardened, helped with the livestock, and also wove, reportedly more finely than her brother, although she did not like people to say so.[40] His weaving was mostly of the overshot variety, and he was also a famous writer of drafts and patterns, which he jotted onto advertisements, paper bags, and wood planks. In 1912, with other local weavers, he organized the Colonial Weavers Association. Although the group did not survive him when he died the following year, members taught others to weave, renewing interest in the craft.

MARGUERITE ZORACH

Marguerite Thompson (1887–1968) rebelled against her Fresno family's expectations, went to Paris to study, became a fauve and cubist painter, and met William Zorach. They were newly married and newly settled in Greenwich Village when their paintings were chosen for the 1913 Armory Show. Soon after that, about 1915, Mar-

FIGURE 3.16. *Dirk van Erp Copper Shop,* Table Lamp, *ca. 1915. Copper, mica, paper; height, 26 in.; diameter, 19.62 in. (Los Angeles County Museum of Art, Gift of Max Palevsky. Photograph © 2007 Museum Associates/LACMA.)*

Van Erp's imitators were not so principled. An outfit called Old Mission Kopper Kraft tried to capitalize on the success of his designs by using the faster technique of spinning on a lathe. That process leaves telltale ridges on the surface, so workers hammered in fake planishing marks. In addition, Old Mission Kopper Kraft lamps were bolted together with a rod running up the middle of the vase, but rows of rivets were added anyhow. The lamps were much cheaper than van Erp's, but the business lasted for only a few years in the early 1920s.

Copper Shop lamps ranged from $20 at the low end to as much as $300 for a large lamp with patterns in the shade. The intended audience was the tasteful middle class and the wealthy. Van Erp retired in 1929, yielding operation of the Copper Shop to his son, William. Over the course of nearly seven decades, the shop produced thousands of articles. Today they are highly collectible and can sell for more than 500 times their original price.

guerite turned to embroidered tapestries because she could find more brilliant colors in wool than in paint. (Figure 3.17)

Zorach had made art with fabric even before then and continued to employ it for various reasons. She decorated their Midtown apartment-studio with painted and batiked hangings to make an inexpensive artistic environment that they called their "Post-Impressionist studio." She created clothes for the family, from silk batik blouses and dresses for herself to crocheted hats for the baby. William wrote in his memoir that she "made almost everything we wore except shoes and my suits."[41] In the first exhibition of the Society of Independent Artists, in 1917, she showed an oil painting as well as a rug, *Adam and Eve*, which sold. By 1917 she was teaching art, embroidery, and design at the Modern Art School in Manhattan. Five of her tapestries were shown at the Daniel Gallery in 1918 and four sold for $1,200. It was her first major sale. In 1918 she received a commission for two embroidered bedspreads, and such major projects made the couple's living for entire years.

By the time her second child was born, Zorach no longer had uninterrupted hours to concentrate on a painting and found that textiles worked better, although they were time-consuming. "All the constructions and relations you find in painting are in the tapestries—just the technique and the materials are different," she once said.[42]

In 1935 Zorach's "needlepainting" was given a retrospective at the Brummer Gallery in New York. Her prices were rising as she became conscious of the time invested.[43] But success didn't mean acceptance. When a collector offered a piece to the Museum of Modern Art,

officials declined, saying it didn't fit into any category that they knew of. While she regarded the works as paintings in wool, museums didn't consider them equivalent to her oils. After 1945 she returned to painting and sculpture. Ironically, the colors of her tapestries, her original motivation, have faded. Today the tapestries are in public collections such as that of the Metropolitan Museum of Art, but they are rarely shown because of light sensitivity.

Craft Institutions

In the teens, a few new guilds were formed—the Guild of Allied Arts in Buffalo (1910), the Guild of Handicraft Industries in New York City (1911), and Wisconsin Designer Craftsmen (1916) among them—and the Elverhöj Colony was established in Milton, New York, in 1913. But the decade saw just as many disappearances: the *Philistine* vanished after Elbert Hubbard died aboard the *Lusitania*; Gustav Stickley's empire collapsed in 1916; the national publication *Handicraft* shut down in 1912. Mass-market magazines such as *House Beautiful* and *Ladies' Home Journal* turned to the fashionable colonial revival.

Nevertheless, significant exhibitions featured Arts and Crafts material. In San Francisco, the 1915 Panama-Pacific International Exposition had craft displays. In 1917 the Metropolitan Museum of Art inaugurated a series of large exhibitions of "industrial art"—in actuality, handmade furniture and related objects—that would become very influential in the 1920s. The museum also hired Richard F. Bach away from the architecture school at Columbia University to play an impor-

tant role, as its annual report stated, in "forwarding the work with manufacturers, designers, and trade journals, a work recognized as essential now at the time of the ending of the war and all that means to our national industries into which taste and style enter as important factors."[44] Other major exhibitions of crafts were mounted at the Detroit Museum of Art (now the Detroit Institute of Arts; tapestries, 1919), the John Herron Art Institute in Indianapolis (German applied arts, 1912), and the Los Angeles County Museum (decorative landscapes and textiles, 1919).

Since craft education was closely associated with the manual-training movement, it prospered. Although the emphasis of manual training gradually shifted from character building and aesthetic education to job training, courses in metalworking and woodworking survived. The whole movement was given a huge boost with the passage of the Smith-Hughes Act in 1917. For the first time, federal funds were available for teaching trades, industry, agriculture, and home economics. The new funding guaranteed a demand for shop teachers, which in turn justified the creation of shop courses at the college level. (The Smith-Hughes Act provided funding for eighty years. It expired in 1997.)

Occupational Therapy

The second decade of the new century brought a new role to the crafts: occupational therapy. It had been observed for some time that inmates in mental hospitals seemed more content when they had some kind of work to perform. At first, crafts were taught to patients because the activity relieved their intense boredom. It was also thought that crafts could prepare inmates for life after institutionalization, in the spirit of manual training. The procedure began to be called occupational therapy, and the first workshop explicitly for that purpose was set up in Chicago in 1908.

In 1917, toward the end of World War I, General John J. Pershing, commander of the armies of the United States, cabled from France to Washington requesting several hundred young women to serve in overseas hospitals to "counteract idleness and build morale by giving instruction in crafts to wounded and otherwise incapacitated soldiers." The surgeon general set up a committee to address the need, and it established a school in Boston for training "Reconstruction Aides in Occupational Therapy." Because of the urgency of the situation, the training course was only twelve weeks long. Applicants had to be healthy, emotionally stable, and at least twenty-five years old and have a background in arts or crafts.[45]

Wounded soldiers facing long periods of recuperation were taught needlework and weaving. Morale went up, mobility of injured limbs improved, and muscle tone got better. Soldiers with "shell shock" (now called posttraumatic stress disorder) gradually relearned how to socialize and take on responsibilities that would be demanded by a job. By the end of the war, the therapeutic benefits of crafts were clear.

The training course closed when war ended but reopened in the fall of 1919 to train therapists for civilian needs. The Boston School of Occupational Therapy was incorporated in 1921. By the end of World War II, 700 hospitals had occupational therapists.

In Short

In the teens, the Arts and Crafts movement entered a precipitous decline. World War I was a major dividing point, and the time when the two most prominent spokesmen for the movement were silenced: Elbert Hubbard died, and Gustav Stickley went bankrupt. The colonial revival became dominant.

The Armory Show in 1913 was the controversial first exposure of the American public to the European avant-garde art. One of the American exhibitors was Marguerite Zorach, who painted and made pioneering rugs, tapestries, and other textiles from 1917 until 1945. Adelaide Robineau was honored for her ceramics in Europe.

Craft as an agent for social improvement was recruited by the army to aid wounded soldiers; it turned into occupational therapy in the civilian world.

CHAPTER 4 1920-1929

BOOM TIME IN A CONSUMERIST SOCIETY

New Styles and Habits

The 1920s was a time of affluence, of increasing sophis-tication, of a desire to define what it meant to be Ameri-can, and yet of influences from abroad in nearly every as-pect of life. The war had exposed many people to Europe, and now a thriving economy allowed travel for pleasure and education. Conversely, immigration quotas passed in 1921 and 1924 stopped the massive influx of earlier years (and declared Asians ineligible for citizenship) and became barriers to designers from abroad. Presidents Warren G. Harding and Calvin Coolidge both supported a laissez-faire stance for business and isolationism in foreign policy. Politically, America retreated behind its oceans to tend to its own affairs.

Prohibition introduced a new social event called the cocktail party, while better education, movies, the popu-lar press, radio broadcasts, and even department stores and women's club meetings were conduits for new infor-mation and styles. By 1929 more than 43 percent of the world's manufacturing output was American. There was a new focus on buying for the home, including towels, toilets, and kitchen appliances. New fashions in cloth-ing tended to erase class distinctions in dress: rich and poor alike followed the same trends. Also characteristic of the time were alternative spiritual concepts, Eastern philosophies, and utopian experiments, tempered by a new suspicion of charlatans.

France was the source of the luxurious art deco style, while Viennese taste was pervasive in sculpture and accoutrements. Another new style was the Hispano-Moresque (or Alhambra), generated by Bertram Good-hue's architecture for the 1915–16 Panama-California Exposition in San Diego. Colonial Williamsburg (1926) in Virginia, the American Wing of the Metropolitan Mu-seum of Art (1928) in New York, and Greenfield Village (1929) in Dearborn, Michigan, promoted the American roots of current culture, while interest grew in Native Americans, Appalachian folk culture, and the myth of the West.[1] Jazz music influenced paintings, clothes, and decorating.

1920
 Price of first-class stamp: 2¢
 Average hourly wage: 55¢
 Prohibition goes into effect
 Women get the vote with the ratification of the
 19th Amendment
1922
 T. S. Eliot publishes "The Waste Land"
 Mussolini seizes power in Italy, founding the first
 Fascist dictatorship in Europe
1923
 Tokyo earthquake kills 200,000
 Charleston is U.S. dance craze
1924
 U.S. Congress grants citizenship to all Native
 Americans born in the United States
1925
 Grand Ole Opry begins broadcasting
 New Yorker begins publishing
 Wonder Bread is the first bread to be sold already
 sliced
 Scopes "monkey" trial tests legality of teaching
 evolution in public schools
 F. Scott Fitzgerald publishes *The Great Gatsby*
 Adolf Hitler publishes *Mein Kampf*
1927
 Charles Lindbergh flies solo across the Atlantic
 First "talking" movie, *The Jazz Singer*
 Kool-Aid developed
1928
 Walt Disney creates animated cartoon character
 Mickey Mouse
 Bubblegum invented
 Penicillin discovered
1929
 U.S. stock market crashes, setting off the Great
 Depression
 William Faulkner publishes *The Sound and the
 Fury*
 Museum of Modern Art opens in New York

Craft Institutions

EDUCATION

In 1908 and 1909 social worker John C. Campbell (1867–1919) and his wife, Olive Dame Campbell (1882–1954), traveled across the South by wagon on a fact-finding mission. He interviewed farmers about agricultural prac-

tices; she collected old ballads and studied traditional crafts. John Campbell eventually worked for the Russell Sage Foundation, promoting economic and educational development throughout the southern mountain country. After his early death, Olive Campbell determined to set up a school along the pattern of the Danish *folke-højskole* (folk high school), dedicated to adult education. With the enthusiastic support of the local populace, she founded the John C. Campbell Folk School in Brasstown, North Carolina, in 1925. Traditional crafts were part of the curriculum and remain so today. The school offers courses ranging from broom making and wood carving to calligraphy and storytelling.

In Detroit, two schools were started in the 1920s. Cranbrook, which was created by newspaper heir George Booth, will be discussed in chapter 5. The other grew out of the local Society of Arts and Crafts, which had opened a salesroom in 1906, following the pattern established by the Society of Arts and Crafts, Boston (SACB). Detroit was already the home of Mary Chase Perry's Pewabic Pottery, so there was no shortage of local interest. Over the years, the society grew, built its own building, sponsored lectures and exhibitions, and opened a playhouse. In 1911 it opened the Detroit School of Design, but financial problems ended the endeavor in 1918. The society tried again in 1926. The Arts School of the Detroit Society of Arts and Crafts offered sculpture, painting, wood carving, and silversmithing. This time, the school prospered. To stay in step with the times, it later added courses in industrial design and commercial illustration. It survives today as the College for Creative Studies.

CRAFT EXHIBITIONS

In the early twentieth century, institutions did not distinguish between manufactured goods and handmade crafts. One museum director reflected in 1927: "The term industrial art . . . relates to the production of things primarily of use in which the effort has been made to introduce the element of beauty. Whether things are made by hand, or by machine, or by both, is a matter of no importance as regards their relation to life."[2] No doubt John Ruskin and William Morris would have hotly disputed this assertion, but they were far in the past. The statement testifies to the diminishing Arts and Crafts influence.

Many of the most important crafts exhibitions in the 1920s featured work from Europe. These shows had to overcome the institutionalized American resistance to the new. Since 1917 New York's Metropolitan Museum of Art had been organizing annual exhibitions of "Art in Industry," with the stipulation that the work exhibited be

Art Deco

The Paris Exposition of 1925 featured agriculture, apparel, decoration, education, garden architecture, and theatrical design, but it is famous for its concentration on the decorative arts, specifically those in the modern style. This was the only fair in history that "gave birth to and then publicized a style."[1] That dramatic new art and architectural style came to be known as art deco and was the characteristic look of the later 1920s and 1930s.

Rules for entry stipulated that all exhibits had to be new and original: "Reproductions, imitations, and counterfeits of ancient styles will be strictly prohibited." The United States was invited, but Secretary of Commerce Herbert Hoover declined to send anything on the grounds that the nation had nothing modern to show. Concerned, however, that the French might compete too aggressively with American manufacturers, he sent a committee of 108 Americans to observe and report back to the government.

NOTE

1. Paul Greenhalgh, *Ephemeral Vistas: The Expositions Universelles, Great Exhibitions, and World's Fairs, 1851–1939* (Manchester, England: Manchester University Press, 1988), 165.

based on objects in its collections. By 1919 the museum began to require new designs, but the emphasis was still historicist. Adding to the museum's conservative power was its American Wing, filled with furniture and other decorative arts from the nation's colonial past.

The first exhibitions of design from overseas gave Americans an inkling that the past was passé. In 1912 an exhibition from the Deutscher Werkbund appeared at the Newark Museum; another of German applied arts was held at the John Herron Art Institute in Indianapolis. There was Danish work in Detroit in 1913, more German at the Newark Museum in 1922, and a broad selection of work by Danish silversmith Georg Jensen at the Herron in 1925. The Wiener Werkstätte opened a salesroom in New York in 1922, as did Jensen in 1923 and French metalsmith Edgar Brandt in 1925. All this exposure prepared Americans for art deco, which exploded onto the American scene in 1926, following the 1925 Exposition internationale des arts décoratifs et industriels modernes in Paris. These presentations had their most immediate effect on furniture design.

Popular enthusiasm gave confidence to Americans who wanted to display experiments with modern craft. There was isolated institutional interest, for example, by the San Diego Museum of Art, whose founding director, Reginald Poland, was deeply interested in contemporary ceramics. Perhaps the most notable efforts came from the American Federation of the Arts (AFA), in Washington, D.C. In 1928 the AFA hired Helen Plumb, former secretary of the Detroit Society of Arts and Crafts, to head its new Bureau of Industrial Art. She had been a member of an American delegation to the Paris Exposition and had already organized several shows in Detroit. She assembled three traveling exhibitions of decorative arts for the AFA, which included both handmade and manufactured items. The first (1928) presented ceramics; the second (1929), glass and rugs; and the third (1930), textiles and metals. Contributors to these shows included Pewabic Pottery, Rose Iron Works, and jeweler and industrial designer Paul Lobel. The ceramic show, known as the International Exhibition of 1928, opened at the Metropolitan Museum of Art, toured widely, and was both popular and highly influential.[3]

THE CRAFT MARKETPLACE

By the 1920s, a specialized market for craft had developed nationwide. Department stores carried craft (particularly ceramics), and a few large stores sold silverware made in-house. The Society of Arts and Crafts, Boston, continued to operate the largest crafts salesroom, and other societies also had stores. New galleries carrying craft sprang up in Cleveland, Philadelphia, Saint Louis, and Kansas City. Retail outlets for folk crafts opened in many locations that served the tourist trade, from New Mexico to New England. The interest in folk crafts also stimulated the founding of many marketing cooperatives, usually within specific geographic boundaries.

Southwest Indian Arts

The inhabitants of the Southwest were the focus of a new wave of interest in Native American culture during the 1920s, although tribes elsewhere were largely ignored. Potters Nampeyo and Maria Martinez and basketmaker Louisa Keyser (Dat So La Lee) were described as creating "revivals" of their ancient heritages, despite the fact that the recycling of motifs and techniques from the past was a continuous practice, a way of linking with ancestors. Questions of tradition and innovation have often played unfairly against Native Americans. At various times, Anglos have decried change from some given "tradi-

tion." Native artistic practices have, in fact, maintained considerable continuity—burial site excavations reveal consistent materials and imagery over centuries—and at the same time a constant openness to change. After all, glass beads and wool tapestries now called traditional were both contact-era developments, the beads acquired from traders, the tapestry weaving learned from the Spanish.

The Santa Fe Indian Market was established in 1921 and the Gallup Ceremonial in 1922. In both venues, craft was juried for quality and sold directly to the public by Native artists. In 1925 Martinez began to sign her pots. This act, along with her subsequent fame, marks a shift in Native American art. Around that time, Mary-Russell Ferrell Colton began advising makers to identify their pieces with an individual mark, so that each could build a personal reputation. Colton, with her husband, Dr. Harold Sellers Colton, founded the Museum of Northern Arizona in Flagstaff in 1928; in 1930 it held the first juried Hopi Craftsman Exhibition. All these steps toward Anglo-style professionalism supported the increased valuation of craft—especially decorated pottery—in the commercial market.

A new attitude toward Native Americans began to evolve. In 1924, Congress passed a bill granting U.S. citizenship to Native Americans, giving them the vote and the obligations of military duty and of paying taxes on off-reservation revenues.[4] The principle of forced assimilation was resisted by some important individuals, among them John Collier, who had worked in social service agencies to aid immigrants in New York and California and who, after a five-month stay in Taos in 1920–21, shifted his focus to Native Americans.

Collier was appointed commissioner of the Bureau of Indian Affairs in 1933. He selected René d'Harnoncourt as his assistant and then, in 1937, as general manager of the Indian Arts and Crafts Board. The procedures d'Harnoncourt pursued in his work with Indian arts and crafts followed methods he had developed in transactions with Indians in Mexico: to work with each tribe as a separate entity. He is famed for the major exhibitions of Indian arts that he organized—in 1939 at the Golden Gate International Exposition in San Francisco and in 1941 at New York's Museum of Modern Art (he was later the museum's director).

NAVAJO WEAVING

Navajos adapted upright looms from the Pueblo peoples in the seventeenth century. The technique was handed down through generations, generally from mother to daughter. In Navajo weaving, outsiders had both nega-

tive and positive effects. Many trading posts encouraged work for low-end markets, which led to loose weaving and the use of poor-quality wools and garish synthetic dye colors. Some traders, however, pushed for improvement of quality in both design and color.

HOSTEEN KLAH

Hosteen (or Hastlin) Klah (1867–1937) was one of the greatest Navajo medicine men of his time. (Figure 4.1) His mother was a skilled spinner and weaver of blankets who had learned the techniques from her Hopi father; she taught weaving not only to her daughter but also to her son. Even as a young man he was skilled enough to be invited to demonstrate rug weaving at the World's Columbian Exposition (1893), although it was the first rug he produced alone. In a roped-off space, he wove a few inches each day.

In 1919 Klah began weaving sandpainting motifs. He had become friends with Franc J. Newcomb, a self-taught ethnographer who lived on the Navajo Reservation with her husband, a trader. She went with Klah to ceremonies, began to record the symbolic motifs, and encouraged him to perpetuate them in rugs. Years later she wrote a book about him. He wove sandpainting rugs only for the chants that he was qualified to sing, including Nightway, Shootingway, and Mountainway. He may not have been the first person to weave these textiles, but he is certainly the best known. He made about twenty-five of these rugs.

Klah was an unusual man, said to be a hermaphrodite. "This accident of birth placed him in a very special category among his family and his contemporaries. The Navahos believed him to be honored by the gods and to possess unusual mental capacity combining both male and female attributes."[5] He did women's work—weaving is a woman's job among the Navajos—and was described as a person of great gentleness. He never attempted carding or spinning, perhaps because his mother was an expert who prepared most of the yarn he used.

In 1911 Klah made and sold a blanket showing a set of Yeibichai dancers, which caused a furor among other medicine men; they wanted it destroyed and an "evil-expelling" rite held, but the matter blew over. When Newcomb suggested that he weave a rug with a ceremonial design, he hesitated; assured that it would be hung on the wall, not walked on, he decided to go ahead, and wove The Whirling Log Painting. His family's looms for weaving ordinary rugs were not large enough to suit Klah, who had one built that would hold a rug twelve feet square. He insisted that the tan background be natural, undyed wool, and it was difficult to locate enough brown

FIGURE 4.1. *Hosteen (Hastlin) Klah with one of his sandpainting tapestries. (Courtesy of the Wheelright Museum of the American Indian, Santa Fe. © Priscilla Newcomb Thompson.)*

sheep to provide the needed material. Other colors were derived from Mexican indigo and cochineal dyes, and Klah's sister made a bright yellow from goldenrod. The rug was sold to a wealthy collector who saw it before it was off the loom, but that fall it was shown at the ceremonial in Gallup, where it won a blue ribbon. The collector commissioned two more, and Klah was established in his new career. A Hail chant sandpainting rug was completed in the summer of 1921 and exhibited at the Gallup ceremonial that fall, where it was purchased by Mary Cabot Wheelwright of Boston.

Demand for ceremonial tapestries led Klah to hold a nine-day ceremony over his two nieces so that they could also weave the sacred symbols. After a few years had passed and neither he nor they suffered any notable misfortune, others also began to take up the practice of "figure blankets." Only Klah and his nieces made exact copies of ceremonial paintings, however. Wheelwright bought twelve rugs woven by Klah and nine by the nieces. These were displayed at the Museum of Navajo Ceremonial Arts at Santa Fe, which Wheelwright, with Klah's collaboration, founded in 1937 (now the Wheelwright Museum of the American Indian).

Newcomb's own records of the ceremonial rugs were lost in a fire in 1936. The relationship between Klah and Newcomb was not unique. Another supporter of rugs was Sallie Lippincott, who, with her husband, Bill, bought the Wide Ruins Trading Post on the Navajo Reservation in 1938. She encouraged cleaner wool, heavier rugs, vegetable dyes, and stripes recalling the old striped wearing blankets.[6]

LOUISA KEYSER

Another Native American textile master linked to an Anglo enthusiast was the Washoe basketmaker Louisa Keyser of Nevada. (Figure 4.2) Keyser (died 1925) signed a contract with businessman Abe Cohn and his wife, Amy. They marketed her baskets through the curio department (managed by Amy) of Abe's Carson City store, the Emporium, and they promoted her work. The contract gave them ownership of her production in return for housing, food, clothing, and medical care for Keyser and her husband.[7]

The Cohns invented a romantic past for the Washoe, falsely claiming that Keyser was the daughter of a chief (the Washoe did not have chiefs) and fabricating an exotic-sounding name for her—Dat So La Lee. They

FIGURE 4.2. *Louisa Keyser (Dat So La Lee), Degikup Basket, 1903–4. Willow, redbud, and bracken fern root; height, 8.5 in. (Courtesy of the Nevada State Museum, Carson City, Nevada Department of Cultural Affairs.)*

made up stories of the basket motifs being symbolic of men's activities and ceremonies (Keyser said there was no meaning). The Cohns were apparently quite persuasive, because both George Wharton James, a collector who published an important book on basketry, and Otis T. Mason, curator of ethnology at the U.S. National Museum (now Museum of Natural History, Smithsonian Institution), published their inventions as fact.

The Cohns' purpose was to attract buyers by emphasizing tradition and making Keyser seem as colorful as possible. They said her characteristic form, the *degikup*, was old, but in fact she had invented it, combining traits of nonfunctional baskets of the Pomo and Maidu of California. They said she was the last of the basketmakers, when in fact her success inspired a revival. And they said she was going blind and would probably never make another large basket, which was also untrue. They kept a detailed ledger on her work in an era when there was little documentation, but unfortunately much of it was fiction. They were able to sell one of her baskets for $2,400 in 1914, when most Washoe crafts sold for only a few dollars.

In Keyser's globular willow baskets, the tight coils are attached with about twenty-five stitches to the inch, with an inward-curving rim and decorative motifs of bracken fern stitched into the sides. Although the livelihood of her tribe had been destroyed by the loss of its land to miners and ranchers, she originated this very successful new type of two-color fancy basket, thus inaugurating the ideas of individuality and innovation for others to follow. The Cohns never credited her with those accomplishments.

PUEBLO POTTERY

Archaeological expeditions came to the pueblos in the early 1880s. By that time, too, there were trading posts on the reservations that would accept pots in exchange for merchandise. And soon the first tourists made their difficult treks to visit America's "exotic" cultures, a business boosted by the transcontinental railroads and the Fred Harvey Company.

The rise of the individual artist in Pueblo pottery began with **Nampeyo** (ca. 1860–1942), a Hopi potter in the village of Hano on First Mesa, in northwestern Arizona. (Figure 4.3) (Her name, Nung-beh-yong, Tewa for "sand snake," has been rendered in various phonetic spellings.)[8] As was traditional, Nampeyo was taught to make pots by her mother. She was gifted at the making of undecorated utility pots and decorated polychrome ceremonial wares, which were common women's products. She must have found nearby sources of red, yellow, and gray

Fred Harvey Company

In the last decades of the nineteenth century, the Atchison Topeka and Santa Fe Railway established a marketing campaign to promote the Southwest as a tourist destination. Commissioning painters and photographers to produce beautiful and striking images for corporate advertising, the Santa Fe also "appropriated the American Indian as one of its key symbols."[1] An Englishman named Fred Harvey persuaded the railroad to enhance its reputation by offering fine dining and comfortable accommodations in restaurants and hotels along the route, which he would manage.

The Fred Harvey Company established an Indian department under the direction of Herman Schweizer in 1902. Schweizer bought quality craft objects wholesale from trading posts and opened curio shops and exhibitions in Harvey hotels. The company modeled its displays on those of the 1904 Saint Louis world's fair. They were so successful that the Santa Fe Railway financed extensive presentations by the Fred Harvey Company of Native American peoples and crafts at the 1915 expositions in San Diego and San Francisco.

Crafts were distributed throughout the country, making the Fred Harvey Company the first major commercial purveyor of Indian handcrafts.[2] In 1926 the company introduced "Indian Detours" by automobile. But by 1931, as the Great Depression deepened, few people could afford to travel for pleasure and even fewer would buy quality pottery, silver jewelry, or basketry. Harvey gift shops could sell only inexpensive modern souvenirs, and the Fred Harvey empire disintegrated.

NOTES

1. Timothy W. Luke, "Inventing the Southwest: The Fred Harvey Company and Native American Art," <www.cddc.vt.edu/tim/tims/Tim464.htm>.

2. Barbara Kramer, *Nampeyo and Her Pottery* (Albuquerque: University of New Mexico Press, 1996), 85.

clay, which she carried home, pulverized, and mixed with water she had carried from the springs below the mesa in a ceramic canteen strapped to her back. She probably used her feet to mix the clay. She would have made a sort of pancake of clay to lay in the *puki* (base mold) and added to it thick coils of clay that she would smooth with a stone

FIGURE 4.3.
Nampeyo, Bowl, 1904.
Ceramic, black-and-white
decorations. (Collection of
Ethnographic Museum,
University of Oslo.)

or shell, periodically setting the vessel aside to dry until it was strong enough to support additional coils. She might coat it with white slip and then paint it with mineral colors she obtained and prepared, applying them with a piece of fibrous yucca that had been chewed into a brush. The pot might be wet-burnished with a smooth stone. It would then be baked in an open fire consisting mostly of piled-up sheep dung supplemented with pieces of local soft coal, protected from direct flame with shards.

All this was standard practice and was generally the same procedure followed later by Maria Martinez, although the latter did not paint and usually collaborated with a decorator in her immediate family. Nampeyo's distinction was making large forms, fitting decoration to the form, and making exceptional use of negative space. She might have been a maker respected within her own community but unknown elsewhere, except that she happened to live at the time when the Smithsonian Institution's Bureau of American Ethnology was established by Congress and sent field researchers to the Southwest. As a consequence, Nampeyo discovered a new "use" for Hopi pottery: as merchandise in a cash economy that she was able to enter "without leaving First Mesa or offending a Hopi sense of balance."[9]

Cohesion, strong patterns, and the masterly placing of five designs around the exterior of a vessel were Nampeyo's fortes. She coil-built both slipped and unslipped vessels. Hopi clay cannot be worked thin, so the pots are heavy although graceful in line. Her signature vessels—low jars with a diameter of eighteen to twenty inches and

flattened shoulders—were difficult to build. A jar of unknown date in the Arizona State Museum is painted with five batwing patterns drawn with both filled-in areas of black and fine parallel lines between thick and thin framing lines.

Nampeyo was the only Pueblo artist identified by name in early tourist literature. In 1900 she was photographed by Edward S. Curtis, and she became a favorite subject. In 1905, when the Harvey Company opened Hopi House at the Grand Canyon, Nampeyo and her family, including her potter daughter Annie Healing, spent three months in residence, producing work and being observed by visitors; two years later, they encamped again. The Harvey Company exploited her fame but hypocritically complained that "Nampeyo's party was pretty independent and pretty much spoiled. . . . They did not want to do anything unless they were paid for it."[10]

By the 1920s, Nampeyo was losing her vision, but she went on, and her three daughters were actively potting, taking advantage of the tourist boom. She made pots until her death, but her painting became crude, and she finally yielded the task of decorating to other members of the family. All her work was unsigned—she did not speak English and never learned to write her name—except for a few pieces signed for her by relatives.

The desire of ethnologists, the traders, and the railroads for old Pueblo pots may have sparked a rash of recreations. While 365 Pueblo women listed their occupation as potter in the 1890 census—at the height of the collection period—only Nampeyo and one other woman

gave that identity a decade later.[11] One ethnologist, J. Walter Fewkes, later claimed to have allowed Nampeyo to copy discoveries at his excavation of a fifteenth-century Pueblo town and thus to have initiated the "Sikyatki Revival" of Hopi pottery. Recent scholarship has called that claim into question.[12] In any case, an even earlier trader, Thomas Keams, had commissioned reproductions of old pieces.

Maria Martinez (1887–1980) of San Ildefonso Pueblo in New Mexico was a traditional potter like her female relatives, and early photos show her sitting at the edge of plazas with other women, rolling coils and building pots with completed vessels beside her for sale. (Figure 4.4) Her husband, Julian (1879–1943), painted her pots as well as watercolors of ceremonies and other traditional subject matter. Their early work was polychrome, but in 1908 Julian was one of the workers at an archaeological dig led by Edgar Lee Hewett in which black shards were found. Maria was asked to reproduce the pot as it might have looked, and Julian figured out how to make it black by smothering the fire to produce a smoky atmosphere that carbonized the pots. The first black works, about 1910, were undecorated and were simply done to aid Dr. Hewett.

The Martinezes, however, were intrigued. By 1918 they were producing decorated black ware with mat backgrounds and polished symbols and patterns. Soon they concluded that it was easier to polish the entire background and then apply mat decoration, and that became their signature method. The pots were inspired by that archaeological beginning, but as they worked, the forms became finer, larger, and more perfect and painted rather than plain or textured like the originals. This was commercial work and not for ceremonial or domestic purposes, and it eventually brought them worldwide attention.

In the early years, the two were equally praised or perhaps Julian was given greater credit. A 1932 art-magazine article, for example, noted: "The combination of Marie and Julian, her craftsmanship, his designs, have produced a valuable addition to the cultural life of the pueblos and the whole country."[13] Julian's stylized nature motifs (lightning, birds, butterflies, and, the favorite, the water serpent) seemed an essential complement to her generous and assured forms. Anthropologist Ruth Bunzel asserted that Julian, more than any other individual, had influenced San Ildefonso decorative style and called him "a man of considerable originality and sensitiveness to problems of design" and a "striking personality."[14] He has faded from history, though, perhaps because Maria's pots did not diminish in quality when they were decorated by others.

In the 1920s and since, the Martinezes' joint production has been described as particularly suited to modern interiors. Indian arts had been featured in Arts and Crafts interiors early in the century, but the silvery black ware with its geometric motifs particularly played off art deco. In addition to signing the forms, Julian and Maria also produced an image of themselves on a pot—a very nontraditional work—and in 1933 Maria submitted three entries to the Syracuse Museum's Ceramic National, another first for a Native American artist. She also demonstrated at the Century of Progress Exposition in Chicago (1933) and the Golden Gate Exposition in San Francisco (1939) and later was a visiting artist on college campuses.

As the demand for the black-on-black ware grew too great for them to meet, Maria and Julian taught the technique to other family members and then other potters at San Ildefonso. About ten years after they began, the nearby Santa Clara Pueblo began to produce black ware also, although using different motifs, such as an impressed bear paw and incised fluting rather than painted designs. The Martinez success story was halted by Julian's death in 1943; Maria made no pots for four years afterward. But she outlived him by nearly forty years, variously working with her sister-in-law Santana as decorator or her son Popovi Da in the 1950s and 1960s. Maria's sister Clara was an expert at perfecting the sur-

FIGURE 4.4. *Maria Martinez, Bowl with Water Serpent Design, ca. 1934–43. Earthenware; 5 × 6.5 in. (Collection of Everson Museum of Art, Syracuse, N.Y., Gift of Mrs. Jesse V. Burdhead, 84.23. Photograph courtesy of Courtney Frisse.)*

faces by scraping, sanding, and burnishing. It might be noted that Maria signed pots others had made and decorated, and she slipped, burnished, and signed pots others had shaped. "To the Western art world, this may seem to be misrepresentation; however, within the Pueblo worldview, where community balance and harmony are valued over individual achievement, this was a mechanism by which other artists could share the high prices brought by Maria's overriding fame," scholars Janet Berlo and Ruth Phillips have observed.[15] Besides, the signatures meant nothing to the Pueblo community, where each maker's work was easily recognized.

Wood: Reactionaries and Progressives

WALLACE NUTTING

The most ardent promoter of the colonial revival in the 1920s was an ex-minister turned photographer, Wallace Nutting (1861–1941). Nutting rose from Rockbottom (quite literally: that was the name of the town where he was raised!) to national fame. Having been sidelined

from the ministry by neurasthenia, he started selling hand-tinted photographs of rural New England. The photographs fit in a middle ground between oil paintings (too expensive for all but the wealthy) and chromolithographs (too cheap and tawdry for the respectable middle class). They were a major success. By 1915 he was marketing more than 800 images in different sizes for different budgets.

One of his specialties was carefully posed interior views in old colonial houses, complete with a comely maiden in period costume. These were charming, sanitized, and nostalgic, comforting in a period of rapid social change. Nutting started buying old houses and filling them with antiques to serve as backdrops, but he decided that they could also function as commercial museums and salesrooms. The houses, billed as "The Wallace Nutting Chain of Colonial Picture Houses," were eventually sold to pay down debt. But Nutting shrewdly observed, "Those who know the pictures want the chairs."[16] In 1917 he started producing his own line of reproductions.

He called the venture Wallace Nutting Period Furniture. (Figure 4.5) He took photographs of furniture in

FIGURE 4.5. *Wallace Nutting, #910 Cupboard, ca. 1926–36. Oak and pine. (Wadsworth Atheneum Museum of Art, Hartford, Conn., purchased through the Gift of Charles A. Goodwin.)*

museums and made measured drawings and patterns for his workers. While the originals might reveal the rough craftsmanship of a country carpenter, the reproductions were flawlessly constructed and nicely finished. (He thought it dishonest to put an antique finish on new furniture.)

Like many Arts and Crafts furniture producers, Nutting employed experienced woodworkers, many of them foreign-born. Twelve craftsmen worked in his shop at its peak in 1928. Some Nutting designs, such as a series of tall Windsor chairs, were made from standardized parts that could be produced in large numbers by machine and used interchangeably in different designs. Carving on the furniture, however, was done by hand, as in the originals. His most elaborate items, such as block-front desks and highboys, were made to order.

Eventually Nutting assembled a small empire for cross-marketing his products. Besides the pictures and furniture, he published travel guides and books on colonial furniture, and he lectured widely. All of it was based on a cult of his own righteous, antimodern personality. His advertisements asserted that he was "the greatest authority on Colonial art" and that his photographs always exerted "an elevating influence." Throughout his factory, he posted his own Ten Commandments of labor, including "Let nothing leave your hands until you are proud of your work" and "If the old method is best, use it." At the bottom of the list was Nutting's motto: "To Insure Individuality and Make Men While Making Furniture." Much of this language came straight from Ruskin and Morris, but Nutting was a businessman, and much of his moralistic posturing was little more than good advertising copy.[17]

Still, Nutting never compromised his conviction that his furniture should be made in modest numbers by skilled craftsmen. Its quality made it too expensive for the mass market. In 1930 a mahogany desk-and-bookcase combination retailed for $1,800, a substantial amount of money at the time. Ultimately, the venture was not very profitable, and it outlived Nutting by only four years.

ART DECO FURNITURE

The second half of the decade saw the introduction of art deco style. Many creative immigrants who had been educated in the art capitals of Europe—Vienna, Berlin, Paris, Stockholm—had an enthusiasm for new trends in design not shared by many native-born Americans. They set up shop in various cities, and although they often had to work outside their expertise to make a living, they served as conduits for new ideas.

Despite the prosperity of the Roaring Twenties, demand for furnishings weakened by mid-decade. Consumers were spending money on new electric appliances such as irons, radios, and vacuum cleaners. The furniture industry, faced with excess capacity, needed to stimulate demand.

The new design was kicked off by the 1925 Paris Exposition des arts décoratifs, which gave us today's name for the style; at the time, it was known as art moderne in France and simply as modern in the States. Art deco furniture was a composite of reactionary and radical tendencies. Many basic forms were classical, consisting of monumental pieces patterned after late eighteenth-century French originals but stripped of gilded ormolu and other baroque cabbage. The materials were traditional, too: rich hardwoods from French colonies in Africa and Asia; luxurious surfaces such as shagreen (a type of sharkskin), ivory, crushed eggshell inlay, and lacquer. To this was added a repertoire of images including urns overflowing with flowers, garlands, fountains, maidens in various states of undress, and the occasional parrot.

French designers also embraced the palette of fauve painters: bright reds, turquoise, orange, yellow, and pink appeared in paintings, folding screens, textiles, and women's fashions. They adapted a vocabulary of elements from prewar cubist painters: geometric shapes and sharp contrasts. (Not for nothing was art deco called "zigzag moderne" by some writers.) The mixture of traditional forms and images with avant-garde colors and geometric patterns was fresh, original, and decisively decorative.

The American commission to the exposition included Charles Richards, director of the American Association of Museums. Through his efforts, in 1925 the Metropolitan Museum obtained a cabinet from the undisputed leader of the French ébénistes, Jacques Emile Ruhlmann. The front of the cabinet is slightly bowed. An image of an urn overflowing with blossoms is inlaid in Macassar ebony and ivory and is surrounded by a row of inlaid ivory dots. The feet, tapered and fluted, terminate in elegant little ivory shoes, a Ruhlmann specialty. It's as sumptuous as furniture can be.

In a complete turnaround from exhibiting new furniture based on its own collections, in 1926 the Met presented an exhibition of some 400 objects selected from the Paris Exposition. The show was tremendously influential. Not only did other museums subsequently host comparable exhibitions, usually with American contributions, but dozens of department stores across the country followed suit. (One writer observed: "Again the modern department store asserts its role as a living museum of decorative and industrial art, informing the pub-

lic as to the newest trends in decorative art and in the wisdom with which the selection is made, exerting a strong formative effect upon public taste.")[18] Shows would typically feature temporary rooms filled with furniture and accessories. A display at Lord & Taylor in 1928 included paintings by Picasso, Braque, and Derain. These department store exhibitions were remarkably popular: Macy's in New York mounted one that drew a quarter-million people in two weeks.

Critical reaction to art deco was mixed. Accustomed to tame revival furniture, many writers thought the new French design was bizarre. Critic Thomas Craven rhetorically asked, "Shall we throw out of our living quarters those things which reflect and charm and relax the many-sided personality of man and for the sake of a shallow theory of beauty, substitute the slippery, sterilized commodities manufactured by indigent Frenchmen?"[19] American manufacturers hesitated to introduce goods in the new style because it would require expensive new tooling, and they feared its popularity would fade quickly. But some designers and studio craftsman, particularly in New York and particularly in the field of furniture, took it quite seriously.

In 1925 most custom-made furniture was produced as part of a coordinated interior, for which a single designer had overall responsibility. Often these designers were trained craftsmen themselves. They worked in the French tradition of the *ensemblier*—we would now call them interior designers. Many, however, operated their own shops, where their designs could be fabricated under close supervision. (Some may have worked with their hands, as William Morris sometimes did, but this information was rarely recorded.) Most shops centered on furniture making, but in-house studios might also produce architectural molding, leatherwork, carpets, draperies, and ironwork. For the most part, these shops catered to the tastes of their rich customers, meaning that they worked mostly in revival styles. But many young designers, both native and foreign born, embraced art deco as a breath of fresh air.

DONALD DESKEY

One such enthusiast was Donald Deskey (1894–1989). Born in Blue Earth, Minnesota, he left for California as soon as he graduated from high school. He studied painting at schools on the West Coast, in Chicago, and in New

York; served in the army; and went to Paris around 1922 to complete his studies. While in Europe, he saw the 1925 Paris Exposition and visited the Bauhaus. Inspired, he moved to New York in 1926 to work as a freelance interior designer.

First he designed window displays for department stores. He must have made a splash, because the president of Saks Fifth Avenue reviewed a portfolio of his furniture designs and referred him to Paul Frankl, a designer from Vienna who ran a modernist showroom in Manhattan. Deskey then made several folding screens for Frankl, charging $35 apiece. Frankl, who had the connections to clients that Deskey did not, sold them for $400 each. No doubt the markup motivated Deskey to go out on his own as quickly as possible.[20]

The screens were pure art deco. In one example, angular black forms divide areas of brushed metal leaf, and double stripes of bright red act as a counterpoint. (Figure 4.6) The pattern was hand-painted on canvas, possibly by Deskey himself. Black and red was one of the most fashionable color schemes of the day, and the brushed metal added a suggestion of machinelike efficiency. In 1928

FIGURE 4.6. *Donald Deskey, Three-Panel Screen, ca. 1928. Oil on canvas, metal leaf, wood; 77.75 × 58.75 × 1.25 in. (© Virginia Museum of Fine Arts, Richmond, Gift of the Sydney and Frances Lewis Foundation. Photograph by Katherine Wetzel.)*

the effect was ultramodern—at once recalling cubism, machines, hot jazz, and French sophistication—as opposed to the cozy, suburban, and middle-class character of Arts and Crafts designs. It is calculated to function as a visual accent in an up-to-date interior.

Deskey formed a company that supplied everything needed for a fashionable interior, including furniture and lamps, murals, carpets, and wall coverings. The firm pioneered the use of industrial materials for interior walls and ceilings: asbestos sheet and aluminum, stainless steel and Vitrolite (cast opaque glass), copper, cork, and Bakelite. The range of materials that he used would present a problem for a traditional craftsman. No one worker could handle all those materials competently, nor could a single studio accommodate all the tools required. Even though most of his furniture in the late 1920s was apparently handmade, he did not follow the craft workshop model. Instead, he sent his work out to job shops. The gulf between designer and fabricator widened, until his furniture was no longer craft but what we now call industrial design.

AND IN CLEVELAND . . .

Other furniture designers in New York embraced art deco and its immediate predecessor, the Vienna Secession style. Among them were Ilonka Karasz, Walter von Nessen, and Eugene Schoen and architects Raymond Hood and Ely Jacques Kahn. The influence of art deco was also felt beyond New York. One of the centers of production was Cleveland, in the late 1920s a prosperous metropolis with the world's second-tallest building. One decorator in Cleveland who worked in the style was Louis Rorimer (1872–1939).

Rorimer's main enterprise was a large company that could build, carve, upholster, and gild furniture and even make draperies. Like many of his colleagues, he designed mostly in historicist styles, from Jacobean to chinoiserie. From about 1906 to 1916, he had cooperated in a metalworking shop with three women: Mary Blakeslee, Ruth Smedley, and Carolyn Hadlow Vinson. Called the Rokesley Shop, it produced Arts and Crafts jewelry and silver, but Rorimer was drawn to art deco. After seeing the 1925 Paris Exposition, he designed a few interiors in a thoroughly French manner, complete with zigzag upholstery. In one 1929 suite of furniture, the frame of a chair is in the shape of a lyre, a classical motif favored by French designers, and upholstered in a fabric of the period that shows a strong cubist influence. (Figure 4.7) Of the three pieces, the side table is the most forward-looking. Its architectural forms and restrained decoration anticipate the streamlined furniture to come.

FIGURE 4.7. *Louis Rorimer,* Armchair, Lamp Table, and "Skyscraper" Bookcase for Mr. and Mrs. John B. Dempsey of Bratenahl, Ohio, *1929. (Western Reserve Historical Society, History Museum, 1971.84.4 and 1971.84.6.)*

FIGURE 4.8. *George Christian Gebelein, Coffee Set, ca. 1929. Sterling silver, ebony. (Collection of David L. Thomas.)*

Jewelry and Metals: Traditionalists and Modernists

GEORGE CHRISTIAN GEBELEIN

George Christian Gebelein (1878–1945) was another smith in the Boston area who came to specialize in colonial revival silver. Born in Bavaria and raised in Cambridge, Massachusetts, Gebelein learned his craft at a prominent Boston firm, Goodnow and Jenks. After working for several other firms (including Tiffany & Co.), he opened a shop in 1909. He styled himself as the modern-day successor to Paul Revere and even managed to acquire some of Revere's old tools.

Gebelein was known to make silver services patterned on original Paul Revere designs. However, Gebelein's versions were not necessarily slavish copies. Proportions might change, as well as details. In one case, Gebelein made a fluted sugar and waste bowl to match a close reproduction of a Revere teapot he had made in 1920, even though Revere is not known to have made any fluted sugars and creamers. In a coffee set from about 1929, Gebelein employed an urn shape that was popular among Philadelphia silversmiths around 1800. (Figure 4.8) The original coffeepots referred to the neoclassical architecture that symbolized the aspirations of the new American republic, but they would have been more heavily decorated than Gebelein's version. Like most colonial revival furniture, subtle revisions identify these designs as belonging to the twentieth century. Still, the coffee set is beautifully made, equal to its colonial-era prototypes.

The cost of Gebelein's craftsmanship caused problems: his high prices brought complaints from retailers (even the New York National Society of Craftsmen, which should have been sympathetic). Things became so difficult that he finally bought a spinning lathe and repro-

duced hollow forms on a semi-industrial basis. He also developed income streams other than his studio work, selling antique English and American silver on the side, but he declined offers to mass-produce his designs.

Gebelein's experience encapsulates the situation encountered by many craftspeople early in the century: while he was highly respected, his client base was reluctant to pay for the best craftsmanship. He adapted in a number of ways. He used colonial prototypes as starting points rather than copying the originals. He produced flatware, ecclesiastical silver, and trophies as well as pewter and brass wares. His business weathered World War I and the Great Depression, and it survived Gebelein's death in 1945. Eventually, the family sold the name to an antiques dealer.

EDWARD EVERETT OAKES

While most Arts and Crafts work was fading by the beginning of World War I, jewelry in the style endured well into the 1940s in Boston due to the standards of the SACB. One of the last innovators in the Boston style was Edward Everett Oakes (1891–1960).

Oakes was a natural craftsman. As a boy, he built kites that were renowned in Boston. At age eighteen, he apprenticed with Frank Gardiner Hale. After five years with Hale, he worked for Josephine Hartwell Shaw for another three. Like many Boston smiths, he was an avid student of historical metalwork, and his jewels could evoke cultures as disparate as the Italian Renaissance and Mughal India.

From Hale he adopted open frames made of gold

FIGURE 4.9. *Edward Everett Oakes, Brooch, ca. 1925. Gold, pearls, beryl; 0.87 × 1.25 in. (Museum of Fine Arts, Boston, Gift of Daniel and Jessie Lie Farber, 1986.764. Photograph © 2008 Museum of Fine Arts, Boston.)*

Georg Jensen

Shortly after the turn of the century, Georg Jensen (1866–1935), a young Danish sculptor, turned to silversmithing and jewelry making to support his family. He evolved a style that was an amalgam of art nouveau and Arts and Crafts. His jewelry was simple, graphic, and based on nature imagery such as fleshy leaves, buds, and dragonflies. It had a chunky quality unlike French jewelry and a rhythmic grace lacking in English Arts and Crafts jewelry. By the 1920s, his company was mass-producing silver jewelry for an international market. At the same time, his smiths made silverware decorated with pods and leaves. The Jensen style had a classical feel but was recognizably modern. His thick, sensuous forms had broad appeal.

Jensen astutely hired talented designers who continued to update the look. He also managed to get his products shown extensively in the United States. Young customers could content themselves with a silver brooch, while wealthier clients could buy whole tea sets. It was a winning formula. In 1924 he opened a shop in New York, which thrived. Jensen silver became an international symbol of tasteful modernity.

MARIE ZIMMERMAN

Marie Zimmerman (1878–1972) was an accomplished metalsmith whose career spanned the first four decades of the century. (Figure 4.10) Born in Brooklyn, she defied her family's wishes by taking metalworking courses at Pratt Institute just before the turn of the century. While she also studied painting and sculpture at the Art Students League, her métier would prove to be metal. She worked in silver, platinum, gold, bronze, copper, steel, and wrought iron, combined with other materials as diverse as precious stones, wood, glass, and mosaics.

Zimmerman received her first major recognition about 1912, when she was invited to join the National Arts Club (whose members included William Merritt Chase, Alfred Stieglitz, and three U.S. presidents). She had a studio in the club's mansion on Gramercy Park in Manhattan, a prestigious address. By the 1920s, she was one of America's best-known metalworkers. The Metropolitan Museum purchased one of her silver boxes in 1922, and her work was featured in magazines such as *International Studio, House and Garden*, and *Vogue*.

Zimmerman's work defies categorization. She is perhaps best remembered for an extended series of bronze bowls based on Tang dynasty examples in silver that she would have seen during her many visits to the Met. Her bowls were modeled into leaves or lobes—a common enough device—but her experiments with an astonishing variety of coloring techniques made them unique. Many were brilliantly colored with both patinas and paints; others were plated in gold. She made prototypes that her staff of skilled craftsmen produced in multiples. The production versions were spun on a lathe, but the various swellings and seams were hammered by hand.

Zimmerman was known for using antique carvings

wire; from Shaw he inherited a taste for semiprecious stones and pearls. Oakes favored oak leaves—they became his signature motif—and would often notch both frames and bezels. A rectangular pin from about 1925 is built around a large faceted beryl, with four large pearls at the corners of the frame. (Figure 4.9) Small pearls and oak leaves enliven open spaces, and two tiny spirals accompany each curved leaf. All these elements are interspersed with minuscule gold beads formed into a cup shape resembling an acorn cap. To add rhythm to the whole composition, both the frame and bezels holding the large pearls are regularly notched. All this is packed into a space of only ⅞ by 1¼ inches!

Despite his finesse, Oakes represented the end of the line. What had started with the "savageness" of Madeline Yale Wynne's funky buckles had transformed into the refinement of Oakes's golden jewels. While he continued to receive wide acclaim through the 1930s, his work began to look out of date. He eventually gave up the fine detail and the enclosing frames and worked in a less elaborate style resembling Georg Jensen's.

FIGURE 4.10. *Marie Zimmermann,* Covered Box on Stand, *ca. 1925–35. Copper, jade; 9 × 15 × 6.12 in. (Museum of Fine Arts, Boston, Gift of John C. Zimmermann, 1991.1094A-C. Photograph © 2008 Museum of Fine Arts, Boston.)*

from all over the world: Egyptian scarabs, Chinese jade, Roman cameos. She mounted these as finials on covered containers, often made of silver. At one point, she raised bowls in the form of dry, curled-up leaves. She also made vessels and candlesticks in cast bronze, which she patinated. In the 1920s and 1930s, she worked with a blacksmith, producing candelabra as much as five feet tall. One of her most unusual commissions was for two sets of mausoleum gates for the Montgomery Ward family. Zimmerman was fearless; she would try anything. Like many artists, she received fewer commissions after 1929. She did not adapt to the taste for streamlined, machine-like forms. Faced with declining business, she gave up the lease on her studio in 1937. Eventually, she withdrew from metalworking completely and was gradually forgotten. Fortunately, the Met, one of her earliest supporters, featured her bowls in a small solo show in 1985, and her reputation has since been revived.

ERIK MAGNUSSEN

An interesting case study of the way silver design changed in the 1920s can be found in the work of Erik Magnussen (1884–1961). Born in Denmark, Magnussen trained as a sculptor and studied at the Kunstgewerbeschule in Berlin. It is said that he taught himself to do metalwork, becoming a skilled chaser. By 1907 he was producing silver jewelry in the manner of Georg Jensen, and he went on to achieve modest success as a silversmith and independent designer. In 1925 Gorham Manufacturing Company hired him to reinvigorate the company's silverware design, at that time dominated by colonial revival. As art director, Magnussen fostered a pleasant neoclassicism that was entirely in keeping with the times. As was traditional for head silversmiths in Danish shops, he sometimes made prototypes for production, thus functioning as both craftsman and designer.

A covered candy dish designed by Magnussen about 1926 is typical of the period. (Figure 4.11) The ivory stem is reeded, and its foot and stem bear balls and little scrolls, flourishes employed by Jensen. The overall look would have appealed to an American customer, but it is clearly not based on a colonial prototype.

When art deco arrived, Magnussen, recognizing that one of its roots was in cubist painting, designed and made an extraordinary coffee set for Gorham in 1927. (Figure 4.12) Titled both *Cubic* and *The Lights and Shadows of Manhattan*, the set consists of a coffeepot, creamer, and sugar bowl on an irregular-shaped tray. The forms are divided into facets enlivened with triangles of applied gold or oxidized silver. The cubist effect continues in the

FIGURE 4.11. *Erik Magnussen, Candy Dish, 1926. Sterling silver, ivory; height, 8.75 in.; diameter, 6.62 in. (Dallas Museum of Art, Gift in memory of Ethyl Carradine Kurth.)*

FIGURE 4.12. *Erik Magnussen, Cubic Coffee Service, 1927. Sterling silver, patinated, oxidized, gilt decoration, ivory; coffeepot: 9.5 in. (Museum of Art, Rhode Island School of Design, The Gorham Collection, Gift of Textron, Inc., 1991.126.488.1-4. Photograph by Erik Gould.)*

handles, spout, and finials. Even the ivory insulators are geometric. While Magnussen's forms have nothing to do with the concepts that motivated Picasso and other cubist painters, they represent a radical break from silversmithing conventions. That the tray has no handles suggests that this set was built for display, not for serving. Maybe its sole function was to propose that silverware design need not be enslaved by historicism.

There were various reactions to the radical gesture. Critic Elizabeth Lounsberg enthused: "In this new design of the sterling silver coffee service a strong response to the spirit of modern America is exhibited. As applied to sterling, this spirit takes the form of sharp angles and sharp variations of light and shade, which are clearly the product of those phenomena found in our skyscraper civilization."[21] But others disagreed. One writer called it "cubist claptrap in silver," and another asserted that the design of silverware should be kept free from both architecture and modernism, saying that "skyscraper architecture belongs to city buildings and not to table silver."[22]

Although several of Gorham's competitors produced imitations, Magnussen never further explored the possibilities of cubist silver. He left Gorham in 1929, worked for a German silver company, and later opened a series of shops in New York, Chicago, and Los Angeles. He returned to Denmark in 1939, eventually becoming known for enameled jewelry.

SAMUEL YELLIN

The premier American blacksmith of the 1920s was Samuel Yellin (1885–1940). Like most of the best American metalworkers, he was born and trained abroad. Yellin was a native of Poland who learned his craft from a local smith. He left his home in 1902 and is said to have worked in Germany, Belgium, and England before he finally settled in Philadelphia in 1906. While taking a course on the history of decorative art at the Philadelphia Museum School of Industrial Art, he caught the attention of the metals instructor. By 1908 he was asked to build a forge in a carriage house in back of the school, and he started teaching a course in wrought iron. He was on his way, meeting architects and future patrons. The next year, he opened his first blacksmithing forge—on the fourth floor of a downtown apartment building.

Yellin's skill and knowledge of historical ironwork served him well. Beginning with one assistant, he built a prosperous business. By 1915 he had constructed his own shop. Ultimately, he employed more than 250 workers, producing mostly architectural ironwork. He was prag-

matic, understanding that large projects demanded division of labor. Yellin would negotiate with his clients, draw up designs, and sometimes forge studies, but most of the labor was done by his employees.

Yellin's work was firmly rooted in tradition. His shop could imitate any period, from the Gothic to the baroque, in pure or hybrid versions. His ironwork fit comfortably in the Beaux-Arts buildings of the 1910s and 1920s, providing detail and texture and a sharp contrast of material. Above all, Yellin iron imparted an impression of establishment grandeur and continuity. Not surprisingly, he never embraced art deco.

An example of Yellin's approach to iron design is a 1922 gate to the Harkness Memorial Quadrangle at Yale University. (Figure 4.13) The basic structure of each door is a framework of eighteen squares. Two interior vertical bars pass through each of five crossbars, a traditional device in European blacksmithing. The horizontal element expands where it is penetrated by a vertical element, thus exploiting the way hot iron can be stretched and manipulated. Within the grid, a variation of a quatrefoil fills each opening. Purely decorative designs alternate with insignia from the American armed forces, and relief images of soldiers are placed in the side panels. No two designs or insignia are the same. The gate's elaborate cresting is more typical of seventeenth-century French baroque, although the scrollwork is populated with animals and birds more common in Gothic work. (Yellin encouraged his smiths to design the decorative animals themselves.) The whole is an eclectic mix, at home in the neo-Gothic architecture it adorns.

Yellin was a purist when it came to technique. He believed that the elastic properties of hot iron should be exploited and respected. He was distraught when iron was made to imitate cast metal and abhorred Renaissance blacksmithing that used mortise-and-tenon joints, treating iron as if it were wood. In a sense, he extended Pugin's idea of truth to materials to a doctrine of true technique. He was willing to use modern conveniences (his shop used electric motors to blow air into his forges, and he used commercial bars and rod stock), but he refused to betray iron's plasticity.[23]

Yellin objected to reproducing designs for ironwork made by architects because they did not understand the form language native to forged metal. He argued that the architect should provide a general description of the job—size, style, function—but leave the design to the blacksmith. He could get away with this attitude most of the time.

The Great Depression diminished Yellin's business,

FIGURE 4.13. *Samuel Yellin*, Gates for Harkness Memorial Quadrangle, Yale University, *1922. Wrought iron; 8 × 7 ft. (Photograph courtesy of Samuel Yellin Metalworkers.)*

and he died in 1940, at the age of fifty-five. His shop continued operating on a much smaller scale until the 1970s. Today he is seen as a hero to many contemporary blacksmiths for his skill and his ambition. Yet compared with such contemporaries as the French smith Edgar Brandt, Yellin showed creativity only in details and refinements. Brandt tried new alloys, including white bronze and stainless steel; Yellin stuck to iron. Brandt embraced art deco; Yellin rarely departed from his familiar eclecticism.

ROSE IRON WORKS

Another major forge in the 1920s was Rose Iron Works of Cleveland, founded in 1904 by Martin Rose (1870–1955), a Hungarian émigré who had studied metalworking in Budapest and Vienna. For years, Rose Iron Works supplied architectural ornament to Cleveland and its surrounds, often in competition with Yellin.

In 1929 Rose hired a talented young designer, Paul Fehér (1898–1992). Fehér, too, was born in Hungary, but he had also designed for a leading art deco blacksmith in Paris, Paul Kiss. French blacksmiths had been experi-

menting with new stainless-steel alloys as well as nonferrous metals such as bronze and aluminum. Much French ironwork was intended for interiors, so it was often finished to a satiny surface. Sometimes parts were gilded or cadmium-plated to prevent rust. Fehér brought this sophistication in both technique and design to American metalworking.

Together, Rose and Fehér produced a range of objects, most for interiors. A screen from 1930 features the nude female almost obligatory in art deco, accompanied by a host of leaves, zigzags, arcs, and scallops. (Figure 4.14) Some flowers are fantastic cubistic inventions. To add color contrast, the figure is plated in gold, and other parts are silver-plated. The only visible references to forging are the light hammer marks on the surrounding frame and thick vertical bands. The rest of the screen is finished like a huge piece of jewelry.[24]

Rose Iron Works made art deco objects for only five years, from 1928 until 1933. It was probably impossible to sell such elaborate productions in the middle of the Depression, and the style had fallen out of favor by that time, even in France. Nonetheless, the Fehér-Rose col-

FIGURE 4.14. *Paul Fehér, Rose Iron Works, Art Deco Screen, 1930. Wrought iron, brass, silver, gold plating; 61.5 × 61.5 in. (© Rose Iron Works, on loan to the Cleveland Museum of Art from the Rose Family Collection, 352.1996.)*

laboration represents one of the few times American decorative arts matched French work in sophistication and technical accomplishment.

WILHELM HUNT DIEDERICH

Wilhelm Hunt Diederich (1884–1953) was the grandson of American painter William Morris Hunt and the son of a wealthy landowner in the Austro-Hungarian Empire. He studied sculpture in Philadelphia, at the Pennsylvania Academy of the Fine Arts, later continuing his studies in Paris and Rome. Unlike most of his contemporaries, who thought of sculpture as cast in bronze or carved in stone, Diederich worked in a variety of mediums. He often employed wrought iron and sheet metal as well as ceramics.

Diederich's metalwork usually featured flat cutouts of animals mounted on a wrought-iron structure. (Figure 4.15) In a 1920 exhibition catalog, he remarked: "As a child of five I embarked on my artistic career by cutting out silhouettes of animals with a pair of broken-pointed scissors, for I love animals, first, last and always. . . . Animals seem to me truly plastic. They possess such a supple, unspoiled rhythm."[25] A 1925 fireplace screen displays two highly stylized running greyhounds with elongated and sinuously curved bodies. A few lines chased

FIGURE 4.15. *Wilhelm Hunt Diederich, Candlestand, ca. 1925. Wrought iron; 78.5 × 18 in. (Collection of The Wolfsonian-Florida International University, Miami Beach, Fla., The Mitchell Wolfson, Jr., Collection, TD1988.153.1.)*

in the sheet metal describe eyes and musculature and overlapping forms, but the effect relies mostly on Diederich's dynamic shapes and idiosyncratic drawing style. The dogs bare their fangs and snap at each other.

Diederich produced functional objects in craft mediums because he thought traditional sculpture was too remote and inaccessible. It was an unorthodox opinion, and he was an unusual person.

WILLIAM BRIGHAM

While most jewelers and metalsmiths in the 1920s produced for the marketplace, William Brigham (1885–1962) made work for his own pleasure. The son of a jeweler, he studied at the Rhode Island School of Design (RISD) and Harvard University. By 1910 he was a teacher, first in Cleveland and then at RISD. He married a prominent socialite; between his academic position and his wife's wealth, he was not obliged to sell his work. After he retired, he specialized in beautifully made, fanciful objects that would have been very difficult to market.

A jeweled ship from the late 1920s is typical. (Figure 4.16) It is based on a nef, a late medieval piece of tableware in the form of a ship. It is consciously historicist

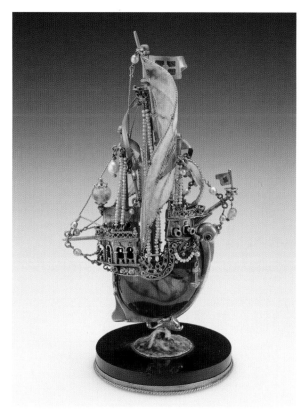

FIGURE 4.16. *William Edgar Brigham, The Argosy, ca. late 1920s. Amber, gold, enamel, pearls; 5.37 × 2.62 in. (Museum of Art, Rhode Island School of Design, Gift of the estate of William E. Brigham, 1963.011.85.)*

and a calculated demonstration of skill—rather like Koralewsky's *Schneewittchen* lock of the previous decade. In a sense, the little ship is craft-for-craft's-sake: an objet d'art that has no function other than to be admired. There is a long tradition of craft objects that were not made to be used, from trophies to Rookwood vases. They were decorative, symbolic, or maybe autobiographical.

In the 1930s, Brigham adapted to the style of the times and worked with an unadorned geometry. He and his wife founded the Villa Handicrafts workshop near Providence, which produced tapestries throughout the 1940s. Late in life he wrote several articles for *Crafts Horizons* magazine, thus providing a rare link between the Arts and Crafts movement and the postwar revival.

Textiles in Transition

The 1920s was a decade of change in textiles. The colonial revival led to new interest in such old forms as samplers, while the aftermath of World War I and the development of occupational therapy added therapeutic purposes for weaving and basketmaking. At the same time, the first indications of modernism in textile design emerged. Here, as in other mediums, design began to split away from hands-on craft, ultimately creating more of a divide than existed in Europe.[26]

The needlework sampler was an archaic form that served an educational function for colonial girls. It was updated by descendants of the early New England settlers, such as Mary Saltonstall Parker of Salem, Massachusetts, who presented in naive style such modern subjects as the railroad and the Great War home front. That the new samplers were brighter in color and more cheerful in sentiment than the originals was attributed to modernist influence, as was the contemporaneous revival of the patchwork quilt. In 1922 a book containing new research on samplers and Candace Wheeler's book on embroidery were published. The new magazine *Antiques* published eight articles on textiles in its first two years, an indication of the regenerated interest.

Hand-hooked rugs were popular for colonial revival houses, though the antiquity of the type is uncertain. Mariet Nutting, wife of Wallace, was responsible for this aspect of the Nutting enterprise. At the same time, at Rosemont, an old house in Virginia, Laura S. Copenhaver designed rugs for women to hook at home. Her designs featured colonial sites such as Washington's birthplace. In New England, 600 women worked in their homes for Pinkham Associates, turning out handmade braided rugs. The Maine firm maintained showrooms on New

York's Madison Avenue. There were also hooked-rug enterprises in the Southern Highlands. In this decade textiles came to be appreciated for their stylistic qualities rather than their pedigrees.[27]

WEAVING FOR MANY PURPOSES: MARY MEIGS ATWATER

Mary Meigs Atwater used her artistic and technical aptitudes to recover forgotten handweaving patterns and techniques as well as to introduce weaving to large numbers of people through a newsletter and books. She was also a popularizer of the workshop method of teaching. Yet she stands slightly outside the twentieth-century shift to studio crafts, due to her preference for the practical and her concern with the needs of subsistence and hobby weavers rather than with gallery shows or personal expression. This stance was criticized in the 1940s (see chapter 6).

Atwater (1878–1956)—born in Rock Island, Illinois, and raised in Keokuk, Iowa—was the oldest of six girls. Her grandfather was a renowned architect who designed the Pension Building (1887), now the National Building Museum, in Washington, D.C. She loved math and wanted to be an electrical engineer, but her businessman father would not let her go to MIT. So she pursued other interests, studying painting and design in Chicago, at the School of the Art Institute, and in Paris. She married a mining engineer and moved to Montana.

There, in 1916, she took up weaving, using information from an industrial arts magazine to experiment on a small table loom. She knew about Berea College's Fireside Industries and decided weaving could be a social-service project in her small community. She hired an instructor from California, bought looms, and set up a program of free instruction in which those who developed skill could then weave for pay. Only a few years later she joined the army and moved to Washington State to become an occupational therapist working with wounded veterans. When her husband died in 1919, she left the army and moved to Seattle, where she worked as a therapist and weaving teacher to support her two children. In 1922 she prepared a correspondence course in handweaving that was tested at the University of Washington. Atwater then established the Shuttle Craft Guild and in 1924 began to issue the handweaving course via monthly bulletins. In the midst of all that she moved to Cambridge, Massachusetts, when her son went to Harvard.

The correspondence course grew so large that Atwater gave up occupational therapy to manage it. She opened a studio to serve as a weaving-supply business, and in September 1924 she began mimeographing the first periodical for handweavers, *The Shuttle-Craft Guild Bulletin*. It continued for thirty years. In 1928 she published her first book, *The Shuttle-Craft Book of American Hand-Weaving*. (Figure 4.17) What she called her *Recipe Book* followed in 1931. Of the latter she wrote in the bulletin: "It is to be a book for weavers on the plan of a cookery book, giving the draft, schedule of materials used, treadling instructions, and in some cases suggestions for color combinations. Most of the recipes are taken from unusually suc-

FIGURE 4.17. Mary Miegs Atwater, bow-knot overshot draft and pattern, reproduced in her Shuttlecraft Book of American Hand-Weaving (1928), 191. (Courtesy of the American Craft Council.)

cessful actual weavings. Guild members are invited to contribute and also to suggest recipes desired."[28]

The instructor Atwater had hired for her original program in Montana was skilled only in four-harness overshot patterns, so that was what she learned first. She later encountered this type of pattern in museum collections. In the Pennsylvania (now Philadelphia) Museum of Art she came upon an old pattern book of drawings by John Landes, a professional weaver in colonial times. She was permitted to publish the drawings as facsimiles; she added her own drafts to enable readers to weave the old patterns.

Atwater also looked for patterns in libraries and private collections. She "unlocked the secret of the summer-and-winter weave—the most beautiful and the most distinctively American of the weaves used by our early craftsmen"[29] and deciphered the construction of a double weave described as lost by various reference books. She speculated that her training in mechanical drawing or "perhaps some special aptitude inherited from forgotten craftsmen of my line" enabled her to puzzle them out.

Atwater answered the questions of hundreds of letter-writers, patiently helping even utter novices, recognizing that many were working in isolation. In 1935 she began summer meetings in Montana, and in 1937 her first "weaving institute" was held in Colorado. Perhaps she was essentially seeing weaving as a kind of occupational therapy. She wrote that weaving was "built into the human nervous system" and that this "urge in our brains and our fingers" persisted even in the face of industrial production.[30]

Atwater introduced her readers to such exotic textiles as Osage braids, Peruvian doublecloth, and Guatemalan patterning. She also employed macramé, inkle weaving, and lace weaves before nonloom construction was widely adopted. She was fascinated by textile constructions and delighted by the logic of drafts, just as she enjoyed mathematical puzzles and crossword puzzles. In addition to her other activities, she wrote novels and short stories and published a detective novel.

MODERN TEXTILE DESIGN

Both the Deutscher Werkbund and the Wiener Werkstätte influenced American textile design. The latter was known through exhibitions, the celebrated but short-lived Werkstätte showroom in New York that opened in 1923, and rugs and interiors by Wolfgang and Pola Hoffmann. It was also seen in textile designs by Joseph Urban, Werkstätte alumna Vally Wieselthier (a ceramic sculptor who immigrated to the United States at the end of the decade), and Maria Kipp, who relocated from Mu-

nich to Los Angeles and designed for decorators and architects, including such fellow émigrés as Richard Neutra and Rudolph Schindler.

In the 1920s the most influential modern European weaves were those of Paul Rodier of Paris—subtle mixed-fiber fabrics woven and embroidered by cottage workers. By 1928, "Rodier fabrics" meant "modern"; the aspiring American designer Dorothy Liebes (see chapter 5) spent 1929 in his atelier. His textiles emphasized weave, not color, but another European influence was the palette of couturier Paul Poiret. French textile design was shown in New York in a 1926 exhibition at the Metropolitan Museum and in Macy's and Lord & Taylor stores in 1928.

Block and screen printing were in use, but the latter became more prevalent; it was faster and more suited to serial production. Particularly important was the ease with which textured ground cloths could be printed, as Ruth Reeves showed by using thirteen different cotton fabrics, including terrycloth and velvet, in a project for W. & J. Sloane. Considered distinctively American, screen printing linked art, craft, and industry.

This period was also characterized by the use of decorative, nondescriptive color, stylized motifs, modern materials, a new appreciation of textured weave structure, and an interest in quoting sources as disparate as European historical patterns and folk art of the Americas.[31] In addition, angularity and abstraction were "new," although they were introduced through Egyptian motifs fashionable after the opening of Tutankhamen's tomb in 1922 and through Russian constructivist textiles. There was increasing interest in "primitive" objects in American museums, including African and Peruvian textiles and pottery and American Indian artifacts. Patterns with stepped or jagged edges, abstract symbols, or geometric motifs were exported to Europe after the war, indicating that Hoover was mistaken when he asserted that the United States had nothing "modern" for the 1925 Paris Exposition.[32] A new consideration was the effect of electric light on interior fabrics. Its relative uniformity seemed to flatten surfaces by washing out shadows. Modern-style furniture responded with reflective surfaces, while the answer in textiles was bold patterns or subtle shifts in color.

RUTH REEVES

Ruth Reeves (1892–1966), who created hand-blocked modern textiles and was influenced by French and non-European precedents, was a designer with close ties to handcrafts. She studied painting at Pratt Institute in Brooklyn and the Art Students League in Manhattan and

FIGURE 4.18. *Ruth Reeves, designer, W. & J. Sloane Ltd., U.S.A., Manhattan Fabric, ca. 1930. Block-printed cotton; 35.12 × 52.5 in. (© V&A Images/Victoria and Albert Museum, London.)*

lightninglike diagonals, symbolizes electricity. The textile firm W. & J. Sloane commissioned twenty-nine designs from her, which were exhibited in 1930. One of them, the block-printed *Manhattan*, reflects her environment of jazz-age New York. (Figure 4.18) It incorporates emerging icons of modernity such as skyscrapers, factories, and bridges, as well as modern modes of transportation, including airplanes, ocean liners, trains, and automobiles. A visual collage, the design encompasses historic sites, switchboard operators, and elegantly dressed partygoers. This fabric, for a wall hanging or curtains, was printed on cotton in various color schemes, such as black on green. Another of the Sloane textiles was *American Scene*, also a collage of vignettes—executed in shades of green, lavender, and blue—which represent Reeves's family and friends. A woman at a table with a cat on her lap is probably the artist herself.

Reeves's "American Modern" designs were displayed first in a solo show, which brought her considerable attention, and later in the third touring exhibition of the American Federation of Arts, *Decorative Metalwork and Cotton Textiles*. Her designs were often published in interior design magazines. Unfortunately her career coincided with the Depression, which limited her options. Most firms were looking for the safe product, not adventurous work.

From the 1930s, Reeves took every opportunity to study the art of early Andean, Mayan, and Guatemalan peoples. In 1934 she traveled to Guatemala, sponsored by the Carnegie Institution, and returned with textiles for an exhibition at Radio City in New York. She was attracted to their simple forms, clear patterning, and color. Reeves was also important as the first national coordinator of the Index of American Design, an ambitious Depression-era government-financed project to create a pictorial record of decorative and folk art, with illustrations by American artists. She conceived of it as an educational and reference tool for future generations of students, artists, and industrial designers.

LOJA SAARINEN

The Loja Saarinen textile studio was an important source of modernist rugs and wall hangings beginning in the 1920s and continuing through the 1930s. But Saarinen's place in the history of studio crafts is uncertain. Louise (Loja) Gesellius (1879–1968) attended art school in Helsinki and studied sculpture in Paris prior to her marriage to architect Eliel Saarinen. At first she continued her work as a sculptor, photographer, and interior decorator. After the birth of their children, Pipsan and Eero, in 1905 and 1910, respectively, she devoted most of her

with Fernand Léger at the Académie moderne in Paris (1920–27). On returning to the United States, she emulated Léger in producing textile designs. Her innovative fabrics were often derived from her cubist-influenced paintings. Along with such modernist peers as Donald Deskey, Paul Frankl, and Ilonka Karasz, Reeves showed her designs in the first American Designers' Gallery exhibition in 1928.

One of her early works was a rug for the "new domestic phenomenon" of the 1920s, the radio room. Her palette of red, blue, and green was chosen to suit modern aluminum furniture, and the design, full of energetic,

time to assisting her husband in his work, especially by constructing architectural models.

The Saarinens came to the United States in 1923, when Eliel was runner-up in a competition to design the Chicago Tribune tower. They first lived in Evanston, Illinois, where Loja and Pipsan exhibited batiks, but moved to Ann Arbor when Eliel began to teach at the University of Michigan. Among his students was the son of George Booth, which led to his being solicited by Booth to design the campus for the new Cranbrook Academy of Art. The family moved to Bloomfield Hills in 1925, and Loja made the original model of the academy after Eliel's plans. She established a textile studio primarily to provide quality fabrics—including rugs, upholstery fabric, tapestries, draperies, and table linens—for the interiors of buildings he designed. Loja did not weave any of the textiles. She kept a small handloom in her home for preparing samples and also designed on paper; she then supervised the execution by others. Some textiles were planned to harmonize with Eliel's furniture designs, and the two collaborated on pieces as well, such as a tapestry map of Cranbrook.

Although it has been asserted that Loja began Cranbrook's important history in weaving, she did not teach. She "established the weaving department"—Marianne Strengell was brought in to teach—and she continued to be "in charge" until she retired in 1942, at which time she sold her stock of fibers to the weaving department for the students' use.

When her business was active, Loja worked by commission only, designing handwoven art fabrics, rugs, and window hangings of fine materials and exceptional durability. Her rug designs employed linen warps and cotton, silk, wool, or synthetic wefts. In addition to working with her husband, and with her children when they became professionals, she also collaborated with Charles Eames and Frank Lloyd Wright. Moreover, she did not consider a design final until her husband agreed. Thus it can be difficult to ascertain her personal style.

The first rug made by Studio Loja Saarinen, in 1928, resembles an Islamic prayer rug. It is directional, not symmetrical, as if meant to be hung. For Kingswood School at Cranbrook, a project that involved all four Saarinens, Loja created subtle, angular tapestries, including one with a central motif that might be a combination of three stylized trees with diagonal foliage symbols, capped by rooflines. (Figure 4.19) Although she designed Finnish pile (rya or ryijy) rugs, she also developed a flat, architectonic style for wall hangings that suited her husband's buildings. Since color was low-key, interest derived from the contrast of wool, silk, and linen yarns. Another inno-

FIGURE 4.19. *Loja Saarinen*, Tapestry #3, *1928–29. Linen, wool; 66 × 50 in. (including fringe). (© Cranbrook Archives, Cranbrook Cultural Properties Collection, Kingswood School.)*

vation was making "tapestries" that were actually brocading over a ground of hand-spun woven linen that played opacity against translucency in a way "prophetic of later work by [Lenore] Tawney and others."[33]

ILONKA KARASZ

Ilonka Karasz (1896–1981) was a pioneering American modernist designer of the 1920s, the only woman in a group of more familiar names such as Deskey, Frankl, and Neutra. Born in Hungary, she was one of the first women admitted to the Royal School of Arts and Crafts in Budapest, where the design curriculum was influenced by the Wiener Werkstätte. She came to the United States in 1913 and quickly became a part of the modern art community of Greenwich Village. She taught at the Modern Art School on Washington Square, a progressive center for art education. The sculptor William Zorach, in his memoirs, described her as "one of the outstanding personalities of the Village. She had great talent and great beauty of a very extraordinary kind."[34]

FIGURE 4.20. *Ilonka Karasz*, Design for Plate, *ca. 1921. Watercolor and graphite on laid paper; diameter, 11 in. (Georgia Museum of Art, University of Georgia, Gift of Mr. and Mrs. R. Kenneth Sigmund, GMOA 2005.99. Photograph by Michael McKelvey, 2002.)*

Karasz created furniture, tea sets, dishes (some for Buffalo Pottery), geometric textiles, wallpapers, lighting, tiles, toys, and set designs for theater and ballet. (Figure 4.20) Starting in 1925, she devised a total of 186 magazine covers for the *New Yorker*. She made furniture in various styles with simple massing of forms. Paul Frankl included her geometric saltcellars and tea set in his 1930 book *Form and Re-Form*, and a 1935 ceramic teapot recalls Bauhaus clarity.

By the late 1920s, Karasz was best known for her rugs and designs for tapestry and embroidery, the latter worked for her by her sister, Mariska (see chapter 7). Several of her early opportunities to have textiles manufactured grew out of design contests. She also exhibited her own batiks, whose exotic qualities suggested to some writers of the time that they were influenced by "gipsy [sic] sympathies."[35] By 1935 she had designed fabric for Mallinson, Schumacher, Lesher-Whitman, Dupont-Rayon, Schwarzenbach and Huber, Cheney, Susquehanna Silk Mills, Standard Textile, and Belding Brothers. She was regarded as a pioneer designer of modern woven textiles, a field that required an understanding of the Jacquard loom.

By the time of her death, however, Karasz had been largely forgotten, "in part because of the implicitly domestic nature of many of her designs, such as her dress fabrics in the 1910s, nursery furniture of the 1930s, and wallpaper of the 1940s—all intended for everyday use until replaced by a newer fashion."[36] Nursery designs—

both decor and adaptable furniture that could change with the growth of the child—did not have much cachet in design books, but today her range is admired.

LYDIA BUSH-BROWN

By the 1920s, a few art-trained individuals were making expressive modernist textiles, such as Marguerite Zorach with her pictorial embroideries. Batik on silk had been introduced in the United States by the Dutch shortly after 1902; its fabric range was expanded by a French designer, Mme Pagnon, and further promoted in the 1920s. Lydia Bush-Brown (1887–1984) made batiks that she called "silk murals." Bush-Brown, whose parents were artists, was born in Florence, Italy; studied at the Pratt Institute in Brooklyn; and traveled extensively, including to the Middle East. As a student she cut woodblocks to print a design on a foundation cloth and then embellished it with embroidery—a combination of techniques typical of the Arts and Crafts period. Her exposure to the Middle East inspired patterns and themes for her textiles. For instance, a red and gray hanging echoes the central niche form of Islamic prayer rugs. Her silk murals evoked "a kind of delicate, mystical symbolism" uncommon at the time.[37] Although Zorach considered her own embroideries to be separate from painting, most textile arts of the time—including batik, embroidery, block printing, and tapestry—accrued status by their kinship to painting. The link was the use of imagery, which was easier to "read" than material and tactile qualities, especially in the era before color reproductions. Batik easily lent itself to imagery, and Bush-Brown's compositions were precisely detailed. She created a modern series of depictions of the New York skyline and waterfront as well as underwater panoramas. (Figure 4.21)

FIGURE 4.21. *Lydia Bush-Brown,* New York Waterfront, *ca. 1929. Hand-drawn, wax resist–dyed (batik) silk; 35.75 × 48.5 in. (Cooper-Hewitt, National Design Museum, Smithsonian Institution, Gift of Marcia and William Goodman, 1974.23.6. Photograph by Ken Pelka.)*

Ceramics: Tiles and Figurines

ARCHITECTURAL USES

Commercial potteries changed with the times, whether they wanted to or not. Terra-cotta workshops were unknowingly experiencing their last days: while the material was still important to architectural ornament, the stock-market crash of 1929 halted building projects, and after the Depression and World War II, modernist architects preferred steel, brick, and glass. Terra-cotta was reduced to serving as a fireproofing material.

In California, however, tile production boomed throughout the decade for use in the popular Mediterranean and Spanish revival architecture.[38] While numerous established potteries continued—Batchelder, for example—there were also new endeavors. In 1921 Fred H. Robertson founded Claycraft; a Scot named James White Hislop, together with his sons, in 1922 organized Clay Glow Tile, later California Art Tile (Caltile); and another Scot, William Flynn Muir, in 1925 began to produce high-relief decorative Muresque (from his name) tiles featuring romantic subjects such as knights riding through the California redwoods. Curiously, many tile makers (Batchelder, Hislop, Muir, Frederick Rhead, and possibly others) were members of the brotherhood of Freemasons; this organization asserted a connection between quality of workmanship, high moral standards exemplified by guilds of the Middle Ages, and a consequent harmony in everyday life. These beliefs may have influenced the character of their work, including the medieval imagery.[39]

Rufus B. Keeler, who had in 1917 established the pottery that became California Clay Products (Calco), left it in 1926 to establish and manage **Malibu Potteries**. The company was located on what was then an isolated beach—an idyllic environment where he and many employees went swimming on their lunch breaks. The pottery, along with the expanse of property called the Malibu Ranch, was owned by May K. Rindge. She was building a mansion in the Spanish colonial style; the area had good quality red- and buff-firing clays and water from a nearby spring; the opening of the Pacific Coast Highway provided convenient transportation routes to rail and shipping centers as well as to a labor supply—all of which benefited the business.[40] At its height, it employed 125 people.

Keeler formulated secret glazes widely appreciated for their color and clarity. All decorating was by hand, either in the *cuerda seca* method, in which glaze was outlined with a resistant black line, or the *cuenca* method, in which small depressions in the surface held areas of glaze. The main product lines were multicolored and predominantly geometric patterns or stylized plant motifs. The company produced floor, fireplace, and mantel tiles.

Los Angeles City Hall includes twenty-three tile panels created by Malibu Potteries (designed by employee J. Donald Prouty). Tiles are also used extensively in Adamson House (1929–30), built as a beach cottage for May Rindge's daughter and now a museum. The Rindge mansion itself was never finished; it became a Franciscan religious retreat in 1942 and was largely destroyed by a brush fire in 1970. Malibu's production was interrupted in 1929, halted again in late 1931, when half the facilities and inventory were destroyed by fire, and closed completely in 1932.

COWAN POTTERY AND FIGURATION

Figurative ceramic sculpture both small and large rose to prominence in the 1920s. Viennese expressionist works—whimsical and bright—were known through exhibitions, Austrian artists who came to the United States, and American ceramists who studied in Vienna. The Cowan Pottery in Cleveland was the major channel.

R. Guy Cowan (1884–1957) was born into a family of potters in East Liverpool, Ohio, and graduated from the ceramics school at Alfred University (1908). He taught ceramics and design at Cleveland Technical High School, experimented at a local potter's studio, and set up on his own in 1912. His career was interrupted by war service, but it resumed in 1920, when he moved his Cowan Pottery Studio to larger quarters in the Cleveland suburb of Rocky River. He changed from redware to high-fired porcelain and shifted his emphasis to ceramic sculpture, beginning commercial production in 1921. To make affordable work, he used molds, but he tried not to let that impair artistic quality. Figures were made in limited editions of 50 to 100, and the mold was then destroyed. (Figure 4.22)

Mass-production items such as ashtrays, desk sets, tea sets, and lamp bases subsidized the limited-edition figurines. A popular decorative item was a dining-table centerpiece with matching candlesticks, into which a figurine could be inserted. These could stand alone or be used with flowers. Characteristic of the studio's work were nude dancing girls, salacious specifics blurred or concealed by swirling scarves. Cowan hired experienced sculptors on a freelance basis and apprenticed recent graduates of the Cleveland School of Art, where he had begun to teach. As he promoted modernism, Cowan was fomenting a "Cleveland school" of ceramics. His leading producer of figurines was Waylande Gregory. Others

FIGURE 4.22. *Walter Sinz, Cowan Pottery,* Radio Figure, *1929. Special ivory glaze with hand decoration in black; 9 × 7.5 in. (Courtesy of the Cowan Pottery Museum at Rocky River Public Library, Ohio. Photograph by Wetzler's Photography Studio, Cleveland, Ohio.)*

associated with the Cowan studio included the sculptor Paul Manship, today remembered for his Prometheus Fountain at Rockefeller Center, as well as Arthur Baggs, Paul Bogatay, Viktor Schreckengost, Russell Barnett Aitkin, and Thelma Frazier Winter.

A group of Russian peasant figures made at Cowan by Alexander Blazys won the first prize for ceramic sculpture—a new category—at the Cleveland Museum's 1927 annual exhibition of local artists and craftsmen (the May Show). Cowan had lobbied for the category and had encouraged the interest of the museum's director. That year the Society of Arts and Crafts, Boston, opened its gallery exhibitions with works from the Cowan Pottery Studio and showed some at its New York shop as well.

By the end of the decade, more than 175,000 pieces a year were being turned out by fifty employees and sold in about 1,500 retail outlets across the country. No seconds were sold or distributed. But in 1929 the market for limited-edition and unique ceramic pieces began to shrink. In December 1930, the company went into re-

ceivership but remained open for one more year to use up materials in stock. Without commercial pressures, the Cowan artists experimented freely, and some of the studio's most creative output dates from this period. In late 1931 the pottery closed, another casualty of the Depression. Cowan became art director for the Onondaga Pottery Company of Syracuse, producers of Syracuse China. He also played a central role in the growth of the Ceramic National exhibitions during the 1930s, often serving as juror. Because of these activities, he was one of the most important figures in American ceramics in the 1920s and 1930s. (Gregory, Schreckengost, and other artists will be discussed in chapter 5.)

The Cowan pottery was not the only producer of American art deco ceramics. **Wilhelm Hunt Diederich**, the Hungarian émigré whose metalwork was discussed earlier, also made decorated pottery. Here, as in his metalwork, he made frequent use of the doe and gazelle, popular motifs of the time; his figures convey a sense of spontaneity and vitality. He made pieces both individually and for mass production. His work won a gold medal from the Architectural League of New York in 1927 and was included in the American Federation of Arts traveling international exhibition of 1928, but by the end of the decade he was no longer working in ceramics.

Most of the important ceramists of the 1920s came out of art schools and universities, where they often were inspired by European art and design. Some began as painters or sculptors and took up ceramics as an additional medium. Other artists, such as Manship and the Bay Area portraitist Jo Davidson, worked in ceramics only briefly.

Elie Nadelman, who had come to New York from Paris in 1914, made inexpensive, small-scale sculptures in terra-cotta (as well as wood, plaster, and bronze) that reflected his respect for common materials and his interest in folk art. In the European style, he employed assistants to produce editions of six, but his artist peers disapproved of the practice. During the Depression, Nadelman formulated his own glazes and fired his own kiln at Inwood Potteries in northern Manhattan. He made mostly genre works of people in action and, after 1935, private works featuring plump fertility goddesses (models were discovered after his death in 1946 and subsequently cast in clay as he had intended).

HENRY VARNUM POOR

Henry Varnum Poor (1887–1970), painter and potter, was also known for building Crow House, his home in Rockland County, about thirty-five miles from New York City, in a show of self-sufficiency and independence that

might serve as a model for the alternative lifestyles later associated with crafts. After World War I, Poor and his second wife, designer Marion Dorn, set up in the country, where he designed a stone structure inspired by French farmhouses. He dug the foundation, felled and adzed trees, laid slate for the roof, dammed a creek for a water supply, made the furniture and even ceramic doorknobs. It was such a striking achievement that he was once called "the personification of Emerson's essay on self-reliance."[41] He went on to design houses for creative people who were neighbors, gradually working from this rustic style to modernist materials and shapes.

Poor was a westerner, born in Kansas and familiar with farm life. He had also attended one of the first midwestern high schools to incorporate manual training, which gave him some experience in wood and iron working. But he was no peasant; he was a Phi Beta Kappa graduate of Stanford and had studied painting in Europe, at the Slade School of Art in London (1910) and the Académie Julian in Paris (1911). During his year in London he saw the Grafton Gallery's bombshell modernist show curated by Roger Fry, one of the major influences on the Armory Show in America. Poor taught at Stanford and the Mark Hopkins Art School in San Francisco. Following service in World War I, he moved east.

Poor's first New York show enjoyed good critical response, but only a single painting sold. Seeing ancient Cretan ceramics at the Metropolitan Museum put pottery into his head, and he thought that "in such work I could perhaps unite the necessity of earning a living with a very complete means of expression as an artist."[42] He dug some clay in his yard and built himself a wheel out of junkyard machine parts. Poor later wrote of this wheel, "Now it may seem primitive to the point of affectation, but remember this was 1920; there were no 'artist' potters' wheels and kilns on the market that I knew of and I had no money to buy them anyway."[43] Someone gave him a kerosene kiln, complaining of the difficulty of firing it; he was attracted by the challenge.

Poor taught himself to throw. Charles Binns's *Potter's Craft* provided the basics of clay bodies and glaze chemistry. "I started doing pottery for the pleasure of decorating it," Poor later said.[44] He treated his clay surface as a canvas for mostly figurative and landscape imagery on jars, vases, and especially plates (he also made undecorated functional ware glazed in aubergine, apple green, cobalt blue, or pearly white). His approach to clay escaped both the necktie-and-lab-coat formality of Binns and his students at Alfred, and the artisanal limitations of factory work. Poor noted: "I turn it out rapidly instead of lin-

gering over each piece. I decorate a dozen plates at one stretch, and as I pick up each plate I have no idea of what is going on it, except that it must be a free expression of something I believe in." His first ceramics show, at Wanamaker's New York department store in 1921, resulted in such a quantity of sales and orders that "I realized I must either become a small factory and have helpers, or stick to my solitude and ask higher prices. The latter is what happened."[45] He became a studio potter, marking and signing the pottery.

Poor preferred spontaneity. In his first exhibition at Montross Gallery in New York, in 1922, he horrified potters by showing warped and cracked plates. Yet the show sold out, and Montross began to pay him a monthly stipend of $200. Poor ceased painting for the whole of the 1920s. In a pamphlet for an early show he wrote, "Distortions, so disconcerting in an easel picture, have a sense of rightness when arrived at through the demands of proper space filling in decorative art."[46] He had the advantage of long experience with drawing and painting, which made him adept and imaginative at composition. That made his work attractive to art critics, who saw it as individual expression and more relevant to the time than traditional pottery.

Poor became known for sgraffito, a technique that he seems to have employed first in painting—using the brush handle to scratch lines into the wet pigment. The decoration included bird's-eye views of landscapes, cubistic interiors, florals, and nudes, all of them vigorous line drawings with the rim of the plate serving as a frame. His best decoration created an illusion of depth that suited the contours of the object, his dynamic, tactile canvas. Some of his plates include scenes marked with heavy black lines evocative of German expressionism, with skewed perspective and flattened planes. (Figure 4.23)

In 1928—along with Deskey, Karasz, Reeves, Winold Reiss, and others—Poor was a founding member of the American Designers' Gallery in New York. Poor's contribution to the initial show was a bathroom featuring tile walls decorated with leaves and chevron patterns in browns and deep blues and, in the shower stall, a tile mural depicting a life-size female nude. The sink was set into an unusual base in the form of an inverted, faceted cone, and there were pierced ceramic lighting fixtures. In 1929 the gallery's second show emphasized furniture. Poor showed a dining alcove, including tableware, a hand-crafted table and benches, wainscoting, a ceramic radiator cover, and two small tile murals. The gallery closed that year, even before the October stock-market crash,

FIGURE 4.23. *Henry Varnum Poor, Plate, 1923. Glazed earthenware; 8.87 × 1.37 in. (The Art Institute of Chicago, Logan Purchase Prize, 1923.355. Photograph by Bob Hashimoto.)*

yet it generated private commissions for Poor. In fact, he had so many commissions for bathrooms that his third wife, novelist and journalist Bessie Breuer, urged him to return to painting and "get out of the plumbing business."[47] Substantial income enabled Poor and his family to spend a year in Europe, and when they returned, he was painting again, and his ceramic activity diminished for a time.

Poor received many architectural ceramic commissions, including tile murals for shop fronts and hotels and a domed ceiling for a bank. He also did tiles for the houses he designed for his neighbors, often consisting of vignettes. (He designed about a dozen, starting with a stone house for textile designer Ruth Reeves in 1922. The last dated from 1966.) In July 1932, Deskey commissioned Poor and twenty other artists for Rockefeller Center designs. Poor was disappointed to be asked only for four molded lamp bases and several vases, all for public lounge areas. The table lamps were stolen within a week of the opening, and the vases have disappeared as well.

In 1946 Poor was a founder and the first president of the Skowhegan School of Painting and Sculpture in Maine and in 1950 was a resident artist at the American Academy in Rome, where he built a little kiln and began a body of portrait busts. After the war, his murals and realistic painting were out of date, but he published *A Book of Pottery: From Mud into Immortality* in 1958 and returned wholly to ceramics in 1963. When he died in 1970, his kiln was ready to be fired.[48]

HULL-HOUSE KILNS

Jane Addams's Hull-House was one of about a dozen urban settlement houses teaching pottery and employing neighborhood residents to make ceramics. The pottery was directed by **Myrtle Meritt French** (1886–1970), who grew up in western New York State and was friends with the daughters of Charles Binns. She became his student at Alfred, graduating in 1913. Binns hired her to teach modeling and pottery for a year and subsequently invited her to run Alfred's summer ceramic program. She did that for twelve years while teaching at Carnegie Tech, continuing even after she moved to Chicago in 1921 to develop a ceramics program at the School of the Art Institute.

French's involvement with Hull-House began in 1924, when an Art Institute colleague who was a resident at the settlement and head of its art studio persuaded her to teach ceramics there. (Figure 4.24) She became a resident, making a commitment to social reform. In 1927 the pottery was reorganized into a separate entity to provide income for young artists. Hull-House had always offered programs and services to newcomers, and in the 1920s the immigrants were no longer Eastern European but Mexican. (Chicago came to have the second-largest Mexican population in the United States.) Special clay classes for Mexicans started in the mid-1920s and then classes for African Americans, both intended to foster a sense of community. Mexican potters became prolific workers and defined a new phase of the pottery's products, in tableware and figurines made with heavy clays and bright glazes. French routinely shared the results of her glaze experimentation but not her orange-red glaze, for which she and the Hull-House Kilns were praised.

FIGURE 4.24. *Myrtle Meritt French, Hull-House Kilns, Green Teapot, ca. 1927. Molded ceramic; 5 × 8.5 in. (Jane Addams Hull-House Museum, University of Illinois at Chicago, 1973.0028.0011.)*

The pottery taught sculpting and modeling as a means to make figures, and the Mexican artists themselves introduced assemblies: they modeled figures one at a time and then joined them in a tableau. This method was more vulnerable to breakage, but it yielded works that were spontaneous and lively. French promoted decorative designs based on pre-colonial North American and modern art deco styles. She also taught a design technique developed by the Mexican artist and art educator Adolfo Best-Maugard, based on his theory of seven essential forms in indigenous art worldwide.[49]

Hull-House Pottery wares were sold at Macy's in New York and at a Hull-House shop on Chicago's Michigan Avenue. The products sold well as modernism became more popular and the style of dining less formal. Spanish colonial architecture was a new trend, and travel, museum shows, and Chicago's 1933–34 Century of Progress world's fair increased exposure to Mexican arts and culture and made the Hull-House styles more popular with the public.

The influence in both design and color of Hull-House Kilns on dinnerware of the 1930s, such as Frederick Rhead's Fiesta Ware for the Homer Laughlin China Company of West Virginia, has been called "too striking to ignore."[50] French served on the American Ceramic Society Art Division executive committee with Rhead; she had urged commercial potteries to update design and color, and now, ironically, Hull-House Kilns was unable to compete with the new, mass-marketed styles. Both the pottery and retail shop closed in 1937.

Crafts in the Southern Highlands

While Arts and Crafts societies and exhibitions were concentrated on both coasts and the Midwest, the South had its own craft revival with a different origin. It was rooted in a religiously motivated desire to help the poor, focused at first on education and then on cottage industry.

During the Reconstruction era, northern churches had sent missionaries to minister to freed blacks in many parts of the South. By the 1890s, their attention had turned to poor whites living in the Appalachian Mountains. The "mountain folk" existed largely outside the mainstream of nineteenth-century progress. There were no factories or large farms in the mountains, which meant cash was scarce. Poverty was common. Allen Eaton claimed, in *Handicrafts of the Southern Highlands* (1937), his voluminous documentation of research for the Russell Sage Foundation, that no other American region had such a variety of handicrafts, because old forms

persisted as new forms developed. He romanticized the isolation of the region, which railroads and paved roads had only begun to penetrate in the previous two decades.

Berea College in Kentucky had been founded by an abolitionist preacher as the first interracial college in the South. In 1893 Berea's new president, Dr. William Frost, began to tour the local countryside to meet students' families. Traditional crafts like weaving, basket-making, quilting, and chair making survived in the hills, and Frost collected some of the homespun, handwoven coverlets he saw. He showed some of the coverlets to supporters in Boston, New York, and Cincinnati, initiating an enthusiastic market for them. To outsiders, surviving crafts took on the cast of folk art: although the objects could be appreciated as continuations of colonial styles and values, the people themselves were seen as quaint or even backward.[51]

By 1902 Berea offered instruction in spinning and weaving to both students and local residents. The program was institutionalized as Fireside Industries. It was a business, with a shop on campus and the college handling all the marketing. Women could work at home and send their finished products to Berea. In 1911 a weaver from Sweden, Anna Ernberg, was hired to oversee the enterprise. Ernberg introduced Swedish-style looms and designed a small loom that local weavers could carry home. Hundreds of students learned to weave at Berea College, and many went on to teach elsewhere.

The crafts revival in the Southeast blossomed in the 1920s, to the extent that Eaton could enumerate rural schools, cooperatives, women's groups, and individual makers who were producing crafts for income. The goods were usually sold through missionary-society outlets in the North and through "sales cabins" sited to catch the eye of tourists. The American social-reform movement, which had begun before the turn of the century, included settlement schools in the South, many of which emphasized hand industries. The schools were sponsored by churches or philanthropic sororities and were typically established and run by women. But the success of the crafts revival of the 1920s and 1930s—when the emphasis changed from social reform to cottage industries—probably had more to do with the ideals of the Arts and Crafts movement than with religious motivations.

ALLANSTAND AS THE MODEL

Another pioneer endeavor that led to the activity of the 1920s was Allanstand, founded by Frances Louisa Goodrich (1856–1944), the daughter of a Presbyterian minister. Her family was devoted to the Social Gospel,

practicing the Judeo-Christian ethic of human brother-hood. She was among the new wave of educated women, having spent four years (1879–82) at the Yale School of Fine Arts, but few professions were open to women then, only education, religious or social service, and art. Her career in North Carolina touched upon all of them, but when she first came to the South, it was as an unpaid volunteer.

Goodrich taught at a missionary day school near Asheville late in the nineteenth century. In 1895 she was given a double-bowknot coverlet. It sparked her interest in the textile traditions of the area. Families who were far from commercial centers and had little disposable income had formerly made their own clothing, homespun and handwoven of yarns from flax they grew or sheep they raised. Goodrich was able to find older women (often familiarly identified as "Aunt" or "Granny") who remembered techniques, patterns, or dye recipes. Few still practiced, but many had spinning wheels or looms stored in attics. Goodrich established Allanstand Cottage Industries in 1897 at a small crossroads of that name. In the spring of 1900, she had the first exhibition of Allanstand crafts in Asheville, and it became an annual event. As early as 1903, Allanstand work was included in an Arts and Crafts exhibition selected by Gustav Stickley, and in 1904 a Bureau of Labor bulletin on cottage industries reported Goodrich's method of organizing and paying. In 1908 she opened a retail shop in Asheville.

Goodrich saw the work as enabling people to stay on the farms, because it could be fitted into the odd bits of time available in the country rhythms of life. Yet she brought inadvertent modifications as well as intended changes of education, social opportunity, and improved income. She introduced lighter-weight and easier-to-use looms of the Berea style. She also "standardized the designs, chose which patterns were to be woven, supervised colors, and rejected work that was not up to her standards."[52] Her close interaction with the weavers was consistent with the settlement idea of teaching through example. She was the first in the southern Appalachians to promote the union of social work and handicrafts.

Allanstand Cottage Industries was Goodrich's own private philanthropic effort, apart from her teaching and religious work and never officially connected with the Presbyterian Church. In January 1917, it was incorporated, with shares available at $25. It operated independently until 1932, when ownership was transferred to the Southern Highland Handicraft Guild.

In 1890 Goodrich had concluded that coverlets were the most interesting products of the region. Quilts remained common across the United States, but coverlets for the most part survived only in the Southeast. Most employed overshot designs in traditional blue and white or in those colors plus rose madder. A coverlet was often the only decorative textile in a cabin, and when mountain families were photographed, a coverlet often appeared as the backdrop, perhaps representing their history.

Home looms allowed the construction of cloth up to three feet wide, so coverlets were always joined by a seam down the middle. Some match across the center seam, giving an effect of one piece of cloth. The matched cloths were the work of the most skilled weavers, semi-professional or professional. The women from the North who ran the schools insisted that the seams of a coverlet be straight. Goodrich was no exception. She would have been familiar with museum-quality coverlets displayed in period rooms of northern museums, and perhaps the perfection was demanded by her own "refined sense of neatness."[53] Noted weavers such as **Josephine (Mrs. Finley) Mast** (1861–1936) attained formidable precision. One of her overshot coverlets, in the blooming-leaf or bowknot pattern, counted forty ends (cotton warp) and seventy picks (wool weft) per inch. Each repetition of the pattern measures twenty-eight inches square, requiring Mast to throw the shuttle approximately 1,960 times for each pattern-block repeat.

Homespun yarns had once been a necessity. Spinning was a pleasurable, rhythmic, but time-consuming activity: it is estimated that it would take eight spinners to keep up with the thread needs of one weaver. Time was also involved in such preparatory steps as carding (combing) the wool to make it into rolls for spinning. When mills began to offer carded wool in fluffy ropes that made the spinning faster, schools and even individuals, when they could, adopted this source. Mast was one weaver who made the transition. In her early years of weaving, she grew her own flax and spun the fiber into linen thread. Sheep on her North Carolina farm yielded wool. Eventually, she turned to commercially spun and dyed thread as it became more available and affordable. A mechanization issue of Goodrich's time was whether use of the fly shuttle, which allowed a longer and more regular throw of the weft, turned weaving into a mechanized process rather than a hand art.

BASKETS AND BASKETMAKERS

Although the Hindman Settlement School in Kentucky (established 1902) was known for basketmaking, as a rule that craft remained a more modest cottage industry than weaving. It required minimal tools, and the whole process could be accomplished by one person. Besides their many uses in the household, baskets were easy to

FIGURE 4.25. *Cordelia Everidge Ritchie*, Dream Basket, *ca. 1920.*
Willow; 8 × 13 in. (Courtesy of Southern Highland Craft Guild,
1988.79. Photograph by Nikki Josheff.)

market because their light weight made transportation
effortless. Highland baskets were often made of plaited
strips of wood or willow switches. The most common
splint shape was the melon basket or hip basket, based
on two hoops fastened at right angles to each other, with
one forming the rim of the basket and the other func-
tioning as the handle and base, filled in with a rhythmic
design.

The solitariness of the craft may have contributed
to innovation. A Tennessee basketmaker, **Lydia Whaley**
(died 1926), gave her name to the Aunt Lydia basket.
She taught at the Pi Beta Phi Settlement School. Her bas-
ket was made of strips of willow bark—the inside bark
being a soft reddish-brown color—worked over unpeeled
smooth willow, with a large switch forming the handle.
Eaton praised the harmony and consistency of her bas-
kets.

Aunt Cord Ritchie, who lived near the Hindman Settle-
ment School, "just made up" a round, bowl-like willow
basket with three spiral handles. (Figure 4.25) She also
worked with oak and hickory splints, but her favorite ma-
terial was willow, including an unpeeled yellow willow
that slowly lost its color but retained a scent in damp
weather. Ritchie was self-taught, having taken apart a
basket from "over the mountains" and worked out her
own methods to duplicate it. She taught many others in
her community.

Another basket innovation was credited to Allanstand.
Mountain baskets were traditionally all white or natural,
but Goodrich encouraged a worker to make a brown dye
from tree bark to color some of the splints in a melon
basket, and the two tones were popular with buyers. The
practice became commonplace.

THE DILEMMA OF CHANGE

This kind of change could be regarded as innocuous or
pernicious. Goodrich later enumerated her purposes as
"to save the old arts from extinction; to give paying work
to women too far from market to find it for themselves;
and, more important than all, to bring interest into their
lives, the joy of making useful and beautiful things."[54]
While her altruism is not questioned, later observers
have noted that while she and others spoke of "pre-
serving" the old ways, they changed the aesthetics, the
production systems, the motivation for producing, the
methods of teaching and learning, the materials, the de-
signs, the tools, the ultimate destination of the products,
the location where the work was done, and, eventually,
who was doing it. They preserved some of the techniques
and found ways to make objects that evoked the past but
were very much made in the present. The irony of the
old brown double-bowknot that started Allanstand—the
grand icon of the Appalachian handicraft revival—is that
it could not have been sold as an Allanstand coverlet, be-
cause, like most old mountain coverlets, it had crooked
seams and a mistake in the weaving.[55]

It is possible to argue that Goodrich and her peers
were arrogantly sure of the superiority of their own judg-
ments and disregarded the locals' view that the older
coverlets had "honest seams" or that "a crooked seam
throws the devil off your track." Yet second-guessing
Goodrich hardly seems fair. The old ways were being
ended by the changing times in any case. She justified
the shifts by describing them as "a natural evolution" of
the old crafts and noting the necessity of similar changes
in other cottage industries.

MORE COTTAGE INDUSTRIES

In the 1920s craft cottage industries were springing up
everywhere in the Southeast, joining several already
established programs. One early industry resulted from
the construction of the Biltmore Estate in 1895, which
brought many skilled artisans to North Carolina. Eleanor
Vance and Charlotte Yale, who had met as missionary
students in Chicago, came to Asheville in 1901 and be-
fore long started a boys' club in which they taught wood-
working. They began to receive orders and pay the boys
for their work.

Mrs. George (Edith) Vanderbilt wanted to introduce
weaving and brought in sheep to provide the wool. Sev-
eral women on the estate learned to spin and weave, and
the business modeled its products on Scottish and Irish
woolens. The target audience was tourists (as many as
30,000 people visited the area annually), but Biltmore
Estate Industries also developed a substantial mail-order

business. At first the weaving was a home project for local women, but carding machines and fly shuttles and increasing centralization changed that.[56] Biltmore also found local wool poor because sheep went free in the woods and picked up burrs and bits of thorn that washing did not remove; they began to buy from large wool growers to make a better product.

In 1914 George Vanderbilt died suddenly at the age of fifty-two. Edith Vanderbilt faced somewhat reduced circumstances and also came to Asheville less often because she became involved in wartime work for the Red Cross. In 1917 she sold Biltmore Estate Industries to Fred L. Seely, developer of the Grove Park Inn in Ashville. He renamed it Biltmore Industries, eliminated woodworking but enlarged the weaving business. He promoted "Home-spun" as a means of advertising western North Carolina and thus his development, where he constructed an Old English shop complex with Arts and Crafts homilies on the walls.

Seely's advertisement in the November 1920 *Ladies' Home Journal* emphasized distinctiveness and quality with a text reading, "It is not easy to blend hand-dyed colors to exactly match the same shade, when in some cases as many as eight colors of wool are in one mixing, and even if we could achieve the sameness that is produced by machine methods, we should not like to do it, for there is charm in the fact that a person is likely never to see two suits of Biltmore Handmade Homespun that exactly match."[57] In 1933 he was producing 200 yards a day and keeping a significant stock. Wool was combed and carded by machine and then woven on handlooms by men, because Seely felt the work was too hard for women. The changed business survived until the 1980s.

The Spinning Wheel, in Asheville, was founded about 1924 by Clementine Douglas, who set up a sales room in an old log cabin that she brought to her property. She also marketed looms. Weavers worked in her home, while outdoors there were kettles for natural dyeing. Douglas, from Jacksonville, Florida, had studied design at Pratt Institute in 1913. Inspired by a Kentucky missionary's talk, she taught arts and crafts at schools in Harlan County, Kentucky, for three summers, while in the fall and winter teaching at Finch School in Manhattan. She operated the Spinning Wheel for twenty years. Douglas sought old drafts and traditional patterns and adapted them to the contemporary market. She was also influenced by the weavings of Greece, Italy, and Egypt and imported weavings to sell in her shop. She encouraged her weavers to be creative, and many developed their own signature motifs.

In 1924 Wilmer Stone Viner (1891–1978) opened the

Weave Shop at Saluda, North Carolina, which continued until 1946. She employed a half-dozen local women and played an important role in researching native plants for dyes in an exceptional array of colors. Colors included browns, blacks, and grays from walnut and butternut hulls, roots, and bark; grays and tan from sumac berries; pinks and lavenders from pokeberries; yellows from hickory bark; deeper yellow and orange from the dye flower (wild coreopsis); pink-yellow from sedge grass; green from pine needles; and many colors from garden plants and flowers. Hues varied according to the mordant used to make the dye fast, which multiplied the variety. (Eaton wrote that one great advantage of natural dyes was the way they faded, since they usually retained "a definite relation to their original color, often becoming softer and more beautiful without losing their character, while a faded synthetic dye usually bears little resemblance to its original tone.")[58]

Viner trained other weavers in her area and produced scarves, table runners, couch covers, blankets, dress materials, and tapestry wall hangings. In collaboration with Louise Pitman, instructor of vegetable dyeing at the John C. Campbell Folk School, Viner created colorful woven-stripe "Carolina" blankets. A wall hanging that looks like a cabbage rose cross-stitch was designed, dyed, and woven by Viner for the Weave Shop in cotton warp, wool weft plain weave.

LUCY MORGAN AND THE PENLAND WEAVERS AND POTTERS

In 1920 Lucy Morgan (1889–1981) arrived in Penland, North Carolina, to teach at the Appalachian School, an Episcopal mission school founded in 1911 and directed by her brother Rufus, an Episcopal priest, from 1914 until about 1918.[59] At first Miss Lucy (as she was called) taught first through third grade. She hoped to learn to weave and to revive that craft in the area. She met Aunt Susan Phillips, then ninety-four, who still had stacks of natural-dyed linsey-woolsey fabric (linen warp, wool weft) that she had woven years before and who still dressed in the same fabric. Aunt Susan had the typical coverlets in a pattern called cat's track and snail's trail. (Figure 4.26) There were few other weavers.

Morgan had been born in the mountains of North Carolina; she went to college at a state normal school in Michigan and taught public school there, in the Chicago suburbs, and in Montana. She took summer classes at the University of Chicago and worked in an office of the Children's Bureau, whose director was a friend of Jane Addams and involved with Hull-House. There Morgan was undoubtedly exposed to new ideas in social service.

FIGURE 4.26. *Susan Phillips, Cat Track and Snail Trail Coverlet (detail), ca. 1900. Natural dyed linen warp, wool weft. (Penland School of Crafts. Photograph by Tom Mills.)*

education. In 1926 a Weaving Cabin was constructed on school property, with logs and labor donated by local people. Weavers met there weekly for instruction and to obtain materials. Smith-Hughes money paid Morgan a salary and began a separation from the Appalachian School and the church. The number of weavers rose from seventeen in 1926 to sixty-three at the end of the decade, and the Fireside Industries changed its name to the Penland Weavers and Potters in 1929. (Pottery, being harder to ship, was never as salable as weaving, but the organization kept this name until it closed in the 1960s.)

At first, Morgan did the weaving instruction herself. In 1928 she studied for nine weeks with Edward Worst, author of *Foot-Power Loom Weaving* (1918), which she had read.[60] That August, Worst came to Penland on his vacation. His visit was written up in a textile publication, and letters began arriving from weavers and students who wanted to be there the next time he came. He agreed to come again and did so for the next twenty years, until his death in 1949. Penland evolved, with his help, into a crafts school. By 1930 a Weaving Institute was organized around his visit. Worst did not want anyone turned away because of lack of knowledge and wanted instruction in a variety of allied crafts, which influenced the direction of the program.

The growth of the institute offered another source of income during the Depression, when sales of weavings

She brought all this to Penland. Her inclinations coincided with the Appalachian School's interest in craft and ideas of improving community life. In 1923 she studied weaving with Anna Ernberg at Berea College, where she saw community women being paid for the yardage they had woven, which was subsequently marketed by the school. Morgan followed that model. She provided Berea looms, plus yarn, instruction, drafts, and boundless support for women willing to try weaving. She also spent her entire savings of $615 buying finished weavings from them.

By 1924 Morgan had established a cottage industry, the Department of Fireside Industries at the Appalachian School, and had recognized a social dimension to weaving as neighbors helped neighbors to warp the looms. Then she had to find a way to market the work. The Episcopal bishop found her a car, and she and helpers peddled the weavings to tourists at nearby resorts, at an Episcopal convention, and at the state fair. All these efforts paid off, and a visitor to the state fair told her about the Smith-Hughes Act, by which funds were available for vocational

Edward Worst

Worst (1866–1949) was in the vanguard of educational reform in Chicago as a spokesman for manual training. He was a teacher and administrator who began introducing handwork to his students in 1894 and published his teaching methods in 1899. He taught summer courses for teachers, which led him to develop a more advanced weaving program. He studied in Massachusetts and Sweden. He pioneered training for occupational therapy in Illinois and organized a craft industry in his home community that even grew flax for weaving linen tablecloths and towels. He owned a workshop that was a small-scale manufacturer of looms. Best known among his several books is the 1918 *Foot-Power Loom Weaving*.[1]

NOTE

1. Account based on Olivia Mahoney, *Edward F. Worst, Craftsman and Educator* (Chicago: Chicago Historical Society, 1985).

fell. Even during that difficult period, Morgan accomplished much by her determination. In 1933 she had a small log cabin mounted on the back of a truck, and it was driven to Chicago to function as a sales outlet and demonstration site at Chicago's Century of Progress exposition. She seems to have been an instinctive promoter.

SOUTHERN FOLK POTTERY

Southern pottery, like coverlet weaving, was often a part-time activity of farming families. As a trade, it began to fail in the early twentieth century but lasted longer in the Highlands because of isolation. (North Carolina was still 80 percent rural in 1920, when the United States reached an urban majority.)[61] Demand for storage jars was undermined by the mass production of cheap glass and metal containers, the growth of large dairies, improved methods of transportation and refrigeration, and Prohibition, which nearly eliminated the demand for whiskey jugs.

Potters began to try out new forms and glaze colors, making "fancy ware" for sale to tourists. Buyers wanted souvenir identification, so both signatures and stamps featuring place names were introduced and became common in the 1920s. Traditional forms were still in existence when the crafts revival started after World War II, so they have been documented more extensively in the Southeast than elsewhere in the United States. The last traditional potters lived until the end of the century.

The contrasts during this long period of transition are embodied in two films made by the Smithsonian's Office of Folklife Programs in the 1960s. One featured the Meaders Pottery of north Georgia, a family pottery dating to 1893 (a comparatively short history where some potteries date back nine generations). The other was on Jugtown Pottery, a business started in the 1920s by an "outside" couple who introduced Asian forms and glazes to the traditional mix. Jugtown, and art, sparked a revival.

In the southern tradition, potters produced inexpensive functional ware in multiples using local clays. They typically stood to "turn" at a treadle wheel (sometimes referred to as a lathe) and built their own low, wood-fired "groundhog" kiln. Potteries were small, and handwork was the rule. While wives and daughters might help in the shop, turning was an exclusively male province until well into the twentieth century. (Things changed when prepared clay became available and large storage containers were not required.) Some slaves had been taught the potter's craft in South Carolina, and the ware of Dave, a literate slave who inscribed verse on his pots, is celebrated. But in Georgia and North Carolina, black potters

were virtually unknown, because training was largely restricted to families descended from German and English immigrants. A child, over the years, would graduate to more complex tasks learned through observation. This method of passing information narrowed the field but also gave it continuity.

The earliest pots were mostly earthenware and often lead-glazed,[62] but stoneware came to be preferred because it was vitreous, more durable, easier to clean, and, significantly, nontoxic. North Carolina was the divide between the northern salt-glazing practice and the southern preference for alkaline-glazing, which employs combinations of wood ashes, slaked lime, sand, and broken glass to obtain a variety of colors. In general, alkaline glazes precluded fancy effects. They were runny (so ware went into the kiln in a single layer), and the caustic ingredients had to be handled carefully.

Functional wares showed little decoration, since they were sold by volume, not by aesthetic appeal. There might be an incised line, which could be applied quickly while the pot was still on the wheel. A piece of glass might be set on the rim or handle of a slip-glazed jug in the kiln, which would melt to make whitish streaks. Brown Albany slip and white Bristol glazes were sometimes purchased rather than made from scratch.

Burlon Craig recalled that a "good potter" was one who could "turn it out reasonably thin and have a pretty nice shape."[63] While this sounds aesthetic, it is practical: thicker wares were heavier to move and wasted materials, and if walls were irregular, glazes might not adhere and the pots would be harder to clean. Utility ruled. The central function was food preservation. Pottery was also used for lighting, indoor plumbing, animal husbandry and in construction. There were flowerpots and "whimsies" to enhance your life and "jug markers" to note your death. Folk potters seldom made plates and cups; farm families used metal dishes or cheap imported white-glazed earthenware.

Traditional potteries displayed their wares on the ground. Pots were also sold (or traded for things like nails) by traveling "waggoners." While southern folk pottery has a local orientation, these sales expeditions made it more of an "export industry" than other folk crafts. With the adoption of Prohibition (in 1907 in Georgia, 1908 in North Carolina, and 1920 nationally) and the end of demand for "little brown jugs," pottery's future seemed bleak. By the 1920s, surviving potteries were paying turners more for "art vases" than for churns or flowerpots. The Depression caused a small retreat in this process, because in hard times, more people preserved food at home. The remaining potteries shifted forms and

gradually adopted mechanized wheels and new kilns and new fuels in which the temperature was easier to control. The more striking changes were the attempts to meet the demand of tourists for smaller and more carefully finished works. By the mid-1920s, potters were experimenting with commercial oxides that produced bright colors.

JUGTOWN

It is ironic that Jugtown is the most familiar name in twentieth-century pottery in the Southeast. It was founded in 1921 by Jacques and Juliana Busbee, artists born into well-to-do families in Raleigh, who became interested in folk pottery and tried to establish a market in New York. When their supply proved undependable, they started their own production business. Their major contributions were their gift for promotion and Jacques's introduction of new forms in the Chinese idiom, since he recognized an underlying sympathy of the traditional jug, churn, and jar forms to historic Chinese stoneware.

James Littlejohn Busbee (1870–1947) was a portrait and landscape painter who studied at the National Academy of Design and Art Students League in New York and, at age twenty-one, replaced his given names with the more dashing Jacques. In 1910 he married Julia Adeline Royster (died 1962), a kindred spirit—she called herself Juliana and was prevented from becoming a professional photographer only by her conventional family. Juliana was active in the Raleigh women's clubs by 1909 and became statewide art chair in 1915. In 1916 she wrote an article for *Everywoman's Magazine* in which she mentioned a potter in a neighborhood called Jugtown who made some floor vases and umbrella stands for them. She also wrote: "One of the loveliest things I have is a brilliant orange plate with flecks of wonderful green here and there on it. Had it been brought from Brittany, it would be thought a museum specimen, but coming from Randolph County, and being a pie plate that costs ten cents, it is not very popular. Those who know its humble origin think it a huge joke on me. But just let me show it to an outsider who is interested in pottery and who knows a thing or two, and I have to keep a watchful eye upon it."[64]

This was a "dirt dish," lead-glazed earthenware pottery. The Busbees spent the winter of 1916 in New York, during which time they became devoted to modern art and discovered that their collection of North Carolina crafts was much admired. When modernism came to America with the Armory Show and gallery exhibitions by European artists, an appreciation of "primitive art" came with it. Modernists discovered American decoys,

weathervanes, and folk paintings. The Busbees found themselves among the avant-garde. When they decided to put their state's product on the market, they needed suppliers, so Jacques wrote letters and in 1917 arrived at the train station in Seagrove in the eastern Piedmont to see what he could find. He looked for old ware so he could judge the best local traditions.

The Busbees' effort blended social service and business opportunity. They began to construct a folklore to link with the "universal" qualities of primitivism, emphasizing the historic pedigree of North Carolina pots and telling a good story without too much concern for fine points of accuracy. In various accounts, the pie plate was discovered by Jacques, or was seen by Juliana in a state fair display, or was furnished to Juliana when she requested a tin one. They reported that hardly any traditional potters remained, which was not true unless one counted only full-time potters. They settled on a starting date and an English lineage for North Carolina pottery, neither of which was correct. But the promotion was effective.

By 1918 Juliana had opened a Greenwich Village tearoom to show, use, and sell ware selected by Jacques. It was written up in the New York papers and magazines and attracted an artistic clientele and then wealthier patrons when it was relocated to the Upper East Side. The Rockefellers, the Fords, and the Roosevelts were interested. In the summer, young southern women helped out by charming customers with their talk. "Colored maids served the lunch. It was all very informal," one of the hostesses later recalled. Juliana presided over a large round table of interesting people. The place was fashionable.[65]

But things did not go as hoped on the other end. Jacques later described the older potters as "hard-baked" and uncooperative. In 1921 he established a workshop in Seagrove, naming it Jugtown Pottery, and hired young men to throw. The traditional rhythm of production suited local agricultural needs but not the Busbees' commercial considerations, and established potters were resistant to exercises of "artistic authority" by outsiders. Jugtown Pottery's first turners were Charlie Teague and, in 1923, Ben Owen (1904–1983). Both were from potting families. Owen, who started at eighteen, stayed with Jugtown for thirty-six years and became indelibly identified with it. He said his work was influenced by two men: his father, who taught him how to make pots and run a pottery, and Jacques Busbee, who taught him the history and aesthetics of ceramics. Jacques would close the pottery over the winter and take Owen to Washington, New York, or Boston to see the ceramics of the world.

FIGURE 4.27. *Ben Owen*, Chinese Blue Bowl, *ca. late 1920s. Stoneware, glaze; height, 7 in. (Collection of the North Carolina Pottery Center, Gift of Fran Irvin. Photograph by Villa Photography.)*

Jugtown started out using mule power to mix clay dug from nearby pits, and pots were fired in a wood-burning kiln. The first wares included white or brown slip-decorated utilitarian forms, from plates to pickle jars, glazed in "tobacco spit," buff, or a salt glaze. (Jacques is credited with giving the name "frogskin" to the effect produced by salt glaze over Albany slip.) The idea was to perpetuate traditional skills. Some years later, the story goes, Tiffany Studios in New York, a customer, suggested that Jugtown make some decorative pieces. Jacques turned to Asia for inspiration. (Figure 4.27)

Juliana closed the New York outlet in 1926, but her promotional activities did not stop. For the rest of their lives, the Busbees lived in a log cabin at the pottery, with bare pine floors and curtains of local overshot fabric. There was cooking in the open fireplace by Juliana, famous for her conversation, her cuisine, and her eccentric habits of dress. It was a picturesque environment for sell-

ing pottery. A Jugtown Pottery leaflet noted that the ware was made entirely of local clays (a declaration of authenticity), but went on to say that clay was now ground to a powder, so no longer included bits of stone and other debris; likewise, the groundhog kilns were fired with wood, yet there were also newer oil-burning kilns. This tension of tradition versus improved technology is a constant in all the surviving potteries.

Juliana spoke at garden parties and women's club meetings—with Owen demonstrating—and continued to write, although her commentary could not have pleased all her neighbors. In 1940, in *Fashion Digest*, she offered the backhanded praise, "The obsolete English, the feudal customs, the pioneer habits and manners, gave the days delight, and made theatre of it all."[66] The theater was Juliana's doing. Jacques wore overalls; Juliana wore gingham. They drew widespread attention to Jugtown ware and to the traditions from which it came, renewing family potters' awareness of their heritage. The "Jugtown philosophy" became widely known, and the Asian shapes were assimilated locally. Yet the Busbees were not potters and could not have made Jugtown pottery on their own.

After Jacques died in 1947, Juliana took over his decorating role. She applied cobalt brushwork to saltware and strived for irregular, handmade-looking glazes. As she began to fail with age, the pottery's outlook was clouded and its ownership confused. Ben Owen—who was widely respected, had been designated a "master potter" in university demonstrations, and was expected to inherit the pottery—was shut out. In 1959 he left to open his own Old Plank Road Pottery nearby. Owen continued to produce the same shapes until he retired because of ill health in 1973, at the age of sixty-nine. He said: "An earthy pot should contain solid firm earthy beauty. I avoid showy color or any display of magnificence. Quietness, modesty of form, and harmony are the elements I attempt to achieve."[67] (His son and now his grandson and namesake have continued the Ben Owen Pottery from 1982 to the present.)

Jugtown Pottery struggled through hard times until, in 1968, a Massachusetts pottery teacher, Nancy Sweezy, arrived via a nonprofit organization, Country Roads, Inc., which purchased it. She looked for outside funding, revamped designs with the help of Vernon and Bobby Owens, brothers who had started working at Jugtown in 1960, and added an apprenticeship program. Vernon Owens purchased Jugtown in 1983, and he and his wife, Pam, who had apprenticed there, have operated it ever since. If Jugtown's purpose was simply to perpetuate tradition, it probably must be regarded as a failure.[68] Yet the

Busbees' introduction of new forms and ideas coincided with the general drift of folk pottery into art ware over the century.

THE LAST OLD-TIMERS

Southeastern folk pottery evolved into a healthy hybrid of artistic utility in the last half of the century. Burlon Craig in North Carolina and Lanier Meaders in Georgia were the last folk potters in the country to use alkaline glaze and were, in their late years, associated with the popular face jugs. Bill and D. X. Gordy, in Georgia, witnessed their father's adaptation and subsequently made their own.

Craig (1914–2002) had worked for a Catawba Valley pottery before World War II and later took over the business. In 1970 folklorist Charles Zug of the University of North Carolina "discovered" him making five-gallon churns, flowerpots, cream risers, and other useful items that he sold at flea markets. He operated a water-powered, homemade "glass beater" to pulverize soda and wine bottles, glass jars, and broken windows for use in his alkaline glazes. His most significant modernization was using a tractor, rather than a mule, to run his pug mill. A few younger potters learned from him and today carry on a self-conscious continuation.

Meaders (1917–1998), of White County in north Georgia, worked at various jobs but continued to "turn" occasionally and assist his father, Cheever, at the family pottery. When the Smithsonian Office of Folklife came to film Cheever in 1967, when he was eighty, Lanier became part of the film. Cheever died six months later, and Lanier was the reluctant heir. He was somewhat chagrined to be associated with face jugs. They are thought to have been made first in South Carolina and may have come from the West Indies. Meaders speculated that every potter had made one or two, but when asked why he made them he answered: "Well, it was the Smithsonian that got me started on them. When they come here, they found one back in under here somewhere. You know, like a ferret they look everything over and they decided that would be a good item to make. They ordered some of them and I made them, a couple of hundred of them, and from then on it just became a full-time job."[69] He was thus cemented in his role as the last practitioner of the old ways—even when he used an electric pug mill and bought glaze ingredients.

The Meaders pottery was established by Lanier's grandfather, John M. Meaders, in 1893. He was a farmer looking for extra income in an area that may have had sixty potters within roughly five square miles (there were deposits of high-firing stoneware clay). John Meaders hired a journeyman potter to turn piecework and to teach the art to his six sons, who were then six to nineteen years of age. Cheever, born in 1887, was the youngest. His formal schooling ended after fourth grade. He was an accomplished turner by age fifteen and stayed with the home and the pottery for his entire life. He dug blue and yellow stoneware clay on the family's property, ground it in a mule-powered "mud mill," and fired it in a "railroad tunnel" kiln (rather than the more usual groundhog kiln). He and his wife, Arie, had four boys and four girls. His sons were all involved in pottery at various times.

After 1930, the road past the Meaders pottery was graded, paved, and linked with the Appalachian Scenic Highway running from Canada to Florida. Electricity arrived in 1936. Cheever survived the decline of business during the Depression by reducing the scale of his operation, burning his kiln less often, and getting help from family.[70] When World War II came—harder on potters than the Depression because of materials shortages and fuel restrictions and harder for Cheever because his sons were in Europe—he refused to make tourist and gift-shop ware and returned to stoneware churns, in addition to unglazed flowerpots. Until very late in life he declined to mark his ware with his name or initials.

Business improved and Cheever's prices jumped in the 1940s, perhaps because of the attention focused on the Meaders shop by Eaton's *Handicrafts of the Southern Highlands*. The more anachronistic his work became, the more he was honored, thus in a sense inverting the folk-craft value of utility.

Bill and D. X. Gordy had both quit school to work in the shop of their father, W. T. B. Gordy, and thus had direct, practical knowledge of folk pottery. When young Bill (1910–1993) became a journeyman potter in North Carolina, he met Edsel Rule, a ceramics instructor at Alfred University known for his glaze formulas. He learned the basics of glaze science and could make the popular pastel shades of art pottery. In 1935 he returned to Georgia and established Georgia Art Pottery near a well-traveled route, presenting his works in a display room, unlike the folk potters. He used the bright glazes then in demand, "But you never saw potters that didn't like earth colors, so when the trend began to switch back it just tickled us to death," he later said.[71] D. X. (1913–1994) stayed in Georgia and inherited his father's shop in 1955. In 1969 he was invited to develop the pottery at Westville, an open-air museum representing a Georgia village of the 1850s. He soon felt confined by the limits on form and glazes there, and after training several younger potters, he re-

turned to his own shop. He made artistic wares using local materials, exploring mineral deposits to create new glaze effects.

The transition from folk pottery to studio pottery took a full century. New considerations replaced the traditional criteria of successful utilitarian ware: that it hold the proper measure and not leak. Beauty of form began to be regarded as more than incidental. The links with farming were broken, and potters became full-time craftsmen. D. X. Gordy reflected: "You think about tradition. I wonder what my tradition is. Pottery, of course, came down to me through [my dad], but then [he] had people hired from everywhere and they were bringing in new ways of doing it. He had people from Pennsylvania and Texas and California working for him, and I remember lots of those people that were coming in and out, and each one would seem to have a little different way of doing it, so I wonder really where my tradition is."[72]

STUDIO POTTERY: WALTER STEPHEN

While there was variation and innovation in traditional pottery, especially when it relied on tourist sales, a few individuals in the Southeast operated with the somewhat different attitude of a studio potter. The first was O. L. Bachelder after 1914, followed by Walter B. Stephen. They, perhaps more than the folk potters, are models for many ceramists working in North Carolina today; although they were earlier in time than Craig and Meaders, they were more contemporary in approach. In 1926, near Asheville, Stephen (1876–1961) founded Pisgah Forest Pottery, which became nationally known for crystalline glazes and for what he called cameo ware; the pottery was handed down to his step-grandson and still exists. (Figure 4.28)

Stephen was born in Iowa, grew up on a family farm in Tennessee, and was trained as a mason and stoneworker. When, in his mid twenties, he discovered pink, white, and yellow clay on family land, he was influenced by a neighbor's description of a pottery-turning demonstration at the Saint Louis world's fair (it may have been George Ohr) and decided to teach himself the technique on a home-built wheel. He whittled, cast, and slab-built objects as well. His mother, Nellie, who had an art background and kept a sketchbook, was also interested and became his decorator in what they called the Nonconnah Pottery.[73] Over mat surfaces, she painted porcelain slip in layers that gave dimension to carefully observed flowers, trees, birds, and occasionally landscape scenes.

Both parents died in 1910. Stephen traveled for two years and settled in western North Carolina in 1913. A

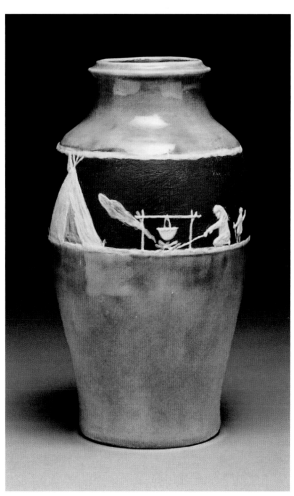

FIGURE 4.28. *Walter Benjamin Stephen, Pisgah Forest Pottery, Cameo Vase, 1929. Stoneware; 12.75 × 7.25 in. (Mint Museum of Art, Charlotte, N.C., Daisy Wade Bridges Collection, H1977.196.6.)*

socially prominent couple, Mr. and Mrs. C. P. Ryman, agreed to finance a pottery Stephen would operate. It, too, was called Nonconnah and was in business by late 1913 or early 1914. North Carolina Nonconnah consisted primarily of souvenir items, turned or molded. Stephen developed his mother's decoration technique using porcelain slip. The white relief against solid brown, green, or charcoal gray background created a classical look that customers compared to English Wedgwood pottery, particularly the naturalistic ivy or grapevines believed to have been decorated by Mrs. Ryman. In 1916 he left the pottery.

Stephen moved to nearby Arden, where he became acquainted with Bachelder and sometimes worked with him. When he established his Pisgah Forest Pottery, he returned to the slip-relief technique, which he now called American cameo pottery, creating motifs inspired by his own childhood experience traveling in a covered wagon.[74]

This, a superlative crystalline glaze, and noted crackle glazes made his name. Pisgah Forest pottery appealed to both tourists and collectors.

In Short

In the 1920s, America discovered art deco after a world's fair in Paris introduced and named the modern style. At the same time, Native American and folk crafts inspired new interest. Art deco was part of the avant-garde sensibility, which also responded to the "primitivism" of these unlettered or exotic expressions. Missionary and settlement efforts initiated the new markets for the crafts of the Southeast, and expanded tourism led to new markets for craft of the Southwest. In both locales, tension between tradition and innovation was problematic, but ultimately it can be seen that folk traditions are not static but flexible and open to change, while for Native Americans, the recycling of motifs and techniques from the past, lamented by some observers, was in fact a usual practice, a way of linking with ancestors.

A number of European expatriates had an important influence on American crafts. Ilonka Karasz, Loja Saarinen, and Wilhelm Hunt Diederich were only three of them. They, and Americans who studied abroad and brought back new ideas, such as Ruth Reeves and Guy Cowan, constituted the cutting edge of craft throughout the 1920s.

CHAPTER 5 1930–1939

INDUSTRIAL DESIGN VERSUS HANDCRAFT

Changes in Life and Craft

During the 1930s, European immigrants continued to arrive, bringing superlative skills and different habits and influencing education as well as styles. Among them were the first creative people displaced by the Nazi threat (most are discussed in chapter 6), but others came under more benign circumstances.

Some features that most distinguished this decade relate to the economic crisis. The WPA, a federal welfare project, proved a boon for all the arts in America. Developments in the crafts led to the founding of important organizations, some for economic benefit and others for professional reasons. The number of studio potters expanded significantly, and industrial design blossomed, while revivals of various traditional crafts continued. The number of educational institutions offering craft courses began to grow.

Modernism, which Herbert Hoover had said did not exist in America, made itself at home—literally. Although the home would seem to be the most conservative and traditional aspect of American life, people could not resist new appliances. "Modern design sneaked into the home by way of the back door, through the garage, the kitchen, and the bathroom, without much notice or resistance," although the living room and bedroom still showed older European or colonial styles.[1] At the same time, in the public sphere, the great construction projects of the 1920s (especially skyscrapers) and 1930s (parkways, bridges, dams, underwater traffic tunnels, radio towers, and electric transmission lines) led to a shift in consciousness, earning the 1930s the sobriquet "The Machine Age."

Chicago's Century of Progress Exposition in 1933 influenced manufacturers and consumers with its displays of metal furniture, both indoors and out, by making it seem more familiar and less cold. In 1934 the Museum of Modern Art (MOMA) presented more than 400 objects in its *Machine Art* exhibition, which received enormous publicity. Many items not usually seen in museums, such as machine parts and appliances, were mounted on pedestals. Although MOMA promoted European functional modernism as practiced at the Bauhaus, ironically

the *Machine Art* exhibition consisted almost entirely of American objects.

The instability of the Depression years led to a compensatory effort to strengthen national unity through emphasizing what was uniquely American. The phrases "an American Way of Life" and "the American Dream" became common.[2] The Whitney Museum, the first institution devoted exclusively to American art, was established in New York in 1931. Painters took up daily life and ordinary people as subjects in realistic representations.

These American Scene artists were interested in the topical, the local, and the anecdotal, in a literal engagement with their community. Crafts of the era shared the egalitarian orientation of social realist painting of the time, and figurative ceramics featured a similar anecdotal approach, but crafts differed in remaining largely open to European influence, which the painters were trying to escape.

Another important artistic current of the time was surrealism. When the surrealist art of Salvador Dalí, Joan Miró, and Hans Arp was shown in New York galleries in the late 1920s and in an exhibition at the Museum of Modern Art in 1936, it was protested and ridiculed, yet it was immediately influential. Its erotic and dreamlike qualities and psychological references showed up in dress design, advertising, and window display. Some art photographers rendered machines with the same intense, almost sexual regard employed by surrealist painters. American interest in primitive and vernacular design supported biomorphic shapes, exemplified by Russel Wright's American Modern ceramics of the later 1930s, rather than angular geometry.

All these influences—economics, the machine, social change, proud Americanism, surrealism—led to drastic change in the decorative arts in the interwar period. The intrinsic character of every sort of material was accorded a new respect. Chrome was particularly attractive because of its reflection of light. Synthetic plastics, invented in the nineteenth century, were accepted during the 1930s. Many synthetic fibers were developed, the most important of which was rayon, because it could be woven to imitate almost any textile. It provided new options for fashion and interior decoration.

Craft Institutions

CRAFTS IN THE NEW DEAL

Governmental support for crafts was almost nonexistent before the 1930s. The massive unemployment of the Great Depression, however, called for action on all fronts, and the Roosevelt administration responded by establishing various work programs—with a confusing array of names and missions. Among the umbrella agencies were the Civil Works Administration (CWA, funded 1933), then the Works Progress Administration (WPA, 1935–39) and Works Projects Administration (also WPA, 1939–43). These large agencies funded smaller ones that put artists to work, such as the Public Works of Art Project (PWAP) and, later, the Federal Art Project (FAP).[3] Many govern-

Part of Bedroom Suite - Timberline Lodge

FIGURE 5.1. *Margery Hoffman Smith*, Guest Room Interior Design for Timberline Lodge, *ca. 1939. (Courtesy of Oregon Historical Society, OrHi 71462.)*

ment programs employed craftspeople in some capacity. Some promoted social improvements already advanced by earlier efforts, especially the settlement-house movement. Preservation of craft traditions and education for the common people were typical goals of federal craft programs.

There was a WPA Arts and Crafts Program and a WPA Welfare and Production Program. Community art centers were set up, and many offered craft courses or sponsored projects focused on a particular medium. At the Cleveland School of Art, Edris Eckhardt operated a large ceramics project. Under PWAP and later the WPA, her venture specialized in figurines drawn from children's stories; they sold so well that as many as ninety people were employed at one point. In Vineland, New Jersey, the WPA rented a glass factory to employ skilled but unemployed glassworkers. For a year or two, the project produced paperweights, vessels, and other items, but high costs forced it to close in 1937. In Milwaukee, the WPA created a household training center that specialized in teaching block printing on textiles to local women as a trade that might bring them financial independence. An Illinois craft project in 1940 supported the design and production of molded-plywood furniture for Crow Island School in Winnetka. There were separate programs for African Americans. Howard University housed a WPA ceramics program, and sculptor Augusta Savage operated workshops for weaving, pottery, and quilting at the Harlem Community Art Center in New York. All told, the WPA funded more than 3,000 craft projects nationwide, and more than 600,000 people took WPA craft classes.[4]

Aesthetically, government craft projects were not at all uniform. Some people hired to teach or work had art aspirations, while some programs targeted traditional or revival crafts. Many of these addressed minority groups, including Senecas and Iroquois in New York State and Hispanic Americans, Navajos, and Hopis in New Mexico.

The WPA constructed buildings, and some were masterpieces of 1930s eclecticism. Timberline Lodge, high on the slopes of Mount Hood, sixty miles east of Portland, Oregon, was one such example. (Figure 5.1) The mountain was a popular destination for skiers in the 1920s, but it lacked a hotel. In 1935 a consortium of the National Forest Service, the WPA, and a private development association began construction of a massive timber lodge in a rusticated art moderne style. The furniture, textiles, ironwork, decorative carvings, and watercolors for every room were made expressly for the building. An on-site forge made hinges, boot scrapers, chandeliers, andirons, and a weathervane. Margery Hoffman Smith (daughter of Julia Hoffman, founder of the Oregon College of Art and Craft) directed the interior scheme, including woven drapes and upholstery as well as hooked rugs made from recycled Civilian Conservation Corps blankets. In the lobby, newel posts feature animal carvings, no two the same. Few textiles have survived, but original furniture, ironwork, and carvings remain in the building today.

A peculiarity of WPA craft projects after 1938 is that they were required by law not to compete with manufactured products. Presumably this was the doing of businessmen fearful that federally supported handmade

goods could eat into their markets. Thereafter, the WPA emphasized education, recreation, public works, and preservation.

ALLEN EATON

A few individuals who never practiced a craft had a profound impact on the field. One of these was Allen Eaton (1878–1962), who started out as a bookstore owner and professor of architecture in Eugene, Oregon. After being forced to resign his teaching position in 1917 for political reasons, he moved to New York and took up social work. With the American Federation of Arts (AFA), he was involved in an "Americanization" project, promoting acceptance of recent immigrant populations by exhibiting old-world folk crafts and sponsoring performances of music and dance. Eaton's exhibition for the State University of New York was called *Arts and Crafts of the Homelands*. In 1920 he was hired by the Russell Sage Foundation, which had already funded John C. Campbell's fieldwork in the Southern Highlands. In 1926 Eaton was sent south to investigate the possibilities of using crafts for public good.

Eaton, like Jane Addams at Hull-House in the 1890s, advocated dignity and respect for immigrants, who were often caricatured in the press as threatening American traditions and virtues. He extended his sympathies to the rural poor. He was also interested in bringing beauty to as many people as possible, preferably in an affordable form.

Eaton defined handicrafts as "all those things which people make with their hands for their own use or for that of others."[5] He included folk arts and hobbies, without regard to originality or quality. This led him directly to cottage industries, people making things at home for sale. He put a Ruskinian stress on the importance of pleasure in work and a sense of self-worth. He wrote that the pursuit of craft built morale. To Eaton, handicrafts were always a means to an end.

His legacy consists of several books documenting handicrafts and folk arts from particular regions: *Immigrant Gifts to American Life* (1932), *Handicrafts of the Southern Highlands* (1937), and *Handicrafts of New England* (1949). He included some surprising topics: tombstone cutting, fishnet knotting, crocheting with dog-wool yarn. Accomplished professionals such as stained-glass master Charles Connick received no more attention than hobbyist Bruce Rogers, who made a singing cuckoo weathervane.

Eaton's surveys presented an image of craft that was friendly and folksy, and he did much to legitimize and build the market for rural craft forms such as coverlets, baskets, and brooms. He became an expert in craft organizations, helping establish several during the Depression. Some of the largest craft exhibitions in the country were assembled with his help, including the enormous *Rural Arts Exhibition* in Washington, D.C., sponsored by the Department of Agriculture in 1937, and *Contemporary New England Handicrafts* at the Worcester Art Museum in Massachusetts in 1943.

LEAGUE OF NEW HAMPSHIRE ARTS AND CRAFTS

One of the organizations that Eaton aided was the League of New Hampshire Arts and Crafts (now the League of New Hampshire Craftsmen). It started with an exhibition of hooked rugs in tiny Center Sandwich in 1925. A group, led by Mrs. Randolph Coolidge, decided to open a store to sell local crafts. They raised money by serving afternoon tea, found a rent-free space, and asked local craftspeople to reproduce some old forms such as fire tongs or rugs. In its first year, Sandwich Home Industries sold $1,000 worth of inventory.

Meanwhile, a group in Wolfeboro, New Hampshire, was conducting metalwork classes. Soon the two communities joined forces, and in 1931 they received a $5,000 government grant. Mrs. Coolidge and her partners established the League of New Hampshire Arts and Crafts that year. It was the first state-funded craft organization in the nation.

The league combined cooperative marketing with adult education. People in twenty-two locales were organized, and ten shops opened across the state. Director Frank Staples ran the program from his Concord home and drove all over the state collecting work and distributing it to salesrooms. He also coordinated instructors; weaving, needlework, and wood carving were the most popular crafts, followed by metalwork and pottery. At first, Mrs. Coolidge said, some of the work was "horribly old-fashioned." Occasionally the league would send designs for members to reproduce, making the design quality of their goods more uniform. As more people took classes, standards improved.

The league also sponsored exhibitions. One of the first was in Crawford Notch in the summer of 1934. A week-long event called the Craftsman's Fair included sales displays and demonstrations, such as making homespun textiles, from shearing a sheep to dyeing and weaving. The combination, in a summer tourist destination, was wildly successful and persists today.

The League of New Hampshire Arts and Crafts was a model for a new generation of organizations in the 1930s and 1940s. In essence, these were self-help groups, founded and staffed by volunteers, which provided a

marketplace for home industries and often conducted educational programs. These cooperative groups became the new public face of craft.

SOUTHERN HIGHLANDS HANDICRAFT GUILD

A federation of craft groups, the Southern Highlands Handicraft Guild (now the Southern Highland Craft Guild) was chartered in 1930 by representatives from nine "producing centers," including Frances Goodrich from Allanstand and Lucy Morgan from Penland Weavers and Potters. It was a marketing and educational scheme. A standards committee, like that of the Boston Society of Arts and Crafts, was set up to jury new members, uphold standards of quality, and assure the authenticity of products submitted for sale. Goodrich's shop became part of the guild in 1932.

The guild often sent designs to member organizations and had fairly clear ideas about what would appeal to their customers, primarily middle-class tourists. As with Allanstand and Berea College earlier, the imposition of design standards was in tension with the desire for authenticity. Patterns originally found in coverlets were adapted to carrying bags; the technique of rug hooking was used to make placemats. Less-expensive items were more salable. The guild claimed that it was preserving genuine mountain culture, but in truth, it only enabled a modest number of rural people to adapt to the modern economy.

A massive 1934 survey conducted by the Women's Bureau of the Department of Labor showed that the vast majority of craftspeople in the Southern Highlands were women: about 95 percent of a total of about 15,000. Of these, some 450 worked for philanthropic groups such as Penland Weavers. Women were typically paid ten to twelve cents an hour, while men earned twenty to twenty-five cents. When the federal government proposed a minimum wage of thirty cents an hour, the guild lobbied against it. It would seem that the guild and its sister organizations were guilty of enforcing sweated labor.[6] But given that most of the women lived in the deep woods, where the only other sources of cash income were crops and illicit alcohol, low pay was better than none.

The Southern Highlands Handicraft Guild was rooted in philanthropy but aimed to develop a workable business model for craft administered by professionals. In a related development, a federally sponsored marketing cooperative, called Southern Highlanders, Inc., opened a salesroom in New York in 1936. Before long, these features would be rolled into the first enduring national craft organization, the American Handcraft Council.

Education

PENLAND

Lucy Morgan's Penland cottage industry was also changing. As the 1930s began, each summer weaving institute, organized around the arrival of Edward Worst, had a greater number of outside students. One innovation of Morgan's school was that there was no permanent faculty: all the teachers came from out of town. As with many craft schools of the time, there were no grades, no set curriculum, and no accreditation. Classes were open to all applicants on a first-come, first-served basis. Although the concept of a summer school for the crafts dated to 1891, the Penland model would inspire the creation of many other seasonal craft schools. There was a relaxed, democratic atmosphere. Students and teachers ate together, worked together, and sometimes forged lasting personal bonds.

In 1932 additional courses were added, starting with pottery, basketry, wood carving, and leather tooling. In 1935 Morgan finagled the construction of a large building on her own land adjacent to the Appalachian School. The project necessitated ingenious fund-raising schemes, including raffling off the first bath in the new bathroom, which drew local press coverage. The school continued to grow, and in 1938 it incorporated as the Penland School of Handicrafts. Penland Weavers and Potters was part of the new organization, but the Appalachian School faded into the background. (It closed in 1965.) While the program still served local populations, students now came to Penland from all over the country and even, in a few cases, from abroad.

Classes were offered in four three-week sessions. Smith-Hughes Act allocations supported the activities, and later students could use GI Bill subsidies for tuition (see chapter 6). Course offerings expanded in variety, ranging from metal crafts and shoemaking to drawing and design.

CRAFT GOES TO COLLEGE

In the 1930s, the Manual Training Movement, aided by state and federal funding, reached into every level of higher education. Dozens of state colleges created programs for teachers of industrial arts and home economics. Some art schools offered hands-on training, and the nineteenth-century model of drawing, sculpture-modeling, and learning the history of decorative styles fell out of favor.

A college education was assumed to qualify the graduate to become a teacher or a designer, not a laborer. Employers and designers in craft-based industries, however,

were divided as to whether a deeper knowledge of a craft medium made a better designer. For instance, in a survey, nearly 80 percent of business representatives of the fine-jewelry industry thought craft training for designers was a good idea, while not one in the costume-jewelry business felt that an art-school education had any value.[7]

Ceramics was probably the most popular craft subject in colleges in the 1930s, followed by jewelry. (Wood carving fell into obscurity.) In the East and Midwest, Alfred University, Ohio State University, and the Cleveland School of Art were the most prominent ceramics programs. Studio instruction in the crafts flourished everywhere, though. As potter Daniel Rhodes explained it, students were seeking both employment and some kind of self-determination: "To get a job was extremely difficult then, especially for those interested in the arts. We all looked to pottery as a way of making a living and a way of keeping one foot in the art world, while keeping some kind of functioning independence."[8]

Two competing trends entered into the educational debate in the 1930s. One was the importation of the Bauhaus system; the other was the development of industrial design as a profession.

After the Bauhaus was closed in 1933, many teachers found their way to the United States and taught in experimental or traditional institutions. Most were sympathetic to the idea of hands-on craft instruction.

In 1937 László Moholy-Nagy founded the New Bauhaus in Chicago. He encouraged students to experiment freely with new materials and processes and to regard machines as tools to bring superior design to the largest number of people. Students made abstract studies to see how different materials and tools produce different forms. Some of the most important members of the first generation of American craftspeople to unite modernism with handwork, such as James Prestini and Margaret De Patta, were among his students. The New Bauhaus lasted only a year, but it reopened in 1939 as the Chicago School of Design, was accredited as the Institute of Design in 1944, and was absorbed by the Illinois Institute of Technology in 1946.

The new field of industrial design tended to regard itself as detached from craft practice. America's first generation of industrial designers started in fields like illustration and stage design. Uniformly they believed that a good designer was qualified to employ any medium for any industry, and they whipped up designs for everything from airplanes to pencil sharpeners. In the middle of the Depression, their most compelling argument was that their streamlined designs stimulated sales.

The Bauhaus

The Bauhaus, an experimental German design school founded in 1919 and closed when the Nazis came to power in 1933, funneled all students through a basic course emphasizing exercises in abstract composition and experiments with materials. They then spent two years in a hands-on studio—such as metals, weaving, mural painting, or stained glass—before they began specialized study of painting or, later, architecture. (Architecture was regarded as the most exalted branch of design.) Every studio had a form master, often a painter or sculptor, who addressed issues of composition and theory, and a craft master, who dealt with technical matters.

This structure was based on the assumption that designing required an intimate knowledge of materials, which are best understood by working with them by hand in a craft studio. The Bauhaus system enshrined the Arts and Crafts ethic of truth to materials, making it a central tenet of early modernism. It was presumed that this approach would make the school a research and development arm for industry. In practice, results were mixed. Still, the school proposed that craft and industry could coexist in a mutually beneficial relationship.

In its later years, Bauhaus design tended increasingly to favor industrial materials such as steel and glass, with no applied decorations or references to historical precedents. In architecture, the Bauhaus look embodied the International Style. Among the studios, style diverged considerably depending on the form master, but most favored a clean geometry amenable to mass production.

The Bauhaus also licensed student and faculty designs to various manufacturers, to promote its vision of modern design for the masses (and to generate cash for the school, which was always underfunded). The most successful designs came from the metals and furniture shops. Some of them, like Marcel Breuer's tubular-steel armchair, are still produced today.

To ensure a future for this new profession, industrial designers established teaching programs. The first school was the Design Laboratory, founded in 1935 in New York. Although supported by some of the most prominent designers in the country (Gilbert Rohde, Henry Dreyfuss, and Walter Dorwin Teague among them), the

school closed in 1937 after its WPA funding dried up. Elsewhere, industrial design programs evolved out of existing applied-arts courses. Silversmith Peter Müller-Munk founded the first degree-granting industrial design program, at the Carnegie Institute of Technology in Pittsburgh in 1935. Pratt Institute, New York University, the Cleveland School of Art, the Rhode Island School of Design, and other art schools and universities developed courses as well.[9]

CRANBROOK

Although George Booth had been very active in the early years of the Detroit Society of Arts and Crafts, he felt that it was not showing and exhibiting the best work. In this matter, he was not exactly an amateur. Before marrying into the family that published the *Detroit News*, he had operated an ironwork company and had founded a small Arts and Crafts press. Both his father and grandfather were coppersmiths.

In 1924 he decided to create a school. Ultimately he created an educational community, encompassing a church, elementary school, separate prep schools for boys and girls, science institute, art library and museum, and art academy. To build a campus near his mansion, in the far northern suburbs of Detroit, he hired Finnish architect Eliel Saarinen (1873–1950). Saarinen was a leader in the Arts and Crafts-influenced national romantic movement in Finland and had designed furniture and rugs in addition to buildings. Booth established several craft workshops to furnish and embellish Saarinen's buildings. To run them, he hired Hungarian sculptor Geza Maroti, Swedish cabinetmaker Tor Berglund, and English silversmith Arthur Neville Kirk. He hoped that these studios would become self-supporting, providing custom-made furniture and silver for discerning patrons. The Depression made that impossible.

For his Christ Church Cranbrook, Booth commissioned wood carvings from John Kirchmayer and ecclesiastical silver from Kirk, both in the Gothic revival style. The art school was designed in an elegant fusion of old world and modern. Between 1925 and 1942, Saarinen designed fifteen buildings and additions for Cranbrook. Stylistically they evolved from restrained quasi-Gothic to restrained neoclassical. His own house is a masterpiece of understated protomodern design, with a flavor of both Austria and France. Furnishings were part of the project, too.

Cranbrook Academy of Art was officially founded in 1932. Booth was inspired by the American Academy in Rome, a program involving scholars-in-residence and students; education occurred primarily through informal contact. Booth also admired the relationship between the Victoria and Albert Museum and the Royal College of Art in London. His academy would combine elements of both systems into an institution that was, and is, unique in America. Sited along a lane in Booth's rural acreage, Cranbrook resembles a monastery dedicated to art.

Unfortunately it opened in the depths of the Depression. Booth closed all the workshops except Studio Loja Saarinen, the weaving shop. Through the 1930s and 1940s, the workshops were opened and closed as economic conditions dictated. Waylande Gregory left the shuttered ceramics shop in a huff in 1933, but it was reopened informally in 1934. Rigorous ceramics instruction was not offered until Maija Grotell was hired in 1938. The metals shop reopened in 1937 under Harry Bertoia (then still a student) and closed again during the war. The bookbinding shop was closed for good, as was the cabinet shop. Still, Cranbrook had both facilities and expertise in place when the war ended, and it became one of the most important centers of high-level craft education in the United States.

Given Booth's passion for the Gothic and his interest in Arts and Crafts principles, one might have expected Cranbrook to retreat from mass production. It did not. Booth felt that artists had an obligation to work in collaboration with industry. The 1932 announcement for the new academy stated unequivocally: "To execute objects of art by hand as original pieces has its value and always will have, but it is, however, an important part of the Academy program to produce a design that can be multiplied by machine. The Academy has to be, therefore, in contact with various industries, which will manufacture the design."[10] Marianne Strengell, whom Booth hired in 1937, redirected the weaving course toward using looms as design tools. The same ideal would motivate Eero Saarinen and Charles Eames to design brilliant furniture in the 1940s.

BLACK MOUNTAIN COLLEGE

Another highly experimental school that figured in the story of American craft was Black Mountain College, located near Asheville, North Carolina. Maverick educator John Andrew Rice founded it in 1933 as an alternative to the more hidebound colleges of the day. After Rollins College in Winter Park, Florida, fired him for advocating curriculum reforms, Rice and some associates decided to found their own school and located a small campus in North Carolina built for summer YMCA conferences.

Black Mountain College was important in the fermenting of avant-garde American art. It was a small liberal-arts college, with the visual arts, theater, and music

playing a crucial part in a well-rounded education. The fledgling school, through a connection with the Museum of Modern Art, in late 1933 hired Bauhausler Josef Albers to run its visual art program. (Albers, who had headed the Bauhaus furniture workshop although he had previously worked primarily in stained glass, was the first of the faculty to come to America.) His wife, Anni Albers, an experienced weaver, accompanied him. He set up a basic course in art after the Bauhaus model. Albers insisted that there was no hierarchy of materials: anything could be interesting if it was used properly. Leaves, mica, chunks of wood, and eggshells were all valid materials for exercises. The idea was revolutionary in American art education. There were also workshops in the Bauhaus manner, including a weaving studio, bookbindery, and, later, a darkroom and a wood shop. Students were expected to make objects for use, but conditions were too primitive for most shops to generate a regular income. Anni Albers headed the weaving studio, which was the most sophisticated of the lot. Over the years, Black Mountain attracted many soon-to-be-prominent artists, and it served as an important way station for dozens of craftspeople.

MoMA and Craft

The 1930s generated the sharpest debates about the relation between craft and the machine since the turn of the century, yet, for the most part, the participants were not craftspeople but designers and architects, along with a few curators who were involved with European modernism.

The epicenter of the debate in America was the brand-new Museum of Modern Art in New York. In matters of painting and sculpture, founding director Alfred H. Barr avoided the "style wars" that pitted surrealism, nonobjective art, social realism, and American regionalism against one another. When it came to design and architecture, however, Barr was not so open-minded. He agreed with Henry-Russell Hitchcock Jr., who in 1929 had written *Modern Architecture: Romanticism and Reintegration*, an extended promotion of the new modernism emerging in Europe. Hitchcock believed that architecture should be geometric, devoid of applied ornament, and more closely allied to engineering than to any historicist style. He approvingly quoted the French architect Le Corbusier, who had written in his uncompromising 1923 book, *Vers une architecture* (published in English in 1931 as *Towards a New Architecture*), "The house is a machine for living in." Le Corbusier was certain that mass production would provide for human needs. *Vers une architecture* is full of

moral indignation—not unlike A. W. N. Pugin's invective against modern England—except that here industrialization is the savior, not the corruptor.

In 1932 MOMA presented *Modern Architecture: International Exhibition*, curated by Hitchcock and Philip Johnson, MOMA's young curator of architecture and design. It was the first exhibition of modern architecture in the United States. The show traveled to fourteen other venues, including art museums in Philadelphia, Buffalo, Cleveland, and Cincinnati as well as the Sears, Roebuck store in Chicago and Bullock's in Los Angeles. It was this exhibition that promulgated the term "International Style."

MOMA became the leader in disseminating modernist design, just as the Metropolitan Museum of Art had led the charge for art deco in the 1920s. Extending the polemic to product design, MOMA mounted the famous *Machine Art* exhibition in 1934. (Figure 5.2) Barr and Johnson decided that modern design should be devoid of decoration. Any complexity of form should be dictated by the function of the object. Otherwise, useful objects were treated as if they were abstract sculptures. Func-

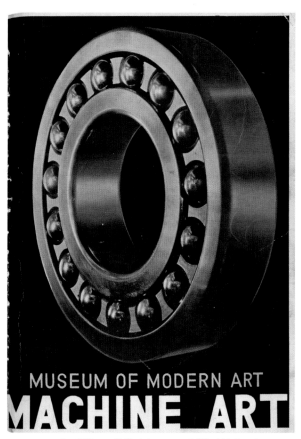

FIGURE 5.2. *Josef Albers, Philip Johnson, and Alfred H. Barr Jr., cover of* Museum of Modern Art Machine Art Exhibition Catalogue, *1934. (© 2009 The Josef and Anni Albers Foundation/Artists Rights Society [ARS], New York. Digital image © The Museum of Modern Art/ Licensed by SCALA/Art Resource, New York.)*

tion comingled with "aesthetic interest," "perfection of shape," and "beauty of surface." The exhibition consisted of unadorned appliances, housewares and furnishings, and, more notoriously, industrial fittings and scientific laboratory equipment displayed like works of art. This was the heart of the show: the street-level sign featured a ship's propeller. There were steel cables, coil springs, and a ball-bearing assembly that was reproduced on the catalog cover. There was even a chrome-plated flush valve for a toilet.

Machine Art was emphatically anticraft. As Johnson put it in the catalog: "The craft spirit does not fit an age geared to machine technique. Machine-made imitations of craft objects are parodies, and the real handicrafts have lost their original vigor." (Years later, in 1994, Johnson admitted that the "machine worship [that] was running wild" clouded his judgment.)[11] MOMA became a taste-maker, so its skepticism regarding craft swayed others. Only occasionally was it receptive.

Ceramics in School

While various studio artists were well known in the first decades of the century, ceramics was rarely taught. The contacts maintained by Charles Binns with his Alfred graduates and the industry-oriented American Ceramics Society were among the few "institutions" of any sort that advanced knowledge of ceramics. The positive aspect of the unstructured situation was that work like Henry Varnum Poor's was shown in art galleries as simply one among many forms of modernist expression; the negative aspect was that most people who wanted to work in clay had to reinvent the wheel (no pun intended).

Among the factors provoking change in the 1930s were the introduction of ceramics to numerous college programs, notably in California; support for some ceramics work by the WPA; the immigration of trained European ceramists; and, perhaps most of all, the establishment of the Ceramic National exhibitions by the Syracuse (now Everson) Museum beginning in 1932. The Nationals immediately provided high-profile exposure for ceramics and did so for decades thereafter. In the 1930s, as studio pottery grew, figurative sculptures were as prevalent as vessels in exhibitions. Heads and masks were popular forms. While traveling exhibitions and Cowan Pottery had introduced figures and humor in the effervescent climate of the late 1920s, whimsy seemed just as meaningful in the difficult times that began with the stock market crash. The cheering effects made ceramists feel they were doing something beneficial, and some of their subjects paralleled those of American Scene painters, such as the circus, children at play, animals, and family groupings.

The preference for informality that distinguished American work from European began to seem like a valid aesthetic rather than an embarrassment. Fine china maintained its traditional status, but increasingly earthenware dinner services became popular. Russel Wright's American Modern pattern was the favored gift for the up-to-date bride of the late 1930s. Mass-produced ceramics adopted new forms: with the introduction of refrigerators, for instance, Hall China produced wares with flat sides and stacking containers that made economical use of space.

CERAMIC NATIONAL

The Ceramic National began in 1932 as the Robineau Memorial Exhibition at the Syracuse Museum, a tribute to ceramic artist Adelaide Robineau, who had died in 1929. Anna Wetherill Olmsted, director of the museum, had such a minimal budget that the first show had no catalog and included New York State artists only, but she persisted, and in 1933 the show became national, with seventy-three ceramists from eleven states entering 199 pieces.

The National was a major source of information on what was happening in the field. Its prizes were treasured validation, and its category of ceramic sculpture stimulated interest in that genre. The exhibition also provided a platform for Native American art when Maria Martinez showed her work.

It raised the stature of American ceramics internationally. Olmsted later frequently told the story of the Ceramic National being shown in the Scandinavian countries and in England in 1937 (funded by the Rockefeller Foundation): "the participating museums, expecting little more than a showing of Indian pots, were completely astounded by the competence and infinite variety of the collection received. In the same way, the Ceramic National display in the Golden Gate Exposition in San Francisco in 1939 opened the eyes of the American public to the achievements of their own countrymen."[12] The growth eventually became cumbersome, however. A coping strategy after the war was to have local juries in major cities screen work before it went to Syracuse. By the seventeenth National, in 1952, 493 ceramists from thirty-nine states submitted 1,171 entries, and a decision was made to go biennial.

THE COWAN CREW

At the beginning of a career that for a time put him among America's leading sculptors, **Waylande Gregory**

(1905–1971) worked at Cowan Pottery and at Cranbrook. A noted modeler, he made seductive female figures, portrait busts, and monumental sculptures, always working in clay. The variety of his work was unusual—in styles (Beaux-Arts to art deco to realist) as well as in size (his monumental works were probably the largest clay sculptures of the time, yet he also made small objects in limited editions).

Gregory studied in his native Kansas, was invited by sculptor Lorado Taft to a residency in Chicago, and accompanied Taft to Italy, spending time in Florence. On his return Gregory became a modeler for Cowan. One of his limited-edition works, *Diana and Two Fawns*, was awarded first prize for clay sculpture at the Cleveland Museum's May Show in 1929. It was a dazzling beginning.

Gregory's figurative pieces were often based on mythological or biblical characters, such as Persephone or Salome. The figures emphasize plasticity and suggest movement in their poses and costumes, veils adding to the implications of motion through their dramatic sweep or teasing the viewer's erotic fancy by barely concealing the body. Other works, such as relief vases, featured deco-style angles and planes.

In 1932 Gregory left Cowan for a position at Cranbrook. He was clearly stimulated by the environment and worked productively, but his stay was not a happy one.[13] He arrived at the end of January and persuaded George Booth to upgrade the kilns to allow high-temperature firing of large works. The process was complicated and expensive, but the kiln was fired that spring. Like the other craftsmen, Gregory received no salary; he lived on the sale of his work and tuition money from whatever students he could attract. He was not pleased with the arrangement. The school's financial situation worsened; Booth closed all the craft shops and cut off electricity and heat. Gregory, in protest, removed his works from the Cranbrook Museum and lined up a teaching job at Cooper Union in New York. He brought a lawsuit against Booth that took two years to settle. The works Gregory made at Cranbrook were extensively shown and helped him gain national prominence, but in his publicity he almost never mentioned the school.

Gregory's output included both roughly textured unglazed terra-cottas, such as *Horse and Dragon* (which won a sculpture award at the Art Institute of Chicago), and works with smoother surfaces and stylized art deco rhythms: *Radio* was a pair of sleek, posed women in relief. The easy contours of *Girl with Braids* (1932) show the influence of Swedish sculptor Carl Milles, one of Gregory's Cranbrook colleagues, while *Girl with Olive*

has more elegant lines that recall Brancusi's heads. In his 1938 *Europa* (a ubiquitous art deco subject), he renders in stained but unglazed earthenware a charging bull leaping over waves with nude Europa wrapped in a veil on his back.

Gregory moved from Cooper Union to his own studio in New Jersey. He supported himself by making limited-edition decorative plates, bowls, and vases, often with abstract patterns or clever figures. He also made portrait busts (Albert Einstein, Henry Fonda, Charles Lindbergh); elegant, stylized heads; and life-size idealized nudes. These works have a languorous, relaxed air and glossy, seductive surfaces. An arrangement with a New Jersey factory allowed access to large kilns where he could fire big pieces, but these were never financially successful for him.

Gregory is most remarked for two fountain commissions. For the WPA's Federal Art Project he created *Light Dispelling Darkness* (1937) on the grounds of Roosevelt Hospital in Edison, New Jersey. (Figure 5.3) The symbolic figures Death, War, Famine, and Pestilence (the traditional Four Horsemen of the Apocalypse) plus Greed and Materialism surround a fifteen-foot-tall shaft featuring reliefs of heroes of technological advancement. The lab where Thomas Edison invented the incandescent bulb was nearby, which provided the inspirational theme in disheartening times.[14]

Gregory then created *The Fountain of Atoms*—probably the largest single work in modern ceramic sculpture—for the New York world's fair of 1939–40. It consisted of twelve huge earthenware figures, each weighing more than a ton, symbolic of Fire, Earth, Air, Water plus "Electrons" (represented by chubby children), to suit the fair's World of Tomorrow theme. A contemporary account described part of it: "In the 'Water' a sculptured male swimmer of warm terra cotta descends through swirling, watery forms of green blue glass, accompanied by maroon fish and lemon bubbles. The fire figure is covered in tongues of reddish glaze and reflected areas of faint blue and green. The colour tone being handled so as to give the sense of being viewed through fumes."[15]

It was an extraordinary technical achievement. Shrinkage, warping, and sustaining the heavy wet clay in a vertical position were problems. Gregory devised a kind of interior honeycombing to make it possible.[16] This work won him a commission to design an eighty-foot ceramic mural for the Municipal Building in Washington, D.C. The social realist–style *Democracy in Action* (1941) consisted of nearly life-size farm and factory workers, plus policemen and firefighters, along with black lawbreakers. The implicit racism of this last feature generated such a

FIGURE 5.3. *Waylande Gregory working on* Light Dispelling Darkness *fountain, 1937. (Courtesy of the Federal Art Project, Photographic Division Collection, 1935–42, Archives of American Art, Smithsonian Institution.)*

furor that the courtyard in which the work was displayed was closed to the public.

In the early 1940s Gregory developed and patented a method of binding glass to clay. He made utilitarian bowls and ashtrays in which fractured glass lies below a smooth surface. His reputation declined, however, and he had no more opportunities to do large work.

Viktor Schreckengost (1906–2008) made one work so successful and so celebrated that it has sometimes overshadowed the rest of his very considerable career. The *Jazz Bowl* (1930), a punch-bowl design for Cowan, stands as a symbol of the vanishing era of flappers, speakeasies, and urban nightlife. (Figure 5.4) Rendered in searing blue and black are skyscrapers, stars, bubbles, and neon signs floating among words such as "jazz," "follies," and "dance." The design was inspired by the young artist's visit to Manhattan and conflates his memories of Times Square, Radio City Music Hall, and Harlem's Cotton Club. The bowl resulted from a commission by a New York gallery; only afterward did Schreckengost learn that Eleanor Roosevelt was the customer. She liked it enough to purchase two more. Although an art deco classic, it heralded the swan song of Cowan Pottery.

Schreckengost was born in Ohio into a family of potters, but he enrolled at the Cleveland School to study cartooning. A class with Guy Cowan changed his mind. In his senior year, 1929, Schreckengost saw Viennese

FIGURE 5.4. *Viktor Schreckengost,* Jazz Bowl, *1930. Engobed and glazed ceramic; 11.25 × 16.25 in. (Courtesy of the Cowan Pottery Museum at Rocky River Public Library, Ohio. © Viktor Schreckengost Studio.)*

ceramic sculptures in the AFA International Exhibition of 1928, then on view at the Cleveland Museum of Art. He decided immediately to go to Vienna to study with Michael Powolny. There he learned to build hollow figures in the Viennese style. When he returned, he was hired by the Cleveland School and also worked part-time at Cowan Pottery.

Schreckengost was also a pioneer industrial designer

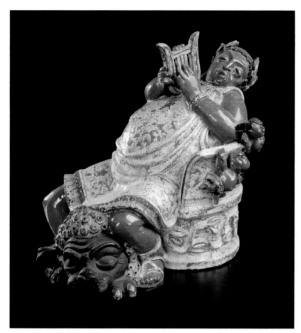

FIGURE 5.5. *Viktor Schreckengost, The Dictator, 1939. Earthenware; 13 × 12.5 × 10.5 in. (Collection of Everson Museum of Art, Syracuse, N.Y., Gift of the Artist, 86.13.* © Viktor Schreckengost Studio. Photograph courtesy of Courtney Frisse.)

who created children's pedal cars, the first cab-over-engine truck, bicycles, riding mowers, and more. In 1933 he founded the industrial design department at the Cleveland School of Art (now Cleveland Institute of Art). He also designed dinnerware for many china companies. In 1934 American Limoges put into production his Manhattan and Americana designs, the first modern dinnerware in America. They sold well, and he was appointed design director for the firm. (His later dinnerware design, Free Form [1955] for Salem China, has become a favorite of collectors.)

Schreckengost continued his personal ceramic work, creating a sculpture, *The Four Elements*, for the U.S. building at the New York world's fair in 1939. His political works are even more memorable. *The Dictator* (1939) depicts Nero strumming a lyre while tiny figures of Hitler, Mussolini, Stalin, and Hirohito climb up his throne (Figure 5.5); *The Apocalypse* (1942) portrays Death in a German uniform riding a wild-eyed horse together with Hitler saluting, Hirohito holding the rising-sun flag, and Mussolini clutching a classical Roman fasces (the origin of the term "fascism"). *The Dictator* is amusing but disturbing in its implications; *Apocalypse* is more intense, recalling anguished newspaper political cartoons.

During most of the 1930s, Schreckengost also created ceramic sculptures on "Negro" themes. He began the series in Vienna: American jazz was attracting attention,

and Josephine Baker was popular in Paris. The first pieces presented dancers and music, then preachers. Probably a third of his ceramic sculptures in the 1930s had black subjects; this somewhat stereotyped imagery seemed to appeal to him for such favorable associations as pleasure, intensity, sensuousness, and sometimes fecundity.[17] He went on to produce architectural reliefs and slab-built sculptural vessels. Schreckengost worked in clay until the late 1960s, when back trouble interfered, and lived to see the twenty-first century, passing away at 101.

Thelma Frazier Winter (1903–1977) has been described as the "most Viennese" of the Cowan artists, but, ironically, she never went to Vienna. She studied at the Cleveland School with Julius Mihalik, a ceramist who had taught in Budapest and Vienna, and her experience at Cowan included close contact with Schreckengost, ceramic sculptor Russell Barnett Aitken, and enamelist Edward Winter (later her husband), all of whom had studied in Vienna.

In 1939 Frazier Winter was the first woman to win a first prize in a Ceramic National. She participated in most of the exhibitions from 1935 to 1958. She also taught in Cleveland public schools and later at the Cleve-

FIGURE 5.6. *Thelma Frazier Winter*, Night with Young Moon, *ca. 1939. Stoneware. (Collection of Everson Museum of Art, Syracuse, N.Y., Purchase Prize given by Hanovia Chemical Co., 8th Ceramic National, 1939, 46.486.)*

land Institute of Art, was a frequent contributor to *Design* magazine, and published *The Art and Craft of Ceramic Sculpture* (1973).

Like others in Cleveland, Frazier Winter mocked ancient myths. She created a fat Jupiter sitting atop Io in the form of a cow. She also took up allegorical subjects, as in *Night with Young Moon* (ca. 1939). (Figure 5.6) The goddess of night is seated on a horse that rises from the sea to begin the journey across the sky. The new moon is represented by a cherub with a hatlike crescent on its head. Other cherubs frolic in the water streaming off the horse. The nude figure of Night shows Viennese elongation, with small hands, small head, and almond-shaped eyes.

EDRIS ECKHARDT

Edris (born Edythe Aline) Eckhardt (1905 [or 1907]–1998) trained at the Cleveland School and studied in New York with sculptor Alexander Archipenko. During her last year of art school, she took part in a collaborative ceramics program at Cowan, but her work was outside

FIGURE 5.7. *Edris Eckhardt*, Walrus and the Carpenter, Alice in Wonderland Series, *1935–36. Ohio clay mixed with 25% flint, glaze; 6.5 × 4.25 in. (Courtesy of Cleveland Public Library. Photograph by Howard Agriesti.)*

its conventions. She set up her own studio and experimented with glaze chemistry. In 1933–34, as part of a pilot program for the Federal Art Project (FAP), she produced small sculptures based on children's literature—including *Alice in Wonderland* and *Green Mansions*—designed for libraries and schools. (Figure 5.7) In 1934, at the Corcoran Gallery of Art in Washington, D.C., her work for the FAP was exhibited among selections designated as the best of the federal program.

Despite her youth, Eckhardt was made local director of the ceramic sculpture division of the FAP. She established a workshop and taught artists from a variety of backgrounds to pour molds, assemble parts, and glaze and fire sculptures. Workers could choose glazes and individualize facial expressions on meticulously executed figures drawn from nursery rhymes or literary works by Charles Dickens, A. A. Milne, and Rudyard Kipling. Other themes included American families, famous artists, Ohio-born presidents, and American folk heroes. Her team also worked with the local WPA applied-arts unit, providing ceramic-relief plaques and decorative tiles for public housing. These murals and panels traced Cleveland's history, including maps and figures, and extended the application of ceramics "into new areas of monumentality and social impact."[18] Other states with clay production also had programs, but Ohio's was outstanding. Eckhardt continued in this office until it closed in 1941.

Eckhardt also made ceramic sculpture of a more personal character, based on her own life and personality. Her 1939 *Earth* is a self-portrait head in brown earthenware. The piece is unglazed, except for the green and blue interweaving leaf shapes on her head. Eckhardt also favored romantic subjects, but their long faces sometimes suggest melancholy. A sad Pierrot character, *Painted Mask* (1946), was said to resemble her husband, who suffered from tuberculosis, which was then not curable. She directed the ceramic sculpture department at the (renamed) Cleveland Institute for many years, and later she became a pioneer in glass (see chapter 7).

VALLY WIESELTHIER

While artists of the so-called Cleveland school of ceramics may have popularized the Viennese style, Valerie (Vally) Wieselthier (1895–1945) brought it directly from her native Austria to America. A leading member of the Wiener Werkstätte group of designers in the 1920s and winner of gold and silver medals at the 1925 Paris Exposition, she first visited America in 1928, when her work was included in the AFA International Exhibition, which traveled the country.

Wieselthier's tart sculptures of "flapperish" women

with bobbed hair, rouged cheeks, and eye makeup were engagingly sensual—a new image of the new woman. (Figure 5.8) Her treatment was as novel as her style: she was unconcerned with unified surfaces and perfect finish, and her ceramics convey a feeling of spontaneity. Wieselthier, along with her compatriot Susi Singer, who emigrated later (see chapter 6), led American ceramists to be freer and more playful in their approach, and she had a lasting influence in expressiveness and color. In articles about the International Ceramics show, Austrian works were singled out as typifying the modern spirit, and Wieselthier's sculpture was described as "natural, spontaneous, childlike in its gaiety" in the *Metropolitan Museum of Art Bulletin.*[19]

As a girl, Wieselthier was interested in fashion drawing. She studied at the Kunstgewerbeschule in Vienna after passing the entrance exam without her family's knowledge or approval. Subsequently, with Josef Hoffmann's encouragement, she left school for the Werkstätte and there designed wallpaper, furniture, glass, and women's fashions. Then she discovered clay and began to model figures, whereupon she returned to the Kunstgewerbeschule to study ceramics with Powolny. She worked from thrown parts. She later wrote, "Whatever is made in clay must grow from the concept of the pot . . . worked from inside to out, not modeled in the round of a lump, in order to have a dynamic surface."[20]

Cowan met Wieselthier in Vienna and invited her to work for him. With her success in the international ceramics show and because the Werkstätte was in trouble due to runaway inflation in Austria, Wieselthier explored the American market. Invitations to show in Detroit and Pittsburgh and a commission to design bronze elevator doors for Ely Jacques Kahn's Squibb Building on New York's Fifth Avenue led her to extend her first visit to eighteen months. After several transatlantic trips, she decided to relocate permanently, but she apparently declined Cowan's offer. In 1929 she joined with a group of American and European artists, among them Rockwell Kent and Paul Poiret, to establish Contempora, Inc., a gallery and artist's collaborative in New York. She produced women's accessories and life-size or larger figures she called "garden sculptures," which drew a great deal of attention. While Contempora did not last long, she had exhibitions elsewhere and designed glass, textiles, and papier-mâché department-store mannequins.

In 1932 Wieselthier opened a studio where she created figures of cosmopolitan women draped in rustic clothing and usually accompanied by small animals or birds—versions of Diana, goddess of the hunt. Her *Europa and the Bull* (1938) is a light treatment of the myth, as Europa

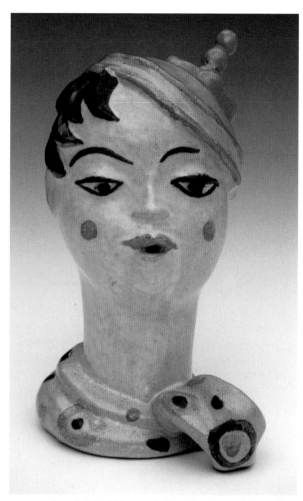

FIGURE 5.8. *Vally Wieselthier,* Head of a Girl, *1929. (Collection of The Baggs Memorial Library, The Ceramics Area, The Ohio State University, 1997.48.)*

clings to the head of a goofy bull. (That so many employed this motif may have reflected concerns about rising European political tensions.)[21]

In the late 1930s, Wieselthier became friends with Waylande Gregory and his wife, Yolande. Their house in New Jersey became her weekend retreat, and they provided moral support when she developed cancer. She continued working, showing at Orrefors Gallery in 1944. Her *Taming the Unicorn* (1945) won first prize in the 1946 Ceramic National, a few months after her death. Although her American work has been derided as sentimental, Wieselthier had an immediate impact on the style of artists such as Schreckengost and Frazier Winter, and her sizable "garden sculpture" figures may have led Gregory to large-scale work.

CARL WALTERS

A 1934 article in an art magazine declared that, in Henry Varnum Poor and Carl Walters, America had produced

FIGURE 5.9. *Carl Walters, Cat, 1938. Earthenware;*
11.5 × 23 × 7 in. (Collection of Everson Museum of Art,
Syracuse, N.Y., Museum Purchase, 81.26.)

two artists whose ceramic work was "unequalled by anything that is being done abroad" and was "as indigenously American as Walt Whitman and Ring Lardner."[22] Walters (1883–1955), like Poor, started out as a painter. Unlike Poor, however, Walters was taken with animals: duck, wild boar, bull, walrus, hippopotamus, lion, and more. (Figure 5.9) Walters's creatures were slightly stylized or even streamlined but realistic enough to be easily recognized and brought to fantasy through lively color or graphic decoration. His works were collected by the Metropolitan and other museums.

Walters came late to the medium, creating his first ceramics when he was nearly forty. He first studied art at the Minneapolis School of Art and then in New York under Robert Henri. He saw blue-glazed Egyptian faience beads at the Metropolitan and was driven to discover how the amazing hue was obtained. He set up a workshop first in Cornish, New Hampshire, and then in Woodstock, New York. Mainly self-taught, he began with candlesticks, bowls, vases, and plates, sometimes embellished with calligraphic designs suggestive of the Middle East. He made his first animal in 1922 by assembling hollow clay cylinders, and he frequently worked with molds but never precisely repeated a piece, altering details and decoration to make each unique. He also created figures set within a box, reminiscent of medieval wood carvings but usually alluding to the circus and other populist subjects.

Walters showed his work at the Whitney Studio Club in 1924, and from that exhibition *Stallion* was purchased by Gertrude Vanderbilt Whitney. His *Ella* (1927) is an intimidating circus fat lady, a massive mound of naked flesh wedged onto a dainty stool. His work found much favor in the 1930s, and his amusing bull and warthog were crowd-pleasers at Chicago's Century of Progress exposition. In 1935 Walters wrote a series of articles on technical aspects of ceramics for the *American Magazine of Art*, and he later taught ceramics in Florida.

MAIJA GROTELL

Maija Grotell (1899–1973) figures in the story of American ceramics in several capacities. She is important as one of the European immigrants of the interwar period, as an individual artist creating vessels for contemplative appreciation, as an independent woman not simply surviving but rising to the top, and, not least, as an influential teacher.

Grotell was born in Helsinki, Finland. She trained in painting, sculpture, and design at the Ateneum (the school for arts and industry in Helsinki) and completed six years of graduate work in ceramics, supporting herself by drawing for the National Museum and working as a textile designer. It was not possible to teach or to work as an individual ceramist in Finland, so in 1927 she came to New York, choosing America because it was less regulated and offered opportunities. She later recounted, "After three days in New York, just with the phone, I had a job."[23]

Her first summer in the United States, she went to Alfred University. She had bought Binns's book before coming to America and wanted to see how ceramics was taught here, since she expected teaching to be her livelihood. Although Alfred offered a chance to make connections, Grotell did not enjoy the experience. Binns gave a demonstration of his constructive method, taking a week to make a little piece in three sections. When he discovered her throwing on a wheel she had stumbled across, she sensed that he was not pleased. Wheel throwing was not yet a common skill. That worked to her advantage sometimes. She was often asked to demonstrate and could easily get work; she went from settlement jobs to being the first art instructor at the School of Ceramic Engineering at Rutgers (1936–38). But the New York Ceramics Society argued about whether to accept her independent work, since it regarded wheel-thrown work as machine made. She insisted that the wheel was not a machine but an instrument, like a piano.[24]

In 1936 Grotell became the first woman to win an important prize in the Ceramic National, and the Boston Society of Arts and Crafts named her a master craftsman in 1938. That year she left the East Coast to head the ceramics program at Cranbrook. She had visited

Cranbrook and shown her work there, so in May 1937, when the school sent out letters seeking nomination of "a young potter and ceramist," Grotell asked to be considered. The response was negative: they preferred a man for the position. In January 1938, however, she was offered the job. Late in life, she recalled hesitating because she could be independent in New York, while her success at Cranbrook would probably be attributed to the favor of her compatriot Eliel Saarinen (whom she barely knew).

In the Cranbrook facilities she began working with high-fire glazes and stoneware bodies, beginning a three-decade practice of glaze experimentation. The kiln Gregory had secured allowed her to increase the size of her work, and she became known for her large scale. She could throw as much as one hundred pounds. (As a girl she had been an athlete and had developed strength and endurance.) She proved herself with her work, exhibiting in Philadelphia, Detroit, Ann Arbor, Charlotte, and New York. She participated in every Ceramic National between 1933 and 1960.

Generally Grotell favored two forms: the cylinder and the sphere. (She said she made spheres just because it was a challenge.) She often used mat glazes, Chinese-inspired wood-ash glazes, and the *pâte-sur-pâte* method, in which slight relief would show in the play of light across a form. Eliel Saarinen admired her deco-style pieces with platinum check marks, which suited the chrome used in contemporary interiors. For a project with Eero Saarinen, she developed a brick with a richly colored surface to be used for the General Motors Technical Center. The result encouraged architectural use of ceramics elsewhere.

A 1940 vase, one of the first pieces Grotell made at Cranbrook, has a strong geometric pattern on the neck, in direct contrast to a large spherical body encircled by dark rings. (Figure 5.10) Like much of her work, it has a monumental presence beyond its actual size. Contrasting parts and angular repetitive markings accentuate the sculptural volumes and set up rhythms that animate bulbous forms, which otherwise might seem heavy.

Grotell was a reserved but penetrating teacher. She rejected what she called the step-by-step method of teaching and the assumption that things could be done only one way. She discouraged imitation and tended to keep her pots out of students' sight. She promoted individuality and mentored many artists who became leaders of the next generation, such as Richard De Vore, John Parker Glick, Howard Kottler, Suzanne and John Stephenson, and Toshiko Takaezu. Notably, they worked in a vast range of styles.

Seeking time and privacy, Grotell for years would work

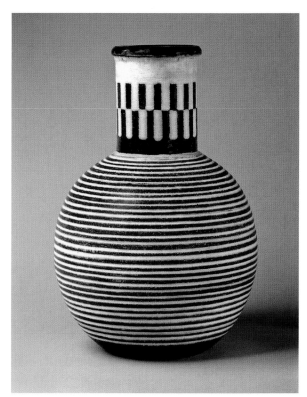

FIGURE 5.10. *Maija Grotell*, Vase, 1940. Glazed stoneware; 15.5 × 10.5 × 10.5 in. (The Metropolitan Museum of Art, Purchase, Gift of Edward C. Moore Jr., 1940.143.1. Image © The Metropolitan Museum of Art.)

all night and go home to bathe, put on fresh clothes, and return before anyone arrived in the morning. Eventually this strenuous work habit took a toll. In the early 1960s, she developed a muscle condition that limited her ability to throw and curtailed her creative productivity. She retired from Cranbrook in 1966, by which time the ceramic department was nationally prominent.

OTHER IMPORTANT TEACHERS

Arthur Baggs (introduced in chapter 2 for his role in Marblehead Pottery) remained an important figure in American ceramics. Besides helping initiate the idea of the studio potter, he taught ceramics at the university level. In his teaching, he insisted that a technical foundation was the basis for the creation of art. He taught pottery in New York, then in Cleveland, and in 1928 became professor of ceramic arts at Ohio State University in Columbus. His own relatively modernist work included abstract, incised decoration and carved outlines of vegetal or animal motifs with monochrome glazes on simple, generous forms.

Baggs is remembered for his salt-glazed wares, which emphasized clay's plasticity. One of his classic works is the cookie jar that was a prizewinner in the 1938 Ceramic

FIGURE 5.11. *Arthur Eugene Baggs*, Cookie Jar, 1938. *Salt-glazed stoneware; height, 13.12 in.; diameter, 10 in. (Collection of Everson Museum of Art, Syracuse, N.Y., Purchase Prize given by Onondaga Pottery Company, 7th Ceramic National, 1938, 39.342A-B. Photograph courtesy of Courtney Frisse.)*

National. (Figure 5.11) While he later indicated that he was not satisfied with it, the fluid and pneumatic form—sturdy, handsome, and functional—found its place in the record books. Baggs was never a daring innovator, but his integrity earned high regard from his peers. Grotell recalled: "I always wanted to be like Professor Baggs. . . . I don't think he ever did it for an audience or publicity. He just kept on doing. He was, I felt, a scientist and an artist combination, which was very rare in anyone in this country or anyone else that I knew anywhere."[25]

Charles Harder (1899–1959) was best known as a teacher and administrator at Alfred; his personal work took second place. Harder was born in Alabama, eldest of nine children. His parents had little education, but his father taught himself Latin and his mother was fascinated by art. Harder graduated from high school in Texas and had a year of college but dropped out to work. When he was able to return to school, he chose the Art Institute of Chicago, completing his degree in 1925. Among his teachers was Myrtle French, whom he assisted at Hull-House. She told him to go to Alfred and loaned him money for two summer sessions. There he came to the notice of Binns, who, in 1927, invited him to teach drawing and painting.[26]

In 1935 Harder earned a bachelor of science degree in ceramics from Alfred. He then studied industrial design theory and production methods at the New Bauhaus in Chicago, an experience that he brought back to Alfred. The writings of László Moholy-Nagy, Herbert Read, and Lewis Mumford "equipped Harder with a new theoretical language, practical applications, and a commitment to functional design."[27] He was appointed acting head of the ceramics program in 1938, the year after he won a gold medal at the Paris Exposition. Harder was especially interested in high-fire glazes and in work on the potter's wheel. He experimented with classical Chinese pottery forms. Generally his only decorative elements were impressed marks that could be enhanced by glaze. Harder was made design department head at Alfred in 1944 and served until he became ill in 1958. He died the next year.

GLEN LUKENS: INNOVATOR WITHOUT PRECEDENT

While California had considerable activity in commercial pottery, both dinnerware and tiles, there were few individual potters before the 1930s. Glen Lukens (1887–1967) played a pioneering role with personal work consisting of minimal forms and restricted yet powerful glazes, and he also had a major influence as a teacher. (Figure 5.12) A Missouri farm boy, Lukens was an education major at Oregon State University when he discovered ceramics.

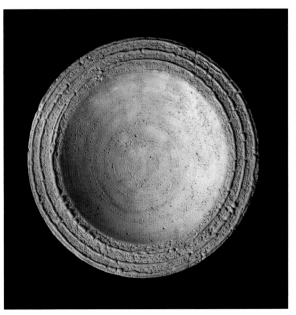

FIGURE 5.12. *Glen Lukens*, Bowl with Death Valley Glaze, 1941. *Earthenware; 3.25 × 18.25 in. (Collection of Everson Museum of Art, Syracuse, N.Y., Purchase Prize, 10th Ceramic National, 1942, 63.62. Photograph courtesy of Courtney Frisse.)*

He went on to study with Myrtle French at the Art Institute of Chicago; after graduating, he worked in a government rehabilitation program for wounded war veterans. He taught in Minnesota, where, after seeing an Egyptian blue glaze in a museum, he became one of many potters in the interwar years trying to reproduce it.

In 1924 he moved to Fullerton, California, where he taught high school and junior-college classes and began glaze experiments. Working with materials dug from the California deserts—a terrain resembling Egypt's—he eventually produced the blue, using clay that contained copper and alkaline substances, fired at low temperatures. When his achievement was written up in local newspapers, he was offered a job teaching evening classes at the University of Southern California (USC), in the school of architecture. In 1933, at age forty-six, he established USC's ceramics department and became chairman.

Lukens was not a skilled thrower; he used a stand-up wheel—operated by a sewing-machine treadle—only for trimming. That did not limit his work, however: he press-molded simple plates, bowls, and straight-sided vessels, often as thick and sturdy as grinding mortars. He used earthenware and almost always left a portion bare—a treatment inspired by Native American pottery[28]—to declare its earthy nature and to contrast with his applications of thick, syrupy, almost lickable glazes. His interest in pooling and dripping glazes was unusual for the time. He liked the lack of control. All in all, he was an "innovator without precedent," particularly because his simplified forms were not derived from European notions of modern design.[29]

Lukens did not know the science of clay bodies. He and Laura Andreson, who around the same time began the ceramics program at the University of California, Los Angeles, were alike in their limited knowledge and sense of isolation. Lukens and his students struggled with local clays until a ceramic engineer who taught at USC and who had formerly worked for the giant Gladding, McBean firm came up with a white, low-fire, high-talc clay. It was an ideal background to keep the glaze colors clear and bright, and it figured in the growth of vivid California dinnerware as well. If it also caused the glazes to crackle, Lukens happily enhanced the effect by rubbing dark oxides into the cracks.[30] That made the topography of his pots like the surfaces of Death Valley, his source for minerals that produced bright yellow, uranium orange, and crimson in addition to turquoise blue.

His bright glazes—so unlike work being done on the East Coast—attracted attention, and in 1936 he won first prize at the Fifth Ceramic National. It was the first time that a California ceramist had been honored in a national

exhibition. Since five of the eight California potters in that show were from Los Angeles, he persuaded the Los Angeles County Museum to bring the show to town the next year. The interest that exhibition generated enabled him to organize the first all-California ceramic exhibition, which opened in 1938 in San Diego. Lukens was the juror and wrote the foreword to the catalog; fifty-three ceramists showed 111 objects, including sculpture. He pushed his own work, trying grogged and tooled surfaces and even pressing clay into molds with rough surfaces, so that the vessel's character could not be determined until it was removed from the mold. His students called these "Guess What" pieces.

Lukens took a leave from USC in 1945 to teach in Haiti on behalf of UNESCO and stayed there well into the 1950s. When he retired, he turned to experimenting with slumped glass and remained active, also writing magazine articles, until his death in 1967.

CALIFORNIA POTTERY

As the Depression curtailed construction and slowed the demand for Hispano-Moresque–style tiles, several California potteries began applying the rich glazes to house and garden wares. The colors followed the Mexican palette, and the populist wares suited the informal lifestyles and open architecture of the West Coast.

The addition of talc enabled clay bodies to bind in a single firing with solid-color glazes and to become almost as vitreous and craze-resistant as actual china. Previous techniques, such as blending colors into the clay or painting them on the surface, required a clear glaze and did not produce the intense, uniform, and durable coloring needed for commercial production.[31] The rest of the country was still in thrall to European style—white china with intricate floral patterns around the rims. California colors must have seemed like bombshells in comparison, but the cheerfulness of the color—like that of Depression glass—surely was central to its appeal at the time.

J. A. Bauer Pottery, established in Kentucky in 1885 and relocated to California in 1909, may have been the first with the idea in 1927, when Victor Houser, a twenty-three-year-old ceramic engineer newly arrived from Illinois, created three solid colors (green, light blue, yellow) for Bauer's flowerpot saucers. Alternatively, Catalina Pottery may have been first with its colored dishes for tourists. In any case, by 1930 Brayton-Laguna, Bauer, and Catalina were all making it. Metlox Potteries would follow in 1932, and Vernon Kilns in 1935. Bauer's mix-and-match, brightly colored Ringware was produced after the company bought Ernest Batchelder's tile plant in 1932; this ware featured concentric circles like potters' throw-

FIGURE 5.13. *Frederick H. Rhead, designer, Homer Laughlin China Company, Fiesta Dinnerware, 1936. (Collection of West Virginia State Museum. Photograph by Michael Keller, West Virginia Division of Culture and History.)*

ing marks. Bauer's production process was mostly automated.

Brayton-Laguna was established by Durlin Brayton (1898–1951) in Laguna Beach. A graduate of Hollywood High School who had studied at the Art Institute of Chicago, Brayton made semihandcrafted, press-molded pottery in "edible-looking colors like citrus orange and lettuce green."[32]

In 1931 Faye G. Bennison and partners bought **Vernon Kilns**. With the encouragement of his daughter Jane, who had studied ceramics with Lukens at USC, Bennison brought in modern designers to create new shapes and designs. Jane herself worked at Vernon for two years and had her own imprint, but it was the Hamilton sisters who received national attention for their work in the 1930s and 1940s. Several of their decorative and dinnerware pieces were selected for the Fifth Ceramic National in 1936. Their work was also shown at the 1939 Golden Gate Exposition in San Francisco. Missouri-born Genevieve Hamilton (1887–1976) and May Hamilton de Causse (1886–1971) designed Rippled dinnerware and also vases, figural pieces, and bowls with clean lines and graphic punch.

Of all the California potteries, Vernon was most ambitious in its decorating program. In 1935 William "Harry" Bird joined the company and created a patented method called Inlaid Glaze (which actually produced a relief effect). In two years at Vernon he created about seventy designs, many of which still look modern. Daniel Gale Turnbull created more than one hundred decorative designs for Vernon. His American landscape paintings—idealizations of nature and industry with stylized factory buildings blending into the hills—were executed by his staff of painters. Most were limited-production items. In 1938 Vernon gave a contract to Don Blanding, a popu-

list poet who illustrated his poems with Western and Hawaiian landscape elements; his designs appeared on dinnerware. Also in 1938 the company commissioned the painter and book illustrator Rockwell Kent to create designs for three dinnerware services.

The most successful extension of California-color pottery came from the **Homer Laughlin China Company** of West Virginia, with its faux-Californian name, Fiesta (named for a "traditional" celebration of Hispanic heritage begun in 1894 to attract tourists to Los Angeles). (Figure 5.13) Laughlin's huge size gave it a promotional advantage. The Fiesta design, by Frederick Rhead, who had once lived in California, consisted of sculptural forms and monochromatic glazes of orange-red, deep blue, cucumber green, egg yellow, and ivory. It was priced low and sold through stores such as Woolworth's, to reach a new working-class audience.

World War II suppressed the ceramic industry around the world and virtually ended it for a time in California. After the war it roared back. In 1948 six hundred potteries of all sizes were active in the state. Most were driven out of business by foreign imports in the 1950s as a result of the U.S. tariff policy designed to rebuild Japan and Germany as bulwarks against the Soviet Union. By the end of the 1950s, the California dinnerware phenomenon was over. Vernon Kilns closed in 1958, Bauer in 1962. Today only a few major potteries survive. The ware was rediscovered, however, by collectors late in the century, and some lines, such as Bauer, began to be reissued.

RUSSEL WRIGHT

Russel Wright (1904–1976) is remembered today mainly for his appealing, affordable, mix-and-match ceramic dinnerware that was part of his concept for the new, informal American lifestyle. His wife, Mary (1905–1952), the daughter of a textile manufacturer and merchant, was the marketing wizard who made him the country's first lifestyle guru. Together they introduced the stage-set approach to department store display, offering his products in inspiring, homelike arrangements. In fact, Wright's early training was in theater design. His work expressed a philosophy: dinnerware should highlight food and create a mood for a meal.

Wright introduced the sectional sofa and, in like concept, the inexpensive "starter set" of dishes that could be bought by itself but would likely lure people into buy-

FIGURE 5.14. *Russel Wright, designer, Steubenville Pottery, American Modern Dinnerware in Seafoam, designed 1937, first produced 1939. Ceramic; plate diameter, 10 in. (Courtesy of Manitoga/ The Russel Wright Design Center. © MASCA.)*

ing more place settings and serving pieces. The forms of his dishes approached the organic, and unlike formal china, they invited handling. Though Wright had trouble finding a factory willing to risk producing his asymmetrical American Modern dinnerware, designed in 1937 and produced in 1939, it is said to be the most popular dinnerware ever made. (Figure 5.14) While the color of the wares—harmonious varieties developed in collaboration with the ceramics department at Alfred[33]—followed the lead of other dinnerware of the decade, the forms have been compared with those of surrealist painting. The bankrupt Steubenville Pottery of East Liverpool, Ohio, took it on—to great profit. While there were problems with the functionality of certain pieces and also problems with quality control in the factory,[34] American Modern remained in production for nearly twenty years and sold somewhere between 80 million and 125 million pieces. New deliveries at Gimbels during World War II were said to have caused near riots. He chose unusual color tones such as seafoam blue and chartreuse curry. Today the design is eminently collectible.

Wright also designed handcrafted furniture as well as glassware in subdued grays and smoky earth tones. He created wooden and spun-aluminum serving pieces (including stove-to-table ware), tablecloths and other textiles, and plastics. He also designed musical instruments, radios, lamps, appliances, shop interiors, and exhibits for the New York world's fair. But after Mary died in 1952, he essentially ceased designing. Wright has been skeptically regarded by craftspeople, who felt that he did not know his materials (although he designed with the

materials directly, not on paper) and that he was capitalizing on new public interest in crafts (although hardly any craftspeople were competing with him to create for mass production). He was also discounted by many designers because he had never formally studied design.[35] His success, however, speaks for itself.

Modern Textiles

In textiles, the 1930s was a period of emerging alternatives, pointing the way to approaches that came to fruition in the 1940s and 1950s. At Cranbrook, Marianne Strengell began teaching Swedish textile style, while North Carolina and Chicago were introduced to the Bauhaus philosophy. In California, Dorothy Liebes was using color, metallics, and then synthetics. The emphasis was on structure and materials rather than pattern.

In 1938 the first Conference of American Handweaving was organized, with Mary Atwater as featured teacher. Traditions other than European began to be acknowledged: in the 1930s, magazines such as *The Handicrafter* and its successor, *The Weaver*, published features on Mexican, Peruvian, Chilean, Guatemalan, Navajo, and other American weaves. Atwater noted that "many of the decorative forms we label 'modernistic' and 'new art' today are curiously akin to the patterns of primitive decoration."[36] Raoul d'Harcourt published information on Peruvian textiles in 1934, Ruth Reeves went to Guatemala in 1934, and Nellie Sargent Johnson went to Peru in 1939. The same thing was happening in mainstream art.

The Museum of Modern Art presented a 1933 exhibition called *American Sources of Modern Art* to show affinity between modernist and Aztec, Maya, and Inca art.

In 1929 the Metropolitan Museum showed handmade rugs in its annual industrial design exhibition, and in 1930 the Newark Museum showed artist-designer-conceived rugs. Artists had many opportunities to try the textile medium. A collaborative project organized by Zolton Hecht and Rosa Pringle Hecht, known variously as the New Age Group or New-Age Workers or Blue Ridge Mountains Group, employed North Carolina craftspeople to execute rugs designed by artists such as Thomas Hart Benton and designers such as Ilonka Karasz. At the same time, hand-hooked rugs were being made to artists' designs by the New England Guild in Portland, Maine. Ralph M. Pearson of New York revived hooked rugs with a contemporary graphic sensibility, and members of Cleveland Print Makers and students at Cleveland School of Art designed rugs that were hooked by Elizabeth Muzslay. They were signed and marketed as artworks. In 1937 the Crawford Shops of New York produced rugs devised by such artists and designers as Donald Deskey, Henry Varnum Poor, Walter Dorwin Teague, and William Zorach.[37] In addition, artists made textile designs for commercial firms. Some were trained in the field—such as the painter Lois Mailou Jones, who had studied textile design in the late 1920s—and others were looking to supplement their incomes, such as the painter Stuart Davis.

In 1939 Dorothy Liebes wrote in the catalog for her decorative arts presentation at San Francisco's Golden Gate Exposition: "Never was there more demand for artists to design, nor more facility in the machine world to carry out the designer's ideas. Since this Decorative Arts Exhibit is an artist-craftsman's show, the stress is rather more on the hand technique, which in turn inspires and suggests future possibilities for the machine."[38]

Liebes also argued in her catalog that tapestry should be regarded "as a bona fide textile expression, not as a painting."[39] She nevertheless included tapestries designed by artists. In 1933 Marie Cuttoli had commissioned from the Aubusson factory in France a series of tapestries designed by European modernist artists, and she organized a rug show for the Arts Club of Chicago and Lord & Taylor in New York including carpets made in Algiers to designs by Fernand Léger and Pablo Picasso, among others. While these works were appreciated at the time, most are now considered failures as textiles, because they are merely reproductions of drawings and show little understanding of fiber capabilities.

Another approach to tapestry was taught by Geza Gilbert Foldes, a Hungarian weaver who offered classes at Greenwich House settlement in New York in the summer of 1931 and that fall opened a school of tapestry weaving, believed to be the first of its kind in the United States. While some of his students made works for sale, others went on to teach in public and private schools and in hospitals.

MARY HAMBIDGE AND THE WEAVERS OF RABUN

In the mid-1930s, a shop opened on New York's Madison Avenue to sell handweavings produced by Georgia mountain women under the direction and design of Mary Hambidge. The odyssey that led her to Rabun County was quite different from that of the missionary women of previous decades but, curiously, she, too, saw her work as a form of spiritual expression.

Mary Crovatt (1885–1973), in New York to pursue an acting career, met and married Jay Hambidge, an artist and illustrator obsessed with the mathematical laws of proportion derived from ancient Greece.[40] He lectured and wrote on his concept of "dynamic symmetry," which Tiffany was said to have used in jewelry design and Chrysler in car design. Yale University Press published his *Dynamic Symmetry: The Greek Vase* and sent him to Greece in 1920 to measure the Parthenon; Mary went with him, stumbled upon Greek peasant weaving, and "knew" she had to learn to weave. She stayed another year to study and then set up looms and thread brought back from Greece and made weavings charged with her sense of color and texture. In 1924 Jay Hambidge died suddenly, while delivering a lecture, at age fifty-seven.

Mary eked out a living as a weaver and designer. She created handmade clothing evocative of ancient Greek apparel. These simply constructed silk garments of rectilinear form and minimal seaming often employed dynamic symmetry motifs in an embroidery-like tapestry inlay technique and were finished with warp fringes. One was introduced as "the gown of the future" at a 1925 New York society entertainment.[41]

Short of money, Hambidge left New York for two years (1926–28) to live and weave at a friend's summer home in north Georgia, and it changed her life. She discovered the American tradition of handweaving in its fading Appalachian form. Back in north Georgia in the summer of 1933, she learned spinning, which drew her attention to raw materials.[42] It was then that she conceived of "a place in the mountains where crafts and agriculture would be practiced within an expanded life view of dynamic symmetry."[43]

Hambidge's benefactor in realizing this dream was Eleanor Steel Reece, an opera singer she had met in New

York, who had a considerable family fortune. Reece enabled her to purchase eight hundred acres along Betty's Creek in Georgia's Rabun Gap area, taking over a cabin; a large house constructed of creek stones, called Rock House; and the foundation of a lodge. Hambidge hired women to spin and weave and men to work the farm. Wheat and corn were ground by a water mill into grits and meal. There were sixty sheep, both black and white; ten cows; and a large vegetable garden that contributed to the noon meal for workers and visitors. Women spun at home, but the weavers—no more than eight at any time—might live at home or in Rock House, and they wove on site, in the Weaving Shed, on four-harness Berea looms.

Most of the production used handspun wool yarns from the Rabun sheep. Hambidge developed a technique of carding and spinning damaged silkworm cocoons as if they were wool and mixing silk and wool together in thread.[44] Some wools were naturally colored, but Hambidge was also known for her synthetic dyes. Sample cards for drapery and upholstery fabrics were woven in color ranges called "earth harmonies," "tree harmonies," and "sky harmonies" and in other nature colors, all inspired by the seasonal environment. (Figure 5.15) Perhaps surprisingly, she blended synthetic dyes for these hues.

The work of the Weavers of Rabun was shown in New York in the fall of 1935 and again in 1936. The New York retail outlet Rabun Studios opened in 1937, again with the financial support of Eleanor Reece, whose husband, Hall Clovis, was the shop manager. Drapery and upholstery fabrics were woven on commission, while wool textiles were typically woven in standard suit lengths. The shop offered interior decorating services, and by 1939 Jugtown pots and George Nakashima's furniture were also shown.

Over the years, the Weavers of Rabun wove linen for book covers, made fabrics for the U.S. presidential yacht, and provided materials for the homes of famous actors. Its work won a gold medal at the Paris Exposition of 1937. After the war, demand for handspun exceeded what the farm could produce from its own sheep, so about half the yardage was woven with commercially spun wool. Different weaves and materials were introduced, and scarves, shawls, and men's neckties were produced for ready sales. Although business began to decline in the early 1950s, as late as 1963 a fashion designer was using Rabun fabrics in shops in New York, London, and Paris.

A Weavers of Rabun promotional brochure stated: "Our work is created by human beings, not produced by machines. Our works are never hurried. Our objects

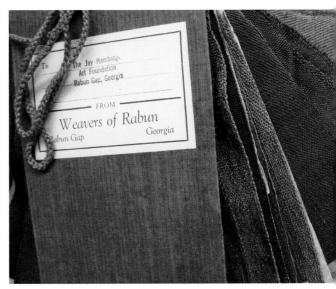

FIGURE 5.15. *Mary Hambidge, Rabun Studios, Sample Book No. 2, Drapery and Upholstery Fabrics, ca. 1937–38. Specialty-dyed textiles. (Photograph by Philis Alvic.)*

are—to bring out the natural beauty of the raw material by simple, honest, hand processes—to produce quality, not quantity—to give a living wage and a creative outlet to the worker and work of individuality to the individual."[45] Unfortunately Hambidge did not make provision for the survival of her lifework; she hoped to open a school but never managed to do so. Mary Creety Nikas, an Atlanta interior designer and longtime friend, ran the foundation for the last few months of Hambidge's life and formalized a residency program and workshops, which continue today.

DOROTHY LIEBES

Dorothy Wright Liebes (1899–1972) was a handweaver who became a designer, and a "California designer" at that—although she spent more than half her career in New York. She was indelibly associated with color and with metallics and was known for her personality and promotion as much as for her fabrics. She was photogenic and stylish and created a public image of "a woman pursuing womanly activities, . . . yet living a glamorous life in a world of architects, designers, industrialists and wealthy clients."[46]

Born in California, she first studied painting at San José State College with the idea of becoming an art teacher. An instructor said her paintings looked like textiles, which inspired her to try weaving. She studied at Hull-House in Chicago during the summer of 1920 and then set up a studio in her parents' attic. She experimented and made small salable items such as baby blankets to help pay for her schooling. For inspiration

she visited the most exotic source available to her—San Francisco's Chinatown. After further degrees in applied arts and education at Berkeley, the California School of Fine Arts, and Columbia, she traveled to Paris to study textile design with Paul Rodier. In 1929 she married Leon Liebes (pronounced lee-bus), a prosperous merchant, and they lived and entertained in a fashionable apartment on San Francisco's Nob Hill.

In 1930 she opened a studio offering handweaving in short lengths of fifteen yards or less for architects and decorators. Liebes became a spokeswoman for the artist-craftsman who could make a living from her work. Soon she was weaving panels for movie sets and yardage for costumes as well as regular apparel. In 1935 she met Frank Lloyd Wright, who influenced her design philosophy. He advised her to take colors from nature—which she did in her combination of blue and green, for sky and land. It was, for a time, a combination associated only with her. Also in 1935 she was awarded two major commissions for architectural textiles in California public buildings.

In 1939 and 1940 San Francisco's Golden Gate International Exposition was an opportunity for many Americans to see contemporary decorative arts for the first time. Liebes, director of the decorative arts display, traveled throughout America and Europe to select work; she organized fifteen rooms designed by architects and decorators featuring new furniture, textiles, and sculptures, each an environment that suggested the kinds of modern lives these objects would enhance. She embedded craft amid painting and sculpture.

Liebes began to work as designer and stylist for Goodall Fabrics, Inc., of Maine. She said she wanted to go beyond one-of-a-kinds for the wealthy and asserted that "handweaving at its best could and should be used as experimental material for reproduction in the weaving factories"; she aimed for machine-produced fabrics with "the handwoven look and feel."[47] (Figure 5.16)

Liebes loved glitter effects like those in Chinese brocade, and she wove with various metallic yarns, including fourteen-carat-gold threads. When she became a yarn stylist for the Dobeckmun Company, manufacturers of Lurex metallic yarns, in 1946, her palette expanded. The reflectivity of metallics enlivened the new window walls of modern architecture; they also made upholstered furniture appear lighter in weight and mass. It was something of a crusade. The textile artist Ed Rossbach later wrote: "She tried to make metallics respected at a time when they were dismissed as vulgar and crass. The Depression and war years had been visually drab; the Liebes color and flash were new and shocking."[48]

FIGURE 5.16. *Dorothy Liebes, designer, Mexican Plaid Drapery Panel, ca. 1938–40. Twill of wool, cotton, silk, synthetic, metal laminate, tri-layered, with colored film-coated foil; 108 × 50 in. (The Metropolitan Museum of Art, Gift of Dorothy Liebes Design, Inc., 1973.129.2. Image © The Metropolitan Museum of Art.)*

Liebes's weave structures were simple, to allow focus on color and texture. In her studio, which typically employed eight to ten weavers, a familiar jingle was "Something dark, something light, something neutral, something bright."[49] She liked to work in complementary colors and seldom used black. She did not piece-dye but allowed each yarn to retain its identity; colors mixed in the viewer's eye. "Color is like seasoning," she said. "At first you may be timid about it, but as you get used to it you can take more and more of it."[50]

Liebes's next enthusiasm was manmade fibers. In the early 1940s, she predicted a "synthetic-fiber world" benefiting from unimaginable new "miracle" finishes. In 1948 she moved her design studio to New York (the production studio remained in San Francisco until 1952), where she vastly expanded her client list and her influence among other designers. She experimented with new fibers for DuPont, was design and color consultant for rugs and carpets by Bigelow-Sanford, and consulted for Sears, Kenwood Mills, United Wallpaper, Columbia Mills, and others. In 1958 she discontinued custom work. Liebes's flair for promotion made weaving far more publicly visible and led to the expansion and proliferation of weaving programs.

Rossbach recalled that Liebes's weavings were sometimes dismissed as "too California," and that someone once said that she wove with garbage. When he saw her 1970 retrospective at the Museum of Contemporary Crafts (only the second such exhibition in the museum's twelve-year history), he saw it as too much of everything, all vying for attention. It was not, in fact, like her California studio, which he remembered as resembling a theater stage. "Everything and everyone seemed positioned for a decorative effect. All the women, including Liebes, wore uniforms—Chinese smocks of an intense clear blue that flattered Liebes. . . . Chinese baskets filled with yarn were scattered here and there, providing color accents. The walls were lined with open bins of brilliant yarns carefully arranged by color." He speculated on how that would have impressed architects and decorators, noting that today this setting would be recognized as a work of art in itself.[51]

Wood: The Modern Moment

For furniture of all kinds, the 1930s were years of transition. The small shops that had flourished in the 1920s shut down or scaled back as clients cut their spending on luxuries. The public enthusiasm for craft that had characterized the first decades of the century gave way to a new enthusiasm for industrial design. It was a glamorous new profession, and the leading designers were keen to promote themselves as the saviors of American industry. Raymond Loewy, for example, boasted that redesigned copy machines and refrigerators increased sales dramatically.

Most industrial designers favored a new streamlined style in which forms were still decorated but with chrome "speed whiskers" and corporate logos. Materials such as cast aluminum, glass, and occasionally tubular steel (an influence from Germany) were favored because of their industrial overtones. These new aesthetics influenced furniture design. The rustic fumed oak of Stickley's day was replaced by woods like bleached maple that downplayed both grain and texture. Finishes were slick and mechanical. Compared with art deco, the new style was reductive, austere, and more dependent on effects of light and shadow. Even handmade work had the gloss and simplicity of factory products. Expensive materials continued to be used in luxury goods, but many furniture makers who had once relied on commissions from the wealthy turned their attention to design for mass production. Articles on furniture uniformly spoke of the "designers" and never mentioned whether the items were made by hand in small shops or were mass-produced in factories.[52]

WALTER VON NESSEN

One of the furniture makers who adopted the look of industrial production but apparently continued to have his work made in a small craft shop was Walter von Nessen (1889–1943). A metalworker trained in Berlin, von Nessen had immigrated to New York in 1923. Although he designed and made side tables, ashtray stands, and other metal furniture, he specialized in lamps and lighting fixtures. (His 1927 design for a swing-arm lamp is still in production today.) His shop also produced high-end commissioned work, using luxurious materials such as rosewood, macassar ebony, and silk. Like many designers in the 1920s and 1930s, he dispensed with historical references and took on a pared-down, functionalist style.

A 1930 table illustrates the change. (Figure 5.17) It is constructed of aluminum and chromium-plated metal with a Bakelite top. All three materials signal the new industrial era. The base consists of sheet metal bent into simple forms that recall structural steel. The table's form could have been reduced even further, but von Nessen must have been interested in devising a visual drama that substitutes for applied decoration. The feet are slightly wider than the boxes that sit on them, cre-

FIGURE 5.17. *Walter von Nessen, designer, Nessen Studio, Inc., Table, 1930. Aluminum, Bakelite; 18.5 × 15.25 × 15.25 in. (The Metropolitan Museum of Art, Purchase, Gift in memory of Emil Blasberg, 1978.492.2. Image © The Metropolitan Museum of Art.)*

ating the stepped effect of classical molding. The deep central box pedestal has a contrasting dark interior, and the polished edges become bright lines in certain angles of light. Finally, a pair of clips holds the Bakelite table-top in place, their C shape echoed in the feet. Nobody regarded von Nessen's table as a sculpture in its own day, but it now looks a lot like minimalist sculpture from the 1960s.

It is likely that this table was substantially handmade in von Nessen's shop, yet all traces of hand fabrication were erased.[53] What remains is function, composition, and industrial symbolism. Its surgical precision implies that concern for the welfare and pleasure of the worker has been forgotten. At this historical moment, Arts and Crafts ideology had come to seem irredeemably old-fashioned.

Cutting-edge design proved to be good business. When other custom shops were shutting down, von Nessen expanded. In 1930 he introduced a catalog of lamps, tables, and mirrors, aimed at the wholesale trade. He also designed extensively for industry, working for Chase Copper and Brass and a number of smaller firms. After his death, his wife continued to reproduce his lamp designs, and the company continues today as Nessen Lighting.

KEM WEBER

The typical 1930s furniture designer embraced industrial materials just as he distanced himself from craft. While tubular-steel furniture was popular among German functionalists, many designers and a majority of American consumers found metal too cold and clinical for the home environment. They preferred wood. Plywood offered a fresh alternative. Advances in mass-production technology and new glue formulas allowed manufacturers to produce large plywood sheets inexpensively. Since plywood is built up of thin layers of wood at cross-grain to one another, it is more dimensionally stable than solid wood and will not split as solid wood does. Furthermore, it can be bent, offering a whole new vocabulary of form.

In 1932 the Finnish architect Alvar Aalto designed one of the first bent plywood chairs; German designer Marcel Breuer produced one in 1935. Another who explored plywood was Karl Emanuel Martin (Kem) Weber (1889–1963). Born in Germany and trained as a cabinet-maker, Weber came to America in 1914 to supervise the installation of the German exhibit for the Panama-Pacific International Exposition, but he was stranded in San Francisco when World War I broke out. He drifted around the West, working as a farmer and a lumberjack for a while. After anti-German sentiment subsided, he set up an interior design studio in Los Angeles. He occasionally worked in the eclectic styles of the day, including Spanish colonial, but specialized in an exuberant modernism. His work in the 1920s bore traces of art deco as well as American innovations like skyscraper furniture. By the 1930s he adopted a more streamlined, horizontal look and designed some tubular-steel furniture: a 1934 armchair for the Lloyd Manufacturing Co. features overstuffed leather upholstery and chrome-plated tubular steel supports. The color schemes of his interiors tended toward a warm California palette: sage green, pale purple, and rose, with accents of gold, silver, and black.

Weber's contribution to bent plywood came in 1934. It was called the Airline chair, reflecting the widespread fascination with all things modern, streamlined, and fast. (Figure 5.18) It is cantilevered like Marcel Breuer's bent-steel chair, but here the side members are made of wood. Each side is a C-shaped assembly of four parts, designed to be strong enough to support the deep cantilever. The

FIGURE 5.18. *Kem Weber, designer, Airline Chair Company,* Airline Armchair, *ca. 1934–35. Birch, ash, wool upholstery (replaced), batting; 31.75 × 25.25 × 36.75 in. (Museé des Beaux-Arts de Montréal, Liliane and David M. Stewart Collection, Gift of the American Friends of Canada through the generosity of Geoffrey N. Bradfield. Photograph by Denis Farley.)*

seat and back were constructed of bent plywood, and versions were sold both with and without upholstery. The chair was light and easy to move. In some versions, the seat was adjustable, much like a typical reclining chair. Weber hoped to mass-market the Airline chair, and he set up a company to produce and sell it. The factory-made chair was supposed to be delivered knocked down in a box, saving the consumer costs for both shipping and assembly. All his attempts to manufacture came to naught, however. Around 1935, Walt Disney Studios ordered three hundred chairs for its office complex. Ironically, these were made by a local cabinetmaker and probably required much handwork.[54]

WHARTON ESHERICK

A few rugged individuals of the 1930s refused to jump on the industrial design bandwagon. One was Wharton Esherick (1887–1970), the paradigmatic artist–furniture maker and probably the most influential woodworker of the twentieth century.

A born rebel, Esherick at first wanted to be an avant-garde painter. Given a scholarship to the prestigious Pennsylvania Academy of the Fine Arts in Philadelphia, he quit a few weeks before graduation so he could paint in the impressionist manner, which was frowned upon by the faculty. In 1910 someone showed him Henry David Thoreau's book *Walden,* which became his inspiration. (He kept a copy on his bedside table for the rest of his life.) Emulating Thoreau, Esherick moved to the country, buying a dilapidated farmhouse on a wooded hillside in

Paoli, Pennsylvania, where he could live the simple life. By the 1920s he was making furniture for his home and frames for his paintings, while his wife taught weaving and rhythmic dance. He was surprised to discover that his clients were more interested in his frames and dining room table than his artwork. After suffering a harsh rejection from New York galleries in 1924, he put away his brushes and never painted again.

Esherick took up carving. He had been making woodcuts in a rustic expressionist style, and it was a logical step to produce figurative images in three dimensions. His carved wood sculptures are not terribly distinguished: abstracted animals and figures with titles like *Oblivion* and *Boredom.* He learned invaluable lessons about composition in the round, though, which led him to think of furniture as abstract form. Furniture was typically defined by its use and how people approached it, and to think of it as sculpture was a breakthrough achieved by no other designer of the period. Although form was constrained to some degree by the demands of utility, Esherick addressed furniture as an artist, not a designer.

He used the material most readily at hand—wood—and employed the hand tools of the wood-carver and carpenter. (The only power tool he used before the 1960s was a homemade bandsaw.) Nor was he interested in the streamlining that was identified with modernism. His modernity was based on abstraction; in all else, he was a throwback.

In 1926 Esherick started building a new studio and filling it with his own furniture. He was a friend of Henry Varnum Poor's, and he may have been inspired by Poor's own handmade Crow House (see chapter 4). His first new furniture was influenced by cubism and German expressionism. By 1928 he had built a five-sided table with splayed legs, the top pieced together from tapered planks. A set of chairs had backs carved into facets, with triangular openings. Esherick was always practical—each chair has a cutout underneath the crest rail so it could be lifted easily—but their splayed legs and irregular seats reinforce the impression that they walked out of a cubist painting. A few adventurous souls gave him commissions. The biggest was from Judge Curtis Bok: to rebuild the interior of Bok's house. (Figure 5.19) This Esherick did in his cubist style, with faceted shapes and irregular paneling in dark wood throughout.

The single object that best exemplifies Esherick's approach to furniture is a staircase he built in 1930. (Figure 5.20) It ascended from the studio space in his new building to living quarters on the second floor. He carved a tree trunk into a twisted sculptural form, to which he

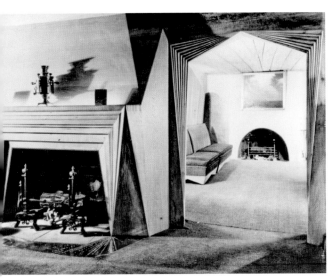

FIGURE 5.19. *Wharton Esherick*, Music Room in Judge Curtis Bok House, Gulph Mills, Pennsylvania, *1937. Plastered stone fireplace and doorway, white pine grille with radio speakers and ventilator, white pine paneling on ceiling, oak paneling on walls. (Courtesy of The Wharton Esherick Museum.)*

FIGURE 5.20. *Wharton Esherick*, Staircase in Esherick Studio in Paoli, Pennsylvania, *1930. Red oak. (Courtesy of James Mario for The Wharton Esherick Museum.)*

attached prismatic steps in a spiral. A sturdy beam is joined to the trunk above the tenth step, leading up to a trap door and Esherick's bedroom. Off to one side, another curved beam swoops down from the kitchen. Everything—trunk, beams, steps—hangs in space. The whole is as much a sculpture as it is a staircase, and it casts delightful shadows on the wall and floor.

The staircase was removed from Esherick's studio for display at the New York world's fair in 1940. It was part of a model interior called Pennsylvania Hill House, designed by modernist architect George Howe. For the display, Esherick made a hickory table with curved edges and a black phenol top, along with a set of spindly chairs, wood paneling in a sunburst pattern, and a biomorphic wall sconce. It was in Esherick's home, however, that the stair really belonged: it was part of an intricate *Gesamtkunstwerk*. Over a period of forty years, Esherick created not only furniture but also doors and latches, light fixtures, floors, wall paneling, and even sinks for his building. Trays, spoons, coat hooks, and light pulls are handmade. Luckily, this unique creation has been preserved as the Wharton Esherick Museum.

Esherick demonstrated that a maker who maintains total control over the product has an advantage over industrial production. The result can be inventive and personal in ways that manufactures cannot. He showed that furniture can be expressive and can explore form in space. Esherick may have been an isolated visionary in the 1930s, but he was the model for all that followed.

ISAMU NOGUCHI

What is now called biomorphism can be traced to relief sculptures made by Jean Arp around 1915. Interested in Dada experiments in manifesting the unconscious, Arp made "automatic drawings" in the shape of abstract blobs, which he then cut out of wood planks, arranged in layers, and painted. By the early 1930s similar forms had appeared in surrealist paintings by Dalí, Léger, Miró, and René Magritte as well as in sculpture by Henry Moore and Barbara Hepworth. Amoeboid shapes were used by Aalto for his famous Savoy vases in 1936 and by Frederick Kiesler for a coffee table in 1935. In another decade or so, the same blobby shapes would be called "free-form," implying unfettered self-expression and the improvised rhythms of bebop jazz. By the 1950s biomorphism was everywhere, but in the 1930s it was avant-garde.

The sculptor Isamu Noguchi (1904–1988) was the first American to design biomorphic furniture. He had briefly been a studio assistant to Constantin Brancusi in the early 1930s, and he was aware of developments in

surrealism. Despite a major commission at Rockefeller Center, his only consistent source of income during the Depression came from making portrait busts. Apparently French designer Jean-Michel Frank, who had hired sculptor Alberto Giacometti to make furniture in the early 1930s, suggested that Noguchi try the same strategy. When the president of the Museum of Modern Art commissioned a living-room table, Noguchi responded with a sculpture-furniture hybrid. (Figure 5.21) The top was a kidney-shaped sheet of glass, similar to the round tabletops used by other designers, but the base was not a geometric construction, signifying modernity with industrial materials and sharp edges. It was carved wood in three parts: a ball and two curvaceous hand-carved elements. The three parts formed a tripod on which the tabletop rested. The sphere acted as a joint, so the base could be rearranged into more open or closed positions. Given pride of place in the living room, Noguchi's table contrasted nicely with the rigid geometry of the home's International Style design. The base of the table can be seen as pure sculpture; only the glass top renders it useful.

In the early 1940s, Noguchi started designing furniture for Herman Miller, Inc. Another coffee table, about 1944, was composed of two jointed slabs of wood supporting a glass top. It was put into production in 1948. About 1947 he devised a free-form sofa and ottoman that would inspire many designers. Noguchi's works for Herman Miller were all mass-produced, not handcraft objects. Just the same, Noguchi, like Esherick, showed that pure sculpture and function could be merged.

THE HISPANIC CRAFT REVIVAL

In addition to modern design and colonial revival, other currents influenced studio furniture. In some parts of the country, revival movements drew from ethnic traditions other than the Anglo-Saxon. Two such groups were the Hispanic and mestizo (mixed Mexican and Native American) peoples of the Southwest, who settled the area decades before the Pilgrims arrived at Plymouth. New Mexico was the center of a distinct revival of Hispanic crafts in the twentieth century.

The 1913 restoration of the Palace of the Governors in Santa Fe focused attention on local architecture. Edgar Lee Hewett, director of the Museum of New Mexico, began to advocate a Santa Fe style about the same time. An amalgam of Pueblo and Spanish building traditions, it was first applied to hotels and government buildings. One aspect of the style is the softly rounded look of adobe construction—now made of stucco over concrete block, not mud over rammed earth. Spanish influences include arched entryways and enclosed patios. The new hybrid has proven to be very durable: Santa Fe style is still promoted today.

In the 1910s and 1920s, these new buildings had to be furnished, but no compatible work was available. (Local carpentry had vanished, unable to compete with mass-produced furniture.) In 1917 an employee of the Museum of New Mexico, Kenneth Chapman, teamed with anthropologist Jesse Nusbaum to design a suite of furniture for the Women's Board Room of the new Art Gallery of the Museum of New Mexico in Santa Fe. Their chairs were influenced by nineteenth-century local antiques: chunky square structural members joined with through tenons, stretchers close to the floor, and plain wood finishes. Mission-style touches were added: the tenons protruded slightly, and some chair backs had multiple vertical splats. Chapman and Nusbaum also designed a large table and a buffet, although the buffet is not a traditional form in New Mexico. The table features painted chip-

carved decorations, and the buffet has raised panels, both traditional Spanish ornament. By the 1920s Nusbaum's furniture was in high demand to furnish the new homes of prosperous Anglos, although he is best remembered today for his work in archaeology.

Appreciation of Hispanic culture grew. By 1925 noted writer Mary Austin and ceramist Frank Applegate helped found the Society for the Revival of Spanish-Colonial Arts (renamed the Spanish Colonial Arts Society in 1929). The society operated a retail store and awarded prizes at the annual Santa Fe Fiesta, thereby reinvigorating crafts that had previously been overlooked by the tourist trade. The name reveals a bias, as it emphasizes the European rather than the Mexican roots of the culture. Some members wanted to support only craft that conformed to historical prototypes, which discouraged innovation. Nonetheless, the society gave some mestizo New Mexicans an alternative to the low-paying service jobs usually available and reinforced the traditions of rural communities.

Many of the so-called revival crafts in New Mexico did not need to be revived at all. Tinwork, wool weavings, adobe construction, and leatherwork had been practiced continuously for centuries. They survived in small villages, and the society simply brought them to the attention of a wider public. One genuine revival was straw work, which had developed in sixteenth-century Europe as a low-cost alternative to marquetry. Small pieces of flattened straw or corn husk were adhered to wooden chests and crosses to create a shimmering design similar to satinwood. Some motifs of Mexican straw appliqué may be traced to Moorish patterning adopted in Spain. The craft had all but died by the 1930s. When painter Eliseo Rodríguez (born 1915) joined the Federal Art Project in 1936, director Russell Vernon Hunter suggested that he try to reinvent the process. Rodríguez and his wife, Paula, developed a technique similar to the original and started making decorated crosses. (Figure 5.22) His work went far beyond historical models, though. While the originals were decorated only with geometric patterns, he depicted figures and landscapes in this unassuming material. Straw appliqué was revived only briefly, but it would undergo yet another rebirth in the 1970s.[55]

When the Federal Art Project constructed the Roswell Museum (completed 1937), Hunter commissioned local artisans to furnish and decorate the interior. (Figure 5.23) Some work was traditional and some quite unconventional. A dado four feet high embroidered in a pattern imitating calico cloth was installed in the ladies' lounge. Furniture was made in a shop in the museum's basement, and one *trastero* (cabinet) was decorated with straw appliqué.

FIGURE 5.22. *Eliseo Rodríguez,* Straw Appliqué Cross, *1978. Pine, paint, straw. (Museum of Spanish Colonial Art, Spanish Colonial Art Society, Inc., Santa Fe. Photograph by Jack Parsons.)*

There were experiments in education, too. Students at the Normal School in El Rito carefully produced furniture and blankets for the Spanish Colonial Arts Society's Spanish Arts Shop. The local market, however, was already saturated, and out-of-state dealers wanted work that looked more worn and crude. (Reduced demand due to the Depression and high shipping costs forced the Spanish Arts Shop to close in 1933.) School programs conducted by the state Bureau of Vocational Education trained numbers of youths for the building trades with skills that eventually paid off: after 1940, many of those trainees got good jobs in war-production factories on the West Coast.

EDUCATION IN WOODWORKING

Quite apart from high-style design and institutionally sponsored revivals, woodworking became a popular hobby for men. Boys who had received manual-arts training in high school returned to the craft when they settled

FIGURE 5.23. WPA/*Federal Art Project workers*, Roswell Museum and Art Center Administrative Office, *ca. 1938. (Courtesy of Roswell Museum and Art Center.)*

down to adult lives. For the most part they were content to make useful domestic objects along traditional lines. Their interest spurred the publication of a variety of books from specialized publishers such as the Manual Arts Press of Peoria, Illinois, and Bruce Publishing Co. of Milwaukee. Some were technical in nature, but from the mid-1920s on, a steady stream of books full of measured drawings were published. Not surprisingly, most focused on American antiques.

In the 1930s woodworking was also promoted as a way to avoid buying new furniture and even to earn money. Magazines such as *Popular Mechanics* were packed with how-to articles for simple furnishings that could be offered for sale. As weaving was a source of income for women, home woodworking became one for men. The combination of hobbyism and enterprise created a do-it-yourself ethos that was not just a middle-class phenomenon: many blue-collar workers installed home shops in their basements and garages. These amateurs created a market for new power tools, most of them small compared with their commercial cousins. By the 1950s and 1960s, when young men and women began to think of woodworking as an art form, their needs for studio-scale

machinery was easily met, which contributed greatly to the rapid growth of the field.

Metals: Silver Tarnishes

The 1930s were difficult years for silversmiths. During the Depression, even the wealthy had less disposable income and cut back on their purchases of nonessential goods. Moreover, there was less interest in the formal meals and high teas that justified silver services. The age of informality was arriving, and certain signs of class and status were becoming obsolete. Those who had silver used it rarely or only for display. Then there was the maintenance problem. Sterling silver gradually turns black if it is not polished. Polishing is tedious work that was often relegated to servants, but servants were far less common. Silversmiths had to charge more than manufacturers to offset the cost of hand labor, and their business declined precipitously. Manufacturers suffered, too; nearly a third of them had gone out of business by 1933. Suddenly chromium-plated hollowware looked much more attractive. By the late 1930s consumers could choose from a wide variety of well-designed factory-made wares made of plated brass, steel, and other base metals. One writer cheerfully noted, "There is something in the idea of having copies of a few really good designs at prices that make it possible for many people to enjoy them."[56] Industry was about to fulfill William Morris's dream of art for all, but in ways he never imagined.

ARTHUR NEVILL KIRK

A few silversmiths took up teaching to survive, avoiding the issue of working with industry. One was Arthur Nevill Kirk (1881–1958). Born and trained in England, he favored a lightly decorated Gothic style. His restrained ornamentation was quite current in the 1920s, and the Gothic style was perfectly suited for ecclesiastical silver. In the 1925 Paris Exposition, Kirk won a gold medal for a quasi-medieval chalice with an enameled triptych. Besides being an accomplished silversmith, he was also an enamelist and a painter of miniatures.

In 1927 George Booth invited Kirk to teach at the Art School of the Detroit Society of Arts and Crafts and to make silver plate for Christ Church Cranbrook. Booth had already commissioned iron gates from Samuel Yellin, wood carving from John Kirchmayer, and silver from Georg Jensen, Arthur Stone, and Tiffany. When the new silversmithing shop opened at Cranbrook in 1929, Kirk was appointed to head the studio. He began

FIGURE 5.24. *Arthur Nevill Kirk*, Hand Mirror, *ca. 1931. Sterling silver, ivory, enamel, semiprecious stones; 9.93 × 5.18 in. (Collection of Cranbrook Art Museum, Bloomfield Hills, Mich., Gift of Henry Scripps Booth, CAM 1987.61. © Marion Kirk Jones. Photograph by R. H. Hensleigh, courtesy of Cranbrook Art Museum.)*

teaching classes and producing silverware and was also expected to produce work designed by Eliel Saarinen. At the time, Saarinen's designs were influenced by the restrained neoclassicism then sweeping Europe, a style that was more up-to-date than Kirk's.

A hand mirror that Kirk made about 1931 shows Saarinen's influence. (Figure 5.24) It is not overtly neoclassical, but it is definitely not Gothic either. The ivory handle terminates in plump scrolls reminiscent of Jensen silver. The metal disk that backs the mirror is ringed with twisted wire and stamped ornament, and the socket is similarly decorated. The enameled medallion depicts two skinny rams butting heads on a mountaintop, a rather odd image that may have held significance for the owner. Kirk's mirror represents the transitional moment when silversmiths tried to invent a language of decoration no longer tied to history.

Kirk was one of the first foreign-born silversmiths who came to America specifically to teach. While at Cranbrook, he took private students, many from nearby Wayne University. (Cranbrook Academy of Art was not formally established until 1932.) Although the Depression forced the closure of Cranbrook's metals shop in 1933, Kirk obtained a teaching position at Wayne, where he taught until 1947. In effect, he subsidized his studio work with his teaching.

Kirk belonged to the antimachine extreme of the English Arts and Crafts spectrum. He would not spin or cast metal. He was one of the last smiths in the United States to take this position. The next generation of smiths and jewelers happily chose efficiency over ideology, and the purist attitude about handwork became a dead issue.

Kirk was, however, among the first generation of hybrid craftsmen-educators, an identity that burgeoned in the 1930s and has continued ever since.

PORTER BLANCHARD

While Boston-area silversmiths including George Gebelein and Arthur Stone never strayed too far from revival styles, Porter George Blanchard (1886–1973) left them behind. He was trained in his father's silversmithing shop in Gardner, Massachusetts, and by 1914 he had joined the Boston Society of Arts and Crafts, which suggests that he accepted the conservative ethos of Boston silversmithing. Then, in 1923, lured by the prospects of sunny Southern California, he moved to Burbank. Producing both hollowware and flatware in large quantities, Blanchard evolved a new look in silverware.

Even though he was capable of reproducing antique silver (and often did), Blanchard's personal work was different. Through the 1920s he gradually stripped the decorative elements from traditional American and English silver forms. Finally his silverware was reduced to the bare bones. Matching tea and coffeepots from about 1930 are as spare as anything coming from France or Germany at the time. (Figure 5.25) Blanchard's model was a generic Federal-period chocolate pot. The handle placed at a right angle to the spout was typical of chocolate pots; the cylindrical body was uncommon but not unknown. Still, a Federal piece would have had molding around the top and bottom edges of the body, a slightly domed lid, and a shaped handle set in a substantial socket. In Blanchard's version, the spouts are reduced to tiny creases. The handles are straight and squared off, so they will not slip in the hand. The lids are flat, and the knops swell outward for easy grasping. The pots are elegant and understated

FIGURE 5.25. *Porter Blanchard,* Coffee and Tea Servers, *1930–40. Silver, ebony handles; coffee server: 7.5 × 9.25 in. (Collection of the Oakland Museum of California, Gift of The Collectors Gallery, Sandra G. and Steven Wolfe, and Kenneth R. Trapp, A1992.3.)*

and entirely lack the nostalgia and class-consciousness that characterized most revival silver.

Blanchard could be still more avant-garde. In 1938 he made a coffee set in the form of recumbent half-circles, with ebony rings on the inner edges serving as handles. They do not look like teapots at all: only a minuscule spout reveals the function. In fact, they look like odd tabletop sculptures, which was probably the point.

Blanchard ran a large shop (with up to twenty-five employees in the late 1920s) and also used heavy machinery. Much of his hollowware was spun, which allowed him to reproduce basic shapes economically. Furthermore, because his silver had little ornament, it could be reproduced easily. Blanchard exploited the efficiencies of his system by wholesaling his silver, especially flatware, to department stores all across the country. In the 1930s, he also sold silver to Hollywood personalities such as Cary Grant and Joan Crawford, becoming the "silversmith to the stars." His protomodernist design has aged well, and his shop prospered long after his death.

PETER MÜLLER-MUNK

One silversmith whose career traced the rapid changes facing the field in the years just before World War II was Peter Müller-Munk (1904–1967). He was trained at the Kunstgewerbeschule in Berlin, set up shop in the early 1920s, and was one of the few Germans who showed work at the 1925 Paris Exposition. Müller-Munk immigrated to the United States in 1926. He worked for Tiffany & Co. and Oscar Bach briefly before opening his own studio in 1927. Like most fashionable smiths in the 1920s, he worked in a restrained neoclassical style characterized by simple forms and light ornamentation. After the stock market crash, as private commissions diminished, he tried adopting the new machine aesthetic.

Müller-Munk's silver coffee and tea service from 1931 was quite a departure. (Figure 5.26) The objects are all rectangular solids, enlivened with rectilinear engraving. The rigid geometry was meant to symbolize the new age, but, ironically, boxy forms with flat sides and sharp edges are extremely difficult to produce by machine. They must be soldered together piece by piece, and at such high temperatures, flat surfaces tend to warp. Müller-Munk's forms had to be carefully handmade, with dozens of subtle adjustments to get the sides to lay truly flat.

Yet if Müller-Munk intended to create an aura of mechanical perfection, he undercut his message. The tusk-shaped handles are decidedly organic. The spout on the creamer flares upward and curves, contrasting with the straight spouts of the coffeepot and teapot. The geomet-

FIGURE 5.26. *Peter Müller-Munk, Coffee and Tea Set, ca. 1931. Silver and ivory; kettle: 5.87 × 10.5 × 3.75 in.; stand: 10.12 × 9.25 × 6.75 in.; burner: 2.12 × 5.62 in.; teapot: 7.87 × 9.5 × 3.5 in.; creamer: 4.5 × 6.25 × 2.25 in.; sugar bowl: 5 × 7.75 × 3.35 in.; tray: 1 × 24.75 × 13.75 in. (The Metropolitan Museum of Art, Gift of Mr. and Mrs. Herbert J. Isenberger, 1978.439.1-5. Image © The Metropolitan Museum of Art.)*

ric legs of the heating stand are supported by elegant S-shaped curves. One might conclude that this design was an experiment, a step away from a decorative style toward a stripped-down one.

Silversmiths often must make presentation drawings to convince clients to commission work, and since good drawing was the essential skill required of an industrial designer, Müller-Munk made the transition easily. In the early 1930s, he worked on design projects as varied as china and electrical appliances, but his best-known work was for the Revere Copper and Brass Company, one of several corporations trying to expand into consumer goods. Müller-Munk's 1935 pitcher for Chase was inspired by the streamlined smokestacks of the ultramodern ocean liner *Normandie*, which had its maiden voyage the same year. (Figure 5.27) His design is thinner, taller, and more elegant than its inspiration, and the sharp trailing edge is his own invention.

The Normandie pitcher has become an icon of art moderne. It is not pointlessly streamlined, since the sharp edge forms an efficient pouring spout. It speaks of a better life through the application of modern technology, a message that appealed to Americans enduring the Great Depression, and it was mass-produced, affordable to millions.

The same year, 1935, Müller-Munk joined the faculty of the first degree-granting program in industrial design, at Carnegie Institute of Technology in Pittsburgh. His shift from craftsman to industrial designer was complete.

FIGURE 5.27. *Peter Müller-Munk, Revere Copper and Brass Co.,* Normandie Pitcher, *designed and produced 1935. Chrome-plated brass; 11.97 × 9.61 × 3.03 in. (Museé des Beaux-Arts de Montréal, Liliane and David M. Stewart Collection, Gift of the American Friends of Canada through the generosity of Geoffrey N. Bradfield. Photograph by Christine Guest.)*

Rockefeller Center

In 1929, as the stock market crashed, John D. Rockefeller Jr. held a ninety-nine-year lease on a three-block property in midtown Manhattan. Originally the site was to house commercial buildings, an opera house, and a public square. Hoping to create a commercial mecca that would draw tenants from all over the city, Rockefeller revised the plan. Part of the attraction was to be an array of artworks and decoration symbolizing faith in the future and designed to make the new Rockefeller Center an unforgettable place.

One million dollars was reserved for the art program, and some of the most renowned artists in the Western Hemisphere were contracted. Not all of them made Rockefeller happy: the Mexican muralist Diego Rivera painted a huge fresco that included a portrait of Vladimir Lenin. When Rivera refused to paint Lenin out of the picture, he was paid in full and let go, and the mural was removed. But overall the vast decorative program was a success, and most of it survives today.

OTHER METALWORK

The 1930s was also a difficult time for the "building arts," the crafts and trades associated with decorating buildings. Many theorists of European modernism thought that any kind of architectural decoration was superfluous. The most extreme position was taken by Austrian architect Adolf Loos. In a famous 1908 essay, "Ornament and Crime," Loos declared: "The urge to decorate one's face and anything else within reach is the origin of the fine arts. It is the childish babble of painting. But all art is erotic. A person of our times who gives way to the urge to daub the wall with erotic symbols is a criminal or a degenerate. What is natural in the Papuan or the child is a sign of degeneracy in a modern adult. I made the following discovery, which I passed on to the world: *the evolution of culture is synonymous with the removal of ornamentation from objects of everyday use.*"[57] Most designers did not completely share Loos's disgust, but the ideals of German functionalism were influential. Every part of design should contribute to use, and anything else should be stripped away. Beauty was to be found in the stark lines of pure form rendered in contemporary materials.

Functionalism was opposed by those who felt that decoration had symbolic purposes. If an architect wanted to create a distinct sense of place or announce a particular social purpose or simply comfort and soothe, he could employ decoration to do so. Decoration was a public language, applied to buildings and objects to address ordinary people. Ornamentalists, however, were on the losing side of the debate in the 1930s. Modernism would render decoration highly suspect for the next fifty years, but the building arts had one last triumph in America: Rockefeller Center.

Many of the architectural decorations made for Rockefeller Center were collaborations between artists and craftsmen. One such effort was three enormous rondels installed on the wall facing Fiftieth Street, outside Radio City Music Hall. (Figure 5.28) Artist Hildreth Meiere was selected to design them; her subjects were dance, music, and drama. Oscar Bruno Bach (1884–1957) was the fabricator.

Like many experienced metalsmiths in the United States at the time, Oscar Bach had been schooled in Germany. By age twenty, he had served an apprenticeship in Berlin and had been chosen to produce metalwork for the Berlin City Hall. Bach immigrated to New York in

FIGURE 5.28. *Hildreth Meiere, designer, Oscar B. Bach, fabricator, Dance Rondel for Radio City Music Hall 50th Street Façade, installed 1932. Cast aluminum, brass, chrome nickel steel, copper, vitreous enamel; diameter, 18 ft. (Photograph by Bruce Metcalf.)*

1912 and opened a metal shop where he worked in all the historicist styles popular then. The core of his practice was blacksmithing, but he expanded his repertoire to include casting and enameling. He also experimented with new types of stainless steel as well as bronze and aluminum and even Bakelite. His willingness to work in materials other than the familiar wrought iron allied Bach with European blacksmiths such as Edgar Brandt more than with his American peers Samuel Yellin and Frank Koralewsky.

Bach was thus the ideal candidate to translate Meiere's watercolor renderings into metal. Positioned some sixty feet above the marquee, each relief had to be colorful and powerfully graphic to have impact on street level. The *Dance* rondel shows how they solved the problem. Overall, it is nearly twenty feet in diameter—so big that it could not be assembled vertically in the studio. The figures are formed in a white metal (probably aluminum) showing musculature and facial features. They are contained in a round frame of multicolored metal with a zigzag motif. The dancer is encircled by a drape of brilliant blue enamel; the warrior has bright red footgear and a sash in blue and red. The whole composition is accented with yellow metal (gold leaf?), distributed evenly throughout. In a final touch, Bach made bracelets for both figures in polished copper.

At Rockefeller Center, art, craft, and architecture are bound together to perform a public service. Unfortunately for American cities, as the Depression deepened, developers could no longer afford to decorate their buildings, and after the war, modernist theory would discourage ornament altogether.

Glass Goes Several Ways

Glass in the 1930s branched off in multiple directions, ranging from the elegance of Steuben to the cheerful and affordable "carnival" or Depression glass and from WPA-sponsored revivals of traditional forms to the first efforts at studio glass production.

Frederick Carder and Louis Comfort Tiffany had been the major glass designers of the early years of the century, but Tiffany's unchanged style became outdated, and the firm went into bankruptcy in the early 1930s. Many other commercial glass companies were also in a rut, reproducing eighteenth- and nineteenth-century standards and ignoring the new styles developed in Europe. Only a few designers picked up on the new ideas, and when modern designs were offered in glass, they tended to be surface embellishments rather than inventive forms.

One exception was Reuben Haley (1872–1933), whose Ruba Rombic glassware echoed both cubist painting and the angularity of art deco. (Figure 5.29) Another responsive designer was Frederick Carder of Steuben, whose forms, if not so animated as Haley's, were elegantly modern, with clear or lightly colored glass incorporating internal bubbles and patterns.

Carder was interested in what he saw at the 1925 Paris Exposition as a member of Hoover's study commission, and he responded to the changing tastes. Some art deco pieces subsequently appeared in Steuben's production. He designed frosted-glass bowls and glass-handled flatware in collaboration with silver-plate companies in England. The colorless handles complemented new lines of tableware, such as Saint Tropez, introduced during the early years of the Depression.

Part of Carder's success was due to his marketing sense. He claimed that when a color or shape was not selling well enough, he would double the price and "it sold like a shot."[58] Nevertheless, sales began to decline in the late 1920s. With the onset of the Depression, Corning considered closing the Steuben division but first brought in Walter Dorwin Teague for a year as a consultant and relieved Carder of most of his responsibilities. Teague designed more than thirty modern items during his year, such as the stepped Lens Bowl of clear crystal

FIGURE 5.29. *Reuben Haley, designer,* Ruba Rombic Vase, *1928–32. Glass; 9.12 × 8 × 7.5 in. (The Art Institute of Chicago, Raymond W. Garbe Fund in honor of Carl A. Erikson, Shirley and Anthony Sallas Fund, 2000.136. Photograph by Robert Hashimoto.)*

and a group of simple-shape vases that were chosen for the MOMA *Machine Art* show in 1934. He also suggested changes to production, sales, and what we would now call branding strategies. He said, "I believe we can make the ownership of Steuben glass one of those evidences of solvency—like the ownership of a Cadillac . . . or a house in the right neighborhood."[59]

Arthur Amory Houghton Jr., a great-grandson of Corning's founder and a younger member of its board, proposed a reconceived Steuben and in the autumn of 1933 became chief executive officer. Taking advantage of Corning's 1932 development of a formula for pure, colorless crystal, Houghton began to exploit the skills of the best glassblowers and engravers and shifted Steuben entirely away from colored art glass. He hired a close friend, architect John Montieth Gates, to revamp Steuben's approach to design, and Gates in turn hired Sidney Biehler Waugh as designer. All three men were under thirty years of age. From 1933 to 1936, Gates and Waugh designed all the pieces made by the new company—cocktail shakers, bowls, serving dishes, and other giftware for the luxury market.

Waugh's Gazelle Bowl of 1935 is the first and most famous of his engraved designs. (Figure 5.30) The leap-

ing animals form a frieze and make the bowl resemble a slowly rotating carousel. The lightness of their bodies contrasts with the heavy, solid base. Steuben forms were sometimes considered a little too heavy to be truly modern, but Waugh asserted: "The secondary form of an object in glass should be somewhat heavier than in an opaque medium. Small forms tend to disappear because of transparency."[60]

At first Steuben was sold in leading department stores in major cities, but gradually it became more exclusive: shown only in Corning, New York (the firm's headquarters), and Manhattan, where Steuben maintained an elegant gallery-like showroom with subdued lighting and spacious display. The Steuben design team was moved from Corning to Manhattan in 1934, with the idea that designers should be exposed to the latest cultural influences, although they were still involved in collaborative exchange with glassblowers (rather than simply sending a drawing off to the factory).

In 1940 the company exhibited designs by twenty-seven contemporary artists, including Dalí, Noguchi, Giorgio de Chirico, Jean Cocteau, Henri Matisse, and Georgia O'Keeffe, each produced in an edition of six. Paul Manship was one of the few to design the form as well as the decoration, and along with Raoul Dufy, he was praised for his thoughtful use of transparency. Most artists merely furnished a drawing in their customary style, and the works as a consequence are illustrative.

When Carder was pushed aside at Steuben, he was seventy years old and, despite his active creative work,

FIGURE 5.30. *Sidney Biehler Waugh, designer, Corning Glass Works, Steuben Division,* Gazelle Bowl, *1935. Glass; height, 7.25 in.; diameter, 6.5 in. (Collection of The Corning Museum of Glass, Corning, N.Y., Gift of Mr. and Mrs. John K. Olsen, 1990.4.244.)*

FIGURE 5.31. *Frederick Carder, Standing Glassblower, 1937. Cast crystal; 12.68 × 3.62 × 6 in. (Collection of The Corning Museum of Glass, Corning, N.Y., Gift of Frederick Carder, 1952.4.324.)*

was seen as representing the old, outdated glass design. It is doubly ironic, then, that he went on to serve as a model for the studio-glass movement. From the 1930s to the 1950s, Carder worked at a small kiln in his studio to develop various glass-molding techniques for his original sculptures, rendered in *pâte de verre*. (Figure 5.31) Maurice Heaton, who in the late 1920s had begun applying modern geometric designs to hand-cut sheets of glass, was possibly the only other American individual artist in glass at the time.

In Short

The many repercussions of the Depression dominated the 1930s. It put potteries out of business, decimated the silversmithing industry, and brought an end to famous institutions like the Roycrofters. Positive effects came from government intervention. With wPA funding, Timberline Lodge was constructed, and New Mexican handmade furniture and decorative techniques were revived. Craftspeople were employed in wPA programs as diverse as screen printing and figurine making.

Modernism, a European import, was seen in the figurative ceramic sculpture of Waylande Gregory, while Glen Lukens found his own route to reductive forms, exposed clay, and spectacular glazes. Wharton Esherick was acclaimed for his sculptural form in furniture and Dorothy Liebes for her brilliantly colored and glittering yardage, both modern expressions but unlike the cool International Style promoted by the Museum of Modern Art. Most important for ceramics was the new Ceramic National, while Bauhaus ideology, introduced by immigrant teachers Josef Albers and László Moholy-Nagy, emphasized abstract form and a nonhierarchical approach to materials that would shape the future.

CHAPTER 6 1940–1949

NEW OPPORTUNITIES

Losing and Gaining

The war decade was a time of shock and changes. World War II absorbed the country's attention from 1942 until 1945. More than 16 million men and women served in the military, and although more than 292,000 of them died, the war also ended the Great Depression. During this period, 27 million people moved, many for better jobs, and 7 million women worked in war industries, tasting financial independence for the first time. Not everyone prospered, though: in February 1942, by authority of Executive Order 9066, some 120,000 Japanese Americans who lived along the West Coast were imprisoned, losing their homes and businesses. The racism of this policy (Germans and Italians were not interned) was admitted only decades later.

Demand for luxury handmade goods collapsed; many materials, from brass to birch plywood, were strictly reserved for the war effort. Many skilled craftspeople took jobs in war industries, if they did not serve in the armed forces. The Syracuse Ceramic National was suspended for the duration of the war. Still, a few fields flourished: small potteries produced replacements for unavailable imports, for instance.

Once the war ended, economic conditions began to change rapidly. The United States was the only major combatant that did not suffer the physical destruction of modern warfare, and it was quick to retool wartime production capacity to serve consumers' pent-up demand. Refugees from Nazi Germany, such as ceramists Gertrud and Otto Natzler in Los Angeles and weaver Marli Ehrman in Chicago, introduced new ideas and methods. Styles changed: sculptures by Alexander Calder and Joseph Cornell employed found objects; Jackson Pollock, interested in automatism and the unconscious, based his new art in "immediate concrete pictorial sensations."[1]

The end of the war ushered in a new era of opportunity. In 1946 the Wichita Art Association held the first of its many National Decorative Arts and Ceramics Exhibitions. Richard Petterson, teaching at Scripps College in Southern California, made the school's Annual exhibition into a national ceramics show starting in 1949. A growth of activity in the crafts was due in part to the landmark expansion of colleges, which in itself was due to another significant piece of wartime legislation.

1940

Average hourly wage: 66¢

Price of an average home: $2,938

Clement Greenberg publishes "Towards a Newer Laocoön," which sets the terms of criticism for abstract art

1941

Roosevelt declares war after the Japanese bomb U.S. naval base at Pearl Harbor, Hawaii

Orson Welles directs *Citizen Kane*

Photographer Walker Evans and journalist James Agee publish the seminal book *Let Us Now Praise Famous Men*

1941–45

Blacks move north for jobs, and women join the labor force

1942

Price freeze imposed; meat, gasoline, shoes, and more are rationed

Walt Disney Studios produces *Bambi*

Edward Hopper paints *Nighthawks*, his realist masterpiece

1942–47

Peggy Guggenheim operates the Art of This Century gallery, supporting European and American Surrealist painters

1943

Casablanca, starring Ingrid Bergman and Humphrey Bogart, is released

1945

Atomic bombs dropped on Hiroshima and Nagasaki, Japan; World War II ends

United Nations established

1947

Jackie Robinson joins Brooklyn Dodgers

Jackson Pollock creates the first of his drip paintings, ushering in abstract expressionism

1948

Bell Labs invents transistor

1949

Mao Zedong proclaims the People's Republic of China

Education

THE GI BILL

Crafts education took a significant step in 1943, when the College of Ceramics at Alfred University awarded its first Master of Fine Arts (MFA) degree, the first craft program in the country to do so. (The recipient was Daniel Rhodes.) Up until then, the MFA was confined to a few art schools and universities and only for subjects like painting and sculpture. Of more immediate impact—in fact, one of the most far-reaching pieces of legislation of the 1940s—was the Serviceman's Readjustment Act of 1944, better known as the GI Bill. Designed to provide a social safety net for returning soldiers, it was hastily drafted, narrowly passed, and signed into law on June 22, 1944. The bill ensured hospitalization for wounded veterans, guaranteed unemployment benefits, and offered low-interest loans for the purchase of homes and businesses. It also provided free tuition and other support for higher education. The GI Bill transformed American society. Hundreds of thousands of servicemen bought homes, many of them brand-new tract houses in the suburbs, and by 1951 more than 8 million veterans secured an education, some 2.3 million of them attending colleges and universities. Higher education was no longer restricted to the elite who could afford it.

The new students, more mature and far more motivated than any freshman class before or since, wanted courses with practical benefits. While many vets were interested in joining the mainstream of American society, a substantial minority wanted nothing to do with bureaucracies or big business. Thousands had visual aptitude and manual skills, and for them, the crafts offered a satisfying way to participate in the arts and earn a decent living. Craft courses, like the schools themselves, were suddenly filled to overflowing.

The best craft programs could hire faculty who had trained abroad, but in many art departments, craft courses were taught by jack-of-all-trades teachers. Often their knowledge was limited to basics or whatever they could pick up from a handy textbook. Because colleges and universities were often located in small towns, most craft teachers could not ask tradesmen for advice. (The surviving trades tended to be either urban or concentrated in certain regions.) There were few remaining Arts and Crafts societies where they could go for information. Many had to teach themselves. Luckily, modernist forms were relatively easy to make. Although many craftspeople lacked a wide range of skills, few felt that was an impediment.

FOUNDATION COURSES AND ABSTRACTION

Not only did art programs grow, they changed. One important innovation in college-level instruction was the introduction of new foundation courses. Educators had thought that drawing, progressing from still lifes to live models, was sufficient basic training for any visual art form. But the Bauhaus, for one, held that beginners should be introduced to art through abstract-design exercises, alongside traditional drawing courses. These exercises focused on universal properties of visual experience: the way the human eye perceives gradations of gray, the dynamism of diagonal lines, the inherent interest of asymmetry. Once they learned the basics, students created abstract compositions to demonstrate their grasp of design principles. Many artists recall these courses as a kind of extended torture, delaying their opportunity to make real art. Teachers responded sagely that students had to learn to walk before they could run.

The upshot was that generations of students were taught to think about craft in terms of abstract composition, rather than the application of conventionalized motifs to a surface. The South Kensington system (see chapter 2) was truly dead and, along with it, the sense that craft and decoration were linked. (The exception was ceramics, in which decorating was still regarded as integral to form.) American craft began to take a decided turn away from applied ornamentation in the 1940s and 1950s, and foundation courses played a central role in this shift.

The manual-arts system had remained intact through the Depression, but critics began to say that it had devolved into rote reproduction of outmoded patterns. Manual-arts textbooks at the time were illustrated with examples ranging from Arts and Crafts to art moderne, and that material looked increasingly stale.

The crafts, however, were given a different educational role altogether in 1949. That year, the National Art Education Association determined that "Art instruction should encourage exploration and experimentation in many media at all levels."[2] The idea that art education should take place in many different mediums stemmed from the new foundation courses. This opened space for ceramics, jewelry, and other craft studies. The emphasis on experimentation was also new, officially placing creativity above vocational training for the first time. Because craft was now equated with art and free expression and was an important component in college-level art education programs, men and women who had studied the crafts in college were now qualified to teach art in high schools and were even in demand.

Craft Institutions

AILEEN OSBORN WEBB AND THE ACC

In the late 1930s, there were no national institutions to link far-flung American craftspeople. The multitudes of local and regional craft organizations established in the 1920s and 1930s were independent, except in the Southern Highlands. There were few opportunities to share information or to initiate projects on a regional or national scale, nor were there any major periodicals devoted to the crafts: *International Studio*, once required reading for every aspiring designer and craftsperson, ceased publication in 1931.

All that changed due to the efforts of a small group of people led by one extraordinary woman, Aileen Osborn Webb (Mrs. Vanderbilt Webb, 1892–1979). Webb was born into great wealth (she inherited some of the Phelps-Dodge Company fortune), and she married into more. She was also born into art: her father was president of the Metropolitan Museum of Art, and she became a skilled potter, enamelist, and watercolorist. She and many of her rich and powerful relatives and acquaintances—Eleanor Roosevelt was a close friend—felt that their wealth obligated them to help others. The chief beneficiary of Webb's generosity and prodigious energy were the crafts.

Her involvement began when she and two friends organized a marketing organ for the "sole purpose of selling whatever a person living in Putnam County [New York] could make or produce."[3] The beginning was modest, a store with only thirteen consignors in 1936, its first year. Then, in 1939, she convened a meeting at her summer home to discuss a national body. Representatives of nine craft organizations attended. Together, they formed the Handcraft Cooperative League of America, with the mission of developing urban markets for rural crafts. Webb was its leader and its pocketbook.

The league immediately embarked on some far-reaching projects. In 1940 it opened a retail store called America House in Manhattan, which was run as a cooperative, like many of the rural craft outlets of the 1930s. In November 1941, the league started publishing a magazine. It was a humble affair, lacking even a name at first, but it was sent out to all the consignors at America House. The next year, titled *Craft Horizons*, it had a print run of 3,500 copies and was distributed through the various constituent organizations.

In 1942 the league changed its name to the American Craftsmen's Cooperative Council, and the following year it spun off the new American Craftsmen's Educational Council. The Cooperative Council remained an associa-

tion of craft organizations; it published the magazine and operated America House. The Educational Council presented exhibitions at America House, operated a library, and ran other informative programs. In 1951 the Cooperative Council was dissolved and its activities taken over by the Educational Council, and in 1955 the organization became the American Craftsmen's Council, or ACC. Although it was East Coast–based, it was national in focus. Webb was involved in every facet of its activities.

THE SCHOOL FOR AMERICAN CRAFTSMEN

The American Craftsmen's Educational Council was instrumental in founding the first college-level American school dedicated to the crafts. During the war, state and federal vocational rehabilitation programs were set up to tend to wounded soldiers. Craft training was considered an essential part of the process, along with physical therapy and some psychiatric treatment. One such program existed at Dartmouth College in Hanover, New Hampshire, using the college's craft workshops, which provided liberal arts students with a creative outlet. As the war wound down in 1944, Webb and the Educational Council organized a craft school at Dartmouth, to be called the School for American Craftsmen (SAC), using the same workshops. The first student, in December 1944, was a marine who had been discharged from service due to his injuries.

The school's mission was ambitious. Not only would SAC "develop and raise the standards of the hand arts in the United States," but students would be prepared for many roles. A *Craft Horizons* article in 1946 noted that a student might find employment as "a producing craftsman, a member of a cooperative group, a worker in industry needing fine skills, or as a teacher of crafts or a designer for the handmade object."[4] The practicalities of making a living came first, and the school's training was oriented toward the production of multiples. Courses in marketing and pricing were also planned. At first, it was thought the entire program could be completed in six months!

SAC initially offered courses in ceramics, woodworking, weaving, and metalworking. By 1946 the program had been expanded to two years and had migrated to Alfred University, the site of the famous ceramics school. By that time, student work was being sold at America House. In 1948 SAC offered the first four-year degree in craft in the country, a bachelor of science. (It was hoped recipients would become teachers, to further "raise the level" of craft.) SAC moved to the Rochester Institute of Technology in 1950, where it remains today. After that

move, the ACC ceased to have any formal affiliation with SAC, although Webb continued to exert an influence.

SAC recruited well-trained craftsmen from abroad, including American-born but Danish-trained silversmith John Prip and Danish cabinetmaker Tage Frid. Its furniture studio was the first in the United States to grant a degree. Frid emphasized sound technique and straightforward design, an attitude that influenced many young woodworkers. In 1950 SAC hired Frans Wildenhain to teach ceramics. He had been a pottery student at the Weimar Bauhaus and had gone on to teach at the State School of Applied Art in Halle-Saale. The idealism of the SAC program and its accomplished teachers attracted many talented students.

A VISION OF THE FUTURE

In November 1943 *Craft Horizons* published a sort-of interview with Russel Wright. Famous for his American Modern dinnerware line, Wright was one of America's best-known designers. The article was constructed as if it were an overheard conversation. In one of the passages, Wright offers a remarkable prediction for the future of the studio crafts:

> *Voice*: Do you mean that the Craftsman should not attempt to make useful articles?
> *Russel Wright*: Yes, in a general way I do. That is, the whole trend for Craftsmanship should be away from making useful articles (he must forget his medieval past) and work toward the realm of the Fine Arts. He can make useful objects but they should always offer something the machine can't offer—like a more sensitive employment of materials—use of form and decoration too difficult for the machine. . . . A concentration of the personal and individualistic must be produced by the Artist and the Craftsman to relieve our new machine made surroundings.[5]

Wright foresaw what would happen to studio craft beginning in the 1950s, when a new generation of makers turned away from function and toward something much more like sculpture. He stressed, however, that the new craft should still be destined for the home, to enliven the domestic environment. In this, he was rather like William Morris. His suggestion that craft should function in contrast to industrial design, not as a replacement, was surprising; in the 1940s and 1950s, studio craftspeople were eager to collaborate with industry.

Jewelry and Enameling: Artists Rewrite the Script

Handmade jewelry survived the 1930s, but without the reformist spirit that motivated Arts and Crafts jewelers or the avant-garde zeal of those who allied themselves with industrial design.

The jewelry trade, however, was not static. One influence came from high-style French jewelry houses like Cartier and Boucheron. The French style emphasized geometric shapes encrusted with faceted diamonds and other precious gems. Metal was limited to serving as an underlying structure for the stones and perhaps a linear outline to tie the design together. Colorless metals such as white gold and platinum were favored: nothing was allowed to distract from the glitter of expensive gems. A contrasting influence came from Denmark, in the form of Georg Jensen jewelry (see chapter 4). For middle-class women, Jensen jewelry offered a tasteful way to display an inoffensively modern tendency.

World War II put a halt to jewelry development for five years. Some metals were reserved for the war effort, forcing the closure of many small shops. Brass, for instance, was needed for shell casings; nickel for steel alloys. Young jewelers and metalsmiths went overseas to fight. Older jewelers found their skills in demand for the fabrication of sensitive new instruments, including bombsights and periscopes for the arms industry.

ALEXANDER CALDER

And yet the periods immediately before and after the war saw the invention of a new kind of craftsperson: the artist-jeweler. This new category was created largely by Alexander Calder (1898–1976). Calder did for jewelry what Wharton Esherick did for woodworking: he aligned it with avant-garde art.

Calder earned a degree in mechanical engineering in 1919 and, after knocking around for a few years, began making lively drawings of athletes and zoo animals. In 1925 he made a sculpture from bent wire (a sun dial in the shape of a rooster). The wire imitated the relaxed quality of his ink drawings; it was as if his line had jumped off the paper and wandered around in space. By 1926 Calder was in Paris. There he made his first wire portrait (of Josephine Baker) and began making figures for his now-legendary *Circus*.

Circus was made to be performed and is best understood by watching the movie made of one of Calder's shows. The piece consists of several dozen toylike figures, mostly made from bent-wire armatures dressed in scraps of fabric, bits of tin cans, or whatever came to hand. Calder would kneel on the floor and, to the accompaniment of a phonograph record, conduct the animals and acrobats and clowns through an entire program. Among the acts were a sword-swallower, a chariot race, an elephant spouting water, and a trapeze artist who fell from the high wire and was carted off on a stretcher.

Calder's father and grandfather were notable American sculptors. They worked in carved stone and cast bronze—solid, substantial, and serious. Calder's *Circus* was the opposite in almost every way: ephemeral, modest in size, and whimsical. It was a conscious departure from everything sculpture was supposed to be. All the figures had an ingenious, do-it-yourself quality that added considerably to their charm. Many had simple mechanisms: tumblers actually tumbled, horses pranced, and an ax thrower could fling tiny axes at a scantily dressed assistant.

Calder started making jewelry in 1929, using the same humble materials and relaxed craftsmanship that he employed for his *Circus* figures. (Figure 6.1) The new jewelry was exhibited publicly for the first time that year at Fifty-sixth Street Gallery in New York. It was shown alongside drawings, paintings, and some textile designs. At first, sales were poor. Calder's early jewelry was often made of brass and found objects, which did not attract people accustomed to gold and silver. In his *Autobiography*, he recounts the first exposure of the Museum of Modern Art's Alfred Barr to the jewelry: "When John McAndrew took over [at MOMA] he bought two brooches from me for his secretaries. One of the pieces was a piece of crumpled-up wire I found in the street. I flattened it out and put a pin on it. This perturbed Alfred Barr, who said on two occasions, 'What does it mean?' On the third occasion, he said to its owner, 'Did you look at it in the mirror?'"[6]

By the late 1930s response improved. In 1938 Calder mounted a solo exhibition of jewelry at the Artek Gallery in Helsinki; he had others in 1940 and 1941 at Willard Gallery in New York. He made display fixtures for the shows, including some jocular heads for earrings and hands for bracelets and rings. He also showed brooches, hair combs, and necklaces.

Calder's tools were never more complicated than some hammers and an anvil, pliers, tin snips, a few punches, and a drill. He used a torch only to ball up the ends of wires, not to solder. His workmanship was direct, even crude. Calder thought of himself as self-consciously primitivist, as did many French artists in the 1910s and 1920s: "I decided a long time ago that primitive art is

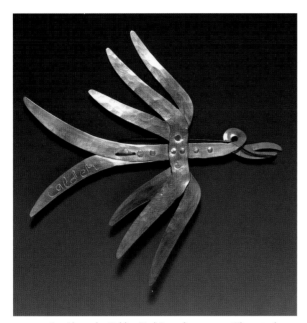

FIGURE 6.1. *Alexander Calder, Bird Brooch, ca. 1945. Silver, steel wire; 7.5 × 8.25 in. (© 2008 Calder Foundation, New York/Artists Rights Society [ARS], New York, The Makler Family Collection.)*

preferable to decadent art. . . . So, I've tried to remain as primitive as possible."[7] In the 1920s he knew prominent Parisian dealers and collectors of Polynesian and African art, and he owned a few examples himself. Indirect references to ethnic jewelry abound in his work.

Most of Calder's jewelry was built around ingeniously manipulated wire, to which he added bits of metal cut from tin cans, chunks of colored glass, or pottery shards. Settings consisted of thin wire wrapped around the found fragments, nothing more. Sometimes he strung engraved pieces of bone or carved wood on leather thongs. A specialty was making monogram brooches for his friends, the letters cleverly abstracted and combined.

The jewelry was built on the shapes that wire takes when it is bent: loops, squiggles, parallel lines, and especially spirals. (At one point, Calder called himself "Mr. Spiral.") To this basic language, he added hands, birds, butterflies, fish, and a menagerie of other animals. He was fearless about scale. The largest of his necklaces hung down to the waist. *Harps and Hearts Necklace* (ca. 1950) is forty-two inches from top to bottom. Another necklace, *The Jealous Husband* (ca. 1940), is a humorous reprisal of a medieval chastity belt, with six-inch claws perched atop the wearer's shoulders. Always the feeling was playful and improvisatory.

Calder produced most of his jewelry between 1933 and 1952, after which his attention turned to the large mobiles and stabiles for which he is most famous. By then, almost single-handedly, he had made a market for abstract jewelry. It became a legitimate form of artistic expression or, at least, a legitimate means to develop cash flow. Either way, other artists followed in Calder's footsteps, and artist-made jewelry became an integral part of the New York art scene in the mid-1940s.

OTHER ARTIST JEWELERS

The painters and sculptors who took up jewelry making had little training in the craft and even less respect for convention. They saw it as compact painting and sculpture, unconnected to any historical style and open to invention.

One of the experimenters was **Julio De Diego** (1900–1979). Little documentation about his jewelry remains, but *Craft Horizons* published a short article by him in February 1947. He noted that the individuality of the maker should be evident: "Our greatest problem is to develop these designs with imagination and individuality. The same striving for form, balance, and line that is every artist's problem should be part of the work of the jewelry-maker, too. There is no formula in craft, just as there is none in art."[8]

The pendant that illustrates the article is an irregular rectangle covered with intricate textures. (Figure 6.2) It is a wearable abstract composition. De Diego started with a sheet of metal (sterling silver or stainless steel) and went at it with a very hot torch. In some areas, he added bits of metal wire, and he melted through other areas. Across the whole surface, he built up textures of molten metal in a direct analogy to painterly impasto. The pendant hung from a strand of yarn that looped through two holes near the top edge. The picture of De Diego's pendant is printed next to one of his abstract paintings, which it resembles. The pendant's only concession to tradition is a small cabochon and the fact that it is made of silver. If it is decorative, that is because the color and texture are fascinating, not because De Diego labored over design or execution.

Another painter who made jewelry was **Richard Pousette-Dart** (1916–1992). He was known for heavily brushed paintings with vague shapes emerging and disappearing in swirls of color. Instead of miniaturizing his paintings like De Diego, he made simple, graphic jewelry. Starting in 1940, Pousette-Dart made a series of pendants, which he called "brasses." (Figure 6.3) He laboriously sawed each from thick brass plate clamped in a vise on his workbench. He used such shapes as a cross and an ankh, but he thought of them as pure abstract form, not symbols. Each was unique. Some are extremely simple:

a disk or a five-pointed star with a hole in the center. Others are more complex, like vertical stacks of inexplicable signs. The surface of each brass is absolutely plain and each hangs from a shoestring, tied in the back. Because the metal is thick, the weight constantly reminds the wearer of its presence. Touching them to feel their thickness and contour is part of the experience.[9]

Pousette-Dart first exhibited his brasses in 1943 at Willard Gallery, where Calder showed. (David Smith also had a solo show of jewelry at Willard in 1942.) The brasses were pinned to the wall, without the shoestrings, and so looked like pure abstractions without function. He showed his jewelry again in 1946, this time with watercolors, and then with photographs at Betty Parsons Gallery in 1948. By the late 1950s he ceased exhibiting the brasses, but he continued making them privately.

In the mid-1940s several other notable artists were making jewelry, sculptors Jacques Lipchitz and José

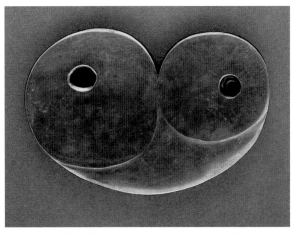

FIGURE 6.3. *Richard Pousette-Dart*, Pendant, *ca. 1955. Brass; 2.43 × 3.68 × 0.25 in. (Collection of the Museum of Modern Art, New York, Purchase SC76.1955. © 2009 Estate of Richard Pousette-Dart/Artists Rights Society [ARS], New York. Digital image © The Museum of Modern Art/Licensed by SCALA/Art Resource, New York.)*

FIGURE 6.2. *Julio De Diego*, Untitled Pendant, *in Julio De Diego, "The Metal Worker Suggests," Craft Horizons (February 1947): 20. Sterling silver, stainless steel, yarn. (Courtesy of the American Craft Council.)*

de Rivera among them. They, Calder, De Diego, and Pousette-Dart were all represented in *Modern Handmade Jewelry* at the Museum of Modern Art in 1946. There were twenty-eight named exhibitors, all but nine of them from New York. (Some Navajo jewelry was also exhibited "to show how forms which have remained traditional for centuries may be re-employed in new ways by imaginative craftsmen," but the Navajo jewelers were not identified in accounts of the show.) MOMA's press release emphasized that "today's jewelry need be neither the princely luxury of precious stones nor the dubious glitter of production-line gadgets sometimes appropriately referred to as 'junk jewelry.'" The most important criterion was that the jewelry express "intrinsic beauty [of materials] in contemporary terms." Much was made of the variety of materials used.[10]

One collection of jewelry exhibited at MOMA became famous. It was made at Black Mountain College by weaver **Anni Albers** and student **Alexander Reed**. Josef Albers, in his design course at Black Mountain, taught that all materials are equally valuable visually and that the designer should attend to intrinsic properties rather than social status. In 1940 Anni Albers and Reed, applying the lesson to jewelry, made a group of necklaces and bracelets out of hardware. It was abstract and probably cheap to boot. One necklace consisted of safety pins, another of washers and wire. The most memorable was made of a perforated metal strainer, paperclips, and a length of ball-chain. (Figure 6.4) Albers and Reed transformed purely functional objects into ornament. It may seem odd that MOMA was an enthusiastic supporter of

FIGURE 6.4. *Anni Albers with Alex Reed*, Neck Piece, *ca. 1940.*
Aluminum strainer, paperclips, and chain; 4.25 × 3.12 in. (Collection
of the Josef and Anni Albers Foundation, 1994.14.16. © 2009 The
Josef and Anni Albers Foundation/BG Bild-Kunst, Bonn, and ARS,
New York.)

the handmade, given its exhibiting of machine art and
International Style architecture. The museum, however,
endorsed anything that could be enlisted in its battle
for public acceptance of modernism. For many years,
crafts were taught by a department of MOMA called the
People's Art Center, and the museum also published a
series of craft instruction books. *How to Make Modern
Jewelry* was printed in 1949, with step-by-step instruc-
tions for projects like a "Wire Pins and Hair Ornaments
or Lapel Pins" and "Repoussé Decoration." Photographs

from the *Modern Handmade Jewelry* exhibition illustrated
the book.

STUDIO JEWELERS: REBAJES, KRAMER, LOBEL, SMITH

Painters and sculptors were not the only contributors to
Modern Handmade Jewelry. There were also studio jewel-
ers in New York. Their studios were usually in Green-
wich Village, which had long been a center of artistic
ferment, from theater and poetry to jazz and abstract ex-
pressionist painting. Young jewelers who wanted to be
associated with the avant-garde gravitated to Greenwich
Village, starting with Francisco Rebajes in 1934. He was
followed by Sam Kramer in 1939, Paul Lobel in 1944,
and Art Smith, Ed Levin, Joan Hurst, and Jill Kingsbury
in 1948. By 1950 there were more than a dozen jewelry
studio-shops in the Village. Elsewhere in Manhattan,
Adda Husted-Anderson opened a shop on First Avenue
in 1944, Ed Weiner on West Fifty-fifth in 1947, Henry
Steig on Fifty-first Street in 1949, and Irena Brynner on
West Fifty-fifth Street in 1949. Very little documentation
exists for some of these people, but others worked for
years and made lasting contributions.

 Francisco (Frank) Rebajes (1906–1990) serves as both
a model and a cautionary tale. He arrived in the United
States as a stowaway from the Dominican Republic at age
sixteen. He worked in cafeterias for a time, but the De-
pression reduced him to panhandling. While staying in a
friend's basement, he happened across some plumber's
tools, and with them he fashioned animals from tin
cans. He set them up on an ironing board at an art fair
in Washington Square and hit the jackpot when Juliana
Force, the director of the Whitney Museum of American
Art, bought the lot. Thus motivated, Rebajes became a
jeweler.

 He specialized in simple jewelry and small objects
such as ashtrays, almost always in copper. The jewelry
was either flat or lightly formed, with a uniform satiny
surface. For contrast, the copper was chemically darkened
in areas; occasionally, cabochons or enamels were added
for color. Rebajes developed a repertoire of designs: an
artist's palette, fish, fleshy leaves in linked bracelets, an
African head, a Mexican on a burro. Some of his designs
were corny, some traded in common ethnic stereotypes
of the day, but compared with current costume jewelry,
they were fresh and original.

 Modernist jewelers Ed Weiner and Ed Levin both
bought jewelry from the Rebajes shop in the late 1930s,
and they may have been inspired by his example to set up
their own shops after the war. Meanwhile, Rebajes devel-

oped a national reputation and a national market. At one point, he had dozens of salesmen traveling the country, 200 sales outlets, and more than 100 people working in his production shop. In the early 1950s, he moved his Manhattan salesroom to Fifth Avenue. It was quite an affair, with spacious glass windows, an S-shaped counter suspended from the ceiling, and a couch and ottomans upholstered in black-and-white pony hide.[11]

Rebajes did not conform to the ideal of the artist-jeweler making one-of-a-kind items in limited quantities. Parts were cut out and shaped with dies and then applied to objects as varied as bracelets and ashtrays. Some jewelry was hammered by hand after being punched out by machine, much like pseudo–Arts and Crafts work from earlier decades.

It is an old story. Because studio jewelers indirectly compete with the costume-jewelry industry, they must either distinguish their work from commercial products or go into manufacturing themselves. Many later studio jewelers emphasized a deliberate crudeness or used techniques like fusing that could not be replicated by machine. Some made only one-of-a-kind jewelry or set up a tiered system in which their least expensive items were repeated but their most elaborate pieces were unique. Rebajes went for volume. In essence, he became a manufacturer. Successful as he was, he found no imitators among the later Village jewelers. By 1960 he tired of running an empire. He eventually moved to Málaga, Spain, where he made jewelry for European jet-setters.

Another Village studio jeweler was a self-styled wild man, **Sam Kramer** (1913–1964). Kramer played the Dadaist bohemian with great abandon. The door to his shop on West Eighth Street sported a bronze doorknob in the shape of a hand; in winter, it wore a pigskin glove. For promotions, Kramer would dispatch a pair of "Space Girls" decked out in black tights and green makeup to distribute handbills. In his late years, he even appeared on television programs like the *Tonight Show* and *To Tell the Truth*. The theatricality was fun, but it was also designed to support his jewelry, a spicy mixture of biomorphism and surrealism. Underneath, Kramer was a serious and studious artist.

Kramer was the first notable American studio jeweler to have taken metals classes in college. His introduction to jewelry was in manual-arts courses at his Pittsburgh high school. He studied journalism at the University of Pittsburgh before transferring to the University of Southern California. There he took a jewelry-making course from ceramist Glen Lukens. After graduating in 1936, Kramer worked as a reporter in Los Angeles and made jewelry in his spare time. He discovered the expressive possibilities of fusing metal, just as Janet Payne Bowles had before him:

> One time, working by trial and error in the fireplace (a convenient place for such experiments) I was trying to evolve a new casting technique. When silver is molten it flares, and dances like mercury. Suddenly a sputtering bubble of liquid silver squirmed out of the ingot-mold and cooled in an odd shape on the hearth. This piece, this accident of spilled metal, vaguely resembled a duck's head. And it started me thinking about how silver and gold could be blasted by flame until it ran almost fluid, then controlled, built-upon and fused again until it resulted in small sculptures with the texture and all the flame-like movement of this kind of primal ordeal by fire.[12]

In 1939 Kramer moved to New York and set up shop. His signature technique was fusing, but he also constructed jewelry from sheet and wire. Always he aimed for a surrealist sense of surprise and ambiguity. Kramer's *Roc* pendant was made in 1958, but it typifies his work of the 1940s. (Figure 6.5) At 4¾ inches tall, it is big for a piece of jewelry. The creature looks like an overweight chicken with a single staring eye (taxidermy glass eyes were another of Kramer's signature devices: their realism provided an unsettling emotional resonance). A piece of carved ivory surrounds the eye. A disk of horn—along with tourmaline, garnet, and coral—adds color and variety to the composition.

Kramer's intention was to provoke, and he reported with satisfaction that some customers fled his shop in dismay, while others thought his work repulsive. Like bebop in music, his jewelry proposed a new world of creative improvisation and free expression. Kramer achieved notoriety, both in the Village and in national craft exhibitions. His first wife, Carol Enners Kramer, often collaborated with him and produced her own jewelry. He also ran a mail-order business selling semiprecious stones, exotic wood, ivory, bone, and the like as well as kits with three stones and some silver wire—enough to make two earrings and a pendant.[13]

There is evidence that Kramer was disappointed toward the end of his life. He had no affection for the then-prominent "good design," finding it lifeless and mechanical. In 1960 he complained that jewelry had become "that slum in the neighborhood of art; that orphan from the family of 'true' arts. . . . [Jewelry] smugly insists on being portable décor for body and dress and, at best,

FIGURE 6.6. *Art Smith,* Lava Bracelet, *designed ca. 1946. Silver; 2.24 × 5.87 × 30.04 in. (Museé des Beaux-Arts de Montréal, Liliane and David M. Stewart Collection. Photograph by Richard P. Goodbody.)*

FIGURE 6.5. *Sam Kramer,* Roc Pendant, *1958. Sterling silver, 14-karat gold, ivory, horn, taxidermy eye, coral, tourmalines, garnets, cast, fabricated; 4.75 × 2.25 × 0.75 in. (Museum of Arts and Design, New York, purchased by the American Craft Council, 1967. © Estate of Sam Kramer. Photograph by John Bigelow Taylor, 2007.)*

is accepted as good design, which is no better than saying it expresses our industrial environment rather than the compelling needs, dreams and skills of an artist."[14]

Art Smith (1917–1982) was another modernist Greenwich Village jeweler. Smith was born and raised in New York. Because he was African American, his experiences differed from those of other jewelers considered here. His father had been an officer in Marcus Garvey's organization, which promoted black political consciousness and self-reliance. In 1942 Smith won a scholarship to Cooper Union, which did not discriminate against minorities. After forays into architecture and advertising, he concentrated on sculpture, graduating in 1946. While in school, Smith became an assistant to Greenwich Village jeweler Winifred Mason, learning the basics of the craft from her. In 1946 he opened his first shop, in Little

Italy. Racial tension forced him to relocate to the more tolerant Village in 1948.

Smith worked in a biomorphic style and was influenced by Calder. His shapes were often rounded and irregular—amoeboid, perhaps—sometimes combined with linear forged parts. His jewelry tended to be large. A bracelet might be six inches long; a necklace nearly a foot from top to bottom. Smith assembled his jewelry by soldering, and the sheer size of his pieces demanded real skill.

His *Lava* bracelet (ca. 1946) extended about halfway up the wearer's lower arm. (Figure 6.6) The form consists of a blobby brass shape riding on top of another one made of copper. The meandering space between the parts and the voids underneath the larger shape establish an active play of positive and negative. The openings reveal the skin beneath. The upper layer lifts off the surface of the lower, so the whole reaches out into the space around the wearer's arm. And yet, for all the drama, Smith was attentive to the wearer's comfort. The three lobes closest to the wrist curve gently upward, allowing the hand to move freely.

Smith believed that the jeweler should consider three elements: materials, space, and the human who wears the object. As he put it, "Like line, form, and color, the body is a material to work with. It is one of the basic inspirations in creating form."[15] Smith designed performance jewelry for several dance companies. (Among them were the black dance companies of Tally Beatty, Pearl Primus, and Claude Marchant.) Seeing the body as a moving backdrop, constantly changing shape, may have stimulated Smith to consider making his jewelry move, too. One of his necklaces consisted of a C-shaped forged

element that hung around the neck, with fins sprouting off both sides. The C is off-center, one end much lower than the other, and from the bottom Smith suspended two elements that balanced like those in a Calder mobile. The necklace was a kinetic sculpture on the body, responding to every shift of the torso.

Smith was attentive to black culture, both American and African. He was a fan of contemporary jazz, and Duke Ellington was one of his customers. He also made jewelry derived from the Vai and Nsibidi scripts of West Africa.[16]

Collectively, artist jewelry and studio jewelry in the 1940s appealed to a clientele that identified with everything avant-garde: jazz, modern dance, modern art. It came to be used as an identification badge for cultural pioneers. Art historian Blanche Brown recalled: "About 1947 I went to Ed Weiner's shop and bought one of his silver square-spiral pins . . . because it looked great, I could afford it and it identified me with the group of my choice—aesthetically aware, intellectually inclined and politically progressive. That pin (or one of a few others like it) was our badge and we wore it proudly. It celebrated the hand of the artist rather than the market value of the material. Diamonds were the badge of the philistine."[17]

ENAMELING: KENNETH BATES

From the late 1930s through the 1960s, enameling dramatically increased in popularity. There had been a modest revival during the Arts and Crafts years, mostly due to the influence of the British enamelist Alexander Fisher and his American student, Laurin Martin. The craft faded in the interwar years but revived in the 1940s, with its epicenter in Cleveland. The key to this revival was Kenneth Bates (1904–1994).

In the 1920s Bates was a student in art education at the Massachusetts Normal Art School. He took a jewelry-making class from Martin, who would bring his enamels to class and unwrap them carefully, one by one. Bates was much impressed by Martin's work but apparently received no instruction in enameling from him. When Bates obtained his first teaching job at the Cleveland School of Art in 1927, he took up enameling. His first piece won a prize in the Cleveland Museum's 1927 May Show.

Consulting turn-of-the-century English instruction books, Bates began to experiment (and continued to do so his whole life). He was stimulated by the unpredictable results of placing a color with a high melting temperature over one with a lower melting point, and he

based much of his work on visual effects he discovered. When transparent enamel is fired over gold or silver foil, it has a gemlike intensity; when this effect of liquid depth is placed next to opaque color, the contrast can be intoxicating.

As long as they dealt with the same images and devices—religious iconography, classical mythology, portraits—the relationship between enameling and painting was comfortable, but modernism changed that. In 1930 Bates considered himself avant-garde. He was, however, primarily concerned with technique and visual delight, not with the intellectual discourses surrounding painting. As time went on, he was increasingly out of sync with developments in the fine arts.

Although he identified with modernism, Bates was most enthusiastic about sumptuous historical works like Byzantine enamels and Chinese headdresses made with kingfisher feathers. His best work exploits similarly rich decorative effects. An avid gardener, he often used floral motifs on round plates and bowls. These works can pack a considerable visual jolt although they are small. In his *Hibiscus Bowl* (1944), brilliant red dominates the composition as it contrasts with a wavering stripe of turquoise blue. Pistil and stamen are rendered in lacy white lines and dots. This high visual drama practically bursts out of the confines of the bowl.

Over the forty-three years he taught, Bates was quite influential. Dozens of his students became dedicated enamelists, and Cleveland became a center for such work. He also published the first comprehensive book on the craft in nearly fifty years, *Enameling: Principles and Practice* (1951). To his chagrin, many hobbyists did not treat the medium with the same reverence he did. Bates grumbled: "Enameling almost fell into complete oblivion because of its prettiness. It got to be extremely popular in the 1930s, done by people who otherwise had no background in art, taste, or design. This nearly killed the whole discipline."[18] In a sense, he was being disingenuous. Having tried for years to democratize his craft, it was not exactly fair to complain about its success.

Wood: The Era of the Designer-Craftsman

The 1940s were not good years for studio furniture. The ostentatious display of wealth—a prime motivation for expensive furniture commissions—was in poor taste while the nation was at war. America's enthusiasm for industrial design and mass production continued unabated, focusing first on the war effort and then on

more and better conveniences, and once the war ended, the enormous capacity of armaments factories had to be switched over to peacetime uses. Unique handmade goods did not play much of a part in these scenarios. Craft skills, however, could be pressed into the development of manufactured goods at the design stage, and the 1940s saw the introduction of a new kind of handworker: the designer-craftsman.

For a craftsperson working in collaboration with industry, there were two avenues, one having to do with research and the other with design. Both had been addressed by the Bauhaus workshops, in which each student studied a chosen material and thus had practical knowledge useful to industry. In the second role, that of "form-giver," the presumption was that the designer-craftsperson would have an artistic sensibility lacking in the designer-engineer employed by industry. In this second role, which had also been important in Scandinavia, expertise in a material was not as important as design skills and good taste. Here the designer-craftsman would follow in the footsteps of American industrial designers in the 1930s. Europeans emphasized the general improvement of taste and quality of life, while Americans looked to the bottom line, but the approaches were otherwise quite similar.

The idea of the designer-craftsman was not rooted in America: it was an import. It was not disseminated through literature (as the Arts and Crafts movement had been) or exhibitions (like art deco and machine style) but was promulgated by a few strong-willed teachers, primarily immigrants.

CHARLES AND RAY EAMES

Cranbrook Academy of Art was, in many ways, the epicenter of change. As noted earlier, George Booth was not ideologically opposed to the machine, and the head of the fledgling academy, Eliel Saarinen, hired teachers like Marianne Strengell, who embraced collaboration with industry. While Saarinen rarely sought to have his own designs mass-produced, he was open to it.

In 1938 Saarinen invited a young architect from Saint Louis to study at Cranbrook. Charles Eames (1907–1978) arrived that fall to join a group of students and faculty that would soon make history. Among them was Eliel Saarinen's son Eero (1910–1961), who was something of a prodigy. When he was only nineteen, he had designed cantilevered bent-tubular steel chairs for an auditorium on the Cranbrook campus. After traveling in Europe and earning a master's degree in architecture at Yale, he returned to Cranbrook in 1936 to work in his father's architectural office.

Charles Eames also met Ray Kaiser (1912–1988) at Cranbrook. Ray had studied painting with Hans Hofmann in New York for six years, but she was auditing a weaving course with Strengell when they met. Together, they entered into a spirit of cooperation that permeated the academy. Their first major collaborative project, in 1940, was helping Eero with designs for a competition for low-cost furniture, which was conducted by the Museum of Modern Art following a suggestion from Bloomingdale's department store. It was hoped that the contest, Organic Design in Home Furnishings, would stimulate design of affordable modern furniture. Winning designs were to be produced by a consortium of American manufacturers.

Saarinen and Eames chose plywood for their basic material. A number of experimental designs for plywood furniture had been produced in the United States, including seating by Rudolph Schindler starting in 1934, cookie-cutter-like chairs by Marcel Breuer and Walter Gropius in 1939, a scrolled settee by Bertrand Goldberg in 1939–40, and Frank Lloyd Wright's hexagonal chairs of 1939. Earlier in 1940 Eero had collaborated with his father on Kleinhans Music Hall in Buffalo, which included an armchair with a bent-plywood seat. All these designs treated plywood as a plane that could be cut into pieces or as a flexible surface that could be bent like a ribbon. To make bent plywood, thin sheets of wood, much like veneer, are placed in a shaped mold with the grain crossing at right angles. Glue is applied to each layer, and the whole placed under pressure. No one had yet managed to form plywood into a compound curve like a cup or saddle—forms that accommodate the human body and have many applications in seating design. Saarinen and Eames, engaging the problem, designed various plywood chairs shaped like shells. They wanted to produce furniture devoid of ornamentation but harmonious and sculptural. Ray Kaiser and metalsmith Harry Bertoia pitched in, building models and making drawings. When two of their molded-plywood chair designs won first prize, the team was obligated to make full-size versions for exhibition. The handmade prototypes did not quite work out, though: the wooden surfaces were uneven, and the thin metal legs had to be abandoned in favor of wooden ones. Although the prototypes were exhibited at MOMA in 1941, the problem was not solved.

Charles and Ray married in June 1941 and moved to Los Angeles the next month. In a spare bedroom in their apartment, they continued working on forming plywood. Their experimental mold was a handmade contraption cobbled together from wood, plaster, a rubber membrane, and a bicycle pump. (They called it the "Kazam!

machine.") The couple focused on one-piece seat-and-back units for chairs and also made abstract plywood sculptures.

The Eameses were, in effect, using handcraft to develop a new industrial process. Their knowledge depended upon their hands-on experience. Furthermore, design and technical means were completely integrated. This, in essence, is the ideal of the designer-craftsman: knowing material and technique, working with a particular aesthetic in mind to solve a problem for industry. While they probably did not think of themselves as practicing a craft, they showed how handwork could serve mass production.

The plan to manufacture the Organic Design prize-winners was canceled at the outset of the war. A doctor the Eameses knew told them that the U.S. Navy was having problems with a metal splint intended to immobilize broken legs under battlefield conditions. Charles and Ray adapted their molded plywood technology to production of a wooden splint. By the early summer of 1942, the navy accepted their design and they set up tooling for rapid production. The Eameses' new company eventually produced more than 150,000 splints—as many as 200 a day. Since they were engaged in the war effort, they were able to obtain materials that were otherwise restricted. They subsequently made airplane parts, prototypes for full-body litters, and even an eleven-by-seventeen-foot molded-plywood section of a fuselage for a glider. By the end of the war, Charles and Ray Eames were ready to make the affordable furniture that they imagined in 1940.

One result was their LCW (for "lounge chair wood"), a side chair designed in 1945. (Figure 6.7) It consisted of five bent-plywood parts, the seat and back in compound curves. All the parts were held together with screws, and each joint was cushioned with a thick rubber shock mount. The LCW was simple, durable, lightweight, affordable, and elegant enough to be used in living rooms and dining rooms as well as kitchens. The Museum of Modern Art showed it, with other Eames designs, in a solo exhibition early in 1946. (Charles and Ray helped design the exhibition, too.) It became a modernist classic. Along with designs by Isamu Noguchi, George Nelson, and others, the LCW helped secure an international reputation for progressive design for its manufacturer, Herman Miller, Inc. It is still in production today.

Charles and Ray Eames went on to operate an industrial-design firm specializing in furniture, exhibitions, and films. They continued to pioneer the use of new materials for furniture, including cast aluminum, fiberglass-reinforced plastics, and welded wire mesh. Each new material required a period of intensive research and development. Their model of a symbiosis between handwork and mass production was one of the most potent paradigms for craft practice until the 1960s.

MOLLY GREGORY

It is also possible to produce objects in modernism's stripped-down vocabulary of forms within a small-shop setting. One of the first Americans to venture into this territory was the tough-minded Mary (Molly) Gregory (born 1914).

Gregory grew up on a farm, where she learned the rudiments of carpentry. In 1936 she graduated first in her class from Bennington College in Vermont. Landing a job teaching sculpture at a private school in Massachusetts, she worked with a shop teacher, picking up some fine points of cabinetry. In 1941 she was hired as an apprentice woodworking teacher at Black Mountain College and subsequently joined the full-time faculty.

Gregory's first task was to supervise the completion of a student-built structure, including furniture. This she did, along with running the wood shop, keeping accounts, and even operating the college's farm at a profit after the resident farmer departed. As a teacher, she emphasized solid craftsmanship and an understanding of basic joinery such as wooden pegs and dovetails. It seems

FIGURE 6.7. *Charles Eames and Ray Eames, Herman Miller Manufacturing,* LCW *Chair (Lounge Chair Wood), designed 1945. Walnut, plywood, rubber, bentwood; 26.5 × 22 × 24.25 in. (Dallas Museum of Art, General Acquisitions Funds.)*

that little of the work that she and her students made survives, but photographs show furniture fully in tune with progressive ideas of the time. A faculty member, A. Lawrence Kocher, designed a bent-plywood chair and a square table set on two planks joined into an X. They were made in the Black Mountain woodshop, presumably by Gregory and her students.

Gregory also made a set of modular wooden units, cubic in form, about 20 inches square. Each consisted of two plank sides and a top stiffened by a single board underneath. The Bauhaus influence is quite strong in the pieces; in fact, a nearly identical (if larger) design was used at the Bauhaus as a worktable in the early 1920s.[19] Her units could be used as stools, or they could be pushed together to become a bench. Alternatively, they could be stacked to become a sculpture stand. A more innovative design of Gregory's was a wooden plate, consisting of a square wooden board into which a shallow depression has been turned on a lathe. Both modules and plates are reductive, examples of functional form boiled down to its absolute minimum. In 1940s America, they were quite radical.

Gregory left Black Mountain in 1947 to run a custom furniture shop in Woodstock, New Hampshire, and eventually established her own shop in Lincoln, Massachusetts (see chapter 8).

JAMES PRESTINI

Wood turning is a craft discipline defined by its major tool, the lathe. The principle is simple: a piece of wood is rotated rapidly, and a handheld gouge is applied to the surface to remove material. The skill of using the gouge, and the intimate understanding of wood that goes with it, makes wood turning a craft.

In faceplate turning, a block of wood is screwed onto a rotating metal plate, allowing the wood to be hollowed out from the inside as well as shaped on the outside, producing a bowl. In spindle turning, a long piece of wood is fixed at both ends and worked along its length, yielding spindles and chair legs. Spindle turning was mechanized early in the Industrial Revolution so that thousands of identical elements could be churned out by an unskilled operator. These turned elements could be quite ornate, and their ease of manufacture contributed to the overwrought designs of the Victorian era. In a slightly simpler form, they were part of the colonial revival. For decades, American wood turners tended to repeat traditional forms like urns, balustrades, and spindles, and wood turning was associated with a certain nostalgic stodginess.

FIGURE 6.8. *James Prestini,* Bowl, *designed ca. 1943. Mexican mahogany; 5.75 × 16.12 in. (Collection of the Museum of Modern Art, New York, Gift of the Designer, 1261.1968. Digital image © The Museum of Modern Art/Licensed by SCALA/Art Resource, New York.)*

During the first decades of the twentieth century, wood turning was taught in many high-school manual-arts courses. Around 1915 safe and affordable electric lathes began to replace those run by overhead drive belts. Turning was regarded as a suitable way to develop hand-eye coordination and to learn good shop practice and a measure of creativity. In the 1930s hobbyists began to buy electric lathes and turn out bowls and platters. About the same time wood turning became a popular means to produce souvenirs for tourists in Northern California and Oregon, using local woods such as redwood and bay laurel.[20]

In the late 1940s turned wood became associated with avant-garde design. The connection was due largely to the work of James Prestini (1908–1993), who had learned wood turning and machining in high school. He earned a bachelor's degree in mechanical engineering and worked in that field for a good part of his life. In the 1930s he became interested in both woodworking and modern design and experimented with turning. In 1938 he studied with the Swedish furniture designer Carl Malmsten, and in 1939 he became a student instructor at the Chicago School of Design (see chapter 5). The school emphasized the innate possibilities of both material and machine, while remaining attentive to the formal aspects of design. Prestini produced elegant wooden bowls and platters. (He never relied on turning to earn a living.)

An undated bowl from the collection of the Museum of Modern Art exemplifies his modernist work. (Figure 6.8) The profile is a flat parabola, a shape that would never be found in colonial forms. The bowl sits on a single point. Impractically, it rocks or spins at the slightest touch. It is more than sixteen inches in diameter and

five inches deep, quite large for a piece of mahogany. In fact, it was constructed of three layers that were glued together, each layer continuing the grain of the previous one. The form has no decoration, and the grain has no complex effects. Elegant and restrained, the object exists only for the pleasure of being looked at and perhaps handled. In effect, it is a modern sculpture in the guise of a wooden bowl.

Prestini's work was featured in *House Beautiful* and *Art and Architecture* and was exhibited at MOMA in 1947. He came to the attention of one of the great promoters of modern design in America, Edgar Kaufmann Jr., who was then curator of MOMA's industrial-design department. (Kaufmann's father commissioned Frank Lloyd Wright's masterpiece Fallingwater.) In 1949 Kaufmann wrote a book called *Prestini's Art in Wood*, in which he admiringly presents the bowls and plates as sculptural form, but he seems uncomfortable with the fact that wood turning is a craft: "Unlike crafts practiced by many enthusiasts, Prestini's revives no lingering local skills, it achieves no vibrant surfaces charged with personal touch and its contribution is minor to the convenience of household routine. Spare, smooth and evenly accented, it has more often borrowed from mechanization than protested against it. In short, it is hard to make a place for Prestini among conventional craftsmen, and his place among artists would be exceptional and marginal. Yet his place is secure as a maker of beautiful, pure shapes."[21]

Despite their highly reductive forms, Prestini's turnings were very much craft objects. Wood is an unpredictable material, and thin shells like these require skill and discipline to produce. Prestini experimented with techniques that were decidedly unmechanical, too: he tried sandblasting wood, ebonizing it, and even used wood from a tree impregnated with dye before it was cut down.

Prestini's Art in Wood inspired innumerable amateurs to make modernist bowls. But Prestini might have sensed the marginal status that Kaufmann suggests, for he quit turning in 1953 and began making steel sculptures instead.

Like Prestini, studio wood turners in the late 1940s and early 1950s concentrated on smooth, soft forms with undecorated surfaces. Other turners in the genre included Arthur Espenet Carpenter (California), John (Jake) May (New Hampshire), and Paul W. Eshelman (Pennsylvania). Together, these men moved wood turning away from the colonial revival and toward a contemporary language of form.

Ceramics Flourishes

The war caused changes in ceramics, of course. The nice yellow orange of uranium glaze was suddenly unavailable, and no one knew why until years later, when the atomic bombs were dropped. New ideas were introduced by immigrants escaping the Nazis. Many commercial potteries turned to war needs: Bauer Pottery produced dinnerware for the U.S. Navy; Pacific Clay Products turned its entire production to military contracts; Syracuse China began a sideline of making ceramic antitank mines. At the same time, small potteries like Edith Heath's opened up to compensate for the shortage of imports.

In general, ceramics flourished. A 1944 article about the Ceramic National noted that the 1932 *Encyclopedia Britannica* had made no reference to American pottery, but the current edition had an article on it by Myrtle French.[22] The decade began with the largest ever Ceramic National—208 artists from twenty-five states showing 457 pieces—before the wartime halt. When the exhibitions resumed, sculpture became less important, and container forms began to dominate. Colors were subtler (browns and grays), in part because certain oxides still were not available. In California stoneware became the rage, and use of the wheel spread rapidly through the increasing number of schools teaching pottery.[23] Ceramics was also a medium for certain populations working separately, and probably not equally.

BLACK POTTERS

Several black sculptors worked in clay during the first half of the century, and ceramics was taught at various historically black colleges, but this work has only recently become the subject of research, and information is limited.[24]

Isaac Hathaway (1872–1967) founded the ceramics department at the Tuskegee Institute in Alabama, where he taught from 1937 to 1947, and then did the same at Alabama Polytechnic. He was a sculptor who produced busts of prominent African Americans, and also an illustrator and later a designer of coins for the U.S. Mint. **Henry Letcher** taught ceramics at Howard; his thrown pottery includes abstract plant motifs and sgraffito effects. **Joseph Gilliard** developed a special wheel for throwing thirty- and forty-inch-tall jars and experimented extensively with glazes during his more than forty years at Hampton University. In the 1940s Gilliard was casting forms and combining them in abstract configurations. All three men studied for a time at Alfred in addition to other universities. **William E. Artis** (1914–

FIGURE 6.9. *Sargent Johnson*, Teapot with Mugs, *1941. Red earthenware, glazed brown. (Collection of the Oakland Museum of California.)*

1977)[25] studied with sculptor Augusta Savage in Harlem. He made terra-cotta busts and also hand-formed vessels in modern styles, and his work appeared in several Ceramic Nationals. He earned BFA (1950) and MFA (1951) degrees from Syracuse and subsequently taught ceramics in Nebraska and Minnesota.

The best-known African American artist working in clay in the 1940s was probably **Sargent Johnson** (1887–1967) of San Francisco. Boston-born Johnson was the nephew of sculptor May Howard Jackson, with whom he lived for a time after he was orphaned at age fourteen. She specialized in portrait busts on "Negro" themes, and so did he in his early work. He later moved toward abstraction in works that alluded to African American music. He worked in multiple mediums and genres in what has been taken as an assertion of his African heritage and denial of the Western urge to categorize and order into hierarchies.[26]

Of most import here is his interest in ceramics, beginning in the 1930s (if not earlier) with award-winning busts and heads in terra-cotta. In 1945 a scholarship allowed him to travel to Mexico (the first of several trips), where he worked with local low-fire clay that was wood-fired to obtain a smoky black color. He hand-formed grotesque hollow figures that he burnished before firing; he also depicted Indian women and made abstract forms. He later traveled to San Ildefonso, New Mexico, to meet Maria Martinez and see her blackware.[27] He made ceramic-tile murals as WPA projects, and in later years created large enamel-on-steel panels. A modest but striking example of his pottery is a 1941 teapot (an offshoot of his WPA work) of red earthenware glazed brown.[28] (Figure 6.9) It has an oblong shape almost like a tumbled river stone, with the lid and spout at the highest end and the long handle set toward the opposite, tapering end. The lid knob is a stylized African head, and the handle takes the form of a long, seated creature. The allusions are tribal yet interestingly modern.

SUSI SINGER

Susi Singer (1895–1955) is often paired with—or contrasted to—Vally Wieselthier, since she also worked at the Wiener Werkstätte and brought the Austrian style with her to the United States when she emigrated. (Figure 6.10) Singer's figures usually had opaque white surfaces and sometimes had sinuous lines like Wieselthier's, but her mature work was quite different.

Singer married Josef Schinnerl in 1924 and moved to a small mountain town, where she established a studio. She based her figures on local people, incorporated humor, and alluded to eighteenth-century figurines that glorified rural life—a very different feeling from Wieselthier's urban sophistication. Like Wieselthier, she showed in the 1925 Paris Exposition and received much attention in the 1928 International Ceramics show in the United States.[29]

When the Nazis annexed Austria in March 1938, Singer began to think about leaving. Her husband died

FIGURE 6.10. *Susi Singer*, Card Players, *ca. 1946. Ceramic; 11.65 × 11 × 7.25 in. (Collection of The American Museum of Ceramic Art.)*

in a mine disaster that year, so she approached the American consulate, showing them sales slips from American galleries to persuade them that she could be self-supporting. A few weeks before the war began, she arrived in Los Angeles with her two-year-old son. She taught classes, conducted workshops, and showed her work locally. She was partly crippled by a bone disease that had been exacerbated by malnutrition after World War I; Richard Petterson of Scripps later recalled "her difficult but determined climb up three flights of stairs to the ceramic classroom."[30] By the end of the 1940s, she was confined to a wheelchair.

Singer's early work in her new country included playful subjects such as *Young Bacchus* (ca. 1939–40), a youth dancing on one foot as he clutches clusters of grapes. She also depicted Chinese figures and beachgoers, reflecting the California environment. She built her figures hollow and nude, manipulated the posture to get just what she wanted, and then clothed them. She tried working for a commercial firm, creating figures that could be reproduced in molds, but she thought it diminished the spirit of her characters, so she decided to stick with individual pieces. "This way I do not have to chop all their charm away to avoid undercuts," she told a newspaper reporter. "I put 30 colors on if I want, and it shimmers, and the form undulates."[31]

Without abandoning her characteristic whimsy, Singer began to incorporate more lifelike details in the late 1940s. She made a few pieces about refugees in 1949, but generally she did not address anxious themes. Figural sculptures began to go out of style, and although she rejected abstraction, her late works nevertheless show a tendency to simplify.

GERTRUD AND OTTO NATZLER

When Gertrud Amon and Otto Natzler met in Vienna in 1933, they were both twenty-five. Otto (1908–2007) had just lost his hated job of five years, designing textiles, and Gertrud (1908–1971) was unhappily working full-time as a secretary. She was taking ceramics classes twice a week. He joined her, and in less than a year they decided it would be more economical to share a workshop and experiment on their own.[32] "Our lack of knowledge," Otto was later to say, "went hand in hand with a lack of inhibitions." Gertrud was better at throwing than Otto was, and since that was the fastest part of their process and she was still working, that became her contribution.

Firing began as a succession of disasters. To stop ruining Gertrud's pots, Otto used tiles; like a research chemist, he numbered each sample and kept a complete record. Since their kiln was small, they fired often, which

encouraged experimenting. Otto was attracted to the mistakes, because they seemed to show more about the medium. "At that time . . . I thought a ceramic was clay and glaze, and one used the kiln and its heat to combine the two. The realization that a ceramic is much more elemental, and that in a true ceramic the fire is an integral part of the medium, came much later."

Since both were of Jewish background, within six months of the German annexation of Austria they immigrated to the United States, arriving in Los Angeles in the fall of 1938 with almost nothing except their wheel and small kiln. Astonishingly, their work took first place at the Ceramics Nationals of 1939, 1940, and 1941. They taught for their first three years in America, out of financial need.

The Natzlers were immediately the subject of much interest in Los Angeles, both because of their modernist European style and because of their kick wheel. Potter's wheels in Los Angeles had a sewing-machine treadle base. The potter stood on one foot, pedaled with the other, and braced his arms against a bar as his hands centered the clay—an awkward balancing act at best. In contrast, Gertrud Natzler's wheel allowed her to sit; after her foot rotated the wheel, her body position helped her hands center the clay. The obvious difference in control soon made the Natzler wheel the prototype for classrooms in Southern California.[33]

Otto later wrote of Gertrud's hands seeming to belong to a dancer because they were so expressive in their movement, and he told an interviewer that "people would practically stop breathing when they watched her" because she could throw so thinly.[34] She contended that what made the pot was not the form per se but the way it developed. She favored four forms: a round bowl with a narrow base and progressively convex curve of the wall; a similar beginning that ends with an outward flare; a teardrop bottle; and a double-curved bowl or bottle that expands and contracts. Her scale ranged from a miniature bowl less than an inch in diameter to a two-foot-tall bottle. It was their policy not to entirely conceal the clay body with glaze; thus the color of the clay was important. Among their distinctive glazes were what they called Pompeian (a lead glaze with pockmarks, blisters, and viscous folds), Lava (either thick with the suggestion of flowing or porous-looking), and Crater (pits caused by emission of gasses through the glaze surface). (Figure 6.11) They also did reduction firing to get smoke and flame marks and used iridescent and crystalline glazes. Otto also developed what he called a "melt fissure," which he eventually determined was caused by a cooling draft separating the layers of glaze.

FIGURE 6.11. *Gertrud and Otto Natzler*, Bowl, 1946. *Glazed earthenware with green Pompeian lava glaze, 9.5 × 6.5 in. (Philadelphia Museum of Art, The Louis E. Stern Collection, 1963. Photograph by Lynn Rosenthal.)*

These kinds of details were the essence of their work. Otto wrote: "You may, depending on your attitude, consider it a virtue or a vice that our work developed in a fairly straight line. Our aim has been purist: we limit ourselves to form and its organic integration with the glaze. There are no unnecessary dramatics, no superficial ornaments, no superimposed deformations." Their collaboration was long and steady, "a process of individual probing combined with the continuing dialogue that caused the gradual metamorphosis of an idea into the final version. We ourselves were always very conscious of this ongoing interchange and the stimulation it exerted on our creative abilities."[35] Imagine, then, Otto's position when Gertrud died of cancer in 1971. They had made nearly 25,000 pots together. It was a year and a half before he attempted to complete the 200 remaining pots that Gertrud had thrown, working until six weeks before her death. Then he began to make tiles and slab containers on his own, which are far more architectonic in feeling. He wished to avoid the quality of their collaborative work, in which her ethereal forms met his earthy glazes.

THE REMARKABLE TEACHERS

Marguerite Wildenhain (1896–1985) was a Bauhausler, a potter, and a refugee as well as an independent, idiosyncratic, and inspiring teacher for many years at Pond Farm in Northern California. She was also noted for her workshop demonstrations at schools across the United States, for writing two significant books — *Pottery: Form and Expression* (1959) and *The Invisible Core: A Potter's Life and Thoughts* (1973) — and for her outspokenness.

Marguerite Friedländer was born in Lyon, France; her father was of German descent but a longtime resident in France, and her mother was English. Marguerite spoke three languages but regarded French as her mother tongue. She arrived at the Bauhaus in 1919 and was one of the few women in the pottery workshop under form master Gerhard Marcks and craft master Max Krehan. There she met and later married Frans Wildenhain, another pottery student (see chapter 8). When the Weimar Bauhaus closed in 1926, Marcks did not move to the new site in Dessau but went to the Kunstgewerbeschule in Halle-Saale, and Wildenhain, who had passed her journeyman examination, went with him to head the ceramics department. There she managed the workshop, made functional ware, and designed porcelain dinnerware for mass production.

In 1933 Nazi pressure on schools employing Jews caused her to leave Halle-Saale. She and Frans established a pottery in Holland. When it became apparent that Holland was not safe either, she, on a French passport, was able to get a visa for America, but Frans, a non-Jew with a German passport, was not. (He was subsequently forced to fight in the German army; he deserted in 1945 and went into hiding.) She arrived in the United States in 1940 on the promise of a California crafts community to be started by Gordon and Jane Herr, whom she had met in Holland some years before. The project was not yet off the ground, so she taught for two years at the California College of Arts and Crafts in Oakland.

When the war ended, Marguerite at last was in touch with Frans. She had become an American citizen, so he was eligible to immigrate as her husband. In 1947 they were reunited. The Herrs' community of craftsmen was finally realized in 1949 as a cooperative venture, with Trude Guermonprez teaching textiles and Victor Ries teaching jewelry and metalwork. Pond Farm, despite its name, was a beautiful, wild place on the Northern California coast, accessible only by a tortuous mountain road through Armstrong Redwoods State Park.[36] Wildenhain responded to the landscape almost viscerally. She wrote that coming there from Lyon, which had a 2,000-year history, was fantastic: "Here everything was new, fresh, and nearly untouched by human hands, virgin land and uncharted mountains. Here one could make history! . . . It was actually an immense challenge, as if right there and then I was to prove what I was worth by myself and without all the help but also the trappings of our so-called civilization."[37]

After she settled in, building a simple home and studio, her work changed. She no longer sought to design commercial ware and rejected mass-production methods. She

FIGURE 6.12. *Marguerite Wildenhain, Tea Set, ca. 1946. Stoneware. (Collection of Everson Museum of Art, Syracuse, N.Y., Purchase Prize given by Richard B. Gump, 11th Ceramic National, 1946, 47.515.1-13. Photograph courtesy of Courtney Frisse.)*

sold her wares through stores in San Francisco, Chicago, and Dallas. Ironically, a stoneware tea set she entered in the Eleventh Ceramic National in 1946 won a prize as best suited for mass production. (Figure 6.12) The spare forms include a footed teapot that is squat and globular, with a tapered spout and curved, ear-shaped handle; the rim is raised, and the lid, with knob, is recessed. A gray speckled glaze covers the upper halves and interiors of the forms. Its concision recalls Bauhaus functionality, but the set also suggests a reserved personal touch—a blend the Wildenhains had achieved in Holland. She said: "We treated these sets so personally in regard to clays used, decorations and textures applied, that all the pieces became very much alive and were in no way impersonal and coldly mass-produced. I learned then that no method is evil in itself; it depends on how the creative man uses it."[38] Other work from the late 1940s was affected by her living environment. Dry grass, rugged slopes, dusty live oaks in the California landscape defined her subtle palette, along with the rocks she collected.

The Herrs' project was short-lived. Guermonprez married and moved to San Francisco; Ries found it necessary to move nearer the city as well. In 1950 the School for American Craftsmen, moving to Rochester, invited the Wildenhains to teach; Frans decided to accept, and their marriage ended. After Jane Herr died of cancer in 1952, Gordon Herr lost interest in the project, and it became Marguerite's alone. She developed it into summer workshops that became "an essential rite of passage" for studio potters and ceramic instructors. She stressed discipline and hard work, to the extent that the summer program was described as a trial by fire. But literal firing was not part of her teaching method: her emphasis on process and attitude meant that student work was recycled.

Richard Petterson of Scripps College inaugurated a new career for Wildenhain by inviting her to give a seminar in 1952, which included a public lecture later published by the college. Thereafter she alternated summer workshops at Pond Farm with winter college demonstrations. Alfred ceramics professor Val Cushing recalled having seen her when he was a student: "Marguerite came into town in faded blue jeans (remember it was 1952) with a handful of pottery tools wrapped in a cloth and stuck in her back pocket. . . . She was the embodiment of strength-conviction-skill-talent-discipline-and-leadership that I needed at the time. . . . Her skills *as a potter* were overwhelming. I had not seen anyone who could handle the 'big three' the way she could—it was like magic. By the big three I mean *idea-process-material* and their relationship to the creative process. In 1952 no one could touch Marguerite as the 'total' potter."[39]

Wildenhain was increasingly interested in Indian pottery, and she began to travel to Central and South America. There, especially in Peru, in a mixture of Catholic and indigenous practices, she saw a primal sensuality that spoke to her, plus an integration of art, religion, and everyday life that she admired. Her late pots were often decorated with figures and scenes from that world, meant to speak of universals such as Woman or Humankind.[40]

Wildenhain's forceful opinions put her on some people's wrong side during her lifetime. During the 1950s and 1960s, for example, she resisted the adulation of Asian techniques, style, and ideology and opposed sculptural ceramics. Doubt about her late work has combined with a reevaluation of her role as a teacher. It has been suggested that her powerful personality brought her many devoted acolytes of similar intensity but did not produce great artists. Yet many of her students persisted

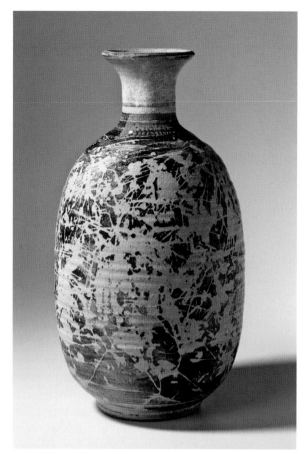

FIGURE 6.13. *Carlton Ball, Vase, n.d. Ceramic; height, 18 in.*
(Collection of Forrest L. Merrill. © Estate of Carlton Ball.
Photograph by M. Lee Fatherree.)

University, and the University of Puget Sound, retiring in 1976 and then teaching at a community college. He was an early contributor to *Ceramics Monthly* magazine, writing more than 140 articles on clays, glazes, and techniques, and subsequently he published *Making Pottery without a Wheel* and *Decorating Pottery with Clay, Slip, and Glaze* as well as syllabi for teaching beginning and advanced ceramics.

When Ball began teaching, hand-building was the dominant process in California. He nevertheless became a leading thrower. At Mills, he built one of the best-known ceramic departments of the day and started an art guild to finance the purchase of new equipment. He built the first salt kiln on the West Coast. While at Wisconsin, he worked collaboratively with the painter Aaron Bohrod, an uncommon relationship at that time that provoked a rash of skeptical letters to *Ceramics Monthly* following an article on the work. Ball also made playable stoneware musical instruments, sectional pots, textured-slab constructions, raku ware, and skillfully thrown pots with fluid decorations that suggested his background as a painter. In his Zelig-like history of doing everything and being everywhere, he also spent part of his sabbatical in 1954 with Peter Voulkos and Rudy Autio at the new Archie Bray Foundation (see chapter 7).

Laura Andreson (1902–1999) began teaching ceramics in the late 1930s, joining Glen Lukens as an important teacher in Southern California and an influential artist in the small community of studio potters.[43] In the late 1940s and the 1950s, she was in the vanguard of California's adoption of the wheel, stoneware, and porcelain. (Figure 6.14)

In 1932 Andreson finished her undergraduate education at the University of California, Los Angeles, and she began teaching art education classes the next year.

in pottery,[41] and she remains a model of independence and integrity. As she put it: "The very fact that without outside help from school or foundation or organization, I have been able to make perhaps better than average pots and also live the life of my choice without need for human or artistic concessions, the fact that I have been able to run an inspiring school in personal independence and in dignity, that is for a student an example and it gives him hope and faith for his own future too."[42]

In the 1930s and 1940s, **F. Carlton Ball** (1911–1992) was the guy everyone turned to for technical help. He was best known for the large size of his pots. (Figure 6.13) Kathryn Uhl Ball collaborated with her husband on decorative treatments, for which they were praised.

Ball took a ceramics course with Glen Lukens at the University of Southern California in Los Angeles, but he obtained his bachelor's in 1932 and master's in 1934 with a thesis on fresco painting—he was not yet sure whether he would be a painter or a sculptor. Starting in 1935, he taught at the California College of Arts and Crafts, Mills College, the University of Wisconsin, Southern Illinois

FIGURE 6.14. *Laura Andreson, Bowl with Vertical Green Lines, 1948.*
Stoneware; 6.5 × 13.5 in. (Collection of Mingei International Museum,
1994.20.003. Photograph by Anthony Scoggins.)

In 1936, after earning a master's from Columbia, she taught a ceramics course, although she had little experience. She took an evening class with Lukens and worked along with her students making hand-built earthenware plates and bowls to which they applied the vivid glazes popular in California at the time. From her first work—slip-cast, coiled, or slab-constructed—she produced objects of interest. As early as 1937, she exhibited at Rena Rosenthal Gallery in New York, and in 1940 she had a show at the Honolulu Academy of Art. In 1946 the Museum of Modern Art bought a piece for its permanent collection.

In the early 1940s, Andreson sent several of her students to Mills College to study throwing with Carlton Ball, and then they taught her. She also had guidance from Gertrud Natzler. She was interested in the character of the clay, and even early on, when she was using bright and shiny glazes, she left areas bare to reveal the clay surface. She experimented with low-fire mat glazes over iron-bearing engobes to obtain stoneware effects. By the time stoneware became available in California, in 1948, the wheel was her primary means for forming. She pursued linear and fluid qualities from then on, making powerfully defined, simple forms inspired by objects from nature, such as eggs, seashells, leaves, and stones. Andreson's pots were made with a low center of gravity, for stability, and were meant to be used. While some observers have said she often let the glaze determine the form, it seems rather that she found a careful balance.

In the early 1950s, with the encouragement of the local British-born potter Albert King, who made molded porcelain ware, she began to throw this unfamiliar and rather difficult material. By the end of the decade, she had become the West Coast expert on porcelain among studio potters. Her porcelain forms recalled Chinese shapes, and the material opened new glazing options.

Andreson continued experimenting throughout her life, traveling a great deal (including to Scandinavia, which influenced her work), developing a dazzling range of intense glazes, lusters, and so on. After retirement she concentrated on her own work and exhibited extensively. Her energy did not flag. In a late interview, she said: "If I'm working for celadon, I want to investigate as many possibilities as I can. For an ash glaze, I went out to Claremont and got lemon ash. I tried mesquite ash, apple, straw, fern, cigarette ash, cigar ash—they used to save me bottles of it. I have about fifty-eight celadons and forty-five reds."[44]

Edwin and Mary Scheier were among the several important pottery couples of midcentury American ceramics. They were both self-taught, with Mary the primary thrower, making functional ware and pots for Ed to decorate.

Mary (1908–2007) was born in Virginia. She studied at several schools in New York and spent a year in Paris with the New York School of Fine and Applied Art (later the Parsons School of Design). Eventually she returned to the South and worked as director of the Big Stone Gap and Abingdon arts centers in western Virginia. Ed (1910–2008) was born in the Bronx, left school following eighth grade, and lived a pickup life—hitchhiking cross-country, working in a factory or restaurant, crewing a ship through the Panama Canal. He was also a menial assistant to silversmith Peter Müller-Monk and ceramist Vally Wieselthier.

What turned out to be a more promising avenue for him started with creating puppet shows for the WPA, which eventually led to making site visits as a field supervisor in the South, where he met Mary. They married in 1937, did puppet shows, and then found another WPA job that offered ceramic facilities in which they could experiment. They got to know local folk potters, began to make their own equipment (such as a wheel built from Ford Model T parts), and established their own pottery in the summer of 1939. Mary threw pots and made molded figures that could be sold at low prices. Ed wedged, glazed, fired in a groundhog kiln, and also threw a few pieces and made figures. They bartered pots for food and furniture and sold their work at a roadside stand, where they were discovered by a pottery teacher from Newcomb College. He told them about an American Ceramics Society conference at Black Mountain; their attendance led to showing in the Ceramic National and jobs in New Hampshire.

The Scheiers seem to have come along at the right time, serving as "an indigenous alternative to well-groomed European design" in the Ceramic National.[45] From 1940 to 1958, with the exception of one year that they served as jurors, they won prizes each year. Beginning in the fall of 1940, Ed taught ceramics at the University of New Hampshire, Durham, while Mary was an unsalaried artist-in-residence in the home-economics department with access to the ceramics facilities. She often helped with her husband's classes and took them over entirely while he was in the military, from 1942 to 1944. She also created a nationally recognized puppetry program for occupational therapists and taught at the Rhode Island School of Design. After the war, they spent a year in Puerto Rico to help develop a community pottery industry.

Meanwhile, they developed and perfected their work.

FIGURE 6.15. *Mary Scheier, American Coffee Set, ca. 1941. Stoneware; height, 12.87 in. (Collection of Everson Museum of Art, Syracuse, N.Y., Purchase Prize given by Richard B. Gump, 12th Ceramic National, 1948, 48.551.1-19. © Edwin and Mary Scheier Archive, Currier Museum of Art.)*

Mary's decorating was compared with that of the folk potters from whom she had first learned as well as the early American pottery of New England. Carafes and mugs were usually glazed in pale blue, gray, or green and only occasionally richer colors. Her forms had more in common with Marguerite Wildenhain's Bauhaus-style work or Laura Andreson's Chinese style, being lighter than the folk wares. Her coffee and tea services were particularly admired—elegant forms with straight spouts and knobbed lids or tall and slim vase-style forms. (Figure 6.15)

After the war, Ed began to throw round earthenware platters and shallow bowls, which he decorated in a linear style akin to contemporary painting, recalling the surrealist creations of Joan Miró or the fragile compositions of Paul Klee. Ed took a drawing course from the influential Hans Hofmann. He developed a distinctive subject matter of entwined or otherwise contained human figures, some recounting the temptation of Adam and Eve—a recurring theme throughout his career.

In the 1950s and 1960s, Ed's usual forms were large jars that he threw and decorated sculpturally, often incorporating sgraffito narratives of entrapment, dark in character. After he retired in 1960, the Scheiers took up residence in Mexico. Mary's throwing career had ended; Ed designed tapestries that were executed by local Zapotec weavers, and he painted and sculpted in wood. In 1978 they relocated to southern Arizona and Ed subsequently returned to pottery. They had largely dropped from sight during their time in Mexico, but they are remembered

for the time when Mary's understated forms and the line of Ed's idiosyncratic drawings made a memorable unity.

Sam Haile (1909–1948) had a short life and an even shorter stay in the United States, but he made a strong impression. (Figure 6.16) An Englishman, Haile had studied painting and ceramics, the latter with artist-potter William Staite Murray. Haile was a pacifist, and when war seemed imminent in 1939, he came to America, where he quickly found teaching jobs—first at Alfred University for a year and then at the University of Michigan.

Haile worked with simple materials—stoneware, feldspathic glazes, and for color mostly iron and copper—and chafed at Alfred's technical orientation (some glazes consisted of as many as thirty ingredients). As Garth Clark writes: "Haile contended that all this technique separated the artist from his expressive powers and he advocated the most direct route—producing glazes from two or three materials—by introducing an aesthetic of informality and spontaneity. He slip-trailed surrealist decoration on his plates and wrapped his pots in sweeping strokes of pigment."[46]

Haile had studied ceramic history, and his pots showed traces of Cretan, Greek, and Etruscan precedents. The forms are straightforward yet casually imperfect, and his bold decoration shows his closeness to modern painting. In retrospect he seems to have anticipated the freedom and sensuality of Pablo Picasso's approach to painting on pots.

Haile returned to England when he was drafted into

FIGURE 6.16. *Thomas Samuel Haile*, Vessel, 1942. Ceramic; 15 × 10.12 in. (Founders Society Purchase, General Membership Fund, 1943.78. Photograph © 1987 The Detroit Institute of the Arts.)

the army in 1944. Soon after the war ended, when he had set up a pottery with his wife, Marianne de Trey, he died in an automobile accident while bringing some pots home from a show. The Institute of Contemporary Art in Washington, D.C., mounted a memorial exhibition of his works in the United States, and *Craft Horizons* printed a tribute. Those who knew him spoke of his energy, and Daniel Rhodes of Alfred said Haile's work was "years ahead of its time" and that it had "commanding importance both in scale and conception of his superb decoration (which) belonged to the mainstreams of Modern Art."[47]

BEATRICE WOOD: THE EXOTIC

Beatrice Wood (1893–1998) seemingly had nine lives, or at least that many identities, over her 105-year existence. (Figure 6.17) As a rebellious young woman, she fled a well-to-do family to study art and theater in France. In New York she became an actress with a French-language troupe, met Marcel Duchamp, and participated in New York Dada. She inspired a character in Henri-Pierre Roché's novel *Jules et Jim*, has been the subject of many articles, and wrote an aptly titled autobiography, *I Shock Myself*.

Wood's tale is relevant to craft history only after the 1930s, when, in Holland to hear a lecture by the Indian philosopher Krishnamurti, she purchased six luster plates in a Haarlem antique shop. Back in her Los Angeles home, she decided she wanted a teapot to match but could find nothing suitable, so she enrolled in an adult-education class to make her own. Instead she learned to cast plates, and she modeled two figures, "which, for some inexplicable reason, someone bought," as she put it.[48] Since it was the Depression and her income was minuscule, she made more figures, purely for income. She became increasingly "infatuated" with clay and glazes.

Wood's first studio and shop was a storefront on Sunset Boulevard, equipped with help from friends. Her ceramic figures in the display window attracted attention and sales. She took classes from Lukens at USC: "Though I was not his most talented student, I was the hardest working. In the end, it is only hard work that counts."[49] In 1940 she took throwing lessons from Gertrud Natzler and from Otto learned to keep precise records of her glaze mixtures. Lukens included two plates and a vase by Wood in his 1938 exhibition of California ceramics, and in 1940 her work was also in *Contemporary American Industrial Art* at the Metropolitan Museum. In 1944 Wood had a solo show at America House in New York (her work was displayed on cloths lent for the occasion by Dorothy Liebes, and the catalog cover drawing—unsigned—was by Duchamp). She became a favorite of *Craft Horizons* and began showing work at Marshall Field's, Neiman Marcus, and Gump's.

In 1948 Wood moved to Ojai, in the hills north of Los Angeles, where her life centered around Krishnamurti's community. At the Happy Valley School, she taught

FIGURE 6.17. *Beatrice Wood*, Bowl, 1948–50. Luster-glazed earthenware; height, 8 in.; diameter, 10 in. (Philadelphia Museum of Art, Gift of the Women's Committee of the Philadelphia Museum of Art, 1984. © Beatrice Wood Center. Photograph by Graydon Wood.)

ceramics in her own casual style, emphasizing imagination rather than technique.[50] In her early works she had painted material onto glazed forms to create a luster surface. She began to make a deeper, seemingly embedded reduction luster glaze by throwing mothballs into her electric kiln.

By the end of the 1950s, Wood's reputation was based on luster vessels. She liked chalices and teapots because they offered more complex structures that allowed her to play with negative and positive space, exaggerated appendages, and figurative suggestion. She also continued to make figural sculptures and insisted that at least one be included in each of her exhibitions. They tended to be ignored by critics, although one writer called her "too often susceptible to an undisciplined humor" and another called the figures corny.[51] She wrote that her exposure to "the tribal arts of India made me determined to continue making my little figures . . . in an unschooled manner. For it is fun in this absorbing technical age to work simply from the heart, and in my case to laugh at men's and women's relationships."[52] Probably the best known is the 1958 work depicting a couple in an intimate embrace, the woman on top. The title, *Settling the Middle East Question*, besides being funny, typifies her way of alluding to complex issues of relationships, from personal to political, with these seemingly simple works.

When Wood died in 1998, James Cameron had based the elderly character Rose in his movie *Titanic* on her, the film rights to her life had been sold for a tidy sum, and a retrospective was touring the United States. One might return to an article she wrote for *Craft Horizons* in 1951, in which she described her Ojai experiment of living, working, and selling in the same place. "It is true that interruptions keep us from 'concert pitch.' But one has to choose whether to be a specialist in art, cutting off life, or whether to bring art into living, thereby losing some of the virtuosity which it is possible to achieve in isolation."[53] It does not diminish her work to note that she chose life.

CERAMIC DESIGN

The line between handmade and mass-produced is not always clear, and the craft field has repeatedly struggled with the issue of business versus art. Is dinnerware a greater public service if the user can feel a communication with the maker through the evidence of handwork or if the user can afford to buy it because of the economies of machine work? **Edith Heath** (1911–2005) did not spend time fretting about such questions. She manufactured, but she did her best to retain the characteristics of the material rather than the machine.

FIGURE 6.18. *Heath Ceramics*, Pitcher, ca. 1940s. Hand-built, burlap-textured ware. (Courtesy of the Archives of the Edith and Brian Heath Trust.)

Born in Iowa to a Danish farm family, Heath lived in a settlement house in the Czech and Polish Howell neighborhood of Chicago from 1934 to 1937. When she graduated from Chicago Teachers College in 1934, the Federal Art Project, which was just beginning, enabled her to take classes at the Art Institute—weaving, metals, painting, and sculpture.

Heath married in 1941, moved to San Francisco soon after, and began making slab-built tableware in her apartment. Although it looks cast, it was actually rolled out like pie dough, sometimes over burlap to give texture. (Figure 6.18) While taking classes at the San Francisco Art Institute, she conceived a hatred of prepared white clay, feeling that it had been refined so much that all the earthy characteristics were bleached out of it.[54] So she took a clay chemistry class and began searching out local brickworks and other sources of native clay. She developed a stoneware body showing darker flecks, which she left unglazed at the rim of her pots. While her aesthetic presages Scandinavian design of the 1950s, both in earthy material qualities and in sculptural form, she had to work hard to convince buyers of the 1940s that her surfaces were not flawed but rather distinctive and natural. Heath complained about conventional dinnerware, insisting that in nature "there's nothing that has that deadly quality of sameness, sameness, sameness. It's like a hospital room, it's all white."[55]

Heath's first solo show was at the Palace of the Legion of Honor in 1943. It was seen by Richard Gump, whose

store had been promoting California design and craft since the 1930s. He financed a studio for her, and she sold exclusively at Gump's until she established her own company. (Gump ordered from other craftspeople as well—printed fabrics, leather clothing, greeting cards. He sent buyers from other department stores to see favored suppliers because he wanted the craft businesses to succeed.) Heath set up a factory in 1946 and altered her designs for a jigger wheel, reasoning that these mass-produced works would be more affordable than her individually made works. America House wrote a letter essentially scolding Heath, saying that if she was going to be making things for the mass market her work would not be the same. She retorted: "The machine doesn't decide what the shape is going to be; a human being has to decide that. So I felt I was just as much in control of what was made as I ever was. Just because I asked someone to help me didn't mean that I had released all responsibility for the piece."[56]

In 1947 Heath bought rubble-strewn land in Sausalito where shipyards had been located during the war. There she built her factory. (Always inventive, she also bought a surplus barge for a pittance and made it into a two-family home, where she and her husband lived for many years.) About 1960 she began to make restaurant ware, and eventually Heath Ceramics was supplying sixty-eight dining establishments, both chains such as Victoria Station and prestigious independents such as Chez Panisse in Berkeley. She also experimented with tile, initially at a customer's request. She tiled the exteriors of the Los Angeles County Museum of Art and the Pasadena Art Museum and made tiles for the Ford Foundation in New York and for a hospital in Saudi Arabia, among other projects. Her tile work earned a gold medal from the American Institute of Architects in 1971, the first time it had been awarded to a ceramist. Heath sold the business in 2003; it continues to produce her designs.

Eva Zeisel, like Beatrice Wood, has a fascinating— even astonishingly dramatic—early history. She was born Eva Amalia Polanyi Stricker in Hungary in 1906 to an accomplished and intellectual family and raised there and in Vienna. In her teens she apprenticed herself to a functional potter, became the first-ever woman journeyman in the guild, and set up her own pottery before she was twenty-one. She became a designer for pottery companies in several German cities, went to Russia as a foreign adviser, and at twenty-nine was named art director of the China and Glass Industry of the Russian Republic. When the political wind shifted, she was imprisoned for sixteen months, twelve of them in solitary confinement, and then abruptly released. She fled to Vienna, but when

the Nazis annexed Austria, she made her way to England, where she married her suitor-in-waiting, sociologist-lawyer Hans Zeisel, and they landed in New York in late 1938. She contacted the editor of a ceramics magazine for work leads and within days had commissions. Within a year, a line bearing her name was in production, and she was teaching ceramic design for mass production at Pratt Institute.

A commission from Castleton China for an all-white dinner service brought Zeisel sudden fame. Castleton had asked Eliot Noyes, director of the industrial design department at the Museum of Modern Art, for a recommendation, since MOMA's Organic Design in Home Furnishings competition and exhibition had not included ceramics. Noyes recommended Zeisel and agreed to debut the collection in an exhibition provided the museum could approve each piece. The project was delayed by the war, but in April 1946, Zeisel's Museum tableware was given a solo show. Coming just months after the exhibition of Charles and Ray Eames's furniture, it brought Castleton and Zeisel enormous prestige. It was the museum's first exhibition devoted to a female designer.

Unlike the three famous modern dinnerware services of the 1930s—Schreckengost's Manhattan, Rhead's Fiesta, and Wright's American Modern, all earthenware—Zeisel's Museum ware was porcelain and was intended for more formal dining (she even read Emily Post for pointers on proper American table settings).[57] Its whiteness was also a shift from the colors of the 1930s. In the strikingly organic design, one surface curves fluidly into the next. She created a thick base for stability and a thin rim for elegance, and she designed a series of bowls whose related but different shapes recall flowers in the stages of blossoming.[58] Her practice was not to use identical shapes but to create sets that show subtle relationships (like cousins rather than siblings, she said). The Museum creamer is without handles, so the user experiences its tactility.

That sensuous quality was repeated in her next line, Town and Country (1946), for Red Wing Pottery, of Minnesota. The company was looking for something "Greenwich Village-y"—spirited and affordable—and Zeisel complied. The salt and pepper shakers, recalling Jean Arp's biomorphic sculptures, became tremendously popular even in the conservative households of Middle America, and a few years later the cartoonist Al Capp adopted the shapes for his Shmoo characters.

Here is introduced a clue to the lasting popularity of Zeisel's designs: their modernism is softened both with humor and with the familiar curves and proportions of the human body. Various pieces have evoked belly but-

tons, breasts, and baby bottoms as well as ripe fruit. And they visually suggest interaction. This may also be why Zeisel still seems close to the personal qualities of craft: not from the wheel-throwing she learned in Hungary but in capturing humanness in industrial design. She insists that design is measured by usefulness and aesthetics and by communication with an audience as well. And consistent with this, her practice has been to make works that are accommodating. She said she hoped her designs "would give pleasure to the user when he had time to notice them, and yet recede when he was too busy or tired."[59]

Zeisel continued this success with other lines, such as the modestly priced Tomorrow's Classic (1952) for Hall China, which grossed $250,000 in its first year. As the domestic china industry began to decline in the late 1950s, she did more work abroad and then ceased designing for twenty years. In 1983 the Musée des arts décoratifs in Montreal and the Smithsonian organized a large retrospective. Subsequently, she resumed designing, including furniture and interiors. In addition, some of her old designs are being offered again, some by KleinReid, a cooperative started by two young men in Brooklyn. Zeisel noted that the computerization of industry production lines makes it expensive to offer new shapes and that this creates an opportunity for small shops "to become the source of the creative expressions of our time."[60] This situation recalls her early days, when there was a flourishing small craft industry in Hungary.[61] Zeisel was the last, but perhaps the greatest, of the modernist ceramics designers.

Glass

MAURICE HEATON

The first person to accommodate glass to a small studio practice was Maurice Heaton (1900–1990). Heaton was a third-generation glass man. His grandfather ran a large stained-glass business in Europe; his father learned the trade but rejected impersonal factory methods and came to the United States to complete commissions arranged by Gothic revival architect Ralph Adams Cram. Heaton took up stained glass, too.

Asked by his friend Ruth Reeves to make some glass shades for floor lamps displayed at the American Designer's Gallery premier exhibition in 1928, Heaton produced some simple designs in keeping with current taste. That led to an invitation to participate in the Metropolitan Museum's industrial art shows in 1931 and 1934. For years, his mainstay was light fixtures. For more than

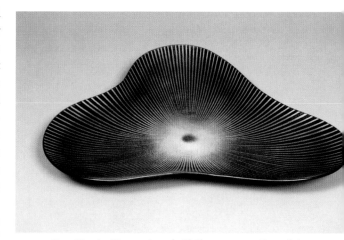

FIGURE 6.19. *Maurice Heaton,* Amoeboid Plate, *ca. 1950. Enameled glass; 2.25 × 20.5 × 16 in. (Museum of Arts and Design, New York, Gift of Simona and Jerome Chazen, 2003.)*

a decade, Heaton produced glass shades for the Lightolier Company in sufficient quantities to require two or three assistants. As a sideline, he began to make glass plates, and it is for these that he is best remembered. (Figure 6.19)

With the help of Karl Drerup, Heaton converted from using glazes on the glass to brighter, more luminous enamels in 1947. After cutting a disk and refining the edges, he sifted enamel onto it. Fixing it in a device similar to a potter's wheel, he inscribed curved lines in the enamel, rotating it slightly after each. The result was a graphic sunburst effect. The disk was then fired to fuse the enamel and again to slump it into a soft, concave plate form. While he occasionally used imagery—bird- and fish-shaped platters or decorative bands of human figures and animals—he usually favored abstract patterns. The technique was unorthodox, but the plates became standards of modern design—quite a leap for a man who grew up steeped in the Gothic revival.

Textile Arguments

Ed Rossbach described the 1940s as a period of intense struggle between "a longing to perpetuate old ways and an eagerness to embrace the new." That description fits the contest between four individuals whom he named as leaders in this decade: Americans Mary Meigs Atwater (see chapter 4) and Dorothy Liebes (see chapter 5) and European émigrés Anni Albers and Marianne Strengell, both of whom came to the United States in the 1930s.

Rossbach, in a series of articles published in *American Craft* magazine in the 1980s,[62] noted that the women had in common their concern with designing utilitarian

goods, mostly for interiors; a commitment to the hand-loom; and attention to the physical qualities of textile (tellingly, their works were almost always photographed as details). Their activities included experimentation with conventional fibers and use of a variety of materials, including the new synthetics.

Beyond that, they diverged. Perhaps the sharpest distinction was between Atwater and the others. She was associated with overshot patterns and colonial coverlets in the folk tradition. Liebes was identified with vivid color and metallics. Albers created geometric fabrics that spoke of the Bauhaus tradition, and Strengell propounded Scandinavian modern design, emphasizing texture.

In 1941 a debate between Albers and Atwater was carried on in the issues of *The Weaver*, each offering a different justification for handweaving in the modern age.[63] Atwater at the time was far better known than Albers, who was a generation younger and represented new ideas. Atwater argued for the pleasure of making and for handmade textiles as a comfort to everyday lives. Albers rejected the idea of recipes or traditional formulas as things of the past—a direct affront to Atwater, known for her workshops and her publications providing exactly that.[64] Albers was, of course, following a different formula—that of the Bauhaus—and though a handweaving revival was going on around her in North Carolina, it is not clear how much she knew of American weaving at the time.

And what was American weaving then? One approach was Atwater's network of hobbyist and small-scale producers of traditional forms. In most schools, handweaving was offered either in the home economics department or as part of a program in occupational therapy. The University of California, Berkeley, offered a master's degree in weaving in the 1940s—a consequence of anthropological study of American Indian and pre-Columbian basketry and fabrics spilling over into a decorative arts department. Lea Miller, the weaving director, had studied Peruvian gauze weave.

Atwater was sometimes dismissed artistically, but she had, in fact, attended the Art Institute of Chicago and had spent time in France. Her writings were chatty and popular rather than scholarly, yet academics such as Dr. Lila O'Neale, a Berkeley anthropologist, marked and saved many Atwater articles.[65] Perhaps an underlying issue was the matter of "studied versus intuitive," which comes up in every account of weaving in the 1940s—the modern weavers often emphasized their own spontaneous composing at the loom. Atwater, for her part, disparagingly referred to the new experimental weaving as

"free form" and called the idea of handweaving as a model for industry—which was espoused by Albers, Liebes, and Strengell—"a big joke," because machine weaving eliminated the very qualities that were attractive and endearing about handweaving. While her three adversaries were all actively weaving samples for machine production in those days, time seems to have proven Atwater right.

BAUHAUS STYLE: ANNI ALBERS

Anni Albers (1899–1994) taught at Black Mountain College, advocated weaving as an industrial prototype, had a solo show in the design department of the Museum of Modern Art in 1949, and later published two slender but eloquent and much-admired collections of essays—*On Designing* (1959) and *On Weaving* (1965). She has been called the most important weaver in America, but it seems likely that her writing was more significant than her teaching or her work.

Albers came to be seen as the embodiment of Bauhaus textile ideology—though she was not a significant figure at the school, as Sigrid Wortmann Weltge points out: "After her graduation from the Bauhaus she had continued to weave at home but, unlike Otti Berger, Margaret Leischner, Benita Otte, and a host of other weavers now firmly ensconced in jobs in industry or teaching, Anni Albers was not involved in either. She was not, as the *New York Sun* called her twice, 'the leader of a movement.' She would only become that in America."[66]

Annelise Fleischmann was born in Berlin. She was privately educated and later studied at the Kunstgewerbeschule in Hamburg. In 1922 she enrolled at the Weimar Bauhaus. The school, after proclaiming egalitarianism, was alarmed at an influx of female students and steered them toward the weaving workshop. Although she later joked that she was attracted to the stained-glass workshop because of its handsome teacher—Josef Albers, whom she married in 1925—she thought that weaving was "too sissy. I was looking for a real job; I went into weaving unenthusiastically, as merely the least objectionable choice. Later, weaving at the Bauhaus developed a more serious and professional character. Gradually threads caught my imagination."[67] The weaving workshop, originally taught by a woman trained as a home economics teacher, was taken over by Gunta Stölzl, only two years older than Albers but a leading student who eventually became the only female Bauhaus master. It particularly benefited from form master Paul Klee, whose own interests and work played productively off fiber structure and color characteristics.[68] His idea of "taking a line for a walk" led in weaving to allowing the thread to do what it did best. Albers and the other students at the time used the struc-

ture of weaving as a key to the medium's aesthetic by creating architectural rectangles out of bands and stripes.

Bauhaus weaving was associated with experimentation, especially with materials. One of Albers's textiles, a wall covering designed for an auditorium designed by Hannes Meyer, was woven on a cotton warp with a cellophane front for increased light reflection and chenille back for sound absorption.[69] Albers received her Bauhaus certificate in 1930. She was an independent designer in Dessau and then Berlin, as the Bauhaus relocated. (She was the only Bauhaus wife to maintain her own creative identity, separate from her husband's.)[70] When the Nazis closed the school in 1933, Anni and Josef, age thirty-four and forty-five, respectively, were without work and without prospects. Fortunately, they had met Philip Johnson and Alfred Barr of MOMA when the two men came to Europe. Johnson knew that Black Mountain College was looking for a visual arts director; Josef was offered the job despite the fact that he did not speak English. Anni was, at first, his indispensable translator and conduit for information.

Probably most important to Albers's development in America was her passion for prehistoric Mesoamerican textiles, from which she adopted the "floating weft" technique: with these long surface threads crossing several warp threads, she could "draw" on the woven structure. Around 1930, she had begun an investigation of open weaves—what she called "modern leno weave"—for her commercial work, noting that the Andean weavers had used the technique long before. She knew of this precedent because German archaeologists had researched and collected in Central and South America, and she frequently visited ethnographic museums in Germany as a young woman.[71] She always credited the ancient Peruvian weavers as her "teachers," along with Klee.[72]

Anni and Josef Albers went to Mexico and other sites in Latin America nearly annually during their years at Black Mountain. Her interest in pre-Columbian art was shared by Josef. It has been noticed that both also simultaneously explored color effects such as theories of adjacency.[73] Certain of Josef's geometric drawings are strikingly weavinglike and might even be mistaken for her work. His interest in serial imagery and pattern modules has been noted by various critics who have not recognized the relationship to textiles.[74]

Anni sought commercial work while she was at Black Mountain. She taught that hand and machine weaving were "fundamentally the same."[75] While she encouraged play with materials, her students wove and sold functional items (yardage, tablecloths, placemats, curtains), making the weaving program at Black Mountain self-supporting—a considerable achievement considering that when she arrived at the school and was appointed a "tutor," there was no weaving equipment. She built the program.

Yet it seems that Albers's teaching, surprisingly, yielded no significant textile artists. The best known Black Mountain graduate using fiber techniques, Ruth Asawa (see chapter 7), studied with Josef, not Anni. Lore Kadden Lindenfeld, who became a successful designer, was mentored by Trude Guermonprez during the latter's few years at Black Mountain.

Albers's exhibition at MOMA in 1949, the year the couple left Black Mountain, was also a mixed story. It consisted almost entirely of functional designs. That may have been because the exhibition, organized by Philip Johnson and Edgar Kaufmann Jr., reflected the design department's Bauhaus-influenced beliefs. The show included ninety items, mostly handwoven industrial samples and yardage made in America, plus a few surviving Bauhaus pieces or designs, eight new hanging screens, and four "pictorial weavings." By and large, Albers's Bauhaus training made her a "rational" designer attractive to the machine biases of MOMA, and her acquaintance with artists and curators because of the Bauhaus and Black Mountain helped her avoid the usual female and low-status circuits.[76]

Ironically, after the MOMA show, she directed her efforts almost entirely to the "pictorial weavings." Perhaps, after more than a decade in this country, she yielded to the greater American divide between craft and industry. Among her earliest pictorial works is *Monte Alban* (1936), which refers in title and in its stepped pictorial elements to the Mayan site the Alberses had visited, and it employs the floating-weft technique. But *La Luz I* (1947) seems to mark her shift to weaving as art and smaller scale. (Figure 6.20) Mildred Constantine and Jack Lenor Larsen later argued that working in America had brought about the change: "The accelerated sense of time, the limited size and complexity of looms, the absence of apprentices or artisan assistants, the isolation and the lack of support or patronage all served to make her Art Fabrics smaller and less formal."[77] She initialed the pictorial weavings, mounted them on linen, and framed them, just like any pictorial art.

Although *La Luz I*, its silvery cruciform almost filling the entire frame and slightly raised against dusty-earth-colored ground, alludes to a Southwestern American church, it is still subject to the structure of weaving. Rossbach observed: "When I look at her works, I am struck by their self-containment, their sense of enclosure, of severity and absolute control, with no loose ends.

FIGURE 6.20. *Anni Albers, La Luz I, 1947. Cotton, hemp, metallic gimp; 18.5 × 32.5 in. (Collection of the Josef and Anni Albers Foundation, 1994.12.2. © 2009 The Josef and Anni Albers Foundation/VG Bild-Kunst, Bonn, and ARS, New York.)*

Her panels are indeed expressive works, with a certain logic, a sense of everything carefully ordered."[78] This was also the residue of the Bauhaus, rather than the abstract expressionist milieu in which she was living. The freest aspect of her work was that she developed her ideas on the loom rather than following drawings.[79] Her emphasis on the meaning of the thread line was a model for other weavers. She employed this idea in *La Luz I*, in a few works that alluded to landscape, and in many works that suggest text.

Albers, like Atwater, made her reputation with her articulateness. She wrote about weaving with great seriousness. She included ancient textiles in her writings for comparison although she was not a scholar; she assumed that such knowledge, analysis, and evaluation were appropriate for discussion by textile artists. By addressing textiles as a "pliable plane" with architectural qualities, historical precedents, and modernist concepts, she gained the respect not only of young weavers but also of designers and architects (in 1961 the American Institute of Architects awarded her its gold medal for craftsmanship).

The final shift in Anni Albers's career was serendipitous. She accompanied Josef on a trip to a printmaking studio and was invited to try her hand. She was delighted to experience a freedom that weaving had not offered her, although she continued to use its compositional elements—the line and the grid—as her vocabulary in the prints that occupied the remainder of her creative life. She gave away her looms in 1970. The tangled lines and the systems of diagonally split squares (resembling graph paper) that she most often employed in her prints can be poignant to admirers of weaving, who recognize

the transformation. Albers herself observed, "I find that, when the work is made with threads, it's considered a craft; when it's on paper, it's considered art."[80] The final irony of her life, then, is that the heroine of weaving eventually abandoned the effort.

ALL FOR INDUSTRY: MARIANNE STRENGELL

Marianne Strengell was the second director of the weaving program at Cranbrook and the one who created its identity as a producer of modern fabrics for industry and who contributed her own creations to a richly productive era in design. (Figure 6.21) Strengell (1909–1998) was born in Finland to parents who were involved in architecture and interior design. She studied textiles in Helsinki and was an established textile designer in Scandinavia when she came to the United States in 1936 at the invitation of Eliel Saarinen, a family friend, to do the teaching that Loja Saarinen declined.

When Loja closed her studio and retired in 1942, Strengell took over the department. She taught by plan and by example but with little direct contact with the students. Rossbach, a student at the time, said she hardly spoke to him in the year and a half he was there. He would

FIGURE 6.21. *Marianne Strengell, Fringed Drapery Fabric, 1945. Cotton and rayon warp, rayon weft with silver threads; 10 ft. 8 in. × 41.25 in. (Collection of Cranbrook Art Museum, Bloomfield Hills, Mich., Gift of the Artist, CAM 1945.30. Photograph by R. H. Hensleigh and Tim Thayer, courtesy of Cranbrook Art Museum.)*

see her sweeping through the student weaving studio on the way to her own, occasionally pausing for an instant to make a comment. "She did not allow students to visit her studio or see her weavings or to know her as an artist," he said.[81] They learned from her by occasionally seeing a piece of her work in her hand as she passed and by following news of her exciting activities such as trips to New York, corporate commissions, collaboration with architects. Her vigor and commitment were evident.

Strengell's rugs and textiles were shown at Cranbrook in 1938 and exhibited across the United States through the American Federation of Art. Two rugs were included in the San Francisco Golden Gate Exposition, and she organized a show on textile techniques for the education department of MOMA in 1940. Her work was published in architectural and interior design magazines, along with her statements extolling professional collaborations and describing the architectural functions of fabrics: for dividing rooms, controlling light, providing insulation.

One of the rugs that Strengell showed in the Golden Gate Exposition was like an impersonal abstraction of earlier folk-inspired Cranbrook designs. She also turned away from the hand-manipulation of tapestry and pile to the more efficient shuttle weaving. Her work relied for its interest on subtleties of color and fiber combinations; it was meant to serve the architectural setting, not to call attention to itself. Yet it was not "hard," like some Bauhaus weaving, but retained a sensitive quality of hand.[82]

Strengell designed automobile fabrics and, as part of a team headed by Eero Saarinen, designed all the fabrics for the General Motors Technical Center. From 1945 to 1960, working with prominent industrial designers in the United States, Europe, South America, and Asia, she designed innovative curtains, upholstery, and many woven fabrics for mass production. In 1947 she created a screen-printed rayon curtain fabric, Shooting Stars, that was the first printed fabric at Knoll.[83] In 1951, with other artists, she went to the Philippines to work on a cottage-industries project. After using hemp, pandanus, and other natural fibers there, she introduced them in her designs at home. Her works were executed by a cottage-industry program in Michigan and later in India, Hong Kong, and Japan.

Strengell sharply changed the emphasis at Cranbrook. Students were considered to be creating "contemporary handweaving" for the new interiors of the future. Only the stylized references to nature typical of Scandinavian modern design—that which harmonized with wooden furniture—were accepted. Her own fabrics suited their time, but as Rossbach noted, her students were working "within a remarkably narrow range of weaving possi-

bilities. . . . Small wonder that in a few years a vigorous reaction occurred."[84] Many of them became important figures in "art" weaving.

SOME TEACHERS AND STUDENTS

In addition to Cranbrook, Chicago was another weaving center. There **Marli Ehrman** taught at the New Bauhaus. Ehrman (1904–1982) was born Marie Helene Heimann in Berlin and studied at the Bauhaus from 1923 to 1926, with another year in the Experimental Workshop as an independent assistant. In 1933 she was dismissed from a teaching position in Hamburg because she was Jewish, but she was able to work at a school in Berlin, and there she met and married Eliezer Ehrman. They immigrated to the United States in 1938 and were barely scraping by until László Moholy-Nagy in 1939 invited her to lead the weaving workshop at the New Bauhaus, which was modeled on the Bauhaus but included fashion and print design.[85] After Moholy died, his successor, Serge Chermayeff, discontinued the weaving workshop in 1947; the records of the Moholy administration were lost, so there is no documentation of the weaving workshop activities.

Ehrman's own work was logical and materials-oriented, the weave sometimes given just a slight shift to avoid predictability. In 1941 she won a first prize in MOMA's Organic Design competition. She designed curtains for Mies van der Rohe's Lake Shore Drive Apartments (1948–51) and wove prototypes that were mass-produced for residential and commercial interiors. In 1956 she founded the Elm Shop in Oak Park, Illinois, an avant-garde source for modern design, which she directed until her retirement. She taught at Black Mountain and Hull-House, but her lasting identity is with the weaving workshop, where her students (all women) were so devoted to her that when the workshop closed they incorporated themselves as the "Marli Weavers" to "preserve the spirit of the former class and to promote the study of handweaving and design."[86] The group continued in existence until 1991.

Among her students were Lenore Tawney (see chapter 8); Angelo Testa, who became widely known in the textile industry; and **Else Regensteiner**, who with Julia McVicker, established a Chicago studio, reg/wick Handwoven Originals, which specialized in production handweaving for industry. Regensteiner, who had left Germany in 1936, became Ehrman's assistant, and although her training had been in teaching, she discovered that she had a natural talent for weaving. With production-weaving experience there and with courses at Black Mountain, in 1942 she became an instructor at the Institute of Design and in 1945 shifted to the Art Institute of

Chicago. She established the weaving department there in 1957 and directed it until her retirement in 1971. She founded Midwest Designer-Craftsmen, a group of professionals, and is the author of books that have become classics in the field. Her business with McVicker operated from 1945 to 1980, benefiting from the building boom in Chicago. They were well known for casement fabrics and also made fabrics that Stiffel Co. used for lampshades. Their work appeared in MOMA's *Good Design* exhibitions.

MODERN TEXTILE ART: EVE PERI

Too little is known about Eve Peri (1896–1966), an independent textile artist active from the 1930s through the 1950s. (Figure 6.22) Her work consists of gouaches, ink drawings, collages, oils, plus embroideries and—of most interest here—what she called "fabric forms."

Peri was inspired to become an artist when she saw Henri Matisse's paintings in Paris. Later, living in Mexico, she and her second husband, Alfonso Umaña Mendez, were partners in a business that produced handwoven fabrics for interiors, theater, and fashion. In an undated catalog for the workshop, they say they are producing modern fabrics and designs using traditional means to demonstrate the value of handweaving in the machine age. For a time they sold their works through a shop in New York's Greenwich Village, and in 1939 a Peri-Umaña piece was shown at the Golden Gate Exposition.

When Peri was making special-order embroidered dresses, she discovered that clients were framing the embroidered sleeves and hanging them on their walls. After seeing the Bayeux Tapestry in Europe in 1939, she made *Head with Flowers*, which may be a self-portrait but

which, in any case, she considered a breakthrough because it led her to "fabric forms," a combination of appliqué and embroidery.[87] These works relate to modern abstract paintings, with artful composition creating senses of space and movement.

A 1949 *Craft Horizons* article notes that Peri used needlework only to highlight a pattern or secure fabric to the canvas, so the work is not really embroidery. The article waxes poetic on the differing effects of her compositions.[88] The ability of fabrics and threads to suggest images or moods ranging from soothing nocturnes to drama was a point repeatedly made about her work. But the materials themselves are more than simply carriers of information and never lose their distinct identities. A 1950 *Art Digest* review commented, "For achieving texture, an important enrichment to abstractions, this ingenious new medium has it all over painting, though the subtleties are limited, as they are not with paint, by the fabrics the artist has at hand."[89]

Peri lived in Philadelphia in the 1950s and opened a shop in New Hope, Pennsylvania, where she sold her wall hangings, collages, and screens as well as more conventional pillow and bed coverings.

In Short

In the 1940s craft activity slowed with the war but then grew dramatically when craft education boomed as a consequence of the GI Bill. Craft institutions found a national voice in the American Craft Council. Craft helped open the American middle class to modern design. Eva Zeisel's dinnerware and Charles and Ray Eames's chairs, both mass-produced, emerged from the craft milieu.

The textile field was the battleground for the idea that the craftsman was a skilled designer and prototype maker for industry. Mary Meigs Atwater—spokesperson for practicality, hobbyism, and historical inspiration—seemed to lose the argument to the industry-favorable positions of Marianne Strengell, Dorothy Liebes, and Anni Albers. Modernism encouraged direct experimentation with materials and process, with the intent of discovering new forms and effects. This approach came naturally to many craftspeople, from Otto Natzler, with his pitted and cratered glazes, to Sam Kramer, with his surreal fusing. Many jewelers were inspired by the rustic directness of Alexander Calder's work in the field.

Despite the influx of new ideas, American craft retained some traditional aspects, including utility and familiar type forms.

FIGURE 6.22. *Eve Peri, Journey to the Moon, ca. 1945. Fabric collage with hand appliqué; 17.75 × 29 in. (Courtesy of Michael Rosenfeld Gallery, LLC, New York.)*

CHAPTER 7 1950–1959

THE SECOND REVIVAL OF CRAFTS

Paradigm Shifts

The privations of the Depression, enormous dislocations of World War II, and sudden return of prosperity in the late 1940s yielded a new lifestyle. Manufacturers promoted all sorts of electric appliances to help the harried housewife: dishwashers, clothes washers and dryers, electric irons, blenders, warming trays. In crowded city apartments or in new subdivisions of small houses churned out to meet postwar housing needs, space was tight and economy became the highest virtue in furnishing the American home.

This atmosphere was not conducive to the handmade. Mary and Russel Wright's 1950 *Guide to Easier Living* emphasized convenience above all else. Mass-produced goods were held up as the best solutions for modern life. Russel Wright was not opposed to craft—he was often quoted in *Craft Horizons* in the 1940s—but his book recommended manufactured products for all kinds of household situations, from vinyl-coated upholstery fabrics and asbestos tabletops to paper plates and cups for buffet-style parties. Everything was simple to use and easy to clean.[1]

The Wrights' curious lack of sensitivity to the sentimental associations of objects points to one of the great potentials of craft in a late-industrial society. If craft could not compete with industry in matters of economy, it might yet compete in matters of symbolism and meaning. The synthetic materials and efficient storage closets that the Wrights favored symbolized modernism but not warmth, community, or connectedness to the natural world. In effect, a gap opened up that craftspeople could fill.

The 1950s initiated a long period of intense experimentation and change in the crafts. At the beginning of the decade, they were still traditional and mostly functional, and in ceramics there was still an ongoing effort to learn techniques and recover glaze formulas. But midway through the decade, a radical alteration of clay aesthetics began—along with unorthodox work in weaving and embroidery and new styles and techniques in jewelry. Wood turning was rediscovered. Lamination and synthetic-bonding elements, developed for multiple purposes during the war (such as propellers), opened new possibilities in furniture design.

Although opportunities to exhibit were still relatively

1950
 Price of an average home: $7,354
1950–53
 Korean War
1952
 Elizabeth II becomes Queen of England
1953
 Watson and Crick publish DNA model
1954
 In *Brown v. Board of Education*, the Supreme
 Court strikes down "separate but equal"
 doctrine
 First H-bomb tested over Bikini Atoll
1955
 Rosa Parks refuses to give up her seat on a bus
 in Montgomery, Alabama
 Supreme Court orders school desegregation
1956
 Allen Ginsberg publishes *Howl*
 Elvis Presley has his first number-one hit,
 "Heartbreak Hotel"
1957
 Russians launch *Sputnik I* satellite
 Jack Kerouac publishes *On the Road*
1959
 The United States Information Agency uses
 abstract paintings to represent progressive
 American values at a Moscow exhibition
 Allan Kaprow stages his first public Happening

began to relieve the sense of isolation in a field that was not concentrated in a few big cities, as were painting and sculpture. The feeling of community grew.

Another shift in the decade was the growth of colleges and art schools. They provided financial stability for teachers, a gathering place, and gradually a site for exhibitions as well. Throughout the decade postwar prosperity created an expanding market for crafts. International travel and information exchange created greater awareness of other cultures, bringing not just foreign styles but also foreign philosophies to America; the nation in general and the crafts in particular were influenced by Japanese aesthetics. Zen was the focus of great interest, served by the writings of D. T. Suzuki and Alan Watts. Expressionism in painting and organic forms in design carried over into the craft world. While political conservatism and the uniformity of the Levittown suburban developments were part of life in the 1950s, in the arts "there was a search on simultaneous fronts for the personal voice, for the immediate impulse and its energy, for the recognition of (even surrender to) process, to the elements of randomness, whimsy, play, self-sabotage."[2] The booming economy and escapist culture coexisted with cold war anxieties. New "free-form" design, sculpture, and craft could be linked equally to the organic origins of life or the melting blobs of atomic warfare.

Craft Embraces Academia

Serious artists in all fields often ignored the master's degree, seeking instead to study with established figures such as Hans Hofmann, who ran his own school. The choice did not matter professionally, because art-school teachers were not required to have a master's degree. But after the war, as more art departments opened at state universities and liberal arts colleges, the visual arts came to be evaluated by the same measures as the rest of the academic community. Soon, any young artist or craftsperson who wanted to teach at the college level needed a Master of Fine Arts degree (MFA). In effect, the academic community created a marketplace for its own product.

Teachers earned tenure by proving that they were actively engaged in their fields. Academic careers can be rather long—thirty-five years is not unusual—and institutions needed a way to ensure that faculty stayed up-to-date. The scholarly proof of engagement is the publication of new research. For artists, exhibitions were the most objective measure.

Starting in the 1950s, getting into the big national exhibitions was crucial for tenure and promotion. Be-

few, in 1950 *Craft Horizons* magazine began publishing a calendar of exhibitions across the nation. America House began giving "one-man shows" to significant "craftsmen" (male and female); a few upscale shops such as Bonniers in New York and Gump's in San Francisco showed quality craft. There were also cooperative galleries here and there, and painting venues occasionally showed jewelry, pots, or tapestries. In 1953 the American Craftsmen's Educational Council sponsored its first exhibition of work by "designer-craftsmen" in conjunction with the Brooklyn Museum; in 1956 the council opened the Museum of Contemporary Crafts practically next door to the Museum of Modern Art; and in 1957 it sponsored its first national meeting at the Asilomar conference facilities on the Monterrey Peninsula in California, where "designer-craftsmen" was again the favored description for craft practitioners in the new consumer culture. All these activities increased professional opportunities and

cause their salaries insulated them from the demands of the marketplace, professors could devote as much time and energy as they wanted to single objects. At the same time, exhibition jurors—often college professors themselves—began to favor larger, more complex, and more experimental work. They selected work on the cutting edge of craft. Standards for acceptance to the major shows changed, and craft objects that were directed more to the marketplace and to the satisfaction of a given function were increasingly rejected.

Craft faculty and students began to think of their field as a type of art rather than as decoration or design. Stimulated by the GI Bill, craft programs expanded in the late 1940s and through the 1950s. Some woodworking courses were taught in industrial arts departments and weaving in home economics departments (since they already had the equipment). Occasionally craft departments existed independently, but in most colleges, craft courses were added to art departments. In those days painting was the queen of the arts. Typically the painting faculty was larger than that of any other discipline, and painters established the context for everything else. Not surprisingly, craft faculty followed along. In classes, they offered critiques of student works as if they were artworks. The language of formalism, invented for painting, was applied to craft objects. Faculty also began to denigrate production crafts. When Maija Grotell, the ceramics teacher at Cranbrook, said, "Doing things to sell is the easy way because you can repeat and repeat an approach. I am only interested in learning when I do a new piece," she betrayed an underlying bias that was taken up by students.[3]

The pressures and expectations unique to the academic environment created a new dynamic in craft. Early modernism had been a big tent. Everybody got in as long as their work had some trappings of the new style. The academy, however, favored craft that resembled fine art. Exceptions were plentiful, of course, but the trend was toward an erosion of unity, a schism between academics and those craftspeople who revered function and marketplace. Academics styled themselves as progressive and adventurous; their opponents saw themselves as protectors of traditional virtues that were being overturned willy-nilly. The crafts stumbled into a state of polarization. Each side claimed the moral high ground.

Another result of craft going to college was a collective amnesia regarding the history of decorative arts. While art history courses were plentiful, craft history courses were rare. Some professors might teach the history of their medium to their students, but an overall sense of the history of craft was neglected. Even recent events

such as the Arts and Crafts movement were unfamiliar. The result was twofold: much American craft in the 1950s and 1960s took modern art as its primary context, and when curious individuals poking around in libraries and museums rediscovered historical material, it was often provocatively strange and powerfully attractive.

MoMA and Good Design

The Museum of Modern Art embarked on an ambitious program of public education in the 1950s to support acceptance of modernism. Handmade objects were part of the campaign. In the early 1940s MoMA had featured affordable design in its Exhibitions of Useful Objects, a series of presentations held during the Christmas season to stimulate sales. Until 1946 prices had to be below $25. A $100 limit drew criticism in 1947, and it was dropped back to $10 in 1948. Despite the appeal to usefulness implied by the title, the wares were marketed as gifts that would announce the superior taste of their buyers.

Other museums followed suit. In 1946 the Walker Art Center in Minneapolis opened a salesroom dedicated to modern design, the Everyday Art Gallery. The first show included James Prestini's wooden bowls and Marguerite Wildenhain's ceramics alongside mass-produced items like radios and an electric iron. The Walker also published a magazine, *Everyday Art Quarterly*, as a study of the best new products. The Akron Art Institute mounted four shows in 1946 and 1947 featuring home furnishings and other products, and the Albright Art Gallery in Buffalo launched one in 1947. By the late 1940s many institutions had gotten into the act, even the New York Public Library.

The culmination of the trend was MoMA's series of Good Design exhibitions from 1950 to 1955. (Figure 7.1) To attract new manufacturers, the Chicago Merchandise Mart proposed to partner with MoMA in presenting modern home furnishings. The director of MoMA's industrial design department, Edgar Kaufmann Jr., was a permanent member of the jury. The shows opened early in the year at the Merchandise Mart, set in tasteful displays planned by a prominent industrial designer. The target audience was not the public but furniture-store buyers, many of whom, in 1950, had probably never seen modern design. The shows were revised for the summer buying season and then shipped (often in abbreviated form) to MoMA for a pre-Christmas showing.

Exhibited works conformed to Kaufmann's standard of good taste. Overt expressiveness was not encouraged; simple and abstract forms were. Applied ornament was

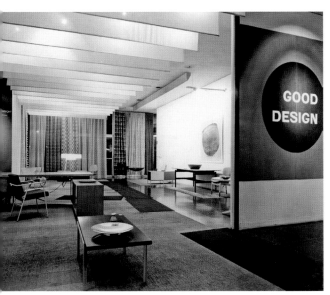

FIGURE 7.1. *Installation view of the Museum of Modern Art's Good Design Exhibition, November 27, 1950–January 27, 1951. (Digital image © The Museum of Modern Art/Licensed by* SCALA*/Art Resource, New York.)*

rare, except for printed fabrics and a few patterned ceramics. All products were to be affordable to the middle class. Everything in the shows was in production somewhere; one-of-a-kind designs were not selected.

The shows were a hit. Accepted designs were given an orange and black tag for retail display, bringing MOMA's imprimatur to Middle America. In 1953 some 6,000 designs were submitted to the exhibition, and only 200 were chosen. *Interiors* and *Time* covered the events. Critics, however, questioned the premise, particularly the fact that work was chosen chiefly for "eye appeal," when function and sound construction should have been equally important.

In time, selections began to look repetitive, and the reductive style favored by Kaufmann began to go out of fashion. In 1955 he resigned his position at MOMA, saying that his job was finished. A spring show opened at the Merchandise Mart but did not travel to New York.[4] Still, the Good Design shows gave modern craft a big boost. Work that was accepted, such as Ronald Pearson's metalwork, received favorable exposure and publicity and was forever associated in the public mind with other quality designs of the era. The Good Design program was, in effect, a twentieth-century reworking of William Morris's old dream of bringing art into life. The difference, though, was that much of this art was mass-produced—and looked like it. Craft could participate only if it was slick, smooth, and not conspicuously handmade. As the 1950s opened, a good deal of craft fell within this

aesthetic. But great changes were coming, and the new work would have to be marketed in a different way.

Ceramics: Import-Export

More schools, more students, more clays. By mid-decade, intractable, elegant porcelain was again in use by studio potters, not just the soft, thick earthenware and high-firing, stronger stoneware. In California, new types of potter's wheels contributed to dramatic increases in scale.[5] New institutions arose, among them nonacademic cooperative studio spaces at the Archie Bray Foundation in Helena, Montana, and Clay Art Center in Port Chester, New York.

Most importantly, the decade in clay featured two explosions that were to have a permanent effect on American ceramics. One was the influence of Asian—especially Japanese—aesthetics, and the other was the sculptural invention of Peter Voulkos and his associates in California.

LINKING EAST AND WEST: LEACH AND OTHERS

Bernard Leach (1887–1979) never lived in the United States, but he cannot be left out of the history of American craft. An English potter living in Saint Ives, Cornwall, he became a household name among ceramists when in 1940 he published *A Potter's Book*. The American edition was published in 1946 and reprinted five times in the next six years. It was the first book written for studio potters. Certainly there had been ceramics books before, but they were aimed at people working in industry or teaching. Leach talked about what you needed to know to go it alone, showing how it was possible to live as a studio potter. And he wrote beautifully. *A Potter's Book* began with a consideration of standards and values in ceramics. To determine "fitness and beauty," Leach proposed "a striving towards unity, spontaneity, and simplicity of form and in general the subordination of all attempts at technical cleverness to straightforward, unselfconscious [work]." From the postwar period of lifestyle changes through the pluralist 1970s, these ideas would remain "a blueprint among many potters for the counter-cultural search for a more meaningful, self-sufficient way of life."[6]

Leach was born in Hong Kong and lived in Japan for a few years as a small child. He was educated in England, and after art school he returned, enticed by the romance of Lafcadio Hearn's mesmerizing tales of old Japan. Leach hoped to get to know the country and make a living teaching etching. Instead he found his life's work in pottery and made lasting friends among young artists,

architects, and critics. Two particularly important colleagues, who figure in the American story, were Soetsu Yanagi and Shoji Hamada.

Soetsu Yanagi (1889–1961) was a twenty-one-year-old editor of a modern art magazine in Tokyo when he and Leach met in 1910. The gift of a piece of Korean pottery led Yanagi in 1916 to a fascination with Korean folk crafts. He subsequently looked at those of his own country, which were vanishing in Japan's headlong rush to industrialize. He began to collect, often acquiring goods for little or nothing because no one wanted "that old stuff" any more. He coined a word, *mingei*, or "art of the people." In 1936 he opened the Nihon Mingeikan (Japan folk crafts museum) in Tokyo, and supporters of the Mingei movement founded similar museums in other cities.

Shoji Hamada (1894–1978) had read about Leach in the Japanese press and seen his exhibitions. Around 1919, as a recent graduate of a ceramic technical school who wanted to be an artist-potter, he introduced himself. In 1920 Leach left to establish his pottery in Cornwall, and Hamada accompanied him—which was fortunate because Leach at the time had little practical knowledge. Hamada remained for three years. He later established a workshop in Mashiko, an old pottery village a few hours north of Tokyo.

Leach made his first trip to the United States in 1950, invited by Robert Richman, director of the Institute of Contemporary Arts in Washington, D.C. Over ten weeks, Leach traveled 12,000 miles and presented about 100 seminars. He spent three weeks at Alfred University in New York state and went on to Minneapolis before flying to Mills College in California. He drew crowds and newspaper coverage.

Leach managed, amid all the laudatory attention, to put his foot in his mouth: he was perceived as saying that American ceramics would not amount to much because it had no "taproot," no grounding in local history. His metaphor may have been striking, but his botany was flawed: plants with spreading roots can be just as healthy as those with a taproot. Marguerite Wildenhain tartly noted that Americans could not possibly grow roots by "copying the way of life of the rural population of Japan," although she did say that no one doubted Leach's sincerity or his wish to support higher standards of craftsmanship.[7]

In an article for *Craft Horizons*,[8] which he incorporated into his book *Beyond East and West* (1978), he wrote that in America, despite the kindnesses he received, he had "a sense of thankfulness that I had been born in an old culture. . . . Americans have the disadvantage of having many roots, but no taproot, which is almost the equivalent of no root at all—nothing but their own individual choice to depend upon. Hence their pots follow many undigested fashions." He said that tradition gives an assurance of "art as part of normal life, not something separate or reserved for superior people." He also said that because Europeans have such roots and Americans do not, "Americans have a freedom of choice greater than ours, an openness and a more insatiable hunger."[9]

Leach was eventually forgiven for this caricature because he had useful information—and not only about studio setups, clay bodies, glazes, and firing. *A Potter's Book* also introduced Japanese, Chinese, and Korean pottery and aesthetics, which were to be the most pervasive foreign ideology in American arts in the 1950s.

Leach was not alone as the source of this interest: Donald Keane, who translated Japanese poems and novels, and Donald Richie, who became an expert on Japanese film, were among the many young men who had their first exposure to Japan as part of the American occupation following World War II. Moreover, it was in the 1950s that D. T. Suzuki taught classes on Zen at Columbia University in New York, sitting at a table spread with documents, speaking so softly—as if to himself—that his audience strained to hear. His classes were packed, more auditors than students, among them such important figures as composer John Cage and psychologist Karen Horney.

Leach's introduction of Asian ideas was even more effective when he returned in 1952 with his friends Hamada and Yanagi, following an international conference of potters and weavers that he had organized at Dartington Hall in England. They traveled across America (a tour organized by the potter Alix MacKenzie) to carry the conference message of "the interchange of two hemispheres," which was apparent in their long friendship.

They had much to show and to tell. During their two-week stay at Black Mountain College, Hamada worked at whatever wheel and with whatever clay he was given; he gathered weeds to make a brush for decorating with slip in the Korean *hakeme* manner. He rarely spoke in public but sat cross-legged, throwing while someone else kicked the wheel for him. He threw off the hump (centering enough clay to make several objects) and produced beautiful forms. Leach did some demonstrating as well but mostly talked. Yanagi probably gave the same two addresses in each venue, but those present at the workshops often reported being lost because the ideas were so unfamiliar.[10] The trio did a workshop in Saint Paul, visited the new Archie Bray Foundation in Montana, and made a presentation in Los Angeles to a packed hall of more

FIGURE 7.2. *Soetsu Yanagi, Bernard Leach, Rudy Autio, Peter Voulkos, and Shoji Hamada (left to right) at the Archie Bray Foundation, 1952. (Courtesy of the Archie Bray Foundation for the Ceramic Arts.)*

Zen and Mingei

While Zen came into American awareness little by little and few claimed to understand it, what people heard had an immediate appeal to craftspeople. Zen embraces imperfection and incompleteness as allowing room for imagination; recognizes the meditative nature of repetitive actions; advocates forgetting the self through engagement in action; and finds meaning in concrete daily existence. "Simplicity of form does not always mean triviality of content," D. T. Suzuki averred,[1] which resonated with those who saw a social value in handwork.

Mingei ideology combines aspects of the English Arts and Crafts movement with Buddhist notions that support and expand them. It was as much a religious movement as an aesthetic one. Yanagi spoke of craftsmen as servants of nature who helped reveal the unforced beauty of materials. He advocated making things that served the user and were not self-imposing; he praised local production and use. He worried that the modern era was an "Age of Signatures," which showed attachment to worldly desires and was an obstacle to enlightenment. He described "direct seeing" through intuitive engagement rather than intellectual knowledge, since the latter was always "about" something and could not get to the core. Mingei, he believed, went beyond ego and created a "healthy beauty" of things "born not made." He said artworks should be approached in a state of nonconceptualization, the Zen state of "no mind."

NOTE

1. D. T. Suzuki, *Zen and Japanese Culture* (1938; Princeton: Princeton University Press, 1970), 257.

than 1,000 people—one account said another thousand were turned away—as well as demonstrating at Chouinard Art Institute in Los Angeles and Scripps College in Claremont, California. (Figure 7.2) They also traveled to New Mexico to meet Maria Martinez and made side tours for sightseeing.

"The Responsibility of the Craftsman" and other essays by Yanagi explaining Japanese ideas of beauty and the philosophy of the folk-craft movement were translated and adapted by Leach after Yanagi's death and published in 1972 as *The Unknown Craftsman: A Japanese Insight into Beauty.*[11] This book as well as publications by Leach and Suzuki and a few earlier titles, such as Kakuzo Okakura's *Book of Tea* (1906), conveyed ideas that had enormous influence on craftspeople, especially ceramists, in the second half of the twentieth century.

Hamada seems to have been the favorite wherever they went. The visit to the Bray has been extensively recalled by American writers because Peter Voulkos and Rudy Autio were then resident artists at the Bray. Autio later said of the experience, "I began to discover that pottery making was not just a matter of throwing pots and selling them in the trade world, but from the way [Hamada] handled things and examined them, turned them around, held them, and communicated with the work that he was doing, I began to sense that there was a kind of spiritual connection to it."[12]

Other Japanese ceramists visited the United States in the 1950s and 1960s, spreading different approaches and unfamiliar ideas. The most eccentric was surely Rosanjin, who was not really a potter but a noted restaurateur who could not find the pottery he wanted and so decided

to make it. He did not throw but had others do that, and he altered or decorated, as Picasso was doing on the other side of the globe. Rosanjin was a flamboyant character, a celebrity in Japan precisely because he violated all the rules of politeness. M. C. Richards was amused when Rosanjin smiled during his lecture at Greenwich House Pottery in New York, and then, when the translation was read to the audience, they discovered that he had been telling them how awful their work was. He also demonstrated, but the piece was too wet and collapsed. He was unconcerned, pushed it around a little more, and said it would be wonderful after it was fired; he even in-

sisted that it be passed among the (aghast) audience for appreciation. On the opposite coast, Rosanjin casually told Tony Prieto, a teacher at Mills College, that his bulbous work was not very impressive. Prieto retorted that Rosanjin's works were turds and kiln shelves. Rosanjin, apparently able to dish it out but not to take it, withdrew his work from a show at Mills the day after it opened and had it moved to the nearby California College of Arts and Crafts.

Another Japanese visitor was Toyo Kaneshige, who had been named a Living National Treasure by the Japanese government (a designation awarded later to Hamada). Less volatile and more skilled than Rosanjin, he impressed those who saw him at work. Paul Soldner, then a student at the Otis Art Institute in Los Angeles, recalled how Kaneshige threw a few small vessels from a ball of clay, casually trimming them with a twig that he had broken off an orange tree outside.

Yet another source of Japanese ideas was the ceramic work made by Isamu Noguchi in Japan in the early 1950s, in his third and final encounter with clay. His unorthodox work influenced a group of young ceramists there who were trying to break out of tradition and into modernism.[13] To Americans, Noguchi's ceramic work was of interest for its architectural character and generous size (for the time) and because it was nearly all unglazed.

The Japanese influence was surprisingly pervasive in America, turning up even in decorating magazines. Leach's impact has continued through his several books, some still in print, and through the Americans who apprenticed with him at Saint Ives. Warren MacKenzie has been the most effective in passing on what he learned. Byron Temple, Clary Illian, Jeff Oestreich, Jeffrey Larkin, and Robert Fishman are others influenced by direct experience at the Leach Pottery.

FUNCTIONAL POTTERS

Minnesota today remains a center for production of functional studio pottery, due largely to the efforts of **Warren MacKenzie** (born 1924) and his first wife, **Alix** (1922–1962).[14] They were Leach's first American apprentices and became his lifelong friends. While their work became steadily less like his, they equaled his devotion to modest pots that could be part of the user's daily life. Their work never aimed for art status or high prices. It offered an alternative to the gallery pieces that increasingly characterized American ceramics. It is sometimes described as traditional or conservative, but it provides a sensitive variety of forms, surfaces, and colors that can be visually gratifying even as they serve daily domestic needs.

MacKenzie had barely started his studies in painting at the Art Institute of Chicago when World War II intervened. When he returned to Chicago in the flood of veterans after the war, no painting classes were open, so he took ceramics. There he met Alixandra Kolesky, daughter of Latvian immigrants, who was working at a settlement house and thought ceramics would be useful for the children there. While their classes were restricted to painstaking coil building, the two were discovering, in places like the Field Museum of Natural History, the visual character and vitality of everyday pottery from many cultures. "There was no sense of ego in any of them," he later wrote, "but instead a feeling of naturalness and rightness. They had a dignity and strength which came from within rather than qualities superimposed from without. When the potters got clever and began to sell their skills to the highest bidder, it usually marked a decline in the culture, and certainly such pots did not interest us."[15] When a fellow student discovered Leach's *Potter's Book* and shared it with his classmates, the couple taught themselves to throw.

The MacKenzies married in 1947 and moved to the Twin Cities, where they taught at the Saint Paul Gallery and School of Art. They almost immediately realized that they didn't know enough. The next summer, they traveled to Cornwall and presented themselves at the Leach Pottery, asking to be taken on as apprentices. Leach and his son David looked at their pots and declined. The MacKenzies, having already paid for their lodgings, asked if they could simply observe for a few days. When they kept Leach company on overnight kiln tending, he changed his mind. The MacKenzies returned in the spring of 1950, traveling with Leach as he returned from his first American tour. They stayed two years, struggling to make the Leach Pottery's "standard ware" to specification and becoming quick and skillful throwers in the process. Equally important to them was the constant discussion of the character, quality, and history of pots, with Leach pulling examples off his shelves and out of his cupboards.

Now charged with the ideology of production pottery, the MacKenzies returned to Minnesota and began an educational crusade, to sell an idea as well as some pots. They bought a farm outside the town of Stillwater and converted the basement level of the barn to a pot shop separated from a sales room by glass, so that buyers could see the process. They accumulated a mailing list. They offered free lectures and demonstrations to any group that asked. They sold most of their work at the studio, which enabled them to keep prices low and also allowed them to talk with the customers. Warren began teaching

FIGURE 7.3. *Warren MacKenzie and Alix MacKenzie, Bowl,
ca. 1956. Stoneware, iron oxide decoration under feldspathic glaze;
1.62 × 7.5 in. (Collection of the Frederick R. Weisman Art Museum
at the University of Minnesota, Minneapolis, Museum Purchase.
© Warren MacKenzie.)*

night classes at the University of Minnesota and then was made part of the regular daytime faculty, where he had another educational task: persuading the professors that ceramics was no less an art form than painting.

The MacKenzies developed an audience as they worked their way toward more organic forms, sturdy and direct. Alix, Warren claimed, would fix his unsuccessful forms with her free decoration, which was often linear, sometimes nearly surrealist. She worked spontaneously, in response to the form in what Robert Silberman has called "a synthetic modernism that echoes artists such as Klee and Arp."[16] (Figure 7.3)

Alix died of cancer in January 1962, at age thirty-nine, leaving two young daughters and a husband now bereft of his creative partner as well. In the pot shop, feeling incapable of replacing her decoration, MacKenzie focused on form and looked for wet-clay treatments to combine with the glazes he liked. He continues in that manner today. He uses fluting, faceting, roller patterns, pinched rims, finger wipes through slip, and such actions other than painting. The result gives a sense of process and touch and thus a kind of communication between the maker and the user. Everything is hand scale and designed for use. This lively, varied, engaging, and serving work is, ironically, so outside the mainstream of art-intention showpieces that it must be explained to followers of art craft. The historian Garth Clark, once skeptical, has since written of MacKenzie and his by-now several generations of students: "At first examina-

tion the work might seem plain, even dull to the casual viewer. But their economy implies a spiritual passion that makes the works, in a contradictory way, distinctly cerebral. They oblige the viewer to ponder nuances in the relationship of lip to foot, spout to handle, interior to exterior."[17]

It is exactly this subtlety that makes the ware suitable for table use and that gives it a lasting interest. MacKenzie believes that his work is best received in the Midwest, where it suits the pace of living and the undramatic landscape, and he compares the process of discovering a pot's pleasures over time to the experience of getting to know a person.[18]

MacKenzie's insistence on selling his work at modest prices has been a troublesome issue. He has been criticized for subsidizing his pottery through his university employment and thus being able to sell his work for less than his students charge. He points out that his university work also took him away from the pot shop and reduced his production. He says that the issue is working quickly and efficiently, a skill that he learned during that grueling apprenticeship but that few American potters can equal. There are not many places where such throwing could be learned today—certainly not in universities, where functional ware is rarely represented. Even MacKenzie's replacement at the University of Minnesota, Mark Pharis, has moved steadily away from functional work.[19] The urge now is toward individuality and originality, and function is often decried as a limitation. "It is not a limitation," MacKenzie asserts, "but instead a framework and support which frees me from the pressures of fashion and the excesses of technical skills as an end in themselves."[20]

Karen Karnes made her own way to production pottery. Born in New York in 1925, she was the child of immigrant garment workers who were active socialists. With both parents working, she naturally learned independence and decided on her own to attend the High School of Music and Art in Manhattan. At Brooklyn College, which had a good art department, she was mentored by Serge Chermayeff, a British architect with Bauhaus ideas. She discovered clay at the New Jersey College of Industrial Art in Newark, where she married her teacher, David Weinrib. Together they worked in industrial ceramics in Pennsylvania; Weinrib was a designer, Karnes made lamp bases and was soon invited to design them as well. They lived for a year and a half in Italy, where she molded "free-form" works and studied at a school that taught factory workers to throw. She had a wheel built and set it up in her apartment, and she found a local factory that liked the novelty of her work and fired it for free. The staff at

the factory introduced her to the design magazine *Domus*, which published her work.

Back in the United States, Karnes entered pieces she had made in Italy in the Ceramic National of 1951 and won a purchase prize. She spent a year at Alfred, and then she and Weinrib were offered the opportunity to work as resident potters at Black Mountain College. They used a workshop and stoneware kiln built by Robert Turner (see chapter 9). Leach and company came that fall; Karnes said, "Watching Hamada work was the most important ceramic instruction I, as a young potter, could have."[21] The next summer Karnes and Weinrib invited Warren MacKenzie, Daniel Rhodes, and Peter Voulkos to conduct workshops. They remained at Black Mountain for more than two years. Karnes never went back to Alfred. She remembers few actual students at the Black Mountain pottery, but it was an ideal place to begin, a protected but culturally stimulating environment.

In 1954 Mary Caroline (M. C.) Richards, a poet and potter (and later author of the classic *Centering: In Pottery, Poetry, and the Person* [1964]) invited them to join her and others, including composers David Tudor and John Cage, in forming the Gate Hill Community of artists in Stony Point, New York. The three ceramists shared a kiln. Karnes and Weinrib rapidly achieved success in ceramics and were recognized in the Ceramic Nationals, Karnes with functional pottery, Weinrib with sculpture and tile murals. They subsequently divorced and parted ways creatively. Weinrib turned to sculpture in plastics and other materials; Karnes, although her forms and purposes have shifted, continues to concentrate on ceramics.

She had worried about how her subtle, domestic works would fare in the New York area, but she found support from the American Craftsmen's Council and Bonniers. In 1957 she met the owner of a New Jersey clay mine who offered her free clay. A ceramic engineer, he lectured her and Richards on potters' technical ignorance, asking why they did not use flameproof clay. Karnes began producing a flameproof casserole, which was an immediate success. (Figure 7.4) It sold for about $35, a considerable sum then, but became a standard production item. It is broad and low for even heating, with a wide mouth for ease of serving and cleaning. The color could be regarded as neutral or as referring to the landscape, and against this sobriety she capped the lid with a twisted ribbon handle that seems almost giddy in comparison.

In the decades since, Karnes became known for salt glazing; the salted surface sheen brought out a subtle eroticism in the contours of her forms. She continued salting until she left Gate Hill (after twenty-five years) and then abruptly shifted to creating distinctive wood-fired effects, quite unlike the Japanese style. She attended a kiln-building workshop at the Pennsylvania farm of Paulus Berensohn (later the author of the philosophical how-to, *Finding One's Way with Clay* [1972]), led by Ann Stannard, an English potter who eventually became Karnes's life partner.

Karnes's functional forms are sturdy, stable, and practical looking. Their simplicity often gives them a sense of monumentality. She has exploited expansive effects of horizontal finger ridges and used both contours and colors that allude to landscape. Storage jars, for example, have a slightly raised lid combed to hint at furrowed fields. She acknowledges influences from many cultures—African granaries, Egyptian and Cycladic sculpture, pre-Columbian weaving and clay in addition to the natural world—but the sources are always imperceptibly blended. Once she began making nonfunctional forms, the specifics of her work changed frequently: vases with disk-shaped lips, long-armed forms, multimouthed vessels, segmented nesting bottles. Fifty years ago, Karnes was described as "an unassuming artist" and one with "an affinity for the 'completeness' of form."[22] The characterization holds.

Another important ceramist couple at midcentury, **Vivika and Otto Heino**, both came to clay after doing other work. (Figure 7.5) Vivika Timeriasieff (1910–1995) went through a three-year program in Rochester, New York, and in 1933 graduated from the Colorado College of Education (now the University of Northern Colorado) with a degree in fine arts. In California she studied wood carving and weaving, was a puppeteer with a WPA marionette theater, assisted Henry Varnum Poor on a mural, and began to take ceramics classes. She learned to calculate

FIGURE 7.4. *Karen Karnes*, Flame Proof Casserole Dish, 1957. *Stoneware; 8 × 14 in. (Courtesy of Garth Clark Gallery.* © *Karen Karnes.)*

FIGURE 7.5. *Vivika and Otto Heino*, Brown Bottle, 1950. *Earthenware, glaze, resist decoration; height, 6 in.; diameter, 4.5 in. (Schein-Joseph International Museum of Ceramic Art at Alfred University, 1995.239. Photograph by Brian Oglesbee.)*

glazes by reading Charles Binns's book, started producing, and obtained department-store commissions (an exceptionally independent course for a young woman at the time). She was subsequently Glen Lukens's lab assistant at the University of Southern California, Alfred's second MFA graduate, an independent potter in New York, and then assistant director of the League of New Hampshire Craftsmen.

It was there that she met Otto Heino (1915–2009). He grew up on a New Hampshire farm, one of twelve children. On leave from the military during World War II, he visited the Leach pottery in England, although he had not heard of Leach at the time. He studied ceramics from 1949 to 1951 with Vivika. After marrying in 1950, they were still peripatetic: she taught in California from 1952 to 1963, here and there on the East Coast after that, and then in 1973 they bought Beatrice Wood's house in Ojai and moved back to California for good.

In their long, varied careers, Vivika was known as an artist, an energetic and emotional personality, and a teacher of technical mastery, committed to sharing information; Otto was an exceptional thrower with a good eye. In contrast to their geographic shifts, their commitment to functional form never changed. They explained their

pottery-making partnership only by saying, "We work well together." Both signed all the works, which were about half porcelain and half stoneware. The constancy for which they have been praised entailed steady production of simple, resolute forms, but their ware is not repetitive. There are tall, cylindrical vases; almost conical, flaring bowls; plates with strong concentric texture or flat, narrow, outward-sloping rims; classic bottles with lively swelling forms; some figurative objects; a flattened sphere with five spouts; and more. Most vessels have a fairly flat, tight glaze, and often there is brushwork or resist design, always in harmony with form.

CAUGHT UP IN TEACHING

As the ceramics field grew in size and complexity, a number of individuals became known for their teaching and administrative achievements and often for their writing as well as (or instead of) for their work. Typically teachers paid a price in lack of time to develop their work, recalling the story of Charles Harder. Two important teachers at Alfred, Daniel Rhodes (see chapter 8) and Ted Randall, were able to create bodies of work near or after their retirement.

From 1951 to 1981, **Ted Randall** (1914–1985) led Alfred into the status of full-fledged art and design school. He was also one of the founders of the National Council on Education for the Ceramic Arts. He served on public councils and commissions and in various departments; maintained a pottery-equipment business marketing his potter's wheels and kiln designs; and designed his own modernist house.

This last may be a key to Randall's work, which has a striking architectonic quality as well as being monumental and self-consciously historical. He had taken a BFA at Yale in sculpture and, after failing to make a living, returned to school for an MFA at Alfred in 1949. In doing so, he was returning to his roots, for he was the son and grandson of editors of the *Clay-Worker*; his father, James, had studied under Binns, and also published technical books.[23] Service to the field must have been in his blood. He retired to part-time teaching in 1975 and had a major show in 1976, but unfortunately he lived only another nine years. While in the 1950s he made functional works (now mostly lost), the late works were more totem or dolmen than container. They evoked a sense of purposeful stillness and an effect of weight. They are distinguished by incised grids on the sides, which are sometimes punctuated with holes, dotted with raised circles, or often scarred with raised alphabet-like elements. Their sturdiness is elemental, and their allusions are archaic.

Susan Harnly Peterson (1925–2009) is best known for her teaching and writing. She studied at Mills College and at Alfred and came to Southern California to teach at Chouinard and USC. Among her students was Ken Price; John Mason was an assistant. The indefatigable Peterson had an educational television program, *Wheels, Kilns, and Clay*, which aired in Los Angeles for two years during the late 1960s, and she published a book of the same title. She subsequently established a ceramics department at Hunter College in New York. Peterson wrote monographs on Shoji Hamada, Maria Martinez, and Lucy M. Lewis, plus many other books. Her work was all wheel-thrown, and she described herself as interested in opposites: "the excitement of glaze exploration at high temperatures, particularly with the elusive copper blues and reds . . . and the stark natural beauty of the unglazed clay surface."[24]

Antonio (Tony) Prieto (1912–1967) was born in Spain and came to the United States at four years of age. He studied sculpture at the California School of Fine Arts in San Francisco and ceramics, painting, and sculpture at Alfred. In 1946 he began teaching at the California College of the Arts and Crafts, where he professionalized the program and built its first kilns for stoneware temperatures. He became involved with the Mills College Ceramic Guild, organized by F. Carlton Ball, who taught there. When Ball left, Prieto took the position and taught at Mills until his sudden death in 1967.

Prieto was probably the most respected of California's teaching potters and achieved a national reputation (showing in the Ceramic National from 1947 on). He exhibited internationally after he represented the United States at Dartington Hall in 1952, and he won a silver medal at the First International Ceramics Festival at Cannes in 1955. Later, on a Fulbright fellowship, he went to Spain, where he met Joan Miró and his ceramics collaborator, Josep Lloréns Artigas.

Prieto's work sometimes showed Asian influence in glazes and elegant calligraphic markings, yet these and figurative surface treatments—sgraffito or trailed slip—also related to the international abstract art of the time. (Figure 7.6) His robust forms contrasted with the spidery surface markings. Among his favored shapes were a square stoneware bottle with a narrow neck, its wide midsection divided into gray and brown, and a tall, tapering vase with a sharply flared lip. He also made bulbous forms with miniature necks and mouths that today we would call classic weed pots. Mills College houses the Prieto Collection, established as a memorial and including more than 400 works donated by ceramists in his honor.

Harold Eaton (Hal) Riegger (1913–2005) taught in Connecticut, Pennsylvania, and California schools as well as privately from his studio in Mill Valley, California. In between teaching stints, he worked as a technician at the Oregon Ceramic Studio in Portland and was a designer-manager at Miltonvale Potteries in Kansas and a technician for Heath Pottery in the Bay Area. He is best known for his advocacy of simple and natural materials and of raku pottery.

Riegger graduated from Alfred in 1938 and did his graduate work at Ohio State.[25] He became interested in raku in the late 1940s, and thereafter he stopped working on the wheel and began to beat on the clay with a piece of wood or with his fists and to layer strips of clay or to combine clay with wood, metal, or rope, going to the extreme of making pottery without studio equipment. He published several books, including *Raku: Art and Technique* (1970) and *Primitive Pottery* (1972) and is distinguished

FIGURE 7.6. *Tony Prieto, Bottle, n.d. Stoneware, sgraffito design; height, 14 in. (Crocker Art Museum, Gift of the Artist, 1959.2. © Mark Prieto.)*

as an "alternative" figure for his development of direct engagement with his material.

ALMOST LOST: LEZA MCVEY

Leza McVey was almost lost to history and was saved primarily by Martin Eidelberg's slender 2002 book on her work and life.[26] Her story illustrates how arbitrary circumstances and social conditions shape the history of art as much as talent does. McVey was a pioneer of

FIGURE 7.7. *Leza McVey, Ceramic Form No. 25, 1951. Stoneware; height, 14.5 in. (Collection of Everson Museum of Art, Syracuse, N.Y., Purchase Prize given by Harshaw Chemical Company, 16th Ceramic National, 1951, 52.635.1. © Estate of Leza McVey. Photograph courtesy of Courtney Frisse.)*

nonsymmetrical ceramics in the postwar era. She may have picked up on the biomorphic forms of surrealism, which found its way into American design in the early 1940s and so-called Googie architecture in the 1950s. Or she may, as she said, simply have been bored with the regularity of thrown vessels and the propriety of ceramic forms of the 1930s and 1940s, no matter how adventurous their glaze surfaces were.

McVey (1907–1984) graduated from the Cleveland School of Art in crafts but also studied sculpture with Alexander Blazys. She met Bill McVey, a sculptor who had returned to Cleveland after two years in Paris. They married in 1932 and moved to a farm outside Cleveland while he taught and began to make a name for himself. She happened to drink unpasteurized goat's milk and contracted brucellosis, also known as undulant fever, which caused persistent weakness—she could not work for two years—along with chronic eye trouble that progressed to near blindness.

During the Depression and wartime, the McVeys moved repeatedly for his teaching jobs and military service. In 1947 he was offered a one-year contract at Cranbrook that turned into a longer stay, and Leza's life changed. She had previously done a little teaching, created a multiple (an ashtray) that was sold by Neiman Marcus, and repeatedly struggled to establish suitable studio and kiln arrangements. At Cranbrook they lived in faculty housing in an art-focused community, and she had access to the ceramic studios, where her work was encouraged by Maija Grotell.

Under these favorable conditions, McVey experimented. Her early works there show traces of Grotell's textures and colors, the Paul Klee–style linear decoration being popularized by Edwin and Mary Scheier, and oriental glazes from Leach's *Potter's Book*. She was attracted to celadons, and she collected ashes from various Cranbrook fireplaces for glazes. After a few asymmetric press-molded dishes, she created a stoppered vessel that she named Pottle. The tall, manipulated form rises in irregular curvature to a narrow and off-center neck. From this breakthrough, she began to build her forms with slabs, coils, and pinching, turning her back on the increasing popularity of wheel-throwing. (Figure 7.7)

McVey's works grew larger, to two or three feet tall. Their vertical movement reached a terminal blossom in the curious stoppers, some of them like minuscule Noguchi or Henry Moore sculptures. The stoppers, more than any other single feature, define the personality of the vessels and seem to lead them gradually toward zoomorphism, a suggestion amplified by the addition of feet in the 1950s. Yet her intention was surely abstract, which

she emphasized by calling the works "Ceramic Forms" and occasionally using planes among the curves.

All this was exceptional—Voulkos was still making neat, wax-resist decorated forms when McVey was staking out new ground. She held to the palette of Leach's glazes, which seemed drab to people then, after the bright colors of the 1930s. When her choices were challenged, she retorted that too many ceramists used bright colors to disguise dull forms. Her work was featured in *Ceramics Monthly* during its first year of publication (1953) and in the Walker Art Center's *Everyday Art Quarterly*, also in 1953.

The dynamic in this artist couple may have been strained, however. After Leza's success with the Neiman Marcus ashtray, Bill began making ceramic ashtrays and boxes; after she began to submit entries to Ceramic Nationals and the Wichita Art Association's Decorative Arts and Ceramics exhibitions, so did he—and his work, more in tune with the times, received more awards. The complicated role of wife and helpmate with talent may have led her to avoid other instances of potential competition, such as teaching at Cranbrook. The novelty of *Ceramics Monthly*'s attention to her work was not to be hers alone, since Bill appears with her in the photograph for the article, wearing an artist's smock as if he had just stepped in from his studio.

The Cranbrook idyll ended when Bill was hired to head the sculpture department at the Cleveland Institute of Art, a triumphal return.[27] There Leza's work was appreciated as daringly new. In 1965 the institute presented a major retrospective of seventy-five of her large works, set into a strikingly architectural installation of diagonal walls devised by jeweler John Paul Miller. Around this time she began making spherical or cylindrical lidded "receptacles" with slabs for feet, handles or finials, and bold applied patterning and new color, works that, had they been more widely seen, would have connected with the current pop art style.

By 1979 her deteriorated vision brought her ceramic making to a close. Bill McVey was a respected and successful sculptor of public works as well as modest-scaled pieces, but Leza's work, recaptured from oblivion, seems the more inventive and predictive of the future.

THE PIVOT POINT: PETER VOULKOS

The importance of Peter Voulkos (1924–2002) in twentieth-century American crafts is sometimes overstated, but in certain respects it cannot be exaggerated. It is possible to regard him as the pivot point at which the entire century's craft making took a striking turn, and it is this and his intense energy and charismatic personality that make him the shorthand explanation for a complex period of reevaluation and change. He became a myth within his lifetime. His early sculptural work, unquestionably remarkable and unforgettable, was, however, not the sole exemplar of the new understanding in American ceramics. In scale and expressive form, it is probably exceeded by the concurrent work of his student-turned-studio-mate, John Mason. Others who were his students in his first teaching job, at the Los Angeles County Art Institute (generally referred to as Otis, the school's previous and subsequent name) made works of major impact that rival his in their inventiveness. Other ceramic achievements sometimes claimed for Voulkos—the first sculptures, the largest works, the first link to contemporaneous art movements—have already been disproved by the histories in the previous chapters of this book.

He was, nevertheless, seminal. Even a casual reading of the 1950s issues of *Craft Horizons* shows what a difference he made. His name first appears as the winner of prizes in various competitions, beginning when he was still a student; then for his residencies and workshops; then for his new teaching job in Los Angeles and the school's building plans. A review of his 1954 show at America House described him as "one of the outstanding potters of our time," and then a 1956 interview by Conrad Brown, the editor-in-chief of *Craft Horizons*, opened by calling him "the most discussed ceramist in California today" and presented his forceful and articulate expression of his new ideas. "Pottery has to be more than an exercise in facility—the human element, expression, is badly neglected," Voulkos told Brown.[28] His New York show at Bonniers in 1957 was briefly but admiringly reviewed by the magazine's new managing editor, Rose Slivka, who was to be the main chronicler of his career.

From then on, sparks flew. Voulkos was criticized in a letter to the editor after his own students were top prize-winners in a show he juried, and he responded with a statement designed to inflame rather than placate:

Ceramics as an art form is at low ebb and could justly use a kick in the pants. I for one, am quite confident that it will take quite a bit more than a bean pot with or without Albany slip glaze to pull it out of its doldrums. My point of view, of course, has no meaning for those who still dwell under the illusion that making a tea cup is great art. But there still are the self-searching and serious few who really count. These few do not have to be told, as they feel what it's all about. It is truly their lives. Of course, there are good tea cups and mostly bad and it takes a high degree of intention to pull one off, but the fact still

Rose Slivka, the Poet of Pete

Rose Slivka—poet, writer for women's magazines, wife of a sculptor, and friend of Elaine de Kooning and many soon-to-be-major figures of the New York school—started with *Craft Horizons* in 1955 as associate editor under Conrad Brown; she moved up to his editor post with the November–December 1959 issue. With Slivka and Brown's arrival, the magazine turned increasingly away from "how-to-do-it" articles and reports from clubs and associations to more professional and art-critical reporting. Her striking and permanent change to the literature of American craft was in introducing the observation and feeling of poetry along with her conviction that craft was capable of metaphor and thus the expressiveness of painting and sculpture. As editor, Slivka encouraged contributions from important writers and thinkers outside the field, and she eventually supervised a substantial review section in the magazine. Unfortunately both she and John Coplans, the other important critic for early postwar ceramics, tended to write of ceramics in terms of painting or sculpture.

In Voulkos, Slivka found her ideal subject: a larger-than-life figure whose vitality excited her imagination and whose work had the great aspirations and heroic dreams of her own writing. Although her often-celebrated 1961 essay "The New Ceramic Presence" did not, in fact, introduce Voulkos to the art world, as is sometimes claimed, it was a paean to the new direction in crafts and set *Craft Horizons* firmly on the side of the new. Slivka's book on Voulkos, published in 1978, was the first contemporary-craft monograph. She also wrote about him for art magazines and later adapted her original essay for a catalog published by the Oakland Museum of California. For all her acute observations of his work, she may be most remembered for her extraordinarily intimate description of his physical character:

> The big-boned Peter Voulkos—wide pelvis and barrel chest, wide back, powerful shoulders, and long, surprisingly thin arms, big supple hands, large palms with slender, tapering long fingers and curving thumb. He walks on bowed legs, as if he were a cowboy, which he never was (he does not even ride a horse; he is a broncobuster of the pickup truck, considered a more masculine and practical skill in the new West), long slender feet toed inward in his pointed flamenco boots. . . . Over the short, thick, strong neck looms his long jaw and prominent chin with lower dental palate pushed forward, somewhat like a Neanderthal man's; long nose hanging over the wide, grinning mouth, booming basso gravel voice gentled with western twang, hazel eyes with the clear fierce piercing look of a hawk. A part of the Voulkos charm is this sense of primitive strength vested in an intuitive and sharp intelligence.[1]

Slivka was replaced as editor in 1979, when the magazine changed its look, name, and orientation. She subsequently started a newsletter for the World Crafts Council and later wrote art reviews for the *East Hampton Star*.

NOTE

1. Rose Slivka, *Peter Voulkos: A Dialogue with Clay* (Boston: New York Graphic Society, 1978), 5–6.

remains that it is just a tea cup even at its best. Why hold such a limitless medium as ceramics to this level of thinking? . . . From my jurying experiences I have come to the conclusion that most handcraft objects are made according to narrow sets of rules. There are too many rules and too little feeling. How is it possible to create *without* excitement?[29]

Things got more exciting once Voulkos was around. Born Panagiotis Harry Voulkos in Bozeman, Montana, to Greek immigrants—his father was a cook—he was familiarly known as Pete. He was part of the genera-

tion presented with the unexpected opportunity to go to college as a result of the GI Bill. At Montana State College (now University) in his hometown, he studied painting but took a required ceramics class and discovered he had a gift. The teacher, Frances Senska, was just a few years older than her students, and although she took classes with Edith Heath, Maija Grotell, and Marguerite Wildenhain, she was just learning herself as she established the classes. The situation was open and experimental, and Voulkos and other students sneaked into the building at night to work with clay—an environment he would later re-create at Otis.

Voulkos graduated in 1951, a skilled thrower and adept decorator. He had already won first prize at the 1950 Ceramic National for bottles using his own combination of wax and inlaid slip to create decorative line. It was a coup for a student from an artistically isolated region.[30] Voulkos then forayed to Oakland to study for an MFA at the California College of Arts and Crafts. He returned to Montana for the summer to work at the brickyard of Western Clay Manufacturing Co., along with his friend from Montana State, Rudy Autio, and Kelly Wong; they were allowed to use the facilities for their own work as well. The owner, Archie Bray, had aspirations to build an art center. When Voulkos and Autio completed their graduate work in 1952, they became resident artists at the new Archie Bray Foundation, which they had helped build—literally, from forming and firing bricks to raising the pottery building.

In the summer of 1953, Voulkos, known for exemplary conventional pots, taught a three-week workshop at Black Mountain College, which made a strong impression on him. Few of the people he met there were already famous, but many would be. More important was their avant-garde thinking. Afterward, he drove to New York with M. C. Richards and David Tudor and there met some of the established New York School painters. It was a heady experience. "He came back to Helena," Autio later said, "But he was never the same again. It must have been about the most important thing that had happened to him up to that time."[31]

The next year, Voulkos left the Bray to teach at Otis, where he started the ceramics department from scratch. One student showed up immediately—Paul Soldner. Together they built wheels, tables, shelves, and, with technical help, a kiln. Within two months, the workshop was ready. Voulkos did not have a studio of his own, so he used the school's space as he had used the communal workshop at the Bray.

And that seems to have been the key: Voulkos did not teach so much as inspire by the example of his energy, curiosity, and enthusiasm, first among equals. Soldner called it "osmotic education."[32] The workshop was an arena for action, open to all competitors. Not everyone who worked at Otis was actually enrolled there; as Voulkos's reputation grew, people just showed up to work with him at all hours, because the pot shop was open twenty-four hours a day. (Otis was the unwitting provider of materials and fuel for this random population.) Students were reluctant to go home to their families, afraid they would miss something.[33] And they challenged one another on any point—largest, fastest, whatever. In this testosterone-fueled environment, it is hardly surprising

Archie Bray Foundation

Archie Bray had a degree in ceramic engineering from Ohio State and was a successful businessman, running Western Clay Manufacturing Co., one of the larger brickyards in the mountain region, on the outskirts of Helena, Montana. Enormous beehive kilns fired as many as ten million bricks and tiles per year. He was an advocate of the arts, an amateur pianist who would travel to New York every year to immerse himself in opera and theater and who sponsored concerts in Helena. He also had a modest art collection.[1] In 1951, with his friends Branson Stevenson (an oil-company salesman who was also a painter and potter) and Peter Meloy (a lawyer and potter), he laid the groundwork for an art center. The beginning would be a pottery, since that was closest in nature to the existing business; it would be open to all serious ceramists as "a fine place to work."

Voulkos and Autio labored on preparations over the summer of 1951, and Lillian Boschen, who had studied at three schools in the Bay Area, arrived in October 1951 as the foundation's first resident artist, teaching classes and making her own work. She was replaced by Voulkos as the potter on site when he finished his graduate degree, and Autio filled a sculptor role. They taught and did production work, making small items that could be sold to raise money for the pottery; their wives, Peggy Voulkos and Lela Autio, also taught classes and made enameled ashtrays for sale. A high point of the early days was the visit of Leach, Hamada, and Yanagi.

The pottery ran into difficulties, and the question of its future became acute when Bray died suddenly in 1953. The story might have ended there, but Archie Jr., surprisingly, decided to continue supporting the foundation as a tribute to his father. It limped along, always short of money but serving the needs of local amateurs through classes and those of more professional potters through occasional workshops by such figures as Marguerite Wildenhain.

NOTE

1. Rick Newby and Chere Jiusto, "'A Beautiful Spirit': Origins of the Archie Bray Foundation for the Ceramic Arts," in *A Ceramic Continuum: Fifty Years of the Archie Bray Influence*, ed. Peter Held (Helena, Mont.: Holter Museum of Art; Seattle: University of Washington Press, 2001), 19.

Abstract Expressionism

The New York school painters, also known as action painters and abstract expressionists, began to exhibit in the 1940s, most of them with surrealist-influenced work. These artists—the best known are Jackson Pollock, Willem de Kooning, and Mark Rothko—did not work in the same style but shared an attitude. Their work emphasized individuality, spontaneity, emotional intensity, rebelliousness, and grand scale. Abstract expressionism was the first specifically American style to gain worldwide influence, and it put New York on the map as an art center. It was most ardently promoted by Clement Greenberg and Harold Rosenberg (the latter coined the term "action painting" and called Pollock's work "not a picture but an event").

The Marer Collection

Fred Marer was a man of modest income, a teacher of mathematics at Los Angeles City College who bought a bowl by Laura Andreson and began to pay attention to ceramics. He saw a small piece by the new teacher at Otis and contacted him to ask if he could buy it. Voulkos agreed, but the piece somehow disappeared. Nevertheless, it brought Marer to the Otis workshop, where he became interested in the activities and the energy of the young artists. He began to stop by after work or on weekends and buy works straight out of the kiln. He got to know the artists, gave them gifts of food, or paid a little more for a piece when he knew they needed the money. Before long, people said that his wife had only a closet and the kitchen to call her own, because the rest of the house was full of ceramics. Marer had amassed about 900 works by the time he gave the core of the collection to Scripps College in 1993.

that there were few women students, though among them was Martha Longenecker, later the founder of the Mingei International Museum in San Diego. The best students—Soldner, Mason, Price, Henry Takemoto, Billy Al Bengston, Michael Frimkess, Jerry Rothman, and others—were provoked and energized by Voulkos but managed to find their own paths. Things were made for the experience and for the discovery; when the space began to get crowded, they were thrown away. That is when Fred Marer began buying.

Voulkos, a voracious consumer of visual information, swept his students along with him to galleries and museums (as well as jazz clubs and beer joints). Even in Montana, he had pored over magazines and books to see what had been done. He later would say that he had thrown his early works large because he had not realized the small size of the works he was seeing in illustrations (a typical self-deprecating joke). Over the years he admitted to an enormous number of influences. During the Otis period, the ceramics of Miró and Picasso were important: Picasso's unorthodox combining of wheel-thrown forms and painting surfaces to deceive the eye rather than to respond to the form spurred Voulkos's imagination, given his continued interest in painting.[34] Japanese brushwork interested him for the same reason.

At that time, the Japanese work of special interest was the prehistoric Jomon, with its grandeur of scale and bare surfaces, and Bizen and Shigaraki pottery, with their acceptance of cracks and other flaws.[35] Voulkos also cited Japanese prehistoric *haniwa* (figures with holes for eyes and mouths), Chinese and Korean ceramics, Noguchi's unglazed ceramics, and Henri Matisse's collage cutouts.[36] He was of course responsive to abstract expressionist painting. Other current thrills were the stencil and cutout works of Conrad Marca-Relli, which he saw at the Los Angeles County Museum and which inspired him to try stenciling on his pots; a Miró exhibition in 1956 that encouraged a brighter palette achieved with low-fire glazes and epoxy paints (both heresy on stoneware); and a show of sculptures by the Austrian Fritz Wotruba in 1957 that directly prompted Voulkos to stack rocklike thrown forms.[37] It has been observed that Voulkos was acutely conscious of being in an art-school context[38] and that he was restless now that he was free of the Bray's production demands.[39] He may also have been affected by seeing the piled masses of raw materials at Bray's brickyard.[40]

Back in Montana over the summer of 1955, Voulkos made his first assemblages of pots, "shaped from the inside and shaped from the outside, done in a very plastic state."[41] *Rocking Pot* of 1956 affronts pottery convention with its rudely perforated structure, the crude weight of the elements, and the very idea of providing for instability in a vessel.[42] In 1957 he began stacking and cantilevering, escaping ceramic symmetry.

That year Voulkos and Mason set up a studio, where they commissioned the building of a high-fire kiln that may have been the biggest private kiln in the country, 120 cubic feet of interior space. Voulkos's most famous works of the Otis period were those inspired by

the Wotruba show, stacked and precariously balanced volumetric elements. While the difficulty of large-scale ceramics meant frequent kiln failures, Voulkos produced many magnificent pieces in this phase, including *Black Bulerías*, which won the Rodin Museum Prize in Sculpture at the First Paris Biennale in 1959. (Figure 7.8) This five-foot-nine-inch aggregation has an integrated base on which are piled perhaps a dozen stony forms, most with irregular planar surfaces. They seem to have tumbled into place. A few slivers of light pass through the joints. Again, however, a relationship to pottery precedent gives them a particular impact. Voulkos had not abandoned ceramic volumes but simply displaced them around an axis in an invigorating way. Other works during this period involved simpler shapes disturbed by the application of color, and others consisted of more and smaller elements, many cut or torn open.

In December 1958 Voulkos's first solo museum exhibition opened to acclaim at the Pasadena Art Museum (now the Norton Simon Museum). Most of that work was presented in February 1960 in the Penthouse Gallery of the Museum of Modern Art in New York. It was reviewed by Dore Ashton in the *New York Times* but otherwise went unremarked by the art world. Probably the lack of response put an end to any thought of relocating to New York—although he taught summer workshops at Greenwich House Pottery and Teachers College at Columbia University from 1959 to 1964.

In the meantime, in 1959, the Otis administration, which had hired a classic potter and watched him turn into a subversive, terminated Voulkos's employment. He was immediately hired by what was then the department of decorative arts at the University of California, Berkeley (when it was phased out in 1976, he became a full professor in the art department). He accrued around him in the Bay Area a new set of students, who went on to create important work quite different from his own, notably Jim Melchert, Ron Nagle, and Stephen De Staebler. He continued to commute to his Southern California studio until 1960 or 1961, when he completed a commission for the sculpture known as *Gallas Rock*. He brought his former and new students into contact through these frequent trips.

After about two years at Berkeley, Voulkos began to work in metal. With Harold Paris, Don Haskin, and later Julius Schmidt, he established a foundry for casting bronze, called Garbanzo Works, in an industrial section of Berkeley. This studio adopted the same loose, experimental, party atmosphere as Otis. He followed somewhat the same working methods, creating a cache of forms that he would assemble into expansive linear works in

FIGURE 7.8. *Peter Voulkos*, Black Bulerías, 1958. *Stoneware with slip, gas-fired; 65 × 44 × 41 in. (Collection of John and Mary Pappajohn. © Voulkos & Company.)*

bronze, structures that the physics of clay would not permit. In 1967 Voulkos won a commission for a major work at the San Francisco Hall of Justice. He produced a thirty-foot-tall construction consisting of a rectilinear table and tower that serve as a stage set for knotting and snaking tubes and a variety of cut spheres or ellipses. Another major work, *Mr. Ishi*, is owned by the Oakland Museum: a bronze sculpture eighteen feet high and forty-nine feet wide combining long, straight tubes that seem to shoot across a plaza, along with compacted, curled tubes and disassembled circular volumes. The piece is entirely unpredictable, even incoherent, yet it seems to dance a jig in the bland concrete arena given to it.

Voulkos's foray into metal was quite successful, with both corporate and museum purchases and commissions, yet it lasted only a decade. Various reasons for the termination have been suggested: the large works required a planning orientation that did not suit him; he missed the speed of clay work; he missed an audience. Considering that his new ceramics beginning at the end of the 1960s

featured slashes, punctures, and "pass-throughs" (porcelain pebbles inserted into stoneware), it may be that what he missed most of all was the responsive surface of clay. His second career in clay is discussed in chapter 9.

RUDY AUTIO

The pairing of Rudy Autio with Pete Voulkos is natural. Voulkos wrote in the foreword to a book about Autio, "From the beginning we had a lot in common; we had clay, music, guitars, art, Montana, immigrant parents, new families, no money, military service, the G.I. Bill, athlete's foot, and a passion for making stuff."[43] But Voulkos was the export version, Autio the domestic model. Autio stayed mostly in Montana, becoming perhaps the major producer of public sculpture in the state, a beloved teacher, and an admirable family man.

Autio (1926–2007) was born in Butte to Finnish immigrants. His father (whose name was altered from Vanhatalo at Ellis Island) worked in the mines; his mother was a maid in a boarding house. After high school Autio joined the navy, and although he never left the United States, his service allowed him the GI Bill entree to college. He started in architecture but quickly switched to art and was in Frances Senska's first class at Montana State, along with Lela Moniger—who became his wife— and Voulkos. He took life drawing in college and did cartoons and caricatures but decided sculpture was his future. He was influenced by Carl Milles, whose elongated figures in classicist compositions were much admired at the time. Some of the same qualities can be seen in Autio's early monumental reliefs. After graduation he hoped to teach high school art but could not find a job, so he spent two years in graduate school at Washington State University in Pullman.

Like Voulkos, Autio spent the summer of 1951 working in the Western Clay brickyard in Helena and returned in 1952 as resident artist. When they had time, both made their own work, Voulkos throwing and Autio coiling. Until they built a large gas-fired kiln for high-fire wares, they fired their work on top of the bricks in the huge beehive kilns. Autio also began to make architectural works. His first large piece was an eight-foot medallion relief of a Native American writing on a skin that he made for the University of Montana Liberal Arts Building. It is an example of what Frances Senska described as "this very strong northern, Nordic kind of imagery, a Finnish, almost Oriental look to it . . . always different from what everyone else was doing."[44] The piece has a WPA mural majesty, yet the figure is oddly proportioned, with short arms and long legs, a disparity that would only be accentuated by viewing it from below.

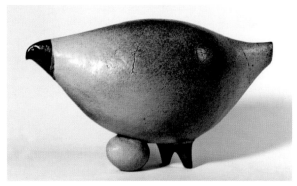

FIGURE 7.9. *Rudy Autio,* Bird and Egg, *early 1950s. Stoneware; 13 × 23.5 × 9.25 in. (Courtesy of the American Ceramic Society. © Lela Autio. Photograph by Louana Lackey.)*

Autio's style and capability changed with the learning processes of each commission. He cast in terra-cotta, or he carved brick; works were religious (for churches) or had a historical bent. They were stylized, representational, or abstracted, but rarely abstract. He made a portrait bust of Archie Bray in 1952 and the thirteen-inch-high simplified *Bird and Egg*, which was published in *Ceramics Monthly* in the magazine's inaugural year, 1953. (Figure 7.9) It is a Brancusi-esque reduction to elemental form that nevertheless has a cartoony charm. A 1955 stoneware slab sculpture thirty-two inches high is an accretion of horizontal elements supporting stacked forms. Autio also made large and small slab vessels with expressionistic poured and brushed glazes.

Voulkos left the Bray to teach in Los Angeles in 1954, but Autio stayed on until 1956. In 1957 he was hired by the University of Montana to teach ceramics and eventually to add architectural decoration to campus buildings as well. Within a few years Autio, like Voulkos, was working in metal. A strong piece was the *Freestanding (McAuslan) Sculpture* he made in 1969 for Montana State, a graceful sixty-six-by-forty-three-inch assembly of waving steel slabs, organic and animated, unfortunately now lost. He also used metal for architectural reliefs, worked in cast cement, and designed stained glass. His arrival at the clay work for which he is best known will be discussed in chapter 10.

THE OTIS GANG

Paul Soldner (born 1921) is known for being Voulkos's first student at Otis, developing an equipment business, throwing pots to astonishing heights in one continuous process, teaching at Scripps College and guiding the Scripps Annual, more or less inventing American raku, and founding the Anderson Ranch Arts Center in Colorado. That's a lot.

Soldner was born in Illinois to a Mennonite family. He attended Bluffton College in Ohio as a premed student, and during World War II, as a conscientious objector, he was assigned to a medical detachment in Europe. After the war he returned to Bluffton but not to medicine. He became an art teacher. Deciding he needed more education, he used the GI Bill to finance four summers at the University of Colorado, Boulder (later buying land outside Aspen).

Looking for an MFA program, he asked potters Jim and Nan McKinnel, who told him that Voulkos would be heading a new program at Otis. Soldner already knew the name from seeing illustrations of prizewinners in *Craft Horizons.*[45] He arrived at Otis in September 1954 and for several weeks was the only student in the program. Voulkos treated him as an equal—not surprising considering that Soldner was three years older and that Voulkos had no experience with college teaching. The two began to find or build what the new department needed. Soldner produced a wheel inspired by the truss design of a wheelchair that was lighter, lower, and less cumbersome than most kick wheels at that time. Easily disassembled, it would fit in the trunk of a car. Voulkos, delighted, ordered eight, thus beginning the Soldner Pottery Equipment Company.

Although Soldner, like so many at the time, was interested in Zen philosophy, he was reluctant to make asymmetrical pots. Instead, he made them tall through "extended throwing." (Figure 7.10) He added rolls of clay to the pot he was throwing and pulled it up, rigging a foot pedal that allowed him to operate the electric wheel even when he was standing on a stool. The forms—which Soldner asserted with some amusement were the tallest cylinders ever thrown[46]—had irregular profiles that suggested the surging process of their growth. He decorated sparingly with poured slips and glazes or made calligraphic marks.

Soldner found a nearby one-year job teaching at Scripps while Richard Petterson was on leave. It was extended and in 1960 became permanent. It was also in 1960 that Soldner turned to raku (see chapter 8).

John Mason (born 1927) was likewise more a peer than a student of Voulkos. A quiet man, Mason may have personally operated in the shadow of Voulkos's outsize personality, but his work was remarkable. He would eventually engage a wide range of idioms—expressionism, minimalism, conceptualism, and, in his work at the end of the century, near figuration—to outstanding effect. He ultimately proved to be more versatile and more lastingly inventive than Voulkos. Although Voulkos retains credit for sparking the midcentury shift in

FIGURE 7.10. *Paul Soldner, Untitled Floor Vase, 1956. Wheel-thrown and assembled stoneware, glazed and high fired; height, 56 in. (Collection of The American Museum of Ceramic Art, 2004.1.044. © Paul Soldner.)*

ceramics, Mason was not overwhelmed by his influence and was, in Voulkos's words, "his own man."

When Voulkos arrived in Los Angeles in 1954, he visited other schools to see their studio setups. Mason, then assisting Susan Peterson at Chouinard, was immediately struck by his energy and openness. He visited Otis, registered for evening classes because he was working as a production potter for Vernon Kilns, and signed on with Voulkos from 1956 to 1957.

At Otis, Mason began with large jars that he marked with strong black lines inspired by Franz Kline's paint-

FIGURE 7.11. *John Mason, X Pot, 1957. Hand-built stoneware, paint; 14 × 9 × 7.5 in. (Collection of Linda and Donald Schlenger. © John Mason.)*

ings. But his interest was not just in surface, so he began to paddle the vessel walls and complicate them with hand-formed additions. Abandoning displays of skill and formal propriety, he dropped slabs on objects to catch an indentation or cause a fold or tear that became part of a vessel. Cross and X shapes—simple geometric signs rather than symbols of anything—appeared in his work. (Figure 7.11) *Spear Form* (1957) heralded his new sculptural direction. Using thick slabs or bars of clay, he created thrusting columnar structures in an anthropomorphic scale.

Mason was not committed to the wheel. As early as 1956 he made huge ceramic reliefs (cut into modules for firing), and he pursued these walls after he and Voulkos set up their studio. He brushed some with cobalt and iron; sprayed from the side to emphasize the rugged depth; contrasted bright low-fire glazes to bare areas; gouged the surfaces; and wove together strips of clay for gestural effects. He worked on an enormous easel for the more solid walls and arranged strips on the floor when he wanted a looser construction. He recalls taking handfuls of clay "right out of the mixer. . . . With the walls and the early vertical sculpture, I was really into the physicality of it, and the surfaces were very important to me. They

were the history of the process."[47] Mason sometimes embedded ropes in the clay that supported the walls or columns as they dried, helped get them to the kiln intact, and then burned away in firing. Probably the best of the open type was his *Blue Wall Relief* (1959), while *Grey Wall* (1960) used the modular squares for a ragged surface evoking geological forces. These were of architectural scale—a typical wall was six by eleven feet, and they ranged from two to fourteen inches thick. He began showing in 1957 with the avant-garde Ferus Gallery in Los Angeles. His work of the 1960s took new forms (see chapter 8).

Jerry Rothman (born 1933) was among the youngest in the Otis gang. While a ceramics student at Los Angeles City College he happened to meet Price and Bengston, who told him about Voulkos. A semester later, Voulkos let him enter the graduate program without a bachelor's degree. His Otis experience (1956–58) endorsed his play with materials, taught him skills such as throwing fast, and encouraged competitiveness. In those two years he generated some version of nearly all the multifarious work he would do later—abstract constructions, expressive figuration, social commentary, and landscape imagery—in a career almost too various to describe. He also made technical advances and did highly successful commercial design work. It does not fit together, but there it is.

Rothman first drew attention with large-scale assembled works: he began to combine pots and slabs on tall iron poles, sometimes adding color. He thought of these as "growth" sculptures. (Figure 7.12) In 1957, after seeing these works, Edward Kienholz, then a partner in the Ferus Gallery with Walter Hopps, asked Rothman to put together a ceramics show. He invited Mason and Soldner to join him. A reviewer for *Craft Horizons* wrote, "Rothman suspends clusters of pots and plaques on waving iron rods to create shadow-casting totems that rival in honest form and votive power the works of the Northwest Indians."[48]

Rothman spent 1958–60 working in Japan for a porcelain manufacturer but also doing his own work. One of his designs for the factory was a dinnerware pattern called Patio Moonglow, which is still manufactured. He also began his long-running personal series called Sky Pots, hand-built vessel forms with slab surfaces on which he created abstract, cloudlike imagery with sand and oxides, framed by thrown bases and necks.

Back in California he, along with a friend, started a production pottery business. Production had always interested him, although it was not popular among his peers at Otis. He soon began a wall installation series

FIGURE 7.12. *Jerry Rothman,* Growth #3, *ca. 1957. Ceramic, hemp rope, steel, concrete. (Courtesy of Jerry Rothman and Laguna Art Museum.)*

he called Not in Central Park, which he associated with landscape, but when someone said they looked like genitalia he embraced the idea and began making more figurative work. He was simply pursuing his interests wherever they led: "In the early 1960s no one talked about career or signature pieces. I was not concerned about style. I wanted content as well as beauty. And I wanted an edge, even then."[49]

In 1963 Rothman was invited to work as a design consultant on consumer products for Gladding McBean, then the largest ceramic manufacturer in the United States. They were looking for a product like Patio Moonglow, and Rothman had the pleasure of surprising them with the information that he had designed that ware. For the Franciscan division of Gladding McBean, he designed Madeira, a pattern of green silk-screened designs on top of a brown glaze, which was successful for the company, outselling its classic Desert Rose.

Among Rothman's later works were intensely expressionistic figures embedded in columns, upside down— a male nude, a female nude, and a representation of

birth—that were quite disturbing. "Back then they argued whether it was pornographic or beautiful," he recalls. "We live in a very uptight society. If a piece has too much content in its form and has a visceral effect, it's a problem, if it's just a symbol it's O.K."[50] His other best-known works are his black, robotlike tureens of the 1970s, which he called Ritual Vessels. The series was Rothman's most commercially successful, although few buyers believed that the tureens were actually functional. Another series, cartoonish in style but painfully pointed in message, consisted of two- to five-foot-high figures making satirical comments on politics and other aspects of life. Near the end of the century Rothman turned to making landscapes that consist of harsh ground and billowing, twisting, almost manneristically figurative clouds. Rothman, in his baffling variety, has hit a number of high points.

Henry Takemoto is the mystery man of the Otis gang. He is named in every account, but despite early shows, teaching at several schools (among them Scripps, the University of Montana, and the San Francisco Art Institute), and doing workshops in between, he disappeared into commercial design for Interpace in the 1960s without his work ever being treated in a solo catalog. He is not forgotten but not well documented.

Takemoto was born in Honolulu in 1930 and earned a BFA degree from the University of Hawaii before arriving at Otis in September 1957. He was strong on both decoration and form. *Ceramic Form, "Spring"* (1958) is a three-foot-tall bottle with two bulbous appendages that make the whole suggest voluptuous hips and breasts. He made giant coil-built vases that rose at a disorienting angle from a narrow base to a ragged flaring rim as well as egg-shaped vessels that sat in special cradles. An example of the latter is *First Kumu* (1959) in the Marer Collection. (Figure 7.13) This kind of near-spherical vessel seems to luxuriate in its casual imperfection.

The size gave him more surface to paint. His linear decorations are sometimes referred to as calligraphic, but that seems like a cultural cliché. Takemoto's line has more accurately been described as "sprawling, elegant doodles"[51] or "curlicues, stripes and tendrils suggestive of marine vegetation or of the painted ceramic vessels of Minoan Crete."[52] They also might recall Miró's painting—not the figures, but the surroundings—and the density of the spirals, dotted lines, radial asterisks, hook forms, and nestled, repeated crescents are evocative of weather maps or the lush vegetation of his native state.

Often his decoration was all in blue, like historic wares of China and Japan, although some red on brown is also seen. Takemoto's work is exceptionally lively. The

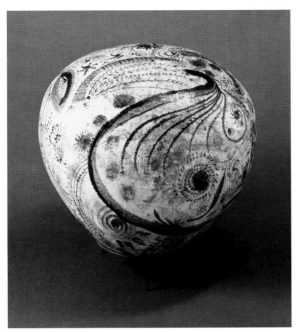

FIGURE 7.13. *Henry Takemoto, First Kumu, 1959. Glazed stoneware;*
21.75 × 22 × 22 in. (Scripps College, Claremont, Calif. Gift of Mr. and
Mrs. Fred Marer. Art © Henry Takemoto.)

ing Wildenhain's "total dedication to the art of pottery as
an integration of the spirit and the intellect"[54] as well as
Hamada's spontaneity and direct simplicity, he neverthe-
less evolved a practice of making light, thin-walled con-
tainers—achieved through controlled throwing and sub-
sequent refinement by trimming—with sprayed glazes,
subtle colors, precise patterns.

A sense of measure might be called his defining
characteristic—from precisely calibrated clean lines, to
rhythmic patterns that seem to extend beyond the ob-
ject, to the subtle tactility of incised lines. A 1950 bowl
with green engobe and ivory mat glaze, 4¼ inches tall,
has a tiny foot and rises with a graceful, almost spheri-
cal swell to a cut rim that is thicker than expected. The
green is mottled and has a flame-stitch or cloud effect,
but at the same time there are sets of pale, probably re-
sist lines striping the bowl from foot to rim. Here, and
also in a 1959 stoneware bowl with irregularly spaced
brushstrokes running from top to bottom, McIntosh bal-
ances a very tight form against decoration that celebrates
ease of hand. He is a master of the formal design ele-

drawing is compelling and can make you forget to notice
the form and, surprisingly, the opposite is true as well;
the viewer's attention can "rapidly shuttle from one to the
other, alternating between comparing and marveling,
moving and pausing," an admirer has observed.[53]

A MASTER OF MEASURE: HARRISON MCINTOSH

Harrison McIntosh (born 1914) is a California potter who
studied with such great teachers as Lukens and Wilden-
hain, was present for both of Leach's tours, and taught
at Otis with Voulkos. His work was not swayed by any of
these contacts, however. (Figure 7.14) He created cleanly
shaped vessels with exacting surface patterns and, later,
reductive sculptures, for the most part keeping to his
early decisions about stoneware body, single-fire pro-
cess, basic engobes and glazes. Another measure of his
steadfastness is that he shared a studio for almost fifty
years with the same friend, the ceramist Rupert Deese.
In addition to his studio work, he designed dinnerware
and glassware for Metlox, Interpace, and Mikasa in the
United States, Japan, and Germany.

McIntosh had a sporadic education, including night-
school classes with Lukens at USC. After wartime ser-
vice he informally apprenticed with Albert and Louisa
King at their Lotus and Acanthus Studio in Los Ange-
les. In 1949 he was admitted to the graduate program
at Scripps as a special student. He spent a summer at
Pond Farm, refining his throwing skills. While admir-

FIGURE 7.14. *Harrison McIntosh, Vase, 1954. Stoneware; height,*
11.87 in.; diameter, 7.87 in. (Los Angeles County Museum of Art,
Gift of Catherine McIntosh. Art © Harrison McIntosh. Photograph
© 2007 Museum Associates/LACMA.)

ments in all their inexhaustible interest. Later, around 1970, he began to make ceramic sculptures that seem to be a natural outgrowth of his elegant and crisp pottery: closed forms mounted on wood bases (sometimes made for him by his old friend Sam Maloof) or on polished metal surfaces that, by reflecting, make the sculpture seem to levitate.

MARGARET ISRAEL

Margaret Ponce Israel (1929–1987) burst into the consciousness of the New York craft world in 1956, when, after a blind selection procedure, jurors of the *Young Americans* exhibition at the Museum of Contemporary Crafts discovered that they had chosen the same artist for first and second place in ceramics. An article by Rose Slivka in *Craft Horizons* the next year said that Israel made pottery "to hold everything that belongs to life and to the imagination."[55] Israel was a longtime and beloved teacher at Greenwich House Pottery in New York, and her 1959 and 1961 shows at Egan Gallery were spoken of in terms of awe, even years later. She never quite became famous, yet her work always found champions and did not fall from view after her death.

Marge Ponce was born in Cuba but brought to New York as an infant. She attended the High School of Music and Art and went to Syracuse University, where she met and married Marvin Israel. She continued her studies while they lived in Paris for several years. Marvin became an art director for *Seventeen* and then *Harper's Bazaar*, and a book and exhibition designer; he was close to Diane Arbus and designed and edited two posthumous books of her photographs. He introduced Marge to Cordier & Ekstrom, a gallery that showed her work for many years.

The eclecticism of Israel's work explains how the jurors could fail to recognize two pieces from the same hand. She loved to coil-build, but it was too slow to keep up with her ideas, so she also did a lot of throwing. She made large-scale columnar forms and created ceramic chairs (as well as transforming many wooden ones found on the streets). She produced doll forms and animals, some whimsical and some poignant. Slab-constructed unglazed vases of various heights that look like bags of topsoil with a neck or two on top—or like sadly dislocated torsos—were roped together in groups that simultaneously suggest both community and coercion. (Figure 7.15) She also created impassive heads that she showed on pedestals and called, surprisingly, Temperaments.

Slivka noted that Israel had a particular tenderness for fragments and discards; a later writer wondered at her crushed heads and dissected bodies—some, perhaps pointedly, missing their breast and pelvic regions.[56] Her early shows were so densely populated that they could be regarded as proto-installations, and she also showed dolls and animals arranged in standing cabinets as if occupying their own little worlds. When she died in a bicycle accident in New York, three years after her husband's death, what some people called her greatest assemblage came to light: the jumbled Midtown carriage house that she was then using as a studio, filled with screens, costumes, paintings, prints and drawings, 130 sketchbooks, inventive furniture, and ceramics of every sort as well as a bantam rooster, guinea hens, doves, a rabbit, dogs, and a cat, all of which had been featured in her works. Only then did it become apparent that although Israel was appreciated for her inventiveness and clearly conveyed joy in making, she was underneath an intensely private person without assistants, relatives, or close friends to categorize or even sequence the work, much of which had never been shown.

FIGURE 7.15. *Margaret Israel,* Town, *1957–59. Ceramic.* (© *Estate of Margaret Israel.*)

Textiles: Ready for Change

The intense and divergent viewpoints that marked the textile field in the 1940s led to a strangely quiet 1950s. The most reviewed textile artist was Mariska Karasz, who sprang upon the scene with numerous exhibitions of con-

temporary embroidery and fabric collage. She showed at the New York gallery of Bertha Schaefer, who, coached by Aileen Osborn Webb, had begun to exhibit textiles.

In the early 1950s both famous weavers (Dorothy Liebes) and young designers seeking fame (Jack Lenor Larsen) set up their studios in New York. Trude Guermonprez came from Europe after the war and made her way to California carrying Bauhaus ideas. Lenore Tawney moved to New York in the mid-1950 and found encouragement there.

Lyn Alexander may have been the first modern artist to use an almost completely exposed warp when she created *Space Hanging* in 1953.[57] This nine-foot-tall work of cotton and rayon, black and bronze, showed "several scales of linear pattern"[58] created by hemstitching horizontal bands in modules of one, two, four, or eight warp threads. The finished piece is held taut between rods at top and bottom and may be hung free or near a wall so that it casts shadows. "The concept is original; the technique that serves so well is masterly; the proportions seem inevitable,"[59] and it is remarkable for its time. Alexander, who soon returned (for financial reasons) to production weaving for others, was fortunately documented in a later survey of the fiber field.

Amateur and semiprofessional activity increased both regionally and locally, with a number of weavers' guilds springing up: Joliet Weavers Guild (1950), North Shore Weavers Guild (1951), and KenRock Weavers in Rockford (1958) in Illinois alone.

The Good Design exhibitions included handwoven items, and in 1956 the catalog for MOMA's *Textiles, U.S.A.* exhibition, which included industrial fabrics and fabric for apparel and home furnishings, noted that artist-weavers were included because "Individual craftsmen still excel in the attention to detail that provides one kind of quality in textiles. But the craftsman's chief contribution now appears to be in the design of fabrics for mass production. Only a very few craftsmen have succeeded in producing new work genuinely original and readily distinguished from that produced in industry."[60] In fact, handweavers were finding other options.

LILI BLUMENAU

One well-known weaver was Lili Blumenau (1912–1976), who a decade earlier had arrived in New York from Berlin via studies in Paris and at Black Mountain (where she briefly studied with Josef Albers). She worked as keeper of textiles at the Cooper Union Museum for six years and taught weaving and textile design at New York University (1948–50), Columbia University Teachers College (1948–52), and the Fashion Institute of Technology (1952–58).

In addition, she ran her own workshop, offering classes but primarily serving as a design resource for industry. Her first book, *The Art and Craft of Handweaving* (1955), went through seven editions.

Blumenau was not committed to a single idiom, although all her hangings were woven and followed the logic of the loom. They were handsome arrangements of blocks of color and texture, and the largest and most opaque were used as room dividers. Some may have been double weave, since photographs show recesses of different colors as well as laid-in line. She also inserted glass rods and beaded ribbons that caught the light, and she explored the possibilities of exposed warps as that option became popular.

JACK LENOR LARSEN

In the design world of the 1950s, the name Jack Lenor Larsen (born 1924) was suddenly everywhere, including the pages of *Craft Horizons*, where he was identified as a "bright young star." As an undergraduate weaving major at the University of Washington in the 1940s, he assisted weaving classes taught by Ed Rossbach (see chapter 8) and at Rossbach's recommendation went to Cranbrook, graduating in 1951 with a thesis titled "Notes on Textile Designing for Mass Production." In New York, Larsen worked with Arundell Clarke, founder of Knoll Textiles, on a commission for lobby draperies at Lever House, the glass-walled Skidmore, Owings & Merrill modernist icon on Park Avenue (1951–52). (Figure 7.16) It made his name. Larsen's translucent fabrics, which included metallics, divided space and modulated light.

Larsen incorporated his business in 1953 and soon added his Cranbrook classmate Win Anderson as president. In the 1950s he became identified with natural fibers and was known for finding foreign processes and sources for yarns, working extensively in Africa and Asia, Ireland, and elsewhere. He was particularly successful at achieving a handwoven look on power looms. He also had an impact on fashion, probably introducing the first down coats and the first stretch upholstery fabric and establishing his own women's line, J. L. Arbiter. There were patterns inspired by Tiffany and Matisse as well as two African collections that were especially well received.

Larsen figures here not for his designs, however, but for his extensive support of contemporary craft. Some of the Larsen fashion textiles were handwoven, and some studio artists (including Rossbach and Kay Sekimachi) designed fabrics manufactured by the Larsen firm. But more than that, Larsen served on the board of the American Craft Council for many years and, starting in 1955,

FIGURE 7.16. *Jack Lenor Larsen*, Leverlin Fabric Used in Lobby of Lever House, *ca. 1952. Linen, cotton, lurex, lace weave.*

wrote often for *Craft Horizons.* He also taught for thirteen summers at Haystack Mountain School of Crafts in Maine as well as serving on its board, most notably in 1958–59 as head of the building committee, which generated the award-winning campus by Edward Larabee Barnes. Later, with Mildred Constantine, former curator at the Museum of Modern Art, he published *Beyond Craft: The Art Fabric* (1973) and *The Art Fabric: Mainstream* (1981), including an exhibition. These oversize, well-illustrated volumes endorsed and documented the blossoming textile field with sensitive and intelligent analysis. The term "art fabric," however, never took hold.

Late in the century Larsen turned his attention to the creation of the LongHouse Foundation (now LongHouse Reserve) at his Long Island home, opening it to the public over the summer to display his extensive collections of Third World and contemporary American and Japanese craft objects. He also presented the work of selected artists in outdoor exhibitions, including Dale Chihuly's

first garden show. Despite an autobiography plus books and shows honoring him, the field awaits objective consideration of his role.

ADVENTURES IN STITCHES: MARISKA KARASZ

Mariska Karasz (1898–1960) came to New York from Hungary in 1914, at the age of sixteen. She studied costume design with fashion designer Ethel Traphagen at the Cooper Union School of Art in New York, and for years was a successful designer of women's and children's clothing. She did occasional embroidery, some on designs by her sister, Ilonka Karasz (see chapter 4). These works were usually influenced by Eastern European craft traditions, especially the strong folk textiles of Hungary, and they occasionally relate to fauvist or German expressionist imagery, such as idyllic scenes by Matisse.[61] The craft of embroidery—in which she was self-taught—became her focus after the mid-1940s, when divorce and a studio fire led to changes in her life.

In 1949 Karasz published a book for hobbyists called *Adventures in Stitches: A New Art of Embroidery,* in which she wrote, "Embroidery is to sewing what poetry is to prose; here the stitches can be made to sing out as words sing in a poem." She insisted that prestamped designs and historical copies were acceptable only for learning techniques and added, "Meaning is born when the designer and the workman are one."[62] That was certainly the case in her late work. It was later observed: "Karasz illustrates the freedom with which the great needle artist approaches stitchery. She improvised on most known techniques and invented some others, working imaginatively with any material that could be threaded through a needle, on a ground, sometimes offbeat, always strong in character."[63]

Karasz's earliest embroideries, relatively conventional small fields of representational imagery appealing for a naive quality, depict farm animals, her children, her garden. She often adapted the lines and colors of nature, even as her work moved toward abstraction. (Figure 7.17) Horizontal passages can evoke landscape strata, while stitches recall patterns of fields and roads seen from on high. She capitalized on the line, color, and texture inherent in her medium, working with a vast collection of yarns, sometimes on specially woven fabric. Karasz worked with anything that caught her eye, including copper wire, fishing flies, shells, cords, and shoelaces. She used these as drawn lines with dimension—a new graphic expression of impressive tactile qualities. With formalist care, she sometimes attached natural objects, such as sand dollars or ivory combs. Late in life she

FIGURE 7.17. *Mariska Karasz, Phoenix, 1953. Linen, wool, hemp on linen with wood slats; 51 × 70.5 in. (Georgia Museum of Art, University of Georgia, Museum Purchase, GMOA 2006.51. Photograph by Michael McKelvey, 2007.)*

made a series of collages consisting mainly of handmade papers, with a minimum of stitches.

Between 1948 and 1960 Karasz had nearly fifty solo shows of her wall hangings. Among the works in her posthumous retrospective at the Museum of Contemporary Crafts in New York was *Parting* (1953), in wool and cotton. Simpler than many of the works, it leaves a great expanse unembroidered and consists of wavering lines that lead downward to the right. The left half offers white and light colors, then an almost solid vertical band of white, and then a selection of browns. A bottom brown line looks like a mountain profile. In her 1958 work *Cactus*, natural and synthetic fibers are combined with appliquéd materials; brilliant colors define a stylized flowering cactus plant with spikes. *Arizona* (1959) has an overall rectilinear outline and horizontally striped blocks, mostly black and white, within the outline. The dark linen background is exposed, and concentric lines of black and blue

define densely filled white blocks, vaguely recalling a city plan. Karasz brought a new freedom and invention to the genre, parallel to the changes in other mediums at the time.

LOOPING WIRE: RUTH ASAWA

Constantine and Larsen called Ruth Asawa's works "America's first monumental Art Fabrics" and "an unequivocal success."[64] By crocheting aluminum, brass, iron, or copper wire, Asawa devised complex forms vaguely recalling fish-trap baskets, sea creatures, or seed forms. (Figure 7.18) Their structural openness is exceptional, and they further engage space with filigree shadows. Asawa worked outside the textile context and always regarded herself simply as a sculptor; her work introduces questions of categorization that become common in later decades.

Asawa (born 1926) was one of seven children of Japanese immigrant vegetable farmers in Southern California. The family was interned after Pearl Harbor, and Asawa was thwarted in her wish to be an art teacher because of racial animosity that persisted after the war. Nevertheless, she studied for three years at Black Moun-

FIGURE 7.18. *Ruth Asawa, Untitled Wire Sculpture, 1959. Monel, tubular knit; height, 84 in.; diameter, 24 in. (© Ruth Asawa. Photograph by Laurence Cuneo.)*

tain College, establishing lasting friendships with Josef Albers and Buckminster Fuller, and she learned to crochet in Mexico in 1947. She also saw wire baskets there, which inspired the work she developed after marrying and moving to San Francisco in 1949. She raised six children—amazingly, she was most prolific when they were small—and also became a civic activist.

In Asawa's sculptures, a continuous line of wire is shaped into interpenetrating forms, like drawings in space. She worked down from the ceiling and out from the center, compacting and expanding. Transparency was both a visual effect and a philosophical stance. The formal characteristics of the work were timeless in their allusions to natural forms and also futuristic, presaging digital designs. She created cross, star, and propeller forms, experimented with electroplating, and cast them in bronze. Within ten years of leaving Black Mountain, Asawa had established a national reputation, and her work was shown at the Whitney Museum of American Art, MOMA, the Art Institute of Chicago, and many other institutions. For the São Paulo biennial in 1955, she made interpenetrating lobes 11½ feet tall.

Some observers thought it ironic that Asawa refused to repeat sculptural forms yet was content with a repetitive process, but the method offered rewarding adaptability and meditative pleasures. Asawa's independent accomplishment was a preview of both the abstraction and the larger field of reference that fiber art would soon engage.

Jewelry, Metals, and Enameling: Toward an American Voice

JEWELRY

The earliest modern studio jewelry—Alexander Calder's forged wire, Sam Kramer's surrealistic fused metal, Francisco Rebajes's biomorphic constructions—was limited in form and technique. But it was conceived in opposition and as an antidote to precious jewelry and costume jewelry; its bones, blobs, and boomerangs looked sophisticated in comparison.

A spate of textbooks—including one series published by MOMA from 1949 until 1960—showed how easy it was to make simple jewelry. Thus modern jewelry was affordable, and it could compete with mass-produced jewelry on the basis of price as well as design. The field grew dramatically: in 1948 the Walker Art Center mounted an exhibition and sale of work by thirty-five jewelers; in 1955 a comparable exhibition featured eighty-four artists.[65]

By then many studio jewelers had emerged from college art programs, where they learned many techniques. The Cleveland Institute of Art became a center of enameling, under Kenneth Bates, and silversmithing, under Frederick Miller. Hans Christensen, who had been a technician for Georg Jensen, brought his considerable expertise in silversmithing to the School for American Craftsmen in 1954. Bob Winston pioneered lost-wax casting at the California College of Arts and Crafts in Oakland. This new technical sophistication, along with the pervasive influence of the Good Design exhibitions and Scandinavian modern silverware, encouraged the creation of polished surfaces, hard-edged forms, and the combination of multiple techniques.

If there was a quintessential jeweler of the 1950s, it was Margaret De Patta. She regarded her jewelry of crisp abstract forms and semiprecious stones cut in unconventional shapes as small wearable sculptures. Many others followed suit, moving well beyond modest scale and compact shapes to test the limits of wearability. By the end of the decade, Hans Christensen would complain: "I feel that jewelry design today should be questioned. Often it is but minuscule sculpture and sometimes the shapes developed—in order to make them visually rich—in such a fashion as to make them a hazard to the wearer and anyone who comes near her. It appears that there has been a too strenuous search for novelty in contemporary jewelry, and the resulting forms are usually suggestive of exaggeration and strain. Jewelry should . . . be materially and structurally coherent—not just an aggregate of sculptural shapes reduced to pygmy scale."[66] Christensen's complaints about novelty would become commonplace but to no avail.

MARGARET DE PATTA

The leader of the new modernist jewelry was Margaret De Patta (1903–1964). She had received formal training in painting at several art schools, including the Art Students League in New York. In 1929 she was disappointed in her search for a suitable wedding ring. About the same time she had seen Egyptian, pre-Columbian, and Turkish jewelry in a museum. She took lessons from an Armenian jeweler in San Francisco and pursued the craft alongside her painting. Her early jewelry was often crudely made of simple sheet and wire forms to approximate tribal pendants and earrings. The transformative event in her artistic life was a 1940 summer class at Mills College with László Moholy-Nagy. Fascinated by his emphasis on abstract line, light, transparency, and motion, De Patta studied with him at the School of Design in Chicago in 1940 and 1941.

Moholy-Nagy encouraged her to treat jewelry as a

FIGURE 7.19. *Margaret De Patta*, Pendant, 1956. *White gold, ebony, rhomboid quartz crystal; 3.75 × 1 × 2.50 in. (Collection of the Oakland Museum of California, Gift of Eugene Bielawski, The Margaret De Patta Memorial Collection, 1967.21.6.)*

formal experiment. This was his approach to art making, influenced by his experience at the Bauhaus. In 1930 he had filmed a motor-driven sculpture he had made of glass, clear plastic, and polished metal. The film—*Lightplay: Black White Gray*—is a classic modernist study of light, shadow, and reflection, all in motion. Moholy-Nagy also advised De Patta to "Catch your stones in air. Make them float in space. Don't enclose them."[67] De Patta took both his example and his advice to heart.

There are two keys to De Patta's remarkable jewelry. First, she used metals that were hard to work by hand, such as white gold or stainless steel, which allowed her to minimize the thickness of structural elements. Second, she used gemstones for their visual and optical properties and not as symbols of wealth. Her favorite stone was colorless quartz crystal, which she often used to experiment with transparency and optical illusion. She is especially noted for pendants set with geometric blocks of rutilated quartz, a clear stone shot through with orange-brown lines of titanium dioxide.

Starting in 1941, De Patta collaborated with stone-cutter Francis Sperisen. She made models of shaped stones out of clear acrylic plastic, and Sperisen faceted or ground the stone. One result of the collaboration is her 1956 white gold and ebony pendant set with a quartz crystal. (Figure 7.19) Instead of being faceted to maximize reflected light, as is usual for precious gems, the quartz is cut into a lens with parallel flat facets on both sides, horizontal in front and vertical on the back. The

lens magnifies and distorts the bold vertical line of the ebony and gold structure behind, breaking it into tiny fragments. The minimal setting holds the stone out in space exactly as suggested by Moholy-Nagy.

In effect, De Patta treated jewelry like a motion picture in miniature. In the 1956 pendant, the refracted image of the vertical playing across the surface of the quartz crystal flickers in and out of sight. She also made jewelry that was jointed so that it could be worn in different configurations. In one pendant, she encased thin slices of pale transparent gems between two layers of quartz, letting the slices overlap to produce unexpected secondary colors. She mounted rutilated quartz into gold frames that echoed the lines inside the stones, a motif that other jewelers would extensively explore in the 1990s. In a pin from 1960, she set a round piece of turquoise into a beach stone, and in a pendant from the same year she set five faceted diamonds inside a teardrop-shaped crystal.[68]

Much of this experimental work was unique and expensive, so, starting in 1946, De Patta and her husband, Eugene Bielawski, made a production line of silver jewelry. De Patta constructed some forty or fifty original models, which were then rubber molded and cast, just as costume jewelry is made. The production jewelry sold for less than $50 and was distributed nationwide. After twelve years the two decided that running a small business was too demanding, and De Patta returned to the one-of-a-kind experiments she preferred.

De Patta was not immune to some of the more exuberant aspects of modernism: she used boomerang, chevron, and kidney shapes as liberally as any jeweler in the 1950s. Her best designs, however, reveal a sobriety and intelligence that have aged very well, and they look as fresh today as they did fifty years ago.

JOHN PAUL MILLER

While De Patta practiced a stringent, undecorated modernism, John Paul Miller (born 1918) embraced ornamentation. His favorite artist was Charles Burchfield, an American Scene painter who was part of a movement in the 1930s to reject European modernism. Sharing Burchfield's interest in nature as well as his penchant for decorative elaboration of form, Miller married those two elements with virtuoso craftsmanship. (Figure 7.20)

As a student at the Cleveland School of Art in the late 1930s, Miller majored in industrial design while practicing watercolor and egg-tempera painting. One of his close friends was Frederick Miller, who had some experience making jewelry. Once Frederick showed him how to solder, John Paul took to the craft immediately.

FIGURE 7.20. *John Paul Miller, Necklace, 1953. Gold; pendant: 2.75 × 1.81 in. (Collection of The Cleveland Museum of Art, 1953.181. © Estate of John Paul Miller.)*

In 1940, while still a student, Miller saw photographs of granulated gold jewelry by a German goldsmith, Elisabeth Treskow. Granulation—making minuscule spheres of gold and fusing them to a surface—had survived in a few shops in Italy and Germany, but good information in English was difficult to find. Fascinated by its precision and decorative quality, he tried to re-create it on his own. Ten years later, after much trial and error, he was making granulated jewelry in a contemporary idiom. Traditionally, as in Etruscan jewelry, the beads are fused in geometric patterns. Miller used rectangles and triangles as well as beads, encrusted surfaces to create more of a texture than a pattern, and enriched his work with transparent enamel.

Over the years he worked on three extended series. One consists of abstract designs of gold granules on a darkened surface. Miller suggested that the pulsing of dark and light in the jewelry calls to mind musical rhythms and intervals. The second series, Fragments, consists of blocky forms resembling fissured rock, enlivened by granulation at the margins. His third series, for which he is most celebrated, consists of tiny creatures—crabs, squids, insects, and the like—exquisitely rendered in gold with granulated and enameled surfaces.

These would most often take the form of small pendants, hung from the neck on a simple black cord. Their intense color, superb craftsmanship, and concentrated beauty immediately caught the attention of the craft press when Miller introduced them in the early 1950s.

Miller's technical skill was unequaled by any other studio jeweler for nearly two decades. (Many trade jewelers had comparable skills, but they tended to stay within the confines of convention.) Because granulation is best done in gold, which fuses more easily than other metals, Miller was also one of the first postwar studio jewelers to shun the use of silver, with its democratic suggestion of low price and accessibility. His jewelry was unapologetically for the few who could afford it.

The modernist ideal, taken from architecture and applied to jewelry by De Patta and others, held that the jewelry object itself should not be decorated. The only legitimate form should be its own structure. Miller departed from that rule almost as soon as it was established. Perhaps unintentionally, he kept the door open to the ornamental impulse in studio jewelry. That option would become attractive again by the late 1960s.

SVETOZAR AND RUTH RADAKOVICH

A relatively new technique that became popular among 1950s studio jewelers was lost-wax casting. Casting metals has been around for thousands of years, and wax has been used to make models for nearly as long. Usually metal was poured into the molds, with gravity supplying the only force, so castings rarely showed fine detail. Early twentieth-century dentists, needing a way to make gold fillings that precisely fit a cavity in a tooth, used centrifugal force, air pressure, or a vacuum to force molten metal into molds. The level of detail was extraordinary. In the 1930s jewelry manufacturers adopted the technique, and studio jewelers were not far behind.

Working soft wax with a heated tool, a jeweler can make highly textured, organic forms with ease. Craft exhibition catalogs from the 1950s are full of blobby rings, brooches, and pendants. Another innovation from the dental industry, hard carving wax, required a bit more discipline. This mix of wax and plastic can be sawed, shaped, and smoothed just like metal but with far less time and effort. Still, it resists naive attempts at free expression. Talented jewelers, appalled by the flood of drippy jewelry, took up hard wax as an alternative. Two of the most accomplished were Svetozar and Ruth Radakovich.

Svetozar (Toza) Radakovich (1918–1998) was born in Belgrade, Yugoslavia, and studied painting at the Royal Academy of Art there before World War II. After some

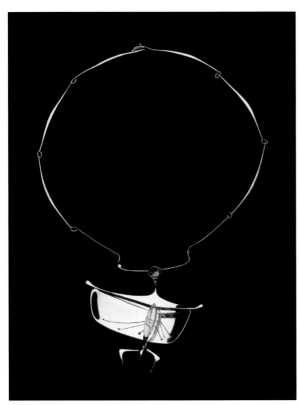

FIGURE 7.21. *Svetozar Radakovich, Pendant, 1956. Silver, moonstone; 16.5 × 2.75 in. (Memorial Art Gallery of the University of Rochester, Purchase Prize from the Second Exhibition of American Jewelry and Related Objects, 1958.133. © Jean Radakovich, Estate of Svetozar Radakovich.)*

vivid experiences in combat, prison camp, and in Tito's resistance army, he worked as a designer for the United Nations. It was then he met Ruth Clark (1920–1975). In 1955 both moved to Rochester to study at the School for American Craftsmen. Working independently, but developing a common visual language, they concentrated on casting jewelry from carved-wax forms.

Both made slick, curving shapes, mostly in gold, that seem inspired by the 1940s surrealist paintings of Matta or Adolph Gottlieb. (Figure 7.21) Much more refined and abstract than Sam Kramer's work, their jewelry is tense, seductive, and strange. While not very large, it is layered, with pockets and shadowed recesses. Both Toza and Ruth exploited the potential of casting to build forms that included thick and thin parts, adding to the sense of drama. The theatrical overtones were deliberate: Ruth said she sometimes tried to "communicate the physical tensions, the line and movement of ballet."[69]

While the Radakoviches' jewelry resembled sculpture, both were adamant that it was not. Ruth pointed out that jewelry is limited in size and weight, and they could not expand the scale. She also noted that both brooches and

pendants are seen by the wearer from above and that vantage point must be considered. Jewelry has to be weighted to rest properly on the body, and most importantly, it must attach to the body. Together, all these factors render jewelry distinct from sculpture, but neither of the Radakoviches felt restrained or compromised by the limitations.

The two were an overnight sensation. Only a year after they started making jewelry, Ruth won first prize in a 1956 national jewelry exhibition, and Toza won an honorable mention. In 1958 their work was shown in the American pavilion at the Brussels world's fair. After moving to California in 1959, they expanded their interests, working in wood, cast bronze, stained glass, forged iron, and resin-reinforced fiberglass. Their open-mindedness reminded the next generation of jewelers that adornment does not have to be made of metal and that a craftsmanlike attitude could be brought to any material.

PHILLIP FIKE

In the 1950s jeweler-metalsmiths were trained in colleges, earned master's degrees, and went on to teach at the college level. In a sense, they lived their artistic lives in the academy. Unlike their modernist predecessors, they did not always tailor their work to the marketplace, and they had a much deeper interest in historical jewelry.

One of the first American academic jewelers was Phillip Fike (1927–1997). Fike had shown a talent for working with his hands in high school but did not decide to pursue the arts until he visited a summer art school in 1946. He studied applied art, as it was still called, under the GI Bill at the University of Wisconsin, Madison. Arthur Vierthaler, the resident metals professor, insisted that his students troll the library for a good research topic. There Fike discovered a recipe for niello (a black alloy including sulfur and lead) in an Arts and Crafts–era textbook. Encouraged by his experience in a hands-on course in historical art processes, he decided to investigate.[70]

This was in 1947, and nobody else in the country was working with niello. Fike had to find his own way through trial and error. (His first batch put out such a quantity of noxious fumes that the art building had to be evacuated.) By 1949 his jewelry began to win prizes in regional and national shows, and he established a reputation for niello inlays. In 1953 he was hired by Wayne University in Detroit. He never retired: he taught until a few weeks before his death in 1997.

To supplement his modest teaching income, he worked from 1953 to 1955 in a machine shop, making

FIGURE 7.22. *Phillip Fike, Cufflinks, ca. 1955. Wood, gold. (Courtesy of Wayne State University, Detroit, Sidney F. Heavenrich Purchase Prize, 1956.30. Photograph © 1996 The Detroit Institute of Arts.)*

jigs and fixtures for the manufacture of B-52 bombers. There he learned to use the lathe. His curiosity piqued, he bought a jeweler's lathe and investigated the tool's possibilities. (In the jewelry trade the lathe is typically used to make watch parts.) Combining his new interest in mechanical precision with the ancient technique of niello, Fike came up with a pair of cufflinks that were one of the great designs of modernist studio jewelry. (Figure 7.22)

Sleeve buttons and cufflinks had been a staple of the jewelry industry for decades, but they were always treated as two decorative surfaces held together by a link, or a single surface with a button behind. Fike's solution was radically simple: a flat-ended catenoid, rather like two funnels stuck end-to-end. Fike reconceived of the cufflink as a sculptural whole. He added niello stripes that run at right angles to the length of the cufflink surface, which enliven the shape and give it a graphic impact. If there was a weakness, it was probably that the thing looked better standing by itself than peeking out of a cuff.

Fike made his cufflinks in several variations. Silver links were probably turned in one piece on his lathe, with shallow gaps for the niello inlay. Other versions were made of stacks of gold discs alternating with disks of wood, either ebony or grenadilla, joined together using a threaded central rod. The design was a fascinating hybrid of ancient and industrial technologies. Like Prestini before him, Fike proved that the machine was not the enemy of handcraft.

Later, in 1965, Fike saw some Etruscan fibulas in Roman and Florentine museums. The fibula is the ancestor of the safety pin, used to gather and fasten fabric draped around the torso. For the rest of his life, Fike made fibulae in countless variations. He also experimented with stainless steel, blown glass, and forged iron. Genial and folksy but always willing to learn, Fike, a model for a new type of academic craftsman, taught his students that ancient materials and forms can be made relevant to the present day and that research is a useful preparation to invention.

SILVERSMITHING REVIVES

Silversmithing took a different path than jewelry. Raising, the most important technique for hand-forming, was probably not taught during the war years due to the rationing of metal, and instruction was still rare at the college level in the late 1940s. The craft remained alive in factories like Tiffany and Gorham and in small companies like the Stone Associates, Allan Adler's studio, or the Kalo Shop. Tradesmen's knowledge, however, had little effect on studio silversmithing in America. Academically trained smiths seldom interacted with the industry, and if they wanted to learn how to raise they had to find their own way.

Into this picture stepped **Margaret Craver** (born 1907), who almost single-handedly jump-started American studio silversmithing. Craver had studied with a few silversmiths in the 1930s, including Arthur Stone and Baron Erik Fleming in Stockholm. In 1944, underwritten by the New York metal-refining company Handy & Harmon, she set up a program that used silver working as a therapy for wounded soldiers. (She could not use brass and copper because of wartime shortages, but silver was still available for government-sanctioned projects.) After the war, Handy & Harmon's executives, aiming to stimulate demand for silver by training new smiths, turned to Craver to refashion the therapy program into an educational one. From 1947 to 1951 she invited jewelry and metalsmithing instructors from all over the country to attend a series of five summer workshops. Each participant could make one or more pieces of silver hollowware, following the technical process being demonstrated. Most notably, Baron Fleming taught stretching, a process of forging thick sheet metal into bowl forms. Stretching was suited to the moment, since asymmetrical shapes could be generated with ease. The Handy & Harmon workshops were a resounding success.[71] Most of the influential silversmithing teachers in the 1950s attended.

Just as the Arts and Crafts movement stimulated a modest revival of silversmithing in America, so did

the entry of the craft into academia. A number of students went on to design for the silver industry, which was looking for modern-style products, while others became teachers or opened studios. This new generation of smiths would often start their businesses by doing repairs and gradually find ecclesiastical or domestic custom orders.

Many of these new smiths learned to raise under John Prip and Hans Christensen (both of whom trained in Denmark) at the School for American Craftsmen, Richard Thomas at Cranbrook, or Frederick Miller at the Cleveland Institute of Art. Still, none of the American-born studio silversmiths could achieve such technical feats as raising tall off-center forms or hammering teapot spouts directly out of the body, as could the best Scandinavian smiths. Hampered by lack of skill, most American studio silversmithing in the 1950s was undistinguished.

FREDERICK MILLER

One of the exceptions was Frederick Miller (1913–2000). He had, as noted, been a student at the Cleveland School of Art at the same time as John Paul Miller. He took no metalsmithing classes there, however; his earliest contact with the craft was informal. A friend who learned to solder at a summer camp showed him how. Later he tried making seamed hollowware from silver his mother had obtained in exchange for souvenir spoons. After wartime military service, he returned to Cleveland in 1946 and started working as a silversmith for an established furnishings firm, Potter and Mellon. The next year, he was hired to teach metalworking at the Cleveland School.

Young designers in the late 1940s looked to Scandinavian silver, in which smooth, soft, biomorphic forms predominated. The silverware was rigorously functional, decoration was absent, and surfaces were polished. The most advanced designs were asymmetrical. Both silver hollowware and flatware (including graceful designs in stainless steel) were heavily publicized in the American press.

Miller attended the second Handy & Harmon workshop in 1948 and learned stretching from Baron Fleming. He was quick to seize its possibilities, and his free-form bowls became leading examples of modernity in American craft. His *Free Form Fruit Bowl* from 1955, seen from above, is shaped like a rounded triangle. (Figure 7.23) The edge meanders up and down, emphasizing the form's asymmetry, yet it is quite thick and strong, which eliminates the need for additional molding. Organic and undisturbed by any ornament, the body of the bowl is strikingly different from traditional silver forms. Miller added three claw-shaped legs, and on the supports that elevate the bowl away from the legs, he provided a slight

FIGURE 7.23. *Frederick Miller, Free Form Fruit Bowl, 1955. Sterling silver, ebony; 6.5 × 10.5 × 8.25 in. (Collection of the Cleveland Museum of Art, 1956.116. © Estate of Frederick Miller.)*

accent with engraved decorative lines. That deft touch is typical of Miller: he often employed a bit of abstract ornament to attract the eye, usually to balance a broad expanse of polished silver.

Miller also learned to raise and later produced a series of asymmetrical silver bottles with narrow necks. He was an inspired teacher, although his influence was limited because the school did not offer graduate degrees. Still, with the addition of John Paul Miller and Kenneth Bates, the Cleveland Institute had one of the most comprehensive metals and enameling programs in the country. As one of the first Americans to break completely from traditional silversmithing forms, Frederick Miller led the way for the next wave of innovations in the 1960s.

ALLAN ADLER

In 1937 the daughter of silversmith Porter Blanchard (see chapter 5) met a young plaster-and-lath worker and married him the next year. This was Allan Adler (1916–2002). Not having a son, Blanchard persuaded the young man to learn silversmithing in his shop. About 1939 Blanchard decided to devote himself to wholesale business and turned his Sunset Boulevard retail store over to his son-in-law. Adler seized the opportunity, becoming the "silversmith to the stars" for the next sixty years. Clark Gable, Frank Sinatra, Julie Andrews, Paul Newman, and dozens of other entertainers were among his customers. A photograph of Adler's store shows a quaint colonial-style building with a neon sign spelling out the word "silversmith." One wonders if it flashed.

Adler followed Blanchard's business model. He hired skilled craftsmen, but much of the work was done with the aid of machines. Hollow forms were spun on a lathe; flatware patterns were struck with steel dies mounted in

FIGURE 7.24. *Allan Adler,* Teardrop Coffeepot and Teapot, *designed mid-1950s. Sterling silver, ebony. (Courtesy of Allan Adler, Inc.)*

a drop hammer. This semimechanization enabled Adler to reproduce designs efficiently, especially to manufacture flatware patterns for the wholesale market. At the same time he and his staff made one-of-a-kind items for his Hollywood clientele. During the war Adler contracted to produce precision silver parts for radar units, keeping his business healthy and ready to benefit from postwar prosperity.

The Adler shop concentrated on silverware for dinners and parties, occasions when his clients wanted to create an impression of good taste, sophistication, and wealth. Most designs were for the tabletop: flatware, salad sets, serving dishes, candlesticks, salt-and-pepper shakers, tea and coffee sets. (Figure 7.24) Like his father-in-law, Adler sold his flatware to upscale department stores such as Neiman Marcus and Marshall Field's. He gave his patterns names like Modern Georgian, Swedish Modern, Starlit, and for a California flavor, Sunset Capistrano.

Adler worked in both traditional and contemporary styles. His historicist flatware confined decoration to the ends of handles, where it could be easily stamped out by machine. His modern flatware broke no new ground. Fork tines were sometimes wide and tapered—a sign of high modernity—and the handles squared off. He avoided more extreme modern details like round bowls on spoons, which are not comfortable in the mouth, or handles that narrow at the end, which are hard to hold. Adler aimed to please, not to challenge.

The business flourished. By 1958 he had twenty-five workers, eighteen of whom were silversmiths. However, social patterns began to change, and fewer people enjoyed the ritual of using silver for home entertainment. Experienced smiths were harder to locate, too. Adler's market declined, and by 1990 he had only four employees. After his death in 2002, his daughter Cynthia took

over the shop, and she continues to produce both old and new designs. She is a seventh-generation silversmith.

ENAMELING IN THE FOOTSTEPS OF PAINTING: KARL DRERUP AND PAUL HULTBERG

By the mid 1950s enameling had become a popular pastime. Many of the jewelry-making textbooks published in the 1950s devoted a few pages to it, and Kenneth Bates's comprehensive *Enameling: Principles and Practice* first appeared in 1951. A more accurate sign of the times may have been the 1953 publication of *Enameling for Fun and Profit.* Enamel in jewelry proliferated. Typically a cloisonné would be mounted in a bezel setting, somewhat like a large flat stone, or small panels would be linked together to make bracelets. This introduction of color to jewelry was seductive, and many people tried their hands at it. Results were mixed. Many jewelers failed to protect the edges of the enamel, leaving it prone to chipping, which gave the medium a bad reputation.

Teachers and professionals in the enameling field had to distinguish their work from the volumes of hobby work. They could do so by complete mastery of technique, larger scale, or artistic sophistication. Bates, with his encyclopedic knowledge of enameling, chose the first option. Monumentality was a path explored by Edward Winter in Cleveland, who created decorative architectural panels using the medium. The third approach for enamelists was following painting, which presented a moving target. What seemed adventurous at the beginning of the 1950s was passé by the end of the decade, and artists who did not change accordingly fell out of fashion. The trajectory can be clearly traced in the differences between Karl Drerup (1904–2000) and Paul Hultberg (born 1926).

Drerup trained as a painter and printmaker in his native Germany. Even as a youth, he was conservative, studying etching and figure drawing while his friends participated in the artistic foment of the Bauhaus. As fascism overtook Europe, he and his wife fled to the Canary Islands and then to the United States, in 1937.

Drerup's first exposure to contemporary enameling was at a New York showing of a Ceramic National exhibition, where he saw an Edward Winter piece. (Because of the technical similarity between enameling and glazing, ceramics and enamels had been lumped together since the Arts and Crafts period.) Hearing that enamels could be produced more quickly and less expensively than ceramics, Drerup set about teaching himself. He read all the books he could find and experimented. By 1940 he was earning a living making enameled trays, plaques, and jewelry, but his primary ambition was to treat enameling as a form of painting.

FIGURE 7.25. *Karl Drerup*, Three Figures, *ca. 1955. Enamel on steel, pewter frame by George Salo, 35.5 × 13.25 × 1.25 in. (Collection of New Hampshire Historical Society, 1986.96.3. © Oliver Drerup.)*

A love of tradition led Drerup to the Limoges technique, in which opaque and transparent enamels are layered gradually over a colored (or bare metal) ground. This technique was ideal for both figuration and lush color effects. He worked in the style of the school of Paris, the avant-garde of his youth. Such paintings featured high-key colors, fractured representation of space, and such conventions as still lifes, harlequins, and female nudes. Many enamelists adopted the style. One of Drerup's painterly enamels is *Three Figures* (ca. 1955). (Figure 7.25) The faceting of analytic cubism, saturated colors of fauvism, chunky figures of Fernand Léger, heavy black outlines of Georges Rouault—all derived from painting before 1920—can be recognized in the work. The composition is safe, with the three figures carefully balanced.

For years, Drerup was regarded as the artistic equal of Kenneth Bates. He exhibited widely in enameling surveys, national craft shows, and even the 1958 world's fair in Brussels. By that time, though, critics were questioning craft's continuing reliance on outdated art styles. Greta Daniel, a curator from MOMA, was not impressed with a 1959 show of French tapestries that similarly worked with the conventions of the 1920s. She dismissed it with the observation that "'Styled' eclectic repetitions of old traditional themes survive there, meaninglessly but enduringly, and with a self-conscious determination which no longer relates to life."[72] Within ten years, Drerup's enamels lost favor. It is not that his work no longer related to life but that it no longer related to contemporary art. In 1970 the biggest event in the craft field was the *Objects: USA* exhibition, and Drerup was not invited.

Paul Hultberg was. He represented a new generation of enamelists who embraced abstract expressionism. (Figure 7.26) His enamels were big, and he specialized in making enamel look like it was applied in bold brush-strokes. The similarity to paintings by the most graphic of the abstract expressionist artists, like Clyfford Still, was unmistakable. The flavor of urban grit and downtown cool was unmistakable, too.

As a young man Hultberg had studied with muralist José Gutierrez in Mexico City. Gutierrez pioneered the use of new synthetic paints to increase the longevity of his murals, and Hultberg became fascinated with the possibility of durable two-dimensional mediums. In the early 1950s, while teaching at the Brooklyn Museum School, he and a printmaker friend started fooling around with enamels, which are durable but cannot be applied like paint (most have a heavy, sandy texture that prevents them from flowing onto a surface).

Hultberg found that he could paint a mixture of water, glycerin, and a commercial binder onto a sheet of copper.

FIGURE 7.26. *Paul Hultberg, Little Fault, 1972. Enamel on copper; 48 × 24 in. (Courtesy of Lawrence Hultberg. © Paul Hultberg.)*

his panels were emphatically not jewel-like miniatures, and she enthused about the kinetic quality of his brushwork. Hultberg contributed a fresh new approach to the enamel medium, but he was more of a popularizer than a pioneer. Even as one of his panels was acquired by MOMA for its permanent collection, his enamels were commissioned for apartment buildings, executive suites, doctors' offices, and the Pan-Am Building. Such wide acceptance suggests that his version of abstract expressionism was, like Drerup's version of the School of Paris, comfortable. He, too, would be eclipsed by a new taste for decorative, jewel-like qualities. The time for expressionist enamels had passed, and by 1980 his work was seldom exhibited.

Paintinglike enamel faded after the 1950s. Perhaps the marketplace had been saturated with too many enameled bowls with trite designs, or maybe the medium became inextricably tied in the public imagination to Trinkit kilns and summer camps. There were a few exceptions, such as **Bill Helwig** (born 1938), a specialist in grisaille (black-on-white) figurative imagery, and **Ellamarie** (1913–1976) and **Jackson Woolley** (1910–1992), who continued to create large architectural work in the School of Paris style. But enameling withdrew to a more intimate scale, to jewelry and vessels in particular. In those two contexts it no longer had to be compared with painting and could find its own standing as a decorative art. Enameling was thus positioned for a renaissance in the 1980s.

Wood: Influences and Inventions

A milestone in the progress of studio furniture was the 1957 exhibition *Furniture by Craftsmen* at the Museum of Contemporary Crafts. Some thirty-seven makers sent seventy-eight pieces of furniture. All the work reproduced in the modest twenty-page catalog was typical of the moment: simple boxy forms relieved, perhaps, by splayed legs or strongly figured wood. The softness of biomorphism and 1940s Danish modern was replaced by a hard, skeletal angularity, usually without ornament. A few pieces, including a table by ceramist William Wyman, incorporated ceramic tile as decorative accents. Two makers incorporated metal into the structure of their furniture, but wood dominated. Without exception, the wood was smooth and silky, bearing no conspicuous trace of handwork. If there was anything to distinguish this craftwork from factory-produced furniture, other than occasional asymmetry or "free edge," it was the careful selection of wood.

The show signaled a coming-of-age for studio furni-

Since the mix was thin, it could have all the qualities of an expressive brushstroke. Since it dried slowly, he could sift dry enamel onto the liquid, and the powder would stick. He would then work on the remaining bare metal with another mixture of vinegar and salt, which would etch and encrust the metal during firing. After running through a moving furnace of Hultberg's design, the copper had splashy brushstrokes in enamel, complemented by oxidized copper in shades of black, rust, and maroon. Hultberg preferred to fire his panels very few times, maintaining a sense of immediacy and bodily gesture.

The potter-poet M. C. Richards wrote a glowing article on Hultberg for *Craft Horizons* in 1959. She noted that

ture. The short preface to the catalog spoke of "craftsmen who today devote their creative inspiration and technical skill in fine joinery and bring their love and understanding of the material to the making of fine handcrafted furniture."[73] Until then, makers such as Esherick had been regarded as designers. (He was held up as an example of "the artist-craftsman as designer-producer" in a 1956 book on American industrial design, *Shaping America's Products* by Don Wallance.) The frame had shifted from design to emphasis on handwork and sensitivity to material. At the same time, recognition by a New York museum suggested a new legitimacy for the entire field. Scholars, collectors, and dealers began to take notice.

Americans searched for expressions of modernist simplicity and functionality that embodied the virtues of handwork instead of mechanization. Shaker furniture was one candidate, Japanese architecture another. In retrospect, it is not surprising that one of the first studio craftsmen to develop a hybrid modernism was a Japanese-American.

GEORGE NAKASHIMA

George Nakashima (1905–1990) made furniture for forty-nine years, was widely celebrated, and was an articulate spokesman as well. He was a modernist, but he did not embrace industrial materials and never saw his primary activity as developing prototypes for mass production. Instead, Nakashima dedicated himself to wood, handwork, and simple technologies. His convictions were derived from a deep spirituality and an equally deep sense that there was something amiss with modern design.

Nakashima was born to Japanese immigrants in Spokane, Washington. He was highly educated for his time, having earned a graduate degree in architecture. In the early 1930s he lived in Paris for a year, soaking up the artistic ferment of the era. One of his activities was weekly visits to the site of a new Le Corbusier building, the Pavillon Suisse. This was one of Le Corbusier's box-on-stilts designs, with a curtain wall on one side and a rustic stone wall on the other. Its geometric form, enlivened by occasional curves and natural materials, seems to have had a great impact on Nakashima. At the same time, he was much impressed by Chartres Cathedral, which he found beautiful and profoundly spiritual. His life's work, in effect, was to synthesize the qualities of these two buildings in furniture.

Nakashima spent three years in Tokyo and another three in India. He went to Pondicherry in 1936 to design a dormitory for the ashram of the Hindu spiritual leader Sri Aurobindo. Nakashima completed the project under

difficult conditions. It was a boxy International Style affair, adapted to suit the hot climate. More importantly, Nakashima became a disciple of Sri Aurobindo. He did not become a strict Hindu but more of a modern spiritualist, assembling his religious convictions from aspects of Hinduism, Shinto, and Zen Buddhism.

In 1939 he reluctantly left the ashram for Japan. Wary of approaching war, he returned to the United States in 1940. On a brief tour through California, he visited some of Frank Lloyd Wright's buildings, which he found to be badly built. After seven years abroad, he noticed the careless construction of American buildings, and it offended him. He later wrote: "Coming back to this country one of the really shocking things was to see a 'good modern' small house under construction. I have never seen such a dishonest use of materials as by American architects in a house under construction—the way it's put together before the skin is on. These people talk well, write reasonably well, but what they say and what they do

Scandinavian Modern Furniture

The cause of craft was aided by a new fashion for furnishings made in Scandinavia. Since the early part of the century, Scandinavians had evolved a spare, elegant style of decorative art. From English Arts and Crafts they took the principles of truth to materials, exposed construction, and availability to all. Somewhat later, they assimilated the Bauhaus aesthetic, but instead of industrial materials like polished metal, Scandinavians favored wood—warm, familiar, and plentiful in northern forests. They softened the geometric vocabulary of form and looked to small-shop processes that sometimes involved a great deal of handwork.

The best Scandinavian work was simple and elegant but rigorously useful. It achieved a combination of comfort, durability, and beauty that gave it an international reputation as humane. Danish modern furniture by designers such as Finn Juhl and Hans Wegner was widely influential in the United States in the late 1940s and 1950s. Many American designers and craftsmen, Vladimir Kagan and Sam Maloof among them, adopted the vocabulary of fluid, organic forms. This look, however, was already giving way in the mid-1950s to a more angular Scandinavian style, with abrupt transitions between parts; angled, tapered legs; and a basic structure made of luscious, dark, highly figured wood.

are entirely different. . . . [I] renounced architecture as it is now practiced."[74] Nakashima loved the folk carpentry of rural Japan and the traditional masonry of India. The consummate skill, intimate knowledge of materials, sense of moral duty to make a building that would last for centuries—all this appealed greatly to him. Disgust with the way even the best American architects built led him to dedicate himself to furniture making. It was a way to retain the old, honest, and simple methods in modern life.

Nakashima set up his first studio in 1941, in the basement of a religious center in Seattle. He turned out sturdy modern furniture with geometric lines, including a kidney-shaped table in the current style. In 1942, along with thousands of other Japanese Americans, Nakashima, his wife, and their newborn daughter were relocated away from the West Coast on the assumption that anyone of Japanese descent represented a security risk for the nation at war. Making the best of his time in an internment camp in southern Idaho, Nakashima learned traditional woodworking techniques from a Japanese carpenter, knowledge that would serve him well for the rest of his life. The next year, an architect friend invited Nakashima to New Hope, Pennsylvania, and the young family was released from internment. There, in a small town known for artistic culture, Nakashima established another studio.

The earliest work in New Hope set the style for which Nakashima became known. Broadly, he made two types of furniture. One consisted of chairs, stools, settees, and various kinds of cabinets of architectural character, geometric to some degree. All had details taken from traditional American furniture. The second consisted primarily of tables and desks with tops made of great slabs of highly figured wood with irregular edges.

One of the first chairs he designed in New Hope was an updated version of the eighteenth-century Windsor chair. Once made in small shops all over the Northeast, the Windsor chair has turned legs with three stretchers in an H configuration, a thick, hollowed-out seat, and a back made of spindles capped by a bent rail. The spindles were typically made of a wood such as ash that is strong and splits easily, while the seats were made of poplar, which carves nicely but costs less than most hardwoods.

Nakashima's first version of the Windsor chair (called the Straight-Backed chair) had splayed legs, like the original, but four stretchers high on the legs, making the design more compact. The sharp corners on the front edge of the seat differed from the rounded seats on the old chairs. And his back rail, though steam-bent as in old chairs, was simplified into one clean, tapered line, with-

FIGURE 7.27. *George Nakashima*, Conoid Chair, *designed ca. 1960. Walnut with hickory spindles; 35.25 × 20 × 19.5 in. (Courtesy of George Nakashima Studio.)*

out the scrolled ends of many antiques. The chair was recognizably modern though based on traditional practices.

Nakashima had to make a living from his craft and was competing with industrial production. Once he perfected a design, which could take several years, he put it into production and sold it through a catalog he published. As his operation grew, he turned work over to his assistants, so his actual involvement could be limited to selecting wood. All workers had to live up to his standards of craftsmanship, though.

Around 1960 he introduced a design radically unlike the Windsor chair. Called the Conoid chair (for the shape of a roof on one of the buildings he erected in his compound), it was a marriage of engineering and craft. (Figure 7.27) Nakashima realized that two slanted columns could combine the functions of both legs and seat back, with the seat cantilevered forward and horizontal "sled runners" attached to the base of each column. The joints between seat, columns, and runners had to resist quite a bit of stress, and thus the wood had to be rather thick, making the chair heavy (but the runners made it easy to slide the chair on a carpet). In a sense, the Conoid chair is equivalent to Marcel Breuer's classic B-32 steel chair: minimal, efficient, starkly modern.

FIGURE 7.28. George Nakashima, Conoid Cross-Legged End Table 1, 1967, *designed ca. 1960–61. English walnut root, English walnut; 21.75 × 26.75 × 38 in. (Courtesy of George Nakashima Studio.)*

Although the spindles were turned on an automatic lathe by a jobber, it is largely a handcrafted object. The connections between seat and back, and back and legs, were bridle joints, which cannot be easily made with a machine: each was chiseled out by hand. The wood for every chair was carefully selected and matched or contrasted. Nakashima refused to engage in shoddy work; his craft was spiritual in the sense that both labor and object could be seen as an extended meditation on the individual's place in the world.

The spiritual dimension was more emphatic in the second type of work that Nakashima made, particularly his tables. He specialized in finding tree trunks with elaborate grain and meandering edges, which he would have sawn into large slabs. The best of these he would mount horizontally on simple modernist supports, making the wood itself into the primary design element. He did not invent the idea. The French designer Charlotte Perriand made a slab-topped wooden table for a Tokyo exhibition in 1941, but it is not known whether Nakashima was aware of it. He was making his own by 1946. They were known as "free-edge" tables, a term associated with surrealism and a wider idea of artistic freedom.

Nakashima did not, however, speak about freedom. He thought of trees as containing a divine soul, a *kodama*, or tree-spirit, as it is known in Shinto, the native religion of Japan. He wrote about his feeling for wood in his 1981 book, *The Soul of a Tree*: "A mature tree has witnessed much. In complete silence it stands immobile, a god con-

sciousness. It is a moving experience to walk through the forest alone, to recognize each tree as a divine body, to pass in its presence day after day with a growing understanding."[75] Nakashima, as a woodworker, recycled the tree, so to speak, into something useful and beautiful. After selecting the slab, he would plane the surface by hand, insert a wooden butterfly joint here and there to control splitting, and finish it carefully with many coats of oil. Otherwise, he left it alone. Once Nakashima stepped out of the way, the user could commune directly with a physical link to a "god consciousness." Nakashima's metaphysics remain beyond the scope of rational criticism, but his sincerity cannot be doubted.

The free-edge tables became Nakashima's signature work. Over the years, the slabs of wood became more and more complex, with deep fissures and even holes that undermined their usefulness. They were also fairly easy to copy, which may have driven Nakashima to use ever more baroque shapes. On occasion, he would mount his slabs on inventive structures. In one version, the Conoid Cross-Legged End Table 1, designed about 1960, a single board was set at an angle, sprouting two legs to form a triangular support. (Figure 7.28) A branched arm farther up the board steadies the tabletop. In such examples Nakashima satisfied his interest in engineering and his taste for figured wood.

Nakashima received quite a bit of publicity, and his opinions became influential. He and a few others represented a new paradigm for studio furniture: the

woodworker. Nakashima's definition of the word was, "One who makes things in wood, adopting an approach that seeks to integrate both art and craft."[76] The woodworker's goal was to have direct personal involvement with wood and hand tools. Power tools were acceptable if they reduced drudgery but not if they compromised quality. Since making useful objects was vital, the woodworker could not be regarded as a pure sculptor. Furthermore, the woodworker was intensely involved with wood, making its color and grain almost a fetish. (Painting wood was unthinkable, even though a great deal of traditional American furniture was painted.) The ideal of the woodworker became the basis for a new subculture with a clearly defined value system. Even today, tool catalogs and websites stress the superiority of meticulous craft over mass production, and beautiful wood is still highly desirable.

WALKER WEED

An alternative to George Nakashima's theology of wood was offered by Walker Weed (born 1918). Weed had no formal training in the craft beyond shop in sixth and seventh grades. But his Yankee grandmother collected antique furniture and shared her knowledge of construction with him. By age twelve, he had his own furniture shop, producing coffee tables for $5 apiece.

By 1951 Weed was living in Gilford, New Hampshire, and had a studio in a barn. He described his furniture as "primarily functional and conservative."[77] His Windsor chair was less aggressively modern than Nakashima's: the seat did not cantilever, nor did it have sharp corners. The back rail of Weed's chair was sawn from a single block of lumber; the inside edge curved to fit the body, but the back edge was straight. (Figure 7.29) This blockiness and the absence of stretchers reinforcing the legs made his chair recognizably modern. He knew the rail was out of proportion compared with the graceful rails of antique examples, but he saw it as a bit of fun. A customer with a discerning eye would realize that Weed's spindles were plain dowels, nothing fancy. Yet the chair was made of solid wood and it cost only $35—about the same as Danish chairs made of plywood and veneer.

Weed sometimes reworked the design of an antique; on occasion, he made a mockup in pine. Functionality and good taste were his goals. His attitude was (and is) common among woodworkers: the past is a useful pattern and a teacher, to be tweaked at will. He criticized splashy design, saying, "I have always objected to the emphasis on doing a striking or new design instead of concentrating on good established things. It would be

FIGURE 7.29. *Walker Weed*, Block-Back Side Chair, *designed 1956. Black walnut; 31.25 × 17.5 × 17.5 in. (Courtesy of Walker Weed.)*

better to make a good wheelbarrow than a very fancy highboy."[78]

In the 1960s Weed incorporated curves from Scandinavian modern furniture. He also experimented with laminated strips, making a basketlike hanging chair in 1981. Because he never courted fame and most of his customers came from the area around his studio, Weed was never as famous as Esherick or Nakashima. Still, his mix of modern and traditional, his respect for wood, and his firm sense that furniture should be practical were widely accepted among American furniture makers. It is doubtful that Weed, a modest man, intended to stake out an aggressive resistance to change. More likely he thought of himself as simply an honest workman.

TAGE FRID

Another whose work might be considered functional and conservative was Tage Frid (1915–2004; his name rhymes with "hey, kid"). Frid, a Dane, was one of the few foreign-trained woodworkers to take part in the postwar American craft revival, and his deep knowledge of technique

FIGURE 7.30. *Tage Frid, Stool, 1982. Walnut; 30.5 × 19 × 15 in. (Museum of Art, Rhode Island School of Design, Gift of the Rhode Island School of Design Class of 1982, 1982.178. © Emma Frid. Photograph by Erik Gould.)*

gave him a special authority. (Figure 7.30) His influence was magnified by the fact that he taught from 1948 until 1985 in two of America's most prominent college furniture programs: the School for American Craftsmen and the Rhode Island School of Design.

Frid was the son of a silversmith. He hated polishing, and he was not much of a student, either. So at age thirteen, he started an apprenticeship with a master cabinetmaker in Copenhagen. Five and a half years later, after enduring the ten-hour days expected of apprentices, he became a journeyman. Although he studied interior architecture in college, his early training permanently colored his attitude toward woodworking. His well-known motto was always "Design around construction." To imagine a form and then figure out how to make it seemed backward to him. He believed that good joinery and an understanding of wood should always come first, and it was this attitude that he tried to instill in his many students.

In 1948 Frid was invited to set up a woodworking program at the School for American Craftsmen (then at Alfred University). It was the first four-year degree

program that treated the craft as a discrete subject, unlike the many industrial-arts courses that prepared college students to teach shop. Frid was a natural teacher: charming, charismatic, open-minded, and eager to help his students seek inventive solutions to problems of construction. Importantly, he did not demand that they imitate his work. Instructors who are educated in the trade often take a narrow attitude, encouraging sameness and punishing innovation, but Frid wanted his students to find their own voices. Many went on to be teachers themselves. Several scholars cite him as the single most influential woodworking teacher in the country.[79]

When Frid teamed up with the new *Fine Woodworking* magazine in 1975, his influence grew. Between 1979 and 1985, he wrote three slim books on basic technique. They were plain and straightforward, and their step-by-step instructions made complex procedures understandable to a large audience. For practical advice on woodworking, they have never been surpassed. Over the years the *Tage Frid Teaches Woodworking* books have sold a quarter of a million copies.

Frid's generosity in sharing information exemplifies a striking difference between the old European guild system and postwar American craft culture. The guilds were founded to limit competition by restricting entry into a trade, so they were often secretive about technique. In twentieth-century craft culture, information is rarely kept secret. This may be a legacy of the many manual arts textbooks and how-to magazines, reinforced by craft's emergence in the academic community.

Information was badly needed in studio furniture, which in the early 1950s showed a sameness of design and detailing that now looks rather naive. Veneering was practically unknown. Frame-and-panel construction, which minimizes problems with expansion and contraction of case furniture, was rare. Upholstery, when used, was rudimentary. Even carving—the subject of the first college-level craft course taught in the United States—was uncommon. Frid, through his extensive teaching and writing, brought to American woodworking technical sophistication.

He regarded machines as conveniences that made work go faster, and he accepted them without comment. He used tenons where strength was necessary but also used screws and bolts if they made the job easier. He occasionally employed a tusked tenon but only to make a table that could be knocked down easily for moving or storage, not to display his moral uprightness. Nor did he share Nakashima's reverence for wood: plywood and veneers were fine when there was a logic for their use.

Frid's own furniture never departed from the ethos of graceful design, workmanlike functionality, and clear structure that characterized late 1940s Scandinavian furniture. He was satisfied with solving technical and functional problems: What is the smallest chair seat that can still be comfortable? How can a chair be both strong and light? On occasion, he would try experiments like a rocking chair with no wood joints at all. Frid glued layers of mahogany on both sides of one-quarter-inch-thick aluminum profiles and bolted the chair together. The seat and back were made of nylon string. His rocking chair was as futuristic as the metal-and-Bakelite furniture of the 1930s had been in its day, but its persistent woodiness combined with jet-age forms gives it an odd quality.

In the mid-1950s Frid expanded his shop to eight employees, but the worries of designing and managing and producing and selling gave him an ulcer, so he returned to a small-scale operation. After that, he might struggle for days to find just the right solution for a particular design, but he did not put his designs into mass production. He accepted all kinds of commissions, from kitchens to restoration of boat interiors—unlike many studio furniture makers, who would refuse such prosaic jobs. Most of Frid's commission work was never publicized and thus did not contribute to his legacy. His best-known works— which illustrated his *Book 3: Furnituremaking*—still furnished his house when he died.

THE DEAN OF AMERICAN WOODWORKERS: WHARTON ESHERICK

Wharton Esherick worked without interruption through World War II and the 1950s, continuing to refine and experiment. He gradually dropped his cubist-expressionist manner of the 1920s and 1930s in favor of flowing, rounded forms with a superficial resemblance to Danish modern. He had first worked in that mode in 1935, when he made a swept-back library ladder. Three curved legs on each side of the ladder support three steps, each molded into the supports. Where the legs come together at the top, one side terminates in a donkey, the other in an elephant: the ladder was made for a friend who had just run for an elected office.

Esherick rejected the sharp-edged geometry of mid-1950s furniture. He said, "I was impatient with the contemporary furniture being made—straight lines, sharp edges and right angles—and I conceived free angles and free forms; making the edges of my tables flow so they would be attractive to feel or caress."[80] His concern for the sensual appeal of his furniture may have stemmed from his keeping prototypes of most of his furniture de-

FIGURE 7.31. *Wharton Esherick, Music Stand, 1962, designed 1951. Cherry; height, 43 in. (The Metropolitan Museum of Art, Gift of Dr. Irwin R. Berman in memory of his father, Allan Lake Berman, 1979.320. Photograph by Mark Darley. Image © The Metropolitan Museum of Art.)*

signs. A few sharp encounters with his own cubist furniture might have convinced him that rounded edges were easier to live with.

Esherick's most famous piece of furniture was a music stand he designed about 1951 and reproduced in the early 1960s. (Figure 7.31) The form is a concert of curves in both the horizontal and vertical planes. The outer frame of the sheet music holder is gently rounded, the sides flowing together. The legs join the frame abruptly, without transition, but continue upward as round dowels. It is a simple, brilliant design, a masterpiece of midcentury American woodworking. It is also widely imitated, and many neophyte woodworkers make an obligatory Esherickesque music stand along the way to finding their own paths.

Esherick loved wood. He harvested some from his own property, and much of the rest came from a local sawmill. He favored American woods such as cherry and walnut, often combining them in one piece. As for

technique, he was utterly unromantic. Although he used only one machine for many years, he felt no loyalty to handwork in and of itself. In 1966 he complained when a colleague brought up the idea of handcraft: "This thing you call handicraft, I say, 'Stop that thing.' I use any damn machinery I can get hold of. The top of this table was all done by machine. We didn't rub it by hand. Handcrafted has nothing to do with it. I'll use my teeth if I have to. There's a little of the hand, but the main thing is the heart and the head. Handcrafted! I say, 'Applesauce!' Stop it!"[81] He employed one or two shop assistants to do his joinery and finishing, which he found tedious. He would be involved in shaping the wood, however, and he signed and dated his furniture. Thinking like an artist, he drew no distinctions between his sculpture and his furniture. "The undisputed dean of American wood workers," Esherick worked until his death in 1970.[82]

A Little Glass

When people refer to glass design of the 1950s, they usually mean industrial work: George Sakier (for Fostoria), Russel Wright (for Imperial and Morgantown), and Wayne Dale Husted (for Blenko). Steuben continued in the direction it established in the 1930s, manufacturing clear glass in classical shapes enlivened with pictorial wheel engraving. Some glass was being blown at isolated sites around the country. For instance, Van Day Truex designed candlesticks and door handles for Tiffany & Co. that appear to have been blown. Most 1950s studio glass was confined to kiln-forming, following the pattern established by Maurice Heaton. Robert Sowers began his study of stained glass, and Robert Willson was also researching. Few in number, these makers did not even add up to a glass community, although they participated in panels discussing glass, as at the American Crafts Council's Asilomar conference in 1957. Perhaps the major event in glass in the decade was the 1958 exhibition at the Museum of Contemporary Crafts of works from the studios of Louis Comfort Tiffany, which had over the years been almost completely forgotten. They were outdated flea-market material until a sudden revival of interest.[83]

Ceramist **Edris Eckhardt** of Cleveland (see chapter 5), inspired by early Christian, Egyptian, and Byzantine gold glass, experimented with lamination and lost-wax casting of glass. She made her glass in a basement studio and is believed to have been the first individual maker to melt raw materials. Eckhardt produced a series of shallow reliefs and figurative sculptures. Some sculptures

FIGURE 7.32. *Edris Eckhardt*, Pharaoh's Horses, 1954. *Fused glass, internal enamels and engraved gold-leaf drawing, lead frame, unsigned; 3.78 × 3.27 in. (Collection of The Corning Museum of Glass, Corning, N.Y., Gift of the Artist, 1954.4.29. © Estate of Edris Eckhardt.)*

combined glass with bronze or other materials, and she invented a tool for drawing with hot glass. By 1953 she had discovered a way to laminate gold or silver between layers of glass. She engraved works with a stylus and rolled the glass with a rolling pin on a marble slab.

Although she said she was happy only when working three-dimensionally, Eckhardt's pieces remain strongly pictorial. (Figure 7.32) Her themes were often religious, which was not uncommon in the 1940s and 1950s. She won a glass prize in 1956 Ceramic National for *Archangel*, using fused gold and copper in the glass. Her other entry—a group of five panels including *King Lear*, *Remembrance of Spring*, and *Holy Family*—consisted of tall, narrow, abstracted figures suggestive of Georges Rouault or early figurative Jackson Pollock, in various sizes. *Uriel* (1968) is a small glass plaque in which the modeling is typically restrained and idealized. The deep blue color renders the angel insubstantial, as if he were transparent, posed against a starry night sky. The network of random lines running across Uriel's face is the result of cracking in the mold; the ragged edge is from grains of glass that later melted. The plaque, however, is not diminished by these accidents: both lines and edge relieve the otherwise highly controlled composition, and the cracks impart a sense of vulnerability to the celestial being.

The most celebrated of the kiln formers were the husband-and-wife team **Michael Higgins** (1908–1999) and **Frances Stewart Higgins** (1912–2004). Frances Stewart had taught crafts at the University of Georgia and had first formed glass in 1942. In 1947, when she was a graduate student at the Institute of Design in Chicago, she met Michael Higgins, an English graphic designer trained at Cambridge and London's Central School of Arts and Crafts, who immigrated to the United States in 1938 and moved to Chicago after World War II to head the institute's visual design department. The next year they married, left the institute, and started producing fused glass in kilns set up behind the sofa in their apartment. Within a few years, they were working split shifts, trying to keep up with the demand for their products.

Higgins glass was bold, brightly colored, and richly decorative. They coated sheets of window glass with colored enamels and discovered that they could build up layers of colors and shapes by working two pieces of glass of the same size and shape and then fusing them or by firing another layer onto the top surface. The overlaps produced secondary colors. The two gradually expanded their operation until they could fire an entire window. Their largest piece was a segmented window eighty feet long. Made for a bank in Wisconsin, it was lost or destroyed when the building was remodeled in the 1980s. They produced everything from earrings to room dividers, which they sold from their studio and at department stores nationwide.

The Higginses never distinguished between art and commerce. They felt they could add a personal touch to consumer goods that larger manufacturers could not manage. In 1957 they partnered with the Dearborn Glass Company of Chicago, functioning more as designers than hands-on craftspeople although they used the firm's facilities. Dearborn promoted their line as Higginsware. For Dearborn they designed Rondelay, a room divider of multicolored disks of molded glass 8½ inches in diameter, with brass fittings. When the partnership was dissolved in 1965, they returned to studio practice in which Michael made hinged boxes and Frances made vessels. A striking piece by Frances is a vase made of fused granules, in which a ragged top edge and scattered perforations contribute to an appearance of melting ice. (Figure 7.33)

Experimenting in California, **Glen Lukens**, after retirement from teaching (see chapter 5), slumped glass into molds he had used for his ceramics. He dribbled oxides over the molds and also colored his glass directly. **John Burton** (1894–1985), also in California, was said to have blown glass for twenty-five years by his own method

FIGURE 7.33. *Frances Stewart Higgins*, Vase, *ca. 1955. Fused, cast, and enameled glass; height, 9.25 in.; diameter, 6.54 in. (Collection of The Corning Museum of Glass, Corning, N.Y., Gift of Judi Jordan Sowers, 1986.4.8. © Higgins Glass.)*

of torch-melting a glass rod, annealing in a tin can, and flattening the bottoms of his forms on a hotplate. An English-born metallurgist, he sold his work in San Francisco and at America House in New York. **Frederick Carder**, long retired from Steuben (see chapter 5), continued his casting experiments until 1959.

Robert Sowers (1923–1990) was important both as a designer of stained glass and as a writer in the field. Broadly educated, Sowers had studied painting with Stuart Davis, art history with Meyer Schapiro, psychology of art with Rudolf Arnheim, and philosophy of art with Susanne Langer.[84] He became interested in stained glass as a contemporary art form in 1950 while in London on a Fulbright grant. He traveled Europe, looking at medieval stained glass, and published his first book, *The Lost Art: A Survey of One Thousand Years of Stained Glass*, in 1954. The book gives surprising weight to contemporary glass, and both here and in *Stained Glass: An Architectural Art* (1965), Sowers was instrumental in bringing the modern German school to the attention of American artists and advocating glass as an integral part of any architectural ensemble.[85]

Sowers's own work encompassed windows meant to be illuminated from behind and panels to be lit from the

FIGURE 7.34. *Robert Sowers, Red One, 1952. Leaded glass; 16.61 × 17.20 in. (Collection of The Corning Museum of Glass, Corning, N.Y., Gift of Judi Jordan Sowers, 1992.2.6. © Judi Jordan Sowers, Estate of Robert Sowers.)*

front. His *Red One* (1952) was included in an exhibition of new talent at the Museum of Modern Art in 1954, while his later facade for the 1960 American Airlines Terminal at Kennedy Airport in New York used smooth, machined glass for a modern look. (Figure 7.34)

In Short

The new academic bias toward exhibition work rather than everyday objects may have set the scene for the in-tense experimentation that began in the 1950s. The most visible exponent was the skilled young potter Peter Voulkos. Working alongside his students in Los Angeles, he inspired them with his energy, curiosity, enthusiasm, and competitiveness. His own work became a massive piling-up of vessels, while his students found ways to throw extremely tall pots, made walls of rough clay, or otherwise introduced an entirely new vocabulary of forms. The major events in clay were the visits of Bernard Leach, whose important book explained how to live as a potter, and the new Asian influence (via Leach and others) that introduced supportive Zen notions such as intuition and engagement in action.

In metals, individual research by various artists recovered or expanded old techniques such as granulation, niello, or lost-wax casting, providing new options for form and for surface treatment. Margaret De Patta's innovation was to create modern jewelry in which materials were chosen purely for visual effect, not for preciousness, and to engage such contemporary considerations as space, transparency, and motion. While there was little activity in glass and the textile field was relatively quiet—the most noted work being Mariska Karasz's unorthodox embroideries—there were new developments in wood. One was George Nakashima's "free edge" work, which left more of the tree in furniture. The Danish woodworker Tage Frid had arrived in 1948 to teach in the first college program to treat wood as a distinct medium, and he was to be an educational force, spreading his knowledge in many ways.

Communication improved inside the craft world. The national conference at Asilomar in 1957 was the most dramatic sign that a national craft community was beginning to coalesce.

CHAPTER 8 1960–1969

YOUTH CULTURE, COUNTERCULTURE, MULTICULTURE

Ringing Changes

The 1960s, a time of societal upheaval—including the civil rights movement, protests against the Vietnam War, and the Free Speech Movement at the University of California, Berkeley—was also a time of important structural changes in the arts. Among them were the beginning of video as an art medium, the emergence of performance art, the establishment of the National Endowment for the Arts (1965), and encouragement of art in public places (the General Services Administration's Art in Architecture program, 1963). The 1960s also saw the first commercial galleries devoted specifically to crafts, which expanded exhibition venues beyond municipal and school galleries. All this was concomitant with the coming-of-age of the postwar baby boom generation, and the flowering of a youth culture.

The 1960s was a decade of experimentation and change, in both life and craft. Alongside the professionals who introduced large-scale fiber, humorous ceramics, junk-material jewelry, and studio glassblowing, craft became an activity of the counterculture (the word itself coined in 1968). Tie-dye, macramé, leather sandals, rainbow-colored candles, and brown pots proliferated. Craft was fundamental to the 1960s ethos. It appealed because it involved the direct encounter of a maker with a material, which evoked America's pioneer roots and rejected the homogenizing pressure of industrial mass production and commercial motivations. Craft often suited a rural lifestyle, and it seemed to support the new "self-realization" motive as well. Rose Slivka asserted idealistically that in this changed climate, "The hero is no longer the man who makes the money but the man who has values beyond money—the artist, the intellectual—and the work he does to which he transmits this value."[1] But the "hippie" influx also confused the public understanding of craft, making people think that craft was newly invented as a protest, and its amateur quality lowered standards.

The folk pottery of the Southeast, which had begun its revitalization in the 1930s, blossomed during the 1960s. One reason was the fear of its loss due to technology; another was the affluence of the time, which encouraged collecting; another was American folklorists' study of

1960
 Price of an average home: $11,900
 Minimum wage: $1 an hour
 Birth control pill introduced
1962
 Cuban Missile Crisis: the United States and the
 Soviet Union come perilously close to nuclear
 war
 Rachel Carson's *Silent Spring* kicks off
 environmental movement
1963
 President John F. Kennedy assassinated;
 Lyndon B. Johnson succeeds him
 Betty Friedan publishes *The Feminine Mystique*
1964
 Gulf of Tonkin Resolution marks deepening of
 American involvement in the Vietnam War
 Civil Rights Act becomes law
 Berkeley Free Speech Movement begins
 Andy Warhol makes *Brillo Box*, an icon of pop art
1965
 Watts race riots in Los Angeles
 National Endowment for the Arts established
1966
 Architect Robert Venturi publishes *Complexity
 and Contradiction in Architecture*, the first
 theoretical text of postmodern design
1967
 Beatles release *Sgt. Pepper's Lonely Hearts Club
 Band* album
1968
 Martin Luther King Jr. and Robert Kennedy
 assassinated
 Richard Serra exhibits splashed-lead piece at Leo
 Castelli Gallery, initiating process art
1969
 U.S. astronauts land on the moon
 Stonewall riots in New York mark beginning of
 gay rights movement
 Nearly 500,000 people attend the Woodstock
 Music and Art Festival
 Between 250,000 and 500,000 protest the
 Vietnam War in Washington, D.C.

southern material culture. There was a sudden realization that contemporary potters, influenced by northern European and Japanese practices, were barely aware of this American precedent.

Folk crafts from other nations became widely available: the far corners of the world were now accessible by air, and collectors could buy things and bring them back to a market attracted to differences of style and hand. The studio craft movement in America had shown interest in Third World cultures since the 1930s, and the connection was institutionally endorsed when a World Craft Congress was held in New York in 1964. The products of the Arts and Crafts movement were also rediscovered in the 1960s, and its idealism seemed a breath of fresh air.

Yet at the same time American craft was shifting away from utilitarian forms and toward expression and intellectual content. As considerations changed, so did language. The 1950s term "designer-craftsman" gave way to "artist-craftsman" or "object maker." Important exhibitions marked the growth of the crafts and the changes within each medium, including *Abstract Expressionist Ceramics* and *Funk* for clay and the Lausanne Biennial, *Woven Forms*, and *Wall Hangings* for fiber. The changes naturally produced confusion as to purposes and standards. Although an entire issue of *Craft Horizons* was devoted to production work—including such major names as Edith Heath, Karen Karnes, Dorothy Liebes, John Prip, Marianne Strengell, Byron Temple, and Eva Zeisel—production became a path separate from the gallery and museum circuit, and never again would the central magazine of the craft field give it such an extensive endorsement.

Confusion about exhibition standards came to a head in 1964 with the jurying of the *Fiber, Clay, Metal* show at the Saint Paul Art Center, one of the major regular exhibitions. Almost 4,000 entries were received; only 101 were chosen by jurors Dorian Zachai (textiles), Peter Voulkos (ceramics), and Christian Schmidt (jewelry). Zachai subsequently wrote an exasperated article about the experience in *Craft Horizons*. She railed against the anonymity of decision making when there are multiple jurors, questioned the handling of a junk jewelry piece submitted under the name "Abraham Isitshit,"[2] and complained that she learned only later that "ceramic sculpture" was not eligible, after they had accepted works that would seem to be just that. In a style that one could imagine being accompanied by flailing hands and rolling eyes, she wrote: "And the basis for judgment? That is what everyone asks. Well, it is at this point that I stop reading articles like this because they usually descend into a mystic phraseology that depresses the guts right out of

FIGURE 8.1. *Christian Schmidt as Abraham Isitshit*, Medal of Honor, 1964. Wire, toy, cameo, rocks. (Collection of the Minnesota Museum of American Art, 1964.13.01.)

me. I would like to imitate it for you—'suitabilityofma terialsforms-experimentalconcepts-structuralconcepts-monumentalsignificance . . .' but I really can't do it. You either do or you don't get the idea. I cannot speak for any other member of the jury, but for myself, I look at things with my insides—and that is all there is to it."[3]

The article did not say so, but in fact juror Schmidt, equally upset that there were no consistent standards of evaluation and that inferior work was being admitted, had gone back to his hotel room and whipped up the worst piece of jewelry he could imagine. His professional work was elegant silver pendants and brooches in the form of pods and seeds. His example of bad jewelry was crudely assembled out of mangled wire, a cheesy toy sheriff's badge, a cheap cameo, and some rocks wired in place. When he slipped it among the submissions as *Medal of Honor*, under the made-up name, it was not only accepted but given a purchase prize. (Figure 8.1) It is reported that Schmidt was annoyed.[4]

Zachai's article also plunged into the ongoing debates about what was art and what was craft and the nature of

"experimental" work. The next two issues of *Craft Horizons* published a deluge of letters taking every possible position on these questions, including one from potter John Glick saying that he now felt better about having been rejected by the jurors.

The most important exhibition of the decade, *Objects: USA* (1969), did not stir such debate, perhaps because of its enormous success. Exposure alone made it a milestone, since it traveled extensively and had a substantial catalog. Large surveys across most craft mediums were familiar enough, but they were usually exhibited only at the originating museums, and exhibition catalogs were rare. (The most significant were those for the California Design series of exhibitions, from 1954 to 1976.)[5] In the mid-1960s, New York art dealer Lee Nordness became interested in craft and proposed to Samuel C. Johnson, president of S. C. Johnson Company (maker of Johnson's Wax), that an exhibition of American craft be assembled for a tour like the show the company had sponsored in 1962, *Art: USA, the Johnson Collection of Contemporary American Painting*. Johnson agreed to sponsor the project. Nordness invited Paul Smith, director of the Museum of Contemporary Crafts, to collaborate on this groundbreaking exhibition.

Objects: USA presented 300 objects (and sets) in most craft mediums. In addition to the familiar kinds of craft objects, there was a mosaic panel, a fiberglass door, and a cast-aluminum chair. (The only significant omissions were handmade books and paper.) The show opened in Washington, D.C., in 1969, traveled to twenty-two American museums, and was sent on a tour of Europe. All the works were purchased by S. C. Johnson Company, and most of them were donated to the American museums that hosted the show.

Most important was the adventurousness of Nordness and Smith's choices: selections represented the cutting edge of craft. Of some seventy-seven fiber pieces, the vast majority were wall hangings, and only six were functional. Newcomers such as Jun Kaneko, J. Fred Woell, Wendell Castle, and Neda Al-Hilali were included, while established figures like Glen Lukens, Allan Adler, and Walker Weed were bypassed. *Objects: USA* drew crowds wherever it was shown, introducing thousands to contemporary craft.

In the meantime, craft shops, with their extensive displays of merchandise by many makers, began to give way to galleries with a more focused selection of works by a small number of artists or even a single one, remaining on display for a fixed period. The crafts, establishing their own sites for display, adopted art's style of exhibition and sale.

Paul Smith

Paul Smith came to New York in the mid-1950s after attending art school in Buffalo. He was hired by David Campbell, president of the ACC and later also director of the Museum of Contemporary Crafts, to develop traveling exhibitions and educational programs. His 1963 exhibition *Woven Forms*, organized when he was assistant director of the museum, was one of its most exciting and historically important shows. When Campbell died suddenly, Mrs. Webb hesitated to appoint Smith to the top job because of his youth but "pushed him off the diving board" in Rose Slivka's words. He swam, developing a reputation for seeing everything and for putting together shows of things that were just beginning to happen, which he could do because there was little institutional bureaucracy and not much in the way of catalogs. He was criticized, however, for crowd-pleasing exhibitions; a show like *Cookies and Breads: The Baker's Art* seemed "frivolous and suspect" to many craftspeople, although it was important to the museum's efforts to address a larger public. Smith ran the museum for more than twenty years.[1]

NOTE

1. This account is based on Robert Kehlmann, "Consummate Connoisseur," *American Craft* 47 (October–November 1987): 50–55.

Textiles Go Large

In this decade, fiber exploded into large scale and into three dimensions, a change all the more impressive because it was mostly women doing it, confounding the still-prevalent stereotypes of feminine modesty and passiveness. The trend was away from utility and toward expression and sculptural form, though the 1950s interest in historical processes continued. Architects took notice of the increased scale and commissioned fiber for display, not for draperies. The work's architectural qualities were exploited autonomously in the new art forms called installations and environments.

Large scale was encouraged by the new Lausanne Biennial, which required a minimum size of ten square meters for exhibited works. The Milan Design Triennial in 1964 included American fiber works. Some pieces were borrowed from museum collections (an indication of the improved standing of craft). In 1969 textiles were shown at New York's Museum of Modern Art when Mildred Constantine and Jack Lenor Larsen organized *Wall Hangings*. They wrote: "The weavers from eight countries represented are not part of the fabric industry, but of the world of art. They have extended the formal possibilities of fabric, frequently using complex and unusual techniques."[6] "Weaver" was becoming an inadequate term.

Fiber also boomed among hobbyists. That gave professionals new opportunities for writing. In 1967 Nell Znamierowski's *Step-by-Step Weaving* and Virginia Harvey's *Macramé, the Art of Creative Knotting* were published. Among the trends of the decade were: moving off the wall, coarse materials such as sisal and loosely spun raw wool, nonloom techniques, and the influence of ethnographic textiles. On the negative side, the 1960s began the convention of extremely tactile works linked to the free expression of emotions, which were newly termed "touchy-feely." Other newly popular materials such as feathers and bones quickly became clichés.

LENORE TAWNEY

If the revolution in clay is attributed to Peter Voulkos, that in textiles should be credited to Lenore Tawney. (Figure 8.2) Although she was not the first to bare the warp and not the only one to move into three dimensions in the late 1950s, the extraordinary power of her works' large scale, simple lines, and reductive color made pieces such as *Dark River* (1961) breathtaking.

Tawney (1907–2007) was born Leonora Gallagher in Ohio. She moved to Chicago in 1927 and worked as a proofreader while studying art, presuming that sculpture would be her métier. She married George Tawney; he died suddenly in 1943, a year and a half later. While essential facts are known about her early life—including that she was a sufficiently impressive student of Alexander Archipenko at Chicago's Institute of Design that she was invited to assist him at his Woodstock, New York, summer studio—she was a private person, and this taciturnity-become-mystery added to the emotional timbre of her work.

After studying weaving with Marli Ehrman in Chicago, Tawney bought her first loom in 1948. But only in 1954—after living in Paris, traveling in Europe and North Africa, and returning to the United States to take a six-week course with the Finnish weaver Martta Taipale at Penland—did Tawney wholly devote herself to weaving. In 1955 she began her open-warp pieces, which contrasted areas of plain weave or laid-in lines with large areas of uncovered warp threads. In *Yellows* (1958), for example, within a conventional rectangular format with

FIGURE 8.2. *Lenore Tawney, exhibition at Elaine Benson Gallery, Bridgehampton, N.Y., 1967. (Photograph © Clayton Price.)*

wood slats at top and bottom, the narrow panel seemingly dissolves into seven zigzags of laid-in yellow and orange yarns. They are densely packed and approximately parallel in movement near the top but become more independently agitated and fluttery until they seem to pool at the bottom boundary. She first incorporated feathers around the same time, not always in conjunction with bird imagery.

Tawney moved to New York in 1957, setting up in an old loft building near the East River in Lower Manhattan, its spaciousness expanding her prospects.[7] Her neighbors were painters and sculptors. One of them, Agnes Martin, became a good friend; the subtle linear qualities of their works were in sympathy despite the different materials, and they named each other's pieces. In that loft, on Coenties Slip, and later in another nearby on South Street, Tawney felt the need for her weavings to break free and grow in scale. She briefly studied gauze weave with Lili Blumenau and looked at pre-Columbian laces and gauzes in museums. She subverted weaving's rectilinear format, abandoning the standard straight selvedges. She wove with two shuttles, throwing from both sides, to strengthen edges that moved in and out for visual effect, and used the split-tapestry technique to create separate segments that seemed to multiply the drama. The structure evokes compression and release, which Tawney has related to "inspiration and aspiration,"[8] as well as the flow of water or air. Single pieces reached sixteen feet in length. She braided the warp ends or let them relax in long fringes.

In 1961 the Staten Island Museum gave Tawney her first solo show. It featured forty works from the previous six years. There were impressionistic tapestries, open-warp works woven in two layers with a space between, and austere new works she called "woven forms"—"forms" implying a third dimension, although "woven" meant "flat." One of the most magnificent of the new type, *Dark River* is a 13½-foot gush of darkness that is interrupted by shifts in the narrow bands of separated warps. Only the inserted rods that mark the shifts between sections emphasize the horizontal. Greater density at the top makes it look heavier there, and the horizontal rods are close together, impeding the movement that, after the widest point in the weaving, pours out into longer and narrower segments that pull the eye downward. Works like this have a powerful, almost figurative presence, to which Tawney allowed more explicit reference in the titles of pieces she made the following year, such as *The King* (a forceful joining of black and natural linen twelve feet tall) and *The Queen* (even taller but more reticent in its all-natural coloration). In these shaped works, image and object are unified.

Tawney regarded the works as sculptural. Although flat, they might incorporate more than one plane, and she hung many away from the wall so that shadows added to their depth. The phrase "woven forms" was picked up by Paul Smith for the title of his celebrated 1963 show of textile work by five women—Tawney, given the museum's lower floor, and Claire Zeisler, Sheila Hicks, Dorian Zachai, and Alice Adams on the second level. In a brief catalog essay, Smith noted that the creation of form was accomplished on the loom, not by cutting and combining after weaving. Observing, further, that most previous tapestry had been religious in orientation, he wrote: "Lacking a coherent conceptual basis of this sort the contemporary artist must find his means of expression within himself. Whether consciously or unconsciously, the initial tendency of the search for a personal idiom is iconoclastic and results in the destruction of traditional form."[9] The new work conceived of weaving in entirely novel ways: the structural twining, twisting, or wrapping of warp seen in the work of Tawney, inspiration from pre-Columbian weaving techniques of Peru in the works of Zeisler and Hicks, and materials influ-

Alice Adams and Dorian Zachai

Adams and Zachai, despite being part of *Woven Forms*, gradually faded from the scene and were largely forgotten. Zachai, however, was the first to stuff a woven form to make sculpture. She had worked in display, painted, and taken up dance before finding fiber. Of the five artists in the landmark exhibition, she was the most copied, especially by student weavers, who found the "spectacular immediacy of her style" irresistible.[1]

Adams had a free approach to materials that later in the 1960s led her to large outdoor environments of cords, including steel cable and tarred rope, and in the 1970s into other mediums and adventurous actions, such as exhibiting a cutout piece of her studio wall. She was also a teacher and an influential critic, regularly contributing reviews and profiles to *Craft Horizons* into the 1970s.

NOTE

1. Mildred Constantine and Jack Lenor Larsen, *Beyond Craft: The Art Fabric* (1973; New York: Kodansha International, 1986), 50.

over another."[11] This experience would contribute to her Cloud series of very large works for public places, beginning in 1978, which involved tying threads as much as twenty feet long into a fabric backing that is suspended from the ceiling; the threads hang freely and move subtly.

For the moment, however, Tawney reached a conclusion in weaving when she created a circle-in-square motif (which, she said, had Jungian significance as the integration of the self) and wrapped the warps in the top half of the circle in manuscript paper. *Waters above the Firmament* (1976) is a union of weaving and collage. Her primary work thereafter was drawings, collages, and assemblages that have been called "boxed and caged narratives."[12] She also made personalized postcards, sent to friends from her travels; she added drawings and even collaged materials that somehow made it through the mail. These have been collected in an eloquent book by Holland Cotter.[13]

It is interesting to note, in today's youth-obsessed culture, that Tawney was almost fifty when she made her first great change, the open-warp works, and she made the daring conceptual shift to woven sculpture still later. Her extraordinary creative life came during what was often dismissed as the downhill side, especially in women.

CLAIRE ZEISLER

Claire Zeisler (1903–1991), the second dazzler in the *Woven Forms* exhibition, had, like Tawney, traveled a long and twisted path to that place. Zeisler had her first solo show in 1962, in her hometown of Chicago. It so happened that Tawney saw the show, and she called Zeisler and said, "Your work is the only work I've seen that I can identify with.... I'm having a show at the Contemporary Craft Museum in New York in '62, ... and you have to be in that show!" as Zeisler later recounted. Zeisler and the others on the second floor of the museum were the artists who had "potential," while Tawney had "arrived."[14]

That was an accurate assessment, for Zeisler had not yet found her signature style. In *Woven Forms*, she showed slit tapestries called *Black Ritual* (1961) and *Purple* (1962). These are hangings with layers and pockets and areas of gauze transparency, the former recalling a fringed deerskin shirt with trappings and the latter offering complex, segmented surface planes. Zeisler, in any case, hardly seemed a candidate for major artistic achievement. She was a wealthy collector of Picassos and Klees, tribal arts, and baskets who had dabbled in the arts for years—"very dilettantish," she would recall with a laugh. She studied sculpture with Archipenko in the 1930s and took classes at the Institute of Design in the 1940s, although not

enced by modern assemblage in pieces by Zachai and Adams.

Despite Tawney's sudden celebrity, her innovations were not universally appreciated any more than Voulkos's were. Some weavers were horrified at her irregular edges, and she would later say that weavers on juries tended to disapprove of her works, while painters supported them. In addition to her monumental pieces, she made the small, convex Shields in heavy linen with goose quills; they evoke American Indian shields as they invoke an idea of protection.

In 1964, when the World Crafts Council met in New York, Tawney took a tour of a Jacquard mill in New Jersey. On the huge mechanized loom "it was the most thrilling thing to see the threads moving and trembling like music," she said.[10] That led her to study the Jacquard loom at the Textile Institute in Philadelphia. It was not the ability to design complex patterns but physical qualities, the bundling of threads, that interested her. What resulted was a series of fine-line, emotive drawings on graph paper. "I kept making these drawings for the whole year," she later said. "They were like a meditation, each drawing, each line. They were wonderful to do.... Some came out in a moiré design, when you do one drawing

Marli Ehrman's weaving courses. Still, she credited her studies there with instilling the discipline that enabled her later achievements. She bought a loom on impulse, studied briefly with a number of teachers, and wove solely to please herself. At the time of her first solo, she was fifty-nine years old and her best work was ahead of her. "I was a slightly late bloomer," she joked.[15]

Recently widowed, Zeisler stayed in New York after the *Woven Forms* opening to study with Lili Blumenau. In the studio, she saw some knotted pieces by Blumenau's Haitian assistant and was fascinated: she recognized the potential for free form this technique would offer, and she was ready to abandon the loom. Knotting was common in the Third World for decorative items like belts and purses, and American sailors knew the knots, but it was otherwise unknown in the United States when she began. The following year, Zeisler, Tawney, and Hicks showed at the Kunstgewerbemuseum in Zurich. Zeisler was represented by slit tapestry, as in New York, but also by ribbonlike works, knotted and plaited pieces, and net-like crochet patterns. There were some sales from that show; European museums, notably the Stedelijk in Amsterdam, had begun to collect American craft. Support at home was not as immediate. Zeisler recalled that there was no press for her first Chicago shows, at the public library and the Renaissance Society, because there was no frame of reference for the work. She found that exciting, but not everyone agreed.[16]

Erika Billeter later said that ultimately Zeisler's work represented the greatest leap from conventional tapestry.[17] By 1967 she was knotting at large scale; her works had left the wall and—remarkably—they were not suspended but rose from the floor. Through tight knotting and angled, buttressing bases, she was able to make them self-supporting. She showed the new works at Feigen Gallery in Chicago in 1968, which she believed was the first time a contemporary textile artist had "passed" into a fine arts gallery. A classic piece of this period is her *Red Preview* (1969), a majestic vertical 8 feet tall with a central mass and two subsidiary flanges bracing it and a cascade of raw threads pouring down on both sides and coiling on the floor. (Figure 8.3) During the decade, knotting became familiar in the United States as the hobby craft of macramé. Zeisler insisted that macramé knots were decorative but that hers were structural and anyway were often concealed by the signature falls of threads she called "hair." *Red Preview* is also characteristic in its intense color. It is strikingly erotic in form, both phallic in its vertical thrust and labial in its organization.[18]

Zeisler's contributions to the Lausanne Biennial of Tapestry in the 1970s included constructed balls of wool

FIGURE 8.3. *Claire Zeisler, Red Preview, 1969. Jute, flanges square-knotted and wrapped, cascading ends; 96 × 60 in. (The Art Institute of Chicago, Gift of Claire Zeisler, 1979.294. © Estate of Claire Zeisler.)*

that looked both very dense and light enough to float away. These were utterly unlike the European notion of textile art, which then meant traditional tapestry, and baffled the biennial audience. Her retrospective at the Art Institute of Chicago in 1979 included relief and shaped weavings, along with knotted works as dimensional as *Red Preview* and others more frontal and rectilinear in form, such as *Untitled (Three Elements)* (1967), in which yellow jute knotted slabs are crowned with square "pillows" of bristling fiber incised with graphic emblems. Zeisler earned a reputation for thinking fully in the round; her largest knotted pieces showed "weight and dignity and a commanding presence," while the fall of threads produced "gravitational movement, slow and deliberate."[19] She also made long, coiling works in which intense red and brilliant turquoise yarn wrapped around and extended children's Slinky toys, and booklike works consisting of piled pieces of chamois that were machine-stitched along the edges to emphasize the crimp.

All Zeisler's larger works were made with the aid of assistants, as many as four at a time working on the knotted pieces. She said that she established a workshop as a discipline, so that she would have to work out all the details of a piece and couldn't "ad lib."[20] But she continued to construct small works by herself: many of these

involved wrapping or knotting or working a buttonhole stitch over small collected objects such as stones, shells, and bones. Their diminutive size and intensity evoke amulets, but her brilliant colors make them contemporary and distinctively her own. She continued working in these varied directions until her death in 1991, at age eighty-eight.

SHEILA HICKS

The third member of the reigning "triumgynate" of 1960s fiber (the word is Lucy Lippard's)[21] was Sheila Hicks. Like Tawney and Zeisler, she was a midwesterner by birth and perhaps a traveler by nature, yet only half their age. Born in 1934, Hicks studied painting and printmaking for two years at Syracuse University before transferring to Yale, where her life was shaped by encounters with several influential figures, especially George Kubler, whose course introduced her to pre-Columbian textiles and convinced her that figure-ground relationships could be interestingly explored in a textile medium, and Josef Albers, who introduced her to color and, when he saw her working on a makeshift frame loom, took her home to meet Anni.

After Hicks's graduation in 1957, a Fulbright fellowship allowed her to go to South America, where she visited sites recommended by Albers and by Junius Bird, curator at the American Museum of Natural History. It was academic research intermixed with adventures worthy of a female Indiana Jones. Her learning, teaching, documentation, collecting, and exhibiting on the trip, plus a stint back on campus, earned her an MFA. Not long afterward, married and living on an apiary ranch an hour outside Mexico City, she began weaving seriously in an exceptionally low-tech way.

Having been exposed to backstrap weaving on her South American adventure, Hicks took up a small frame, like painting stretchers, and constructed squares or rectangles with four selvedges by needle-weaving yarns back and forth. This method—lacking loom, reed, shuttle, and the ninety-degree organization of threads—gave her a great opportunity to develop line, color, and especially an irregular and evocative texture. She showed some of these unusual works to a gallery owner in Mexico City and was given a show in 1961. He also recommended contacts in New York, so on her next trip she called Greta Daniel, a design curator at the Museum of Modern Art, and was able to meet her and show works to her, to Arthur Drexler of the architecture department, and to Alfred Barr, the director. This access was perhaps a reflection of the connections she had already established but also an indication of the smaller and less bureaucratic art world of the day.

MOMA was interested in the work but wanted larger scale. When she returned some months later with works four times as large, the result of enormous effort by Hicks with help from others on the ranch, MOMA was disappointed at the still-modest size but bought some pieces. Hicks has continued to weave these portable improvisations throughout her career, but this encounter defined a difficulty that persists: their intimate dimensions evoke studies, not completed works, despite her insistence on their importance.

MOMA led Hicks toward architectural work, yet also at this time she was introduced to the craft world, when Paul Smith invited her to participate in *Woven Forms*. She lived in Mexico only a few more years and has since lived in Paris, where she has created major works for corporate commissions and shown smaller pieces within the textile milieu. She made her living from commissions. Early in her search for means to large scale, she found a factory in Wuppertal, Germany, where workers using a tufting gun could rapidly create texture in quantity. Works of this type were shown in the showrooms of Knoll and Herman Miller in Europe. MOMA's acquisition of one in 1966 coincidentally led to a commission for the CBS Building in New York and introduced Hicks to interior designer Warren Platner, with whom she collaborated on several subsequent commissions. The culmination of the tufted pieces was *Grand Hieroglyph* (1968), an eleven-by-twenty-five-foot expanse of pile that presents soft and shifting geometry and directional relief. (Figure 8.4)

Hicks established her workshop after she accepted a commission through Platner for an enormous wall at the Ford Foundation in New York City. "He wanted a textile artist whose works could be integrated with architecture without being decorative, so that thread was not ornament but a constructive material," she explained.[22] Her design consisted of silk threads crossing (and concealing) a metal disk (thus a raised twist in the center), this motif repeated in rows across a huge wall. Here fiber contributed its tactility to the cool, elegant space, although the color is quite reserved.

Hicks has at various times worked with textile-producing communities (once in her South American journey, once in Mexico). In 1966 she accepted a commission from a handloom textile factory in southern India to create designs in cotton that would suit the European market; she returned to India two years later to create the Monsoon Collection, including silks. One of the designs, *Palghat*, featured extrusions of supplementary yarns that tumbled out in the middle of a panel and were braided or wrapped with a contrasting color; another, *Badagara*, was shown in the 1967 Lausanne Biennial,

demonstrating the seamless relationship of her art and her commercial design.

Badagara was a double-sided cloth of fat, protruding weft masses that periodically split into two smaller fingers. Another of Hicks's approaches to texture, seen in the monumentally proportioned Principal Wife series, was inspired by both the wrapping of warps for ikat dyeing (which she had seen in Mexico) and the ancient Peruvian *quipu* system of recording data in knots. *The Principal Wife Goes On* is an assembly of eleven fifteen-foot bundles of natural linen threads wrapped at intervals with dazzling colored silks. Impressive in its size and vibrancy, it is mysterious in its complexity of line and teasing title. Hicks also used the technique in a wall piece for a restaurant at the TWA terminal in New York, wrapping red yarn in other reds and stabilizing it against a background so that the unwrapped portions bulge voluptuously.

In 1969 Amsterdam's Stedelijk Museum mounted a show of new textiles. Hicks took the opportunity to create several dramatic environments. She also introduced a new way to make big works in her small studio: a modular approach using folded and tied bundles of yarn with one end cut to make a tassel, which she calls a ponytail. These could be rearranged in various configurations; *Banisteriopsis* (named for a hallucinogenic plant) consisted of 3,000 yellow ponytails.

A later Hicks theme (introduced in 1977) was to create displays or environments of used clothing. These were community-participation projects that seemingly had the features of both textile arts and contemporary instal-

Lausanne Biennial

In 1961 Jean Lurçat, who had undertaken a government-sponsored revival of the Aubusson tapestry industry in France in 1939, founded the Centre International de la Tapisserie Ancienne et Moderne at Lausanne, Switzerland. This organization began holding international biennial exhibitions of tapestry in 1962. From the start, the intended focus—designs (called cartoons) by artists (mostly painters), executed by artisans—was overwhelmed by monumental textiles designed and made by weavers themselves, led by eastern European innovators such as Magdalena Abakanowicz. By 1967, when the first Americans (Hicks and the now-unknown Louise Pierucci) were included, the traditional pictorial tapestries and the "applied arts" mind-set were disappearing in favor of greater freedom, variety, expression, and experimentation. The exhibitions—which encouraged large-scale, ambitious presentations of textiles in the 1960s and 1970s—continued biennially until 1989; the last was held in 1995.

lation work but have not been widely popular with craft audiences. Her more appreciated forms were the most tactile, such as the arch-form wall rugs she produced at a craft community in Morocco and sheared with scissors, or her schematic expansions of textile structure, such as the gigantic grid interwoven of cords 1½ inches in diame-

Wall Hangings

In February 1969 MOMA opened *Wall Hangings*, organized by Mildred Constantine and Jack Lenor Larsen. In this unprecedented show—which, despite the title, included freestanding pieces—the new textile emphasis on construction, abstraction, and the fibrous substance itself was introduced to a large audience in a variety of experimental works. A Willem de Kooning retrospective was up at the same time, and viewers reached it through the *Wall Hangings* show, ensuring great exposure. Artists from eighteen countries participated, Sheila Hicks contributing another in the Principal Wife series and *Evolving Tapestry*, which she recomposed on the spot after some parts of the shipment were lost. This was the first major museum show presenting such work as art rather than as decorative art or design.[1]

NOTE

1. Mildred Constantine and Laurel Reuter, *Frontiers in Fiber: The Americans* (Fargo: North Dakota Museum of Art, 1988), unpaged.

ter, tied here and there with loops of brilliant color, which she created for IBM at La Défense in Paris in 1972. Late in the century, Hicks returned to enlarged structure in works of intertwined yarns, in which the yarns were actually skeins worked as one. In the late 1990s, she was involved in the development of fine stainless-steel threads of various color tones, which could be worked like any threads but could also tolerate exposure to the weather. This high-tech material, which she showed along with work by Japanese textile artists at MOMA in 1998, exemplifies the creative reach of an artist who began with an interest in low-tech Andean methods.

Though Hicks was championed by important curators, especially Constantine, and her work was featured on the catalog covers for both the *Wall Hangings* and Stedelijk shows of 1969, the work received little press. She refers to her artworks as "homeless orphans" rarely acquired by private collectors, and she feels that the effort and time spent was disproportionate to the results.[23] She never stopped making art but found greater recognition and satisfaction in her architectural projects.

ED ROSSBACH

Ed Rossbach was probably the twentieth century's most important teacher of textiles. (Figure 8.5) He was influ-

ential far beyond the confines of the University of California, Berkeley, through his writings, which included study articles on specific techniques, historical articles on important personalities in textiles, and, most of all, his books *Baskets as Textile Art* (1973, reissued as *The Nature of Basketry* in 1986) and *The New Basketry* (1976), which ignited the explosion of basketry in the 1970s and then recorded where it was going.[24]

Rossbach was also influential in his work, in an unconventional way. He was uninterested in selling and did nothing to promote his output as art. He was, however,

FIGURE 8.5. *Ed Rossbach, Delta, 1964. Raffia, synthetic raffia and found synthetic ribbon, plain weave with interlocked discontinuous warps and wefts; 18 × 8.5 in. (Museum of Fine Arts, Boston, The Daphne Farago Collection, 2004.2100. Photograph © 2008 Museum of Fine Arts, Boston.)*

intensely interested in the discovery and recuperation of textile techniques of structure and of ornamentation, and his unceasing experimentation in this regard was widely inspirational.

Charles Edmund Rossbach (1914–2002) was born in Chicago, but his family later moved to Seattle. He graduated from the University of Washington in 1940 in design and painting, took a master's in art education at Columbia University in New York, and began teaching seventh grade in a small town in Washington State. He enlisted in the army after Pearl Harbor and served for a time in the isolation of the Aleutian Islands off Alaska, where he made his first, unsuccessful attempt at forming a basket, using local grasses that were too brittle.

After the war Rossbach went to graduate school at Cranbrook on the GI Bill, studying textiles with Marianne Strengell and ceramics with Maija Grotell. He had no previous weaving experience, but he had seen the Golden Gate Exposition with its decorative arts display organized by Dorothy Liebes, and he had been exposed to many textile techniques through his mother, aunts, and three sisters, although he was excluded from participation. Strengell's Scandinavian and commercial biases were unsatisfying to him, but Grotell responded emotionally to fiber and provided balance in his Cranbrook experience. Upon finishing his degree, he began teaching at the University of Washington, where Jack Lenor Larsen, an undergraduate with weaving experience, was his assistant for a weaving class. There he met and married another teacher, Katherine Westphal (see chapter 9), and together they moved to the Bay Area in 1950, when he began teaching at Berkeley.

Berkeley was then the only American school offering a master's degree in textiles. It also had an unusual orientation toward pre-Columbian and other ethnic textiles, since the previous director of the department, Dr. Lila M. O'Neale, was a weaver who became an anthropologist; she had analyzed Peruvian textiles and then published her own research on the baskets of the Yurok Indians of Northern California and Oregon. Dr. Anna Gayton, who taught textile history, required students to analyze fabric. Rossbach, struggling to stay ahead of his graduate students, felt that to truly understand a method he had to do it himself. This may explain his devotion to experimenting, but he also simply had an appetite for experience; he did not like to repeat himself and would not even create works in series.

About the only thing Rossbach ever repeated was the Mickey Mouse motif, which he employed in many works, especially those involving laborious techniques. It served

as an acknowledgment of popular culture (no matter how esoteric his method) and also as a diminution of claims for status. "It's not that I'm so fond of him," he said, "but he's a statement of our present condition in the crafts. There is no imagery that seems appropriate, and yet there is a strong desire to use imagery."[25] Another of his means to reduce pretension was using ephemeral materials. He used newspapers—symbolic of brevity in being outdated in a day—as background and even, when rolled, as structural elements for baskets. Someone said that he obtained his materials from the wastebasket. He demurred: "I am not trying to be ingenious or clever, or to make a statement about junk or waste in our society. Really, I am declaring my fascination with the very simple, wonderful things that are a part of our lives."[26]

Rossbach's lighthearted mastery was revealed in other unexpected ways. He knotted a relief face into the bottom of a plate when he explored macramé. He heat-set a newspaper image of actor John Travolta's face onto a gauzy sheet of silk and mounted it on a small tabletop easel made of reeds tied with string, their ends finished with electrical tape.

Jan Janeiro says that, from the 1960s to the 1980s, Rossbach progressed from "classical" works (studying structure) to baskets and other constructions (most showing spontaneity and immediacy).[27] That's a coherent outline for a staggeringly diverse output, which seems to have been a direct rebellion against Strengell and the educational climate that allowed little experimentation or imagination when he was a student. There is a popular misapprehension that he also rebelled against his schooling by never doing commercial work, but in fact he and Westphal made textile designs that were marketed by a New York agent, and Rossbach said he "absolutely loved it." The advantage was that the agent was far away and contact was by mail. But the agent retired after a few years, and they never found another.[28]

Rossbach and Westphal traveled extensively, often to see living textile traditions or to do research. Besides his basketry book, he also published one on paisley and wrote a book on French silks that never found a publisher. Rossbach may have been the first contemporary fiber artist to use ikat. He was among the first to explore plaiting. He was the first to use paper for textile art and was a leader in using plastic film and thermoplastic bonding. When he used stuffed transparent tubes, a critic noted, he added a new dimension to his work: the space within the fiber.[29] At the same time, he declined some practices: monumentality, commissions, opportunities to show or sell, to lead workshops, to lecture or to

compete in any sense. His pleasure in textiles was almost bafflingly pure. His legacy is his writing and his many students who went on to do important work, both making and teaching. It is a staggering irony that Berkeley, the employer of Voulkos and Rossbach—two of the most important figures in a century of American craft—closed the department in which they taught.[30]

TRUDE GUERMONPREZ

Trude Guermonprez (gwer-mon-pray; 1910–1976), perhaps even more than Anni Albers, linked the Bauhaus tradition to new American textile forms, since she was a major teacher of fiber arts in the textile-focused Bay Area. Born Gertrud Jalowetz to an Austrian couple living in Poland in 1910, she studied at several European art and textile schools, notably, at Halle-Saale, where Gerhard Marcks and Marguerite Wildenhain taught after leaving the Bauhaus. She was a favorite model for Marcks (and, some claimed, his mistress).[31] After graduation she became a textile designer in Holland and also executed private commissions. She remained there, in hiding, throughout the war; her husband, active in the Dutch Resistance, was captured and killed by the Nazis.

Guermonprez's parents (a conductor and a voice teacher) were in America, teaching at Black Mountain College. She came there as a visiting consultant in weaving in 1947, filled in when Anni Albers left on sabbatical, and was appointed to the faculty in 1948. She showed a gift for teaching, but she left Black Mountain in 1949 to teach with Wildenhain at Pond Farm.[32] In 1951 Guermonprez married and moved to San Francisco, where she began teaching at the California College of Arts and Crafts in 1954, chairing the weaving department from 1960 until her death in 1976.

Having studied weaving as a commercial activity, Guermonprez designed and wove on commission and for production. But in the United States there were not so many opportunities for design and greater expectation of expression. Even at Black Mountain, perhaps influenced by Albers's turn to "pictorial weaving," she created *Leaf Study* (1948), her first use of painted (or stencil-printed) warp threads, which began a body of work she called "textile graphics." From 1960 to 1965, she developed "space hangings" and banners. (Figure 8.6) The former were double-cloth weavings that opened to form four supported panels meeting perpendicularly or diagonally. She also made shaped tapestries, starting with *Birth of Round* in the mid-1960s. Her textile graphics went from warm but reserved neutrals to brighter colors reflecting the landscape of California, became personal through the

FIGURE 8.6. *Trude Guermonprez*, Untitled Space Hanging. *Double cloth weaving; 35 × 25 × 25 in. (Collection of the Oakland Museum of California, Gift of Eric and Sylvia Elsesser, A1989.1.)*

use of imagery, sometimes adopted text, and addressed current events.

Guermonprez's most famous work was one she made when terminally ill. *Mandy's Motto* (1975) repeats the words of her housekeeper, "The wind don't blow one way all the time." This wall hanging—in red, white, and blue with strips of cloth (a recycled flag) hanging from the left and right sides, and with the image and words repeated upside down—speaks to the end of the Vietnam War, the political upheaval following the burglary of the Democratic campaign headquarters in the Watergate building, and the resignation of President Richard Nixon.[33] This memorable work might have opened new possibilities had she lived longer. The drift of the time was toward exhibitions and away from production design; her posthumous retrospective at the Oakland Museum did not feature her commercial work.

LILLIAN ELLIOTT

A much-praised early figure in the Bay Area craft scene, Lillian Elliott was a weaver, collagist, and basket maker who later drew attention for her collaborations with Pat Hickman (see chapter 10). Elliott (1930–1994) earned an MFA from Cranbrook and was a fabric designer for the Ford Motor Company from 1956 to 1959, the first

FIGURE 8.7. *Lillian Elliot*, A Walk with Cézanne, *1965. Appliqué collage; 10 × 28 in. (© Lillian Elliot. Photograph courtesy of Patricia Hickman.)*

woman employed as a designer there. By 1964 she was established in the Bay Area, and her show of nineteen wall hangings and a quilt was reviewed in *Craft Horizons.*

Emphasizing stitchery, the show included works Elliott had woven, knitted, printed, or dyed. Weavings employed random-ply wool yarns to create abstractions through varied textures; needlepoint tapestries were suspended from and weighted with small branches. The most noted work, *A Walk with Cézanne,* was a ten-by-twenty-eight-inch collage of tiny, raw-edged bits of colorful cloth, appliquéd and embroidered. (Figure 8.7) Shown again in the Museum of Contemporary Crafts' 1965 show *Fabric Collage,* it was regarded as particularly painterly and showing "a keen feel for abstract design."[34] Yet when it was honored in a California art festival, there was some outrage "that anyone could just tear up pieces of cloth that way and paste them together and win a prize," according to Margery Anneberg, who showed Elliott's work at her gallery in the 1960s and 1970s.[35]

Elliott taught at the University of California, Berkeley; the California College of Arts and Crafts; and later the Pacific Basin School. Her experimentation won the admiration of Ed Rossbach, who said she influenced his work and his thinking about textiles.[36] She began making baskets in the 1970s, and here, too, she could not be pinned to one material or technique, and her nervy work played an important role in the development of the field.

MARY WALKER PHILLIPS

Among the many innovations in postwar fiber, the one in knitting is creditable to Mary Walker Phillips alone. (Figure 8.8) She showed her hand-knit hangings at the Milan Design Triennial in 1964, alongside the work of Liebes, Albers, and Tawney. In a knit linen wall hanging, a conical area in shell stitch created texture; it was blocked and starched, unlike familiar knitting. Phillips wrote five books on knitting and macramé, one of which sold more than 700,000 copies in a year. Obviously, she was speaking to the world of hobbyists, but she held her own among sophisticated makers.

Phillips (1923–2007) was born in Fresno, California, and learned needlecrafts as a child. She studied at several California colleges, earned a BFA in weaving from Cranbrook, and moved to San Francisco in 1947 to work as a weaver in Liebes's studio. In 1949 she spent three weeks at Taliesen West, weaving her designs for Frank Lloyd

FIGURE 8.8. *Mary Walker Phillips*, Knitted Wall Hanging, *1965.*
(© Mary Walker Phillips Estate. Photograph courtesy of
Patricia Abrahamian.)

Wright's home. She worked in Europe and taught and freelanced in her hometown before returning to Cranbrook. She earned an MFA in the textile department in 1963 with a thesis on experimental fabrics. It was there that she developed a fascination with the continuous-thread unity of knitted structure.

In 1964 the Fresno Art Museum showed 100 pieces of Phillips's work in a survey of fifteen years, including woven upholstery, drapery and clothing yardage, tie-dye, blankets, stoles, pillows, rugs, double-weave wall hangings, and "illuminated cylinders" of knitting (as well as her ceramics). By that time she was living in New York City and had begun to create architectural-scale casements, screens, and wall hangings, knitted in both natural and synthetic fibers. These were not, of course, the

stretchy wool yarns of sweaters. One fabric was knit of alternate rows of narrow leather strips and hand-spun mohair. She worked with asbestos thread and fiberglass yarn. She knitted two sizes of synthetic straw together to encourage a twist; another technique she developed was to knit with needles of different sizes. She usually simplified color to emphasize structure. Her works involved both overall repeated patterns like those of utilitarian weaving and special rippling effects to give dimension to a surface.

By 1967 Phillips had discovered macramé and approached it with the same exploratory enthusiasm, developing decorative structures and then turning her grasp of the possibilities into books for the general market.

KAY SEKIMACHI

As the loom seemed to fall from favor at the end of the 1960s, Kay Sekimachi contrived a complex, multilayered weaving that, when removed from the loom, could be pulled open into a fully three-dimensional, free-hanging, gracefully intricate form. (Figure 8.9) Added to that innovation was her use of nylon monofilament—essentially fishing line—which enabled her airy structures to capture and pass light, and to be nearly transparent. She called the works Nagare, "flow" in Japanese. They were immediately included in the major shows of 1969: *Wall Hangings* at the Museum of Modern Art and the traveling *Objects: USA.*

Sekimachi was born in San Francisco in 1926 to a Japanese immigrant couple. Her father died in 1937, and mother and daughters lived in considerable hardship. After the bombing of Pearl Harbor, they were interned, eventually in a camp at Topaz, Utah. The conditions were hardly worse than before—at least they had regular meals. When the mother was released to work as a domestic in Cincinnati, the daughters were also freed and had to find work. Sekimachi for a time worked at Rookwood pottery.

Back in San Francisco after the war, Sekimachi took art classes at California College of Arts and Crafts (CCAC). The family lived in a house so small that when she became interested in weaving and spent all her savings on a four-harness loom, she set it up in her bedroom and then had to crawl under it to go to bed. She had a day job, and she and a sister had a business silk-screening Christmas cards, but she was a devoted hobbyist in weaving. Sekimachi says the turning point in her life and career was hearing Trude Guermonprez speak at Pond Farm in 1951 and subsequently studying with her in two summer sessions at CCAC (made possible by an older hobby weaver

FIGURE 8.9. *Kay Sekimachi, Nagare III, 1968. Black nylon filament, woven; 87 × 10 × 11 in. (Museum of Arts and Design, New York, Gift of the Johnson Wax Company, 1977, through the American Craft Council. © Kay Sekimachi. Photograph by Christopher Dube.)*

plished on the loom—a mastery that has earned her the accolade, "the weaver's weaver." Her later works of the 1970s continued to be so complex—tubes, card weavings, and woven books and boxes that folded to display related patterns—that it would seem to take a mathematician, or a magician, to figure them out.

Sekimachi later shifted to paper. She used strong persimmon-treated stencil paper to construct large standing works that might remind viewers of Brancusi's *Endless Column* because of their monumental simplicity. She also molded torn-up pieces of finer paper, sometimes using Stocksdale's bowls as the mold. These shapes, already elegant in wood, became ethereal in the translucent paper. These much-admired works show a poetic sensibility rather than the innovation of her works of the 1960s.

Jewelry and Metals: Looking Elsewhere

For all the experimentation in American jewelry and metals in the 1950s, the basic structure laid down by Scandinavian modern remained dominant. Most studio jewelry was tastefully designed, of modest size, and highly polished. But some jewelers began to question the formula. Arline Fisch's feelings were typical. She said, "I needed to get away from the Danish influence, which was very compelling—the idea that everything had to be perfect in design and technique, that only precious metals, properly treated, constituted real jewelry, and that everything had to be suitable for millions of anonymous people."[37] By the end of the 1960s, the field had acquired a new character.

Silversmithing followed a different trajectory. Many smiths embraced the Scandinavian style of elongated, angular forms, but there was competition to be distinctive, brought about partly by an increasing number of exhibitions in which some judges responded favorably to personal flourishes. The most notable competition was an annual student show sponsored by the silver industry. The result was teapots with oddly proportioned spouts and handles, whole tea sets standing on little pedestals, knobs shooting off into space, and aggressive asymmetry. Craftsmanship was uniformly good, but design seemed to embrace the baroque excesses of American automotive design, lacking only tailfins.

The more enduring trend in silversmithing was away from function and toward artistic expression. Perhaps students resisted the idea of making symbols of wealth and privilege, or maybe they saw that the market for handmade silver was withering; few students in the

who insisted on paying her tuition). Guermonprez introduced her to the idea of independent creativity, that she could imagine, and do, anything. After Sekimachi studied at Haystack with Jack Lenor Larsen, his associate Win Anderson invited her to come to New York to design for them (she declined). Another boon was her marriage to wood turner Bob Stocksdale; their congenial creative lives were later presented in a dual retrospective called *Marriage in Form* at the Palo Alto Art Center.

Sekimachi's earliest creative work, in the late 1950s, consisted of linen yardage and tapestries with pictorial imagery as well as abstract, angular planes in slit technique; it was good enough to get a feature article in *Craft Horizons* in 1959. Beginning in 1963, she wove monofilament to make dimensional, see-through wall dividers that inspired other weavers with their possibilities. The free-hanging monofilament sculptures, held open by Lucite rods or guy wires, are exceptional in being accom-

1960s had grown up with silverware at home. Over the decade, silversmithing became increasingly sculptural. In a direct parallel, the most experimental jewelry increased in size until it covered the whole body.

In the 1960s, both fields completed their migration into the academic environment. Individuals still came to the crafts independently, and trade schools continued to teach skills like gem identification or watch repair. But for anyone who wanted a taste of current design ideas along with a general introduction to the craft, universities and art schools offered the best education available. A graduate with a bachelor's degree was—in theory— flexible enough to teach, to design, to do skilled work with minimal retraining, or to set up a private studio. There were jobs available: manufacturers wanted to add contemporary looks to their lines, and they hired recent grads to bring a youthful sensibility to products.

SILVERSMITHING: ALMA EIKERMAN

Throughout the decade, a new breed of college teacher began to change the course of metalsmithing. Many had earned master's degrees in design and education since there were few graduate programs in metals. Their teaching reflected their backgrounds.

Alma Eikerman (1909–1995) earned an MA from Columbia University in 1942, a generalist degree with no specialization. Her teachers urged her to see contemporary art firsthand, so she visited the Museum of Modern Art, Peggy Guggenheim's Art of This Century gallery, and other venues where modernist art was exhibited. In one class, students were assigned to buy an example of good design, which the class would critique. The idea of nonobjective art was in the air, and the hot topic was formalism.

At the same time, Eikerman was learning silversmithing. She attended the 1948 Handy & Harmon workshops, and in 1950–51 spent a year in Europe, learning crimped raising in Karl Gustav Hansen's shop in Denmark, visiting Baron Fleming in Stockholm, and going on to Paris and Munich. By the time she returned, she was quite good with a hammer. She emphasized silversmithing skills throughout her teaching career.

When Eikerman started teaching at Indiana University in 1947, she brought her passion for formal analysis with her. All her metals students had to draw, and she conducted weekly graduate seminars. One point of discussion was the way sculptor Julio González used voids to balance masses, making emptiness an active compositional element. Eikerman in effect treated both silversmithing and jewelry as sculpture.

That was a radical shift, for it displaced the emphasis

FIGURE 8.10. *Alma Eickerman*, Untitled Bracelet, *1968. Sterling silver; 1.25 × 3.37 × 3 in. (Museum of Arts and Design, New York, Gift of the Johnson Wax Company through the American Craft Council. © Alma Eickerman. Photograph by John Bigelow Taylor, 2008.)*

on function that was a mainstay of Scandinavian taste. In silversmithing, what remained of tradition was the vessel: a container that enclosed an axial space. Jewelry became a vehicle for exploring abstract form in relation to the body. An example is Eikerman's untitled silver bracelet (1968). (Figure 8.10) It is a composition of surfaces and edges, highlighted by a polished area. On one side are small patches soldered to a textured surface. On the other side is a series of gently curving lines, disappearing around the wrist. In the center, where one might expect a gem, is an interruption: four bright edges and three dark gaps. It is design as high drama, even if on a small scale.

Eikerman taught for thirty-one years. More than a dozen of her best students went on to be teachers themselves. Her ideas about metalsmithing as a means to develop abstract form have been modified over the years to include symbolism, imagery, and materials other than metal. Helen Shirk and Marjorie Schick are only two of Eikerman's artistic progeny.

THE STUDIO JEWELRY MAINSTREAM: RONALD HAYES PEARSON

Ronald Hayes Pearson (1924–1997) did not rebel against modernism but worked within it. Like many of his generation, he was educated just before and after the war. Emerging from the merchant marine in 1947, he wanted a career that offered a high degree of self-determination: craft looked good. Although he had been a ship's carpenter, he enrolled in metals classes at the School for

American Craftsmen. Since he didn't qualify for the GI Bill, he quickly ran out of money. So he borrowed $500, rented an old chicken coop, bought a used spinning lathe and a stack of bronze sheet, and in 1948 went into business making modernist metalware. In 1949 he served an internship with Reed & Barton.

Pearson's spun bowls were shown in all five of MOMA's Good Design shows. Simple and undecorated, they recall James Prestini's wooden bowls of the same period. Working solo, Pearson produced about twenty designs, including desk accessories, ashtrays, and candleholders. Prices ranged from $1 to $11.25 wholesale. Marketing was a problem, since there were few outlets willing to take on modernist designs. After seven years, he licensed some of his designs to a small manufacturer and quit the metal-spinning business.

Pearson began to make silver jewelry, supplemented by ecclesiastical commissions. Although he drew constantly, he preferred to develop his designs by working directly in metal. His favorite technique was forging, in which line can shift from thick to thin, and thick rods can flare out into flat surfaces. His jewelry almost always has elegant curved forms with polished surfaces. Some is similar to Swedish jewelry, but Pearson said, "If there's an influence, it's probably the process of working with the metal."[38] His jewelry is lovely and logical: a V-shaped choker that gently embraces the neck; an earring that loops twice, one end becoming the ear wire and the other a catch. They were immensely popular and widely imitated. For decades, one could not stroll through a craft fair without seeing knock-offs of Pearson designs.

Unlike some jewelers who settled down with a modest repertoire of techniques, however, Pearson always experimented. He tried casting silver, fabricating Monel metal, hot-forging copper and iron. He was equally open to different business models. With John Prip, he founded Shop One in Rochester, New York, and operated it for nineteen years. Pearson designed for major silverware and jewelry manufacturers. He sold retail for years and later shifted entirely to wholesale.

In all his experiments, Pearson tried to let the metal suggest the form it would take. When copper is hot-forged, for instance, it is amazingly soft, almost too weak to hold up its own weight. So Pearson left a thick spine of metal running down the center of his shapes and hammered fins out from either side. (This was for a hanging light some six feet tall.) On another occasion, he tried making a necklace from heavy bars of silver, doing most of the shaping with files. A flat file produces flat facets; a half-round file produces rounded grooves. Deciding the rounded forms were more interesting, Pear-

FIGURE 8.11. *Ronald Hayes Pearson*, Silver Necklace with Ball-and-Socket Joints. *Sterling silver. (Courtesy of Carolyn Pearson.)*

son made seven links of polished, undulating silver, each fastened to the next with an ingenious ball-and-socket joint. (Figure 8.11) Save for a few drilled holes, everything is laboriously filed by hand.

At the same time, Pearson was dedicated to producing well-made multiples at reasonable prices. Because he competed directly with industry, he worked hard to devise designs that could not be easily reproduced by machine, such as forged wire. His career proved that handmade products could compete with manufactured goods—if the craftsman knows what machines cannot do.

CHARLES LOLOMA

One of the most successful of all American studio jewelers was Charles Loloma (1921–1991). Born in Hotevilla on the Third Mesa on the Hopi reservation, Loloma was never limited by the familiar way of doing things: the Hopi, unlike the neighboring Navajo and the Zuni, had no tradition of making metal jewelry.

Loloma began his education on the reservation but finished high school in Phoenix. He learned how to paint murals, and he sold drawings and watercolors. In 1939 he was hired to paint murals at the San Francisco Golden Gate Exposition, which led to other jobs. He also made a connection with René d'Harnoncourt, who soon became director of the Museum of Modern Art.

After his wartime military service, Loloma and his wife, Otellie, attended the School for American Craftsmen. Both studied ceramics. They returned to the Southwest, where they set up a ceramics shop. But by 1958

Charles was devoting most of his energy to jewelry. At first, he taught himself, using as a guide a 1945 book on Southwestern Indian silversmiths by John Adair. Later he learned lost-wax casting from West Coast studio jeweler Bob Winston.

Loloma also taught from 1961 to 1965 at the Institute of American Indian Arts in Santa Fe. The school was crucial in moving Indian artists away from Anglo-sanctioned styles—typically a formula developed by a white instructor that was intended to represent a tribal sensibility, such as the invention of Hopi jewelry based on patterns found on potsherds. Individual innovation was seldom encouraged. But Indian artists were just as capable of finding a personal approach to design and art as Anglos, and that's what Loloma did. Ironically, his early jewelry was rejected three times from a Gallup wholesale market because it was not Indian enough.[39]

By the late 1960s, he had developed a unique way of making jewelry. His most famous designs were bracelets, which started life as simple, flat bands. (Figure 8.12) Taking off from the Zuni and Navajo technique of inlaying flat colored stones in channels, Loloma made chunky stones project well above the metal edge. Using turquoise, lapis lazuli, charoite, mastodon ivory, ironwood, coral, and other materials, he clustered elements to evoke rock formations, cityscapes, and modernist grids. In the most extreme of his bracelets, the stones radiate outward several inches. Another Loloma inno-

vation was to set stones on the insides of his rings and bracelets, to give the owner a private experience. Clearly, he saw jewelry in abstract terms, perhaps grounded in tradition but not bound by it. His massing of stones was more attentive to form than meaning, and he chose color like a painter.

Loloma was a masterful promoter—he took several Dale Carnegie courses, including one on salesmanship. Charming and voluble, he attracted many wealthy clients. In 1965 he moved back to Hotevilla, where he was happy to flaunt his wealth, owning two airplanes and several fast cars. In other ways he remained a traditional Hopi, growing his own food and actively participating in ceremonial life. He negotiated Anglo and traditional cultures with a vivid presence in both.

EXPRESSIONIST JEWELERS

One of the ambitions shared by many jewelers in the 1950s and 1960s was to give abstraction a sense of relaxed spontaneity. Jewelers had managed to work metal loosely before: Madeline Yale Wynne, Janet Payne Bowles, Alexander Calder, and Sam Kramer all come to mind. But they worked before the ascendancy of abstract expressionist painting. After Willem de Kooning and Jackson Pollock, jewelers began to think of a brooch or a necklace as a self-contained abstract composition, with individual elements playing the role of brushstrokes, giving metal a sense of spontaneous gesture, as if a wire flowed off the tip of a brush.

Many studio jewelers who came of age around 1960 made painterly jewelry, Olaf Skoogfors, Glenda Arentzen, and Richard Reinhardt among them. One of the first was **Miyé Matsukata** (1922–1981). She started by sketching rough lines and surfaces on white paper. The roughness was replicated in metal by forging wire or melting and hammer-texturing sheet metal. The white paper became negative space. As most studio jewelers gained skill, their designs tended to become dense and compact, but Matsukata went in the opposite direction, bringing plenty of air into her jewelry. The same trend toward open compositions could be observed in the work of sculptors such as David Smith and Mark Di Suvero as the favored process shifted from casting to construction.

Matsukata also used found objects to great advantage. She favored ancient artifacts: Egyptian faience, Chinese bronze coins or brocade, and Maya bone figures, especially comparatively crude artifacts and fragments. Their irregular surfaces and shapes fit the equally irregular frameworks she constructed for them.

As a working jeweler, Matsukata used gold most of

FIGURE 8.12. *Charles Loloma, Bracelet, ca. 1975. Fabricated 14-karat gold bracelet with lapis lazuli, wood, fossilized ivory, coral, and malachite; outside diameter, 4 in. (Wheelwright Museum of the American Indian, Santa Fe. © Georgia Loloma. Photograph by Addison Doty.)*

FIGURE 8.13. *Miyé Matsukata, Cuff Bracelet, ca. 1970. 18-karat and 14-karat gold, rubies, sapphires; 2.75 × 1.5 × 1.75 in. (The Renwick Gallery of the Smithsonian American Art Museum, Gift of Alexander and Margit Matoltsy, 2003.43.)*

FIGURE 8.14. *Olaf Skoogfors, Necklace with Pendant, 1970. Gilded silver, tourmalines, amethysts, sodalite, cast and constructed; 9 × 6.5 in. (Philadelphia Museum of Art, Gift of the Artist, 1970. Photograph by Graydon Wood.)*

the time and used precious stones liberally. (Figure 8.13) On many occasions, clients brought their own stones, trusting her to arrange them in one of her distinctive works. She sprinkled diamonds, rubies, and sapphires around her jewelry with the same informality—and the same eye for dynamic composition—that she used for bits of beach glass or rutilated quartz. The result could never be mistaken for trade jewelry.

Matsukata opened her jewelry business in 1949 with two fellow students from the Boston Museum School. They named it Janiyé, a composite of their first names. Her partners dropped out by 1958, and she reopened the shop on Boston's Copley Square as Atelier Janiyé. For three decades she made jewelry that was unconventional but not confrontational. After she died in 1981, two of her employees continued to operate the studio under that name.

Olaf Skoogfors (1930–1975) thought of jewelry in much the same way as Matsukata. He learned the craft at the Philadelphia Museum School of Art and the School for American Craftsmen (SAC) in Rochester, New York. By the time he graduated from SAC in 1957, he was adept in both smithing and jewelry construction. Although his skill as a hammerman allowed him to accept commissions for domestic and ecclesiastical silverware, his hollowware never went beyond the clean, regulated Danish form language. His gift was in jewelry.

At SAC, Skoogfors became friendly with Ruth and Svetozar Radakovich, who were making jewelry of castings with constructed additions, a technique he adopted. He often started a piece with a highly textured and organic casting, and added pieces of sheet and wire, composing directly in the metal. He also added semiprecious stones

and pearls. His goal was always to harmonize form, line, and color while keeping a certain rough vitality. It is a difficult balance, but he was very good at it. His improvisatory approach is likely responsible for the enduring freshness of his work.

To counter agitated textures and lively forms, Skoogfors usually enclosed his works in a geometric frame, either real or implied. A 1968 pendant is an example: an irregular casting sits atop a flat sheet with an eroded upper edge, contained in a three-sided box. (Figure 8.14) Three set stones, slightly off balance, reinforce a sense of formality and recall jewelry conventions. The necklace is not wildly inventive, but it is a polished performance, with every detail resolved.

OPENING DOORS

As an undergraduate at Wayne State University, **Stanley Lechtzin** (b. 1936) shared his teacher Philip Fike's interest in researching techniques and updating ancient

FIGURE 8.15. *Stanley Lechtzin*, Brooch 57-C, 1969. *Silver-gilt, quartz, watermelon tourmaline quartz; 5 × 3.87 × 2 in. (The Museum of Fine Arts, Houston, Helen Williams Drutt Collection, Gift of the Morgan Foundation, 2002.3906. © Stanley Lechtzin.)*

forms. Lechtzin started teaching in 1962, right after he received his MFA from Cranbrook. Like other academic jewelers at the time, he wanted to increase the size of his jewelry, making it more graphic when worn and more sculptural when displayed off the body. (Figure 8.15) He carved Styrofoam to make his patterns because he could obtain a variety of rough, granular textures. When he cast it, however, the jewelry was too heavy to wear. Since he was familiar with silver plating for color, he looked into electroforming, an industrial process that results in the formation of a thin and lightweight but self-supporting shell of metal around a matrix. Teaching himself the technology, Lechtzin downsized it for use in a small-studio setting. By 1964 he was producing a brilliant, smooth surface that had eluded other metalsmiths who had tried the process.

Lechtzin applied the technology in surprising ways. He developed blocky, fissured forms in Styrofoam or poured molten wax into water to create twisted, highly textured forms, and he coated these originals with a conductive paint to electroform them. High current would deposit crusty granules on edges and corners; outlining the edges of stones with the conductive paint would lock them in position without prongs or bezels. And because the shells were so thin and strong, he could make jewelry three or four times larger than cast forms.

Lechtzin's electroformed jewelry shared an aesthetic of crusty surfaces with 1950s sculptures by Ibram Lassaw, Seymour Lipton, Theodore Roszak, and others who were interested in processes that could not be entirely controlled. This attraction had its roots in the surrealist association of the accidental with the unconscious, raw creativity, and even violence. In Lechtzin's jewelry, though, such forms stood for the rejection of Danish good taste and moderation. They may suggest American excess; the tortured shapes carried a certain dark emotional charge.

Lechtzin's gnarly, bright forms created a sensation. In 1964 he demonstrated the process to the World Congress of Craftsmen meeting in New York City. It was quite a coup for a young man only two years out of graduate school. His work occupied a new position between industry and studio craft. He observed that the commercial jewelry business usually took a decade or two to respond to new ideas, so he was not interested in collaborating with industry. He proposed that artists use industrial processes to generate unique objects, not in competition with industry, but as a principled alternative to it.

Later in the 1960s, Lechtzin began to explore another technology: cast plastics. Although widely considered cheap and irremediably low, plastic appealed to him because of the range of colors and forms it offered. Cast acrylic plastics gave him the hardness and durability he desired.

Perhaps inspired by Fike's investigation of the fibula, Lechtzin undertook a series of large torques. The torque—a one-piece open metal collar favored by the Gauls and early Britons—was usually forged and twisted. It was put around the neck by bending the ends apart, slipping it on and allowing the metal to spring back into position. Lechtzin's joined two C-shaped plastic elements with a hinge at the back of the neck. On the front of the body, he paired two electroforms, each grown directly onto the plastic. These torques were high-tech wonders, beyond the technical ability of any other American jeweler at the time.

Lechtzin believed that a truly contemporary craftsman should embrace contemporary technology. He never deviated from that position: in time, he became one of the first studio jewelers to investigate the potential of digital technologies.

Arline Fisch, one of the jewelers who felt hemmed in by the language of Scandinavian modern jewelry (with its absence of overt references to history or metaphor), turned her back on it. Fisch (b. 1931) studied painting through high school and college. She came to jewelry indirectly, changing her major after she started graduate

school. Landing her first college teaching job in 1954, she discovered that her technique fell far short of her ambitions. She was awarded a Fulbright grant to study in Copenhagen in 1956–57 and dedicated herself to learning the fine points of the craft. But her stay convinced her that the Danish taste was too restrictive.

Back in the United States, she was asked to teach weaving. Willing to give it a try, she studied with Jack Lenor Larsen and Ted Hallman at Haystack, which stimulated a lifelong interest in textile techniques. At the time, her jewelry was based on geometric combinations of wood and metal; it was nicely designed, well made, and impersonal. Then, on a trip to Central and South America in 1963, she saw ancient garments that combined textiles and metal in a way she never imagined. They were pre-Columbian ponchos from the Ica culture of southern Peru, between 500 and 1,000 years old. Hundreds of small panels of gold were sewn onto tapestry-like weavings. The burnished metal caught and reflected light, but because the pieces were so small, the garment retained the suppleness of fabric. The panels were sewn in an irregular grid, creating a relaxed structure. Technique was simple: cutting, drilling holes, and sewing.

For several years, Fisch experimented with combinations of metal and fiber. In a series of large necklaces, she sewed panels of metal onto fabric or inserted shaped pieces of metal into weavings she made herself. Her breakthrough came when she returned to Denmark in 1966 to study chasing and repoussé. There she produced the first of an extended series of garmentlike composites. The word "jewelry" hardly seemed sufficient: Fisch called them body ornaments. They were revolutionary.[40]

Fisch's 1966 *Body Ornament* ingeniously synthesizes ancient and modern. (Figure 8.16) Dozens of chased and forged elements are sewn onto a long rectangle of black velvet that has an opening cut for the head. It is worn rather like a poncho but reaches almost to the feet. The silver elements coalesce into the image of a tree, with roots and branches. (The metaphor of a strong, growing woman was meaningful for the times.) The metal construction was flexible and could move freely as the wearer walked and gestured, and the silver reflected light in ever-changing patterns. *Body Ornament* is clearly not for everyday wear; in its ceremonial associations, it is like the Ica garments that inspired it.

Body Ornament was widely exhibited and reproduced: it was one of the centerpieces of *Objects: USA*. For better or worse, Fisch opened the floodgates for all manner of body jewelry in the early 1970s. Oversize jewelry suited impulsive self-expression. A 1973 book called *Body Jewelry: International Perspectives* shows everything from

FIGURE 8.16. *Arline M. Fisch*, Body Ornament, 1966. Sterling silver, synthetic crepe, silk, chased, forged; overall: 53 × 15.5 in.; front: 45 × 12.25 in.; back: 41 × 4.5 in. (Museum of Arts and Design, New York, Gift of the Johnson Wax Company through the American Craft Council. © Arline M. Fisch. Photograph by John Bigelow Taylor, 2008.)

feathered capes to macramé monstrosities. Little of it had the discipline and elegance of Fisch's work.

She later said of the influence she draws from non-Western and ancient cultures: "Over the years I have studied the ornaments of many cultures which approach human adornment with a freedom and dramatic power which is perhaps not possible in contemporary Western society. However, the visual and psychological impact of such jewelry stimulates my imagination and influences my choice of form, object, image, and material."[41] Fisch never looked for associations with authenticity or unfettered primitivism that Western audiences often extract from tribal artifacts. Nor did she trespass on cultural

ownership: her designs were so abstracted from her sources that there is no question of stealing. She always handled her sources with respect—and a certain objective distance.

About 1969, Fisch started experimenting with working copper wires like threads. She found that she could weave, twine, and braid to produce metal textiles. Research showed that textile techniques were employed in metal in many cultures, from Europe and Africa to China and Japan. (One mundane example is aluminum window screening, which is woven.) In time, she found that metal can be plaited, twisted, knit, knotted, or worked like crochet or bobbin lace, with almost as great a variety as that possible with fibers.

Fisch has made light, flexible structures virtually unlimited in size that can be worn like clothing or jewelry, and she has addressed the sculptural possibilities of basketry. Objects can be airy and transparent or dense and opaque. Her textbook, *Textile Techniques in Metal for Jewelers, Sculptors, and Textile Artists* (1975), is the standard volume on the subject. She taught for many years at San Diego State University and inspired many women, especially, to dedicate themselves to jewelry and metalsmithing.

In 1965, when **J. Fred Woell** (b. 1934) took a collection of his cast silver jewelry to some New York galleries, they turned him down flat. Basically, they told him to use gold or forget it. Woell was irked. He could see no reason why his work should be measured by the value of its materials, any more than painting or sculpture was. An instinctive contrarian, Woell decided to use materials that had no intrinsic value whatsoever. It was anti-jewelry.

The idea of anti-art was in general circulation at the time and was usually connected to the idea of inversion. Pop art had recently emerged in New York City, confronting fine art notions of separating high from low. In the same spirit, Woell began a series of Badges, a low form of adornment that nobody took seriously. Each badge was recycled from pop culture detritus: buttons, Pepsi bottle caps, Boy Scout awards, beer can tops.

Woell was the first jeweler to consistently use such found objects. He was also among the first to add an undertone of social commentary. *The Good Guys* (1966) consists of a wooden disk about four inches in diameter, with cheap commercial pins of Superman, Little Orphan Annie, and Dick Tracy inset like jewels. (Figure 8.17) For decoration, Woell punctured the disk with a pattern of staples and then colored it gold. He made it into a pendant, hanging from a decidedly nonprecious leather thong. It was at once artful, funny, and pathetic.

The suggestion that the best American heroes are

FIGURE 8.17. *J. Fred Woell, The Good Guys, 1966. Walnut, steel, plastic, copper, silver, gold leaf; 4 × 0.5 in. (Museum of Arts and Design, New York, Gift of the Johnson Wax Company through the American Craft Council. © J. Fred Woell. Photograph by Eva Heyd.)*

comic-book characters gives *The Good Guys* a rather disturbing subtext. Some other Badges from the period were darker and sharper in their critique. *November 22, 1963 12:30 pm* has a small round photo of a smiling John F. Kennedy set under a broken piece of glass. Above the picture, there's a single star. Below, dangling from a scroll, hangs a single .22 shell casing. There are few pieces of art that mourned JFK with such economy and poignancy. Woell connects the president's death to America's love affair with guns and violence.

Later Woell returned to silver casting, but this time with plastic bits and pieces from American material culture as his raw material. He fashioned spoons and brooches from plastic soldiers, Colonel Sanders spoons, model parts, whatever came to hand. He also made assemblages, with beer cans a recurring material and motif.

After Woell, jewelry could be made from any material at all. Moreover, he showed that jewelry could have meaning as broad or sharp as anyone wished. Like Lechtzin's use of industrial processes and Fisch's expansion of the scale of jewelry to encompass the entire body, Woell's experiments opened doors, helping to liberate studio jewelry from convention.

PLASTIC JEWELRY

The 1960s was the decade of inflatable furniture, Nauga-hyde upholstery—and plastic jewelry. Originally developed for applications such as aircraft canopies, Plexiglas, a form of acrylic plastic, could be shaped with heat and cut with an ordinary jeweler's saw. Manufacturers released some wild colors, such as fluorescent orange and green, mirrored bronze and gray, even a few pastels. It suited body jewelry.

Carolyn Kreigman (1933–1999) became one of the best-known makers of Plexiglas jewelry when her plastic necklace was exhibited in *Objects: USA*. Her studies with Josef Albers at Yale made her sensitive to abstract, formal structure. She also made jewelry in metal, but her large Plexi necklaces are perfect symbols of the Swinging Sixties. (Figure 8.18) She cut sheet plastic into geometric panels, bent them to fit the torso, and linked the segments with metal rings. Because plastic is much lighter than metal, she could make large, biblike structures that were light enough to wear. A typical necklace might be ten inches wide and almost twenty inches from top to bottom. The forms recalled armor, but the bright, transparent colors were cheerful and playfully hip, in tune with miniskirts and Marimekko fabrics.

The new interest in plastics and found objects posed a problem of definition for college teachers. Many departments were set up to teach metalsmithing, with jewelry understood as being made primarily of metal. Yet this boundary for the discipline could be maintained only by excluding unusual materials from the classroom. Most jewelry teachers tolerated experimentation, but that made it difficult to label their programs. Ceramics and glass were defined by material, but jewelry (like textiles) was now in a gray area.

ENAMELING

In the 1960s, the market for decorative enameled objects was fading. Few could figure out how to marry technique with a contemporary sensibility. One who did was **Bill Helwig** (b. 1938). He had studied watercolor painting in college but wound up working for a craft center at Buffalo (New York) State College in the mid-1960s. A colleague saw his watercolors and suggested he try enamels. He did, conducting exhaustive research until he had as much control over the medium as anybody in the country. He decided to specialize in grisaille because there was little competition.

Helwig became a master of white-on-black figurative imagery in relatively small scale. He used commercial copper blanks, usually flat, round plates, which he treated as a neutral ground. He rarely planned his compositions ahead of time; he simply sifted on the enamel and started dusting and scribing it away, allowing figures to emerge during the process. This was a common approach to painting; using the method, Helwig would tease out crowds of figures and faces. (Figure 8.19) They interlocked and overlapped in jumbled waves of humanity. Personages seemed to merge, grow wings, touch one another and dissolve, as metaphors for complexities of relationships, conflict, physical interaction. All the writhing bodies must have suggested an orgy, because genitals and sexual activity appeared by the early 1970s. Helwig's enamels—mixing hallucinatory imagery, spontaneity, and sexuality—were perfect emblems of the age.

Helwig's technical expertise was widely respected as well. He constantly tried new techniques or revived old ones. He formulated some of his own colors, especially pinks and ruby reds. By 1977 he was hired to develop lead-free enamels for the major suppliers. The enamels

FIGURE 8.18. *Carolyn Kriegman, Plastic Neckpiece (Green and Blue), 1969. Plastic; 27 × 19 × 5 in. (The Renwick Gallery of the Smithsonian American Art Museum, Gift of Sam Kriegman, 2006.34.4. © Estate of Carolyn Kriegman.)*

FIGURE 8.19. *Harold B. Helwig,* Angelic Devils, *1968. Enamel on copper; 0.87 × 11 in. (Museum of Arts and Design, New York, Gift of the Johnson Wax Company through the American Craft Council. © Thompson Enamel. Photograph by Ed Watkins, 2007.)*

FIGURE 8.20. *Ellamarie Woolley,* Some Like It Cold, *ca. 1967. Enamel on copper. (Collection of Everson Museum of Art, Syracuse, N.Y., Purchase Prize given by Ferro Corporation, 25th Ceramic National, 1968, 68.79.)*

he formulated made the craft safer to practice. But when he returned to his studio, stream-of-consciousness style no longer resonated. His moment had passed.

On the West Coast, **Ellamarie Woolley** (1913–1976) developed an equally contemporary approach to enameling. (Figure 8.20) She originally worked closely with her husband, **Jackson Woolley** (1910–1992). In 1947 the two saw a demonstration of enameling in the home of an art professor and took up the craft, teaching themselves. At first they produced individualized modernist bowls and plates. (Over thirty years, they sold more than 5,000.) Looking to expand their business in the late 1950s, they sought architectural commissions. They certainly didn't lack ambition: their first enamel mural was 32 feet long and 5½ feet high.

Because they didn't have access to an industrial kiln, the Woolleys had to divide the mural into segments that could fit into the kiln in their garage. The first commission, for instance, consisted of 416 rectangles. This commission, for the Fresno County Free Library, derived a symbolic program based on the Dewey decimal system, with ten interpenetrating squares for each main category. An angel stands for religion, a man reaching for a star for science, and so on. Like other figurative murals of the era, it is a period piece. The science man, for instance, holds the symbol for atomic energy in his hand.

For many years, the Woolleys earned a good living

entirely from their production of enamels. In 1965 they decided to work independently. Jackson concentrated on painted wood constructions, while Ellamarie continued with enameled plaques. She dispensed with both imagery and regular grids. Instead, she pieced small panels into hard-edge abstractions that were thoroughly avant-garde. Abandoning all the fine points of the craft, she enameled each section of her compositions in one opaque color and assembled them on a wooden backing. Her patterns sometimes created an optical illusion of depth. At the same time, the saturated colors were quite decorative, which gave them great potential for public use. But most were under four feet in size, and none were installed permanently. The era of pictorial enamels was drawing to a close. The next renaissance would come in the 1980s.

A New World of Glass

HARVEY LITTLETON

Harvey Littleton was a guy with a bee in his bonnet. As a teenager he wanted to be an artist; as a young man he wanted to find a way to work with glass. He ultimately

started a movement. He kept asking questions and trying until he made it happen.

Littleton was introduced to glass at an early age, since he was born and raised in Corning, New York, where his father was a physicist developing new consumer products for Corning Glass Works. But Corning did not support the development of studio glass; rather, Littleton's teaching from 1949 to 1951 at the Toledo Museum School of Art was crucial, because it introduced him to Otto Wittmann, the museum's director, who later offered a site for the first glass workshops. He also met Dominick Labino, who worked at Johns-Manville Fiber Glass Corporation and took evening craft classes; Labino was to provide invaluable technical information, materials, and support at the start of the contemporary glass movement, as well as to exemplify an alternative approach to glass work.

In college, Littleton made a brief attempt to follow his father's path but then went to Cranbrook. His sculptural aspirations were not encouraged, so he pursued industrial design. After World War II, he ran a potters guild in Ann Arbor, completed an MFA with Maija Grotell at Cranbrook, taught ceramics in Toledo, and then was hired by the University of Wisconsin, Madison.

Littleton was a successful utilitarian potter but remained curious about glass. He visited small factories and one individual glass studio in Europe (Jean Sala in Paris) and spent two and a half months at Murano, the Venetian center for glass production. He chaired panels on glass at ACC conferences in 1959 and 1961. At last he pulled together an experimental workshop in glassblowing at the Toledo Museum in March of 1962.

Littleton's own work is important for its seriousness, formal and expressive quality, and technical experimentation. His developments in form were not as imaginative as his students'—his tended to be "classic" almost from the beginning. The earliest works were dribbled and accepting of collapse; then there were functional bowls and vases. As early as 1963 Littleton showed glass works at the Art Institute of Chicago, and Michael Higgins wrote that they recalled the "loosest" early American glass[42] and exploited the liquidity of this very plastic material, and that Littleton was already exploring secondary techniques such as casing.[43] Alternate layers of clear glass and colors occupied him for some years: he drew them into bars, swung them into loops, cut them at various angles, capturing in permanent form the drama of glassmaking. (Figure 8.21)

In 1971 Littleton published *Glassblowing: A Search for Form*, which was exhortatory but included plenty of technical backup. He retired from teaching in 1977 and

The Toledo Workshops

Otto Wittmann, director of the Toledo Museum of Art, offered the use of a garage or shed on the Toledo Museum grounds for a glass workshop in March 1962. Seven students signed up, earning three college credits at the University of Toledo, and a few other people attended unofficially. Presentations on glass history and a tour of the city's Libbey Glass Factory were included, but the heart of the event was the attempt to blow glass. After Littleton's glass formula failed, Labino provided glass marbles that he had formulated for Johns-Manville, as well as a burner and advice about constructing a furnace. Two retired factory glassblowers demonstrated the process. The experience was promising enough that a second session was held three months later, in June 1962. There was no annealing at the workshops, so few works survived; in any case the works made there were products of gravity and cooling rather than artistic control. A better keepsake was the mimeographed "Glass Workshop Report" produced for the second session.

The goal of the workshops was to show that an individual craftsman could melt, blow, and anneal glass forms without industrial training or a long apprenticeship. But that seems to have been more of a sales pitch than an accurate assessment, and as the field developed, it moved steadily toward teams, the European practice. Further, the first decade at least focused on learning techniques, not making art, which indicates the considerable technical demands.[1] The extended exposure of an academic term, not a brief workshop, was more appropriate as a substitute for apprenticeship. Also ironic is the fact that of those who attended these groundbreaking workshops, only Tom McGlauchlin and Littleton went on to make careers of glass. That suggests how tenuous the situation was, and how hard it is to get something new going: without Harvey Littleton's drive, it wouldn't have happened.

NOTE
1. As noted by Henry Halem, in J. T., "Garage to Glory," *American Craft* 53 (August–September 1993): 11.

Glass Goes to School

At the time of the Toledo workshops, no hot-glass courses were offered in the United States (only scientific lampworking was available). In the fall after the workshops, Littleton offered an independent study course in glassblowing at the University of Wisconsin, using the furnace he set up at his home studio. In 1963 there was a regular graduate-level offering, and university facilities were established. He introduced hot glass only; later practitioners would take up warm and cold techniques.[1] Also in 1963, Andre Billeci offered independent study in glassblowing in the ceramics program at Alfred—a reasonable development since the vast majority of the beginning blowers were former potters. By 1966 glass was a regular undergraduate offering there.

From Littleton's first courses, Robert Fritz went on to teach at San Jose State University; Marvin Lipofsky, at the University of California, Berkeley; and Tom McGlauchlin, at the University of Iowa, all in the fall of 1964. Norm Schulman, who had been teaching ceramics at Toledo, founded the glass program at Rhode Island School of Design in the fall of 1965 and before long was being assisted by grad student Dale Chihuly. In 1966 and 1967, Labino offered workshops at his studio under the Toledo Museum's auspices; the museum set up a glass studio and offered classes for credit with the University of Toledo, under the direction of Fritz Dreisbach. As early as 1964, the first European guest artist led a workshop at an American school (the German artist Erwin Eisch at Madison), a practice that would become widespread.[2]

NOTES

1. Martha Drexler Lynn, *American Studio Glass, 1960–1990: An Interpretive Study* (New York: Hudson Hills Press, 2004), 50.

2. Susanne K. Frantz, *Contemporary Glass: A World Survey from the Corning Museum of Glass* (New York: Abrams, 1989), 57.

FIGURE 8.21. *Harvey K. Littleton,* Falling Blue, *1969. Cut barium/potash glass tubes colored with copper oxide, assembled on bronze plate glass base; 21.5 × 12.5 × 6 in. (Museum of Arts and Design, New York, Gift of the Johnson Wax Company through the American Craft Council. Photograph by Eva Heyd.)*

with a resident master printer and invited artists from America and abroad to create works in residence. By 1991 he had turned off his furnace.

DOMINICK LABINO

A scientist who made a place for himself in the history of glass, Dominick Labino (1910–1987) both paralleled and opposed Littleton. Labino, ultimately vice president and director of research at Johns-Manville, had been working in the industry since 1940. By 1958 he had made paperweights, and by 1960 he had melted batch glass and made a blowpipe. Professionally, he accrued more than sixty patents for glass composition, furnace designs, and glass processes. His "475" marbles were used in both of Littleton's 1962 Toledo workshops, having the advantages of a short and rapid remelting cycle and the ability to remain molten without crystallizing for weeks.

By 1966 Labino had taken an early retirement and was at work in an eighty-by-forty-foot studio lab on his farm. In 1968 he published *Visual Art in Glass,* a survey

moved to the Penland area of North Carolina, where he founded a glass company that supplied batch for continuous-melt furnaces. He had already invented a method of printing with sandblasted glass plates, which he called vitreography, and he established a print studio

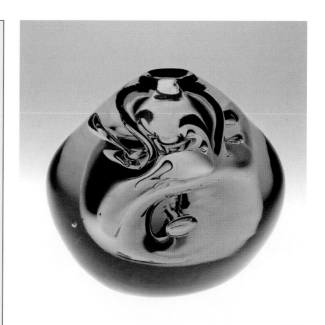

FIGURE 8.22. *Dominick Labino*, Objects in Space, *1966. Free-blown glass; height, 3.75 in.; diameter, 4 in. (Toledo Museum of Art, Museum Purchase Award, 1966.131. © Estate of Dominick Labino.)*

"Technique Is Cheap"

Labino constantly asserted the importance of artists understanding the physical nature of their material. On his own, he systematically researched color formulas. Littleton, by contrast, advocated free experimentation in form and pushing glass in new directions. "Technique is cheap," Littleton told the National Sculpture Conference in 1972, adding that ideas were more valuable and more of a challenge to the artist. In retrospect, it can be seen that neither had it quite right: few artists have labored on their own colors,[1] yet virtuoso mastery of technique seems to have motivated many. And in the context of decades of studio glass, Littleton's and Labino's works are more similar than different.

NOTE

1. Fritz Dreisbach was one of the few artists who devoted much time to researching compatible color systems. But most schools, studios, and businesses now use commercially available color rods, so knowledge of how to mix color is no longer necessary. See Tina Oldknow, *Pilchuck: A Glass School* (Seattle: University of Washington Press, 1996), 94.

emphasizing technology, with only the last chapter addressing the twentieth century. His attitude toward glass naturally differed from Littleton's. In his own work, Labino developed color with particular characteristics of depth, clarity, and selective absorption.[44] (Figure 8.22) He asserted that color itself suggested form. Among his best-known works are teardrop shapes enclosing bubbles or veils of color.

MARVIN LIPOFSKY

Marvin Lipofsky was not at the Toledo workshop but arrived early in the next round of the glass movement—Harvey Littleton's first official class at the University of Wisconsin—and got up to speed fast. He initiated glassblowing at the University of California, Berkeley, in 1964 and also started the glass program at the nearby California College of Arts and Crafts, so when Berkeley shut down its entire design department, he still had a home. Lipofsky was the first artist to cover up the material's seductive surface—with a substance as kitschy as flocking. He produced sculptural work very early on, when the field as a whole was still struggling with technical skills and control. He is also exceptional in having almost

entirely avoided the most characteristic glass form, the vessel.

Lipofsky (b. 1938) majored in industrial design at the University of Illinois but took sculpture classes, as well as studying ceramics with David Shaner. As an undergraduate, he was thrilled with the Voulkos and Mason works he saw at the Art Institute of Chicago, and he headed for graduate school at Wisconsin expecting to work in ceramics with Littleton as well as in metal. In 1963 he became part of the glass program and often assisted Littleton when he traveled for workshops, lectures and exhibitions. It was a fortuitous opportunity to meet many major figures in craft. Ed Rossbach's request that Littleton teach at Berkeley for a semester gave Lipofsky his chance. At Berkeley he built the equipment with his first class, six women students. The program grew rapidly. In 1968 he organized the first Great Glass Symposium at Berkeley, continuing it until 1986 at CCAC and bringing international artists to the Bay Area. In 1971 Lipofsky attended the GAS II conference, where the decision was made to form the Glass Art Society; he served as president from 1978 to 1980. Teaching and organizational responsibilities—the bane of many artists—never kept him from his work.

Lipofsky's most important development was his California Loop series from the late 1960s to the mid-1970s. (Figure 8.23) These are "bulbous shapes connected by sinuous lengths of tubing that Lipofsky sprayed with

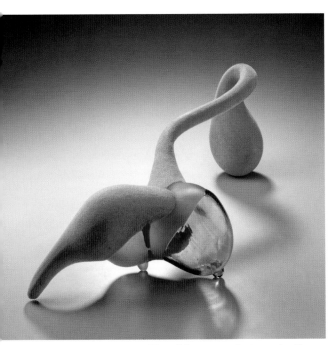

FIGURE 8.23. *Marvin Lipofsky, California Loop Series, 1969. Blown uranium glass, sandblasted and rayon flocked assemblage; 8.5 × 25 × 12 in. (© Marvin Lipofsky. Photograph by M. Lee Fatherree.)*

flocking to obscure the inherent beauty of the glass. What he couldn't hide was the abundant sensuality of the forms, which were read alternately as sex organs, internal body parts or exploded views of microscopic events."[45] The flocking, by eliminating reflection, puts a particular emphasis on form and spatial interaction. These works excited much critical reaction, being described rather vividly as "trains of peristaltic translucent entrails" and "hermaphroditic eroticism."[46] Color was direct and powerful—yellows and oranges with black, for example. Lipofsky got his decorative idea from a hot-rod show, and the works in turn are said to have inspired Wendell Castle (who bought one) to use flocking in a 1970s environment. Some of Lipofsky's early works were encased in Plexiglas boxes, which allowed them to encompass more space—a natural aspiration, given the environmental scale of much art of the time—but obscured the tactile qualities.

Early on, Lipofsky developed an international routine: secure an invitation to a glass factory somewhere in the world, devise a mold, look around for a motif or color or material specific to the place, work with the blowing team to realize objects, and ship the forms home to be cut, polished, sandblasted or otherwise finessed into the finished work. He already had this practice in place when, as president of the faculty senate, he conflicted with the CCAC administration and was fired in 1987. In the travel-produced works, over a period of more than

two decades, the forms are generally amorphous, multi-lobed, and cut to allow a rippling view into the interior. Their free-flowing nature and cursive rhythms, rather than offering a tension of opposites, have a vague effect. At best these works create moods; they can be lovely but are never as challenging as the early works.

Wood: Furniture as Design, Expression, and Concept

FURNITURE

In studio furniture, the 1960s brought radical change. The center of the field was held by established figures such as George Nakashima and Sam Maloof. Among some woodworkers, there was a purist attitude that color and grain were not to be disturbed. Uncomplicated functionality was esteemed, and good workmanship was held almost sacred. Although proposed by open-minded men such as Walker Weed and Tage Frid, these ideas were frozen into a set of conventions that suppressed artistic imagination. In studio furniture, as in other craft mediums, the 1960s brought a burst of experimentation and bitter conflict.

If a single idea ran through the new experimental woodworking, it was self-expression. The idea that an artist could impress his or her emotional state on the material while creating a dynamic abstract composition emerged from painting, particularly the rhetoric of abstract expressionism. Ceramics, with the example of Voulkos and the Otis group in the 1950s, opened all the crafts to the possibilities of expression. Furniture makers faced two obstacles, however: the modernist notion that the designer should remain in the background, since the primary purpose of furniture is to serve, and the fact that wood is a stiff material, not as responsive to gesture as oil paint or wet clay.

Most adventurous young woodworkers studied at art schools, where they came to think of furniture as a type of sculpture. They developed techniques that could accommodate sculptural form or intense expressiveness. Wendell Castle revived stack lamination. Tommy Simpson invented a low-tech way to create hybrids of cabinetry and sculpture. J. B. Blunk went at hunks of wood with a chainsaw. All had the same goal: making forms in space, with flat tabletops or hollowed-out seats as concessions to use.

From 1948 until 1962, the School for American Craftsmen was the only degree-granting institution for furniture in the country. Woodworking was taught elsewhere, but as an adjunct to other programs, especially

vocational education. The North Bennet Street Industrial School in Boston had offered vocational woodworking courses since 1951, for example. But in the early 1960s, several new programs opened, starting with the furniture design "area" at Rhode Island School of Design under the direction of Tage Frid in 1962. Next was the Philadelphia College of Art in 1964, San Diego State University and University of Wisconsin, Madison, in 1967, and Virginia Commonwealth University around 1968. All these programs were associated with art schools or art departments. Their graduates thought of themselves as artists and wished to make abstract sculpture, not simply furniture. Wharton Esherick was the leading model since most of his furniture was abstract: under formal analysis, the functional aspect could be disregarded, and a strong sculptural quality remained.

WENDELL CASTLE

One of the young woodworkers influenced by Esherick was Wendell Castle (b. 1932). As an undergraduate, Castle studied both industrial design and sculpture. In a sense, the two disciplines circumscribe his career. Industrial design dealt with practical objects; sculpture, as it was conceived in the 1950s, dealt with composition of form and space. Castle loved to make things, so the hands-off role of the designer in mass production did not appeal. At the same time, he liked the idea that the only limits in sculpture are self-imposed. Freedom was probably his most important consideration.

On his way to becoming a sculptor, Castle picked up a copy of *Shaping America's Products*, a book that reviewed progressive American designs in the 1950s. Tucked away in the back of the book were three pictures of Esherick's furniture, including the famous staircase. The impact was immediate and intense. Castle later said, "Esherick taught me that the making of furniture could be a form of sculpture; Esherick caused me to come to appreciate inherent tree characteristics in the utilization of wood; and finally he demonstrated the importance of the entire sculptural environment."[47] Inspired, Castle started making furniture in 1958, the year he received his BFA. He also went on a pilgrimage to meet Esherick. He arrived unannounced, and Esherick wouldn't let him in.

In the early 1960s, some American sculptors were gluing up stacks of wood and carving back into them. One was Leonard Baskin, who carved stylized animals and figures; another was George Sugarman, who made disjointed abstract compositions. Stack lamination didn't predetermine any particular shape and could yield forms that looked nothing like conventional furniture, especially rounds and curves. Castle was the first furniture maker to use the technique regularly.

One of his early stack-laminated pieces, *Blanket Chest* (1963), looks rather like a large tomato perched on the top half of a radish. It bears a distant resemblance to a wooden sculpture that Castle made the year before, but it doesn't look like furniture. It represented a nearly complete break from tradition, and yet it was still useful: a lid opens to reveal a hollow interior. While *Blanket Chest* was an ungraceful form, it gave evidence that the gap between sculpture and design could be bridged.

Like potters who wanted to transcend pots and weavers who wanted to move beyond tapestries, Castle wanted to escape the rigors of traditional furniture: "I believe that furniture should not be derived from furniture. This practice can only lead to variations on existing themes. New concepts will arise only when we clear our minds of preconceived notions about the way furniture should look. . . . To me an organic form has the most exciting possibilities."[48] His goal was realized when he made a beautiful stack-laminated desk (1967). (Figure 8.24) The only element that identifies the object as furniture is the flat top surface. Even that is unconventional because it has been covered with silver leaf. The poetic fancy is that the desktop is the exposed interior of some vast fleshy plant. Both form and metaphor are extracted from horticulture. The support—you could hardly call it a leg—that gives the desk its sculptural quality is a thick, sinuous zigzag that has no precedent in the history of furniture. It is also a tripod that provides stability for the

FIGURE 8.24. *Wendell Castle, Johnson Desk, 1967. Mahogany, silver leaf; 40 × 96 × 72 in. (Racine Art Museum, Gift of S. C. Johnson in honor of the fiftieth anniversary of Wustum Museum, 1992.240A-B. © Wendell Castle, Inc.)*

FIGURE 8.25. *Wendell Castle*, Molar Chair, *ca. 1969. Molded fiberglass; 26 × 36 × 30 in. (Collection of The Detroit Institute of the Arts, Gift of Jerome M. and Patricia J. Shaw, 1987.95. © Wendell Castle, Inc.)*

writing surface. Stack lamination allowed creation of an unconventional form that could still function as furniture.

Through the 1960s and 1970s, there was no more influential studio furniture maker than Castle. His vision echoed Esherick's amalgam of function and sculpture, but his work was much more widely exhibited and reproduced. A little later, a maverick craftsman named Jack Hopkins developed a version of stack lamination in California. His style was more planar, Castle's more massive, but both men's work could be called organic. The style became hugely influential, and stack lamination became the technique of choice for ambitious woodworking students everywhere. Few, however, had Castle's sensitivity to form.

Continuing to experiment, Castle briefly tried plastic in the late 1960s. Industry had used plastic for years. Eero Saarinen's Womb armchair from 1948 is one well-known example; Verner Panton's flowing one-piece chair from 1967 is another. Most plastic furniture was injection-molded, requiring metal molds and injection machines far too expensive for a small shop, but Castle knew that molded fiberglass, in which a fiber mat is reinforced with a liquid resin, could be fabricated on a modest scale. Fiberglass boats and canoes, for instance, did not require vast capital investments to produce.

Castle hoped to augment the expensive, one-of-a-kind wooden furniture he was making with something more affordable, but he also wanted to keep the strong sculptural quality for which he was famous. The result was a series of chairs, lamps, and tables in brightly colored fiberglass-reinforced plastic. The first design, produced around 1969, was his Molar chair: a single white biomorphic form that looked rather like a large cartoon tooth

(Figure 8.25) It was a production item fabricated in a job shop in Syracuse.

Castle's plastic lamps were exhibited at the Lee Nordness Gallery in 1970. While their forms, which could suggest the mutant offspring of a worm and hot rod, would have been familiar to anyone who followed Italian design, the slick plastic surfaces and the pop art shapes were too much for his audience: not one of them sold. Nor did the production designs meet his expectations. Faced with the rising costs of oil-based plastics and an unresponsive public, Castle terminated the experiment in 1973.

TOMMY SIMPSON

Of the thirteen woodworkers in *Objects: USA*, two stuck out like sore thumbs: Tommy Simpson and J. B. Blunk. Like most of the American-born studio furniture makers at the time, Simpson (b. 1939) had no formal education in the craft. He studied painting and printmaking at Cranbrook, where he also experimented with wooden constructions, which he painted. His style of folksy surrealism, with flying lovers and human-headed cats, was within the stream-of-consciousness mode then in fashion. In some cases, he turned the familiar nomenclature of furniture into literal legs, feet, and bodies. His layered allusion, extensive color, and quirky shapes made the work unique.

Simpson used pine, a low-grade wood that most studio woodworkers avoided because it is soft and the grain is unexceptional. For him it was ideal, since it was not a serious wood and therefore invited play and experimentation. His contribution to *Objects: USA* was *Man Balancing a Feather on His Knows*, a fantastic contraption with two oversize legs and a cabinet body, topped by a painted wood feather as a stand-in for a finial. (Figure 8.26) The legs can be read as a goof on the cabriole leg, a respectable element of high-style eighteenth-century furniture. The interior of the cabinet is filled with a busy rice-paper collage on wooden shapes that bear a resemblance to internal organs, right down to a triangular void where a belly button should be. The anatomical reading is reinforced by a gaily painted penis dangling between the cabinet's legs.

Simpson was aiming for the poetic possibilities of furniture rather than the utilitarian ones: "I see an object which is for the safekeeping of goods take on meaning as the depository of hopes, loves, sorrows as well as for books, foodstuffs, and underwear. Furniture can expand to receive more of man's needs."[49] A 1966 exhibition called *Fantasy Furniture* at the Museum of Contemporary Crafts showed that other makers were thinking along

FIGURE 8.26. *Tommy Simpson*, Man Balancing a Feather on His Knows, *1968. Pinewood, acrylics, rice paper, glue, wood pegs, steel hinges; 74.5 × 45 × 13.5 in. (Museum of Arts and Design, New York, Gift of the Johnson Wax Company through the American Craft Council. © Tommy Simpson. Photograph by Ed Watkins, 2007.)*

these lines. (Among them was Kate Millet, to be better known for her 1970 best-seller, *Sexual Politics.*) There is a long tradition of playful and exotic furniture in Western history, from Black Forest bear settles to chairs made of Texas cattle horns. Simpson made a career of whimsical furniture. His work established a precedent for highly personal, even autobiographical pieces.

Eventually he developed a style less dependent on painting and more concerned with traditional forms. A typical piece is a Windsor chair with a fanciful animal for a stretcher and spindles mutating into faces or fat, scrolled plants. On some pieces he appends his own poetry. His style is not for everyone. In pursuit of child-like innocence, Simpson can fall into greeting-card sentimentality that annoys more than it charms. Still, he staked out a distinctive position and does not yield to fashion or criticism.

J. B. BLUNK

The other standout furniture maker represented in *Objects: USA* also had no formal education in the genre. J. B. Blunk (1926–2002) studied ceramics with Laura An-

dreson at UCLA. After service in the Korean War, he spent some time in Japan. For eighteen months, he apprenticed to the potter Toyo Kaneshige. Returning stateside in 1954, Blunk worked as a potter but made a living as a carpenter. By 1965 or so, he turned to furniture full-time.

Blunk's approach was unconventional to say the least. He lived in a state forest, and huge chunks of redwood and cypress were readily available. He went at sections of tree trunks with a chainsaw, sculpting the wood directly. Woodworker David Holzapfel called it "subtractive furniture," to distinguish the process from the traditional way of assembling furniture from parts. In the field it is known as "stump carving."

In throwing pottery, form emerges under the hand in the moment of making. Blunk must have recognized the analogy. He said: "Since I principally use a chainsaw to do this, it is a process that moves quickly. At times the cutting away and forming happen so fast it is almost unconscious. . . . Often, as I uncover more of the form, I encounter unexpected qualities, faults or voids in the wood which may change my intention, and sometimes the theme itself."[50] He had discovered a way to make ad-lib furniture, deciding as he went along.

Working on large logs, Blunk carved out elaborate seating sculptures that were ideal for public places. They resemble Voulkos's clay sculptures from the late 1950s: facets and blocks protruding from an organic matrix, dark recesses, some parts refined and others raw. A commission for the University of California, Santa Cruz, was carved from a piece of a redwood fifteen feet long, weighing two tons. Another, for the Oakland Museum, was carved from a twelve-foot ring of redwood. (Figure 8.27)

FIGURE 8.27. *J. B. Blunk*, Planet (Seating Sculpture), *1969. Redwood burl; 12 × 12 × 3 ft. (Collection of the Oakland Museum of California. © J. B. Blunk Estate.)*

Sometimes Blunk employed the same language of forms to make sculpture. To him, the distinctions between art and craft were not meaningful.

Some commentators place Blunk within a California woodworking sensibility: self-reliant, inventive, and independent of the mainstream. Like most other notable California woodworkers, he was not part of the hedonistic, drug-saturated culture of the 1960s but was private, disciplined, and probably quite aware of the historical precedent for his work.

Blunk made smaller furniture—scaled for homes—that had similar knobby forms and rustic surfaces. Other craftsmen have used the same direct-carving techniques, among them Jon Brooks and Howard Werner.

MOLLY GREGORY
AFTER BLACK MOUNTAIN COLLEGE

Not all prominent woodworkers in the 1960s were interested in experimental furniture. There were also those devoted to making comfortable, functional pieces. Molly Gregory left Black Mountain College in 1947 to become designer and manager for Woodstock Enterprises in Vermont. This shop produced cabinetry and custom furniture and also undertook construction projects. By 1953 she was supervising four all-male building crews. She opened her own small furniture shop in 1954, first in Lexington and later in Lincoln, Massachusetts. She produced custom-made furniture and church fittings and carvings, as well as building and renovating houses. Most of her clientele was local, and she did not court publicity.

In many ways, Gregory was the contented laborer that William Morris dreamed of. She insisted that the experience of work itself was a central consideration: "I wanted to do every job myself, all of it, savoring the appropriateness or uniqueness of each assignment. . . . Each job had its own place, each a different rhythm and its own way to be done that was quiet, considered, and somehow serene."[51]

For the most part, Gregory made understated modernist furniture with occasional nods to tradition. A sideboard from the early 1960s is an example. Its long, arched stretcher is modern, as are the short, tapered legs. The six drawer fronts cover up the underlying casework, but round pulls in contrasting wood keep the top section from becoming monolithic. The three doors below are frame-and-panel construction, as opposed to veneer over plywood, which would have been too plain. The panels are raised and framed with thin molding, a detail that might be seen on an eighteenth-century cabinet. The entire facade is also framed with strips of half-round mold-ing, unusual for progressive design of the time. But the modernity of the piece is confirmed by a cupboard built into the side, intended to hold trays. It is the one touch of asymmetry in the whole design.

Gregory closed her shop in 1988, when she was seventy-four, and shifted to making quilts. She showed that making furniture was not the sole province of men. Soon enough, other women would find the door she opened, and many would become leaders in the field.

SAM MALOOF

Sam Maloof (1916–2009), another exponent of function, is regarded as one of the founding fathers of American studio furniture. Thirty years younger than Esherick and ten years younger than Nakashima, Maloof remained active into his nineties. A genial, easygoing man, he was, to many people, what a woodworker should be.

A Lebanese American, Maloof grew up in Southern California. He attended a trade school where he learned mechanical drawing, but he had no formal education in design. Before World War II, he worked for a Bauhaus-educated industrial designer (who taught him the basics of joinery) and later he worked for painter-educator Millard Sheets. While he supported himself mainly as a graphic designer, he was always self-reliant. In 1949 he made furniture for his apartment out of old forms for pouring concrete. To make them presentable, he had the plywood sandblasted. The finished furniture was boxy, with the angled legs typical of the day, but it attracted enough attention to be published in *Better Homes and Gardens* in 1951. Encouraged, he quit his day job and began to make furniture full-time at the age of thirty-four.

Maloof insisted that his style was simply the outcome of his direct work with wood and not the result of influences. Still, his furniture has the earmarks of Danish modern furniture from the late 1940s, particularly that of Finn Juhl. *Interiors* magazine featured Juhl's work in 1948 and again in 1950, and Maloof read the magazine regularly. Furthermore, he modified and then reproduced a Hans Wegner chair for Henry Dreyfuss in the early 1950s.[52]

Maloof's iconic rocking chairs echo Danish modern's organic flow of one part to another. (Figure 8.28) The only elements that do not merge with the rest are the spindles on the back, and such flattened spindles were used by Wegner. Maloof's parts are slightly thicker. His rockers extend further than they need to, and that flourish is exactly what makes his design unique. His construction techniques are different, too. The stretchers on a Finn Juhl chair are joined to the legs with blind tenons,

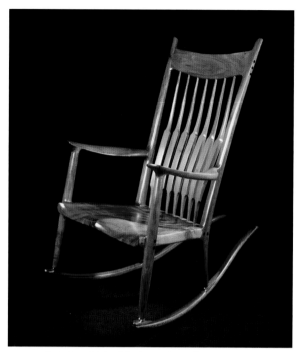

FIGURE 8.28. *Sam Maloof, Rocker, 1980. Walnut; 44.75 ×
45.75 × 26.75 in. (The Renwick Gallery of the Smithsonian American
Art Museum, Gift of Roger and Frances Kennedy, 2003.43.
© Sam Maloof.)*

For more than half a century, Maloof made a living as a furniture maker. He had a refreshing, commonsense practicality that came from having to balance quality with the bottom line. He dismissed the "reverence for wood" espoused by Nakashima, saying he just didn't have the time to obsess about every piece of wood he used. He doubted the value of 1960s and 1970s experiments, finding them extravagant and wasteful of wood. (He may have been talking about Wendell Castle's stack laminations.) Most of all, he insisted that good furniture must be functional: "No matter how beautiful a chair is, if it is not comfortable, it is not a good chair."[53]

Maloof's design sense was rooted in the late 1940s, and his personal style matured in the 1950s. And yet, like many of the classic designs of the period (the Eames LCW plywood chair), his furniture does not look old-fashioned. Design in the 1950s, when he was starting out, sought a middle ground between the impersonal forms of industrial production and the personal expression of art. Maloof, a skilled craftsman, showed that point of balance in the simplicity, utility, and graceful proportions of his furniture.

ARTHUR ESPENET CARPENTER

Furniture making seems to attract tough-minded individualists, perhaps because of the difficulty of making objects that compete directly with mass production. Another crusty character appeared in the 1960s: Arthur Espenet Carpenter (1920–2006). After studying economics and then serving in the Navy during the war, Carpenter drifted to New York City. There, in 1947, he saw Prestini's bowls in one of MOMA's design exhibitions. The idea of creating beautiful, utilitarian objects inspired him. So he moved to San Francisco, where he had once spent a pleasant two months on shore leave, and bought a lathe.

With the help of a few old tradesmen, he taught himself to turn and was soon producing Prestini-like bowls in quantity. Over the next decade, Carpenter expanded his repertoire to include chess sets, pepper mills, and wine racks. He thought of himself as a manufacturer making useful and affordable products for the middle class. In a sense, he was a convert to Edgar Kaufmann Jr.'s vision of "good design." But where MOMA favored an ultra-clean industrial look, Carpenter added a quirky individuality.

Unlike many college-trained woodworkers on the East Coast, Carpenter developed his own approaches. Noting that heavily used furniture wore away into a soft roundness at the edges, he rounded his edges and corners using a router mounted upside-down over an oil drum, a solution that is both cheap and efficient. He then

while Maloof's joints are made with a complex hand-routed notch that is reinforced with two sheet-metal screws. He hid the screw ends with ebony plugs, a bit of obfuscation that would horrify purists. Maloof insisted that his joint was stronger.

His work differs from Danish design for factory production in several respects. He depended on judicious use of power tools complemented by hand labor. He used patterns but adjusted them according to the demand of the client. He shaped every one of his chairs himself, by eye, giving each a slightly different character. Over the years, his designs evolved; they were not static, nor were they reproduced with mechanical precision. He favored lower-grade wood, enjoying its more complex grain and color variations, as well as the occasional knot or sapwood that would never be seen in Scandinavian furniture.

Many of Maloof's chairs have very low arms, which allow them to be shifted easily while being sat upon. And most have creases that accent his curved forms (which Maloof called "hard lines"), instead of having the round or oval section common to Scandinavian designs. Generally, though, Maloof's furniture is an American extension of Danish modern design, not a radical departure. His work is comfortable—both physically and conceptually—in ways that probably contribute to its considerable popularity.

FIGURE 8.29. *Arthur Espenet Carpenter, Roll-Top Desk, 1970. Walnut, mutenye, canvas; 40 × 55.74 × 32 in. (Museum of Fine Arts, Boston, Museum Purchase with funds donated anonymously, Frederick Brown Fund, bequest of Maxim Karolk and Gift of Estelle S. Frankfurter, by exchange, and American Decorative Arts Curator's Fund, 2003.152. Art © Estate of Arthur Espenet Carpenter. Photograph © Museum of Fine Arts, Boston.)*

modified the form by hand with planes and rasps. The technique, while rooted in Scandinavian modern, distinctively added a pleasing sensuality and invited touch. It was widely copied, too, especially on the West Coast. Before long it became known as the "California round-over" style. (Figure 8.29)

Carpenter designed his Wishbone chair about 1960. Front and back legs converge at the back rail, creating a wishbone profile when seen from the side. The legs taper, but they swell out at the bottom so that they seem sturdy and earthbound. To simplify construction, all the parts (four legs, joined seat and back rail) were made and finished separately and then bolted together. Bolt heads were covered with rounded wooden plugs. No refined elegance here, just pure practicality: Carpenter could make a Wishbone chair in two and a half days.

Another of his innovations was the band-sawn drawer. Traditionally, drawers are constructed of four boards and a bottom, each corner jointed. Among obsessive "woodies," the care, craft, and time invested in drawer joints are a big deal, and the drawer is always a rectangular box. Carpenter took a solid (or laminated) block of wood and simply cut the drawers out with a band saw along meandering curves. No problems with fitting or joining, and the drawer fronts could have a funky, organic quality in keeping with the 1960s spirit.

Carpenter described four basic criteria for good furniture design: function, durability, simplicity, and practicality of construction. Any compromise to utility bothered him, which put him at odds with the sculpture-furniture hybrids.

JERE OSGOOD

At the School for American Craftsmen, Tage Frid showed his students how to build and use jigs and fixtures to hold or guide a part so that it could be worked in a specific way, often by a machine. The results can be very precise and can be easily repeated. To Frid's more skillful students, the use of jigs and fixtures also offered an opportunity to develop forms that were impossible to make with any other technology.

The woodworker who pushed handmade forms in constructed furniture the furthest is Jere Osgood (b. 1936). As a student, Osgood took Frid's advice about jigs and fixtures but departed from his taste for designing around the construction. In 1959 Osgood saw some Esherick works at America House and was inspired to develop his own language of forms and a body of new techniques to make them.

Osgood was fascinated with curves. Flat boards failed to express an organic sense of "treeness," he felt, whereas bent legs and swelling surfaces could. One example of his ability to impart a subtle quality of growth to furniture is his 1969 chest of drawers made of highly figured fiddle-back mahogany. (Figure 8.30) The chest swells outward from the legs up to its widest point between the second and third drawers. The sides press out and up, as do the five drawer fronts. The chest creates a vivid impression of having just inhaled.

Osgood's compound curves resemble those that Charles and Ray Eames produced in plywood. Presumably each side could have been carved from a massive slab of wood (or stack-laminated), but that would have been wasteful. Instead, the curved surfaces are pieced together from narrow laminated planks, a technique called compound stave lamination. It is comparable to assembling part of a barrel, except the tapered staves are laminated from thin layers and then glued together to create a three-dimensional form. Each lamination requires a jig to secure all the layers while the glue dries. It is a complex and difficult process, but it allowed Osgood to obtain the swelling shapes he wanted.

Osgood never pursued making large numbers of multiples with his jigs, preferring to explore new forms and the technologies to make them. For instance, he devised a way to make gorgeous bent, tapered legs by laminating strips that tapered in thickness. He used S-shaped legs in a design that he has varied many times, a shell-like desk-on-pedestal. It's a logical extension of the economy

FIGURE 8.30. *Jere Osgood*, Chest of Drawers, *1969. Fiddleback mahogany; 59.75 × 33 × 17.25 in. (Courtesy of the Artist and Pritam & Eames Gallery.)*

and grace of Scandinavian design and another highlight of American studio woodworking.

Like Frid before him, Osgood was an influential teacher, first at Philadelphia College of Art, then at SAC, and finally at the Program in Artisanry at Boston University. A significant number of the most innovative furniture makers of the 1980s and 1990s were Osgood's students, including Rosanne Somerson, Wendy Maruyama, and Timothy Philbrick. The widely divergent styles of his former students testify to Osgood's nondogmatic teaching. He was open-minded but demanded that his students learn a high degree of skill. He stopped teaching in 1985 and went back to making furniture full-time.

NEW TURNS IN WOOD

The Museum of Modern Art had lost interest in wood turning around the time that James Prestini quit the field in 1953, but turners found a home in the rapidly growing craft field. When the Museum of Contemporary Crafts opened its inaugural exhibition, *Craftsmanship in*

a Changing World, in 1956, eleven of the fourteen woodworkers in the show were turners. The first American turners capitalized on the modernist idiom developed by Scandinavian designers and by Prestini, but in the 1960s many abandoned smooth surfaces and pure forms. Two of the leaders in that trend were Bob Stocksdale and Rude Osolnik.

Bob Stocksdale (1913–2003) was raised on a farm in Indiana. When still a young man, he gained access to a wood lathe and taught himself spindle turning. During World War II, as a conscientious objector, he was placed in a government camp in Michigan, where he again had access to a lathe. There he started making bowls, which became his lifelong pursuit. After the war he moved to California, set up a shop in Berkeley, and began to make a living as a wood turner.

A true studio craftsman, Stocksdale could attend to his production in ways that a pure designer, removed from the process of making, could not. He sought exotic woods with unusual grain patterns, or he cut into tree trunks in unpredictable ways, producing unexpected configurations of grain. His *Ebony Bowl* (undated but possibly made in the 1960s) shows the result. It is a "bird-mouth" bowl, so named for its resemblance to the upturned beak of a baby bird. The shape was devised about 1950 by Finn Juhl. These bowls, made of teak in generous numbers, were design icons in the 1950s, and a picture of one appeared in *Craft Horizons* magazine in 1953. Stocksdale's was not a slavish imitation, though. The grain and the shape of his *Fluted Birdmouth Bowl* conform to the edge of the tree from which it was cut. Form and material work in perfect concert, something that was not possible in Juhl's semi-industrial production, which dictated that expensive teak logs be used efficiently, irrespective of the qualities of the wood. Stocksdale was able to envision how unseen patterns of wood color and grain would enhance an equally unseen turned shape—quite an act of imagination. He also had a deep knowledge of wood and the time to select the right log.

Stocksdale often used exotic woods, from macadamia to Malaysian boxwood, sometimes singling out a dramatic vein of color and locating it on a plate or bowl to create an abstract composition. (Figure 8.31) The streaks of colored wood can look like brushstrokes. His figured wood is also similar to painterly glaze effects in some Japanese ceramics. Adding to the Asian aesthetic of Stocksdale's work were the small feet and pregnant curves of his bowls. He joked that Chinese potters had imitated him for thousands of years.

Rude Osolnik (his first name is pronounced ru-dy; 1915–2001) was a gregarious fellow and a great storyteller

Furniture That Became Art

Despite the wish of many furniture makers of the 1960s to be regarded as artists, only one woodworker made the transition to acceptance by those who drew a line between craft and art. Furniture was, however, often used as a vehicle by young sculptors who wanted to blur boundaries. Perhaps the first 1960s sculptor to use furniture as a symbol was **Claes Oldenburg** (b. 1929), with his 1963 *Bedroom Ensemble*. It is a room in which everything is emphatically fake, a creepy vision of American taste in vinyl and turquoise-colored marbling. The objects are made in forced perspective, underlining their phoniness.

Lucas Samaras (b. 1936), too, alters familiar forms in surprising ways. He is probably best known for his later altered photographs, but in the late 1960s he addressed chairs. One work in the series presents the outline of a chair formed of plastic flowers fixed to a wire armature. Perhaps the most iconic is *Chair Transformation Number 10A* (1969–70). The left half of the chair is white laminate over wood, looking much like a classic Parsons chair. The right half maintains the same geometric shape, but the surface appears to have mutated into shaggy brown wool.

The sole studio furniture maker who crossed into art was **Richard Artschwager** (b. 1923). He was one of the thirty-seven woodworkers who exhibited in the Museum of Contemporary Crafts' *Furniture by Craftsmen* exhibition in 1957. The catalog illustrates his Scandinavian-influenced walnut desk with thin tapered legs, a top with curving edges, and three drawers suspended from the framework in a boxy cabinet. Artschwager was an able cabinetmaker. In fact, he helped Oldenburg fabricate *Bedroom Ensemble* in 1963, which may have affected his thinking about the whole craft project.

The next year he produced a series of three-dimensional images of furniture, including *Chair and Table*. Artschwager described the work's indeterminate category: "It's more like a painting, pushed into three dimensions. It's a picture of wood."[1] He said that he was sick of looking at all that lovely wood grain, and he chose Formica—widely reviled by woodworkers—as a corrective. The art world embraced him, but the craft world divorced him. His work was never again shown in a major furniture exhibition, and histories of studio furniture mention him only in passing.

Lucas Samaras, Chair Transformation Number 10A, *1969–70. Melamine laminate, wood, wool; 38 × 20 × 18 in. (Whitney Museum of American Art, New York, purchased with funds from the Howard and Jean Lipman Foundation, Inc., 1970.1572. © Lucas Samaras. Photograph by Jerry L. Thompson.)*

Richard Artschwager, Table and Chair, *1963–64. Formica on wood; table: 29.7 × 52 × 37.5 in.; chair: 45 × 17.25 × 21 in. (Collection of the Tate Gallery, London. © 2009 Richard Artschwager/Artists Rights Society [ARS], New York. Digital image © Tate Gallery/Art Resource, New York.)*

The conception of sculpture as an organic form in space was a modernist notion. While Wendell Castle and other craftspeople continued to admire the abstract form in space, that assumption would separate craft and leading-edge art as the century progressed.

NOTE

1. Quoted in Jan McDevitt, "The Object: Still Life; Interviews with the New Object Makers Richard Artschwager and Claes Oldenburg on Craftsmanship, Art, and Function," *Craft Horizons* 25 (September–October 1965): 54.

FIGURE 8.31. *Bob Stocksdale*, Bowl, *ca. 1950. Cocobolo; 4.25 × 6 in. (Collection of Forrest L. Merrill. © Kay Sekimachi. Photograph by M. Lee Fatherree.)*

who became a worldwide ambassador for wood turning. He was introduced to turning in an eighth-grade industrial arts class, in which his shop teacher taught him sensitivity to wood, even to its flaws. He continued turning at Bradley University during the Depression. He did contract work with his teacher, such as 10,000 parts for a theatrical company. Dealing with those kinds of numbers, he became a master of rapid turning. Even though he taught industrial arts at Berea College for forty years, from 1937 to 1978, he ran a turning business, too. By any standard, he was incredibly industrious: he would get up at 2 A.M., turn candlesticks and other items until 6 A.M., then change his clothes and head off to his teaching job.

The craft business model must fall between two extremes: large numbers of affordable objects made quickly, or small numbers of expensive objects made slowly. The first model, Osolnik's, was preferred well into the 1960s. Making affordable handmade objects demands machine-like efficiency, however. Osolnik could produce one of his famous candlesticks—a simple hourglass form that was in keeping with "good design" precepts—in only six minutes. When one was finished, he inserted a new blank in his lathe while it was still rotating: no time was wasted waiting for the machine to come to a stop. His wife, Daphne, sanded, finished, and packed them. They sold the wares at craft fairs and retail stores. Some of Osolnik's outlets were fairs run by cooperative groups like the Southern Highlands Handicraft Guild and the Kentucky Guild of Artisans and Craftsmen, where he often set up a lathe and demonstrated his craft, a sure crowd-pleaser and a great advertisement. (Along the way, he inspired untold numbers of men and women to take up wood turning.) Osolnik often estimated that he made more than 150,000 of his candlesticks, enough, he said, to cover a football field!

He also experimented on scrap logs or trees he harvested on his own property. One of the defining characteristics of American wood turning is that turners, like stone carvers, coax a shape from a solid mass of raw material. Using logs rather than milled dimensional lumber distinguishes them from most furniture makers, and their inclination to let the character of the wood suggest what they do on the lathe distinguishes them from traditional sculptors. Osolnik was the first to let the rough, unprocessed quality of the log into his work.

Previously, cracked wood was discarded, and all traces of bark were cut away. But Osolnik saw the design potential of wood in its natural state. In the 1950s, he started turning bowls in which the edge conformed to the irregular shapes of unused chunks of wood that he salvaged from a nearby veneer factory. Sometimes he retained a strip of rough wood and bark around the edge. This natural edge was similar to the "free edge" that George Nakashima was using. A typical work exploiting the irregularity of wood is his *Bud Vase*, made in 1965. (Figure 8.32) The flat ovoid form is broken by deep fissures, which occur naturally in the redwood burl from which it is made. There is enough turned form to establish a sense of elegance and simplicity that sets up a startling contrast with the scarred surface of the burl. The whole is a satisfying balance of opposites. Osolnik's bud vases weren't turned on the inside; he simply drilled a hole down the narrow spout to accommodate a single stem. (A flower or weed would add another contrast between nature and artifice.) Osolnik opened a world of possibilities that is still being explored today.

Another first-generation turner who pioneered the use of wood once thought unfit was **Melvin Lindquist** (1911–2000). His innovation was to use spalted wood, which woodworkers used to call "pig wood." Spalting

FIGURE 8.32. *Rude Osolnik*, Bud Vase, *ca. 1965. Redwood burl; 6.12 × 10.75 in. (Mayo Art Clinic Collection. © Joe Osolnik, Estate of Rude Osolnik. Photograph by John Carlano, courtesy of the Wood Turning Center's Research Library, Philadelphia.)*

is caused by a fungus that leaves carbon-containing deposits inside a tree trunk; it's actually the first stage of rotting. Like strong grain and bark inclusions and fissures, spalting produces a decorative abstract design of irregular lines and ovals along with brown or colored stains, now much admired. The carbon deposit is weaker than the surrounding wood, making a piece of spalted wood difficult to work. Lindquist solved the problem by shaping his wood with a power sander while it rotated on the lathe, after roughing it out with a gouge. Like Osolnik, Lindquist inspired many woodworkers. His forms, however, tended to lack the taut precision of the work of Prestini or Stocksdale.

American wood turning developed upon the ideas first explored by these three pioneers. Most turning was based on familiar vessel forms, functional or not, which are more or less round when seen from above and centered on a cavity in the middle. Figure, bark, and fissures largely defined (and limited) studio turning throughout the 1960s. It was not until the 1970s that turners started to explore new possibilities.

Ceramics: Sorting Out Options

Following the Otis "revolution" of the 1950s, the ceramics world moved in multiple directions in the 1960s. While the design option that, at the ACC's Asilomar Conference, had seemed to be the future of the field, was in abeyance, committed producers of utilitarian ceramics such as Karen Karnes and Robert Turner were models for pottery as an moral alternative lifestyle—living simply, making objects of service that sold for modest prices, not pursing fame or wealth, and in some cases being pacifist or supporting other human welfare causes. Another approach was the pursuit of large-scale sculptural form, exemplified by the work of John Mason. At vessel scale, one introduction was the hippie style of applying photographic imagery and silk-screened decals, often alluding to sexual liberation, drug culture, and the like. Two of Voulkos's former students—Ken Price in Los Angeles and Ron Nagle in the Bay Area—created small, high-color precisionist work that contrasted with their teacher's loose, muscular style. At the same time, Paul Soldner developed an American form of raku pottery. The expanded use of nonceramic materials—such as auto lacquer—marked a turn away from commitment to purity of materials. A recovered high-fire technique, salt glazing, began to be popularized by Don Reitz late in the decade.

Yet another approach to ceramics, funk, is sometimes described as a crude inversion of pop, with the same attention to domestic and commercial objects but rather more primitive and vulgar, scatological and jokey. In addition, a small number of artists, most importantly Jim Melchert, created conceptual works in clay, still object-oriented yet based on games, literary styles, and other ideas. There were also a few ceramic-based performances, by Melchert and Howard Yana-Shapiro, among others. With the adoption in the Bay Area of low-fire whiteware that encouraged a new range of surface treatments and colors, artists such as Richard Shaw created trompe l'oeil assemblages. On the East Coast, Ka-Kwong Hui produced finely crafted, slightly surreal objects or vessels painted with hard-edge optical patterns.

In 1961 Rose Slivka, by then the editor of *Craft Horizons*, wrote an evaluative essay called "The New Ceramic Presence." This was a discussion of the new ideas of expression and free form in clay, primarily on the West Coast. The text did not name Voulkos or any other artist, but the illustrations made clear whom she was talking about. A boxed note in the article asserted that the essay was not meant to endorse any specific type of work, but no one was fooled: letters of complaint and even canceled subscriptions followed for months. There were also many letters of praise.

Over the years, the article has been misrepresented as having introduced Voulkos's work to the East Coast, but he had been interviewed by Conrad Brown, then editor of *Craft Horizons*, in 1956. But whereas Voulkos then had seemed to be an individual aberration, Slivka was now describing a movement, the shifting of an entire field of reference. It has also been asserted that the reader response was unparalleled, but that may not be true either. The magazine received and published many letters in the days when that was the primary form of communication. At least as many letters followed Dorian Zachai's plaint about jurying the Saint Paul *Fiber, Clay, Metal* show. It has also been said that complaining respondents were merely reactionaries, afraid of the new. Marguerite Wildenhain famously referred to Voulkos's work as "the big pile," and Warren MacKenzie followed that by associating those piles with the ones in his neighbor's cow pasture. A look at the black-and-white illustrations accompanying Slivka's article makes those reactions understandable, however: the works shown were without exception free-form, expressionistic, loosely shaped vessels. "Blob" would not be an inappropriate word. Artists such as Robert Arneson and others who would later be famed for far more controlled work were then simply trying to break free of propriety and convention.

Slivka, whose husband was a sculptor and who was

friends with many central figures in New York school painting, was predisposed to appreciate the loosest and most avant-garde works. She became the champion of the adventurous, and her support was important in the movement of the crafts toward art. Unfortunately, she wrote from a painting perspective and slighted ceramic precedents for the work. She wrote a parallel appreciation titled "The New Tapestry" following the 1963 *Woven Forms* exhibition, which provoked a similar, if briefer, reader response. She regularly wrote summarizing yet exhortatory articles, attempting to define the American character and how it was expressed in creative work, something that sounds impossible today but was then part of the process of American art defining itself independent of Europe, rising to international prominence with the abstract expressionists. In fact, Slivka *was* endorsing the most expressionistic work in all mediums. She became the biographer (or hagiographer) of Voulkos and never herself wrote about traditional, folk, and ethnic crafts, though such work, particularly from abroad, was extensively featured in the magazine.

The second major event of the 1960s that grew out of the Otis revolution was a 1966 exhibition called *Abstract Expressionist Ceramics* at the University of California, Irvine, organized by John Coplans, director of the school's gallery but better known for his association with *Artforum* magazine (then still based in California). The exhibition traveled to the San Francisco Museum of Art in 1967. It was a mixed presentation of works by Voulkos and friends from both Otis and Berkeley, and it was rather oddly selected, including some work, such as Price's, that was not at all "abstract expressionist" and leaving out some major participants in the movement, such as Soldner. The exhibition was exciting, however, both because it was the response of an intelligent and literate art critic and curator and because it declared the consequentiality of the work and brought wider attention to it. Many of the works Coplans selected have become icons, and nearly all the artists remain major names. Since then, however, the show has been a double-edged sword. It provided a shorthand way for the California clay innovations to be dismissed: they were simply a regional expression of a painting movement, after the fact.

Yet another landmark in ceramics was the publication of M. C. Richards's book *Centering: In Pottery, Poetry, and the Person* in 1962. Richards (1916–1999) taught writing at Black Mountain College and translated plays by Jean Cocteau and the writings of Antonin Artaud. She studied ceramics with Robert Turner when he was potter-in-residence at Black Mountain and later shared a studio with Karen Karnes. Her book is a collection of essays, filled with anecdotes and poetry, focusing on self-understanding. Richards wrote in the introduction to Paulus Berensohn's similarly philosophical book of pinch-potting, *Finding One's Way with Clay* (1972), "It is the pots we are forming . . . and it is ourselves as well."[54] Using the metaphor of centering clay on the wheel, she addressed creativity, spirituality, the environment, education, and more, gently advocating a concern for wholeness. Published by a university press, the book became an underground classic and sold more than 120,000 copies. It suited the counterculture idealism of the 1960s yet has continued to speak to readers since.

EXCEPTIONAL SUBJECTS: MICHAEL FRIMKESS

Michael Frimkess (b. 1937), part of the Otis group around Voulkos, was exceptional in adopting political subject matter from very early on. He was also unusual in his fascination with ceramics of antiquity (which he studied on trips to New York and Boston in the mid-1960s) and his conviction, after he saw an Italian potter throwing "dry" (without lubricating water) in a Pennsylvania pottery, that the old pots had been done that way and that he must learn to do it. The technique led to many kiln failures, but when successful, it produced vessels with walls of a thinness usually seen only in porcelain.

Frimkess made oversize Chinese ginger jars and Greek hydras, kraters, and amphoras, as well as Pueblo pottery forms. Inspired by the figurative scenes characteristic of Greek pots, he covered his jars with white slip and then china-painted them with cartoonish contemporary mélanges of pop-culture and traditional figures, making reference to sexuality, ecology, race relations, music, and so on. His Melting Pot series of the mid-1960s related to his childhood experience of "being the last Jewish family left in Boyle Heights," a Los Angeles neighborhood where he grew up with Chicano, Japanese, and black children.[55] The Melting Pots allude to the ideal of a peaceful mixing of the world's multiple cultures, races, and religions.

Frimkess's subjects and actors range from a college ceramics class in *Things Ain't What They Used to Be* (1965) to Santa, Uncle Sam, and Superman in *Jumpin' at the Moon Lodge* (1968) (Figure 8.33) to endangered animals and a four-person bicycle in *Ecology Krater II* (1976). Text is often included in the form of speech balloons or legends. This blend of past forms and present subjects presaged the issue-oriented ceramic art of the 1980s. Since the mid-1970s, Frimkess's wife, Magdalena, has been decorating the shapes he has thrown and fired, and the works carry both their names.

FIGURE 8.33. *Michael Frimkess, Jumpin' at the Moon Lodge, 1968. Stoneware; 28.25 × 26 in. (Scripps College, Claremont, Calif., Gift of Mr. and Mrs. Fred Marer. © Michael Frimkess.)*

KEN PRICE: ENIGMATIC OBJECTS

Among the Otis gang's younger members and never officially a student there, Ken Price (b. 1935) went in a direction quite opposite to Voulkos's. He is known for working in small scale and for using low firing temperatures to allow a full range of ceramic colors. He is interested in subtle contours and seductive surfaces. (Despite these contrasts, he has said: "From Pete I learned the difference between developing a body of work by direct onslaught instead of just piddling with it, which is what I'd been doing with most of my time. Pete taught me good productive work habits, among many other things.")[56] Both men have used nontraditional coloring materials.

With the exception of one major series, Price has stuck with unitary and often organic forms. In the 1960s he made an extended series of cups and various strange, imaginative, unclassifiable, sometimes sexually suggestive, or repellant objects. All have been influential, and his independence has also been a model for many younger artists. Most important is that he pioneered his

own genre, equally painting and sculpture, unquestionably art yet about—and respecting—craft. Like few of his peers, Price has been an original within the larger art world, not simply in ceramics. He has brilliantly manipulated objectness and surface characteristics of the clay genre within a sculpture milieu nonplussed by such color, such detail, such intensity.

Price started out in painting at the University of Southern California. He and his friend Billy Al Bengston heard about Voulkos and joined the activity at Otis, Price staying until 1958. His Otis works in stoneware are not remarkable, although in retrospect his reductiveness and attention to edge can be recognized.[57] He then went to Alfred, where he completed a two-year MFA degree in one year, learning the glaze technology that Voulkos had minimized.

Subsequent works were produced in series: lumps, domes, eggs, and thin-walled cups with splayed, expanded bases on which rested snails, frogs, and the like. The cups—funny, clunky, sometimes repulsive with their slimy addenda—presaged Clayton Bailey's creatures from the muck and David Gilhooly's frogs of the 1970s. But Price was going somewhere else. The cups became studies in form and color, and such color was not common in ceramics or in sculpture. Ron Nagle recalled with awe: "He was some guy who was making grandma five-and-dime ware and getting it from both sides. He was an innovator, a poet, and a real artist. The fact that he dared to use earthenware in the stoneware era, that he dared to make the colors bright instead of earthlike . . . real brave stuff. There is something about what he did that was totally transcendent."[58]

Escaping pottery reference, Price's forms, as he wrote to a friend, recalled "fond memories of mountain peaks, breasts, eggs, worms, worm trails, the damp undersides of things, intestines, veins, and the like."[59] Most unsettling was his color—acid or garish or sour. Price said that he tried to make color and form indistinguishable, that he wanted the works to look like they were made of color. Yet if the forms were biomorphic, the colors were artificial, creating a tension between the appealing and the discomfiting that describes most of his work since then. His things were called surrealist or linked to Brancusi or Arp, but they were his own contemporary merging of opposites.

Many of the forms had dark recesses, suggestively erotic, and small extrusions—like fingers or intestines or tongues or flaccid penises—that gave them a creepy edge, especially as Price worked on perfecting the surfaces, experimenting with hot-rod lacquers. (Figure 8.34) The work was shown at Ferus Gallery, the cutting-edge

FIGURE 8.34. *Ken Price, S. L. Green, 1963. Clay, paint; 9.62 × 10.5 × 10.5 in. (Whitney Museum of American Art, New York, Gift of Howard and Jean Lipman Foundation, Inc., 1966.35. © Ken Price. Photograph by Jerry L. Thompson.)*

L.A. venue, starting in 1961. There he associated with painters and sculptors developing the aesthetic of obsessive refinement known as "finish fetish." He constructed a pedestal for each form to emphasize that it was an object of contemplation.

Price became increasingly solitary, and he worked in his own way and at his own pace, without concern for wider acceptance. He said he wanted to "control the various kinds of input into my life,"[60] and his next move was a literal one. He relocated to Taos, New Mexico, where he produced a sharply different body of work in the 1970s, which will be discussed in the next chapter.

MORE FROM SOLDNER AND MASON

These two artists associated with Voulkos at Otis followed their early innovations with strikingly different work in the 1960s that brought them even greater praise.

Paul Soldner, known for his "extended throwing" in graduate school, was hired as a sabbatical replacement at Scripps College in nearby Claremont, and the job eventually became permanent. For a campus arts festival in 1960, he had the idea of demonstrating the rapid and relatively low-temperature firing of the raku process, although he didn't know much more about it than Leach's story, in *A Potter's Book*, of painting on a pot at a party and having it brought back to him, still warm from the kiln, a short time later. Soldner built a small, portable gas kiln, did his public firing, used tongs to pull out a red-hot stoneware pot, and dunked it in a fish pond to cool it. It cracked but made a pretty good show. Later, on impulse, he put a hot pot in a pile of leaves, which burned, interestingly altering the glaze colors and leaving a subtle pattern. That night he mixed a differ-

ent clay body, bisqued and glazed some pieces, and had better results.

Soldner was not the first American to experiment with raku. In the 1940s and 1950s Warren Gilbertson of Chicago had been interested in the tea ceremony and in 1948, at Alfred, made raku pots; Jean Griffith in Seattle had tried smoking pots in organic matter; and Hal Riegger and Carlton Ball had also investigated it. But Soldner more than anyone is identified with the dramatic process that became his workshop specialty and soon was a feature of art fairs across the country. He was exposed to Zen notions of chance and acceptance of accidents as part of the climate of the times, and his mechanical resourcefulness allowed him to capitalize on the unexpected. Each piece was fired individually, so each was an opportunity to experiment. He tried smothering the hot pots in sawdust, newspaper, straw, and rope. His glazing varied as well.

At first, the raku firings consisted mainly of tea bowls, but Soldner was interested in raku as a technique rather than as a tradition, so he soon varied his forms, paddling, adding a doughnut of clay to serve as the vessel's neck and foot. In charge of Scripps College's annual ceramic exhibition, Soldner made the 1963 edition an all-raku event. In 1964 he submitted his low-fire raku work to the Syracuse Ceramic National. Stoneware was still the dominant mode, but, to his surprise, all three of his pots were accepted, and one won first prize. This recognition contributed to the increasing acceptance of low-fire ware.

Along with Frimkess, Soldner reintroduced the figure on ceramic ware. (Figure 8.35) He cut photos from magazines and used them, on plywood or Masonite backings, as stencils. By this means he introduced both contemporary culture and implications of movement to his work. His forms were free in conception and sometimes nearly triangular in profile, flaring from a small foot to an uneven rim. They were started on the wheel but usually altered by hand, sometimes folded, creased, rolled, pressed with found objects, or worked with tools. The liveliness of these forms and their freedom from symmetry suited the 1960s cultural climate, from which he borrowed imagery of "Afro" hairstyles, *Playboy* nudes, and John Lennon. His placement of pop culture images against an earthy, smoky base was criticized as disjunctive, but looking back from a greater distance, it seems that the images, linked to their time, are as evanescent as smoke.

When Soldner had the opportunity to visit Japan in 1971 and 1978, he discovered that raku there—associated with a particular family of potters—is not smoked and is

FIGURE 8.35. *Paul Soldner, Vessel, 1965. Stoneware, partially glazed, raku-fired; 16.5 × 13.5 in. (Scripps College, Claremont, Calif., Gift of Mr. and Mrs. Fred Marer. © Paul Soldner.)*

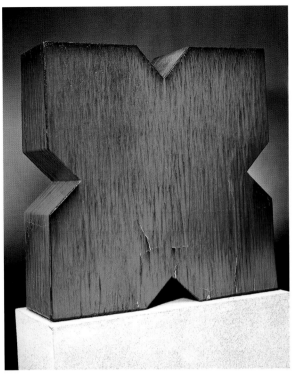

FIGURE 8.36. *John Mason, Red X, 1966. Ceramic; 58.5 × 59.5 × 17 in. (Los Angeles County Museum of Art, Gift of the Kleiner Foundation. Art © John Mason. Photograph © 2007 Museum Associates/LACMA.)*

not placed in water after firing; what he had developed was an almost wholly American process. He said years later that while, in the beginning, he thought raku was about "the accidental, the spontaneous, today he realizes raku is really about discipline and an ease that comes only when the potter has total command so that he can forget technique and surrender to intuition."[61]

John Mason also took his work in new directions in the 1960s. On some of his early vessels he had inscribed graphic X marks, and he now developed them into forms, moving away from expressionism to reductive geometry in architectural scale. The intermediate step was a wall with a ragged relief surface from which a broad, blunt X emerged into relative smoothness.

Now he created nearly five-foot-tall geometric forms in both the X and Greek cross shape, the former glazed in red and the latter in an acid yellow. (Figure 8.36) These were shown in his solo show at the Los Angeles County Museum of Art (LACMA) in 1966 and certainly relate to the concurrently developing minimalist sculpture on the East Coast. Garth Clark has suggested that this effort was a dead end and that it was impossible to achieve the perfection of industrial materials seen in the sculpture of Donald Judd and Carl Andre.[62] But there is no reason to suppose that minimalism was Mason's goal.

While this work does not look expressionist, as his 1950s sculptures did, Mason continued to work without drawings or plans, following impulse. Moreover, a critic at the time spoke of the "seductive" glaze surface creating a "totally different feeling from the machine made precision of so many of his colleagues. . . . The curious tension in these works between the bare geometry of their forms and their sumptuous surfaces could only arise from this one medium, clay, and it is to Mason's credit that he has exploited this tension."[63]

The way that worked might be understood by considering a totem piece, an earlier type included in his LACMA show. It was described as resembling a vertebral column and pelvis, made of stacked chunks of rough clay. If the work had been unglazed, one would have noted the details of surface, slowing visual movement up and down the form. But Mason covered it with a shiny orange glaze that gave it "a greater unity of impact," making it "graspable as a whole and referring to nothing outside itself."[64] A colored geometric form, viewed from a distance, would be a powerful sign. From an intermediate distance, a work of this size and intense hue would radiate color; from close up, the surface quality of the glaze and details of form would be apparent. These geometric forms oppose the additive character of Voulkos's largest and most

powerful sculptures, which had been shown earlier at LACMA, in favor of architectural character. Mason's purpose was to make a complex unity.

For many artists, the high of a museum show is followed by a "down" period of reconsidering. After the LACMA show, Mason tested clay bodies and rethought his purposes and needs. But even at this point, John Coplans wrote in a catalog essay, Mason was "endowing his massive images with a rich complexity of associative values" and "helping to free ceramics from its long tradition of vessel shapes and intimate scale" by persuasively demonstrating the flexibility of his material.[65]

RECONSIDERATIONS: FRANS WILDENHAIN AND DANIEL RHODES

Being a famous name in American ceramics, having a long and successful teaching career, producing a powerful array of functional as well as sculptural forms and public works, and claiming devoted friends and collectors who wrote and spoke emotionally about him—with all this, **Frans Wildenhain** (1905–1980) would seem to have had everything. But there's sadness in his life story at the beginning, middle, and end. He had a difficult young life in Germany, was caught there during World War II, ended a marriage to his more famous wife, Marguerite, and concluded his career before the craft field offered substantial documentation and analysis, so his lifework seems inaccessible today.

Wildenhain, born in Leipzig, was interested in art from an early age, but because of his family's poverty, he was apprenticed to a lithographer of architectural renderings at the age of fourteen. He became a journeyman but still aspired to art. He was inspired by a lecture by Bauhaus director Walter Gropius, and a scholarship enabled him to go to there in 1924. He needed practical work, so enrolled in the Pottery Workshop, where he met Marguerite Friedländer and the important form master Gerhard Marcks. Frans and Marguerite's life together (see chapter 6) ended in 1950, when he began to teach at the School for American Craftsmen's new home at RIT. There he joined woodworker Tage Frid and metalsmiths John Prip and Ronald Pearson to establish Shop One, the only craft shop and gallery in the area.

Wildenhain produced functional pottery throughout his life, at least in part for the income. The functional work displays clean form and often a striking muscularity in big loop handles and jutting spouts. He could manage color when he wished and used resist and sgraffito decoration, as well as selected relief embellishment. He was equally skillful at creating abstract or allusive forms. He was making sculptural works by the mid-

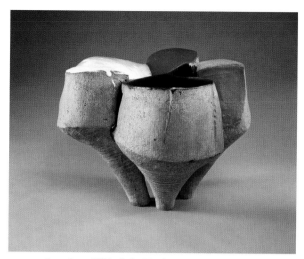

FIGURE 8.37. *Frans Wildenhain*, Mushroom Pot, 1969. *Stoneware; 14.5 × 14.5 × 18.5 in. (Collection of Everson Museum of Art, Syracuse, N.Y., Museum Purchase, 70.33. © Estate of Frans Wildenhain. Photograph courtesy of Courtney Frisse.)*

1950s and was pleased to discover Voulkos's efforts in the same direction. He did not work so savagely, but neither was he constrained by efforts at perfection. His sculpture of the 1960s titled *Mushroom Pot* is evocative more than depictive; it consists of four flat-topped elements, two with angular, sliced sides, each raised on a single tapering leg. (Figure 8.37) A trip to Puerto Rico at the end of the decade provoked a tall, vaselike form in which upper walls of blue, black, and purple curve at an angle before yielding a curl that captures the power and motion of breaking waves. He also made modernist figures with positive and negative spaces.

Wildenhain was inspired by nature, his observation of which expanded when he and his second wife, jeweler Marjorie McIlroy, moved to a home and studio in the country. He responded to Asian ideas, and in 1969, two years after her death, he visited Japan, where he studied ink painting and Zen Buddhism. (His third wife, weaver Lili Rankin, was also a student of Zen.) His best works fit no categories. At a time when American ceramics seemed split between Alfred's tight aesthetic and the West Coast's avant-garde, Wildenhain's was neither. He played with a great many glazing treatments, from scumbled abstract painting to overall mottled mat to patches of smooth color laid on almost like sheets of plastic, as well as poured effects. He also seems to have appreciated unconcealed natural surfaces. He said that he had come around to thinking of a vessel without glaze as being "like a body before clothes are put on."[66]

Wildenhain was honored with a Guggenheim fellowship and named an American Craft Council fellow yet was not really part of the public dialogue. Even his regu-

FIGURE 8.38. *Daniel Rhodes, Form, 1962. Wheel-thrown and slab-built stoneware; height, 47 in. (Collection of Everson Museum of Art, Syracuse, N.Y., Purchase Prize given by Helen S. Everson Memorial Fund, 22nd Ceramic National, 1962, 62.34. © Estate of Daniel Rhodes.)*

lar participation in the Ceramic National was essentially local. It didn't help that he had an impolitic streak that could offend or intimidate people. The work of some such artists finds recognition posthumously, when the artist's personality is no longer in the way, but Wildenhain has never quite received this reconsideration.

Daniel Rhodes (1911–1989) likewise is a major figure of his time who seems in danger of being forgotten. Rhodes showed an early talent for drawing and studied sculpture at the School of the Art Institute of Chicago and art history at the University of Chicago. He moved to New York in 1933 hoping for success as a painter and eventually did a few WPA murals, but after his marriage to Lillyan Jacobs in 1940, her interest in Pueblo pottery led him to ceramics. In 1941 he began studies at Alfred that made him the school's first MFA recipient. War work in a ceramics factory and then making a living as a production potter occupied him until 1947, when he was invited to teach at Alfred.

There Rhodes wrote his first and perhaps most noted book, *Clay and Glazes for the Potter* (1957), which became a standard reference.[67] He also began experimenting with off-wheel sculpture, high-fire glazes, and reduction firing techniques (the latter two of concern to many around this time). In a solo exhibition at the Des Moines Art Center in 1965, Rhodes showed assembled figures up to six feet tall, with tactile, unglazed surfaces. A 1967 show at the Museum of Contemporary Crafts in New York included five monumental pieces placed at the gallery entrance like guardian figures. He developed a process of using fiberglass fabric to reinforce the clay, enabling larger size.

Rhodes was compared with Voulkos, yet his figures—even when monumental, unglazed, and scratched—retain a sense of propriety. The works were striking, however. *Form* (1962) has a thrown cylinder (leg) supporting a slab-built rectangular "torso" with vestigial breasts. (Figure 8.38) There is no head, but a shelf of small elements makes up the shoulders, as if alluding to a collection of thoughts or memories. The unglazed clay shows applied and incised embellishments. While slightly smaller than human size, the piece has presence.

Rhodes continued to produce such works after retiring from Alfred in 1973 and moving back to California. There he pursued the relationship of his figures to earth features and also made over-life-size modeled heads. Both suggested nobility in the face of decay and death. Rhodes is now better remembered for his teaching and his writing than for the once-important work.

ROBERT ARNESON

Following a long and twisting road to his aesthetic maturity, Robert Arneson started out making conventional stoneware pottery and ended up making agonized figurative bronzes. Along the way he had works thrown out of exhibitions, a major public commission notoriously rejected, and work in a show at a New York museum dismissed as trivial. Yet he grew after each of these setbacks and became one of the central ceramic artists of the century.

Arneson (1930–1992) was a high school cartoonist in Benicia, California, and went to art school expecting to be a commercial artist. Instead he taught art at the high school level following graduation. He had to know a little about a lot of art techniques for that job, and one of the many ironies of his life was that he barely passed his college ceramics class, earning a D and feeling not at all fond of the medium. He tried to brush up by taking classes once he was working, pursuing it doggedly, and finally came to be genuinely interested.

FIGURE 8.39. *Robert Arneson*, No Return, *1961. Earthenware; 10.75 × 5 × 5 in. (Los Angeles County Museum of Art, Smits Ceramics Purchase Fund, Modern Art Deaccession Fund, and the Decorative Arts Council Acquisition Fund. Art © Estate of Robert Arneson/ Licensed by VAGA, New York. Photograph © 2007 Museum Associates/LACMA.)*

In 1957 Arneson enrolled in graduate school at Mills with Tony Prieto, since family obligations made it impossible to go to Otis to study with Voulkos, as he wished. He became Prieto's assistant and, in 1960, fellow teacher. By that time Voulkos was in the Bay Area. Arneson and Prieto, who disagreed on the merits of Voulkos's work, became estranged. Arneson recognized that Voulkos's local students were pushing clay in new ways.[68] In 1961, demonstrating throwing with Prieto at the California State Fair, Arneson threw a bottle form and then, on a whim, constructed an imitation of a fluted metal bottle cap and spelled out "No Deposit, No Return" in raised letters. (Figure 8.39) *No Return*, the work's title, could have been his motto: this piece was a break with well-behaved ceramics, and there was no turning back to his handsome functional ware.

One of his "organic" vases was illustrated in Slivka's "New Ceramic Presence" essay, but his sharp shift be-

came public knowledge only when he participated in a group show that included work by Voulkos, Mason, and other "greats," as he put it. Arneson did not want to look like a second-generation copyist; he wanted to find his own voice. His idea was to tell the truth about ceramic identity. He made a ceramic commode, misshapen and rough-surfaced, "and cut loose and let every scatological notation in my mind freely flow across the surface of that toilet."[69] This work, which he titled *Funk John* and stacked on concrete pads so that it stood above eye level (appropriate for a "throne"), was removed from the show. (It was subsequently destroyed.) He followed it with other toilets, some modeled with breasts on the tank or phallic pipes and handles, and complete with ceramic excrement. "It's very aggressive," he later said of this series. "The form is overwhelmed by the content. The image is so heavy you can't see it as form. But it was a great challenge to confront something one wasn't supposed to do, and do it. It was the toughest, most powerful work I could make."[70]

This was the start of what was called funk art, a term that came to mean irreverent and vulgar and was particularly associated with Arneson and his students at the University of California, Davis, where he began teaching in 1962. The art department at Davis was being formed as he arrived; Arneson first taught ceramics in the home economics department of the College of Agriculture. Other teachers were also new to the campus, including William T. Wiley, Wayne Thiebaud, and Manuel Neri. With no tenured deadwood, the department was exceptionally lively, and for a time it provided a creative community that stimulated all the participants. Some artists, including Jim Melchert, came from San Francisco to join the social events. Some of the first graduate students, among them Bruce Nauman, were equally a part of the inventive ferment.

Arneson rapidly achieved a national reputation for the toilets and for various ordinary objects treated to a punning realization or a kind of Dada inversion. Most of the early ones were salacious, macabre, or sophomoric. There was *Toasties* of 1965 (a toaster with fingers emerging from the slots), *Typewriter* of 1966 (with red-lacquered fingernails serving as keys) and *Call Girl* of 1967 (a tall telephone with breasts). There was also a late 1960s series of thirty-five teapots featuring, for example, genitalia. He also shifted from stoneware to low-fire white earthenware that allowed brighter colors.

Expanding his concept by narrowing his reference, Arneson produced a 1966–67 series of works based on the tract house on Alice Street in Davis where he and his wife were raising their four sons. He made relief plaques

Funk

Funk was institutionalized in 1967, when Peter Selz organized an exhibition of that name at Berkeley's University Art Museum. It showed that ceramics was dominating a Bay Area movement that had begun in the 1950s with surrealist and Dada-influenced art, which had borrowed its name from jazz. Selz wrote: "Funk art is earthy, gutty and sensual. It is more likely to be ugly than handsome. It is eccentric to the point of idiosyncrasy. Though indebted to abstract expressionism for the breakthrough to an informal art, it is not abstract. It makes use of an imagery that is organic and biomorphic, and includes sexual, scatological and other subliminal associations. It is articulate about aspects of art that rarely have been articulated. And it is filled with the wit of paradox."[1]

Some observers claimed that there was no funk movement and that Selz was just doing a show of West Coast art to cement his new position (he had come from the Museum of Modern Art in New York). If the term is used, it describes high-spirited, irreverent, antiestablishment work, concerned with the banality of making, using shock tactics. Funk is alternative both to the coolness of pop and to the muscular expression of Voulkos. While Arneson went on to more nuanced wit from this beginning, not everyone followed.

NOTE

1. Peter Selz, "Funk Art," *Art in America* 55 (March–April 1967): 92.

and three-dimensional models of the house, complete with landscaping and a car in the driveway. He was amused by the middle-class normality of his existence, and these works might be seen as the first examples of the self-ridicule of his signature self-portraits.

In the 1960s Arneson employed his own image in a few works. *Silver Dollar Bob* (1965) had him on a fake coin. That year he made his first self-portrait bust, the only one that shows him thin and dark-haired: *Self-Portrait of the Artist Losing His Marbles*. Real marbles fill a crack down his center front. He began depicting himself engaged in everyday activities on a series of plates. But only after *Smorgi-Bob, the Cook*, in the early 1970s, and as his hair turned prematurely white, did he begin his celebrated and long-running series of self-portrait busts, which will be discussed in the next chapter.

JIM MELCHERT

Jim Melchert was one of the high-visibility students from Voulkos's second teaching gig, at the University of California, Berkeley. His work conveyed the sheer joy of outrageous innovation and irreverent mixing of materials: he taped a metal muffin tin to the center of a large thrown plate, for example. He has also consistently shown a conceptual bent, to the extent that he staged performance pieces and for a time worked in other materials altogether, often using photography. The cerebral approach distanced Melchert from the clay community, as did teaching sculpture and design rather than ceramics for most of his career, as well as his two stints in important administrative posts, as visual arts director for the National Endowment for the Arts (1977–81) and as director of the American Academy in Rome (1984–88).

Moreover, Melchert (b. 1930) has a rather unconventional background for a craftsperson, being the son of a minister and having studied art history at Princeton. Perhaps he was already attempting to break from that background when he taught English in Japan following graduation, and he went further in deciding to be a painter. While earning an MFA in painting from the University of Chicago, he saw some Voulkos pots in a museum and was horrified. "I thought to myself, 'It *would* take somebody from California to do this.' I couldn't get out of the room fast enough."[71] But he couldn't stop thinking about them, and since he needed more ceramics training for a new teaching job, he faced Voulkos in a summer class at the Archie Bray Foundation in Montana. "It was the most important encounter I ever had with another artist. I had been a painter and that class turned everything around."[72] Melchert moved his family to California so that he could continue to study with Voulkos and has been there ever since. After completing his MA at Berkeley in 1961, he began teaching at the San Francisco Art Institute and freeing himself from Voulkos's expressionist influence. He and Ron Nagle stirred things up by switching the ceramics department to a white clay body and bright low-fire colors. After four years there, he began teaching at Berkeley.

Melchert's early pots were meant to confound definitions and boundaries and literally play games. *Leg Pot* (1962) is a dark, blocky, unpretty form, with a tubular, ribbed extension on one side. (Figure 8.40) He had been looking at African and Oceanic art, with its juxtaposition of unlike shapes and mix of materials, and as he later put it, "I was impatient with the conventions that seemed to tyrannize potters, the vertical bilaterally symmetrical structure of a vessel and the unquestioning acceptance of a single material."[73] The leg, separated from the torso

FIGURE 8.40. Jim Melchert, Leg Pot I, 1962. Stoneware, lead, cloth inlay, wheel-thrown, slab-constructed; 11 × 32 × 13 in. (Museum of Arts and Design, New York, Gift of the Johnson Wax Company through the American Craft Council. © Jim Melchert. Photograph by Ed Watkins, 2007.)

by cloth, does not lift, support, or make mobile, but lies flaccid and useless.

After many works that involved sticking foreign materials into clay, Melchert produced his notable Ghostware boxes and plates (1964). As he tells it, the blindfolded, press-molded face on the top of each form was specifically intended to violate the current bias against figurative imagery. If you weren't supposed to, that was reason enough to do it. These disturbing yet somehow evasive works were based on a mask and individually altered. The face is gap-toothed and vacant-looking. The series was triggered by the Ingmar Bergman movie Silence, in which it is said that one must tread carefully among the ghosts from one's past. The content of the boxes was, intangibly, secrets. This series incorporated china paints and decals, then uncommon in serious ceramics.

Another distinctive series began in 1969, inspired by Raymond Queneau's Exercises in Style, a story repeated in a succession of styles. This was Melchert's "a" series, which included the lowercase letter formed in gilded, glazed, or raw clay or made of other materials, such as wire, chain, Plexiglas, leather, or oak. A wire one was the Palmer Penmanship a, which includes a tiny arrow indicating stroke direction. The early 1970s works were mostly black and about twenty inches tall, presenting the letter in funk, surrealist, and grotesque styles. There were also some with parts carved away, titled a Made 4 Lbs Lighter and ⅞ of an a. He also made one just three inches tall, overglazed in gold and platinum, which he mounted under a Plexiglas cover. This was Precious a; it amused him enough to make several more, and it is probably the most photographed of the works.

In the 1970s, Melchert and several friends dipped their heads in slip and sat in a row in a Dutch artist's studio that was heated at one end only; the differing rates of drying were recorded on film (Changes: a performance with drying slip, Amsterdam, 1971). This was, one might joke, about as interesting as watching paint dry, but it in fact continued his practice of transgression, and it also pointed to the intellectual approach extended in the next few years in a series of "photographic rubbings." These oxymoronic endeavors, along with works of projected slides, were shown at the San Francisco Museum of Modern Art in 1975. Such activities are far from mainstream ceramics, but they relate both to other artworks of the time and to Melchert's own teaching at Berkeley, which had to do with developing powers of imagination, observation, and what in later business terminology would be called "thinking outside the box." Back in Berkeley after taking leave for the two administrative jobs, he began a series of works in tile that have occupied him to the present. He is again working in clay, but not wet clay: he uses commercial tiles for works that explore patterns of accident: the randomness of wire dropped on a tile surface or the fractal shattering of dropped tiles. Melchert's consistent curiosity and humor have led to a body of work that is among the least acknowledged major contributions to the ceramic field.

AT THE BRAY: FERGUSON AND SHANER

The Archie Bray Foundation, early on managed by resident artists Peter Voulkos and Rudy Autio, seems to have been a breeding ground for achievement by their successors, Ken Ferguson and David Shaner. The two had known each other at Alfred—Ferguson taught Shaner to throw—and later, as director of the Bray from 1958 to 1964, Ferguson invited Shaner to follow him in the job. Their routes afterward were quite different, Ferguson becoming an influential teacher and mentoring a host of important artists of the next generations, while Shaner turned to an idyllic life in which he potted, gardened, hiked, raised a family, and quietly participated in a community.

Ken Ferguson (1928–2005) was born in rural Indiana; grew up in Pittsburgh, where his father was a millworker; took a Bauhaus-style program in design at Carnegie Tech; went to Japan while serving in the army; and stumbled across clay when he got back. On the GI Bill, he enrolled in the MFA program at Alfred, studying with Ted Randall and Val Cushing and becoming fascinated with colonial pottery, which he saw as simple, strong, quiet, and functional. This was the sort of work he made when he went to the Bray. (Figure 8.41) For example, a 1962

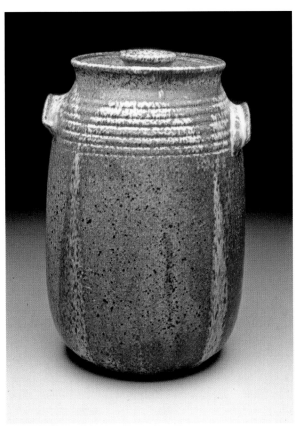

FIGURE 8.41. *Ken Ferguson, Covered Jar, 1962. Stoneware; 13.75 × 8 × 8.25 in. (Archie Bray Foundation for the Ceramic Arts Permanent Collection, 1962.1.1A-B. © Estate of Ken Ferguson.)*

storage jar now in the collection of the Everson Museum is a classic form with incised parallel lines, poured glaze, two lug handles, an everted lip, and inset knob. Ferguson was a traditionalist and enjoyed the discipline of production pottery, but he began to think that he was misguided and afraid of risks, so he struggled to be more open.

Teaching at the Kansas City Art Institute, Ferguson branched out into wood firings, salt firing, and low-fire ware. He wrapped pots in straw to fire, in the Japanese Bizen style. He described it as "letting the clay and the fire show me something."[74] He learned all the methods to keep ahead of his students, and he showed the whole range until some people asked, "which is you?" He decided he wanted to play, like the students, and began to move away from function.

One means of doing so was exaggerated scale. For many years Ferguson incorporated hares into his work, often as a handle. They are regarded as amusing, but their slightly uneasy distortion also contrasts with the efficiency of the container forms. When he was about fifty, Ferguson began to incorporate wrinkles or sags into his jars. Barbara Okun, who encouraged him, called them "slump pots" when she showed them in her Saint

Louis gallery. Particularly striking were his teapots with spouts like failing erections, attached to the vessel with a sagging scrotal pouch and featuring a faintly glistening rim. The glaze was mottled and unattractively skinlike. These works were more poignant or funny than erotic, a kind of truth telling from the far side in a youth-oriented culture, and surprisingly personal considering where he started. Another favored motif was a "mermaid" of somewhat frightening visage that he derived from the hood ornament on a 1937 Pontiac. Tripod legs of his vessels were sometimes breastlike and titled "udders." "I do not make cute pots," he declared.[75]

When he retired from teaching in 1996, Ferguson had nurtured an exceptional number of young artists: Irv Tepper was one of the first and John Balistreri among the last, with Andrea and John Gill, Chris Gustin, Chris Staley, Akio Takamori, Kurt Weiser, and Arnie Zimmerman in between.[76]

David Shaner's life, in comparison, seems almost monkish, but serene and self-sufficient may be better terms. Shaner (1934–2002) was born in Pennsylvania, attended Kutztown State College, and then took an MFA from Alfred. Daniel Rhodes later wrote of Shaner as student: "He did not seem to be striving directly for originality or for the uniquely personal. He was building something solid, laying it up brick by brick. He did not resort to the theatrical or showy elements which so often tempt students."[77]

Shaner taught at the University of Illinois, but lacking time for his own work, in 1963 he accepted the invitation to the Bray. All the early resident directors were productive, of necessity. They supported the foundation, not the other way around. Shaner saved the Bray when the brick company failed and the government seized the property and sold it at public auction, somehow raising the money to buy the foundation facilities. (The brickyards were acquired later.) He is also credited with obtaining the Bray's first government grants, confirming its professionalism and putting it on sound financial footing. He left in 1970 to set up a home, studio, and wood-fire kiln in Bigfork, Montana.

Shaner's production pots were classical hand-built or wheel-thrown forms, but his winner at the 1966 Ceramic National was an almost expressionist slab—torn, partly glazed, with natural wood ash glaze pooling in the center, a "hedge apple" burned onto the surface. In the 1960s and 1970s, he made heavy square vessels stamped with words, along with his Garden Slabs and River Rocks, which evoke Noguchi's reductive yet sensuous forms. (Figure 8.42) At Alfred, he had developed Shaner red and Shaner gold, the former "an entirely new

FIGURE 8.42. *David Shaner, Garden Slab, 1964. Stoneware; 5.75 × 17.5 × 17.5 in. (Archie Bray Foundation for the Ceramic Arts Permanent Collection, 1964.3.1. © Estate of David Shaner.)*

color to the palette of reduction stoneware: a rich mahogany red quite unlike the usual saturated iron or khaki red," and in 1974 he developed a black crystalline glaze that he named in honor of Maria Martinez.[78]

Shaner's way of working was inspired by the model of Hamada and Leach: rural life, traditional and useful forms, living simply, producing steadily. His career was cut short by amyotrophic lateral sclerosis, or Lou Gehrig's disease. He died in 2002, at sixty-seven.

TOSHIKO TAKAEZU

Known for her "closed" forms, including large, spherical Moon Pots and tall cylinders, Toshiko Takaezu has defined an aesthetic all her own. (Figure 8.43) Her work blends the robust fullness of pots by her Cranbrook teacher and mentor, Maija Grotell, with abstractness and quiet that hint at her Japanese heritage.

Takaezu was born in Hawaii in 1929, the sixth of eleven children of a farming couple. She did not speak English until she started school. She learned to make pottery when she moved to Honolulu and went to work in the house of a couple who ran a potter's guild. She went on to study at the University of Hawaii and teach at the YWCA and concluded that she would have to leave Hawaii for further study. Seeing Grotell's work in a magazine settled her choice.

Cranbrook took some adjustment, but in her time there (1951–54), Takaezu established a lasting friendship with Grotell. She would later say, "Hawaii was where I learned technique; Cranbrook was where I found myself."[79] During her last year she was Grotell's assistant. She traveled to Japan in 1955 with a sister and her mother to investigate her roots. She stayed eight months, visiting Zen temples, studying the tea ceremony, and meeting

the major figures in Japanese pottery with connections to the West, including Hamada, Rosanjin, and Kaneshige.

Takaezu consequently recognized a Japanese influence in her work, but it was the culture as a whole, not the pottery, that affected her. She also concluded that there were no answers in Japan, only in herself, so she put even more effort into her work. From 1956 to 1964 she taught full-time at the Cleveland Institute of Art. Her tenure there was happy; she won awards at the Cleveland Museum's May Show and began to get national attention, being interviewed for *Craft Horizons* by editor Conrad Brown in 1959, just as Voulkos had been in 1956. In 1964, however, she relocated to rural New Jersey, and from 1966 to 1992 she taught part-time at Princeton, which allowed her more hours in the studio.

The earliest post-Cranbrook pots in Takaezu's rapidly evolving oeuvre were conventional in size, almost pumpkinlike flattened spheres with curved lines or circles emphasizing their pneumatic swelling. By 1954 she was using multiple thrown spouts—one two-bottle example from 1956 seems to illustrate cell mitosis. *Triple Form* (1958) consists of three fat jugs with short, thick necks, joined shoulder to foot and unified by a sweep of horizontal brushstrokes, two broad and one thin. In the same year, seeking a continuous surface for her painted glazes, she made her first closed form, leaving only a tiny airhole at the top, usually marked with a miniscule nipple, to

FIGURE 8.43. *Toshiko Takaezu, Small Closed Form, 1967. Porcelain with painted decoration; 5.5 × 4.6 × 5.25 in. (Collection of The Newark Museum, Newark, N.J., purchased 1968 Membership Endowment Fund, 1968.8. Art © Toshiko Takaezu. Photograph © The Newark Museum/Art Resource, New York.)*

FIGURE 8.44. *Detail from Bryon Temple order leaflet, n.d. (© Estate of Byron Temple.)*

prevent the pots from blowing up in the kiln. The forms are thrown, coiled, or slab-built, depending on the size.

Takaezu's earliest colors were soft earth tones. In the late 1950s, she began to develop the rich blue, pink, and yellow glazes she still employs. These are certainly not Japanese tonalities but are perhaps Hawaiian (she returns every winter). She mixes and paints spontaneously, seldom recording a glaze formula. Her poured, brushed, or smeared fields of color have become, along with the ambitious scale, the most admired features of her work. She likens the process of moving around the pots as she paints to dancing. The works achieve a striking presence, whether it is the intimate sort of her small porcelains or the monumental power of the larger. She drops a paper-covered piece of clay inside many pots as she closes them. After firing, it will make a sound when the pot is moved, deepening the sense of private space. (Once she and her work were faced with a government official's entourage, and someone asked what her work was for. She impulsively said that the most important part of it was the black air space that can't be seen. She now thinks that was an important statement, although it wasn't something she consciously knew.)[80]

The Moon Pots (large spheres) began in the 1960s, followed by extended-cylinder Tree Forms and Lava Forest groups, austerely recalling a burned landscape. In the early 1980s, Takaezu wood-fired in an *anagama* (Japanese tunnel kiln) at Peters Valley, New Jersey; later she was offered use of a large car kiln at Skidmore College in upstate New York. She was able to make pieces five feet tall that stand freely in installations; an outstanding group of these works is now in the collection of the Racine Art Museum. Critic John Perreault has described the slow and steady development of Takaezu's work as happening "almost by stealth." He observes that her laconic manner and disinclination to explain her works have given her an

air of mystery. But, he says, "She knows who she is. Is it her fault that some see her as a kind of priestess of clay, a nun of earth and fire, a female monk?"[81]

BYRON TEMPLE

Like David Shaner, Byron Temple (1933–2002) simply wanted to make pots, free of institutional servitude. He prepared for it by apprenticing as a thrower at the Leach Pottery in England. But unlike Shaner, he never softened his commitment to utility: Temple continued to produce pottery forms that were his particular combination of Scandinavian, Japanese, English, and American, from the establishment of his studio in New Jersey in 1963 until his death. (Figure 8.44) "As a production potter I limit myself to designs which can be easily repeated," he once wrote. "I do not find this restrictive or inhibiting; rather I'm able to explore more intensely the very basic qualities of the clay."[82]

Temple grew up on a farm in Indiana, where the first pottery he knew was crocks used to preserve food. He tried coil building in high school art class, then learned to use the wheel at Ball State University. He moved to New York City, studied ceramics at the Brooklyn Museum Art School, and was later a technician at the School of the Art Institute of Chicago but felt he needed more experience before opening his own pottery. He wrote to Bernard Leach, showed him pots during a U.S. visit, and was accepted (exceptionally, he later realized). He stayed in England about three years. It sharpened his skills, improved his discipline, and encouraged him intellectually, since the aesthetic quality of pots was the constant topic of discussion and Leach urged him to read and see as much as he could.

While Temple's interest in Scandinavian design was not shared at the Leach Pottery, he stuck with it when opening his studio in Lambertville, New Jersey. His basic

form was the cylinder, and he threw by weight (a trick learned from Leach) in a manner that made trimming unnecessary. His practiced efficiencies enabled him to throw 10,000 pieces of tableware per year. They were often half-glazed—either dark (tenmoku) or light (off-white satin mat)—leaving some clay bare.

Through repetition Temple sought "what Mark Rothko called the 'essence of the essential,' and his rationale for repeating forms was not much different, as unusual as that might sound, from that of Rothko, who had said, 'If a thing is worth doing once, it is worth doing over and over again—exploring it, probing it, demanding by this repetition that the public look at it.'"[83] Standardizing glazes and clay bodies clarified nuances of form, balance, and proportion, yet he was still open to innovation. After sawdust firing with Paulus Berensohn at Penland, he began to fire his cylinders to high temperatures in saggers (clay containers) packed with sawdust, causing irregular patterns that make the pieces unique despite consistency of form. He adopted a flameproof clay body and porcelain.

After Leach's retirement, Temple was invited to co-direct the pottery with Janet Leach. While that arrangement did not last long, it was surely another measure of his attainment of his ideals.

DON REITZ

Known for his introduction of salt glazing to contemporary American pottery after discovering that its texturing and unpredictable effects suited his work, Don Reitz is also famed for his high-energy workshop demonstrations. In his late twenties, working as a skilled butcher and painting in the evening, Reitz (b. 1929) decided to try college on the GI Bill. After a single semester, he was obsessed with clay and proved to be a natural on the wheel. After graduating from Kutztown State, he earned an MFA at Alfred, where he made modernist-style clean, functional forms. As he joined the faculty of the University of Wisconsin, Madison—taking over clay instruction so that Harvey Littleton could inaugurate his glass course—he added embellishments. Conventional glaze tended to obscure the marks that recorded his engagement with wet clay, so he took up salt glazing.

In college he had read a *Craft Horizons* article about Voulkos and had taken to heart Voulkos's maxim, "No rules, only concepts." Reitz's intuitive way of working, and his strength and skill on the wheel, recalls Voulkos, while his formal complexity allies him more with Ken Ferguson or Jerry Rothman. His energy was legendary: it is said that while teaching at Madison and doing workshops across the country, he nevertheless fired the 135-cubic-foot salt kiln on his farm sixty-five times a year,

FIGURE 8.45. *Don Reitz, Large Amphora, ca. 1970. Stoneware, salt glaze; 18 × 19.5 in. (Milwaukee Art Museum, Gift of Janet and Marvin Fishman, M1987.22. © Don Reitz. Photograph by John R. Glembin.)*

making eccentric and extravagant forms—a kind of counterculture baroque. (Figure 8.45) As Jody Clowes notes, "Reitz's exuberant tactility is his signature—he can't leave well enough alone."[84]

In the last decades of the century he took up wood firing as a collaborative activity, firing at far-flung sites across the United States to take advantage of the potentialities of certain kilns—to say nothing of the social pleasures. The drama of the flames appealed to Reitz's romantic temperament, and the collaborative process suited his social nature. While his works have become more abstracted and expressive, he retained vessel form in his wood-fired pieces: large jars, platters, pitchers, and big abstract pieces he calls "tea stacks" (a bow to Voulkos). He believes that he was the first contemporary potter to employ slips on wet clay and fire pieces wet. He introduced foreign materials into the clay, such as oil and sawdust; added colored slips, oxides, and carbonates; and altered kiln atmospheres to lively effect, remaining devoted to the decorative.

OTHER CHOICES: BAUER, NG, HUI

The 1960s, as a period of contrasts and options, produced vastly disparate bodies of work, including the distinctive oeuvres of Fred Bauer, Win Ng, and Ka-Kwong Hui. **Fred Bauer** (b. 1937) was much shown and much discussed in the 1960s, from his period as a graduate student at the University of Washington through his several years

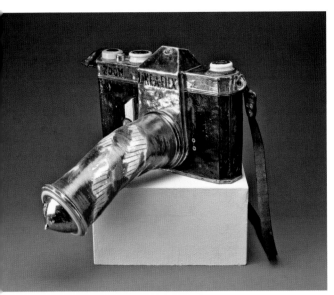

FIGURE 8.46. *Fred Bauer, Like-a-Flex, 1968. Porcelain, glaze, luster, leather; 16.25 × 17.5 × 24 in. (Arizona State University Art Museum, Ceramics Research Center, Gift of Jay and Joyce Cooper.)*

of teaching in the Midwest and his return to teach in Seattle. He left for Mills College in 1970 and soon thereafter dropped out, in the style of the times.

As a graduate student in 1963–64, Bauer produced "sarcophagi," large hinged boxes with attached clay ornamentation (sometimes in the hippie drug-culture style), resting on tall thrown legs or even legs of different materials. He also did huge ornate urns with wooden spouts. He painted the glaze failures with acrylic as he moved toward brilliantly colored low-fire works. These, along with functional pieces, appeared in the joint graduate show of Bauer and his wife, Patti Warashina. They were also feted with a duo show at the Northwest Crafts Center before they left for his teaching job at the University of Wisconsin, followed by the University of Michigan.

In the mid-1960s Bauer created elaborate nonfunctional machines with the support of a grant from the Tiffany Foundation. *Steam Drill—Slop Pump* (1967), for example, is a five-foot tower with windmill-like arms, wings, shooting "flames," and a sexually suggestive hose, all consistent with his rather dark humor. His works often came with some kind of second reading or shock detail, only somewhat ameliorated by his exacting craftsmanship. Of considerably smaller scale are several late-1960s cameras. The brand name reads "Like-a-Flex" and the lens is unmistakably penile. (Figure 8.46) It was works like this that contributed to the notion that Seattle offered a northern, finely crafted version of funk when Bauer joined Howard Kottler on the University of Washington faculty and Warashina also taught locally. It was,

at least, a high-energy brand of pop, blending satire with threat.

Win Ng (1936–1991), a native of San Francisco's Chinatown and a graduate of the San Francisco Art Institute, was among the first wave of American ceramic artists making abstract sculpture. He was also an enamelist and a founder of the Bay Area Metal Arts Guild (1951). He painted watercolors and oils, made collages, designed fabric, and cofounded and designed for the artware retailer Taylor & Ng.

Although Ng regarded himself as influenced by natural textures, he was noted for slab-constructed stoneware sculptures consisting of stacked rectangular forms, rather than for anything organic. (Figure 8.47) Sometimes the blocks rested horizontally atop a vertical form. He saw his elements as referring to positive and negative forces, and the arrangement of forms suggested balance in a larger sense. The notion of interval can be usefully applied to consideration of his works. He used white, tan, blue, and brown glazes or applied broad strokes of engobe in earth tones; his surfaces are painterly.

Ka-Kwong Hui (1922–2003) was born in Hong Kong and educated in China. He was the eighth of ten children of a dealer in herbal medicines who was interested in art and encouraged him to study sculpture. After the war, he came to the United States to study, expecting to stay

FIGURE 8.47. *Win Ng, Retreat No. 5, 1964. Stoneware; 35 × 21 × 14.5 in. (Collection of Everson Museum of Art, Syracuse, N.Y., Purchase Prize given by O. Hommel Company, 23rd Ceramic National, 1964, 64.79.)*

FIGURE 8.48. *Ka-Kwong Hui, Ceramic Form, 1968. Stoneware, low-fire glaze; 22 × 30 in. (Collection of Everson Museum of Art, Syracuse, N.Y., Purchase Prize given by Dansk Designs, 25th Ceramic National, 1968, 68.69. © Estate of Ka-Kwong Hui.)*

only a few years, but found he had changed too much to go back.[85] In 1948 he worked as an apprentice to Marguerite and Frans Wildenhain at Pond Farm, before the regular program was established. He went from there to Alfred, where he wanted to learn about industrial production of dinnerware and worked in a nearby factory.[86] His work started out earthy, with soft, subtle brushwork and mat glazes. In the 1950s he threw quiet, ovoid bodies terminated with extravagant features that resembled an Elizabethan ruff, a cluster of tentacles, or a birdlike open mouth. He used only a few glazes, along with slips, underglazes, and stains.

Hui and Roy Lichtenstein both taught at Rutgers University in the early 1960s. When Lichtenstein had had the idea of creating comic-image sculptures, essentially three-dimensional pictures of stacked restaurant-style dishes, he turned to Hui for the realization. A year of collaboration involved much research in color, which Hui subsequently applied in his own work. He didn't want to be regarded as a pop artist. The work he produced on his own directly after the work with Lichtenstein is not pop, in that it doesn't relate to commercial products, yet it was brilliantly colored and precise in decoration, crisp and symmetrical in form, and offered a visual force and distinct expression that has come to represent his entire oeuvre. (Figure 8.48) The curvilinear forms included hard-edge stripe, zigzag, and circle patterns and vivid colors that he considered reflective of the times. Hui followed these works with a group of forms that incorporated operating incandescent bulbs.

Craft Institutions

THE CRAFT MARKETPLACE

The number of retail craft outlets grew steadily in the 1960s, providing a reliable wholesale market for craftspeople. Small fairs sprang up all over the country, offering direct retailing; many craftspeople sold in both markets. The up-front cash from wholesale was good, but so was the higher profit margin of selling directly to the public.

In 1966 the northeast region of the American Craft Council (ACC) sponsored a craft fair at Stowe, Vermont. Some 175 craftspeople set up in a ski lodge and in tents nearby. The event shrank the second year but thereafter grew steadily. In 1969 it moved to Bennington and in 1973 to Rhinebeck, New York. Each move brought it closer to the New York City market, which proved decisive. The Northeast Craft Fair became one of the premier craft fairs in the country and a powerful moneymaker for the ACC.

Late in the decade, craft fairs added wholesale-only days to their calendars—a boon to craft-shop owners. Previously, they either had to find craftspeople or the makers had to find them. Having hundreds gathered in one place, all willing to fill orders, simplified the business greatly.

The 1960s also saw the first commercial galleries dedicated to showing craft. The difference between shop and gallery can be fuzzy, but in general a gallery carries a limited number of artists and features them in solo exhibitions, while a shop shows many, together. A few art galleries featured craft in solo exhibitions: Ferus Gallery in Los Angeles, which showed many of the Otis ceramists, was an important one. A gallery with a stable consisting entirely of craftspeople was new. Among the first were Signature Shop in Atlanta; the Works Gallery in Philadelphia, Galeria del Sol in Santa Barbara, Anneberg Gallery in San Francisco, and the Egg and the Eye in Los Angeles (it incorporated a restaurant that specialized in omelets).

MEDIUM GROUPS

A number of medium groups organized in the ten-year period after 1965. The oldest among them, the National Council on Education for the Ceramic Arts (NCECA), became an independent not-for-profit organization in 1967. The Society of North American Goldsmiths (SNAG) was formed in 1969, the Handweavers Guild of America in 1969, the Glass Art Society (GAS) in 1970, the Artist-Blacksmiths Association of North America (ABANA) in

1973. Many of these organizations took education as their essential mission, and they attracted college teachers in quantity.

The medium groups sponsored varied activities, just as guilds had early in the century. All of them held annual national conferences, reflecting the new ease and affordability of air travel. These conferences became important clearinghouses for technical information as well as crucial networking opportunities. Some organizations published magazines; some formed close alliances with galleries and collectors. All contributed to the technical sophistication of their members and the development of a sense of identity. Many people who attended the ACC's first conference in 1957 said they felt quite isolated. That feeling vanished as the medium groups expanded.

At the same time, medium groups undermined a common identity in the crafts, since they fostered the illusion that each field could or should follow its own trajectory. Communication among mediums decreased, and the crafts became balkanized.

EDUCATION

In the 1960s, almost any talented MFA recipient could get a teaching job. Colleges, universities, art schools, and local art centers were all hiring, and it seemed that the demand would be endless. In the 1960s, the future of craft education looked bright.

At the same time, some of the verities of modern design were under fire. Students were no longer fascinated with good design for the masses. Even the fine handmade object was no longer greeted with exaltation. As ceramist Daniel Rhodes noted in 1966: "There used to be a certain snobism about the handmade utensil, but lately there's been a questioning of this—and the whole idea of taste. It's been thrown out the window by a large percentage of our young people. I think the emergence and status of Pop culture bears on this. Who wants to have a fine, so-called beautiful handmade mug around. To hell with it. Use the dime store one."[87]

In Short

What was started in the 1950s came to fruition in the 1960s. Like the Free Speech, civil rights, and antiwar movements, the crafts embraced free expression. And as in the larger society, that embrace was contested. Certain ideas were seen across all the mediums. One was the ambition to work big. Another was a spirit of wide-open experimentation. Some innovations were rooted in the past, like the alteration of Japanese raku. Others were very much of the moment, like Plexiglas jewelry. And all mediums had a few individuals who were compelled to break the rules. Their most memorable work delighted in transgression: Marvin Lipofsky's flocked glass, J. Fred Woell's pop icons made of wood and staples, Robert Arneson's toilets with ceramic turds.

Not everybody went along. Byron Temple knew full well that his functional ware stood in opposition to the transgressions of the day. Art Carpenter was nonplussed by furniture that posed as sculpture. Their skepticism was widely shared. The crafts did not collapse into discord, however, but developed a remarkable tolerance for diversity. Confusion as to purposes and standards was matched—imperfectly—by open-mindedness. The crafts made inroads into the enormous middle-class marketplace. Medium groups provided forums for a broad spectrum of opinions, promoted the sharing of knowledge, and fostered a sense of community; they also encouraged pluralism.

CHAPTER 9 1970–1979
ORGANIZATIONS AND PROFESSIONALS

An Explosion of Crafts

In the 1970s, the new genres in metal were blacksmithing and electroforming. Fiber was at its peak, with basketry, felting, wearable art, surface design, and hand papermaking causing excitement. Japanese textile techniques spread in America. In ceramics, salt-glazing and wood-firing blossomed in popularity, and women rose to prominence. The decade began with the traveling exhibition *Objects: USA*, which was seen by more than half a million people in America before departing on a European tour. It was a remarkable promotion of crafts, although not everyone was enthusiastic about it.[1] Also in this decade international visitors became an institutionalized presence in glass.

Many influential magazines emerged, including *Surface Design Journal, Fiberarts, Studio Potter, Fine Woodworking, Metalsmith,* and *Bead Journal.* Glass magazines came and went in bewildering succession. Major craft-focused galleries opened in large cities: Helen Drutt Gallery in Philadelphia; Mobilia in Cambridge; Braunstein/ Quay Gallery, Elaine Potter Gallery, and Meyer, Breier, Weiss in San Francisco; Del Mano in Los Angeles; and the Hand and Spirit in Scottsdale. Exhibit A in Chicago made contractual agreements with the fifteen artists it represented and gave guarantees—a first in the craft field. The most important artwear galleries—Obiko in San Francisco and Julie: Artisans' Gallery in New York— both opened in 1973.

Although most books about studio craft were essentially picture books or instructional texts, a sense of history began to grow. Precipitating a gradual change toward research and analysis was a 1972 exhibition catalog from Princeton University, *The Arts and Crafts Movement in America, 1876–1916.* Helen Drutt had first taught a crafts history course at the Philadelphia College of Art about 1966, and now she was a professor of art history at Moore College of Art.[2] Paul Evans published his encyclopedic *Art Pottery of the United States* (1974), and Garth Clark arrived in America and introduced himself as a ceramic historian. In 1979, with Margie Hughto, he published *A Century of Ceramics in the United States, 1878–1978.* It was not the first contemporary history,[3] but it was important both because it accompanied an exhibition and because of the

1970
 Price of an average home: $17,000
 Average hourly wage: $3.36
 Robert Smithson builds *Spiral Jetty* in Great Salt
 Lake
 An Ohio National Guard unit kills four students
 at Kent State University during protests
 against the U.S. invasion of Cambodia
1971
 Voting age lowered to 18
1972
 Burglary of Democratic National Committee
 headquarters at Watergate complex in
 Washington, D.C.
1973
 The Woman's Building, an early center for
 feminist art, founded in Los Angeles
 Vietnam War ends
1974
 President Nixon resigns; Gerald Ford becomes
 the new president
1976
 Scott Burton makes *Lawn Chair*, which recasts a
 functional Adirondack chair as sculpture
1977
 George Lucas releases *Star Wars*
1979
 Radiation escapes from nuclear power plant at
 Three Mile Island, Pennsylvania
 Germaine Greer publishes *The Obstacle Race*, a
 feminist reworking of Western art history
 Sherrie Levine rephotographs well-known images
 by Walker Evans, questioning the idea of
 originality
1979–81
 Fifty-two Americans held hostage by Iranian
 radicals in Tehran

who interviewed southern practitioners and published the tales, at first in periodicals. Wigginton, as a small boy, had come to the Hambidge Center in Georgia (see chapter 5) with his father, and he returned to teach in the area after college. He lived on Mary Hambidge's property for six years and would later say that the Foxfire books were "born on her kitchen table."

Craft also enjoyed exceptional support in Washington, D.C. In 1972 the Renwick Gallery, a branch of what is now the Smithsonian American Art Museum opened as a showcase for American crafts. During the Carter administration, 1977–81, craft had a champion in the person of Joan Mondale, wife of Vice President Walter Mondale and herself a potter. Among other things, she installed craft works in the vice presidential residence, generating much press and public attention.

Ceramics Down and Up

The decade began with the Ceramic National in extremis. Anna Wetherill Olmsted, director emeritus of the Syracuse Museum—now called the Everson—in an open letter printed in the December 1970 issue of *Craft Horizons*, announced that the National was dead but "earnestly hoped," considering its record, "that there may be a resurrection." By then it had been uncovering new talent for nearly forty years (with a wartime interruption) and had toured to more than fifty museums in dozens of states and gone overseas as well.

The resurrection came, but only briefly. In the June 1971 *Craft Horizons*, Olmsted reported that the museum's director, who was not "ceramic minded," had resigned his post after widespread protest of the cancellation. A 1972 National was announced, with jurors Peter Voulkos, Robert Turner, and Jeff Schlanger. Some 4,500 slides were submitted, but then stunned applicants received notice that the National would not take place after all because the jurors found slides to be an unsuitable means of choosing. That was not the whole story. Turner later said: "We were all, in a sense, shaking our heads. . . . I felt the absence of energy and conviction. Some people didn't send their best work. Things were not new or different. . . . It was sad."[4] Apparently the times and needs had changed. The National has never resumed on a regular basis.

At this seeming nadir, clay was, in fact, burgeoning. There were new galleries and new ideas. One stylistic innovation was the skillful imitation of everyday objects; another was bright colors and patterns that fit the pop category. Garth Clark called such works "Super Ob-

quality of Clark's writing, which addressed the artistic development and social history of ceramics in the same terms and with the analytical rigor typically applied to fine art. The other mediums were not so well served.

Martha Longenecker established the Mingei International Museum of Folk Art in San Diego in 1978, and the groundwork for San Francisco's Craft and Folk Art Museum was laid in 1972. At the same time popular interest in folk craft was generated by the Foxfire books produced by high school teacher Eliot Wigginton and his students,

jects" and said they were "characterized by unbounded preciousness, by carefully considered execution, and by a meticulous craftsmanship."[5] This effort to categorize and name was useful in a maturing field, although the term did not stick.

At the same time, avant-garde conceptual work examined the fundamental nature of clay as liquid or as dust. A free-spirited 1970 exhibition at Southern Illinois University, *Unfired Clay*, was held outdoors in January. The winners were the pieces that lasted longest.[6] On Jim Melchert's behalf, a slab was draped over the crest of a small hill and embellished with the paw prints of a passing dog. Robert Arneson's entry was a forty-eight-by-twenty-four-by-two-inch hole filled with Kentucky Ball Clay. Bill Boysen pounded metal flashing around clay soil. David Gilhooly's clay frogs were propelled with a slingshot to shatter when they landed on a frozen pond. "There was something spiritually appropriate in the implication of the pot returning to the earth, of artists participating physically in the installation of their own exhibit," *Craft Horizons* reported. "The whole idea was a joyful denial of the notion that art is a precious commodity."[7] Another well-known conceptual work was Melchert's drying-slip performance in Amsterdam, recorded on video, called *Changes* (see chapter 8). A group of avant-gardists in Los Angeles worked in a like manner: Doug Jumble covered his house and car in slip, Sharon Hare set up installations in the desert, and Joe Soldate used wet and dry clay in installations.[8] Responses to such works were largely negative, although they can be seen as an extension of Voulkosian directness.

Another strong movement, unfortunately not well documented, was committed to functional pottery. The College of Wooster in Ohio started an annual exhibition of functional ceramics in 1974; *Craft Multiples* was organized by the Renwick Gallery in 1975; Ken Ferguson organized *Eight Independent Production Potters* in 1976. Gerry Williams turned his social-reform instincts to serving the needs of working potters, creating a magazine based on open exchange and reader contributions. The first issue of *Studio Potter* was published in November 1972, its twenty pages including thoughts on apprenticeship, information on photoresist, and a homemade clay mixer—and no advertising. The magazine featured potters from a given area in each issue, fostering a sense of community among (according to Williams) some 12,000 Americans engaged in studio pottery. It also regularly covered health issues and included historical subjects. Other early articles included a proposal to fire with methane derived from waste and responses to questions such as "What is the role of the Potter? Is it to be

Art Borrows Clay

Margie Hughto at Syracuse University established a program of inviting painters and sculptors to make assisted work in clay, which yielded an exhibition, *New Works in Clay by Contemporary Painters and Sculptors*, at the Everson Museum in 1976. The idea was adopted from print workshops that invited artists. Thirty years later the resulting work has still not been objectively evaluated, since most observers within the clay world were either outraged or dismissive (finding the work primitive and obvious), while observers from the art world have little knowledge of ceramic precedents. Certainly the ambition of the work and some forms, such as sculptures by Stanley Boxer and Jules Olitski, broadened the existing approaches to clay.

Equally controversial was Judy Chicago's use of clay (and textiles) in her 1974–79 installation *The Dinner Party*. This tribute to women throughout Western history consists of a triangular table with thirty-nine place settings (including china-painted plates of elaborate relief, cast goblets and flatware, and a needlework runner) set upon a floor of triangular porcelain tiles inscribed with the names of 999 important women. While the plate designs—personalized to each honoree—are Chicago's, the research and the execution were accomplished by some 200 volunteers. Many craft issues, such as containment and ritual, are embedded in the work, but it is usually discussed in terms of social argument and representations of history.

primarily an Artist, or to be primarily a producer of Functional Objects?" The magazine continues today.

Cast work was regarded with some doubt. In 1974 the Kohler company started an artist-in-residence program at its factory that was so successful that it became permanent. In 1978 the John Michael Kohler Arts Center held the exhibition *Clay from Molds*, and after that, casting was no longer an issue. Other new emphases included the figure and the larger scale enabled by technological developments, both highlighted by *Large Scale Ceramic Sculpture* at the University of California, Davis, in 1979. Humor was the focus of *Clayworks: Twenty Americans* at the Museum of Contemporary Crafts in New York in 1971, treated by Rose Slivka in the October *Craft Horizons* as "Laugh-In in Clay."

In this high-energy period, ceramists established

their own programs and services. One such was the Clay Studio in Philadelphia, founded in 1974 as a collective studio and communal kiln. Exhibitions and classes were added, and by 1979 it was a nonprofit organization, which still exists.

VOULKOS BACK HOME

Peter Voulkos returned to clay at the end of the 1960s with mat black, tactile works. Jim Melchert, reviewing the show, said it was "composed of the most haptic pottery I've seen in a long time; it wouldn't surprise me if the pots were made in the dark."[9] These pieces remain exceptional in Voulkos's oeuvre.

In the 1970s he developed a small number of forms that he continued to use until his death. (Figure 9.1) These were "stacks" (tiered, tapered vertical forms), wide platters, and "ice buckets." All were imposingly massive. The best show a powerful physicality coupled with sensitivity to proportion and line.

Of course, Voulkos could not stay young forever, so eventually he had others throw the heavy elements for him, and he became the arranger of parts and the marker of surfaces—and proved to have a special touch with both. He left his track in the clay, a portrait in the brutality and finesse of his gestures. In 1979 he began having his pots wood-fired by others, accepting the fire as a partner in his surface effects. This change was an attempt to retain excitement, to avoid the problem he had described to Conrad Brown in 1956: "The minute you

begin to feel you understand what you're doing, it loses that searching quality."[10] Yet when he returned to clay he was going back to what he knew, and while the results were handsome, these works show more mastery than invention.

Voulkos the radical became the standard against which everything was measured. He tried to avoid becoming an institution. He mocked himself, presented himself as anti-intellectual, noting that he had not been in an art museum until after he graduated from college and claiming (falsely) that he did not know the history of ceramics and was not interested in it.[11] He unquestionably exerted a lasting influence on his students and peers. Jim Melchert flatly said, "He rescued me from what I think would have been a rather pedestrian life."[12] Robert Arneson said Voulkos encouraged him to abandon traditional pottery for the expressive energy that came to be called funk.[13] M. C. Richards, naming teachers important to her, wrote: "Peter Voulkos, who told me to work with the clay till it collapses, that there's nothing to it, that if pots weren't breakable potters would be sunk, that there's lots more where these come from."[14]

With an audience to the last, he died in 2002 in Ohio, where he was the center of a two-week workshop, Voulkos & Friends, that included Rudy Autio and other long-time associates.

PRICE AND MASON REDUX

In 1971 **Ken Price** and his family moved from Los Angeles to Taos, where they remained until 1982. The cups he continued to make shifted in character, becoming abstract and geometric, sometimes mineralogical (the Slate Cups, which appeared to be assembled of broken stone) or architectural.

Price's major work in Taos, occupying five years of his life, was *Happy's Curios*, a complex installation of multiple wooden cabinets he called "units" or "shrines," each displaying groups of matching pots or ceramic tiles. (Figure 9.2) The cabinets, constructed by Price or under his supervision by a Taos furniture maker, are exactingly considered, down to the direction of the grain, shelf thickness, and exposure of knots. The units were undated to avoid any sense of progression among the works. Essentially, Price has said, *Happy's Curios* (named for his wife) was a fantasy piece, one sufficiently seductive to consume him for years.

Price was thinking about roadside stands and storefront curio shops, and he recalled seeing functional Mexican folk pottery (not tourist wares) during his teenage years. That ware was handmade but mass-produced by families working quickly and loosely. Laboring on this

FIGURE 9.1. *Peter Voulkos, Untitled Plate, 1978. Stoneware, glaze, gas-fired; 4.75 × 23 in. (Collection of Everson Museum of Art, Syracuse, N.Y., Museum Purchase, 80.21. © Voulkos & Company.)*

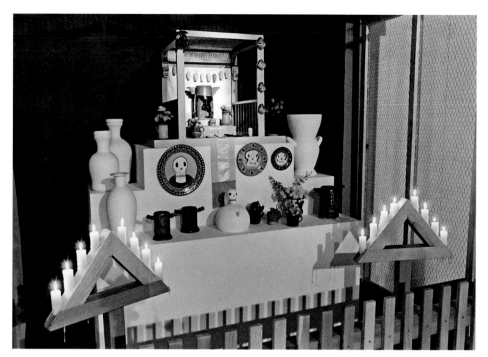

FIGURE 9.2. *Ken Price, Installation of Death Shrine 3, from Happy's Curios, 1972–78. Mixed media; overall: 102 × 108 × 72 in.; cabinet: 79 × 61.87 × 32 in. (Art © Ken Price. Photograph © 2007 Museum Associates/LACMA.)*

installation taught him "how much time and skill is involved in making what are seemingly off-hand decorations—to do them requires sustained, relaxed concentration. I've seen decorators working in Tonala. Those guys' minds were riding on the tips of their brushes."[15]

It was ironic, Price thought, for an art-educated twentieth-century person like himself to attempt to make identical vases, plates, and cups. He regarded it as an homage to the anonymous Mexican artists; he was motivated by the low status of pottery (except for Native American pottery) in the art worlds of the United States and Europe. The shrine elements make reference to Shinto shrines of Japan; Price had lived in Kyoto in 1962 and also saw Asian influences in Los Angeles. While he used a primarily Mexican palette, *Happy's Curios* is a kind of visual autobiography, including references to Jackson Pollock alongside the cliché imagery of a sleeping boy in a sombrero.

In 1978, his intense work on this project having been "financially disastrous," Price showed the units in a solo exhibition at the Los Angeles County Museum of Art. That was his cue to stop. As he later put it, "I did what we did in Vietnam at the end—I called it a victory and got the hell out."[16] *Happy's Curios* was important as a complex formal composition, a spatial arrangement of color, and an elaboration of the philosophy of making. It touches on other social or institutional meanings, and it has subsequently been described as framing objects as commodities or offering a critique of the idea of authenticity.[17] Neither idea was in circulation then, and neither has played a part

in Price's other work. The ability to add meanings is a bonus, however, and *Happy's Curios* is an atypical work.

At the end of the 1970s, Price made geometric objects with various protrusions and angular openings. Each plane is a bright or saturated color crisply outlined with a white edge revealing the unglazed clay body. While they resemble no known vessel form and often look like an assembly of toy blocks, they perpetuate vessel/volume considerations and operate at pottery scale. Price then resumed his earlier themes—the organic against the geometric, the seductive against the discomfiting, and, above all, the three-dimensional development of color— in ambiguous forms that generate the same difficulty of discussion as the domes, eggs, and other early series.

Price continued to invent new, unclassifiable forms in his own intransigent manner, apart from both craft traditions and art styles. Painted and sanded acrylic layers create a spotted polychromy all their own. His later works are perhaps cooler—with less of the bad-boy gross-out attitude—but a dislocation or strangeness persists and has brought him widespread respect.

John Mason's next step—after the walls of the 1950s and the large, colorfully glazed geometric forms of the 1960s—was an even greater surprise. He began to work with firebrick, the material of kilns.[18] In 1973 and 1974 Mason made outdoor pieces consisting of plinths and graduated stacks or semicircles of brick. After moving to New York City in 1974 to teach at Hunter College, he embarked on a project of a magnitude unimagined in the craft field: he created twelve floor works, site-specific

FIGURE 9.3. *John Mason, Hudson River Series II, Installation at Corcoran Gallery of Art, June 17– August 13, 1978. Firebrick scale #4; 22 ft. × 24 ft. × 5 in. (Courtesy of the Artist and Frank Lloyd Gallery.)*

installations, consisting of loose, low aggregations of firebrick in various configurations. (Figure 9.3) They were shown in six museums across the United States and called the Hudson River series in honor of the Hudson River Museum, just north of New York City, which organized the show. The pieces were installed at two-week intervals over a period of three months in sites that ranged from an I. M. Pei poured-concrete building in Des Moines to a 1912 McKim, Mead, and White rotunda in Minneapolis (other venues were the San Francisco Museum of Modern Art; the University Art Museum, University of Texas at Austin; and the Corcoran Gallery of Art in Washington, D.C.; in addition to the Hudson River Museum).

Mason's conceptual plane was not pottery, not modernist sculpture, but architecture and landscape. The firebrick pieces were governed by modular repetitions and series progressions and thus theoretically could extend infinitely. They suggested both man-made structures and sites or organic patterns such as natural paths. The firebricks are related to ceramics yet are uniform industrial products like the materials of minimalist sculpture. (They were available locally at each venue, eliminating shipping expense.) While the works have been compared with Carl Andre's metal floor pieces because of their low profile and multiple units, Mason's were not meant to be walked on. That was not his issue. He had created a piece of similar profile as early as 1960.

This work was the linchpin for critic Rosalind Krauss's theory of "sculpture in an expanded field," which is not object, place, event, or landscape but something in between.[19] Krauss, from her larger perspective, wrote: "The experience they offer is both systematic and sensuous, at once highly rational and elusively eccentric. One might describe them as achievements in the scenographic, for these plinths, composed by means of a methodical geometry, end up by being a stage for the transformational play of light and shade. Assured and beautiful, they join that class of work known as post-modern sculpture."[20] Moreover, they dealt with monumentality in an unusual way— not just the size of the firebrick fields but the size of the project. Each installation pointed outward from its concreteness to aspects of the real world, and it also engaged time and place in such a way that it could never be seen whole. It was a model for a new kind of work in clay.

At the end of the decade Mason made another modular installation, this time a permanent one of black and white steel frames set on a hill in Reno, Nevada.[21] It seemed that he, like Voulkos, had left ceramics. But when he returned to Los Angeles, he turned back to vessels. They were like none he had made before: torque pots, straight-walled forms that rotate ninety degrees between base and shoulder. These led to even more complex twisting sculptures composed of angled slabs of clay that sometimes evoke a figurative posture. Mason continued to surprise.

FOR THE TABLE: JOHN GLICK

In the 1960s and 1970s, when ceramics programs and craft fairs proliferated and functional ware became a statement of philosophy, John Glick (b. 1938) made a name for himself by his devotion to production pottery,

FIGURE 9.4. *John Glick*, Plate, 1978–79. *Wheel-thrown and altered porcelain, glaze color washes, reduction-fired; diameter, 15 in.; depth, 3 in. (Courtesy of the Artist.)*

his business skills, and his intensely decorative style. He earned an MFA at Cranbrook and after two years in the army established Plum Tree Pottery in Farmington, Michigan, in 1964. He produced limited-edition and one-of-a-kind pottery on commission as well as dinnerware sets.

Early pots were inspired by Scandinavian design and Asian stoneware, with subdued surfaces that were sometimes incised and featured a black glaze that thinned at the edges to expose a brown underglaze. He focused on form, making casseroles whose shape eliminated the need for handles. He developed a signature decoration of dripped and brushed color, his compact gestures creating abstract compositions that can be vaguely floral or atmospheric. Strokes, squiggles, and splotches seem to converse with the notches in a plate rim or the lobes of a teapot yet do not conventionally echo form. (Figure 9.4) In the late 1960s Glick introduced mold-made forms, which grew increasingly complex: "Handles were squeezed, wire-cut, crimped and sprigged with decorative pads; knobs faceted, stamped, modeled or incised; bellies and shoulders textured to catch pools of glaze."[22] The formal effects became a set of constituents that he could play with. He favored large plates and long extruded boxes for the fields they provided. He later worked on panels, a more pictorial format.

Glick's early audience stuck with him through such experiments of form and surface as "mead horns" and electroplating. His professional management of showroom and studio was a model for the field, and he be-

came known for his willingness to share ideas and information. His use of assistants was uncommon when he began, seeming more European than American. The helpers threw pots or assembled parts of hand-built forms from his patterns so that he could decorate. Glick also led the return to the extruder, widening its possibilities beyond handles by using it to construct parts of his slab-built wares.[23]

ABSTRACTING BEYOND THE VESSEL: WILLIAM DALEY

William Daley's large-scale vessels create an effect of topological transformation. (Figure 9.5) The walls of his distinctive unglazed forms bend inward and outward to create a complex and allusive structure that reads differently from inside and outside. His breakthrough to this unconventional approach followed a guest-teaching stint in New Mexico in 1972, where he was fascinated by kivas and pueblos. His vessel walls are less evocative of these buildings than of the spaces around and between them. The inside of a vessel might, for instance, evoke a plaza and its architectural surroundings. The vessel walls are membranes between different spaces. Daley has jocularly noted that pottery is typically convex, with bumps

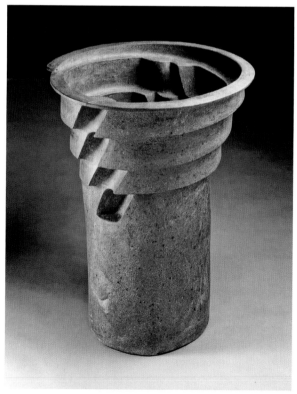

FIGURE 9.5. *William Daley*, Columnar Floor Pot, 1973. *Stoneware, unglazed; 27 × 16 × 16 in. (Courtesy of the Artist. Photograph by James Quaile.)*

on the outside, but he has enjoyed "the caprice of making bumps inside."[24] His stoneware is left in a reddish brown bisque state, sometimes burnished or brushed.

Daley was born in 1925 in a Hudson River town to working-class parents with only elementary-school educations. Straight out of high school he enlisted in the military—and became a German prisoner of war on his first mission—and thus was eligible for college on the GI Bill. He graduated from Massachusetts College of Art in 1950 and earned an MA in art education from Columbia in 1951. He joined the Philadelphia College of the Arts (now University of the Arts) in 1957 after a stint at the State University of New York, New Paltz; the job required teaching design as well as ceramics, and he remained involved in those two worlds throughout his academic career.

Daley typically develops his forms by drawing on his studio wall (it is later painted over). He drapes clay slabs on a carved Styrofoam mold, opening down, and inverts the form when it is dry enough, for further manipulation. He makes drawings of finished pots he likes. His favored forms are stairs, cones, pyramids, ovoids, cylinders, hemispheres, tetrahedrons, one that he calls a Chiclet (neither square nor round), and the almond-shaped *vesica piscis*. The completed works are environments for the imagination, places of projected ritual or meditation by means of what he calls sacred geometries.

Daley's search for symbolic meaning was not unusual at the time: as a veteran of war he was among those hoping to make a different world in whatever personal or social way might be possible. He believes "the hands inform the mind, not the other way around. Process has always been my trigger; understanding for me comes through doing and redoing."[25]

PROTEST, IMAGERY, WIT

Gerry Williams has become so deeply identified with *Studio Potter*, the magazine he founded in 1972, that it is easy to forget that he also had a life as a creative artist. He is among the modest number of craftspeople who have made works of explicit political protest.

Williams was born in 1926 in India, where his parents were educational missionaries. He came to the United States in 1943 to attend college. Interest in utilitarian pottery—consistent with his Gandhian pacifism—led him to New Hampshire, which had the only well-organized state crafts agency. He studied with Vivika Heino and spent a year as an apprentice to potter John Butler. By the early 1960s he was throwing large stoneware bowls and coil-building urns, decorating both with slips and glazes. He made fine classical Chinese-style forms with celadon or copper red glazes, sometimes with stylized figurative ornamentation, and also thick, rough-surfaced, undecorated pots. All that fell away at the end of the 1960s, when his series of works called Political Constructions included graffiti, relief lettering, photographic imagery, effigy figures, and additions of cloth, plastic, or glass. He also used polyester resin and acrylic paints. All this combined in comments on the hot issues of the day.

Several critical pieces dealt with the Democratic Party power structure during the 1968 election campaigns. *Watching Hanoi Watching* referred to preprimary newspaper ads urging voters to "stay the course with Johnson." A slab box enclosed two hollow-headed figures sitting back to back and looking toward the viewer and toward figures standing on a fence. Chicago Mayor Daley's "harangue" at the Democratic convention was conveyed by an open mouth in a large head amid a sea of other open mouths. On other works Williams carved freighted words such as "military-industrial complex" and "ABM." The title *Void Where Prohibited* (1970) is carved into a square column with a photoresist image (then a new technique) of a black man at the top, to imply American racism. (Figure 9.6) Other ceramic cubes or "commemorative"

FIGURE 9.6. *Gerry Williams, Void Where Prohibited, 1970. Stoneware, photo resist; 36 × 10 × 10 in. (© Gerry Williams.)*

FIGURE 9.7. Howard Kottler, Naughty Pine, 1974–75. Slip-cast
and assembled earthenware with glaze and ceramic detail; 15.37 ×
14.37 × 11 in. (Henry Art Gallery, University of Washington, Seattle,
purchased with funds from Evelyn Howie, PONCHO, and the
National Endowment for the Arts, 77.29. © Estate of
Howard Kottler. Photograph by Richard Nicol.)

vases showed photoresist images of American Indians,
Gandhi, or presidential candidate Eugene McCarthy.

Howard Kottler was the advance man for the baroque
forms, elaborate constructions, and identity themes that
became widespread in the 1980s and 1990s. (Figure 9.7)
He started out conventional and ended up as an "irrever-
ent provocateur who mercilessly goaded traditional cera-
mists."[26] Like Williams, he employed social and political
commentary and was even more idiosyncratic in his lack
of devotion to craft processes.

Kottler (1930–1989) had a prolonged career as a stu-
dent, starting with a BA in biological sciences and later
an MA and a PhD in ceramics, all at Ohio State. He also
earned an MFA from Cranbrook and spent a year at the
School for Industrial Crafts in Helsinki on a Fulbright
Fellowship. His work borrowed widely—Grotell and
Takaezu forms, Chinese glazes, Persian decorations.
An imaginative series inspired by Voulkos, called Tear
and Repair, consisted of a slab vase forced into a thrown
vessel. Only after he was hired to teach at the Univer-
sity of Washington in 1964 did Kottler find himself. He
mixed a sense of humor, a joy in kitsch, and an increas-
ingly provocative personal style as he began to come out
of the closet.

Part of his expression was verbal, through artist's

statements and text incorporated in his works. He wrote,
in the *Objects: USA* catalog, that he produced "palace art"
for people who did not need anything. He took up raku
in 1965, attracted by its irregular forms and iridescent
effects. These strange, crusty works were his first explo-
rations of sexually suggestive shapes, with both male
and female associations. He also began working with
Egyptian paste, attracted to its acidic colors. He liked the
fakery of gold and silver lusters—it seemed very Ameri-
can. He took up hobby-shop glazes for the colors and
experienced the same kind of criticism that Price and
Ron Nagle were enduring. Technical transgression was
followed by equally improper subject matter—but this
was, of course, an era when ceramic feces was a copied
feature. He made a group of works incorporating fur
from thrift-shop coats and cast Barbie-doll arms. By the
beginning of the 1970s, his works were recognizable as
his own.

Kottler regularly visited San Francisco and had seen
the *Funk* exhibition at Berkeley. His works are among
those sometimes described as a northern manifestation
of funk, with the same irreverence, humor, and vulgarity
but more elegant form. His decals and bright glazes and
lusters on white clay were also influenced by art deco
ceramics, which he collected. Throughout the 1970s, he
made several series of decaled plates, employing com-
mercial blanks, which appalled traditionalists. The ready-
made decals were cut up and reassembled in "surprising,
surreal, and uproariously funny ways, often unpatriotic
and sacrilegious."[27] These were not just one-liners, how-
ever. They were critical of the Vietnam War as well as of
superficiality and conformity in American society, con-
veyed especially by the use of American flag and U.S.
Capitol decals. Other decal works alluded to homosexu-
ality with differing degrees of obviousness: Grant Wood's
American Gothic couple altered so that the male head is
on both bodies is clear and funny, while *Signals* (1967–
72), which consists of only the hands from the *Last Sup-
per* stretched across the center of a plate, is less so.

With utmost irony, these manufactured decals on
manufactured plates were encased, singly or in sets, in
handmade leather envelopes or in specially made wooden
boxes. The presentation might be read as investing value
in objects through the way they are treated, which was
a philosophical issue in the craft field. Some people
thought it strange that he lavished more attention on
the container than the contained, but Kottler explained
in an interview: "Actually, the packaging was all farmed
out: a friend who had a leather shop did the leather work.
The embroidered lettering was done by a guy who makes
bowling shirts. The boxes I used for some of the plates

were made by someone else, too—someone who could do the woodwork better than I could. My work was the total concept and the alteration of the ready-made decals. There was more irony in the imagery than in the packaging."[28]

In 1973 Kottler began a molded cup series that included mind-bending illusions mounted in Plexiglas boxes, sometimes with double-entendre titles such as *Hand Job*, showing that even a functional form could express ideas. Many addressed the theme of artifice through the amusingly egregious use of wood-grained contact paper and other kitsch. Around 1977 he initiated a self-portrait profile series. The best-known variation was the use of his profile to define the contours of a vase. The subtext of identity politics is almost always elliptical.

Kottler, who died of lung cancer at fifty-nine, exemplified a particular and new attitude in the development of ceramics as an art form. As he put it: "My concerns are to use the material of clay in any way that answers my needs. I refuse to let the materials or tradition dominate my direction."[29]

Patti Warashina emerged in the 1960s, and her work drew attention early on. Her MFA exhibition at the University of Washington and many of her early shows were duo presentations with her first husband, Fred Bauer. Following the conventions of the time, the couple relocated for his teaching jobs, and she found something if she could, and exhibition reviews always mentioned his work first. That the second-class citizenship was not justified was proved by her meteoric rise after they split at the end of the 1960s. She not only got his job at the University of Washington in 1971 and stayed there until she retired, but her work appeared in major national shows. Her car-kiln series of the early 1970s and feminist altars of the mid-1970s were fierce and funny, quintessential expressions of their time.

Warashina (b. 1940) showed an urn covered with a bright-colored painting of parts of a woman's face, torso, and feet, jumbled or inverted, in *Objects: U.S.A.* She used acrylic paint to get bright color; later she shifted to low-fire glazes and decals. In her works, the car kiln—in which a platform stacked with ceramics ready to be fired rolls in on a track—is conflated with the automobile. Both were part of a macho vocabulary of heat, capacity, fuels, speed, danger, and competitiveness. In whiteware, Warashina rendered the kiln's hundreds of individual bricks and the festively surreal transformation of the car amid luster-glazed flames (a joke on Hotwheels toys).

Even more trenchant are the altars, which recall Buddhist altars (her grandmother still had one, although the family had converted to Christianity after emigrating

FIGURE 9.8. *Patti Warashina, Love It or Leave It, Altar Series, 1975. Slab-built ceramic, china paint; 30 × 18 × 18 in. (Collection of Robert L. Pfannebecker. Courtesy of M. Patricia Warashina.)*

from Japan). These works allude to women's servile position in American culture and to the stereotype of Japanese women as especially docile. A seemingly cheerful woman is drawn or spray-painted on a vertical plane. She presents a seventh-anniversary cake in *Love It or Leave It.* (Figure 9.8) The woman's smiling face has a slightly glazed look (in the nonceramic sense), with a hint of craziness that makes the knife she carries ominous. In addition, an electric cord that plugs into the back of her neck suggests that she is a kind of appliance, and her dress is tied at the back like a hospital gown.

Warashina insists that her early works are simply personal and denies a specific feminist content, but they have spoken to (and for) women who lived through those times. The next series, in smaller scale and without color, presents women who have thrown off their bondage and their clothes to engage in an ecstatic dance: these ten-inch unglazed white forms are gendered but not sexually detailed, and they are shown in groups on black Plexiglas and enclosed in clear boxes (like Japanese dolls). This

FIGURE 9.9. *Robert Arneson,* Fragments of Western Civilization, *1972. Terra-cotta; 41 × 120 × 120 in. (Collection of the National Gallery of Australia. © Estate of Robert Arneson/Licensed by* VAGA, *New York. Image courtesy of George Adams Gallery.)*

series approximately coincided with Warashina's second marriage, to ceramist Robert Sperry.

The tiny white figures were her focus for twelve years, after which she made a radical shift to figures as much as eight feet tall. She has continued to innovate in form and subject.

Robert Arneson came into the 1970s on a roll. In 1972 he created *Classical Exposure*, a play on the antique Greek boundary marker called a herm, with a bust of himself atop a column of figurative scale. He spoofed the convention by adding genitals at the appropriate level and feet poking out from under the base, as if from beneath a long robe. The cigar in his mouth was another bit of insouciance. Art critic Donald Kuspit and art historian Elaine Levin have ascribed the works of this period— for example, *A Hollow Jesture* (the artist sticking out his tongue; the misspelling alludes to his clownish behavior)—to Arneson's personal anxieties as a consequence of his divorce in 1972. But he was not confessional, as many young artists with cameras in their hands soon became. He was, rather, being a character. "You're modeling in the most traditional manner, so you use yourself, but the self is not the inner self. You end up acting, becoming someone else, although you use your own features," he explained.[30] What gives these works their power is the tension between a real person embarrassingly exposed and a construct employed to make a joke or a point.

The mix is perfect in his *Fragments of Western Civilization* (1972). (Figure 9.9) Arneson made bricks marked with his name, birth date, place of birth, and astrological sign. They are scattered, along with his own helmeted visage, around the remains of a herm still bearing partial genitals. This is at once a ceramic joke, an admission of

vanity (like names carved into trees or park benches), and a larger story of hubris and futility recalling Shelley's poem *Ozymandias.*

Arneson was derided as a jokester, but a perceptive treatment of his work in 1974 noted that he used the pun as "a flexible and probing mechanism" by which he could "process and reflect the complexities of artistic experience and our awareness of it." The problem, the critic wrote, was that puns are seen as simplistically humorous but, in fact, their primary function is "the expansion of meaning."[31] The development of his work during the 1980s, which will be discussed in chapter 10, demonstrated that it was so.

David Gilhooly's work, more than most, was the expression of his time. The artistic offspring of Arneson, he was immediately successful, included in every exhibition that represented funk or the humor of UC Davis. He occupied the "younger generation" slot when California ceramics made it to New York's Whitney Museum of American Art in 1981. His wit was so engaging that reviews and articles often simply described or named his pieces, as if that were enough, but what went without saying then tends to fall flat in retrospect.

At the end of the 1960s, when Gilhooly came of age, there was an unpopular war, race riots, and student protests. Gilhooly invented "Frog Fred" as a protagonist in a "Frog World" that was somewhere between a description of then-current foibles and a projection of a social fantasy that ridiculed institutions. The work was described as narrative painting realized in three dimensions and as a political and social satire in the tradition of *Gulliver's Travels.*[32] In the 1970s his frogs, Jens Morrison's pigs, and Douglas Baldwin's ducks were representative social

commentary from the ceramics field: a joke rather than a lament.

Gilhooly (like Arneson) drew cartoons in high school; he was also an actor, an avid cook, and a prankster. He started college as a biology major, switched to anthropology, and by his second year was in art. He took Arneson's first ceramics class at Davis, soon becoming his assistant. Gilhooly used hobby-shop glazes and molds to make landscapes with volcanoes that served as ashtrays or incense burners, the smoke wafting out of the top to contributing to the visual effect. He made pieces inspired by Babar books and Tarzan movies. He then began modeling life-size animals from slabs shaped over excelsior, which were cut into sections for firing. His first solo show, at the Richmond Art Center in 1965, the year he graduated, was followed by a solo show at the San Francisco Museum of Art the next year. He began teaching in Saskatchewan in 1969.

Gilhooly's civilizations were based on extensive readings that provided him with obscure facts that people assumed were his invention.[33] His most celebrated frog works, including *Mao Tse Toad* and *Tantric Frog Buddha*, came early in the decade; after 1976 he worked with the notion of an ark, filled with Frog Fred and animal companions. (Figure 9.10) Also in the 1970s food became a major subject matter in his work because he was overweight and went on an all-protein diet. He began selling clay food and frogs at a roadside stand, although he had gallery representation at the time.[34] Canadian critics regarded this work as consumer satire. Gilhooly later made layered tableaux of colorful Plexiglas sheets and works on paper, established his own press, and gave up clay.

Jack Earl, a small-town Ohio artist with a fine sense of the absurd, was the subject of a monograph—*Jack Earl: The Genesis and Triumphant Survival of an Underground Ohio Artist*—by Lee Nordness, organizer of the *Objects: USA* show. It was published in 1985, when books on individual craftspeople were rarities.

Earl was born in 1934 in Uniopolis, Ohio, and went to the local Mennonite college, Bluffton (coincidentally, Paul Soldner's alma mater, but he had already left). He finished in 1956 and started teaching art and English at a high school in New Bremen (coincidentally, the town where Jim Melchert was born and raised, but he had already left). Earl married his high-school sweetheart, the daughter of a preacher whom he came to admire, and soon was the father of three. As a graduate student at Ohio State in the 1960s, he was influenced, typically, by Japan, Voulkos, and Autio, and also, less typically, by the work of Brother Bruno (LaVerdiere), a potter-monk whose work attracted wide interest at the time.

FIGURE 9.10. *David Gilhooly,* Frog Buddha, *1975. Low-fire white earthenware, glaze, gold luster; height; 16 in. (Crocker Art Museum, The Jane K. Witkin Collection, Gift of B. E. Witkin, 1981.202. Courtesy of David Gilhooly.)*

The big change began about 1967, when Earl made a realistic scene in plaster. The material was not hard enough for the details he wanted, so he turned to porcelain and coil-built both sculptural forms and vessels. His vases were shown in *Objects: USA*, but the sculpture became his life work: figurines and tableaux that are folksy, surreal, and suffused with humor, good nature, commitment to family, and religious feeling. A prime player is Bill, a character based on Earl's neighbors and family. Always in a baseball cap, Bill is shown in situations mundane and foolish but in a manner that is joshing, not satirical.

In 1972 Earl was invited to show at the Museum of Contemporary Crafts in New York and Kohler Art Center in Wisconsin. The piece in his New York show that set the crafts world talking was a dog: it squats, head low, with

a foolish expression on its face, upon a pair of women's pumps. The title does not explain that oddity but is odd in itself. It is a rambling monologue about dogs:

> Dogs are nice and make wonderful companions I've been told, and most people get dogs when they are young and cute and so much fun to play with, not thinking about how long a dog can live. You got to train a dog right. I wouldn't take a grown dog who had had a previous owner, cause you never can tell what you are getting, even though some of them look real good and will lay still for you. You can't change a used dog's bad habits either and they stink, dogs all smell the same. The best dog has a greedy streak and will howl and drool and paw until they get what they want and I like old dogs best because they just lay around and don't bother you so much anymore.

FIGURE 9.11. *Jack Earl*, Where I Used to Live in Genoa, Ohio, . . . , *1973. Porcelain, china paint, glaze; 5.62 × 7 × 4.75 in. (Collection of Roxana and William Keland. Courtesy of the Artist.)*

The entire paragraph appears on a plaque, handwritten in gold, grammar and spelling unedited. It offers no comment on this particular dog, instead pulling the viewer into a reverie concerning dogs and people, known and observed. The animal is neither a cartoon nor an idealized form but very particular, down to its hanging tongue and the gunk draining from its eye.

The thread of surrealism in Earl's work may be explained as the imaginings of his characters or as his expression of the rural storytelling tradition of the "whopper"—as seen in a 1978–82 series of men with vegetables (or other objects) for heads and a guy with a carrot finger. Earl's subsequent imaginative scenes include images seen inside an unrelated form at a different scale; coherent spaces seen from front and back or inside and outside; and scenes with front and back only poetically related, such as *Where I Used to Live in Genoa, Ohio, People Lived in Houses* . . . (1973). (Figure 9.11) Here, in an all-white interior scene, a naked woman opens her front door slightly as if to look out into her yard, but on the reverse is a flat yet full-color rendering of a bucolic landscape and distant blue mountains—certainly not Ohio. Is it her dream?

Ceramic figures and genre scenes are often derided for their sentimentality. Earl deflects that weakness with humor and with mystery. In a surprising variety and complexity of forms, he achieves his aim, which is "to tell a story through art, to have a philosophy and to picture it in art."[35] The philosophy may be insinuated by the use of biblical text or citations, usually without an obvious correspondence to the imagery and so creating a certain provocation. Earl leads viewers toward profundity, and

on the way they may meet Bill emerging from a café restroom still tugging at his fly.

Mark Burns does not care whether clay looks like clay and has applied decals and other supplementary imagery to his slip-cast forms (perhaps not surprising for someone who first studied to be an illustrator). His installations incorporate all kinds of articles and substances—wood, plastic, and other materials, sometimes unified with paint. He is an assemblagist. His work has been described as punk; it shares with that genre an interest in 1950s style and an undercurrent of danger. He is fond of the populist art and artifacts of his childhood (he was born in 1950) and combines an affectionate treatment of style with trompe l'oeil and sadomasochistic imagery, keeping everything off balance.

Burns's shows have been full of surprises. *Hotel Lobby*, his 1976 exhibition at Helen Drutt Gallery in Philadelphia, included an eight-foot section of wall furniture along with his sculptures in a mixed-medium environment. (Figure 9.12) A newspaper article about his home and collections published the weekend before the show opened led to a television news crew visiting the exhibition opening, and his impromptu invitation for viewers to come visit drew crowds to the block until 11 p.m. In another Drutt installation, *Fairy Tales*, he offered nine sculptures in a space painted pink and given linoleum flooring. Fake toy building blocks on the mantel spelled out his name.

Burns grew up in a congenial Ohio bedroom community and earned a BFA at the Dayton Art Institute in 1972, where he had some exposure to clay. Guest lec-

FIGURE 9.12. *Mark Burns*, Decorator Wall, Hotel Lobby Series, 1976. (*Courtesy of Mark Burns.*)

turer Howard Kottler was encouraging, so he went to the University of Washington and studied with Kottler and Patti Warashina for his MFA. He has taught regularly since then, for many years at the Philadelphia College of Art and more recently in Las Vegas. He developed a vocabulary of motifs, particularly fire, which can refer to Prometheus, to his own name, and to his primary medium. He also uses pulp media, classical and religious mythology, B movies, illustrations by John Tenniel and Maurice Sendak, toys, and art history. Individual works are often organized around two figures (or hearts or parrots), reminiscent of Kottler's gay symbolism. Burns says his binary compositions relate to two sides of his personality—humorous and irascible.[36] There are often implications of violence, more cartoonlike than anguished. The craftsmanship is superb, both in Burns's installations and in his eccentric, black-humor vessels.

TROMPE L'OEIL

A Canadian with a master's degree in chemistry, **Marilyn Levine** (1935–2005) saw her scientific career come to an end when she married; under nepotism rules, she could not teach at the university in Regina because her husband did. So she decided to take some art courses and discovered a natural facility in ceramics. Her background was useful: a teacher used chopped fiberglass in his clay (which Daniel Rhodes had pioneered), but Levine concluded that nylon would be stronger when fired because it was a nonsilicate.[37]

After touring California in 1968 and meeting important figures in the ceramics scene, Levine was accepted in the graduate program at Berkeley (her husband took a sabbatical). There she was influenced by funk and learned low-fire methods. She started imitating cardboard boxes with clay slabs and in 1969 made tennis shoes and socks, and in 1970 a knapsack. Then someone gave her a worn pair of boots that she copied, and that was a turning point. "Leather makes a record of its own history better than most materials. A fabric frays and tears, and you throw it away. A leather jacket takes on the shape of the wearer, gets dirty, scratched."[38] She became a master of illusory leather, making handbags, suitcases, shoes, and other goods with all their particularities, using nonceramic materials such as oil paint and shoe polish to heighten the illusion.

Levine's work was widely appreciated at a time when artists such as Duane Hanson and Richard Estes were making photorealist works in sculpture and painting but was received by critics with some doubt. Some called the work conceptual, yet the story the object told had nothing larger to say about the world or the times. Instead the work shows a commitment to manual skill that flies in the face of such 1960s art movements as conceptualism (which claimed that the idea, not the artifact, was the artwork) and minimalism (which often relied on fabricators to execute a work).

Richard Shaw (b. 1941) creates precariously stacked or amusingly figurelike assemblies of objects such as books, pencils, and playing cards—all ceramic illusions achieved with decals or china paint. (Figure 9.13) Shaw studied with Jim Melchert and Ron Nagle at the San Francisco Art Institute in the early 1960s and, as a graduate student, under Robert Arneson at Davis, where he made small inhabited environments such as restaurant interiors or theater box offices.

In 1971 he created his well-known ceramic sofa about three feet wide on which is painted a ship sinking in the ocean. He began working in porcelain that year and making photo-silkscreen decals that yielded the illusionistic effects he admired in nineteenth-century trompe l'oeil paintings by John Frederick Peto and William Har-

FIGURE 9.13. *Richard Shaw*, House of Cards #3, *1979. Porcelain with glaze; height, 18 in. (Collection of the Oakland Museum of California, Gift of the Collector's Gallery, A1979.153.)*

nett. He cast from real objects. In 1978 he edged into stick figuration, still using the humorous or poetic juxtapositions of realistic forms.

Shaw also used commercial molds. In 1972–73 he and sculptor Robert Hudson shared a studio and plaster molds, making independent works that were exhibited together. The project brought them attention (almost twenty-five years later curator Jock Reynolds reunited them at Andover to make new molds and new work). Shaw has continued in this style, creating technically impressive but conceptually mild assemblies. The viewer's consciousness of being fooled gives the work its piquancy.

ABSTRACT AND SPIRITUAL
Rudolf Staffel and Robert Turner offer interesting parallels: their lives almost exactly coincided (Staffel lived from 1911 to 2002, Turner from 1913 to 2005), both started in painting but found their métier in clay, both were decisively shaped by religious beliefs (Staffel adopted Zen Buddhism, Turner was a Quaker), both were modest and gentle men more apt to recognize their shortcomings than their achievements, both were memorable teachers who achieved greater success with their work when retirement gave them more studio time. Both have gener-

ated repeated efforts by others to speak of their work in the poetry it seems to deserve.

Rudolf Staffel was born in San Antonio, Texas, to a German immigrant family. Even as a child, he was drawn to Asian art, and as a student at the Art Institute of Chicago, he spent most of his time in museums. After he apprenticed to a potter in Mexico, chance took him to New Orleans, where he taught at the Arts and Crafts Club. Then he was offered a job at Tyler School of Art in Philadelphia, which appealed to him because the program was based on John Dewey's principle of exposing students to many disciplines before they specialized.[39]

Staffel worked in stoneware from the 1930s to the 1950s. He made classic glazed vase forms and decorated them with fluently painted New Orleans street-life scenes. After seeing a show of Picasso's ceramics in the mid-1940s and finding the clay magnificent in itself, he reduced his use of glaze to allow attention to the body substance. His life-changing event, however, was a commission in the 1950s for porcelain dinnerware. He had not previously worked in porcelain, and the slip he applied shivered off in the firing, leaving translucency exposed and reigniting his longtime interest in light. He engaged in a series of test pots, hundreds of them. When he studied the outcome of these trials, he decided that the test pots were more interesting than the "artistic" pots he had been self-consciously making. Thereafter, he would say, "Everything I do is test pots so now there are no test pots."[40]

This testing, or risk, in his work has elicited comparison with Voulkos's early sculptures (other parallels are their commitment to the vessel and the work's record of gesture). But they differ radically in every other quality. Staffel's pots are scaled to the hand and have a wide opening at the top to catch light: he called them Light Gatherers. (Figure 9.14) Their details differ enormously. Some are smooth and orderly, with thick and thin spots that seem to silhouette vegetal or geometric shapes. Some might have been constructed of ragged strips of biscuit dough, or of leaves, or of mushroom stems. Some are incised, some perforated. Some have neat, regular rims, while others swoop or curl over at the top. Some are shaped like melons, some like cones pushed into a pile of rocks; others are like cylinders plunked down on a pad. Staffel used a little color, especially early on, but that was never what made them interesting.

The patterns of translucency differ in each, and Staffel continuously pressed for new constructive methods, by wheel or by hand, inserts or incisions, to embrace whatever porcelain could do. That meant he often exceeded its

FIGURE 9.14. *Rudolf Staffel*, Light Gatherer. *Porcelain.*
(Courtesy of Helen W. Drutt. Photograph by Will Brown.)

limits, but failure was okay. "Translucence was about the only thing I wanted," he said.[41] Being "in the moment" in the Zen manner, he never dated or titled the pieces. Everything about the work is about process: why his vessels look the way they do, what they meant to him, and how they present special qualities to the viewer. Imperfection of form gives them a childlike quality, a sense of play or of innocence that he was able to sustain because he planned nothing and intended as little as he could. "Inadvertence" (his word) is the key to his work.[42] Thus there is very little ego in them, although there is a great deal of touch.

Robert Turner was, during the 1940s and 1950s, an exemplar of functional potting as a moral choice. He is also noted for his struggle in middle age to find personal expression, which involved opening himself to emotion and experience. His later works address specific themes in abstracted terms, often referring to landscape. They are most striking for their combination of emotional intensity and visual reserve.

Turner muddled through economics at Swarthmore (BA 1936) but wanted to be a painter. He studied at the Pennsylvania Academy; a travel scholarship allowed him to go to Europe in 1939 and to the American Southwest and Mexico in 1940. During the war, as a conscientious objector, he worked in a forestry conservation camp and at a school for the "mentally deficient." When the war ended, he wanted something more practical than painting and decided on clay.

After earning an MFA at Alfred (1949), Turner was hired to establish a pottery program at Black Mountain College. It was a good place to work, to refine what he had learned. Josef Albers had disapproved of ceramics, thinking it lacked the "resistant properties" that made other materials more suitable for students. But he was gone, and the students wanted ceramics.[43] Turner did not identify himself as an artist but as a potter, yet he enjoyed the rich dialogue of the avant-garde for which Black Mountain is famous.

After two years he left to establish his own pottery in the Alfred area, teaching occasionally but devoting himself to the rhythms of pottery production. He developed a dense clay that could be sandblasted to make it more receptive to the eye and the touch, and he honed simple forms that referred to Minoan and early Greek precedents and classical proportions—not that the shoppers at Bonniers or America House who readily bought the work would recognize that. Most pieces showed the compactness and clarity that were popular in Scandinavian design at the time and were also consistent with Bauhaus principles espoused by Marguerite Wildenhain, who occasionally came to Alfred.

Turner had some distinctive forms, including a free-form Garden Bowl and a low casserole with a broad, flat unglazed base and a fountainlike profile generously opening out to a wide rim that is echoed by a wide, low knob on the lid. There is nothing extraneous, even handles having been made unnecessary by the flaring rim, which provided a grip. The integrity of his pottery was appreciated then and since. Just a few years ago, critic Edward Lebow took issue with a traveling retrospective that presented only a single example of Turner's functional ware and spoke of a breakthrough in which he abandoned utility and began to create art. Lebow argued that Turner was too contemplative for such sudden shifts, and that in any case, "Each of the insights [the curator] perceptively describes was present in Turner's utilitarian pots."[44]

In 1957 Turner began to teach at Alfred, and so it happened that he had a student audience for his gradual change. He was newly aware of the contrast between Western notions of the ideal and of man above nature

FIGURE 9.15. *Robert Turner, Ashanti, 1975–76. Wheel-thrown stoneware; height, 11.75 in.; diameter, 10.5 in. (The University of Iowa Museum of Art, Iowa City, Gift of Joan E. Mannheimer, 1991.221. © Estate of Robert Turner.)*

and Zen notions of chance and man as part of nature. He began to lift his new Dome vessels off the wheel when they were still wet, and if they shifted and deformed, that was fine—it was what the clay wanted to do. He led his classes in experiments with movement, trying to open his own mind as much as theirs. He traveled to Africa in 1972, where he visited Charles Counts, an American potter then teaching at the University of Nigeria. Turner was moved by exposure to animistic cultures shaped by spirituality in every aspect of living. He has described a search for "integration" as a common motivation in the crafts field in the 1950s and 1960s,[45] and he saw that aspiration realized in Africa.

Subsequent travel to the American Southwest was also important to him. In neither case did he copy the specific forms he saw, although he gave several series African names in honor of his experience there, beginning with the Ashanti works that merge the memory of hut forms with the tradition of covered jars. (Figure 9.15) Simplicity, sense of ritual, and sense of place were central. Other vessel-sculptures started with primary forms and evolved: a circle turning into a square at the rim of a bowl or the neck of a vase was a favorite. His Beach and Shore series of white forms consist of a cylinder on top of a cone. They are sandblasted, giving them the softness of a fine-grained beach. Here and there they are scarred, or a long incision races across the contours, or a spot

bulges outward. They recall the way sand changes color as a wave withdraws and the small airholes that reveal the presence of mollusks under the surface. In other series, such as Akan, he added straps of thick, roughly cut slabs, and in the Ife series he inserted a slab "key" at the mouth of a cylindrical neck to direct attention to the dark interior; both devices also refer to geological effects. The surface has the directness of spare drawing. The softened outlines of Turner's forms imply deliberation[46] rather than the speed of instinctive gesture that he admired— perhaps even envied—in the work of Voulkos.

Turner's own meditation and contemplation were equally needed in contemporary ceramics. After his retirement from Alfred in 1980, he exhibited regularly with two prominent galleries, Helen Drutt in Philadelphia and Exhibit A in Chicago, and he continued to teach workshops at Penland, Haystack, and Anderson Ranch into his old age.

MUTE FIGURATION

Viola Frey's signature work consists of larger-than-life-size figures in 1940s- or 1950s-style clothing, stiff, as if holding still for the camera, yet surface-animated by riotous polychrome strokes, dots, and patches. A related body of work was inspired by flea-market figurines that she arranged in ensembles. Frey also produced many oversize plates that she painted with autobiographical imagery and some figurine representations, often amid miasmas of darkness or obscuring textures.

Frey (1933–2004), who taught at the California College of Arts and Crafts (CCAC), was born in a farming community in California's central valley, to a family exceptionally given to accumulation and reuse. At CCAC she studied painting with Richard Diebenkorn. There was no ceramics major, but she took it as an elective. She went to graduate school at Tulane, in New Orleans, where her painting continued under Mark Rothko and her ceramics with Katherine Choy. She moved to New York and worked in the accounting department at the Museum of Modern Art while potting at the suburban Clay Art Center. Then it was back to California, where she worked at Macy's in downtown San Francisco. It is amusing to think of her riding the subway or bus to work at these jobs, undoubtedly in a dress, maybe carrying a lunch—the very plodding normality of this activity contributing to the images she would later produce of men in blue suits or women with hats and handbags. Her work of this period consisted of generously proportioned pots that sometimes supported draped figures.

By 1974 she had purchased a house in Oakland and had an attached studio built. During construction she

FIGURE 9.16. *Viola Frey, Double Grandmother, 1978–79. Whiteware, underglaze, glaze, overglaze; 61.5 × 50 × 21.5 in. (Minneapolis Institute of Arts, Gift of funds from the Regis Corporation, 1981.29.1-3. © Artists' Legacy Foundation/Licensed by VAGA, New York.)*

began grouping and photographing kitsch figurines she bought at the Alameda flea market: reclining in chairs, examining each other, floating in the kitchen sink in cups. Thereafter they played a major role in her work. She cast them in whiteware and joined them in groups painted with nets of color that made the whole dominate the elements. She also began populating her backyard with figural sculptures of increasing size. In her mature work, color seems to dissolve the figure's surface, diminish its three-dimensionality, and make it more like her painting. Some work shows light and dark nervous lines, like a paint-by-numbers pattern of shadows; another favored approach was slashes of orange, yellow, and blue, expressionist in impact if not in message. Frey used the same colors on small and life-size sculptures. The distinctive quality of her work is the uneasy relationship between static form and active surface. Color acts as a mask.

Frey's life-size sculptures of the 1970s usually depict farm women holding mundane objects or imposing grandmother figures. (Figure 9.16) She was saying something about women's roles. ("You don't feel sorry for my six-foot grandmother with a splashy dress like that; you feel she has a certain leverage and power. If you remember grandmothers, they weren't always such

willing baby-sitters, they weren't always so nice about toys. The pink on my grandmother's dress is that lovely, soft, cuddlesome pink, but you wouldn't offer to help her across the street!")[47]

Frey's figures became giants seven to ten feet tall, built hollow, and fired in undisguised sections. They were the largest ceramic figures since Vally Wieselthier's and Waylande Gregory's, yet they were neither mythological nor heroic. Frey concentrated on regular, working-class people. Attire defines identity. She described one male figure as being "about the suit" and noted that blue invested the men with respectability and power. She liked the idea of clothing as a cultural artifact. The dresses and hairstyles were out of date even when they were made, probably because Frey was remembering her childhood.

The figures are abstracted. Early men, for instance, do not have mouths. Besides being stiff, the figures are oddly proportioned—heads too large and arms too short. She also liked to make the life-size or smaller ones in doubles to encourage the viewer to study and compare. Frey's people seem to be slightly nonplussed or befuddled; they manage to be characters rather than artifacts and to evoke sympathy.

Frey's plates, produced throughout her career, are similarly exaggerated in size. She collaged relief imagery including figurines and favored motifs—doorways, eyeglasses, hands, horses, skeletons, self-portrait profiles, Howard Kottler (friend and inspiration) in a hat, a man in an overcoat—in an evocative, nearly chaotic mélange. Frey once said that all her work dealt with power, treated ambivalently: "Predators and fears have a lot to do with it."[48] That does not really explain the imagery, but it does explain the feeling.

The figures of **Stephen De Staebler** (b. 1933) sometimes seem to have spiritual implications, which perhaps is not surprising since his degree from Princeton was in religion. He is best known for monumental figurative and landscape forms. (Figure 9.17)

De Staebler is a native of Saint Louis who studied painting with Ben Shahn and Robert Motherwell at Black Mountain College. His college major was actually a way out of an impasse—he was caught between studying art history and making art. After other detours (army service, social work, teaching history), he earned a master's from Berkeley, where he studied with Voulkos. While he is counted among those influenced and inspired by Voulkos, he was not one of the young rebels, being a quieter and more pensive personality. He taught sculpture at San Francisco State University from 1967 to 1992. Both at the beginning of his career and again more recently, he has cast figures in bronze, but his major works are clay.

FIGURE 9.17. *Stephen De Staebler*, Standing Man with Pregnant Woman, 1978. Porcelain, stoneware, low-fire clays; 92.37 × 16.5 × 12.87 in. (Minneapolis Institute of Arts, Gift of Bruce B. Dayton and the National Endowment for the Arts. © Stephen De Staebler.)

De Staebler said his works of the early period were all figures trying to get out of a block of clay. Landscape also engaged him. As a midwesterner accustomed to the concealment of foliage, he was fascinated by the bare California hills and the evidence of erosion. His early wall sculpture *Moab I* and his Thrones series are related to landscape in various degrees, especially a permanent installation of public seating for the Berkeley Art Museum (1970) that resembles rocky terraces or ledges. These works emphasize earth not just in their material but in the suggestion of gravity, erosion, and other natural forces. He rubbed them with oxides—both earth tones and unexpected pinks, blues, and greens—but used no glazes.

For his figures, De Staebler made a rule that there could be no armatures; the clay had to support itself. So they lean backward in what he calls a wedge and express the randomness of decay. While they are commonly identified as woman or man, with breasts or genitals confirming gender, they are not erotic. Early figures seem embedded, as if buried and being revealed by erosion. Their mass and solemnity evoke Egyptian art. The work can convey a sense of vulnerability or entrapment but at the same time persistence or endurance. While endurance can be ennobling, there is also a quality of stoic suffering, and De Staebler seems to link private losses (indicated by missing body parts) with cultural losses (indicated by reference to antique sculptural forms).[49]

Over the years De Staebler worked at reducing the mass of clay, finally eliminating context to make Figure Columns. Without archaic references, these recall the work of Wilhelm Lehmbruck and Alberto Giacometti. Other works consist of body parts, usually legs. Late bronzes, avoiding the difficulties of structural support presented by clay, incorporate movement or gesture. In general, De Staebler is drawn to the "deepest elements of human experience: loss and rebirth, entropy and energy, grief and healing."[50]

Mary Frank works in many mediums, mainly painting. During the 1970s and early 1980s, she made ceramic sculptures so effective and so sensitive that they were more than visits to the medium. She created incomplete figures of several terra-cotta slabs, defined by contour and incision. (Figure 9.18) The face might be clearly indicated, but the slab spreads out beyond the depicted cheeks and forehead, as if this partial body was continuous with the rest of nature. Frank sometimes posed the sculptures outdoors, where they seemed to be merging into the natural environment.

The bodies, despite their fragmentation, convey movement and sensation. Eyes are often shut; the figure seems turned inward and concentrated on receptive experience. When they stand, they seem to be caught in a moment of dance, but their more natural posture—unusual for sculpture—is reclining so as to resist nothing, not even gravity. Frank may have meant the figures to be mythical, since her subsequent painting has focused on archetypes.

Frank credits Margaret Israel and Reuben Nakian for showing her the expressive qualities of clay and Jeff Schlanger for helping her accomplish the work. The clay remained natural in her sculptures, without glaze or paint in the service of her characteristic themes: "woman as a figure of passion and compassion, dance and motion as indicators of emotional state, the coming together

FIGURE 9.18. *Mary Frank*, Woman, 1975. *Stoneware; 23 × 96 × 12 in. (Collection of Agnes Gund. Art © Mary Frank. Photograph © William Suttle.)*

of plant, animal and human life, and the influence of dreams and visions on our conscious lives."[51]

VESSEL LANGUAGES

Ron Nagle's prominence in the last few decades makes it hard to believe a tale of difficulties and lack of recognition when he started out. His greatest satisfaction then was being included in John Coplans's *Abstract Expressionist Ceramics* show in 1966, although his work was hardly expressionistic. Finally his career blossomed; he received the San Francisco Art Institute's prestigious Adaline Kent Award in 1978, the same year he began a long academic career at Mills College after years of occasional and itinerant teaching.

Nagle (b. 1939) started out with an interest in jewelry and in music, and the latter has persisted (he has written songs for major vocalists, produced his own recordings, and created sound effects for some well-known movies). At San Francisco State College, he became increasingly devoted to ceramics, and he took a summer course at the San Francisco Art Institute with Henry Takemoto, which introduced him to the work of the Otis gang. He immediately responded, trying to copy everything. After graduating in 1961, Nagle applied to the graduate program at Berkeley with Voulkos but was rejected. Voulkos hired him as a studio assistant and gave him a place to work. Technically he was never Voulkos's student, but he nevertheless was influenced by Voulkos, particularly by his personal style, from his cowboy boots to how he lit his cigar, and as a rebellious kid, he exulted in the impudent behavior of Voulkos's past. The adulation, however, did not extend to echoing his work.

Perfume Bottle (1960) is Nagle's earliest important piece in the history of California ceramics. It is about two feet tall, dark and rough-surfaced with two glaring green handles, and capped with a stopper as tall as the bottle that resembles tombstones or biblical tablets. The exaggerated scale plus the ominous and absurd form show a kinship with the work of another Voulkos associate of the time, Jim Melchert.

Nagle switched to small size and color concentration, so over the years his works have regularly been linked to Price's. Only in the cup form that engaged each of them for a while has there been any close overlap. Nagle restricts himself to china paints, which were still stigmatized as the material of hobbyists when he began to use them. He tried out the materials his mother used in a china-painting club, applying them in unorthodox ways, airbrushing, developing lusters, refiring up to thirty times to get layered hues. (Figure 9.19)

Nagle's preferred colors are associated with California design, recalling pottery of the 1930s, bright Latino styles, stucco architecture, swimming pools, linoleum motifs, and hot-rod detailing. His early cups were displayed in vacuum-formed and flocked liners in wooden boxes that set off the diminutive scale. During the 1970s he further abstracted the cups, until a mass-and-extension configuration was all that remained of cup-and-handle format.

Nagle's forms are slip-cast but one-of-a-kind. Color and form are artificial and self-conscious, giving the works a precarious tone of doubt, with beauty on the verge of bad taste. The meaning sits on the surface, one writer noted critically.[52] Yet that seems a valid contemporary and American stance. Nagle's commitment to high craft was an independent path, starting, as he did, in the era and neighborhood of funk. He told an interviewer: "You gravitate toward whatever moves you and then you run with it. It was all intuitive. . . . I'm attracted to the

FIGURE 9.19. *Ron Nagle, 55, 1975. Cast earthenware, glaze, multifired china paint; 4 × 3 × 3 in. (The Scott & Kolleen Mathews Collection. © Ron Nagle. Photograph by Don Tuttle.)*

FIGURE 9.20. *Richard De Vore, Bowl, 1978. Stoneware, low-fired overlays; 4.75 × 11.25 in. (Collection of Karen Johnson Boyd, Racine, Wis. © Estate of Richard De Vore.)*

format emotionally. It's appealing to me on a real dumb, basic level."[53]

Richard De Vore (1933–2006) began to develop his distinctive style of metaphoric vessel around 1970 and continued it for the rest of his life. (Figure 9.20) There were times when people muttered about monotony, but it was a futile complaint. Despite the fact that he essentially made only a shallow bowl, a tall vase, and a form in between the two and used only earth colors and dryish surfaces, he could not have exhausted the resonance of his forms, surfaces, and colors if he had lived decades more, because they allude to both landscape and the body, and in a sense, that is everything.

De Vore expected to become a painter, but while studying for his MFA at Cranbrook, he was encouraged by Maija Grotell to change his focus to ceramics. He taught at Flint Junior College until 1966, when Grotell retired and he replaced her. He then reconsidered his work, trying to get beyond fads, looking at ancient Anasazi and Mimbres pottery. A stone that he picked up on a lakeside vacation set him off: its rose blush had the color of life, and the surface showed the effects of slow geological change.

Through painstaking layering of transparent glazes and exacting placement of crackle, De Vore developed a surface and a palette, from black to pink, that suggested both earth and skin. He constructed forms with indentations and protrusions evoking body contours. He made false bottoms—sometimes three layers visible through irregular openings—and odd interior folds. His irregular rims were paths for the eye to follow, and he sometimes created incisions or punctures that provided an alternate—and somehow intimate—view. The vessels con-

veyed both masculine and feminine identification. As if to confound these immediate and palpable associations, De Vore avoided any direct expression of emotion, any sign of the maker's hand, creating an abstract and intellectual balance. His remarkable feats were to make work simultaneously large and small in scope and to make the austere sensual.

German, British, American: **Ruth Duckworth** (1919–2009) created her identity from change and chance. Born Ruth Windmüller in Hamburg, she wanted to go to art school, but in Nazi Germany that was not allowed because her father, although raised Christian, was of Jewish descent. In 1936 she joined an older sister in England and studied drawing, painting, and sculpture at the Liverpool School of Art. During the war years she was a puppeteer and worked in a munitions plant; she then studied stone carving in London and supported herself for a time as a carver of tombstones. She married sculptor and product designer Aidron Duckworth in 1949 (they divorced in 1966). In the mid-1950s she became interested in clay and, at the suggestion of émigré ceramist Lucie Rie, went back to school.

When an artist finds the right medium, things begin to happen. Duckworth had loved stone carving but never sold anything. Her ceramic sculpture found immediate response and sales, too. About 1960 she began teaching part-time at the Central School of Arts and Crafts in London and also had her first solo show of ceramics. Her coiled stoneware did not aspire to symmetry but had a kind of botanical logic in its sculptural swelling. This work differed from conventional pottery in its rough naturalness and relatively large scale (she was a very small woman), and her "weird" small porcelains also es-

FIGURE 9.21. *Ruth Duckworth*, Untitled 13975 (detail), *ca. 1978. Porcelain on plywood, epoxy, acrylic paint; 20.25 × 82 × 16 in. (Collection of Museum of Contemporary Arts, Chicago, Gift of Sylvia and Joseph Radov. © Ruth Duckworth Studio.)*

caped the norm. Both bodies of work offered an exciting new model.[54] Her reputation spread as far as America, and in 1964 the University of Chicago invited her to teach for a year. She arrived in Chicago at age forty-six and remained for the rest of her life. After thirteen years she left teaching for full-time studio work.

Duckworth was most interested in coming to America for the chance to work in large scale. Soon she talked her way into a commission for the walls and ceiling of the entry to the university's Geophysical Sciences Building; *Earth, Water, and Sky* (1968) was inspired by satellite images given to her by a meteorologist.

Even as Duckworth was working at this environmental scale, she was also producing abstract vessels in stoneware and porcelain. Her first important freestanding sculptures, from 1966 through the 1970s, were based on bone forms. She soon engaged other organic shapes such as gourds and horns. Her larger Mama pots, their craggy surfaces stained with earthy oxides and coated with mat glazes, are often cleft into pairs like the lobes of the brain, or buttocks or breasts. Her porcelain wall reliefs are frequently divided into quadrants and further subdivided into curving, almost interlocking plates with contours and holes that imply secrets and unknown dimensions. (Figure 9.21)

In addition, she later created a large body of very small works, some hand size. The most incisive are the Cup and Blade series, in which a simple volumetric form receives a flat, sharply cut shape that splits the space (again, this favored theme). (Figure 9.22) "However elegant and seductive these may be, contrariety and even a sort of contained violence are their essence," the critic Barry Schwabsky has observed.[55] Her porcelains have probably

FIGURE 9.22. *Ruth Duckworth*, Untitled (Blade Cup), *1994. Porcelain; 8.75 × 5 × 3 in. (Los Angeles County Museum of Art, Smits Ceramics Purchase Fund. Art © Ruth Duckworth Studio. Photograph © 2007 Museum Associates/LACMA.)*

been her most admired work; their unglazed surfaces are quite unlike the shiny porcelains of China and Europe and recall works in marble, such as ancient Cycladic sculptures.

In age and inclination Duckworth is of modernist lin-

FIGURE 9.23. *Wayne Higby*, Return to White Mesa, 1978. *Earthenware, raku-fired; 12 × 22 × 13.5 in. (© Wayne Higby.)*

eage. Her forms recall the sculptures of Henry Moore or other biomorphic abstractionists, and they are also kin to the diminutive vessel sculptures of her friends in England, Lucie Rie and Hans Coper—elegant, reductive, timeless. A sense of female sexuality comes up in any discussion of her work, which one would not say of the others: Moore may have depicted the look of the female body, but Duckworth conveys the existential feeling of it.

Wayne Higby is another in the long line of important teachers at Alfred. His work has been mostly raku-fired earthenware, and he quickly chose a focus on idealized or remembered American landscape. (Figure 9.23) Higby's first landscape innovation was a box structure with mountains on the lid and clouds inventively held above them by means of a block of lines representing rain. He also constructed sets of attached container forms on which are drawn simplified or romanticized western vistas. He is best known for bowls in which imagery of canyons and distant winding rivers is carefully calibrated to confound the viewer, offering near and far perspectives from inner and outer surfaces.

Higby (b. 1943) remembers an idyllic youth filled with long, solitary horseback rides in the magnificent landscape around Colorado Springs. He turned to ceramics after visiting the Heraklion Museum in Crete during a college *Wanderjahr*. He studied with George Woodman at the University of Colorado, Boulder, and with Betty Woodman in Parks Department classes; he did his graduate work with Fred Bauer and John Stephenson at the University of Michigan.

The landscape around Alfred has not been reflected in his work, possibly because its gentle contours lack the drama of the West. He later took the landscape bowl series into distorted forms and darker color referring to the rocky seashore at the Haystack Mountain School

of Crafts, where he has taught and served on the board. More recently, after traveling to China, he adopted celadon-glazed porcelain for forms resembling rock escarpments but incised with representations of various surfaces and perspectives of Lake Powell, a dam-flooded canyon in Utah.

VIEWS FROM ABROAD

Jun Kaneko (b. 1942) came from Japan to the United States in 1963 to study painting and, through a connection with Jerry Rothman, had the opportunity to house-sit for Fred and Mary Marer while they were traveling. Alone among the tactile and painterly objects of the Marer collection, he was converted to clay.

Kaneko showed a gift for graphic clarity and color contrasts more related to Japanese design than to ceramics. It can be seen in an early dark plaque with a red line like a cursive *U* flowing across it and a black handprint in the notch. He has applied his painting background to the three-dimensionality of clay by making spatially invigorating works, beginning with his Sanbon Ashi series of the late 1960s and early 1970s. (Figure 9.24) These three-legged forms with vibrant color and pattern are shown individually or knotted together in a row, like dancers doing a kick routine. The linear structure and color clarity of this work relate to op and pop art, and he has shown them on a stripe-painted floor to heighten the impact.

With his English improved and his work exciting much interest, Kaneko found teaching opportunities at Rhode Island School of Design (1973–75) and Cranbrook (1979–86). His work has taken many forms. The Dangos (named after a Japanese dumpling) are vertical blobs that

FIGURE 9.24. *Jun Kaneko*, Untitled, Sanbon Ashi Series, 1971. *Ceramic; 4 different patterns, 4 works, each work 30 × 36 × 10 in. (Scripps College, Claremont, Calif., Gift of Mr. and Mrs. Fred Marer. © Jun Kaneko.)*

he has made up to 11½ feet tall; Parallel Sounds are enclosures of stacked bars made of nonwarping clay from a Japanese ceramic company. His work is not sculpturally inventive but creates power and presence through color and pattern.

Kaneko's oeuvre also includes paintings, drawings, a little glass and textile work, performances, earthworks, sound art, and installations. Its distinguishing quality is its experiential focus. At its most successful, it hooks viewers with its immediate visual appeal and then leads them to a sense of the sublime (in Western terms)[56] or the void (in Eastern understanding). The underlying meaningfulness of Kaneko's work makes it something more than crowd-pleasing exercises in design.

Tony Hepburn has been an important figure in American ceramics, first from London, reporting for *Craft Horizons* from 1969 to 1973, and then in America as a teacher at Alfred (1978–92) and Cranbrook (1992–2008).

Hepburn is a curious case: although committed to clay, he has always approached it as a sculptor. He has little interest in vessels. His oeuvre is so varied that it has not furnished a signature image. Some works reflect a notion of site, inspired by Stonehenge in England and other historic places: this type of work ranges from vertical assemblies with kivalike ladders to slabs with markings suggesting a primitive compass. Hepburn's works have their distinctive values but, like Jim Melchert's, they are the signs of the mind more than of the hand. This conceptual orientation and the deliberateness and reserve of much of his work distinguish him from his peers.

Hepburn (b. 1942) was educated at Camberwell College of Arts in London with Hans Coper and at London University. His early work was seen as akin to American, rather than British, pottery. In the 1970s his small sculptures employed slabs and solids to allude to scale. He used a simplified cup form on angled planes to call attention to volume, mass, weight, and gravity. (Figure 9.25) The sculptures were created by slicing, carving, inverting, or pressing. Similarly a Dome Mapping series of clay slats and glass sheets had to do with measurement, placement, and containment and can be related to the Nonsite works of Robert Smithson.

Subsequent works include ritual gates that combine clay, marble, slate, and sometimes wood; Rural Sculptural Allegory, using old tools and other objects to mirror his environment (in part an homage to Robert Turner); and riffs on contemporary forms, such as the contours of plastic detergent bottles. He has said, in his own, independent way, that his work is not about labor, craft, art galleries, objects, style, technology, theater, "truth to materials," authorship, difficulty, or allusion, and it is not

FIGURE 9.25. *Tony Hepburn*, Rock Island Line, 1977. *Ceramic; 10.5 × 13 × 7 in. (The University of Iowa Museum of Art, Iowa City, Gift of Joan E. Mannheimer, 1999-93. © Tony Hepburn.)*

idealistic.[57] Yet it is certainly thoughtful and provocative, an uncommon body of ceramic work.

Jewelry, Metals, and Enameling: Pluralism Takes Over

For studio jewelry and metalsmithing, the 1970s was the decade of the thirty-five-millimeter slide. As in all craft mediums, the dominant paradigm was self-expression, but the field increasingly looked within for its influences. Most college teachers had a collection of slides that they showed to students. Teachers built their collections by copying images from books and magazines or by trading with colleagues. A star system began to emerge. Established masters like John Paul Miller and June Schwarcz were joined by radicals like J. Fred Woell and Albert Paley as the frame of reference for emerging jewelers and smiths, much more so than industrial designers, painters, or sculptors.

The burgeoning craft marketplace provided a good living for many young jewelers—only ceramics was more popular. Some studio jewelers, like Ed Levin and Ron Pearson, had six to ten employees working under a shop foreman. The bulk of production jewelry was made of silver, and the use of semiprecious stones was common. A few studio jewelers developed a clientele for gold and gems; the greater profit made possible by using expensive materials was very attractive.

The silver industry went into a rapid decline in the 1970s. First, silver was released from the last vestige of price controls and became sharply more expensive by the end of the decade. Second, American factories could

not compete with the lower labor costs overseas. Domestic production plummeted. A few midsize companies survived, but their taste for experimentation vanished. Industry made a few last-ditch attempts to reach out to studio metalsmiths. In 1977 Reed & Barton introduced the Signature V Collection, attempting to capitalize on the artistic reputations of five well-known jewelers. Glenda Arentzen, Arline Fisch, Ronald Pearson, Mary Ann Scherr, and Lynda Watson were asked to submit designs for silver jewelry. Reed & Barton produced twenty designs and marketed them nationally, but it was not an unqualified success.

ALBERT PALEY

One man's influence was felt throughout studio metalsmithing in the 1970s. Albert Paley (b. 1944) was highly opinionated and extraordinarily skilled, and this combination served him well. He went to Tyler School of Art, and though he had little prior training, his gift was recognized immediately. He explored casting for a while but rejected the technique as too indirect—he preferred the immediacy of construction and forging. He believed that jewelry could serve personal and public purposes: "Contemporary jewelry . . . allowed you to express yourself as an individual. It projected an image of nonconformity which was an important aspect of the '60s social revolution."[58]

Following the lead of his teacher, Stanley Lechtzin, Paley became interested in historical jewelry, particularly the fibula. He admired the way form and mechanism were unified in an organic whole. The ideal of the organic became his theme, not just in flowing vegetal lines but in working methods.

Although Paley was a good draftsman, he rarely made study drawings for his jewelry. Instead, he set up a problem for himself—how to use a new technique like *mokume-gane* (layers of contrasting metals fused together and manipulated to resemble wood grain) or how to refresh trite jewelry forms like the circle brooch—and simply started working. Given the complexity of his later jewelry, his off-the-cuff approach to design is astonishing. He would make parts, rearrange them on his desk, and modify until each composition was complete. Generally a Paley brooch or necklace is a carefully balanced set of contrasts: blackened silver against gold, transparent stones against opaque metal, lines against swelling surfaces. (Figure 9.26)

Paley was a brilliant technician, too. He forged thick sheet metal into convoluted surfaces with ruffled edges. He worked rods into long tapers, which he curled into

FIGURE 9.26. Albert Paley, Pendant, 1973. Forged, fabricated, pierced, and carved copper, sterling silver, 14-karat gold, ivory, labradorite, moonstone, jade, glass; 22 × 8 × 1.75 in. (The Renwick Gallery of the Smithsonian American Art Museum, Gift of the James Renwick Alliance and Museum Purchase through the Smithsonian Institution Collections Acquisition Program, 1991.135. © 2009 Paley Studios Ltd.)

whiplash lines reminiscent of the art nouveau ironwork designs of Belgian architect Victor Horta. Paley's jewelry was eye-popping in its complexity, and it was big. Most body jewelry (like Arline Fisch's) consisted of simple modules linked together somewhat like chain mail, but Paley's largest necklaces cover the body from shoulders to waist, absolutely dominating the torso.

Some observers criticized him for reducing the women who wore his jewelry to walking pedestals. Typically a Paley piece demanded a simple black top with a high neck and basic black pants or skirt. Clothing could not compete with his jewelry. Most of it was worn for special occasions and became the center of attention. He wanted it to be worn by strong, confident women who were not afraid of spectacle.

Paley had an immediate impact on studio jewelry in America. Every ambitious young jeweler had to make a generously proportioned neckpiece to prove his or her chops. For more than a decade, jewelry exhibitions were crammed with baroque extravaganzas, overburdened with virtuosity. None of it equaled Paley's.

FIGURE 9.27. *Richard Mawdsley, Medusa, 1979–80. Fabricated sterling silver, lapis luzuli with repoussé head. (© Richard Mawdsley.)*

the Scarab Vase; 1910–11), his works are repositories of endless hours of labor.

An early piece, the *Feast Bracelet* (1974), reveals Mawdsley's astonishing powers of concentration. He calls it a "genre scene." Spread out along 4½ inches of a silver tabletop are the remnants of a silver banquet: a wine bottle in a cooler, an artichoke on a compote, a pie with every berry carefully soldered into place. The table and the architecture that supports it are lined with hundreds of bits of tubing in a decorative frieze. This amazing object is now in the craft collection of the Smithsonian American Art Museum in Washington, D.C.

Mawdsley must have feared that the intensely detailed miniature might be too reminiscent of dollhouse furniture, for he never made another quite so literal still life. He turned to pendants that depict masklike female faces, with abstract bodies and headdresses. The expressions are frozen into stiff smiles, and the eyes and mouth open into empty space. The effect is perhaps most peculiar in *Medusa* (1979–80). (Figure 9.27) True to the subject, the grinning mask has sprouted a mass of writhing hair. The body resembles a machine as much as a human torso. Three pairs of ribs curl forward, enclosing no heart but revealing a spine. Armlike appendages dangle from her sides. At the base of the spine sits a domed piece of silver, which sprouts more restless hair. The joke— that Medusa's pubic hair must have consisted of snakes, too—is as unsettling as the rest.

RICHARD MAWDSLEY

Another of the most original American jewelers is Richard Mawdsley (b. 1945). Mawdsley came to the medium inadvertently: when he was a sophomore at Kansas State Teacher's College, all the art classes were filled except jewelry. He took a course and discovered that it suited him perfectly. A shy young man with an active fantasy life, he developed imagery of pipes and gears, the machine elements reminding him of his grandfather's farm and old equipment rusting out by the barn. Mawdsley began to make quasi-mechanical contraptions in silver. They were brooches and necklaces for the most part. By the time he earned an MFA in 1969, he had developed a unique way of working.

The first thing that strikes a viewer about a Mawdsley piece is its excessiveness. He works primarily with tubing: hundreds and hundreds of tiny pieces, soldered together in extraordinary accretions. Triangular tubes, bent tubes, twisted tubes, fluted tubes, twisted *and* fluted tubes: all permutations are present in abundance. Like Adelaide Alsop Robineau's *Apotheosis of the Toiler* (also known as

MARY ANN SCHERR

One of the best indicators of the diversity of American jewelry in the 1960s and 1970s was the tremendous variety in attitudes toward technology. Some metalworkers revived and extended old techniques, while others looked to industry. Mary Ann Scherr (b. 1921), more than anyone else, melded high technology with jewelry.

Scherr worked as a designer, although she had no formal education in the field. She devised posters for various clients during the war and then worked with her husband's firm, Scherr and McDermott Industrial Design International. For one of the firm's first big projects, a stove for the Tappan Range Corporation, she became involved in the intensive research required by the commercial project, and research continued to be important to her work.

In 1949, while at home with her infant son, Scherr took a night class in jewelry making at the Akron Art Institute. Within two years, she was teaching all the jewelry courses there and was teaching at nearby Kent State University, too. She made numerous industry con-

FIGURE 9.28. *Mary Ann Scherr, Heart-Pulse Sensor Bracelet, 1972. Gold, sterling silver, electronics; length, 3.5 in. (© Mary Ann Scherr.)*

tacts, including a commission from U.S. Steel to fabricate stainless-steel jewelry. She figured out how to etch stainless steel, which experts said could not be done. Stainless has been one of her favorite metals ever since.

In 1969—while watching a broadcast of the first moon landing, including live feeds of Neil Armstrong's pulse and breathing—Scherr was struck by the thought of jewelry that monitored bodily functions. By coincidence, she was making a space-themed costume for the 1969 Miss Ohio. Scherr contacted research scientists at Kent State and elsewhere and assembled teams to design and make circuitry and outputs that could be incorporated into wearable objects.

The first problem was miniaturization. For one of Scherr's projects, a pendant that measured air quality, her engineering consultant reduced the electronic component from a wall of electronics fifteen feet long to a mere seven by three inches. Later body monitors would use miniature video displays, light-emitting diodes, and fiber optics, all technologies then in their infancy. By 1979 Scherr had assembled eleven ingenious working prototypes, all addressing particular health concerns. One was a portable electrocardiogram, another a smoke detector. One of the most spectacular had a color video display that visualized the wearer's heartbeat as rings of pulsating color. Scherr's body monitors were unique and far ahead of their time.

Heart-Pulse Sensor Bracelet (1972) compared the wearer's heart rate with a given baseline; if the rate was too far off, an alarm would sound. (Figure 9.28) A little container was provided for medication. Most designers would have encased the high-tech circuitry in a bland container symbolizing scientific efficiency. But Scherr, like many American industrial designers before her, felt

the visible parts of devices should appeal to customers, so she covered the silver bracelet with ornamentation. Instead of reading as a medical device, Scherr's *Sensor Bracelet* was boldly decorative.

She hoped that the body-monitor jewelry could be manufactured someday, but it never happened. Companies were afraid of lawsuits should the devices fail. Bloomingdale's wanted to retail her *Waist Watcher* belt, which beeped when the wearer slouched, but did not order sufficient quantities to justify development costs. Ironically, now that her patents have expired, several companies are exploiting her ideas.

Scherr produced thousands of pieces of jewelry over the years, most intended simply to decorate the female form. Her body-monitoring jewelry showed that handcraft and high technology can be allied and refuted claims that handwork necessarily turns its back on progress.

KEN CORY

Ken Cory (1943–1994) could be regarded as the one true funk jeweler: he was in San Francisco at the right time, and he epitomized funk's nonconformist stance. Cory, who attended California College of Arts and Crafts from 1963 to 1967, was a prankster at heart, so his jewelry often made wry jokes. Like other art students at the time, he rebelled against the dominant abstract expressionism. The logic was simple: if ab-ex was huge, work small. If it celebrated the splashy gesture, be meticulous. If it was grimly serious, plant your tongue in your cheek.

Nevertheless, just as art followed art, Cory determined to make jewelry about jewelry. In the 1970s Navajo jewelry was highly desirable among Anglo collectors, and fake Navajo jewelry was widely available. Cory satirized both real and fake with his *Squash Blossom Necklace* (1974). He followed the basic form closely, but the blossoms are flashlight bulbs and the crescent-shaped *naja* is a pencil that appears to have been bent into a horseshoe. Instead of silver beads as spacers, Cory used .22 caliber shells. The combination of affection and sarcasm is typical of his work.

Throughout the 1970s Cory produced belt buckles and brooches. Most of his jewelry is small, possibly a contrarian response to body jewelry as well as to abstract expressionism. There is always a flavor of the absurd and the satirical. One brooch depicts a parrot on a perch, encircled by the caption, "Fuck you lady, said the parrot." Another pin, only three-quarters of an inch wide, depicts a dog sniffing a red high-heeled shoe. Cory's irreverence was also manifested in lowbrow objects: measuring spoons, a comb, a Scotch tape dispenser.

With his collaborator and buddy Les LePere, he made

FIGURE 9.29. *Ken Cory*, Tape Measure Case (Side Two), *ca. 1980. Sterling silver, turquoise, bone, steel tape; 2 × 2 × .74 in. (© Beverly Cory for the Estate of Ken Cory.)*

enameled light-switch plates. The "Pencil Brothers," as the two called themselves, collaborated in 1976 on an enameled ashtray called *Match*. (Most studio metalsmiths refused to make ashtrays, fearing their associations with summer camps and hobbyists.) Constructed of copper and enameled in the champlevé technique, the ashtray depicts a pencil, a thermometer, a bent nail, and an asparagus stalk. The bowl of the ashtray shows hammer marks, a dig at Arts and Crafts lineage. In a final twist, Cory's opaque colors are peppered with impurities. No doubt he knew exactly what he was doing: offending propriety was the heart of funk.

Cory subscribed to the hippie uniform of long hair and, often, overalls. In one of his pockets he carried a tape measure for which he had made a silver case. (Figure 9.29) After years in his pants, it acquired a soft patina of age and use. Each side had a cartoony female face. The story is that they are portraits of two women who were angry at him: each has prominent gnashing teeth.

Cory's sense of humor was sometimes bawdy, which some people found annoyingly adolescent. Still, his work is an incisive representation of his time and place. He died from complications of diabetes when he was only fifty.

FUNCTIONAL METALSMITHING: FRED FENSTER

While the trend in all the crafts during the 1970s was toward greater ambition, not everyone went along. One metalsmith who purposely limited himself to modest functional objects was Fred Fenster (b. 1934). Fenster grew up in working-class Bronx. While he was attending City College, a friend encouraged him to take indus-trial arts courses. The curriculum was a typical manual arts program: along with "metal arts," he studied casting, machining, and other industrial technologies. Fenster was inspired, and he learned as much as he could about metalworking. After graduation, he taught shop in a tough Bronx high school for two years, then earned a Cranbrook MFA and settled into teaching at the University of Wisconsin, Madison.

While at Cranbrook, Fenster saw a student from Norway using pewter. Responding to its malleability and the speed with which it can be worked, Fenster wrote his graduate thesis on the material. In later years he would conduct hundreds of workshops on pewter, boosting its popularity among studio metalsmiths.

Fenster loved all metals, though, and he tried his hand at most of the common ones, as well as sampling the traditional forms of smith and jeweler. Over the years, he produced silver and gold jewelry, silver teapots, copper cooking pots, ironwork, vases, tableware, candlesticks, liturgical silver, and pewter. His was the last generation of academically trained smiths who had to struggle to learn technique. Fenster set up his own program to learn hammer work. He made dozens of pieces of hollowware, each one more difficult than the last.

Like most metalsmiths trained in the 1950s, Fenster embraced Scandinavian modernism. While he did not eliminate decoration, he felt that it should be incorporated into structure. A pewter cream pitcher from 1974 epitomizes his approach. (Figure 9.30) It sits on the table and does its job without pretensions to importance. He said: "I don't think of myself as an artist. I think of myself as a craftsman. There's a need, you have some skills, so you sit down and you fill the need, you know. Every once in a while, something is better than you expect it to be and that pitcher was one of those things. Nothing earth-shaking, just a nice plain piece that does the job."[59]

The creamer is more than a nice plain piece. Everything about it is balanced and resolved. The handle lifts up and outward in pleasing contrast, terminating in an amusing pigtail that adds a rhythmic detail. Body and handle merge in a gently curving edge and a swelling lip. Fenster made this creamer as a gift for his wife, and his emotions are commemorated in the heart-shaped fillip at the base of the handle. It is workmanlike but also a beautiful example of how a handmade object in a domestic setting can be satisfying—and meaningful—on many levels.

Fenster made a substantial body of ceremonial metalwork as well. One of his best designs is a kiddush cup, used for the ritual drinking of wine during the Jewish Shabbat. A cup sits on a tapered base, much like an ordi-

FIGURE 9.30. *Fred Fenster,* Cream Pitcher, *1974. Sheet pewter with cast and forged handle; 7 × 5 × 3 in. (© Fred Fenster—Maker and Photographer.)*

nary chalice, but Fenster folded the bottom edge of the cup into six deep creases—seen from above, the Star of David is revealed. Thus an ingenious technical device makes an otherwise ordinary object special. Fenster noted that his kiddush cups become instant heirlooms. They focus on family and cultural identity in the present and become repositories of memories in the future. In modesty lie great possibilities.

SILVERSMITHING: JOHN PRIP

A jeweler or a silversmith could be successful in various areas: teaching, production, industrial design, even sales. Only one American, John Prip (1922–2009), excelled in every aspect. Born in New York, Prip grew up amid silversmithing. His Danish father was a smith; his grandfather owned a silver factory. It is said that his childhood toys were hammers and stakes. The family returned to Denmark when Prip was ten, and he was apprenticed to the trade at the age of fifteen. He received a sound technical training that made no demands on his imagination. "You did what you were told," he said.

In 1948 the School for American Craftsmen (SAC) was

looking for a new silversmithing teacher. (Philip Morton had the nerve to emphasize the expressive possibilities of metal and was fired.) The school's director, Harold Brennan, wanted a man who would fulfill its mission of training students to make a living as smiths. Feeling that the best candidates came from abroad, he recruited Prip.

At first, Prip stuck with the Danish style. His *Onion Teapot* (1954) exemplifies his skill as a designer and a smith. The squat onion shape of the body is beautifully made: the perfectly smooth surface was the product of many hours of careful planishing and polishing. The forged handle is an innovation. Normally teapot handles are carved of an insulating material like wood or bone and riveted to the body, but carved handles are thick. Here, Prip made the handle a thin metal line that echoes the silhouette of the body. (Rattan provides insulation.) The only disjunctive detail is an obtrusive flat hinge for the lid. Presumably Prip decided to have his lid swing away from the opening, to make filling and cleaning easier. Such are the compromises encountered in designing for use!

In 1954 Prip left his teaching position to work as a full-time craftsman and designer. He had already cofounded Shop One in Rochester and was producing jewelry and silverware to sell there. In partnership with Ronald Pearson from 1954 to 1956, he designed jewelry for a local manufacturer, the Hickock Corporation. At one time the team had designed both Hickock's best-seller and its worst seller, a fact that Prip recalled with amusement.[60]

In 1957 silver manufacturer Reed & Barton hired Prip as its designer-craftsman in residence. In this unique arrangement, he was given a factory studio, materials, and access to consult with skilled craftsmen. His job was to make prototypes, models, and drawings, all with the goal of production. The company imposed no other restrictions. It was a fruitful relationship: several of Prip's designs remained in production for more than twenty years. He moved on in 1960, eventually to teach at the Rhode Island School of Design (RISD).

Prip was intrigued by the freedom of American craft, especially when compared with the trade work he knew back in Denmark. He said, "The technical quality of American work wasn't very good, but it was done with spirit and determination and very often with a great deal of imagination."[61] When Frans Wildenhain arrived at SAC in 1950 and infused the school with his attitude that craft was a legitimate expressive medium, Prip took note, unusual for a man who came up through the trade. He adopted a spirit of experimentation. His *Leaking Box #1* (1970) consists of geometric shapes that seem to be oozing molten metal. (Figure 9.31) The textured surface

FIGURE 9.31. *John Prip*, Leaking Box #1, *ca. 1970. Silver, bronze. (Collection of Daphne Farago. Courtesy of Museum of Art, Rhode Island School of Design. © John Prip.)*

on the cube and its dome would have been unthinkable twenty years before, when everything was polished to a mirror finish. Here, the polish is confined to making solid metal look fluid.

Prip taught at RISD until 1980, powerfully influencing several generations of students. His teaching methods were legendary. He might not talk to students for weeks and then walk around the empty studio one night rearranging the works in progress on his students' desks. In the morning they would find Prip's silent critique waiting for them.

HEIKKI SEPPÄ

Some silversmiths in the 1970s turned their attention to sculpture. One of them was a true individualist, Heikki Seppä (b. 1927). Seppä tried to assemble a systematic rationale for making sculpture with various smithing techniques, and to illustrate his theories, he produced one of the most eccentric bodies of work ever made by an American smith. (Figure 9.32)

Seppä learned smithing in his native Finland, honing his craft in various production centers in Scandinavia, in-

cluding the Georg Jensen shop. After immigrating to the United States, he earned a graduate degree at Cranbrook and took a teaching job at Washington University in Saint Louis. Over a period of years, he lost confidence in the future of silversmithing as he considered the problem of tarnish, changing lifestyles, and industrial competition. He believed that people would become more interested in complex, expressive objects and concluded that the future for silversmiths lay in sculpture.

To that end, Seppä developed a range of innovative hammer techniques. His first invention was a long, tapered tube (essentially an elongated teapot spout) that he could bend without collapsing it. He investigated techniques of subtly pinching sheet metal on specially shaped stakes. His techniques were faster and produced some interesting shapes—saddles, twists, funnels, and grooves. At the same time he developed a distinctive vocabulary of forms. A cup was a "domical form," his tapered tube a "spiculum." He aimed to free smiths from "rotational forms" (vessel forms symmetrical about an axis). He declared that all the traditional silversmithing forms were exhausted. The artist-metalsmith could take up Seppä's nomenclature and techniques to take "full advantage of the vast potential for developing new forms that the plasticity of metal affords."[62]

Seppä used most of the shapes he named at least once, and he tended to join numbers of them in a single work, without preparatory sketches or studies. He also had a taste for tricky effects: he once made a hollow knot out of sheet metal. He polished most of his sculptures to a high finish, which tended to dissolve his forms into networks of reflections. Because he used his sculpture to illustrate technique rather than to seriously explore form, it was often weak. The best of it had a peculiar sur-

FIGURE 9.32. *Heikki Seppä*, Untitled. *Sterling silver. (© Heikki Seppä. Photograph courtesy of Kent State University School of Art.)*

realistic energy of odd things oddly juxtaposed. Most of his sales came from jewelry and commemorative items.

In hundreds of workshops and a book, Seppä promoted his ideas. In the end, the hammer techniques he developed were best suited to jewelry. Used with restraint, spiculums and other Seppä shapes could be quite elegant. Jeweler Michael Good, for instance, has been very successful at applying and extending the techniques. As for his nomenclature, it was used only by the metalsmiths who adopted his techniques.

GARY NOFFKE

The first antimetalsmith was Gary Noffke. The development announced a certain maturity in the field, for two conditions had to be in place. First, there had to be a dominant ideology, and second, young practitioners had to perceive it as a set of propositions against which they could argue. This dynamic was seen in all the visual arts at the time. Minimalism was a critique of abstract expressionism, pattern and decoration was a critique of minimalism, and so on.

Noffke initially studied painting at the University of Iowa but switched to metalsmithing in graduate school (at Southern Illinois University, with Brent Kington). His paintings were packed with scribbled markings, and he simply transferred this approach to metals. Typically he made a simple, useful thing—a cup, a spoon, a pocketknife—in a familiar shape. The craftsmanship had none of the finesse expected of a trained smith. Then Noffke worked the surface extensively. He used simple, standard techniques such as chasing, stamping, onlaying bits of metal. He also made use of the flexible shaft, a tool rather like a dentist's drill, which could be used to carve into a metal surface. Every square millimeter of surface was encrusted with detail. This was not just decoration; it was obsession. He labored on the surface of the *18k Gold Goblet* for months. (Figure 9.33) In its 6¼-inch height, shapes, images, words, and textures jostle one another. Inspection reveals hearts, crosses, stars, sperm, and innumerable marks and signs. Part of the impact comes from knowing how much labor has been invested. In a sense the decorated surface is like stream-of-consciousness writing, like reading Noffke's mind.

In a metalsmithing culture still concerned with pleasing forms and perfect finishes, to pack so much ornament on a surface was an act of rebellion. Noffke spoke of himself as a reprobate, a scofflaw who refused to live up to standards of the Scandinavian ideal. He was saying that useful things could be clunky, crusty, and irreverent; they could be crammed with personality.

Noffke is selectively respectful: he loves the color and

FIGURE 9.33. *Gary Noffke, Gold Goblet, 1971. 18-karat gold raised with chased surface; height, 6.25 in.; width at rim, 4 in. (© Gary Noffke. Photograph by Evon Streetman.)*

luster of gold. He thinks it is possible to make something meaningful. Yet in other respects, he is satirical to the point of cynicism. He purposely misdates his work, for instance, hoping to confound future historians. His work may be an acquired taste, but his sincerity is beyond question. Noffke spawned a broad interest in surface embellishment, and he had a powerful influence on many jewelers, notably Robert Ebendorf. He later abandoned intense decoration for roughly made vessels and flatware in which the metal speaks for itself.

ENAMELING: JUNE SCHWARCZ
AND WILLIAM HARPER

To call June Schwarcz (b. 1918) an enamelist does her a disservice, because she uses many different techniques. In a career spanning more than half a century, enamel and copper have been constants for Schwarcz, but she has also used electroforming, patination, and metal plating.

Trained as an industrial designer at Pratt Institute before World War II, Schwarcz gave up the profession after she married and had children. She was introduced to enamels as a hobby in 1954, learning with three other

housewives around a card table. (One of them had taken classes from a student of Kenneth Bates.) Attracted by the colors, Schwarcz soon was selling items made from precut commercial blanks at local craft fairs. Not needing to make a living, she treated enameling as an artistic pursuit.

Schwarcz had done some etching in high school, so she tried etching her copper. Finding the commercial blanks too thin, she made her own copper shapes. She etched these heavily, using a variety of techniques drawn from printmaking. The textures she achieved were quite unusual, rich with allusions to natural processes of erosion. She layered transparent enamel over the etched metal in the *basse-taille* technique. While she was inspired by worm-eaten wood or the course of a stream through a field, her enamels were rarely representational.

Schwarcz quickly earned national recognition. In 1956 she met the curator of the not-yet-open Museum of Contemporary Crafts, Dominique Maillard, who told her, "You've restored my faith in enamels."[63] Her work was shown in the museum's debut exhibition. The next year she had her first solo show, and she began to exhibit and win prizes in the major ceramic shows.

By 1962 Schwarcz tired of *basse-taille* enamels. One day her husband, who worked at the Stanford nuclear research facility, brought home some very fine copper foil, so thin it could be folded and sewn like fabric. Schwarcz, an experienced seamstress, immediately realized that it could be shaped into vessel-like forms and stitched together with copper wire. It was too flimsy to enamel, but her husband introduced her to a technician at the Stanford linear accelerator plating shop, who taught her how to electroform. Not only did the plating stiffen the copper foil, but it also built up edges and lines into thick encrustations of metal. Here was an ingenious confluence of material and technique. The copper foil could look as fragile as a leaf or as brutal as concrete. Enamel added contrast, depth, complexity, or drama as needed. The stitched and enameled vessel became Schwarcz's preferred vehicle.

Through the 1960s the craft world grew increasingly professionalized. Thus it is important to note that Schwarcz's experiences as a hobbyist and as a housewife were essential to her artistic development. She has a rare lateral vision that allowed her to see extraordinary possibilities in the daily circumstances that others might dismiss.

Schwarcz's sense of beauty is very much of the modern world: gritty, sometimes harsh. She rejects prettiness, although she never seeks to overwhelm. Since she experiments so much, it is difficult to point to a typical

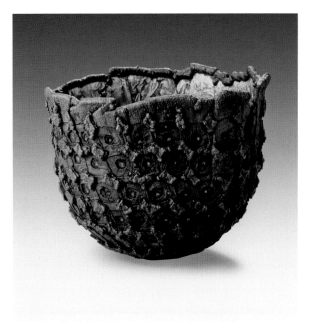

FIGURE 9.34. *June Schwarcz*, Plique-á-Jour Vessel #626, 1974. *Copper, enamel; 5.25 × 6.75 in. (Courtesy of Bernard Jazzar. © June Schwarcz. Photograph by M. Lee Fatherree.)*

vessel. She has squashed vessels immediately after they emerged from the kiln, giving them a dejected, off-kilter stance. She has tried raku, thrusting the red-hot enamel into acanthus leaves to force a reduction atmosphere. She has also been inspired by dozens of source materials, from Fortuny's pleated fabrics to Japanese prints.

Two elements, however, run through all Schwarcz vessels: a sense of fabric and an innovative use of enamels. Her *Plique-à-Jour Vessel* (1974) illustrates both. (Figure 9.34) It is formed like a pleated skirt upside down: the copper foil has been gathered, fold by fold, to generate the shape of a bowl. The fabriclike properties of the foil are recorded in the crumpled interior, the zigzag edge, and the pleats running down the sides. The interior is coated in transparent enamel, exposing the delicately wrinkled foil. On the outside, heavy electroforming adds a contradictory sense of encrustation. The surface is gridded like a printed fabric, and Schwarcz pierced the foil with hundreds of tiny openings that are filled with transparent blue-green enamel. When the object is lit from behind, each hole becomes a point of light. All this is packed into a composition only 5¼ inches high.

While Schwarcz was surely influenced by abstract art, she avoided the fraught relationship between painting and enameling that Kenneth Bates, Karl Drerup, and Paul Hultberg never managed to escape. Her vessels are emphatically not paintings and thus cannot suffer in the comparison. At the time, paintings (color field, pop) had grown to such huge proportions that modest-size enam-

els were lost in comparison. Many jewelers made cloi-
sonné enamels, usually tightly rendered drawings, boxed
in like precious stones. Schwarcz and a younger jeweler,
William Harper, however, changed the course of enamel-
ing. All the best enamelists of the next generation would
follow their example.

Harper (b. 1944) was a student of Kenneth Bates at the
Cleveland Institute of Art, and even before graduation in
1967, he won awards at the Cleveland Museum's annual
May Show. He started out as a high school art teacher,
but his enthusiasm for the job waned while his reputa-
tion as an enamelist grew. In 1973 he wrote a popular
how-to book on enameling, and the next year he moved
to full-time teaching at Florida State University.

Harper's abstract panels of the mid-1960s secured his
early reputation. After seeing Schwarcz's earliest enam-
eled vessels, he tried working in three dimensions, too.
A series of welded copper forms was not successful. At
Florida State, he was obligated to teach jewelry, a subject
he had ignored as a student. After immersing himself in
textbooks for a few months, Harper decided that he had
to make jewelry himself to have credibility as a teacher.

Concluding that small-scale work best exploited the
gemlike qualities of enamel, Harper focused on cloi-
sonné. Instead of using cloisonné wire to separate colors,
he treated it as an abstract linear element that could float
in the freely colored enamel surface. He cut the wires
from sheet metal so that they could be any thickness or
shape. Combining an off-the-cuff approach (he never
made preparatory drawings) with a sure color sense, his
revision of cloisonné was an eye-opener.

The Pagan Baby brooches (1977–78) were Harper's
breakthrough. (Figure 9.35) They were fibulas with
simple wire stems and joints prominently placed above
round or oval enamels. A collection of animal parts hung
below: beetle wings and a baroque pearl for one; a snake
rattle, pearls, and a shell for another. Harper asked his
audience to abandon their preconceptions and see these
materials for their rich visual qualities.

Later Harper used an array of found objects in his
jewelry: taillight reflectors, pop-tops from soda cans,
teeth. Of course, Picasso and Joseph Cornell used found
objects before Harper was even born, and both J. Fred
Woell and Robert Ebendorf were established found-
object jewelers, but nobody else made broken plastic look
so good.

Harper often spoke of his jewelry as having the quali-
ties of amulets and talismans. And yet it is obvious that
a Harper brooch cannot be a real amulet because he lives
in a culture that does not ascribe supernatural powers

FIGURE 9.35. *William Harper, "Pagan Baby #4: The Serpent"*
Brooch, 1977. *14-karat and 18-karat gold, silver, freshwater and
saltwater pearls, snake rattle, shell, cloisonné enamel, copper; 5.62 ×
3 × 1 in. (The Museum of Fine Arts, Houston, Helen Williams Drutt
Collection, Gift of the Caroline Wiess Law Foundation. © William
Harper.)*

to objects. Most Americans, and certainly white middle-
class Americans like Harper, have limited access to that
kind of faith. He is a tourist in the realm of talismans,
and so are his clients. There is no doubt, however, that
African artifacts fascinate urban Westerners as windows
into alien cultures that seem more closely tied to natu-
ral rhythms than their own. This idea of authenticity is
troubling, however. It is easy to forget, while dreaming
about a lost spirit world, that Westerners' relations with
tribal cultures have often been deadly and destructive.
Harper, like most craftsmen who trade in primitivism,
fails to take responsibility for the fantasy his jewelry
stimulates.

He is more articulate about the emotion he wants
his clients to feel when they wear his jewelry. The large
size and brilliant coloring of a Harper brooch are sure
to attract attention, so the woman (or man) who wears

it cannot be timid. Not everyone cares to be a center of attention; jewelry is, after all, sometimes employed as a badge of sameness. Wearing a Harper is like accepting a dare, and a certain sense of satisfaction comes from pulling it off. For several decades Harper was the most successful American studio jeweler. He was represented by prestigious New York galleries, and his work was widely imitated. Ambitious enamelists used to think big. After Harper, they thought small.

BLACKSMITHING REVIVAL: BRENT KINGTON AND ALBERT PALEY

In the 1960s blacksmithing was not exactly dying, but it was in full retreat. Most urban forges had closed, victims of the Depression, war, and the modernist attack on decoration. Every town used to have a blacksmith who made and repaired tools, produced hardware, and shoed horses, but village smithies were vanishing, too. At least farriers (horseshoeing specialists) prospered wherever there were horses to be serviced. Blacksmithing was perceived as a trade, and few people saw any potential for aesthetics or expression in it. Fred Fenster and Ronald Pearson both experimented with hot-forging in the 1960s but never concentrated on it. The man who drove the revival was **L. Brent Kington** (b. 1934).

Kington, who held an MFA from Cranbrook, taught at Southern Illinois University in Carbondale (1961–97). His early work was in casting. He made silver toys for his children, whimsical little cars and airplanes with fanciful, long-nosed drivers. Adults enjoyed them too, so he started producing them for exhibition. His experience with toys led Kington to a populist sense that art could and should delight and invite active participation.

In 1964 Kington visited the Metropolitan Museum of Art in New York and saw medieval armor for the first time. Most armor is iron, hammered into forms intended to ward off the blows of weapons, and few of the shapes related to anything in the silversmithing tradition he knew best. He resolved to try blacksmithing. Back home in Illinois, he scraped together a coal forge, an anvil, and a ragtag collection of tools. He sought advice from a few old blacksmiths in the area, but for the most part, he taught himself by trial and error.

By 1968 Kington produced his first two major works in steel, both enlargements of silver toys he had made. The two pieces took eighteen months to complete, but he was fascinated by the malleability of hot steel. He was used to raising and forging cold metal—a slow and incremental process of hammering, annealing, cleaning, and repeating. Steel heated to a red glow is soft, like butter in comparison to cold metal, and it can be pushed around with ease. As Albert Paley put it: "When [steel] is hot, it is extremely plastic and fluid. It is very submissive and yielding to a cause and effect response, a directness, and spontaneity. The paradox of the material is that one is able to visually record all this in a very hard, rigid, and permanent material."[64]

Kington invited Alex Bealer, the author of a new book on blacksmithing, to conduct a three-day workshop near Carbondale in 1970. About fifty people attended, many of them college teachers. Most had never seen a forge, much less tried working red-hot metal. Kington's workshop had the same effect on blacksmithing that the Handy & Harmon workshops had on silversmithing thirty years before. It prompted teachers to install forges in school workshops, and a few of them became quite skilled. Blacksmithing as a studio practice was on its way.

Most of the neophyte blacksmiths were enamored with forging out long tapers and bending them into coils and curves. Kington, however, was more interested in contrasts of thick and thin. He studied these contrasts in a series of weathervanes made from 1978 to about 1981. (Figure 9.36) A spike of metal emerges from a cylinder of darkened steel, twisting upward to a fine point. On it balances a single curling line, thick in the middle and tapering at both ends. A hollow disk at one end keeps the vane pointing in the wind, and the other end reaches much farther out. Not only is the asymmetry dynamic, but the whole vane swings and pitches. Kington's were not truly designed for outdoor use—they were painted, but steel rusts if left to its own devices. Indoors they re-

FIGURE 9.36. *Brent Kington*, Untitled #4, *ca. 1978.*
Mild steel; 37 × 59 × 26 in. (© Brent Kington.)

FIGURE 9.37. *Albert Paley*, Sculpture Court Enclosure for Hunter Museum of Art, Chattanooga, Tennessee, *1976. Steel; 11 × 85 × 14.5 ft. (Collection of the Hunter Museum of Art. © 2009 Paley Studios Ltd.)*

sponded to the slightest touch. Even with an abstract form, he found a way to engage people and invite them to play.

While he may have been the evangelist for blacksmithing, Kington never went beyond the idea of the lone artist-craftsman. Ironworking, however, had been a collaborative craft for centuries, mostly to produce architectural embellishments like railings, gates, and fences. That tradition had lived in the United States in large shops like Samuel Yellin's (see chapter 4), but by 1970 architectural blacksmithing seemed nothing more than a memory. **Albert Paley** revived it.

Like most college-trained metalsmiths, Paley learned to cold-forge silver and nonferrous metal, and he incorporated the technique quite often in his jewelry. In 1969 Kington came to Tyler, where Paley was a student, to demonstrate blacksmithing. Paley and his teacher, Stanley Lechtzin, were intrigued. They borrowed every book on blacksmithing they could find in the Philadelphia Free Library (none had been checked out since 1912!) and set up a forge in Lechtzin's garage. Over the summer the two taught themselves to hot-forge iron.

Paley started teaching at the School for American Craftsmen in 1969 and continued to investigate blacksmithing. His first efforts included candle stands, lecterns, and a few nonfunctional objects. At first, he enlarged the tendrils and scrolls that had already appeared in his jewelry. In 1973 he won a competition for a gate to be installed in the Renwick Gallery: two doors, 7½ feet high.

His *Portal Gates* for the Renwick were more elaborate than anything he had ever done and took a year to make, even with a former student assisting. Paley designed the doors as a series of rods that ran up the inside edge of the steel frame, each peeling off into a scroll or swirl. The two doors are mirror images, so nearly identical versions of every part had to be made. Maxing out all his credit cards to complete the gates, Paley achieved instant suc-

cess once they were installed. The Renwick Gates were widely publicized, and the world of studio metalsmithing was astonished. Few people had ever heard of Samuel Yellin at that time, so Paley's accomplishment seemed absolutely Herculean. Overnight he became the leading architectural blacksmith in the country, and a steady stream of commissions followed.

Paley topped the Renwick gates with his next commission, an eighty-five-foot-long fence for the Hunter Museum of Art in Chattanooga. (Figure 9.37) Its exuberance and sheer size were unparalleled in postwar metalsmithing. The fence consisted entirely of tapers, bent into short or long curves. At the corner, one taper shifts into the horizontal, drawing a circle in space around the post it springs from. Each taper also thickens radically at the bottom. It is an effect that can be achieved only with hot-forging.

Paley had to rent a large shop space and buy new tooling to accommodate the new scale, and he had to hire a full-time staff. His jewelry work fell by the wayside. (He felt that opportunities for recognition as a jeweler were extremely limited.) By the end of 1977 Paley was devoting all his energy to blacksmithing.

Textiles in Depth

Among the forms, techniques, and materials that characterized 1970s textiles were the miniature, the package, dyeing, paper, plastic sheeting, and architectural environments. Soft sculpture and felt were new.[65] Mildred Constantine and Jack Lenor Larsen identified a "New Classicism" in the 1970s, with symmetry, order, moderate size, a return to the wall, and little relief; they called it a shift away from the "charged, romantic expressionism of the 1960s."[66] The options of the time were so broad, however, that "romanticism" can be applied to the 1970s as well. Knotting was a fad at the beginning of the decade

but faded from the structural work of Françoise Grossen and others by the end of the period, to find new applications in smaller scale. The early focus on natural, organic materials in textiles yielded to exploration of new synthetics and plastics. The grid, natural to fiber structure, became an intensely influential theme in painting, drawing, and sculpture.

Americans came to dominate the Lausanne Biennial, which, in 1971, included Constantine as a juror. Among works by the ten Americans shown that year, not much looked woven. The jury broke precedent to accept *Fibrous Raiment*, a heavy open-knit work by Debra Rapoport, a wearables artist then teaching at Davis. She wore it at the opening, causing an uproar, and Jack Lenor Larsen speculated (correctly) that another garment would never be accepted. Rapoport reported on the event in *Craft Horizons*, saying that her works of this type were "formless in their development. A changeable form evolves when there is the involvement and participation of the human body."[67]

Major shows contributed to the sense of excitement in fiber, including Bernard Kester's *Deliberate Entanglements* at the University of California, Los Angeles (1971), the first international exhibition of large-scale fabric sculptures on the West Coast; a showing of American nonloom work, *Sculpture in Fiber* at the Museum of Contemporary Crafts (1972); Constantine and Larsen's *Wall Hangings: The New Classicism* at the Museum of Modern Art (1977); and the Cleveland Museum's big *Fiberworks* show organized by artist Evelyn Svec Ward (1977). Textiles found sympathetic audiences at commercial and noncommercial galleries all over the country, with a few venues concentrating on the medium, especially Hadler-Rodriguez Gallery in New York and Jacques Baruch Gallery in Chicago, which showed eastern European fiber and the work of a few Americans.

The Handweavers' Guild of America, founded in 1969, held its first Convergence conference in 1972. There were also smaller organizations here and there: the Association of Northwest Weavers' Guilds traces its history to conferences in 1957 and 1969 but became more formally organized in the 1970s. It had thirty-five member organizations by 1976 and still exists. Virginia Harvey played an important role in the first meeting, and in 1974 she and her husband organized HTH Publishers and resumed printing of the Shuttle-Craft Guild Monographs, which had been initiated by Harriet Tidball, successor to Mary Meigs Atwater.

Constantine and Larsen published *Beyond Craft: The Art Fabric* in 1973, emphasizing structural approaches and omitting surface-oriented work such as embroidery, appliqué, or printing. That was reasonable, because interest in what has since been called "surface design" had been minimal since the 1930s and 1940s. This was, however, yet another burgeoning aspect of the textile plethora of the 1970s. A conference on surface design in 1976 led almost immediately to formation of an association and publication of a periodical, *Surface Design Journal*.[68]

The return to surface design may, like wearables, have grown out of the hippie fashion for dyed clothing and richly patterned ethnic textiles in the 1960s. It presaged the rise of design in the 1980s, since the surface emphasis was amenable to commercial production as well as the creation of art. Larsen organized an exhibition and published a book called *The Dyer's Art: Ikat, Batik, Plangi* in 1976, and Yoshiko Wada introduced Japanese *shibori* techniques to the United States. The Surface Design Association, two years after its founding, sponsored a 1978 exhibition in conjunction with another conference. Some 500 people attended from thirty-seven states and Canada, and there were 364 entries to the exhibition. Clearly the interest was substantial.

FIBER INSTITUTIONS

Textile activity in the Bay Area was boosted in the 1970s by the establishment of two school-centers. The first was Pacific Basin School of Textile Arts, founded in 1972 by Inger Jensen and Pat McGaw, both graduates of CCAC. Since Trude Guermonprez's program at CCAC was small and hard to get into and Berkeley's was phased out between 1968 and 1972, the two women created a comprehensive program of technique, history, design, color theory, spinning, dyeing, loom and nonloom weaving, and sometimes basketry and stitchery. The facility included a yarn store, gallery, private work areas, and apartments. There was also a production studio, which aspired to produce fabrics commercially in the Bauhaus manner. Faculty included Pat Hickman and Anne Wilson among many others.

The more experimental Fiberworks Center for the Textile Arts was founded in Berkeley in 1973 by a group of artists primarily associated with the university and led by Gyöngy (pronounced jinj) Laky, who was its director through 1977. First they met monthly to exchange slides, resources, and critiques. Deciding to establish a place, they first called it a school, although it was always seen as alternative. They tried to affiliate with an accredited institution, Lone Mountain College in San Francisco, to offer degrees via independent study, using the college's facili-

Yoshiko Wada and *Shibori*

One of the landmark events at Fiberworks was the class in *shibori* dyeing techniques taught by Yoshiko Wada and Donna Larsen in 1975. Wada, who had trained as a textile artist in Kyoto and as a painter and printmaker at the University of Colorado, had bought a limited-edition book of sample swatches done by elderly Japanese dyers whose methods were in danger of being lost. Wada and Larsen based their class on the samples and thus introduced *shibori* (shaped-resist dyeing) to the West. Wada began work on a book in collaboration with early participants; after five years of experiments and research, they published *Shibori: The Inventive Art of Japanese Resist Dyeing* (1983).

Among those who took the classes were Ana Lisa Hedstrom, Katherine Westphal, Junco Sato Pollack, and Virginia Davis (who carried the information to New York). Wada also owned Kasuri Dyeworks in Berkeley, a shop featuring Japanese textiles, garments, dyestuffs, supplies, and tools. She led annual tours to Japan, providing Americans access to Japan's Living National Treasures. She and Hedstrom helped curate a *shibori* exhibition in Japan in 1984–85; she established the World Shibori Network, and international symposiums were held in Japan in 1992 and India in 1997. *Shibori* techniques have not gone mainstream because they are too laborious, but they are rich in options for art or fashion.

ties for art history and humanities courses, but the college closed the next year. Fiberworks supported conservation and study groups, referral and resource services, and offered courses in ten subject areas. Faculty included Laky, Nance O'Banion, Jan Janeiro, Yoshiko Wada, and many others.

Fiberworks also sponsored community outreach programs. In addition to its warehouse studio, it had a gallery space for regular shows and held off-site exhibitions, bazaars, and craft sales. Another major event was a three-day international symposium in 1978, directed by Wendy Kashiwa, which drew 475 participants from the United States, Canada, and Europe, including most of the major artists and curators in the textile field.

In 1982 Fiberworks began offering an MFA in textiles in affiliation with John F. Kennedy University and tried to stay alive by merging with the school, but plans fell

through. It closed in 1987; Pacific Basin had closed the year before due to deficits. An era came to an end.

The Fabric Workshop, founded by Marion "Kippy" Stroud in Philadelphia in 1977, survived the changes. It proposed "the use of an industrial process—repeat yardage—as a new art form," spreading the idea through artist residency and exhibition programs, with a concomitant goal of introducing fabric printing to inner-city youth and placing them in industry.[69] This experimental silkscreen-production studio still operates as a nonprofit organization. Stroud visited Marimekko and American workshops and consulted with industry figures before establishing her facility. Artists come for one- or two-week residencies with modest funding. They may use the studio for their own work as well as designing editions and yardage to be executed by the technical staff and apprentices and exhibited and marketed by the workshop. Artists from any medium are introduced to fabric printing and the concept of "repeat." Craftspeople who have had the opportunity include Betty Woodman, Jun Kaneko, Dale Chihuly, and Richard De Vore.

WEARABLES

Drawing on street style, wearables emerged in the late 1960s and early 1970s in New York and the Bay Area. The idea was that people should express "their real inner selves, their thoughts, aspirations, beliefs, or even just aspects of their daily lives."[70] Many makers took up wearables to get away from "the elitism of the museum and out into the real world."[71] The definition of the form in the beginning required handmade textiles but later included one-of-a-kind clothing of any sort. It was equally related to art and fiber interests, but the field at first held itself at a distance from fashion by using laborious techniques, drawing on ethnic sources (particularly kimono form) or extending the hippie style of personalization, embellishment, and use of vintage garments. The artists, mostly female, displayed the works either as wall hangings or photographed on models—both usually emphasizing the garment back, which provided a large surface for decoration. Later in the 1970s folk styles began to give way to smoother works that were less obviously handmade, and in the 1980s limited production (fashion) increased, although the one-of-a-kind approach remained dominant.

In New York the story began when **Jean Williams Cacicedo** learned to crochet in the summer of 1968 and taught the craft to her roommates and others at Pratt Institute, where she was studying. There were no fiber courses and little contact with the fashion department,

so they worked freely, making sculpture or clothing. In the fiber-intensive Bay Area, independent programs were open to artists lacking textile backgrounds. Fiberworks was probably the most important site for the wearables community since it held many exhibitions of such work. The first, in 1974, was *Art Couture*, a runway-style fashion show. The Oakland Museum presented *Bodyware* the same year. Allrich Gallery in San Francisco was also a supporter of textile arts. In New York the Museum of Contemporary Crafts presented *Body Covering* in 1968 (which included fashion, costumes, and handmade clothing), *Fur and Feathers* in 1971, *Homage to the Bag* in 1976, and *The Great American Foot* in 1978. While the earliest wearables were made for personal use or as gifts, a market rapidly developed through boutiques, trunk shows, or specialty shops. In 1973 the two seminal artware galleries opened on the coasts, Obiko in San Francisco and Julie: Artisans' Gallery in New York. The owner of the latter, Julie Schafler Dale, produced a lavishly illustrated book about the field, *Art to Wear*, in 1986.

Among the significant figures are Cacicedo (b. 1948), who switched from crochet to knitting (both hand and machine) and has also employed dyeing, piecing, and appliqué. (Figure 9.38) The British-born **Marian Clayden**, a painter who in the 1970s dyed fabric for the touring companies of the rock musical *Hair*, has designed both clothes and the cloth they are made from. She later moved to fashion and production business. **Yvonne Porcella** by

FIGURE 9.38. *Jean Williams Cacicedo*, Pink Petals, *1978. Hand- and loom-knitted wool, dyed, pieced, appliquéd; 24 × 18 in. (Collection of Fine Arts Museums of San Francisco, Gift of Bunny Horowitz, 1992.161. © Jean Williams Cacicedo.)*

1975 was producing her own ethnic-derived clothing and selling in galleries and shops in the western states and Hawaii. She published two books of ethnic patterns, followed by a 1980 book on pieced clothing. **Joan Steiner** created astonishingly dimensional and pictorial "wearable sculpture" starting with *House Vest* (1978).

In wearables, the low-tech process of felting was sometimes exploited for the skinlike qualities of the fabric. Many other wearables techniques, however, were dependent on machines, including knitting machines, photocopiers, dye-sublimation printers, and computers. As time went on, surface rather than structural techniques were favored, with dyeing probably the most widely used process.

Wearables are often purely aesthetic in motivation, but one move to increase credibility as an art form has been to incorporate subject matter: natural images, pop elements of everyday life, and language. Sometimes the work moves toward metaphor. Wearables have been collected less than other craft forms and have tended to be taken up only by history, craft, or academic museums. Within the craft world these works were of lower status, perhaps because of unease with their nearness to fashion, in which rapid change seems antithetical to craft values. The image or format of clothing, however, is often used in mainstream art to address matters of identity and sexuality or gender, and the empty garment has long served as a body surrogate and as a symbol of loss.

PERFORMANCE TEXTILES

Performance emerged in textiles as it appeared in the art world, again, seemingly an outgrowth of 1960s street activity. **Friends of the Rag** was a Seattle-based consortium of about forty artists and designers who appeared at public gatherings—including, in the beginning, political events—in outrageous attire. It began in 1971, when Mickey Gustin, director of the Factory of Visual Art (an art school), and clothing designer Madeline Foster staged the *Two-Bit Fashion Show* at a tavern in the seedy but artistic Pioneer Square neighborhood, using a shuffleboard as a runway. A presentation called *Hung at the Henry*, at the University of Washington's Henry Art Gallery, had models on pedestals while the audience moved around them.

Friends of the Rag's first paid performance was an Andy Warhol reception at the Seattle Art Museum, when Ruth Pelz, in a multibreasted costume, gave birth to twins from a zipper pocket. (Figure 9.39) While participants included at least one theatrical costume designer, the backgrounds of other members ranged from elec-

FIGURE 9.39. *Ruth Pelz*, Martian Fertility Goddess from "Traveling Modes & Devices," *1978. Cotton, polyester, nylon, velvet. (Courtesy of Thames & Hudson Ltd. © Ruth Pelz.)*

tronics to jewelry. All asserted that wearable art should be seen in motion. At its peak, Friends of the Rag had a traveling show in 1978 and performances at the Renwick Gallery and at a Halloween party at the Carter White House. The last performance was in 1994. A founding member reflected: "It wasn't until 1976 that a lot of people started coming to the shows. By 1977 they were coming dressed-up. By 1980 they were costumed better than we were. We'd bring them up from the audience and put them on stage."[72] Around the same time, in New York, **Robert Kushner**, now best known as a pattern-and-decoration painter, staged performances with a costume emphasis. He created *The Persian Line* (1975–76) of fifty-five flowing costumes inspired by the Iranian chador, for which he painted the fabric. He also made wearables for the Fabric Workshop and Crown Point Press.

Pat Oleszko (b. 1947) may be the most notorious among artists of the theatrical wearable because of her characteristic bawdiness and bad puns. That she is six feet tall, works mostly alone rather than within a collaborative, and is based in New York also increased her visibility. She got her start amid the challenging of boundaries characteristic of the 1970s: there were cross-genre works and alternative spaces (including the street); new interest in public art and participatory sculpture also contributed to the scene.[73]

Studying sculpture at the University of Michigan, Ann Arbor, in the late 1960s, Oleszko was inspired by visiting artists such as Andy Warhol, Claes Oldenburg, and Robert Rauschenberg. Seeking scale, she used her own body as an armature and focused on satire and burlesque. She made some film works, and her costumes also had an independent life in exhibition. In 1972 the Museum of Contemporary Crafts gave her career a boost by showing her piece about female stereotypes, *New Yuck Woman*, and in 1990, at the renamed American Craft Museum, her work was given a solo survey.

Among her best-known works are *Coat of Arms* and *The Handmaiden (Japan)*, both 1975 and covered with stuffed imitations of human limbs. (Figure 9.40) In 1976, the Bicentennial year, she created *Liberty's a Broad* and, attired as the Statue of Liberty, appeared on the cover of the July issue of *Ms* magazine. A widely reproduced photo shows her costumed as Liberty on a New York street, her right arm raised not to hold a torch but to hail a cab. Among her most popular works is *The Padettes of P.O. Town*, a takeoff on a Motown girl group in which, as she puts it "I'm the dummy in the middle." Three stuffed figures, of red, yellow, and blue, move in unison because they are literally joined; the middle figure in this sixty-pound costume is occupied by Oleszko.

This work differs from art wearables in that it has no

FIGURE 9.40. *Pat Oleszko*, Handmaiden *and* Coat of Arms, *1975. Mixed media. (Courtesy of the Artist. Photograph by Neil Selkirk.)*

sense of preciousness. Oleszko uses stretch fabric over a cane framework, made to be collapsible and packable for her performance tours. She traveled in Europe carrying all her costumes in a couple of suitcases. Taking up inflatables allowed even greater scale with less weight. They grew large enough to function as set pieces. Also unlike functional wearables, her work is usually commentary—on fashion; on our relationship with our body; on appearance versus essence; on art precedents such as the work of Picasso or Oskar Schlemmer; on news events that are inflated out of proportion but quickly fizzle; on sexuality, language, humor.

NONTRADITIONAL QUILTS

A revival of quilting began with the National Quilting Association, founded in 1970. On the West Coast quilts began showing up in exhibitions in 1972. The movement picked up steam from Jonathan Holstein's groundbreaking exhibition *Abstract Design in American Quilts* at the Whitney Museum in 1971. The interest in historical crafts expanded with the nation's bicentennial in 1976, and the feminist movement also generated interest in traditionally female arts: Patricia Mainardi published "Quilts: The Great American Art" in *Feminist Art Journal* in 1973. The appeal of quilts consisted of direct handling, integral color, narrative themes, or formal design as well as the attractions of fabric itself.[74] The first Quilt National exhibition, held at the Dairy Barn Southeastern Ohio Cultural Arts Center in Athens in 1979, encouraged visual development and technical innovation.

One of the pioneers was **Jean Ray Laury**,[75] an academically trained artist and designer who made her first full-size but unorthodox quilt in 1956. It happened to be seen by the editor of the new magazine *Woman's Day*, who invited her to contribute to the publication. In her articles there, in books, and in other popular magazines, she encouraged women to create their own designs. **Radka Donnell**, a Bulgarian-born painter-turned-quilter, was an art therapist and considered quilting a healing art. She was one of the first to machine-quilt for speed and sturdiness, and she wrote the foreword to Pattie Chase's *The Contemporary Quilt*, published 1978. **Charles** and **Rubynelle Counts** had studied weaving and pottery at Berea College in Kentucky in the 1950s, and Charles had also studied with Marguerite Wildenhain before the couple founded a craft center in northwestern Georgia. In 1965 he began to design quilt tops that were sewn by local artisans. His unique style included compartments of color and strips of quilted lines that created textural effects.

Another pioneer was **M. Joan Lintault**, a longtime teacher at Southern Illinois University whose early quilts

FIGURE 9.41. *M. Joan Lintault*, Shroud IV: Obscenities, *1975. Kwik print on satin, dye crayon, hand-pieced and quilted; 79 × 69 in. (© M. Joan Lintault. Photograph by Eric Long.)*

have not received the recognition they deserve. (Figure 9.41) Peace Corps work in Peru and living in Hawaii contributed ideas to quilts in which she used "thread as line, fabric as shape, and color as a painter [would]."[76] Quilts also began showing up in contemporary art on a regular basis, as in **Lucas Samaras**'s pieced fabric collages of the late 1970s called Reconstructions (elaborate, jazzy compositions of bright or patterned fabrics and glittering things). As a feminist gesture, **Miriam Schapiro** collaged fabrics onto her paintings in the mid-1970s.

Most studio quilt makers employed pieced construction. The appliqué of geometric or free-form shapes onto a fabric base was also popular from the beginning as was reverse appliqué (cutting through a top layer to disclose other colors underneath). Appliqué escapes the regularity of the grid and facilitates pictorial imagery. New practices included direct application of permanent dyes and opaque textile pigments, and the use of various printing and photo-transfer methods.

KATHERINE WESTPHAL

Katherine Westphal is often described as a leader in surface design, but it is a term she does not like. She considers herself a painter and her method textile printing.[77] She is known for her use of photographic-transfer processes, especially photocopying. (Figure 9.42)

Miriam Schapiro

In 1971 Miriam Schapiro and Judy Chicago founded the Feminist Art Program at California Institute of the Arts, where they team-taught a class for women artists.[1] This unprecedented program was meant to encourage women to make art out of their own lives and fantasies. With twenty-one students, they produced *Womanhouse*, transforming a house scheduled for demolition (lent to them by its owner) into an environment. Combining painting, collage, assemblage, weaving, needlework, and sculpture as well as performance pieces, *Womanhouse* electrified—or appalled—thousands of visitors over a three-month period.

 Schapiro (b. 1923) soon carried these new ideas into her painting. Her innovation was to combine fabric and acrylic paint in what she called "femmage" to express the previously marginalized creativity of women. Many paintings featured handkerchiefs or aprons, and a series of prints focused on doilies. In 1976, after returning to her native New York City, she finished the ten-section *Anatomy of a Kimono*, a study of the meanings of costume. This work was part of the pattern and decoration movement of the mid-1970s.

NOTE

 1. Thalia Gouma-Peterson, *Miriam Schapiro: Shaping the Fragments of Art and Life* (New York: Abrams, 1999), passim.

FIGURE 9.42. *Katherine Westphal,* Puzzle of the Floating World #2, *1975. (© Katherine Westphal. Photograph by Tom Grotta.)*

Westphal was born in Los Angeles in 1919, earned bachelor's and master's degrees in painting from Berkeley, and began teaching. When she returned to Berkeley with her husband, Ed Rossbach, she could not be hired at the university because of nepotism rules, so she found other things to do. A friend introduced her to textile printing, and she sold her fabric designs for a period of years, although she tired of the pressure to use fashionable colors and meet deadlines. She simply wanted to do what she wanted to do, not what others wished, which essentially summarizes her philosophy of life. When her agent retired and returned unsold design samples, Westphal cut them up and sewed them back together collage-style to make "art to wear" and also to make the first art quilts (one was included in the Milan Design Triennial in 1964). Such recycling is another Westphal characteristic, along with her attraction to the ephemeral.

In 1966 UC Davis asked her to teach design. She first declined but eventually agreed to teach a single class for one quarter. But she stayed, became full time, and turned a design appreciation class that no one else wanted into a roaring success with 300 students enrolling each term and ten assistants working with her. When the aggravations of academic bureaucracy led her to retire in 1979—the same year Rossbach did—she was honored as a professor emeritus.

Westphal continued her own work without stop and was a leader of the wearables movement in the 1970s. She ran through a series of enthusiasms (for example, for handmade paper; among other things she made paper clothing). She favored the kimono form because the flat, unfitted shape gave her the most options for decoration, and she noted with amusement that she several times showed her kimonos in Japan. She exhibited at Anneberg Gallery in San Francisco for the fun of it, not for career advancement or critical recognition.

Westphal typically combined techniques in her works: appliqué, stitchery, batik, tapestry, and quilting were common. She said: "I let the textile grow, never knowing where it is going or when it will be finished. It is cut up, sewn together, embroidered, quilted, embellished with

tapestry or fringes, until my intuitive and visual senses tell me it is finished and the message complete."[78] Photographic images are reproduced on fabric by her signature method, heat transfer, especially after alteration in a color-photocopying machine—she was a pioneer in using it as an artistic tool. Her work evokes the transfer images of Robert Rauschenberg and the photocollages of David Hockney. One image is never enough: her work is also characterized by repetition. The effect is kaleidoscopic and often effusive, mixed, she says, in the "eggbeater" of her mind.[79]

It is not easy to show the specific influence of her work, but she can be seen as a "permission-giver," one who showed that nothing was off limits. Certainly she was at the crest of the wave of changes in the 1960s and 1970s, including feminist revaluation of "women's work," quilting as a collage reflecting the fragmentation of women's lives, and the escape from textile traditions of precision and order.[80]

NONLOOM AND LARGE

Françoise Grossen, who was born in Switzerland in 1943 and completed a master's degree in fiber at the University of California, Los Angeles (UCLA), in 1969, was another—like Claire Zeisler—who transformed the knotting technique that, as macramé, was then a decorative fad, into a structural method for large-scale forms. In her graduation year Grossen had her first piece accepted for the Lausanne Biennial. In 1970 she set up her studio in a loft in New York, a 3,000-square-foot space with fourteen- to sixteen-foot ceilings (fitted with pulleys) that allowed her to make large hangings. She used a variety of nonprecious fibers, including a cotton-mop yarn, rubber tubing, and various sorts of ropes. By the mid-1970s she shifted to plaiting and other constructive means.

Grossen worked in both planned and impulsive ways. Her hangings had a strong material presence featuring rhythmic patterns and voids. They were rarely symmetrical. Some involved such thick and coarse ropes that they were called "almost barbaric," while others employed near-glossy sisal. Color—including assertive reds, blues, or bronzes—unified the forms. In her first large commission, in 1972, she created thirty-eight overlapping knotted relief panels for John Portman's Hyatt Regency O'Hare Hotel in Chicago. She was able to make a living from her work, teaching only occasionally, during the glory days of public-scale textiles.

Grossen also made exhibition pieces. (Figure 9.43) The Inchworm series of 1971–73 consisted of segmented knotted works as much as thirty-nine feet long. She showed *Inchworm II* in the Lausanne Biennial in 1973

FIGURE 9.43. *Françoise Grossen, Contact II, 1977. 17 elements, manila rope; 84 × 360 × 12 in. (© Françoise Grossen. Photograph by Tom Grotta.)*

and at Museum Bellerive in Zurich in 1976, both times as a floor piece working its way up the wall. In 1978 in Portland, Oregon, she showed it floating on a pond, which its rubber-tubing material permitted. A few long cords extending from each segment gave it a rippling, organic character on the water surface. *Ahnen Galeries* consists of five pairs of fibrous "guardian figures" always shown facing each other in pairs and seemingly on their bellies with flattish "legs" stretched out behind them. She showed these rope works first at the 1977 Lausanne exhibition on pedestals arranged so that viewers walked between the pairs. Elsewhere they have been shown on steps, enhancing their ceremonial character.

In the mid-1980s, Grossen made a large series of what might be materials studies, called Metamorphosis, generally hung from the wall. They included both metal and natural fibers, paper, leather, papier-mâché, and acrylic paint and were strikingly rich in color. Nearly all featured both exposed and wrapped cords, creating an emotional effect of concealment and disclosure. After her Metamorphosis series, she stopped work in fiber.

Walter Nottingham (b. 1930) crocheted and knotted fiber into primitivist sculptural forms. A Montana native with a Cranbrook MFA who taught at the University of

FIGURE 9.44. *Walter Nottingham*, Rope Shrine (Basket Shrine), *ca. 1976. Crocheted wool; 8 × 7 × 2 ft. (© Walter Nottingham.)*

Wisconsin, River Falls (1960–90), he worked in single-element, off-loom techniques. His catch phrase, widely quoted, was that he was trying to make "the unseen visible." He asserted that fibers have an "intense life of their own" and that he wished to probe "the mystical content within my life and the medium of fibers."[81]

Nell Znamierowski, reviewing an exhibition of his work at the Larsen Showroom in 1970, noted that the large, pendulous wall pieces looked like totems and were based on the magic forms of Sioux and other tribes, although titled with names from the *I Ching*. Besides crochet, they included weaving, hooking, wrapping, and braiding, heavy wool yarn and unspun wool, photosensitized cloth, beads, feather, bones, even a dead bird. Two years later, one imposing work, titled *Dukkha*, was said to suggest "some mythical creature with wings spread; many hanging strands create a swampy, Spanish moss aura of mystery about this rather menacing work."[82] The quintessential Nottingham works, the Basket Shrine series, often consisted of a sequence of diminishing ovals that led the eye to an inner chamber, which might, for instance, contain bright red and green feathers. (Figure 9.44)

Neda Al-Hilali played a major role in the excitement of the 1970s with her gargantuan constructions of plaited paper, especially a group of pieces installed on a beach like creatures emerging from the sand or something the tide had brought in.

Al-Hilali was born in Czechoslovakia in 1938 and received her initial art training in London, Munich, and Baghdad before immigrating to the United States in 1961. She took up fibers as her medium only when she

attended UCLA and came under the influence of Bernard Kester. Her early work included knotting, braiding, and lace techniques and was bold in both scale and color. Amid the variety of forms, one praised in a 1974 show was *Black Passage*, "a hairy primordial environment flanked by winglike appendages. The menacing barbarism of its black dangling fibers changes only after one sits upon the thronelike mound of rope at its base. Then, looking up into its protective opulence, one seems to soar out into a mystical space."[83]

By 1976, when Kester profiled her in *Craft Horizons*, Al-Hilali was using long sheets of paper dyed, crumpled, and manipulated as constructive elements in plaiting. Some were flattened by pressing and framed under Plexiglas. While her fiber forms were known for textural qualities and physical presence, she took up paper as a way of breaking out of fiber's traditions and established associations; it seemed more neutral. She said: "In the language of paper, people are more willing to speak in conceptual, intellectual terms; whereas fiber is sometimes treated like a household, pedestrian, uninspired thing. I also wanted to move away from fiber as a physical material. It is this physicality, the texture, that is always seen first in a fiber piece; it will shout 'fiber' before any other message can get across. Texture is like loud static, the drone of a sensual material. Through this 'fiber noise' it is very difficult to make audible the ring of illusion or the clear sound of spirituality."[84]

Plaiting yielded a diagonal grid with structural rhythm and an anonymous surface. Al-Hilali flattened the paper with a printmaker's press, taking it back toward its original two-dimensionality by creating a dense, smooth surface. Seeking a larger pressed surface, she even tried a street-maintenance steam roller!

Tongues (1975), constructed over a period of months, had seventeen sections, each measuring between 144 and 216 inches in length, each plaited in deep relief from many rolls of heavy brown industrial paper. (Figure 9.45) She and her students took the elements to a beach near her studio in Venice and left them half-buried in the sand to make a new landscape. They were later retrieved, moved to the exhibition hall at the California Museum of Science and Industry in Los Angeles, and suspended from a thirty-foot-high ceiling.

Later Al-Hilali worked with solid rectangles of canvas or stiffened paper, with cutouts collaged onto its surface and elaborate painted patterns. She also laminated paper with Rhoplex (acrylic latex) and affixed it to walls and ceilings like crumpled cloth, poised against ceilings or against buildings as if blown there by the wind. Her next move was to aluminum.

FIGURE 9.45. *Neda Al-Hilali, Beach Occurrence of Tongues, 1975. Outdoor fiber installation, Venice Beach, Calif. (Photograph courtesy of the Neda Al-Hilali Papers, 1960–95, Archives of American Art, Smithsonian Institution.)*

NEW OPTIONS IN WEAVING

Not everyone gave up the loom; there was creative work in that realm as well. **Gerhardt Knodel** (b. 1940) made work for the large scale of public spaces. As artist-in-residence and head of the textile program at Cranbrook from 1970 to 1996 and director of the school for the next eleven years, he was central to one of the most important programs in craft. At the same time his fabric installations enlivened the airspace of hotel atriums, commercial and corporate sites, and educational facilities. These works generally involved fabric under tension, with a visible structural order. Both features might sound coldly rational, but colors soften that order and convert it to more pleasurable manifestations such as rhythm or pulse.

Sky Court (1978), in a Xerox Corporation building in Stamford, Connecticut, is a good example. Sections of fabric that echo the patterns of the atrium skylights cascade downward in pendant curves. The work can be seen from various perspectives on seven floors surrounding the space. It responds to air currents but is held by colored cords, provoking associations with Japanese kites, Romanesque vaults, and Arabian tents (an ancient form of fabric architecture).

Knodel earned degrees at UCLA and California State University, Long Beach. He came to fiber when tactile masses were popular; his own approach seemed weightless in comparison. His first major architectural commission, *Free Fall* (1977), was designed for John Portman's Plaza Hotel in Detroit. (Figure 9.46) To produce the necessary 700 yards of fabric, he developed a relationship with Churchill Weavers in Berea, Kentucky. He designed

FIGURE 9.46. *Gerhardt Knodel, Free Fall, 1977. Mylar, wool, rayon, metal, acrylic; 840 × 180 × 120 in. (GM Renaissance Centre, Detroit. © Gerhardt Knodel. Photograph by Balthazar Korab.)*

the fabrics, wove a few small panels, and then went to Berea to prepare the warps.

Knodel has also designed work for the Jacquard loom, and he has created environmental installations using textiles as visually permeable walls. His tapestries are quite opposite to the euphoria and serenity of the aerial public works: here imagery or structure creates multiple views within a single flat work; represented space is fractured with a mix of illusionism and tactile actuality. He added social content to the tapestries in later works such as *Pontiac Curtain*, a portrait of a city that has been likened to a WPA mural. He also created room installations in various evocative forms, such as cutting fabric with screen-printed or painted imagery into strips and weaving every other strip through black plastic netting, so that the viewer's mind must fill the gaps.[85] Knodel's particular gift is his development of space.

Warren Seelig's great-grandfather, grandfather, and father were all involved in the textile industry. When he studied at the Philadelphia College of Textiles from 1970 to 1972, he was fascinated by the structural movements of the Jacquard loom and by the notations and symbols of old sample-pattern books and mill catalogs. This bent toward abstract thinking and mathematical quantification has shaped his creative work. (Figure 9.47) He was

FIGURE 9.47. *Warren Seelig, Double Accordian Gesture, 1975. Double woven cotton, encased vinyl skeleton; 65 × 40 × 1.5 in. (Collection of Greenville County Museum of Art, Greenville, S.C. © Warren Seelig.)*

also influenced by Gerrit Rietveld's De Stijl designs and Anni Albers's application of Bauhaus principles.[86]

Thus, when Seelig (b. 1946) arrived at Cranbrook as an MFA student, he, like Knodel, was not interested in the tactile aspects of fiber but in the orderly meeting of threads and the clarity of structures. Working in double cloth, Seelig discovered that he could treat the intersection of layers as a hinge, insert something rigid to hold the shape, and open the fabric to form a totemlike structure. Constantine and Larsen, impressed by his precociousness, said that the works were so neatly engineered that they would have impressed the makers of early stretched-cloth airplane wings. They also raised the question of the work's cool intellectualism, which has dogged Seelig to the present. When pieces of this type were exhibited in the mid-1970s, a reviewer conjectured, "These precise forms of unrelieved tautness are a demanding intellectual search for a statement."[87]

At the end of the 1970s Seelig shifted from black and white threads to color. Predictably, he set himself a task. He used cotton sewing threads for their wide color range and worked them in grosgrain (dense rib weave, as in ribbons).[88] The resulting Ribbon Folds consisted of yardage bent across a rod or two to make a check mark or hexagonal form against the wall. The works were "completely filled with vibrancy," and to experience them was "to surrender to the demands of the ecstatic," Joan Livingstone wrote in *American Craft* in 1983. Yet she also noted a "consistent 'lack-of-hand,' a high finish, an industrial quality to the pieces, which constantly reminds us that this is just a length of cloth."[89]

Seelig's later work involved industrial synthetic fabrics stretched on metal rods, the stiffeners now apparent. The visual tension and austerity remain, the structural orientation continues, and the fabric is impersonal. In an artist's statement, Seelig surprisingly refers to textile "images of connection" and sees the work as an "energy field" with "organic unity" and an inner life. He sees an "authentic spiritual element" in the transformation of ordinary materials and aspires to "speak of the ineffable."[90] The hard and cold materials, if one follows this thinking, are meant to renounce the egotism of expression and the distraction of sensuality to achieve a universal detachment.

Another committed weaver, **Helena Hernmarck** (b. 1941) was trained in her native Sweden, but when she burst upon the international textile scene in the 1960s, she was living in Canada. Her traditional large-scale tapestries were shown in the Lausanne biennials, and a tapestry commissioned for Montreal's Expo 67 was seen by, among others, the architect Moshe Safdie, who commissioned a piece for the lobby of his celebrated Habitat. Public works have been her main output.

As fiber was blossoming into three dimensions, Hernmarck happily stuck to flatness, but her imagery was often based on current photographs—her own or those she chose from newspapers and magazines. She also adopted old techniques to new effects: in a 1968 work she used both tapestry joining and rosepath, a traditional Swedish overshot weave that floats yarns over the surface of the cloth, to mimic newspaper halftone dots.

Hernmarck first visited the United States in 1967 on a tour of architectural offices that led to commissions for tapestries for corporate headquarters. By the time she repeated the excursion in 1972, she had developed the photorealistic style with which she became identified. She also created special effects by experimenting with materials such as the sheets of commercial plastic from which sequins are stamped: she cut them into strips, folded them double, and used them as wefts in com-

FIGURE 9.48. *Helena Hernmarck*, Sailing, 1976. *Wool, linen, cotton; 120 × 264 in. (Courtesy of the Artist. Photograph by Norman McGrath.)*

bination with yarn. A portrait using that method, *Mao Yin/Yang* (1972), is in the collection of the Museum of Modern Art, but her most interesting use of this material hangs in a corporate office in Japan: she made a two-sided double-weave tapestry of swimming carp; the perforated plastic not only makes the water shimmer but makes the carp woven on one side into shadowy presences on the other.

In the early 1970s, Hernmarck was living in England, but after a solo show organized by the design department at the Museum of Modern Art in 1973 and one at the Los Angeles County Museum of Art in 1974, coupled with the realization that ten of the eleven pieces she produced between 1972 and 1975 were for American destinations, she decided to relocate again. The first major piece she produced in New York was *Sailing* (1976), for the Federal Reserve Bank of Boston. (Figure 9.48) One of her best-known works, due to its vitality and bright colors, it is based on a cover photograph from *Sail* magazine. Hern-marck has been criticized for using imagery by others. She rebuts the argument by describing the difficulty of finding the right picture and getting one-time reproduction rights and by emphasizing the knowledge and judgment required to translate it into thread. Working with an assistant, using yarn of ten different thicknesses in about 700 hues, she captured in *Sailing* the illusion of moving water and glistening slickers.

Lia Cook (b. 1942) is among the most prominent of the "Rossbach progeny" in the Bay Area. A longtime

teacher at CCAC, she developed distinctive expressions in handweaving and embraced the computerized Jacquard technology as it became available to studio weavers. Her work has developed subjects and themes without compare in contemporary weaving.

By the time Cook enrolled with Rossbach in the early 1970s, she had already studied theater, painting, and ceramics as an undergraduate; taken a degree in political science; traveled to Mexico and become interested in textiles; and studied weaving in Sweden. Immediately after graduate school she showed in the Lausanne Biennial. The early work investigated dimension and movement on a flat and regular woven surface. A group of weavings looked like Bridget Riley's op art paintings, with the addition of raised channels under the patterning, filled with unseen foam that gave additional dimension. She also wove or printed the image of knots, which played across an actually undulating surface.

In 1979 Cook began to make the pressed works that brought her widespread recognition. (Figure 9.49) They were paradoxical: a complex weave (on a twenty-harness loom) was freely painted over. It elicited the illusion

FIGURE 9.49. *Lia Cook*, Pressed X, 1979. *Pressed rayon, woven; 20 × 14 in. (Courtesy of the Artist. Photograph by Jay Ahrend.)*

FIGURE 9.50.
Cynthia Schira, One
Day at Padre, *1979.*
*39 × 51 in. (Collection
of Michael Monroe.
© Cynthia Schira.)*

of space but might or might not be a plane. For these works she used industrial white viscose rayon, which, with a mechanized loom, avoided any "romanticizing of the hand process."[91] That was a contrarian position when there was still much tactile fiber work being done. Cook's elaborate procedure was even more surprising: she wove, washed, and then pressed or hammered the surface, bringing out beautiful, light-reflective qualities in the rayon. Then she applied silver pigment until the surface resembled metal (she later used dyes or thinned pigments so as not to conceal the surface). The procedure and imagery were, in the parlance of the time, "self-referential." As baffling as the process might seem to a casual viewer, it wrestled provocatively with textile expectations.

She later adopted drapery imagery from old master paintings as subject matter, an approach praised as undercutting art-world hierarchies and inverting the relation of painting to cloth.[92] It also offered the chance to allude to veiling and eroticism. ("Sensuality is always in my work, whether it is in the fabric or on it," Cook has said.)[93] These works were sometimes exhibited framed by actual Jacquard-woven draperies.

Cynthia Schira has also retained the loom as her primary expressive means. She was not looking for gesture or bombast or other qualities that weaving could not provide, but in any case she consistently invented ways to add relief and irregularity to the loom's relentless logic.

Schira (b. 1934) earned a BFA from the Rhode Island School of Design in 1956 and spent the next year at the Aubusson factory in France. She earned an MFA from the University of Kansas and joined the faculty there in 1976. Joan Simon describes three phases in Schira's work.[94] The first was a three-year investigation of inserting wide strips of aluminum into a linen warp. The finished works are sometimes wall installations of piled-up pieces, faintly recalling John Chamberlain's crumpled-metal sculptures. In her next series, Supplementary Weft, Schira inserted additional fill into a normal weave structure. (Figure 9.50) Bandages, tapes, ribbons, and other narrow strips of cloth contributed color and texture and provided diagonal or meandering lines, breaking weaving's right-angle orderliness. The result is quite painterly, yet the surface remains textile. Her third body of work, Complementary Warps, is a type of triple weave, with three separate sets of warps and one weft thread that moves between them. They were accomplished on a thirty-two-harness computerized loom. The computer-aided works of Cook and Schira will be discussed in chapter 11.

A PERSONAL SPIRITUALITY: DOMINIC DI MARE

The spiritual urge that recurs in twentieth-century crafts finds a moving embodiment in the constructions of Dominic Di Mare (b. 1932), in which threads, strings, and hairs have personal and symbolic import. (Figure 9.51) He has named his series Shrines, Reliquaries, Mourning Stations, Rune Bundles, and Shaman, among other titles. Di Mare's story is unusual on many accounts, first, because major artists do not often emerge from the ranks

FIGURE 9.51. *Dominic Di Mare*, Ancient Tides/1932, 1978. *Hawthorn, gampi, Prismacolor, silk, bone; 10 × 12 × 12.5 in. (Collection of Daniel and Hilary Goldstein. Courtesy of the Palo Alto Art Center, Palo Alto, Calif. © Dominic Di Mare. Photograph by M. Lee Fatherree.)*

of junior high school art teachers and, second, because his materials and forms recapitulate those of his boyhood as the son of a Sicilian immigrant fisherman in Monterey, California. Di Mare—whose name, appropriately, means "from the sea"—gradually came to realize that Catholic ritual as well as the nets, lures, and boats that he grew up with shaped his artistic expressions. While altarlike works and "primitive" materials such as bones and feathers have been debased by people capitalizing on their emotional resonance, he uses them by right of inheritance.

Di Mare had a traditional upbringing, helping his father and accompanying him on fishing trips. He was not a good student, but his earnestness and art abilities attracted help from teachers and others, and he eventually attended San Francisco State College and took summer classes at the California College of Art and Crafts. Working toward teaching credentials, he was first exposed to weaving at San Francisco State. What he most loved was setting up the loom, dealing with all the threads.

To teach himself, Di Mare worked on a loom at home, where he copied Kay Sekimachi wall hangings from pictures in *Craft Horizons* until he realized that he could invent rather than copy.[95] Helen Pope, one of the owners of the Yarn Depot, a San Francisco supply source, gave him his first show in the early 1960s. When she traveled to New York, she took some of his work to show to Paul Smith at the Museum of Contemporary Crafts; five months later Di Mare was given a show there. At the time he was making layered boxes and three-dimensional volumes in the "woven forms" style. They ranged from lacy and transparent to fetishistic.

Soon after the New York show, Di Mare stopped weaving and did not exhibit for a decade. He isolated himself from the Bay Area art world, trying to find his own way. He taught school every day and came home to make drawings on built-up layers of translucent paper that he pierced or sliced. In the mid-1970s he reemerged with an entirely new type of work, intimate in scale and evoking religious icons or Native American ritual objects. The critic Betty Park, who wrote eloquently of his work, compared Di Mare's with other metaphoric works in the mainstream art world of the time, such as Charles Simonds's villages of imaginary civilizations and Michael Singer's "ritual" gates. (Lucy Lippard's *Overlay* of 1983 chronicled this same motive in the work of many artists of the 1970s.) Considering his intuitive way of working and his subsequent recognition of sources in his past, she compared Di Mare with the rower of a boat: while taking pleasure in the act of rowing and feeling connection to the water around him, he takes direction from what lies behind him yet has the power to change course.[96] It is an elegant metaphor, especially considering his relation to the sea. After his new works were exhibited to acclaim, Di Mare stopped teaching in 1976.

In both his "scroll" and "shrine" forms, Di Mare was a pioneer in using handmade paper sculpturally. He worked with the idea of messages or objects hidden within a structure, which was often a box or another sort of enclosure, draped or fringed with knotted fiber. Lines symbolize relationships or the sequences of generations through time. He restricted his knotting to the double half hitch (which is—of course!—the fisherman's knot).

Di Mare has also drawn upon his environment. He uses wood from the hawthorn tree in his backyard, bones he finds on the beach, and feathers from road-kill barn owls, and he has made paper of artichokes from his garden. His use of bundles is indebted to a son who, charged with cleaning up prunings from the hawthorn tree, cut the branches and twigs to equal lengths and tied them up. Even as the times changed and irony became a major theme in contemporary craft, Di Mare made his mark with works that are "among the most poetic and meaningful yet created."[97]

IDENTITY, POLITICS, MEMORY

Barbara Chase-Riboud (b. 1939) is a sculptor, poet, and novelist who crossed paths with textile art in an interesting way. She produced dramatic and elegant abstract sculptures with narrative implications, which became part of the reclaiming of black identity of the 1960s and 1970s. An important part of her works is tangled or knotted falls of silk or wool.

After completing a master's at Yale, Barbara Chase

FIGURE 9.52. *Barbara Chase-Riboud*, Confessions to Myself, *1972. Bronze, painted black, and black wool; 120 × 40 × 12 in. (University of California, Berkeley Art Museum and Pacific Film Archive, purchased with funds from the H. W. Anderson Charitable Foundation, 1972.105.)*

FIGURE 9.53. *Arturo Alonzo Sandoval*, Cityscape No. 3, *1977. 16mm microfilm, laundry tag paper, and Lurex with cotton edging and Velcro; 84 × 84 in. (National Hispanic Cultural Center Art Museum, Gift of the Artist in memory of his parents, Lorenzo Sandoval of Cordova, N.M., and Cecilia Archuleta Harrison of Blanco, N.M. © Arturo Alonzo Sandoval. Photograph by Margot Geist.)*

moved to Paris, where she met the Magnum photographer Marc Riboud; they were married in Mexico at the home of her classmate and friend Sheila Hicks. When Hicks later moved to Paris, Chase-Riboud was creating cubistic torso or shieldlike masses for casting in bronze. The relationship between these large "crumpled" forms and the floor was problematic—neither pedestal, table, nor stand seemed right. Hicks suggested a fall of fiber, and its similarity to raffia, cords, or fringing of African masks pleased Chase-Riboud.

Chase-Riboud's *Malcolm X #2* (1970), now in the collection of the Newark Museum, is a six-foot-tall presence in black polished bronze above heavy wool cord dyed black. It seems to synthesize masculine and feminine. *Confessions to Myself* (1972) was acquired by the Berkeley Art Museum from her solo show there. (Figure 9.52) Braided yarn makes the piece seem to stand on invisible legs or to hover supernaturally.

Chase-Riboud has used the same materials, or gold

and silk, to make jewelry in small editions. In this scale the folds in the metal may suggest drapery or female genitalia, and the cords hang in swags. She showed sculpture and jewelry at Betty Parsons, an important New York gallery, in the 1970s.

Arturo Alonzo Sandoval (b. 1942) first drew attention for weavings using nontraditional structural materials typical of modern times, such as Mylar and movie film, as well as for his imagery from photocopies, photographs, and magazine pictures. (Figure 9.53)

Sandoval was born to a family of Spanish and Native American weavers in New Mexico but grew up in Mexican American neighborhoods in Los Angeles and identifies with that ethnicity. He has master's degrees from California State University, Los Angeles, and Cranbrook and has taught since 1974 at the University of Kentucky.

At Cranbrook and afterward, Sandoval worked in basket techniques, making mummylike forms encased in feathers or fur. By 1973 he was working on his series Escape Route, in which ladders reached toward suspended masses of fiber that suggested clouds. He then went off-loom to plait with film and other reflective and transparent materials. He used them to suggest the rectilinear architecture, reflective surfaces, and visual density of cities. He could also evoke nature. In *Pond with Scum* (1976–78)—an unromantic subject—strips were treated with transparent stain that produced an opalescent effect,

so that the surface changes according to the light illuminating it. The work ironically evokes chemical pollution of waterways by using a petroleum product. In a variety of modern materials, working at large scale and quilting transparent layers together with an industrial sewing machine, Sandoval created dimensional and illusionistic surfaces of considerable complexity.

Another development of note, starting about 1980 and continuing for the next two decades, was Sandoval's political focus. Inspired by a Billy Joel album, *Nylon Curtain*, he adopted such symbols as the American flag and the Statue of Liberty. He also quoted from the dire predictions of Nostradamus, a sixteenth-century astrologer, adding images of New York City and warnings and symbols of nuclear war and the nuclear ground zero (distressingly close to what would happen twenty-some years later). Although the threat of nuclear catastrophe was not a new artistic subject, Sandoval approached it with a subtlety that insinuated itself into the viewer's consciousness.[98] Here again, he turned the timeless details of textile process to an unexpected end.

BASKETRY REDISCOVERED

Contemporary basketry, like the other fiber arts, is a predominantly female field. One notable exception is Ed Rossbach; another is **John McQueen**. The variety, ambition, intelligence, and wit of McQueen's work make it outstanding. He has respected traditional materials, once saying, "My baskets still have the tree in them, the bark, the bug marks—all those things that show they were alive."[99] He has also been irreverent enough to use staples and plastic rivets to fix his elements. He has made abstract forms whose interesting subtleties and complexities give evidence of his original study of sculpture, and he has so often incorporated words that he might be considered a conceptualist—or a poet.

McQueen is the quintessential studio artist: while he has conducted many workshops, he has never taught in a formal program. Born in Illinois in 1943, he grew up in Florida, where his father was an aircraft mechanic for small planes, and he and his brother could help with rib stitching on an industrial sewing machine. After stop-and-go college studies, he took an MFA in weaving at Tyler in Philadelphia (1975). His turn to baskets was inspired by Rossbach's *Baskets as Textile Art* (1973).

From the first, McQueen was committed to gathering his materials locally and preparing them himself. He was able to do that even when living in Philadelphia, finding plenty of scrub growth in vacant lots and along railroad tracks. He lived for some years near Alfred, where he gathered materials in the woods, each in its season; more

FIGURE 9.54. *John McQueen*, Untitled #88, 1979. Elm bark, maple; 14 × 15 × 10.5 in. (Collection of Robert L. Pfannebecker. © John McQueen.)

recently he has used willow grown in his own city yard in upstate New York.

McQueen chose to call what he made baskets rather than sculptures because he likes the associations of a container and the facts that a basket has to be structurally sound to stand independently and that all the working parts are visible. He refers to this as "showing its nature."[100] The self-directed, exploratory quality of his work has been clear from the beginning. *Cocklebur Cube* (1975) consists of woven squares of wool held together with alternate layers of burrs, and the spherical *Patchwork Basket* of the same year is pieced together of irregular patches of tapestry-woven morning glory vines and daylily leaves. He also tried out a variety of applications for bark, not just the conventional plaited strips. One of the more surprising was a replication of the form of a section of tree trunk: he removed and reassembled its bark, showing the two together as *Tree and Its Skin* (1984).

McQueen's word baskets began in 1979 with a cubic frame of slender forked branches held in tension by a constructed mesh on two opposite sides—which, with considerable effort, can be read. (Figure 9.54) (One side, for example, says, "Always is always a ways away.") His words have ranged from witty to wise. In a later work

the feet of a basket form the words "under stand," and in another, raised seams spell out "Trees are only waiting for us to bury ourselves."

McQueen has successively sampled the communication of meaning through form, through language, and through pictures or figuration. The earliest were the most abstract; those baskets addressed singularity and wholeness, separation, containment, organizing, control, process, and time—all conveyed through formal means. Language is, of course, a much more common and specific way of expressing thoughts in our culture; the novelty in McQueen's word works is the many ways he found to form letters with the aid of his materials, rendering words palpable. In his more recent figurative basket constructions, he is speaking through body language—posture, tension, gesture—and his technique creates meaningful allusions through structure and transparency. That all these expressions have been accomplished in the hand processes of basketry is a credit both to McQueen and to basketry itself.

Ferne Jacobs (b. 1942) became interested in weaving when she took a class with Arline Fisch in 1965. Jacobs had mostly studied painting, but she responded to the sensual nature of the materials, including smell and touch. She began to do off-loom work in 1970 after a friend introduced her to Native American basketry techniques, and she became a basketry pioneer.

Jacobs uses traditional techniques of coiling (in waxed-linen carpet thread) but has never produced traditional forms, and she is inclined to speak of her work not as baskets but as containers in an abstract sense, functioning in the realm of ritual. (Figure 9.55) "I consider my work to be in the service of something that is feminine in myself, and feel that I am building bodies and that each wrap of the thread is a cell," she says. "How that relates to the concept of baskets, I don't know."[101] The early works were solemn and moved immediately toward sculptural expression. They often feature multiple and unconventional openings that evoke orifices in some unidentifiable body. As early as 1976–77 (just after earning an MFA from the Claremont Graduate School), she was making forms as tall as forty-one inches.

Jacobs considers the spiral of her coiling to be not just a method but an image of significance, representing a path or journey of constantly encountering new space. Another important image for her is the mountain, which symbolizes the unchanging part of a person. She extends this personal mythology into her work. She also sees colors as living entities, and her use carries a personal meaning, though viewers tend to perceive colors only for their positive emotional associations. While exploring

FIGURE 9.55. *Ferne Jacobs, Container for a Wind, 1974–75. Coiled waxed linen thread; 44 × 11 × 4 in. (Courtesy of the Artist. Photograph by Jay Ahrend.)*

size, postures, and strong color, her work has remained steady and recognizable. "My commitment grows out of a fascination that thread can be made solid," she has said, "that by using only my hands and the thread, a form can be made that will physically stand on its own."[102] The process is time-consuming, with a typical sculpture taking from two to seven months to complete, and thus her works are not numerous. She also makes and exhibits collages and drawings on rice paper.

Glass Goes Mainstream

In the 1970s the glass movement institutionalized. In 1970 Joel Philip Myers left the Blenko Glass Company to establish the glass department at Illinois State University, and dozens of other programs were initiated in the next few years, in art schools, in workshop-oriented craft programs, and occasionally independent of both.

The Glass Art Society (GAS)—loosely modeled on the National Council on Education for the Ceramic Arts—was formed by a group of artists who met at Penland in 1971. GAS elected its first president, Henry Halem, in 1972 and began to publish a newsletter (later the *Glass Art Society Journal*) in 1976. Harvey Littleton's *Glassblowing: A Search for Form* (1971) was for several years the only book targeting glass artists.

The Corning Museum of Glass began an annual overview with *New Glass Review* in microfiche and later in magazine format. As the field heated up, director Paul Perrot concluded that the museum needed a full-time curator of twentieth-century glass and hired J. Stewart Johnson, previously curator of contemporary design at the Museum of Modern Art, who built a collection of works dating up to the World War II era. Subsequent curators brought it to the present.[103]

In 1971 Dale Chihuly, with the support of John and Anne Gould Hauberg, held the first summer workshop that became the Pilchuck Glass Center, beginning a glass dynasty in the Seattle area. In New York, Richard Yelle and Erik Erikson established the New York Experimental Glass Workshop in 1977 as the first open-access glass studio, enabling artists to work in glass without being associated with an art school or factory. (Its name was changed to UrbanGlass after a 1991 relocation to Brooklyn.)

In 1971 Ferdinand Hampson and Tom Boone opened Habatat Galleries in Lathrup Village, Michigan, and the Contemporary Art Glass Group got its start in New York. Promotional activities initiated by these two galleries, such as Michigan Glass Month and a lecture series in New York, boosted the new medium's visibility. In 1975 Habatat held its first national survey of glass works, and the show nearly sold out during its preview. The gallery later opened spaces in Florida and Chicago. Contemporary Art Glass was started by Doug Heller and a partner, to represent young glassmakers; in 1974 Heller opened a Madison Avenue outlet. By 1976 it was self-supporting, and in 1978 he sponsored *Glass America 1978*, showing the work of fifty artists at Lever House on Park Avenue, with a catalog. After his partner left that year, his brother Michael joined him in opening a second space, Heller Gallery, representing 100 artists and drawing international clients.

In 1978 David Huchthausen curated the first of three *Americans in Glass* traveling shows, organized by the Leigh Yawkey Woodson Museum in Wausau, Wisconsin. In its catalog, Huchthausen praised the achievement of individual expression as well as technical competence in the short history of the medium. In the second show, in

1981, he identified a move from the vessel toward sculpture and asserted that the best ideas in glass were coming from outside the field, in the work of such artists as Larry Bell, Christopher Wilmarth, and Laddie John Dill. In the third exhibition, which toured Europe, he complained of stagnation and self-ghettoization. (Huchthausen's work will be discussed in chapter 10.)

Another significant show was *New Stained Glass*, at the Museum of Contemporary Crafts in 1978, which presented "autonomous" panels (not meant to be installed in window openings). There were a few precedents for such work, but now, for the first time, a group of artists had dedicated themselves to the genre. Each piece was designed and fabricated by a single individual.[104] Among the technical innovations were sandblasting, photographic processes, double and triple glazing, appliquéd lead lines, unleaded cut lines, and raised forms as well as the use of sheet lead, lenses, mirrors, and shaped-metal armatures. The work aspired to personal expression and seemed related to modern drawing and painting.

New Glass: A Worldwide Survey, at the Corning Museum in 1979, was equally eye-opening. In Corning's 1959 show, 16 percent of the entries had been designed and made by individuals; now 90 percent were. Jurors for the earlier show saw 1,800 entries, while now there were more than 6,000.[105] The new show toured nationally, and one of the stops was the Metropolitan Museum of Art. The exhibition, its catalog, and the approval of one of the country's most important art institutions all had considerable impact on collectors. By mid-decade there was a market for glass. Chihuly had his first show of sellable objects in 1976, and by 1977 his pieces were going for $1,000 each.[106]

Although museum glass exhibitions were relatively frequent, because the work proved to be crowd-pleasing, almost all were general surveys, the "what crafts can do" approach that has also plagued other mediums. Consequently no critical standards were discussed. With so much of the work generated outside academia, there was equally little academic discourse. Among the visual tropes were pop-style pictorial imagery, anthropomorphic forms, decorative vessels, translations from non-glass sources, optical effects, emotionally suggestive color forms, and a little social commentary.

The developing medium was the beneficiary of several coincidences and some astute planning. It was fortuitous that Tiffany glass had come back into fashion, and many new glassblowers learned how to imitate the famed iridescent surface and trailed peacock feather design. Thus antique collectors could easily relate to early studio glass. Moreover, they could understand its cost:

hot glass is expensive to produce. A furnace full of molten glass must be kept at temperature until it is emptied. Even when a hot shop is standing empty, it costs money. And when energy prices began to escalate in the mid-1970s, hot shops had an increased cost at a scale faced by no other medium. Collectors paid amounts for new blown glass that far exceeded the prices of ceramics or jewelry. It helped that some glassblowers were natural showmen and studio visits were fascinating affairs: the heat and sweat, the fiery glass, the roaring furnaces, the dancelike coordination of blower and assistant made for great public relations, and studio glass developed a loyal following.

DALE CHIHULY

Like Tiffany, Dale Chihuly has made himself a product name associated with the beautiful and flamboyant qualities of glass. Also like Tiffany, he has a gift for collaboration and has worked with other artists as well as with employees to find new directions and to serve his needs; he has been an entrepreneur, creating vast quantities of work for which he is the designer rather than the maker, and he has become a great showman, developing presentations as well as objects. His works are beautiful and imaginative, inspired by visual precedents yet without metaphor. He turned out to be a master of spectacle, which perfectly suited the late twentieth-century attraction to celebrities and the mesmerizing entertainment of the television set and computer monitor.

Chihuly was born in 1941 in Tacoma. He attended the University of Washington in Seattle, majoring in interior design. Encouraged in a weaving class to add other materials, he incorporated glass since he was attracted to transparency—at first crude chunks, then pieces he had melted in a kiln in order to embed copper wires. Before long he enrolled in Harvey Littleton's graduate program in glass at the University of Wisconsin. It was there that he discovered collaboration, learning from working with his peers what he had missed by not making art as an undergraduate.[107] He went on to RISD for an MFA, taught at Haystack, and on a Fulbright Fellowship, went to Venice for exposure to the glass masters and the teamwork of Murano and to Germany and Czechoslovakia to meet glass artists. He returned to RISD in 1969 to begin building a glass department. The school has turned out many significant glass artists, starting with Dan Dailey, Michael Glancy, Therman Statom, and Toots Zynsky. Chihuly taught not so much by demonstrating as by involving students in a working situation.

Chihuly began making collaborative works—large-scale, complex environments—with Jamie Carpenter, an exceptional undergraduate eight years his junior: neon embedded in ice, a sculptural "forest" of glass and neon, a "wall" of blown-glass roundels, and so on. (Figure 9.56)

In 1975 Chihuly and Carpenter decided to stop working together, and Chihuly concentrated for the first time on vessels. He had recently taught at the Institute of

FIGURE 9.56. *Dale Chihuly and James Carpenter*, Glass Forest #2, 1972. *Opaque glass stalks, lit with argon and mercury; 160 sq. ft.; height, 6–9 ft. (© Dale Chihuly Studios.)*

Pilchuck

In the fall of 1970, Chihuly contacted Ruth Tamura, who ran the glass department at the California College of Arts and Crafts, with the idea of a summer glass school in the Northwest, where students would build their own equipment and camp outdoors, close to nature. It was to be a free, learn-by-doing experience, funded by faculty grants. Students had to arrange their own credit. Jack Lenor Larsen, whom Chihuly had met in Seattle, put him in touch with John and Anne Hauberg, collectors and philanthropists, who offered a farm site on forested acreage they owned north of Seattle. But Chihuly walked up a logging road and was so taken with the view that he set up there, without any buildings or utilities.

Some eighteen students came. There was little distinction between faculty, students, staff, or friends, since all hands were needed to build the equipment and rudimentary quarters. Despite the fact that it turned out to be an exceptionally rainy summer and the site became a wallow, they had constructed furnaces within sixteen days as well as a low-tech propane annealer. After the second summer, Hauberg put up the first building—a hot shop.

While its definition was the subject of debate among the initial participants, Chihuly ultimately achieved his desire for a program devoted solely to glass (antiestablishment ecological artist Buster Simpson, who preferred the Black Mountain College model, lost out). It began with much experimentation and project-oriented work. After the third summer an acting director was hired, giving Chihuly time to function as artistic director and do his own work. Grants were obtained from local and federal agencies, Pilchuck became a legal entity, and more buildings went up. With the arrival of European masters starting in 1977, "the school—and the American studio glass movement in general—was shifting from a disregard for technique to an ardent desire for it."[1]

NOTE

1. Tina Oldknow, *Pilchuck: A Glass School* (Seattle: University of Washington Press for Pilchuck Glass School, 1996), 175 and passim.

American Indian Art in Santa Fe and was interested in Navajo blankets, so he lined up another partnership in which Flora Mace executed his blanket drawings using a glass thread method she had developed. He had another important Native American inspiration: visiting the Tacoma Historical Society storeroom in 1977, he noticed a stack of Indian baskets softly collapsing into one another; he thought that he could make the glass move the same way if he blew it very thin (his blanket cylinders were thick, weighing up to twenty pounds each). It was an innovation to nestle together forms of several sizes, making single works of multiple elements.

With his move into objects and his first gallery show in 1976, Chihuly began to sell. That year, he lost the sight in his left eye in an auto accident and with it his depth perception, and in 1979 he suffered a shoulder injury that made him unable to lift. These events and his resignation from full-time teaching led to a new phase in his work, which will be discussed in chapter 10.

JAMES CARPENTER

Jamie (as he was known then) Carpenter was the first major collaborator with the glass world's master tactician, Dale Chihuly. Together they created inventive installations in neon and devised doors and panels, and together they kicked off what became the Pilchuck glass school. Carpenter was only an undergraduate, yet he held his own. He went on to design glass for industry, to earn a National Endowment of the Arts artist's grant for technical developments in glass, and to establish a design business that has created major public and commercial commissions, noted especially for the use of dichroic glass (which shows different colors in reflected and transmitted light).

When he met Chihuly, Carpenter (b. 1949) was already interested in light, and the two conceived such projects as freezing glass tubing in blocks of ice five feet tall. The tubing was filled with powders that fluoresced different colors, producing various effects as the ice melted. Later that year they blew, pulled, poured, and sagged tubing in which they enclosed neon, argon, and mercury gases in an installation at the Museum of Contemporary Crafts. A third environmental piece, inspired by the form of the Crystal Palace, involved arched sheets of glass laid across blocks of dry ice. Their four window or wall projects included the *Corning Wall* (1974), in which blown-glass roundels were set in three vertical panels, both flattened and cut in an unorthodox approach.

Carpenter went to Venice on RISD's European honors program in 1971–72 and subsequently did some de-

signing for the Venini Glassworks. He conceived Double Volume vessels—blown in two different-colored parts— which he returned to in 1977, when he was artist-in-residence for Steuben's research center, producing them in Steuben's flawless glass. A particularly successful, albeit sentimental piece he designed for Steuben involved a pair of indented cylinders sliced at an angle to make *Paired Hearts* (1978). He became interested in new techniques to create color in glass, but Corning preferred its colorless standard.

In 1977 Carpenter organized his firm, James Carpenter Design Associates, with an architect and two industrial designers. In the next decades they would engage in large projects, and he continued to wear many hats— "artist and sculptor, glass technician and inventor, systems designer, researcher, and dichroic glass evangelist" in his own terms.[108] His later individual works include glass-tile screens and furniture that allowed for optical effects and light towers of dichroic glass.

JOEL PHILIP MYERS

After studying advertising design at Parsons in New York, working for six years in graphic and packaging design, and then leaving that field to take BFA and MFA degrees in ceramics at Alfred, Joel Philip Myers (b. 1934) inadvertently became the sole major first-generation glass artist who did not come to the material through Harvey Littleton's efforts. When he finished at Alfred, he was hired as a designer by Blenko Glass Company of West Virginia and worked as design director under industrial conditions. He followed news of the studio glass movement and began to experiment during the factory's two one-hour breaks each day. Among his experimental pieces is *Dr. Zharkov's Mirror* (1970), a stack of globes that looks like a piece of equipment in Dr. Frankenstein's lab. He began to exhibit, attend conferences, and demonstrate at workshops. When a reviewer for *Craft Horizons* suggested that the factory glassblowers were making the work for him, Myers replied testily to the contrary.

In 1970 Myers established the glass department at Illinois State University. Free from the furnace time constraints, he soon turned to applying broken fragments of thin colored glass on the surface of a hot bubble— his well-known Contiguous Fragments series, begun in 1978. (Figure 9.57) Myers proved to be not only a colorist but gifted at composition. He balanced dense color patches against empty ground, floating the fragments on the surface to create a sense of free depth, allowing hints of the familiar (especially landscape) without ever becoming pictorial. He iridized and cold-worked the vessels to refine the compositions. His is one of the few bodies

FIGURE 9.57. *Joel Philip Myers*, Contiguous Fragment Series, Black 22, 1979. *Black glass, fragments and hot Kugler additions, fumed, sandblasted, and acid-etched; height, 6.75 in.; diameter, 5.33 in. (Courtesy of Joel Philip Myers. Photograph by John Herr.)*

of work in glass that can be compared favorably with abstract painting. Early pieces in the series used white opaque glass, handsome enough but flat in comparison to his black-glass forms, on which the color appears to hover in deep space or seems to explode like fireworks in a night sky.[109]

Myers was criticized for emphasizing surface and not letting light into the work—which is ironic, given that the field as a whole has since then moved toward concern with surface rather than form. Nevertheless, stung by such comments, in the early 1980s he began to embed the color fragments in transparent layers and worked happily in this expanded realm, stretching his vessels horizontally to give himself a more painterly surface. Some years later he decided that despite his satisfaction with the Contiguous Fragments series, he was not pushing himself as he pushed his students. He stopped working for three years, and when he resumed, it was with literally tougher, irritable work: installations of vessels with dressmaker pins sticking out from the pricked glass surface or with what might be bullet holes.

RICHARD MARQUIS

In 1969, a year after Dale Chihuly went to Venice to observe the glass factories on Murano, Richard Marquis (b. 1945) was awarded a Fulbright Fellowship and went

to Italy for a year. Marquis was already one of the most skilled American blowers, but he quickly learned how inferior American standards were: "It was a pitiful state of affairs. I was about as skilled as any ten-year old in Murano."[110]

Marquis gained entry to the famous Venini factory, and by working hard (and siding with the workers during a strike), he gained the Italians' respect. He learned many of the classical Venetian methods, including *murrine* and decorative canework techniques. His work in Venice consisted of striped, wide-bottomed cups, many in *murrine* patterns of stars and stripes—ironic in a time of bitter division over the war in Vietnam. When he returned to the United States in 1970, he shared his new knowledge generously. He became a key figure in the move toward greater technical expertise in American glass.

Marquis had started out in ceramics, studying with Voulkos at Berkeley, where he also picked up the funk aesthetic of the times. He was equally taken with Ron Nagle's small, highly finished cups and Ken Price's affectionate references to pop culture. When he came back from Italy, Marquis made teapots using Venetian techniques. He chose the teapot because it had no precedent in glass, only in clay or metal, and since his were not functional (special glass would have been needed to resist thermal shock), he was not constrained by physical requirements. His most famous teapots from the 1970s were made in checkerboard patterns. Looking like the offspring of a quilt and a blob of Silly Putty, they are absurd and oddly festive.

Marquis invested much time in learning to control the techniques he acquired in Murano and others he developed on his own. When he was hired to teach glass at the University of Washington, he put up a sign that said: "Technique is not so cheap." It was his declaration that control over a medium is crucial to artistic freedom and an obvious riposte to Littleton's "technique is cheap" (see chapter 8). By the late 1970s, Marquis was no longer content to limit himself to glassblowing. New glues had been invented that could permanently bond glass surfaces. Forms could be crisper, and found objects could be incorporated. The possibilities for jarring juxtapositions increased dramatically.

Potato Landscape Piece (1979) is typical of his early "cold-fabricated" glass. (Figure 9.58) The base is a glass souvenir filled with colored sand depicting a desert. On top of that sits a glass potato, which sprouts pointed *murrine*. And on top of the potato sits a faux teapot. Its spout is another *murrine*, which reads in minuscule letters: "Chuck the Duck says life is mostly hard work." The thing is not just a piece of yuk-it-up surrealism; it is a

FIGURE 9.58. *Richard Marquis*, Potato Landscape Piece, Fabricated Weird Series, *1979. Blown and cold-fabricated glass, assembled with murrini cane extrusions and sand-filled paperweight base found object; 2.76 × 4.21 in. When magnified the solid white murrini spout shows internal decoration of the words, "Chuck the duck / says life is / mostly hard work." (Collection of The Corning Museum of Glass, Corning, N.Y., 1985.4.8. © Richard Marquis.)*

meditation on the various uses to which glass has been put as well as a nod to the history of functional craft. It is also an exercise in calculated irreverence, designed to destabilize the identity of everything it touches.

Marquis went on to explore permutations of superb technique, absurdity, kitsch, odd objects, and much more. He combined his collections of kitsch and his glass in the series Personal Archive Units in the 1990s, further blurring boundaries between high and low. He also developed traditional Venetian processes in his Marquiscarpa series of tall-stemmed, shallow bowls made of *murrine* that have been carved to a mat finish that is perplexingly unglassy. As always, Marquis imbues it with a cheerful disrespect for all established boundaries and categories.

STUDIO GLASS MEETS SCULPTURE

Amid all the testing of limits in the 1970s, two artists pushed glass to the boundaries of craft and perhaps be-

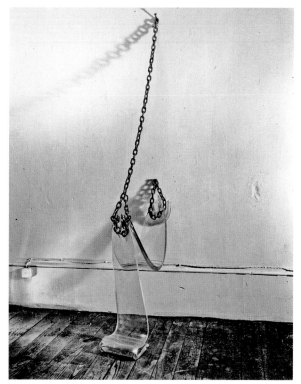

FIGURE 9.59. *Mary Shaffer*, Glass and Chain, 1974.
Glass, chain; 62 × 8 × 21 in. (© Mary Shaffer.)

be a confrontation between male and female principles. As Shaffer put it: "Because I work with gravity . . . I say I work with nature. I call this the 'female principle' in the Jungian sense—the idea of yielding and joining forces with nature, versus the 19th-century attitude of 'man over nature.' This is the fundamental philosophy behind my work."[111]

In an untitled sculpture from 1974, two long, layered rectangles of thick sheet glass were suspended from two pieces of chain, one end extended into space and the other resting against a wall. (Figure 9.59) When heated, the glass draped elegantly, folding where it hit the floor. The tension between hardness and apparent softness has a powerful emotional undertone.

Shaffer's "midair slumping" offered the same gestural quality as freehand blowing, with less control over the material, no reference to vessel form, and larger scale. Observers identified her work as postminimalist sculpture, then in vogue. She was one of the first studio glass artists to be exhibited by a New York art gallery (OK Harris in 1975). In the late 1970s, Shaffer slumped squares of glass on vertical grids of iron wire. These hung from the ceiling a few inches away from the wall. In strong light, they project distorted shadow images of themselves. Later she slumped glass from the grip of old tools such as hooks, cleats, and tongs.

NEW DIRECTIONS IN TWO DIMENSIONS

A graduate student in English literature with plans to write fiction is hardly a person one would expect to become an artist in a nearly forgotten nonmainstream art medium. But such is the story of Berkeley-based **Robert Kehlmann** (born in Brooklyn in 1942, a graduate of Antioch College and UC Berkeley). The benefit of his nonglass training is an ability to look carefully and think critically, leading him to make deliberate works in what he declines to call by the misnomer "stained glass" or a term that promises boredom, "flat glass." He calls his works "drawings with lead and glass." They are always abstract, always seeking specifics of mood that can be conveyed by formal means. They are never windows, and he was among the advocates of the "autonomous panel" of glass on the wall or on a stand and lit from the front, like a painting. Although he came to this medium independently, the store where he bought his glass was owned by Peter Mollica and Casey Lewis, and they—along with Paul Marioni, Kathie Bunnell, Sanford Barnett, and Ed Carpenter—made the Bay Area a center for serious work in two-dimensional glass.

In his early Compositions—a word that applies equally

yond. Both were students at RISD early in the decade, and both profited from the spirit of experimentation established there by Chihuly. One was **Bruce Chao**, who as a student created installations using plate glass (in one case, blocking a stairway by leaning a glass sheet against it) and went on to make sculptures and installations in glass, metal, and wood, often with strong overtones of architecture.

The other was **Mary Shaffer** (b. 1947), a painting student who decided to paint on glass. When she consulted with Fritz Dreisbach, who was teaching there at the time, he suggested that she give the glass some three-dimensional form by slumping it. So she began experimenting. Unlike Heaton and the Higginses in the 1950s, she used no molds. Instead, she suspended clear plate glass in space and softened it with heat. The glass would sag, the ultimate shape depending on the temperature and its duration, the thickness of the glass, what it was suspended from, and other variables.

Shaffer's theme became the contrast between hard metal supports and yielding glass. She used iron wire, hardware, rusty tools, chain, anything that could endure the heat of the kiln. Usually the metal would be rectilinear, structured, and constricting, while the glass was soft, curving, and responsive to gravity. The results seemed to

FIGURE 9.60. *Robert Kehlmann, Quartet, 1979. Leaded, sandblasted plate glass, acrylic; 6 ft. 5 in. × 4 ft. 6 in. (Private Collection, San Francisco. Courtesy of the Artist. Photograph by Richard Sargent.)*

behind it, so that the drawing is dimensional and catches light. These works convey a drawn-and-smudged looseness. A 1982–95 series, Stations of the Cross, is a response to the death of his brother that conveys emotional weight in its somber or serene colors and downward-pulling lines.

Surprisingly, Kehlmann has not used his literary skills to produce poetic titles for his work. But his background has made him a respected writer in the field, a regular contributor to publications and author of *Twentieth-Century Stained Glass: A New Definition* (1992).

Paul Marioni (b. 1941), like Kehlmann, took no formal instruction in glass. He earned an undergraduate degree in English and philosophy, which perhaps explains the thoughtfulness that runs through his work. Like Kehlmann he was drawn to flat glass, at first preferring autonomous panels. He incorporated all sorts of nontraditional elements: Fresnel lenses, Polaroid filters, two-way mirrors, headlights, even X-rays and photographic film. But Marioni's work was never totally abstract.

His 1975 leaded-glass panel *Journey through the Valley of the Kings* depicts a schematic valley with a bloodred stream running diagonally through it. The landscape serves as a background for three elements: left to right, an X-ray of an infant with medical sensors attached, a planetlike object, and a round black emblem with a skull. Each casts a shadow on the landscape. Critic Matthew Kangas saw such juxtapositions as garden-variety surrealism, given over to sex, death, and dreams.[112] Maybe so, but the image could also be read as a poetic meditation on the cycle of birth and death and our uncertain ability to hold dominion over the world. The open-endedness of the image invites us to draw our own conclusions.

Marioni felt limited by leaded glass, especially the lead lines that hold each part in position. In 1974 he started looking into blown glass for ways to eliminate the line. He experimented with the ancient technique for making flat glass: blowing a cylinder, cutting it open, and flattening it out. He developed an image on the bubble and then expanded it in the blowing process. Wobbly distortion is inevitable, yet Marioni was drawn to the spontaneity of blowing. After a time, he decided to leave his cylinders whole, treating them as a three-dimensional ground on which he composes his narratives.

In the 1970s Marioni also experimented with casting. He learned to produce relief images and deep textures in glass, which opened up possibilities for large realistic imagery wholly independent of the leaded line. (Figure 9.61) In the early 1980s, abandoning his opposition to architectural siting, he adjusted his imagery to commu-

well to art and literature—Kehlmann used the lead line as a drawn line, never simply for piecing or support. *Composition XXVIII* of 1976 is representative: before a billowing golden background—something like a sunset haze—a more or less rectangular figure of red and a boat-shaped form in brown seem suspended in swinging motion. At the middle of the left and right edges, scribbled loops of lead touch the main colored figures. *Quartet* (1979) is far more segmented, with its finely gridded plate glass seemingly set upon by a ruler and protractor that divide it into fields and interrupted arc motions. (Figure 9.60) The whole suggests a tick-tocky mechanical motion that might have come out of a Charlie Chaplin or Buster Keaton movie. Kehlmann used sandblasted opacity and transparency to control depth.

Pursuing various ways of coloring, marking, and organizing the glass fields, he layered colors to create relief forms or double-glazed to create slight shadows. Later he laid vaguely fluttery sheets of dark color over paler or grayed sandblasted areas. He worked both on a glass surface and with charcoal or other mediums on a board

FIGURE 9.61. *Paul Marioni, The Warriors, Shapers of Our Destiny, 1984. Cast glass, steel; 20 × 24 × 1.5 in. (© Paul Marioni. Photograph by Roger Schreiber.)*

FIGURE 9.62. *Peter Danko, Armchair, 1982. Walnut veneer, poplar, leather upholstery; 30.5 × 21.75 × 24 in. (Museum of Fine Arts, Boston, purchased through funds donated by the National Endowment of the Arts, Ethan Allen, Inc., and the Robert Lehman Foundation, 1982.507. Art © Peter Danko/The Danko Design Initiative. Photograph © 2008 Museum of Fine Arts, Boston.)*

nicate with a wider audience. Works such as a 1980 cast-glass window depicting two realistic boxers and a robotic-looking crowd have, however, none of the mystery of his earlier panels. When he returned to making glass panels in the 1980s, he reclaimed his poetic sensibility.

Wood: Actions and Reactions

FURNITURE

After the revolution of the 1960s, studio furniture evolved more slowly. Certain ideas remained constant. Wood was still given the highest respect, and most makers used an oil finish, so the grain and texture showed clearly. Painting on wood was still unusual and even offensive. Other ideas fell out of favor, such as the 1950s concept of designer-craftsmen working in collaboration with industry or reproducing their own designs. Exceptions existed—Peter Danko's one-piece bent plywood chair—simple, durable, and eco-friendly—was designed in the mid-1970s and eventually licensed to Thonet. (Figure 9.62) When all the kinks were worked out, Danko could produce a $130 side chair in three and a half hours, using $10 in materials and wasting almost nothing in the process.[113] For the most part students in art schools had little interest in designing for industry or even making multiples. A more attractive role model was Wendell Castle, who aspired to treat furniture as art—expressive, sculptural, and unique. Even cabinetmakers like James Krenov, steeped in the ethos of functionalism and fine craftsmanship, made mostly one-of-a-kind furniture.

Woodworkers created a fair amount of sculpture in

the 1970s. Most of it was carved; much of it was awful. The few exceptions—Jon Brooks, Robert Strini, and Castle among them—had been honing their distinctive visions for years and knew the pitfalls. Other woodworkers churned out swoopy shapes, pretend knots, and sophomore surrealism. The most cringe-inducing wood sculpture was figurative, almost all of it evidencing the woodworker's poor grasp of anatomy.[114]

The teaching of woodworking at the college level expanded rapidly in the 1970s. By 1979 a survey in *Fine Woodworking* magazine listed 150 undergraduate programs nationwide, and ten that offered master's degrees. The approach to teaching was not uniform, though. On the West Coast, teachers were more concerned with self-expression and paid scant attention to the niceties of the craft. In the East, many new teachers were students of Tage Frid and, like him, insisted that their students learn traditional cabinetmaking techniques. Wendy Maruyama, who had moved east to continue her studies after starting at San Diego State University, says: "I remember my first assignment at SDSU as an undergraduate student in wood: 'Go into a place of nature and find a beautiful and organic form—bring it back and design an object of wood inspired by this form.' (I mean, it was the '70s.) At most institutions back East, the first assignment was to

learn to true up a handplane and plane a board by hand and with that board cut your first set of dovetails. I didn't even know what a dovetail or a mortise and tenon was until I moved back East."[115]

The most influential of the new wood departments was the Program in Artisanry at Boston University. For years, Jere Osgood, who had studied with Frid, was the senior woodworking teacher. He offered a mix of sound technique and tolerance for experimentation.

In time, a focus on virtuosity came to dominate woodworking programs, influencing the type of work that students produced. If the beginning of the decade was characterized by organic stack-laminated furniture, the end of the decade featured difficult techniques and exotic hardwoods. Cabinetmaking methods, once used mostly for commercial furniture and reproductions of antiques, acquired a new sheen of exoticism. A new generation wanted to make furniture, not sculpture.

Also contributing to the interest in technical prowess was the debut of *Fine Woodworking* magazine in 1975. It was the first comprehensive periodical for technical information on hand skills, new techniques, machine tools, woods, antiques, and much more. Its primary audience was the amateur woodworker. Information was clear and accurate. There were pages of shop tips (most submitted by readers), measured drawings, and how-to articles. The magazine was democratic: all types of furniture were represented, from antique replicas to the most experimental studio work. *Fine Woodworking* is the most successful studio-craft publication: by 1985 it had a circulation of 250,000.

The inaugural exhibition at the Renwick Gallery, in 1972, was *Woodenworks: Furniture Objects by Five Contemporary Craftsmen*, featuring Esherick, Nakashima, Maloof, Castle, and Carpenter. The Museum of Fine Arts, Boston, acquired fifteen pieces of furniture by Maloof in 1976. To follow up, it started an innovative program of commissioning seating furniture, called Please Be Seated. Many of the chairs or benches were placed in the museum's galleries, where they could be used by the public.

Around the country, many craft galleries sold furniture along with ceramics, jewelry, and weavings. Typically only a few pieces of furniture would be available, due to high shipping costs and requirements of space. In 1973, though, a furniture maker opened a small showroom in Philadelphia devoted exclusively to showing studio woodworking: the Richard Kagan Gallery was the first of its kind in the country. Students and teachers visited frequently, for it was their only opportunity to see the actual work. Although the gallery was never profit-

able and closed in 1983, it signaled the beginning of a national marketplace for unique handmade furniture.

WENDELL CASTLE ON TOP

By 1970 Wendell Castle was the star American woodworker. His furniture was widely acclaimed and widely imitated. He continued to produce throughout the 1970s, but he was bothered by the bricklike patterns of lamination joints on his surfaces, which conflicted with the organic forms. He also worried about placing too much emphasis on pure form and drifting too far from the mainstream. Plus, with all the imitators, his work no longer stood out as it had in 1967.

Castle decided to emphasize workmanship. To aid in the changeover, he assembled a team of highly skilled woodworkers. (Eventually, he opened a woodworking school and recruited his best students to work for him.) This enabled him to use specialists for carving, veneering, or painting. For a time he produced a series of desks with veneers in figured tropical woods and sculpted legs. While pleasing, they had none of the drama of his best stack-laminated pieces. Then, in 1976, he began to think about trompe l'oeil carving. His first effort was a hat on a shelf, but the carving was not fine enough. Castle hired a French carver in 1978 to teach him and two of his workers, and that year he produced his first illusionistic furniture.

The typical illusion, made entirely in one hardwood, represented in life size a piece of furniture (usually historical) and a still life: keys and gloves on a demilune table, an umbrella in an umbrella stand, a coat hung from a hall tree. (Figure 9.63) What distinguished Castle's carved replicas was that his furniture was completely functional.

Carving life-size images was not new: Fumio Yoshimura was already known for his carved limewood replicas, and several other woodworkers were experimenting with the genre. But only Castle combined the illusionistic element with a real piece of furniture. It was a complete reversal of his antihistorical position in the 1960s. He now accepted history as a legitimate resource. He quoted freely from any source, even his own earlier work. He brought a scholarly self-consciousness to studio furniture as he became the first postmodernist furniture maker.

Castle's illusion series eventually culminated with *Ghost Clock* (1985). It appears to be a fine antique grandfather clock draped with a white cloth. The carving is so intricate and the surface so refined that, even on close inspection, it is hard to tell that the whole thing is wood and there is no "real" clock underneath. For Castle, the piece posed no challenge: he and his team were so good

FIGURE 9.63. *Wendell Castle, Coat Rack with Trench Coat, 1978. Honduran mahogany; 75 × 22.87 × 21.5 in. (The Museum of Fine Arts, Houston, Gift of Roy M. Huffington, Inc., and anonymous donors, 1984.299. © Wendell Castle, Inc.)*

at carving that they knew exactly how to fool an audience. To go further in that direction would make him an entertainer, not an artist. He never made another trompe l'oeil piece.

WILLIAM KEYSER

Given Castle's sudden ascendance, nearly every other furniture maker had to respond to his work somehow. William Keyser (b. 1936) arrived at a synthesis. Keyser earned an undergraduate degree in mechanical engineering, which gave him a good eye for ingenious technical solutions to construction problems. He studied with Frid at the School of American Craftsmen and learned his commonsense approach to furniture construction with boards. In 1962 Keyser was hired as Frid's replacement

at SAC. The very next year, Castle was hired as the second teacher in the program. Keyser had to take a stance.

Much of Keyser's work was liturgical commissions, for which he made gently flaring modern furniture. Since there was a boom in church building in the 1960s and 1970s, Keyser had plenty of work. His style fit well with the progressive, unobtrusive architecture of the moment. A typical altar might consist of a thick, solid top supported by two wooden planes that flared outward at the bottom and were the key to his subtle and elegant effect. He assembled thick curved surfaces much as a barrel is built, smoothed them over and tapered them from top to bottom.

These pieces were an American version of the Danish mode. They did not approach sculpture or rise to Castle's challenge. So Keyser embarked on another series: he produced monolithic sculptural forms without resorting to stack lamination, constructing them instead. He drew from techniques of boatbuilding and aircraft fabrication. He investigated steam-bending and figured out how to bend plywood surfaces in sharp curves over molds. To hold the plywood in position, Keyser used vacuum tables, a technology developed for plastics forming. He glued the resulting bent surfaces over frameworks for rigidity. The forms could twist and turn, and they could be as massive and sculptural as anything Castle ever made.

Keyser obtained some rather surreal effects. A 1966 table looks like a cube with two bites taken out of it, one from each side. The inside of each "bite" is an irregular half-tube, made by laminating tulipwood veneer over a plywood core and forming the sandwich in a vacuum press. He set these shapes into a particleboard box, which he veneered in walnut. The finished table looks like a solid block of wood—except that it appears to be walnut on the outside and, improbably, tulip on the inside. A spectacular coffee table, made in 1978, has a hollow base in an impossible-to-describe geometric shape entirely veneered with cherry, maple, and walnut. (Figure 9.64) No end grain is visible. The volume of the base is contradicted by the obviousness of the veneer, presenting an amusing visual conundrum. The clearly synthetic base contrasts with the elm cutoff that serves as the tabletop.

Keyser experimented with alternative materials, too. For one memorable cabinet, he made doors out of red vinyl that opened and closed with zippers. He is best remembered, though, for his ingeniously constructed sculptural furniture. It was highly influential, not least because of his remarkable technique. Woodworkers appreciated the fact that he made complex woodworking processes visible. In a decade in which many young wood-

FIGURE 9.64. *William Keyser, Coffee Table, 1978. Cherry, elm, maple, walnut; 16 × 73 × 18 in. (Collection of the artist. Art © William Keyser. Photograph © 2009 David J. Leveille.)*

FIGURE 9.65. *Daniel Jackson, Leda, the Devil, and the Moon (Looking Glass), 1973. Rosewood, osage orange, and lauan plywood; height, 30 in. (Philadelphia Museum of Art, Gift of the Friends of the Philadelphia Museum of Art, 1973. © Julia Jackson.)*

workers were overcompensating for the previous generation's lack of mastery, Keyser's work was seductive.

DANIEL JACKSON

Daniel Jackson (1938–1995) explored the middle ground between the sculptural forms of Castle and the pure furniture of James Krenov (see p. 372). A student of Frid's at SAC, he absorbed the lessons on use of machines and jigs and to construct in accordance with the properties of wood. In 1960 he made his pilgrimage to Copenhagen to study with Peder Moos, who concentrated on unique pieces of furniture in which fluid forms are enlivened by subtle hand carving of structural members and by pronounced through tenons made by machine. Jackson incorporated both tendencies into his own furniture.

Jackson sought ways to give greater expressive power to the tradition of constructed furniture. He loved to carve—not to flow parts together in the Maloof manner, nor to give a piece of furniture the appearance of sculpture, but to accentuate individual parts in ways that did not obscure the structural purpose of the member. A 1973 mirror frame that he called *Leda, the Devil, and the Moon* shows how he used wood. (Figure 9.65) The four basic parts of the frame are visually distinct, and each is carved into forms that have nothing to do with function. The carving serves either as decorative flourish or as symbol, with the weird split devil's face the most surprising element. But the whole is clearly a mirror frame, not a sculpture.

Some of Jackson's more extreme furniture took on animal-like characteristics, especially in the legs. He pursued this quality in a rocking horse for his daughter, then an adult-size rocking peacock and a rocking unicorn. People loved them. Jackson said their function was to create pleasure.

Jackson was reputed to be a brilliant teacher. His students Ed Zucca and Alphonse Mattia testified to his intelligence and ability to inspire. He was, however, afflicted with bipolar disorder and had to quit both woodworking and teaching by 1976. He retired from the field just as it started to grow by leaps and bounds, and his work never reached a national audience. Still, he was among the first Americans to make lyrical, expressive furniture.

FRANK E. CUMMINGS III

Californian Frank Cummings (b. 1938) is one of the most distinctive woodworkers the state ever produced. He picked up woodturning around 1960, but he did not make the smooth forms typical of mainstream turners like Bob Stocksdale. Instead his frame of reference was Africa, which he visited about the same time. There he witnessed the rich and complex relationships between objects and ritual. As an African American, he asserted his cultural heritage by using materials identified with the continent, such as tropical hardwoods, ivory, or goatskin. He thought it possible to build a sense of spiritual significance into objects made in contemporary America. In this he was also inspired by the Shakers. By using fine natural materials, treating them with the utmost respect, and investing them with extraordinary workmanship, Cummings felt that he could make objects that were not just useful but ceremonial.

In 1960 he made a turned vessel out of rosewood, which he embellished with a passage of twined goat hair, horse hair, and buffalo wool. The surprising coarse, furry texture lends the vessel a peculiar emotional overtone. Cummings also carved its upper two-thirds into an array of protruding stalks, a ruffle, and a band of dense, pebbly texture. The object is emphatically removed from

FIGURE 9.66. *Frank E. Cummings III, "It's about Time" Clock, 1979–80. Ebony, curved glass panels, clock mechanism, African blackwood, ivory, 14-karat, 18-karat, and 24-karat gold, Black Star sapphires; 68 × 24 × 16 in. (Collection of the Museum of Fine Arts, Boston. Art and photograph © Frank E. Cummings III.)*

the functional and machinelike ideals of Good Design. Instead, it is to be treasured for its uniqueness and the many hours of labor lavished on it.

Cummings went on to make jewelry, furniture, and clocks. His tall case clock from 1979–80 carries the notion of domestic ceremony even further. (Figure 9.66) The skeletal case is made of ebony and ivory with a fine finish. The clockworks, normally enclosed in a cabinet, are exposed to view through glass walls, for good reason: they are made entirely by hand of ivory and African blackwood, with accents of polished metal. The gears and escapement are carved in patterns inspired by snowflakes (perhaps incongruous for a clock made in Southern California) and seedpods.

It is nearly impossible not to treat Cummings's clock with reverence. Clocks of this kind, even manufactured ones, require periodic winding, which becomes a domestic ritual. Winding Cummings's clock would be a

multilayered experience: handling the case to open the door, winding, listening to the works as they mark out time, and observing the exquisite craftsmanship. While not exactly a religious ceremony, the experience would certainly stand apart from ordinary life. This is precisely what he intended: a chance to pay close attention to one's senses, a numinous pause in everyday routine.

THE VOICE OF CONSERVATISM: JAMES KRENOV

Between 1976 and 1981, woodworker James Krenov (1920–2009) published four books: *A Cabinetmaker's Notebook* (1976), *The Fine Art of Cabinetmaking* (1976), *The Impractical Cabinetmaker* (1979), and *James Krenov: Worker in Wood* (1981). They became quite popular, selling more than a half-million copies. His books, as well as his work, staked out a distinctive position in American woodworking.

Disturbed by the experimentation of the 1960s and early 1970s, Krenov spoke for the conservative, skill-oriented segment of the field. He thought woodworking was plagued with fashionable and pointless furniture, "exaggerated forms and coarse dimensions" and "contrived expressionistic sculptures." As he wrote in 1979, "people urge woodworkers toward an expression ever more similar to that of some far-out pottery. We get things that remind us of melting chocolate, something from a bakery, gooey objects in wood, bad imitations of art nouveau."[116] He also attacked unimaginative education, furniture designers who did not have an intimate understanding of wood, and poor craftsmanship in general, each of which represented a corruption of his notion of fine furniture. He is a twentieth-century Pugin, calling for a return to integrity.

Krenov describes a kind of morality for woodworkers. His ideal has four parts: pleasure, craftsmanship, refinement, and style. Where Morris mentioned happiness, Krenov stresses the whole of the experience of making: "At a time when to many of us life is so strangely complex with its problems of identity and fulfillment, work takes on a new meaning: To do something we enjoy is to know ourselves. Philosophical talk and all kinds of uneasy moving around won't by themselves give us wholeness. We need to work in a way that is satisfying."[117]

Satisfying work is a way to find meaning in the world. Krenov writes of "the condition of undisturbed closeness to what we are doing," a state of absorbedness that is deeply enjoyable.[118] Psychologist Mihály Csikszentmihályi called this state of consciousness "flow" and said that achieving it can significantly enhance one's quality of life. (His best-selling book on the subject is *Flow: The Psychology of Optimal Experience*, published in 1990.) Krenov

writes eloquently of absorbed work: "A few satisfactions are almost embarrassingly simple. Like noticing, as you try a first cut with a wooden plane left set as it was some days earlier, that the weather has changed. It's been raining, and you have to tap the iron down a hair—and you find yourself smiling as you do so."[119] A careless worker, somebody who was not paying full attention, would not notice that the wooden plane had swollen slightly in the humid air and that the blade needed adjustment, nor would the worker think about the interconnectedness of things and how the rhythm of the workshop is intimately tied to the rhythms of weather and seasons. From such connections are meanings made.

For Krenov, such skilled and satisfying work is the only means to produce fine furniture. He clearly distinguishes between hand production and mechanical reproduction, since machines are indifferent to variables like wood color or grain, or to the desires of a particular client, or to changes in the weather. Krenov writes about the wood "talking back" to the craftsman through the tools. Good craftsmanship opens up endless possibilities for refinement and experimentation. The refinement improves the object; the experimentation makes the worker's life more interesting. It is a win-win situation.

Krenov did not dispute the fact that all his design processes and careful handwork were slow, too slow to be very profitable. (He made between six and eight major pieces a year; Maloof made forty or fifty.) In the interest of maintaining total control, Krenov did not employ assistants. In the interest of maintaining quality, he did not license his designs to manufacturers. Further, he rarely (if ever) made the same design twice. He did not make tables; he did not make chairs; he did not make upholstered furniture. He did not take commissions, either. He was one of the most uncompromising of American woodworkers.

All this idealism, in the end, became an inflexible ideology, which led Krenov into the rather odd position of insisting that he was an amateur, not a professional. Apparently he felt that no true professional would lavish so much time and energy on a single piece of furniture. Krenov was no amateur, however: he taught for more than twenty years, his books are among the best-selling craft titles ever published, and his work is recognized around the world. Having made himself into a star in the woodworking world, he refused to admit it. Nonetheless, Krenov's uncompromising idealism speaks to many aspiring woodworkers, and they like the fact that his work *looks* like furniture. It does not challenge any assumptions about what furniture should and should not be.

FIGURE 9.67. *James Krenov,* Cabinet, *1992. Kwila and spalted hickory; height, 61 in. (Philadelphia Museum of Art, Gift of the Women's Committee of the Philadelphia Museum of Art, 1992. © James Krenov.)*

Curiously, Krenov had little to say about his style, other than to insist that it was timeless. But in fact it is a reworking of mid-twentieth-century Swedish modern. His forms are spare, devoid of applied decoration. Wood is exposed. Finishes are mat, never glossy, never painted. Through tenons are visible but discreet. Everything is straightforwardly functional and built to last. Krenov did not invent new forms: he adapted existing ones and refined them.

Krenov departs from the Swedish model in his typically American fascination with highly figured wood, like spalted maple. He sometimes put a panel of figured wood front and center, as if it were in a picture frame. He favored cabinets, cabinets on stands, and boxes. (Figure 9.67) Most of his work is smallish, inviting close inspection of details. In effect, his work represents the tail end of the Scandinavian modern movement exported to America. He kept it alive in woodworking for the time being.

FROM FURNITURE TO SCULPTURE

Ed Zucca (b. 1946) was one of the first of a long line of woodworker-comedians. He learned construction and carving as a student of Daniel Jackson's in the late 1960s

FIGURE 9.68. *Edward Zucca*, Shaker Television, *1979. Maple, basswood, zebrawood veneer, cotton seat tape, gold leaf; 36 × 24 × 18 in. (© Edward Zucca.)*

and then established a studio in Connecticut. His early furniture was influenced by the organic stylizations of the times, along with a touch of art nouveau. After a trip to Mexico, he took in other influences, including pre-Columbian, ancient Egyptian, twentieth-century consumer goods design, and art deco. In the early 1970s such a wide range of references was unusual, given the fixation on personal expression or technical prowess.

While he made a living from commissions, Zucca also made a body of work that was nominally functional but mainly intended to be ironic. He usually targeted woodworking culture, especially its more absurd articles of faith. To poke at the dictum of truth to materials, he made a hard-edged, industrial-looking table of wood, which he sprayed with metallic silver paint. The illusion is quite convincing and the gesture quite outrageous. He also made a hollow table out of Plexiglas, filling the interior with shavings.

One of Zucca's best parodies was his *Shaker Television* (1979), a functional chest with a usable drawer. (Figure 9.68) When he made it, most people still remembered 1950s televisions that were fitted in wooden cabinets. This faux television appears to be joined with dovetails; there are Shaker-style knobs for tuning and volume, and Shaker seating tape impersonates a speaker grille. The TV

is stamped (in gold, no less) with a replica of the Shaker logo that appeared on their mass-produced chairs. The screen is inlaid with zebrawood veneer, which resembles the bad reception that every child of the 1950s remembers. Zucca noted that if real Shakers had TVs, they would probably be content watching static.

Zucca may have been influenced by sculptor H. C. Westermann, who made perplexing objects out of wood and other materials. Zucca's best pieces are non sequiturs transformed into objects, inviting and deflecting all rational interpretation. Some works lack the sharp edge of *Shaker Television*, though, and the jokes can wear thin rapidly.

Craig Nutt (b. 1950) has made furniture in the form of familiar vegetables. A chair in which a celery stalk imitated a reeded column and carrots represented saber legs was clever enough. (A saber leg imitates the form of a sword and has roots in ancient Roman metal furniture.) Nutt knew enough of his decorative arts history to know that many classical architectural forms were derived from plant structures, including the Egyptian reeded column. His chair simply inverted the process and stands as both a joke and an informed commentary. Woodturner **Michael Brolly** (b. 1950) once produced a series of baseball jokes: *Baseball Bat*, a black baseball with wings; *Fly Ball*, a baseball with a zipper, and so on. Once the wisecrack is comprehended, what is left to consider?

As woodworkers became more interested in sculpture-furniture hybrids, some crossed the line completely and gave up all references to furniture. Much bad art was made by people who did not want to be bothered learning what contemporary sculpture was all about, but a few produced extraordinary works. Two Californians steeped in car culture, **Michael Cooper and Robert Strini**, stand out.

In California, cars were almost fetishes, lavished with astonishing paint jobs and improbable bodywork. Cooper and Strini met as art students at San Jose State University in the 1960s and shared a studio for some years thereafter. They adapted the aesthetic of custom automotive work to a taste for surrealist weirdness. Both were excellent craftsmen. Between them, they used stack and bent lamination techniques to create various forms, especially linear elements that looked like aerial calligraphy. Neither was interested in function, although Cooper (b. 1943) played with furniture as a sign. One of his memorable sculptures is the stylish and perverse *Captain's Chair* (1975), a cross between art nouveau office furniture and science-fiction illustration that pivots on a tilted wooden platform. It is made with conspicuous joinery and a gleaming finish and is mounted on two

FIGURE 9.69. *Robert Strini*, Wing Piece, *1972. Vermillion wood, Masonian or African walnut wood, rosewood; 82 × 191 × 30 in. (Collection of the University of Virginia Art Museum, Gift of Michael T. and Sylvia Gage, 2003.7. Courtesy of the Artist.)*

wooden wheels, so any attempt to sit in it will cause it to roll away.

Strini (b. 1942) improvised everything, never making preparatory drawings: "I make a bunch of forms. I don't know what they're going to be. Then I come on high on energy and put them all together."[120] *Wing Piece* is typical of his sculptures from the early 1970s. (Figure 9.69) The individual forms are unique, and the whole is a rather mysterious contraption. There is a flavor of art nouveau in the repeated curved lines, a nod to hot-rod culture in the pseudo-wiring and the two undersize wheels. Unstained wood and skilled craftsmanship connect it to traditional furniture. Between them, Strini and Cooper invented a sculpture-woodworking hybrid that could probably happen only in California.

In the 1970s one woodworker epitomized the obsession with sheer craftsmanship: **Fumio Yoshimura** (1926–2002). Yoshimura had studied sculpture at the Tokyo University of Fine Arts, a school famous for strict training in realistic sculpture in craft mediums. He graduated in 1949, came to the United States in 1963, and set up his studio in New York. There he carved everyday objects in linden wood. Starting with forms like an artichoke or an apple core, Yoshimura gradually made more elaborate and difficult objects such as a shopping cart (1976), a grouper skeleton (1976) (Figure 9.70), and a spindly tomato plant complete with ripe tomatoes (1979). His tour de force was *Three Bicycles* (1984–85). The fidelity was remarkable, down to jointed wooden chains, wooden brake lines, and wooden spokes. The piece was one of the first things visitors to the 1986 inaugural exhibition

FIGURE 9.70. *Fumio Yoshimura,* Grouper, *1976. Linden; length, 58 in. (Collection of Norton Museum of Art, West Palm Beach, Fla. © Carol Yoshimura/Estate of Fumio Yoshimura.)*

of the new American Craft Museum saw, and it was the first image in the catalog.

Yoshimura pointed out that his sculptures were loosely rendered, but what he thought was artistic license looks impressively realistic at first glance. The work is strong on the "gee-whiz!" factor, astonishing audiences with sheer craftsmanship. The truth is that it takes as much patience as skill to make a Yoshimura sculpture, and his workmanship is on the same level as that of any good maker of ship models. Luckily, he added an element of poetry. Since linden is a pale wood and he left it uncolored, the objects have a disorienting lightness. Yoshimura said they were the "ghosts of the original objects," an apt description.[121] At the same time, the labor invested in his sculptures gives them an odd density. The contrast is impossible to ignore.

BENNETT'S NAIL CABINET

At the end of the decade a relative newcomer to woodworking produced what may have been the first example of conceptual furniture. Called *Nail Cabinet*, it was meant to be controversial, and it succeeded brilliantly. The perpetrator was Garry Knox Bennett (b. 1934), a former sculpture student who had been working with metal for some time. His business, Squirkenworks, manufactured roach clips and peace sign medals. Not satisfied with commerce, Bennett made jewelry, clocks, and containers that increasingly incorporated wood. He employed a cheerful assortment of pop images: clouds, hearts, drips, wings, sperm, and the occasional penis. His approach to woodworking was pragmatic.

The late 1970s saw the publication of Krenov's first books and Frid's first articles in *Fine Woodworking* magazine. In Bennett's opinion, both men treated technique with altogether too much respect. He felt Frid's dictum that design must follow construction would suppress creativity. And Krenov, he thought, had turned process into a fetish: technique for technique's sake.

FIGURE 9.71. *Garry Knox Bennett*, Nail Cabinet *(replaced-nail version), 1979. Padauk, glass, lamp parts, copper; 74 × 24 × 17 in. (Courtesy of the Artist. Photograph by M. Lee Fatherree.)*

Bennett decided to retaliate against the "techno-weenies," as he called them. "I wanted to make a statement that I thought people were getting a little too goddamn precious with their technique. I think tricky joinery is just to show, in most instances, you can do tricky joinery."[122] His response consisted of two cabinets. Both were the same size—a bit over six feet tall—and the same overall shape. They were divided unequally down the middle: on the left side a single illuminated display case with a curved glass door; on the right a column of doors and drawers. The first cabinet was designed in Bennett's typical style: made of poplar, cherry, and redwood, lacking moldings or conspicuous joinery and painted on some of the drawer fronts with a raindrop pattern in black or red.

The second one was the *Nail Cabinet*, completed in 1979. (Figure 9.71) It is made of padauk, an exotic rainforest wood. The five drawers have elaborate finger joints that face outward in an ostentatious display of technical

finesse. The carcass is joined with handmade dovetails (which Bennett recruited a friend to cut). The drawer pulls are made of brass, carefully graduated in size to match the drawers. Most edges are lovingly rounded over. Bennett's provocation was to drive a sixteen-penny nail right into one of the cabinet doors and bend it over, letting the nailhead scar the wood. To finish up, he banged the wood once with his hammer. Bennett's crooked nail looked like the embodiment of inept craft. It was a joke, to be sure, but a precisely calibrated one.

A picture of *Nail Cabinet* was published in a brief photographic piece called "Decoration vs. Desecration" on the back cover of the September–October 1980 issue of *Fine Woodworking*, along with a writing desk by Wendy Maruyama. (Her provocation was to scribble a calligraphic line on her desktop.) Bennett drew fire from irate readers right away. His detractors thought he had ruined a perfectly good piece of furniture or that he had violated the field's hard-won technical standards. Of course, they misunderstood. The expensive padauk and flashy detailing were intended only to serve as context for the bent nail. *Nail Cabinet* is a commentary. Bennett addressed the stark division between those who wanted fine workmanship to stand as its own reward and those who wanted it to serve the maker's intentions.

The course of furniture history after *Nail Cabinet* is full of irony. Frid's students turned out to be some of the most inventive woodworkers of the 1980s and 1990s. Krenov, largely via his books, attracted a dedicated following, all of them impervious to Bennett's critique. Bennett's style of pop furniture has also been quite influential, but his assertion that furniture should be a vehicle for an idea would have to wait for two decades before it became widely accepted.

Craft Institutions

The 1970s was a time of contradictory trends. America House, for two decades the premier retail outlet for crafts in the nation (at one point, more than 1,500 craftspeople sold work through the store), closed its doors in 1971. It lost money for several years in the 1960s, and some prominent craftspeople complained that quality had declined. When new federal taxes forced a sharp rent increase on the space America House occupied, the American Craft Council (ACC) decided to close it. About the same time Bonniers, the department store that had been another showcase for craft in New York, changed its emphasis to mass-produced design, imitating the popular Design Research store in Cambridge, Massachusetts.

Shop One, the pioneering outlet in Rochester, New York, closed in 1976.

Still the market for craft was booming. The Northeast Craft Fair in Rhinebeck, New York, doubled attendance between 1977 and 1978. The ACC decided to set up a quasi-independent entity called American Craft Enterprises to start new craft fairs all over the country. Other groups, both businesses and not-for-profit organizations, followed suit. Even "renaissance faires," which required exhibitors to dress up in period costumes, prospered.

Craft galleries opened in many major cities. Some promoted craftspeople exactly as artists were handled in major commercial galleries, with solo exhibitions advertised in national magazines and with gallery directors cultivating a select list of collectors. In 1979 the big news was Alice Westphal's Exhibit A in Chicago. When she opened her ceramics gallery, Westphal demanded exclusive representation from all her artists. (That is, they were not allowed to be represented by other commercial galleries.) In return, she raised their prices considerably. Her opening show featured Richard De Vore with a top price of $4,000 — ten times higher than his prices only five years before. The idea was that the hefty prices would attract the interest of major art galleries in New York and elsewhere, which would put on shows in cooperation with Exhibit A.

Before the rise of the gallery system, collectors bought directly from the makers, but only the most dedicated collectors could travel the country in search of the best work. Now galleries gathered work from outstanding craftspeople in one place, creating a more efficient marketplace. Collectors tended to focus on one medium, with ceramics and fiber taking the lead. Craftspeople had to learn to take photographs and write résumés. What was once a freewheeling, unorganized livelihood was rapidly becoming professionalized.

In the 1970s the National Endowment for the Arts (NEA) began to have an impact on the crafts. Originally created in 1965 to support diverse artistic ventures, it had been giving grants to individual painters and sculptors since 1967, but only in 1973 was a separate category for individual craftspeople offered. (Even then, artists qualified for higher grant amounts for many years.) Other programs were added to fund studio and exhibition spaces, craft apprenticeships, and folk arts. By the end of the decade NEA grants to individual craftspeople could be as much as $10,000. Federal support for craftspeople was frequently augmented by state grant programs.

Through the Nixon and Ford presidencies, the NEA grew rapidly, from a total budget in 1970 of $8.3 million to a 1979 budget of more than $149 million. Craftspeople shared the wealth. Many invested their grant money in new tools or better studios. Some took time off from teaching or production, spending concentrated periods in their studios. Others traveled, seeing overseas museums for the first time. The apprenticeship program enabled young craftspeople to work for those they admired most, many of whom could not afford to hire apprentices without grant support. Publications and special projects were also aided by NEA grants. A considerable amount of prestige was involved: by the late 1980s *American Craft* magazine was publishing pictures and brief biographies of every major NEA craft grant recipient. In sum, the impact of federal support for the crafts was very positive.

Nationally the rapid growth of craft education was slowing. Hundreds of students had entered MFA programs expecting to move on to teaching jobs, but few new programs were opening, and existing programs were staffed by faculty not yet ready to retire. College teaching jobs started to become scarce by mid-decade. Suddenly there was a glut of MFAS, and many of them, disappointed, left the field.

The most famous experiment in craft education in the 1970s was the Program in Artisanry, which opened in 1975 as a department of Boston University. The program was intended to prepare students to make a living at their craft (like the original SAC). It offered a two-year certificate of mastery in addition to regular degrees. The focus was on learning craft skills and business practices. The program hired top-notch teachers, Arline Fisch and Jere Osgood among them. The first studios to open were for textiles, ceramics, metals, and woodworking. Ambitious plans calling for eight more studios never came to fruition.

Program in Artisanry students were among the most talented in the country, and some were exhibiting and selling work before they graduated. Many, like students everywhere in the 1970s, were more interested in art than commerce. In response, the program offered an MFA degree in 1983 — hardly necessary to earn a living in craft. In 1985, amid great acrimony, the program was pushed out of Boston University. It never met its optimistic enrollment projections, and the university would no longer support it. The remnants of the program now survive at the University of Massachusetts Dartmouth.

Meanwhile a demand for adult and summer-season craft education enlarged as leisure time increased. Neighborhood art centers and summer craft schools filled the void. Some of the oldest of the summer schools had grown out of missionary and settlement projects, and at midcentury a number of new summer craft schools were founded, many of which continue to operate, among them

the Haystack Mountain School of Crafts in Maine (1950), Anderson Ranch Arts Center in Colorado (1966), Peters Valley Craft Education Center in New Jersey (1970), and Touchstone Center for Crafts in Pennsylvania (1972).

Instructors, including major figures in every medium, work for paltry wages. They teach as a service to the field and to enjoy the fellowship. Typically classes last only a week or two, but the educational experience is intense. Students usually live in spartan housing provided by the school and eat in a school cafeteria. They come to learn from experts they might otherwise never encounter, and many careers have been transformed because of experiences at a summer school.

Through the 1960s and 1970s the Museum of Contemporary Crafts mounted an inventive series of craft exhibitions. The museum's director since 1963, Paul J. Smith, was keenly attuned to developments in the crafts. He frequently recognized innovations as soon as he saw them, and he was instrumental in advancing the careers of many young craftspeople. Not only did the museum continue the Young Americans exhibition series, but Smith originated many important solo and group shows, including *Fantasy Furniture* (1966), *Made with Paper* (1968), and a large Peter Voulkos retrospective (1978). Other shows were offbeat. Nobody who witnessed them will ever forget the two enormous inflatable legs by Ann Slavit—complete with dressy high-heeled pumps—that draped over the museum's cornice for the *Great American Foot* exhibition. These entertainments had a populist appeal but may have undercut the museum's credibility as an advocate of craft's more serious ambitions.

In 1972 the Renwick Gallery opened in Washington, D.C., as the Smithsonian's contemporary craft venue. Located in the building that once housed the capital's first art museum, the Renwick proved that craft had found a place on the nation's cultural agenda. Its first director was Lloyd E. Herman.

In 1979 the American Craft Council reconfigured its magazine, *Craft Horizons*, giving it a new name, *American Craft*, and a more visual orientation as a coffee-table magazine. Longtime editor Rose Slivka departed. At the same time, the ACC changed the name of its museum to the corresponding American Craft Museum.

COOPERATIVE ACTION: THE BAULINES CRAFTSMAN'S GUILD

One of the best aspects of the counterculture was a tendency to organize mutual-help societies. It was the era of co-ops in groceries, galleries, and garages. On the East Coast, a manifestation of the trend was the New Hamburger Cabinetworks Collective in Boston, dedicated to producing affordable "furniture for the people." On the West Coast the Baulines Craftsman's Guild was created in Bolinas, California, in 1972. A young woodworker named Tom D'Onofrio had apprenticed under Arthur Espenet Carpenter and was quite taken with Carpenter's sense that the modern craftsman could stand as an exemplar of self-reliance. The idea of a life of craftsmanship, outside mainstream values, also appealed. D'Onofrio reasoned that Carpenter's vision could be shared and even increased through an apprenticeship system. So he organized a small group of craftspeople into a guild, with the purpose of creating a school without walls.

Each guild member committed to taking on an apprentice but not necessarily for years of rigorous training. Technical knowledge was not really the point. Instead people could choose mentors and work for them for indefinite periods of time, ranging from days to years. The idea was to allow individuals to see firsthand the possibilities of a life of creative self-fulfillment. This was held to be a modest form of social activism, changing the world one craft convert at a time. Being self-supporting was crucial to the grand design: to continue working, people had to be able to make a living. Unlike the hardline Marxism that dominated some circles, the Baulines Guild accepted small-scale capitalism as a useful tool for a life well lived.

To help commerce along, the guild organized sales. In 1973 7,500 people showed up for a three-day event, set up along the roadside in front of Carpenter's house. Photographs of the event show a ragamuffin assortment of long-haired hippies, complete with kids and dogs, and Carpenter looking like the straight man. The guild was also an extended social group and a networking system.

In time, some felt that the Baulines Guild became too hostile to the kind of woodworking that best paid the bills: custom interiors, kitchens, and the like. Many young woodworkers, however, passed through the guild and picked up some of D'Onofrio's idealism. The organization survives today as the California Contemporary Craft Association.[123]

In Short

If the 1960s was the decade of untrammeled invention, the 1970s was a decade of consolidation. Innovation continued in a more organized fashion. Medium groups and magazines encouraged a new measure of self-consciousness. Commercial galleries and major medium-based exhibitions proliferated. As craft fairs expanded, market forces favored good presentation and

sound business practices: craftspeople had to learn to be professionals.

In most mediums the decade was characterized by intense exploration of new techniques. In textiles, off-loom methods attracted so much attention that weaving was suddenly the exception rather than the rule. In woodworking, complex construction and bending techniques were explored in depth. And in glass, cold-working techniques expanded the range of forms. The new emphasis on mastery of technique may have had a downside: risk taking was sometimes overshadowed by a glossy virtuosity.

American craft had always been profoundly affected by immigrant designers and craftspeople. The latest foreign influx came in the form of workshop instructors. And for the first time, Americans were going abroad in large numbers to study, bringing back distinctly American interpretations.

CHAPTER 10 1980–1989

MONEY AND IMAGES

Business and Baroque

While the 1970s, as it was happening, seemed aimless and undefined, the 1980s had a clearly different character, apparent even at the time. Money was one difference. Stock-market highs carried over into the art world; auction sales reached record levels, and gallery sales flourished. Interior-design magazines voiced the desires of a decade in which commodification, marketing, investment, and consumption were watchwords.

Chicago's New Art Forms Exposition introduced the style of international art fairs to the craft world: high prices, no trinkets, increasingly professional. The market for craft grew, especially for glass, and the craft field in general became more attuned to fashion and less of an alternative lifestyle. "It is no coincidence that painted surfaces, richly colored [materials], and strong graphic designs dominated the field during the mid-1980s," Edward S. Cooke Jr. noted. Such works, "rather than complex or quiet examples, were the most clearly understood in photographic images."[1] Cooke was writing of furniture, but the observation applies broadly; other mediums also adopted a more frontal, photographable appearance. The first voicing of discomfort with the word "crafts" occurred in the 1980s. Craft enrollment in advanced education had begun to slow in the late 1970s, and some programs were curtailed.

Studio furniture was the new genre of the decade. After the 1986 exhibition *Craft Today: Poetry of the Physical* featured many examples, magazines began to include such works. Baroque styles emerged in furniture and elsewhere—perhaps, curator Lloyd Herman has conjectured, because designs are not protected by copyright so making them too costly or difficult to copy was a way of avoiding knock-offs.[2] New materials in furniture, jewelry, and other craft mediums included titanium, aluminum, resins, and plastic laminates. Warm techniques such as casting and fusing became more popular in glass, and color expanded. Women glassblowers broke out of their subservient positions, led by the examples of Flora Mace and Joey Kirkpatrick. Women met in a special-interest group for the Glass Art Society conference in 1988; their position had improved because men, though generally more powerful glassblowers, are not necessarily better artists.[3]

1980
> Average hourly wage: $7.15
>
> John Lennon murdered in New York
>
> Ronald Reagan elected president, signaling a revival of conservatism in America
>
> First exhibitions in New York of neo-expressionist painting; Julian Schnabel and David Salle become leading Americans in the movement

1981
> Sandra Day O'Connor becomes the first female Supreme Court justice
>
> Acquired Immune Deficiency Syndrome (AIDS) is first diagnosed

1982
> Equal Rights Amendment fails to be ratified
>
> First artificial heart implanted
>
> Keith Haring's first solo exhibition at Tony Shafrazi Gallery draws international attention to graffiti art

1984
> Apple introduces the Macintosh computer, which popularizes the mouse

1986
> Space Shuttle *Challenger* explodes on takeoff
>
> Major nuclear accident at Chernobyl, Russia

1987
> Van Gogh's *Irises* sells at auction for $53.9 million, the highest price ever paid for a painting at that time

1989
> Fall of the Berlin Wall
>
> Tanker *Exxon Valdez* spills 11 million gallons of crude oil in Prince William Sound, Alaska
>
> Controversy over Robert Mapplethorpe's photography retrospective in Cincinnati and Washington, D.C.

Wood: Classicism and Postmodern Play

FURNITURE

During the 1980s the studio furniture field struggled with pluralism. To some who might be called "new classicists," the exuberant furniture-as-sculpture that began in the 1960s looked dated, its unfettered self-expression inelegant and undisciplined. In reaction, this new generation examined antique furniture and began to incorporate finely crafted historical details into their work. Some objected to the way furniture had been taught as a form of expression rather than a discipline. Richard Scott Newman, for instance, questioned Wendell Castle's experimental and freewheeling approach to teaching. "I don't think the education we had at RIT [Rochester Institute of Technology] was training. It was sort of a fertile bed perhaps in which you sprout and were expected to blossom. [This approach to education] was part of Wendell's attitude, that technique will get in your way. I would have preferred to have learned how to make furniture."[4]

If Newman valued displays of virtuosity, others spoke instead of developing personal bodies of work. This ambition may have been a response to crafting fairly traditional work in order to learn cabinetmaking skills, or it may have come from comparing the speed of Voulkos-style tearing into clay against a whole day of cutting dovetails. One way to open possibilities was to use nontraditional materials and techniques. Wendy Maruyama used feathers and fur on her earliest work and neon later. Painting became a popular option, but usually in high-key contrasts totally unlike the simple colors employed by the Shakers.

In New York City, there were suddenly more galleries exhibiting and selling studio furniture. Alexander F. Milliken added Castle to his stable in 1980 and promoted his work aggressively with advertising and dramatically higher prices. It was exhibited alongside highly finished realist paintings and sculptures. Max Protetch Gallery and Art et Industrie also exhibited artist-made furniture, aligning it more closely with architecture and design. The Gallery at Workbench, a nonprofit exhibition space intended to create a market for studio furniture, opened in 1981. On Long Island, two fans of handmade furniture opened a gallery devoted to it: Pritam & Eames. Of all the experiments in gallery presentation of furniture, this last has been the most successful.

In 1982 Formica Corporation introduced a plastic laminate pigmented all the way through, called Color-Core. Laminates were suffering from an image of low-budget tackiness but received a boost when the Memphis Design Group used them for bright colors and strong patterns. While ColorCore was not produced in patterns, it was manufactured in ninety-four hues and was very durable. To promote its product, in 1983 the corporation organized a competition and exhibition called *Surface and Ornament*. Both Robert Venturi and architect Frank Gehry contributed innovative designs to the show. Two years later, Formica teamed up with the Gallery at Workbench and invited nineteen American studio woodworkers to experiment with the material. All the works were made especially for the show. Two sponsors (one of them gallery director Bernice Wollman) purchased all

eroded wall and a painted frieze. The wide range of ref-
erences, along with the abandon with which makers
embraced color and decoration, indicated that postmod-
ernism had supplanted modernism.

THE NEW CLASSICISTS

At the beginning of the decade a new type of studio furni-
ture appeared when a group of young woodworkers began
to look intently at the past. Among them were **Richard
Scott Newman** (b. 1946), **Timothy Philbrick** (b. 1952),
and **John Dunnigan** (b. 1950). All had spent time in one
or more of the major East Coast college woodworking
programs in the 1970s and had previous woodworking
experience. Newman and Dunnigan had made contem-
porary furniture, while Philbrick had always worked with
antiques or reproductions.

Each, for his own reasons, was less interested in inves-
tigating furniture's sculptural potential than in making
furniture that looked like furniture, its signs and signi-
fiers intact. Their interests went back to the early 1800s
and even before. Newman felt that studio furniture
"lacked sophistication and complexity when compared to
the masterpieces of the past. I guess I always thought we
were making a sort of folk art really." He felt that working
within a tradition was more "relaxed and natural . . . as
opposed to the self-conscious forced innovation so preva-
lent in much modern furnituremaking."[5]

American woodworkers had been drawing from Wind-
sor chairs and Shaker furniture since the early 1950s, so
historicism was nothing special. But to adopt styles that
had no connection to the modernist sensibility was new.
Newman's story best illustrates the process. He intended
to study physics and engineering at Cornell but dropped
out to build banjos and guitars. Finding no jobs in that
line of work, he hired on at a piano factory. About the
same time, in 1964, he saw studio furniture for the first
time at the Museum of Contemporary Crafts. Inspired
by its originality, he transferred to the School for Ameri-
can Craftsmen in Rochester, New York. After he went
through a stint of producing furniture for local interior
designers, Newman's mother-in-law commissioned him
to design and make a dining table to match an existing
set of Louis XVI chairs.

The job was an eye-opener. Newman felt embarrassed
at first, worried that his venture into unrestrained his-
toricism was too amateurish. His research on antique
French furniture, however, excited him. He found a vo-
cabulary of forms and details that could be recombined
at will, and the elegance of well-designed French fur-
niture pleased him. While no individual could match
the richness and detail of the best eighteenth-century

the submissions so they could be sent on tour. The show,
Material Evidence, was a defining moment in 1980s fur-
niture.

Rory McCarthy made a table in pink, blue, brick red,
ivory, and gray, a palette unimaginable in studio furni-
ture only a few years before. Garry Knox Bennett's entry,
ColorCore Desk, which had almost no wood in it, was a
highlight of the show. Rick Wrigley offered an armoire
in the form of a neoclassical portico, complete with faux

FIGURE 10.1. *Richard Scott Newman*, Demilune Table with Ormolu Decorations, *1989. Cherry, Gaboon ebony, vermeil; width, 10 ft. (Courtesy of Pritam and Eames Gallery. © Richard Scott Newman.)*

FIGURE 10.2. *John Dunnigan*, Settee with Cleavage and Bolsters, *1988. Curly maple and silk; 34 × 72 × 32 in. (Courtesy of Pritam & Eames Gallery. © John Dunnigan.)*

work—those pieces were made by dozens of highly skilled craftsmen and could take thousands of hours to complete—he responded to the idea of working within a tradition. Innovation was possible within clear boundaries.

Newman gravitated toward American neoclassicism, especially the Federal period, from 1780 to 1810. Furniture of this era was restrained, light, and airy. It was seldom heavily carved, had a sense of structure, and with its thin, straight legs and taut upholstery, could be surpassingly elegant. A large demilune table that Newman made in 1989 illustrates his mix-and-match approach to neoclassicism. (Figure 10.1) The original demilune tables were three to four feet wide, but Newman stretched his to ten feet. The legs are fluted, like early Federal examples, but they flare upward instead of following a straight line. This detail made the job of fluting more difficult, which

indicates Newman's taste for technical challenges. The raised banding on the table's apron and the sunburst pattern on the top are fairly typical Federal details, but the tapered bentwood stretchers do not belong to the style at all.

While few could match Newman's technique, many others embraced the new classicism. Timothy Philbrick's furniture also refers to American neoclassicism: one of his signature pieces is an exquisite upholstered couch patterned after the "Grecian couches" of the 1820s. John Dunnigan looked abroad to art deco, especially the sumptuous furniture of Jacques-Emile Ruhlmann, which itself had classical overtones. Dunnigan's chairs and tables often have sabots (small tapered feet that recall wooden shoes), just as Ruhlmann's did. Dunnigan's strength is in voluptuous chairs and couches upholstered in fine fabrics, some of the sexiest furniture ever made by a studio craftsman. (Figure 10.2)

The new classicism had a mixed effect on the field. Not surprisingly, there was a ready market for such work, for it fit easily into homes already stocked with antiques and reproductions. High-end outlets like Pritam & Eames and, later, the Peter Joseph Gallery in New York City sold a generous amount of this furniture, which translated into a decent income for some woodworkers.

The new classicists did not treat history with irreverence, nor did they treat their work as a discourse about furniture, so the superficial similarity to postmodernists is misleading. Thus they represent a conservatism not seen in the studio crafts since the colonial revival petered out. Their creativity is applied to choosing graceful proportions, selecting appropriate details from historical models, and developing techniques that can generate the decorative embellishments they value. The new classicists add an option to the menu of possibilities and thus can be seen as a positive influence, but some observers see historicism as backward looking and regard the new classicism as irrelevant or futile.

CASTLE MOVES ON

By the early 1980s, Wendell Castle had stopped making his stack-laminated pieces and was growing disenchanted with illusionistic furniture, too. He decided to move away from sculpture-furniture hybrids and focus exclusively on furniture. To distinguish his new work from other studio furniture, he adopted an attitude of "more is more."

Perhaps influenced by his former student Newman, Castle embarked on a series of historicist works. His reference point was often Ruhlmann, the art deco master. The first piece in the series, a luxurious lady's writing

desk in sycamore with some 8,500 tiny ebony and plastic dots embedded, was sold for $75,000, a record for studio furniture at the time. (The actual price has been debated: it is possible that the buyer received a hefty discount.) Thus encouraged, Castle assembled an entire show of historicist furniture in 1983 for his New York dealer, Alexander F. Milliken. Some pieces were plausible reincarnations of art deco; others combined familiar 1920s geometry with more contemporary forms. One object, *Late Proposal for the Rochester Convention Center in the Form of a Jewelry Box* (1982), is a ziggurat-shaped box veneered in beautifully figured wood, supported by four lacquered legs shaped like fat traffic cones. The show was successful enough for Milliken to suggest a thematic exhibit. Castle responded, in 1985, with a collection of thirteen clocks.

The clocks were hugely ambitious, unlike any American woodworking seen before. An average of 4,000 man-hours was invested in each, and prices ranged from $75,000 to more than $200,000. They were massive, between six and eight feet tall. Castle referred to art deco clockworks and neoclassical objects that conflated architecture and furniture as well as alluding to the correspondence between case clocks and the human body. The works shared no visual style. The clock faces sometimes played only a minor role in the overall designs. One, *Ghost Clock* (mentioned in chapter 9), was nonfunctional. Some critics, expecting Castle to take a consistent stand in the furniture-sculpture spectrum, saw the show as a failure. Others dismissed the project as pretentious. The clocks were not profitable, either. Although they were included in two traveling shows, Castle discontinued the series even before the exhibitions concluded their tours.

A table from 1985 is typical of Castle's work from that time. There are echoes of historical work: the inlaid triangles recall a library table in the collection of the Metropolitan Museum of Art in New York.[6] But a forest of black cones is Castle's invention, and gold-plated rings, while similar to iron mooring rings, are not a usual furniture detail. In what may be a defiant gesture from a beleaguered maker, a scattering of tiny dots on the tabletop spell out the words of the title, *Never Complain, Never Explain*. (Figure 10.3)

Since that time, Castle has oscillated between practical (but luxurious!) furniture and more sculptural forms. He calls one extremely conservative, while the other is "the who-knows-where-it-will-lead side. I've been afraid of both of these, but might get close to either of them."[7] His work has tended to align with sculpture; occasionally he has made what appears to be pure sculpture, except

FIGURE 10.3. *Wendell Castle,* Never Complain, Never Explain, *1985. Poplar, purpleheart, flakeboard, holly veneer, purpleheart veneer, gold-plated copper, rings, plastic; 29.5 × 95.5 × 56 in. (© Wendell Castle, Inc. Photograph by Mark Haven.)*

for a tiny drawer located somewhere in the form. Perhaps the nod to function undercuts the work's identity, placing it—as Castle says he prefers—in the gap between art and craft.

GARRY KNOX BENNETT

The perpetrator of the *Nail Cabinet* rose to increasing prominence during the 1980s. By the end of the decade Garry Knox Bennett was recognized as one of the central figures in American woodworking, probably much to his amusement. Bennett had a unique approach to furniture. While a student at the California College of Arts and Crafts in the early 1960s, he was among the artists who made ad hoc sculptures out of driftwood washed up on the Berkeley mud flats. The sculptures were playful and direct, and Bennett brought a similar attitude to making furniture. He never does preparatory drawings but makes his design decisions during the process of fabrication. Nor does he engage in highly refined, time-intensive craftsmanship. Much of his furniture takes a week or so to put together, no more.

Bennett devoted himself to exploring the permutations of furniture elements, sifting through combinations of supports, surfaces, containers, joints, and light sources. His forms include geometry, blobs, puffy curves "drawn" directly with the band saw, references to traditional furniture both Eastern and Western, architectural details. He mixes and matches, often using paint to heighten the contrast between dissimilar forms.

Given his background in metalwork, it is not surprising that Bennett has been open to using diverse materi-

FIGURE 10.4. *Garry Knox Bennett*, ColorCore Desk, 1984. Aluminum, ColorCore, particleboard, rosewood, gold-plated brass; 30 × 90 × 32 in. (Courtesy of the Artist. Photograph by George Erml.)

als. He has worked with leather, PVC plastic, bone, paper, silicone sealant, coffee cans, even golf tees. So he was perfectly willing to give ColorCore a go. His *ColorCore Desk* is characteristic: playful, transgressive, and smart. (Figure 10.4) The thin aluminum desktop rests on a slim wedge of red ColorCore and a gleaming aluminum tube. The ColorCore is laminated over particleboard, exactly as in kitchen counters. To protect the sharp upper edge of the wedge, a cylinder of gold-plated brass is fitted over it and let into an aluminum carcass that holds a drawer. The drawer front is faced with strips of ColorCore that have been built up and then incised, exposing vertical stripes of red, yellow, and blue. The polished surface of the aluminum desktop further dematerializes the structure, giving the whole a visual lightness impossible to achieve in wood. The craftsmanship is superb throughout. In a final twist Bennett lined the drawer with rich, dark rosewood, as if to prove his chops as a "woodie," but only after a series of feints and diversions.

WENDY MARUYAMA

Some of the new furniture makers of the 1980s thought of themselves as artists who happened to work with wood. Many of these were women, and one of the pioneers was Wendy Maruyama (b. 1952).

Maruyama first saw the artistic potential of furniture in a class on furniture design. The textbook was Thomas Simpson's *Fantasy Furniture* (1968), and one of her first projects was to make a piece of furniture out of papier-mâché. It was not wood that interested her but the genre of furniture itself. Ever since, Maruyama has pushed the limits of traditional furniture forms with her quirky design sensibility and freewheeling spirit of experimentation.

After studying with Lawrence Hunter at San Diego State University, where she learned the stack-lamination process, Maruyama headed east for graduate study with Alphonse Mattia at Virginia Commonwealth University. She followed Mattia to the Program in Artisanry at Boston University, where she also studied with Jere Osgood. Her technique, confined to stack lamination and doweling, was insufficient, but she quickly gained control of her craft. When she and Gail Fredell enrolled in the MFA program in furniture at the School for American Craftsmen (SAC) in 1978, they were the first women to do so. They endured something of a culture clash. SAC was the most prestigious wood program in the country, but it had become fairly conservative since Wendell Castle left some ten years before. Maruyama refused to give up her open-minded attitude toward materials, and she experimented with glass, metal, colored epoxies, and paints while she was there.

An early classic by Maruyama is *Mickey Mackintosh Chair* (1982). It is a simple chair with two vertical slats making up the back and the rear legs. The top-to-bottom slats echo chair designs by the great Scottish architect Charles Rennie Mackintosh, but each terminates in a large round ear: the resulting profile is unmistakably that of the cartoon mouse. The chair is painted entirely in dark gray Zolatone, a spatter paint that approximates granite. The chair is a perplexing mixture of high and low. Within the studio-furniture culture, the *Mickey Mackintosh Chair* was as much a challenge to convention as Bennett's *Nail Cabinet*.

By the late 1980s Maruyama had settled into her signature style: abstract forms, often pod- or shield-shaped, attached to boxes or cabinets, everything painted in deep, saturated colors. The pods and shields were often roughly carved, with the tool marks plainly visible. Paint was applied to heighten the facets and textures. Sometimes

FIGURE 10.5. *Wendy Maruyama, Bedside Box #1, 1980. Carved and painted basswood, jelutong; 42.12 × 27.5 × 11.5 in. (Art © Wendy Maruyama. Photograph by Dean Powell. Image © Collection of the Fuller Craft Museum, Brockton, Mass., Gift of Diane and Arthur Dion.)*

the cabinetry dwindled in size until it was one among a collection of contrasting shapes. At that point Maruyama's work recalled the jagged assemblages of George Sugarman or perhaps the peculiar funk constructions of Californian Jeremy Anderson. *Bedside Box #1* (1980) is typical of her work from this period. (Figure 10.5)

Like other women woodworkers then, Maruyama was sensitive to the emotional colorings of the experience of furniture. Her cabinets and containers invite a process of discovery that engages the realm of feelings. Virginia T. Boyd has observed that case furniture is "covert, mysterious, revealing itself only in stages" and that "The moment of pulling a door, opening a drawer is a moment of suspended curiosity about the unknown beyond. . . . Thus, there is always a sense of expectation when approaching a case piece."[8] Given furniture's central place in the home, there are plenty of opportunities to stimulate memories, play with expectations, or orchestrate experiences. The emotional component became a central concern of studio furniture makers, and it was women like Maruyama who led the way.

JUDY KENSLEY MCKIE

Judy Kensley McKie (b. 1944) had studied painting at the Rhode Island School of Design (RISD) in the 1960s. As she set up her household, she began to make simple furniture in her basement. Friends asked her to make pieces. Eventually she got involved in a woodworking co-op (the New Hamburger Cabinetworks) in the Boston area, and furniture became her focus. She worked in an anonymous, boxy style that resembled things sold at the Design Research store in Cambridge. The work paid the bills, but McKie longed to make something more personal. In her words, "The furniture would have to have a certain feeling to it. . . . You could see that it was made by a human being who thought a certain way."[9]

As a painter, she was aware of the whole range of art history, but she was most drawn to figurative art from ancient cultures. In 1975 she began to carve low-relief patterns and images of fanciful animals on basic boxes. Her creatures were cartoonlike, lively, and highly stylized. They immediately struck a chord. Soon she was carving animals into the structural members of her furniture, which in turn suggested that the animals become the structure. (Figure 10.6) In 1979 the American Craft Museum showed her work in its *New Handmade Furniture* exhibition. Amid all the polished sculpture-furniture hybrids in the show, there was nothing else like her sophisticated faux-naïveté. One of her standouts was a table in which two skinny dogs with bones in their mouths and absurdly long tails balance a glass tabletop on their heads. McKie became a furniture celebrity; commissions and sales followed.

She aspires to make "inanimate objects that are animated" by combining animal forms with conventions of furniture making.[10] She mines art history freely, both for images and surface effects. Her work is always ingenious

FIGURE 10.6. *Judy Kensley McKie, Leopard Couch, 1983. Bleached and burned mahogany; 30.5 × 90 × 25 in. (© Judy Kensley McKie, 1983.)*

and unpretentious. Much of the delight lies in how she presses imagery into the service of function. *Sly Rocking Chair* (1980) has a pair of friendly rattlesnakes for rockers. The legs of *Table with Birds and Fish* (1979) are standing waterbirds; their beaks and the fish they grasp are the apron underneath the tabletop.

McKie often makes her designs in multiples, jobbing out the carcass construction and even the rough carving. She prefers wood without showy grain, such as poplar, basswood, walnut, or mahogany. She is open to experimentation. She painted her furniture years before it became fashionable and at Bennett's urging began to make cast-bronze furniture in 1987. Recently she looked into cast plastic resins—a long way indeed from the wood fetishism of the 1970s.

JOHN CEDERQUIST

One of the most inventive studio furniture makers to emerge in the 1980s was John Cederquist (b. 1946). He followed the standard trajectory from BA to MFA in craft (in his case, from Long Beach State College) and then settled down to teach art. For a time he made cabinets of shaped wood and leather in quasi-industrial forms resembling piping or old radios. By the late 1970s he began to search for an alternative.

Cederquist was teaching two-dimensional design, and part of his syllabus included drawing in two-point perspective. Watching old Popeye cartoons on TV with his young daughter, he noticed that the interiors were given a credible illusion of depth with simple drawings of furniture in two-point perspective. He photographed Popeye interiors right off his TV, wondering if it would be possible to build things in the same manner. As he put it, he wanted to explore furniture in "two-and-a-half dimensions."[11]

One of his first pieces in forced perspective is *Olive's Chair* (1982). The design is taken almost verbatim from a Popeye episode: a friendly, rubbery image of an ordinary household chair. The twist is that Cederquist, using different shades of wood veneer, rendered both front and sides of the chair legs, stretchers, and slats on sheets of plywood. What appears to be three-dimensional is flat. The seat, while solid, is a parallelogram not a rectangle. The upshot is that *Olive's Chair* looks almost exactly like the cartoon drawing from one point of view, but since it is a three-dimensional object, the illusion breaks down from any other viewpoint. The skewed shape of the seat becomes obvious, the edges of the plywood are exposed. The chair also proves almost impossible to sit on: an effective metaphor for the interface between reality and illusion.

FIGURE 10.7. *John Cederquist*, Le Fleuron Manquant (The Missing Finial), *1989. Baltic birch plywood, mahogany, Sitka spruce, purpleheart, koa veneers, pigmented epoxy, anline dye; 79 × 38.25 × 14.25 in. (Private Collection. Photograph © 2008 Museum of Fine Arts, Boston. Art © John Cederquist.)*

Over the next few years Cederquist made larger, more elaborate constructions, including some spectacular representations of antique case furniture. The most compelling of these is *Le Fleuron Manquant (The Missing Finial)*, made in 1989 for *New American Furniture: The Second-Generation of Studio Furnituremakers* at the Museum of Fine Arts, Boston. (Figure 10.7) He represented a 1760 highboy in the museum's collection as if it were fragmented and packed into crates stacked in a pile roughly the shape and size of the original. Crates and highboy are skillfully rendered in veneer, colored dyes, and epoxy lines that heighten the sense that it is a drawing and not a photograph. Bits of the illusory highboy are visible in illusory openings in the illusory crates. To add to the confusion, the side of the assemblage is built at an acute angle to the front. Cederquist also built drawers, all parallelograms, which could actually be used. The real drawer fronts do not correspond to the represented drawers, and their location is not at all obvious.

In *Le Fleuron Manquant*—the title refers to an incident in which a piece from the Boston MFA's collection was returned from an exhibition with one finial miss-

ing—a multitude of references, from the history of furniture to a speculation on the nature of reality, are bundled together in a single object. It is not surprising that the noted philosopher and art critic Arthur Danto has written about Cederquist several times.

Cederquist went on to produce quasi-furniture that reflected his interest in surfing, cartoons, Japanese prints, and industrial imagery. In one chest of drawers, waves appear to crash out of packing crates. Its title, *How to Wrap Five Waves* (1995), is a play on the title of a famous book on Japanese folk packaging. A bench, called *Couchabunga* (1992–93), is composed of waves and broken planks, suggesting the act of sitting on pure chaos.

In a sense, Cederquist departed at right angles from both Castle (functional sculpture) and Krenov ("pure" furniture). His work is too distinctive to be widely influential, but he showed that an inventive woodworker could escape from the polar opposition that had defined studio furniture.

HOWARD WERNER

Most direct-carved furniture in the 1960s was made in organic forms, blobs, and chunks. Usually "stump-carvers" responded to the shape of the wood or to the grain as they worked. The freewheeling process perfectly suited the times, except that sanding was required. In the 1980s Howard Werner (b. 1951) brought more rigor to the method. A graduate of the School for American Craftsmen, where his teachers were Castle and direct carver Jon Brooks, Werner was familiar with modern sculpture; he saw carvings from Africa and Oceania at the Metropolitan Museum and responded to the abstract forms. At the same time he thought traditional Western furniture made from boards was too boxy to have sculptural potential.

At first his direct-carved furniture and sculpture repeated the earlier fluid shapes. In 1985 he made a decisive change. The hard geometry of Memphis design was in the air, and Werner was also interested in modern architecture. An early attempt was a coffee table in the form of a hollow curl of wood carved from a single block. He had to place glass on top to make it useful. Soon he started carving simple geometric shapes that allowed him to dispense with glass. Typically, as with *End Table* (1985), he joined two solids, one triangular and the other round. (Figure 10.8) This work reads equally strongly as an abstract sculpture and a functional table.

As sculpture, it can stand on its own. It might recall one of Brancusi's bases, but it is more dynamic, even unstable. Werner rested the triangular form on a sphere, which looks like it could pop out at any time. Nor is *End*

FIGURE 10.8. *Howard Werner, End Tables, 1985. Direct-carved beech; each 22 × 34 × 26 in. (Courtesy of Howard Werner. Photograph by Woody Packard.)*

Table minimalist, since the geometry contrasts with intense figuring and checking in the wood. Werner's carvings also rebut the baroque tendencies of some woodworking. He worked from study drawings and models to impose a predetermined form on solid wood. He did not have an improvisational dialog with the log.

PALEY FURNITURE

As Albert Paley enlarged his blacksmithing operation to accommodate increasingly complex architectural jobs, he had to keep his workers occupied in the slack periods between commissions. Since his first iron objects had been functional candlestands, lecterns, and planters, he began to make furniture forms—tables, plant stands, floor lamps—that were unlike anything in woodworking.

At first all individual shapes were developed at Paley's forge—direct results of pounding on hot steel. He assembled a repertoire of forms, starting with long tendrils that he could bend into whiplash curves and adding upsets (thickened ends), twists, and blades. Once he started using a power hammer, he could squash thick bars of steel effortlessly, and heavy iron rods could suddenly flatten out to the thinness of a shovel.

Paley's early furniture consisted entirely of writhing tendrils and curlicues, giving them a rather unpleasant, frantic quality. As his variety of forms increased, so did the density and complexity, and his sense of balance and modulation improved. In a 1989 plant stand, the structural core consists of four vertical rods, each with a ropy surface of twists—an ancient process of squaring off a bar of metal and twisting it like a wet towel. (Figure 10.9) Paley updated the cliché. He clamped one end of a bar in a converted elevator motor and held the other motionless while blasting the steel with torches. All four verticals have variations of Paley's power twist. The ribbons that cascade down the side like paper from an adding ma-

FIGURE 10.9. *Albert Paley*, Plant Stands, 1989. *Steel, brass, slate; each 56.5 × 25 in. (Collection of the Museum of Fine Arts, Boston, 1989.78. © 2009 Paley Studios Ltd.)*

chine, however, are made by simply heating sheet metal and bending it. Over the next decade, Paley would gradually abandon forge-based forms, and this plant stand is an early example of his transition.

Paley's furniture paralleled the trajectory of woodworking in that he was similarly involved in developing techniques, and his work may have been guilty of a kind of brazen showiness. He was also constantly expanding its size. He made a bed and a couch late in the decade. In the 1990s he went further, making huge tables and sideboards that could hardly be contained in the average palace. He added wooden parts—tabletops and cabinets that were made for him—as well as slabs of slate and granite. His gradual evolution away from the forge was in motion.

ALPHONSE MATTIA

Alphonse Mattia was born in 1947 to a working-class Italian immigrant family in Philadelphia. His father had trained as a carpenter. Mattia took no high-school art classes and never considered going to art school until the owners of a hobby shop he worked for recognized his talent. Following their recommendation, he went to Philadelphia College of Art. There he encountered Daniel Jackson, who was at the height of his power as a teacher and a furniture maker.

From Jackson, Mattia learned an appreciation for carv-

FIGURE 10.10. *Alphonse Mattia*, Golden Banana Valet Chair, 1988. *Walnut, birch, soft maple, plywood; 75.37 × 18.25 × 17.62 in. (Yale University Art Gallery, Please Be Seated Collection, Funded by Julian H. Fisher, B.S. 1969, in memory of Wilbur J. Fisher, B.A. 1926, and Janet Fisher, 1988.64.1. © Alphonse Mattia.)*

ing and shaping parts while retaining furniture identity as well as a curiosity about historical examples. He also absorbed Jackson's ideal of furniture as a form of personal expression. In many ways Mattia brought Jackson's ideas to the next generation of studio-furniture makers. After studying with Tage Frid at RISD in 1976, Mattia landed teaching jobs in Virginia, at the Program in Artisanry, and eventually at RISD in 1991.

In 1983 Mattia began to use valet chairs, a conventional furniture form, as a starting point for works that often reveal his sense of humor. He remarks: "I try to ground my work in the context of familiarity.... Once the familiar connection is established, anything goes."[12] To experience a piece of his furniture is partly to play a game of contrast-and-compare. The iconic modern valet chair, with a back that incorporates a hanger to hold a coat or shirt, was designed by Hans Wegner in 1951. Mattia's riff on the form included the low seat (for tying shoelaces)

Scott Burton

Just as artists were interested in making jewelry in the 1940s and early 1950s, they were drawn to making furniture in the 1980s. Among the notable artists to design or make furniture during the decade were Sol LeWitt, Donald Judd, Larry Bell, and David Ireland. Much of their furniture was functional, designed in the minimalist idiom that they had developed in sculpture. Some of it, like Larry Bell's "de Lux" chairs and tables, was based on historical prototypes. Of all the artists who took on furniture, the most committed was Scott Burton (1939–1989).

Burton's first furniture was made from pieces he bought or found on the street. He was interested in a kind of semiotic play, altering aspects of furniture to skew its reading. One such example was a pair of Adirondack lawn chairs veneered with pale yellow Formica so that the surface seemed all wrong for the form. In time he turned to the most honorable and conservative of all sculpture materials: stone. He had simple, blocky chairs, benches, and tables made up by fabricators, usually in gorgeous stones like colored granite, marble, flint, or gneiss. In one series he had a ninety-degree notch cut out of a boulder, leaving the most elemental of seats.

Burton wrote eloquently about his public furniture. Early on, he distinguished his position: "Contemporary designs are mostly pastiches of the modernist classics, and organic crafts furniture is no more authentic or fresh, and promotes illusory, sentimental values. I want to be neither a corporate hireling nor an aging hippie."[1] The critique of craft as espousing "illusory, sentimental values" reflects a standard art-world view that craft stood for a pointless celebration of handwork and lack of intelligence.

Burton had problems with the political disengagement (and intense commercialism) of many New York artists, and he felt that his public furniture

Scott Burton, Schist Furniture Group (Settee with Two Chairs), 1983–84. Schist; settee: 39 × 71 × 47.5 in.; left chair: 43 × 28 × 32 in.; right chair: 39 × 27.5 × 35 in. (Raymond and Patsy Nasher Collection, Dallas, Tex. © 2008 Estate of Scott Burton/Artists Rights Society [ARS], New York. Photograph by David Heald.)

was a corrective. Accessibility and use were crucially important values. When he placed two massive stone benches in the lobby of the Equitable Center in Manhattan, it was a populist gesture, to provide aid and comfort to ordinary people. In the context of the art world, usefulness was a radical critique of the way artists had built a ghetto for themselves behind a wall of elitism and theory. After some initial resistance, his ideas were widely accepted. By the time he died of AIDS in 1989, he was credited with changing the way many people thought about the relation between art and society. It was a critique that any craftsperson would recognize, but none would be given credit for.

NOTE

1. Quoted in Denise Domergue, *Artists Design Furniture* (New York: Abrams, 1984), 59.

and the clothes hanger, but he made the back taller, so the chair more closely resembled the human figure, and he surmounted the hanger with a head. When the chair is used as intended, it becomes a clothed figure and an alter ego for its owner. Over time, the valet chairs could be absurd (*Golden Banana Valet Chair*) (Figure 10.10), narrative (a series depicting a nun, Saint Sebastian, and a devil, ruminating on Mattia's Catholic upbringing),

or even a little creepy (*Brains*, a chair with exposed gray matter for a head and intestine-like legs).

Mattia also pursued more formal design in commissions. An extended series in the 1980s incorporated the triangle as a motif for both design and construction—a triangular tube became a tabletop, or triangular patterns were inlaid into surfaces. He has also explored upholstered furniture since 1973, enjoying the heavy volumes

possible in upholstered forms. Because of his wide-ranging interests and insistence that furniture can be an expressive vehicle, he has been a role model for younger makers.

TURNING

Through the 1960s and 1970s, wood turning continued in the direction established by Bob Stocksdale, Rude Osolnik, and Melvin Lindquist. Most attention was focused on wood grain and "raw-wood" effects. In an effort to produce ever more spectacular displays of gorgeous grain, turners acquired larger lathes and experimented with new techniques. Turnings gradually increased in size; the leader in large-scale turned bowls was **Ed Moulthrop** (1916–2003), who roughed out his forms and then soaked them for weeks in polyethylene glycol, which stabilizes the wood and fixes the color. He then completed the turning and coated the form with a heavy layer of plastic resin. The results were very large and brilliantly colored. His most famous bowls were flattened elliptical shapes with fairly small mouths, some of them big enough for one of his grandchildren to hide in. (Figure 10.11)

Thus far American wood turners made vessels. Even if they were not intended to hold salads, the forms played on variations of platter, bowl, or vase. Display of pleasing grain and wood effects was their primary raison d'être. Turning remained conservative, tied to familiar craft antecedents. By the early 1980s, however, its comfortable stasis had been transformed by a young second-generation turner.

Mark Lindquist (b. 1949) had worked with his father, Melvin, harvesting spalted wood on their Adirondack property. Mark had his own wood-turning shop, built by his dad, by the time he was ten. He studied art in college but dropped out of grad school to apprentice with a potter, Darr Collins. He intently studied the ceramics associated with the Japanese tea ceremony and was drawn to the Zen virtues of *wabi* (poverty) and *sabi* (imperfection and unpretentiousness). Collins did not allow his apprentice to throw pots on his own, so Lindquist began turning wood again but with the studied informality of Japanese pots in mind.

At first his work did not depart much from his father's gnarly raw-wood works, but by the early 1980s Lindquist made two radical departures. First, he used a chain saw as a turning tool. His father had pioneered the use of electric sanders and body grinders to shape spalted wood, so why not? The chain saw produced a rough, rhythmic, textured surface that was utterly unconventional. Lindquist's *Nehushtan* (1982) owes much of its rustic vigor to

FIGURE 10.11. *Edward Moulthrop, American Chestnut Ellipsoid, 1988. Lathe-turned American chestnut wood; 8.5 × 15 in. (Mint Museum of Craft + Design, Charlotte, N.C., Gift of Jane and Arthur Mason, 1997.108.2. © Estate of Edward Moulthrop.)*

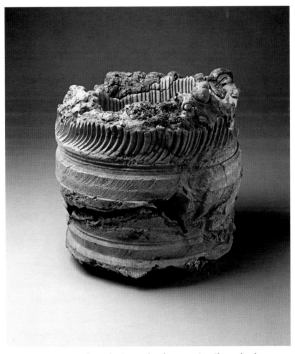

FIGURE 10.12. *Mark Lindquist, Nehushtan, 1982. Cherry burl; 14 × 14 in. (Collection of Robert A. Roth. © Mark Lindquist. Photograph by Paul Avis.)*

the use of the chain saw. (Figure 10.12) The upper and lower edges as well as the gash in the middle of the form relate to Osolnik's natural-edge works from the 1950s, but Osolnik would have sanded his turned surfaces smooth. Lindquist left textured striations on the side of the form, and immediately below the rim, he carved a row of deep, rounded grooves into the wood. After carving one, he rotated the form a few degrees and then carved another. On the interior of the piece, he did the same.

FIGURE 10.13. *Mark Lindquist, Silent Witness #1, Oppenheimer, 1983. Walnut, pecan, elm; height, 85 in.; diameter, 22 in. (Collection of Margaret A. Pennington. © Mark Lindquist. Photograph by Paul Avis.)*

Lindquist wanted to escape the restrictions of the vessel, probably as a result of his art-school education. He left part of the log attached to one of his turned forms, *Evolutionary Bowl (Proto-Captive)* of 1982, and flipped it on its side. Suddenly a vessel could be seen in a new way, as a sculpture. This was Lindquist's second departure.

Silent Witness #1, Oppenheimer (1983) summarizes his evolution from maker of wooden vessels to sculptor. (Figure 10.13) More than seven feet tall, it is a stack of four turned parts. Three have heavily scored surfaces that would have exemplified awful technique only a few years before. The crowning segment is deeply fissured. The sculpture can be seen as a human figure, reminiscent of ancient Japanese funerary sculptures called *haniwa*, but it is also a mushroom cloud. The Oppenheimer of the title is the brilliant and tragic Robert Oppenheimer, the physicist who led the development of the atomic bomb. On witnessing the first test of the bomb on July 16, 1945, Oppenheimer thought of a verse from the Bhagavad-Gita, "I am become Death, the destroyer of worlds." Lindquist's austere figure conveys something of this dread without the shrillness or specificity of much political art at the time.

Yet *Silent Witness* demonstrates remaining constraints on the craft. By 1983 American sculpture could be the size of small buildings, in steel or concrete or even piles of dirt, but wood turners would be hard-pressed to make pieces much bigger than eight or ten feet tall. In addition, *Silent Witness* is composed of variations of cones, spheres, and cylinders. These are the forms that the lathe produces most naturally, only a small segment of the nearly infinite variety of sculptural forms in the world. Because wood turning is tied to a single tool, it is more restricted than any other craft discipline. The next generation of wood turners sought ways to add to the vocabulary of turning and to build on Mark Lindquist's ambitions. Lindquist was seriously injured in a car accident in 1985, and his level of production slowed. Although he experimented with an installation of turned forms in the late 1980s, he works on a lathe only sporadically now. Nonetheless, his influence on the insular world of wood turning was enormous.

Another turner who contributed to the development of the field in the 1980s was **David Ellsworth** (b. 1944). While Lindquist favored rough, gestural turning, Ellsworth favored refinement and control. The two turners are a study in opposites.

Ellsworth was first exposed to wood turning in a junior-high shop class. He studied architecture, drawing, and sculpture in college and received an MFA from the University of Colorado (1973). Experience in both clay and sculpture made him more sensitive to formal issues than most turners.

The closed vessel familiar to potters seemed beyond the means of turners, but Ellsworth found a way to do it. He first turned the outside form, then bored a hole down the center of the solid mass of wood. Using a bent cutting tool, he hollowed out the interior by feel, while reducing the thickness of the wall to as little as one-sixteenth of an inch. He calls this process "blind turning," because the turner cannot see what the tool is doing. Needless to say, such work requires considerable practice and finesse. Ellsworth became known as one of the most skilled turners in the country, and he shared his knowledge freely at symposia, summer craft schools, and beginning in 1991, at his own studio school in Quakertown, Pennsylvania.

Ellsworth's early bowls were frequently flattened, with a modest opening centered in the top. He cites Nampeyo, the Hopi potter, as an important influence at this time. He often used exotic woods for their rich and complex grain. In the early 1980s, he started a series of taller forms, often closely related to traditional Chinese and contemporary American ceramic pots. There was one key difference, though: Ellsworth also exploited the free edge pioneered by Nakashima and Osolnik. Sometimes the rough edge would expand from a narrow opening at

FIGURE 10.14. *David Ellsworth, Bowl, 1985. Broadleaf maple burl; height, 12.5 in.; diameter, 19 in. (Collection of the High Museum of Art, Atlanta, purchased with funds from the Special Friends of Decorative Arts, 1985.274. © David Ellsworth.)*

the top of the form, but in other cases openings would appear unexpectedly on the sides or even at the bottom of the forms, revealing the interior. Ellsworth sees this in metaphorical terms: "Ultimately, I find myself drawn to the privacy of the interior to discover the origins of its force. It is within this volume that one encounters an object's spirit and 'pulse,' elements that engender the same qualities of mystery that we find within ourselves."[13]

The openings contrast with a sleek, simple form. In a 1985 Ellsworth bowl, the ragged gap extends more than halfway across the form, revealing a suggestively dark interior space. (Figure 10.14) The edge also conspicuously displays the maker's skill: it is astonishingly thin and lends a note of fragility to the piece. He tried other devices to intensify both the expressive power and the sculptural potential of his vessels. He sometimes carved back into the forms, making gashes or holes in the surface. Later he burned his turned forms to a deep black. In some pieces the wood was so stressed by the burning that it cracked and began to crumble. The contrast between destruction and creation in these works has a visceral impact.

In the 1980s other turners extended Ellsworth's accomplishments. **Todd Hoyer** used the free edge even more aggressively and later turned large asymmetrical fins that extend off a bulbous central form. **Dale Nish** used wood that had been damaged by boring insects, which yielded fascinating patterns of holes in his straightforward forms. The champion of thinness was **Del Stubbs**, who could turn wood down to the vicinity of one-hundredth of an inch thick. He would often wet the wood to achieve this thinness and illuminate the moving wood with a light to accurately estimate the thickness

of his walls. The damp wood was so flexible that Stubbs could fold it in his hand, and he dried his turnings in evocative folded and bent shapes.

Clay Variations

In ceramics, even as increasingly elaborate and tight pictorial works were seen in the galleries on both coasts, in the heartland, due to Warren MacKenzie's dogged teaching and promotion, the second and third generation of his students created a thriving community of functional potters in the Upper Midwest.

An important new venue for large-scale ceramics was Omaha Brickworks, opened by gallerist Ree Schonlau at the beginning of the 1980s. It was a working brickyard that allowed artists to take advantage of such features as a thirty-five-foot-diameter beehive kiln. Tony Hepburn was among the first artists invited, in 1981; Jun Kaneko made his Dangos there. The Watershed Center for the Ceramic Arts was established in 1986 in Maine, on the site of a nineteenth-century brickworks. Four artists laid the groundwork for a summer residency program that continues in expanded form today.

The decade's most debated exhibition was *Ceramic Sculpture: Six Artists* at New York's Whitney Museum in 1981. It featured Arneson, Gilhooly, Mason, Price, Shaw, and Voulkos, all of whom had appeared in past Whitney annuals and biennials. The show received press attention but not necessarily understanding, except for West Coast critics. The complicated relationship between clay and the art world continued.

The most important critical development was the establishment of *American Ceramics*, published by Harry Dennis and sensitively edited by Michael McTwigan. It gave serious, analytical consideration to clay exhibitions throughout the United States and included historical articles as well. Unfortunately, the magazine slipped after McTwigan left a few years later and financial strains made publication increasingly irregular.

Good news for ceramics was the establishment of the Garth Clark Gallery in 1981 and the inception of a regular program of showing and collecting American crafts at the Museum Het Kruithuis (pronounced krout-house) in the Netherlands.

EARTH, SKY, AND IN-BETWEEN: RUDY AUTIO

As Rudy Autio was creating abstract, constructive forms in metal, cast cement, and other materials, among the occasional clay pieces he produced were *Fleshpot* (1962), a nearly hemispherical vessel with a black lid, the body

FIGURE 10.15. *Rudy Autio,* Pow Wow Ponies, *1985. Glazed stoneware; 27 × 24 × 16 in. (Arizona State University Art Museum, Ceramics Research Center. © Lela Autio.)*

of the pot covered with arms, legs, faces; and *Ladypot* (1964), a twenty-eight-inch-tall shaped vessel painted with a single fleshy nude, the neck of the pot forming her narrow face. These works presaged the direction he took in earnest beginning in 1980. (Figure 10.15) He settled on a wide, essentially two-sided form with extensions he called "ears," which are often occupied by the elbows or knees of the nudes that populate the surfaces. Autio took this vocabulary through innumerable permutations, starting with dark, dense framing colors in 1980, followed by pastel colors that seem illuminated from within on the porcelain vessels he made during a residency at the Arabia Factory in Finland in 1982. He also employed discontinuous heavy outlines, silhouettes, shading, and more.

Female nudes and horses were the usual subjects, and Autio was regularly asked about the horses. People expected symbolism. He usually said he was the horse, everyone laughed, and that seemingly took care of it— except that neither he nor any critic justified the appropriateness of the imagery applied to a ceramic object in the late twentieth century. Garth Clark ascribed the lack of analysis to "Autio's modesty, his geographic isolation from the main art centers, and his small, intermittent output (about twenty vessels a year)," yet he did not offer his own interpretation.[14] Autio's nudes seem to have sur-

vived from another era, since they have a cool sensuality and a sketchy rendering style (such as two-line eyes). It seems likely that he simply adopted conventions from his surroundings: the nude refers not only to European art but also to the painting over the bar. The horse speaks of the West, perhaps an homage to Autio's boyhood hero, cowboy artist Charlie Russell. There is no sexual explicitness, no allusion to the erotic attraction of girls to horses. It is fiction rather than reality. Autio used the nude to express the pot's anthropomorphism, with a curvaceous form occupying an undulating surface.

The horses may represent the active, as opposed to the nudes' passivity, or exemplify the animal world in its closeness to but differentness from the human, or they may signal contact with the earth (the potter's experience) as opposed to the floating, unstable, sky-borne figures. Autio's motifs are almost never seen whole, and they are usually multiple. Perhaps that reflects complicated modern times, yet they have an out-of-time quality, vaguely recalling the work of Matisse. Autio was also influenced by the horses of Hank Meloy, an important Montana painter during his youth, and the joyous nudes of the Japanese contemporary printmaker Shikō Munakata. Autio's achievement was to combine such disparate influences in a distinctive material with forceful line and color.

ARNESON'S TRAVAILS

In the late 1970s Robert Arneson made a series of ceramic portraits of his artist friends, and in the 1980s he began making tributes to artist exemplars, including Picasso, Pollock, Guston, and Bacon. His most important portrait, however, was a 1980 commission for a memorial to George Moscone, the recently assassinated mayor of San Francisco, to be placed in the convention center named for him. Arneson's drawing of a jovial likeness, a head atop a short, broad pillar, was accepted. The finished work added graffiti to the pillar, including biographical information, some of Moscone's favorite phrases— and references to his murder.[15] In the resulting uproar, Arneson returned his advance and regained control of the sculpture. It is hard to say who was more foolish: the commissioners to expect something traditional from an artist with Arneson's record or Arneson for assuming that humor would be acceptable in such a context. It was, however, acceptable as art: the piece was shown the next year in *Ceramic Sculpture: Six Artists* at the Whitney and then at the San Francisco Museum of Modern Art.

Arneson's work at the Whitney was savaged by the *New York Times'* supercilious critic Hilton Kramer, who referred to the "spiritual impoverishment" of life in Cali-

fornia and found in Arneson's sculptures "a gruesome combination of bluster, facetiousness and exhibitionism—placing a fatal limit on what his gifts allow him to accomplish or even conceive."[16] Arneson's response was a half-length portrait of himself, *California Artist* (1982), with sunglasses, a denim jacket over a bare belly, and a pedestal littered with beer bottles, cigarette butts, and a marijuana plant. In fact, however, thereafter he made fewer self-portraits, and his subjects became darker.

One of Arneson's new themes was the threat of nuclear war, and he made chilling images of death and devastation as well as a war-mongering *General Nuke* (1984) atop a pedestal of blackened bodies. Yet another dark theme arose following a recurrence of cancer. His 1992 collapsing heads, representing the experience of chemotherapy, are the visual equivalents of screams.

There were some good new things in Arneson's life as well. After an abortive flirtation with bronze casting early in his time at the University of California, Davis, in 1980 he established a relationship with the Walla Walla Foundry in Washington State and made more than ninety-five unique or editioned pieces there over the next twelve years. He did pieces physically impossible in clay or too large for a kiln. His last bronze piece was a model for a full figure. It is a takeoff on the classical Discobolus, an athlete ready to hurl a discus. Arneson instead represented the sagging body of a middle-aged man. In his left hand he holds his own head, smiling pleasantly, while his free hand, held at his back, suggests lower-back pain (a disk rather than a discus). His wit never flagged.

THE AESTHETIC VALIDITY OF POTS

Betty Woodman began as a functional potter making dinnerware; over time she became one of the most distinctive and risk-taking ceramists of the century, stretching the conceptions of form and surface, expanding her work's compass in space—yet never completely abandoning function. (Figure 10.16) Her flamboyant vases are still shown filled with flowers as she pointedly continues to make a claim for the aesthetic validity of utilitarian objects. Arthur Danto notes: "It is plain that the vase as subject and, nearly as often, as form, is the dominating object in Woodman's oeuvre, and this singular dedication to the vase is justified, in her view, by her bold claim that the vase holds a central place in Western culture itself, symbolizing the spirit of our culture much in the way the tea-bowl emblematizes what is deepest in the East."[17]

In 1948 Elizabeth Abrahams (b. 1930) enrolled in the two-year journeyman program at the young School for American Craftsmen, then located at Alfred, studying with many returned veterans. Her teacher, Linn Phelan,

encouraged her first trip to Italy. She had glancing contact with Bernard Leach at Alfred when he spent several weeks in residence, but she did not follow the Japanese influence that was exciting everyone then. What "took" was the exposure to Italy. She returned many times, eventually buying a farmhouse near Florence. Mediterranean lead-glaze color, earthenware clay, and even Italian cooking shaped her life. She had entered pottery during the stoneware era, but the exposure to Italian majolica (and Native American pottery of the Southwest) led her to work primarily in earthenware. Its softer character and relative warmth suited her breezy, natural approach. Her works have never been about precision, except to the degree needed to produce sets of dinnerware, and she didn't do that for long. Even the few works she has made in porcelain have escaped that material's historic association with refinement and perfection.

Living in Albuquerque and then Boulder with her husband, the painter and photographer George Woodman, she began teaching at the Boulder Parks and Recreation Department and then at the University of Colorado as she produced and sold her wares. There were times when she felt stigmatized as a woman, especially as a wife and mother—simply overlooked on the stereotyped assumption that she could not be serious. She remembers praise

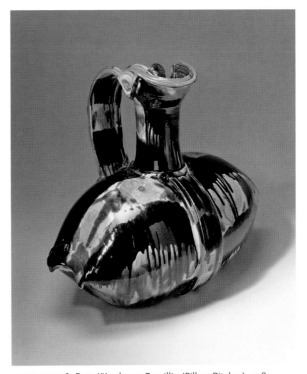

FIGURE 10.16. *Betty Woodman,* Camillia (Pillow Pitcher), *1982. Ceramic; 19.29 × 23.23 in. (SM's Stedelijk Museum 's-Hertogenbosch [formerly Museum Het Kruithuis], Netherlands. © Betty Woodman Studio.)*

from Paul Soldner as the first important reinforcement of her efforts. In 1978 the Woodmans bought an apartment in New York and became involved in the pattern and decoration movement. She collaborated with Cynthia Carlson on wall reliefs, and other pattern and decoration artists, such as Joyce Kozloff and Robert Kushner, became close friends. The feminist movement was emphasizing recognition of women artists, and suddenly gender was far less of a liability.

Woodman was by now making what she described as "Sunday" pottery. The pieces were larger than expected, and the purposes of serving dishes were treated with both greater ceremoniousness and greater insouciance. Her asparagus server and mussel server, for example, magnified purposes not usually singled out. They were almost too large to use and seemed monumental in relation to ceramic convention.

Woodman began to make wall pieces consisting of a shelf or sconcelike support and a vase to sit on it. Her tabletop pieces often consisted of pairs and trios (which she refers to by the painting terms diptychs and triptychs) rather than single forms. She continued to throw everything on the wheel. Even flat, cutout "handles" reveal the spiral of throwing. A former student gave her the idea of throwing a disk and then casting it down on a prepared surface so that it stretches and flattens. From such thrown slabs she cut idiosyncratic handle shapes, often finding the leftovers equally interesting. These handles, and the negative shapes they create, both between the vessels of a diptych or triptych and all around when they are mounted on the wall, are one of her signatures. It is not just their tactile reality but their spatial expansion that is exceptional.

After starting as a maker of simply glazed functional forms, Woodman spent a half-dozen years with her husband doing the decorating, and then resumed responsibility for all parts of the process. When he stopped, she was at first uncertain what to do and left the works uncolored. Seeing Islamic pottery inspired a palette, and she began to work at redefining form through the application of color. She worked out a distinctive painterly style, to the point that critics interested in painting reviewed her shows. Her approach involves very free applications of color—in the vivid hues permitted by low-temperature firing—that jump gaps and reappear on other parts of the work. It acts as gesture. Her decoration has been described as offering "a corrective for the pretty-pretty, sometimes concealing a certain aggression" and as "contesting" and "teasing" her forms.[18]

Woodman's colors have been called bright, brilliant, vibrant, chromatically boisterous, dissonant, and, in her words, "not necessarily subtle"; garish might be in the list, too. They are interrupted by texture, and they may be muted (if mat) or magnified by gloss. Often one side of the vessel is more lavishly colored and the other more reserved or neutral. Nearly everyone who writes about her work mentions Matisse, and some bring up Bonnard. Her debt to Tang dynasty three-color ware is also noted. The mix of solid and pattern in Japanese seventeenth-century Oribe ware is an important precedent, and she has identified many more sources for her forms and colors. Travel has brought new ideas; observation and interpretation of other objects is a frequent resource. She notes that ceramics has always been multicultural, and much development has come from one culture's attempt to copy another.

Richard De Vore once described Woodman's ability "to present visual form as a new reality of experience."[19] She developed the basket handle and invented the pillow pitcher. Late in the century she made enormous wall installations, played volumetric against flat (in reality and in effect) to cause figure-ground shifts, designed pieces in colorless glass, made fountains and benches in bronze, produced prints and drawings, and employed *terra sigillata* as a painting material on paper. Woodman's staggering eclecticism, ahead of the curve, is as exploratory and freewheeling as the work of her younger colleagues in painting, Elizabeth Murray and Judy Pfaff, and has been cutting edge in ceramics for decades.

IN TERMS OF ART: ANDREW LORD

Andrew Lord is a sculptor who used clay to capture fugitive effects of light and shadow inspired by modern painting, and he has in addition used it to record deliberate acts of contact with working parts of his body.[20] Lord (b. 1950), a graduate of London's Central School of Art, arrived in New York in 1981 with a sold-out and extensively reviewed exhibition at a leading gallery. His handmade vessels are jaggedly irregular and do not quite stand up straight. They are not well-crafted objects. They are expressive and intelligent works that respect clay as a material and the meanings of the vessel form—with novel and provocative variations on convention. Moreover, as the British ceramist and critic Edmund de Waal puts it, "There is an almost aggressive and polemical feel to some of this work, a daring of the critics not to take seriously work that appears decorative, or overtly historicist."[21]

Lord now splits his time between New York and London. In the 1970s, when he was living in the Netherlands and looking at impressionist and cubist painting, he began to make ceramic pieces that considered the fall

FIGURE 10.17. *Robert Sperry, #625, 1984. Ceramic; 128 in. × 360 in. (King County Public Art Collection. Courtesy of M. Patricia Warashina.)*

of light. Titles specify morning or afternoon and reflect a process of marking the actual pattern of shadows on forms inspired by Meissen, Delft, Staffordshire, or pre-Columbian pottery. He diagrammed and geometricized these marks on paper and then rebuilt the pot to reflect that intellectualization of natural observations.

Later Lord responded to the agitation or angular twists of Rodin's and Matisse's modeling, and more recently he has made "collections" (from two to twenty-seven vessels in a group) that embody different methods of forming. Some surface marking involves actions such as punching and slapping, while pressing and squeezing nearly collapse the forms. He takes the idea of recorded touch beyond the obvious contact of hands by biting or by holding clay to his throat as he swallows. His eccentric and uncertain vessels portray him and his actions in a peculiarly intimate way and metaphorically extend the equation of clay with flesh.

Despite his success, Lord has taken flack from all sides. A painting critic admired his ability to "exploit glazing as an element in form, rather than as a decorative addition to it" yet wished that he had not presented the work in sets, since (the critic claimed) the sculptural form would have been more striking if seen alone.[22] Sets are, of course, associated with pottery; Lord's sets, however, are usually mismatched. At the same time his unconcern with fine craftsmanship and his very success in the art world has rankled craft writers. Knowledgeable and sophisticated, Lord found fruitful approaches that respect the capabilities of clay and the demands of art.

ROBERT SPERRY

Robert Sperry (1927–1998) was one of the more elusive major figures in postwar craft, repeatedly shifting his creative identity. Within the ceramic medium he moved from function to expressionism to a kind of abstracted pictorial symbolism; he also made films. He was esteemed in the Pacific Northwest, but his national exposure was irregular.

Born in Illinois, Sperry grew up in Saskatchewan. In 1953 he received a BFA from the School of the Art Institute of Chicago—in painting, although he was throwing pots on a wheel in his apartment. In 1954 he spent time at the Archie Bray Foundation, where he met Autio and Voulkos. By the end of his three months there, he had been offered both a teaching fellowship at the University of Washington and the job of resident potter at the Bray, since Voulkos was leaving. He chose Seattle.

Sperry tried almost everything: functional pottery on the wheel, slab-built plates and covered boxes he could paint on, raku, tall sculptural works—and all that within the 1950s. He was known for "the fast tempo at which he works, the effortless brushwork, the uninhibited expressive qualities,"[23] yet he also would obsessively build up surface with tiny bits of clay or dense patterns of gouging. (He ascribed his *horror vacui* to a rejection of the open spaces of Saskatchewan.) In the 1960s he made stoneware wall reliefs. He also purchased his first movie camera, went to Japan and made a film about Onda potters, and became involved with experimental filmmaking. In the 1970s he returned to clay full-time and used drawings as motifs for wall-hung plates.

Sperry's ceramic work of the 1970s was pivotal: he began to work in black and white and developed the crackled glazes and crawling or pooled white slips on black for which he is best known. Firing processes influenced the slip's shrinkage and its cracking or blistering (random within certain limits) to create spectacular surfaces. The graphic drama of these works recalls Japanese design; textures suggest crusty earth and compositions evoke stellar debris swept through dark regions by cosmic winds. In the 1980s he applied this approach to large circular plaques and even to public murals (as much as eleven by thirty feet) that he made by ladling or mop-brushing slip over kiln shelves. (Figure 10.17) The grandeur of these effects recalls the abstract expressionist painting important in his younger years.

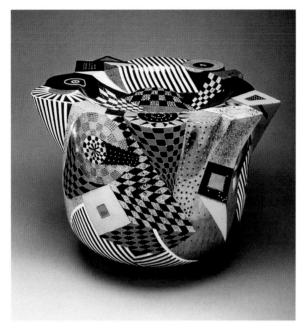

FIGURE 10.18. *Ralph Bacerra*, Double Wall Vessel, *1988. Whiteware; 15.75 × 23 × 19.5 in. (Los Angeles County Museum of Art, Gift of Howard and Gwen Laurie Smits in honor of the museum's twenty-fifth anniversary. © Ralph Bacerra.)*

THE PRECISIONISTS:
BACERRA AND HIS STUDENTS

Ralph Bacerra (1938–2008) made what is arguably the most intensely decorated ceramic ware of the 1980s and 1990s. (Figure 10.18) A native Californian of Mexican heritage, he studied with Vivika Heino at Chouinard and succeeded her as head of the department, staying until the school closed in 1972. In 1965 he bought a Tang dynasty horse that had been deaccessioned by the Los Angeles County Museum of Art, and it inspired him to make fanciful animals, each with four stemlike legs, an abstracted head, patches of color, and metallic division lines on a segmented body. That was a step toward his signature decorative constructions.

A series of two-foot platters in the mid-1980s offered ample surfaces for his compactions of geometric forms, lines, and stylized birds and flowers. Dimensional protrusions magnified the vertiginous visual complexity. He went on to make teapots, "portrait" vessels and chargers, and porcelain "cloud" vessels. The small scale of his pattern elements, the perfect execution, and the lustrous surfaces turn excess into elegance.

Bacerra's significance as a teacher matches that of his work. Although the trend of the 1960s was toward unstructured education, he insisted on hard work, technical performance, and formal critiques. His students— Elsa Rady, Adrian Saxe, Peter Shire, Mineo Mizuno, and others—developed exacting, vividly colored styles after study with him. His work moved in the same direction, inspired by Persian miniatures, Kutani and Imari porcelains from Japan, and even the graphic art of M. C. Escher. After Chouinard closed, he became a designer for the ceramic industry and a studio potter; he began to add relief to painted illusion. He returned to teaching in 1983, as chair of ceramics at the reorganized Otis-Parsons, remaining until 1997.

Adrian Saxe is a paragon of postmodernism in clay, a creator of ironic masterpieces of appropriated symbolic imagery. His exacting vessels, topped by elaborate lids and set upon specifically conceived bases, are tributes to and spoofs of Sèvres porcelains of the eighteenth century. Saxe could adopt the motifs of China and Japan as easily as European and pop-culture themes. His eclectic knowledge and superb craftsmanship made him a model for younger ceramists and defined him as a pioneer of what Peter Schjeldahl has called "the smart pot"—a self-conscious object that called attention to the confusion of values and identities in the late twentieth century.[24]

Saxe was born in 1943 near Los Angeles and grew up amid the mix of Pacific Rim and transplanted European styles. His mother was a cel colorist for Disney Studios and his father a photographer as well as a licensed embalmer who sometimes worked at the ornate Forest Lawn Cemetery. Perhaps his pop-baroque duality was established at birth. He lived in Hawaii as a teen and studied at Chouinard under Bacerra. Like a number of Los Angeles ceramists, Saxe worked at Interpace (originally Gladding, McBean), which gave him knowledge of factory methods of production and low-fire glazes.

Saxe's first exhibited bodies of work—the Huladicks and Lollycocks, phallic and lipstick forms mounted on a base and given a Plexiglas cover—reflected a youthful crudeness. He also made molded domes that he colored and hung on the walls like color-test dots. In his early days he made mugs, covered boxes, and casseroles for the sales income and discovered that porcelain pieces would sell for higher prices, which made him think about the prestige and value of different ceramic traditions—and by extension, all cultural preferences.

In 1983 Saxe was awarded an artist's fellowship and six-month residency at the Sèvres manufactory outside Paris. From that experience he gained an appreciation of a nineteenth-century architectural environment, a greater sense of the layering of styles and times, and an expanded attraction to gold lusters and opulent forms. Sèvres reinforced his interest in display.

After the residency, Saxe made a series of oil lamps employing vegetable shapes; these were not abstracted or idealized forms but were modeled on actual vegetables.

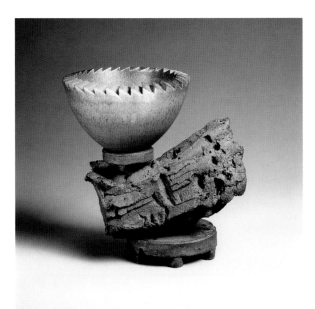

FIGURE 10.19. *Adrian Saxe, Untitled, 1982. Porcelain, raku-fired;*
5 × 14.5 × 15.25 in. (The Metropolitan Museum of Art, Gift of
Barbara S. Rosenthal and Kenneth W. Juster, 1997.416.3A-B.
Art © Adrian Saxe. Image © The Metropolitan Museum of Art.)

Untitled Oil Lamp (Fenouil) of 1985 is an eight-inch celadon-colored lamp in the shape of fennel, with wicks at the top of all four shoots. The fennel sits on a stepped plinth and is given gold-lustered handles. The vegetable, dignified in its fullness and erectness, seems to stoically endure the silliness of the ornament.

A frequenter of junk stores and flea markets, Saxe collected commercial ceramic molds and used them as a catalog of both fine and popular culture, with the objects he assembled functioning as a rebus or a text. (It is a postmodern attitude to see more interest in contradiction than in purity.) Finials became his favorite way of literally topping off. He often used a cactus but then settled on the antelope as a symbol of natural energy and grace. Another characteristic Saxe composition is the serrated rim on a bowl, as friendly as a saw blade but contrarily presented in a lovely gold or yellow. (Figure 10.19)

Postmodernism, which works against the idea of universals and recognizes specific and temporary contexts that establish meaning, supported Saxe's assemblage creation of culture: everything has potential meaning, and presumably anything is certified as legitimate if it sells. Some writers, however, have seen Saxe's use of varied and once-meaningful forms, particularly from eighteenth-century France, as cautionary in their reference to obsolete societies. The crux is the viewer's perception of his sincerity: Is he mocking voracious consumption of forms and styles—in the past and also in present American culture? Or does he, in fact, exemplify the problem

in his obsessive borrowing and mixing, constantly seeking the new sensation? Is he thoughtfully criticizing "the way in which the making of useful objects is degraded to the production of trinkets and mere status symbols"?[25] Or is he "a PoMo [postmodern] potter shopping in the aisles of world culture"?[26] How do we evaluate an artist who studs one vessel with rhinestones and another with three-dimensional snails?

"A superb formalist," **Elsa Rady** (b. 1943) studied at Chouinard under Bacerra as well as with Vivika Heino.[27] The tight clarity of her work echoes Bacerra's control but not his decorativeness. Rady worked for Interpace for two years, designing tiles and border decorations for dinnerware, and was exposed to a variety of glaze colors and to high production standards. Since establishing her own studio in 1968, she has been known for precise, thin-walled porcelain vessels with sharply carved rims, which might be mistaken for metal if they did not retain the skinlike sensuousness of ceramics.

In her studio in Venice, California (featured in *Progressive Architecture* magazine in 1982), Rady has concentrated on refinements: the cone or bullet or bowl shape, the notched or almost winglike flaring rims, the distilled serenity of monochrome surfaces. Another major concern has been presentation. She has devised many controlled situations, including sets of vases arranged on slabs of dark granite, bolted to aluminum shelves, or suspended. The works, in their drama, can recall the splendors of art deco, but their austere elegance also seems very contemporary. The flaring rims might recall the flaring skirts of dancers; a photograph of her mother as a Martha Graham dancer, mounted on the studio wall, is mentioned in every feature story on Rady's work.

Rady also coaxes out other associations. Both the title

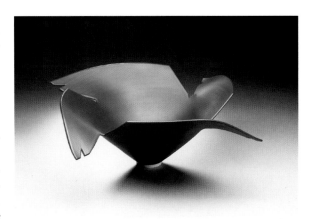

FIGURE 10.20. *Elsa Rady, Winged Victory, 1983. Wheel-thrown*
porcelain, glazes; 5 × 14.5 × 15.25 in. (Los Angeles County Museum
of Art, Gift of Howard and Gwen Laurie Smits. Photograph © 2009
Museum Associates/LACMA. Art © Elsa Rady.)

and form of *Brushed Flight* (1983) or *Clipped Wings* (1984) bring to mind avian or aviation features. (Figure 10.20) The perfection of vertical form can suggest spun aluminum and mechanical devices such as fans, but it is always a fantastic ideal, never workaday industrial. She finely calibrates both scale and placement to effects of lightness and logic; the control might be oppressive if the works did not embody sensuous tactility and motion at the same time.

VARIETIES OF UTILITY

Dorothy Hafner and Peter Shire, more than any other late twentieth-century American ceramists, happily retained a ceramics identity while finding success in the design world. **Peter Shire** (b. 1947) earned a BA in ceramics from Chouinard in 1970, studying with Bacerra. He regards as his first mature work teapots from 1974 built of slabs, with rigidly independent handles and spouts; the image of jumbled parts that they convey was inspired by the piles of waste lumber at his carpenter father's job sites. The pots featured California colors, brilliant or sunbleached, and had nothing to do with the "natural" appearance of clay.

Ettore Sotsass, soon to establish the Italian design group called Memphis, in 1979 happened to see a Shire teapot in the background of a magazine photo and invited him to come to Italy for a few months. Some of Shire's designs appeared in the first Memphis show in 1981, furniture as well as ceramics. He was the only American participant. He did not shift to neat forms for mass production but kept the arms-akimbo designs and slightly softened edges that make his vessels look more

FIGURE 10.21. *Peter Shire,* Sunburst Accordion (Teapot), *1983. Earthenware, glaze; height with lid, 16 in.; diameter, 17 in. (Los Angeles County Museum of Art, Promised Gift of Alpert & Alpert Iron & Metal, Inc. © Peter Shire.)*

like colorful toys than impersonal products. Shire insists that his teapots are functional, saying that if they did not function, they would be less radical because they would just be sculpture.[28]

But they are not *apparently* functional. It is not always clear how to pick one up, and in a work like *Sunburst Accordion* (1983), the container portion is quite small. (Figure 10.21) The works appeal as inventive California-spirited constructivism, joyous and warm. "This is function as a game, with a kind of irony still unfamiliar to the ceramics field," an observer said in 1982.[29] Shire contends that he is not interested in "timeless beauty" because it takes a work out of the present; he is more interested in creating a diversion. The work appeals simply as an arrangement of the unexpected, but a subtext can be discovered: the architectural character of the Los Angeles Shire grew up in and its invasion by the steel-and-glass high-rises and boutique architecture of its expanding commercial core. The jumble can likewise be seen as a metaphor for the confused engagement of art, craft, and design.

Today Shire is known for his designs for furniture, jewelry, fashion accessories, architecture, stage sets, and even a disco as well as his ongoing production of teapots. He makes an effort to disguise clay's plasticity and to remove evidence of the hand; he evades the classic rituals of tea (which he does not drink).

Dorothy Hafner (b. 1952) studied ceramics at Skidmore College and wanted to make sculpture. After she moved to New York City, she made and sold individual plates to cover the cost of the studio where she worked nights and weekends. A commission for dinnerware, which she at first resisted, set her to thinking, as did the fact that a fashion designer who had bought her plates planned to steal the design.

In 1978 Hafner introduced a white porcelain ware with a graphic pattern that got good press—it was different from most handmade dinnerware at the time, and it photographed well. She studied business management, talked to people, and made some large one-of-a-kind platters, and then, with a boost from a well-connected acquaintance, she was invited to design a dinnerware line for Tiffany & Co. She spent six months developing three lines; Tiffany took two. She also produced the Kyoto Homage pattern, an extension of her one-of-a-kind plates, which she marketed privately and through galleries. The designs seemed an expression of the highly charged 1980s—colorful, energetic, certain.

Hafner's characteristic style is complex, varied, and colorful, often juxtaposing completely different patterns and colors in a manner inspired by Japanese Oribe ware. The square plates of Kyoto Homage consist of a

FIGURE 10.22. *Dorothy Hafner, Kyoto Homage Platter, Kyoto Homage Series, 1989. Porcelain, applied glazes; 1.2 × 17 × 12.25 in. (Collection of The Newark Museum, Newark, N.J., Purchase 1989 Estate of Pearl Gross Lee, 89.29. Art © Dorothy Hafner. Photograph © The Newark Museum/Art Resource, New York.)*

white-outlined central square that seems to sit on top of large and small diagonal stripes. (Figure 10.22) The colors sound incompatible—mostly golden orange, navy, purple, brick red—but they are all put slightly at ease by a dusky value. Her sets employ a given vocabulary, but decoration is not identical from piece to piece.

From 1979 to 1981 Hafner developed and supervised a staff to make production wares. The team also manufactured limited-edition sets that she decorated, and she made unique works by herself. She was the first American artist to produce signature collections for Tiffany, and she continued to work with the company for ten years. During the 1980s she also designed for the porcelain manufacturer Rosenthal and created a bed-and-bath textile collection for Cannon Royal Family. In the early 1990s she took a sabbatical and made a surprising shift to glass (which will be discussed in chapter 11).

Functional pottery continued to be widely produced yet not widely exhibited in galleries. Fairs, studio sales, and various sorts of shops served better to keep prices in a practical range. A few potters staked out distinctive positions. One of them, **Jim Makins**, made both production ware and exhibition pieces. Makins has the unusual background of being a talented tap dancer as a youth. His ceramic work emphasizes fluidity rather than the percussive repetition of tap, but the notion of rhythmic movement carries through.

Makins (b. 1946) studied at the Philadelphia College of Art. After graduating in 1968, he spent two years as an assistant to Byron Temple, learning to throw the forms in Temple's production line. In 1972 he enrolled at Cranbrook. His breakthrough came after Richard De

Vore commented on the ceramist's need to focus body and mind at his fingertips in contact with the clay, which Makins related to his former absorption in dancing. He was inspired to throw in a single continuous contact, defining a form without breaking the link of touch. This made the throwing marks on his utilitarian porcelain forms extraordinarily directional and coherent and embedded ideas of performance and process in the plates, goblets, and teapots. (Figure 10.23)

The works were limited to black, white, and gray so as not to take attention from the form. Given that he once said color was too emotional and distracting, it is surprising that the "tray pieces" Makins began making in the early 1980s seem formed of color. These are superficially still lifes in the manner of the arrangements of bottles by modernist painter Giorgio Morandi. The important differences are the intense use of slightly acid hues and the extreme tactility and motion of forms pulled up loosely to the tottering verge of collapse. They are thrown individually and combined later, so each has a sort of persona, and the tray seems like an arena stage.

Michael Simon's pots still keep company with function, even if they are not in the everyday kitchen. He started out committed to utility and still values it, although from a contemplative distance now. In the years of finding his way (he calculates that it took twelve years of working to really learn to be a potter), he grew unhappy with glazed stoneware, wanted to simplify, and preferred the revealed body that was possible with salt-firing. Yet he also had the urge—inspired by Hamada's simple brushed grass and bamboo motifs—to paint on the surface. He eventually produced distilled, evocative drawings of things from nature and abstract marks that suggest architectonic space as an abstract painting

FIGURE 10.23. *Jim Makins, Black Tray Demitasse Set with 6 Cups, 1983. Porcelain, glaze; 11.62 × 18.12 × 18 in. (Arizona State University Art Museum, Ceramics Research Center. © Jim Makins. Photograph by Daniel Swadener.)*

FIGURE 10.24. *Michael Simon, Jar with Lid, 1983. Stoneware.*
(Courtesy of Michael Simon. Photograph by Walker Montgomery.)

might. His squared vase and covered-jar forms are his canvas. (Figure 10.24)

Simon (b. 1947) studied at the University of Minnesota with Warren MacKenzie. He has lived in Georgia since 1970, when he and his then-wife, Sandy, established a production pottery. He took time out after a decade (and a divorce) to earn an MFA at the University of Georgia under Ron Meyers. Simon's vessels often have solid and sturdy-looking feet that raise the pot but do not make it look lightweight. The effect is to isolate the volume, emphasizing the sense of capacity that is inherent to pottery but not always foregrounded. With his turn to painting, Simon developed a method of incorporating wax resist and hatch marks so that his imagery often looks either like an ink drawing or a woodcut print. These opposite attractions, volumetric and graphic, identify his distinctive body of work.

Simon discovered that a covered jar he was making was strikingly like recently excavated archaic Middle Eastern forms. Pleased to find a pottery solution shared across a vast time, he began calling his versions "Persian Jars." Other signature forms include three-legged vases and jars that are thrown thick and then squeezed and carved into the final shape. His forms combine grace and robustness—the odd combination defining them as contemporary—along with simplified, silhouetted animal motifs that evoke both cave painting and modernist painting.

ABJECT FIGURES: ROBERT BRADY AND ARTHUR GONZÁLEZ

Robert Brady is sometimes identified with Bay Area figuration in both painting and sculpture, but his work seems more akin to pre-Columbian art, with a wan but perhaps spiritual tone. (Figure 10.25) His best-known figures convey a distinctive emotional timbre, a hapless, plaintive, asocial mark of injury recalling hermits or the chronically homeless. They can seem profoundly sad, yet he has recurrently created images of wings and winged figures, promising the possibility of transcendence.

Brady was born in 1946 in Reno, Nevada, to an unstable family, and he suffered a debilitating arthritic illness as a teenager. He developed his own imaginative creative life and a deep feeling for the western landscape. After finding ceramics in high school, he attended the California College of Arts and Crafts, where he made utilitarian wheel-thrown vessels. He took a workshop from Hal Riegger, and later they did desert raku workshops together. Brady loved the processes of digging, making, and firing and in the counterculture years of the 1960s was unconcerned with finished products or with money. He subsequently became a longtime teacher at Sacramento State University, with an important two-year

FIGURE 10.25. *Robert Brady, San Simone, 1981. Clay.*
(Crocker Art Museum Purchase, 1989.4. © Robert Brady.)

break teaching at the then-new Appalachian Center for Craft in Smithville, Tennessee.

After his first solo show—coiled pots five or six feet tall covered with patterns—he was discovered by important art collectors and his works appeared in fashion and decor magazines. In 1980 he began his Ancestor series of "crippled, vulnerable, nude males . . . always under-endowed. Legs that could never carry the weight of their accumulated lifetimes of suffering."[30] These standing figures often have overlarge heads and are supported by props. Other works of the 1980s included animal-human combinations and large coiled boulders with scarred surfaces and blooms of color. Brady turned to wood in 1989 (although he never completely abandoned clay and also makes drawings, paintings, prints, and masks); in this medium the figures evoke folk art. He titled both ceramic and wooden works with references to healers, Sherpas, pilots, and angels—implying getaway attempts of one sort or another and broadening his emotional effects.

FIGURE 10.26. *Arthur González, Ensconced, 1988 [1987].*
Clay, mixed media (clay, wood, epoxy); 47.5 × 21.5 × 14 in.
(Collection of Stephen and Pamela Hootkin. © Arthur González.)

The figure was also the focus of **Arthur González**'s ceramics through the 1980s and 1990s. The representations are usually partial and usually seen on the wall, often with some element that suggests an environment. Trapped, struggling, morose, the figures seem pained and burdened with some unmet need, whether for food, rest, or emotional succor, or they engage wearily in some inexplicable action. The torsos of the early 1980s often have faces smeared with white slip that exposes only their eyes and mouths. It looks like a porcelain mud-pack, but its effect is to suppress emotion. The white-face could in addition raise questions of racial identity or evoke ritual face painting in various cultures.

Boats (also seen as fragments) repeatedly appear in González's works. He regards them as symbolic of spiritual search.[31] These are among his most gripping works, even if mysterious. For example, *Ensconced* (1987) includes the prow of a rowboat tipped up on the wall so that it resembles a Gothic arch. (Figure 10.26) It shelters a sad, thin boy whose left arm is longer than possible and whose right arm, over his head, is lashed by a rope to the prow. His body follows the curve of the hull, and his genitals are exposed, making him particularly vulnerable. He is imprisoned within that protective hull. In *Anchor* (1988), a figure with a rope pulls a boat in which a second figure sits—both the boat and its inhabitant smaller than the puller, though all occupy the picture plane of the wall.

González (b. 1954) had never been out of his hometown of Sacramento until Robert Brady took him to the Newport Harbor Art Museum and, on his first flight, to Missoula. González earned an MA in painting at Sacramento State and then studied with Robert Arneson and sculptor Manuel Neri at UC Davis. While Brady's influence can be seen in his work (helpless, passive figures), in Arneson he probably found an example for defending provocative work.[32] González was an itinerant teacher in the 1980s and spent time in New York's East Village. He began teaching at the California College of Arts and Crafts in 1991. He also makes mixed-medium tableaux, ceramic books, and pastel sketches.

CULTURAL AND PERSONAL IDENTITY

While the nude body has been a recurrent focus in Western art, including figurative ceramic sculpture earlier in the twentieth century, **Akio Takamori**'s approach offers few easy comparisons. His early innovation was to make the vessel into a spatial narrative, with one figure represented in contour and painting on the front wall and another on the higher back wall: the interior volume of these "envelope vessels" becomes the charged space

FIGURE 10.27. *Akio Takamori, Couple, 1980. Hand-built stoneware, salt-fired; 12.5 × 19.5 × 6 in. (Courtesy of Akio Takamori.)*

between them, which reflects a physical relationship. (Figure 10.27) It was an idea that came to him after he had moved to the United States, when he was looking at a work by the Japanese print master Utamaro in which reclining lovers face each other. It would take a potter to look at the intimate scene and see a vessel form!

Takamori's subject matter is sometimes, in the parlance of late twentieth-century gender studies, the male gaze—when the female body is of symbolic or carnal significance. But even these works are colored by emotions and generally deal with intimate ties, between lovers or between mother and child, for example. Nakedness is a matter-of-fact condition. Early works were unglazed, but later he began to use a light salt glaze to suggest "the damp sheen of skin" and amplify sensuality.[33] The works may employ different skin colors, suggesting a racial theme, but more likely the meaning is simply otherness, a psychological sense of distance, which he himself has experienced.

This distinctive attitude combines the sexual liberality of Japan, where Takamori was born in 1950, with the social openness of the American culture that has been his home since 1974. He went to art school in Japan and then apprenticed to a folk-craft potter. Ken Ferguson came to the pottery and responded to his interest by encouraging him to study at the Kansas City Art Institute. Despite Takamori's limited English at the time, he did so. There he began to slab build. He earned an MFA from Alfred but consigned his Alfred work to the Dumpster and went off for a summer at the Archie Bray Foundation. Not long afterward, while guest teaching in Ontario, he built his first envelope vessel. He chose to establish his home and studio in the Seattle area and was invited to teach at the University of Washington, where he is now a full professor.

None of Takamori's figures are exactly realistic; the modeled detailing is limited, and not much more is added by painting. His rendering of clothing and facial features is simple and loose. These are sculptures, only recalling pots in that they are hollow volumes (and therefore have a certain sense of lightness). These personages coexist as characters and as constructs. He has captured some essence that makes each an individual—with a sense of self-consciousness—without constraints on his expressive style.

Sexual imagery has been central to Takamori's work. He says: "We live between birth and death. Once a person is born, he cannot avoid death. The only energy that goes directly against death is what I call eros. . . . We should set a proper value upon sexuality."[34] Yet the nude has not, of course, been his sole subject. A striking shift occurred during a three-month 1996 residency at the European Ceramics Work Center in the Netherlands; he introduced art historical and Japanese imagery to his work and a greater range of sizes.

Moving to New York without his pottery equipment in 1979, **Michael Lucero** broke up orange crates and other street discards and made figures from the splinters. Then he took up shards—any pot's likely future—and tied them together and to a partial wooden armature with telephone wire, leaving the wire ends bristling like an aura around an abstracted human form seven or eight feet tall. (Figure 10.28) An intact pot stood for the head and was the only part of the sculpture with volume. Arms and legs sometimes dangled and sometimes were bent at angles. The whole was an inspired invention that has been repeatedly revisited by writers proposing interpretations, which is a measure of great work.

Lucero's work has long engaged the vessel form and the human body, but since that series it has increasingly involved painting and found objects and has varied widely in scale. His Dreamers series, which followed a stay in the Adirondacks in 1983, consists solely of an oversize, abstracted head, usually resting on its side on a pedestal. The form is borrowed from Brancusi's Sleeping Muse works, which may have enlarged the audience for this work beyond those already interested in ceramics. In contrast to Brancusi's elegantly blank remove, Lucero's painted landscapes reveal the dreams of these sleepers, and the imagery makes it difficult to see the form. The series relates to environmental concerns of the time, picturing what might be a primordial past or a cosmic future.

In the next decade Lucero was inspired by Native American pottery of the Southwest and pre-Columbian and Afro-Carolinian face jugs. The works allude to con-

FIGURE 10.29. *Richard Notkin*, Cube Skull Teapot (Variation #6, Yixing Series), *1985. Stoneware; 5.25 × 6 × 2.75 in. (Collection of Everson Museum of Art, Syracuse, N.Y., Purchase Prize given by the Robert and Dorothy Riester Fund, 27th Ceramic National, 1987–89, 87.37.7. © Richard Notkin.)*

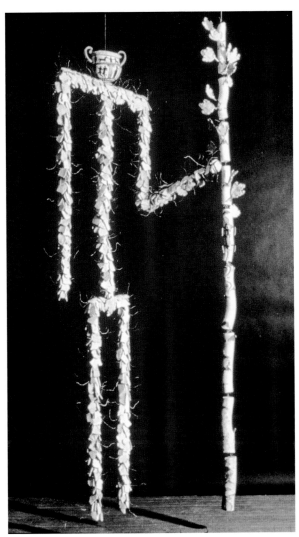

FIGURE 10.28. *Michael Lucero*, Untitled (Lizard Slayer), *1980. Hand-built porcelain, wire, birch wood; 110 × 52 × 24 in. (Collection of Stephen and Pamela Hootkin. © Michael Lucero.)*

temporary multiculturalism and define themselves as merchandise with a large bar code (which also literally dates the work). They were not universally well received amid the debates about who "owns" cultural imagery, but they show interesting thinking, along with an impulse to synthesize, which has long been characteristic of ceramics. A Reclamation series incorporates flea-market finds with ceramic elements used to supplement or repair.

Lucero (b. 1953) is a California native whose family had deep roots in New Mexico. At Humboldt State College, he developed figural sculptures of various materials and techniques. In graduate school at the University of Washington, he enlarged and "distressed" figures in coiled clay and exhibited them suspended. Then it was off to New York and the big time.

MORAL ISSUES: RICHARD NOTKIN

One of the small number of ceramic artists devoted to addressing sociopolitical concerns, Richard Notkin (b. 1948) ascribes his social conscience to having gone to synagogue as a child with Holocaust survivors who had not believed the Nazi threat until it was too late. He was instilled with an activist spirit. His work has long featured antinuclear themes and alluded to environmental threats. Beyond that, he has regularly shown an acute awareness of "the vagaries of chance, the tentativeness of life, the illusion of social and personal well being, and the impossibility of escape."[35]

The foreboding messages have largely come in the form of fantastically detailed teapots. His 1980 *Pyramidal Skull Teapot with Two Cube Skull Cups: Homage to Josiah Wedgwood* shows that image and reference already figured in his early work. Then, in 1983, ten years after completing his studies at the Kansas City Art Institute and UC Davis, he began to follow the Chinese trompe l'oeil Yixing tradition. (Figure 10.29)

"From the time I was five years old," Notkin says, "I've been making very detailed images. I love Netsuke. I've always been a fan of Hieronymus Bosch and Salvador Dalí. . . . Making objects that are consummately crafted gives me the most joy in creating."[36] He gave up low-fire clay and shiny glazes because they obscured the desired detail; then he gave up colored porcelain—when he real-

ized he did not need color to carry the message—to work with a Yixing-type fine stoneware clay. He sometimes made pieces inspired by particular Chinese teapots, but the motifs were adapted to contemporary economic, environmental, and political issues. A mushroom knob on a Chinese lid, for example, became a mushroom cloud on his, coupled with his skull faces with their endless, zipperlike rows of leering teeth.

In 1986 Notkin began a series of teapots resembling life-size anatomical hearts—variously growing thorns, bearing the spikes of a medieval weapon, or incinerated. The new work offered no more optimism than before. After ten years in the Yixing mode, he took time out, and at the end of the century turned to hands and ears carrying portents of disaster.

FIGURE 10.30. *Anne Currier,* Konostroma, *1989. Glazed earthenware; 14.53 × 25.98 × 13 in. (Museé des Beaux-Arts de Montréal, Liliane and David M. Stewart Collection, Gift of George O. Hrycun. © Anne Currier. Photograph by Giles Rivest.)*

EXTENDED VESSELS

Despite the excitement of imagery and especially figuration returning to prominence in the decade, there was also a substantial amount of subtler but richly allusive abstract pottery, some of it hinting at the figure or architecture or other interests.

Anne Currier's ceramic sculptures have been likened to William Daley's: both are architectonic and minimalist. Her works have also been compared with Escher's staircases for their complex congregation of planes that you can follow with your eyes and not end up where you thought you would. Currier combines wheel-thrown and hand-built elements to make complex, sharp-edged works that imply motion and refer to the monumental, although they are generally modest in size. (Figure 10.30) She works in earthenware and with mat—even faintly gritty—surfaces that absorb light and seem to recede slightly from immediate presence, an effect that is reinforced by the evasive shades of gray, buff, or olive she likes to use. These surfaces ease the hardness of the form.

In the 1970s, when she studied at the Art Institute of Chicago and the University of Washington, Currier (b. 1950) created cubed boxes from which a shard or a T shape could be extracted. Her first works shown at Exhibit A in Chicago were all quite angular, but by 1984 she was including curves. Curiously, they often have the effect of turning the work back into itself in a self-contained fashion. The visual movement of the curved elements is emphasized by rubbed edges disclosing a different color below, which creates a linear underscore.

While her work of the 1980s seemed assembled of industrial elements, like a compacted model of Alexander Lieberman's boiler sculptures, Currier later turned to still-life allusions, more decisive colors such as yellow or

black, and relief plaques. Her focus throughout has been volumetric containers that can shift from projection to recession, depending on light source and angle of view. She has spoken of seeking "continuousness" in what is, in fact, singular and interdependent.[37] This may equate with Cézanne's seeing the world in cones and cylinders or the Buddhist notion that our surroundings may be distinguished for our convenience but are nevertheless irrevocably intermeshed.

Andrea and John Gill do not collaborate or even share a studio. But they both make rather large vessels with complicated forms and decorations, both have a distinctive hand with color, and both teach at Alfred. Andrea is a painter turned ceramist who is known for earthenware amphoras embellished with faces or featuring winglike additions that provide additional surfaces for patterned color. John has always had a sculptural bent, expressed in the hand-building of often angular and irregular stoneware teapots, ewers, and vases.

Andrea (b. 1948) grew up in New Jersey and Maryland and had an early interest in art. In 1971 she graduated from RISD with a degree in painting, after spending her senior year in Italy mostly looking at historical and modernist ceramics. After working in a production pottery, she enrolled at the Kansas City Art Institute and there met John Gill. Both went on to Alfred (MFA 1976), where she became committed to low-fire clays.

Coiling, press-molding, or otherwise hand-building, she shaped the forms in advance of any idea of decoration, starting with low bowls, lidded forms, and vases that suggest female figures—a voluptuous, hippy torso or a shoulders-and-head combination. She worked on expanses comparable to a sheet of drawing paper, with a frontal orientation. The exuberance and emphasis on majolica-inspired decoration show the influence of Betty

FIGURE 10.32. *John Gill*, Ewer Number 3, 1984. *Hand-built stoneware, applied glazes; 14.5 × 18 × 4.5 in. (Collection of The Newark Museum, Newark, N.J., Purchase 1986 Mathilde Oestrich Bequest Fund, 86.2111. Art © John Gill. Photograph © The Newark Museum/ Art Resource, New York.)*

FIGURE 10.31. *Andrea Gill*, Untitled, 1982. *Terra-cotta, colored slip, glaze; 28.35 × 18.50 in. (Collection of Dienst Beeldende Kunst, SM's Stedelijk Museum 's-Hertogenbosch [formerly Museum Het Kruithuis], Netherlands. Courtesy of the Artist.)*

Woodman, who was visiting Alfred when Gill was there, but Gill's colors are more muted or pastel. Her imagery is often seen as conveying a feminist attitude and identity, but she has also played formalist games—depicting a vase on a vase or using patterning to confuse perception of form. (Figure 10.31) She remains committed to the vessel—if an unconventional one—and finds it suitable for drawing because, she says, "when you look at a pot, most of the time, you're looking at a line."[38]

The stoneware vessels of John Gill (b. 1949) are influenced by Asian and Persian ceramics and modernist painters such as Arthur Dove and Giorgio Morandi. They may feature hints of urban place, such as rooflines or smokestacks.[39] He develops his thinking via drawings and then freely hand-builds works that are (almost coincidentally) often functional. He develops a form in movements of planes, sometimes exaggerating the spout or handle for visual purposes. (Figure 10.32) In the 1980s he made House Pots with funnels for chimneys in a marriage of mechanical and organic.[40]

Gill works with a limited and slightly dulled or acid palette, using colors to emphasize contours or establish a rhythm that seems to bend and fracture the form. The effect may recall cubism or modern architecture. In other cases the application of color is provocatively arbitrary. The amusing unexpectedness of his work gives it a sophistication that has appealed to art galleries that handle modernist painters, such as Grace Borgenicht and Kraushaar in New York.

A former resident artist–director of the Archie Bray Foundation and a longtime teacher at Arizona State University, **Kurt Weiser** (b. 1950) studied at the Kansas City Art Institute and the University of Michigan. At the Bray (1977–88), he developed a body of work slip-cast in porcelain or earthenware, especially tall vases of undulant silhouette and leaning posture. (Figure 10.33) On these works, dark monochrome glazes feature resist lines, dots, or tiny glaze-chip lozenges scattered across surfaces that seem vast and empty. The marks were inspired by Montana petroglyphs and Eskimo line drawings, and the slightly irregular forms seemed a natural base for them.

At the end of the 1980s Weiser spent a year scratching drawings into black or brown glaze on cast teapots. They were night scenes of exotic, overwhelming vegetation against turbulent, moonlit skies, which, a friendly critic suggested, were probably inspired by underlighted foliage at Arizona malls.[41] Weiser's skilled draftsmanship was a surprise, since it had not figured in his earlier work. The equally drastic next change was to add color through china paints. In no time at all he had moved from austere

FIGURE 10.33. *Kurt Weiser,* Vessel, *1988. Stoneware; 25.5 × 10.5 × 5 in. (Archie Bray Foundation for the Ceramic Arts Permanent Collection, 1988.1.1. © Kurt Weiser.)*

vessels with abstract markings to images of lush landscapes and portentous creatures applied to teapots and covered jars in an exacting, slow process. He shared in the trend of the late twentieth century to turn ceramics away from abstraction and toward the pictorial.

LARGE-SCALE SCULPTURE

Painting and sculpture became aggressively large toward the end of the century. While monumental ceramics were introduced in the 1930s and 1950s, they remained a minority interest. A few exceptional artists, however, have always found specifically ceramic approaches to larger-than-conventional size.

Paula Winokur (b. 1935) has been a production potter, a maker of feminist-tinged and landscape-inspired sculptures, and a creator of architectural-scale works including unusual residential fireplace surrounds. (Figure 10.34) She also taught for more than thirty years at Beaver College (now Arcadia University) in Pennsylvania. A painting student at Tyler who turned to clay under the influence of Rudolf Staffel, she married ceramist Robert Winokur.

After stints in Texas and Massachusetts, they returned to Philadelphia when he was hired to teach at Tyler.

Having children set Winokur to thinking about femaleness, which influenced her work, as did the burgeoning women's movement and the death of her mother. She adopted porcelain as a more suitable medium for evoking sensuality and spirituality. Beginning in 1973 and continuing into the 1980s, she created boxes, concentrating on lids with embellishments suggesting dream imagery, personal musing, or Victorian womanhood. She began pressing lace into clay to create patterns in which celadon glaze pooled, an effect sharply unlike the expressionist work of the time. She imagined the boxes as repositories for love letters or jewelry.[42]

Winokur turned to landscape after flying west for workshops and visiting Mesa Verde, in Colorado. Her "clay drawing," *Aerial View: Winter Plowing* (ca. 1980), alluding to humanity's marks on the earth, employs colors from sulfates and oxides. She also made wall pieces that suggested precipices as well as vastly more immediate still lifes. In 1983 Winokur was commissioned to create a residential fireplace surround. She constructed a combination of slab boxes and landscapes with a backing of large

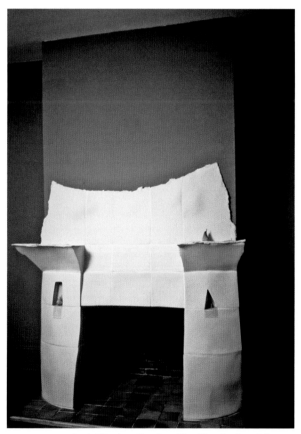

FIGURE 10.34. *Paula Winokur,* Fireplace Site IV, *1985. Porcelain; 68 × 55 × 14 in. (Private Collection. Courtesy of the Artist.)*

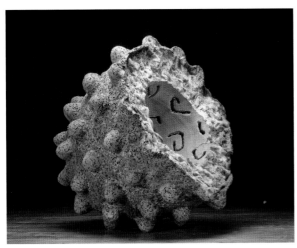

FIGURE 10.35. *Graham Marks, Untitled, 1986. Coil construction, sandblasted earthenware; 34 × 34 × 35 in. (Collection of The Detroit Institute of Arts, Gift of Roger Robinson. © Graham Marks.)*

rectangular tiles that suggested stone blocks. For subsequent surrounds, she made large triangular volumes at the sides and cut niches into them or pressed slabs together to make a triangular mass that looks eroded or raw along the front edge. The mantel sometimes incorporates a landscape scene. She also constructed porcelain doorframes that ritualized passage. These continued in the 1990s, when she also began to make landscape sculptures that, through texture changes, suggest glacial ice or plate tectonics. Winokur's environmental sensitivities responded to issues of her time, if not ceramic fashion.

There were three routes to lasting fame in the twentieth-century craft world: teach, have a long career, or make outstanding work. **Graham Marks** had an important teaching job for a while, at Cranbrook from 1986 to 1992, but he vanished from the ceramics world when he was still a young man. Yet no one who knew his work in the 1980s is likely to forget it. Marks (b. 1951) studied at Philadelphia College of Art and at Alfred. He made large vessels shaped like half an egg, sometimes double-walled, sometimes almost completely closed. (Figure 10.35) They suggest cut fruit, seedpods, or geodes of unnatural size. As they rest on their curved sides, it seems they might roll. The "cut" surface seems to turn upward toward the viewer whether they lie on the floor or on a pedestal. One work might recall a cantaloupe rind, another is inscribed with strange glyphs from an unknown culture, and another is embedded with bolts, nuts, and washers. Yet the forms themselves still evoke the natural. These works allude to archaeology, to contemporary waste, to pollution and mutation; simultaneously the form implies the potential of growth, while the surfaces and fragmentary condition give evidence of decay.

Marks hand-built the forms of extruded coils, some hand-rolled for variation. They were fired multiple times to get color effects (such as a turquoise exterior—not recalling anything vegetative—that is set off by the terracotta body color) and sandblasted to create an effect of age. When the interior is visible, it is separated from the exterior by a wide lip, which covers the skeleton structure within the double walls. A tension between inside and outside persists. The works are without narrative implications, but the definitive surface character—corded, crumbly, ragged—gives them an assertive physicality. Michael McTwigan wrote that they seemed to combine the fruit and jug of still-life arrangements into a single form; he also offered a division into Celestial Forms (the use of blue and a smooth-cut face) and Earthly Forms (browns that appear to have been broken open and evoke our own internal sensations).[43] These objects convey a sense of both passive resignation and impending change. "No explanations are offered. . . . They sit as though picked by an enormous hand from the tree of life."[44]

In the 1980s, fresh out of graduate school and with the vigor of youth, **Arnie Zimmerman** created vessels of human scale with deeply contoured surfaces. (Figure 10.36) Massive both visually and actually, they were also strikingly organic and animated in their surfaces. By the end of the decade they became even more magnificent combinations of vessel and totem, as much as nine feet tall and with deep relief.

Zimmerman (b. 1954) studied at the Kansas City Art

FIGURE 10.36. *Arnold Zimmerman, Untitled, 1984, 1985. Stoneware; left vessel: height, 107 in.; diameter, 46 in.; right vessel: height, 94 in.; diameter, 43 in. (Milwaukee Art Museum, Gift of Opus North Corporation, M1992.115-116. © Arnold Zimmerman.)*

Institute and at Alfred. One might imagine that some of Ken Ferguson's crude vitality and inclination to soft forms rubbed off on him, but no Alfred effect is apparent. Romanesque architecture and French stone carving surely were influential, along with exposure to tiles and terra-cotta architectural ornament in Portugal. In the large vessels, he carved into the three-to-five-inch-thick walls, slicing out spirals, ripples, and zigzags and attaching other strips, so that one powerful graphic pattern overlays another. He went on to freestanding arches and gates and columnar forms in which the relief is even greater but the vases' angularity gives way to more rounded and textured surfaces. There are writhing vines and swollen pod forms and others that suggest human agency, such as a shell-shaped niche containing a vessel or lyrelike form. These works evoke both natural germination and human accumulation, and they seem bursting with riches. Their scale and vigor are unmatched in American ceramics.

Zimmerman's subsequent work is smaller but no less ambitious. Cast-iron sculptures made in residency at the Kohler factory in 1989 seemingly blended organic elements with human artifacts such as needles and ladders. An assembly called *Kohler Sticks* consists of units ninety-two inches tall and only three inches wide or deep, an attenuation permitted by the iron material. In the 1990s he shifted to accretion of masses of small figures as social critiques.

WOOD-FIRING

In December 1982, *Studio Potter* magazine devoted a full issue to wood-firing; in April 1983 forty people attended a symposium on the subject sponsored by the magazine and held at the Japan Society in New York. A month after that, sixty people gathered at an *anagama* (Japanese tunnel kiln) at Peters Valley, New Jersey.[45] If wood-firing could not exactly be said to be mainstream, after these three events it was certainly established.

Wood-firing links to Native American, European, and African traditions, and it had never completely died out among folk potters in the Southeast. But it began to make inroads into studio pottery only as American potters went to Japan and were exposed to Japanese kilns. (Bernard Leach, living in a part of England with few trees, fired with oil and said little about wood-firing in *A Potter's Book*.) The first travelers were J. B. Blunk, Janet Darnell (Leach), Marie Woo, and Toshiko Takaezu, all in the 1950s, but circumstances did not permit them to pursue it. In the 1960s academics began to go to Japan for research, and the first experimental Japanese-style kilns were built for university ceramics departments.

Daniel Rhodes's 1968 book on kilns included information and photographs of Japanese wood-burning kilns, and in 1970 he wrote about the process in *Tamba: The Timeless Art of a Japanese Village*. A different tradition was introduced in Michael Cardew's *Pioneer Pottery* (1969), and Fred Olson's *Kiln Book* (1973) was also informative. Louise Allison Cort described wood-firing in her *Shigaraki: Potters' Valley* (1979).

Wood-firing was covered by *Studio Potter*, particularly as an alternative kiln fuel after the "oil shock" of 1972, but the discussion shifted to the romance of the process rather than its practicality. The ideas of chance and of the kiln as a living, fire-breathing creature were introduced. Ruth Gowdy McKinley, an American trained at Alfred and living in Canada, became an advocate of a European-style kiln for wood-firing and asserted that considerable control was possible. In the meantime working potters were going to Japan to learn via arduous apprenticeships.

By the 1980s potters answered the question of what they were trying to achieve with wood-firing by citing "flashing" as well as fuel efficiencies. Technique was no longer a question; aesthetics was. The various works showed the influence of study in Japan (Rob Barnard, Richard Bresnahan, Peter Callas, Paul Chaleff, Randy Johnston, Jeff Shapiro) or in England (Todd Piker); there were also individuals who had learned Euro-American methods (Karen Karnes, Mary Roehm) and the self-taught (David Shaner, Ken Ferguson). The styles varied enormously, from Barnard's dry gray-brown surfaces on robust functional stoneware forms of modest size to Roehm's thin-walled and undulating porcelains, some with a tiny foot, a flaring rim, and tenuous function. The subtleties of fire marks contrasted with the precise surfaces and brilliant colors dominating American ceramics then.

Wood-fire conferences at the University of Iowa in the 1990s attracted 200 and then 450 participants, Jack Troy published *Wood-Fired Stoneware and Porcelain* (1994), and a wood-firing journal began to circulate from Ireland. Critical standards were almost nonexistent, particularly because much of the work was functional ware—least served by the critical establishment. Although the Japanese have discussed such issues for 500 years, Americans have barely gotten below the surface.

Glass

Although women had been involved in studio glassblowing from the beginning, with seven of the eighteen students in the Toledo workshops (see chapter 8) being

female, their numbers remained small and their influence minimal until the 1980s. The women's movement in the 1970s may have led to gradual change. By the mid-1980s all the executive officers of the Glass Art Society board of directors were women, with Susan Stinsmuehlen-Amend the organization's first female president.

"Stained" glass continued to develop away from architectural settings. Robert Kehlmann, Casey Lewis, and a few others were showing works requiring reflective (front) rather than transmitted (back) lighting to bring out the qualities of the materials, which could be displayed in galleries as easily as paintings.

Stinsmuehlen-Amend (b. 1948) experimented with a pop culture mix of mediums, adding glitter, jewels, foils, decals, and tapes to her glass. She was inspired by the decor of fast-food restaurants, hobby craft materials, and tourist trinkets. Many of these pick up light and color with kitsch allusions, like John Torreano's "gems" and Thomas Lanigan-Schmidt's tinfoil and glitter works of around the same time. She wrote, "My philosophy of 'Too much is not enough' . . . allows almost anything to be glued, sprayed, tied and laminated to the glass plane. Glass is treated as if it were a shiny canvas 'painted with' textures that play with light."[46] Glass artists who primarily worked on commission for religious or other public settings or for domestic installations tended to be overlooked in the gallery orientation of the time but formed an active subset of studio glass nevertheless.

A 1983 exhibition at the Tucson Museum of Art, *Sculptural Glass*, provided a then-uncommon presentation of large-scale site-specific works related to concurrent sculpture and installation. At the same time, warm- and cold-working techniques were proving more practical for artists limited by space or finances or unable to deal with the more elaborate safety and pollution considerations of hot glass.

CHIHULY'S NEXT PHASE

In 1980 Dale Chihuly's sales from exhibitions equaled his salary as head of the RISD sculpture department, which at the time was $18,000. He resigned the position for the more flexible role of artist-in-residence.[47] That year he began making Seaforms, fluid vessels in subtle, cool colors, shaped by using movement and gravity in the blowing process to ripple the walls. They were made by a team with William Morris as gaffer. His relinquishing the doing made greater production possible, although it put Chihuly at odds with the crafts-movement ideal of the hands-on maker. Using teams seemed a violation of that, and stepping out of the process entirely crossed the threshold of design and industry, some thought.

In 1983 Chihuly moved back to Seattle. Subsequently his forms, styles, and colors multiplied with a speed that was hard to grasp. Seaforms were followed by the brighter-colored Macchia (an Italian word meaning "spotted" or "splotched"). In 1987, working with the visiting master blower Lino Tagliapietra, he created Venetians, inspired by art deco Venetian glass and growing increasingly baroque. Persians are ornately patterned with swirling stripes, and on and on. All Chihuly's vessels begin with an evocative intention, inspired by some real thing in the world and riffing off a quality until it is recognizable only in the loosest sense.

He began presenting the increasingly flamboyant work in gallery installations consisting of large numbers of parts. Scale was expanded by lighting that threw copious colored shadows. Next were public works placing glass vessels in unexpected sites, from ceilings to the landscape.

Chihuly continued to occupy a pivotal position, but success is never without controversy. His New York dealer, Charles Cowles, repositioned the work by identifying it as "sculpture" rather than "glass."[48] Henry Geldzahler, then curator of twentieth-century art at the Metropolitan Museum, acquired pieces he compared to color-field painting as well as to decorative arts precedents. A survey by the arts journalism program at Columbia University in 1999 placed Chihuly among the twenty most familiar names to art critics, the only craftsperson on the list, but he did not appear on the list of most respected. And there's the rub: as art, his work has been formalist in a period preoccupied with social message and precious when junk materials or intangibles are more often employed.

As Chihuly began to stage-manage his traveling exhibitions and gargantuan public projects, it became impossible to gauge his work as any kind of craft or art; it became instead an accessible popular entertainment—a realm not even Tiffany entered—and he an impresario. The beauty of his work never faltered, but in its prodigious volume it became impersonal, like a stage set, and curiously recalled the complaints of both art and craft worlds about mass production. Considering the Chihuly-Carpenter installations and Chihuly's own outdoor pieces in the early days of Pilchuck, which were received with enthusiasm, his work now raises questions about the philosophical limits of craft scale.

CHARTING NEW COURSES

David Huchthausen (b. 1951) found glass on his own, and although he subsequently was associated with Harvey Littleton, his curatorial activities and his rapid abandon-

FIGURE 10.37. *David Huchthausen,* Leitungs Scherbe #10, *1982. Glass. (Collection of The Metropolitan Museum of Art. © David Huchthausen.)*

ment of blowing indicate his independence. He was a student at the University of Wisconsin at Wausau when he discovered an old glass furnace. He struggled to use it for six months before he learned of Littleton, just 150 miles away in Madison. They talked, he got the furnace working, and he subsequently transferred and became Littleton's assistant. He went on to Illinois State University, studying with Joel Philip Myers and capably filling in while Myers was on sabbatical. As a consultant to the Leigh Yawkey Woodson Art Museum back in Wausau, Huchthausen organized three important Americans in Glass exhibitions and advised on acquisitions. He subsequently moved to Seattle.

After various interesting explorations, Huchthausen developed his best-known series, Leitungs Scherben (which might be translated from German as "transmission shards"). (Figure 10.37) These constructions consist of angular slabs of black glass, the polished top element inlaid with patterns of different colors and varying opacity or transparency. The top is held aloft by ragged-edge pieces that look eroded but have been carefully broken by thermal shock. The parts are glued together. Shadows cast by the top slab are not what would be expected, due to transmission qualities of the glass. This disconnect sets up a circular, spatially active process of examining the slab and its shadow. A critic has called these works beautifully made but not beautiful, more compelling than appealing, and a way for Huchthausen to manage his perfectionism.[49] They are, in any case, unforgettably dramatic. He continued the series through 1988 and followed it with objects that play a similar puzzle-piecing process against contrasting clear and amorphous sections, often including icelike interior fracturing.

Howard Ben Tré (b. 1949) is an exceptional glass art-

ist in both qualities and inclinations. He was never attracted to blowing glass and has created all his sculptures through industrial casting. He has pushed steadily toward the monumental and in the late 1980s became a public sculptor of fountains, plazas, lighting, and street furniture. Among craft artists, only Albert Paley has worked so extensively in the public realm. Ben Tré's public art facilitates social interaction as well as concentrated sensory experience.

Ben Tré is also notable for his political activism. In the 1960s he was involved with Students for a Democratic Society and the antiwar and civil rights movements. He met his first wife when both were volunteering to harvest sugar cane in Cuba with the Venceremos Brigade in 1969, and they took as their family name that of the first Vietnamese city to resist French colonialism, a name also given to a new town in Cuba. A case could be made that his public work reflects the same populist values, especially considering that among his projects have been works for an English industrial town and, fittingly, one in Cuba.

Ben Tré's sculptural practice is to prepare molds and rent a factory several times a year for casting. The labor-intensive process of sequential steps is quite unlike the rapid forming and relatively brief annealing of blown glass. All his sculptures, since his early works in the 1970s, evoke the past, including Mayan, Greek, Gothic, and American-industrial forms. His first important body of work after graduate school at RISD consisted of forms resembling abandoned machinery parts. Since then, Ben Tré has inflated the scale of vases, basins, and scientific glassware in various series. Other forms suggest abstracted figures, lingams, and columns, transformed in scale and material.

The material, like commercial plate glass, has a greenish tinge; Ben Tré has never pursued the vivid coloration common to blown glass. Variation is introduced via metal banding, metal insertions within the form, and also metal lining in carefully prepared molds in which the molten glass melts and fuses with it. Glass removes his references from association with a specific time, and its translucence and light-trapping can create a haunting effect or a peaceful aura. Ben Tré alters surfaces by sandblasting or waxing.

The cast forms look strikingly weighty, but Ben Tré does not seek effects of excitement or danger. The works are quiet, patient, perhaps spiritual. He regarded his Dedicant series as quasi-religious objects (some resemble fonts, all have the vertical aspiration that has often signaled the spiritual). (Figure 10.38) In some works gold leaf recalls the dream of alchemical transfor-

FIGURE 10.38. *Howard Ben Tré*, Dedicant 10, *1987. Cast glass, brass, copper leaf, gold leaf, pigmented waxes; 48.62 × 13.87 × 16.5 in. (Collection of the Hirshhorn Museum and Sculpture Garden, Smithsonian Institution, Gift of Dr. and Mrs. Joseph A. Chazen, 1988. © Howard Ben Tré. Photograph by Lee Stalsworth.)*

FIGURE 10.39. *Therman Statom*, Chair on Base, *1987. Plate glass, paint, blown-glass elements; 58 × 24 × 26 in. (Los Angeles County Museum of Art, Black American Artists Fund. Art © Therman Statom. Photograph © 2007 Museum Associates/LACMA.)*

mation. Some of the sculptures take body scale and may be entitled *Figure* or, more poignantly, *Bearing Figure*. Embedded simple shapes imply bearing in the sense of pregnancy, while the allusion to caryatids identifies another sort.

In terms of originality, development of concept, and large-scale professional execution, Ben Tré stands with Paley, Chihuly, and Castle. His works, however, have been more circumspect, never straining for effect.

As the glass world argued about technique and beauty, **Therman Statom** (b. 1953) was among those who avoided the fluid forms and inherent loveliness of blown glass. He rejected virtuosic technique and "eye candy." By the late 1980s, he had developed a flexible, accommodating approach to works that reached considerable size. First, he glued up glass houses, ladders, chairs. (Figure 10.39) On the inside and outside of these iconic forms he glued a variety of small glass elements: fragments, blown globes and vessels, and canes. He painted his constructions with vigorous, brushy strokes that related to the neoexpressionism then current in the art world. These works were wide-ranging in their references.

The first impression of a Statom piece is of barely con-trolled chaos. The glass structure might be rigid and rec-tilinear, but its contents and surfaces teem with visual action. Bits and pieces seem to float everywhere. Bright colors compete for attention. He plays a covert game of directed association, combining symbols so that an atten-tive viewer might draw certain conclusions. The house is a symbol of security and comfort, but by linking it to painted dice—symbols of the randomness of fate—he suggests that our lives are infused with instability and that security is an illusion. Another of his favored motifs, the ladder, symbolizes aspiration. Each element is like a line in a poem.[50]

DISTURBED GEOMETRY

In 1976 a man walked into the Contemporary Art Glass Gallery in New York carrying a paper bag, from which he took several small glass objects. Owner Douglas Heller was impressed: he put the work into a group show a few months later and gave the artist a solo show the next year. The work made such an extraordinary impression that both the Museum of Modern Art and the Metropolitan Museum of Art bought pieces from the solo show. Two years later, one of the man's works was on the cover of the

FIGURE 10.40. *Tom Patti*, Solar Riser, 1978. Architectural glass, laminated and blown; 5.6 × 3 × 2.4 in. (Collection of The Corning Museum of Glass, Corning, N.Y., 1979.4.3. © Tom Patti Studios.)

Corning's *New Glass* catalog, thrusting him into glass-world stardom.

The man was **Tom Patti** (b. 1943). He had earned a master's degree in industrial design and worked in various design capacities. He had been fooling around with glass on his own since 1970, when he took a glassblowing course at Penland. Lacking space and funds for a hot shop, Patti scrounged a discarded lab furnace from a local junkyard and invented a tiny portable kiln made of a firebrick and a rotisserie heating element.

He developed a unique process of heating a stack of commercial plate glass until it was soft enough to blow a single bubble into the mass, sometimes with the aid of compressed air. (Figure 10.40) The bubble would distort the layered block, altering its basic geometry as much or as little as he wanted. By using different colors of glass or texturing the surfaces of the sheets, he could make the individual layers visible, although they were fused. He could give the block winglike projections or insert drops of liquid that would gasify under heat, causing a cavity to appear in the middle of an otherwise solid mass.

The work had the green or brown cast that was the hallmark of cheap glass, which people had been trying to eliminate for centuries before the recipe for lead glass

was discovered. It also had no trace of the familiar blown form, no taut membrane or decorative qualities. Instead there was a gently disturbed geometry, and the bubble was the visual center of the composition, always drawing attention to itself, playing against the regularity that contains it.

Patti worked small, again going against the grain in the glass field. His work shrank from a scale of eight to twelve inches tall down to two or three inches. Curiously the smallness intensified the serene and flawless compositions. He worked slowly, making only ten or so pieces a year. The publicity he earned from the *New Glass* cover helped his galleries justify comparatively high prices, and his low output seemed to enhance his reputation.

William Carlson (b. 1950)—who taught at the University of Illinois for twenty-five years and after that at the University of Miami, Coral Gables—is a skilled glassblower. He is best known for work with industrial materials such as plate glass, safety glass, and the Vitrolite and Carrara glass found in storefronts and elegant bathrooms of the 1930s. He used these in polished wedge-shaped assembled works that he made through the 1980s and 1990s in several related series. Like Joel Philip Myers, he happily worked variations on a distinctive concept for many years, before making a sharp change in the new century, outside the time frame of this book.

Carlson's signature style developed from perfume bottles based on earth-color millefiori sections stacked in a mold that he cut to reveal curving lines. He called the first series Kinesthesis because color vistas would appear or disappear depending on the angle of vision. Then, to create a more dynamic piece, he cast and laminated separate glass elements and cut them precisely to fit together. The top part in the Compression series was made with millefiori and the bottom by slumping. His Prägnanz series consisted of three or four sections, sleek surfaces and opaque bands, often black; typically a square or trapezoid in the middle is pierced by two wedge forms. (Figure 10.41) These looked machined, with their sleek grids and triangles, and were part of a neo-deco style that provided a sharp contrast to the seductive fluidity of most glass then made. These pieces kept the appealing qualities of glass within tight framing and control.

Carlson's works have been called minimalist, but they certainly are not; they are quite lavish. As angular assemblies, they are more appropriately associated with constructivism. He exploited glass features such as bubbles or added other matter to give a sense of depth to the objects: safety glass with its built-in wire lines contributed

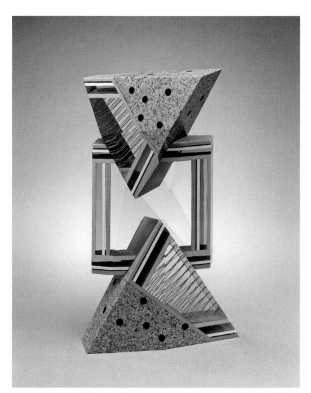

FIGURE 10.41. *William Carlson, Prägnanz Series II, 1986. Cast glass, Vitrolite, granite, wire; 10 × 11.5 × 4 in. (Toledo Museum of Art, Gift of Dorothy and George Saxe, 1991.114. © William Carlson.)*

to the effect of order and control. Carrying him into the 1990s, the Contrapuntal series included panels of glass fitted into granite.

THE ALLUSIVE AND THE FORMAL

American studio glass had its comedians, like most other craft mediums. The first and most original humorist in the medium was **Dan Dailey** (b. 1947). Some of his early works were simple vases with lightly incised graphic ornament, and sometimes an art deco flavor is obvious. It was a movement that did not take itself too seriously, that had very high standards of craftsmanship, and that freely combined voluptuous materials. Its decorativeness and faintly absurd excess emerged in Dailey's work.

After grad school Dailey spent a year working at a factory in Venice. Employing processes only as they suited his purposes, he did not develop signature techniques. His extended series of blown vessels with shallow-relief decoration was supplemented by more elaborate portrait heads. His most complex pieces are constructions often incorporating metal and other materials.

One type of Dailey work is, in effect, glass cartoons. He was a cartoonist in his youth, so stylization came easily to him. These constructions, built mostly of Vitro-

lite and plate glass, are satirical commentaries on urban sophistication. One, called *Vanity* (1986), features an angular hipster with pointy brass hair getting a trim from a curvaceous and probably equally fashion-conscious hairdresser. *Café* depicts a jagged dude with dark shades, leaning on a bar. He is flat, rendered in sheets of colored glass, but he takes his drink in a real cordial glass.

The back-and-forth play with context, along with the skeptical point of view, raises these objects above disposable pop culture ephemera, but humor in art is tricky business. If unrelieved by some kind of gravity, comical art is always in danger of being a throwaway. At his best, Dailey avoids this pitfall because his work also addresses the history of decorative arts as it reflects on contemporary society.

An example is *Huntress* (1993), which depicts—in ridiculous semiabstract forms—a bronze female spearing a plump, tomato-like object. (Figure 10.42) Her head sprouts a glass flame. In fact, the piece is a lamp, with the bulb hidden inside the flame. *Huntress* plays off art deco figurines of athletic women, who often managed to be topless. Dailey is also referring to Tiffany lamps—when electric light was still a novelty—and even to ba-

FIGURE 10.42. *Dan Dailey,* Huntress, *1993. Fabricated and patinated bronze, gold-plated bronze, and cut, polished, and blown glass; plate: 32.37 × 24 × 13 in. (The Renwick Gallery of the Smithsonian American Art Museum, Gift of the James Renwick Alliance, 1994.77. © Dan Dailey.)*

roque candelabra. In other words, *Huntress* fits within a centuries-long tradition of lighting fixtures, which he proposes to update. The lamp is decorative and amusing, and he has the chutzpah to suggest that such pleasures might be taken seriously.

While studio glass quickly gave up the ideal of the artist alone in his studio and moved toward teamwork or assisted work, actual collaborations have been only short-term or occasional events. The major exception is **Flora Mace and Joey Kirkpatrick**, who have jointly signed work since 1980. They met at Pilchuck in 1979, when Kirkpatrick (b. 1952) wanted to learn a way to put her drawings on glass and Mace (b. 1949) had already developed a technique of glass-thread drawings in a graduate class, used it to make farm-scene drawings on vessels she blew herself, and employed it for Chihuly's designs for his early Indian-blanket vessels. The technique did not quite work for the delicacy of Kirkpatrick's drawings, however, and Mace brainstormed a way of bending wire of various gauges and applying it to the vessel.

They met again the next year when both were artists-in-residence at RISD and again worked on the method, gradually establishing a collaborative process for which they gave equal credit. They became life partners as well as artistic collaborators and went back to Pilchuck, working there for a time—and becoming the first female hot-glass instructors—and then setting up a studio in Seattle.

When Mace began filling in the wire outline of Kirkpatrick's drawing with torched threads and dots of colored glass, she was creating a glass cloisonné. The compositions were applied to a partially inflated vessel with tweezers, pressed and torched to eliminate air bubbles and prevent the drawing from crawling as blowing continued. The drawings included sad-faced robed figures and odd dream images. (Figure 10.43) In the Wind Kite series, images seemed to sweep across turbulent skies.

As these plaintive drawings won an audience, Mace and Kirkpatrick shifted in 1983 to making equally plaintive mold-blown dolls' heads, set on top of milk-glass tubes, which were combined with symbolic blown forms and wooden elements depicting leaves, ladders, hoops, balls, and oars. The white faces have androgynous features. Just as these haunting figures began to be accepted, the pair turned to making gargantuan blown-glass fruit in still-life arrangements. The fruits, as well as some large heads, were blown by William Morris; in return, Mace did details for his Artifacts series.[51] In addition, Kirkpatrick shows her paintings and prints independently, and Mace makes furniture, builds kayaks, and restores antique model sailboats. In the 1990s they

FIGURE 10.43. *Flora C. Mace and Joey Kirkpatrick*, First Doll Portrait/Chinamen, 1980. *Blown glass, wire, glass threads; height, 10.25 in.; diameter, 5.87 in. (Toledo Museum of Art, Gift of Dorothy and George Saxe, 1991.99. © Flora C. Mace and Joey Kirkpatrick.)*

began to create basketlike wooden elements, which opened new directions.

As has been noted, the beauty of glass often makes it resistant to other messages. **Jay Musler** has produced grim, aggressive, pessimistic works in which beauty submits to his bleak vision and the fragility and dangers of glass are symbolic. He is known for lampworked, cold-worked, and cut glass, on which he creates his desired tonalities with oil paint.

Musler (b. 1949) attended the California College of Arts and Crafts but left to blow production goblets for Maslach Art Glass in Northern California. Gradually growing unhappy with the "boy's club" environment there and wanting more time to pursue his own work, he quit in 1981. His work had by then appeared in the Corning Museum's 1979 *New Glass: A Worldwide Survey*, and the museum purchased a vase (interesting but atypical) in which he had etched the interlace pattern of a basket and rubbed oil color into the lines.

Conscious of Paul Marioni's social-commentary approach, Musler also found himself drawn to German neo-expressionism and tribal art in San Francisco museums. He began cutting jagged edges on his bowls to suggest violence and rubbing the sandblasted surfaces with red,

FIGURE 10.44. *Jay Musler*, Cityscape No. 2, *1982. Cut, sandblasted, painted glass; 17.7 × 7.9 in. (Collection of The Corning Museum of Glass, Corning, N.Y., 1982.4.8. © Jay Musler Studios.)*

the handkerchief-like flutter of the walls, she settled on a relatively restricted format. Thus dazzling color, rather than the form, is primary. In her early works, pulling the glass threads by hand from thicker colored rods, she tried a variety of forms. In 1982 she showed an open, thin, flattish crusty bowl of rather thick threads, in which sits a blown bowl (a blank) with threads stuck to the outside in a tangle; another is a sort of nest of short threads framing a translucent deep bowl that has a thread wrapped around and around its upper half, growing thicker at the rim; there is also a transparent blank with wet-looking, almost tubular threads wrapped over the edges.

The physical, somewhat messy, process-obvious appearance of those works contrasts with those made with the much finer threads she has used since Mathijs Teunissen van Manen invented a thread-pulling machine for her that vastly increased the speed of the process. She lays the fine threads in bundles that give the effect of scrubbed brushstrokes. They remain individually visible even after fusing. Sometimes the look is rigid, like icy needles, but more often they seem to flow and to suggest feathers, seashells, or the dramatic patterning of certain tulips (perhaps a reasonable association, since she lived for sixteen years in Amsterdam). Some color schemes have been inspired by exotic birds and some by her travels in Africa, the Far East, and South America. The relation to nature is often noted, yet her works also provoke very different associations, such as rock music[52] and fractured urban light and sound.[53] Because of her innovative method, Zynsky's was the first work from the studio-glass movement to become part of the Museum of Modern Art's design collection.

flesh-color, or black oil paints. (Figure 10.44) He moved to the industrial outskirts of San Francisco, where he saw rotting boats and the distant city skyline, both of which became his themes. He cut the rim of industrial-discard Pyrex domes into a fine city skyline in his Urban Landscape series. The skyline is black, and he gave the bowls such colors as radiant atomic orange, beautiful yet just as lethal in its implications as the more histrionic sharp-edged work. This series captures a "nuclear sublime," exquisite and horrifying.

Musler's boat forms are not for idyllic cruises or even for escape from the charred cities: the boats are soiled, decaying, or simply ghostly relics. Among his methods was a constructive one of building the superstructure with glass rods. He also began working with forms blown for him by Therman Statom, which became masks of a sort. His work has shifted to a more finely nuanced ambiguity—not Pollyanna but no longer apocalyptic.

Other notable work of the 1980s accomplished the difficult task of making purely formal considerations seem justified. One example is **Toots Zynsky**'s. Mary Ann Zynsky (b. 1951), known since childhood as Toots, was there at the founding of Pilchuck and the New York Experimental Glass Workshop. She invented a technique and produced signature objects. She is known for intensely colored bowls kiln-formed of *filet-de-verre* or glass threads. (Figure 10.45) They are like abstract paintings folded into vessel form, and double walls allow the interior to differ from the exterior in both color and thread direction.

While Zynsky has varied the scale of the vessels, played with the degree of openness, and manipulated

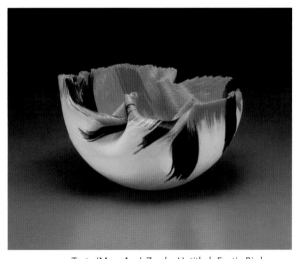

FIGURE 10.45. *Toots (Mary Ann) Zynsky*, Untitled, Exotic Bird Series, *1986. Glass threads, fused and kiln-formed; 7 × 10 × 9 in. (Indianapolis Museum of Art, Gift from the Collection of Marilyn and Eugene Glick. © Toots Zynsky.)*

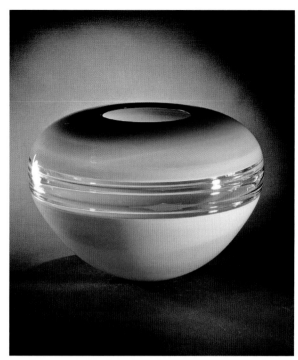

FIGURE 10.46. *Sonja Blomdahl*, Glass Sphere (Tangerine, Clear, Blue), *1987. Glass; height, 9.5 in.; diameter, 14 in. (Collection of the Museum of Arts and Design, New York. Courtesy of Sonja Blomdahl. Photograph by Roger Schreiber.)*

In the context of late twentieth-century art's cynicism and doubt, being called the "Queen of Symmetry" is a questionable accolade. But **Sonja Blomdahl** has fearlessly pushed the beautiful toward the sublime. She blows glass—the macho practice—and assertively follows her own preference for order and clarity regardless of the latest trend. In 1979 she discovered the Italian method called *incalmo,* which involves joining two bubbles of hot glass, and has mastered and developed it since. Typically her vessels involve a different interior and exterior color in each bubble and transparency where they join, which reflects the constituent hues. Her forms are simple, always full-contoured, heavy, and stable looking, conveying a quality of serenity. This work is not a reflection of its time but an alternative to it. (Figure 10.46)

Blomdahl (b. 1952) was a student at the Massachusetts College of Art and Design when she discovered glassblowing and found she had a knack for it. She graduated with a BFA in ceramics because glass was not yet an official program. She took advantage of an Orrefors factory apprenticeship in Sweden, a structured vocational training program that taught her efficiency, in contrast to the experimentation at Mass Art. She went to Pilchuck as an assistant to Dan Dailey and there saw the Italian master Checco Ongaro demonstrate *incalmo.* She stayed in Washington as a partner at Seattle's Glass Eye Studios

and as an assistant at Pilchuck. Two years later, in 1981, she had her first show (at Traver Sutton Gallery) and two years after that opened her own studio. Blomdahl said in an artist's statement: "From the beginning, what I liked about blowing glass was the concentration that it required. . . . The perfectionist in me compelled me to master the process until by repetition it became an act of meditation." She recalls that in the somewhat difficult environment of Pilchuck, she came to the conclusion "that I liked things round and symmetrical and beautiful. That wasn't even a credible notion at the time."[54]

All her work has been within the vessel tradition. There have been spheres divided into two colors or with slight banding, open bowls of functional shapes, and others with walls that become straight-sided. The sense of stability and weight perfectly balances contrary feelings of floating, liquid motion in her best work. She might be described as having invented an expression of purity—reductive yet voluptuous and cool yet radiant with incisive colors. Among the busy surfaces and conceptual posturings that are problematic in the glass field, Blomdahl's work is distinguished by quiet involution.

Michael Glancy (b. 1950) was a business major when he saw a glassblowing demonstration in 1974 and was hooked. He started over as a glass student at RISD, where he discovered the work of Maurice Marinot, a French studio glassblower in the 1920s and 1930s known for stout vases and bottles that are heavily etched, leaving a pattern that stands out in deep relief. Fascinated by the simple, vigorous effect, Glancy tried various processes of cutting into glass and settled on sandblasting.

Glancy's early efforts followed Marinot: thick vases with geometric patterns in relief. In the RISD metals studio, he saw the electroforming process, and he tried plating metal into the areas he had cut away. The metal—usually copper but later silver and occasionally gold—made the surface metallic and opaque. The exposed glass stood out in vivid contrast. A typical Glancy piece is a vessel with an irregular pattern cascading across its surface; only the highest parts are visibly glass, the rest plated in metal, often colored with a patina that recalls ancient artifacts. (Figure 10.47) The vessel stands on a surface of fissured glass resembling eroded canyons seen from the air. This, too, is electroformed. This setup allows endless variations in form, color, and pattern.

Glancy's formula was immediately successful. Heller Gallery gave him his first solo show the year he earned his MFA, and the Metropolitan Museum purchased pieces before the opening. Suddenly every major collector had to own one. His success is a cautionary tale for the glass field, however. Graduate students who wanted the same

FIGURE 10.47. *Michael Glancy*, CURIE POINT, *1982. Blown glass, copper electroform, silver electroplate; vessel: 8 × 6 in.; base: 0.75 × 11.11 in. (© Michael Glancy.)*

FIGURE 10.48. *Paul Stankard,* Pine Barren Bouquet Botanical, *1989. Glass; height, 5.5 in. (© Paul Stankard. Belkin Collection. Photograph by John Bigelow Taylor.)*

success as Glancy began to tailor their work to appeal to collectors. Collectors, however, come with certain biases: large objects fill up houses too fast; free-form sculptures might be too challenging; disturbing content is not desirable. They prefer predictability so that the work can be recognized. The formula for success is to invent an easily recognized style and stick to it. Too many ambitious studio glass students went for the money.

Glancy, meanwhile, stayed within the vessel-on-ground, pattern-and-electroform system. He tried other ideas, but none took off in the marketplace, and for more than twenty years he kept returning to the format that made his name in 1980.

THE PAPERWEIGHT TRADITION

As Americans looked into different glass techniques in the 1970s, flamework (also called lampwork) came up for consideration. This method of manipulating small amounts of glass in an open flame survived into the twentieth century as decorative souvenirs (such as glass animals), paperweights, and scientific lab equipment. A few flameworkers joined the studio craft movement long before glassblowing was revived. Among them were John Burton (1894–1985), who taught himself to make small decorated vessels, and Charles Kaziun (1919–1992), who helped revive paperweight making in America.

Paperweights had been popular in the mid-nineteenth century. Typically they consisted of millefiori or lampwork encased in a block of clear glass. Imagery was flowers, leaves, and occasionally animals. Like many glass technicians, **Paul Stankard** (b. 1943), who worked for the Rohm and Haas Company near Philadelphia, made paperweights for fun after work. He had heard about Littleton's experiments with blown glass and had seen an early exhibition of German artist Erwin Eisch's glass in 1966. He also heard Helen Drutt lecture about studio glass in 1970, when she dismissed paperweights as kitsch.

Stankard resolved to move his paperweights beyond stylized floral imagery. He wanted to maintain the intense detail of French antique work, and floral imagery still fascinated him. So he began to depict species of plants that grew around his home in southern New Jersey, giving his work a distinct American character. (Figure 10.48) A painstaking craftsman, he could replicate colors and forms exactly. The refinement of his tiny plants quickly equaled the historical standard.

Stankard's innovation was to turn the paperweight upright so the viewer no longer looked down on the image. Once he positioned his plants vertically, he added complex root structures. This, in turn, added meaning: he was revealing what is normally hidden and bringing the obscure secrets of nature to light. He later elaborated on the idea of hidden life by making tiny figures intertwined with the roots and later still added masks. Compared with the wild shapes, expansive size, and rejection of function that other glassblowers were pursuing, Stankard seemed quite conservative. Still, it is one of the strengths of craft to treat tradition with respect, and Stankard intentionally never moved too far from historical precedent. About 1972 he was picked up by a dealer linked to paperweight collectors, who immediately recognized his skill and his contribution to the genre. The dealer sold out Stankard's first run of 15 paperweights and ordered 150 more. Stankard has been making his objects full-time ever since.

Textiles and the New Basketry

The decade opened with the hopeful title of the 1981 exhibition *The Art Fabric: Mainstream*. While weaving was surely *not* suddenly accepted in every art gallery and museum, what did occur in conjunction with the growing multiculturalism of the art world was a great crossover in techniques. Art about ideas made use of the most salient technique, so Elaine Reichek showed embroidered samplers with sharply political and social messages, and fabric appeared in many other art contexts.

Within textiles, structural exploration was no longer the focus. Innovative materials included various synthetics and plastics. Patricia Malarcher, Joyce Crain, Gerhardt Knodel, and Arturo Alonzo Sandoval, among others, used reflective Mylar, iridescent film, colored gels, and similar materials to produce special effects of manipulated light, to refer to such elements of the contemporary world as computer circuitry, and to convey the age-old theme of the spiritual. Plastics were also available and economical, and their nonbiodegradable character had some appeal considering the ephemerality of most textiles. Paint and other art materials were used in combination with fiber, and the new use of commercial cloth allowed traditional textile references without the time-consuming process of weaving it.

Embroidery also picked up in the 1980s, probably because of the blossoming of neoexpressionist painting; like painting, it offers options of color and imagery. D. R. Wagner, Elizabeth Tuttle, Tom Lundberg, Mary Bero, and

Faith Ringgold

Painter, activist, and advocate for artistic expression of identity, Faith Ringgold (b. ca. 1930) began painting on unstretched cloth after seeing Tibetan Buddhist *thangkas*, which led her to think about African cloth and her mother's involvement with fabric as a clothing designer. In the early 1980s, Ringgold adopted the quilt form, most famously her Story Quilts, which incorporate painted imagery, text, and piecework as a border. Ringgold had been using words on her paintings since the 1960s, and she also wrote for performance. The quilt paintings became an alternative method of autobiography (*Faith Ringgold's 100 Pound Weight Loss Performance Story Quilt*, 1986), political complaint (*Who's Afraid of Aunt Jemima?* 1983), and inspirational narrative (*Tar Beach*, 1988, which was made into a children's book). The quilting is not the expressive technique in these works but is used as a feminist emblem, associated with home and comfort. Although her works were sometimes labeled "folk" or "decorative," Ringgold considered the application of such labels to "reveal more about the prejudices of the art historians than the art itself."[1]

NOTE

1. Patricia Mainardi, "Quilts: The Great American Art," *Feminist Art Journal* 2 (Winter 1973): 22.

Renie Breskin Adams were among the top embroiderers. In wearables, handwoven, hand-knit, or quilted and pieced garments lost ground to a tremendous growth in surface design. Color and pattern became more important, tactility less so. The evolution of the genre led to a gradual division into artist-craftspeople making unique pieces and production craftspeople creating through cost-effective production. The latter was the larger group, but the former defined the aesthetic.[55]

Professionalism increased with the establishment of organizations encouraging serious attention to the medium, such as the Textile Society of America in 1987. Yet around the same time the institutional structure faded in the Bay Area with the closing of Fiberworks and the Pacific Basin School. Another great loss was the death of Betty Park (1938–1990), a gifted writer who was the most perceptive critic of contemporary fibers and who had given up her own work to bring attention to the field.

QUILT VARIATIONS

The biggest boom was in quilt making, with numerous exhibitions and festivals and also regional documentation projects for historic quilts. The *Quilt Digest* was launched in 1983 by San Francisco dealer Michael Kile. With Penny McMorris, he organized *The Art Quilt*, a traveling show that introduced that term, which is now in general use. Joining the American Museum of Quilts and Textiles in San Jose, California, founded in the late 1970s, were four new institutional endorsements of quilts: the Los Angeles County Museum of Art's American Quilt Research Center, under the direction of Sandi Fox; the New England Quilt Museum in Lowell, Massachusetts, created by the New England Quilter's Guild in a former mill; the American Quilt Museum in Marietta, Pennsylvania; and the American Quilter's Society Museum in Paducah, Kentucky.

By the end of the decade, quilters Nancy Crow, Michael James, and Joan Schulze were receiving frequent invitations from abroad, and the new quilts garnered increasing press in America, although it was the kind of coverage *Surface Design Journal*'s Pat Malarcher calls "Granny Would Be Surprised!"[56]

There were two great and rather paradoxical movements in African American quilting in the 1980s. One was an attempt to validate the aesthetic of characteristic quilts produced by rural southern black women; the other was an effort to win acceptance for the idea that there was not a single African American style in quilting any more than there was a single style for all white quilters.

The idea had become widespread—through an exhibition organized by John Vlach in 1976 and through Maude Wahlman's 1980 doctoral dissertation—that five characteristics were shared by "most" African American quilts: the use of strips, bright and high-contrast colors, large design elements, offset designs, and multiple patterning.[57] Wahlman co-organized a 1979 exhibition, *Black Quilters*, that related these principles to the rhythmic phrasing of black music.

These features were indeed seen in a 1987 traveling exhibition organized by Eli Leon, titled *Who'd a Thought It: Improvisation in African-American Quiltmaking*. Consisting of quilts from Leon's extensive collection, it debuted at the San Francisco Craft and Folk Art Museum in December 1987 and traveled for a number of years. The catalog preface, by Yale art history professor Robert Farris Thompson, carefully conjectured on relationships between African precedents and the works under consideration. Leon, in his essay, made an argument for the creativity of the "irregular" quilt, explaining that the black quilters considered the format of the quilt block "an invitation to variation" and thought measuring "takes the heart outa things."[58] Leon also asserted that the "standard" quilt tradition was significantly influenced by African American quilters from an early date.

Leon's argument was difficult to sell, since, to those accustomed to "standard" quilting, these works looked sloppy and unskilled. Yet the quilts can be seen to have a freedom and vitality that makes "standard" quilts look tepid, like an unimaginative corseting of the eye. **Rosie Lee Tompkins** (1936–2006), a California maker who grew up helping her mother piece quilts in rural southeastern Arkansas, lived to see her work in art galleries, in a solo exhibition at the Berkeley Art Museum, and in a Whitney Biennial.[59]

The Berkeley curator, Lawrence Rinder, wrote: "In front of Tompkins's work I feel that certain Modernist ambitions may in fact be achievable. Here are feelings of awe, elation, and sublimity; here is an absolute mastery of color, texture, and composition; here is inventiveness and originality so palpable and intense that each work seems like a new and total risk, a risk so extreme that only utter faith in the power of the creative spirit could have engendered it."[60] While she used a variety of materials, Tompkins purchased velvet for its depth of color and also selected other cloths with decisive textures such as velveteen, velour, corduroy, and terrycloth. She also liked synthetics (including Lurex) for their shiny or glittery qualities. These were not scrap quilts. Tompkins clearly had aesthetic goals that would probably be easier for craftspeople to appreciate if the work were called a fabric collage or simply a cloth composition. But, in fact, in a work such as the untitled eighty-by-seventy-four-inch 1985 piece made of velvet, velveteen, and rayon chenille (in Leon's exhibition, he refers to it as her *Framed Improvisational Block*), she worked with the convention of a quilt block. (Figure 10.49)

Tompkins simply allowed herself an enormous range of variation. Her prototype block was a frame of one-color strips around a group of diagonally split squares. Since she did not measure and was not concerned with precise replication, some frames are squares, some vertical rectangles, some horizontal rectangles, some double width. She adjusted the half squares as needed, making them larger or smaller or adding more. As a variation on a theme, the piece is dazzling: colors swoop and soar, the plane of the surface flexes, the diagonal fragments in all their varied hues flutter behind the foot-stamping emphasis of the yellow frames and red blocks, which visually

FIGURE 10.49. *Rosie Lee Tompkins, quilted by Willa Ette Graham,* Put-Together, *1985. Velvet, velveteen, velour, panné velvet, chenille, backed with cotton sheeting and cotton-polyester broadcloth; 82 × 74 in. (Courtesy of Eli Lion.)*

advance as the margins heave. Depending on viewers' energy levels, they might wish to dance or to sit down.

Leon's exhibition appeared at the American Craft Museum in 1989, but not until fourteen years later, with another show, did the art world begin to catch on.[61] Whether African Americans influenced early patchwork quilts is still an open question, but the more recent influence is clear: Michael James and others have adopted strip quilting, which, while not unknown in "standard" quilts, is much more common among black quilters. And even more strikingly, Nancy Crow, following an admired model, taught herself to let loose and cut shapes without measuring.

In 1989 the Williams College Museum of Art organized a traveling exhibition called *Stitching Memories: African-American Story Quilts*, featuring nineteenth- and twentieth-century quilts. The guide states on its first page that "there is no uniform look to quilts made by black Americans." Curator Eva Grudin acknowledges the assistance of Cuesta Benberry, who in 1992 organized her own exhibition (with catalog) for the Kentucky Quilt Project, called *Always There: The African-American Presence in American Quilts*. In her catalog, Benberry notes, "A procedure in which the quilts of a small group of black quiltmakers from a limited time frame are selected, examined for common characteristic, conclusions reached, interpretations of the works devised, and extrapolations

from these made to all African American quilts of all times, is at odds with the accepted method of historical inquiry."[62] The "characteristic" black quilt was based on both geography and class. *Spirits of the Cloth: Contemporary African American Quilts*, a 1998 book by Carolyn Mazloomi, a former aerospace engineer who founded the Women of Color Quilters Network in 1985, gave a taste of the styles of the 1,700 members of her group.

Nancy Crow (b. 1943) was one of the leading figures in the development of art quilting that began in the 1970s and flourished in the 1980s. She was a founder of the Quilt National exhibitions that began in 1979, and in 1990 she instigated an annual symposium. She has lectured and presented workshops internationally, and in 1994 she established a workshop facility on the Ohio farm where she lives. She is known for her dazzling (and instinctive) use of color, composing shapes on her studio wall before fixing the patches by machine sewing (subsequent hand-quilting is done by others, who are credited).

In the mid-1970s Crow gave up ceramics—in which she had earned an Ohio State MFA—for the more brilliant color effects possible with fabric. From the beginning, she orchestrated color for its graphic power, and after experimenting with the variable Log Cabin pattern—having a dialogue with tradition, in a sense—she began to invent her own asymmetric compositions. She worked through the influence of tramp art, Mexican motifs, and African American improvisational quilts.[63] She dyed cotton fabrics to achieve desired colors and shadings, such as lighter or darker edges on a block that give a sense of relief to the surface.

Every account of Crow mentions her emotionalism, and her works are seen to convey pain, depression, and joy through color and shape. Their expressiveness has also addressed specific subject matter, such as her Passion series of five quilts (1983–84), which came out of caring for her dying mother. These use colors symbolic of Christianity. A later series resulted from her distress at seeing a cattle truck full of men being driven to their execution in China. Generally, however, her works elaborate on a recognizable traditional pattern, such as the double wedding ring, or some other purely formal theme to produce compositions of great visual power.

The Bittersweet series—twenty-two quilts produced in the three years after she and her husband moved to the farm—covers an emotional spectrum of adjusting to isolation. (Figure 10.50) Other major series are two periods of Color Blocks and, in the 1990s, the emphatic Constructions. Crow was not the first art quilter—Katherine Westphal probably deserves credit for that—but with her energy and organizational ability and her ambitious pro-

James (b. 1949) became interested in quilts about 1970, and he soon stopped painting in favor of quilt-making. Just five years later he published his first book, *The Quiltmaker's Handbook: A Guide to Design and Construction* (1978), and he participated in the jurying of the first Quilt National in Athens, Ohio, in 1979. In 1981 he published a second book and began working in the strip-quilting technique adapted from the Seminoles, as opposed to the traditional assembled squares. He had from the beginning committed to machine sewing and to quilting in the seams so that the stitching did not introduce a tactile pattern.

His approach could be called conservative, since he did not adopt new image-making techniques such as photo-transfer or cross-genre techniques such as painting on the surface. His interests are pattern, color transitions, and figure-ground relationships, especially implying space through juxtaposed shapes.[64] All those formal issues were natural to traditional quilting. Still, by the end of the 1980s, James thought he might be at a dead end with grid organization, which still peeked out even in works like *Red Zinger* (1986) or *Flying Buttress* (1988), in which he violated the rectilinear perimeter of the quilt with extensions.

The shift began with the three panels of *Panorama: Konkordiaplatz* (1989), in which the center panel is organized in a different scale from the side pieces. (Figure 10.51) This important change is almost invisible amid the complexity of his color shifts and the stripes that seem to pass through every suggestion of form. This quilt, like a number of earlier pieces, has curved bands defined by color change. Here they abstractly represent flowing water. After this, James found his way to defining an overlapping curve that promises a circle but delivers something else, a fluttering variation of an Escher visual puzzle. Through the 1990s he worked with these dancing, free-form visual perceptions.

FIGURE 10.50. *Nancy Crow*, Bittersweet XII, *1980. Cotton-polyester broadcloth; 79.5 × 79 in. (Collection of American Folk Art Museum, New York, Gift of Nancy Crow, 1981.3.1. © Nancy Crow. Photograph by Scott Bowron.)*

duction of books (both instructional and autobiographical), she has made a difference.

Michael James is one of the minuscule number of men in the field, yet he and Crow are the most prominent quilters (it is a term he continues to embrace). Their careers are nearly parallel, but while she has taken a leading role in organizations and developed a workshop business, he remained a studio artist until the new century took him into academia at the University of Nebraska-Lincoln, where the International Quilt Study Center was established in 1997.

FIGURE 10.51. *Michael James,* Panorama Konkordiaplatz I, *1989. Machine-sewn cotton and silk; 50 × 150 in. (Courtesy of the Artist. Photograph by David Coras, courtesy of the Hand and Spirit Gallery, Scottsdale, Ariz.)*

WEARABLES

One of the students in Yoshiko Wada's first *shibori* class at Fiberworks in 1975, **Ana Lisa Hedstrom** (b. 1943), collaborated with Wada and other artists in forming a professional *shibori* association. By the late 1970s she had her own business, selling through Julie: Artisans' Gallery, Obiko, and Bergdorf Goodman.

Inspired by the Metropolitan Museum textile collection, Hedstrom began in 1980 to use many kinds of pleats, some left in the cloth to create relief in the finished piece. She went to Japan in 1983 to visit the dyeing villages and discovered the *arashi shibori* technique, which she decided to preserve. It involves wrapping fabric around a pole, binding it with thread, and pushing it into pleats before dyeing; the tight pleats resist the color. Hedstrom wraps her fabric around PVC tubes, the lightness of which allows her to lift the pole without an assistant. She started *shibori* work with wall hangings and then made clothing that she sells through shops and galleries. (Figure 10.52)

Hedstrom grew up in Indiana, where her mother was a dressmaker and gave her fabric and dresses to cut up and play with. She went to Mills College, where she studied ceramics and Asian art history. Then she lived in Japan, studying ceramics at Kyoto Art College and teaching English. On her journey home—two years of travel through Southeast Asia and India—she saw sarongs and saris and decided she wanted to work with textiles. After her return, she took the class with Wada.

Hedstrom's technique produces beauty on the first try, but she adds other processes, including painting and screen-printing on the silk she uses. She has also used stitch-resist via a smocking machine and other techniques such as discharge (bleaching) and *devoré* (burnout) for more complex effects. She has cut and pieced large graphic designs and has used the idea of language patterns in a series called Lexicon. She closed her production business in 1992 but continues her art.

Tim Harding (b. 1950) is a painter who became a maker of wearables famed for their layers of slashed fabrics. The idea many sound punk, but it goes back a long way: almost any portrait of Henry VIII shows him with puffs of cloth sticking through slashes in his sleeves. Harding's source was not historical, however. After graduation from college in Saint Paul, he went to work as a cutter for a garment manufacturer and became more interested in the canvas than in paint.[65] He enrolled at the Minneapolis College of Art and Design with an emphasis on fabric, studying screen-printing, painting, dyeing, and shaping. He developed a screen-printing business and became a wholesaler of hand-screened supergraphics that were

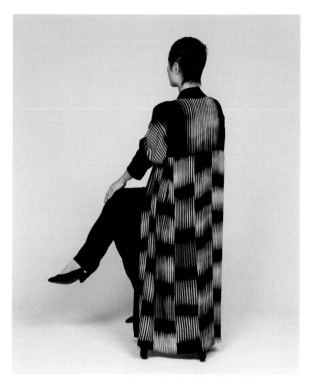

FIGURE 10.52. *Ana Lisa Hedstrom, Coat, 1987.* Arashi shibori *resist-dyed, silk crepe. (Collection of the Museum of Arts and Design, New York. Courtesy of the Artist. Photograph by Elaine Keenan.)*

stretched and sold as wall hangings, but in the meantime he was engrossed in turning surface into structure rather than image.

Harding experimented with fabric, abusing it to see what would happen with scorching, blowtorching, even blasting it with a shotgun. By the end of the 1970s he had developed his method. At first he used cottons because they frayed well without raveling, but more recently he has used silks. He dyes fabrics, layers different colors, quilts them together, slashes to let the undercolors show in controlled order. He washes and dries to get the desired degree of fray and then meticulously presses. He calls his process a form of reverse appliqué, akin to the famous *molas* of the San Blas Indians, and he acknowledges the European precedent, which began in the Renaissance. When he began, he did not know of Issey Miyake or Vivienne Westwood, clothing designers who became influential because of their use of tattered fabric edges and other unorthodox ideas.

Some of Harding's early works were irregular and peltlike. He has more commonly used the greatcoat and especially the kimono form (actually the shorter, jacket version, with narrower sleeves, called a *hippari*) because their simple, squared elements furnish uncomplicated expanses that show his manipulations well. (Figure 10.53) He also endorses the Japanese view that garments

FIGURE 10.54. *Gaza Bowen*, The Little Woman's Night Out from the Shoes for the Little Woman Series, *1987. Mixed media; 19.68 × 30.68 × 9.06 in. (Collection of Fine Arts Museums of San Francisco, Museum Purchase, Barbara Donohoe Jostes Bequest Fund, 1999.143. © Dennis Wheeler, Estate of Gaza Bowen.)*

FIGURE 10.53. *Tim Harding*, Swing Dynasty, 1986. *Cotton, dyed, layered, stitched, and cut fabric; 98.5 × 68.5 in. (Minneapolis Institute of Arts, Gift of Richard and Roberta Simmons, 1987.97. © Tim Harding.)*

can be aesthetic objects. In 1988 he wrote: "I believe that a garment can be as legitimate a form of artistic expression as a painting. My goal is to create truly functional, aesthetic objects; wholly contemporary, yet evoking the magic of tribal, ritual garments; anthropomorphic and architectonic in nature; which are as rich conceptually as they are visually."[66]

Gaza Bowen was the only twentieth-century craftsperson known for shoes. She started out in the 1960s as a hippie making sandals in California and was self-taught, although she took an apprenticeship in shoe repair and in 1976 spent two months at Colonial Williamsburg, learning to make lasted shoes. For a decade after that, Bowen (1944–2005) made unique functional shoes. After inclusion in the 1978 *Great American Foot* exhibition at the Museum of Contemporary Crafts, she began to receive commissions. Interesting in cut and color, her shoes were displayed by their owners when not in use.

Bowen began to move away from practicality and toward symbolism in *Loligo Sandalia* (1985), a pair of pumps in which each foot seems to be caught by a squid, with tentacle-laces wrapping the ankle and an eye on

each side of the heel. They were made of rawhide, hog casing, acrylic paint, and Plexiglas. Soon after she produced Shoes for the Little Woman, a series that brought her widespread attention with its craftsmanship, unorthodox materials, and pointed humor. (Figure 10.54) In seven works, made at the end of the 1980s and the beginning of the 1990s, she mixed shoe leather with cleaning supplies and kitchen products such as sponges, clothespins, and sink drains. Some give a first impression of being fashionable mules, until one sees that they are made of detergent bottles and scrub brushes, with a scouring-pad rosette on each toe. Some have a more threatening quality, incorporating knives and skewers. While most of Bowen's works addressed women's wear, she also wove a pair of wingtips of shredded currency and calfskin (*In God We Trust*, 1988).

Following this series, Bowen created the *Red Shoe Reader*, a small accordion-fold book that quotes an enormous range of sources in characterizing women's shoes. She moved on to personal and somber assemblages of found materials dealing with her childhood in an essentially closeted Jewish family in the South, and then to installations dealing with consumption and waste. As worthy and moving as her late work could be, the shoes remain her claim to fame for their unique craft and wit.

MULTICULTURAL MOTIVATIONS

Born in 1948 in Albuquerque to a Hopi father and a mother of German-Irish descent, **Ramona Sakiestewa** grew up feeling close to the Southwest traditions and the Native American artifacts her mother collected. As a teenager she taught herself to weave on the type of vertical frame loom used by the Hopi and Navajo, yet she also spent a year studying design in New York. She is known

FIGURE 10.55. *Ramona Sakiestewa, Dragon Flies, 1986. Wool warp and weft, tapestry; 48 × 38 in. (© Ramona Sakiestewa.)*

FIGURE 10.56. *Glen Kaufman, Kyoto Rooftop: Kita-ku, 1985. (Collection of The Cleveland Museum of Art, 1996.185. © Glen Kaufman.)*

today for her vibrant weavings combining elements from historic precedents with a contemporary language of composition and expanses of intense colors punctuated by stripes or small floating motifs. (Figure 10.55) Drama and a sense of openness characterize the works, which are woven on a treadle loom but finished on both sides, in the Pueblo manner.

Sakiestewa lives in Santa Fe but has spent lengths of time in New York City, Mexico City, Peru, Japan, and China and has traveled through Europe, with consequent effects on her work. She tells the story of a 1987 commission from Taliesin West in Scottsdale to create thirteen tapestries from Frank Lloyd Wright's original artworks—a congenial project because she and Wright both emphasize strong colors and clean geometric shapes. She had trouble, however, with green, because it is not a color of the desert. The problem was solved by a trip to Japan, where she saw temple gardens with hundreds of greens, which inspired her *Tenryuji* tapestry.[67]

Earlier Sakiestewa's studies had included natural dyes, and her first commission, in 1975, was from the Park Service at Bandelier National Monument, which asked her to replicate an Anasazi turkey-feather blanket. Although she spent nine months on it, working with anthropologists to reconstruct the ancient techniques,[68] she did not feel that her destiny was to preserve or to reproduce the old. Rather, she draws from that range of influences, including Southwest architecture, the landscape and its colors, and Navajo and Pueblo designs from tapestry, pottery, and basketry as well as elements of ceremonial dance. She is also influenced by the paintings of Frank Stella and Gene Davis.

Glen Kaufman (b. 1932) had a long history before his gridded, Japanese-inspired tapestries brought him re-

doubled attention in the mid-1980s. Following completion of his MFA at Cranbrook in 1959, a Fulbright Fellowship took him to Copenhagen for a year; he then spent a year weaving for Dorothy Liebes; and from 1961 to 1967 he headed the fabric department at Cranbrook. While there he and a design student, Meda Parker Johnston, collaboratively wrote *Design on Fabrics* (1967). He left Cranbrook to establish a program in weaving and surface design at the University of Georgia, Athens, where he also began a study of textile history.

Continuing his eclectic production, at the end of the 1960s Kaufman began a twelve-year series of olefin and polypropylene garment forms. He worked large: in his *Super Graphic Soft Surface Environment* (1969), an expanse of machine-tufted black and white nylon on vinyl ran from the floor up the wall and onto the ceiling. And he worked small: when Ann Sutton organized the first miniatures exhibition in England in 1974, Kaufman contributed his first glove works, a series he would continue for a decade—another widely shown body of work. He sewed on beads in contoured patterns, combined work gloves into unified compositions, inserted the spines of a fan into the fingers, tied on brass bells, and applied newly learned *shibori* and discharge-dyeing techniques.

The most lasting and preeminent phase of Kaufman's work is linked to Japan. Since 1984 he has spent half of each year in Kyoto, leading a university study-abroad program and doing his own work in that enduring textile

center. He has been able to learn processes and materials in small-production kimono and obi studios. He soon developed a complex concept: he twill-weaves a surface pattern in silk, composes collages of photo imagery, and photo-silk-screens that onto the cloth, further abstracting it with the application of metal leaf. (Figure 10.56) The imagery is often architectural, and Kaufman incorporates a grid on his surfaces that recalls both Western windowpanes and Japanese shoji screens. He has engaged in many variations, picturing celestial bodies, American scenes, an umbrella-carrying alter ego, and scenes of Korea. It is a concept and creation entirely his own.

INTIMATE SCALE: DIANE ITTER

In a short but productive career, Diane Itter (1946–1989) made knotted works widely admired for their optically playful patterns, splendid color, and determined smallness and detail. (Figure 10.57) A complex order of patterns was certainly her forte; she magnified it by leaving a long fringe that seems to pour downward or explode upward from the body of the work, which was typically a tight, almost smooth surface of 400 double half-hitch knots to the inch. The fringe enlarges the scale of the work, its freedom contrasting with the compacted imagery. She said that without the fringe the work lost everything and looked like a potholder.[69]

Itter learned knotting from Virginia Harvey's book on macramé and produced belts, sashes, and neckpieces to sell at craft fairs and shops. Moving to Bloomington, Indiana, for her painter husband's teaching position, she soon enrolled in the graduate textile program. By the time she completed her MFA in 1974, she had begun the lecture and workshop practice that would become a major professional activity, and her work had already been discovered by Mildred Constantine in a national invitational show.

The color-and-pattern effects that became Itter's signature first emerged in a needle-woven tapestry and a strip-woven tapestry while she was still in graduate school. She created a series of very small baskets and pouches before, in 1976, beginning her famous knotted-and-fringed works, which she called "slow painting." She employed every one of the several hundred hues available to her in Swedish linen and found ways to layer or scatter them to create further chromatic variation.

Itter almost never worked from a single idea, and she developed a method of knotting small segments and then linking them into a whole, which meant that she did not have to work from the center outward and could more spontaneously organize the compositions. She worked

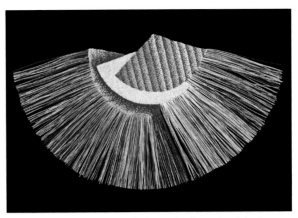

FIGURE 10.57. *Diane Itter, Triple Fan, 1980. Knotted and dyed linen; 16.25 × 9.5 in. (Racine Art Museum, Gift of Barbara-Rose and Ed Okun, 2001.252. © Estate of Diane Itter/Bill Itter. Photograph by Jon Bolton.)*

with double layers of threads for optical mixture and to allow the introduction of new colors or the subtraction of hues in hard-edged patterns.[70] Her commitment to a single material and a single technique meant that all her creativity poured into the imagery. Among the influences on her works were the ethnic and historic textiles she and her husband collected. African, Peruvian, Amish, Native American, and Japanese aesthetics contributed to her imagery along with such bits of popular culture as bandanas and Victorian floral carpeting. Typically she created a spatial or conceptual shift, whether it is a set of geometric "carpet" motifs that dissolve into one another and interlock (*Split Decisions*, 1984), a grid that bends into a fan and shifts its palette (*Blue Point Fan*, 1981), or a kimono shape that discloses a cosmic diagram inside its demure neckband (*Anniversary Eclipse*, 1989). Itter embraced everything: "For me it's just nonstop visual information going into my brain. No matter where I go, what I do or what I see, bing, I've got ideas. It's almost like visual overload."[71] She compacted it all into exquisite vignettes.

THE CHICAGO CONCEPTUALISTS

Two women teaching at the School of the Art Institute dominated Chicago's fiber work starting in the 1980s, producing exceptionally intellectual works that orchestrate associations and references with a certain coolness.

The fiber elements that define the formal and associative aspects of **Anne Wilson**'s works specify man-made and socially determined contexts and raise environmental questions. Wilson (b. 1949) attended the University of Michigan's art school but dropped out at the end of her second year and began working with a local weaver,

FIGURE 10.58. *Anne Wilson, Bulls Roar, 1986. Fiber, paint; 75 × 74 × 5 in. (Collection of Cranbrook Art Museum, Bloomfield Hills, Mich. Courtesy of the Artist.)*

FIGURE 10.59. *Joan Livingstone, Dyad, 1988–89. Felt, suture thread, epoxy resin; left: 68 × 12 × 12 in.; right: 72 × 15 × 15 in. (Collection of Robert L. Pfannebecker. © Joan Livingstone.)*

learning traditional overshot patterns, hand spinning, and natural dyeing. She enrolled at Cranbrook, receiving a BFA in fibers in 1972, and worked independently for a while before entering the graduate fiber program at the California College of Arts and Crafts with Trude Guermonprez. She moved to Chicago to teach at the School of the Art Institute in 1979.

Wilson's works of the 1980s alluded to furs and hair. She first addressed these provocative materials through woven or off-loom grids to which she contrasted an independent line—a supplementary weft of abaca fiber that sprang out to introduce texture, dimension, irregular direction, and flexibility. By 1983 her Kesa series (named after a Japanese garment) featured what she called "organic hair-like scribbles," and then she created a "visceral" quality with denser threads in the Hairfields, which employed unnatural, chemical-dye colors in response to the greens, blues, and rose reds of punk and new wave hairstyles of the time. In vitrines she displayed hanks of long hair that identified race, giving this work a contemporary edge. She also addressed fake furs, since she was struck by the irony of commercial simulations of things that were being destroyed in the natural world. *Bulls Roar* (1986) is both organic and artificial and seems to allude to both real hides and the symbolic skins of mythology. (Figure 10.58)

In the 1990s Wilson made several series of works employing used damask tablecloths—worn and stained linens that implied a history of human interactions—

that she ostensibly "mended" with hair. Hair is transgressive on a tablecloth, as repellent as finding it in food. Hair on linen may also evoke bed linens, where hairs are intimate and private, and their discovery seems to violate some order of proper distance. Continuing her thoughtful work, Wilson has since reached into video, interactive and sound work, and installations.

Joan Livingstone (b. 1948) has been teaching alongside Wilson since 1983, and in that context her large felt sculptures have taken on great symbolic weight. Early on she hung handmade felts on visible armatures suggested by theater sets. By the end of the 1980s, she was producing works such as *Dyad*, which consists of two upright volumetric elements that are approximately human size but lack appendages or other elements of literal depiction. (Figure 10.59) They lean against the wall and twist from a minimal point of contact with the floor to broad shoulders—one squared and one rounded—and terminate with something like a cap on a tube of toothpaste, again the first squared and the second rounded. These are nonspecific shapes that may recall sculptures by Tony

Cragg or Martin Puryear as well as, critic Dennis Adrian suggested, early-twentieth-century biomorphic and surrealist painting.[72] They remain tantalizingly on the verge of suggesting figures in an insolent crossed-leg slouch against the wall. At the same time they suggest industrial forms. Their makeup of resin on industrial felt is another marvelously calibrated balance, between comforting and repellent associations.

Livingstone has gone on to produce shapes in felt that might suggest medical squeeze bags or enormous tough-skinned fruits and cascades of somewhat torsolike contours as well as twists of felt that might bring to mind strangulated viscera. These ambivalent body allusions shifted, at the end of the 1990s, into still more abstracted references consisting of funnel forms with greatly elongated necks and a variety of possibly natural colors and crusty residues, arranged in extensive wall installations that recall musical notation.

All this is, of course, sculpture. Livingstone's connection to craft is distant, not through form and not much through concept. She uses a fibrous material and stitches forms together with suture thread in a handwork process. The stiffened and sometimes pigmented felt resembles a cast or a shell more than a blanket. Form—or perhaps positioning—conveys a sense of waiting. She acknowledges the model of Eva Hesse's work, but her own sculpture has greater ponderousness, less sense of skin and more of husk. In her own writing and that of others, the work has unfortunately been impaled on the academic hook of gender issues, but the presence and ambiguity of the forms suggest wider meanings.

MARY JACKSON

Sweetgrass baskets entered the twentieth century as a regionally specific African American craft, adapted and perpetuated by Gullah women in the area around Charleston and the Sea Islands, passed down through generations. In 1916 a Charleston merchant formed a company and started buying the baskets to sell to tourists and via mail order. It did not take the makers long to realize that they would do better without a middleman, so they set up stands along what became U.S. Highway 17 to sell directly to a mostly white clientele. Nonbasket forms were developed for this market, such as tablemats, hats, coasters, and wastebaskets.

Mary Jackson was born in 1945 in the heart of the basketmaking district, learned the coiling techniques from her mother and grandmother, made baskets during the summer, and was an accomplished "sewer" before she was out of high school. She lived in New York for ten years and, when she returned, had a good administrative

FIGURE 10.60. *Mary Jackson, Two-Lips, 1981. Bulrush, sweet grass, pine needles, and palmetto; 19 × 16 × 19 in. (South Carolina Arts Commission, State Arts Collection. © Mary Jackson.)*

job at the Charleston Medical University until she gave it up to stay home with a chronically ill child. It was then that she resumed basketmaking. She first offered her works in public in the spring of 1982 and that fall won her first award, from the South Carolina Crafts Guild. Since then she has become the star of the craft.

Half the attention is due to Jackson's perpetuation of an endangered skill. She regards it as a commitment to her ancestors to work within this context, and others have praised her as "one of the most poetic speakers on behalf of Gullah culture and African culture."[73] But more important in the context of studio crafts are her innovations and aesthetic sense. While sweetgrass is becoming rarer because of development on the coastal sites where it grows, these Sea Island baskets may now incorporate other materials such as longleaf pine needles and bulrush. Jackson has exploited the contrast the materials allow to strengthen her patterns of light and dark. She developed *Two-Lips* (1981), a low basket that creates the impression of a second lip because the handle continues around the circumference below the actual lip. (Figure 10.60) Her sense of proportion shows in the work. In other pieces she has allowed a strand of sweetgrass to break free of a coil and extend outward in a flourish, and she adds French knots to the forms as accents. Her extension of tradition is thus a design-conscious manipulation of profile, volume, and surface.

JOHN GARRETT

The stereotype of baskets as gathered from nature and making a statement about the relation of humanity to

FIGURE 10.61. *John Garrett, Fiesta Basket, 1981. Painted vinyl and plastic slats, hardware cloth, welded wire mesh, plastic covered wire, beads and sequins; 54 × 36 × 36 in. (Private Collection. Courtesy of the Artist. Photograph by Bill Svendsen.)*

its environment gets a twist in the work of John Garrett. (Figure 10.61) He began making baskets when he was living in Los Angeles, and the materials his environment provided him were forms of plastic and vinyl. When he later moved back to his native New Mexico, his primary material shifted to metal. His aesthetic, throughout, has been one of lively color and sheer visual excess that he describes as evoking "parties, fiestas, confetti, city lights and discos."[74] His interest was not in inventing sculptural form but in embellishing surface, and he has also made "quilt" and "net" constructions.

Finding a heap of Venetian blinds inspired Garrett to try hard materials. He began painting sheets of fabric-backed vinyl with various colors and designs, cutting them into strips and plaiting them into squares, or lashing spray-painted plastic slats onto metal hardware cloth with plastic-coated wire. He then pulled the four corners toward the center, creating an interior space; he added plastic beads and sequins. His *Nesting Basket* (1983) is made of hot pads, clothespins, plastic toys, and a feather duster to allude to domestic work, comfort, and pleasure; his *Vulcan Purse* (1983) is formed of steel and aluminum strips lashed to a wire grid in a rather aggressive fantasy

of use. It seems to support assertions that he is creating a kind of protective armor.[75]

Garrett (b. 1950) studied with Neda Al-Hilali at UCLA and was influenced by the *Deliberate Entanglements* show in 1971, which seemed to "give permission" for complex and ambitious works in fiber. His have been so, no matter what the scale, small pieces and floor installations alike. Examples of the latter are *Night Temple* (1984), included in the *Fiber R/Evolution* exhibition at the Milwaukee Art Museum in 1986, or his *Shelter/Basket* (1990), pairing two human-scale forms framed out in PVC pipe and filled in with wire fencing and mats woven of plastic bags. These showed the surprising beauty of the materials and contrasted with the preciousness of other artists' textile works shown with them. That is as he wishes: Garrett has said that he is not interested in topical subject matter—such as recycling—but simply in the visual power of commonplace, cast-off materials.[76]

JANE SAUER

In the new waves of activity in basketry, some artists focused on structure and some on finer points: it was the difference between fastening twigs or knotting waxed linen. Jane Sauer, like Diane Itter, was interested in an essentially smooth surface that could be manipulated for subtleties: Sauer's three-dimensional knotted forms include sculptural nuances, relief additions to surface, and figural allusions in addition to variations of color and occasional text. Her closed forms began with the notion of basketry but soon pursued other, expressive ends. Her works of the 1980s and 1990s may be the most emotionally suggestive textile sculptures of the era (her only real competition is Norma Minkowitz).

Having grown up in the charged environment of an unhappy family, Sauer (b. 1937) came to identify that as an early source of her concern with interpersonal tensions. Her own activities as a civil rights activist and as a public school teacher for twelve years, and her experience with failed marriages and then a successful blended family of seven children have only reinforced such concerns.

Sauer began her artistic career as an oil painter after study at Washington University, but that was problematic once there were children underfoot. She took up embroidery and other less messy and easier-to-interrupt mediums. Exposure to Constantine and Larsen's *Beyond Craft: The Art Fabric* raised her ambitions, and a how-to book received as a gift introduced her to the threads that became her medium.

Sauer's first works, including a piece accepted into

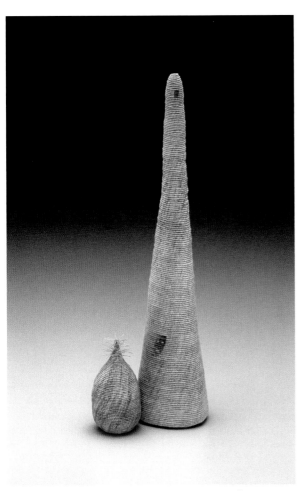

FIGURE 10.62. *Jane Sauer*, Maternal Vestiges, *1987. Left: 4 × 2 × 2 in.; right: 13.5 × 2.5 × 3 in. (Collection of Arizona State University Art Museum, Ceramic Research Center, Gift of Sandy Besser, 2005.012.014A-B. Courtesy of Jane Sauer. Photograph by Mark Katzman.)*

the *Fourth International Exhibit of Miniature Textiles* at the British Crafts Center in 1980, were open at the top. But as early as 1983, in a work called *Lesotho*, she opened the long side of the tall, dark form to reveal a shadowy interior and then finished the opening's edges with bristling, stingerlike elements. She thought of it as representing the dark conditions of South Africa at the time and the moments of darkness that occur in any life.

Since then Sauer has employed various expressive treatments, both abstract and more specific. *Midnight* (1988) is an elongated conical form surrounded by an aura of light from projecting fibers treated with bronzing powder. This can be seen as representing radiance or as a fearsome bed of needles. In *Maternal Vestiges* (1987), she paired a tall form and a small, chubby one and painted on them such symbolic elements as a raised hand and a long, spiraling ladder. (Figure 10.62) In many works

she knotted verbal messages into the wall of the form, but her most effective device is, as here, the use of forms in relationship. Later pairs stand close together and lean slightly, as if yielding to magnetic attraction, or seem split from one into two or literally grasp each other, touch sensuously, or even interpenetrate. Emotional variations of form are extended by Sauer's skilled manipulation of color in the knotted lines of structure.

NORMA MINKOWITZ

Norma Minkowitz (b. 1937) attended Cooper Union, specializing in ink drawings. Her mother had taught her to crochet, but it was only in the 1970s that she put the two together. Her innovation was to turn a domestic decorative art into sculpture by using various methods to stiffen crocheted forms and allow them to be freestanding; she also took crochet into subjects never previously connected with it.

The work for which Minkowitz is now known began when she crocheted around everyday items such as shoes and then removed the object; the crochet yielded a "drawing" of the form, linear and transparent. In the 1980s her work was shown in exhibitions of fiber in general and of basketry, although crochet is not a traditional basketry method and she was not reproducing basket forms. Transparency was the linking factor. She used light wire for a degree of rigidity or set up twigs and roots as armatures or created around a removable mold and impregnated the threads with shellac.

The expressive advantage of crochet is the simultaneous visibility of inside and outside, which Minkowitz exploited for emotional effect, evoking such feelings as disclosure, vulnerability, and entrapment. She has also constructed forms in which lighting reveals or obscures a smaller object or figure inside; painting the crocheted threads also allows her to manipulate the degree of transparency. Although crochet does not show the direct effect of the hand, its tiny units clearly indicate the artist's investment of labor, creating a personal yet inexplicit tension.

Minkowitz's work picked up a deeper sadness in the late 1980s. Abstract forms carried emotional suggestions reinforced by the title. For instance, *Silent Whisper* (1985) is a low bowl with a top that slopes to reveal a slightly darker interior bowl; *Nadir* (1986) is a sort of Devils Tower shape in tan with a conical inside that is darker, resembling a funnel. Both convey a sense of emotional weight. *I Can't Touch You* (1988) features the shadow of hands on a transparent yet closed-off box. (Figure 10.63) It is a response to the death of her mother a few years

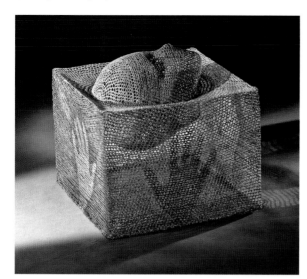

FIGURE 10.63. *Norma Minkowitz, I Can't Touch You, 1988. Crocheted cotton, acrylic paint, colored pencil, shellac; 13 × 12 × 12 in. (Collection of Barry Fisher. Courtesy of the Artist. Photograph by Bob Hansson.)*

earlier. Layering (symbolizing life and death) and the apparent fragility but actual toughness of her material have become increasingly affecting.

ELLIOTT AND HICKMAN

Lillian Elliott (see chapter 8) worked freely and widely in basketry. She plaited, sewed, and tied materials together. Her baskets emphasize the particularities of the material and reveal the artist's hand in assembling them but never emphasize fine craftsmanship. They seem more concerned with structure and airy volumes than with surface, which marks a change from the woven and collaged works that brought her attention in the 1960s. She purchased rather than harvested materials and used grasses, raffia, reeds, and rattan that she joined by tying, interlacing, or twining.

"For a while," Elliott once said, "I was concerned with the idea of making baskets which were a 'contemporary statement,' so I tried to find man-made materials which spoke to me. . . . Somehow, though, bark and branches and other natural materials felt so much better in my hands that I have decided, at least for now, to make the baskets as personal and compelling as I can and forget the other 'message.'"[77] That seems to have been enough. She was known for loose and irregular—almost skeletal—structure, for casual joining of elements with ties, or for changes in the width of elements that evoked painterly fluidity. She sometimes, shockingly, painted her baskets in a light-absorbing black. She justified painting them by saying, "I'm not an amateur ethnic; I'm urban and sophisticated."[78]

About 1980 Elliott and her friend and former student Pat Hickman (b. 1941) decided to collaborate for a year. Collaborations are rare in American craft practice, and those of any duration have generally been the shared work of couples, so this was unusual in all regards. Hickman had studied loom and nonloom weaving with Elliott at Berkeley; later the two women began meeting regularly to work on their own projects and critique each other's. Elliott mentioned that she was thinking about a skin to cover the structure of her baskets, assuming it would be paper or cloth; Hickman suggested gut, the material she was working with, whose use she pioneered in the textile field. Hickman had seen gut in ethnological collections and admired its translucence; she bought casings from a local deli, washed and dried them, and began experimenting. Meanwhile Hickman had begun to think about working three-dimensionally, to understand volume, and she thought Elliott could help her with this.

They began their collaboration carefully. "Trust is essential, and so is absolute, brutal honesty, so that neither person adapts or compromises just in order to please the other," Elliott said.[79] Planning was shared, but each did her part alone; only with the largest pieces did they both address the same work at the same time. At the end of the year they exhibited five of the pieces at Fiberworks. They hung a boat-shaped construction of twigs and gut from the ceiling; another piece was a thirty-eight-inch-diameter basket covered with gut that Elliott painted black and in which Hickman poked tiny holes. Perhaps most surprising to both the audience and the artists was *Charcoal Drawing* (1981), coconut-palm midribs dipped in india ink and bundled together with

FIGURE 10.64. *Lillian Elliott and Patricia Hickman,* Charcoal Drawing, *1981. Painted reeds, gut (hog casings), linen, India ink; 9.5 ft. × 10 ft. × 4 in. (Courtesy of Patricia Hickman.)*

gut: the artists had envisioned it as a wall piece, but the installation designer hung it in midair, cutting across the gallery. (Figure 10.64)

This project was so interesting for both that they continued to collaborate occasionally over the next decade. Some of the forms are entirely abstract and others are associative, such as *Ghost Dirigible* (1987), a work accurately described by its name. They also shared paperwork and photographic chores, with both feeling that their ability to capture the qualities of the work improved. A joint proposal was accepted for the Twelfth Lausanne Biennale, for a large work neither would have ventured alone.

GYÖNGY LAKY

Gyöngy Laky's first important role in the fiber world was cofounding Fiberworks Center for the Textile Arts in 1973 and directing the program for four years. She also began teaching at the University of California, Davis, in the 1970s. Her artwork burgeoned in the 1980s, proceeding simultaneously in three directions: installations, word works, and basketry.

The installations, in their ambitious scale, might owe some debt both to Laky's interest in architecture (especially aboriginal and vernacular) and the birth of the environmental movement during her college years at Berkeley. The word works—sometimes a grid of twigs with a letter in each square, sometimes a freestanding constructed object—might be linked to the language sensitivity of a sophisticated immigrant family. (She was born in Budapest in 1944 and came to the United States as a child.) Her baskets are constructed of recycled orchard and street-tree prunings that are not so much woven together as carpentered with wires, screws, or nails that seem excessive in size or number. What Jim Melchert has called their "dissonance" is a comment on the troubled relationship of humans to the natural world.[80]

Probably Laky's best-known work is a ninety-inch-tall basketry-style construction that spells out A-R-T. (Figure 10.65) This work—of orchard prunings and electrical wire on a welded substructure—was shown in the Fourteenth Lausanne Biennale in 1989 and is entitled *That Word*. The title expands the frame of reference, alluding to the ambiguous identity of craft forms with conceptual purposes. Laky has regularly used unconventional joining materials. She has stapled strips of cardboard, wired together long aluminum nails, and constructed baskets of industrial plastic "remainders," brass drawer labels, telephone wire, and toothpicks in addition to twigs. The variety suggests that exploration rather than refinement is her concern, an idea supported by the fact that in an open studio in the 1980s, her demonstration was

FIGURE 10.65. *Gyöngy Laky*, That Word, *1989. Orchard prunings, electrical wire, welded substructure; each letter approximately 90 × 54 × 50 in. (Courtesy of the Artist. Photograph by Georg Rehsteiner.)*

not a particular technique but what she called "textile thinking." That is also what she demonstrated in three large outdoor installations she created in 1984, gridding off a section of hillside measuring 100 by 125 feet with colored surveyor's tape in weaving's language of rectilinear intersections. "To me the definition of textile goes beyond process, even beyond material. I think of it as a system," she has said.[81]

PATRICK DOUGHERTY

A maker of large sculptural object-environments in relatively short-term installations, Patrick Dougherty is linked to the crafts because he uses the materials of baskets—often willow branches, although he can use any flexible tree branch or brush—and because he works the materials with his hands, his only tool a cutting implement.

Dougherty (b. 1945) is a maker who found his way from a great distance: he was a hospital administrator and then a stay-at-home father who built a stone and timber house that won praise for its artistry. He then started making, out of saplings and sticks, fencelike structures and abstract forms wrapped around the base of trees on his property. He took art classes at the University of North Carolina and was on his way.

Dougherty's sculptures hold themselves together through entanglement, so they have a twist that echoes natural growth patterns and spinning forms such as dust devils. He works only by commission, and the performance of making, which often involves volunteer help over a period of weeks, is central. Each work is site-specific. An early work, *Brushwork at #1 Water Street*—made in Salisbury, North Carolina, in 1985—consisted of snagged-together maple saplings, beginning with a spiraling mass on the sidewalk near the building entrance,

FIGURE 10.66. *Patrick Dougherty,* Brushwork at #1 Water Street, *1985. Maple saplings, 8 × 20 ft. (Work sponsored by Waterworks Visual Arts Center, Salisbury, N.C. © Patrick Dougherty. Photograph by David E. Setzer.)*

vaulting over the roof, and ending in another rotating form in the site's sculpture garden. (Figure 10.66)

While Dougherty's practice is to make a work from natural materials available near the site, he has also made indoor works. At Manhattan's World Trade Center (1988), he was not allowed to put branches on the wall, floor, or ceiling of the lobby site, which presented a problem. Then he saw electricians on very tall ladders and had the idea of using those as supports for an entanglement that flowed across space like wind or water. He has elsewhere snagged limbs into spheres as well as archways, domes, turrets, and "hobbit-like garden follies."[82] None of his projects last more than a few years, but the decay is natural, not lamentable.

Jewelry, Metals, and Enameling: Declarations of Independence

JEWELRY GOES POLYCHROME

In the 1980s color broke into jewelry. The shift was driven by technologies and materials new to the field, especially anodized aluminum and titanium. Anodized aluminum—an oxidized surface colored with light-fast dyes—is an industrial technology that had been around for decades before it was adapted for small-studio use. Industry favored loud hues like electric blue and blood red. Jewelers went along for the ride, often using hot colors in hideous combinations. It was not a high point of the craft.

Titanium and niobium can be colored by subjecting the surface to electric current while it is submerged in a bath. Cheap and easy to use, the technique can produce subtle metallic colors as well as bright hues. After being introduced from England, it spread through studio jewelry like wildfire. It was taken up by the costume-jewelry industry, and cheap titanium jewelry flooded the marketplace. In only a few years the look was reduced to cliché.

The 1980s also saw a surge of interest in patination, the chemical coloring of metal surfaces. Recipes became more available, culminating with the 1991 American publication of the definitive book on the subject, *The Colouring, Bronzing, and Patination of Metal*, by Richard Hughes and Michael Rowe. Some metalsmiths investigated painting metal, following precedents long established in sculpture. Others used materials like Color-Core, dyed wood veneers, and drawing mediums.

In other ways American jewelry and metalsmithing followed trajectories initiated in the 1960s and 1970s. Both jewelers and smiths used a formalist vocabulary of geometric shapes, sometimes reminiscent of a tame Russian constructivism. This was jewelry's house style in the 1980s: lines and rectangles arranged in pleasant diagonals, with decorative accents here and there. The influence of Memphis furniture was unmistakable.

Otherwise no single style or concept dominated. Some jewelers played up the rich colors of transparent enamels in the manner of William Harper. Others explored the medium as a vehicle for narrative. References to historical work showed up with increasing frequency, especially at the end of the decade.

The 1980s saw the introduction of two influential magazines. One was *Ornament*, which was originally *The Bead Journal* and whose core audience remained bead enthusiasts. A growing number of people were stringing new and antique beads. *Ornament*, however, broadened its content and was generous in its support for new studio jewelry. The other was *Metalsmith*, a quarterly publication of the Society of North American Goldsmiths. First appearing in the fall of 1980, *Metalsmith* grew out of the earlier *Goldsmiths Journal* but had a professional editor and designer. Like *American Craft*, it was conceived as a members' benefit, with the primary goal of disseminating information.

THE NEW JEWELRY IN THE UNITED STATES

If a single influence dominated the field in the 1980s, it was the "New Jewelry." This was a loose grouping of English, Dutch, and German avant-garde work. It was roundly criticized but taken up by some Americans who enjoyed its theatricality. The New Jewelry was in some respects a modernist project. For decades artists and critics had been reducing painting and sculpture to fundamental properties in an intellectual and rather controversial process. Clement Greenberg had declared that the essence of painting was flatness; now jewelers looked for the essence of jewelry.

Their conclusion was simple: jewelry is attached to the human body or its surrogate, clothing. As definitions go, this ignores all the social and personal aspects of jewelry, but it is true for all jewelry in all cultures in all periods. The definition says nothing about material, size, or placement of jewelry on the body. From the point of view of a young jeweler eager to defy convention, it was a recipe for unfettered experimentation. The most radical jewelers decided that it did not even have to be worn; it could simply be *about* jewelry.

The bad boy of the New Jewelry was Pierre Degen, a Swiss man working in London. When he saw a chimney sweep carrying a ladder, he wondered if that scale might fall within the range of jewelry. So he made a series of flimsy ladderlike objects that were carried over the shoulder. Was it jewelry? Degen didn't care. He was posing a question, not answering it. Such work was introduced to the United States in the American Craft Museum's exhibition *New Departures in British Jewelry* in 1983 and by extensive coverage of the collection of an adventurous New York couple, Malcolm and Sue Knapp.[83] Needless to say, reaction was not uniformly positive. Still, in an intellectual environment that had accepted conceptual art, the notion of unwearable jewelry should have come as no surprise.

Despite the previous American engagement with body jewelry and nonprecious materials, the New Jewelry hit American jewelers — most of whom were preoccupied with making sculpture-craft hybrids — like a bombshell. Some dismissed it out of hand as bad sculpture or failed high-fashion clothing. Some thought that Americans like Arline Fisch had already covered the same ground. Some followed it with great interest. Several took up the challenge and participated in the movement themselves. One — **Marjorie Schick** — had been making a homegrown equivalent for more than a decade.

Schick (b. 1941) had been a student of Alma Eikerman's and had absorbed her teachings about formalism — art as a vehicle for exploring line, shape, mass, void, and color. In graduate school, Schick worked exclusively in metal, but the year after she graduated in 1966 she started experimenting with papier-mâché. She made a chicken-wire or window-screen skeleton and built up hollow forms, completing them by applying acrylic paints. Papier-mâché jewelry was unconventional, and it was rejected by most of the exhibitions she entered. (The metal objects she continued to make tended to be accepted.) Schick persisted. By the mid-1970s she was working on the scale of the whole body — shoulders to floor. She collaborated with a company of student dancers, who wore her body jewelry and responded to her formal language with their own improvised movements.

By 1975 Schick tired of papier-mâché. She explored other untraditional mediums: paper, plastics, ceramics, foam rubber, even string mops. About 1981 she produced a series of large jewelry pieces in wooden dowels painted

FIGURE 10.67. *Marjorie Schick, Collar, 1988. Painted wood; 25.75 × 31 × 6 in. (Museum of Arts and Design, New York, Gift of Dr. James B. M. Schick, Robert M. Schick, and Mrs. Eleanor Krask, 1993.* © *Marjorie Schick. Photograph by John Bigelow Taylor, 2008.)*

in bright colors. The combination of large scale, densely packed lines, and exuberant hue was instantly validated—not in America but in Europe. The New Jewelry was stirring, and Schick was accepted into one of the first international surveys of the movement (*Jewellery Redefined*, at the Crafts Center in London, October 1982). The most avant-garde jewelry gallery in the Netherlands offered her a solo show the next year, and Schick was recognized as one of the leading practitioners in the movement. Her success in Europe caused Americans to reevaluate her work.

Schick always thought of her large jewelry as formalist compositions, much like sculpture, but she insisted that they remain wearable, for the uniqueness of the experience. She said that wearing her jewelry "makes you reconsider how you move in space—how others see you—because it takes a great deal of nerve to wear such a large piece. And then there's the weight of it and you can't move through a doorway maybe. You might have to turn to get through the door. Obviously you couldn't put a coat on over most of these pieces. You couldn't . . . get into the car with a lot of them on, so that means you've got to carry it with you and then put it on when you get there."[84]

Schick tries on each piece and often recruits her students to do the same. She notes that not all jewelry is worn everyday; some is only for special occasions. (A soldier's medals are one example; a bishop's regalia another.) The largest of her body sculptures are used chiefly in dance performances. Her *Collar* (1988) shows why: it is thirty-one inches wide and six inches deep. (Figure 10.67) Her colors are bright and her forms hyperactive. Like the Europeans, she was pushing the limits; her work is hypothetical rather than practical. In wondering what jewelry can be, Schick invites viewers to participate in her delightful acts of imagination.

Another American jeweler who was inspired by the New Jewelry was **Hiroko Sato Pijanowski** (b. 1942). Between 1985 and 1988 Pijanowski made a series of large wearables out of traditional Japanese paper string, called *mizuhiki*. Gluing the *mizuhiki* side by side to build up planes, she constructed oversize collars two feet across or even bigger. Because she used *mizuhiki* that had been wrapped with thin metal foil, her jewelry had the sheen of polished silver and gold. (She satirized the fact with the title *Oh! I Am Precious!*) By the early 1990s, though, Pijanowski had moved on to other interests.

Students loved the New Jewelry. In the era of punk and new wave, it seemed to perfectly express a spirit of ebullient rebellion. As a bonus, it did not demand a lot of difficult craftsmanship: a hot-glue gun and a can of spray paint could suffice. Teachers, understandably, were sometimes ambivalent. In the end, the New Jewelry reinforced the pluralism already present in American jewelry, adding to the range of options.

LISA GRALNICK

One of the first jewelers to think like a contemporary sculptor was Lisa Gralnick (b. 1956). Educated as an enamelist at Kent State University and the State University of New York, New Paltz, she soon chafed at conventional approaches. In order to be worn, enamels, like stones, are mounted on something else, something that protects it and offers an attachment. Furthermore, enamel is inherently pretty. Finding both properties confining, she gave up enameling by the mid-1980s.

One day Gralnick came across a house that had been sheathed in black rubber by its eccentric owner. The industrial rubber, entirely inappropriate for a residence, rendered the house rather mysterious. What if jewelry were similarly sheathed in black? Instead of coating a metal form with a black finish, she made it out of a black material: acrylic sheet. (Figure 10.68) By shaping the plastic and gluing parts together, she made four- or five-inch brooches that remained lightweight and thus comfortably wearable. She settled into a vocabulary of geometric shapes that recalled machines and architecture but could be read as pure abstraction. They were ambiguous, richly allusive, but impossible to pin down to a single reference, even as they were vaguely menacing. For instance, they have some of the same visual qualities as handguns, surely a disturbing association for jewelry.

The unrelieved black was radically unconventional. Still, there were elements of beauty. Gralnick contrasted mat surfaces to polished ones or inserted bits of gold in holes. The forms were impeccably fabricated, the glue joints so tight that they were virtually invisible. The fine craftsmanship adds a sense of care to the emotional tone of the works, counterbalancing their darkness.

In the 1980s sculptors such as Martin Puryear and Richard Deacon showed a new interest in the associations stimulated by odd materials and indeterminate forms. Gralnick's black jewelry signaled a similar fascination with ambiguity and materials once excluded from the realm of ornament. In time an entire generation of college-trained jewelers would adopt this attitude toward material and form.

In other series Gralnick selected her materials carefully, fully attentive to their meanings. In one, she inserted glass ampoules filled with substances such as water and salt that are associated with bodily functions.

FIGURE 10.68. *Lisa Gralnick*, Three Brooches, *1988. Black acrylic; group of three, 9 × 6 × 0.75 in. (Courtesy of the Artist. Photograph by George Erml.)*

FIGURE 10.69. *Joyce Scott*, What You Mean Jungle Music?, *1987. Beadwork and mixed media; 11 × 8 in. (© Joyce Scott.)*

In another, she folded thin gold into complex geometries relating to her understanding of musical composition. In time, Gralnick became almost the poet laureate of American jewelers.

JOYCE SCOTT

Joyce Scott (b. 1948) came to jewelry as both an artist and an African American woman. She had no formal jewelry training and subscribed to none of the usual assumptions. Issues of craftsmanship, utility, scale, and preciousness meant nothing to her. In addition to her jewelry, Scott makes sculptures large and small, weavings, quilts, and clothing. She also performs. She regards her jewelry as continuous with everything else she does, not an isolated practice with distinct characteristics. In that sense she is unlike most studio jewelers in this book.

Her mother, Elizabeth Talford Scott (b. 1916), a well-known quiltmaker, taught her to work beads when she was five or six, and she has been making beaded jewelry professionally since she was sixteen. Glass beads were introduced into Africa several hundred years ago as a

medium of trade. In an irony not lost on Scott, one of the commodities purchased with beads was slaves. In the twentieth century West African peoples have used glass beads to fashion intricate ornaments and ritual objects. Yet in the United States, beadwork is associated with tourist souvenirs and summer-camp projects, a patina of kitsch that is difficult to escape. Beadwork contains elements of pride and degradation, of high and low.

Scott's jewelry plunges into difficult issues such as violence, sexism, and racism. In her necklace *What You Mean, Jungle Music?* (1987), she takes on the racial prejudice that greeted rock 'n' roll in the 1950s and hip-hop more recently. (Figure 10.69) She criticizes the way black music is exploited by white business interests and white kids embrace rock and hip-hop although many whites demonize the culture that produced it. The beaded necklace is a collage of images: white kids dancing, Chuck Berry, the rapper Darryl McDaniels of Run-DMC, a scrap of sheet music, an orange head grimacing in dismay, a black head singing. It even incorporates photographs. The whole is tied together with rhythmic orange and

red lines, the visual equivalent of the driving beat of the music.[85]

What You Mean, Jungle Music? does not aspire to rigid neatness and precision. Instead the necklace has a wobbly, improvisatory quality that imbues it with energy. It is big—eleven inches from top to bottom—and Scott simply notes that it takes an assertive person to wear her jewelry. In the 1990s she made a series of mixed-medium figures, often dealing directly with tough issues of race relations. One of her most notorious was *Cuddly Black Dick #3*, which depicts a prim white woman seated on a chair, embracing an overlarge black penis. The rest of the man is missing. The image is shocking and harshly critical of racial stereotyping, but its raucous humor underlines our common humanity.

ROBERT EBENDORF

Robert Ebendorf (b. 1938) is the chameleon of American jewelry. He has never committed to a single style but explores whatever interests him most. Ebendorf followed the typical academic track in the late 1950s, earning BFA and MFA degrees at the University of Kansas and then making the familiar pilgrimage to Scandinavia, in his case to Norway. His early work was competent but not cutting-edge.

Dissatisfied with high polish and slick forms, Ebendorf sought a way to make himself uncomfortable as an artist. He turned to a collection of secondhand curios he had accumulated. His earliest found-object works, assemblages, were made in 1967. By 1971 he made brooches incorporating sepia-toned photographs and old instrument panels fastened together in simple copper-and-brass constructions. Ebendorf had become a collage artist, cutting and pasting three-dimensional objects into wearable jewelry.

Compared with J. Fred Woell's earlier found-object jewelry, Ebendorf's are apolitical. They are more about drawing formal relationships between parts and giving neglected stuff a new life as adornment. (Ebendorf says he did not know about Woell's work until the two met in 1970.) In the early 1980s, he collaborated with photographer François Deschamps to make trompe l'oeil collages of brooches, photos, and found objects in which reality and illusion constantly trade places. The mid-1980s saw him working with his then-wife, Ivy Ross, on jewelry made of ColorCore laminate.

A found-object necklace from 1988 is widely acknowledged to be one of his best. (Figure 10.70) It is composed of thirteen beads, each about two inches in diameter. Each has been encrusted with one or two oddities such as Chinese newspapers, old photographs

FIGURE 10.70. *Robert W. Ebendorf*, Necklace, ca. 1988. Mixed media, including Styrofoam, ColorCore, auto body putty, slate, bones, 1930s glass, tantalum, photographs, Christmas wrap, Chinese newspaper; 24-karat gold foil, colored glass, stones, seashells, rubber, hammered copper ends, plastic beads; 2 × 11.25 in. (Museum of Fine Arts, Boston, The Daphne Farago Collection, 2006.139. Art © Robert W. Ebendorf. Photograph © 2008 Museum of Fine Arts, Boston.)

trimmed down to just the eyes and nose, fragments of seashells mixed with beach stones, and antique glass. The beads vary in size somewhat, and the depth of texture changes as well. The whole is like a symphony of once-worthless materials, brought into visual counterpoint. There are odd correspondences, too: the rectangular blue glass bits are the same size and shape as the gray stones three beads to the right and similar to the fake gems glued onto another bead at the top. Formal connections crisscross from one bead to another in an endless game of mix and match.

Ebendorf has used fragments of text in many of his works. In a perceptive 1989 essay, Vanessa Lynn pointed out that he is severely dyslexic, which makes the written word something of a foreign territory to him.[86] His compensation was to become acutely visual and deeply sensitive to formal relationships. He often uses text as a kind of background, like wallpaper. In the bead necklace he uses fragments of Chinese, as if reminding the viewer what it is to experience the written word as something indecipherable and mysterious.

For a long time Ebendorf claimed that he used found objects only for their visual qualities. When his marriage collapsed in the early 1990s, he found himself drawn to severed fragments of dead animals: bird beaks, squirrel paws, crab claws. Images of death and aggression, they seemed to speak for his wounded psyche. From these grisly bits he made a series of pendants he called Lost Souls. One of them, a loose bundle of crab and lobster claws, speaks of death yet also power. Imagine meeting someone wearing the crab necklace—you might be repulsed, but you would never forget.

MARY LEE HU

While it may seem logical to align utility and conservatism, in the crafts such a correspondence has never been accurate. A case in point is the jewelry of Mary Lee Hu (b. 1943). Hu concentrated on making jewelry from wire, beginning in her graduate student days, in 1966 (several years before Arline Fisch took it up). She took a weaving class and studied macramé, but instead of using fibrous materials, she tried wire. She quickly found that knotting made the wire too hard to manipulate, and wrapping one wire around another was better. Basketry techniques allowed her to build large, light forms.

Since Hu never enjoyed soldering or buffing metal, wire was an ideal medium. She worked directly with her fingers: "I don't separate myself from my material with a lot of tools. . . . I'm working from one end of the piece to the other, doing all the work on it [at once]. When I move from it, it's finished completely. It's the way a weaver works, not the way a metalsmith works."[87]

In a particularly fine series from 1976, Hu amassed silver wire like hair. One neckpiece has a cascade of silver wire descending the wearer's torso in undulating lines reminiscent of the art nouveau whiplash. Only two years later she was weaving colored copper wire into metal fabrics that she would bend into curves resembling a ribbon. Always her work was marked by ceaseless experimentation.

In 1985 Hu began to work entirely in gold wire. A scholar of historical jewelry, she wanted to draw a connection with adornment from Grecian, Egyptian, and Celtic cultures. Meticulous craftsmanship was one way to do so, the lustrous yellow color of high-karat gold another. This conscious linkage with history, more typical of ceramists and weavers than jewelers, underlines her contribution to the lineage of ornament.

Since she used gold in inventive ways, Hu was not worried that its symbolism of wealth and power would outweigh her artistic accomplishment. If anything, she hoped people would see gold anew. All Hu's jewelry is

FIGURE 10.71. *Mary Lee Hu,* Choker #70, *1985. 18-karat and 22-karat gold, woven; 9.5 × 6 × 3 in. (Collection of The Metropolitan Museum of Art. Courtesy of Mary Lee Hu. Photograph by Richard Nicol.)*

easy to wear. Her necklaces conform to the body and are light enough to be worn for hours without discomfort. They are not designed to be used every day, but they fit within the rhythms of ordinary life.

Choker #70 shows how Hu used woven gold in the mid-1980s. (Figure 10.71) She discovered a way to weave *X* shapes by setting up a weft made from *L*-shaped wires, which made a diamond-shaped pattern of voids if joined side by side. She soldered twenty-two units into a collar, which she terminated with flat wire at the top and bottom edges. The geometric form implies rigidity, yet the woven structure implies softness and mutes reflections, complicating the play of golden light and shadow on the choker.

ROBERT LEE MORRIS

While college programs pumped out a constant supply of new studio jewelers, the field continued to attract a stream of outsiders with no formal education in the craft. One of the most talented was Robert Lee Morris (b. 1947).

Morris had taken undergraduate sculpture classes at Beloit College in Wisconsin, where his teacher welded some jewelry on the side; the immediacy of the process impressed him. Morris tried setting himself up as a jeweler in a commune in Wisconsin—which burned down— and later in Vermont. In 1971 he worked for Sculpture to Wear, a jewelry gallery in New York that concentrated on artist-designed jewelry by the likes of Pablo Picasso, Louise Nevelson, and Roy Lichtenstein. Again Morris was inspired, this time by seeing how different artistic styles could be incorporated into wearable objects. When

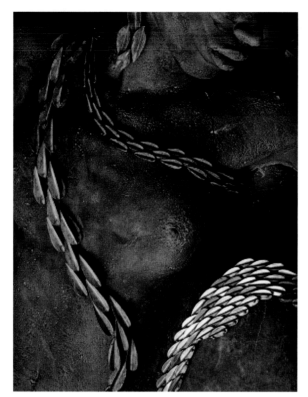

FIGURE 10.72. *Robert Lee Morris, large dart belt, small dart necklace, four dart cluster earrings, double dart earrings, and small dart cowel necklace on black plaster cast, ca. 1985. (Artwear catalog, 1985, p. 5. Photograph by Klaus Laubmayer.)*

Sculpture to Wear closed in 1977, he set up his own outlet. Artwear was one of the few New York venues dedicated to bold, experimental jewelry, and Morris attracted a following. He also enjoyed the attention of fashion magazine editors, who asked him to send his jewelry out for shoots. Soon Robert Lee Morris jewelry was on the covers of *Vogue, Harper's Bazaar, Elle,* and other prominent fashion magazines. In time he would work with such designers as Calvin Klein, Karl Lagerfeld, Geoffrey Beene, and, above all, Donna Karan.

Fashion editors found Morris's jewelry ideal for photographs because of its size, simplicity, and satiny surfaces. Until the late 1970s, costume jewelry was usually small and safe. (The exceptions tended to be tastelessly encrusted with cheap stones.) Moreover, the industry had ignored the modernist tendency toward simplicity and inventive forms, preferring historicism. Morris offered a fresh alternative. Working solo in his studio, he made prototypes and then found dozens of permutations for every shape. For instance, a circular form with the center pushed out in a soft belly, made large, could wrap around the wrist as a bracelet; repeated on medium scale and linked together, it became a necklace; made small, in ones and twos, it became an earring. Adding drops,

spears, crescents, saddles, beads, crosses, and dozens of other shapes, Morris developed a distinctive vocabulary of forms. (Figure 10.72)

Morris had a great eye for presentation. He constantly changed the displays in his store. To give a feeling of how his jewelry looked when worn, he made a standard fixture of a plaster cast of a nude woman's torso. Substituting for the familiar department-store mannequin, the torso was ideal for displaying necklaces, belts, and scarves and was widely copied. Morris brought his sense of visual drama to images produced with photographer Klaus Laubmayer. In one memorable series, the models are caked with black mud; in another, they roll in flour. To Morris, life is theater, and jewelry is a vital prop.[88]

Through the 1980s and 1990s, Morris built a multimillion-dollar business. His designs remained rooted in the studio, even though they were mass-produced. In time, though, he took on so many clients that he compromised his work. One of his customers was Warner Bros., and Morris was reduced to churning out Superman rings and Bugs Bunny pendants—hardly the transformative jewelry he once envisioned.

METALSMITHING

Ambitious young jewelers and metalsmiths wanted to make sculpture. Most had MFAS, had spent time in the art school environment, and compared themselves with their colleagues in painting and sculpture. Many had begun to teach and had no immediate need to make a living from their craft. As faculty, they were expected to produce and exhibit new work. The highest value in the art academy was innovation, not service to a clientele.

These young professionals within the academy saw two options: jewelry or sculpture. Sculpture could be based on traditional processes and materials. The trend was already established in ceramics and textiles. Yet while widely exhibited throughout the decade, metalsmithing-as-sculpture was not well received among more conservative members of the community. A schism developed between the production community and the academic community, with the bitter dispute occasionally framed in sexualized terms: when some production jewelers accused the academic community of masturbation, production jewelers in return were accused of prostitution.[89]

METALSMITHS MAKING SCULPTURE

In the early 1980s manufacturers were making limp revival styles, and although a few silversmiths survived, few students were inspired to follow them. Many turned to sculpture, but what they made bore little resemblance

FIGURE 10.73. *Randy Long*, Vessel for a Magician, *1983.*
Sterling silver, nickel silver; 6 × 7 × 6 in. (© Randy Long.)

FIGURE 10.74. *Carol Kumata*, Stone Setting, *1980. Steel,*
sterling silver, copper, brass, straw, stone; 3.5 × 7 × 7 in.
(Courtesy of Carol Kumata.)

to the sculpture in art magazines and major exhibitions. This disjunction—shared with all other craft mediums—tempted some observers, such as art critic John Bentley Mays in 1985, to categorically dismiss all sculpture made by craftspeople. He believed that good art is primarily critical, a virtue he failed to find in craft-as-art.[90] While it may not have been critical of the wider culture, though, metalsmithing-as-sculpture had its own characteristics, which some observers, partial to the craft project, saw as an alternative to mainstream sculpture practice.

Because metalsmithing springs from the tools, techniques, and materials traditional to the craft, sculptures produced within the field were usually modest in size, which made it easy for viewers to enter into a relaxed and intimate experience, free of intimidation. Metalsmiths often added details to their sculptures that rewarded close and sustained looking. In some pieces beautiful craftsmanship itself became part of the content.

John Prip had been experimenting with sculpture since the 1960s, and blacksmiths like Paley and Kington made sculptures as well. Still, some of first sculptures to reflect the sensibility of a trained silversmith were made by **Randy Long** (b. 1951), who admired the nonfunctional object-sculptures of ceramists Ron Nagle and Richard Shaw. In the early 1980s Long worked with bent sheet-metal forms such as cones, avoiding the bowl-like shapes typical of raising. She also exploited the strength of silver-soldered joints, which allowed her to join two parts together by a single point. It was possible to make a form look like it was balancing on its corner, violating all visual logic.

Long's *Vessel for a Magician* (1983) is only six inches tall and made mostly of silver, with some added nickel silver. (Figure 10.73) The dominating form is a cone that has been slightly flattened, forcing its upper edge into a curve

trimmed with a two-color twisted wire. The cone bears a decoration of gray dots. Both the wire edging and dot pattern are jewelry techniques. Where *Vessel for a Magician* departs from tradition is in its improbable relationship of forms. The cone is attached to the supporting rectangle by a single point, as if about to levitate. (Long was imagining the cone as a magician's hat, with the suggestion that a rabbit or dove would appear momentarily.) A ring and a sphere appear to be equally unsettled, the whole held in precarious suspended animation. Neither the narrative nor the tenuous connection would have been thinkable twenty years earlier. Long retains the impeccable craftsmanship of Scandinavian modern; *Vessel for a Magician* is emphatically a piece of silversmithing, with the ancient craft applied to an entirely new purpose.

Carol Kumata's *Stone Setting* (1980) shows how the same skills might look if the Scandinavian aesthetic were discarded. (Figure 10.74) A vestige of traditional form remains: the sculpture is a box, but here it is a metaphor, not a container. A single strip of metal has been given a bright finish but not polished. Other surfaces are patinated, mostly in rich, dark colors. And the symbolic heart of the piece is not metal at all but a river rock.

Kumata (b. 1949) is a third-generation Japanese American. She spent only one year in Japan, but she was familiar with the ceramics, kimonos, and fans her mother kept in their home. Whether or not she was influenced by her cultural background, Kumata was exquisitely sensitive to the character of materials. Every substance has intrinsic qualities as well as learned associations (we all connect steel with toughness and protection). Materials can acquire personal meanings, too, especially from childhood memories. To Kumata, making a sculpture was about orchestrating associations as much as composing a form, perhaps more so.

Stone Setting depicts a speckled rock in a box of flexible material—paper, perhaps—in the process of being opened by some unseen hand. The box itself is rigid steel, colored dark gray. Each succeeding layer appears to be more like paper or fabric—a carefully managed illusion, since each one is metal. The presentation seems ceremonial, as if the stone were extraordinarily precious and the viewer had interrupted a ritual. Each layer is lovingly crafted, including a deep red copper surface that has been enriched with a flamelike pattern in silver. The stone, lightly carved and tied in raffia, is a symbol for the self, the representation of—what? Emergence? Suffocation within the boundaries imposed by culture? The transcendent potential of the ordinary? The lack of resolution is precisely what gives the sculpture its power. *Stone Setting* is an enigma, a story without an ending.

Kumata retained some of the traditions of metalsmithing: careful workmanship and a thorough respect for her material. She affectionately toyed with the lingo of her craft in the pun of the title. She turned away from function, however. Her goal was to communicate something personal. Much of her work was intended to be serene and contemplative, and yet a certain anxiety lurks under the calm. (The stone is tightly bound.) Kumata admitted that her sculpture was confessional: a poetic self-portrait of a woman struggling with her own uncertainties.

At the same time, other young artists, smart and unsentimental, dispensed with the deeply personal and became shrewd observers and critics, holding everything at an ironic distance. One of the first truly postmodern metalsmiths was **Lisa Norton** (b. 1962). Under the guidance of Gary Griffin at Cranbrook, she read French poststructuralist theorists like Roland Barthes and Jacques Derrida and set a goal of realizing some of those insights in sculpture rooted in the practices of metalsmithing.

There are many kinds of metalsmithing, not just the lineage of modern studio smithing and jewelry. There are trades and industrial practices and non-Western traditions as well. Norton discovered the neglected history of popular tradecraft that grew out of the manual arts movement. Old magazines like *Mechanix Illustrated* were full of how-to articles that usually opened with a motivational sentence, often linked to self-improvement, followed by measured drawings and a brief text detailing the assembly procedure. She made a series of sculptures using such projects as source texts.[91]

Useful Project with Sentimental Appeal (1987) looks like an oversize tin jug of some sort. (Figure 10.75) It appears useful until one realizes that it would hold three or four gallons of liquid and would be far too heavy to pour. It is a sculpture, not the useful object the title promises. Fur-

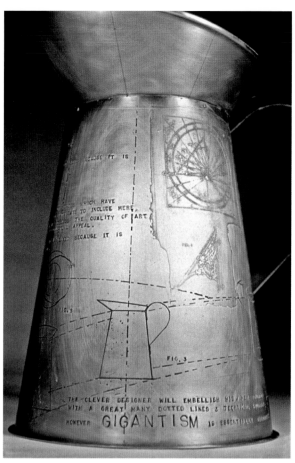

FIGURE 10.75. *Lisa Norton, Useful Project with Sentimental Appeal (detail), 1987. Bronze; 17 × 20 × 19 in. (Collection of Robert L. Pfannebecker. © Lisa Norton. Photograph by Lisa Norton.)*

ther undermining its practicality, the surface is covered with diagrams and ersatz instructions. Norton sought out texts from various sources, treating words as if they were found objects. Some speak in the voice of authority and others as a subjective response. One passage reads, "The clever designer will embellish his project with a great many dotted lines. . . . However gigantism is essential." Norton is mocking her design, which is large and covered with dotted lines. Knowing and sarcastic, *Useful Project* showed how postmodern theory might be applied to crafts.

Since the flat sheets of metal on which Norton diagrammed and lettered were just like printing plates, she pulled a few prints before she assembled the sculpture. Each piece then consisted of image (with lettering reversed) and object, each commenting on the other. It was intertextuality made tangible.

Norton's pioneering works opened the door for a new type of metalworking. Taking the craft as a subject and then manipulating information became a new modus operandi. The metalsmiths who were making personal,

expressionist sculptures found little market for their work, aside from a few museums. Eclipsed by younger smiths who worked in postmodern idioms, many turned back to jewelry. By the end of the 1990s the moment for small, finely crafted metalsmithing-as-sculpture was over.

GARY GRIFFIN

When metalsmith Gary Griffin (b. 1945) accepted a teaching position at Cranbrook in 1984, he walked into a hotbed of deconstructive theory. Chair of architecture Daniel Libeskind and cochairs of design Katherine and Michael McCoy were leading figures in the discourse about design as both semiotics and social practice, and they subjected their fields to a rigorous critique. In this environment Griffin was challenged to explain precisely how metalsmithing should maintain its own identity. One of the most urgent questions was how it was different from sculpture. If it was too similar, there was no reason to continue it as a separate discipline.

Griffin responded in word and deed. He had already produced a series of machined jewelry in the 1970s and another series of forged and constructed iron sculptures just prior to arriving at Cranbrook. He knew that technique alone could not provide the answer: metalsmiths and sculptors can both use the same processes. Griffin arrived at two lines of reasoning. First, he concluded that metalsmithing (and all craft) has a different history than sculpture and thus a different context. Second, the root of craft lies in service.

Because he was deeply involved in blacksmithing, Griffin thought in terms of the history of iron forging. The majority of historical blacksmithing is useful but far surpasses the requirements of utility. Iron fences might enclose, but they are usually decorated, too. Thus Griffin concluded that one of the factors separating craft from sculpture is ornament, often designed to carry complex meanings.

Griffin began making gates and fences to test his ideas and later expanded to other functional objects. *American Scroll* (1991) is a pair of steel, bronze, and wood benches. (Figure 10.76) Griffin's decorative program calls up associations with the rural life he knew growing up in Wichita Falls, Texas: plowshares, shafts of wheat, the dressy belts that cowboys sometimes wear. The round form conflates plow blades with the "Victoria Shank," a special spur created by a blacksmith in Texas. On one leg Griffin applied the word "Sowin'," on the other "Reap'n." The bench addresses the vast changes worked on the American prairie by farmers and ranchers, while simultaneously honoring the vernacular tradition of blacksmithing.

FIGURE 10.76. *Gary Griffin, American Scroll (detail), 1991. Steel, bronze, painted wood; 18 × 48 × 14 in. (Private Collection. © Gary Griffin. Photograph by Gary Griffin.)*

American Scroll is a meditation, an idea given tangible form. However, Griffin did not restrict himself to the world of ideas. When prospective clients approached him to make fences and gates for their properties, he accepted; a culminating commission was the large entrance gate to the Cranbrook community in 1999. It was important to Griffin that his work be used in the real world because service is crucial to his concept of craft. (The term "service" suggests a wider range of possibilities than "function," since it implies psychological and social uses as well as physical utility.) If craft serves clients or the public, it must somehow reflect their interests. The maker must put his or her personal agenda aside and reach out to another. Without actual use, the gesture is hollow.

Griffin gave up making sculpture and declined to expand the scale of his blacksmithing beyond the bounds of utility. His decision was made on principle, and he stuck to it. Griffin's career contrasts with that of his fellow blacksmith Albert Paley, who eventually turned away from service objects to make ever-larger sculptures.

ENAMELING

In the 1980s there was an enormous growth in the quantity of enameling. At one point a gallery in New York sold enamels exclusively. The bulk of American enamelists followed one of two courses. Some imitated painting, hoping to impress with transparency or another seductive enamel effect. Everybody else—save a few rugged individualists like June Schwarcz—had to deal with the model of William Harper. Most could not resist his formula for jewel-like enamels and ritualistic objects.

At the beginning of the decade Harper was the premier American enamelist, approaching a star status like that of Voulkos, Castle, and Chihuly. He had reoriented enameling from murals to jewelry. He showed his work in prestigious New York galleries and in major shows around the world.

The most persuasive response came from **Jamie Bennett** (b. 1948). Bennett had struggled to master enameling as a college student, and not until he took a summer course with Harper at the Penland School of Crafts did he begin to understand the medium. He then made some basic choices about enamels that he has stuck with for more than thirty years. First, he rejected the luxuriant depths of transparency and used only opaque colors, plain and unglamorous. Second, he eliminated found objects and other extraneous details. He asked people to look at his enamels and very little else. His works offer a more subtle beauty than Harper's. They are more restrained and sober and perhaps not as immediate in their appeal.

Bennett's early enamels were usually jewelry or small plaques and often related to imagery of animal hides or dressmaker's patterns. (His mother was a clothing designer, and he was always interested in the way fragments of cloth became garments.) His compositions wavered between representation and abstraction. Often his enamels were framed in a silver bezel. In these respects, they resembled paintings. The effects he created were always flat, however, and the constructions were relatively flat as well.

About 1985 Bennett began to cut his enamels into fragments and reassemble them in open, somewhat chaotic arrangements. He thought of the fragments as tiles; he was influenced by mosaics that he had seen in Italy. Freed of having an object consist of a single enamel, he was able to contrast very different surface effects. In lively, open compositions of fragments, such as *Palermo* (1985), one segment might be a pebbly monochrome, another might have a smooth mat finish, and another might be simply painted. (Figure 10.77) The juxtaposition of surface, color, and enameling techniques was entirely new

to the medium, although mixing was a familiar device in other arts.

Still Bennett thought they were too closely tied to the picture plane, too close to the potential for illusion inherent in painting. To him, jewelry is an *object*, not a plane, and he wanted his enamels to be more fully three-dimensional. He turned to copper electroforming and was able to find a way to keep it from becoming too soft once the enamel was fired. He could enamel fully in the round.[92]

Bennett's first enamels on electroforms were like highly colored stalks, sometimes with gold leaves or pods attached. His Rocaille series, from 1992, was more complex in form, recalling the decorative flourishes of rococo buildings and the fecundity of plant growth that historically inspired those features. It got him thinking about the ancient connection between ornament and beauty. After several decades of unmitigated self-expression, Bennett and many other American jewelers began to look back to the ancient purposes of jewelry, a subject that became crucial in the 1990s.

One of the enamelists to embrace a certain dark beauty was **Rebekah Laskin** (b. 1955). She learned the basics of enameling from Bennett at Penland and picked up some of his artistic sensibility as well. Like him, she used opaque enamels, preferring severity over the lushness of transparent enamels. She did not, however, want to make objects. Her approach may be a throwback to the 1950s focus on enamel painting, but she had no interest in plaques and worked small. Generally she made rectangu-

FIGURE 10.77. *Jamie Bennett, "Palermo" Brooch, Coloratura Series, 1985. Silver, enamel, copper; 1.12 × 4.25 × 0.25 in. (The Museum of Fine Arts, Houston, Helen Williams Drutt Collection, Gift of the Caroline Wiess Law Foundation, 2002.3623. © Jamie Bennett.)*

FIGURE 10.78. *Rebekah Laskin, Rectangular Brooch, 1984. Enamel on copper, sterling silver; 2.7 × 2.2 × .5 in. (The Renwick Gallery of the Smithsonian American Art Museum, Gift of Aaron Faber Gallery, Carl Pforzheimer III, and Kenneth R. Trapp, 1998.22. © Rebekah Laskin.)*

lar brooches no more than 2½ inches on a side. (Figure 10.78) She cited painters Robert Motherwell and Helen Frankenthaler as inspirations, although her own works were moodier and more atmospheric and layered. Often a single geometric slot or opening appeared, setting up a sharp contrast to the surface. Instead of cloisonné lines, Laskin overpainted lines and textures, adding to the density of her compositions.

Like many jewelers, Laskin insists that her pieces are not miniature paintings but full-size enamels. The intimacy of wearing and seeing jewelry offers a different experience than seeing a painting on a wall, and she wanted to cultivate this closeness.

Craft Institutions

In the 1980s the postwar craft revival matured. Many medium-based magazines appeared. Craft books, once focused mostly on technique, shifted their emphasis to images of objects. In the 1980s woodworking was the subject of one of these books, Michael A. Stone's *Contemporary American Woodworkers* (1986), and studio glass was another with Susanne K. Frantz's *Contemporary Glass: A World Survey from the Corning Museum of Glass* (1989).

Every young craftsperson who wanted to get ahead had to learn how to take great thirty-five-millimeter slides or

hire a professional to so. Craftspeople who sold at fairs had to be able to process credit cards to stay competitive. Business relationships, once sealed with a handshake, were formalized with contracts. What was once informal and subversive became codified and regulated.

The boom years that began in the 1970s continued unabated for craft fairs. In general the crafts on display at top-level fairs were well designed and well made, to some degree with the market in mind. In 1980 the gross sales at the Rhinebeck Fair, sponsored by the American Craft Council (ACC), was about $4.5 million. (The first ACC fair, in 1965, grossed $18,000.) More than 50,000 people attended that year. Responding to the trend, craft fairs proliferated. Companies like the Wendy Rosen Group operated fairs as commercial ventures, while nonprofit groups like the Women's Committee of the Philadelphia Museum of Art organized fairs that became major income producers. In 1984, however, the ACC made a huge blunder when it moved the Rhinebeck fair to West Springfield, Massachusetts, much farther from its home market in New York City. Sales dropped by half that year.

In 1986 the American Craft Museum opened a brand-new and larger condominium exhibition space, three levels including street exposure, in a high-rise office building on Fifty-third Street, across from the Museum of Modern Art. Paul Smith retired from the directorship a year later, when the museum was settled in the space.

Galleries continued to expand in the 1980s, and their business was conducted more and more like that of art galleries. Unfortunately, the experiment of Chicago's Exhibit A with exclusive representation and high prices was not successful, and the gallery closed by 1984. Still, other galleries paid attention. Prices for major pieces of studio glass rose steadily, until glass could consistently command the highest prices among the crafts.

The growth of the gallery business stimulated the first of the craft expositions, the Chicago International New Art Forms Exposition (CINAFE) in 1986. Only galleries could participate. Collectors could go to CINAFE with the knowledge that the work on display had passed the qualitative judgment of a gallery owner. The more astute dealers could represent a consistently interesting stable of craftspeople to attract the attention of the most sophisticated collectors. There were two side effects, though. Functional craft tended to be underrepresented, as the priciest pieces were usually more sculptural than useful. The high costs of participating made dealers cautious. They tended to bring works they were confident would sell, leaving more experimental works at home.

A niche market opened to craftspeople in the 1980s:

architectural commissions. More and more governments enacted percent-for-art laws for public buildings, generating a substantial demand for appropriate works. Large scale was encouraged. Fiber artists and blacksmiths benefited most, since they could increase the size of their work most easily. In 1985 Toni Sikes founded the Guild as a publisher of sourcebooks to help interior designers, architects, and other design professionals locate artists for commissions.

In step with the growth of galleries and expositions, craft-collector groups began to form. The first was associated with the Cleveland Museum's annual May Show. Members could see the show before it opened and make purchases before the masses were allowed in. On a national scale the American Craft Museum organized a three-day Collector's Weekend in 1982. Attendees went on museum tours, heard panel discussions and individual artist talks, and concluded with cocktails at Jack Lenor Larsen's New York loft. It must have been a hit, for the museum formed a Collector's Circle in 1985. In the next decade groups formed for some individual craft mediums.

Collector's groups had the effect of turning collecting from a solitary pursuit into a social occasion. Members became friends, and a good part of the fun was reconnecting with old acquaintances. One of the favorite events was to visit various collectors' homes, where owners could show off their treasures and visitors could see how they measured up. Another favorite was visits to studios, fairs, and expositions. The groups fostered a keeping-up-with-the-Joneses mentality, and competitive shopping became part of the thrill. At the same time some collectors liked to brag about how little they paid. Many started to demand discounts for every purchase.

A certain venality crept into collecting, much to the distress of gallery owners and artists. It was also in the high-rolling 1980s that the secondary market began to grow, and auction sales of contemporary craft followed.

In Short

Throughout the 1980s the crafts became increasingly commercialized. Galleries specializing in high-end crafts proliferated. The first craft exposition opened in Chicago, and fairs became profit centers for both organizers and exhibitors. Because shows were dependent on photography for entrance procedures and publicity, craft that photographed well sold well. Glass sold for the highest prices, while fiber benefited from the expanding of architectural commissions.

Medium-based magazines appeared, along with substantial numbers of object-centered books. Craftspeople attended single-medium conferences, sometimes contributing to sophisticated discussions about the nature of craft. The most perplexing subject was the relationship between craft and art. The bright, decorative style of Memphis influenced woodworking, jewelry, and perhaps ceramics. Postmodernists interpreted all fields as texts or languages, which reinforced the tendency of young craftspeople to treat objects as texts and history as a vast library of source material. The vessel format was a popular vehicle in all mediums, even (as basketry) in textiles, but no single style or philosophy dominated. Geometric abstraction, personal narrative, and musings on the nature of decoration could be found in every medium. And in furniture, there was even a return to eighteenth- and nineteenth-century forms.

CHAPTER 11 1990-1999

MASTERY AS MEANING

Got It Made

The 1990s seem to lack a personality—perhaps because they are still too close or perhaps because they really did. There was the negative of the Persian Gulf War, a recession, a succession of scandals associated with the Clinton presidency. But the recession turned to a boom and a balanced budget. The country was going virtual and electronic—cell phones in every hand, e-mail burgeoning. DVDs and flat-screen televisions brought a new vividness to home entertainment, while videos dominated cutting-edge art exhibitions, and Web-based artworks began.

And so the United States approached the end of the twentieth century. It was a very different nation than it had been in 1900. After the collapse of the Soviet Union, the United States stood as the most powerful and influential nation in the world. Over the century, the population nearly quadrupled, to 281 million, many of them immigrants. In 2000 one in every ten people living in the nation was born abroad. More Americans lived in suburbs than in either cities or rural areas. The nation, with less than one-twentieth of the world's people, consumed about a quarter of the world's energy each year.

The "Year of American Craft" in 1993 featured a White House Collection of American Craft, selected by Renwick Gallery director Michael Monroe. The first wave of postwar craftspeople, now retiring from teaching posts but continuing to create work, could credit themselves with success: craft was in galleries and museums, and institutions and markets were established. After decades in which old skills were recovered, options from other cultures were embraced, and new technologies were adapted, mastery of technique was a striking reality in every medium. In some cases, it meant that showy but inconsequential work proliferated. While some craftspeople saw the positive in this emphasis on virtuosity—that concentrated engagement in skilled tasks had a meaning in itself, satisfying human instincts for mastery and embellishment—it brought the field to a self-conscious reevaluation: change is a constant, and the shifting context was bound to present new questions.

1990
 Price of a first-class postage stamp: 25¢
 Average hourly wage: $10.78
 World Wide Web debuts
 The art market deflates, led by a decline in
 auction prices
1990–91
 Persian Gulf War
1991
 Soviet Union breaks up
1993
 The Food Network begins broadcasting
 World Trade Center in New York bombed
1995
 Truck bomb blows up Oklahoma City Federal
 Building
1997
 Hong Kong returns to Chinese rule
1998
 Federal budget balanced for first time in 30 years
1999
 World population reaches 6 billion
 Tobacco companies admit that cigarette smoking
 is harmful

Craft Institutions

By the late 1980s, the American Craft Council (ACC) had been losing money for several years, mostly because American Craft Museum expenses grew much faster than anticipated. The two institutions were housed in different locations by 1990, and the educational mandate of the ACC seemed increasingly distant from the exhibition program of the museum. In October 1990, the two bodies parted ways. While the ACC owned the space on West Fifty-third Street that the museum occupied, the museum was allowed to rent it for one dollar a year for five years. Other assets were divided between the two: the museum got the collection of craft objects, and the ACC kept the library, and so on. The museum appointed its own officers and board of directors.[1]

In 1989 the museum's new director, Janet Kardon, decided to take a more scholarly approach to craft. One of her first major projects was to convene a symposium at the museum in 1990, with an eye to assembling the first-ever history of American studio craft. The symposium led to plans for eight exhibitions and scholarly catalogs.

The scheme was dubbed "A Centenary Project." First in the series was *The Ideal Home, 1900–1920* (1993), which documented the American Arts and Crafts movement, an era that had already been the subject of several large exhibitions. Second was *Revivals! Diverse Traditions, 1920–1945* (1994), which covered folk craft traditions and the colonial revival; the third, *Craft in the Machine Age, 1920–1945* (1995), looked at craft that was influenced by early modernism.

Unfortunately, Kardon became ill late in 1996 and resigned. Her replacement, Holly Hotchner, addressed other priorities, and the Centenary Project was put on hold.

Throughout the 1990s, prices for craft continued an upward trend. Marketing became more sophisticated: advertising changed from black-and-white to color, and galleries developed extensive client lists. The niche for craft expositions expanded. In 1994 SOFA (Sculpture, Objects, and Functional Art) took over the fall date in Chicago that the New Art Forms Exposition once held. The business grew. At first, glass dominated the booths at SOFA, but by the end of the decade, jewelry was increasingly popular. In 1998 SOFA opened a spring exposition in New York.

At the ACC craft shows, in which the exhibitors are the craftspeople themselves, public attendance started to slide in the 1990s. Sales figures, which had increased every year for two decades, went flat or declined slightly.[2] While the explanation for this state of affairs is uncertain, it seems clear that both exhibitors and audiences aged and were not replaced by younger generations.

The National Endowment for the Arts had exerted a positive influence on the craft world for twenty-four years, most importantly through grants to individuals. Over the years, millions of dollars flowed into the craft community. But in the late 1980s, several politicians seized on the fact that the NEA had given grants to artists whose work involved nudity, human blood, and references to homosexuality. Such works were deemed obscene by militant conservatives, and the NEA became one subject of the "culture wars" of the time. Conservatives demanded that the agency be closed. In 1996 funding for the NEA was cut drastically. The same year, in an effort to avoid further controversy, grants to individual visual artists were eliminated. Grants to individual craftspeople suffered the same fate, and those for apprenticeships and studio space were also terminated. The NEA survived the storm, but the days of generous federal support for the crafts were over.

In the 1990s, museums devoted to craft began to

spring up or shift direction. Some were small regional museums that found they could claim a distinct mission if they refocused on craft. One of these was the Charles A. Wustum Museum of Fine Arts in Racine, Wisconsin (founded in 1941). Through the 1980s and 1990s, the Wustum concentrated on acquiring American crafts, until a new building was constructed to house the collection. It is now the Racine Art Museum, and it has one of the best craft collections in the country. In Charlotte, North Carolina, the Mint Museum of Craft + Design opened in 1999 as an offshoot of a larger parent museum. Museums devoted to one medium were also founded, such as the Schein-Joseph International Museum of Ceramic Art at Alfred (established 1991). By 2000 there were museums in America dedicated to every major craft genre but furniture and jewelry.

Following the precedent of ceramics in the 1970s and wood and glass in the 1980s, overviews of other contemporary craft mediums were published in the 1990s. These might focus tightly on a few makers or try to take in a whole field, writing history as it was still happening. Some were exhibition catalogs, others independent books. In the 1990s, gallery owner Helen Drutt English cowrote a book on international jewelry (*Jewelry of Our Time: Art, Ornament, and Obsession*, 1995, with Peter Dormer), and wood turning got its turn with the publication of a book about a private collection with essays by two critics, Matthew Kangas and John Perreault, and an art historian, Edward S. Cooke Jr. (*Expressions in Wood: Masterworks from the Wornick Collection*, 1996). By the end of the decade, only jewelry and textiles, among the major fields, lacked a comprehensive history.

The usefulness of the Internet for marketing became apparent. More and more craftspeople set up websites, usually as sales tools. The most sophisticated Web-based craft-marketing site belonged to Guild.com (now ArtfulHome.com), an offshoot of a commercial publishing company. The original plan of the Guild (note the Arts and Crafts link in the name) was to publish catalogs. Craftspeople contracted to buy a page in a book, and the Guild marketed the book to retailers, architects, and interior designers. In 1999 owner Toni Sikes targeted Web-based sales and created Guild.com. She provided pages on a massive website to craftspeople, who would offer work for retail sale. Those who browsed the site would order directly from the makers, while Guild.com processed payments. It was an ingenious system, because Guild.com did not have to bear the costs of packing and shipping. The question was whether it could achieve the economies of scale necessary to turn a profit.

Glass Ascendant

Glass flourished: professionalized, collected for high prices, methods mastered (although warm and cold techniques grew more than hot). The PR machines of Pilchuck, Corning, and a few influential collectors worked toward broader appreciation of the medium, leading to more museum collecting. Pilchuck invited major artists to create art in glass by working with a skilled hot-shop team, and some important figures took up the offer. There was an increased effort to develop a critical theory or language. The art historian and critic Thomas McEvilley, keynote speaker at the Twenty-third Glass Art Society meeting, offered a framework. He said that there are three perceptions of modern art: Matissean, or pleasing; transcendental/metaphysical; and Duchampian, or critical. Modernism tilts toward the first and postmodernism toward the third. He saw glass becoming an avant-garde material through negating its own special qualities and suggested that while whole glass was modernist, broken glass was postmodern and might "shatter the aesthetic totality of glass, to create air to breathe."[3]

Other observers were noting geographic distinctions in current glass work, with "more of a concern for form on the East Coast, while coming out of Pilchuck, and coming out of Seattle, there is a greater sense of color, more multi-element installations," and interest in larger scale.[4]

DOROTHY HAFNER'S GLASS

Dorothy Hafner's sudden conversion from ceramics to glass in 1992 was triggered by two experiences: first, scuba diving amid the brilliant hues and dazzling, fluid light of Australia's Great Barrier Reef and, second, making a paperweight in a workshop at UrbanGlass during an "art sabbatical" she gave herself after fifteen years of professional design work, primarily in ceramics. Glass's liquidity and range of colors furnished the possibilities she wanted. She then found a technique, tesserae, that would allow her to compose fields of precisely fitted flat glass shapes that could be picked up by hot glass on a blowpipe; all she needed was a wizard technician, and she found that in Venetian master Lino Tagliapietra, starting in 1994. The challenges—unequal expansion of different colors and the need for the blown bubble's circumference to precisely match the dimensions of her prepared mosaic—were only increased by her wish to use curves and circles rather than the square format of traditional tesserae.

The success of the project was demonstrated by a

FIGURE 11.1. *Dorothy Hafner*, Black Lagoon, *1997. Hand-blown glass; 19 × 8 × 6 in. (© 1997 Dorothy Hafner. Photograph by Eva Heyd.)*

show at Heller Gallery in New York's SoHo in the summer of 1995. The forms were simple, with smooth, emphatic profiles to give maximum play to the encased color shapes. The fresh, sunny pastels and use of circles recalled the Orphism and synchromism of the early twentieth century, which Hafner acknowledged in naming a piece after Sonia Delaunay (*Blue Sonia*, 1997). But this was hardly the limit of reference. Plaid fabrics, basket structure, 1950s biomorphic design, 1960s graphics, and innumerable associations with water are evoked by her vessels. One of the most physically evocative is *Black Lagoon* (1997), with shades of blue, lavender, and black in slightly pendulous curves that, along with the low belly of the form and the concave mouth, create a sensation of drifting in undulant currents and flickering light. (Figure 11.1)

GINNY RUFFNER STARTING OVER

Ginny Ruffner (b. 1952) toughed her way into an important place in the glass world. Her medium is lampworking, which was stigmatized for its association with state-

fair trinkets. When she taught at Pilchuck, she would not allow her students to make swans or ships and would smash the works if they tried.[5] She introduced the use of a higher-temperature glass that allowed larger scale. In 1985 she moved from her native Georgia to Seattle in order to be eligible for public art commissions. There she established a studio, soon employing as many as seven assistants to carry out her designs of assemblages decorated with paint, pencil, and pastel. She did a commission for Absolut vodka and in 1989 was invited to make designs for the Vistosi glassworks of Murano, a rare woman in the traditionally masculine milieu of Italian glassmaking. She served as president of the Glass Art Society (1990–91).

Then her story starts over. A car crash in late 1991 left Ruffner in a coma for six weeks, with brain injuries that prevented her from walking or speaking. Her determination and a campaign of therapy and finding ways of compensating for lingering limitations had her exhibiting her art again within two years; fortunately, working with others was familiar and thus not a strain for her. Although one looks for differences between works made before and after the accident, the spirit and the energy are the same. She has continued to use a vocabulary from home and garden to deal with ideas of creativity, beauty, and love, which she had developed when she first abandoned abstraction and began painting on glass. As Vicki Halper notes: "Pencils stand for art, wings for transcendence, hearts for feeling, tornadoes for creativity, fruit for bounty, webs for interconnectedness, and the Old Masters for inspiration. A headless and armless winged figure, taken from Greek sculpture, is Ruffner's embodiment of Beauty, an active force as well as a quality residing in objects."[6]

Two comparable all-glass works were made in 1990 and 1999. The first, *The Power of Words to Invent Beauty*, identifies Ruffner's themes and also suggests the verbal approach that is typically paired with her rebus imagery. Here, tiered like a party cake, is a circular colonnade of translucent, mat bones, which supports a smaller round of colored pencils standing on their erasers, which supports an explosion of multicolored dancing snakes, all seemingly paying homage to an enormous blue faceted gem that arises from the middle, like the stereotypical girl who pops out of the cake.

The later work, *The Art Game*, is a four-sided pyramid with the same kind of stable organization as the earlier work. Outlining the base are playing cards—kings and queens—and tumbling dice. From the corners, links of chain, one of them transparent, lead upward to meet at the top. Filling in the sides are such symbolic items

terials. (Figure 11.2) The tornado, which symbolizes "the inexorable sweep of life"[7] in addition to creativity, may be equated with the transporting power that took Dorothy to Oz; given Ruffner's productivity and will, it may also summarize her work. Occasionally the symbolism is too obvious or the form chaotic and ungraspable, but Ruffner reaches higher and higher.

THE YOUNG MASTERS

In 1997 **Josiah McElheny** emerged into New York art-world consciousness with a display of what appeared to be antique glass, in a museum case, with labels—a rather surprising setup in an edgy gallery known for sophisticated and intellectual work.[8] What was this: a new form of appropriation art in the manner of Sherrie Levine, who rephotographed Walker Evans images? a political critique of the art world in the manner of Fred Wilson's manipulation of museum collections? a study of history in the manner of Mark Dion's research and projects in ecology?

It was, rather, an exploration of the motivations of making in the newly developed style of McElheny himself. He already had a reputation in the glass field. At a Glass Art Society conference in Toledo in 1993, he had given a talk on "hired guns"—young, highly skilled itinerant glassworkers. He called them "a cadre of professionals who take [the work] very seriously, who are concerned with craftsmanship and with helping people" and predicted, "We'll see a different kind of work coming from these people."[9]

The prediction held for McElheny himself. A native of Boston (b. 1966) with a BFA from Rhode Island School of Design, he had spent a year in Rome on a RISD honors program, studied with English master Ronald Wilkinson (1987), and apprenticed to Swedish masters Jan-Erik Ritzman and Sven-Åke Carlson (1989–91) and the Venetian master Lino Tagliapietra (1992–97). Throughout, he expanded his knowledge of techniques and of glass history. In 1990, in Sweden, he created the first of his fiction-based installations, called *The Hunter's Glass Museum*: a log structure outdoors containing a few glass items on plain shelves with a map of the Middle East and a handwritten text.

Of about a dozen such conceptual creations completed by the end of the decade, perhaps two can represent the larger spectrum. *Verzelini's Acts of Faith (Glass from Paintings of the Life of Christ)* (1996) consists of a large wooden display case of four shelves of glassware. A text explains that Giacomo Verzelini—a Venetian glassblower who worked in Venice, Antwerp, and London in the late sixteenth century—had re-created, as a private

FIGURE 11.2. *Ginny Ruffner, Large Conceptual Narratives Series: The Fragile Balance of Artist and Art, 1997. Mixed media; 8 ft. × 7 ft. × 29 in. (Courtesy of the Artist. Photograph by Mike Seidl.)*

as colorful brushes and a painted scene of a cozy living room with a door that opens to a flowering garden and a footpath that leads toward the distant horizon. These works are similarly organized, concerned with like issues, richly colorful, and slightly atypical in their stability; Ruffner has always composed with flamboyance, seemingly tossing into the air more elements than anyone should be able to juggle and constantly suggesting motion.

She has worked in large scale, both for gallery exhibitions and for public commissions for parks and plazas. Through the 1990s, she added both cast and welded metal to the glass to allow increased size. Using bronze also gives her the option of displaying work outdoors. She has created tableau-type framed installations in which she constructs a picture in glass and other ma-

devotional act, the glassware depicted in medieval and Renaissance paintings of the life of Christ. Shelves are organized by subjects (the Annunciation, the Last Supper, etc.), and objects are identified by painter. The whole is so exactly and soberly carried out that one would take it for fact. But with the knowledge that it is all fiction comes the realization of the scope of McElheny's research and achievement. It is a performance of impressive cleverness that justifies a display of masterly craftsmanship that the art world would discount if this were solely an issue of virtuosity.

An Historical Anecdote about Fashion (1999) flaunts its historical perfection in the archaic grammar of its title but is modern in its attention to fashion, erotic desire, and class consciousness. It tells the evocative story of daily visits to the factory office of the glamorous French wife of a Venetian glassworks' director. Wearing her Dior "New Look" fashions, she is observed by the glassblowers, and their afternoon production, exhibited in a display case, is an echo of her seductive, wasp-waist form. Most of the bottles are quite familiar shapes of postwar design, with twists and flares.

In these works and others, McElheny moves from language to its realization as an object. *Verzelini's Acts of Faith*, the critic Dave Hickey has noted, "may be taken as an effort to relocate the practice of making blown glass within the intellectual tradition of Western art making" through devising a Borgesian, parallel history.[10] Hickey imputes McElheny's use of language to the fact that glass knowledge is an oral tradition. Yet McElheny is so far the only creator of glasswork with such an elaborated context. In fact, he is caught between glassworkers who do not understand his intellectual construct and artists who do not understand his devotion to craft. His extraordinary practice here is to use the art system to reverse its direction and return it to understanding objects, valuing labor and skill and respecting materials, while in no way refuting art's demand for ideas and critique. In carrying out his concern with objects, he engages many important philosophical issues in art today, such as how an artist creates meaning or what implications are embodied in objects and how they can be known.[11]

One of the primary interests of those "hired guns" McElheny mentioned was functioning within decorative arts traditions. For some, this meant connecting to Venetian glass. They had to become expert glassblowers, teach themselves about the long tradition of European decorative arts forms, and somehow make an original contribution to it. It was a rebellious gesture, a rejection of both the noisy personal expression that emerged in the 1960s and of the modernist resistance to historical ref-

FIGURE 11.3. *Dante Marioni,* Yellow Trio, *1999. Blown glass; height, 39.5 in. (Collection of Michael and Lydia O. Adelson. © Dante Marioni. Photograph by Roger Schrieber.)*

erence. Another personification of this new historicism is **Dante Marioni** (b. 1964). The son of Paul Marioni, he never responded to the sculptural, highly decorated work produced by his father's glassblower friends, even as he respected their technical ability. He first blew glass when he was fifteen, inspired by Benjamin Moore, whose precise, restrained geometry he admired. Later his determination to become a glassblower was reinforced when he saw Tagliapietra blow glass at Pilchuck in the summer of 1983. Marioni loved the accuracy of Tagliapietra's work and took him as a model.

By 1987 Marioni produced his first mature work. All his forms could be traced back to some point in the European vessel-making tradition: Greek ceramics, Roman glass, and especially Venetian glass design from the 1920s. A few pages from the 1921–25 catalog of Vittorio Zecchin's designs for Venini & C. have about half the elements Marioni used in the 1990s: narrow forms, flaring lips, tiny stems on flat bases, thin paired handles, and more. (Figure 11.3) He said that developing new forms was not his goal: "I was more interested in perfecting something than in inventing it."[12]

Marioni's large, simple shapes required tremendous skill: the slightest deviation from symmetry and perfect

line ruined them. In time, his workmanship approached that of the most accomplished Venetian artisans. He always worked with a team, true to the Venetian model. What was not conventional were the colors, size, and proportions. He used bright, fully saturated colors, usually two at a time: yellow and black, blue and red, orange and turquoise. They were the colors of cheap plastics and pottery, previously unthinkable for studio glassblowing. He also made his pieces much larger than historical glass—in some cases more than four feet tall. Many are exaggeratedly tall and skinny, almost cartoons of historical work. In fact, he frequently starts out with simple outline drawings resembling basic cartooning.

Marioni often groups two or three pieces, which emphasizes their formal qualities and, by foregrounding the play of shape and line, declares their uselessness. The combinations can be stunning. His supporters assert that his work is art, but the claim does him a disservice, for it suggests that art is better than decorative art. Marioni has chosen the latter and has made a distinctively American contribution to its history.

While some commentators have seen the art of the late twentieth century as mannerist—simply playing with and exaggerating what has come before, rather than actually inventing—there are also indications of the occurrence of another phase of romanticism. **William Morris**'s technically astounding work, beautiful in color and surface and amazing in size and configuration, takes the lead in this regard. Reflecting the white anxiety of the multicultural era, he imagines tribal peoples as the source of all natural virtues; Caucasians are entirely absent from the world he depicts. Morris (b. 1957), like his mentor Dale Chihuly, became one of the most financially successful and critically doubted figures in glass at the end of the century before retiring at age forty-nine.

New to glass and to Pilchuck in 1978, Morris entered into a productive eight-year association with Chihuly, who was increasingly unable to do his own furnace work. Morris became probably the most skillful American gaffer of his time. Eventually he needed to find subjects for work of his own if he was not to remain simply an extraordinary worker. He began to develop his own vision, concentrating on opaque color, with his Stone Vessels (1984–86), some of them so hotly radiant that they seem to be on fire and others of oddly outer-spacey blues and greens, and all of them featuring compositions of dark-colored shapes that may look like carved relief or seem to float before the background color. These allude to Paleolithic structures and also recall volcano-and-wildman adventure movies. The Petroglyph Vessels of 1988 were again dramatically polychrome but with the addi-

FIGURE 11.4. *William Morris, Canopic Jar: Fawn, 1992. Blown glass; 27 × 11 in. (Collection of Norton Museum of Art, West Palm Beach, Fla., Gift of Dale and Doug Anderson, 1996.10. © William Morris. Photograph by Rob Vinnedge.)*

tion of ghostly shadows of deer, horses, and bison, as well as figures with spears and bows.

The Artifact Still Life series included glossy crystalline and colored bones, in complex multipart installations. While the works were not always shiny, they never failed to take advantage of the seductive qualities of glass. Morris's funereal themes, a flag of seriousness, grew to include borrowings from antiquity—his Canopic Jar series, which included animal heads. (Figure 11.4) These were not cast but shaped molten, using a technique that he learned in Venice in 1988. His subsequent move was in the direction of nature's creatures, a suitably "green" subject for the environmental concerns of the era and comfortable for him since he is a rock climber, hiker, and bow hunter. He did not try to make the forms realistic but regarded them as part of a ritual that respects the spirits of animals and acknowledges the reality of death that he knows as a hunter.[13] Such works were artfully shown in darkened spaces, lit for dramatic impact.

At the end of the century, Morris was a glass celebrity, praised by his apologists as a spiritual, sensitive man. It is an image hard to reconcile with the marketing of a hunky glassblower. Being photographed in tank tops to muscular advantage in the hot shop is entirely reason-

able, but Morris's catalogs featured his shirtless glory on vacation, even on a snowy peak. His work, too, seemed more and more market-oriented—presented in numerous large-format full-bleed color books with dark backgrounds as he moved toward a cast of Others worthy of a Disneyland boat tour: composite figures with the face painting of one culture, the hair architecture of another, and the body ornament of still another. As early as 1989, his work was being called "picturesque escapism."[14] Somehow not embarrassed by this, his collectors pushed his prices toward six figures. It is a sobering demonstration of the centrality of craftsmanship to the field, for although one may disparage his themes, his skill is beyond dispute.

DANIEL CLAYMAN

"Capturing" light sounds like something done aggressively with a weapon or a trap, but Daniel Clayman's work does so with an exceptional serenity and clarity of form. Clayman (b. 1957) is a RISD graduate whose cast glass has some of the same feeling of magnitude as Howard Ben Tré's, although it is not as massive and he is more interested in color. Clayman's smallish works of the late 1980s and early 1990s, most of which include metal sleeves or cuffs between the glass parts, might be models of art deco buildings with arched elements on their flat roofs, or might be handbags of elegant character. Other shapes recall bells or steam irons. The object reference in such tranquil forms and perfected surfaces gives a valuation to the mundane, even a numinous quality. It makes a cultural statement. The forms are also quite beautiful and satisfying in themselves.

Other works make clear allusions to stringed instruments, incorporating wires, although the glass elements tend to be either more attenuated than any usable instrument or an abstraction of another source, such as a natural form. An example of the latter is *Bract* (1998), a sixty-inch-long evocation of a sort of leaf, with a single copper wire running down its center. One might imagine a plucked tone resonating, but the line also simply creates an exquisite visual tension. It is a particularly light-handed way of combining glass and metal, something Clayman has done in much of his work. It is probably no accident that he was a studio assistant to Michael Glancy from 1987 to 1989, although their use of metal is nearly opposite. Glancy's is like armor, an exterior barrier, while Clayman has used it as punctuation, as framing, and as protection.

That last option shows in Clayman's works of the late 1990s, when he used more equal combinations of glass and metal, but the metal is always a support. In *Tender*

FIGURE 11.5. *Daniel Clayman*, Tender, *1998. Cast glass, bronze; 12 × 15 × 20 in. (Collection of Museum of Fine Arts, Boston. © Daniel Clayman.)*

(1998), a round, fluted bronze shell, patinated yellow, cradles glass of the same contours that bulges outward in a circular tongue at one end. (Figure 11.5) The glass has the translucent lusciousness of lychee fruit. Other works of the same date include *Meniscus*—a conical metal vessel with a long spout, held up within a circular metal stand like the ones used for globes, and nestling within it a white glass vessel—and *Quiver*, a fluted metal shell split open at the top that contains a lavender glass repeat of the metal shape. Clayman has offered an interpretation of these forms: they express his protective concerns as a father. Given that suggestion, the delicate, tentative extension of the protected glass forms in *Tender* or the nut-shaped *Cascade* (1996) convey, with the subtle quality of metaphor, the tentative steps of children's emergence from the protection of their parents.

Bract, however, with its longer form, predicted Clayman's move to greater extension (vertical or horizontal) at the end of the decade, toward simpler and more abstract forms. He also further developed a theatrical quality of presentation, something that works better with simple forms than with complexities. His interest in presentation may be due to the fact that before he came to glass he studied technical theater and designed lighting for opera, theater, dance, and rock performances. The dark stage, the piercing, focused light, and the dazzling energy of the focal object are physical memories for him as well as idealized projections.

JACK WAX

Jack Wax (b. 1954) has a philosophical bent and a surprising range of teaching experiences. With a RISD MFA, he has taught at a number of universities and art schools, most recently Virginia Commonwealth University. But

FIGURE 11.6. *Jack Wax*, Issue, 1998. *Glass, pigment, adhesive; overall: 7 × 15 × 9 in. (Los Angeles County Museum of Art, purchased with funds provided by the Glass Alliance of Los Angeles and the Decorative Arts Council. Art © Jack Wax. Photograph © 2007 Museum Associates/*LACMA.*)*

an unusual feature on his resume is nearly five years of teaching at the Toyama Institute of Glass in Japan. Such exposure may account for the fact that he isn't eager to talk about his work in sound bites, or perhaps a disinclination to be specific drew him to Japan, where that attitude is shared. His indirect or metaphoric or free-associational method of titling results in simple mysteries such as a single object called *Plural* or a totem of recognizable forms—a head, a globe, a wheel, and a hemisphere, among others—titled *The Same River Twice*. The tension between the forms and seemingly unmatched titles creates a kind of third place, a consideration of relationship, in the viewer's imagination.

Wax works at both object and installation scale. His forms are more pictorial than abstract and can be described in terms of the known shapes that they resemble, yet they function as signs more than illustrations. Early works recall implements or toys, and some mid-1990s works presented outdated hairstyles, isolated like caps or wigs, lying on long wooden trays or tables in matched sets of cast metal and mold-blown glass. Related works include a severed head in mold-blown glass and mica flakes, seemingly in the process of dissolving, and a cupped hand, palm up, probably inspired by a Buddha hand.

While working in Japan (1991–96), Wax generated works that suggested enlarged seeds or other organic forms. (Figure 11.6) A later example is *Outset* (1998), a twenty-one-inch sphere studded with lumpy, indeterminate objects, all approximately the same size and nature but seemingly as individual as people. These may communicate a sense of aggregation or of some kind of at-

tractive force. It has been noted that Wax is purposely making his process of assembly obvious in such works.[15] By doing so, he seems to be calling attention to such implications as interdependence, need, or sense of commonality. *Outset* is a closed form and gives no obvious information, yet it visually communicates qualities that can be perceived by the viewer and is particularly attractive to those who do not expect to be handed a meaning on a plate.

JUDITH SCHAECHTER

Most flat-glass makers reject the conventions of religious stained glass: careful modeling to describe form and shadow, decorative patterning, stiff figures, storytelling. All these devices seem as remote as the Gothic culture that produced them. But a few outcast art students were drawn to Gothic for its darkness and complex emotional overtones, among them Philadelphia-based Judith Schaechter (b. 1961).

As a student at RISD, Schaechter painted nothing but cats for the best part of a year—so many, in fact, that her teachers threatened to fail her unless she painted something else. About that time, she took up stained glass and looked back to medieval sources for her cues. Moody atmospheres and tortured saints appealed to her, as did gorgeous color flooding through the glass itself. Rather than glorify the sacred, though, she chose to illuminate the secular.

"I think I'm a fairly normal human specimen," Schaechter explained. "My main interests are sex and death, with romance and violence the obvious runners-up."[16] She also seems exquisitely attuned to pain and despair. Her panels are shot through with high anxiety. In *Fragile* (1989), a doll lies awkwardly in an orange room, brightly colored moths fluttering around her. A blue frieze is filled with spiders and webs, and the doll's skin is fissured and cracked nearly to the point of disintegration. Another panel depicts a distraught clown about to rape a naked woman, accompanied by two rather unpleasant singing monkeys (*Rape Serenade*, 1990). The conflation of sex and death is made explicit in *Tiny Eva* (1993), in which a dead (or sleeping) woman lies in a coffin, surrounded by more moths and a worm-eaten garland of flowers. (Figure 11.7) The narrative is complicated by the two shoes before the coffin, which suggest that the victim stepped into it of her own volition.

The disturbing imagery is presented with a number of conventional stained-glass devices. Schaechter often uses decorative bands to frame her compositions, and backgrounds are frequently filled with pattern. Her technique is just as painstaking as the medieval originals,

FIGURE 11.7. *Judith Schaechter, Tiny Eva, 1993. Stained glass; 21 ×
22 in. (Private Collection. © Judith Schaechter. Photograph by
Laurie Seniuk.)*

too: while she sometimes fuses silver oxides to her glass
in the traditional manner, much of her detailing is pro-
duced by carving away the thin colored layer of flashed
glass. Her figures are accentuated with heavy lead lines,
and some panels are divided into diptychs and triptychs
like an old altarpiece.

The effect is jarring, like seeing an old master paint-
ing of a car crash. Complicating matters even more are
Schaechter's lush, high-key colors. Most of her work is
shown in light boxes, and light filtered through glass has
long been a metaphor for religious illumination. It is dif-
ficult not to respond as if in the presence of something
sacred, and yet her intensely emotional imagery speaks
more of an existential hell on earth. The experience is
both thrilling and disorienting.

Jewelry, Metals, and Enameling:
A Spectrum of Possibilities

There was no overarching theme to 1990s studio jewelry
and metalsmithing, although there was a pervasive his-
torical consciousness. Production jewelers looked to an-
tique jewelry—perhaps not surprisingly, because studio
jewelers were turning to gold and precious stones. To dif-
ferentiate their jewelry from trade work, they had to look
beyond Cartier and Tiffany, so Etruscan granulation,
Japanese sword guards, and Roman architectural decora-
tion became candidates for interpretation.

Within MFA programs, students saw no inherent con-
flict in applying the strategies of conceptual art to objects.
Myra Mimlitsch-Gray and Jana Brevick made bodies of
work that took conceptual approaches to silverware and
jewelry, respectively.

Tracking developments in sculpture, many metal-
smiths and jewelers tried making installations. The in-
herent problem is that an installation must somehow
command the space it occupies, but metalsmiths were
trained to make small, finely crafted objects. Few were
able to adjust their ways of working. Some of the best in-
stallations invited viewers to imagine wearing an object
on display. Heather White, for instance, hung oversize
metal representations of hats from a ceiling, just above
head level. The experience of standing beneath one of
the hats, or watching somebody else do the same, was
intriguing. A few others, such as Christina DePaul and
Gary Griffin, also made convincing installations.

Enameling had something of a revival, especially
among jewelers who had explored the newer color tech-
nologies in the 1980s and wanted a technique with his-
torical resonance. Blacksmithing mushroomed in popu-
larity, drawing a good number of women into the craft.
Many smiths tried making steel furniture and vessels, in
which the lack of precedent required them to come up
with innovative solutions.

Computer-aided design and manufacturing (CAD-CAM)
made some inroads into studio jewelry. Several pro-
grams, most notably the one at Tyler School of Art under
Stanley Lechtzin, equipped their studios with digital
three-dimensional printers so students could experiment
with these new technologies. The learning curve was very
steep, however, and it took years for students to mas-
ter the complex software that drives three-dimensional
modeling. At first, little resolved work emerged. Things
changed very rapidly about 2004, but that work falls out-
side the time span of this book.

No production craftsperson can stray too far from
public taste. Those who do are ruthlessly eliminated from
the marketplace. This Darwinian fact makes many pro-
duction jewelers conservative. Through the 1980s and
1990s, a number of them resorted to the familiar signi-
fiers of jewelry: gold and precious stones. A few, Whitney
Boin and Tom Herman among them, made truly inno-
vative work. Boin designed stark, minimalist rings and
pendants, and Herman carved gold rings and bracelets
into intricate acanthus-leaf patterns. Otherwise, gold
jewelry was often uninspired, and it was hard to tell one
jeweler's work from another's.

PAT FLYNN

Still, gold and gems can be rescued from clichés. Pat Flynn (b. 1954) has given a personal twist to precious jewelry. Flynn worked for trade jewelers for several years, doing benchwork tasks like repair, ring sizing, and stone setting. He mastered skills such as stone setting that many studio jewelers never bother with. Still, he was impatient with commercial jewelry, finding it thoughtless and boring. He was eager to incorporate into his own work the opposite of whatever passed for industry standards: "When I got back to my studio the last thing I wanted to do was make perfect polished things. . . . I was drawn to slate, busted pieces of glass, saw blades and nails, bits of iron. I'd take my garbage to the landfill and come back with a bunch of cool stuff to make jewelry with."[17]

Flynn settled on iron nails as his favorite device. (Figure 11.8) The choice of unassuming materials in precious jewelry was not new; Flynn's distinction is that he colors and reshapes cheap hardware-store nails, making

FIGURE 11.8. *Pat Flynn,* Brooch, *1993. Iron, 22-karat gold, diamonds; 4.25 × 1.62 × 0.25 in. (Museum of Fine Arts, Boston, The Daphne Farago Collection, 2006.196. Art © Pat Flynn. Photograph © 2008 Museum of Fine Arts, Boston.)*

them look old and hand-forged. (He used rusty found nails occasionally but preferred the control he could get from forging his own.) He worked his faux nails with exquisite care, hollowing out the backs so that his brooches and necklaces are surprisingly light. He then arranged all sorts of juxtapositions: nails with lines or surfaces of forged gold or with colored stones, or even diamonds set directly in the blackened steel.

Flynn pays particularly close attention to finish, which ranges from roughly filed surfaces to brightly burnished edges. He makes his own efficient mechanisms. He wants his jewelry to be worn, even worn out. If a ring shank gets perilously thin, that means it has been worn every day for decades and most likely was important to the owner.

Although Flynn's way of contrasting high and low is a twentieth-century strategy, his jewelry is embedded in the long tradition of goldsmithing. It does not address any of the discourses of art making today, but it is superb jewelry. Questions of category will have to be resolved sometime in the future.

FORD AND FORLANO

In the 1990s, polymer clay became popular for making jewelry. Commonly known by its trade names Fimo and Sculpey, it is a pliable mixture of polyvinyl chlorides, plasticizers, and pigments. (Technically, it is not clay.) Developed in the 1930s, it was sold as a hobby material for decades. Pier Voulkos, Peter Voulkos's daughter, was one of the first people to see its potential for jewelry. Around 1984, she started making beads in the bright-colored plastic, and they were an instant hit. The material can be made to mimic almost anything that is translucent or opaque. And since it is so easy to use—it is baked in an oven to harden—amateur beadworkers embraced it.

One of the most obvious ways to use polymer clay in jewelry is to make colored canes. Stack up layers of alternating colors, roll the stack into a stick, cut slices off the end, wad the slices together, and presto, instant beads! Two painting students at Tyler, Steve Ford and David Forlano (both b. 1964), saw a way to make some money by collaborating on polymer clay jewelry. The two had complementary abilities: Ford was the designer, setting up structure and form; Forlano was the colorist, inventing unusual ways to work the material. (Figure 11.9) He wrapped beads with thin rectangles, like strips of bacon. He pressed disks of hard polymer into balls of soft polymer. He pressed it onto textured surfaces or abraded it so that it appeared to be weathered and worn. The two produced consistently innovative jewelry.

FIGURE 11.9. *Steven Ford and David Forlano,* Brown Big Bead Necklace, *1997. Polymer clay; 22 × 1.75 in. (Courtesy of the Artists. Photograph by Ralph Gabriner.)*

Ford/Forlano jewelry is colorful and decorative. Forlano did not use the bright colors of commercial polymer clay but mixed countless tints and shades on his own. While their patterns and shapes may have had correlates in the real world—glass canes, pebbles, scribbles—they relied on experimentation rather than historical quotation.

The typical reaction to marketplace success is to endlessly repeat a signature style, but Ford and Forlano made their open-ended editions in different color schemes. No two pieces are ever alike. Furthermore, they constantly add new designs to their line and eliminate old ones. Customers can see new work and also trace Ford and Forlano's growth and change. In the long run, this organic evolution has stimulated sales, and demand for their work has only increased.

BEAUTY IN JEWELRY: SHARON CHURCH AND SUZAN REZAC

After the wild gyrations of the New Jewelry, a number of American studio jewelers conducted their own reexamination of the form. Believing that the point of jewelry is to be worn, not to be an experiment in scale, content, or weird art supplies, and asserting that good jewelry must enhance the appearance of the person wearing it, they re-

asserted a traditional idea that was somewhat neglected in advanced jewelry circles. The train of thought led directly to the topic of beauty. Most importantly, they felt that jewelry works two ways: outward toward the people in the room and inward toward the wearer. Most of these jewelers were women, and as jewelers who wore jewelry, they believed that beauty has transformative power and can make women feel different about themselves.

Sharon Church (b. 1948) is among the most accomplished of these advocates for beauty. As a student, Church was inspired by John Paul Miller's granulated jewelry, but her sense of beauty is more attuned to the emotional lives of women. In Church's estimation, jewelry can act as a kind of psychological armor, because a woman who feels beautiful also feels strong.

Church, an avid gardener, sees the garden's cycles of growth, fruition, and decay mirrored in life. (This was made painfully vivid for her when her husband was killed in a bicycling accident.) Her jewelry often has a shade of darkness that is both seductive and disturbing.

A 1999 brooch, for instance, depicts a single leaf hanging from a vine. Not promising material, one would think. The leaf is carved from antler, which has a dry, papery quality. It is carved with meticulous attention to the withered surfaces and broken outlines of real things. The vine is made of silver, oxidized black, in startling contrast to the pale leaf. The final touch, which draws the brooch back into the realm of traditional jewelry, is a tiny diamond set in the middle of the leaf. The sparkle of light signifies the promise of renewal: Persephone emerging from the underworld, joy following pain. Church's poetry is not so much read as felt in the juxtaposition of materials.

Church offers a slightly more conventional version of beauty in her *Foliate Harness* (1997). (Figure 11.10) Two

FIGURE 11.10. *Sharon Church,* Foliate Harness, *1997. Sterling silver, leather; 11.5 × 10 × 1.25 in. (Collection of Lois Boardman. © Sharon Church. Photograph by Thomas Brummett.)*

FIGURE 11.11. *Suzan Rezac,* Archeoloia Mundi Volume I (Necklace), *1999. Constructed and inlaid silver, shakudo, 18-karat gold, shibuichi, copper; 0.25 × 20 × 1.25 in. (Courtesy of Suzan Rezac. Photograph by Tom Van Eynde.)*

branches of fleshy silver leaves encircle the neck. They are joined on the back of the neck by a piece of black leather, trimmed in silver. One spray has rounded leaves, the other forked. All are given a bright, softly glowing finish, not quite polished but reflective enough to accent the tool marks remaining from forming. The leaves are linked like a chain, so the branches are pliable and yielding. It is a gorgeous piece of jewelry, appealing and immensely seductive. But Church added a twist: the leather harness carries implications of bondage and captivity. In one deft stroke, she asks unsettling questions, and lets her viewers decide.

A jeweler who takes a different approach to beauty is **Suzan Rezac** (b. 1958). In the late 1990s, Rezac started making necklaces and brooches that referred to historical decorative arts. The first versions were generalized images of plants in a vaguely Japanese style. Around 1999, she made a series of necklaces based on examples of ancient Greek pottery fragments. (Figure 11.11) The shards were laboriously pieced together from contrasting metals: gold, silver, copper, and Japanese alloys. The patterns are discontinuous, and the jagged shapes speak of decomposition. And yet her skilled design gives the composition an unexpected visual unity.

Rezac's necklaces reflect a taste for fragments that goes back at least to the eighteenth century, when cultivated Europeans appreciated Roman and Greek ruins for their aesthetic qualities. But her craftsmanship and sumptuous materials contradict the sense of destruction, creating an enjoyable buzz of cognitive dissonance– a postmodern pleasure if there ever was one.

KEITH LEWIS

Figurative jewelry's last flowering was the art nouveau period, when French masters such as René Lalique produced *femmes fatales* in carved glass and ivory. Modernist abstraction suppressed the impulse to combine figures and jewelry, although a modest number of Americans kept it up: Sam Kramer, Robert von Neumann, and Francis Stephen all made wearable figures in the 1950s and 1960s. Later, J. Fred Woell made pop figurative metal objects out of cast toy soldiers, and Bruce Metcalf made cartoonlike brooches in carved and painted wood. In the 1990s, Keith Lewis (b. 1959) gave the genre a thorough updating.

Lewis first made jewelry because he wanted something flamboyant to wear for nights out on the town. He started by stringing beads, then studied at summer workshops and eventually went to graduate school and then took a teaching position at Washington State University. His jewelry became increasingly complex and intellectualized. But more importantly, Lewis felt that his work should reflect something of his position in the world as a homosexual.

As the AIDS plague swept through the gay community, Lewis became an activist and a sharp critic of government policies. He knew dozens of young men who succumbed to AIDS, and he was intimately familiar with the grotesque ways that its victims can die. Lewis brought all his anger and grief to jewelry making. While this was a common enough agenda in the art world, it was relatively rare in craft.

A memorable early necklace is called *Thirty-five Dead Souls* (1992–93). Actually it is thirty-five necklaces, each bearing a different small head shaped much like a bird skull. Every head stands for a friend who died of AIDS. A few recall something about the person. One head, in memory of a drag queen, sports a plumed hat. Others represent medical consequences of AIDS such as dementia and Kaposi's sarcoma. They can be worn separately, but Lewis preferred wearing all thirty-five together in a clanking lump on his chest. *Thirty-five Dead Souls* is a powerful testimony to one man's despair.

Lewis later turned to making individual figurative brooches, usually self-portraits. Typically, he fabricated a torso with his own slightly pudgy physique and substituted the head of an animal. In one, a fellow with a mouse head, symbolizing timidity, examines a hefty strap-on dildo. Another, made in response to Lewis's failure to call an old friend who was dying, is a vulture-headed figure bearing human bones. A third is the follow-up to *Thirty-five Dead Souls*, which depicts a silver figure with a dog's head, holding a curved knife. Only when the back

FIGURE 11.12. *Keith Lewis*, Well Doug . . . It's 36 Now Pin (Self-Portrait in Memory of Doug DiSimone), *1994. Sterling silver, willow, pigment, resin, steel; 2.76 × 2 in. (Collection of Don and Heide Endemann. © Keith A. Lewis.)*

of the figure is seen does the narrative become clear: it is covered with thirty-five scars and a fresh, bloody wound. The brooch is called *Well Doug . . . It's 36 Now.* (Figure 11.12)

JANA BREVICK

By the late 1990s, art students who were paying attention looked upon the history of metalwork and jewelry as a vast library of interesting subjects. Comfortable with idea-based art in a way that separated them from every preceding generation, they began to produce a very different kind of jewelry.

An excellent example of conceptual jewelry is Jana Brevick's *Everchanging Ring* (1999). (Figure 11.13) It doesn't look like much: a simple pure gold band with a rough surface texture. The backstory makes it interesting. Technically, *The Everchanging Ring* is a production item: Brevick makes it in an unlimited edition. The ring is sold with a contract, which is detailed in an accompanying handmade book. Each ring comes with a promise that Brevick will take it back once a year, melt and refine the gold, and make a new ring. In concept, the metal is permanent, the form mutable. If the contract is exercised fully, the buyer gets a different ring every year for five years, although some owners grow attached to their rings and don't return them.

The Everchanging Ring mocks the old idea of "timeless design." Here it can change to reflect whims of fashion or taste. In fact, the history of goldsmithing shows that every design is deeply embedded in its own moment. Furthermore, Brevick's ring plays on a condition peculiar to precious metals: anything made of gold or silver is like a portable bank account. It can be melted down or

converted to cash at any time. Over the centuries, most gold and silver is recycled—entire periods of jewelry and tableware have vanished into crucibles. Thus, every time Brevick remakes one of her rings, she reenacts a bit of history.

ENAMELING

For the most part, enameling continued along a well-worn path in the 1990s. William Harper's work, with its luscious transparent colors and quasi-ritualistic overtones, remained as influential as ever. Jamie Bennett's early opaque enamels with cloisonné lines that acted like drawings were also widely imitated. A few hardy souls continued to make painterly plaques.

In the 1980s and 1990s, some studio jewelers took up enameling to add color and historical resonance to their work. They did not necessarily make important contributions to the craft, however, but used enamel as a tool, a solution for visual and conceptual problems. One trend that emerged in the 1990s was to use enamels to represent real objects, recalling the representational enameling that reached a height in early seventeenth-century Germany. Some of the most convincing work in this vein was made by Daniel Jocz and Rebecca Brannon.

Daniel Jocz (b. 1943) was one of the first studio jewelers to move polymer clay away from beadwork, making a series of innovative rings. He also experimented with computer-aided design, flocking, and drawing directly on metal with markers. Using enamel, he produced a jewelry series that investigated common ideals of attraction and repulsion.

FIGURE 11.13. *Jana Brevick*, The Everchanging Ring, *1999. 24-karat gold; 1 × 1 × 0.25 in. (Courtesy of the Artist. Photograph © Douglas Yaple.)*

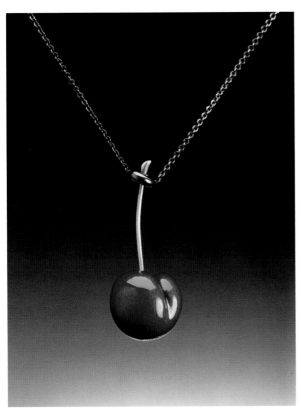

FIGURE 11.14. *Daniel Jocz*, Cherry Solitaire Pendant, Marlene Series, 1997. *Repoussé, soldered construction, enameled copper, 14-karat gold, sterling silver, enamel; pendant: 2.25 × 1 × 1 in.; chain: 17 in. (© Daniel Jocz. Photograph by Dean Powell.)*

When artist Jeff Koons showed his controversial sculptures of oversize cartoon bears, puppies, and the Pink Panther in 1988, Jocz thought about the way certain artworks become guilty pleasures. He liked the Koons sculptures, but he knew he was supposed to hate them. What jewelry, then, could be utterly tasteless but undeniably attractive? At the same time, he was thinking of a photo of Marlene Dietrich smoking a cigarette in the most erotic manner possible. Conflating these thoughts, he arrived at a lowbrow image of virginity (a cherry) and a repellent image of seduction (a cigarette butt). He recruited enamelist Rebecca Brannon (b. 1956) to help him execute the jewelry. After much trial and error, they figured out how to make life-size cherries and cigarette butts with stunning fidelity. Jocz made most of them into pendants—a single, deep red cherry hanging from a fine chain. (Figure 11.14) The scrumptious image stands in sharp contrast to the crude sexual innuendo. The cigarette pendants are accurate down to lipstick traces and gray ash. He jarringly combined the two in the culmination of the series, a necklace called *Marlene's Dijes* (Spanish for "pendant").

Collectors responded predictably. Every cherry Jocz and Brannon put on the market sold; not one of the cigarette necklaces did. The prospect of wearing a realistic cigarette butt, even though it was a piece of fine workmanship, repulsed buyers. The response amused Jocz, but it shows that craft collectors, expecting their jewelry to be beautiful, missed the point.

MYRA MIMLITSCH-GRAY

Ensconced in academia since the 1960s, craft teachers inevitably picked up on the debates circulating through the contemporary art world. One of them regarded the analytical strategy of deconstruction, originally an examination of unquestioned metaphysical assumptions and internal contradictions in philosophical and literary language (as the *Oxford English Dictionary* puts it). Some craftspeople interpreted this term literally, breaking up familiar forms and reassembling them in a jumble. While the visuals were nice enough, that did not get to the critical tendencies of real deconstruction. One craftsperson who understood was Myra Mimlitsch-Gray (b. 1962). A graduate student of Gary Griffin's at Cranbrook, she read the standard literature of the moment—Jean Baudrillard and Jacques Derrida. She was a gifted metalsmith, but it took time to meld her passion for craft with her postmodern sensibility.

If silver can be "read" like a text, it informs us about class identity and privilege. The deconstructive impulse was to reveal and then undermine such codes. Mimlitsch-Gray's first step was to cut apart silver holloware (some recycled, some that she made), revealing the interiors. Then she encased the parts in blocky geometric forms, subverting both the function and symbolism of the original. (Figure 11.15) One example is *Encased Teapot II* (1993). At first, it looks like a brick-shaped copper construction scattered with orifices, almost sexual in form. Closer inspection reveals that the holes are the body, spout, and handle of a silver teapot, rendered useless.

In real life, however, most silverware is rarely used. It is made to be displayed as a badge of wealth and status. Thus, an irony of *Encased Teapot II* is that it is almost as useful as the original teapot. It, too, is mostly symbolic. In other pieces, Mimlitsch-Gray restored function. She split a candlestick in two from top to bottom, then placed the halves, insides facing out, in silver boxes that she constructed. What was once a rounded form was presented as a negative, a space. When she added two new sockets, the original use was revived, even as both form and meaning were altered.

For a set of decanters, Mimlitsch-Gray constructed a replica of a nineteenth-century silver goblet. She sliced it in half and encased the halves in two undulating cylin-

FIGURE 11.15. *Myra Mimlitsch-Gray, Sugar Bowl and Creamer, 1990. Copper, found object; bowl: 3 × 7.25 × 7.25 in.; creamer: 3.5 × 4 × 7.25 in. (Private Collection. Courtesy of the Artist. Photograph by Larry Erickson.)*

ders, leaving the tops open so that they could be filled with liquid. In these pieces, the inside of the goblet is to be understood as a metaphor for the inner life of women, and the transformation of the object as the transformation of women's roles in society. This metaphor was probably less than obvious to most observers, but it offered another level of interpretation for those who wished to read it.

Mimlitsch-Gray has gone on to make other postmodern riffs on traditional metalsmithing. In one series, she enlarged the facets of planishing marks, carefully constructing a strangely pocked surface. She then edged the surface and added handles or feet, making the object into a tray. One might think the facets would render the tray useless, but in fact, it makes a decent fruit tray, each apple or orange secure in its own facet. Later still, she made silver hollowware that appears to be melting into a puddle on the tabletop. In each series she showed an affectionate respect for both traditional craftsmanship and the history of her medium. At the same time, her strategies identify her as an artist, even by the most advanced definitions of the term.

HARRIETE ESTEL BERMAN

Although the impetus for small sculptures based on highly personal subject matter faded in the late 1980s, some metalsmiths continued to make sculptures—with less emphasis on autobiography. Among them was Harriete Estel Berman (b. 1952), who came of age as the "second wave" of feminism had a powerful influence on young women. It questioned the separation of men and women into distinct social roles, with women often getting less pay, prestige, and opportunity. Women's traditional role in the home was also sharply challenged.

By the 1980s, Berman had married, set up a household, and taken on the role of housekeeper and, eventually, mother. She was frustrated by all the predictable routines and turned her ambivalence into the subject of a series of sculptures. While there was a strong element of feminist critique, her motivation was "more an effort to deal with my frustration and conflicting goals. I somehow embraced the idealization of the perfect mother, the perfect house, and yet, I found the role severely limiting and I wanted to explode or burst out."[18]

The Family of Appliances You Can Believe In consisted of handmade replicas of common appliances, each with visual and verbal elements of critique. Berman chose those that summarized the ideal of prosperous, progressive domesticity and yet stood for all the drudgery of housework. One sculpture was an electric drill/eggbeater hybrid, *Everready Working Woman* (1982). Meticulously constructed of painted copper and brass, it featured a chrome-plated drill chuck, a lipstick that fit into the handle, and a compartment for six colors of eye shadow. The piece satirized the have-it-all mentality of the 1980s, quietly suggesting that some of the responsibility for a woman's dilemma might lie with a man. About 1987 Berman started cutting up a collection of old tinplate dollhouses, which she liked for their cheery celebrations of domesticity, and piecing them into cubes. All sides of the cubes were designed like traditional quilts, with images of a fractured house.

Hourglass Figure: The Scale of Torture (1994) is a faux bathroom scale constructed from Slim-Fast cans in a quilt pattern. (Figure 11.16) Berman cut the cans with pinking shears, leaving the characteristic zigzag edge, resulting in a surface of hundreds of tiny triangles with all the jagged edges folded upward. One imagines standing on her make-believe scale, probably oozing blood. The quilt pattern Berman used here is called "wild goose chase," a comment on the futility of dieting. The dial, which is motorized to rotate under the window where numbers usually appear, provides a long list of food-based endear-

FIGURE 11.16. *Harriete Berman*, Hourglass Figure: The Scale of Torture, A Pedestal for a Woman to Stand On Series, *1994. Printed steel, Plexiglas window, plastic dial with lettering, battery-operated motor; 3 × 12.5 × 13 in. (Courtesy of the Artist. Photograph by Philip Cohen.)*

ments given to women: cupcake, cookie, tootsie. All the foods are fattening.

PALEY SCULPTURE

From the beginning of Albert Paley's involvement with blacksmithing, he made sculptures with the same visual effects and techniques he used in his gates, screens, and furniture, and he saw their potential for transformation into monumental sculpture. He arrived at a format that would serve him well: a variety of elements attached to a steel core. At first, Paley used enlarged versions of forms that he developed at his forge: blades, leaves, petals, and tendrils. As the sculptures grew—approaching thirty feet tall in 1990—the parts grew too large for a forge. So they were cut out of steel plate, cold-formed, and welded together. That allowed more forms: flat profiles, ribbons uncurling in space, squares, and boxes sprinkled like confetti.

Paley favored large outdoor commissions in public places, especially transitional spaces where people moved from outside to inside, from the street to an institution. He wanted his sculptures, as public signs, to be approachable and celebratory. At first sight, many of them appear jumbled. Dynamic forms shoot off into space in every direction. But close examination reveals a precise composition, balanced and active from every point of view. Allusions to plants and repetition of forms refer to decorative arts traditions. *Passage* (1995) is a typical piece, though made of Cor-Ten steel without color. (Figure 11.17) Some thirty-seven feet tall, it can be read as two leafy trees—a positive image for the entrance to the U.S. Federal Building in Asheville, North Carolina.

FIGURE 11.17. *Albert Paley*, Passage, Federal Building, Asheville, North Carolina, *1995. Self-weathering steel; 37 × 23 × 16 ft. (© 2009 Paley Studios Ltd.)*

The parts were cut out in a job shop, with computer-guided technology, and welded together. The technology is industrial, not craft-based. And yet Paley's sculpture is more successful than the majority of craft-as-sculpture produced in the 1980s and 1990s. He kept his decorative sensibility intact, his steel material allowed vast increases in size, and he offered an alternative to contemporary sculpture conventions—an accomplishment by any definition.

TOM JOYCE

Tom Joyce's attitude toward ironworking was shaped by his understanding of iron as a repository of memory. When he was fifteen or so, he worked in a print shop in rural New Mexico. The owner kept a working forge to repair his presses, and Joyce got a practical education in forging. He learned that iron had once been a precious commodity in New Mexico, and implements were repeatedly repaired because they were costly to replace. They accumulated a visible record of their existence, of stress and failure and resurrection at the forge.

Joyce (b. 1956) set up his first forge in 1972, when he was working in tiny El Rito, turning out the usual assort-

ments of hardware and fixtures. Over the course of nineteen years, he worked up to architectural commissions of considerable size and expanded his shop until he had five apprentices and workers. He wanted to devote more time to making sculpture and other time-consuming projects, however, so he returned to a solo operation. As he put it: "I wanted to think about using iron as though it were something precious. I was thinking about how I can make each project matter—how to make something that is needed in the community."[19]

Joyce developed a way to fold strips of steel back over themselves to make platters. The underlying layers, although not directly visible, leave welts on the metal above. In a sense, the platter displays a memory of how it was constructed. In another series of plates, he recycles small scraps of steel that would otherwise be discarded, embedding them in a larger piece. He arranges the scraps like bits of fabric in a quilt. Not only are these patchwork pieces quite lovely, but they also involve recycling, much like the old tools he repaired as a youth.

In 1994 Joyce had an opportunity to use his blacksmithing to reach out to the Santa Fe community. Santa Maria de la Paz Catholic Community was building a new church, and they had placed a massive block of granite inside the church to be carved into a baptismal font. When the sculptor started carving the block, he discovered faults in the rock that made it impossible to continue. The architect called Joyce, who decided that a forged steel font could be a collaboration with the entire parish. (Figure 11.18) Parishioners donated their own pieces of iron, and he forged them into the font.

One person brought in a section of iron fence from a deceased grandmother's garden plot. A nun donated a key she found while on pilgrimage to Nazareth a quarter century before. In one of the most moving gestures, a local *penitente* brought in some nails he had gathered from the ruins of his former church, which had been destroyed by arson. Taking everything that was offered, Joyce forged each gift into an irregular panel and pieced them together into an iron quilt. It is now the church's baptismal font, with water constantly running into a larger pool. Volunteers oil the steel every day so that it won't rust from contact with the water.

In keeping with his community engagement, Joyce trains high-school-age boys in his shop. Some of them are at risk, others gifted with their hands but not so good at schoolwork. They are not true apprentices, in that they stay only briefly, but several have gone on to set up their own forges. His modest program is so successful that the Santa Fe public school system developed plans for high-school blacksmithing instruction—for the first

FIGURE 11.18. *Tom Joyce*, Baptismal Font, Santa Maria de la Paz Catholic Community, Santa Fe, New Mexico, 1994. *Forged iron, bronze, granite; 42 × 72 × 40 in. (Courtesy of the Artist. Photograph © Nick Merrick, Hedrich Blessing.)*

time since the manual-training movement faded years ago.

Textiles to Fiber

The 1990s was a difficult time for wearables because recession affected the market for luxuries, but the genre survived, and Julie: Artisans Gallery even moved to a larger space. Some one-of-a-kind and limited-edition clothing began to associate itself more with fashion than with wearable art. Commissions for public-scale textiles also dried up.

Yet there was no net loss of activity, and some areas continued to professionalize. The Textile Center was established in Minneapolis in 1994 as an umbrella organization that provides a meeting place and information center for dozens of active guilds, both hobby and professional. The International Quilt Study Center was established at the University of Nebraska, Lincoln, with the donation of an international collection of 950 quilts from Robert and Ardis James, along with a pledge of financial support.

The Bay Area was still feeling the loss of Fiberworks and Pacific Basin schools. *Surface Design Journal*'s ad-

mired San Francisco–based editor, Charles Talley, decided to leave that position to take religious vows. Yet at the same time, local schools—especially the California College of Arts and Crafts and the University of California, Davis—continued to produce active graduates, who worked on a more intimate scale than before and often in a more personal style.

Curator Nancy Corwin picked up on that trend in 1992, when she organized a national traveling show called *The New Narrative: Contemporary Fiber Art*. Surface design continued its rise. Amid these mixed portents, the field reconsidered its name. In a shift that had started probably two decades earlier, the term "textiles" came to seem associated with industry and was less favored than the category "fiber."

RANDALL DARWALL

Randall Darwall (b. 1948) is a rare studio weaver whose interest lies in usable textiles that are appreciated for their sensuous feel and subtle, glowing color. He has created a cottage industry in which he dyes the yarns and winds the warps but encourages his weavers, most of whom live near his Cape Cod studio, to work freely and not make identical works. He advertises his silk scarves and shawls as individual creations, no two alike. (Figure 11.19) He has said that his concern as a studio cloth maker is to be the opposite of "run of the mill" and to follow impulse, keeping up a "conversation with colors, fibers, structure and the constantly chiding voice of function."[20]

Darwall seemingly backed into this work. With a Harvard BA in art history and an MA in art education from RISD, he established a weaving studio in Cambridge, Massachusetts, as he worked full time as head of the arts division at the Cambridge School, Weston, from 1973 to 1981. During that time he gradually came to employ eight part-time assistants to help weave, finish, and sew his cloth. And he came to feel that he was running a sweatshop. He quit his job, moved to Cape Cod, and began doing the majority of the work himself. But just as he looks for diversity in the weaving, he has tried a variety of studio arrangements. In the 1980s he collaborated with Linda Faiola, a Boston-based clothing designer, who made one-of-a-kind garments from his cloth. In the 1990s he began designing and weaving vests and jackets that were constructed in Philadelphia by Heide Harper. Rather than selling wholesale, he began showing at American Craft Enterprises fairs with the support of his more gregarious partner, Brian Murphy.

Known for his silks of saturated hues, Darwall concentrates on the drape and the hand (feel) of the cloth. The sheen of silk and the intense bits of color are most memorable, but the cloth also has durability due to its tight weaving. Darwall concedes that in an industrial sense, he is an anachronism, but he sees purpose and meaning in the fact that "a handweaver is a human who can change its mind, something still impossible for the machine." He may respond to market demand, but he also aspires to a spiritual content and hopes that the user might feel a sense of connection.[21] Both his role and this aspiration continue a minority legacy in craft. Weavers of specialty cloth in America have more often moved into production and design; Darwall's commitment to cottage industry recalls the work of British weaver and dyer Ethel Mairet in the first half of the century.

SANDRA BROWNLEE

Sandra Brownlee's distinctive approach to weaving in the 1990s was to work primarily in black and white and to work intuitively at the loom in the supplementary-weft pickup method, which allows her to make decisions about shape as she goes along, passing a weft yarn over and under various groups of warp threads. That wouldn't seem too difficult, except that there's no changing her mind, no going back and undoing. It requires a particular concentration or adaptable imagination to do this spontaneously in the sequential process of adding each new line of weft.

It was at Cranbrook that Brownlee chose this unusual approach. She creates basic geometric forms: squares and checkerboards, repeating angular letterforms such as the X or V, and various moderately representational forms. Influenced by brocaded Indonesian ship cloths and pre-Columbian mantles, she created her Unusual

FIGURE 11.19. *Randall Darwall*, Satin Plaid Shawl, 1999. *Silk; 23 × 100 in. (Collection of the Fuller Craft Museum. Courtesy of the Artist. Photograph by Morgan Rockhill.)*

FIGURE 11.20. *Sandra Brownlee, Woman, 1994. Sewing thread, supplementary weft pickup; 7 × 9 in. (Collection of Anna and Bill Smukler. © Sandra Brownlee.)*

FIGURE 11.21. *Dorothy Gill Barnes, Seven Moon Dendroglyph, 1994–96. Marked white pine bark; 15.5 × 11 in. (Collection of Racine Art Museum, Gift of Karen Johnson Boyd, 1999.15. © Dorothy Gill Barnes. Photograph by Tom Grotta.)*

Animal series in the 1980s. These eight pieces, each with a five-by-five-inch square dominated by a mythical creature, sewn onto a fifteen-by-fifteen-inch patterned ground cloth that acts as frame and environment, were later scanned, manipulated, printed, collaged, made into a narrative sequence, and published as a book. All her works, the Creation series (1991) in particular, "are about how things take form out of the chaos; an energetic sea of dots congeals into meaningful semblances."[22] The result is one of evolution and relationship that leaves specifics to the viewer's interpretation. For instance, *Woman* (1994), despite its name, suggests a landscape from the air or as shown on a map, with squiggles representing mountains, a dark river emerging at the top and growing wider, a marshy or sandy slope symbolized by dots that fall freely within a zigzag pattern. (Figure 11.20) In *Hanging Figure* (1993), a checkered band might represent ground level, with the vertical and angled lines below suggesting roots; within a dark block is a pocket of space in which a bent human figure seems suspended, its presence causing a disorienting shift in referential scale.

DOROTHY GILL BARNES

Dorothy Gill Barnes is, like John McQueen, a maker of basketry sculptures rather than baskets in the conven-

tional sense, and probably no one equals her in responding to the peculiarities of an individual tree (except perhaps the British sculptor David Nash, in his early works). She has no interest in traditional patterns. When she collects materials near her home in Ohio, or in a pine woods about sixty miles away, she looks for discoveries of form—particular meetings of limbs and alteration of bark. She uses only trees that are to be thinned out or removed for health or development reasons, plus windfall debris. Most of her material is pine or mulberry, but occasionally she uses buckthorn, cedar, and gingko. Living bark can be pulled off only between April and July, so that is her busiest period, and when she works in the woods, she must decide whether to work the bark immediately, while it is pliable, or stockpile it to work later. As a consequence of her choice of methods, her works are relatively few in number.

Barnes (b. 1927) also inserts time into her works in a distinctive way. She incises marks in the bark and harvests it as much as two years later, after scar tissue—

the tree's response—has formed. She calls these marks "dendroglyphs," a word she found in a historical study of initialed aspen trees in New Mexico. (Figure 11.21) She likes the fact that, as in ceramics, what she has done is recorded in the material, yet she doesn't entirely escape the feeling that the tree is an animate being and is wounded. She has also wrapped branches with thread or twine, which leaves fine lines as the tree grows and the thread disintegrates. Another procedure is wrapping fresh bark around stones; as the bark dries around the stone, it takes that contour and makes the stone seem embedded.

Barnes's interest in power tools as well as hand forming is unusual. The tools suggest ideas and allow forms that could not be achieved by handwork alone and also give her forms their particular toughness and muscularity. In photographs, the works often look monumental. She is also unusual in having continued to use the loom: she can weave more delicate materials such as fern stems and lichens, working flat and then pulling the warp threads to yield the shape she wants, often working it over a spherical form while wet. Barnes doesn't fall into a category, even when it comes to size: she has made wall pieces up to ten feet long inspired by the slenderness of sucker growth on apple trees. It is that responsiveness that distinguishes her work, along with the persistent animistic character of the materials as she works with them.

LISSA HUNTER

In 1979 Lissa Hunter (b. 1945) gave up a teaching job, moved to Maine, and devoted herself to full-time studio work. She was still weaving then and making collages, and she had begun to work on baskets as well. Each basket started without a plan; she would simply begin coiling, stop when it seemed right, cover the surface with layers of her own handmade paper, apply acrylic medium, "age" it with watercolor, and add decorative elements. The result was a basket that looked burnished with time, that seemed to be an ancient artifact but that was not derived from any known culture.[23] She was looking for spiritual embodiment, and Native American objects seemed a good model. But she labeled her borrowings, so to speak, by applying a tribal pattern in crochet so it was clear that she was quoting rather than copying the traditions.

These elements—the coiled baskets, handmade paper, painting—along with drawing, continued to be central to her practice throughout the 1980s and 1990s. The specifics changed considerably as she created arrangements, often boxed within a larger paintinglike expanse, that relate to still life and to figural tableaux. In the 1990s

Hunter moved away from individual objects and tribal associations, disclosing her baskets' true utility as containers of recollections and emotions.

A pivotal work was *Hostages* (1991), a group of eight forms of similar size that are not baskets in form but rather evoke solemn figures in somber cloaks—perhaps a family milling about, waiting. They are made helpless by bindings. The forms, which stand on a metal plinth and are a maximum of 8½ inches high, are coiled raffia as usual, and their budlike heads show that they are covered with paper as usual, but linen cloth obscures the details to an atypical degree and spruce roots wrap like wires around them. The forms are nearly inverted cones, and their width at the base suggests that they are of the earth, or grounded. This work came from a very different place than Hunter's thoughtful archaic baskets. It was created while her father was dying of cancer, trapped in a failing body.

The form and process of writing, free of specific content of language, has also become a signature feature of Hunter's work. *Old Soul* (1999), for example, is a square five-inch-deep "canvas" marked with wide lines within a neat border, like notebook paper, and scrawled in what looks like pencil and white chalk, resembling effaced documentation. (Figure 11.22) A square central niche holds a full-bellied basket with a wide mouth and a tattered crocheted covering. Because of the snug fit, the contents of the basket, if any, cannot be seen. Along the

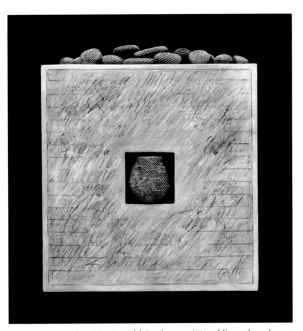

FIGURE 11.22. *Lissa Hunter,* Old Soul, *1999. Waxed linen thread, wire, paper, paint, fiberboard, plaster, pencil, stones; 18 × 18 × 5 in. (Private Collection. Courtesy of the Artist. Photograph by K. B. Pilcher.)*

top edge of the piece, a dozen or so small, flattish stones are piled up. They, too, are encased in crochet, causing one to wonder what that means: to carry? to protect? to conceal?

Within her vocabulary of forms, Hunter's most memorable works elevate the attempts at communication, efforts at remembrance, and evidence of loss, but her oeuvre is far from morose. She also demonstrates the satisfactions of making and repeating, the pleasures of materials and the symbolic importance of objects, charting a course between the Scylla of sentimentality and the Charybdis of illustration.

NICK CAVE

A designer of a line of men's and women's one-of-a-kind and limited-edition clothing and a professor who heads the fashion department at the School of the Art Institute of Chicago, Nick Cave is best known for an expansive series of expressionist costumes—perhaps inspired by West African masquerade garb—that he calls Soundsuits. (Figure 11.23)

Clothing is a constant in Cave's work, but he came to it indirectly. Inspired by the Alvin Ailey Dance Company, whose performance he saw when he was in high school, Cave (b. 1959) took dance classes. In the late 1970s, at the Kansas City Art Institute, he became interested in fashion of the outrageous kind and engaged in street performances with other students. From Shigeko Spear, a Japanese-born textile artist who taught at the school (and whom he followed to North Texas State University for a year), he learned techniques, a work ethic, and respect for materials.

The symbolism of materials became the heart of Cave's Soundsuits, which he initiated in the late 1980s when he was at Cranbrook—ostensibly to continue fiber studies but in fact spending most of his time painting. He was the only black student there, and he has at various times been the target of racial profiling by police, which increased his sensitivity to issues of African American identity. He believes that minorities are viewed "as less than significant," so he chose to use his art to explore the transformation of "insignificant" materials. He regards that as both a religious idea and as something out of science fiction, which he hopes to emulate by moving the familiar "toward the fantastic."[24] The materials of his Soundsuits are chosen for aural, visual, and symbolic reasons. The noise they generate when Cave and others perform in them symbolizes the need to listen to others; the concealment that they offer suggests the uncertainty of appearances.

FIGURE 11.23. *Nick Cave*, Soundsuit, 1992. *Afghan, wire, mirror, found objects. (Private Collection. Courtesy of Jack Shainman Gallery. © Nick Cave.)*

The Soundsuits were originally conceived for street performance, with the plan to make about twenty, but as of the end of the 1990s there were nearly one hundred. The most striking are probably those with enormous headgear/masks that make the wearer as much as eight feet tall. A suit entirely of twigs and another of prickly black- and red-tipped sisal play off African wood-and-raffia masks and can seem powerful and intimidating. Others incorporate flattened tin cans and jar tops, feathers, found crocheted afghans, or key chains. His performances include appearing in flowing and flaring veils of translucent green and black cloth symbolizing Africa, use of pointed hoods and references to blackface, activities relating to gender in which he represents himself as an androgyne, and moments when he is seen in street clothes to emphasize the transformative quality of the costumes. In performance, Cave both reveals the personal and generalizes it, and his costumes, though not overly concerned with craft skills, share the sensibility of respect for material and valuing of touch.

HIGH-TECH WEAVING

In the 1990s, a Jacquard loom suitable for the studio became available. While weaving was no longer the predominant medium and many fiber departments had disposed of their looms, several longtime weavers took advantage of the new technology. Cynthia Schira (see chapter 9) had developed her Complementary Warps series using a thirty-two-harness Macomber loom with a simple computer built in, which was an advanced piece of equipment when she bought it in 1983 (using National Endowment fellowship money). Schira painted dye onto her warp threads and structured the pieces so that the warps were sometimes revealed and sometimes hidden and, by these means, controlled the purity or mix of color. She also used several weave structures, so that different patterns appear in the weaving. The nonexpert viewer might recognize nothing of this technical sleight of hand but could find abstracted, atmospheric landscapes.

In 1994 there was finally a software program practical for the artist's studio. Over the next few years Schira created complex graphic orchestrations that resembled graffitied urban walls and incorporated allusions to traditional woven textiles. She could add blocks of computer-code-like letters and symbols, making reference to the very device that enabled her to compose such complicated works. Spending time at the keyboard did not worry her. "If you're a weaver, you are using technology right from the very beginning. You're not just working with your hands,"[25] she says, adding that new technology simply makes the execution easier.

Lia Cook (see chapter 9) likewise was able to make works that would have been impossible with a simpler loom. In the 1990s she began to create large wall hangings based on childhood photos. These works were soft and sensual, with rich though limited color. From a distance they are recognizable as faces, but from nearer they dissolve into the abstraction of pointillist dots—a degree of variegation that would have been unthinkable by hand.

Cook upped the ante when in 1997 she began making self-portraits and body imagery in the Presence/Absence series, based on video stills. These works have been described as "disrupting conventional binary logic: they are at once sentimental and mechanically cool, traditional and new media; uniquely personal and emblematic of how we all collectively depend on photographs to harness our memories."[26] Though still working in weaving, she adopted the photo and computer language of the new generation.

Wood: All Options Open

Studio furniture continued as a pluralistic collection of styles and intentions. Latter-day historicism prospered just as much as furniture-as-sculpture, with plenty of options in between. Only a few first-generation modernist woodworkers survived, but they continued to exert a tremendous influence. Innovation was still sometimes tied to technique, as shown by the interest in direct-carved surface decoration. Many makers looked to other materials, including metal, concrete, and plastics. As in weaving, digital technologies began to be incorporated into studio practice.

Through the 1970s and 1980s, as woodworkers became more interested in referring to traditional forms, more and more studio furniture was made of tropical hardwoods. Mahogany, purple heart, cocobolo, rosewood, wenge, and many others were used for their strength, deep colors, beautiful grain, and ability to take a glossy finish. But woodworkers knew that some tree species had already become rare. For instance, the great teak forests were depleted during the heyday of Scandinavian modern.

When the destruction of tropical rainforests became a public issue, woodworking was affected. While studio and hobby woodworking is only a tiny fraction of worldwide consumption of endangered hardwoods, some makers felt that they had to take the lead in ethical use of woods. Writer Scott Landis helped found the Woodworkers Alliance for Rainforest Protection (WARP) to discuss irresponsible use of endangered woods and to propose solutions. Two responses evolved. One was to create guidelines for forest management and a certification procedure, so makers could be sure that wood they bought was grown and harvested with sustainable methods.

The second response was to avoid the use of tropical and endangered wood altogether and turn to American timber. The United States has generous supplies of hardwoods such as maple, walnut, beech, or elm, although western softwoods are diminishing. Bruce Beeken and Jeff Parsons, who run a shop near Burlington, Vermont, salvage trees blown down in storms, and they use less desirable woods like hop hornbeam. They conducted a focus group to discover the public's reaction to wood with knots and other imperfections. Euphemisms helped, they found: if they called knots and wormholes "evidence of the random workings of nature," responses were more positive.[27]

A major event in the furniture market was the opening of the Peter Joseph Gallery in 1991. Joseph was a wealthy

businessman and a steady customer at Pritam & Eames on Long Island. As his knowledge grew, he decided to promote fine furniture in New York City. He opened a gallery and offered generous contracts, including monthly stipends, to a select group of woodworkers. The goal was to give makers the time and freedom to assemble ten or more major pieces for a solo exhibition every eighteen months or so. Many major figures signed up, including Wendell Castle, Garry Knox Bennett, Richard Scott Newman, Albert Paley, and Wendy Maruyama. Joseph also purchased pieces from his shows, which had the effect of supporting the high prices he charged. Yet the enterprise was never intended to make money.

Joseph consistently referred to the work he showed as "art furniture" and the people he showed as artists. He published a catalog for each show and hired well-known figures such as Arthur Danto to write essays. All the activities were calculated to establish a high-end market, as well as art world credibility. Some observers accused him of creating an artificial elite (a reminder of craft culture's democratic impulse). Still, the gallery gave studio furniture a new presence.

After Joseph's early death, his gallery closed in 1997. Prices slid as his stable looked for representation elsewhere. As for acceptance of furniture as art, there is little evidence that critics and curators thought differently about the field in 2000 than they had in 1990. It may have gained a modicum of acceptability as design, but not yet as art.

Meanwhile, a vigorous secondary market developed. Prices for Nakashima and Esherick furniture grew steadily, as did prices for the best Arts and Crafts material. Sam Maloof was designated a California Living Treasure, and there was a nearly endless demand for his work. Hundreds of others made modest livings from their furniture, but many continued to subsidize their studio work with teaching or custom cabinetmaking.

Studio furniture had seen two failed attempts at organization in the 1980s: the American Wood Workers and the American Society of Furniture Artists. In 1996 the field finally succeeded in organizing itself as the Furniture Society (FS). The FS is unusual among craft organizations in that it is based on a class of functional objects rather than a material. Still, it acknowledges the "woodies" among its membership: presentations on technique are always part of its annual conferences. In a parallel venture, the Society of American Period Furniture Makers formed in 1999, dedicated exclusively to the reproduction of historical work.

MICHAEL PURYEAR

Many of the furniture makers cited in the past two chapters are college professors and thus insulated from the problems of making a living at their craft. Affordability and utility are not such pressing questions when paying the mortgage does not depend on the next sale. Production woodworkers like Michael Puryear (b. 1944) have to consider marketplace at all times.

Puryear came to woodworking by a roundabout route: a nine-to-five job, a degree in anthropology, a brief period as a professional photographer, work as a general contractor, more work as a maker of built-in and freestanding cabinetry, and finally studio woodworking. Like Walker Weed in the 1950s, he was drawn to woodworking for the independence it allowed him, especially freedom from rigid schedules and dull work. Studio work made it possible for him to pursue all his interests—family, work, tai chi, outdoor sports—as he desired. For him, the life of craft is an integrated life. He notes, however, that the craftsperson is rarely rich and that the trappings of wealth are usually out of reach.

While Puryear might have chosen sculpture—his brother Martin did—he likes the logic of function as a justification for form. By this logic, decoration should have little or no place in furniture, and indeed, there is nothing in his work that cannot be explained by struc-

FIGURE 11.24. *Michael Puryear*, Screen, *1999. Dyed and filled ash, 69 × 59 in. (© Michael Puryear.)*

tural necessity, function, or perhaps beauty. There is no decoration.

Wood appeals to Puryear because of its natural warmth and receptiveness to touch. He lets the wood speak clearly. His joinery is often exposed but rarely conspicuous. More than anything else, his work is characterized by refined proportions and curves. One of his most spectacular pieces is a two-part folding screen from 1999. (Figure 11.24) Each half is a sheet of laminated ash bent into a C-shape that stands on edge. The two halves are hinged along the straight edge to make a single S-curve. The whole is dyed a dark green, but the grain of the ash remains clearly visible. The simplicity and elegance of the screen make it a masterpiece of American woodworking.

Puryear hopes that his work embodies *shibui*, a Japanese term for understated beauty. Because he operates within the craft marketplace, it is also practical beauty. His furniture is intended to enhance somebody's home, to bring delight where there might otherwise be a factory-made anonymity. His work (like all good studio furniture) is meant to last many lifetimes, which makes ecological sense. At the same time, Puryear benefits because he can do what he feels is right and good. William Morris would approve.

SURFACE PATTERNS

In the 1990s, there was a surge of interest in pattern on furniture (and on turnings as well). Woodworkers had mastered the subtleties of construction, so form was no longer such a challenge. The adoption of paint and materials like ColorCore turned attention to the surface. After an initial period of bright colors and exuberant form, woodworkers settled into an exploration of pattern and decoration more rooted in tradition. The traditions were not necessarily Western, however.

One of the first to immerse herself in surface pattern was **Kristina Madsen** (b. 1955). She learned woodworking as an intern with David Powell, who had apprenticed under Edward Barnsley in England. (Barnsley's father was linked directly to the English Arts and Crafts tradition.) Powell's conservative design sense and rigorous instruction in the use of hand tools influenced her greatly. After she saw a catalog of South Pacific wood carving, however, she began to incorporate simple patterns into her work. At first, she routed parallel grooves into a board, cut it up, and reassembled it into a variety of checkerboard-like motifs. A 1988 residency in Tasmania and subsequent travels to New Zealand and Fiji brought her into direct contact with indigenous carving traditions of the Maori and Fijian peoples. Much impressed, she returned to Fiji in 1991 to study with master carver Makiti Koto. She lived there nine months as part of Koto's extended family, learning what is traditionally regarded as a man's work.

In Fijian carving, a small knife or gouge is used to cut notches into a surface freehand, without the aid of templates or jigs. The visual power comes from repetition: thousands of cuts build up into geometric patterns. In Fiji, carving reinforces a chief's status by enhancing the value of his possessions. In the United States, it can't have the same meaning, so Madsen developed the technique rather than the imagery. Doing so, she avoided issues of cultural theft.

Madsen applied freehand carving to Western benches, tables, and cabinets on stands. She also elaborated on the technique itself. To create a color contrast, she carves through a layer of veneer or paint, exposing the underlying wood. At first, she carved into fully three-dimensional forms like the legs of a table, but gradually she confined ornament to flat surfaces. Simplicity suits intricate carving.

Typically, Madsen makes casework forms such as a cabinet or a chest of drawers. Her *Blanket Chest* (1995) shows how she divides form and decoration. (Figure 11.25) The wenge stand is very simple, made with miter joints at the corners to minimize distractions. Her carving is restricted to the top and a wide band that wraps around the sides. This pattern is actually three separate motifs: wavy vertical lines, zigzags between the waves, and a row of abstract winged forms between two lines. The light color is maple revealed by the carving. On top, the motif is repeated with a secondary design. The chest vibrates with pattern. At the same time, Madsen's meticulous labor creates its own resonance.

Once surface embellishment became established, it

FIGURE 11.25. *Kristina Madsen,* Blanket Chest, *1995. Maple, dyed pear, wood veneer, wenge; 23.5 × 51 × 15 in. (Courtesy of Pritam & Eames. © Kristina Madsen. Photograph by David Stansbury.)*

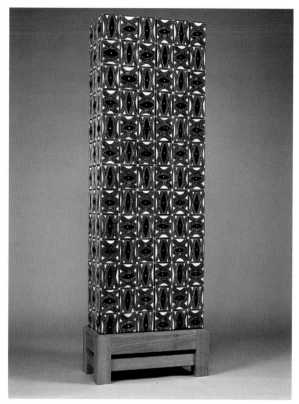

FIGURE 11.26. *Jenna Goldberg*, Tall Cabinet, *1999. Carved and painted basswood, mahogany; 73 × 24 × 12 in. (Courtesy of the Artist. Photograph by Tim Barnwell.)*

attracted a younger generation of makers. **Jenna Goldberg** (b. 1968) had completed an MFA when she took a summer workshop in freehand carving with Madsen in 1994. Goldberg's mother was a textile designer, and she was already attuned to decorative traditions such as ancient Roman and Islamic tilework. Goldberg uses freehand carving to make strongly graphic patterns with the wood underlying a painted surface exposed in broad areas. Her sense of pattern seems structured by a grid, with repeats that resemble textile or wallpaper design.

In her *Tall Cabinet* (1999), Goldberg used a blocky form on a short stand, which has an art deco character. (Figure 11.26) The outside pattern, developed from an eye motif, has overtones of both Australian and African indigenous art. Dark and light are more evenly balanced than in Madsen's chest. Goldberg decorated the inside of her cabinet with a red-on-white diagonal pattern, setting up both a contrast and a conversation with the exterior.

PETER PIEROBON

One woodworker who has continued to develop Wendell Castle's style is Peter Pierobon (b. 1957). He was a student at Castle's school from 1981 to 1983 and then worked for him for a time. Like Castle, he carves many

of his forms and thinks of furniture as form in space, although he makes completely functional furniture.

Pierobon departs from his teacher in the way he deals with meaning. Through the 1980s and 1990s, there was a certain pressure in the academic environment to make furniture that carried meaning. As a teacher at the University of the Arts and later at the California College of Arts and Crafts, he must have felt that pressure. His first strategy was to borrow historical details and use them like words, presumably building a meaningful sentence. In the 1990s, historicism and appropriation began to look stale. Pierobon discovered a way to write on his furniture without the literalness of ordinary English.

About 1991 he started incorporating texts in obscure languages. He used Celtic runes on a clock as cast-bronze elements applied to the surface. Some years later, he used International Sign Language. His favorite device was Gregg shorthand, a system of curved glyphs that can appear highly abstract. (Figure 11.27) With these, he could write a message on his work that would be decorative to most observers but would hint that meaning was hidden within. Since Gregg shorthand glyphs are abstract, he could treat them as modules and construct furniture entirely out of symbols. A 1994 example is a cast-bronze

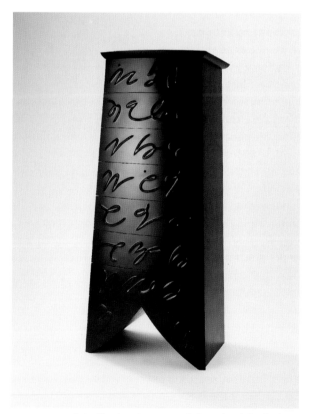

FIGURE 11.27. *Peter Pierobon*, Jargon, *1998. Carved and ebonized mahogany; 71 × 31 × 26 in. (Courtesy of the Artist. Photograph by Joe Chielli.)*

clock consisting of repeated signs for "time." Later he made glyph forms in large pieces of wood and used them as legs for a cabinet or a table. The cursive forms contrasted with the more regular geometry of the carcass or tabletop.

Pierobon is an excellent carver, and he shaped glyphs that stand up from the surface. In the early 1990s, he carved a series of chargers (a large, round dish) with inscriptions on the perimeter. To match the form, he chose quotations that were equally circular, such as "Things turn out best for those who make the best of the way things turn out."

Pierobon often used ebonized mahogany or poplar. In experienced hands, the dyed surface is rich and uniformly black and can be brought to a finish that looks almost metallic. While it is an old technique, it was revived by Castle in his 1980s clock series.

ROSANNE SOMERSON

For **Rosanne Somerson** (b. 1954), furniture is a means of exploring memory and emotion. Somerson was a student of Tage Frid's at RISD, but she chafed under his regimen. After stints of writing for *Fine Woodworking* and teaching, she renewed her commitment to furniture under other influences. She looked at art deco, Japanese architecture, preliterate art, and other material.

In the early 1980s, there was no clear sense of what women's woodworking should look like, other than something with frills and decorations, which Somerson rejected. She did not represent herself as a feminist, but she made work that was clearly feminine. In the context of studio furniture, that was interpreted as a feminist gesture. An earring cabinet from 1986 makes the point. Somerson gave it the form of a loop earring, with a mirror inside the circle. A painted box with drawers appears to be a pendant. Most designers would stop there. But Somerson added a small half-cup pressed against the mirror, which doubles the image so it reads as a whole cup. The illusion is a surprise. The drawers are lined with paper, and both cabinet and frame are carefully painted. The cabinet offers an intimate encounter that is both unexpected and pleasurable.

From then on, Somerson was drawn to the emotional aspect of the experience of furniture. She reasoned that furniture could provoke specific memories and feelings, since it is a silent partner in every stage of life and supports many of our most private moments. Somerson writes: "My hope is to help the viewer to find his or her own place of emotive satisfaction, coaxed and guided by the furniture's utility in both its obvious and more subtle functions. The emotive drive often overtakes the

FIGURE 11.28. *Rosanne Somerson*, Botanical Reading Couch, *1992. Polychromed mahogany, cherry, fabric; 35.5 × 76 × 32 in. (Collection of Smithsonian Museum of American Art. © Rosanne Somerson.)*

utilitarian protocol. . . . When someone brushes against a memory, spurred by my pieces, I then feel the satisfaction of having succeeded."[28] Her *Botanical Reading Couch* (1992) puts theory into practice. (Figure 11.28) The form is sensuous and sleek. Warm wood complements an exotic upholstery fabric. The couch invites people to lie back, take off their shoes, relax, pick up a book. The user might remember an old couch at home or simply enjoy the self-indulgence. Her couch is not about artistic self-expression. It is more about a kindly solicitation, a concern for the emotional well-being of the people lucky enough to use it.

It would have been more difficult to orchestrate the experience of the couch if the form were unfamiliar. Innovation takes place within a given context, and Somerson is not trying to reinvent furniture. These two areas—the context and the experience—were the most productive subjects for studio furniture in the 1990s.

ALTERNATIVE MATERIALS

Because furniture making was taught in woodworking studios, most studio furniture was made of wood. The preference did not accurately reflect either history or industry. Historically, Western furniture has been made of materials as diverse as cast iron, papier-mâché, glass, and cattle horns. Industry employed many technologies and materials soon after they became available: welded steel, bent aluminum, cast plastics, fiberglass. While alternative materials have been part of studio furniture—Castle's Molar chair is only one example—it was only in the late 1980s that most makers began to investigate them.

Artists and designers led the way. Architect Frank Gehry produced a series of tables and chairs of laminated corrugated cardboard (Easy Edges series, 1969–

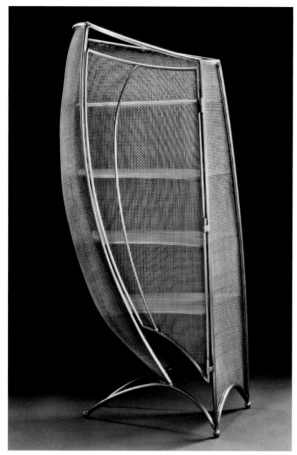

FIGURE 11.29. *Wendy Wiesner Gochnour, Caged, 1997. Wire cloth, steel, ash; 72 × 36 × 30 in. (Courtesy of Wendy Wiesner Gochnour.)*

73). From the early 1980s, R. M. Fisher made lamps of metal plumbing, mixing bowls, and consumer cast-offs. In London, Ron Arad made an icon of "high touch" design with his stereo system housed in cast concrete (*Concrete Stereo System*, c. 1985).

The self-imposed isolation of studio furniture was impossible to sustain. A wave of interest in cast iron went through the field, and craftspeople were soon investigating colored, fiber-reinforced, lightweight concrete, which requires almost no equipment. To replace textile upholstery, furniture makers can use expanded foam, felt, latex, rubber, and flexible surface coatings. With more advanced technology, there's resin reinforced with carbon fiber.

The most prevalent of the nonwood technologies is welded steel. It is cheap and widely available, fabrication processes are simple enough, and lots of art students learned how to weld in sculpture classes. An obvious step was to render familiar forms in sheet steel, especially blocky pieces like bureaus and chests. Then makers began using steel for a wider range of forms, some with no specific relation to furniture or sculpture.

Wendy M. Wiesner's *Caged* (1997)—a functional cabinet—is an example of the freedom with which steel is now handled. (Figure 11.29) The curving contours and the cantilevered structure take advantage of steel's strength and its ability to be formed. The walls are made of wire cloth, turning what would otherwise be a ponderous object into "see-through" piece of improbable lightness. Steel adds a metaphorical level, too, as the title suggests. Wiesner (b. 1966) did not abandon wood completely—the shelves are made of ash—but *Caged* goes far beyond traditional craft.

RUSTIC FURNITURE

On the other end of the technological spectrum, the 1990s also saw a renewal of interest in rustic furniture. The roots of this genre are uncertain: perhaps in gypsy culture, perhaps in Africa, maybe even in China. In any case, in the West it goes back to the eighteenth century, and by the beginning of the twentieth century, it was quite the fashion. Broadly, rustic furniture is made of unprocessed wood: twigs, sticks, logs, burls, and roots. Bark can be left on or stripped off. Such work came to represent unsophisticated rural life and was a favorite for furnishing summer camps in the East and ranches in the West. By the 1950s it was associated with rural backwardness and fell into disfavor, only to be reinvigorated by baby boomers seeking hands-on labor and the trappings of authenticity.

By the time former TV producer Daniel Mack wrote *Making Rustic Furniture* in 1992, a full-blown revival was under way. Mack traveled the country conducting workshops. Because it is comparatively easy to make rustic furniture, hobbyists were attracted to his workshops. And because of the infinite variety of branches, it is easy to make rustic furniture that is individualistic. But only a modest number of makers had the patience to go beyond the obvious formulas and be consistently creative.

Daniel Mack was one. **Clifton Monteith** (b. 1944) is another. Monteith is no country bumpkin. He has an MFA in painting, so he is sensitive to issues of form and originality. Once he took up bent-willow furniture, he looked at every aspect of the practice with an artist's eye. One of his hallmarks is a surface constructed of close-packed branches bent into wavelike patterns (normally, bent-willow twigs were spaced like bars in a birdcage). He also took advantage of the three-dimensional possibilities of this flexible material in nontraditional ways. His *Moon-Viewing Chair* (1999) is composed of four flowing planes. (Figure 11.30) The two sides meet in a crease that sticks out behind the chair, which terminates in a curve to echo the lines of the chair's arms and back. While it

FIGURE 11.30. *Clifton Monteith*, Moon-Viewing Chair, *1999. Willow, aspen; 44 × 24 × 43 in. (Museum of Arts and Design, New York, Gift of Robert and Gayle Greenhill, 2000. © Clifton Monteith. Photograph by Ed Watkins, 2007.)*

might superficially appear to be old-fashioned, it is any-thing but.

Monteith is attentive to all the subtleties of construc-tion, too. He chooses the color of his branches carefully. Bends play against straight lines. In a series of tables, branches are nailed into abstract curves reminiscent of the art nouveau whiplash line, while the understructure might be an elaborate truss. An unpromising medium, once thought to offer about as much artistic potential as potholder making, was redeemed.

WOODWORKING AS SCULPTURE: BOB TROTMAN

Like a number of other prominent woodworkers, Bob Trotman (b. 1947) came to wood after a more academic pursuit. In his case it was philosophy. Except for two workshops, Trotman is self-taught in his craft. Starting around 1976, he made animated furniture with occa-sional touches of cartoonlike figuration. In time, the figures overtook the furniture, and the rendering be-came much more realistic. Other woodworkers pursued sculpture through figuration, but their work was undis-tinguished.

What set Trotman apart was his use of the figure to represent a rather dark point of view. He says: "I am most interested in expressions of alienation: alienation of the

self from society, from the physical environment, and even of the self from itself. Not only is this feeling reso-nant for me personally, but, I believe, by way of attempts to avoid it, it is responsible for much of our social behav-ior. For me the expression of alienation is more penetrat-ing with a certain amount of ironic humor."[29] No other woodworker chose a subject like that. It is an idea with roots in both Marxism and sociology, but it became one of the central themes of intellectual modernism. Trot-man gave it his own twist.

The ironic humor was visible early on. *No Brainer* is a carving of a man's head about twenty-one inches high. The top is sheared off and nothing is inside the fellow's skull. The point would be obvious, but Trotman gives the sculpture another meaning by placing a few art maga-zines in it. His figures are almost realistic but not quite. They are carefully carved and finished, and he often adds thinned-out color to pull them away from associations with classical figure sculpture. Instead, they relate to American vernacular carving like ship's figureheads and religious statues. It is clear that his figures are made of wood, and sometimes they are obviously pieced. He

FIGURE 11.31. *Bob Trotman*, Louise, *1997. Bleached, dyed, and pigmented limewood, maple, casters, rubber; 54 × 36 × 36 in. (The Renwick Gallery of the Smithsonian American Art Museum, Gift of an anonymous donor and the Franklin Parrasch Gallery, New York, 1998.65. © Bob Trotman.)*

allows modest distortions to creep in, such as a certain exaggeration of facial expression. Later he used checked wood, with cracks running through the carvings. He wanted to remind people that they were looking at hand-made fictions.

As fictions go, they could be pretty blunt. *Louise* (1997) is a set of library steps, complete with a post to steady the climber. (Figure 11.31) The steps, however, are carved out of the back of a woman who seems to emerge from the floor at midtorso. She supports her head in her hand as she stares off into space. To use the steps, one must stand on her shoulders. In a final bit of perverse irony, *Louise* is mounted on wheels. She can be pushed around with minimal effort.

Further exploring the metaphorical possibilities of furniture, Trotman put drawers in several figures. Dalí had used the same idea in his statue *Venus de Milo with Drawers* (1936), reducing fine art to furniture and woman to object, but Trotman is subtler. *White Guy* (1994) depicts a forlorn middle-class fellow—presumably an urban office worker, since he's wearing a white shirt and a tie—riddled with small drawers. He is highly compartmentalized: there are drawers in his chest, his belly, his forehead, his elbows. For a final touch, Trotman mounted the drawers on metal runners so that, when operated, *White Guy* sounds much like a metal filing cabinet.

WOOD TURNING AS SCULPTURE

In the 1990s, wood turners concentrated on two enterprises: creating surface patterns in wood to enliven turned forms, and developing new ways to shape wood on the lathe to escape the familiar vocabulary of cylinder, cone, and bowl. A number of turners abandoned all connections to functionality, producing small abstract sculptures or quasi-vessels with baroque outgrowths. The discipline with which Prestini or Stocksdale approached form was forgotten. Flames, fins, trumpets, tendrils, swirls, pods, and batwings proliferated, along with a rainbow of colors, all resembling the most egregious excesses of studio furniture in decades past.

The swoopy, flamelike forms that many turners employed had been part of the vocabulary of avant-garde sculpture from the 1930s to the mid-1950s. Turners rarely acknowledged any development in sculpture after 1960. When they and their apologists claim that turning is "wood art," one wonders what kind of art they are referring to. They needn't follow the art world, but they do—only it is an antiquated form language that risks an impression of kitsch.

One explanation for the questionable quality is that most turners are self-taught, in the tradition of Osolnik and Stocksdale. Many adopted the craft as hobbyists. But the mastery of technique is only half of what makes good turning. A few escape this criticism, however, among them Mark Lindquist and Stoney Lamar.

Stoney Lamar (b. 1951) makes entirely plausible sculpture. In his late twenties, Lamar earned a BS degree in woodworking from Appalachian State University. At first, he intended to make furniture, but he found the immediacy of turning wood more satisfying. In 1984 and 1985, he worked as assistant to Melvin and Mark Lindquist and was influenced by them both: Melvin's sense of the whole tree, flaws and all, as a raw material, and Mark's ambition to make sculpture rather than vessels.

Perhaps to distance his work from Mark Lindquist's, Lamar began to investigate multiple-axis turning. If a piece of wood is mounted only once on a lathe, the resulting turned form is always round in section and always symmetrical. If the same piece of wood is repositioned, rotating on a different axis, both section and symmetry can be altered. The further the second axis differs from the first, the more irregular the resulting shape. There are technical problems: attaching wood securely to a lathe can be tricky, and multiple-axis turning often requires the wood to be severely unbalanced. But the payoff is a form that no longer resembles a traditional vase or plate.

Lamar first made variations on vases, but in the early 1990s he began to make upright pieces that had the stance and gesture of human figures. One such sculpture is *No Looking Back* (1998). (Figure 11.32) The form is deeply cut, suggesting two legs in the act of walking. The metaphor is of forward progress, leaving one phase of life for another. Of course, it could also be about Lamar himself giving up the long tradition of making vessels. In truth, though, Lamar is looking back at his craft. The irregular surface at the top of the sculpture is raw madrone wood, and he left conspicuous inclusions and stains in the wood. Both refer to the rusticated turnings of his elders. Similarly, there is a cup-shaped depression on the other side. This reference to the hollow of a bowl constitutes the metaphorical center of the whole object. Lamar also finished the wood in an unconventional way: instead of playing up the grain, he suppressed it by bleaching the whole piece.

Lamar thinks of his sculpture in terms of form, gesture, metaphor, and even beauty. This kind of sculpture was developed in the 1940s by artists such as Henry Moore, Barbara Hepworth, and Isamu Noguchi. It was supported by theories that explained the value of art in

Ceramics: Individuals and Themes

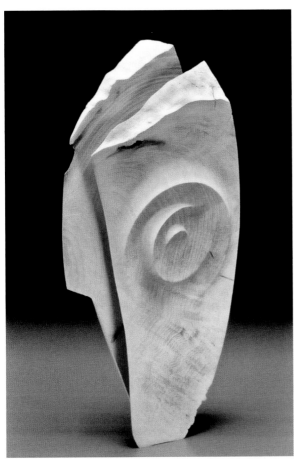

FIGURE 11.32. *Stoney Lamar*, No Looking Back, *1998. Bleached madrone; 20 × 10 × 5 in. (Courtesy of the Artist. Photograph by Tim Barnwell.)*

terms of an aesthetic experience, stimulated by pure line, color, and form—an interest Lamar shares. The extension of these ideas is seen today in the sculpture of, for example, Martin Puryear and Mel Kendrick in larger scale and with more concentrated allusions. Turners, however, continue to be attracted to the personal, intimate qualities of object scale. Most craft sculptures—in any medium—fit comfortably into a domestic living space. They fulfill the old function of the decorative arts: they decorate homes and apartments.

It can be argued that craft never abandoned beauty, even if the concept of beauty has changed over the years. There is grace to the bleached-out grain, the gentle shadows, and the long curves of Lamar's *No Looking Back*. For those who find present-day art ugly and overpowering—and there are many—craft sculpture offers a respite and refuge, while the best of it pushes for a distinctive place of its own.

After decades of survey shows, a welcome increase in depth and sophistication was offered by the two major ceramics shows of the decade, retrospectives of the work of Michael Lucero (organized by Mark Leach and Barbara Bloeminck) and Adrian Saxe (organized by Martha Drexler Lynn). At the essential end of the ceramic spectrum, wood-firing continued its growth. At the other end, that of artifice, the most famous and expensive ceramic works were those fabricated for Jeff Koons. Koons's work was not based on the artist's skill of hand, or even the artist's design skill and activity as a general contractor supervising skilled artisans. Rather, his concept was to monumentalize bad taste, thus undercutting art, craft, and creativity.

Within the ceramics field, however, many avenues were being explored, among them political commentary. Art historian Judith Schwartz organized a traveling exhibition and catalog called *Confrontational Clay: The Artist as Social Critic*, which, while scattershot in approach, made clear that contemporary issues and contemporary ceramics were not incompatible. Another trend was the renewed orientation toward design rather than expression, which found a ceramist such as Kathy Erteman, known for functional vessels with black and white carved surfaces, producing lines of vases, plates, and other forms for upscale stores such as Barneys or Japanese department stores, as well as hands-on designing products for Dansk, Crate & Barrel, and Tiffany. Jonathan Adler got his first order from Barneys in 1994 and subsequently opened his own stores and branched out into other design projects. KleinReid, a New York City production pottery established in 1993, specializes in porcelain and is licensed to reproduce Eva Zeisel's designs.

SANDY SIMON

Functional pottery is still a vital force in Minnesota, New England, and the Southeast, so it may be no coincidence that Sandy Simon, though long based in the Bay Area, has been associated with two of those regions. Sandra Lindstrom studied at the University of Minnesota with Warren MacKenzie and lived and worked as a studio potter in Georgia with her then-husband, Michael Simon, from 1970 to 1978. It was there that she began to work in porcelain, and she lists that entire period on her resume under "education." After that she taught in Chicago, Indiana, and then, from 1980 to 1982, at the Appalachian Center for Crafts, where she met and married Robert Brady.

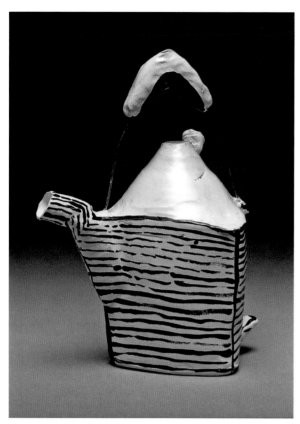

FIGURE 11.33. *Sandy Simon*, Teapot with Wire Handle, *1991. White earthenware, nichrome wire support, clay lug handle; 9 × 6 × 4 in. (Collection of Walnut Creek Art Center. Courtesy of Michele Maier.)*

Returning with him to California, Simon continued her functional work, developing a well-known style in porcelain or whiteware that in the 1990s was characterized by simplicity and strength of full, rounded forms; smooth and even application of clear glazes; and handles or knobs featuring nichrome wire. The forms are sturdy looking but not heavy; they may be lightly faceted but more often are characterized by uninterrupted contour, integral feet emphasizing lift, and sometimes a double lip on a bowl or a flaring, cufflike rim as the setting for a lid. Among her signature effects are the surprising wire handles, which often feature ceramic beads. An early instance, in a teapot, flexes slightly when the tea is poured, which adds excitement. (Figure 11.33) Another distinctive motif is tiny squares or triangles of pinpoint perforations, like a cross between an Asian signature chop and a vaccination.

Simon's work elevates service through aesthetic interest. It is unpretentious and unshowy, traditional in size and type. Her throwing is fluent, so the works do not look labored or precious. She has regularly developed variations. She used color for decisive effect—at various times as folded colorful handles, in small candy-colored "rocks" embedded in a white surface for punctuation, and also as washes, thin lines, bolder stripes, or unexpected interior color inside white forms. In the 1990s she added red earthenware brushed with creamy white slip. She tries not to overdecorate because it makes food look bad.

Simon frequently does workshops and has periodically taught, during the 1990s at San Jose State University. In 1994 she opened TRAX, a gallery featuring functional ceramics, in the Berkeley industrial building where she and her family lived, along a railroad track. Simon buys the work that she shows at TRAX, assuming the risk for the makers. She has made other efforts to promote functional pottery in the Bay Area, including, in association with Dorothy Weiss and Braunstein/Quay galleries, furnishing a San Francisco loft for short-term rentals with pottery, sculpture, and wall works, so that people could experience living with art and see handmade pottery as something more than a fad.

IMAGES FOR THE TIMES?

In another of the periodic shifts and fluctuations common to all the arts, figurative imagery was prominent in the 1990s, most of it with a disturbing cast. A decade before, this darkness would not have been acceptable in a commercial market, and earlier still it would have seemed too painterly and outside craft traditions. But now there were no limits on subject matter, any more than there were required techniques. The result was a new richness of expression.

Ed Eberle (b. 1944) studied at Edinboro State College and Alfred University and taught at the Philadelphia College of Art and then at Carnegie-Mellon University from 1975 to 1985, before deciding to devote himself to his work full-time. He is known for varied and often complex vessel forms that are densely covered with drawings of figures, most often nude but sometimes wearing medieval garb or things suggestive of exotic ethnicities. (Figure 11.34) During the late 1980s and 1990s, Eberle restricted himself to black *terra sigillata* on porcelain, and characteristically he depicted his figures in continuous but nonrational space. They abut or overlap and occasionally seem to casually touch yet do not seem to be in the same physical space. It is as if each is in his or her own dreamworld. The countless figures set up a slow rhythm that becomes mesmerizing if the shifts of scale and absence of gravity don't produce queasiness first.

Eberle draws impulsively, without plan or narrative to organize his composition. This results in lines that seem personal and slightly hesitant, or perhaps their worked-over smudginess produces the effect. The imperfect per-

FIGURE 11.34. *Edward S. Eberle*, Sentinel, *1995. Porcelain;
17 × 16 × 16 in. (Los Angeles County Museum of Art, Smits
Ceramics Purchase Fund. Art © E. S. Eberle. Photograph
© Museum Associates/LACMA.)*

FIGURE 11.35. *Cindy Kolodziejski*, Microcystis Pyrifera, *ca. 1997.
Porcelain painted with faux gold; height, 43 in.; width, 23 in.;
diameter, 23 in. (Collection of the Gardiner Museum. Courtesy
of Frank Lloyd Gallery. © Cindy Kolodziejski.)*

sonality of the line is contemporary; without that, the
classical qualities of many vessels would be too closely
allied with ancient pottery. Figural painting on Greek
pottery, however, involved coherent space, with the curv-
ing surface of the pot treated as an unrolled scroll, so to
speak, while Eberle's figures inhabit various parts of the
surfaces and run up against the edges as if by accident.
The pot and the drawing are independent orders that just
happen to connect.

Eberle's draftsmanship is usually the center of any dis-
cussion of his work, but the forms have been inventive as
well. In the late 1980s, he made some pieces three feet
tall or more, but generally in the 1990s they were object
scale, twelve to eighteen inches tall, and incorporated ar-
chitectural features. *Hermetic Crown II* (1991) has a coni-
cal lid that is wrapped with (painted) stairs leading to a
strange ball-and-crescent knob, like some sort of observa-
tory. *Place* (1993) might be an Ottoman fancy. Although
it is raised on multiple-patterned feet, its rim recalls a
castle walkway with sentry sites. It is both formed and
painted in patterns of architectural decoration. The inset
lid depicts figures within arches, and above them is a fan-
ciful dome, again elaborately detailed. *Twenty-five Years to
Bachelard* (1995) is a four-sided, tall, somewhat houselike

structure, painted on the sides and roof with figures too
large to inhabit it. It is elevated on four thick posts and
also includes guard positions at the corners. The roof—a
gable with another small gable centered on top—looks
possibly Asian. The complexity of the mixture stirs the
viewer's imagination. A dazzling conflation of time and
space is set against the multiplicity—but aloneness—of
the figures.

In forms as baroque as Adrian Saxe's, with painting as
evocative as Kurt Weiser's new work, **Cindy Kolodziejski**
(b. 1962) presents her own sophisticated take on modern
culture, especially controlling relationships. Her vessels
are typically given recto and verso images that cannot be
seen simultaneously but that are meant to be puzzled
out in summary. They are subject to diverse interpreta-
tions that probably reflect as much on the viewer as on
the artist. (Figure 11.35)

Kolodziejski started making finished drawings while
a student of Ralph Bacerra. But mostly her drawings are
applied to her cast Victorian-style vessels, which have
faux-metal feet and handles. Her subjects are people
and objects; they may be adapted to the curvature of her

ground by painterly foreshortening or by clever and un-
expected cropping. She seems more interested in the
psychological effects of close-ups and isolation than
in laying out a full scene. Sex is often the subtext, in a
cross of the propriety of another era and contemporary
erotic suggestiveness. *Pajama Party* (1998) has a Victo-
rian prostitute spanking another as a sexual teaser that
seems to enrage the snarling baboon on the reverse—a
symbol of male aggression. On one side of *Pearl Neck-
lace* (1999) is the pearl-draped torso of a buxom woman
in an evening gown; on the other side, a phallic cucum-
ber is being peeled. The vessel is a wasp-waisted pitcher,
which evokes the constrained femininity of another era
and heightens the tension. Other works are gentler—two
views of an older man in a playground swing might be
a parable of life—but Kolodziejski's knowing analysis of
gender and power relationships marks out her distinctive
territory.

The animals **Daisy Youngblood** makes are mostly clay,
but an elephant or horse may have a stick for a leg. (Figure
11.36) They are usually incomplete, and all have empty
holes for eyes, making them seem inscrutably other. The
same provocation occurs in *Mother and Child* (1987), in
which the naked, handless, and footless woman has a
newborn lying on her breast; her expressionless face with
a prominent mouth in a hairless head is blatantly strange
and emotionally distant. The same thing happens in a dif-
ferent way in the head called *Lama* (1997). Here the eyes
are closed, the cheekbones and brow ridge prominent,
and the ears large: this person seems to focus inward in
what the title suggests is an exemplary way of medita-
tion. The effect in Youngblood's work is that the animals
seem near human—vulnerable, thinking, feeling—while
the humans seem near animal—heedless, instinctive.

Youngblood (b. 1945) has chosen to work outside the
mainstream, partly as a way to isolate herself from some
aspect of success. As she explains it, her art began with
visions during a personally difficult time in her late twen-
ties, when she was living in New York.[30] She "received"
images and worked on them, was picked up by a good gal-
lery (Willard, then Barbara Gladstone), and achieved rec-
ognition and a modest income but felt that she couldn't
keep herself in balance. She moved to Costa Rica. Years
of Jungian study and analysis, as well as interest in Zen
and the philosophy of the New Age theorist Ken Wilbur,
helped her sort things out, even as visions and dreams
continued to influence her work (such as an animal face
superimposed on a person's, or a certain gesture).

Youngblood's sculptures are pervaded by solemnity
and melancholy. They convey a sense of essences through

FIGURE 11.36. *Daisy Youngblood, Elephant, 1991. Low-fire clay,
wood; 8.5 × 11.25 × 7.75 in. (Courtesy of McKee Gallery.
© Daisy Youngblood.)*

the coarseness of the low-fire clay and the shadows and
limited tones derived from pit firing at first, and later
wood or electric firing and immersion of the hot object
in sawdust or leaves. She forms with coils and slabs, but
only the general sense of touch from reworking forms is
evident. She works and reworks slowly and thinks of the
process as a practice, like meditation.

Teapots painted with strange and often repellent
nude figures were the spectacular introduction of **Sergei
Isupov** to the United States when he arrived with his
American wife in the early 1990s (they later split). Isu-
pov (b. 1963) grew up in the Ukraine in an artistic family.
He turned to ceramics while studying at the Art Institute
of Tallinn, in Estonia.[31]

Isupov's work in the United States shifted from nudes
on teapots—both of which he regarded as lures for the
viewer—to nudes on sculptural forms. The forms are not
abstract but replicate various creatures, humans or com-
posites, in vessel scale. They are often elongated, com-
bined in disparate sizes, or given awkward but emotion-
ally loaded postures. *To Run Away* (1999) consists of a
relatively realistic body, albeit extremely long, thin, and
rubbery, curled as if tumbling, with the head almost be-
tween the feet. (Figure 11.37) But out of the figure's high
back grows an enormous head that lies on its side and
immobilizes the figure. Isupov is most noted for his sur-
realistic, illustrational painting. In this case, the big head

FIGURE 11.37. *Sergei Isupov, To Run Away, 1999. Hand-built porcelain, mason stains, glaze; 8 × 17 × 7.5 in. (Mint Museum of Craft + Design, Charlotte, N.C., Gift of Leslie Ferrin and Donald Clark, Ferrin Gallery, 2003.14. © Sergei Isupov.)*

is painted with a vast, desolate landscape featuring two figures, one sitting and one standing, who occupy the eye and brow region, and a double-faced moon in the sky. In *Two Planets* (also 1999), the form is a frog stretched out on its belly. On its back are painted two large grisaille faces of narrow-eyed, long-nosed, cruel-looking men whose dark hair is shaved short; trying to emerge from beneath these faces are natural-colored bald men, one on each side, whose arms, projecting in three dimensions, serve as the amphibian's front legs. Glossy glaze suggests slimy skin.

Isupov has said that his works are about interpersonal relationships. More likely, they're about the lack of such. In his dreamlike scenes, the figures have pallid, unmuscled bodies and suspicious expressions on their faces; they look as if they have emerged from some underground isolation chamber. The clothed human bodies with pointy, ferretlike animal heads are no more reassuring. These works, executed with great skill of hand, imply stories or obsessions with fetishistic originality.

EXUBERANT VIEWS

But certainly not all works of the 1990s presented such disturbing perspectives. There were also artists engaging the human comedy. The title and form of a single 1997 work seem to map out the clever and engaging qualities of **Kathy Butterly**'s diminutive works. The title is *Mon Smooch*. (Figure 11.38) The pretension of a title in French is self-ridiculed with the addition of a vernacular Americanism, the implications of which—humor,

affection, giddy femininity, cultural referentiality—are carried out in a 4¾-inch-tall form that plays off Brancusi's stone sculpture *The Kiss*. But Butterly could not make her homage with a straight face. So her "Kiss" is, like most of her work of the 1990s, based on that quintessential ceramic form, the cup, and the embracing arms of Brancusi's figures are recalled in the doubled handle of her faux cup. The body of the cup is gray like Brancusi's stone but crackled, thus supposedly aged yet showing the warmth of skin beneath. The bodies of the lovers are not cubic like Brancusi's but plump and pumped and fleshy. Near the top edge, the gray falls short and reveals a two-part vessel with an exterior the licked pink of lipstick, and the parts seem to press together so hard that the wall between them is warped. Completing the form in her characteristic style, Butterly makes reference to ceramic tradition by placing the cup on a "lacquered" stand in the Chinese manner. But again she undercuts elegance by running an imitation bungee cord around each foot of the stand as if to hold the cup in place.

Butterly (b. 1963) studied with Robert Arneson at the University of California, Davis, and the humor of her

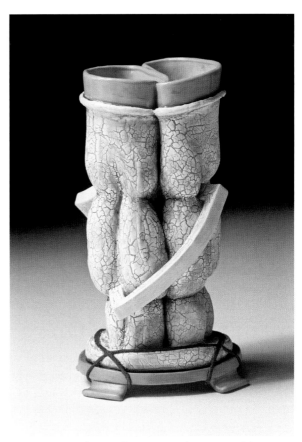

FIGURE 11.38. *Kathy Butterly, Mon Smooch, 1997. Porcelain, earthenware, glaze; 4.75 × 3 in. (© Kathy Butterly.)*

work, especially when self-mocking, certainly seems in keeping with his. But whereas the funk style once identified with Davis was often vulgar and slovenly and guy-jokey, Butterly embraced the opposite, making works that were small, pretty, decorative, and detailed, and doing it so extravagantly and confidently that it became a strength. The character of her work has been summarized as "bold shapes boldly colored, their anthropomorphic slump and twist, the confectionary glazes, the cartoonish accumulation of incongruous details and the monumental wallop delivered in pint-sized form."[32]

Mixing public with private seems to be the heart of **Ann Agee**'s work. Her figurative and pictorial ceramics have dealt with sexual and excretory functions and with social questions as crucial as choice of attire. She has folded in ceramic history as well, creating a number of sex toys in the style of Delftware. She is probably best known, however, for *Lake Michigan Bathroom*, made in 1992 during a residency at the Kohler factory in Wisconsin, which was one of the high points of the *Bad Girls* exhibition at the New Museum of Contemporary Art in New York in 1994. (Figure 11.39)

Agee (b. 1959) took BFA and MFA degrees in painting from Cooper Union and Yale, respectively. She began working in clay during the summer of 1985, between her two years of graduate school. She had no training but just painted on clay and learned from others. Her Yale professors were not particularly supportive. She learned more at the Watershed ceramic facility in Maine, where she took classes for three summers. By 1990 she was making complex teapots that stirred together an amusing pastiche of ceramic history, jumbling centuries and continents in ostensible seriousness and mounting these hybrids on bases embellished with rather contemporary and self-conscious nudes.

In 1991 Agee went to Kohler for a three-month artist-in-industry grant, intending to work on teapots. But after her first month creating three complicated teapot molds and beginning to cast, she aborted the project. The method was not for her. She had been sketching factory employees and began writing down their stories. This led to her producing a ceramic mural featuring twenty-five of the workers and a series of sixteen-inch portrait platters that presented a worker's face surrounded by small pictures of families and friends and a short biography. Her three months, with extensions, turned into two years, the mural of workers was permanently installed in the casting shop at Kohler, and she also produced two murals of surrounding Sheboygan County. More significantly, perhaps, she also made five decorated bathroom fixtures and a nine-by-eleven-foot tiled wall depicting

FIGURE 11.39. *Ann Agee*, Lake Michigan Bathroom, 1992. *Porcelain; 9 × 11 × 3 ft. (Courtesy of PPOW Gallery. © Ann Agee.)*

bathroom activities and their consequences—including sewage-treatment facilities and Lake Michigan, where all the treated liquid eventually ends up. They are all painted in Delft blue in an old-fashioned, ornate style.

Agee's fashion figures, shown in New York in 1997, were different in style. The people seemed to represent types and characters with a concerted innocence that recalls Beatrice Wood's romanticized scenes of prostitutes and their customers from a half-century before. The figures are posed and dressed in the styles of the 1990s, yet they recall the 1940s in proportions and sometimes palette. Following her exhibition, she was commissioned by the style section of the *New York Times Magazine* to create a group of female figures dressed in renditions of selected fashions by contemporary designers, which were reproduced in the magazine. Among her later figurative subjects were childbirth classes. The intense realness of her subjects is mediated by the cheerful stylization of her forms.

SPEAKING IN ABSTRACT FORMS

Whether **Annabeth Rosen**'s work is described in terms of urban detritus, viscera, botanic growth, or simply obsessive labor, it elicits words of excess. It embraces repetition and accumulation while shrugging off the refinement, imagery, and messages that attracted many ceramists in the 1990s. Rosen's forms can vary considerably: among the formats she has used are tiles or spheres with many small objects applied to the surface, stacks of slab forms, and bundles of tube forms. The overall effect can seem goofy, but it can also verge on the overwhelming and grotesque. (Figure 11.40)

FIGURE 11.40. *Annabeth Rosen*, Studio View of Sample, *1999. Lead glaze over white slip on earthenware, metal; 28 in. × 9 ft. 6 in. × 6 ft. 5 in. (© Annabeth Rosen.)*

Rosen's accretive surfaces are very far from ornament and do not pursue the easy appeal of beautiful color or seductive tactility. Her typical method is to apply a white slip over a shiny brown glaze so that the slip shrinks and splits in firing; glints or shadows of the brown are revealed, and the white goes dingy. When she adds other colors, they're likely to be a yellow that is a little sour and a cold green. Her work has been said to evoke lichen on statuary, the ash of a disaster, or a plate of food begging to be thrown out. This is not always the case, however; she has also used glossy glazes on the surface, but even here the forms look battered or decayed. The artistic comparisons that have come to mind include Arcimboldo's sixteenth-century paintings of fruits and vegetables that form faces and, among contemporary works, Julian Schnabel's broken-crockery paintings and John Chamberlain's crushed-metal sculptures.

Despite all these seemingly repellant or brutal associations, Rosen's work is much admired. She produces prolifically, hand-making the forms. She stockpiles parts and then builds her works. Firing failures are still useful; she has been known to break up and reassemble elements of even her finished works. The packed-surface tiles are sometimes stacked, creating a feeling of accident (collapsed shelves?) or suggesting something produced by a trash compactor.[33] The sheer multiplicity of elements creates an aura of energy. The bottom line is a kind of life force: one manifestation is the plant forms, fruits, and seeds that in their unreasonable numerousness seem to want to take over the world, while another manifestation is the shaping and placing of such forms as a process of human creativity—Rosen's own contribution.

After returning from a three-year apprenticeship with Tatsuzo Shimaoka in Mashiko, Japan, **Tony Marsh** (b. 1954) tried to be a potter. He found it impossible:

functional work was not sufficiently valued or marketable in the Los Angeles area to allow him to make a living. Since then he has carved out a unique place in the ceramic spectrum, creating nonfunctional works that pay homage, he said in an artist's statement, to the fact that vessels serve and preserve, beautify, commemorate, protect, and ritualize. Marsh continues to make containers, but he has eliminated the practicality that contemporary culture disparages and retained the profundity that comes with vessel form (although that is not necessarily any better understood).

Marsh creates containers and contained, all of clay. In the early 1990s, he shaped low dishes with divided interiors that resembled Third World wooden bowls, and placed in them simple forms reminiscent of shells, bones, or stones. They evoked counting games or collections of admired natural objects. Later in the decade, he began his long-running series Perforated Vessels, in which the walls are drilled with tiny holes that turn them into grilles through which light and air can pass. (Figure 11.41) This emphasizes their nature as a membrane dividing space and also makes them seem evanescent, as if this were a physical state represented in transition or a visualization of dissolution over time.

As strange as the perforated walls are in themselves, an equal surprise is that the reductive containers are filled with simple objects—doughnut, wheel, mace, cylinder, pod—all of which are equally perforated, so that the sense of tentative substance is uniform throughout. Marsh has noted that he seems unable to accept the void and leave the vessels empty.[34] But he has nevertheless integrated voids into their very being. He has described the drilling as "small acts of devotion" that re-

FIGURE 11.41. *Tony Marsh*, Perforated Vessel, *1996. Earthenware; 8.5 × 22 in. (Los Angeles County Museum of Art, Howard Kottler Testamentary Trust. Art © Tony Marsh. Photograph © 2007 Museum Associates/LACMA.)*

FIGURE 11.42. *Michael Sherrill*, Turning Leaves (Set of Nine Bottles), *1998. Stoneware, alkaline glaze; tallest: 31.5 × 11.75 × 4.5 in.; shortest: 9.5 × 9.75 × 4.5 in. (Los Angeles County Museum of Art, Gift of Gump's San Francisco. © William Michael Sherrill.)*

quire a satisfying concentration. It seems, then, that he has exchanged the Japanese potter's *kata* state of heightened instinctive response for a kind of concentration that equally shuts out distraction.

Michael Sherrill (b. 1954) found clay in high school, where it was a rewarding outlet for someone struggling with dyslexia. His early influences included Native American forms, early American salt-glazed wares, and Chinese ginger jars, along with the work he saw around him after moving to western North Carolina in 1974. There he was exposed to potters at Penland, Arrowmont, and the Southern Highland Craft Guild communities. He worked first in salt glaze, later expanding into raku. His work of the 1970s and 1980s was functional ware.

Sherrill found a wider audience in the 1990s, when he began distorting his functional forms and giving them brilliant colors. The works remained wheel-thrown but were considerably altered, particularly through vertical stretching and through multiplying the expected curves. For example, his *Incandescent Bottles* (1993) consist of one short and two tall and slender forms of white stoneware with intensely cobalt-hued bodies, ring handles of magenta or moss green, and skinny, stretched necks with caps of contrasting colors. These might have been described as postmodern, but they lacked the designerly and mocking quality of that genre. Rather they seem simply exuberant.

But a different explanation began to emerge within a few years. *Oak Tree Tea* of 1997 is a single object but far more complex in form. It is an elongated teapot with handle and spout that snake upward from the base so that they almost frame the body of the pot—which, in turn, consists of three distinct lobes with a zigzag spine running up the middle. Every part of body, handle, and

spout is split into separate colors, all slightly grayed but including a mint green, a greenish yellow, a squash yellow, brick red, and warm and cold blacks. Only when reflecting upon the title is one likely to realize that the inspiration is an oak leaf with its veins and lobes. And this was the direction in which his work was moving: in 1999 he showed sculptural forms of "organic romanticism" evoking (though not precisely realistically) curling leaves and various blossoms. (Figure 11.42) The color was heightened yet not jarring. The pots, in retrospect, seem to be fantasies inspired by the flora of western North Carolina, evocative but not descriptive, blossoming in their own way.

UNTOUCHABLE: MAREK CECULA

Marek Cecula (pronounced ses-oo-la) is a ceramist, but considering that he was born in Poland (in 1944), studied art there, immigrated to Israel (in 1960) and worked on a kibbutz, studied ceramics there, opened his own studio, moved to Brazil to design for a pottery factory (in 1974), and came to New York, where he headed the ceramic design department at Parsons for many years, one would expect him to have a distinctive approach to the material. And indeed he does, but it is not just one approach. For a time he maintained a shop, Contemporary Porcelain in New York's SoHo, that sold functional ceramics. He has packaged and marketed Polish scientific ware for American kitchen use, and he has made lines of ware in high-tech ceramic formulations, such as extraordinarily thin and translucent but strong vessels. He has operated as a small factory, able to design, test-market, distribute to retailers, discount, and close out with great rapidity.[35]

And then there's his studio work, which is not just distinctive but utterly unique to the field. Following an experience as a hospital patient, which called his attention to the sanitary uses of ceramics in the medical field, he had a residency at the European Ceramic Work Center in Holland. There he created his Scatology series (editions of six sets of six pieces), which led to a related Hygiene series. In both he has used the vitreous china familiar to everyone in the form of sinks, tubs, and toilets to create suggestively organic forms. Perhaps the deep background for these works was his residency at the Kohler factory in 1982.

The Scatology series presents vaguely familiar shapes—something like bedpans or tongue depressors—on perforated stainless-steel trays. (Figure 11.43) The perforation suggests drainage of fluid, as do the depressions or tubular extensions of several of the forms. Each work is immaculate. The curves of the ceramics are visually seductive, even erotic, yet one would hesitate to

FIGURE 11.43. *Marek Cecula, Scatology Series Set I, 1993. Porcelain, stainless steel; 20.5 × 14.5 × 10 in. (SM's Stedelijk Museum 's-Hertogenbosch [formerly Museum Het Kruithuis], Netherlands. © Marek Cecula.)*

touch the forms because every association is with the unclean or microbe-contaminated. The Hygiene series extends the idea into several larger fixtures that suggest body substitutions or forms of control. One structure of vitreous china and wood might evoke a Parsons table, the top ceramic curving down in its middle to form a large drainpipe that suggestively protrudes from between a pair of wooden legs. Another is a narrow grooved oval—rather labial—standing on tall steel legs with a thin hose extending more than a foot below it. Another is a double-handled container that splits into two legs and resembles the male pelvic region—but since it has no base, it cannot contain. So is it to be used as a shield? Is it a male chastity belt?

Toward the end of the 1990s, Cecula visited Poland for the first time in many years. Inspired negatively by a sea of identical products in a ceramics factory, and ambivalent at finding a fragment of pottery marked with the Nazi swastika, he initiated a Violations series. He applied the swastika trademark to readymade domestic objects to suggest the pervasiveness of Nazi standards in every aspect of life, however seemingly inconsequential. Ce-

cula's objects are the apotheosis of manufacture: exquisite glazes, perfect whiteness, marked with a code that would seem to be a production or inventory number. All these works cause us to weigh the relationship between the object and the user, to consider the source of the standard, and to puzzle out our attitude toward the products of our own bodies, to mull over intimacy and death. It is surprising that the ceramic is the untouchable.

In Short

The last decade of the century saw a maturation that would have been inconceivable fifty years earlier, including museums dedicated strictly to craft, improved scholarship, and more marketing opportunities—from large expositions to websites. But at the same time, troubling signs appeared. Some colleges closed their craft studios, and few new programs opened. Attendance at and income from craft fairs began to decline. Collectors aged.

As in all the arts, pluralism ruled. Each medium encompassed a spectrum of possibilities that ran from modest function on one end to conceptual art on the other. Glass could accommodate Dorothy Hafner's vessels and Josiah McElheny's installations; textiles could range from Randall Darwall's weavings to Nick Cave's Soundsuits. If there was a common development in all the crafts, it was that many young practitioners thought of themselves as artists and employed precisely the same strategies that any artist would.

Differences remained, though. Craftspeople often focused on the particular history of their own mediums. In glass, a culture of professional "hired guns" appeared in the form of young makers who traveled widely, working for established glass artists. Several of them have gone on to find their own distinctive voices. A few disciplines seemed to lag behind in terms of sophistication and development: neither wood turning nor enameling produced a convincing conceptual/craft hybrid. As the century closed, technical expertise ceased to be a major issue. Information and expertise were now widely available.

NOTES

CHAPTER ONE

1. A. W. N. Pugin, *The True Principles of Pointed or Christian Architecture* (London: J. Weale, 1841), 61.

2. A. W. N. Pugin, *The Present State of Ecclesiastical Architecture in England* (London: C. Dolman, 1843), 99.

3. Pugin, *True Principles*, 37–38.

4. John Ruskin, *The Stones of Venice*, vol. 2 (New York: E. P. Dutton, 1907), 176–77.

5. Ibid., 181.

6. Ibid.

7. Ibid., 183.

8. Quoted in Tim Hilton, *John Ruskin: The Later Years* (New Haven: Yale University Press, 2000), 307.

9. Quoted in Clive Wilmer, introduction to John Ruskin, *Unto This Last and Other Writings*, ed. Wilmer (London: Penguin Books, 1985), 28.

10. Ruskin, *Unto This Last*, 227.

11. Linda Parry, ed., *William Morris: Art and Kelmscott* (London: Society of Antiquaries of London, 1966), 33.

12. Fiona MacCarthy, *William Morris: A Life for Our Time* (New York: Knopf, 1995), 210.

13. William Morris, "The Lesser Arts" (1877), in *William Morris on Art and Socialism*, ed. Norman Kelvin (Minneola, N.Y.: Dover, 1999), 17.

14. It was an experiment he apparently did not repeat. See Jeremy Cooper, *Victorian and Edwardian Decor from the Gothic Revival to Art Nouveau* (New York: Abbeville, 1987), 159.

15. Ibid.

16. Morris, "Lesser Arts," 1–2.

17. Quoted in Elizabeth Aslin, *The Aesthetic Movement, Prelude to Art Nouveau* (New York: Frederick A. Praeger, 1969), 13.

18. Ibid., 79.

19. This variation of the widely quoted statement appears in Richard Ellmann, *Oscar Wilde* (New York: Alfred A. Knopf, 1988), 45.

20. Ibid., 70.

21. Ibid., 107.

22. Ibid., 102.

23. Catherine Lynn, "Decorating Surfaces: Aesthetic Delight, Theoretical Dilemma," in *In Pursuit of Beauty: Americans and the Aesthetic Movement*, by Doreen Bolger Burke et al. (New York: Metropolitan Museum of Art and Rizzoli, 1987), 66.

24. Ibid., 69.

25. From the *Hobby Horse*, quoted in Cooper, *Victorian and Edwardian Décor*, 487.

26. Paul Greenhalgh, *Ephemeral Vistas: The Expositions Universelles, Great Exhibitions, and World's Fairs, 1851–1939* (Manchester: Manchester University Press, 1988), 3.

27. Brent R. Benjamin, foreword, in David Conradsen and Ellen Paul Denker, *University City Ceramics: Art Pottery of the American Woman's League* (Saint Louis: Saint Louis Art Museum, 2004), 7.

28. W. Scott Braznell, catalog entry in Wendy Kaplan, *"The Art That Is Life": The Arts and Crafts Movement in America, 1875–1920* (Boston: Little, Brown, 1987), 281.

29. *School of Design of the University of Cincinnati: Annual Catalogue, 1872–1873* (1873), 40, quoted in Kenneth R. Trapp, "Toward a Correct Taste: Women and the Rise of the Design Reform Movement in Cincinnati, 1874–1880," in *Celebrate Cincinnati Art: In Honor of the One Hundredth Anniversary of the Cincinnati Art Museum*, ed. Kenneth R. Trapp (Cincinnati: Cincinnati Art Museum, 1982), 50.

30. An article in the *American Architect and Building News* in March 1877 was the first of many.

31. Amelia Peck, "Candace Wheeler: A Life in Art and Business," in *Candace Wheeler: The Art and Enterprise of American Design, 1875–1900*, by Amelia Peck and Carol Irish (New York: Metropolitan Museum of Art; New Haven: Yale University Press, 2001), 24.

32. Carol Irish, "Catalog," ibid., 101.

33. Quoted in Peck, "Candace Wheeler," 38.

34. Irish, "Catalog," 118.

35. Ibid., 140.

36. Paul Evans, *Art Pottery of the United States: An Encyclopedia of Producers and Their Marks* (New York: Scribner's, 1974), 2.

37. William Morris, quoted in Paul Thompson, *The Work of William Morris* (London: Quartet Books, 1977), 97.

38. Anita J. Ellis, *The Ceramic Career of M. Louise McLaughlin* (Cincinnati: Cincinnati Art Museum; Athens: Ohio University Press, 2003), 41.

39. Ibid, 48.

40. Quoted in Ellen Paul Denker, "Grammar of Nature," in *The Substance of Style: Perspectives on the American Arts and Crafts Movement*, ed. Bert Denker (Winterthur, Del.: Henry Francis du Pont Winterthur Museum, 1996), 297.

41. Ellis, *Ceramic Career*, 74.

42. Ibid., 79.

43. Ibid., 91.

44. Martin Eidelberg, "Art Pottery," in Robert Judson Clark, ed., *The Arts and Crafts Movement in America, 1876–1916* (Princeton: Princeton University Press, 1972), 164.

45. Ellis, *Ceramic Career*, 92.

46. From a brochure written in 1895, quoted in Evans, *Art Pottery*, 255.

47. Ulysses Dietz, "Art Pottery 1880–1920," in *American Ceramics: The Collection of Everson Museum of Art*, ed. Barbara Perry (New York: Rizzoli; Syracuse, N.Y.: Everson Museum of Art, 1989), 64.

48. William Watts Taylor, "The Rookwood Pottery," *Forensic Quarterly* 1 (September 1910): 213–14, quoted in Leslie Greene Bowman, *American Arts and Crafts: Virtue in Design* (Los Angeles: Los Angeles County Museum of Art, 1990), 196.

49. Anita J. Ellis, "American Tonalism and Rookwood Pottery," in Denker, *Substance of Style*, 306. Kenneth R. Trapp was the first to recognize the tonalist qualities of Vellum glaze. Valentien and other decorators had attended the Cincinnati Art

Academy, and some knew tonalist painter and former Cincinnatian John Twachtman.

50. Peck, *Book of Rookwood Pottery*, 47–48.

51. Ibid., 67.

52. Garth Clark and Margie Hughto, *A Century of Ceramics in the United States, 1878–1978* (New York: E. P. Dutton in association with the Everson Museum of Art, 1979), 10.

53. Richard D. Mohr, *Pottery, Politics, Art: George Ohr and the Brothers Kirkpatrick* (Urbana and Chicago: University of Illinois Press, 2003), passim.

54. Dietz, "Art Pottery 1880–1920," 65.

55. Ellen Paul Denker and Bert Randall Denker, catalog entry in Kaplan, *Art That Is Life*, 323, no. 176.

56. Evans, *Art Pottery*, 177–78.

57. Sharon S. Darling, *Chicago Ceramics and Glass: An Illustrated History from 1871 to 1933* (Chicago: Chicago Historical Society, 1979), 52.

58. Evans, *Art Pottery*, 217–20.

59. McLaughlin to Charles Binns, quoted in Ellis, *Ceramic Career*, 148.

60. Designed by Morris, Burne-Jones, and Brown and installed in 1874 in Trinity Church, Saugerties, New York.

61. Darling, *Chicago Ceramics and Glass*, 83

62. Ibid., 92.

63. Royal Cortissoz, *John La Farge: A Memoir and a Study* (1911; New York: Kennedy Graphics, 1971), 31.

64. Ibid., 197.

65. Incriminating but perhaps not conclusive evidence is presented by H. Barbara Weinberg in *The Decorative Work of John La Farge* (New York: Garland Publishing, 1977), 364–66 (based on her 1972 doctoral dissertation at Columbia University). One might note that Tiffany's biographer (Koch) avoided assigning credit for primacy of use. Certainly Tiffany, like Maria Longworth Nichols, had the benefit of parental financial backing to develop and promote achievements with the new techniques, and the talent to carry them further.

66. Ibid., 365.

67. Theodore E. Stebbins Jr., "Trinity Church at 125," in *The Makers of Trinity Church in the City of Boston*, ed. James F. O'Gorman (Amherst and Boston: University of Massachusetts Press, 2004), 18.

68. Weinberg, *Decorative Work*, 357.

69. Robert Kehlmann, *Twentieth-Century Stained Glass: A New Definition* (Kyoto: Kyoto Shoin, 1992), 202.

70. Ibid.

71. Eileen Boris, *Art and Labor: Ruskin, Morris, and the Craftsman Ideal in America* (Philadelphia: Temple University Press, 1986), 144.

72. Robert Koch, *Louis C. Tiffany, Rebel in Glass* (New York: Crown Publishers, 1964), 16.

73. Marilynn Johnson, "The Artful Interior," in Burke et al., *In Pursuit of Beauty*, 125.

74. Ibid., 21–22.

75. Tiffany became an avid gardener when he built a home on Oyster Bay, Long Island. Gardens became a preoccupation of many during the second half of the nineteenth century, as the country urbanized.

76. Quoted in Koch, *Louis C. Tiffany*, 58.

CHAPTER TWO

1. T. J. Jackson Lears, *No Place of Grace: Antimodernism and the Transformation of American Culture, 1880–1920* (New York: Pantheon, 1981), xiii and passim.

2. William Morris, "How I Became a Socialist," in *On Art and Socialism*, ed. Holbrook Jackson (London: J. Lehmann, 1947), 276, quoted ibid., 62.

3. Marie Via and Marjorie B. Searl, *Head, Heart, and Hand: Elbert Hubbard and the Roycrofters* (Rochester, N.Y.: University of Rochester Press in association with Memorial Art Gallery, 1994), 24

4. Hunter also made "one-man" books: he created the type, made the paper, and designed and printed the sheets.

5. Advertisement for Morris chair, published in *Little Journeys to the Homes of Eminent Artists: Botticelli*, March 1902, cited in Via and Searl, *Head, Heart, and Hand*, 56.

6. Felix Shay, *Elbert Hubbard of East Aurora* (New York: Wm. H. Wise, 1926), 207, quoted in Eileen Boris, *Art and Labor: Ruskin, Morris, and the Craftsman Ideal in America* (Philadelphia: Temple University Press, 1986), 150.

7. Richard Guy Wilson, in *The Arts and Crafts Movement in California: Living the Good Life*, ed. Kenneth R. Trapp (Oakland: Oakland Museum; New York: Abbeville Press, 1993), 13, states authoritatively that the chairs were designed by A. Page Brown and made by Alexander J. Forbes. More recent scholarship gives no definitive attribution for the design.

8. Robert Judson Clark, ed., *The Arts and Crafts Movement in America, 1876–1916* (Princeton: Princeton University Press, 1972), 40.

9. Irene Sargent, foreword, *Craftsman* 1 (October 1901): i.

10. According to David Cathers, *Gustav Stickley* (London: Phaidon, 2003), 41, the most reliable source on Stickley, the only gesture toward a guild organization was a "rudimentary profit-sharing plan," and United Crafts was in every other respect identical to Stickley's established furniture business.

11. Joseph Cunningham, *The Artistic Furniture of Charles Rohlfs* (New Haven: Yale University Press, 2008).

12. The desk is discussed in Tod M. Volpe and Beth Cathers, *Treasures of the American Arts and Crafts Movement, 1890–1920* (New York: Abrams, 1988), 40–41.

13. Frank Lloyd Wright, *Frank Lloyd Wright* (London and New York: Longmans, Green & Co., 1933), 347.

14. Wright's design for "A Home in a Prairie Town" appeared in the February 1901 issue of *Ladies' Home Journal*, in a series of house designs that editor Edward Bok began publishing in 1895. This design may have originated the "Prairie" style.

15. Clark, *Arts and Crafts Movement*, 83.

16. Harvey L. Jones, *Mathews: Masterpieces of the California Decorative Style* (Layton, Utah: Gibbs M. Smith, 1985), 92.

17. Edmund de Waal, *Twentieth-Century Ceramics* (London: Thames & Hudson, 2003), 33.

18. Sharon S. Darling, *Chicago Ceramics and Glass: An Illustrated History from 1871 to 1933* (Chicago: Chicago Historical Society, 1979), 67.

19. Boris, *Art and Labor*, 154.

20. Fred H. Wilde, *Bulletin of the American Ceramic Society* 22, no. 5 (1943): 148, quoted by Joseph A. Taylor, "Creating Beauty from the Earth: The Tiles of California," in Trapp, *Living the Good Life*, 111.

21. "The celebration and dignifying of labor that figures

prominently in the themes of Mercer's tiles was less evident in the reality of his Pottery" (Cleota Reed, *Henry Chapman Mercer and the Moravian Pottery and Tile Works* [Philadelphia: University of Pennsylvania Press, 1987], 73).

22. Quoted ibid., 97.

23. Ellen Paul Denker and Bert Randall Denker, catalog entry in *"The Art That Is Life": The Arts and Crafts Movement in America, 1875–1920*, by Wendy Kaplan (Boston: Little, Brown, 1987), 256, no. 114.

24. Meyer, who had learned his trade from his father and had come from Alsace to Biloxi, Mississippi, as a boy, skillfully reproduced pottery shapes from drawings. He exhibited pieces of his own at the Saint Louis world's fair in 1904 and won prizes for his glazes. When Meyer began throwing, Sheerer allowed him to use his own glazes. They were recipes from his father—glazes deriving their lead from measures of buckshot! He at first obtained clay from a Biloxi riverbank and continued to favor local and regional clays. He was the Newcomb thrower from 1896 to 1927, when he retired.

25. Woodward and Sheerer both retired in 1931, and that year Juanita Gonzalez, a Newcomb alumna who had studied with sculptor Alexander Archipenko in New York, joined the faculty to teach ceramics and assist in directing the pottery. She was a studio potter and could do the dirty and heavy work formerly considered unsuitable for women. Unfortunately Gonzalez died young, in 1935.

26. Martin Eidelberg, "Art Pottery," in Clark, *Arts and Crafts Movement*, 147.

27. Ellsworth Woodward, quoted in Suzanne Ormond and Mary E. Irvine, *Louisiana's Art Nouveau: The Crafts of the Newcomb Style* (Gretna, La.: Pelican Publishing Co., 1976), 32.

28. Denker and Denker, catalog entry in Kaplan, *Art That Is Life*, 325, no. 179.

29. Eidelberg, "Art Pottery," 144.

30. In 1925 Sheerer attended the Paris Art Deco exposition in an official capacity. She saw that the new art related to the "mechanical, scientific age as shown in the right-angled, triangled, straightened lines of our new architecture in New York and Paris" and suggested that this was more appropriate than to "fall back on the thought of other times and rely too long and too entirely on the curves of precedent?" This may have been a subtle criticism of Cox's preferred style (Sheerer, quoted in Jessie Poesch, *Newcomb Pottery: An Enterprise for Southern Women, 1895–1940* [Exton, Penn.: Schiffer Publishing, 1985], 76).

31. Margaret Carney, *Charles Fergus Binns, the Father of American Studio Ceramics* (New York: Hudson Hills Press in association with the International Museum of Ceramic Art, New York State College of Ceramics at Alfred University, 1998), 81. This account is based on the essays of the Carney book, her own writing often limited by special pleading, and also on Melvin H. Bernstein, *Art and Design at Alfred: A Chronicle of a Ceramics College* (Philadelphia: Art Alliance Press, 1986), passim.

32. Richard Guy Wilson, "Scientific Eclecticism," in *The American Renaissance, 1876–1917* (Brooklyn: Brooklyn Museum, 1979), 57.

33. Bernstein, *Art and Design at Alfred*, 42–43.

34. Binns was a stickler about terminology and apparently chastised Frederick Hürten Rhead for loose wording in his *Studio Pottery* (Saint Louis: People's University Press, 1910). A reply from Rhead survives, in which he wrote, "I will certainly be more explicit in the future when I am giving formulas, and am very glad you are interested enough to offer the corrections" (Paul Evans, "Context and Theory: Binns as the Father of American Studio Ceramics," in Carney, *Charles Fergus Binns*, 111n37).

35. Charles F. Binns, *The Potter's Craft*, 4th ed. (Princeton, N.J.: Van Nostrand, [1967]), viii.

36. Richard Zakin, "Technical Aspects of the Work of Charles Fergus Binns," in Carney, *Charles Fergus Binns*, 116–17.

37. Elaine Levin, "Ceramics: Seeking a Personal Style," in *The Ideal Home, 1900–1920: The History of Twentieth-Century American Craft*, ed. Janet Kardon (New York: Abrams, 1993), 81.

38. Martin Eidelberg, "Robineau's Early Designs," in *Adelaide Alsop Robineau: Glory in Porcelain*, ed. Peg Weiss (Syracuse, N.Y.: Syracuse University Press and Everson Museum of Art, 1981), 66.

39. Marshal Fry, quoted in David Conradsen and Ellen Paul Denker, *University City Ceramics: Art Pottery of the American Woman's League* (Saint Louis: Saint Louis Art Museum, 2004), 30.

40. Richard Zakin, "Technical Aspects of the Work of Adelaide Alsop Robineau," in Weiss, *Adelaide Alsop Robineau*, 121. Here, as with Binns, Zakin closely analyzes the work and its materials and technique, thoroughly and in accessible language.

41. Paul Evans, *Art Pottery of the United States: An Encyclopedia of Producers and Their Marks* (New York: Charles Scribner's Sons, 1974), 30.

42. Paul Cox, letter of January 27, 1967, quoted in Eugene Hecht "The Times and Life of G. E. Ohr," in *The Mad Potter of Biloxi: The Art and Life of George E. Ohr*, by Garth Clark, Robert A. Ellison Jr., and Eugene Hecht (New York: Abbeville Press, 1989), 180n28.

43. "Some Facts in the History of a Unique Personality," *Crockery and Glass Journal* 54 (December 12, 1901), quoted in Hecht, "Times and Life of G. E. Ohr," 10.

44. Robert Ellison Jr. notes precedents for Ohr products and treatments in puzzle mugs common among folk potters, ruffled rims of commemorative flowerpots of Chester County, Pennsylvania, and gently manipulated vases by Bell Pottery of the Shenandoah Valley. There were even some precedents in industrial ceramics: the Belleek-style pottery line manufactured in New Jersey included indenting of the bodies and the ruffling and symmetry of the necks ("'No Two Alike': The Triumph of Individuality," in *Mad Potter*, 68).

45. Quoted by Hecht, ibid., 34.

46. *Announcements for MDCCCXCIX, the Society of Arts and Crafts, Boston, Massachusetts*, December 1898, quoted in Beverly Brandt, "'All Workmen, Artists, and Lovers of Art': The Organizational Structure of the Society of Arts and Crafts, Boston," in *Inspiring Reform: Boston's Arts and Crafts Movement*, by Marilee Boyd Meyer (Wellesley, Mass.: David Museum and Cultural Center, 1997), 33.

47. Ellison, "No Two Alike," 81.

48. Ellen Paul Denker and Bert Randall Denker, catalog entry in Kaplan, *Art That Is Life*, 252, no. 110.

49. See W. Scott Braznell's catalog entry on Wynne, ibid., 264–65.

50. George Twose, "The Chicago Arts and Crafts Society's Exhibition," *Brush and Pencil* 2 (May 1898): 76–79, quoted in W. Scott Braznell, "Metalsmithing and Jewelrymaking, 1900–1920," in *The Ideal Home*, 55.

51. See W. Scott Braznell's catalog entry on Thresher, ibid., 158–59.

52. Alice Cooney Frelinghuysen, *Louis Comfort Tiffany at the Metropolitan Museum* (New York: Metropolitan Museum of Art, 1998), 77.

53. *Craftsman* 4 (December 1903): 276, quoted in Clark, *Arts and Crafts Movement*, 76.

54. Jane S. Becker, *Selling Tradition: Appalachia and the Construction of an American Folk, 1930–1940* (Chapel Hill: University of North Carolina Press, 1998), 63.

55. Quoted in Boris, *Art and Labor*, 177.

56. Sally Buchanan Kinsey, "A More Reasonable Way to Dress," in Kaplan, *Art That Is Life*, 371.

57. Martin Eidelberg, "Tiffany and the Cult of Nature," in Alastair Duncan, Martin Eidelberg, and Neil Harris, *Masterworks of Louis Comfort Tiffany* (New York: Abrams, 1989), 67.

58. Ibid., 82, 66.

59. Charles de Kay, *The Art Work of Louis C. Tiffany* (1914; reprint, Poughkeepsie, N.Y.: Apollo, 1987), 26.

60. See Martin Eidelberg, Nina Gray, and Margaret K. Hofer, *A New Light on Tiffany: Clara Driscoll and the Tiffany Girls* (New York: New-York Historical Society in association with D. Giles, 2007).

61. Neil Harris, "Louis Comfort Tiffany: The Search for Influence," in Duncan, Eidelberg, and Harris, *Masterworks*, 36–37. Harris discusses Tiffany's broader market.

62. Lloyd E. Herman, *Art That Works: Decorative Arts of the Eighties Crafted in America* (Seattle: University of Washington Press, 1990), 14.

63. Leslie M. Freudenheim, *Building with Nature: Inspiration for the Arts and Crafts Home* (Salt Lake City: Gibbs Smith, 2005), 69–71.

64. Another Minneapolis center of Arts and Crafts was John S. Bradstreet's Minneapolis Crafthouse, opened in 1904. Bradstreet—a furniture designer, interior designer, and tastemaker—showed his own and others' designs and drew attention even from the prestigious *International Studio* magazine. For a full treatment of his life and work, see Sarah Sik, "John Scott Bradstreet: The Minneapolis Crafthouse and the Decorative Arts Revival in the American Northwest," *Nineteenth-Century Art Worldwide* 4 (Spring 2005), <http://19thc-artworldwide.org/spring_05/articles/sik.html>.

65. Announcements for MDCCCXCIX, the Society of Arts and Crafts, Boston, Massachusetts, December 1898, quoted in Brandt, "'All Workmen,'" 33.

66. Report of the Jury, Society of Arts and Crafts Boston annual report, 1906, quoted in Marilee Boyd Meyer, "Historic Interpretations: Boston's Arts & Crafts Jewelry," in *Inspiring Reform*, 95.

67. Mary Ware Dennett to the Chairman of the Council, January 27, 1905, in SACB Papers, roll 300, 446–50, quoted in Boris, *Art and Labor*, 40.

68. Rose Valley incorporation papers, July 17, 1901, quoted in Catherine Zusy, catalog entry in Kaplan, *Art That Is Life*, 314, no. 166.

69. Will Price, "Man Must Work to Be Man," *Artsman* 3 (January 1906): 101–8, quoted in Boris, *Art and Labor*, 162.

70. Jane Byrd Whitehead to Ralph Whitehead, July 1900, quoted in Heidi Nasstrom Evans, "Jane Byrd McCall Whitehead: Cofounder of the Byrdcliffe Art School," in *Byrdcliffe: An American Arts and Crafts Colony*, ed. Nancy E. Green (Ithaca, N.Y.: Herbert F. Johnson Museum of Art, Cornell University, 2004), 66.

71. Charles Robert Ashbee, *The Ashbee Memoirs* 4 (June 1915): 227, quoted in Tom Wolf, "Byrdcliffe's History: Industrial Revolution" in Green, 30.

72. Ralph Waldo Emerson, quoted in Calvin M. Woodward, *The Manual Training School* (1887; reprint, New York: Arno Press, 1969), 181.

73. C. M. Woodward, *The Manual Training School, Comprising a Full Statement of Its Aims, Methods, and Results* (Boston: D. C. Heath, 1887), 326; facsimile edition (New York: Arno Press, 1969).

74. Isaac Edwards Clarke, "The Democracy of Art," U.S. Commissioner of Art Report, quoted in Roger B. Stein, "Artefact as Ideology: The Aesthetic Movement in Its American Cultural Context," in *In Pursuit of Beauty: Americans and the Aesthetic Movement*, by Doreen Bolger Burke et al. (New York: Metropolitan Museum of Art and Rizzoli, 1987), 30.

75. Joy Cattanach Smith, catalog note in Kaplan, *Art That Is Life*, 319–20.

76. For general works on Dewey's sense of art education, see Herbert M. Kliebard, *The Struggle for the American Curriculum 1893–1958*, 3rd ed. (New York: Routledge Falmer, 2004), and Donald Soucy and Mary Ann Stankiewicz, eds., *Framing the Past: Essays on Art Education* (Reston, Va.: National Art Education Association), 1990.

CHAPTER THREE

1. Matlack Price, "Industrial Art and the Craftsman," *Arts and Decoration* 16 (January 1922): 186–88, quoted by Richard Guy Wilson, "The Arts and Crafts after 1918: Ending and Legacy," in *The Arts and Crafts Movement in California: Living the Good Life*, ed. Kenneth R. Trapp (Oakland: Oakland Museum; New York: Abbeville Press, 1993), 233.

2. In 1876 Clarence Cook suggested that if suitably artistic furniture could not be bought new, antiques might do, and a good place to look was hen yards. Cook claimed that chickens gave old furniture "a good healthy color, and their angles are enough rubbed down to take away the disagreeable newness which troubles us in things just out of the shop" (Cook, quoted in Marilynn Johnson, "Art Furniture: Wedding the Beautiful to the Useful," in *In Pursuit of Beauty: Americans and the Aesthetic Movement*, by Doreen Bolger Burke et al. (New York: Metropolitan Museum of Art and Rizzoli, 1987), 162.

3. R. T. H. Halsey and Elizabeth Tower, *The Homes of Our Ancestors as Shown in the American Wing of the Metropolitan Museum of Art* (Garden City, N.Y.: Doubleday, 1937), 239, 288, quoted by William B. Rhoads, "Colonial Revival in American Craft: Nationalism and the Opposition to Multicultural and Regional Traditions," in *Revivals! Diverse Traditions: The History of Twentieth-Century American Craft*, ed. Janet Kardon (New York:

Abrams in association with American Craft Museum, 1994), 45.

4. Big Bill Haywood, quoted in Martin Green, *New York 1913* (New York: Scribner's, 1988), 185.

5. Milton W. Brown, "The Armory Show in Retrospect," in *1913 Armory Show Fiftieth Anniversary Exhibition 1963* (New York: Henry Street Settlement; Utica, N.Y.: Munson-Williams-Proctor Institute, 1963), 37.

6. Milton W. Brown, *The Story of the Armory Show* (Washington, D.C.: Joseph H. Hirshhorn Foundation, 1963), 64, 90.

7. William Zorach, quoted ibid., 94.

8. Elizabeth Overbeck, quoted in Kathleen R. Postle, *The Chronicle of the Overbeck Pottery* (Indianapolis: Indiana Historical Society, 1978), 50.

9. Ellen Paul Denker, "A Remarkable Moment in Time: E. G. Lewis and the Potters of the Peoples University," in *University City Ceramics: Art Pottery of the American Woman's League*, by David Conradsen and Ellen Paul Denker (Saint Louis: Saint Louis Art Museum, 2004), 20.

10. Frederick Hürten Rhead (text selected and edited by Paul Evans), in *Adelaide Alsop Robineau: Glory in Porcelain*, ed. Peg Weiss (Syracuse, N.Y.: Syracuse University Press and Everson Museum of Art, 1981), 102.

11. Ibid., 113.

12. Ibid.

13. Ibid., 106.

14. Conradsen, *University City Ceramics*, 39.

15. Elaine Levin, "Ceramics: Seeking a Personal Style," in *The Ideal Home, 1900–1920: The History of Twentieth-Century American Craft*, ed. Janet Kardon (New York: Abrams in association with the American Craft Museum, 1993), 83.

16. Weiss, *Adelaide Alsop Robineau*, 25.

17. Sharon Dale, *Frederick Hürten Rhead: An English Potter in America* (Erie, Penn.: Erie Art Museum, 1986), 10.

18. Paul Evans, *Art Pottery of the United States: An Encyclopedia of Producers and Their Marks* (New York: Scribner's, 1974), 235.

19. Suzanne Baizerman, Lynn Downey, and John Toki, *Fired by Ideals: Arequipa Pottery and the Arts and Crafts Movement* (San Francisco: Pomegranate; Oakland: Oakland Museum of California, 2000), 8.

20. Grace Armistead Doyle, "Pottery Workers of Arequipa," *San Francisco Chronicle*, June 7, 1914, quoted ibid., 80.

21. Dale, *Frederick Hürten Rhead*, 85.

22. Quoted in Trapp, *Arts and Crafts Movement in California*, 151.

23. Evans, *Art Pottery of the United States*, 19.

24. Timothy J. Anderson, Eudorah M. Moore, and Robert W. Winter, eds., *California Design 1910* (Los Angeles: California Design Publications, 1974), 75.

25. Ibid.

26. Robert W. Winter, ibid., 26.

27. Ellen Paul Denker and Bert Randall Denker, catalog entry in *"The Art That Is Life": The Arts and Crafts Movement in America, 1875–1920*, by Wendy Kaplan (Boston: Little, Brown, 1987), 262–63, no. 124.

28. Helen B. Camp, "A Craftsman of the Old School," *International Studio* 78 (October 1923): 55.

29. Ibid., 56.

30. Edward S. Cooke Jr., "Arts and Crafts Furniture: Process or Product?" in Kardon, *Ideal Home*, 75–76.

31. Information on Wheelock is scarce. See Catherine Zusy's catalog note in Kaplan, *Art That Is Life*, 321–22.

32. "Current Art Events," *International Studio*, September 1906, lxxxvi; quoted by Marilee Boyd Meyer, in *Inspiring Reform: Boston's Arts and Crafts Movement* (Wellesley, Mass.: David Museum and Cultural Center, 1997), 95.

33. The best source on Boston area Arts & Crafts jewelers remains Marilee Boyd Meyer, "Historic Interpretations: Boston's Arts and Crafts Jewelry," in *Inspiring Reform*, 87–98.

34. *Creative Design in Home Furnishings* 1 (Winter 1934–35): 30, cited by W. Scott Braznell, catalog entry in Kaplan, *Art That Is Life*, 283, no. 145.

35. W. Scott Braznell, catalog entry in Kaplan, *Art That Is Life*, 135–36, no. 19.

36. These courses would have put Shortridge on the leading edge of manual-arts instruction at the turn of the century. The art teacher had been producing art pottery with students from the late 1880s. There was even a William Morris Society at Shortridge starting in 1905.

37. W. Scott Braznell, "The Metalcraft and Jewelry of Janet Payne Bowles," in *The Arts and Crafts Metalwork of Janet Payne Bowles*, by Barry Shifman (Indianapolis: Indianapolis Museum of Art in association with Indiana University Press, 1993), 52, 54, 56–57.

38. Edgar W. Morse, *Silver in the Golden State* (Oakland: Oakland Museum History Department, 1986), 16–20.

39. Leslie Greene Bowman, *American Arts and Crafts: Virtue in Design* (Los Angeles: Los Angeles County Museum of Art, 1990), 126–29.

40. "American Woven 'Coverlids': Coverlets from the Historic Textile and Costume Collection," November 5, 2004–February 25, 2005, Department of Textiles, Fashion Merchandising and Design, University of Rhode Island, <http://www.uri.edu/hss/tmd/Gal5Coverlets2.htm>.

41. William Zorach, *Art Is My Life* (Cleveland: World Publishing, 1967), 53.

42. Interview by Joan Bazar, "'Pure Color' Search Led to New Art Form," *Tucson Daily Citizen*, February 26, 1964, 19, quoted in *Marguerite Zorach: The Early Years, 1908–1920* (Washington, D.C.: Smithsonian Institution Press for the National Collection of Fine Arts, 1973), 50.

43. "It is slow work but it is never tedious because it is always full of creative problems. It requires no patience because the mind is always alert and lively," Zorach wrote in "Embroidery as Art," *Art in America* 44 (Fall 1956): 66.

44. *The Metropolitan Museum of Art: Forty-ninth Annual Report 1918* (New York: Metropolitan Museum of Art, 1919), 29.

45. Allen H. Eaton, *Handicrafts of New England* (New York: Harper & Brothers, 1949), 333–35.

CHAPTER FOUR

1. Jane Addams Allen—in undated notes for a social history of American crafts, which she initiated on a James Renwick Fellowship in American Craft in 1994–95 but never completed due to ill health—wrote: "The 1920s were a fascinating time for American crafts because they had such high symbolic value for so many different groups. When the strains between

modern and traditional values are exacerbated and when the clashes between normative values and economic realities are greatest, the crafts seem to take on a symbolic aura. . . . In reality these struggles over craft are displaced from the more crucial struggles over economic dominance. It is easier, however, to focus on the crafts because they are so fractured, so dispersed that they are amenable to attack and absorption. On the one hand the colonial revival touted their craft objects as untainted products of the American past. The wealthy used them as indices of present affluence in the decoration and furnishing of homes, as adjuncts to exotic building styles, and the modernists looked on them, for a brief period at least, as standard bearers for the design excellence of America's industrial future. And by decade's end, still a fourth group saw the crafts as a needed source of extra income for the rural poor" (manuscript in the possession of Janet Koplos).

2. Preface in Charles R. Richards, *Industrial Art and the Museum* (New York: Macmillan, 1927), unpaged.

3. On Helen Plumb and industrial arts exhibitions, see Joy Hakanson Colby, *Art and a City: A History of the Detroit Society of Arts and Crafts* (Detroit: Wayne State University Press, 1956), 26–32.

4. Barbara Kramer, *Nampeyo and Her Pottery* (Albuquerque: University of New Mexico Press, 1996), 127.

5. Franc Johnson Newcomb, *Hosteen Klah: Navaho Medicine Man and Sand Painter* (Norman: University of Oklahoma Press, 1964), 97.

6. Ralph T. Coe, "Native American Craft," in *Revivals! Diverse Traditions, 1920–1945: The History of Twentieth-Century American Craft*, ed. Janet Kardon (New York: Abrams, 1994), 69.

7. This account based on Marvin Cohodas, "Louisa Keyser and the Cohns: Mythmaking and Basket Making in the American West," in *The Early Years of Native American Art History: The Politics of Scholarship and Collecting*, ed. Janet Catherine Berlo (Seattle: University of Washington Press, 1992), 88–133 passim.

8. Ibid., 8.

9. Gail Tremblay, "Cultural Survival and Innovation: Native American Aesthetics," in Kardon, *Revivals!*, 79.

10. Quoted in Kramer, *Nampeyo and Her Pottery*, 101.

11. Ibid., 34.

12. See the detailed discussion of Joseph Traugott, who adds that Fewkes's assertion "raises important issues of academic distance, cultural interference, and scholarly ethics," in *Native American Art in the Twentieth Century: Makers, Meanings, Histories*, ed. W. Jackson Rushing (London: Routledge, 1999), 17.

13. C. Norris Millington, "Modern Indian Pottery," *American Magazine of Art* 24 (June 1932): 454. She was first known as Marie, on the suggestion of the director of the Indian school in Santa Fe that this name would be more familiar to Anglos; it is presumed that her son Antonio, who legally changed his name to Popovi Da in 1948, persuaded her to switch to Maria about 1954. See Susan Peterson, *The Living Tradition of Maria Martinez* (Tokyo: Kodansha International, 1989), 98–99.

14. Ruth L. Bunzel, *The Pueblo Potter: A Study of Creative Imagination in Primitive Art* (New York: Columbia University Press, 1929), 57, 82, 88.

15. Janet Catherine Berlo and Ruth B. Phillips, *Native North American Art* (Oxford: Oxford University Press, 1998), 59.

16. Thomas Andrew Denenberg, *Wallace Nutting and the Invention of Old America* (New Haven: Yale University Press, 2003), 123.

17. Ibid., 162, 156, 97, 141.

18. Helen Appleton Read, "Modern Note Is Interpreted in the Livable House, Now on view at Abraham & Straus," *Brooklyn Daily Eagle*, February 5, 1928. A week later, an unsigned article in the same voice expanded on the assertion: "The modern department store is thus proving its value as an educational and cultural factor in the community. Its influence upon public taste is probably more direct than that exercised by museums because its vast daily audience is made up of potential buyers" ("Modern French Decorative Art in Furniture Will Be Shown at Lord and Taylor's," *Brooklyn Daily Eagle*, February 12, 1928).

19. Thomas Craven, "Mad Houses," *Forum* 82 (August 1929): 80, quoted in Martin Battersby, *The Decorative Twenties*, ed. Philippe Garner (New York: Whitney Library of Design, 1988), 171.

20. David A. Hanks with Jennifer Tober, *Donald Deskey: Decorative Designs and Interiors* (New York: Dutton, 1987), 35.

21. Elizabeth Lounsberg, "Modernistic Influence on Sterling Silver," *Arts and Decoration*, April 1928, 52, quoted in Alastair Duncan, *American Art Deco* (New York: Abrams, 1986), 82.

22. A. Frederick Saunders, "Modernism in Silverware," *Jeweler's Circular*, February 27, 1930, 103, quoted in Duncan, *American Art Deco*, 83.

23. Samuel Yellin, "Design and Craftsmanship" (1926), in Jack Andrews, *Samuel Yellin, Metalworker* (Ocean Pines, Md.: Skipjack Press, 2000), 71–75.

24. For Rose Iron Works and Fehér, see Jewel Stern, "Striking the Modern Note in Metal," in *Craft in the Machine Age, 1920–1945*, ed. Janet Kardon (New York: Abrams in association with the American Craft Museum, 1995), 132, 234, 260.

25. From Christian Brinton, *Hunt Diederich* (New York: Kilgore Galleries, 1920), unpaged, quoted in Karen Davies, *At Home in Manhattan: Modern Decorative Arts, 1925 to the Depression* (New Haven: Yale University Art Gallery, 1983), 37.

26. Allen manuscript (see note 1).

27. Beverly Gordon, "Spinning Wheels, Samplers, and the Modern Priscilla: The Images and Paradoxes of Colonial Revival Needlework," *Winterthur Portfolio* 33 (Summer–Autumn 1998): 177.

28. Quoted in Veronica Patterson, ed., *Weaving a Life: The Story of Mary Meigs Atwater*, compiled by Mary Jo Reiter (Loveland, Colo.: Interweave Press, 1992), 173.

29. Ibid., 141.

30. Ed Rossbach, "Mary Atwater and the Revival of American Traditional Weaving," *American Craft* 43 (April–May 1983): 26.

31. Otto Charles Thieme, *Avant Garde by the Yard: Cutting Edge Textile Design, 1880–1930* (Cincinnati: Cincinnati Art Museum, 1996), 43.

32. Mary Schoeser and Celia Rufey, *English and American Textiles: From 1790 to the Present* (New York: Thames & Hudson, 1989), 171.

33. Mildred Constantine and Jack Lenor Larsen, *Beyond Craft: The Art Fabric* (1973; New York: Kodansha, 1985), 28.

34. William Zorach, *Art Is My Life: The Autobiography of William Zorach* (Cleveland: World Publishing, 1967), 78.

35. Quoted in Ashley Callahan, *Enchanting Modern: Ilonka Karasz (1896–1981)* (Athens: Georgia Museum of Art, 2003), 45.

36. Ashley Brown [Callahan], "Ilonka Karasz: Rediscovering a Modernist Pioneer," *Studies in the Decorative Arts* 8 (Fall–Winter 2000–2001): 88.

37. Davies, *At Home in Manhattan*, 43.

38. The biggest tile businesses were American Encaustic and Gladding, McBean & Company, which dominated the market by mid-decade.

39. Joseph A. Taylor, in *Batchelder Tilemaker*, ed. Robert Winter (Los Angeles: Balcony Press, 1999), 9, and Taylor, "Creating Beauty from the Earth: The Tiles of California," in *The Arts and Crafts Movement in California: Living the Good Life*, ed. Kenneth R. Trapp (New York: Abbeville, 1993), 120.

40. Ronald L. Rindge et al., *Ceramic Art of the Malibu Potteries, 1926–1932*, ed. Marcia Page (Malibu, Calif.: Malibu Lagoon Museum, 1988), 14.

41. Peyton Boswell Jr., *Varnum Poor* (New York: Hyperion Press, Harper & Brothers, 1941), 21.

42. Ibid., 41.

43. Henry Varnum Poor, *A Book of Pottery: From Mud into Immortality* (Englewood Cliffs, N.J.: Prentice-Hall, 1958), 53.

44. Ibid., 42.

45. Ibid., 43.

46. Quoted in Helen Comstock, "A Painter Who Became a Potter," *International Studio* 79 (May 1924): 136–37.

47. Quoted by Jeanne Chenault Porter in Harold E. Dickson and Richard Porter, *Henry Varnum Poor, 1887–1970: A Retrospective Exhibition* (University Park: Pennsylvania State University Museum of Art, 1983), 12.

48. Linda Steigleder, ibid., 57.

49. Cheryl R. Ganz, "Shaping Clay, Shaping Lives: The Hull-House Kilns," in *Pots of Promise: Mexicans and Pottery at Hull-House, 1920–40*, ed. Cheryl R. Ganz and Margaret Strobel (Urbana: University of Illinois Press, 2004), 78–79; Ganz's reference is to Adolfo Best-Maugard, *A Method for Creative Design* (New York: Knopf, 1926).

50. Ganz, "Shaping Clay, Shaping Lives," 82.

51. See Eileen Boris, *Art and Labor: Ruskin, Morris, and the Craftsman Ideal in America* (Philadelphia: Temple University Press, 1986), 130–31; and Berea College Web page, <www.berea.edu/about>.

52. Jan Davidson, in the introduction to Frances Louisa Goodrich, *Mountain Homespun: A Facsimile of the Original, Published in 1931* (Knoxville: University of Tennessee Press, 1989), [6].

53. Ibid., [4].

54. Goodrich, *Mountain Homespun*, 25.

55. Davidson, in Goodrich, *Mountain Homespun*, [4–5].

56. Kelly H. L'Ecuyer, "Uplifting the Southern Highlander: Handcrafts at Biltmore Estate Industries," *Winterthur Portfolio* 37 (Summer–Autumn 2002), 143.

57. Jane Ellen Starnes, catalog entry in *Southern Arts and Crafts, 1890–1940*, by James C. Jordan III (Charlotte, N.C.: Mint Museum of Art, 1996), 107.

58. Allen H. Eaton, *Handicrafts of the Southern Highlands: With an Account of the Rural Handicraft Movement in the United States and Suggestions for Wider Use of Handicrafts in Adult Education and in Recreation* (New York: Russell Sage Foundation, 1937), 135.

59. Lynn Jones Ennis, *Penland and the "Revival" of Craft "Traditions": A Study of the Making of American Identities* (Ann Arbor: UMI Dissertation Services, 1995), 89, 94.

60. Study with Worst is not mentioned in Morgan's ghost-written autobiography, which also does not acknowledge Francis Goodrich's having accomplished a similar textile revival not so many miles away twenty years earlier.

61. Charles G. Zug III, *Turners and Burners: The Folk Potters of North Carolina* (Chapel Hill: University of North Carolina Press, 1986), 237.

62. By the late eighteenth century, the dangers of lead were recognized, but even in the twentieth century, it continued to be appreciated as a beautiful glaze of warm, luminous orange-browns, sometimes called "the old, true glaze." Nancy Sweezy, *Raised in Clay: The Southern Pottery Tradition* (1984; Chapel Hill: University of North Carolina Press, 1994), 213. Its use was prohibited by the Food and Drug Administration only in 1971.

63. Quoted in Zug, *Turners and Burners*, 250–51.

64. Mrs. Jacques Busbee, "North Carolina Pottery and Pine Needle Baskets," *Everywoman's Magazine* 1 (October 1916): 9, quoted in *New Ways for Old Jugs: Tradition and Innovation at the Jugtown Pottery*, ed. Douglas DeNatale, Jane Przybysz, and Jill R. Severn (Columbia: McKissick Museum, University of South Carolina, 1994), 5.

65. Jean Crawford, *Jugtown Pottery: History and Design* (Winston-Salem, N.C.: J. F. Blair, 1964), 18–19.

66. Quoted in DeNatale, Przybysz, and Severn, *New Ways for Old Jugs*, 29.

67. Quoted in Barbara Stone Perry, ed., *North Carolina Pottery: The Collection of the Mint Museums* (Chapel Hill: University of North Carolina Press, 2004), 150.

68. As Garth Clark has said in *Shards: Garth Clark on Ceramic Art*, ed. John Pagliaro (New York: Ceramic Arts Foundation; Distributed Art Publications, 2003), 412.

69. Quoted in Charles R. Mack, *Talking with the Turners: Conversations with Southern Folk Potters* (Columbia: University of South Carolina Press, 2006), 125.

70. Ralph Rinzler and Robert Sayers, *The Meaders Family: North Georgia Potters* (Washington, D.C.: Smithsonian Institution Press, 1980), 35. Shops with hired turners closed during the Depression because the turners had to be paid in cash, but the output from family potteries could be bartered for goods at stores (John A. Burrison, *Brothers in Clay: The Story of Georgia Folk Pottery* [Athens: University of Georgia Press, 1983], 219).

71. Quoted in Sweezy, *Raised in Clay*, 203.

72. Quoted in Mack, *Talking with the Turners*, 133.

73. Rodney Henderson Leftwich, "The Nonconnah Pottery of Tennessee and Western North Carolina, 1904–1918," in *May We All Remember Well: A Journal of the History and Culture of Western North Carolina*, ed. Robert S. Brunk (Asheville, N.C.: Robert S. Brunk Auction Services, 2001), 2: 70.

74. Tara Leigh Tappert and Peggy Ann Brown, "Resource List," in Kardon, *Revivals!* 245.

CHAPTER FIVE

1. Dianne H. Pilgrim, "Design for the Machine," in *The Machine Age in America, 1918–1941*, by Richard Guy Wilson, Dianne H. Pilgrim, and Dickran Tashjian (New York: Brooklyn Museum in association with Abrams, 1986), 272.

2. Warren I. Susman, *Culture as History: The Transformation*

of American Society in the Twentieth Century (New York: Pantheon, 1984), 154, quoted ibid., 310.

3. The national director of the Federal Art Project, Holger Cahill, had discovered American folk art in 1926, struck by the contemporary look of weathervanes, decoys, and primitive paintings. In 1930 and 1931, on the staff of the Newark Museum, he organized important exhibitions of these works, and, in 1932, as director of exhibitions for the Museum of Modern Art in New York, he organized *American Folk Art: The Art of the Common Man in America, 1750–1900*, which established folk art as a presence in the art world. He was affected both by the studio-based values of the art world and a deep interest in American material culture.

4. Hildreth J. York, "New Deal Craft Programs and Their Social Implications," in *Revivals! Diverse Traditions, 1920–1945: The History of Twentieth-Century American Crafts*, ed. Janet Kardon (New York: Abrams in association with American Craft Museum, 1994), 55–61.

5. Allen H. Eaton, *Handicrafts of the Southern Highlands: With an Account of the Rural Handicraft Movement in the United States and Suggestions for Wider Use of Handicrafts in Adult Education and in Recreation* (1937; New York: Dover, 1973), 22.

6. For a detailed accounting of the economics of craft in the Southern Highlands, see Jane S. Becker, *Selling Tradition: Appalachia and the Construction of an American Folk, 1930–1940* (Chapel Hill: University of North Carolina Press, 1998).

7. Charles R. Richards, *Art in Industry: Being the Report of an Industrial Art Survey Conducted under the Auspices of the National Society for Vocational Education and the Department of Education of the State of New York* (New York: Macmillan, 1929), 121–45.

8. Quoted in "The New American Craftsman: First Generation" (roundtable discussion), *Craft Horizons* 26 (May–June 1966): 22.

9. For an account of industrial design education before World War II, see Arthur J. Pulos, *American Design Ethic: A History of Industrial Design to 1940* (Cambridge, Mass.: MIT Press, 1983), 398–401.

10. Cranbrook Announcement, October 1932, quoted by David Farmer, "Metalwork and Bookbinding," in *Design in America: The Cranbrook Vision, 1925–1950* (New York: Abrams in association with the Detroit Institute of Arts and Metropolitan Museum of Art, 1983), 154.

11. *Machine Art, March 6 to April 30, 1934* (1934; New York: Museum of Modern Art, 1994), unpaged. Philip Johnson, in his preface to the sixtieth-anniversary edition, continued: "My catalogue text seems juvenile today, with its quick, unsubstantiated judgments thrown around and conclusions reached without documentation or research. Nevertheless, the thrust was clear: anti-handcraft; industrial methods alone satisfied our age; Platonic dreams of perfection were the ideal."

12. Anna Wetherill Olmsted, in *Designer Craftsmen U.S.A. 1953: Ceramics, Textiles, Wood, Metals, Leather, Glass* (New York: Brooklyn Museum, 1953), 37–38.

13. Martin Eidelberg, "Ceramics," in *Design in America*, 217.

14. This massive creation, damaged by vandals and time, was restored in 2007.

15. Ernest W. Watson, "Waylande Gregory's Ceramic Art," *American Artist* 8 (September 1944): 12, quoted in Garth Clark, *A Century of Ceramics in the United States, 1878–1978: A Study of Its Development* (New York: Dutton, 1979), 95.

16. When the fair ended, the work was returned to Gregory's studio and stayed in his garden until his death in 1971. What became of it is not known.

17. Henry Adams, *Viktor Schreckengost and Twentieth-Century Design* (Cleveland: Cleveland Museum of Art, 2000), 56.

18. Karal Ann Marling, "New Deal Ceramics: The Cleveland Workshop," *Ceramics Monthly* 26 (June 1977): 25.

19. Louise C. Avery, "International Exhibition of Contemporary Ceramic Art," *Bulletin of the Metropolitan Museum of Art* 23 (October 1928): 238.

20. Vally Wieselthier, "Ceramics," *Design* 31 (November 1929): 101, quoted in Elaine Levin, "Vally Wieselthier/Susi Singer," *American Craft* 46 (December 1986–January 1987): 47.

21. Ibid., 48.

22. E. M. Benson, "Twentieth-Century Ceramics," *American Magazine of Art* 27 (May 1934): 260.

23. Quoted in Jeff Schlanger and Toshiko Takaezu, *Maija Grotell: Works Which Grow from Belief* (Goffstown, N.H.: Studio Potter Books, 1996), 49.

24. Ibid., 51, 53.

25. Maija Grotell, interview by Jeff Schlanger and Toshiko Takaezu, May 24, 1968, typescript, 67, American Craft Council Library, New York.

26. Melvin H. Bernstein, *Art and Design at Alfred: A Chronicle of a Ceramics College* (Philadelphia: Art Alliance Press, 1986), 97, 98.

27. Marcia Yockey Manhart, "Charting a New Educational Vision," in *Craft in the Machine Age: The History of Twentieth-Century American Craft, 1920–1945*, ed. Janet Kardon (New York: Abrams in association with the American Craft Museum, 1995), 70–71.

28. Lukens credited his unusual attitude to Mary Austin, who urged him not to pursue ceramic cleverness but "to be natural, honest and sincere, to reclaim and regenerate rare experience," quoted in Hazel V. Bray, *The Potter's Art in California, 1885–1955* (Oakland, Calif.: Oakland Museum, 1980), 25.

29. Ibid.

30. Elaine Levin, *The History of American Ceramics, 1607 to the Present, from Pipkins and Bean Pots to Contemporary Forms* (New York: Abrams, 1988), 171; and Elaine Levin, *Glen Lukens: Pioneer of the Vessel Aesthetic* (Los Angeles: Fine Arts Gallery, California State University, 1982), unpaged.

31. Bill Stern, *California Pottery: From Missions to Modernism* (San Francisco: Chronicle, 2001), 40.

32. Patricia Leigh Brown, "Jazzy Pottery from the Thirties Comes of Age," *New York Times*, August 16, 2001.

33. Levin, *History of American Ceramics*, 171.

34. For an account of design flaws, see Garth Clark's introduction in Karen McCready, *Art Deco and Modernist Ceramics* (London: Thames & Hudson, 1995), 14–15.

35. Arthur J. Pulos, "Russel Wright: American Designer," *American Craft* 43 (October–November 1983): 11.

36. Quoted by Mary Schoeser, "Textiles: Surface, Structure, and Serial Production," in Kardon, *Craft in the Machine Age*, 118.

37. Ibid., 114–15.

38. Dorothy Wright Liebes, "Modern Textiles," in *Decorative Arts: Official Catalog, Department of Fine Arts, Division of Decorative Arts, Golden Gate International Exposition, San Francisco,*

1939 (San Francisco: San Francisco Bay Exposition Company; H. S. Crocker; Schwabacher-Frey, 1939), 92.

39. Ibid.

40. Some recent research suggests that they never married; nevertheless, she used his name for the rest of her life.

41. Jane Ellen Starnes, "Mary Crovatt Hambidge: Art and Nature," in *Southern Arts and Crafts, 1890–1940*, by James C. Jordan III (Charlotte, N.C.: Mint Museum of Art, 1996), 55.

42. Ibid.; other accounts say she had learned spinning in Greece.

43. Philis Alvic, *Mary Hambidge, Weaver of Rabun* (1989; Murray, Ky.: Privately printed, 1993), 4.

44. Jordan, *Southern Arts and Crafts*, 55–56.

45. Quoted in Alvic, *Mary Hambidge*, 9.

46. Ed Rossbach, "Fiber in the Forties," *American Craft* 42 (October–November 1982): 15.

47. Quoted in Rossbach, *Forties*, 17.

48. Ed Rossbach, "The Glitter and Glamour of Dorothy Liebes," *American Craft* 42 (December 1982–January 1983): 10.

49. Ibid., 12.

50. Quoted in Paul J. Smith, *Dorothy Liebes* (New York: Museum of Contemporary Crafts, 1970), 9.

51. Ibid., 12, 10.

52. For example, C. Adolph Glassgold, "Audac Exhibit of Modern Industrial and Decorative Art at the Brooklyn Museum," *Creative Art* 8 (June 1931): 437–40.

53. Karen Davies, *At Home in Manhattan: Modern Decorative Arts, 1925 to the Depression* (New Haven, Conn.: Yale University Art Gallery, 1983), 111.

54. Christopher Wilk, catalog entry in *Design, 1935–1965: What Modern Was; Selections from the Liliane and David M. Stewart Collection*, ed. Martin Eidelberg (Montreal: Musée des arts décoratifs de Montréal; New York: Abrams, 1991), 77.

55. Rey Móntez, "The Revival of Straw Appliqué and Tinwork," in *Spanish New Mexico: The Spanish Colonial Arts Society Collection*, ed. Donna Pierce and Marta Weigle (Santa Fe: Museum of New Mexico Press, 1996), 2: 48–51.

56. "Machine Molds Metal," *Interior Architecture and Decoration* 37 (December 1931): 274–75, quoted in Alastair Duncan, *American Art Deco* (New York: Abrams, 1986), 91.

57. Adolf Loos, "Ornament and Crime" (1908), in *Ornament and Crime: Selected Essays* (Riverside, Calif.: Ariadne Press, 1998), 167.

58. Quoted in Paul V. Gardner, *Frederick Carder: Portrait of a Glassmaker* (Corning, N.Y.: Corning Museum of Glass; Rockwell Museum, 1985), 26–27.

59. Quoted by Mary Jean Smith Madigan, *Steuben Glass: An American Tradition in Crystal* (New York: Abrams, 1982), 70.

60. Sidney Waugh, *The Making of Fine Glass* (New York: Dodd, Mead, 1947), 11.

CHAPTER SIX

1. Herbert Read, quoted in Brooke Kamin Rapaport and Kevin L. Stayton, *Vital Forms: American Art and Design in the Atomic Age, 1940–1960* (New York: Brooklyn Museum of Art in association with Abrams, 2001), 100.

2. Elliot W. Eisner and David W. Ecker, *Readings in Art Education* (Waltham, Mass.: Blaisdell, 1966), 428, quoted in Marcia Manhart, "The Emergence of the American Crafts-
man—à la BA, BFA, MA, and MFA," in *A Neglected History: Twentieth-Century American Craft*, ed. Janet Kardon (New York: American Craft Museum, 1991), 24.

3. "American Craft Council, 1943–1993: A Chronology," *American Craft* 53 (August–September 1993): 137.

4. "The School for American Craftsmen, New England Division, Hanover, N.H.," *Craft Horizons* 4 (August 1945): 8.

5. "Eavesdropping on Russel Wright," *Craft Horizons* 2 (November 1943): 6.

6. Quoted in Daniel Marchesseau, *The Intimate World of Alexander Calder* (Paris: S. Thierry; New York: Abrams, 1989), 256.

7. Quoted ibid., 260.

8. Julio De Diego, "The Metal Worker Suggests," *Craft Horizons* 6 (February 1947): 20.

9. Evelyn Pousette-Dart, interview by Bruce Metcalf, Suffern, New York, November 25, 1995.

10. Press release from the Museum of Modern Art, "Exhibition of Modern Handmade Jewelry Opens at Museum of Modern Art," undated.

11. For a personal account of Rebajes, see Patricia Riveron Lee, "Uncle Frank: The Story of Francisco Rebajes," <www .modernsilver.com/unclefrank.html> (November 17, 2008).

12. Sam Kramer, quoted in Meg Tolbert, ed., *Design Quarterly* 45–46 (1959): 56.

13. Sam Kramer advertisement, *Craft Horizons* 15 (November–December 1955): 45.

14. Sam Kramer, quoted in Mark Foley, "Sam Kramer: Fantastic Jewelry for People Who Are Slightly Mad," *Metalsmith* 6 (Winter 1986): 17.

15. Art Smith, *Art Smith: Jewelry* (New York: Museum of Contemporary Crafts, 1969), unpaged, quoted by Toni Lesser Wolf, "Art Smith," in *Design, 1935–1965: What Modern Was: Selections from the Liliane and David M. Stewart Collection*, ed. Martin Eidelberg (Montreal: Musée des arts décoratifs de Montréal; New York: Abrams, 1991), 99.

16. Toni Greenbaum, *Messengers of Modernism: American Studio Jewelry, 1940–1996* (Montreal: Montreal Museum of Decorative Arts in association with Flammarion, 1996), 86.

17. Blanche R. Brown, "Ed Weiner to Me," in *Jewelry by Ed Weiner* (New York: Fifty/50 Gallery, 1988), 13, quoted ibid., 20.

18. Quoted in Mark Baldridge, "Kenneth Bates: Dean of American Enameling," *Metalsmith* 8 (Spring 1988): 32.

19. See a photograph of Oscar Schlemmer and Josef Hartwig at work on the Bauhaus building, Weimar, 1923, in Magdalena Droste, *Bauhaus, 1919–1933* (Cologne: Benedickt Taschen, 1998), 89.

20. The most thorough history of studio wood turning is Edward S. Cooke Jr., "From Manual Training to Freewheeling Craft: The Transformation of Wood Turning, 1900–76," in *Wood Turning in North America since 1930* (Philadelphia: Wood Turning Center; New Haven, Conn.: Yale University Art Gallery, 2001), 12–63.

21. Edgar Kaufmann Jr., *Prestini's Art in Wood* (Lake Forest, Ill.: Pocahontas Press; New York: Pantheon, 1950).

22. Anna Wetherill Olmsted, "Are Ceramics Art? The Story of an Experimental Exhibition," *Craft Horizons* 3 (May 1944): 6, 8.

23. Glen Lukens was away in Haiti during this postwar

change, and when he returned in the mid-1950s, not only these changes but the spread of Japanese traditional aesthetics by Bernard Leach and Shoji Hamada (see chapter 7) made him feel like Rip van Winkle, he said.

24. The accounts of all but Johnson are primarily dependent on Winifred Owens-Hart, "Ceramics: From Africa to America," in *Revivals! Diverse Traditions, 1920–1945: The History of Twentieth-Century American Crafts*, ed. Janet Kardon (New York: Abrams in association with American Craft Museum, 1994), 114–18.

25. Artis, Hathaway, and Johnson have been profiled on the African American Registry, <www.aaregistry.com>.

26. Nkiru Nzegwu, "A Circle of *Dibias*: Making Vessels of Memory and Life" in *Uncommon Beauty in Common Objects: The Legacy of African American Craft Art* (Wilberforce, Ohio: National Afro-American Museum and Cultural Center, 1993), 11.

27. Evangeline J. Montgomery, "Sargent Claude Johnson: A Retrospective," in *Ijele: Art eJournal of the African World* 1, no. 2 (2000), <http://ijele.com/vol1.2/montgomery.html>.

28. Hazel V. Bray, *The Potter's Art in California, 1885 to 1955* (Oakland: Oakland Museum, 1978), 46, 48.

29. Elaine Levin, "Vally Wieselthier/Susi Singer," *American Craft* 46 (December 1986–January 1987): 49.

30. Ibid.

31. Ibid.

32. Accounts of their lives and aesthetics are drawn primarily from several wonderful catalog essays by Otto, especially in *Gertrud and Otto Natzler: Ceramics: Catalog of the Collection of Mrs. Leonard M. Sperry* (Los Angeles: Los Angeles County Museum of Art, 1968).

33. Elaine Levin, *The History of American Ceramics, 1607 to the Present, from Pipkins and Bean Pots to Contemporary Forms* (New York: Abrams, 1988), 175.

34. Quoted by Peter Clothier, "Otto Natzler," *American Ceramics* 9, no. 1 (1991): 20.

35. *The Ceramic Work of Gertrud and Otto Natzler* (San Francisco: M. H. de Young Memorial Museum, 1971), 9, 11.

36. The property was later acquired by the state to add to the park, although after a public protest by her friends and students, Wildenhain was given life tenancy.

37. Marguerite Wildenhain, *The Invisible Core: A Potter's Life and Thoughts* (Palo Alto, Calif.: Pacific Books, 1973), 61.

38. Ibid., 36.

39. Quoted in Nancy Neumann Press and Terry Faith Anderson Weihs, *Marguerite: A Retrospective Exhibition of the Work of Master Potter Marguerite Wildenhain* (Ithaca, N.Y.: Office of University Publications, Cornell University, 1980), 26.

40. Hunt Prothro, "Marguerite Wildenhain: Sustained Presence," *American Craft* 40 (August–September 1980): 76.

41. Hunt Prothro, conversation with Janet Koplos, New York, February 16, 2007.

42. "Development of the Pond Farm Pottery and School," Marguerite Wildenhain Papers, 1930–82, Archives of American Art, Smithsonian Institution, Washington, D.C., quoted in Press and Weihs, *Marguerite*, 10.

43. Other active individual potters in Southern California were Albert King after 1926, Lukens at USC after 1933, William Manker at Scripps after 1934, Fred Robertson at the Robertson Pottery after 1934, Ernest Batchelder at the Kinneloa Pottery after 1936, and Gertrud and Otto Natzler after 1939.

44. Diana Rico, "Laura Andreson: An Interview," *American Ceramics* 3, no. 2 (1984): 17.

45. Edward Lebow, "A Sense of Line," *American Craft* 48 (February–March 1988): 28.

46. *Shards: Garth Clark on Ceramic Art*, ed. John Pagliaro (New York: Ceramic Arts Foundation; Distributed Art Publications, 2003), 114.

47. Quoted ibid.

48. Beatrice Wood, *I Shock Myself: The Autobiography of Beatrice Wood* (San Francisco: Chronicle, 1985), 94.

49. Ibid., 105.

50. Ibid., 127–28.

51. Quoted by Francis Naumann in *Intimate Appeal: The Figurative Art of Beatrice Wood* (Oakland: Oakland Museum, 1989), 34.

52. Quoted ibid., 15–16.

53. Beatrice Wood, "A Potter's Experiment," *Craft Horizons* 11 (Summer 1951): 31.

54. Edith Heath, *Tableware and Tile for the World: Heath Ceramics, 1944–1994*, ed. Julie Gordon Shearer and Germaine LaBerge (Berkeley: University of California Regional Oral History Office, Bancroft Library, 1995), 69–70.

55. Ibid., 110.

56. Ibid., 137.

57. Martin Eidelberg, *Eva Zeisel: Designer for Industry* (Montreal: Le Château Dufresne; Musée des arts décoratifs de Montréal, 1984), 32, 35.

58. Sarah Bodine, "Eva Zeisel: Humanistic Design for Mass Production," *American Ceramics* 3, no. 3 (1984): 33.

59. Quoted in Eidelberg, *Eva Zeisel*, 97.

60. Quoted in *Clay Talks: Reflections by American Master Ceramists*, ed. Emily Galusha and Mary Ann Nord (Minneapolis: Northern Clay Center, 2004), 97.

61. Eidelberg, *Eva Zeisel*, 74.

62. Ed Rossbach, "Fiber in the Forties," *American Craft* 42 (October–November 1982): 15–19; Rossbach, "The Glitter and Glamour of Dorothy Liebes," *American Craft* 42 (December 1982–January 1983): 8–12; Rossbach, "Mary Atwater and the Revival of American Traditional Weaving," *American Craft* 43 (April–May 1983): 22–26; Rossbach, "In the Bauhaus Mode: Anni Albers," *American Craft* 43 (December 1983–January 1984): 7–11; Rossbach, "Marianne Strengell," *American Craft* 44 (April–May 1984): 8–11.

63. See Mary Schoeser, "Textiles: Surface, Structure, and Serial Production," in *Craft in the Machine Age, 1920–1945: The History of Twentieth-Century American Craft*, ed. Janet Kardon (New York: Abrams in association with American Craft Museum, 1995), 118–19, as well as the Rossbach articles (see note 62).

64. Albers wrote, "There is a danger of isolationism . . . handweavers withdrawing from contemporary problems and burying themselves in weaving recipe books of the past: there is a resentment of an industrial present, which due to a superior technique of manufacture, by-passes them; there is a romantic overestimation of handwork in contrast to machine work and a belief in artificial preservation of a market that is no longer of vital importance" (Anni Albers, *On Designing* [1959; Middletown, Conn.: Wesleyan University Press, 1962], 15).

65. Rossbach, "Fiber in the Forties," 16.

66. Sigrid Wortmann Weltge, *Bauhaus Textiles: Women Art-*

ists and the Weaving Workshop (1993; New York: Thames & Hudson, 1998), 164.

67. Quoted in Gene Baro, *Anni Albers* (Brooklyn: Brooklyn Museum, 1977), 6.

68. On Klee's influence on Albers, see Virginia Gardner Troy, *Anni Albers and Ancient American Textiles: From Bauhaus to Black Mountain* (Aldershot, U.K.: Ashgate, 2002), 83–84.

69. Weltge, *Bauhaus Textiles*, 104.

70. Ibid., 99.

71. Troy, *Anni Albers*, 3.

72. She did not credit the Bauhaus "preliminary course" of Johannes Itten, although his emphasis on materials and their textures, use of grids and registers, and interest in world art forms were all ideas important to weaving and to her weaving in particular (Troy, *Anni Albers*, 46, 47).

73. Ibid., 75, 79.

74. Ibid., 136, 137.

75. Quoted in Rossbach, "Fiber in the Forties," 17.

76. Rossbach speculated that "museum directors felt safe with the weavings of Anni Albers. They trusted her intellectual approach to fiber, her control, her absence of sensuous color, her emphasis on the grid. With her work they avoided the artsy-craftsy stigma" ("In the Bauhaus Mode," 8).

77. Mildred Constantine and Jack Lenor Larsen, *Beyond Craft: The Art Fabric* (1973; New York: Kodansha, 1986), 24.

78. Rossbach, "In the Bauhaus Mode," 10.

79. One of the points in Mary Jane Jacob's letter to the editor rebutting Rossbach's article, *American Craft* 44 (February–March 1984): 90.

80. Quoted in Baro, *Anni Albers*, 8.

81. Rossbach, "Marianne Strengell," 8.

82. Ibid., 9.

83. Screen printing was an old technique but was only revived in America as a WPA project in New York. Strengell's 1942 plan for Cranbrook included the study of block printing and screen printing.

84. Rossbach, "Marianne Strengell," 10.

85. She was offered the job after Otti Berger was unable to get a visa to the United States; Berger subsequently died in a concentration camp.

86. Weltge, *Bauhaus Textiles*, 178.

87. William Earle Williams, *Eve Peri: A Retrospective in Painting, Collage, and Fabric* (Haverford, Penn.: Haverford College, 1991), unpaged.

88. "Eve Peri's Fabric Forms," *Craft Horizons* 9 (Spring 1949): 14–15.

89. Doris Brian, "'Fabstracts' by Peri," *Art Digest* 24 (May 1, 1950): 15.

CHAPTER SEVEN

1. *Mary and Russel Wright's Guide to Easier Living* (1950; Salt Lake City: Gibbs Smith, 2003), 1–2.

2. Martin Duberman, *Black Mountain: An Exploration in Community* (New York: Dutton, 1972), 337.

3. Quoted in Joy Hakanson, "Cranbrook," *Craft Horizons* 19 (May–June 1959): 20.

4. For an account of the Good Design shows, see Mary Anne Staniszewski, *The Power of Display: A History of Exhibition Installations at the Museum of Modern Art* (Cambridge, Mass.: MIT Press, 1998), 173–91.

5. That is Susan Peterson's assertion in "Conversation: Susan Peterson with Robert Silberman," *American Craft* 61 (December 2001–January 2002): 60.

6. Emmanuel Cooper, *Bernard Leach: Life and Work* (New Haven, Conn.: Yale University Press for Paul Mellon Centre for Studies in British Art, 2003), xiv–xv.

7. Marguerite Wildenhain, letter to the editor, *Craft Horizons* 13 (May–June 1953): 43.

8. The article was accompanied by an unidentified picture of his son David at the wheel, which an unknowing reader might have presumed was the author.

9. Bernard Leach, *Beyond East and West: Memoirs, Portraits, and Essays* (New York: Watson-Guptill, 1978), see 230–41.

10. In 1952 the Archie Bray Foundation published a limited edition of the texts of Yanagi's lectures, "The Responsibility of the Craftsman" and "Mystery of Beauty," which focused on Buddhist aesthetics.

11. Yanagi has lately been subject to the same kind of critical revisionism given to Leach's career by Edmund de Waal and Julian Stair. See Yuko Kikuchi, *Japanese Modernisation and Mingei Theory: Cultural Nationalism and Oriental Orientalism* (London: Routledge Curzon, 2004); Kim Brandt, *The Kingdom of Beauty: Mingei and the Politics of Folk Art in Imperial Japan* (Durham, N.C.: Duke University Press, 2007).

12. Louana M. Lackey, *Rudy Autio* (Westerville, Ohio: American Ceramic Society, 2002), 26–27. Art historian Patricia Failing speculates that the famous picture of the three esteemed visitors and the two young Montanans has had a disproportionate influence on the image of the Bray, which was not, in fact, especially Japanese-inspired. She suggests that it was more the meeting of the generations, a suggestion of past and future, that has made the photograph memorable (Failing, "The Archie Bray Foundation: A Legacy Reframed," in *A Ceramic Continuum: Fifty Years of the Archie Bray Influence*, ed. Peter Held [Helena, Mont.: Holter Museum of Art; Seattle: University of Washington Press, 2001], 41–43).

13. The group was called Sodeisha. For an excellent account in English, see Louise Allison Cort and Bert Winther-Tamaki, *Isamu Noguchi and Modern Japanese Ceramics: A Close Embrace of the Earth* (Washington, D.C.: Arthur M. Sackler Gallery, Smithsonian Institution; Berkeley: University of California Press, 2003), 103ff.

14. To the extent that Minnesota is now often called by insiders "Mingei-sota."

15. Artist's statement in *Warren MacKenzie, Potter: A Retrospective* (Minneapolis: University Art Museum, University of Minnesota, 1989), 6.

16. Robert Silberman, "Down to Earth Idealist," *American Craft* 49 (June–July 1989): 34.

17. Garth Clark, "The Purist, the Symbolist, the Stylist: Utility in Contemporary American Ceramics," in *Shards: Garth Clark on Ceramic Art*, ed. John Pagliaro (New York: Ceramic Arts Foundation; Distributed Art Publications, 2003), 417–18.

18. *Warren MacKenzie*, 32, 37.

19. Pharis moved to functional-referent forms of architectural character, including teapots and soy bottles with surfaces broken by faceting or color patches.

20. Artist's statement, in *Warren MacKenzie*, 6.

21. Karnes, quoted in *Clay Talks: Reflections by American Master Ceramists*, ed. Emily Galusha and Mary Ann Nord (Minneapolis: Northern Clay Center, 2004), 22.

22. Dido Smith, "Karen Karnes," *Craft Horizons* 18 (May–June 1958): 12, 14.

23. Melvin H. Bernstein, *Art and Design at Alfred: A Chronicle of a Ceramics College* (Philadelphia: Art Alliance Press, 1986), 161.

24. *The Grande Dames of Ceramics: Susan Peterson and Friends* (Carefree, Ariz.: Andorra Gallery, 2004), unpaged.

25. Hazel V. Bray, *The Potter's Art in California, 1885 to 1955* (Oakland: Oakland Museum, 1980), 69–70.

26. *The Ceramic Forms of Leza McVey*, ed. Martin Eidelberg (New York: Philmark, 2002).

27. Name changed from Cleveland School of Art in 1949.

28. Conrad Brown, "Peter Voulkos," *Craft Horizons* 16 (September–October 1956): 12.

29. Peter Voulkos, "The Miami Annual," *Craft Horizons* 17 (May–June 1957): 42–43.

30. Elaine Levin, *The History of American Ceramics, 1607 to the Present: From Pipkins and Bean Pots to Contemporary Forms* (New York: Abrams, 1988), 188.

31. Quoted in Rose Slivka, *Peter Voulkos: A Dialogue with Clay* (Boston: New York Graphic Society, 1978), 16.

32. Quoted ibid., 83.

33. *Paul Soldner: A Retrospective, in Honor of Paul Soldner* (Claremont, Calif.: Lang Gallery, Scripps College; Seattle: University of Washington Press, 1991), 15.

34. Levin, *History of American Ceramics*, 202. Mason suggested that Voulkos's real motivation for creating large forms was the larger "canvas" they gave him (quoted in Slivka, *Peter Voulkos*, 27).

35. Garth Clark, "American Ceramics since 1950," in *American Ceramics: The Collection of the Everson Museum of Art*, ed. Barbara Perry (New York: Rizzoli; Syracuse, N.Y.: Everson Museum, 1989), 201.

36. Galusha, *Clay Talks*, 68.

37. Clark, *Shards*, 276.

38. Mason, quoted in Slivka, *Peter Voulkos*, 28.

39. Levin, *History of American Ceramics*, 201.

40. Letter from Ben Sams, quoted in LaMar Harrington, *Ceramics in the Pacific Northwest: A History* (Seattle: University of Washington Press for Henry Art Gallery, 1979), 68.

41. Mason, quoted in Slivka, *Peter Voulkos*, 31.

42. Garth Clark has asserted the importance of regarding such works as pots rather than as sculptures because they are more meaningful in terms of violated conventions, and it also more clearly shows the Otis atmosphere of playing, escaping expectations (see *Shards*, 228–29, 231).

43. Voulkos, quoted in Lackey, *Rudy Autio*, ix.

44. Senska, quoted in Held, *Ceramic Continuum*, 22.

45. Paul Soldner, interview by Elaine Levin, 1980, in Mary Davis MacNaughton, *Revolution in Clay: The Marer Collection of Contemporary Ceramics* (Seattle: University of Washington Press, 1994), 69n19.

46. Ibid., 33.

47. John Mason, interview by Ben Marks, in *John Mason* (Santa Monica, Calif.: Frank Lloyd Gallery, 2000), 2.

48. J. Bennett Olson, "Soldner-Mason-Rothman," *Craft Horizons* 12 (September-October 1957): 41.

49. Rothman, quoted in Susan Peterson, Garth Clark, and Mike McGee, *Feat of Clay: Five Decades of Jerry Rothman*

(Laguna Beach, Calif.: Laguna Art Museum; Santa Ana, Calif.: Grand Central Press, 2003), 23.

50. Ibid., 25.

51. Kurt Weiser's words in praise of Takemoto, quoted in Edward Lebow, "Kurt Weiser: Storied Forms," *American Craft* 54 (December 1994–January 1995): 44.

52. Marcia Manhart and Tom Manhart, eds., *The Eloquent Object: The Evolution of American Art in Craft Media since 1945*, (Tulsa: Philbrook Museum of Art, 1987), 26.

53. Weiser, quoted in Lebow, "Kurt Weiser," 44.

54. Hazel V. Bray, "Harrison McIntosh," in *Harrison McIntosh, Studio Potter: A Retrospective Exhibition* (Rancho Cucamonga, Calif.: Rex W. Wignall Museum Gallery, Chaffey Community College, 1979), 11.

55. Rose Slivka, "The Magic World of Marge Israel," *Craft Horizons* 17 (July–August 1957): 11.

56. Gretchen Adkins, "Margaret Israel," *American Ceramics* 9, no. 1 (1991): 29–30.

57. Earlier examples can be discovered, such as the Norwegian Arts and Crafts weaver Frida Hansen, who developed a "transparent weaving" technique.

58. Mildred Constantine and Jack Lenor Larsen, *Beyond Craft: The Art Fabric* (1973; New York: Kodansha, 1986), 33.

59. Ibid.

60. Quoted ibid., 38.

61. Karen Davies, *At Home in Manhattan: Modern Decorative Arts, 1925 to the Depression* (New Haven: Yale University Art Gallery, 1983), 53.

62. Mariska Karasz, *Adventures in Stitches: A New Art of Embroidery* (New York: Funk & Wagnalls, 1949), 9.

63. Constantine and Larsen, *Beyond Craft*, 39.

64. Ibid., 31.

65. The Walker Art Center published a magazine (first titled *Everyday Art Quarterly*, later *Design Quarterly*) that occasionally served as a catalog for the jewelry shows. Every contributor was represented by at least one image. Issues number 7 (spring 1948), number 33 (1955), and number 45–46 (1959) are fascinating records of the era's rapidly changing studio jewelry.

66. Christensen, quoted in Deborah Norton, "A History of the School for American Craftsmen," *Metalsmith* 5 (Winter 1985): 19.

67. Moholy-Nagy, quoted in Yoshiko Uchida, "Margaret De Patta," in *The Jewelry of Margaret De Patta: A Retrospective Exhibition* (Oakland, Calif.: Oakland Museum, 1976), 15.

68. The standard reference for De Patta is the Oakland Museum's 1976 catalog of her retrospective exhibition (ibid.).

69. Rose Slivka, "Radakovich," *Craft Horizons* 18 (September–October 1958): 28.

70. Jan Yager, "Phillip Fike: American Metalsmith, 1927–1997," *Metalsmith* 18 (spring 1998): 17–25.

71. Margaret Craver, "The Handy & Harmon Conferences" (manuscript, 1982, in the collection of Bruce Metcalf), 8.

72. Greta Daniel, "Aubusson's Tapestries in U.S.: Varied Reactions to the French Style," *Craft Horizons* 19 (May–June 1959): 31–32.

73. Thomas S. Tibbs, preface to *Furniture by Craftsmen* (New York: Museum of Contemporary Crafts, 1957), unpaged.

74. George Nakashima, "Craftsmanship in Architecture," *Craft Horizons* 16 (May–June 1956): 31.

75. George Nakashima, *The Soul of a Tree: A Woodworker's Reflections* (1981; Tokyo: Kodansha, 1988), 105.

76. Ibid., 219.

77. Walker Weed, "Walker Weed: A Self-Portrait," in *Walker Weed: A Retrospective Exhibition 1950–1981* (Hanover, N.H.: Dartmouth College Museum and Galleries, 1981).

78. Weed, quoted in "Makers' Biographies," in *The Maker's Hand: American Studio Furniture, 1940–1990*, by Edward S. Cooke Jr., Gerald W. R. Ward, and Kelly H. L'Ecuyer (Boston: Museum of Fine Arts, 2003), 140.

79. The first was Michael A. Stone, *Contemporary American Woodworkers* (Salt Lake City: Gibbs M. Smith, 1986), 48. Later, in *The Maker's Hand*, 120, Edward S. Cooke Jr. cites Stone approvingly.

80. Quoted in Stone, *Contemporary American Woodworkers*, 11.

81. Esherick, in "The New American Craftsman: First Generation/Wood," *Crafts Horizons* 26 (June 1966): 19.

82. Lee Nordness, *Objects: USA* (New York: Viking, 1970), 252.

83. The revival of interest began after Nikolaus Pevsner described Favrile glass as an expression of art nouveau (in *Pioneers of Modern Design from William Morris to Walter Gropius*, 2d ed. [New York: Museum of Modern Art, 1949]) according to Robert Koch, *Louis C. Tiffany, Rebel in Glass* (New York: Crown Publishers, 1964), 213.

84. Nordness, *Objects*, 167.

85. Sowers also published *The Language of Stained Glass* (1981) and *Rethinking the Forms of Visual Expression* (1990), in which he outlined an aesthetic for the success of stained glass and attempted a comprehensive understanding of the visual arts.

CHAPTER EIGHT

1. "The American Craftsman/1964," *Craft Horizons* 24 (May–June 1964): 32.

2. The spelling according to Minnesota Museum of American Art records. Zachai's *Craft Horizons* article (see note 3 below) spelled the name "Isitshits," while the caption for the illustrated work gave the artist's name only as "Abraham."

3. Dorian Zachai, "Fiber-Clay-Metal," *Craft Horizons* 25 (January–February 1965): 17.

4. Philip Morton, *Contemporary Jewelry: A Studio Handbook* (New York: Holt, Rinehart & Winston, 1970), 40.

5. These influential shows have recently been treated in Jo Lauria and Suzanne Baizerman, *California Design: The Legacy of West Coast Craft and Style* (San Francisco: Chronicle, 2005).

6. Mildred Constantine and Jack Lenor Larsen, *Beyond Craft: The Art Fabric* (1973; New York: Kodansha International, 1986), 55.

7. Not only did it allow her to work at large scale, but a view of the waterfront offered tugboats that inspired her with their enormous rope knots (Jean d'Autilia, *Lenore Tawney: A Personal World* [Brookfield, Conn.: Brookfield Craft Center, 1978], unpaged).

8. Ibid.

9. Paul J. Smith, *Woven Forms* (New York: Museum of Contemporary Crafts, 1963), unpaged.

10. Quoted in Sigrid Wortmann Weltge, *Bauhaus Textiles: Women Artists and the Weaving Workshop* (New York: Thames & Hudson, 1998), 172.

11. D'Autilia, *Lenore Tawney*, unpaged.

12. Warren Seelig, "Meditative Image: The Art of Lenore Tawney," *American Craft* 50 (August–September 1990): 43.

13. Holland Cotter, *Lenore Tawney: Signs on the Wind* (San Francisco: Pomegranate, 2002).

14. Oral history interview with Claire Zeisler, conducted by Dennis Barrie, June 26, 1981, Archives of American Art, Smithsonian Institution, <http://www.aaa.si.edu/collections/oralhistories/transcripts/zeisle81.htm>.

15. Janet Koplos, "A Conversation with Claire Zeisler," *Fiberarts* 10 (July–August 1983): 23.

16. Barrie, oral history interview with Claire Zeisler.

17. Erika Billeter, essay in *Claire Zeisler: A Retrospective*, by Christa C. Mayer-Thurman et al. (Chicago: Art Institute of Chicago, 1979), 9.

18. Zeisler discovered that people referred to it as "that vagina." She said that when it was pointed out to her she could see it, but she was thinking only of formal and structural matters when she made it (Koplos, "Conversation with Claire Zeisler," 28).

19. Constantine and Larsen, *Beyond Craft*, 288.

20. Janet Koplos, "Escaping the Wall: Claire Zeisler Retrospective," *New Art Examiner* 6 (March 1979): 4.

21. Lucy Lippard, "Give and Takeout: Toward a Cross-Cultural Consciousness," in *The Eloquent Object: The Evolution of American Art in Craft Media since 1945*, ed. Marcia Manhart and Tom Manhart (Tulsa: Philbrook Museum of Art, 1987), 222.

22. Oral history interview with Sheila Hicks, conducted by Monique Lévi-Strauss, Paris, February 3, 2004, Nanette L. Laitman Documentation Project for Craft and Decorative Arts in America, Archives of American Art, Smithsonian Institution, <http://www.aaa.si.edu/collections/oralhistories/transcripts/hicks04feb.htm>.

23. Lévi-Strauss, oral history interview with Sheila Hicks.

24. The first book was not well received by prospective publishers because it wasn't a how-to, but Lois Moran, then education director for the American Crafts Council, took it upon herself to find a publisher. The ACC got part of the royalties (*Charles Edmund Rossbach: Artist, Mentor, Professor, Writer: An Interview*, interview conducted by Harriet Nathan, 1983, Fiber Arts Oral History Series [Berkeley: Regional Oral History Office, Bancroft Library, University of California, 1987], 109).

25. Jan Janeiro, "Ed Rossbach: Influential Presence," *American Craft* 50 (April–May 1990): 50.

26. Quoted in Margo Shermeta, *American Baskets: The Eighties* (Chicago: Department of Cultural Affairs, 1988), unpaged.

27. Jan Janeiro, "Ed Rossbach: Prizing the Journey," *American Craft* 50 (June–July 1990): 42, 44.

28. *Charles Edmund Rossbach*, 84, 71.

29. Dido Smith, "Ed Rossbach, Lee Nordness Galleries, New York; May 12-June 2," *Craft Horizons* 30 (August 1970): 55.

30. The decorative arts department was folded into the art department in 1976. A footnote to the Berkeley story is that Rossbach was the one sent to Los Angeles by the department

to interview Voulkos about the possibility of teaching at Berkeley.

31. *Kay Sekimachi: The Weaver's Weaver: Explorations in Multiple Layers and Three-Dimensional Fiber Art*, interviews conducted by Harriet Nathan, Fiber Arts Oral History Series (Berkeley: Regional Oral History Office, Bancroft Library, University of California, 1996), 103.

32. Lore Kadden Lindenfeld, one of the few textile designers to emerge from Black Mountain, praised her way of building understanding and suggesting possibilities, saying that from Guermonprez she learned to work independently (Weltge, *Bauhaus Textiles*, 172). Kay Sekimachi echoed the assessment in California (*Kay Sekimachi*, 100).

33. For any college student or adult at the time, it also would have evoked Bob Dylan's 1960s protest song, "Blowing in the Wind" and the radical Weathermen, who drew their name from a lyric in another song by Dylan, "Subterranean Homesick Blues." Mandy's words parallel the more general idea that "this, too, shall pass," but the use of the flag adds political implications.

34. Kenneth Sawyer, "Fabric Collage," *Craft Horizons* 25 (March–April 1965): 51.

35. Margery Anneberg, *Anneberg Gallery, 1966–1981, and Craft and Folk Art in the San Francisco Bay Area*, interviewed by Suzanne B. Reiss, 1995, California Craft Artists Oral History Series (Berkeley: Regional Oral History Office, Bancroft Library, University of California, 1998), 85.

36. *Charles Edmund Rossbach*, 131.

37. John Coyne, ed., *The Penland School of Crafts Book of Jewelry Making* (Indianapolis: Bobbs-Merrill, 1975), 86.

38. Ronald H. Pearson interviews, conducted by Robert Brown, Deer Isle, Maine, May 31, 1979, and November 23, 1981, Nanette L. Laitman Documentation Project for Craft and Decorative Arts in America, Archives of American Art, Smithsonian Institution, <http://www.aaa.si.edu/collections/oralhistories/transcripts/pears079.htm>.

39. Erin Younger, unpublished manuscript of interview with Charles Loloma, May 26, 1978, from the archives of the Heard Museum, Phoenix.

40. The most comprehensive source of information on Fisch's early years is the oral history interview conducted by Sharon Church, San Diego, July 29 and 30, 2001, Nanette L. Laitman Documentation Project for Craft and Decorative Arts in America, Archives of American Art, Smithsonian Institution, <http://www.aaa.si.edu/collections/oralhistories/transcripts/fisch01.htm>.

41. Quoted in Wendy Ramshaw, "Ornamenting the Body," *American Craft* 46 (April–May 1986): 14.

42. This is kinder wording than Fritz Dreisbach's recollection of his own early work from nearly the same time: "It was really funny, all these little turds of glass sitting around with these beautiful lights on them" (quoted in Joan Falconer Byrd, *Fritz Dreisbach Glass* (Cullowhee, N.C.: Western Carolina University, 1979), unpaged.

43. Michael Higgins, "Letter from Chicago," *Craft Horizons* 23 (September–October 1963): 43.

44. Robert Florian, "Dominick Labino: 'The Color of Glass Dictates Form,'" *Craft Horizons* 26 (July–August 1966): 29.

45. David M. Roth, "Marvin Lipofsky," *American Craft* 63 (December 2003–January 2004): 41.

46. Wolf Kahn, "Marvin Lipofsky at the Museum of Contemporary Crafts," *Craft Horizons* 29 (July–August 1969): 40; Dido Smith, "Marvin Lipofsky at Lee Nordness," *Craft Horizons* 30 (January–February 1970): 45.

47. Michael A. Stone, *Contemporary American Woodworkers* (Salt Lake City: Gibbs M. Smith, 1986), 4.

48. Quoted in Gervais Reed, introduction, *The American Craftsman's Invitational Exhibition* (Seattle: University of Washington Henry Art Gallery, 1968), 49.

49. Thomas Simpson, *Fantasy Furniture: Design and Decoration* (New York: Reinhold, 1968), 51.

50. Edward S. Cooke Jr., Gerald W. R. Ward, and Kelly H. L'Ecuyer, *The Maker's Hand: American Studio Furniture, 1940–1990* (Boston: Museum of Fine Arts, 2003), 113.

51. Edward Cooke Jr., "Women Furniture Makers: From Decorative Designers to Studio Makers," in *Women Designers in the USA, 1900–2000: Diversity and Difference*, ed. Pat Kirkham (New York: Bard Center for Studies in the Decorative Arts, Design and Culture; New Haven, Conn.: Yale University Press, 2000), 298.

52. Jeremy Adamson, *The Furniture of Sam Maloof* (Washington, D.C.: Smithsonian American Art Museum, 2001), 36.

53. Sam Maloof, *Sam Maloof, Woodworker* (Tokyo: Kodansha International, 1988), 200.

54. M. C. Richards, introduction, Paulus Berensohn, *Finding One's Way with Clay: Pinched Pottery and the Color of Clay* (New York: Simon & Schuster, 1972), 12.

55. Quoted in Garth Clark, *American Potters: The Work of Twenty Modern Masters* (New York: Watson-Guptill, 1981), 41.

56. Wayne Higby, *5x7: Seven Ceramic Artists Each Acknowledge Five Sources of Inspiration* (Alfred: New York State College of Ceramics at Alfred University, 1993), 39.

57. Suzanne Foley, "Ceramic Sculpture in California: An Overview," in *Ceramic Sculpture: Six Artists*, by Richard Marshall and Suzanne Foley (New York: Whitney Museum of American Art; Seattle: University of Washington Press, 1981), 18.

58. Susan Wechsler, "Ron Nagle: An Interview," *American Ceramics* 1, no. 1 (1982): 19–20.

59. Ken Price to John Wood, 1960, quoted by Ed Lebow in *Ken Price* (Houston: Menil Collection, 1992), 27.

60. Maurice Tuchman, *Ken Price: Happy's Curios* (Los Angeles: Los Angeles County Museum of Art, 1978), 8.

61. Garth Clark, *American Potters: The Work of Twenty Modern Masters* (New York: Watson-Guptill, 1981), 48.

62. Garth Clark and Margie Hughto, *A Century of Ceramics in the United States, 1878–1978* (New York: E. P. Dutton in association with the Everson Museum of Art, 1979), 166–67.

63. Helen Giambruni, *Craft Horizons* 27 (January–February 1967): 38, 39.

64. Ibid.

65. John Coplans, "The Sculpture of John Mason," in *John Mason: Sculpture* (Los Angeles: Los Angeles County Museum of Art, 1966), unpaged.

66. Quoted in Deborah Norton, "Frans Wildenhain," *American Ceramics* 4, no. 2 (1985): 50.

67. His others were *Stoneware and Porcelain* (1959), *Kilns* (1968), *Tamba, the Timeless Art of a Japanese Village* (1970), and *Pottery Form* (1976).

68. Neal Benezra, *Robert Arneson: A Retrospective* (Des Moines: Des Moines Art Center, 1986), 17.

69. Robert Arneson interviews, conducted by Mady Jones, August 14–15, 1981, Archives of American Art, Smithsonian Institution, <http://www.aaa.si.edu/collections/oralhistories/transcripts/arneso81.htm>.

70. Quoted by Beth Coffelt, "Arneson: Portrait/Self-Portrait," in *Robert Arneson: Self-Portraits* (Philadelphia: Moore College of Art, 1979), 14.

71. Emily Galusha and Mary Ann Nord, eds., *Clay Talks: Reflections by American Master Ceramists* (Minneapolis: Northern Clay Center, 2004), 130.

72. Ibid.

73. Quoted in Lee Nordness, *Objects: USA* (New York: Viking, 1970), 122.

74. Ken Ferguson, "A High Altitude Wood-Burning Kiln," *Studio Potter* 11 (December 1982): 37.

75. Patricia Degener, "Celebrating Ken Ferguson . . . ," *American Craft* 55 (October–November 1995): 66.

76. These and a few other artists took part in *Keepers of the Flame: Ken Ferguson's Circle* at the Kemper Museum of Contemporary Art in Kansas City in 1995 (see ibid.).

77. Daniel Rhodes, "David Shaner," *American Craft* 43 (February–March 1983): 2.

78. Ibid., 5.

79. Conrad Brown, "Toshiko Takaezu" (interview), *Craft Horizons* 19 (March-April 1959): 23.

80. Althea Meade-Hajduk, "A Talk with Toshiko Takaezu," *American Craft* 65 (February–March 2005): 52.

81. *Toshiko Takaezu: Heaven and Earth* (Racine, Wis.: Racine Art Museum, 2005), 8–9, 6.

82. Quoted in Nordness, *Objects: USA*, 60.

83. Rob Barnard, "Byron Temple: The Gift to Be Simple," *American Craft* 51 (August–September 1991): 36, citing a review of a Rothko exhibition in the *Washington Post*, May 13, 1984.

84. Jody Clowes, *Don Reitz: Clay, Fire, Salt, and Wood* (Madison: Elvehjem Museum of Art, University of Wisconsin, 2004), 9.

85. Dido Smith, "Hui Ka Kwong," *Craft Horizons* 17 (March–April 1957): 29.

86. Margaret Carney, "Hui Ka Kwong," *Ceramics Monthly* 53 (May 2005), 41–42.

87. "The New American Craftsman: First Generation" (roundtable discussion), *Craft Horizons* 26 (June 1966): 24.

CHAPTER NINE

1. Ed Rossbach, in "Objects: USA Revisited," *Craft Horizons* 32 (August 1972): 38, wrote that he saw the emphasis changing from the craft or skill (such as weaving) to the medium (fiber) and now to the result (the object). He took that to mean the museum object, which was only something to photograph. He saw this as a loss.

2. Philadelphia had an active and important crafts scene in the 1960s and 1970s, stimulated by the existence of craft faculties at three schools. The Philadelphia Council of Professional Craftsmen was formed in 1967 with Helen Drutt as director until she opened her gallery in 1974.

3. In 1978 Paul Donhauser published *History of American Ceramics: The Studio Potter*, and in 1979 LaMar Harrington published *Ceramics in the Pacific Northwest: A History*.

4. Quoted in Marsha Miro and Tony Hepburn, *Robert Turner: Shaping Silence, a Life in Clay* (Tokyo: Kodansha, 2003), 99.

5. Garth Clark and Margie Hughto, *A Century of Ceramics in the United States, 1878–1978* (New York: E. P. Dutton in association with the Everson Museum of Art, 1979), 201.

6. Evert Johnson, "Two Happenings at Southern Illinois University: 1/Clay Unfired," *Craft Horizons* 30 (October 1970): 36–39.

7. Ibid, 39.

8. Clark and Hughto, *Century of Ceramics*, 198.

9. Jim Melchert, "Peter Voulkos: A Return to Pottery," *Craft Horizons* 28 (September–October 1968): 21.

10. Quoted in Conrad Brown, "Peter Voulkos," *Craft Horizons* 16 (September–October 1956): 12.

11. Voulkos, in "Ceramics West Coast," *Craft Horizons* 26 (May–June 1966): 26.

12. Oral history interview with James Melchert, conducted by Renny Pritikin, 2002, Nanette L. Laitman Documentation Project for Craft and Decorative Arts in America, Archives of American Art, Smithsonian Institution, <http://www.aaa.si.edu/collections/oralhistories/transcripts/Melche02.htm>.

13. *Shards: Garth Clark on Ceramic Art*, ed. John Pagliaro (New York: Ceramic Arts Foundation; Distributed Art Publications, 2003), 294.

14. Mary Caroline Richards, *Centering in Pottery, Poetry, and the Person* (Middletown, Conn.: Wesleyan University Press, 1964), 29.

15. Quoted in Wayne Higby, *5x7: Seven Ceramic Artists Each Acknowledge Five Sources of Inspiration* (Alfred: New York State College of Ceramics at Alfred University, 1993), 35.

16. Joan Simon, "An Interview with Ken Price," *Art in America* 68 (January 1980): 104.

17. Edmund de Waal, *Twentieth-Century Ceramics* (London: Thames & Hudson, 2003), 191.

18. Beginning in 1966, minimalist sculptor Carl Andre worked with firebrick, among other materials, for his floor pieces. They became notorious after the Tate Gallery in London bought and exhibited one of the firebrick works in the mid-1970s.

19. Rosalind Krauss, "John Mason and Post-Modernist Sculpture: New Experiences, New Words," *Art in America* 67 (May–June 1979): 120–28.

20. Ibid., 120

21. The work was recently dismantled when its site was needed for campus construction, and it was returned to Mason's studio.

22. Jody Clowes, "John Glick," *American Craft* 51 (June–July 1991): 38.

23. Elaine Levin, *The History of American Ceramics, 1607 to the Present, from Pipkins and Bean Pots to Contemporary Forms* (New York: Abrams, 1988), 223.

24. "William Daley, March 1998," in *Clay Talks: Reflections by American Master Ceramists*, ed. Emily Galusha and Mary Ann Nord (Minneapolis: Northern Clay Center, 2004), 35.

25. Ibid., 31.

26. Patricia Failing, *Howard Kottler: Face to Face* (Seattle: University of Washington Press, 1995), 3.

27. LaMar Harrington, *Ceramics in the Pacific Northwest: A History* (Seattle: University of Washington Press for Henry Art Gallery, 1979), 97.

28. Quoted in Failing, *Howard Kottler*, 74, 76.

29. Howard Kottler, typescript, April 1986, quoted in Failing, *Kottler*, 63.

30. Robert Arneson, "Guardians: The Spirit of the Work," *Ceramics Monthly* 39 (April 1991): 32.

31. Dennis Adrian, "Robert Arneson's Feats of Clay," *Art in America* 62 (September–October 1974): 80.

32. Suzanne Foley, "Ceramic Sculpture in California: An Overview," in *Ceramic Sculpture: Six Artists*, Richard Marshall and Suzanne Foley (New York: Whitney Museum of American Art; Seattle: University of Washington Press, 1981), 28, 29.

33. Ibid.

34. Kenneth Baker, foreword, in *David Gilhooly* (Davis, Calif.: John Natsoulas Press, 1992), 10.

35. "Jack Earl March 2000," in Galusha and Nord, *Clay Talks*, 99.

36. Sid Sachs, "Mark Burns," in *Mark Burns: A Decade in Pennsylvania, 1975–1985* (Verona, Penn.: Society for Art in Crafts, 1986), unpaged.

37. Susan Peterson, "The Ceramics of Marilyn Levine: An Interview," *Craft Horizons* 37 (February 1977): 41.

38. Ibid., 63.

39. Sid Sachs, "Rudolf Staffel: Past and Present," *American Ceramics* 1, no. 1 (1982): 35.

40. Quoted in Marianne Aav, "Searching for Light: Ceramics, 1936–1996," in *Rudolf Staffel: Searching for Light* (Helsinki: Museum of Applied Arts, 1996), 9.

41. Quoted in Rob Barnard, "Rudolf Staffel/Temple Gallery," *American Craft* 49 (December 1989–January 1990): 73.

42. Janet Koplos, "Rudolf Staffel: Playful Magician of Light," *American Ceramics* 9, no. 2 (1991): 20.

43. Mary Emma Harris, *The Arts at Black Mountain College* (Cambridge, Mass.: MIT Press, 1987), 188.

44. Edward Lebow, "Robert Turner," *American Craft* 46 (June–July 1986): 32, 67.

45. "Ceramics East Coast" (roundtable discussion), *Craft Horizons* 26 (June 1966): 20.

46. Lebow, "Robert Turner," 69.

47. Quoted in Susan Wechsler, *Low-Fire Ceramics* (New York: Watson-Guptill, 1981), 73.

48. Quoted in *Viola Frey* (San Francisco: Quay Gallery, 1983), 3.

49. Ramsay Bell Breslin, "The Figure as Fragment: The Sculpture of Stephen De Staebler," in *Stephen De Staebler: Recent Work* (San Francisco: Campbell-Thiebaud Gallery, 1994), unpaged.

50. Rick Newby, "Stephen De Staebler," *American Craft* 64 (October–November 2004): 62.

51. Press release, Zabriskie Gallery, New York, Mary Frank exhibition, April 29–June 6, 1981.

52. Rob Barnard, "Kitsch as Avant-garde," *New Art Examiner* 16 (September 1988): 39.

53. Susan Wechsler, "Ron Nagle: An Interview," *American Ceramics* 1, no. 1 (1982): 20, 19.

54. Tony Birks, "The Early Years," in Jo Lauria and Tony Birks, *Ruth Duckworth, Modernist Sculptor* (Aldershot, UK: Lund Humphries, 2004), 28.

55. Barry Schwabsky, "Ruth Duckworth Modernist Sculpture," *American Craft* 65 (October–November 2005): 58.

56. Lorne Falk, "Jun Kaneko," *American Ceramics* 3, no. 3 (1984): 44.

57. Tony Hepburn, "An Attempt at a Context," in *Tony Hepburn* (Omaha: Ree Schonlau Gallery; Chicago: Klein Gallery, 1984), 5.

58. Quoted in Deborah Norton, "A History of the School for American Craftsmen," *Metalsmith* 5 (Winter 1985): 20.

59. Quoted in Jody Clowes, *Metalsmiths and Mentors: Fred Fenster and Eleanor Moty at the University of Wisconsin, Madison* (Madison: Chazen Museum of Art, University of Wisconsin, 2006), 23.

60. John Prip, tape-recorded recollections sent to Bruce Metcalf, March 1996.

61. Quoted in Norton, "History," 17.

62. Heikki Seppä, *Form Emphasis for Metalsmiths* (Kent, Ohio: Kent State University Press, 1978), 3.

63. Oral history interview with June Schwarcz, conducted by Arline M. Fisch, January 21, 2001, Nanette L. Laitman Documentation Project for Craft and Decorative Arts in America, Archives of American Art, Smithsonian Institution, <http://www.aaa.si.edu/collections/oralhistories/transcripts/schwar01.htm>.

64. Quoted in Robert L. Cardinale and Lita S. Bratt, *Copper 2: The Second Copper, Brass, and Bronze Exhibition* (Tucson: University of Arizona Museum of Art, 1980), 38.

65. Dorian Zachai made the first soft sculptures in the early 1960s; starting in 1962, Claes Oldenburg took it further.

66. Mildred Constantine and Jack Lenor Larsen, *The Art Fabric: Mainstream* (1981; New York: Kodansha, 1985), 163.

67. Debra Rapoport, "Tapisserie vivant," *Craft Horizons* 31 (October 1971): 24.

68. Since 1993 the magazine has been edited by Patricia Malarcher, a longtime contributor to *Fiberarts* magazine, a former craft critic for the New Jersey edition of the *New York Times*, and herself a fiber artist.

69. Marion Boulton Stroud, ed., *An Industrious Art: Innovation in Pattern and Print at the Fabric Workshop* (Philadelphia: Fabric Workshop, 1991), 7.

70. Melissa Leventon, *Artwear: Fashion and Anti-fashion* (New York: Thames & Hudson for the Fine Arts Museums of San Francisco, 2005), 28.

71. Katherine Westphal, in *Katherine Westphal, Artist and Professor*, interview conducted by Harriet Nathan, 1984, Fiber Arts Oral History Series (Berkeley: Regional Oral History Office, Bancroft Library, University of California, 1988), 49.

72. Indian Owen-Griffin, quoted in Lynn Basa, "The Return of the Rag," *Fiberarts* 14 (May–June 1987): 30.

73. Janet Kardon, *Street Sights* (Philadelphia: Institute of Contemporary Art, 1980), 2.

74. Michael James, "Beyond Tradition: The Art of the Studio Quilt," *American Craft* 45 (February–March 1985): 18.

75. The account of these pioneers is drawn from Robert Shaw, *The Art Quilt* (New York: Hugh Lauter Levin, 1997), 49–51.

76. Ibid., 51.

77. Westphal, in *Katherine Westphal, Artist and Professor*, 45.

78. Quoted in Lee Nordness, *Objects: USA* (New York: Viking, 1970), 281.

79. Quoted in Jan Janeiro, "Piece Work: The World of Katherine Westphal," *American Craft* 48 (August–September 1988): 33.

80. Ibid., 38.

81. Quoted in Irene Waller, *Textile Sculptures* (New York: Taplinger, 1977), 100.

82. Jack Stoops, "Lee Nordness Selects," *Craft Horizons* 32 (August 1972): 52.

83. Tom Schantz, "Neda Al-Hilali at Sharadin Gallery, Kutztown, PA," *Craft Horizons* 34 (October 1974): 55.

84. Betty Park, "Neda Al Hilali: An Interview," *Fiberarts* 6 (July–August 1979): 40.

85. Laurel Reuter, "Walls," *American Craft* 51 (October–November 1991): 42, 44.

86. Joan Livingstone, "Warren Seelig's Ribbon Folds," *American Craft* 43 (October–November 1983): 29.

87. Shirley Marein, "Warren Seelig at Hadler," *Craft Horizons* 36 (January 1976): 57.

88. Livingstone, "Warren Seelig," 29.

89. Ibid., 29, 30.

90. Philip Beesley, *Warren Seelig: Machina Textrina* (Toronto: Museum for Textiles Contemporary Gallery, 1996), 3.

91. Jan Janeiro, "Lia Cook: On the Loom of Contradiction," *American Craft* 40 (June–July 1980): 29.

92. Melissa Leventon, foreword, in *Lia Cook*, by Meredith Tromble and Jenni Sorkin, Portfolio Collection 14 (Winchester, U.K.: Telos, 2002), 13.

93. Quoted ibid., 22.

94. Joan Simon, "Drawing on Tradition," in *Cynthia Schira*, Portfolio Collection 30 (Winchester, U.K.: Telos, 2003), passim.

95. Oral history interview with Dominic Di Mare, conducted by Signe Mayfield, June 4 and 10, 2002, Nanette L. Laitman Documentation Project for Craft and Decorative Arts in America, Archives of American Art, Smithsonian Institution, <http://www.aaa.si.edu/collections/oralhistories/transcripts/dimare02.htm>.

96. Betty Park, "Dominic Di Mare: Houses for the Sacred," *American Craft* 42 (October–November 1982): 6.

97. Jeremy Adamson, "Mnemonic Connections: The Transcendental Art of Dominic Di Mare," in *Dominic Di Mare: A Retrospective*, by Signe Mayfield (Palo Alto, Calif.: Palo Alto Cultural Center, 1997), 22.

98. Jane Kessler, "Arturo Alonzo Sandoval at Headley-Whitney Museum, KY," *American Craft* 48 (December 1988–January 1989): 71.

99. Quoted in Betty Park, "John McQueen: The Basket Redefined," *American Craft* 39 (October–November 1979): 27.

100. Betty Park, "John McQueen: An Interview," *Fiberarts* 6 (January–February 1979): 25.

101. Quoted in Patricia Malarcher, "What Makes a Basket a Basket?" *Fiberarts* 11 (January–February 1984): 37.

102. Ferne Jacobs, artist's statement, Flintridge Foundation Visual Arts Awards, 2006, <http://www.flintridgefoundation.org/visualarts/recipients20052006_fernejacobs.html>.

103. David Donaldson, William Warmus, Susanne Frantz, and Tina Oldknow are the subsequent curators.

104. *New Stained Glass* (New York: Museum of Contemporary Crafts, 1978), 3.

105. Susanne K. Frantz, *Contemporary Glass: A World Survey from the Corning Museum of Glass* (New York: Abrams, 1989), 159.

106. Tina Oldknow, *Pilchuck: A Glass School* (Seattle: University of Washington Press for Pilchuck Glass School, 1996), 156.

107. Ibid., 39.

108. Paul Hollister, "James Carpenter: Adventures in Light and Color in Space," *American Craft* 51, no. 3 (June/July 1991): 31, 33.

109. Dan Klein, "Joel Philip Myers," in *Joel Philip Myers* (Los Angeles: Kurland/Summers Gallery, 1988), 23.

110. Quoted in Tina Oldknow, *Richard Marquis: Objects* (Seattle: University of Washington Press, 1997), 17–18.

111. Quoted in Dan Klein, *Artists in Glass: Late-Twentieth-Century Masters in Glass* (London: Octopus, 2001), 189.

112. Matthew Kangas, "Paul Marioni: The Visitor," *Glass* 74 (Spring 1999): 39.

113. John Kelsey, "A One-Piece Chair," *Fine Woodworking* 20 (January–February 1980): 46–47.

114. An enthusiastic and startlingly uneven record of 1970s woodworking is Dona Z. Meilach, *Creating Modern Furniture: Trends, Techniques, Appreciation* (New York: Crown, 1975).

115. Wendy Maruyama, e-mail message to Bruce Metcalf, October 6, 2006.

116. James Krenov, *The Impractical Cabinetmaker* (1979; Fresno, Calif.: Linden Publishing, 1999], 13.

117. Ibid., 14.

118. Ibid., 22.

119. Ibid.

120. Quoted in Jean Musser Batie, "Works in Wood: Robert Strini," *Craft Horizons* 36 (February 1976): 25.

121. Dona Z. Meilach, *Woodworking: The New Wave* (New York: Crown Publishers, 1981), 139.

122. Quoted in Michael A. Stone, *Contemporary American Woodworkers* (Salt Lake City: Peregrine Smith, 1986), 140.

123. Glenn Adamson, "California Dreaming," in *The Heart of the Functional Arts*, ed. John Kelsey and Rick Mastelli, Furniture Studio 1 (Free Union, Va.: Furniture Society, 1999), 32–42.

CHAPTER TEN

1. Edward S. Cooke Jr., "Wood in the 1980s: Expansion or Commodification?" in *Contemporary Crafts and the Saxe Collection*, organized by Davira S. Taragin (New York: Hudson Hills Press; Toledo: Toledo Museum of Art, 1993), 152.

2. Lloyd E. Herman, *Art That Works: The Decorative Arts of the Eighties, Crafted in America* (Seattle: University of Washington Press, 1990), 19.

3. Charles Parriott, in Tina Oldknow, *Pilchuck: A Glass School* (Seattle: University of Washington Press, 1996), 217.

4. Richard Newman, interview by Bebe Pritam Johnson and Warren Eames Johnson, 1990–91, in "Speaking of Furniture: Conversations with the New American Masters," unpublished manuscript in possession of the interviewers, 5.

5. Dick Lignum, "Interview: Richard Scott Newman," *Workshop* 4 (Spring 1984): 10.

6. It is a library table by the Herter Brothers, 1882, with inlaid mother-of-pearl dots and stars. Wendell Castle and

Penelope Hunter-Steibel discuss the table in *The Fine Art of the Furniture Maker: Conversations with Wendell Castle, Artist, and Penelope Hunter-Steibel, Curator, about Selected Works from the Metropolitan Museum of Art* (Rochester, N.Y.: Memorial Art Gallery of the University of Rochester, 1981), 55–60.

7. Wendell Castle, interview by Bebe Pritam Johnson, Warren Eames Johnson, and Peter Joseph, in "Speaking of Furniture," 9–10.

8. Virginia T. Boyd, "Doors, Drawers, and Cabinets," in *Contemporary Studio Case Furniture: The Inside Story* (Madison: Elvehjem Museum of Art, University of Wisconsin, 2002), 23.

9. Judy Kensley McKie, interview by Bebe Pritam Johnson, Warren Eames Johnson, and Peter Joseph, in "Speaking of Furniture," unpaged.

10. Quoted in "Makers' Biographies" in Edward S. Cooke, Jr., Gerald W. R. Ward, and Kelly H. L'Ecuyer, *The Maker's Hand: American Studio Furniture, 1940–1990* (Boston: MFA Publications, 2003), 132.

11. Quoted in Kate Rothrock, artist biography, in *The Art of John Cederquist: Reality of Illusion*, by Arthur C. Danto and Nancy Princenthal (Oakland: Oakland Museum of California, 1997), 129.

12. Quoted in Joy Cattanach Smith, "Furniture: A Sculptural Medium," *Art New England* 6 (December 1985–January 1986): 4.

13. "David Ellsworth—Vessels," Ellsworth Studios, <http://www.ellsworthstudios.com/david/vessels.html>.

14. Garth Clark, *American Potters: The Work of Twenty Modern Masters* (New York: Watson-Guptill, 1981), 36.

15. The gun was named as well as another politician killed in the same attack; the word "Twinkies" referred to the murderer's claim that he had been unbalanced by eating too much junk food.

16. Hilton Kramer, "Ceramic Sculpture and the Taste of California," *New York Times*, December 20, 1981, 33.

17. Arthur C. Danto, "The Vase as Form and Subject: Craft and Meaning in the Work of Betty Woodman," in *Betty Woodman* (Amsterdam: Stedelijk Museum, 1996), 20.

18. Gert Staal, "Betty Woodman, Backcloth Drama," in *Opera Selecta Betty Woodman* ('s-Hertogenbosch: Museum Het Kruithuis, 1990), 19; and Robert Berlind, "Between Sculpture and Painting: The Art of Betty Woodman" in *Betty Woodman: Between Sculpture and Painting, Recent Work* (Fort Dodge, Iowa: Blanden Memorial Art Museum, 1999), 8.

19. Richard De Vore, "Ceramics of Betty Woodman," *Craft Horizons* 38 (February 1978): 29.

20. Lord did not permit his work to be illustrated in this book.

21. Edmund de Waal, *Twentieth-Century Ceramics* (London: Thames & Hudson, 2003), 197.

22. Barry Schwabsky, "Andrew Lord at 65 Thompson," *American Ceramics* 10, no. 4 (1993): 52.

23. LaMar Harrington, *Ceramics in the Pacific Northwest: A History* (Seattle: University of Washington Press for Henry Art Gallery, 1979), 60.

24. Peter Schjeldahl, "The Smart Pot: Adrian Saxe and Post-Everything Ceramics," in *Adrian Saxe* (Kansas City: University of Missouri Gallery of Art, 1987), 13.

25. John Bentley Mays, "Stylistic Ensembles," *American Craft* 47 (October–November 1987): 43.

26. Edward Lebow, "The Clay Art of Adrian Saxe: Book Review," *American Craft* 54 (August–September 1994): 27.

27. Mac McCloud, "Elsa Rady: Porcelain Vessels," *American Ceramics* 3, no. 4 (1985): 60.

28. Hunter Drohojowska, "The Playground of Modern Desire," in *Tempest in a Teapot: The Ceramic Art of Peter Shire* (New York: Rizzoli, 1991), 62.

29. Joanne Burstein, "Peter Shire at Janus Gallery, L.A.," *American Ceramics* 1, no. 2 (1982): 52.

30. Gnosis Nos, "Stay with Your Numbers: A Story about Robert Brady," *American Ceramics* 4, no. 2 (1985): 15.

31. Gretchen Adkins, "A Pilgrim's Progress on the Treadmill of Twentieth-Century Life: The Lessons of Arthur Gonzalez's Sculpture," *American Ceramics* 10, no. 4 (1993): 46.

32. Jo Lauria, "Teasing Emotion Out of Clay: The Figurative Works of Arthur González," in *Bay Area Ceramic Sculptors: Second Generation; Arthur González, Annabeth Rosen, Nancy Selvin, Stan Welsh* (Sedalia, Mo.: Daum Museum of Contemporary Art, 2003), unpaged.

33. Edward Lebow, "It Takes a Village: The Ceramics of Akio Takamori," in *Between Clouds of Memory: Akio Takamori, a Mid-Career Survey*, ed. Peter Held (Tempe: Arizona State University Art Museum, Ceramics Research Center, 2005), 39.

34. Quoted in Andy Nasisse, "The Battleground of Eros: Akio Takamori," *American Ceramics* 5, no. 1 (1986): 32.

35. Vicky Halper, "Strong Tea: Richard Notkin and the Yixing Tradition," in *Strong Tea: Richard Notkin and the Yixing Tradition* (Seattle: Seattle Art Museum, 1990), unpaged.

36. Quoted in Patricia Failing, "Richard Notkin: Conduits for Social Meaning," *American Craft* 51 (April–May 1991): 46.

37. Helen Williams Drutt English, "Mental Travel Time," in *Anne Currier: Sculpture/ Skulpturen*, by Nancy Weekly, Mary Drach McInnes, and Helen Williams Drutt English (Stuttgart: Arnoldsche, 2006), 20.

38. Quoted in Susan Wechsler, *Low-Fire Ceramics* (New York: Watson-Guptill, 1981), 79.

39. Carolyn Carr, "Andrea Gill/John Gill," *American Craft* 43 (December 1983–January 1984): 19, 20.

40. Michael McTwigan, "A Handful of Beauty/A Hint of Beast," *American Ceramics* 3, no. 4 (1985): 23.

41. Edward Lebow, "Kurt Weiser: Storied Forms," *American Craft* 64 (December 1994–January 1995): 47.

42. Paula Winokur, "Porcelain: The Transformation of Alice Mermaid," *Studio Potter* 6, no. 2 (1978): 30.

43. Michael McTwigan, "The Fruitful Mysteries of Graham Marks," *American Ceramics* 1, no. 2 (1982): 33.

44. Dominique Nahas, foreword to *Graham Marks: New Work* (Syracuse: Everson Museum of Art, 1986), unpaged.

45. This account is based on Louise Allison Cort, "A Short History of Wood Firing in America," parts 1–4, first published in the catalog *Great Shigaraki Exhibition* (Shigaraki, Japan, 2001) and reprinted in *The Log Book* 9–12 (February, May, August, November 2002).

46. "Introducing Fragile Art '80," *Glass* 9 (January 1982): 47.

47. Oldknow, *Pilchuck*, 180.

48. Martha Drexler Lynn, *American Studio Glass, 1960–1990: An Interpretive Study* (New York: Hudson Hills Press, 2004), 119.

49. Mark S. Talaba, "Projection and Transformation: The

Mysteries of Leitungs Scherben," in *David R. Huchthausen* (Lathrup Village, Mich.: Habatat Galleries, 1985), unpaged.

50. Maria Porges, "Therman Statom: Northern Tide," *American Craft* 55 (June–July 1995): 38–41.

51. Patterson Sims, *Kirkpatrick/Mace* (Ames, Iowa: Brunnier Gallery and Museum, Iowa State University, 1993), unpaged.

52. Dan Klein, "Toots Zynsky," in *Toots Zynsky: Tierra del Fuego Series* (Amsterdam: Stedelijk Museum, 1989), 3.

53. Her own assertion, quoted in Eleanor Heartney, "Toots Zynsky, Barry Friedman Ltd., New York, New York, September 26-October 24, 1998," *American Craft* 59 (February–March 1999): 112.

54. Quoted in Shawn Waggoner, "Sonja Blomdahl: 'Queen of Symmetry,'" *Glass Art* 15 (March–April 2000): 5.

55. Julie Schafler Dale, "Wearables: Developments and Trends," *Fiberarts* 17 (January–February 1990): 42–43.

56. Quoted by Penny McMorris, "Quilts and the End of the '80s," *Fiberarts* 16 (November-December 1989): 36.

57. Janet Catherine Berlo and Patricia Cox Crews, *Wild by Design: Two Hundred Years of Innovation and Artistry in American Quilts* (Lincoln: International Quilt Study Center at the University of Nebraska in association with University of Washington Press, 2003), 28.

58. Eli Leon, *Who'd a Thought It: Improvisation in African-American Quiltmaking* (San Francisco: San Francisco Craft and Folk Art Museum, 1987), 25, 30.

59. Rosie Lee Tompkins is the pseudonym of Effie Mae Howard, whose identity was not publicly associated with her quilts; Leon acted as a go-between for her. Her name was revealed in her obituaries.

60. Lawrence Rinder, "Greatness Near at Hand," in *Rosie Lee Tompkins* (Berkeley: Berkeley Art Museum, 1997), 4.

61. *The Quilts of Gee's Bend*, organized by the Museum of Fine Arts, Houston, and Tinwood Alliance, Atlanta, featured more than sixty quilts made between 1930 and 2000 by four generations of quiltmakers in Gee's Bend, Alabama. The exhibition premiered in Houston in the fall of 2002 and traveled for four years. Other exhibitions were subsequently organized, and the quilts appeared on U.S. postage stamps.

62. Quoted in Laurel Horton, review of *Always There: The African-American Presence in American Quilts* by Cuesta Benberry, *Journal of American Folklore* 106 (Summer 1993): 335.

63. Berlo and Crews, *Wild by Design*, 29.

64. See Patricia Harris and David Lyon, "Michael James: A New Order," *American Craft* 54 (October–November 1994): 64; and their essay "Ideas of Order: The Art of Michael James," in *Michael James: Studio Quilts*, by Patricia Harris, David Lyon, and Patricia Malarcher (Neuchâtel, Switzerland: Éditions Victor Attinger; Swansea, Mass.: Whetstone Hill, 1995), 7–27.

65. Robert Silberman, "Harding Style," *American Craft* 51 (December 1991–January 1992): 36.

66. Artist's statement, Tim Harding file, American Craft Council Library, New York, New York.

67. Betty Freudenheim, "Ramona Sakiestewa at the Newark Museum," *American Craft* 51 (August–September 1991): 65.

68. Patricia Harris and David Lyon, "The Tapestries of Ramona Sakiestewa: Patterned Dreams," *Fiberarts* 17 (November–December 1990): 32.

69. Diane Itter, interview by Richard M. Polsky, 1987, transcript, American Craftspeople Project, Columbia University, New York, 58.

70. Ursula Ilse-Neuman, "Tradition and Innovation in the Work of Diane Itter," *Diane Itter: A Retrospective* (New York: American Craft Museum, 1995), 9.

71. Itter, interview by Polsky, 70.

72. Dennis Adrian, "Joan Livingstone," *American Craft* 53 (June–July 1993): 40.

73. Willis "Bing" Davis, in "That Connectedness to Ourselves: A Conversation Between Willis 'Bing' Davis and David Driskell," in *Uncommon Beauty in Common Objects: The Legacy of African American Craft Art* (Wilberforce, Ohio: National Afro-American Museum and Cultural Center, 1993), 19.

74. John Garrett, "The Baskets of John Garrett: A Mesh of Ideas and Materials," *Fiberarts* 11 (January–February 1984): 27.

75. Jan Janeiro, "John Garrett," *American Craft* 61 (April–May 2001): 52.

76. Jan Janeiro, "Bridging Worlds: The Art of John Garrett," *Fiberarts* 22 (Summer 1995): 33.

77. Quoted in Martha Longenecker, ed., *Heirlooms of the Future: Masterworks of West Coast American Designer/Craftsmen* (San Diego: Mingei International Museum, 1993), p. 15.

78. Quoted in Mary Stofflet, "Collaboration: Elliott/Hickman," *American Craft* 41 (December 1981–January 1982): 28–29.

79. "Lillian Elliott and Pat Hickman: The Pleasures and Problems of Collaboration," *Fiberarts* 12 (September–October 1985): 25.

80. Jim Melchert, foreword to *Portfolio Collection: Gyöngy Laky*, by Janet Koplos (Winchester, UK: Telos, 2003), 7.

81. Quoted in Jessica Scarborough, "Gyöngy Laky: Experimental Thinking in Textiles," *Fiberarts* 11 (January–February 1984): 22.

82. Edward Lebow, "Patrick Dougherty," *American Craft* 65 (June–July 2005): 33.

83. The Knapp collection was documented in an influential catalog, *The Jewellery Project: New Departures in British and European Work, 1980–83* (London: Crafts Council Gallery, 1983).

84. Oral history interview with Marjorie Schick, conducted by Tacey A. Rosolowski, April 4–6, 2004, Nanette L. Laitman Documentation Project for Craft and Decorative Arts in America, Archives of American Art, Smithsonian Institution, <http://www.aaa.si.edu/collections/oralhistories/transcripts/schick04.htm>.

85. Joyce Scott, interview by Bruce Metcalf, February 8, 2007.

86. Vanessa S. Lynn, *Robert Ebendorf Retrospective Exhibition* (New Paltz: State University of New York College at New Paltz, 1989), unpaged.

87. Quoted in Robert Cardinale, *Copper 2: The Second Copper, Brass, and Bronze Exhibition* (Tucson: University of Arizona Museum of Art, 1980), 50.

88. Robert Lee Morris, interview by Bruce Metcalf, June 3, 1987.

89. This occurred, for instance, at "Conversations," a symposium for jewelry students at the State University of New York, New Paltz, in 1986. A visiting production jeweler stated that some student work on display was "masturbation," and several students overheard his remark. In the informal debates that followed, it was noted that production jewelry could equally well be regarded as prostitution.

90. John Bentley Mays, "Comment," *American Craft* 45 (December 1985–January 1986): 38.

91. Lisa Norton, interview by Bruce Metcalf, February 6, 2007.

92. Enameling on three-dimensional forms was familiar to Renaissance goldsmiths, but it was usually done over castings—too heavy for all but the smallest jewelry.

CHAPTER ELEVEN

1. "The American Craft Council and the American Craft Museum: A Brief Chronology," prepared by Michael McKay, American Craft Council, revised August 2001.

2. The general downward trend was confirmed informally by Carmine Branagan, former executive director of the ACC. Figures for the large Baltimore show, published in *American Craft*, document peaks in attendance in 1996 and in sales in 1998.

3. Quoted Joyce Tognini, "Garage to Glory," *American Craft* 53 (August–September 1993): 11–12.

4. Davira Taragin, quoted in Tina Oldknow, *Pilchuck: A Glass School* (Seattle: University of Washington Press, 1996), 225.

5. Ibid., 196.

6. Vicki Halper, "Ginny Ruffner Unlimited," in Ginny Ruffner, *Creativity: The Flowering Tornado*, exhibition brochure (Montgomery, Ala.: Montgomery Museum of Fine Arts, 2003), unpaged.

7. Ben Marks, "Field of Dreams," *American Craft* 50 (June–July 1990): 49.

8. McElheny, like Andrew Lord, has refused to allow his work to be reproduced in this book.

9. Quoted in Tognini, "Garage to Glory," 10, 18.

10. Dave Hickey, "Hearts of Glass," in *Josiah McElheny* (Boston: Isabella Stewart Gardner Museum, 1998), 18.

11. See his interview with Louise Neri, in *Josiah McElheny* (Santiago de Compostela, Spain: Centro Galego de Arte Contemporanea, Xunta de Galicia, 2002), 73–89.

12. Dante Marioni, interview with Tina Oldknow, November 1999, quoted in Tina Oldknow, "Dante Marioni, Glassblower," in *Dante Marioni: Blown Glass* (New York: Hudson Hills Press, 2000), 24.

13. Patricia Failing, "William Morris: Glass Remains," *American Craft* 53 (February–March 1993): 50.

14. Patterson Sims, quoted ibid., 51.

15. Geoffrey Wichert, "Waxing Poetic," *Glass* 80 (Fall 2000): 35.

16. Quoted in Maria Porges, *Judith Schaechter: Heart Attacks* (Philadelphia: Institute of Contemporary Art, University of Pennsylvania, 1995), 11.

17. Marjorie Simon, "Pat Flynn: Making Things Right," *Metalsmith* 16 (Fall 1996): 13.

18. Harriete Berman, e-mail correspondence with Bruce Metcalf, February 21, 2007.

19. Elizabeth Cook-Romero, "Tom Joyce, Forging Ahead," *Santa Fe New Mexican*, October 12, 2006, <www.freenewmexican.com//news/50564.html>.

20. Stephen Beal, *Men of the Cloth: Contemporary Fiber Art* (Loveland, Colo.: Loveland Museum/Gallery, 1999), 14.

21. "Randall Darwall: Infusing Function with Life," *Fiberarts* 21 (March–April 1995): 41.

22. Anne West, "The Woven Imagination," in *Sandra Brownlee: Weaving Out Loud* (Toronto: Museum for Textiles Contemporary Gallery, 1995), 13.

23. Jessica Scarborough, "Contemporary Archaeology: The Baskets of Lissa Hunter," *Fiberarts* 8 (September–October 1982): 25.

24. Fred Camper, "Nick Cave: Stuff of Life," *American Craft* 58 (October–November 1998): 76, and artist's statement in *The Surface Designer's Art: Contemporary Fabric Printers, Painters and Dyers* (Asheville, N.C.: Lark Books, 1993), 106.

25. Quoted in Joan Simon, "Drawing on Tradition," in *Cynthia Schira*, Portfolio Collection 30 (Winchester, U.K.: Telos, 2003), 34.

26. Lydia Matthews, "Expanding Networks and Professional Proposals: Shaping the Future of Craft in an Age of Wicked Problems," in *Shaping the Future of Craft: 2006 National Leadership Conference* (New York: American Craft Council, 2007), 20.

27. Scott Landis, "Furniture with a Sense of Place," in *Tradition in Contemporary Furniture*, ed. Rick Mastelli and John Kelsey (Free Union, Va.: Furniture Society, 2001), 128–39.

28. Rosanne Somerson, artist's statement, in *Masterworks* (New York: Peter Joseph Gallery, 1991), 50.

29. Bob Trotman, artist's statement, bobtrotman.com/about.

30. Daisy Youngblood, artist's statement, in *Daisy Youngblood* (Glenside, Penn.: Beaver College Art Gallery, 1992), unpaged.

31. This account is based on Karen S. Chambers, "Sergei Isupov," *American Craft* 59 (February–March 1999): 62–65.

32. Thomas Piché Jr., "Kathy Butterly at Tang Teaching Museum," *American Craft* 66 (February–March 2006): 87.

33. Ken Johnson, "Art in Review: Annabeth Rosen," *New York Times*, March 28, 2003.

34. Artist statement in *Tony Marsh* (New York: Garth Clark Gallery, 2002), unpaged.

35. Lloyd E. Herman, *Art That Works: Decorative Arts of the Eighties Crafted in America* (Seattle: University of Washington Press, 1990), 20.

ACKNOWLEDGMENTS

In 2002 the Center for Craft, Creativity and Design (CCCD), a regional center of the University of North Carolina, held the first North Carolina Craft Think Tank, convening leaders in the field to a meeting that would identify and prioritize initiatives to advance craft in America. The group selected a history of craft in America, which could be used as an undergraduate text, as the highest-priority initiative. Participants in the 2003 North Carolina Craft Think Tank brainstormed the original outline for the book, and by 2004 authors Janet Koplos and Bruce Metcalf began research for the history under the auspices of the CCCD. Participants in the 2002 and 2003 Think Tanks included Glenn Adamson, Joan Falconer Byrd, Garth Clark, Edward (Ned) Cooke Jr., Diane Douglas, Mary F. Douglas, Robert Ebendorf, Andrew Glasgow, Vicki Halper, Janet Koplos, Martha Drexler Lynn, James Melchert, Bruce Metcalf, Bruce Pepich, James Tanner, Kenneth Trapp, and Consuelo Jimenez Underwood.

As research progressed, this major endeavor was aided by members of a national advisory committee recognized for their knowledge of specific craft media: W. Scott Braznell, independent scholar; Wendell Castle, furniture artist; Edward S. Cooke Jr., chair of the Department of the History of Art, Yale University; Arline Fisch, professor of art emeritus at San Diego State University; Andrew Glasgow, then director of the Furniture Society; Peter Held, curator of the Ceramics Research Center, Arizona State University Museum of Art; Robert Kehlmann, glass artist; Gyongy Laky, then professor of design at the University of California at Davis; Mark Richard Leach, then director of the Mint Museum of Craft + Design; Albert LeCoff, director of the Wood Turning Center; Gloria Lieberman, Skinner, Inc.; Wendy Maruyama, professor of art at San Diego State University; John McQueen, basketry artist; Jim Melchert, professor of art emeritus at the University of California, Berkeley; Michael Monroe, director and chief curator of the Bellevue Museum of Art; Tina Oldknow, curator of modern glass at the Corning Museum of Glass; Joyce Scott, artist; Kenneth Trapp, independent scholar; Jim Wallace, former director of the National Ornamental Metal Museum; Gerry Williams, former editor of *Studio Potter* magazine; and Anne Wilson, professor at the School of the Art Institute of Chicago.

Special thanks go to Carmine Branagan, former executive director of the American Craft Council, as well as Michael McKay of the ACC and David Shuford, ACC librarian. The ACC library is the only public collection of books and catalogs in the United States devoted specifically to modern crafts. Without this invaluable resource, it would have been nearly impossible to create this book. Glenn Adamson of the Victoria and Albert Museum, London, also aided the effort.

A project of this scope and significance to the craft field required major financial support. The Windgate Charitable Foundation took the lead as a major contributor to this publication, as it has in so many craft programs across the country. Craft organizations recognizing the need for this publication with their support include the American Craft Council, Collectors of Wood Art, Friends of Fiber Art International, and the Society of North American Goldsmiths. Private foundations supporting the project include the Rotassa Foundation, the Fidelity Foundation, and Furthermore: a program of the J. M. Kaplan Fund. Individual contributions to the publication include the Andora Gallery, Ken and JoAnn Edwards, the Grainer Family Foundation, John and Robyn Horn, Dewey Garrett, the Karma Foundation, Dian Magie, Terry F. Moritz, George and Dorothy Saxe, the Greenburg Foundation, and David and Ruth Waterbury. This project is also supported in part by an award from the National Endowment for the Arts.

The University of North Carolina Press was selected to publish the book, guided by Assistant Director and Senior Editor Chuck Grench. Preparation of the manuscript for publication included copyediting by Karen Jacobson and Kathleen Preciado, creation of an image data file by Constance Humphries, and clearance of rights for reproducing images by Kristen Watts. Dian Magie, executive director of The Center for Craft, Creativity and Design, a regional center of the University of North Carolina, provided administration and fund-raising for the project through publication, with the assistance of Assistant Director Katie Lee. UNC campuses affiliated with the CCCD are the University of North Carolina at Asheville, Appalachian State University, and Western Carolina University.

On the book's companion website,

<www.americanstudiocrafthistory.org>,

readers will find an expanded list of the many individuals and institutions that contributed to this complex project, truly a community of friends. To any we have inadvertently omitted, our apologies and our gratitude! Please also refer to the website for an extensive bibliography, a glossary, additional images, and supplementary material for many chapters.

NATIONAL
ENDOWMENT
FOR THE ARTS

INDEX

Note: Italic page numbers refer to illustrations.